W9-DBR-285

Futurism&Futurisms

FUTURISMO &

FUTURISMi

Futurism&Futurisms

Organized by
Pontus Hulten

Palazzo Grassi
Venice

Abbeville Press
Publishers New York

Page 6: *Train Born from the Sun*
Fortunato Depero, 1924
Oil on canvas, 131 x 90.5 cm.
Private collection

Translated from the Italian by Asterisco, Karin Winter Beatty, Andreana Emo Capodilista, Jean Chapman, Doriana Comerlati, Patrick Creagh, Jane Dollman, Rosangela Fiori, Clive Howard Foster, Margaret Kunzle, Carol Lee Rathman, Anthony Shugaar, and Clive Unger-Hamilton.

First American Edition
ISBN 0-89659-675-3
Printed and bound in Italy

LC Number: 86-17271

With "Futurism & Futurisms" the "Society Azioni Palazzo Grassi" starts its activity. The exhibition aims to give an overview of one of the most intense and interesting cultural movements of our century, which appeared in different forms in different countries, with a complex interweaving of linguistic and artistic inventions. But the exhibition is also intended to represent the first realization of the new Company's program, which is to provide a fresh space for cultural enterprise, organizing exhibitions, conferences and performances that will make possible a better understanding of past and present history, and of the connections between culture and the society, industry, and economy in which it lives.

Their wish to represent an international point of reference in this field has led the Company promoters to choose Venice as their base, a city where art and economy flourished at the highest level, a city that today stands at the center of the world's cultural currents.

This choice was encouraged by the opportunity of acquiring a historical palace dating from the 18th century, Palazzo Grassi, that has been transformed and equipped with all the modern facilities needed to host exhibitions of the highest prestige.

The "Society Azioni Palazzo Grassi" was founded in 1984 as an extension of a great industry's commitment toward the problems and expectations of the world. This commitment is certainly not new, as is evidenced by initiatives taken in the recent past, but in this case it becomes permanent, not episodic, to show its awareness that economic realities are part of a wider dimension, in which the various parts complement one another and together contribute to the continuous progress of society.

President
Feliciano Benvenuti

General Manager
Giuseppe Donegà

Artistic Director
Pontus Hulten

Contents

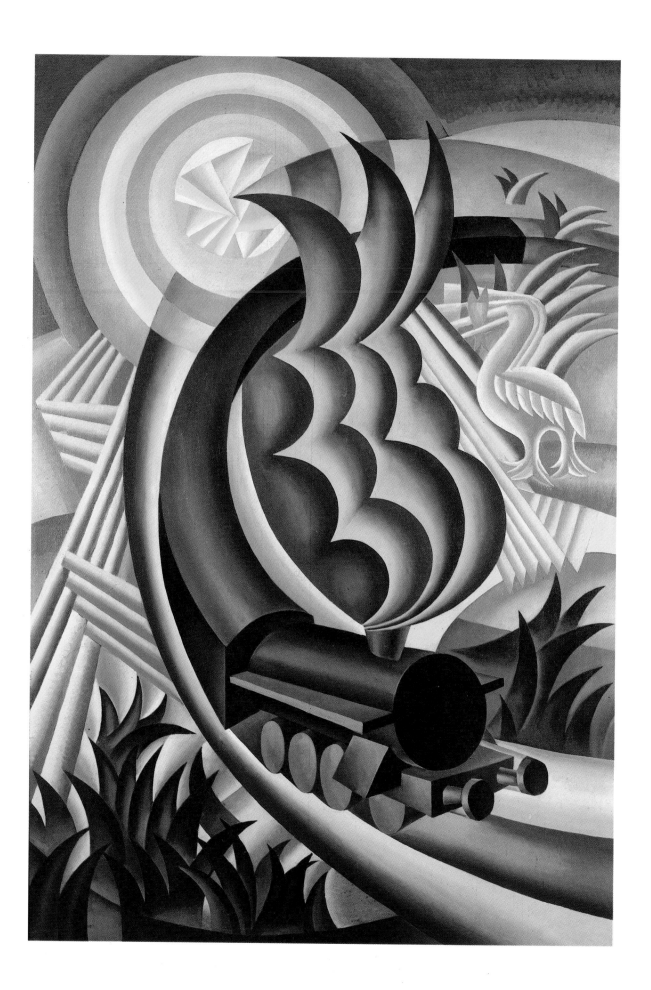

Acknowledgments

I would like to thank a certain number of people for making this exhibition possible.

First of all Giovanni Agnelli who had enough confidence to give me this opportunity.

The exhibition was prepared during the restoration of Palazzo Grassi, a major enterprise directed by Gae Aulenti and Antonio Foscari. They did most beautiful work, bringing the Palazzo back to its old splendour and equipping it with the most perfectioned installations.

Gae Aulenti is the architect of the exhibition and it has been a pleasure to work with her.

Pierluigi Cerri has shaped the catalogue. He has given it its clearness and beauty. He has also designed the posters and other printed material connected with the exhibition.

The group directly responsible for this exhibition is not very large:

Ida Gianelli has been coordinating both the exhibition and the catalogue. With her intelligence, patience and stamina she has at all times kept the plans for the exhibition together and at every moment preserved the quality of the operation.

Three experts and friends have worked on the exhibition and all of them have been involved in every part of it.

Germano Celant has specially taken care of several different aspects of Futurism such as architecture, photography, theatre, cinema, music, interior decoration and fashion. He has conceived the section called "Futurism and Everyday Life". He has formulated the section dealing with Italian Futurism after 1918.

Serge Faucherau has been specially responsible for literature. He took a particular interest in all aspects of Futurism in countries like Great Britain and Mexico.

Stanislas Zadora was specially concerned with the Futurism of the Eastern European countries. He has discovered a number of little or virtually unknown Futurist artists. It would not be right for me to thank these individuals, as if they had been somehow less connected with the exhibition than I have been myself. We did put the exhibition together, it was a common adventure. Tina Marengo's efficient kindness was greatly instrumental for the elaboration of exhibition.

We want to thank the Ministry of Culture and its Minister Antonino Gullotti for the efficient support that he has given our project all along.

Two "Futurist" families have been very helpful: the Marinetti family and the Balla family. To Ala, Luce and Vittoria Marinetti and to Elica and Luce Balla go our most sincere thanks.

Guido Rossi gave invaluable help at all times.

Gianluigi Gabetti intervened at the very beginning of the preparations in a way that became determinant.

A great many museums, galleries and private collectors have helped with loans. They are listed separately, we thank them from our hearts. The Museum of Modern Art in New York and its Director of Collections and Exhibitions William Rubin and its General Director Richard Oldenburg, very early in the process of preparing the exhibition decided to support the project with an extensive loan from what is the major collection of Italian Futurist work. This decision was obviously the most important backing that the exhibition could get.

The Fine Arts Museum in Philadelphia through its Director Ann d'Harnoncourt, who herself mounted a major exhibition of Futurist Art in her museum in 1981, is the other institution that very early decided to help our project and thus was setting the tone for other museums and also for private collectors around the world.

The Museum of Contemporary Art of São Paulo University and its Director Araci Amaral, permitted us to show in Europe, for the first time in more than half a century, the original plasters of Boccioni.

It was a great gesture of cultural responsibility.

Moderna Museet in Stockholm and its Director, Olle Granath, gave support when it was needed, so did Centro Storico Fiat and Stato Maggiore Aeronautica Militare.

For the literary part of our exhibition, three institutions have been especially helpful: The Humanities Research Center, University of Austin, Texas and particularly Carlton Lake, the Beinecke Library at Yale University, New Haven and its Director, Ralph Franklin and the Fondazione Primo Conti at Fiesole.

Several official services have supported us heartily in Mexico: The Ministry of Foreign Affairs, the Ministry of Public Education, the National Institute of Fine Arts and the Embassy of Mexico in Italy, the Embassy of Italy in Mexico. At this point our gratefulness also goes to all the private collectors and friends whose help was also determinant in Mexico City.

I wish to thank also the Italia-USSR Association.

Many institutions, organizations and individuals have gone to a great length to support this exhibition and we are most grateful. Amongst many supporters who have made extraordinary efforts, I would like to mention especially Marc Martin-Malburet and Kazyr Varnelis. Our most sincere thanks.

It would also be unfair not to mention various persons who devoted a lot of their time to our project: Massimo Carrà, Milan; François Daulte, Lausanne; Anne-Marie Héricourt, Paris; Irena Jakimowicz, Warsaw; Ivana Kilesova, Prague; Anthony d'Offay, London; Bianchina Riccio, Rome; Orlando de la Rosa, Mexico City; Erich Steingräber, Munich.

Last but not least my most hearty thanks to my colleagues at Palazzo Grassi Spa. For me it has been a great new experience to be part of such an efficient group. (PH)

Lenders to the Exhibition

Museums and Institutes

Albright-Knox Art Gallery, Buffalo, New York

Art Council of Great Britain, London

Art Gallery of Ontario, Toronto

Badische Landesbibliothek, Karlsruhe

Bayerische Staatsgemäldesammlungen, Munich

The Beinecke Rare Book and Manuscript Library, Yale University Library, New Haven, Connecticut

Berlinische Galerie, Berlin

Biblioteka Glowna Akademii Satuk Pieknych, Cracow

Bibliothèque Royale Albert Ier, Brussels

Birmingham Museums and Art Gallery, Birmingham

British Council, London

Cátedra Gaudí, E.T.S. Arquitectura, Barcelona

Centro de Arte Moderna, Fondação Calouste Gulbenkian, Lisbon

Musée National d'Art Moderne, Centre National d'Art et de Culture Georges Pompidou, Paris

Centro Studi Anton Giulio Bragaglia, Rome

Cinémathèque Française, Paris

Civico Gabinetto dei Disegni, Castello Sforzesco, Milan

Civica Galleria d'Arte Moderna, Milan

Civica Raccolta delle Stampe Achille Bertarelli, Castello Sforzesco, Milan

Civico Museo d'Arte Contemporanea Palazzo Reale, Milan

Civici Musei, Como, Italy

Collège de France, Paris

College of Fine Arts, University of Texas, Austin, Texas

Peggy Guggenheim Collection (Solomon R. Guggenheim Fund), Venice

The Dance Museum, Stockholm

Dipartimento di Storia dell'Arte dell'Università, Gabinetto Disegni e Stampe, Pisa

Diputació de Barcelona, Biblioteca de Catalunya, Barcelona

George Eastman House, International Museum of Photography, Rochester, N.Y.

The Fine Art Museum of San Francisco, San Francisco, California

Fondazione Russolo Pratella, Varese

Fondazione Primo Conti, Fiesole

Galleria Civica d'Arte Moderna, Ferrara

Galleria Civica d'Arte Moderna, Turin

Galleria Internazionale d'Arte Moderna Ca' Pesaro, Venice

Galleria Museo Depero, Musei Civici di Rovereto, Rovereto, Italy

Galleria Nazionale d'Arte Moderna, Rome

Haags Gemeentemuseum, The Hague

The Cecil Higgins Art Gallery, Bedford

Hirshhorn Museum and Sculpture Garden, Smithsonian Institution, Washington, D.C.

Houghton Library, Harvard University, Cambridge, Massachusetts

Archer Huntington Art Gallery, University of Texas, Austin, Texas

Imperial War Museum, London

Istituto Nacional de Bellas Artes, Mexico City

Kettle's Yard Gallery, University of Cambridge, Cambridgeshire, England

Kunsthaus, Zurich

Kunstmuseum, Düsseldorf

Lolland-Falsters Kunstmuseum, Maribo, Denmark

Malmö Museum, Malmö, Sweden

Magyar Nemzeti Galéria, Budapest

Metropolitan Museum of Art, New York

Moderna Museet, Stockholm

Munch-museet, Oslo

Musei Civici d'Arte e Storia, Brescia

Museo de Arte Contemporáneo, Universidade de São Paulo, São Paulo

Musée d'Art Moderne de la Ville de Paris, Paris

Musée des Beaux-Arts, Orléans

Musée des Beaux-Arts et de la Céramique, Rouen

Musée des Beaux-Arts, Valenciennes

Musée E.J. Marey et des Beaux-Arts, Beaune, France

Museum Ludwig, Cologne

Museum Bochum, Bochum, West Germany

Museum of Art, Carnegie Institute, Pittsburgh, Pennsylvania

Museum of Fine Arts, Houston

Museum of Modern Art, New York

Musée d'Orsay, Paris

Musée de Peinture et de Sculpture, Grenoble

Museo Medardo Rosso, Barzio

Museo Nazionale del Cinema, Turin

Musées Royaux des Beaux-Arts de Belgique, Brussels

Museo Provinciale d'Arte, Sezione d'Arte Contemporanea, Trento

Museo Teatrale alla Scala, Milan

Muzeum Górnóslaskie, Bytom, Poland

Muzeum Lenina, Warsaw

Muzeum Literatury, Warsaw

Muzeum Narodowe, Warsaw

Muzeum Narodowe, Poznań

Muzeum Sztuki, Lódź

National Gallery of Art, Washington, D.C.

National Gallery of Canada, Ottawa

National Gallery of Victoria, Melbourne

Národni Galeri, Prague

Národni Muzeum, Prague

Nemzeti Széchényi Könyvtár, Budapest

Neuberger Museum, State University of New York at Purchase, New York

Ohara Museum of Art, Okayama

Oeffentliche Kunstsammlung Kunstmuseum, Basel

Petöfi Irodalmi Múzeum, Budapest

Philadelphia Museum of Art, Philadelphia, Pennsylvania

Pinacoteca di Brera, Milan

Harry Ransom Humanities Research Center, University of Texas, Austin, Texas

Santa Barbara Museum of Art, Santa Barbara, California

Sheldon Memorial Art Gallery, University of Nebraska, Lincoln, Nebraska

The Solomon R. Guggenheim Museum, New York

Staatsbibliothek Preussischer Kulturbesitz, Berlin

Städtische Galerie im Städelschen Kunstinstitut, Frankfurt am Main

Städtische Galerie Albstadt Städtische Kunstsammlungen, Albstadt, West Germany

Städtische Galerie im Lenbachhaus, Munich

Stedelijk Museum, Amsterdam

Svenska Filminstitutet, Stockholm

Tate Gallery, London

Van Abbemuseum, Eindhoven

Victoria & Albert Museum, London

Von-der-Heydt-Museum, Wuppertal, West Germany

Wadsworth Atheneum, Hartford, Connecticut

Walker Art Center, Minneapolis, Minnesota

Whitney Museum of American Art, New York

Wilhelm-Hack-Museum, Ludwigshafen am Rhein

The Whitworth Art Gallery, University of Manchester, Lancashire, England

Yale University Art Gallery, New Haven, Connecticut

Západočeská Galerie v Plzni, Plzeň, Czechoslovakia

Private Collections and Galleries

Joan Abelló Juanpere, Barcelona

Paride Accetti, Milan

Rachel Adler, New York

Arlette Albert-Birot, Paris

Alva de la Canal Family

Augusto Alvini, Milan

Thomas Ammann Fine Art, Zurich

Gaetano Anzalone, Rome

Automobile Club d'Italia, Rome

Elica e Luce Balla, Rome

Banca Commerciale Italiana, Milan

Eugène Baranoff-Rossiné, Paris

Timothy Baum, New York

A. Belenius, Stockholm

Loriano Bertini, Calenzano

Marc Blondeau, Paris

Fulgenzio Borsani, Varedo

Silvia e Angelo Calmarini, Milan

Davide Campari - Milano S.p.A., Milan

Rodney Capstick-Dale, London

Massimo Carrà, Milan

Carus Gallery, New York

Leonardo Clerici, Istituto di Scriptura, Rome

Pieter Coray, Lugano

Richard and Vena Cork, London

George Costakis / Art Company Ltd, Nassau

Maria Galán de Cueto, Mexico City

Francesco Dal Co, Venice

Beatrice B. Davis, Kansas City, Missouri

Charles Delaunay, Paris

Galleria dello Scudo, Verona

Paul Destribats, Paris

Terry Dintenfass Gallery, New York

Anthony d'Offay Gallery, London

Jean Dypréau, Brussels

Salomé Eleuterio-Lligonya, Barcelona

Rosa Esman Gallery, New York

Salome and Eric Estorick, London

Galleria Farsetti, Prato

Galleria Gian Ferrari, Milan

Galerie Karl Flinker, Paris

Galleria Fonte d'Abisso Edizioni, Modena

Antonio e Marina Forchino, Turin

Forum Gallery, New York

Giorgio Franchetti, Rome

Nino and Gina Franchina, Rome

Salvatore Giaquinto, Naples

William Hardie, New Lanark-Strathclyde

Hirsh & Adler Galleries, New York

Leonard Hutton Galleries, New York

Ella Jaffe Freidus, New York

Riccardo and Magda Jucker, Milan

Annely Juda Fine Arts, London

Fernando Leal, Mexico City

B. Lohaus-De Decker, Antwerp

Tai Kanbara, Tokyo

Rudolf Kicken, Cologne

Paul Kovesdy Gallery, New York

Galerie Jean Krugier, Geneva

Germán List Arzubide, Mexico City

Susi Magnelli, Meudon

Blanca de Maples Arce, Mexico City

Marchi Family, Anzio

Ala Marinetti, Rome

Luce Marinetti, Rome

Vittoria Marinetti, Milan

Marlborough Fine Arts, London

Martin Diamonds, New York

Marc Martin Malburet, Paris

Mattioli, Milan

N. Richard Miller, New York

Jan and Meda Mladek, Washington, D.C.

Modernage Ltd., New York

Morton G. Neumann Family, New York

Harvey Mudd, Santa Fé

Galleria Narciso, Turin

Italo Pietra, Romagnese (Pavia)

Pinacoteca della Cassa di Risparmio di Macerata, Macerata

Eda Pratella, Ravenna

The Regis Collection, Minneapolis

Silvestre Revueltas, Mexico City

Salvador Riera, Barcelona

V.A. Rodčenko, Moscow

Michel Roethel, Paris

Laura Ronchi Braga, Brescia

Frederick Roos, Zurich

Danila Rosso Parravicini, Milan

Savinio Estate, Rome

Omar Shakespear Pound, Princeton

Galerie Nathalie Seroussi, Paris

Paolo Sprovieri, Rome

Alain Tarica, New York

Thyssen-Bornemisza, Lugano

R. e M. Santos Torroella, Barcelona

Turske & Turske Galerie, Zurich

René-Jean Ullmann, Paris

Milena Ugolini, Rome

Luis Araujo Valdivia, Mexico City

Juame Vallcorba Plana, Barcelona

Ronny Van De Velde, Antwerp

Maurice Verbaet, Hove

Eugene Victor Thaw Co Ltd, New York

Antonella Vigliani Bragaglia, Rome

Anna Lena Wibom, Stockholm

Sam and Ayala Zacks Abramov, Jerusalem

and others who wished to remain anonymous

Futurism&Futurisms

Futurism & Futurisms
by Pontus Hulten

It has frequently been necessary to go back and explore the great moments of the early 20th century, moments that have been forgotten due to the century's complex history and the tragic events of a long and difficult intermediary period. The revolutionary impact of the cultural events before World War One has become obscured and must be re-established.

In Paris a series of four exhibitions were organized which traced the cultural interchange between Paris and New York, Paris and Berlin, Paris and Moscow, and Moscow and Paris. In terms of establishing the identity of France and of Paris, these exhibitions were important. They demonstrated in all their complexity the exchanges that took place between French culture and three other countries. These exhibitions reinforced our ideas about the beginning of the 20th century and the origin of our present situation. Thus they concerned the identity of today — both the identity of a culture and a city and the identity of a century.

Discovering the mistakes that the intellectuals at the turn of the century sometimes permitted themselves to make has been part of the experience of rediscovering our predecessors. And it is not a minor adventure to see with what courage and strength they launched the new age, even if many of their innovations were later left behind. Generally speaking, the century was to become the apotheosis of the visual, and the artists' productions in many cases survived more gracefully than did the literature.

Futurist pictorial art is more polyvalent and less obviously aggressive than the literature; perhaps the intrinsic beauty of the artists' materials prevented their works from becoming too violent.

Like the Paris exhibitions, this exhibition will establish the identity of the Italian voice within the international discussion of those years.

We tend to think of our own period as extraordinarily fragmented and diverse, but actually the Futurist period was no different.

In the same year that Matisse painted *Luxe, Calme et Volupté*, which represented what was then the most radically new in French art, Marinetti wrote *Let's Kill Moonlight*. Two utterly contradictory and extreme statements!

The exhibition "Futurism & Futurisms" is the first of its kind in Europe. A beautiful Futurist exhibition was displayed in the Fine Arts Museum in Philadelphia in 1981, and has been an inspiration for us while working on this show. Its catalogue remains one of the best contemporary documents on the subject. There have been Futurist exhibitions in France and elsewhere, but they were limited by the conception that Futurism was a specifically Italian art movement. In the exhibition at Palazzo Grassi, Futurism will be studied for the first time as an international cultural phenomenon involving virtually every aspect of culture: painting, sculpture, literature, architecture, music, photography, typography, theatre, cinema, fashion and interior decoration. Thus we can see Futurism as "arte totale", an all-encompassing cultural expression that produced an answer to any question posed.

Futurism is a very Italian product and its ambitions probably reflect the national characteristics. It required a sense of the grandiose to conceive and launch a new movement using the model of the Baroque, a general programme that embraced all aspects of culture. In this exhibition an effort is made to display and explain in the best possible way the extraordinary Futurist literature in its many different languages and settings — from Russia to Mexico, from Japan to Great Britain.

The first time something new is expressed, the expression may be crude and immature, but the new later appears in its purest and most impressive form. In pictorial art the first years are the most interesting. They are the launching years when the fight is the hardest because the environment is still, in most cases, hostile to the new; they are the years of the strongest concentration, because of the surrounding tension. They are also the years of struggle with the media of expression in order to define in the clearest way the new ideals. Little by little a decorative tendency appears; the attitude behind the work is not so much one of effort as of production. There is a period of good, mature work, and then the decorative begins to take over. In the case of Futurism, the strong period was relatively long; it lasted from 1909-10 until 1918. There seems to be a metaphysical reason

for the great number of major works produced in those years. ("Metaphysics" is used here in the sense of appealing to the unconscious.) The force and speed of the evolution was an incitement in itself, movement was an element of stabilization, as when one is cycling.

The going was good, very good for a number of years. Then towards the end of the war many things changed — Boccioni and Sant'Elia died; the frontiers opened again. Futurism entered a different phase, Cubism in France was dead and the Dada movement, which had learnt much from the Futurists, began to attract young artists and intellectuals around the world. A special section will be devoted to Futurist architecture in this exhibition, and it may be one of the most surprising.

This architecture, which said goodbye to archeology and hailed the new technology, was aborted in its homeland by the premature death in the war of its main figure, Antonio Sant'Elia, but was further developed by the next generation. A great number of the ideas that later became central to the functionalist theories of Gropius and Le Corbusier were already present in Boccioni's and Sant'Elia's texts on architecture. In his drawings, Sant'Elia's ideal city is conceived as a man-made mechanized mountain landscape, artificial Alps whose peaks and valleys are built of steel and glass, connected by escalators and elevators leading to different levels in connected complexes. These mountains were to be decorated by gigantic neon images and publicity slogans; it would be the city of the progressive, pluralistic, biomechanical men and women of the future.

The most extreme ideas in the Futurist manifesto on architecture, "each generation creates its own architecture in exchangeable materials", was not understood until much later, by Buckminster Fuller and the Archigram-Group of London in the Sixties, with their "plug-in city" and "instant architecture". The Centre Georges Pompidou in Paris, conceived by two architects of Italian origin, Renzo Piano and Richard Rogers, and completed in the beginning of 1977, is clearly an expression of Futurist ideas in architecture.

Many different, but related, activities have been scheduled to coincide with the exhibition in Palazzo Grassi. There will be a varied film programme connected with the exhibition, and a special publication dedicated to Futurism and film. The cinema played a central role in the Futurist world; the movement studies by the American Eadweard Muybridge and the Frenchman Etienne-Jules Marey, who spent much time in Italy, were essential in formulating the Futurist image. Mareys's studies became one of the most important factors leading to the creation of the cinema — one could say that he invented the movies. His movement studies will be displayed in the exhibition. The few films that are directly related to Italian Futurism will be shown, along with a great many important productions inspired by Futurist ideas.

The exhibition is divided in three sections: "Towards Futurism", "Futurism" and "Futurisms". The small section "Towards Futurism" will occupy four rooms on the ground floor of Palazzo Grassi and contain works that were created independently in different countries between the Eighties and 1909, the year of the first Futurist manifesto. This material has been drawn from science, literature, photography and film. There are also paintings, sculpture and drawings. Also in this section are works by Italian Futurists produced previous to 1909. "Futurism" occupies the entire first floor of Palazzo Grassi and contains the works of the Italian Futurists created between 1909 and 1918. "Futurisms" is presented on the second floor of the Palazzo and traces the extraordinary expansion of Futurist ideas from 1909-10 until the mid-Twenties. It also follows developments in Italy after World War One. This section ends with a presentation called "Futurism and Everyday Life", demonstrating how the Futurist style penetrated the environment. There are plans for a continuous presentation of Futurist cinema and related films shown on video monitors to be included in this section.

14

Futurist Prophecies
by Pontus Hulten

*"What you so rightly
thought though it was wrong..."*

An exhibition in Venice on Futurism can be seen as an ironic comment on the history of 20th century culture as a whole. This city was the special target of the contempt of Filippo Tommaso Marinetti and the other Futurists. It was for them the apotheosis of passéism; they singled out Venice to represent the kind of Italian culture that had to be defeated and destroyed, to give way to a new future. In this programme the Futurists failed shamefully, for the historical Venice is more protected than ever, sometimes to an absurd and self-destructive degree. The present-day attitude toward the past is an illustration of our dependence upon history.

Archeology takes precedence over construction, by law. We protect the physical monuments, the old buildings, the old cities, but our interest even embraces the history of families, regions, nations, in a way previously unknown.

On the other hand the new has triumphed in a way similar to the Futurists' wildest and most aggressive fantasies. High technology skyscrapers, freeways, space travel — all belong to everyday life. Marinetti understood that the new culture was to be of a technological nature; but to see a robotized automobile factory in modern-day Turin would nevertheless be a shock to him. He died in 1944, little more than forty years ago and it would surely be hard for him to realize that his outrageous prophecies, thrown out as aggressive jokes and provocations, had so soon become realities.

The Futurists wanted wars in order to clean the world, and they got wars, to the point that the world received such a good cleaning that little was left. However, the new, from which a part of the world population is now profiting, is not the product of war but of peace; for forty years, under the shadow of a world catastrophe, humanity has lived in relative peace compared to the first half of the century. The glorification of war has come to seem very old-fashioned, a definitely *passéist* notion.

The idea of the new triumphed in the middle part of the century. In the field of art, quality was for many years identical with invention, and one source of this conviction was the Futurist conception of the new. Recently we have, at least momentarily, become tired of this notion and have adopted a more mannerist attitude, mixing old and new in complicated systems of reference. The Futurists had the advantage of a simpler frame of reference. For young people in Italy in 1900 there were two worlds before their eyes, the old and the new. In countries like Italy and Russia this contrast was more exaggerated than, for example, in France, and this probably explains the differences in the attitudes adopted by the young people and their subsequent reactions. In France the new technology entered gradually; one must remember that the first automobile (Cugnot) existed in France before the revolution in 1789. In Italy the new was largely an imported product and the contrast between old and new was therefore much sharper. Consequently the reactions were stronger, more violent, less nuanced.

The two great nations of Europe (France and Italy) launched two different cultural movements: Cubism and Futurism, each movement characteristic of the nation where it was born. Both movements were essentially theories of visual expression, and in fact the century became visually oriented. Cubism profoundly influenced both the way we see and the way we conceive the world. The Cubists put a large question mark after the Reinaissance theory of perspective, created by Alberti and Brunelleschi, and replaced it with a new theory. Cubist ideas penetrated virtually every form of expression after 1910 in a profound and permanent fashion; they represented a new art and therefore a new man.

Within the cultural milieu of 1910, Cubism was an elite affair, fully accessible intellectually to only a small number of people. But the world was waking up to a new age, the industrial and technological age, and this awakening affected even peripheral and less educated areas. Futurism had no less influence than Cubism but its tactics and theories were different. Cubism was individualistic and contemplative; Futurism was social, political and aggressive.

One of the elements that Cubism and Futurism held in common was an interest in movement, a fascination with the dynamics of existence; they both revolted against the old static manner of perception. The study of movement in modern times began at approximately the same moment in

the late 19th century with two different men, Etienne-Jules Marey in Paris and Eadweard Muybridge in California. Marey was a highly cultivated Parisian, a professor and a physiologist. He was acquainted with the most sophisticated painters and poets of his time. (He seems, for example, to have known Rimbaud.) Muybridge was an adventurer (he was involved in a murder case) who began his study of movement in 1872 when Leland Stanford, the ex-governor of California, commissioned him to take photographs of a racehorse of which he was especially proud. (The famous legend that Stanford wished to win a bet about whether a galloping horse ever has all its feet off the ground at one time unfortunately seems to be apocryphal. However, Muybridge's photographs did in fact establish that this is the case.) The respective approaches of the two men were as different as their personalities and environments. Marey worked in a methodical subjective manner, and Muybridge in a more aggressive, social, even political fashion. The resulting difference in procedure was that Marey tried to synthesize on a single photographic plate successive movements such as those of a bird, as seen from a single point of view. One person looked through a lens that followed the trajectory of the subject. Muybridge, on the contrary, set up several cameras side by side, so that each one successively captured an isolated picture of movement; the separate images were then combined to approximate the flow of movements.

The connections between these first modern studies of movement and space and the birth of Cubism and Futurism in Paris and Italy at the beginning of the century have often been studied and described but are still not very clear.

The conception of movement and space proposed by Picasso and Braque in the analytical phase of Cubism is of a contemplative, clinical, subjective, almost introverted type, based on studies of what happens when the eyes of one person move over an object, a landscape or a figure. A Cubist painting can show the different aspects of a drinking glass, for example, in one image: in profile, seen from below, seen from above, etc., but it is not the glass that has moved, it is the gaze of the spectator (the artist). The environment of the operation is the artist's studio, or the space surrounding the artist and his easel. The spiritual atmosphere of the creation is dominated by a feeling of intimacy between the painter and his subject, an atmosphere of patience and formal contemplation in a kind of studio-laboratory. It is a new concept of perspective more than a study of movement. The underlying attitude is more psychological than literary, as much an exploration of the self as of the world.

The Futurist involvement with movement was of another kind. The agitation, even the violence, of the new industrial society was the subject of their interest, and their inspiration was more literary. If French Cubism was the result of a long, complicated and mostly obscure evolution, combining elements taken from Symbolist poetry, from the most advanced science of the period, and from philosophy and mathematics, Italian Futurism was the almost single-handed creation of Filippo Tommaso Marinetti. Futurism's characteristic fascination with movement arose out of an intelligent analysis of what was specific in the new, and a wilful application of the result of this analysis. This attitude resembled Muybridge's method of study in its clear-cut forcefulness, its application of great means and resources, its great power of realization.

There is no doubt that Marinetti created Futurism as an Italian answer to the discoveries in Paris, and it is of course for that reason that in February 1909 he published his Futurist Manifesto in the Parisian newspaper *Le Figaro*. When the Manifesto was published not a single Futurist painting or sculpture had yet been conceived. It was through Marinetti's extraordinary energy and through his financial resources that the movement was launched and developed with such lightning rapidity. At the time of the publishing of the first manifesto, Balla was a Post-Impressionist Symbolist painter of great talent, but without the force that he later achieved as a Futurist. Boccioni, who was much younger (born in 1882, whereas Balla was born in 1871), had produced brilliant work in several eclectic styles, but was nothing more than ''promising'' in 1909. Only a full year later, in February 1910, did Marinetti meet those who would become the great

Futurist painters. He virtually enrolled all of them — Balla, Boccioni, Carrà, Russolo and Severini — in a creative venture that has no counterpart in modern cultural history. He could do this because he possessed a unique combination of skill and strength.

Futurism became an unprecedented success. One of the reasons was that a cultural vacuum existed in Europe, which was strongly felt by young people. They possessed much more money and education than their fathers and mothers had, and the bourgeois society with its established tastes and opinions seemed stale and confining. Strindberg wrote: "Wreck, to get air and light". The anarchist movement, which had a mostly proletarian following, seemed to set an example that could not be ignored.

This was true with regard to Italy and even more so with regard to countries such as Russia, Scandinavia, Spain and Portugal, even Mexico and Japan. Expanding industrialization and the media had created a new public, which could not be content with the warmed-over culture that their parents and grandparents had been served generation after generation. Futurism had an accessibility, a journalistic quality that appealed strongly to youth. It was perfectly clear that the future was going to be with the new, not with the old. The Futurists' aggressive delivery of their message was attractive.

At the turn of the century the French avant-garde was very isolated. There was scarcely any connection between official French cultural politics and the avant-garde. The avant-garde was highly individualistic, and each man and woman had his or her standpoint and opinion. The attitude was more scientific than journalistic (for example, Marcel Duchamp created some of his most important Dadaist works before the outbreak of World War One, but he did not think of showing them publicly). The rather exclusive, contemplative and introspective character of Cubism made it difficult to grasp and appreciate. Cubism was totally concentrated in Paris, in a small and sophisticated circle around Picasso and Apollinaire, neither of whom wanted to adopt the role of the prophet and leader of an international movement representing the *Zeitgeist*.

The situation in each country was different, but there was a general pattern. The closer to Paris, which was the centre, and the more established the bourgeois culture, the stronger was the resistance to the new ideas, and the more sophisticated the opposition of the bourgeoisie. Farther away the ideas met with a warmer reception, at least in some of the countries less bound by tradition. This distinction between a centre and the periphery became even more marked in the next, wartime phase, when Dada and Constructivism appeared. Far away from the centre, the surrounding support was weak but so was the resistance. The more sophisticated countries had to go through the Dada revolution, with its radical destruction of old values, whereas the more peripheral countries moved directly into a new, constructive phase, as there was less to be destroyed. Italy, which had already launched Futurism, had no Dada movement at all. Then the enormous political upheavals in the Twenties and Thirties again totally changed the international picture.

In the gigantic Russian Empire, whose young intellectuals were struggling to overcome their provincialism, Futurism experienced one of its high moments. The Russian "Cubo-Futurism", as Kazimir Malevich chose to call it, became a special brand, and in consequence an extraordinary artistic adventure took place. Cubo-Futurism led to the creation of Suprematism and the great Russian Futurist architecture inspired by Vladimir Tatlin's tower for the Fourth International of 1917. Russia was a nation without a great pictorial tradition, and this may be one reason why Futurism could develop there with such fantastic rapidity. Futurist literature also flourished for a few years in Russia, before, during and just after the revolution, with leading figures like Kruchenykh, Khlebnikov and Maiakovsky. Khlebnikov strongly insisted on what was characteristically Russian in his production and his position, but Maiakovsky modelled himself on Marinetti, and became a great traveller, performer and public figure, and an international torchbearer for Futurism. Marinetti and Maiakovsky thus became the figureheads of the two main branches of Futurism, the Italian and the Russian. Both in different ways became victims of their political roles, poets

destroyed by their involvement in political developments that they could not control, and the evolution of forces and ambitions to which they were too close to evaluate clearly. Maiakovsky committed suicide in 1930. Marinetti was by that time almost completely isolated from contemporary intellectual life.

In Germany very interesting things were occurring both in Munich and in Berlin during the first part of the century. But generally speaking Germany was only slightly touched by Futurism. Nevertheless, almost every good young German artist of the time produced a few Futurist works. The extraordinary self-sufficiency of the German bourgeois culture was hard to penetrate. The Dada movement would have to do the great revolutionary work, after the war, after 1918.

In Great Britain a dissident branch of Futurism, Vorticism, brought together for a very short time some of the most brilliant young intellectuals in the country. Poets such as Ezra Pound, painters such as Wyndham Lewis, Wadsworth and Bomberg, sculptors such as Gaudier-Brzeska and Jacob Epstein.

Who was this young Italian poet who created Futurism? At the beginning of the century, Filippo Tommaso Marinetti was an ambitious but rather conventional young Symbolist writer, dividing his time between Paris and Milan. He was born in Alexandria, and had the strong nationalist feelings of the foreign-born, who have to prove their patriotism to themselves and others. The very large fortune that he inherited as a young man from his father, gave him the power to expand his ideas that no other poet of his generation possessed, and he did not hesistate to use it.

One can guess that the poet in France who made the strongest impression on the young Marinetti was Alfred Jarry; and, later, the public figure who especially caught his eye was Guillaume Apollinaire, the great promotor and defender of the Cubists.

To understand the rapid expansion of Futurism in Italy and in the world, Marinetti's volcanic energy and ambition must be taken into account. He could also do what many poets dreamed of but could not afford: publish, if necessary, at his own expense, and travel when necessary. He could rent an art gallery for an exhibition or a theatre for a performance. It may be unusual to bring in an argument like this to explain the success of an art movement and a cultural phenomenon, but Marinetti is a very unusual and extraordinary poet.

He had a sense for public relations that has remained unsurpassed, at least in Europe. Maybe Barnum had some of Marinetti's talents. Half a century before Marshall McLuhan, Marinetti realized that "the medium is the message". One only has to look at the way he launched the first manifesto to see how daring and skilful he was at public relations. Through the efficient publication of a pseudo-event (the creation of Futurism) in the mass media, information became reality. Also the *Manifesto of the Futurist Painters* was published (1910) before there was much Futurist art to be seen. The information preceded and formed the evolution. Perhaps it could be said that Futurism, more than anything else, has formed the present media situation. It is not so much an example of art entering real life, as of art breaking out of its confinement within the cultural sphere. According to every testimony, Marinetti had phenomenal stage presence — he could magnetize the public with his enormous energy and wit. We are told that Marinetti asked a spectator who continued to whistle while he was reading one of his poems: "Has your head sprung a leak?"

Thanks to Marinetti, the Futurists were quite well organized. During the heroic years between 1909 and the middle of the war there was an office in Milan that took care of correspondence, publicity, distribution of books, pamphlets and manifestos, something that no other art movement had ever disposed of. H. Walden used it as a model when he organized Der Sturm in Berlin. It is believed that two thirds of the books, magazines and broadsheets that the Futurists published were distributed free of charge as "propaganda" material. The office followed in detail any mention of Futurism in the world press, whether in Japan, Armenia or South America. Marinetti was such an active correspondent that one recipient of his letters finally answered: "Just let me die in peace" (the composer Saint-Saëns).

Much of Marinetti's writing was aggressive and sometimes bombastic in tone and can be tiresome to read. This side of his work has not survived well. To understand the violence of Marinetti's statements one must remember that just before the Manifesto was published an extraordinary number of revolutionary books and theories had appeared. He felt that he had to compete with such works as:

Baudelaire, *Les fleurs du mal*, 1857
Marx, *Das Kapital*, 1867
Nietzsche, *Götterdämmerung*, 1888
Wilhelm Ostwald, *Die Überwindung
des wissenschaftlichen Materialismus*, 1895
H.G. Wells, *The Time Machine*, 1895
Bergson, *Matière et mémoire*, 1896
Emile Verhaeren, *Les villes tentaculaires*, 1896
Gabriele D'Annunzio, *La città morta*, 1898
Freud, *Traumdeutung*, 1900
Rudolf Steiner, *Theosophy*, 1904
Mario Morasso, *La nuova arma (la macchina)*, 1905
Bergson, *L'évolution créatrice*, 1907
Papini, *Il crepuscolo dei filosofi*, 1908
Georges Sorel, *Réflexions sur la violence*, 1908
Jules Romains, *La vie unanime*, 1908.

The two strongest personalities in the Futurist movement were Marinetti and Boccioni. Boccioni died at the age of thirty-four, in August 1916, in an accident during the war. One is of course tempted to speculate on what would have happened if, instead of disappearing, he had become the Futurist counterpart to Pablo Picasso, something that speculatively speaking is not at all impossible, considering the quality of the work he produced before he died. The saying that "nobody is irreplaceable" does not seem to be proven by history, at least as history is seen in the Western world. For example, if neither Marinetti nor Boccioni had existed, it is doubtful that Futurism would have existed. Boccioni's disappearance created a vacuum in Italian culture for a great number of years; none of the other Futurists could replace him.

One can take the next step and speculate about Marinetti's personality. If Marinetti had not been fascinated with violence and death, would Futurism have taken another road? A cultural phenomenon like Futurism depends on a great many factors: the evolution of history, the spirit of its birthplace, geography, economics, world events. But it also depends on a very small number of people and their strengths and weaknesses.

Marinetti called Futurism "an aesthetic of violence and blood". His cult of strength was related to his faith in evolution and optimism. He derived his ideas from Social Darwinism and from evolutionism in the natural sciences of the 19th century, but gave them an extreme interpretation, not realizing until it was too late the dangers of dehumanization, of *fisicofollia*, and of replacing human values with the concept of energy. He saw that humanity was being "materialized", and matter "dematerialized". War was to be the remedy and the agent for great changes. Even if much of Marinetti's worship of violence was there for its shock effect (*pour épater le bourgeois*) the events of the Thirties and Forties tragically illustrated what he had written.

Eros and Thanatos were confused in Marinetti's imagination, as they were in the Marquis de Sade's and Lautréamont's. Even if everybody can understand that sexuality is necessary for the continuation of the human race and that death is needed for the same reason, so are, for example, eating and medicine. This pathological confusion, several times expressed in Marinetti's writing, was perhaps the source of his worship of violence, and was certainly a determining element in his personality. The incompatibility of power and love seems not to have been clear to Marinetti. He seems to have had difficulty understanding the relation between sexuality and love. Perhaps this connection was too sophisticated and not scientific enough, not "new" enough. This problem is evident in a title such as *Contro l'amore ed il parlamentarismo* (and with Marinetti titles are important); it is a part of *War the Only Hygiene for the World*, 1915.

Marinetti at least had the courage to mention the word *amore*, he was not hiding behind a scientific term, as did most of the people involved in the emotional confusion of the Twenties and Thirties. The emotional crisis of the mid-century is still with us today, and it is the element in this century that is the hardest to understand and digest.

It is no accident that the five major Futurist artists each painted before 1914 one large ambitious and important painting: Balla, *Speeding Car*; Boccioni, *The City Rises* (which was meant to be part of a triptych); Russolo, *Revolt*; Carrà, *Funeral of the Anarchist Galli*; Severini, *Pan-Pan a Monico* (now lost). The Futurists were a closely knit and well-organized group, almost like a commercial, political or military operation. To rival the Cubists in Paris was their aim.

Balla's most impressive Futurist work is undoubtedly the series called *Speeding Car*. There are between fifteen and twenty works in the series, all of different sizes, with a very large final painting. With the kind of methodical, stubborn, logical attitude that one expects from a scientist, Balla studied the cars passing on Via Veneto in Rome. The first small drawing represented a realistically drawn Fiat; only a single feather of dust by the back wheel showed that the car was in motion. Then in painting after painting (whose chronological order is not known) Balla developed the intricate interrelations between the rotation of the wheels, the movement of the car in its totality and the roar of the motor. Balla's cars in this series became more and more abstract. In the end, although the image no longer represented movement, it expressed movement.

Carrà's largest and most important Futurist work is *Funeral of the Anarchist Galli*. It is Carrà's counterpart to Boccioni's *The City Rises*. Carrà's aim in the painting was not to show the workers and the police on a specific occasion, but rather to depict powers in society confronting each other in a conflict determined by destiny.
Carrà had a profound and original conception of Futurism that he also expressed not only in paintings but in dense collages such as *Interventionist Demonstration*. When one sees the originals, one is surprised that they are so small and yet so monumental.

In the suite of great Futurist paintings Russolo's *Revolt* possesses the strongest symbolic density. This painting was probably the inspiration for Lissitsky's famous *Red Wedge*. Russolo was a mystic, and the energies he was interested in were transcendental. For Russolo, matter was a form of energy, as were music and aromas, but with a slower rate of vibration. His world was made of vibrations and pure sensibility. Russolo's main interest was perhaps his music. Those who heard his music-machines, the "intona-rumori", were surprised to find that the sounds were discreet and subtle, even difficult to hear.

Severini had a great formal talent and was very productive. In the great dance scenes that he painted, mostly in Paris, the pattern of movement is different from that of the other Futurist works. It is not a movement from right to left or left to right; rather it is centred and frontal, like a spasm in a mass of bodies. In this respect his work resembles that of the Cubists. Severini's dance paintings suggest different kinds of music: foxtrot, waltz, tango. In several portraits he experimented with a combination of Futurist and Cubist conceptions. Severini was to become the liaison between Paris and Milan.
These five large paintings definitively belong to the best work produced by the greatest Italian Futurist painters. None of these painters ever attained later a level of quality comparable to that of the works they produced between 1910 and 1918.

Futurist aesthetics have become a source of inspiration for several generations. The integration of the human figure in the environment, the idea that energy is running through matter and man (one aspect of the *fisicofollia*), has been assimilated by our culture. The Futurists embraced subjects that once lacked cultural status (science, technology, big cities) but are now part of our cultural heritage.
The media of today have enforced the notion of simultaneity to such a degree that one sometimes wants to escape it; so is it with the fragmentation of reality. Such a complex notion as the *state of mind*, the expression

of the combination of energies that exist in matter as well as in human beings, and their dynamic interaction, is not strange to us, although it has seldom been shown as beautifully as by Boccioni.

Sant'Elia's, Boccioni's and Marinetti's ideas about architecture were followed by the functionalist architects and theoreticians, and had their apotheosis in the Sixties in England. Great realizations in this vein have been made in France. Recently Futurist interior decoration has regained popularity, and probably will reappear from time to time.

Will there be a Futurist exhibition in the year 2986? What will it look like? Will it be as strange as the opening of a tomb-city in China with its miniature rivers of mercury, all surprising and beautiful? Or will it look almost like this one in Palazzo Grassi, assembled with love and care and a lot of work? One thing is sure, by accelerating time, Futurism has profoundly changed our ideas about ourselves and about history.

Towards Futurism 1880 — 1909

Giacomo Balla
Bankruptcy
1902
oil on canvas, 116 × 160 cm
Private Collection

Giacomo Balla
A Worker's Day
1904
oil on paper, 100 × 135 cm
Private Collection

Giacomo Balla
The Mad Woman
1905
oil on canvas, 175 × 115 cm
Private Collection

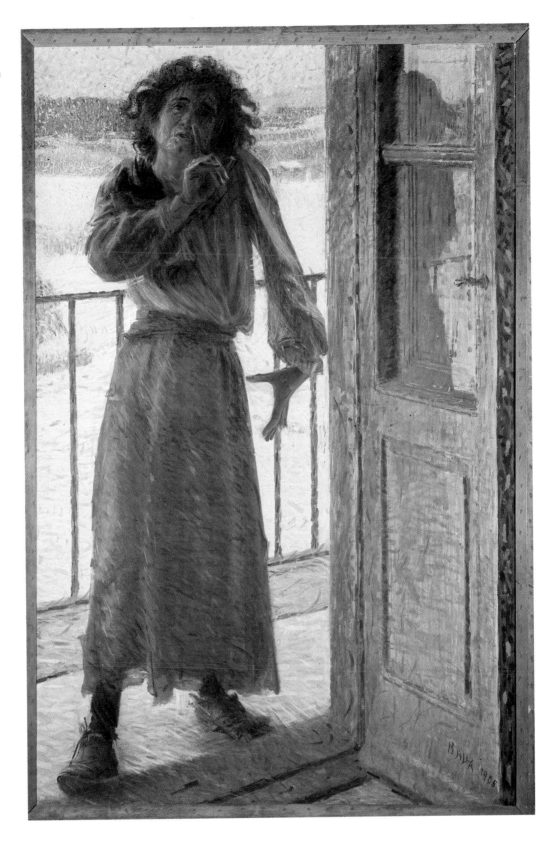

Wladimir Baranoff-Rossiné
Sunset on the Dniepr
1907
oil on canvas, 63 × 85 cm
Paris, Eugène Baranoff-Rossiné Collection

Baranoff-Rossiné and the other future
Russian Cubofuturists developped
a divisionist style parallel to the Italians

Umberto Boccioni
Speeding Car
or *Motor Car and Fox Hunting*
1904
tempera on thin paste-board, 55 × 105 cm
Automobile Club d'Italia

Umberto Boccioni
Workshops at the Porta Romana
1908
oil on canvas, 75 × 145 cm
Milan, Banca Commerciale Italiana S.p.A.

Umberto Boccioni
The Dream or *Paolo and Francesca*
1908-09
oil on canvas, 140 × 130 cm
Private Collection

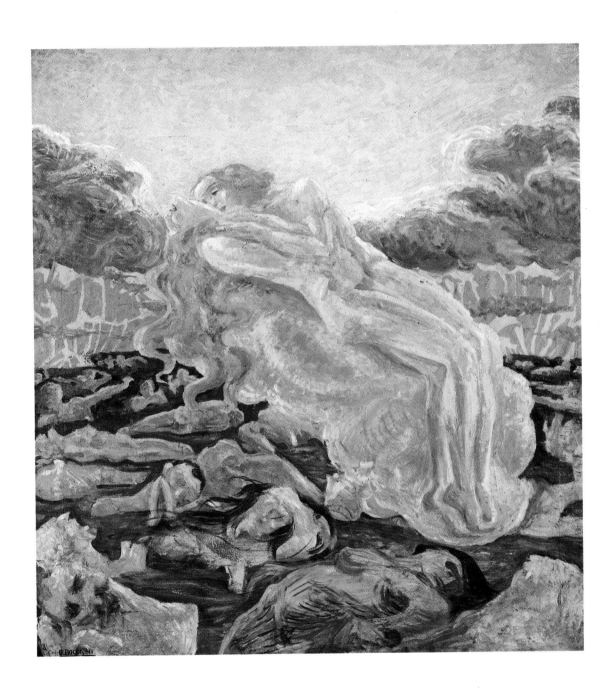

Carlo Carrà
Leaving the Theatre
1909
oil on canvas, 69 × 91 cm
on loan from Salome and Eric Estorick

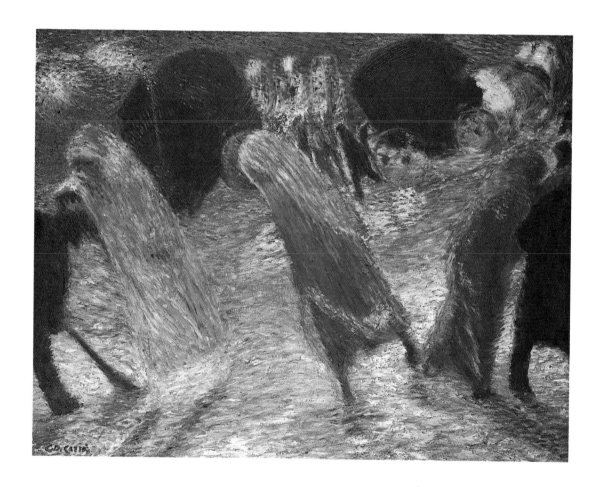

Carlo Carrà
Piazza del Duomo
1909
oil on canvas, 45 × 60 cm
Private Collection

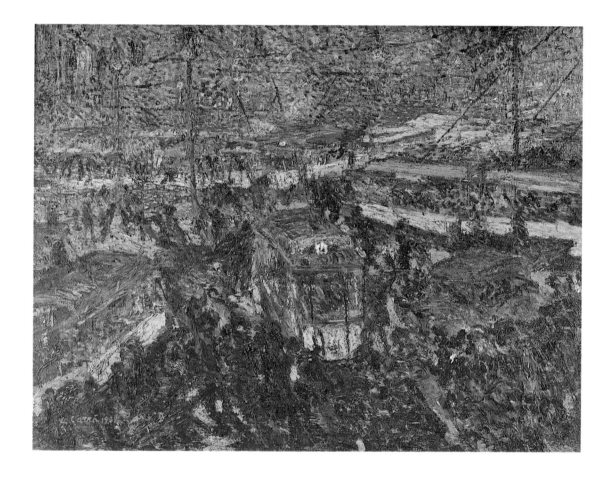

Mikalojus Konstantinas Čiurlionis
Star Sonata. Allegro
1908
tempera on paste-board, 72,2 × 61,4 cm
Kaunas, Lithuania, Museum Čiurlionis

Čiurlionis, who died in 1911, had shown
such work in Paris
at Bernheim Jeune in 1910

Mikalojus Konstantinas Čiurlionis
Sea Sonata. Allegro
1908
tempera on paste-board, 73,4 × 63 cm
Kaunas, Lithuania, Museum Čiurlionis

Raymond Duchamp-Villon
Football Players
1906
bronze, 68,5 × 68 × 53 cm
Rouen, Musée des Beaux-Arts

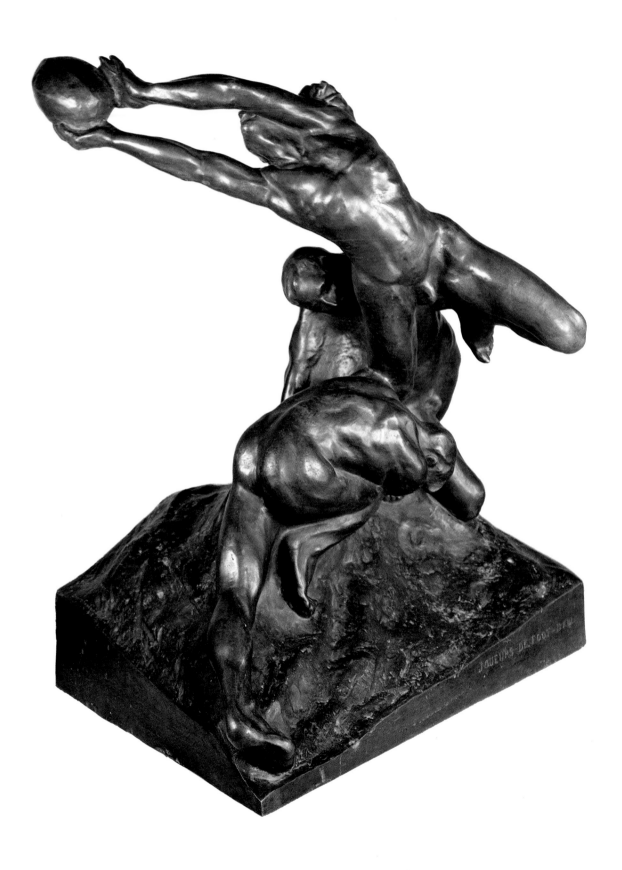

Augusto Giacometti
Music
1899
chalk and oil on paper, 186 × 109 cm
Zurich, Kunsthaus

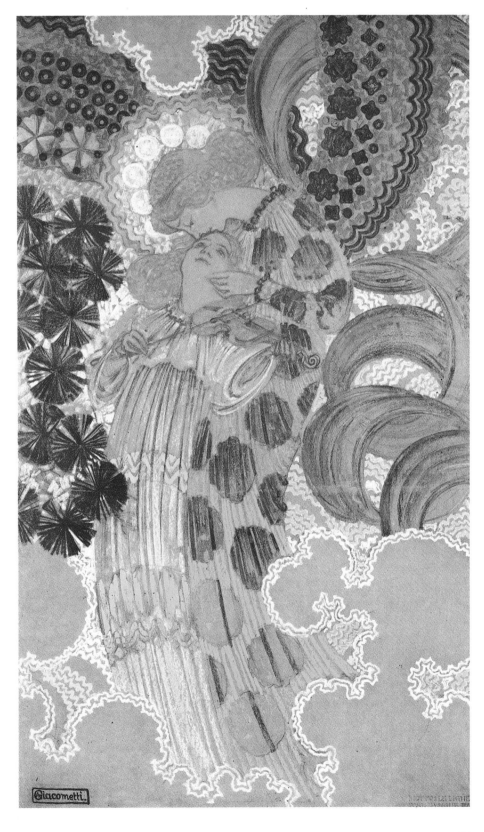

František Kupka
Riders
1900 c.
ink on paper, 40,5 × 54 cm
Paris, Musée National d'Art Moderne,
Centre Georges Pompidou

František Kupka
The Dream
1906-09
oil on paste-board, 30,5 × 31,5 cm
Bochum, Bochum Museum

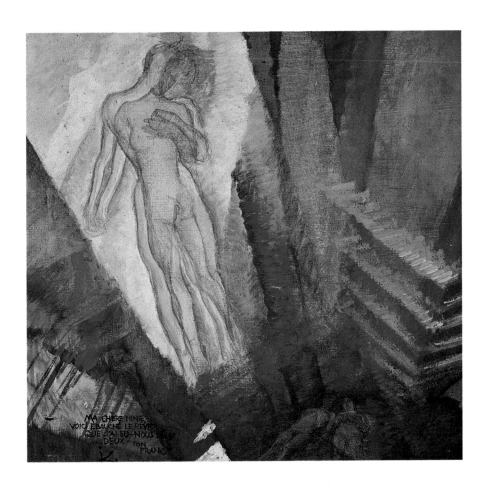

Mikhail Larionov
The Rain
1904
oil on canvas, 85 × 85 cm
Private Collection

Mikhail Larionov
Fish at Sunset
1906
oil on canvas, 89 × 125 cm
Private Collection

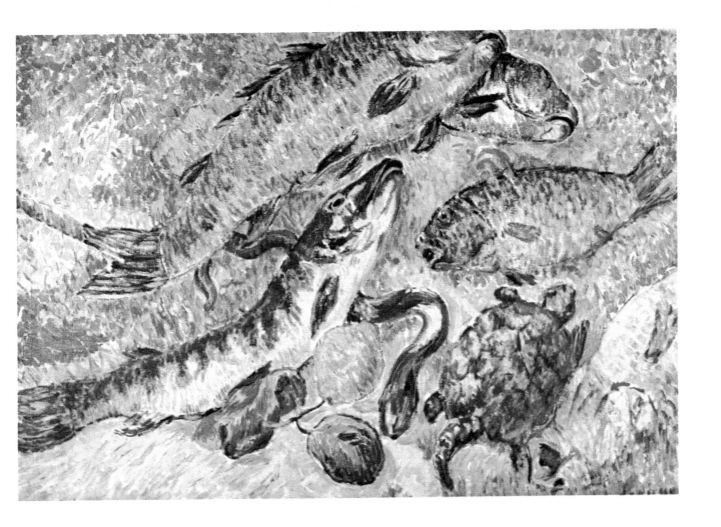

Lumière Brothers
Camera-projector Lumière Carpentier n. 31
1895
Paris, Cinémathèque Française

*The Lumière Brothers commercialized
the ideas of Marey and Reynaud*

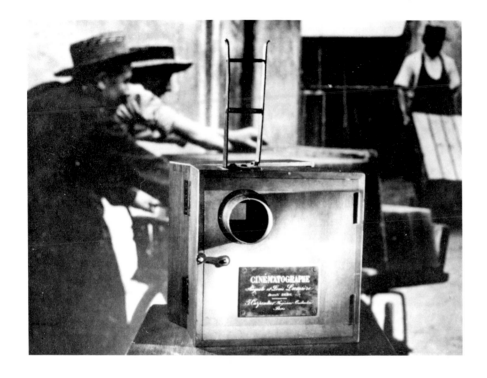

Étienne-Jules Marey
*Chronophotographic Study
of Human Locomotion.
Man in a black costume
with white lines and dots*
1886
photograph b/w, 9 × 25 cm
Beaune
Musée E.J. Marey et des Beaux-Arts

*Chronophotographic Study
of Human Locomotion.
Successive views
of a man running*
1886
photograph b/w, 9 × 30 cm
Beaune
Musée E.J. Marey et des Beaux-Arts

*Chronophotographic Study
of Human Locomotion.
Man walking
in a white costume with one black leg*
1886
photograph b/w, 9 × 30 cm
Beaune
Musée E.J. Marey et des Beaux-Arts

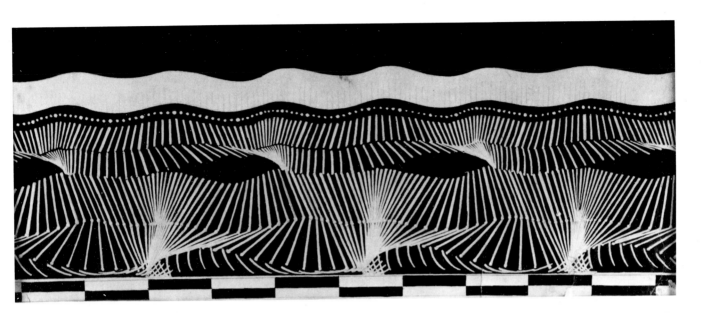

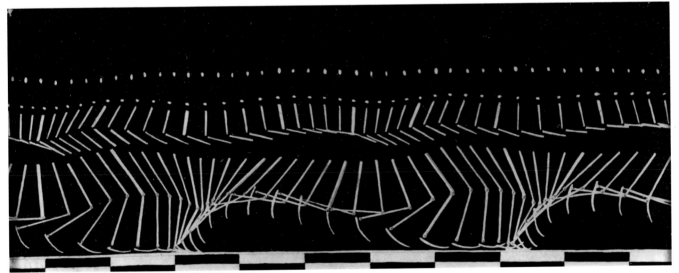

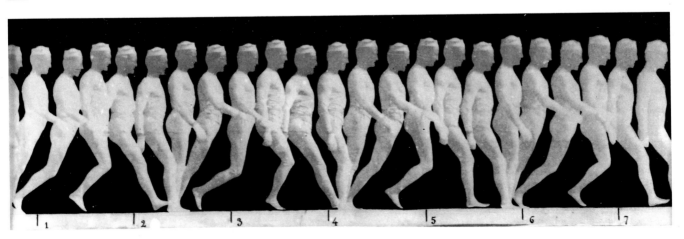

Etienne-Jules Marey
Chronophotograph. Man Pushing a Cart
1891 c.
photograph b/w, 14 × 35 cm
Beaune
Musée E.J. Marey et des Beaux-Arts

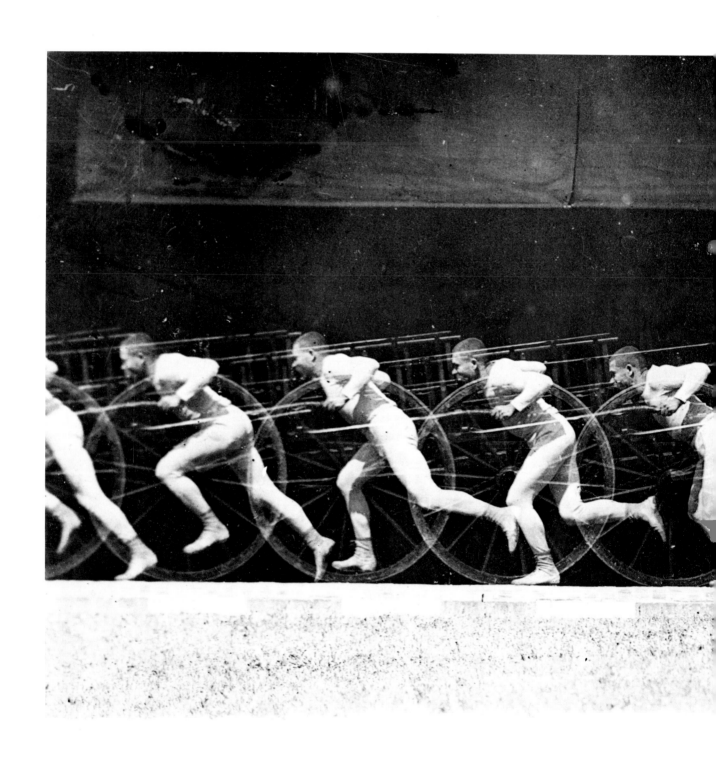

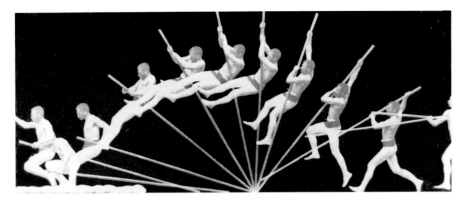

Etienne-Jules Marey
Chronophotograph. Long Jump with a Pole
1890
photograph b/w, 14 × 35 cm
Beaune
Musée E.J. Marey et des Beaux-Arts

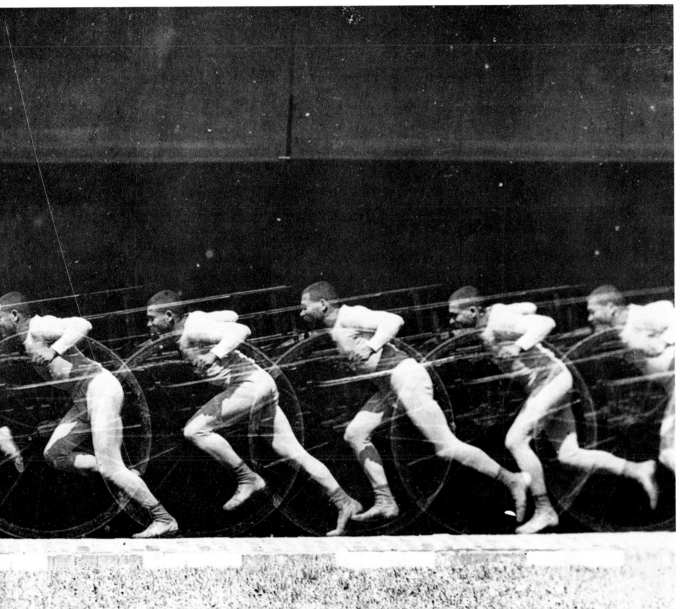

Étienne-Jules Marey
The Flight of a Gull
1887
bronze, 16,4 × 58,5 × 25,7 cm
Beaune, Musée E.J. Marey
Collection du Collège de France

This sculpture was executed for scientific
purpose

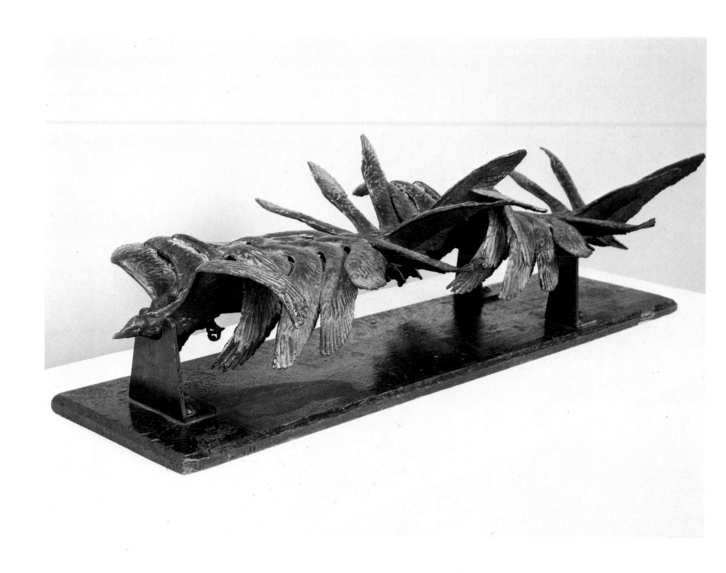

Georges Méliès
20,000 Leagues under the Sea
1902
China ink and blue pencil on paper
21 × 30 cm
Paris, Cinémathèque Française

A Trip to the Moon
1902
ink on paper, 25 × 32 cm
Paris, Cinémathèque Française

The Impossible Voyage
1904
China ink on paper, 17 × 26 cm
Paris, Cinémathèque Française

The Devil Makes a Hullabaloo
1906
China ink on paper, 16 × 23 cm
Paris, Cinémathèque Française

*With Marinettian energy, Méliès drew
the costumes and machines, staged,
played, shot and distributed his own films*

Edvard Munch
Despair
1893
oil on canvas, 92 × 63 cm
Oslo, Munch-Museet

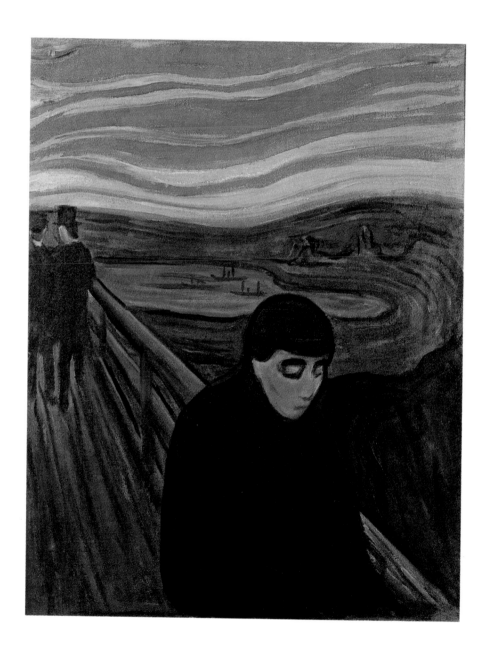

Edvard Munch
Children on the Road
1906
oil on canvas, 75 × 90 cm
Oslo, Munch-Museet

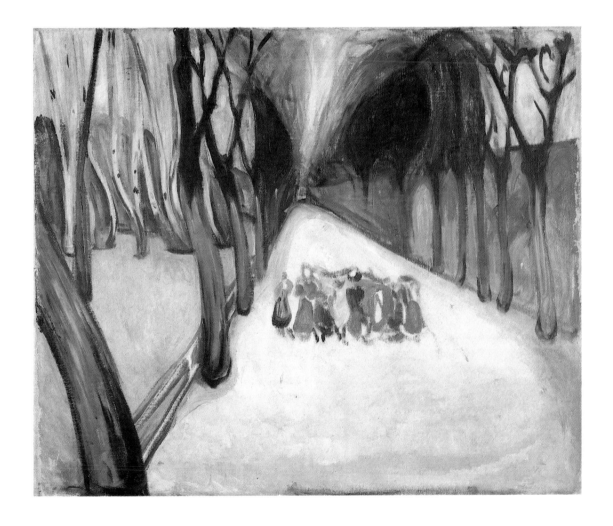

Eadweard Muybridge
Animal Locomotion, plate 616
1887
photography b/w, 22 × 33 cm
New York, Timothy Baum Collection

Animal Locomotion, plate 755
1887
photography b/w, 19 × 40 cm
New York, Timothy Baum Collection

Animal Locomotion, plate 133
1887
photography b/w, 23 × 31 cm
New York, Timothy Baum Collection

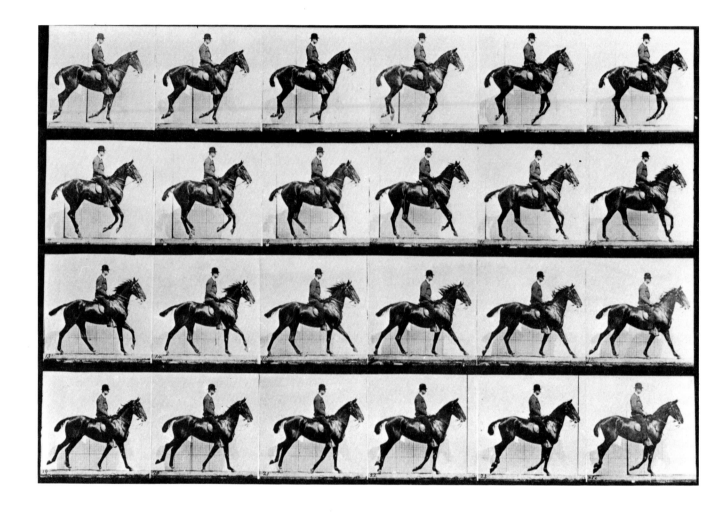

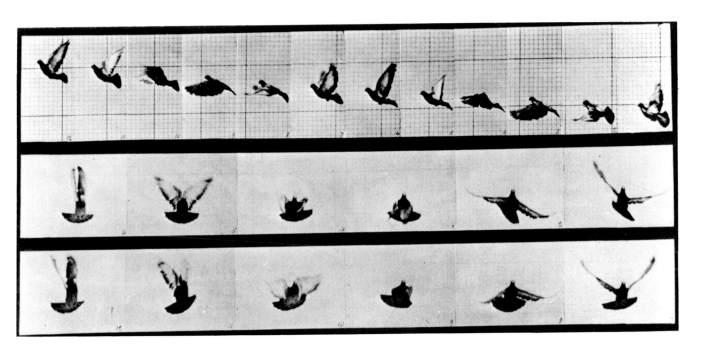

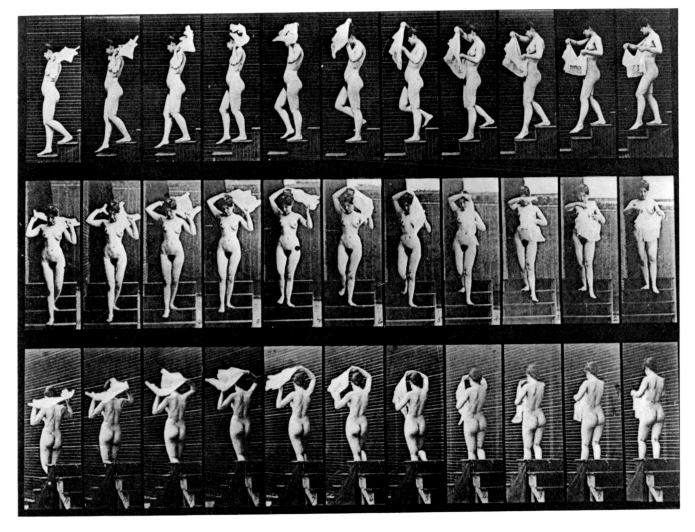

51

Giuseppe Pellizza da Volpedo
Car at the Passo del Penice
1904
oil on paste-board, 35 × 50 cm
Romagnese, Pavia, Italo Pietra Collection

Giuseppe Pellizza da Volpedo
The Rising Sun
1903-04
oil on canvas, 150 × 150 cm
Rome, Galleria Nazionale d'Arte Moderna

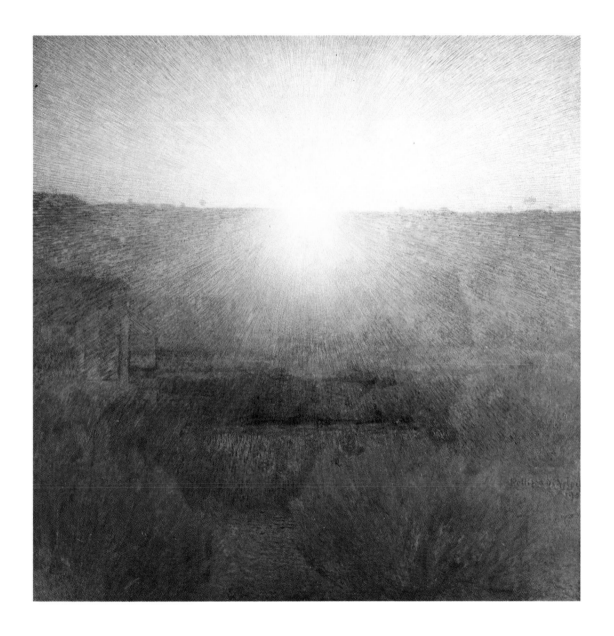

Pablo Picasso
Bust of a Woman
(study for *Les demoiselles d'Avignon*)
1907
oil on canvas, 81 × 60 cm
Private Collection

Les demoiselles d'Avignon *finished*
in july 1907 would become
the most influencial painting
in 20th century before Guernica *(1937)*

Gaetano Previati
Paolo and Francesca
1901
oil on canvas, 230 × 260 cm
Ferrara, Galleria Civica d'Arte Moderna

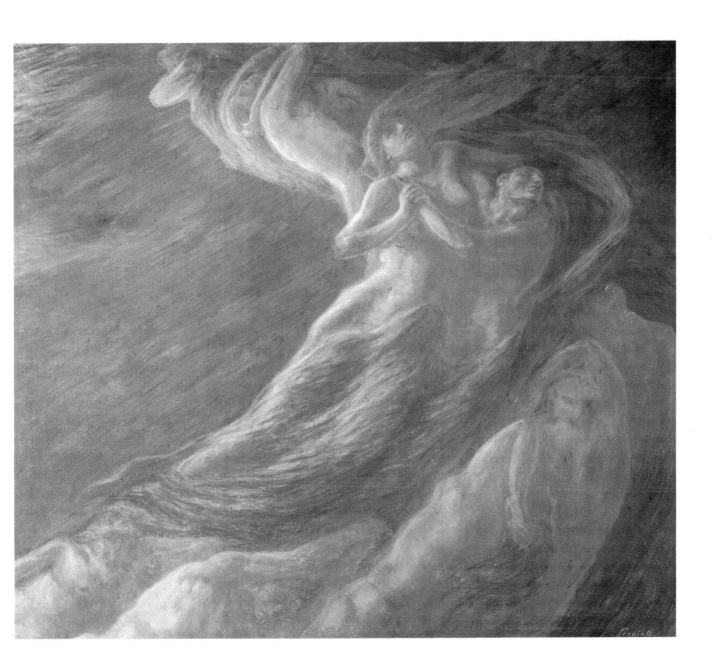

Gaetano Previati
Eroica
1907
oil on canvas, 116 × 144 cm
Private Collection

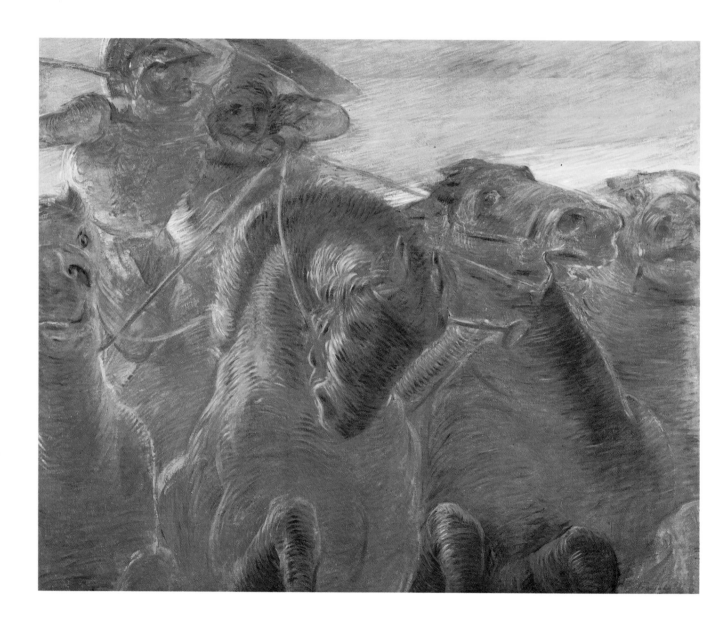

In the 80's Reynaud made the first public
film, he had painted
himself on perforated stripes

Emile Reynaud
About a Bathing-Hut
1894

Steeple-Chase
Cartoon for Praxinoscope

The Swing
Cartoon for Praxinoscope

The Charmer
Cartoon for Praxinoscope

The Smoker
Cartoon for Praxinoscope

The Butterflies
Cartoon for Praxinoscope

Romolo Romani
Lewdness
undated
pencil on paper, 62 × 47 cm
Brescia, Musei Civici d'Arte e Storia

Romolo Romani
The Scruple
undated (1904-06)
pencil on paper, 63 × 48 cm
Brescia, Laura Ronchi Braga Collection

Medardo Rosso
Smiling Child
1889
wax, 27 × 19 × 18 cm
Lugano, Pieter Coray Collection

Madame X
1896
wax, 30 × 19 × 17 cm
Venice, Galleria Internazionale
d'Arte Moderna, Ca' Pesaro

Child at the Kitchen-Range
1892 c.
wax, 45,5 × 47,5 × 13 cm
Milan
Danila Rosso Parravicini Collection

Portrait of Mrs Noblet
1897
plaster, 67 × 57 × 55 cm
Rome, Galleria Nazionale d'Arte Moderna

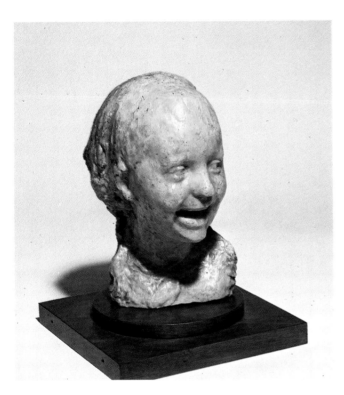

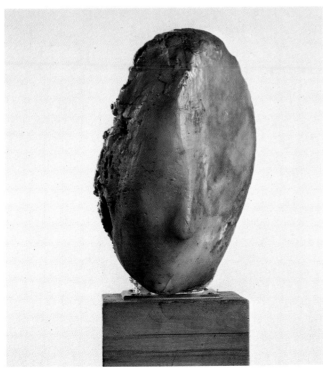

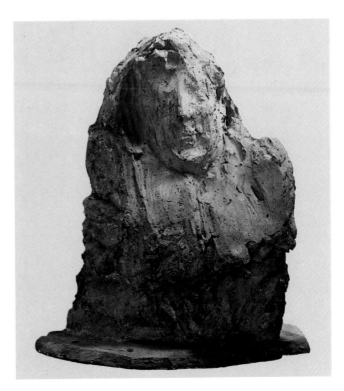

Medardo Rosso
Bookmaker
1894
wax, 48 × 43 × 46 cm
Milan
Danila Rosso Parravicini Collection

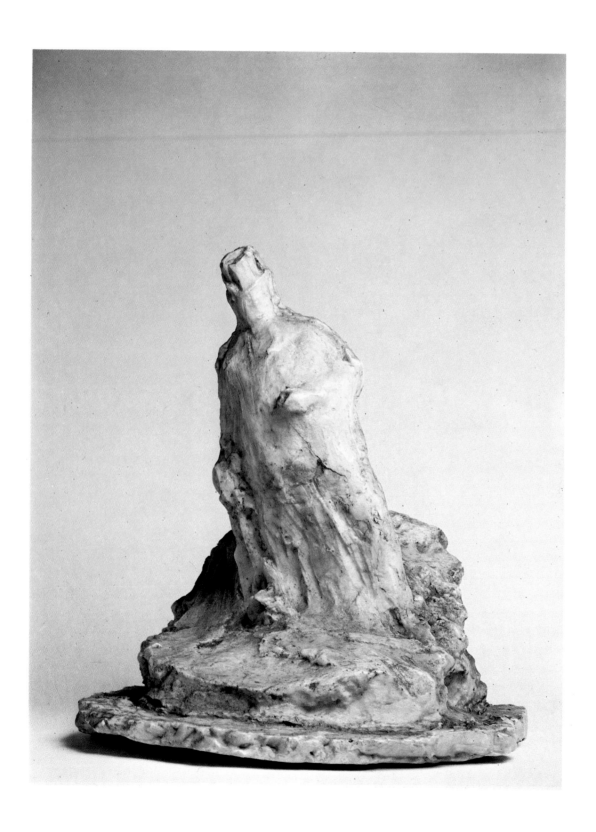

Medardo Rosso
Conversation in the Garden
1896 c.
plaster, 35 × 66,5 × 41 cm
Barzio, Museo Medardo Rosso

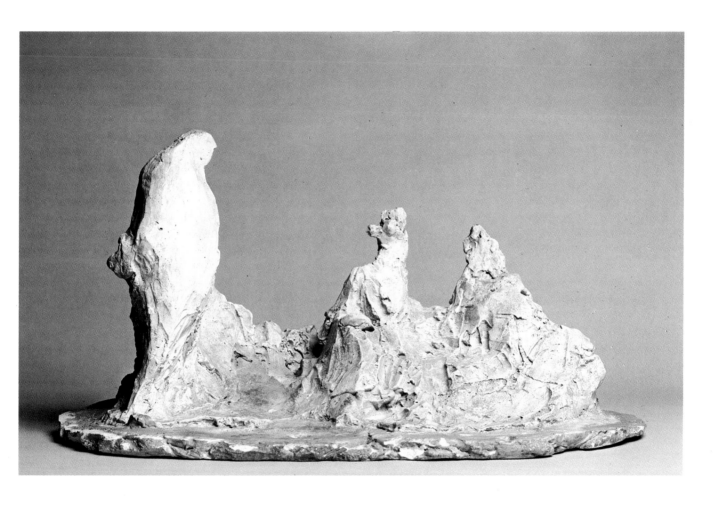

Luigi Russolo
Nietzsche and Madness
1907-08
etching, 12,6 × 12,7 cm
Milan, Civica Raccolta delle Stampe
Achille Bertarelli, Castello Sforzesco

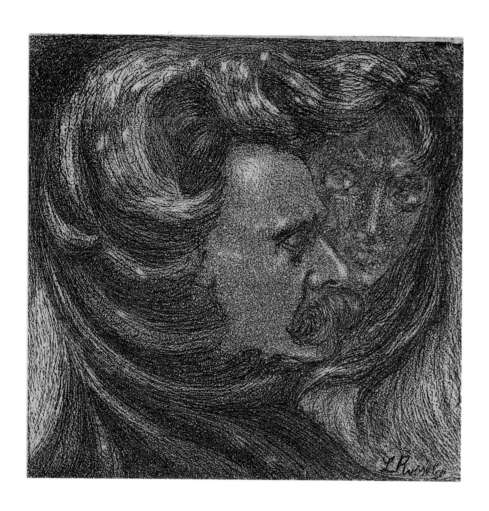

Georges Seurat
The Eiffel Tower
1889 c.
oil on panel, 24 × 15 cm
San Francisco, The Fine Art Museum
of San Francisco
purchase William H. Noble Fund

This painting was made before
the Eiffel Tower was completed

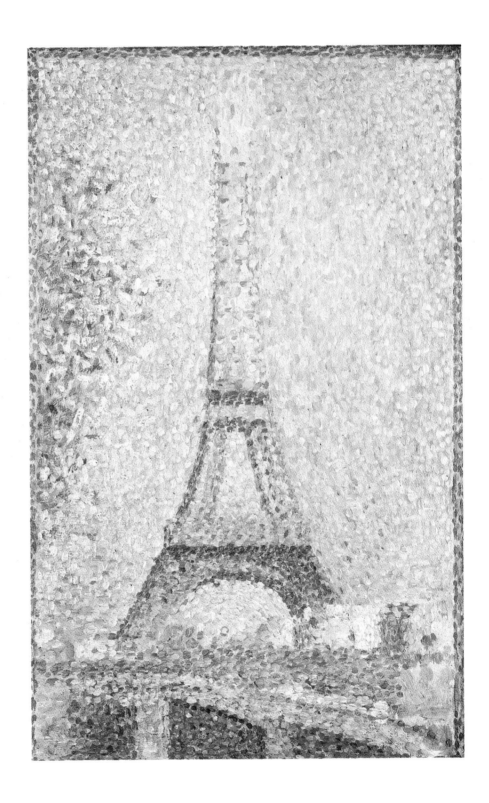

Georges Seurat
Le Chahut (Final study)
1889-1890
oil on canvas, 67,2 × 57,8 cm
Buffalo-New York, Albright-Knox Art Gallery
General Purchase Funds, 1943

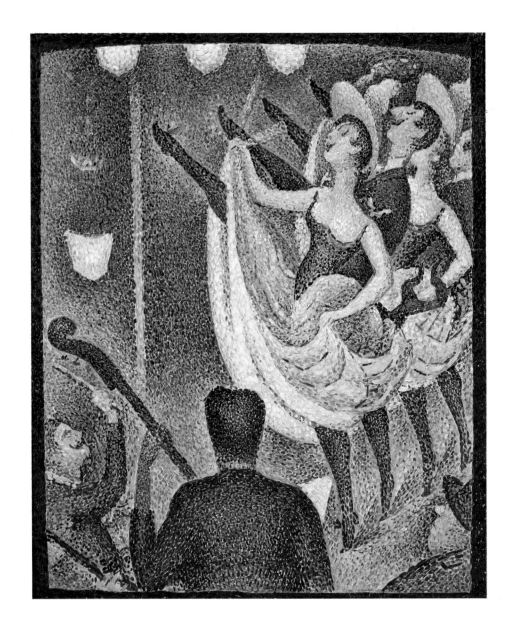

Georges Seurat
Le cirque, study
1891
oil and pastel on canvas, 53 × 45 cm
Paris, Musée d'Orsay

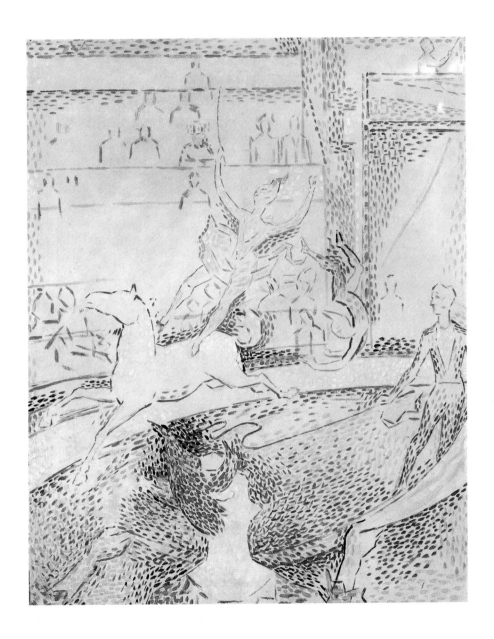

Mikhail Vrubel
The Pearl
1904
pastel and gouache on paste-board, 35 × 47,7 cm
Moscow, Tretjakovskaja Galeria

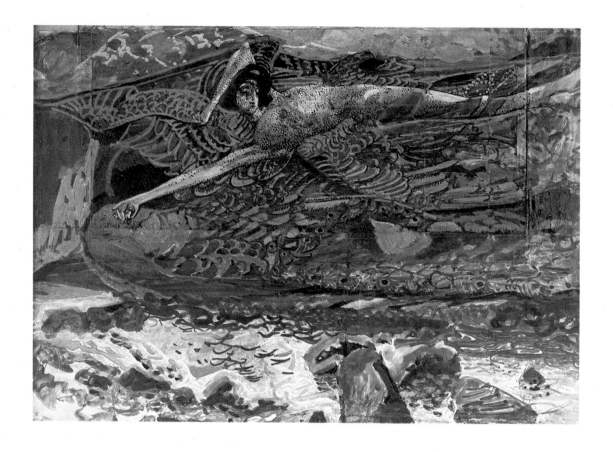

55ᵉ Année — 3ᵉ Série — Nᵒ 51

Le Numéro avec le Supplément — SEINE & SEINE-ET-OISE : 15 centimes — DÉPARTEMENTS : 20 centimes

Samedi 20 Février 1909

Gaston CALMETTE
Directeur-Gérant

RÉDACTION — ADMINISTRATION
26, rue Drouot, Paris (9ᵉ Arrᵗ)

POUR LA PUBLICITÉ
S'adresser au siège du journal

H. DE VILLEMESSANT
Fondateur

LE FIGARO

Le Futurisme

Manifeste du Futurisme

LA VIE DE PARIS

"Le Roi" à l'Élysée... Palace

Échos

Les Courses

A Travers Paris

Nouvelles à la Main

Le complot Caillaux

Giacomo Balla
Street Light
1909
oil on canvas
174,7 × 114,7 cm
New York,
The Museum of Modern Art
Hillman Periodicals Fund
1954

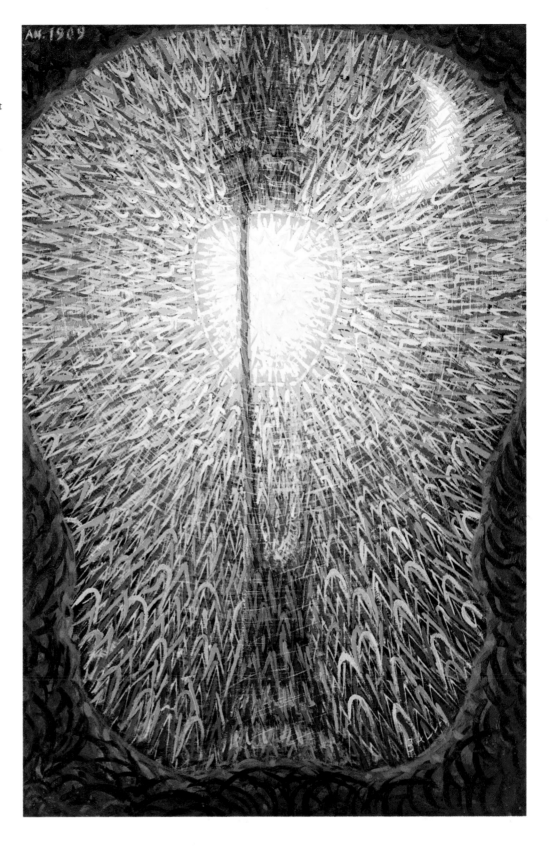

Giacomo Balla
The Hand of the Violinist
or *Rhythm of the Violinist*
1912
oil on canvas, 52 × 75 cm
on loan from Salome and Eric Estorick

Giacomo Balla
Dynamism of a Dog on a Leash
1912
oil on canvas, 90,8 × 110 cm
Buffalo-New York, Albright-Knox Art Gallery
bequest of A. Conger Goodyear
gift of George F. Goodyear, 1964

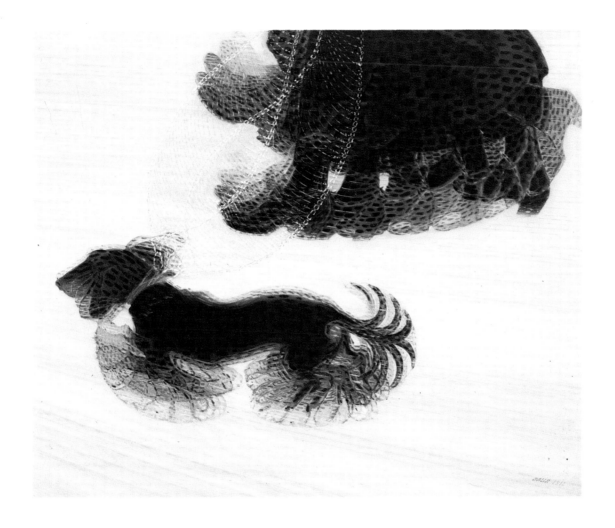

Giacomo Balla
Girl Running on a Balcony, study
1912
pencil and ink on paper, 24 × 26,5 cm
Private Collection

Giacomo Balla
Girl Running on a Balcony, study
1912
ink on paper, 17 × 24,5 cm
Milan, Civica Galleria d'Arte Moderna
Raccolta Grassi

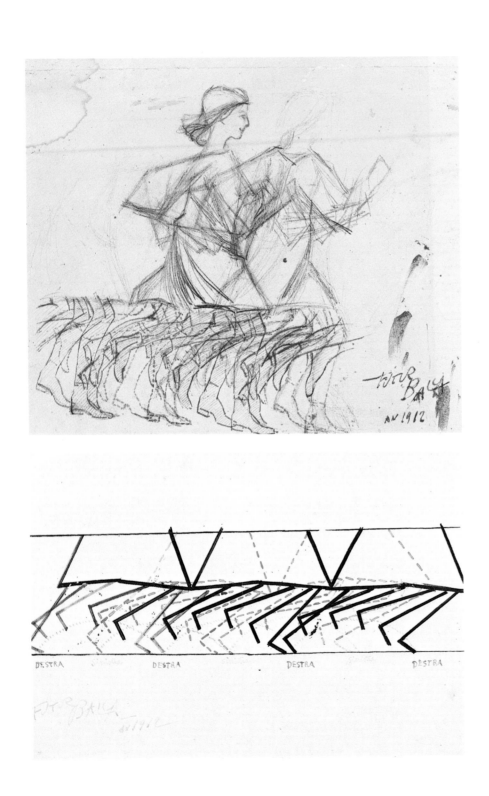

Giacomo Balla
Girl Running on a Balcony
1912
oil on canvas, 125 × 125 cm
Milan, Civica Galleria d'Arte Moderna
Raccolta Grassi

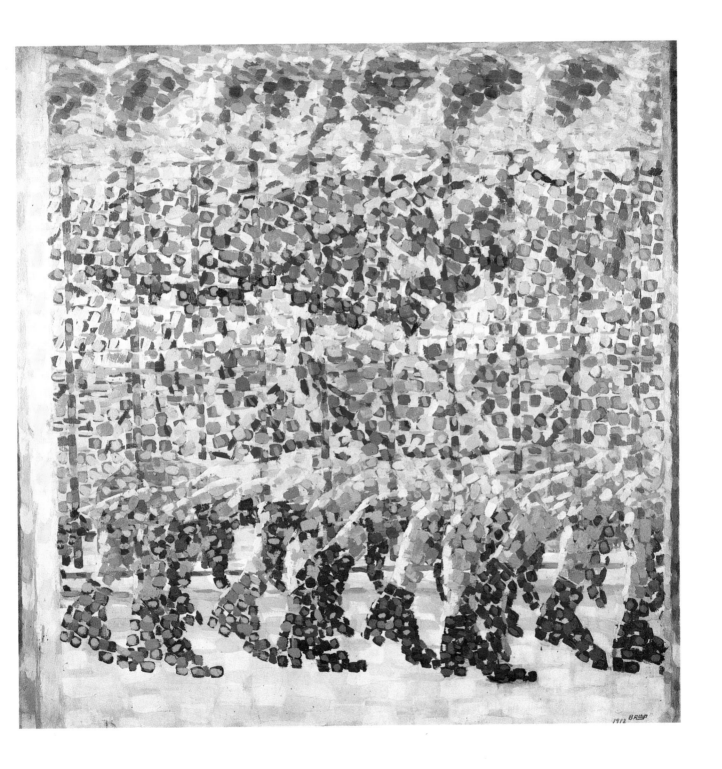

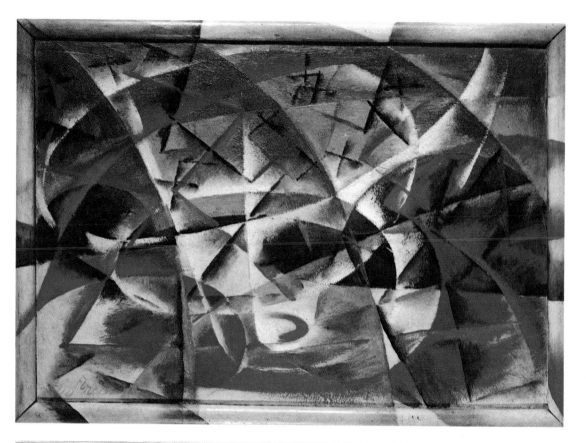

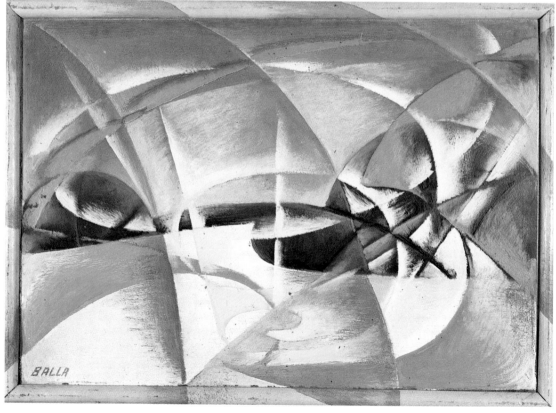

Giacomo Balla
Abstract Speed + Noise
1913-14
oil on wood, 54,5 × 76,5 cm
Venice, Peggy Guggenheim Collection
(Solomon R. Guggenheim Fund)

Giacomo Balla
Abstract Speed
1913
oil on canvas, 53 × 75 cm
Private Collection

Giacomo Balla
Speeding Car
1912
oil on wood, 55,6 × 68,9 cm
New York, The Museum of Modern Art

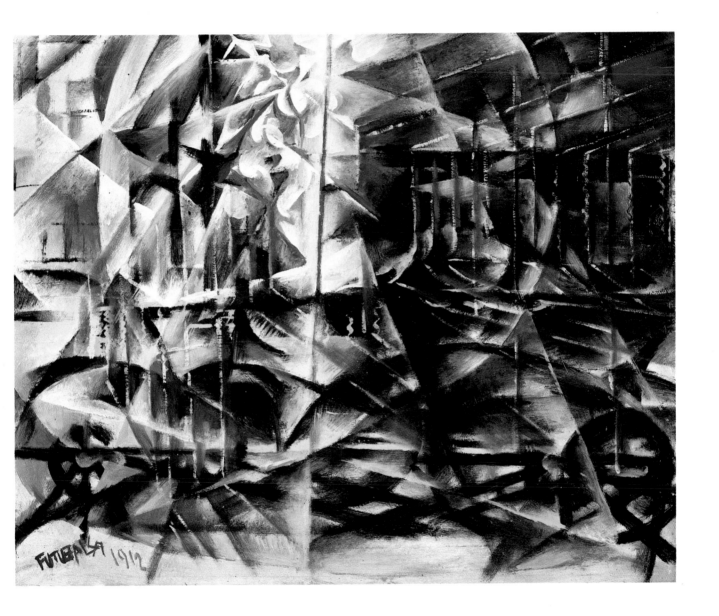

Giacomo Balla
Dynamic Expansion + Speed
1913
lacker on paper pasted on canvas
64 × 106 cm
Rome, Private Collection

Giacomo Balla
Abstract Speed (or *Passing Car*)
1913
oil on canvas, 78 × 108 cm
Private Collection

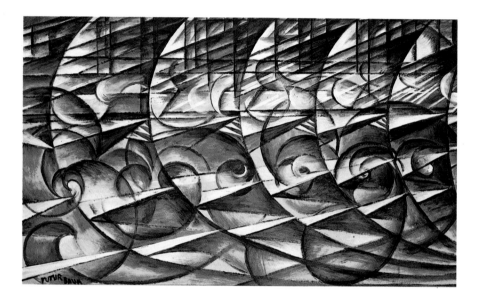

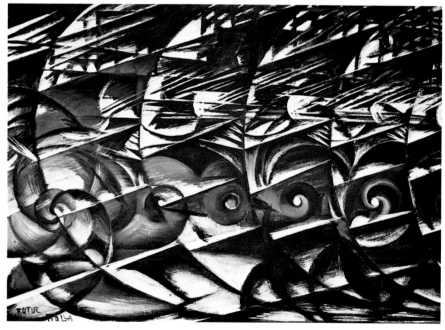

Giacomo Balla
Abstract Speed
1913
oil on canvas, 332 × 260 cm
Private Collection

*One of the five large paintings by the five
artists in the central Futurist group*

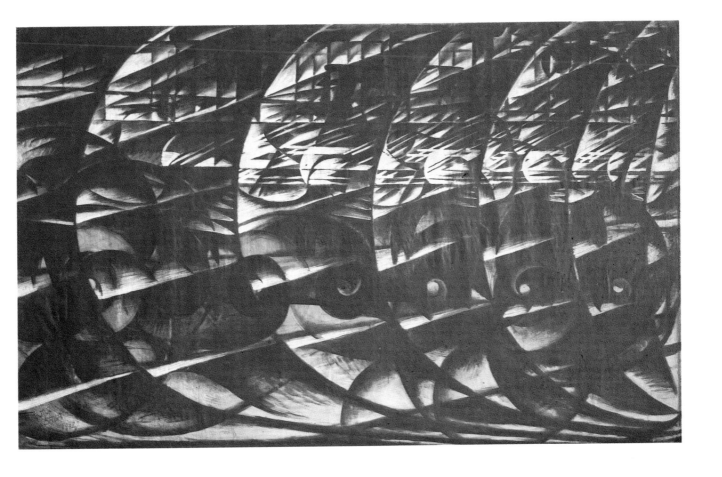

Giacomo Balla
Speeding car + Light
1913
oil on paper, 84 × 109 cm
Stockholm, Moderna Museet

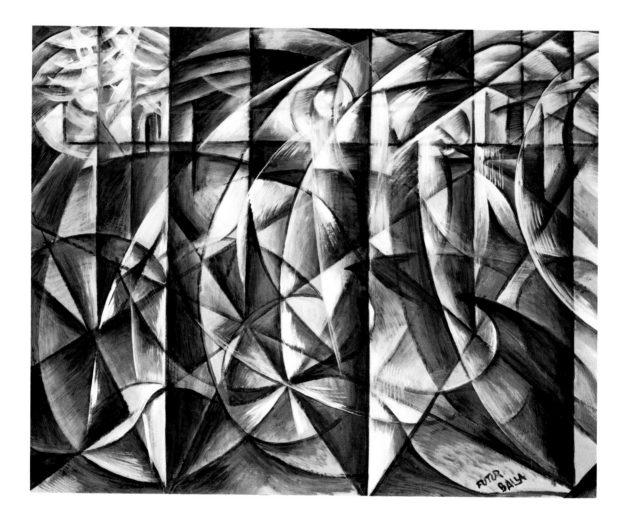

Giacomo Balla
Speeding Car + Light + Noise
1913
oil on canvas, 87 × 130 cm
Zurich, Kunsthaus

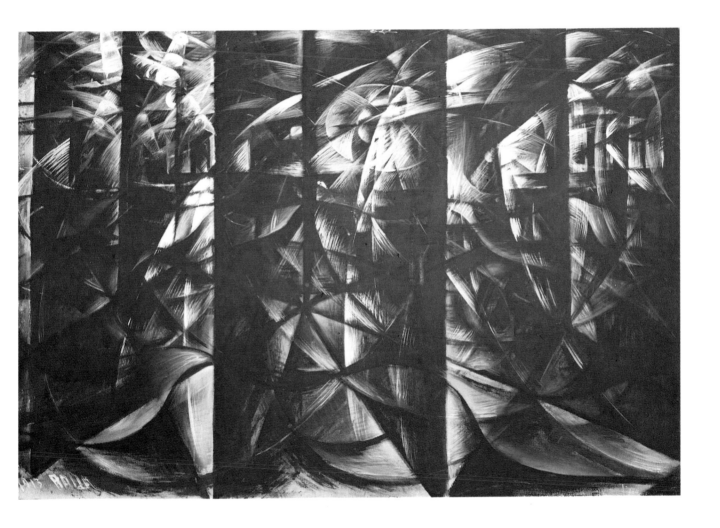

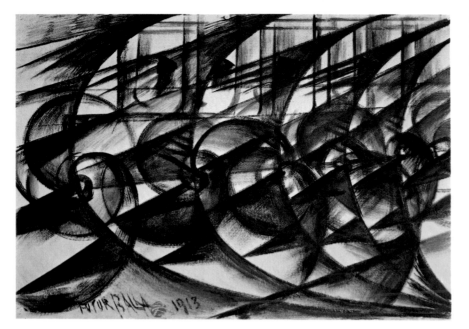

Giacomo Balla
Speeding Car. Abstract Speed
1913
gouache and tempera, 70 × 100 cm
Amsterdam, Stedelijk Museum

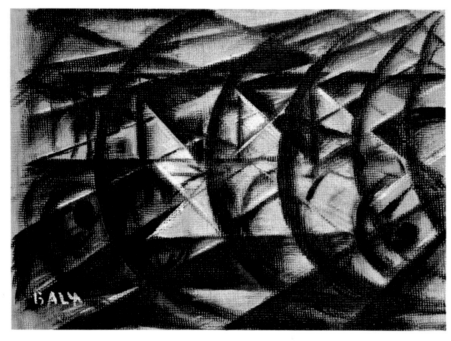

Giacomo Balla
Speeding Car + Lights
1913
oil on golden paper, 39,5 × 54 cm
Rome, Private Collection

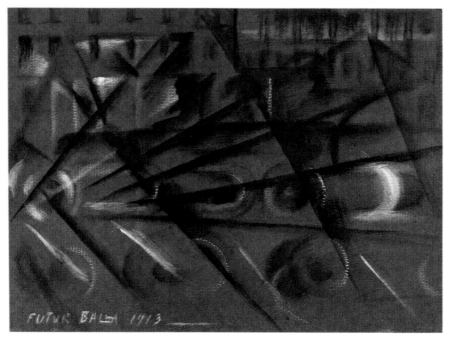

Giacomo Balla
Speeding Car
1913
oil on paper, 48 × 66,5 cm
Private Collection

Giacomo Balla
Speeding Car + Lights
1913
oil on paste-board, 48,3 × 68 cm
New York
Morton G. Neumann Family Collection

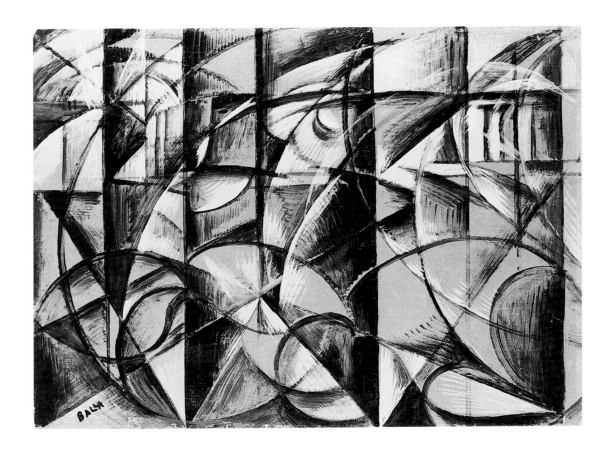

Giacomo Balla
Speeding Car
1913
oil on paste-board, 66 × 94 cm
Milan, Civica Galleria d'Arte Moderna
Raccolta Grassi

Giacomo Balla
Speeding Car
1913
watercolour on paste-board on canvas
46,5 × 60 cm
Private Collection

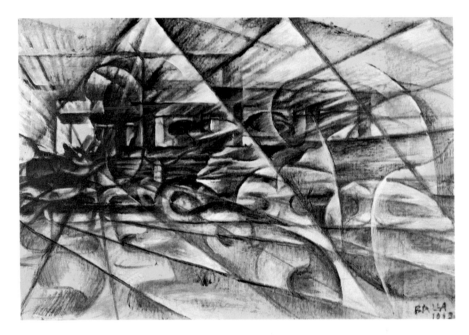

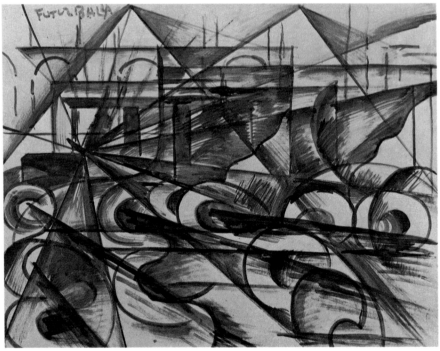

Giacomo Balla
Rhythm + Noise + Speeding Car
1913
lacker on paper pasted on canvas, 64,5 × 72,5 cm
Naples, Giaquinto Collection

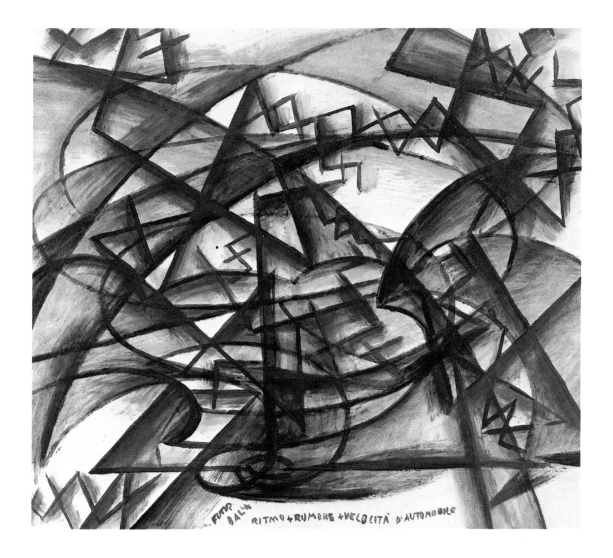

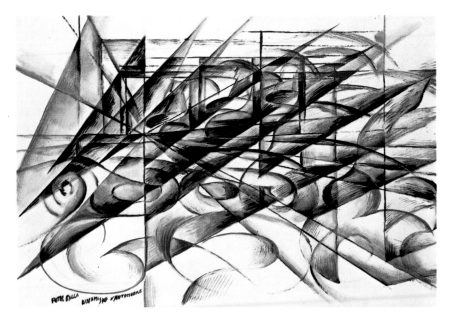

Giacomo Balla
Dynamism of a Car
1913
China ink and lacker on paper
53 × 75,5 cm
Rome, Private Collection

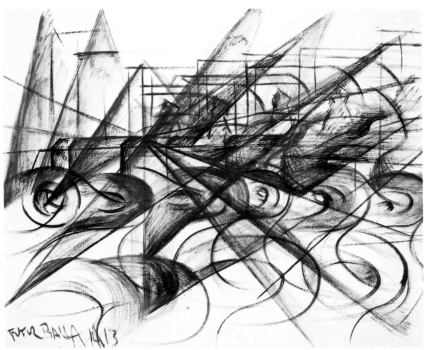

Giacomo Balla
Car + Speed + Light
1913
watercolour and seppia on paper
67 × 88,5 cm
Milan
Magda and Riccardo Jucker Collection
on loan to Pinacoteca of Brera

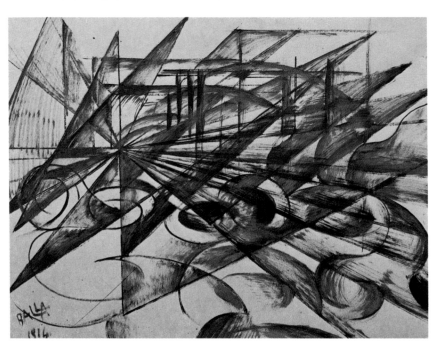

Giacomo Balla
Speeding Car
1914
lacker on paper pasted on canvas
53,8 × 73,3 cm
Jerusalem
Sam and Ayala Zacks Collection

Giacomo Balla
Speeding Car
1913
oil and mixed media on paper and paste-board
73 × 104 cm
Private Collection

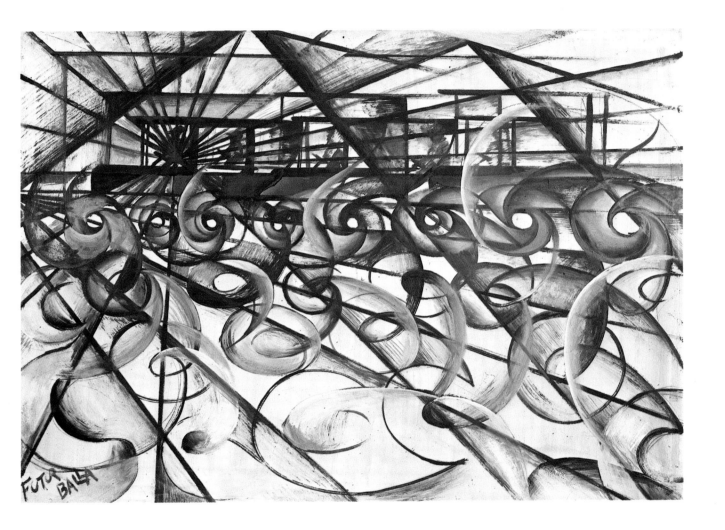

Giacomo Balla
Study for Furniture
in Lowenstein House in Düsseldorf
1912
colour inks on paper, 73 × 97 cm
Private Collection

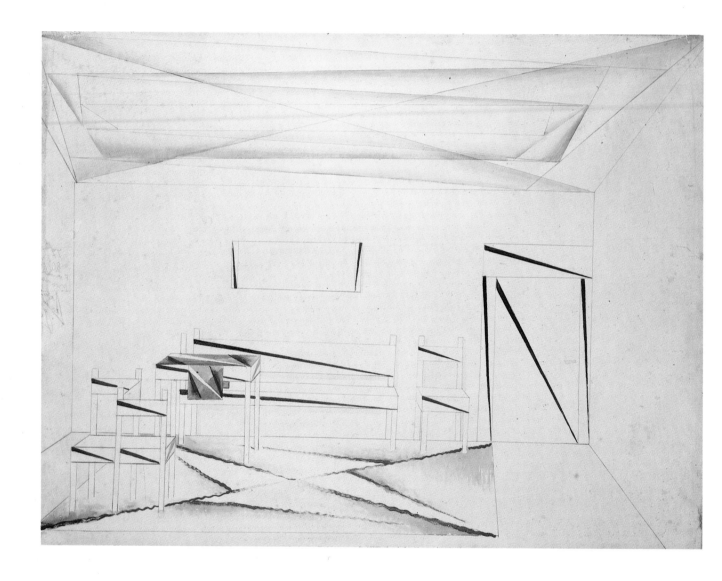

Giacomo Balla
Iridescent Compenetration n. 13
1912
tempera on paper pasted on canvas
94 × 72 cm
Turin, Galleria Civica d'Arte Moderna

Giacomo Balla
Compenetrations
1913 c.
mixed media on paper pasted on canvas
50 × 25 cm
Zurich, Turske & Turske

Giacomo Balla
Iridescent Compenetration n. 7
1912
oil on canvas, 77 × 77 cm
Turin, Galleria Civica d'Arte Moderna

Giacomo Balla
Iridescent Compenetration n. 10
1912
tempera on paper, 50 × 32 cm
Turin, Galleria Civica d'Arte Moderna

Giacomo Balla
Iridescent Compenetration n. 11
1912
tempera on paper, 56 × 36 cm
Turin, Galleria Civica d'Arte Moderna

Giacomo Balla
Iridescent Compenetration n. 4
(Study of Light)
1913 c.
oil on paper pasted on canvas, 55 × 76 cm
Zurich, Turske & Turske

Giacomo Balla
Iridescent Compenetration n. 5
(Eucalyptus)
1914
oil on canvas, 100 × 120 cm
Private Collection

Giacomo Balla
Radial Iridescent Compenetration
(*Prismatic Vibrations*)
1913-14
tempera on thin paste-board, 41,3 × 54,2 cm
Turin, Galleria Civica d'Arte Moderna

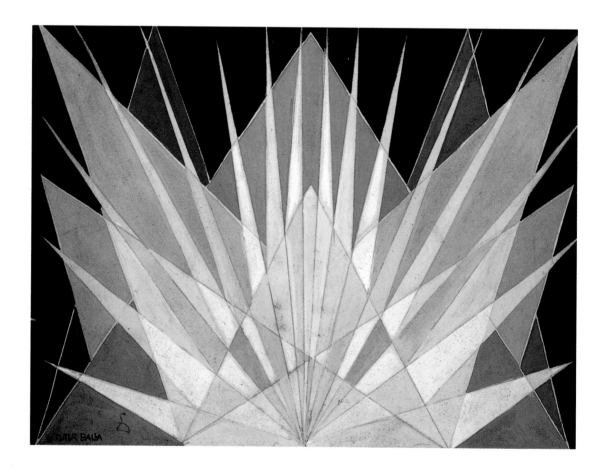

Giacomo Balla
Iridescent Compenetration, study
1912-13
watercolour on paper, 18 × 22 cm
Zurich, Private Collection

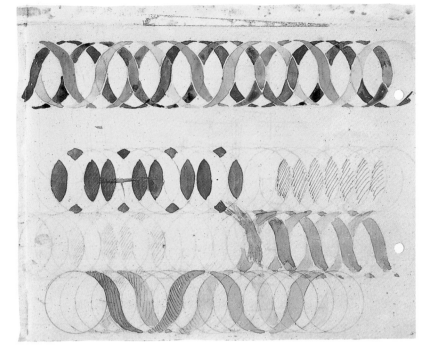

Giacomo Balla
Iridescent Compenetration, study
1912-13
watercolour on paper, 12,5 × 17,5 cm
Zurich, Private Collection

Giacomo Balla
Iridescent Compenetration, study
1912
watercolour and pencil on paper,
24 × 18,5 cm
Turin, Galleria Civica d'Arte Moderna

Giacomo Balla
Iridescent Compenetration n. 2, study
1912
watercolour on paper, 22 × 18 cm
Turin, Galleria Civica d'Arte Moderna

Giacomo Balla
Iridescent Compenetration
Radiating in the Circle, study
1912
watercolour, 22 × 18 cm
Turin, Galleria Civica d'Arte Moderna

Giacomo Balla
Radial Iridescent Compenetration, study
1912
watercolour, 22 × 18 cm
Turin, Galleria Civica d'Arte Moderna

Giacomo Balla
Iridescent Compenetration
(Round Ceiling), study
1912
watercolour, 22 × 18 cm
Turin, Galleria Civica d'Arte Moderna

Giacomo Balla
Iridescent Compenetration
(Square Ceiling), study
1912
watercolour, 22 × 18 cm
Turin, Galleria Civica d'Arte Moderna

Giacomo Balla
Iridescent Compenetration n. 11, study
1912
watercolour on paper, 20,5 × 12,5 cm
Turin, Galleria Civica d'Arte Moderna

Giacomo Balla
Iridescent Compenetration n. 9, study
1912
watercolour on paper, 20,5 × 12,5 cm
Turin, Galleria Civica d'Arte Moderna

Giacomo Balla
*Swifts: Paths of Movement + Dynamic
Sequences*
1913
oil on canvas, 96,8 × 120 cm
New York, The Museum of Modern Art
purchase, 1949

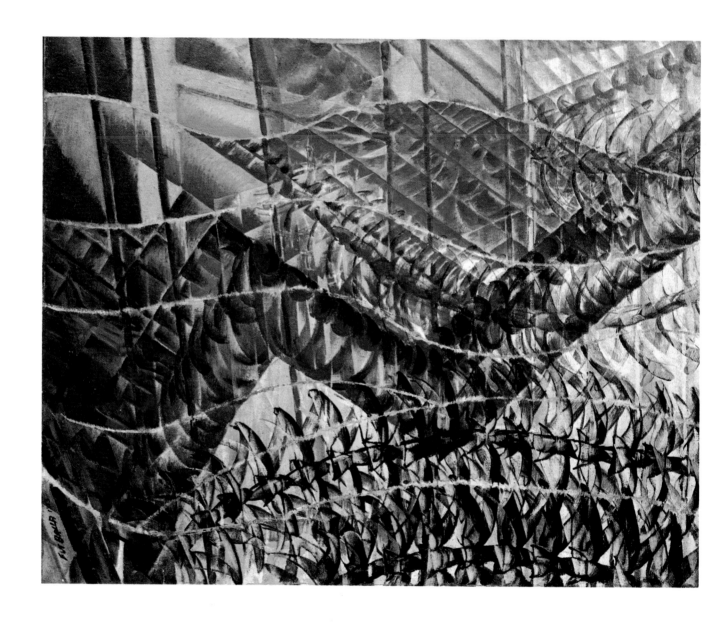

Giacomo Balla
Paths of Movement + Dynamic Sequences
1913
tempera on paper pasted on canvas
49 × 68 cm
Milan, Mattioli Collection

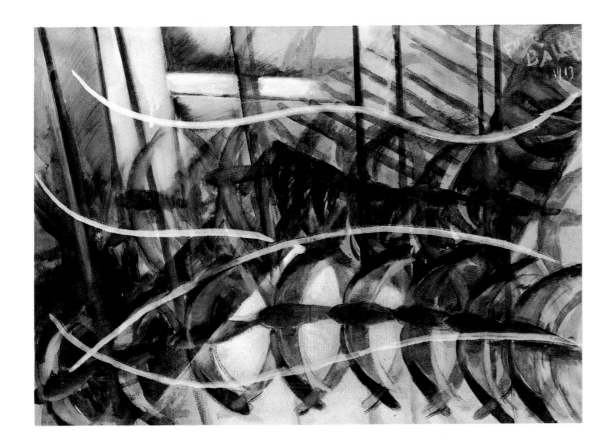

Giacomo Balla
Mercury Passing in front of the Sun
1914
tempera on paper, 120 × 100 cm
Milan, Mattioli Collection

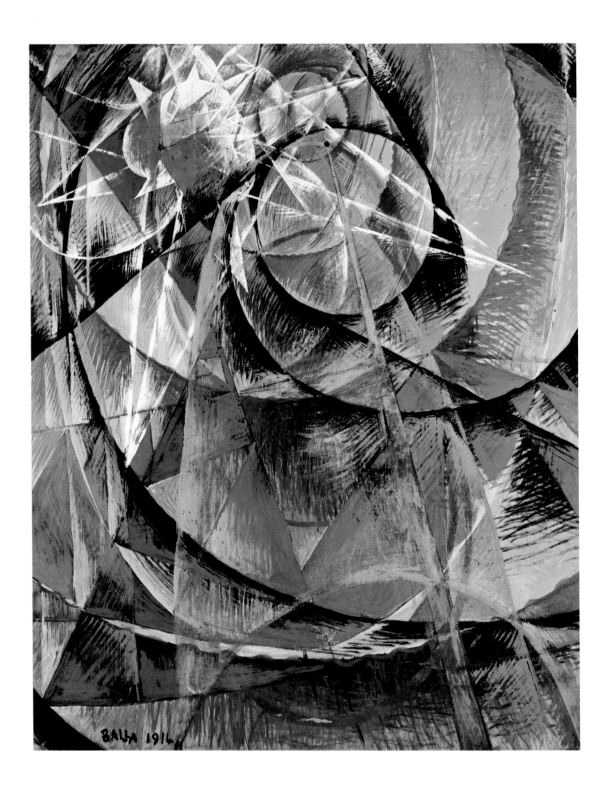

Giacomo Balla
Mercury Passing in front of the Sun
1914
oil on paper, 61 × 50,5 cm
Paris, Musée National d'Art Moderne
Centre Georges Pompidou

Giacomo Balla
Mercury Passing in front of the Sun
1914
tempera on paper pasted on canvas
45 × 34 cm
Private Collection

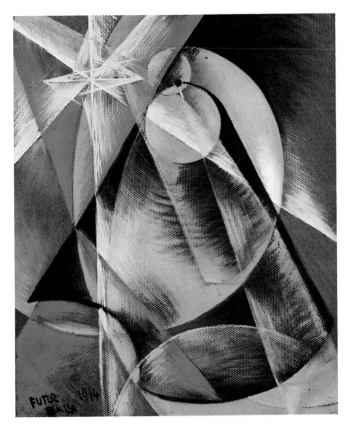

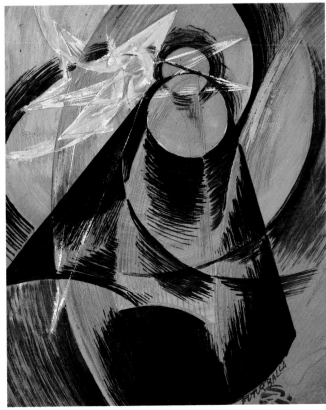

Giacomo Balla
Mercury Passing in front of the Sun
1914
oil on paper, 61 × 50,5 cm
Paris, Musée National d'Art Moderne
Centre Georges Pompidou

Giacomo Balla
Mercury Passing in front of the Sun
1914
tempera on paper pasted on canvas
45 × 34 cm
Private Collection

Giacomo Balla

Printing Machine or *Typography*
project for choreography
1914
inks on paper, 22 × 32 cm
Milan, Museo Teatrale alla Scala

Printing Machine or *Typography*
Rumorist Onomatopoeia
1914
red ink, 32 × 22 cm
Milan, Museo Teatrale alla Scala

Printing Machine or *Typography*
sketch for a costume
1914
pencil, ink and collage on paper, 32 × 22 cm
Milan, Museo Teatrale alla Scala

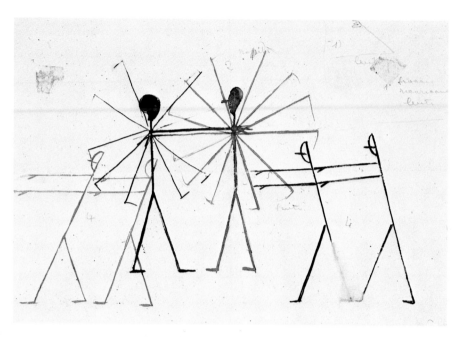

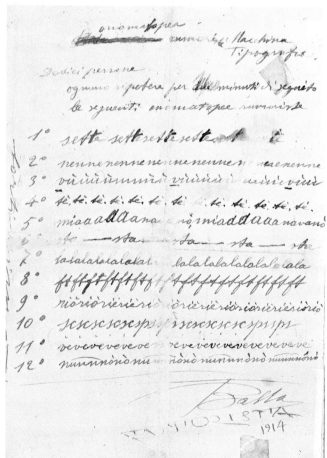

Giacomo Balla
Printing Machine or *Typography*
sketch for stage
1914
ink and pencil on paper, 22 × 32,5 cm
Milan, Museo Teatrale alla Scala

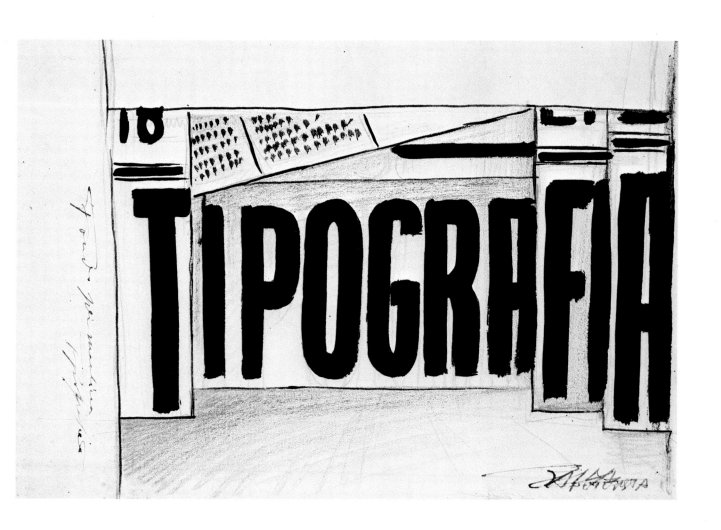

Giacomo Balla
Synoptic Mimic Art or *Spring*
Rumorist Text, 1915
ink on paper, 22 × 32,5 cm
Milan, Calmarini Collection

Costume for Valley, 1915
watercolour on paper, 32 × 41 cm
Milan, Museo Teatrale alla Scala

Woman Sky, 1915
watercolour on paper, 32,5 × 44,5 cm
Milan, Museo Teatrale alla Scala

Giacomo Balla
Synoptic Mimic Art or *Spring*
Landscape, 1915
watercolour on paper, 22 × 32,5 cm
Milan, Calmarini Collection

Woman Tree or *Woman Flower,* 1915
pencil and watercolour on paper, 43 × 32 cm
Milan, Museo Teatrale alla Scala

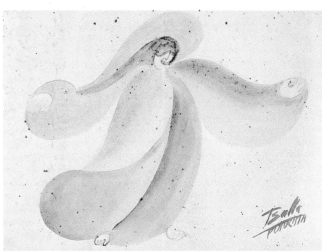

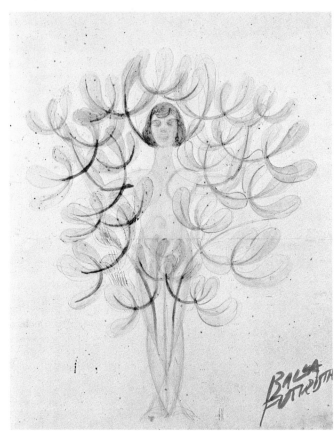

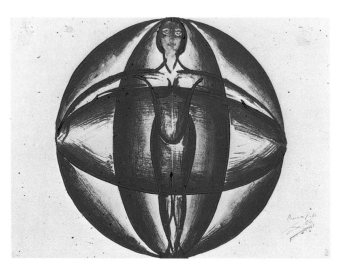

Giacomo Balla
Synoptic Mimic Art or *Spring*
sketch for stage
1915
watercolour on paper, 48 × 66 cm
Milan, Museo Teatrale alla Scala

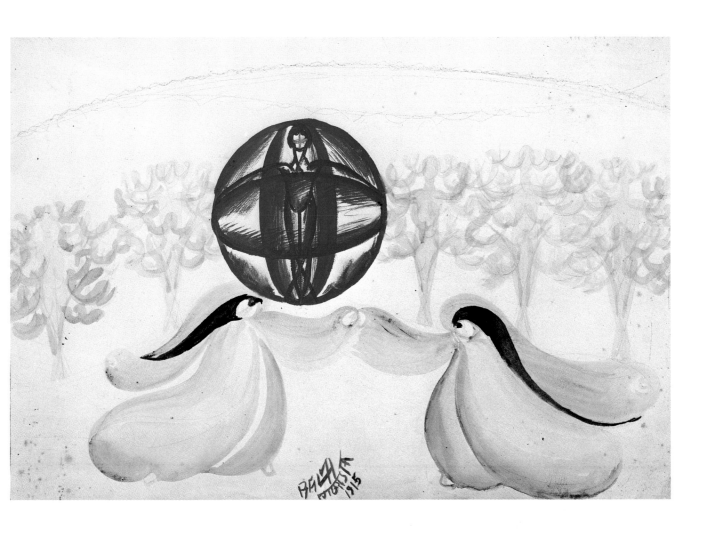

Giacomo Balla
Poster for the Exhibition
of Galleria Angelelli, Rome
1915
watercolour on paper, 94 × 65 cm
Milan, Calmarini Collection

Giacomo Balla - Francesco Cangiullo
Palpavoce (Tactile word)
1914
ink on paper, 37 × 24,5 cm
Milan, Calmarini Collection

Giacomo Balla
Confuse Moods
1916
pen on paper, 31,5 × 22 cm
Milan, Calmarini Collection

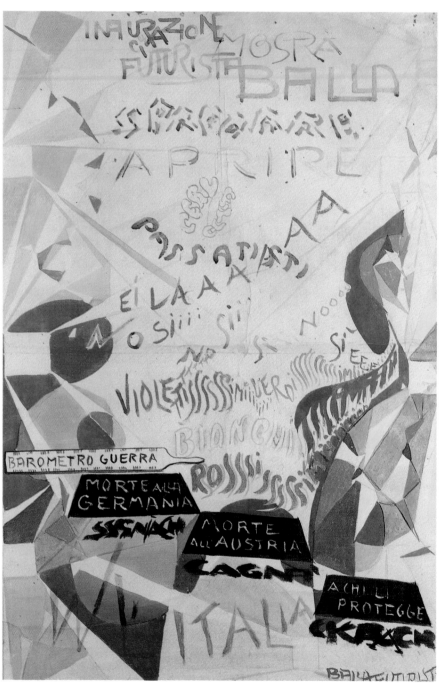

Giacomo Balla
Sironi Going to Milan
1914
ink on paper, 28 × 22 cm
Milan, Calmarini Collection

Giacomo Balla
Abstract Onomatopoeia "Baltrrr"
1914-16
pencil and watercolour on paper, 30 × 22 cm
Rome, Milena Ugolini Collection

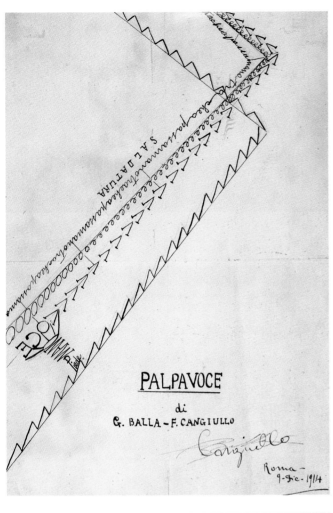

PALPAVOCE

di

G. BALLA – F. CANGIULLO

Roma –
9-Dic-1914

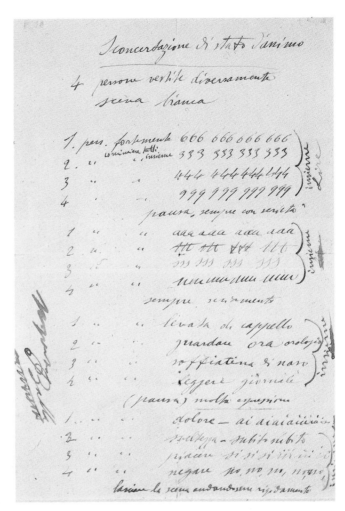

Giacomo Balla
Feu d'artifice, sketch for stage, detail
1915-16
tempera on paper pasted on canvas.
33 × 48,5 cm
Milan, Museo Teatrale alla Scala

Giacomo Balla
Feu d'artifice, sketch for stage
1915
tempera on paper, 15,9 × 19,5 cm
Milan, Museo Teatrale alla Scala

*Commissioned by Diaghilev in 1916
for Stravinsky's* Feu d'artifice,
*this "scena plastica" by Balla
was performed on 12 April 1917
at the Costanzi Theatre in Rome*

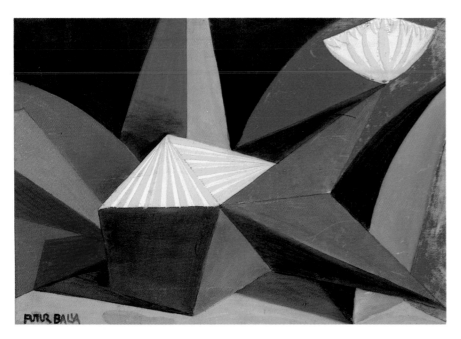

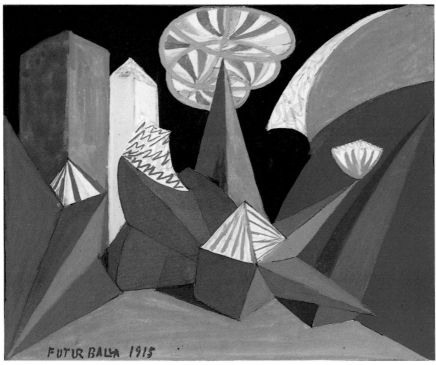

Giacomo Balla
Feu d'artifice, sketch for stage, detail
1915-16
tempera on paper, 48 × 35,5 cm
Milan, Museo Teatrale alla Scala

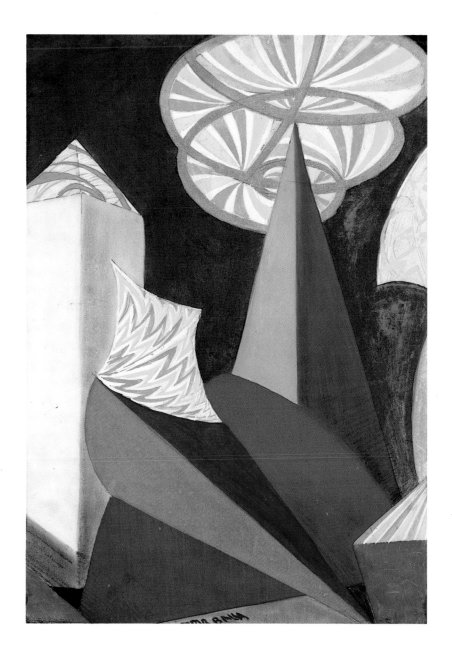

Giacomo Balla
Flags at the Country's Altar
1915
oil on canvas
100 × 100 cm
Rome, Private Collection

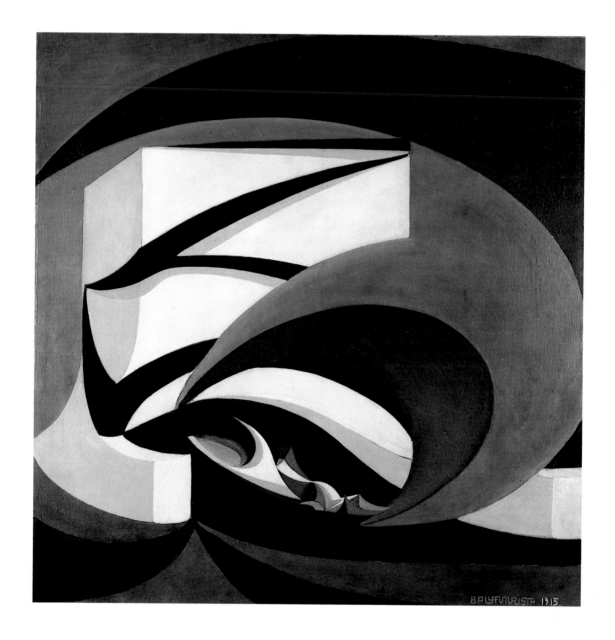

Giacomo Balla
Boccioni's Fist
1915
tempera on paper, 58,5 × 73,5 cm
Private Collection

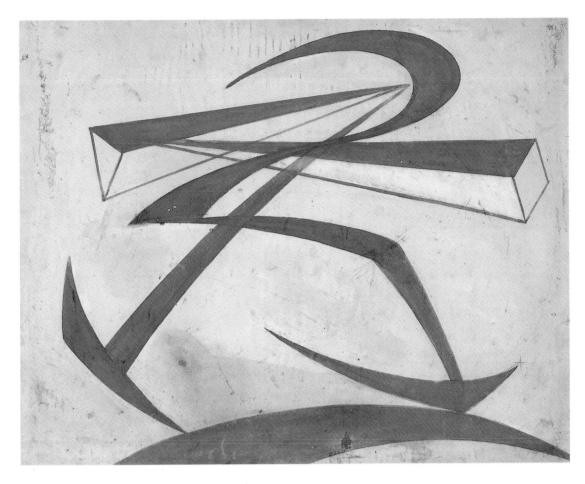

Giacomo Balla
Boccioni's Fist
1915-1956
brass, 80 × 75 × 33 cm
Private Collection

*Sculptures in metal
have been recently
executed after
the original drawings*

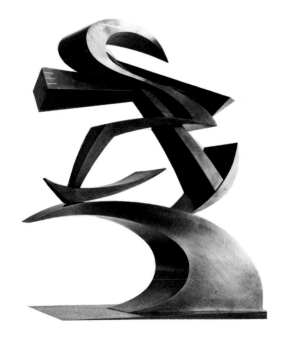

Umberto Boccioni
Riot at the Gallery
1910
oil on canvas, 76 × 64 cm
Milan, Pinacoteca di Brera
Bequest Emilio and Maria Jesi

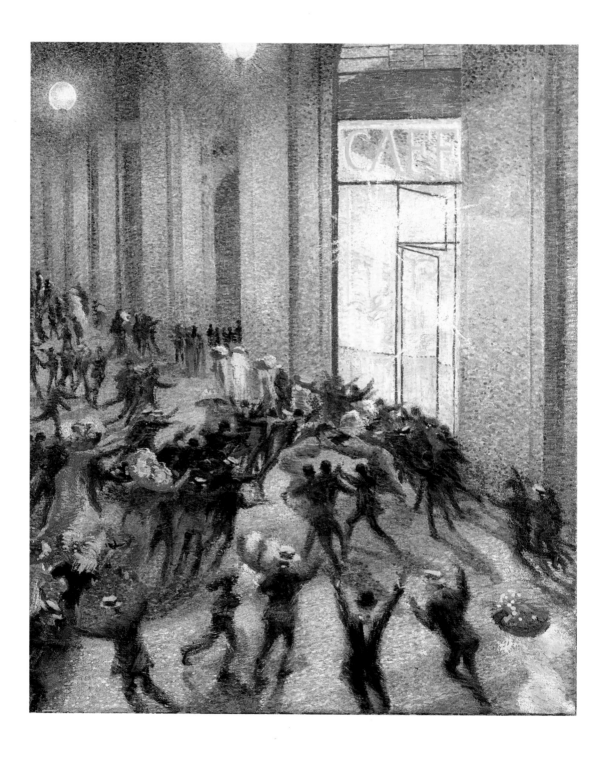

Umberto Boccioni
States of Mind: The Farewells
1911
charcoal and chalk on paper, 58,4 × 86,3 cm
New York, The Museum of Modern Art
Gift of Vico Baer

Umberto Boccioni
States of Mind: Those who go
1911
charcoal and chalk on paper, 58,4 × 86,3 cm
New York, The Museum of Modern Art
Bequest Vico Baer

Umberto Boccioni
States of Mind: Those who stay
1911
charcoal and chalk on paper, 58,4 × 86,3 cm
New York, The Museum of Modern Art
Gift of Vico Baer

Umberto Boccioni
States of Mind: The Farewells
1911
oil on canvas, 70,5 × 96,2 cm
New York, The Museum of Modern Art
Gift of Nelson A. Rockefeller, 1979

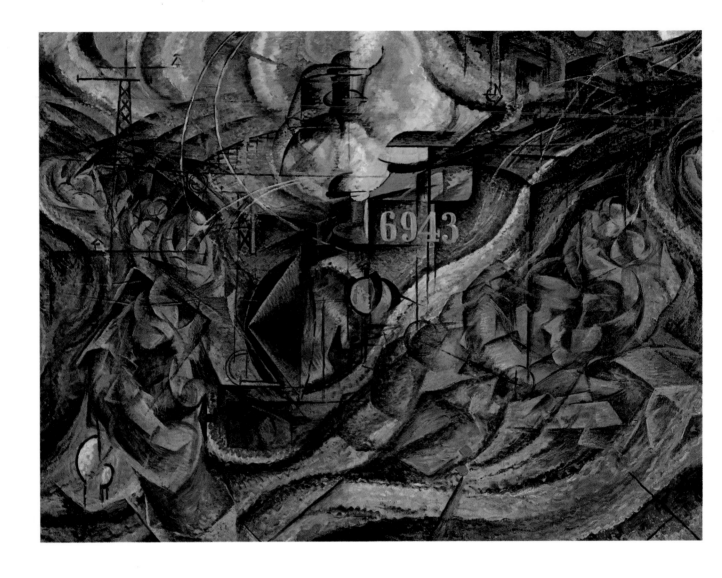

Umberto Boccioni
States of Mind: Those who go
1911
oil on canvas, 70,8 × 95,9 cm
New York, The Museum of Modern Art
Gift of Nelson A. Rockefeller, 1979

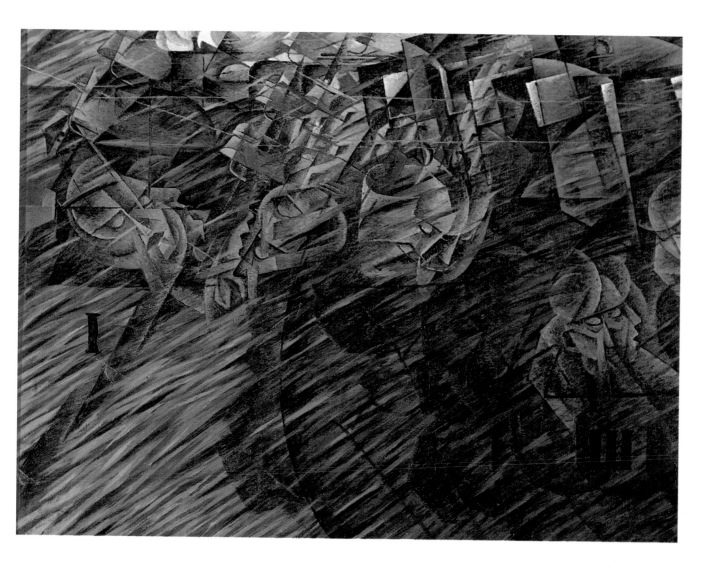

Umberto Boccioni
States of Mind: Those who stay
1911
oil on canvas, 70,8 × 95,9 cm
New York, The Museum of Modern Art
Gift of Nelson A. Rockefeller, 1979

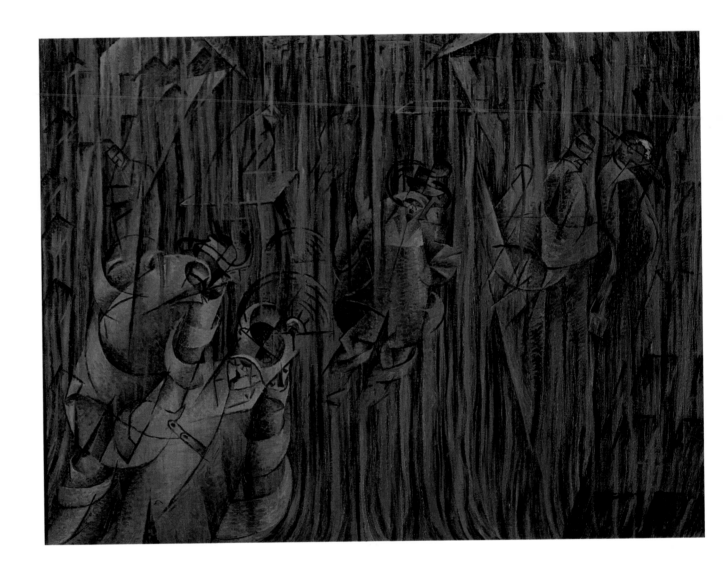

Umberto Boccioni
States of Mind I: The Farewells
1911
oil on canvas, 70 × 95 cm
Milan, Civico Museo d'Arte Contemporanea
Palazzo Reale

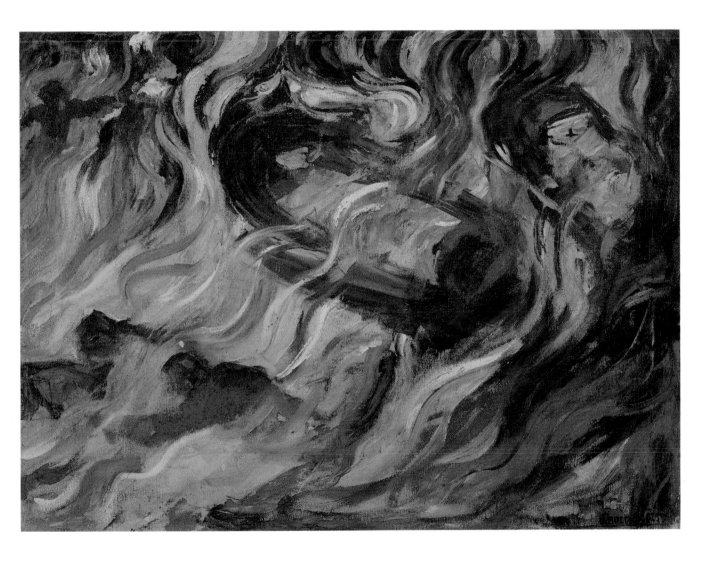

Umberto Boccioni
States of Mind I: Those who go
1911
oil on canvas, 71 × 96 cm
Milan, Civico Museo d'Arte Contemporanea
Palazzo Reale

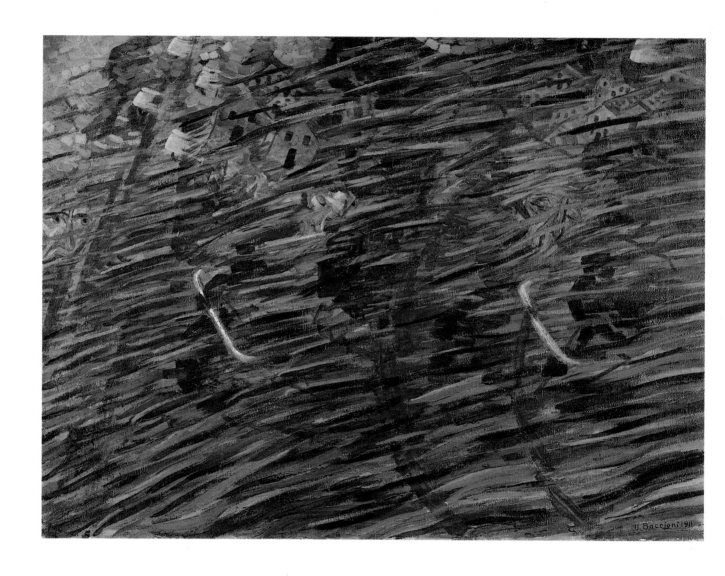

Umberto Boccioni
States of Mind I: Those who stay
1911
oil on canvas, 70 × 95,5 cm
Milan, Civico Museo d'Arte Contemporanea
Palazzo Reale

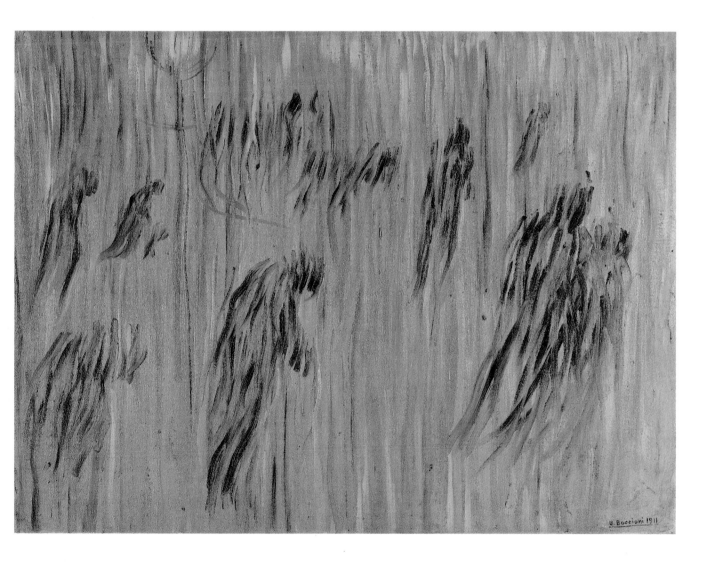

Umberto Boccioni
Men
1910
tempera on paper, 14 × 20 cm
Private Collection

Umberto Boccioni
The City Rises
1910
oil on wood, 17,5 × 30,5 cm
on loan from Salome and Eric Estorick

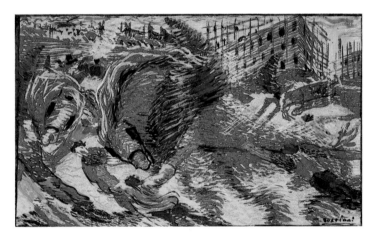

Umberto Boccioni
The City Rises, sketch
1910-11
tempera on paper on canvas, 36 × 60 cm
Milan, Pinacoteca di Brera
Bequest Emilio and Maria Jesi

Umberto Boccioni
The City Rises
1910
oil on paste-board, 33 × 47 cm
Milan, Mattioli Collection

Umberto Boccioni
The City Rises
1910-11
oil on canvas, 199,3 × 301 cm
New York, The Museum of Modern Art
Simon Guggenheim Fund, 1951

Painted in 1910-11, initially entitled Work
it was exhibited for the first time
on 30 April 1911 in Milan
at the Mostra di Arte libera.
One of the five large canvases
painted by the five major futurist artists

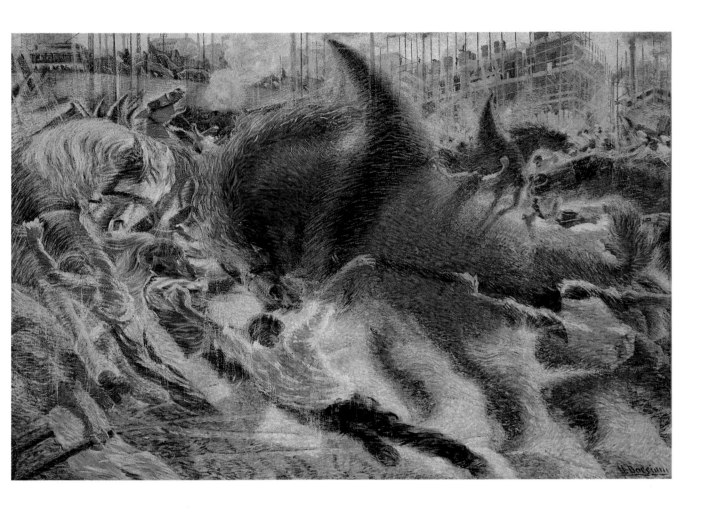

Umberto Boccioni
Modern Idol
1911
oil on wood, 59,7 × 58,4 cm
on loan from Salome and Eric Estorick

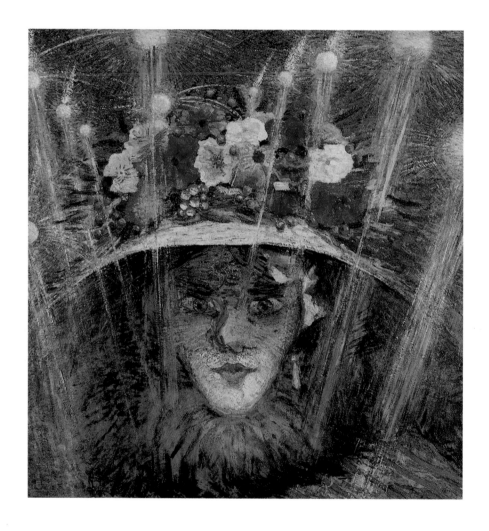

Umberto Boccioni
The Laughter
1911
oil on canvas, 110,2 × 145,4 cm
New York, The Museum of Modern Art
Gift of Herbert and
Nannette Rothschild, 1959

Exhibited in April 1911 at the Mostra
di Arte libera in Milan, this canvas provoked
such reactions in the press and in the public
that an unknown visitor ripped it.
It is known that the canvas was completely
repainted in the fall of the same year

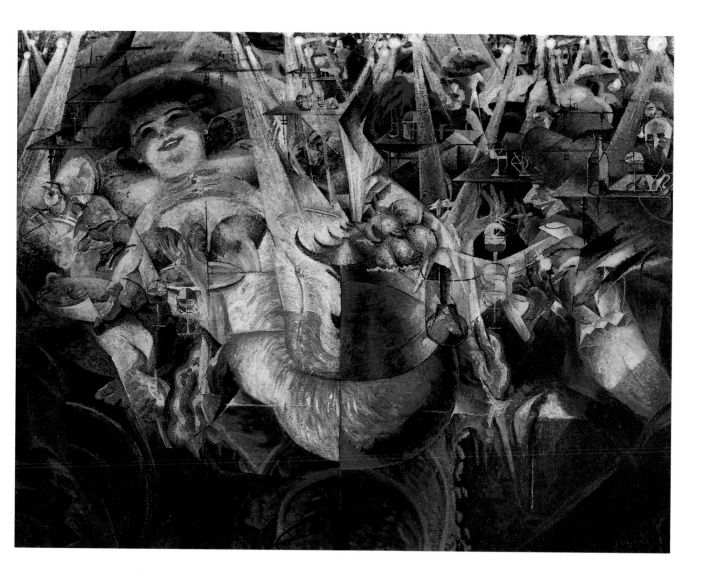

Umberto Boccioni
Simultaneous Visions
1911
oil on canvas, 60,5 × 60,6 cm
Wuppertal, Von der Heydt-Museum

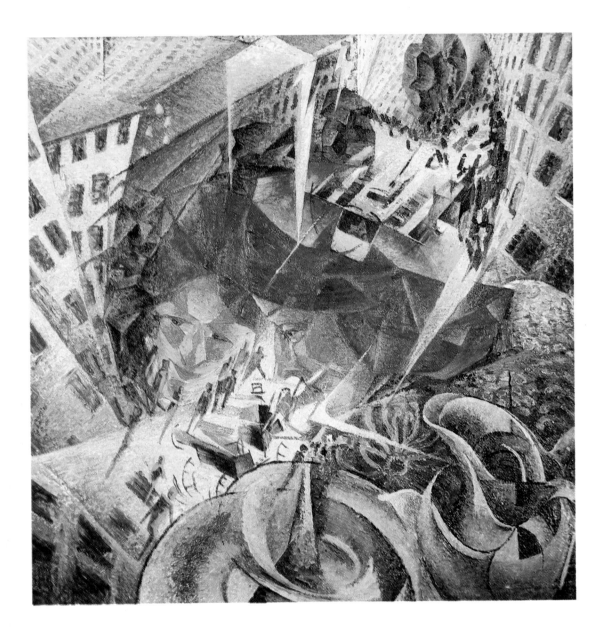

Umberto Boccioni
The Street Enters the House
1911
oil on canvas, 100 × 100 cm
Hannover, Kunstmuseum Hannover
mit Sammlung Sprengel

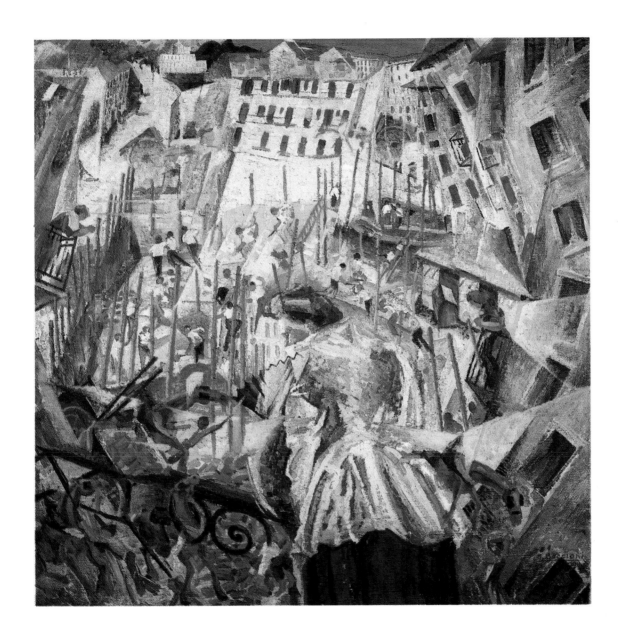

Umberto Boccioni
Elasticity
1912
oil on canvas, 100 × 100 cm
Milan, Riccardo and Magda Jucker Collection
on loan to Pinacoteca of Brera

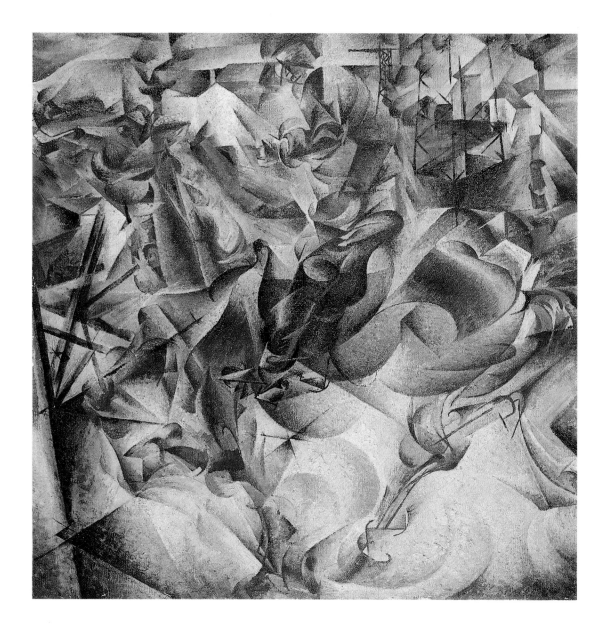

Umberto Boccioni
Head
1912
wood, 32 cm
Private Collection

(following page)

Umberto Boccioni
Development of a Bottle in Space
1912
bronze, 39,5 × 59,5 × 32,8 cm
Saõ Paulo, Contemporary Art Museum
University of Saõ Paulo

Umberto Boccioni
Development of a Bottle in Space
1912
plaster, 39,5 × 59,5 × 32,8 cm
Saõ Paulo, Contemporary Art Museum
University of Saõ Paulo

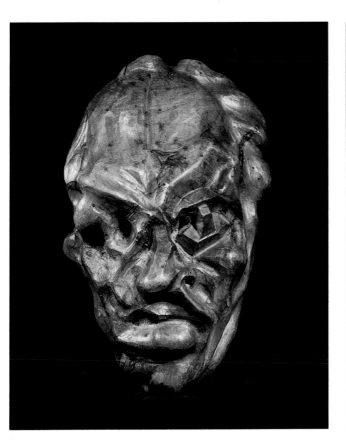
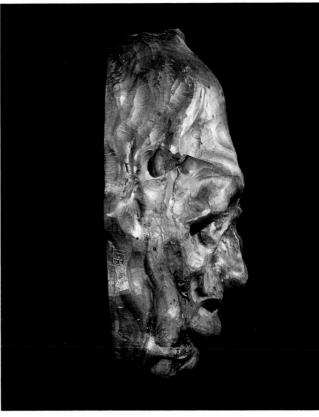

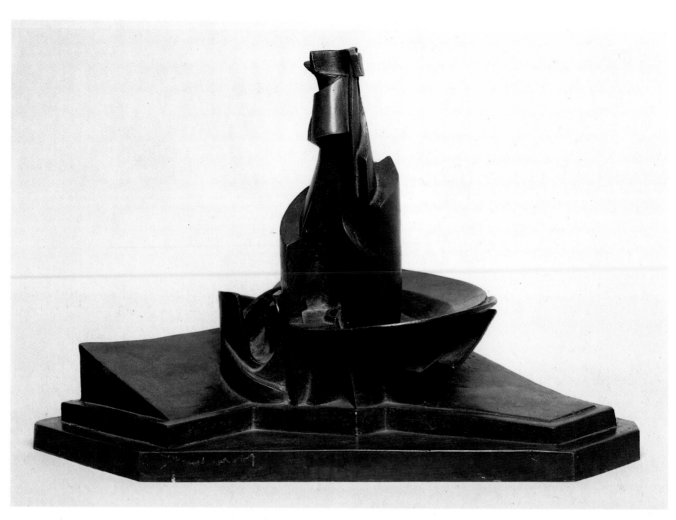

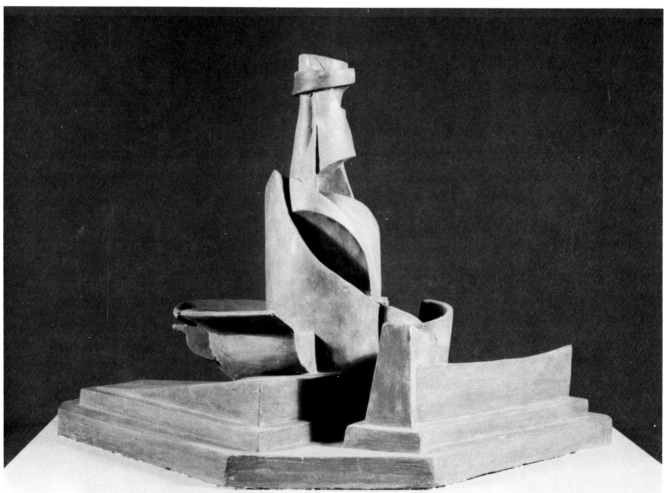

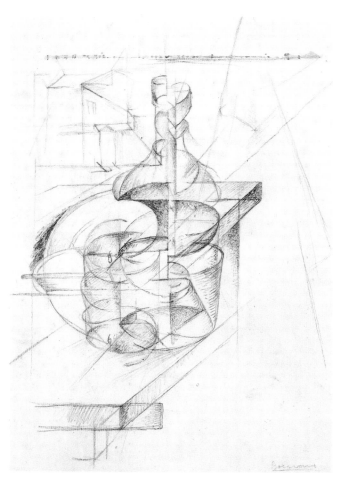

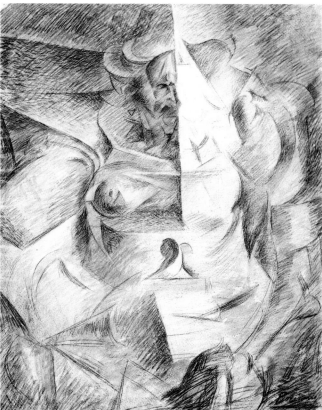

Umberto Boccioni
Table + Bottle + Building
1912
pencil on paper, 33,4 × 23,9 cm
Milan, Castello Sforzesco
Civico Gabinetto dei Disegni

Umberto Boccioni
Head + House + Light + Studio
1912
charcoal and watercolour on paper
61 × 48,8 cm
Milan, Castello Sforzesco
Civico Gabinetto dei Disegni

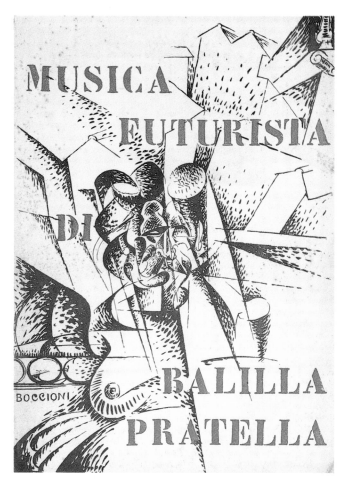

Umberto Boccioni
*Drawing for the cover of Musica Futurista
by Francesco Balilla Pratella*
1912
tempera and ink on paper, 53 × 39 cm
Ravenna, Pratella Collection

Umberto Boccioni
Horizontal Construction
1912
oil on canvas, 95 × 95 cm
Munich
Bayerische Staatsgemäldesammlungen

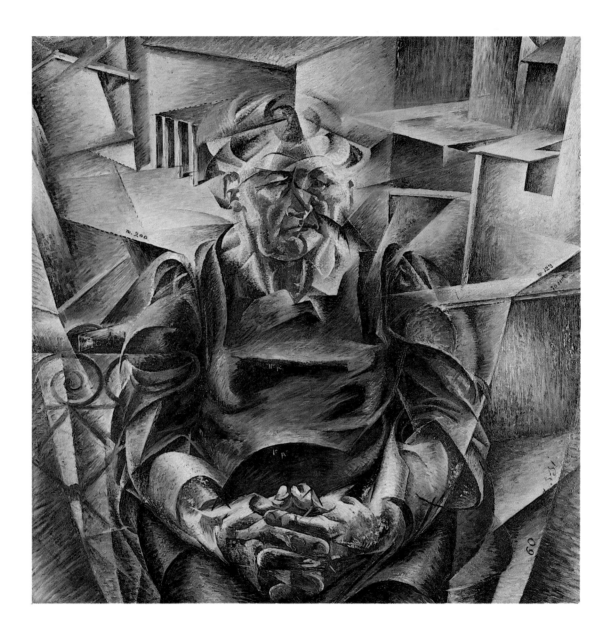

Umberto Boccioni
Materia
1912
oil on canvas, 225 × 150 cm
Milan, Mattioli Collection

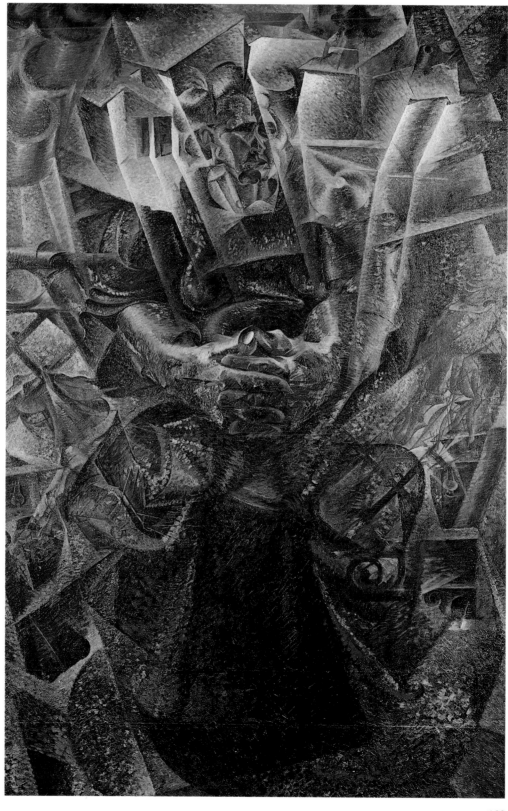

Umberto Boccioni
Anti-gracious
1912-13
plaster, 58 × 50 × 40 cm
Rome
Galleria Nazionale d'Arte Moderna

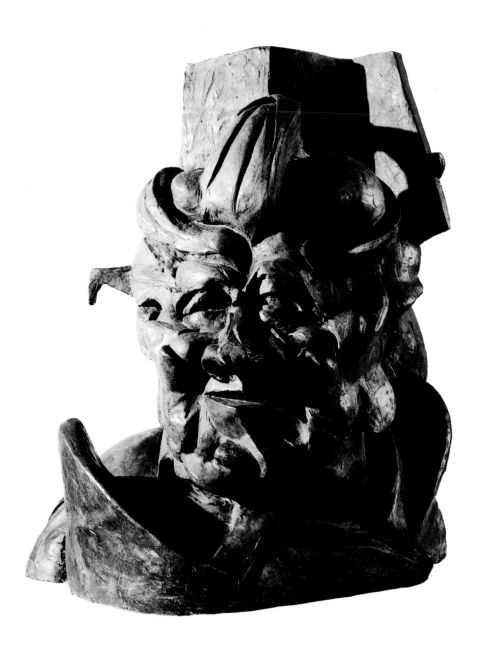

Umberto Boccioni
Anti-gracious
1912
oil on canvas, 80 × 80 cm
Private Collection

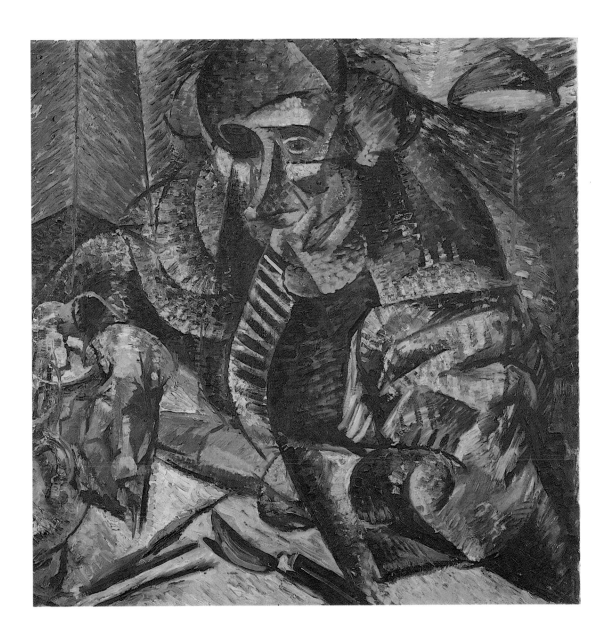

Umberto Boccioni
Unique Form of Continuity in Space
1913
plaster, 126,4 × 89 × 40,6 cm
Saõ Paulo, Contemporary Art Museum
University of Saõ Paulo

Umberto Boccioni
Unique Form of Continuity in Space
1913
bronze, 126,4 × 89 × 40,6 cm
Rome, Private Collection

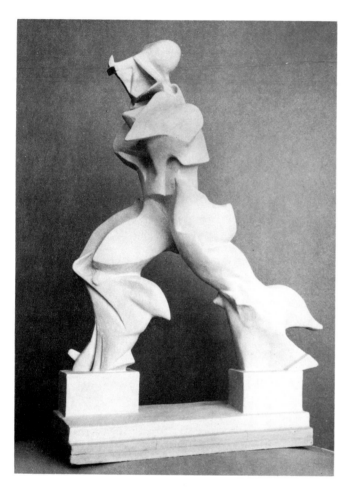

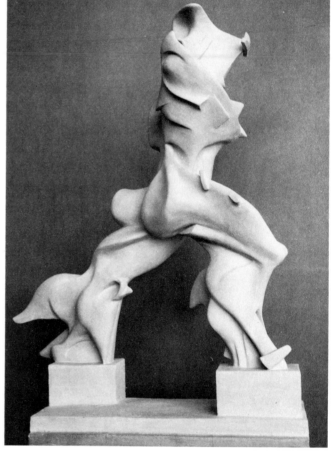

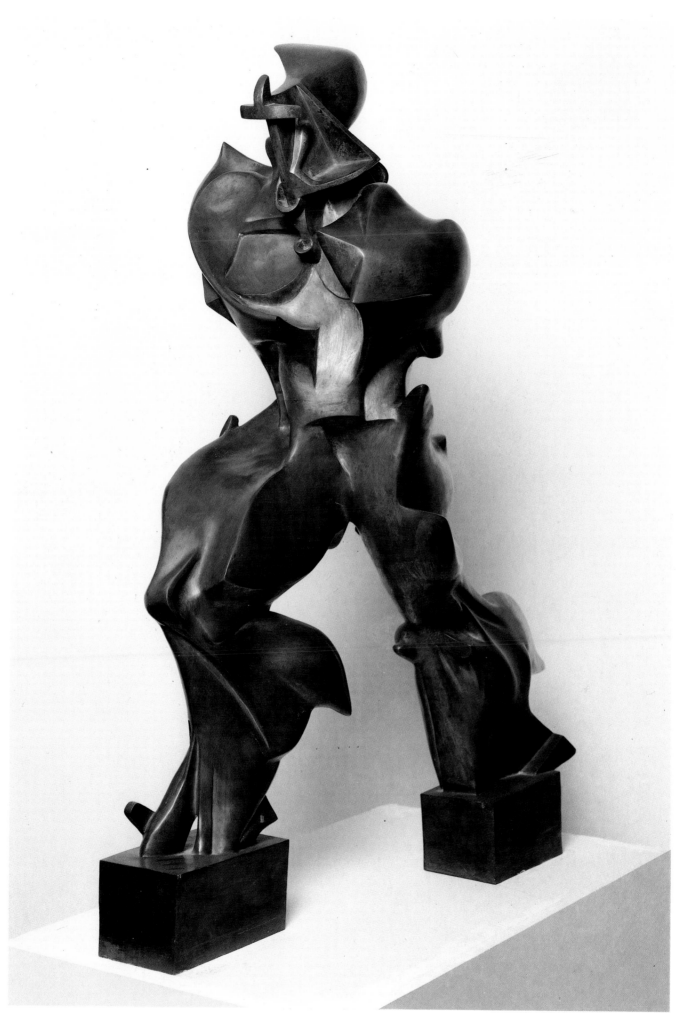

Umberto Boccioni
Dynamism of a Cyclist
1913
oil on canvas, 70 × 95 cm
Milan, Mattioli Collection

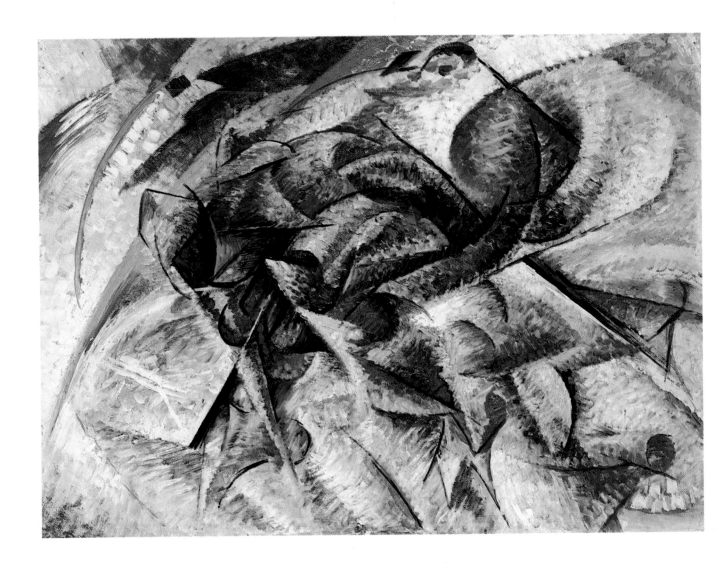

Umberto Boccioni
Dynamism of a Soccer Player
1913
oil on canvas, 193,2 × 201 cm
New York, The Museum of Modern Art
Gift of Sidney and Harriet Janis, 1967

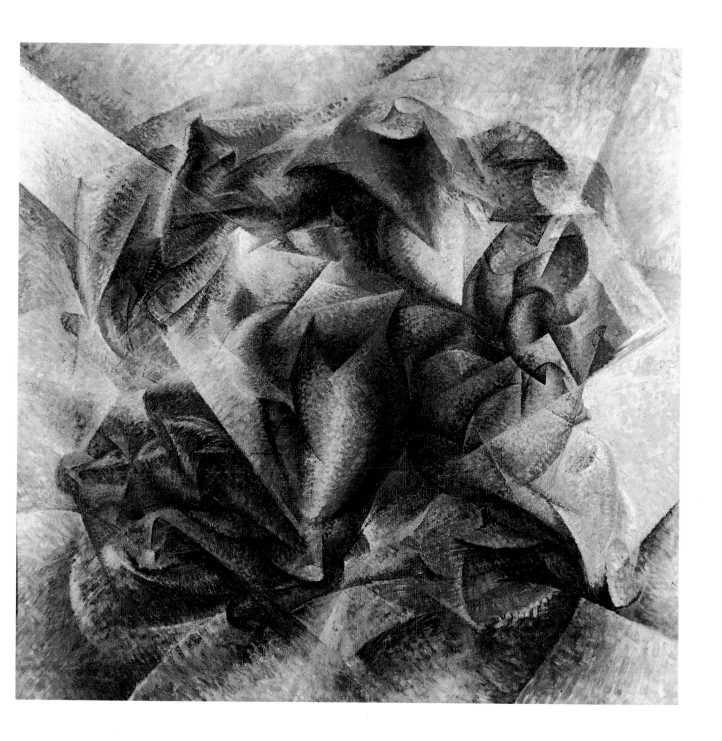

Umberto Boccioni
Decomposition of a Woman Figure
or *Woman in a Cafè*
or *Compenetrations of Lights and Plans*
or *Woman at a Table*
1912
oil on canvas, 86 × 86 cm
Milan, Civico Museo d'Arte Contemporanea
Palazzo Reale

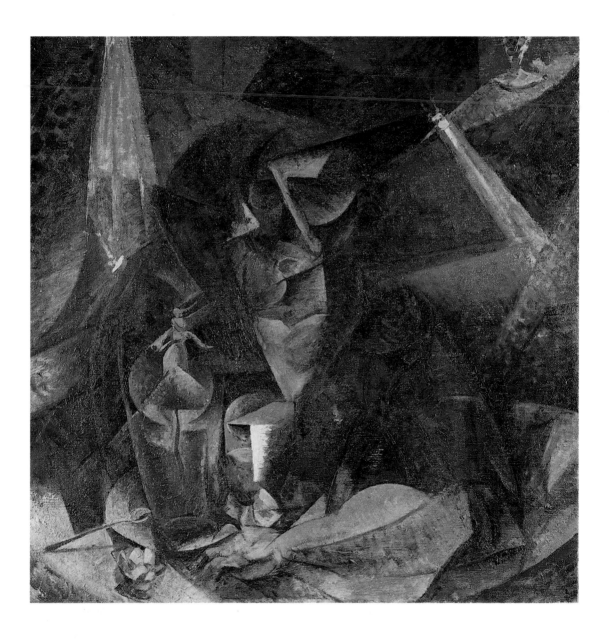

Umberto Boccioni
The Drinker
1914
oil on canvas, 87 × 88 cm
Milan, Riccardo and Magda Jucker Collection
on loan to Pinacoteca of Brera

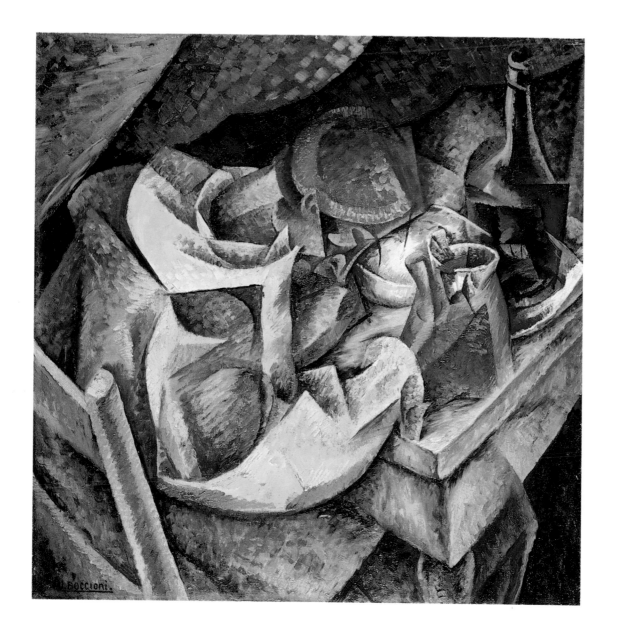

Umberto Boccioni
Charge of the Lancers
1915
tempera and collage on paste-board
32 × 50 cm
Milan, Riccardo and Magda Jucker Collection
on loan to Pinacoteca of Brera

Umberto Boccioni
Dynamism of a Racing Horse + House
1914-15
gouache, oil, wood, paste-board, copper
and painted iron, 112,9 × 115 cm
Venice, Peggy Guggenheim Collection
(Solomon R. Guggenheim Foundation)

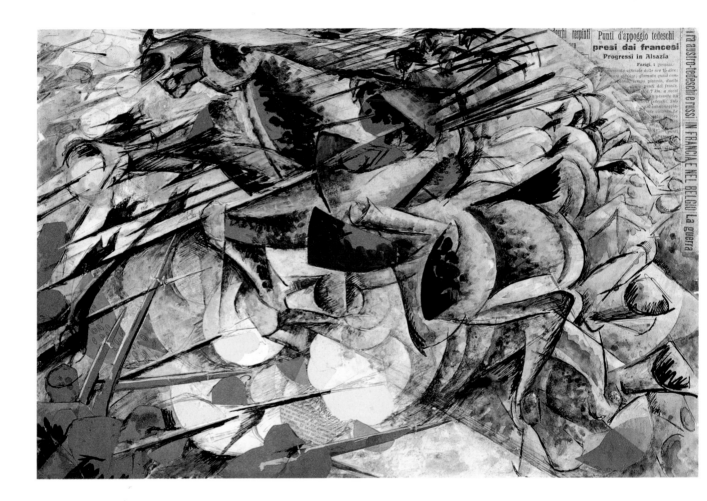

... The condition of this work — Boccioni's sole surviving futurist construction — of which only circa fifty per cent remains in the original form, poses considerable problems, both for an understanding of the artist's intentions and for an assessment of the degree to which he achieved them.

The earliest surviving record of the condition in which he probably left the piece at his death, is a photograph published in 1923. However, it is likely that Boccioni never regarded the work as finished, and that he was still struggling with the resolution of its conceptual problems when he died in 1916. The existence of an important group of earlier drawings and watercolours on the same theme, many of which were 1913-14 studies for paintings, throws considerable light on the nature of Boccioni's ambitions for Dynamism of a Racing Horse + House. Taken together with his own theoretical statements, these works on paper provide a background for the reading of the image: the notion of the horse's speed was to be conveyed through an integration of its form with that of its environment. In his 1913 catalogue preface for the La Boétie exhibition, Boccioni had articulated the essential components of the problem for the first time: "if a spherical form (the plastic equivalent of a head) is traversed by the façade of a building situated farther back, the interrupted semi-circle and the square façade which intercepted it will form a new unit, composed of environment + object... The conception of the sculptural object becomes the plastic result of the object and its environment, and thereby abolishes the distance which exists, for example, between a figure and a house 200 metres apart. This conception produces the extension of a body in the ray of light which strikes it, the penetration of a void into the solid which passes before it."

The issues articulated in this text remained critical for Boccioni as he worked on the construction Dynamism of a Racing Horse + House. "not pure form, but pure plastic rhythm, not the construction of bodies, but the construction of the action of bodies." Above all, he aimed to achieve a "complete fusion of the environment with the object by means of the interpenetration of planes"...

(Angelica Zander Rudenstine)

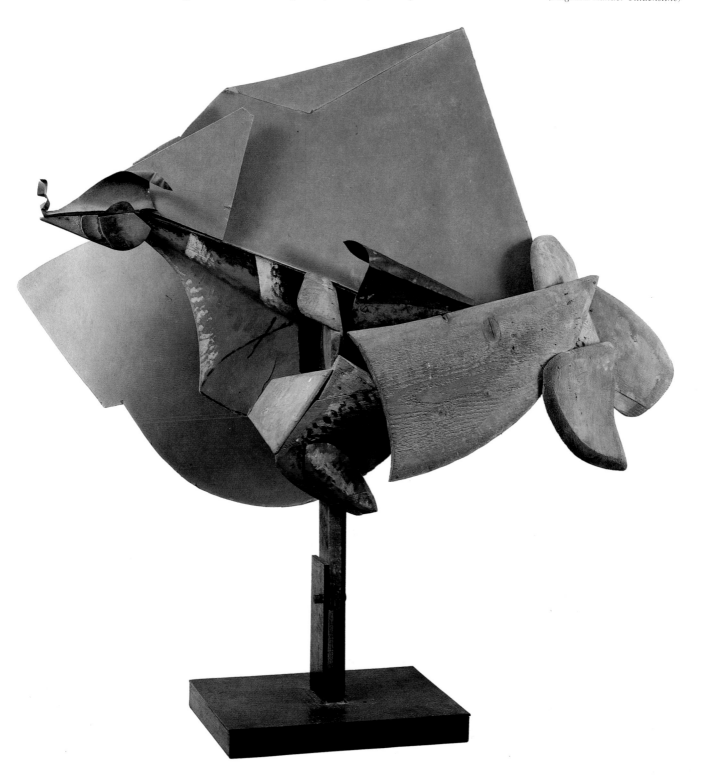

Anton Giulio Bragaglia
Hand in Movement
1911
photodynamic, 13 × 18 cm
Rome
Antonella Vigliani Bragaglia Collection
Centro Studi Bragaglia

Presented by Marinetti the photodynamics
were exhibited for the first time
in 1912 in the Picchetti Room in Rome

Anton Giulio and Arturo Bragaglia
Typist
1911
photodynamic, 9,5 × 14 cm
Rome
Antonella Vigliani Bragaglia Collection
Centro Studi Bragaglia

Anton Giulio Bragaglia
Double Print
(study of a new photographic image)
1911
12 × 9 cm
Rome
Antonella Vigliani Bragaglia Collection
Centro Studi Bragaglia

Anton Giulio Bragaglia
Figure descending stairs (Self-portrait)
1911
photodynamic, 17 × 12 cm
Rome
Antonella Vigliani Bragaglia Collection
Centro Studi Bragaglia

Anton Giulio Bragaglia
Shaking Head
1911
photodynamic, 18,5 × 13,5 cm
Rome
Antonella Vigliani Bragaglia Collection
Centro Studi Bragaglia

Anton Giulio Bragaglia
Thais, stills
1916
Rome
Antonella Vigliani Bragaglia Collection
Centro Studi Bragaglia

Script by A.G. Bragaglia and R. Cassano
Cast: Thais Galitzky, Ileana Leonidof
Augusto Bandini, Mario Parpagnoli
Costumes and stage, E. Prampolini, 1446 m
Commercially distributed
in Italy and abroad in the summer of 1917

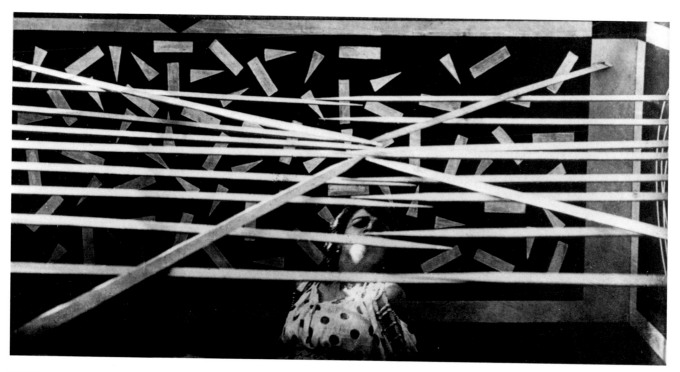

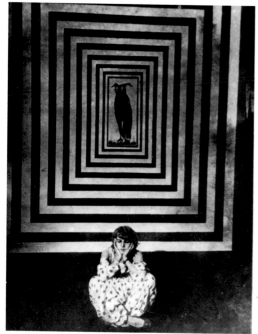

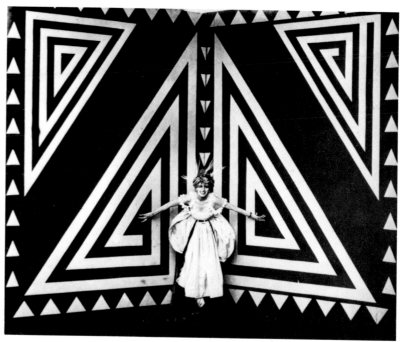

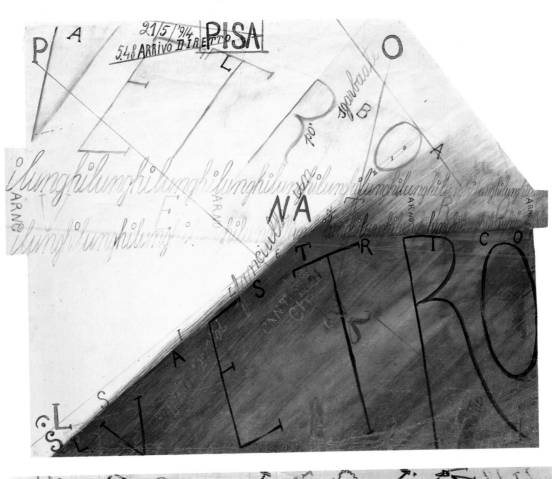

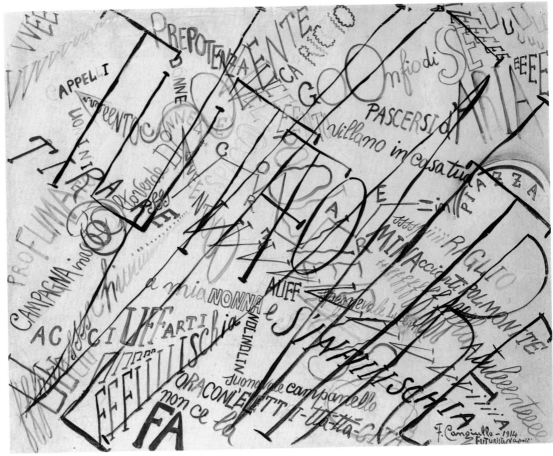

Francesco Cangiullo
Pisa (plate)
1914
tempera on paper, 57 × 74 cm
Milan, Calmarini Collection

Francesco Cangiullo
Words in Freedom
1914
watercolour and gouache on paper
58 × 74 cm
Private Collection

Francesco Cangiullo
University (plate)
1914-15
grey ink and watercolour on paper
21 × 27 cm
Private Collection

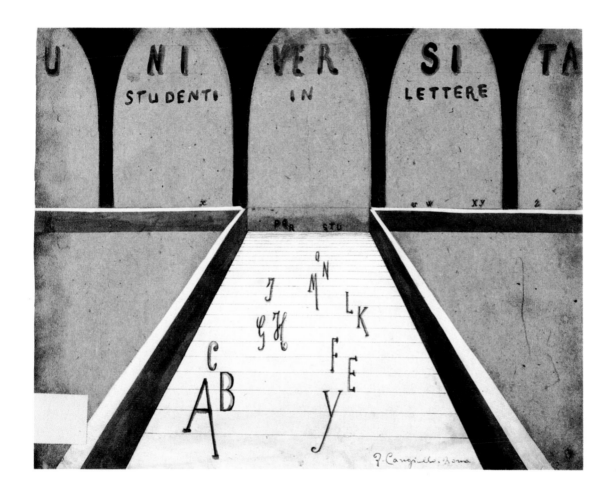

Francesco Cangiullo
Beautiful. Humanized Letters
1914
pen on paper, 27,6 × 21,6 cm
Milan, Calmarini Collection

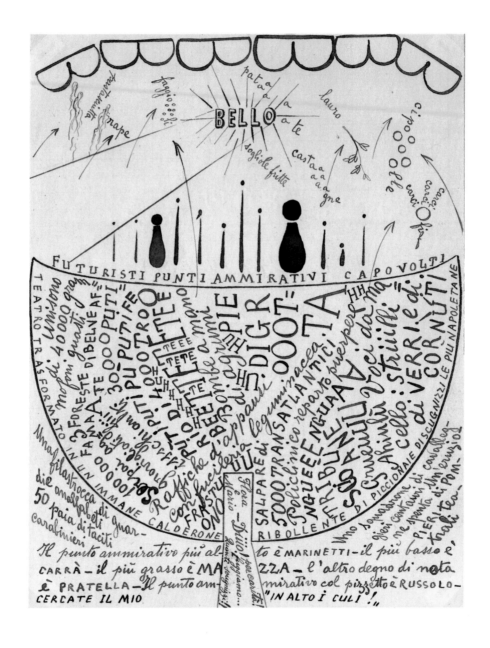

Francesco Cangiullo
Words in Freedom (Chorus Girls)
1915
pen on paper, 38,5 × 26 cm
Private Collection

Francesco Cangiullo
Words in Freedom (Chorus Girls)
1915
pen on paper, 49 × 26 cm
Private Collection

149

Carlo Carrà
Night Scene in Piazza Beccaria
1910
oil on canvas, 60 × 45 cm
Milan, Riccardo and Magda Jucker Collection
on loan to Pinacoteca of Brera

Carlo Carrà
The Swimmers
1910
oil on canvas, 105,3 × 155,6 cm
Pittsburgh, Museum of Art Carnegie Institute
bequest G. David Thompson, 1955

Carlo Carrà
Funeral of the Anarchist Galli, sketch
1910
pastel on thin paste-board, 57 × 78 cm
Private Collection

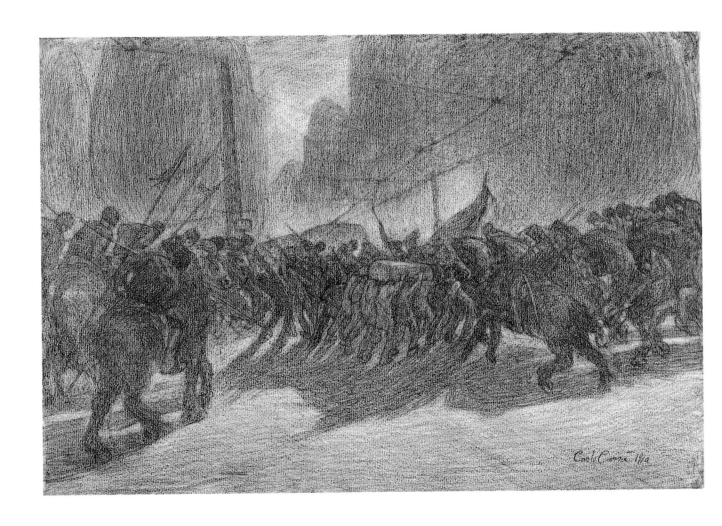

Carlo Carrà
Funeral of the Anarchist Galli
1911
oil on canvas, 198,7 × 259,1 cm
New York, The Museum of Modern Art
acquired through
the Lillie P. Bliss Bequest, 1948

One of the five large paintings by the five
artists in the central Futurist group

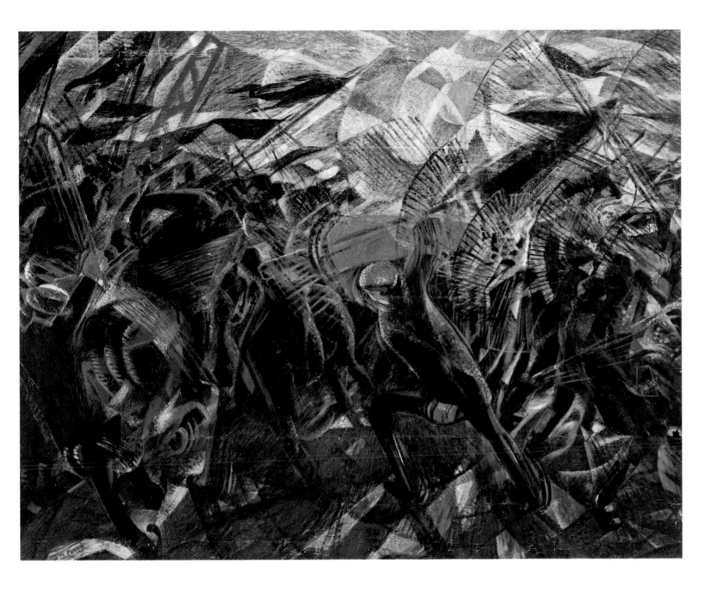

153

Carlo Carrà
Portrait of Marinetti
1910-11
oil on canvas, 100 × 80 cm
Private Collection

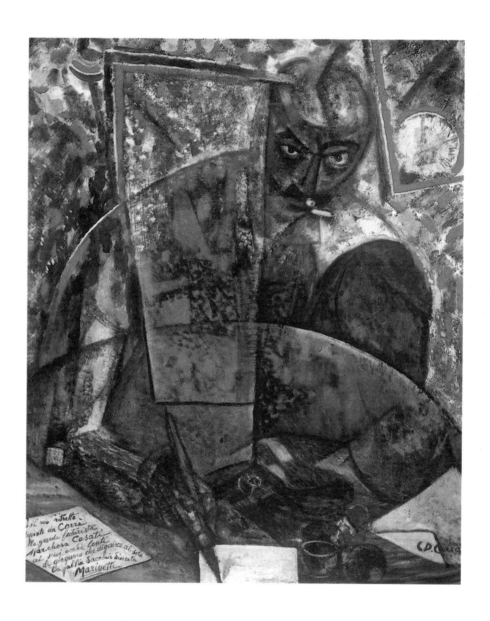

Carlo Carrà
What the Street-Car Told Me
1910-11
oil on canvas, 52 × 67 cm
Frankfurt, Städtische Galerie
des Städelschen Kunstinstitutes (on loan)

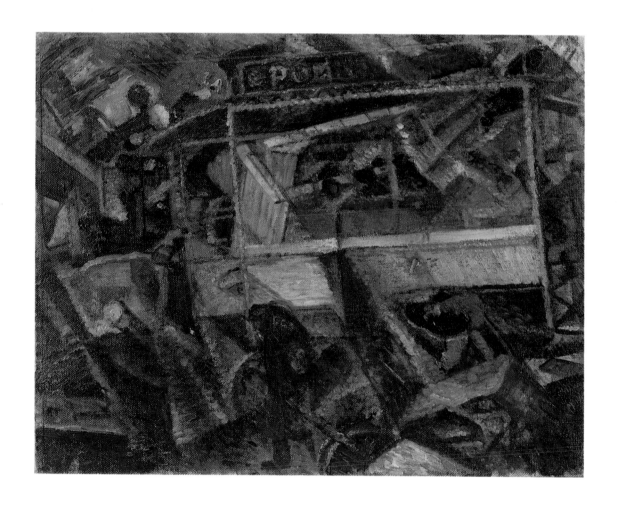

Carlo Carrà
Jolts of a Cab
1911
oil on canvas, 52,3 × 67,1 cm
New York, The Museum of Modern Art
Gift of Herbert and Nannette Rotschild, 1965

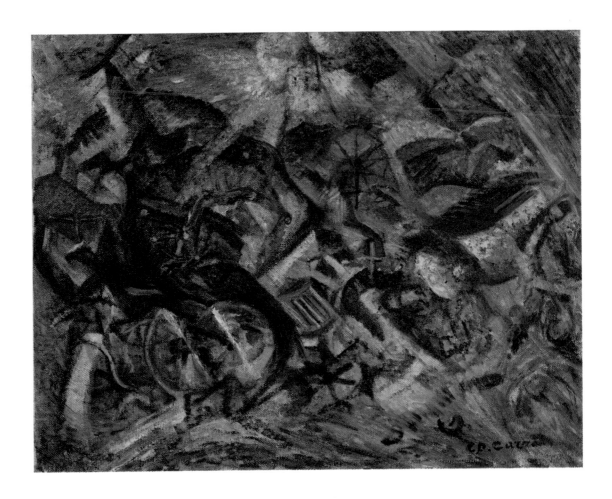

Carlo Carrà
The Absinth Drinker or *Woman in a Café*
or *Woman with Absinth*
1911
oil on canvas, 67 × 52 cm
Cologne, Ludwig Museum
Private Collection

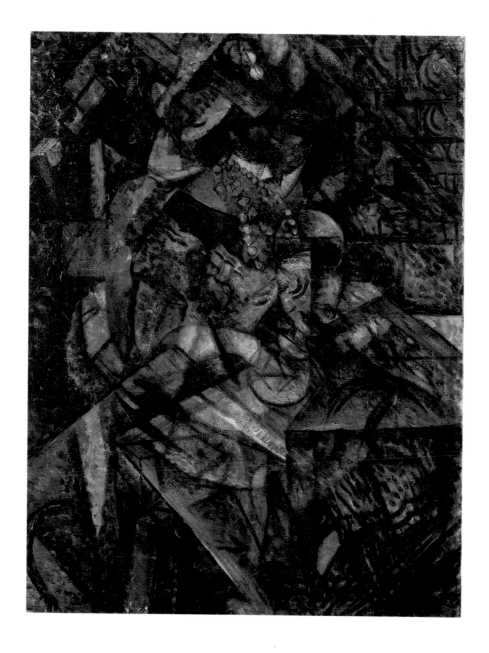

Carlo Carrà
Synthesis of a Café Concert
1910-12
charcoal and tempera on paper
76,2 × 66 cm
on loan from Salome and Eric Estorick

Carlo Carrà
Cab
1911
ink on paper, 10,8 × 15,8 cm
Private Collection

Carlo Carrà
Speeding Car
1910
charcoal on paper, 20,2 × 27,2 cm
Private Collection

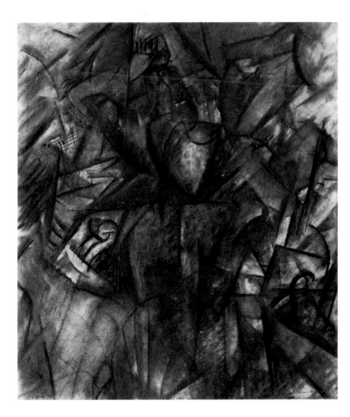

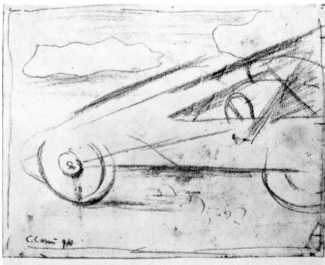

158

Carlo Carrà
The Galleria in Milan
1912
oil on canvas, 91 × 51,5 cm
Milan, Mattioli Collection

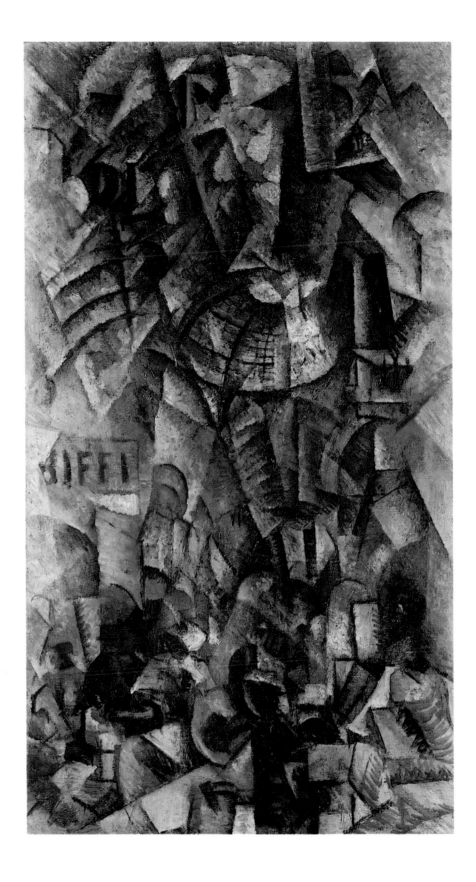

Carlo Carrà
Horse and Rider or *The Red Rider*
1913
ink and tempera on paper pasted on
canvas, 26 × 36 cm
Milan, Riccardo and Magda Jucker Collection
on loan to Pinacoteca of Brera

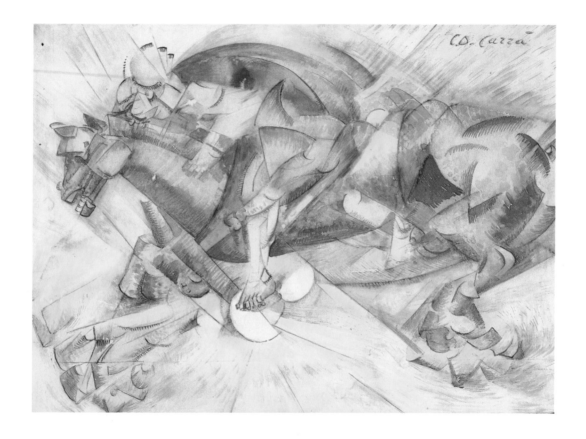

Carlo Carrà
The Chase
1914
collage on paste-board, 39 × 68 cm
Milan, Mattioli Collection

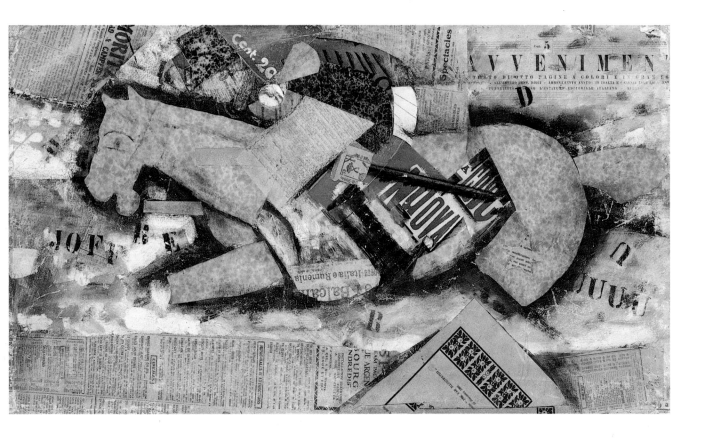

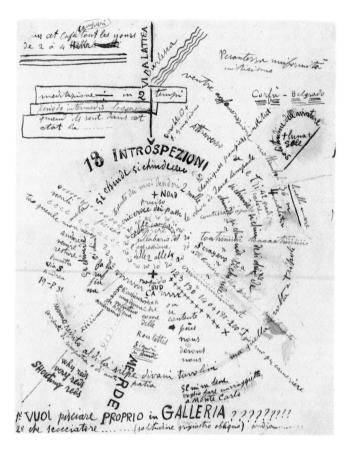

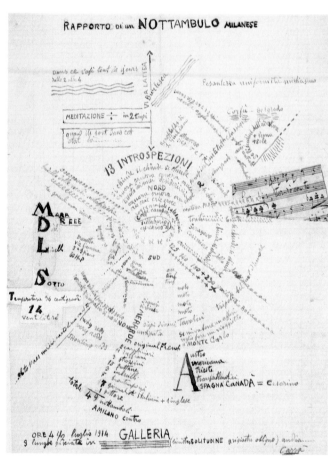

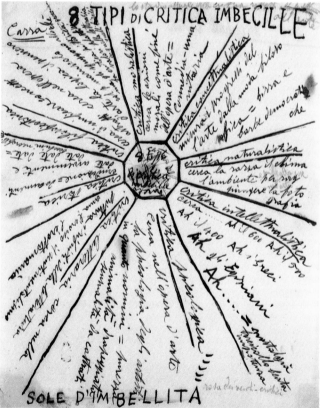

Carlo Carrà
13 Introspections
1914
ink, pencil and collage on paper
26,5 × 21 cm
Private Collection

Carlo Carrà
Sun of Cowardice
1914
ink on paper, 28 × 23,5 cm
Milan, Calmarini Collection

Carlo Carrà
Report of a Milanese Noctambulist
1914
ink and collage on paper, 37,4 × 28 cm
Milan, Calmarini Collection

Carlo Carrà
Interventionist Demonstration
1914
collage on paste-board, 38,5 × 30 cm
Milan, Mattioli Collection

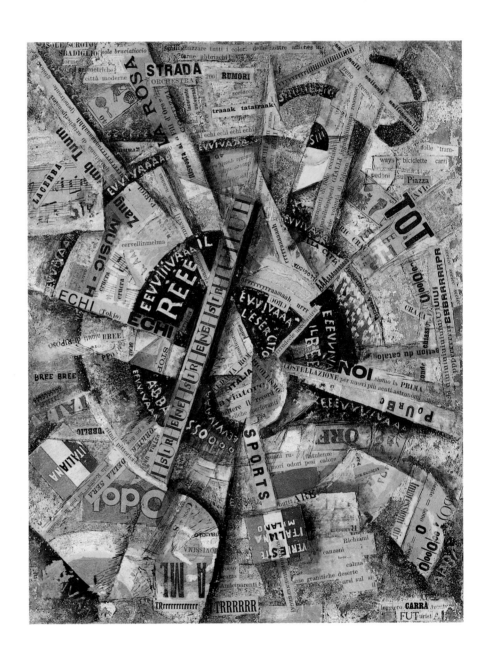

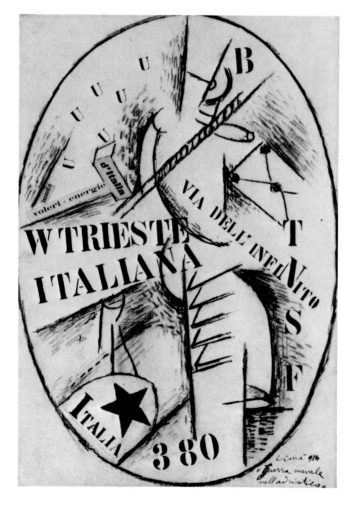

Carlo Carrà
Cineamore
1914
ink and pencil on paper, 39 × 28 cm
Milan, Calmarini Collection

Carlo Carrà
Naval War on the Adriatic
1914
ink and collage on paper, 37 × 27 cm
Turin
Antonio and Marina Forchino Collection

Carlo Carrà
Homage to Blériot
1914
ink, pencil and collage on paper
39 × 28 cm
Private Collection

Carlo Carrà
Graphic Composition
1914
ink and pencil on paper, 31 × 21 cm
Private Collection

Carlo Carrà
Atmospheric Swirls. A Bursting Shell
1914
ink and collage on paper
on loan from Salome and Eric Estorick

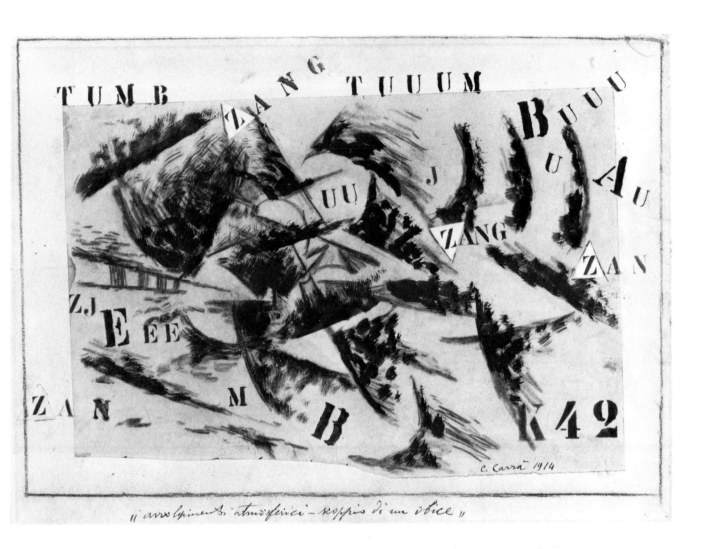

Mario Chiattone
Bridge and Study of volumes
1914
watercolour and China ink on paper
65 × 47,5 cm
Pisa, Dipartimento di Storia delle Arti
dell'Università, Gabinetto Disegni e Stampe

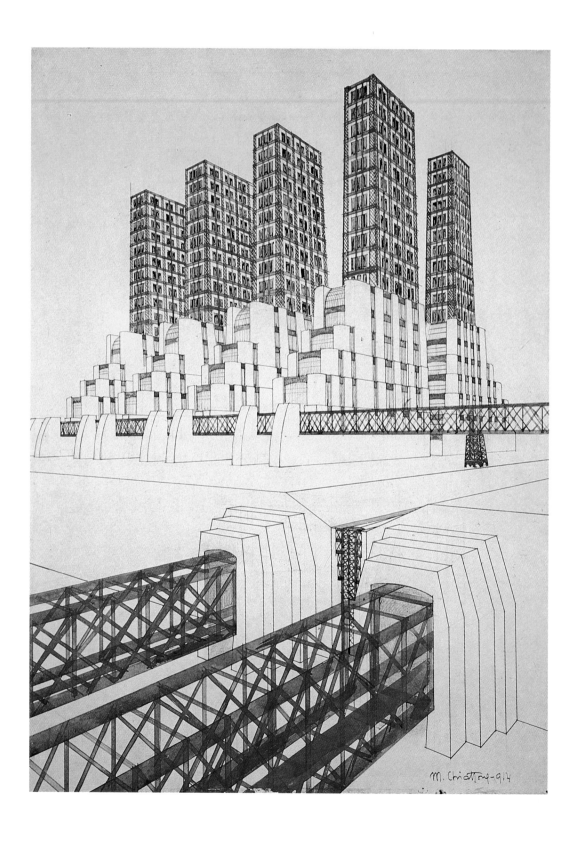

Mario Chiattone
Construction for a Modern Metropolis
1914
watercolour and China ink on paper
106 × 95 cm
Pisa, Dipartimento di Storia delle Arti
dell'Università, Gabinetto Disegni e Stampe

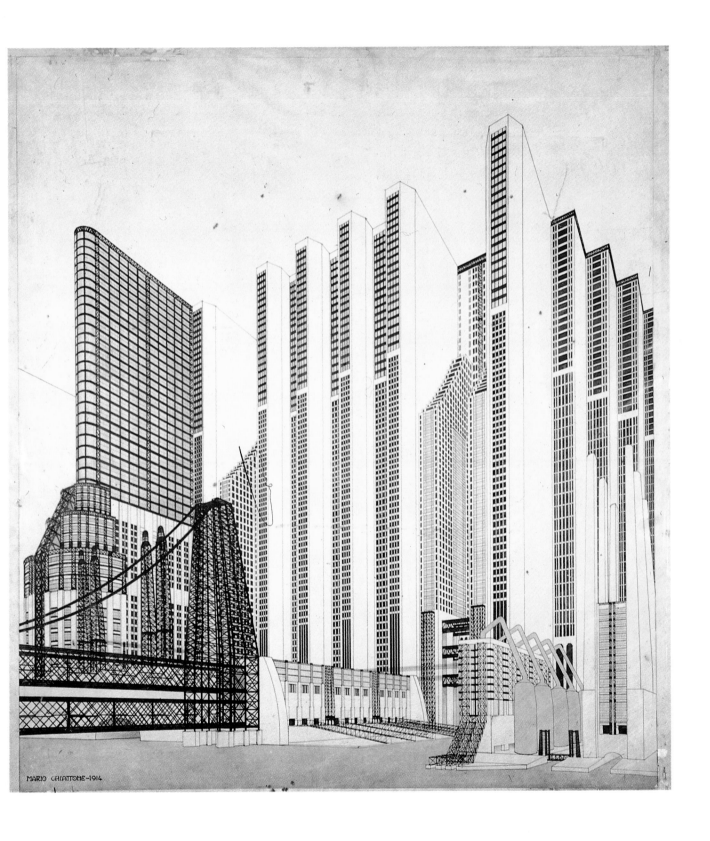

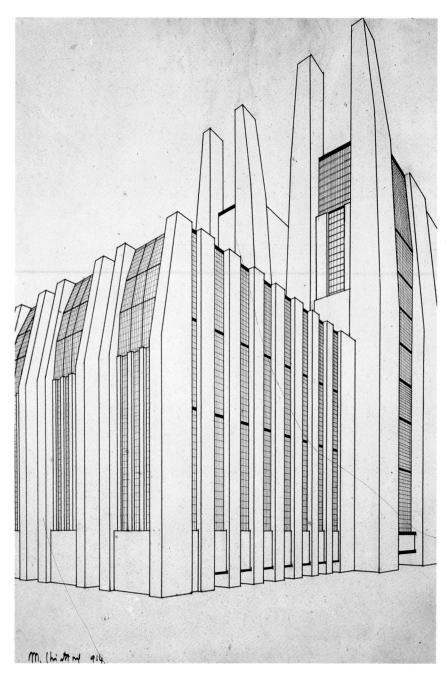

Mario Chiattone
Factory
1914
China ink on paper, 57 × 40 cm
Pisa, Dipartimento di Storia delle Arti
dell'Università, Gabinetto Disegni e Stampe

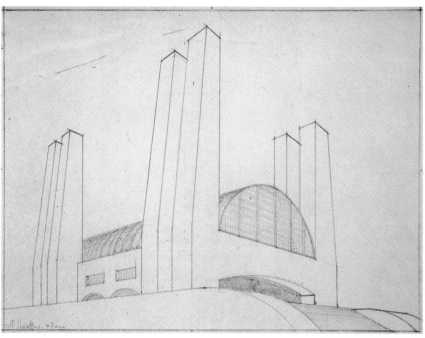

Mario Chiattone
Palace for Exhibitions II or *Building with Corner Pillars* or *Workshop*
1914
pencil on paper, 30 × 40,5 cm
Pisa, Dipartimento di Storia delle Arti
dell'Università, Gabinetto Disegni e Stampe

Mario Chiattone
Apartment Building III
1914
watercolour and ink on paper, 47 × 41 cm
Pisa, Dipartimento di Storia delle Arti
dell'Università, Gabinetto Disegni e Stampe

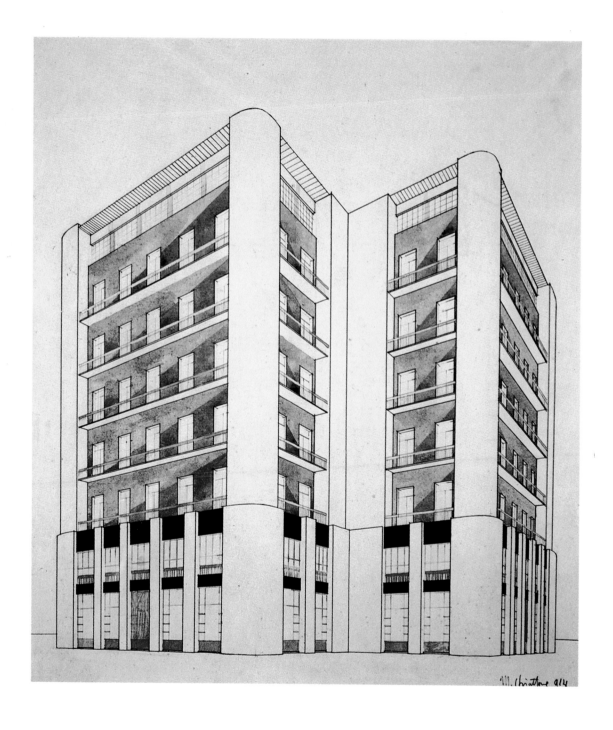

Mario Chiattone
Concert Hall
1914
watercolour and China ink on paper
32,5 × 58 cm
Pisa, Dipartimento di Storia delle Arti
dell'Università, Gabinetto Disegni e Stampe

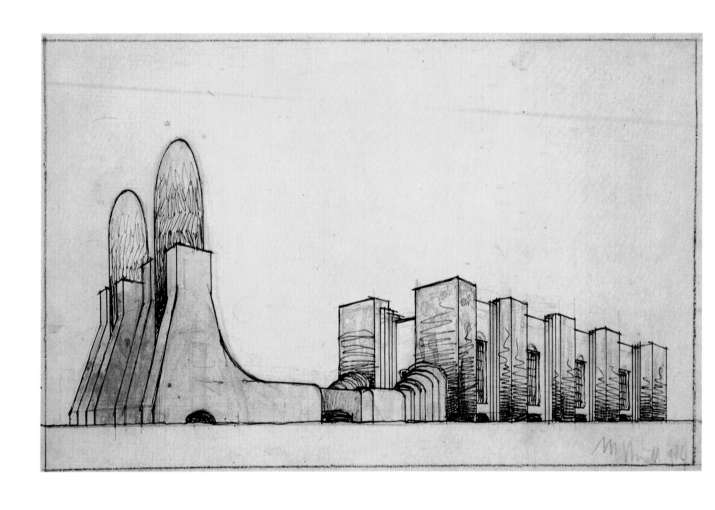

Mario Chiattone
Bridge
1915
watercolour and pencil on paper
35 × 45 cm
Pisa, Dipartimento di Storia delle Arti
dell'Università, Gabinetto Disegni e Stampe

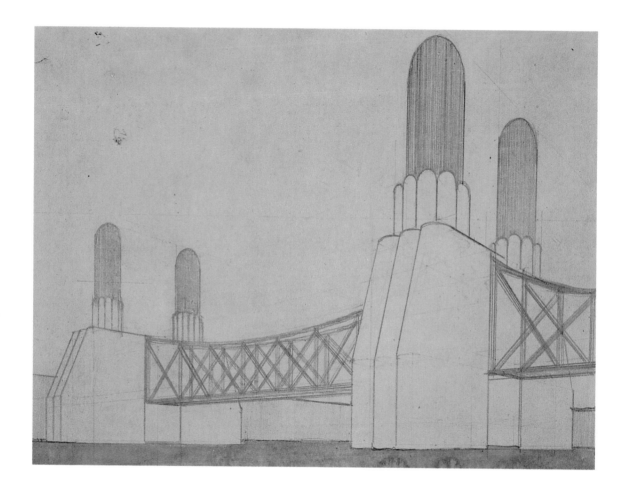

Mario Chiattone
Building with two Towers or *Workshop*
or *Building with two Towers VI*
1915
watercolour and pencils on paper
34,5 × 35,5 cm
Pisa, Dipartimento di Storia delle Arti
dell'Università, Gabinetto Disegni e Stampe

Mario Chiattone
Apartment Building VI or *Luxury Building*
or *Collective Building*
1915
watercolour, China ink and pencil
on paper, 60 × 80 cm
Pisa, Dipartimento di Storia delle Arti
dell'Università, Gabinetto Disegni e Stampe

Fortunato Depero
Movements of Birds
1916
oil, tempera and enamel on canvas
100 × 135 cm
Rovereto, Galleria Museo Depero

Fortunato Depero
The Big Wild Woman
1917
tempera on canvas
197 × 129 cm
Zurich, Private Collection

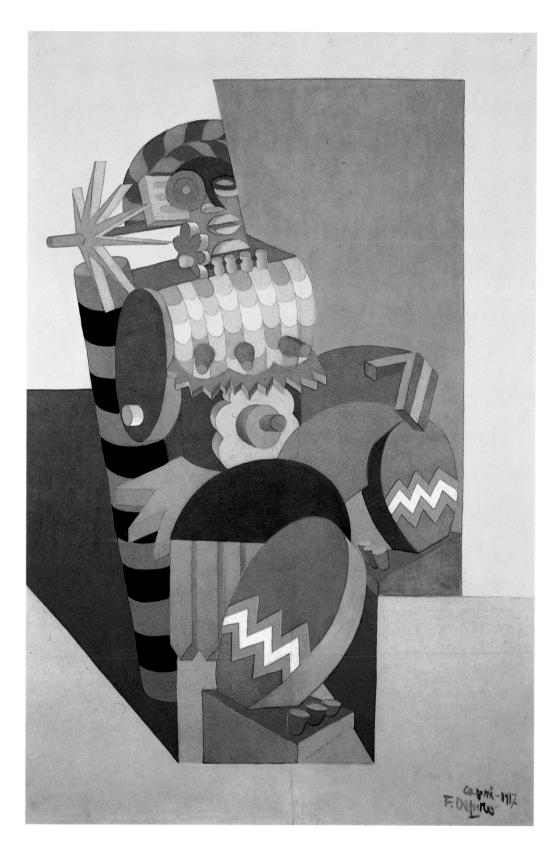

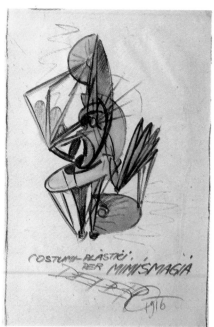

Fortunato Depero
Costume for Mimismagia
1916
watercolour on paper, 24 × 16 cm
Rovereto, Galleria Museo Depero

watercolour on paper, 30,5 × 20 cm
Rovereto, Galleria Museo Depero

watercolour on paper, 23 × 14 cm
Rovereto, Galleria Museo Depero

Fortunato Depero
Ballet Dancer for Le chant du rossignol
1916
collage of colour paper on paste-board
50 × 38 cm
Modena, Galleria Fonte d'Abisso Edizioni

*Prepared for Stravinsky's ballet but never
performed by the Russian Ballets*

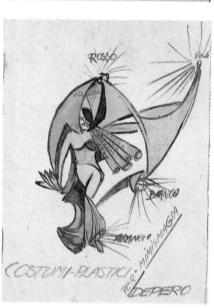

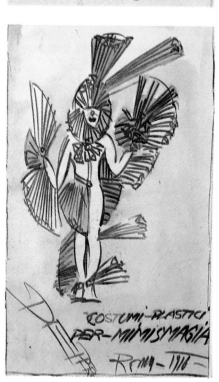

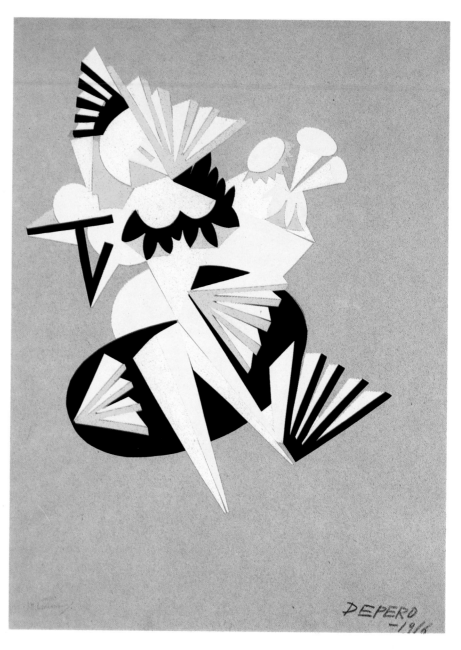

Fortunato Depero
Ballet Dancer
1917
China ink diluted on paper
18,9 × 13,8 cm
Rovereto, Galleria Museo Depero

Fortunato Depero
Costume (the Chinaman) for
Le chant du rossignol
1917
blue ink on velino-paper, 14,9 × 9,8 cm
Rovereto, Galleria Museo Depero

Fortunato Depero
Ballet Dancer, study of costume
1917
tempera on canvas, 75 × 52 cm
Rovereto, Galleria Museo Depero

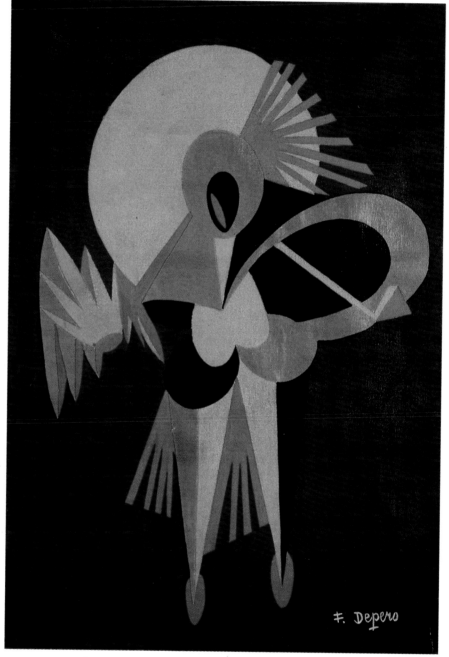

177

Fortunato Depero
Model of Pinocchietto
1917
painted wood, 38 × 13 cm
Private Collection

Fortunato Depero
Model of a Lady
1917
painted wood, 41 cm
Private Collection

Fortunato Depero
Three Puppets from the Plastic Theatre
1918
tempera on paper, 50 × 35 cm
Rovereto, Galleria Museo Depero

Fortunato Depero
Geometric Construction of a Lady
1917
oil on canvas, 63,5 × 60 cm
Private Collection

Fortunato Depero
Blue Doll
1917
oil on canvas, 60 × 51 cm
Milan, Private Collection

Fortunato Depero
Idol Dancer
1917
oil on canvas, 75 × 71,3 cm
Trento, Museo Provinciale d'Arte
Contemporary Art Section

Fortunato Depero
Portrait of Clavel
1917
oil on canvas, 70 × 75 cm
Milan, Mattioli Collection

Fortunato Depero
Rotation of a Dancer
and Parrots
1917-18
oil on canvas, 142 × 90 cm
Private Collection

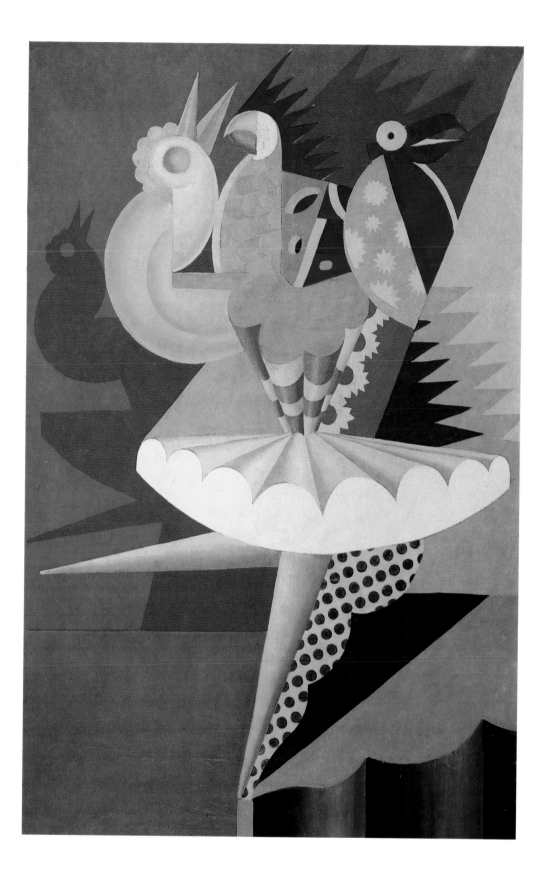

Fortunato Depero
Lady with a Rosary
1918
marquetry of coloured wood, 60,6 × 45,5 cm
Trento, Private Collection

Fortunato Depero
Chinaman
1917-18
wooden collage, 52 × 44 cm
Private Collection

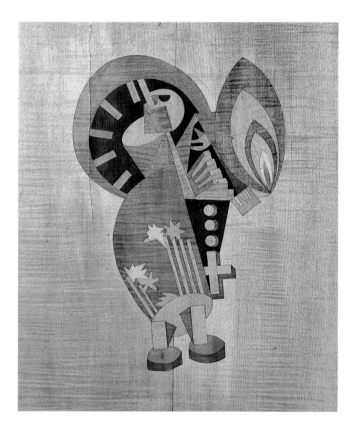

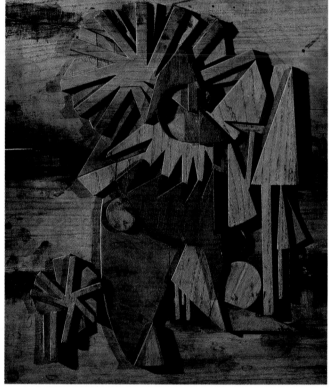

Fortunato Depero
Plastic Ballets
1918
oil on canvas
100 × 70 cm
Rovereto
Galleria Museo Depero

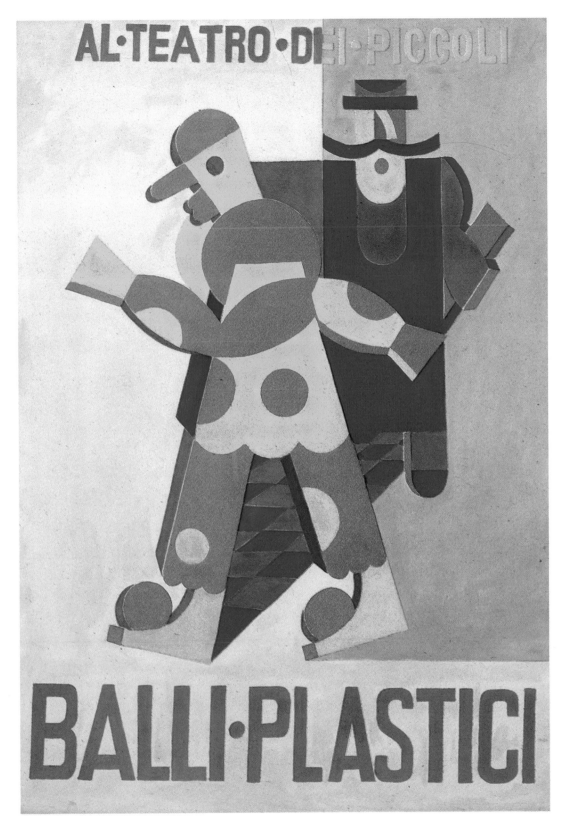

Fortunato Depero
Man with Moustache
costume for I baffuti giganti
1918
China ink on paper, 28,7 × 29,4 cm
Rovereto, Galleria Museo Depero

Fortunato Depero
Costume for the Teatro plastico, sketch
1918
China ink on paper, 21,6 × 27,5 cm
Rovereto, Galleria Museo Depero

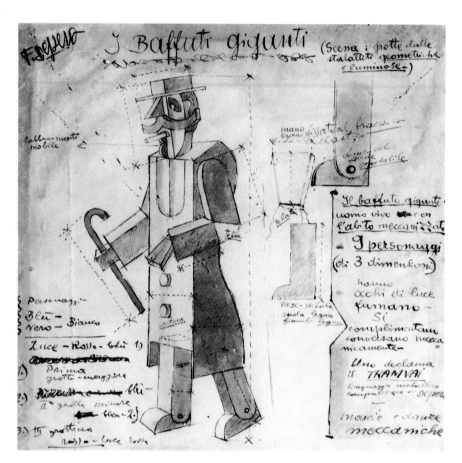

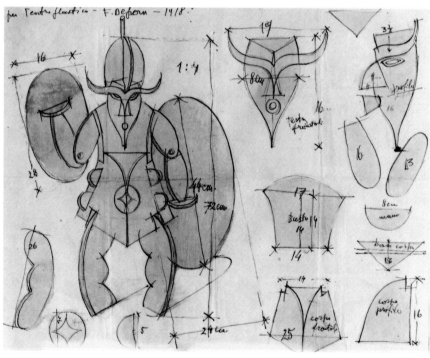

Fortunato Depero
Men with Moustaches
1918
collage of colour papers on paste-board
44,5 × 28,5 cm
Modena, Galleria Fonte d'Abisso Edizioni

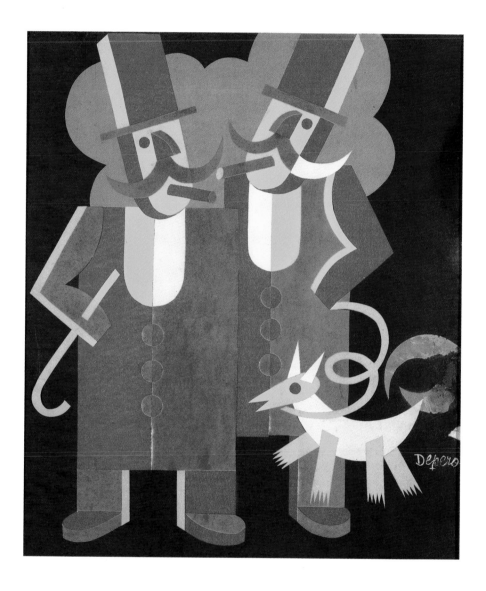

Filippo Tommaso Marinetti
Words-in-Freedom (Chaudronneries)
1912?
ink on paper, 31 × 21 cm
Private Collection

Filippo Tommaso Marinetti
Words-in-Freedom (Grève)
1912-14
ink and collage on paper, 31 × 21 cm
Private Collection

Filippo Tommaso Marinetti
Words-in-Freedom (Anche noi)
1914-15?
ink on letter paper, 26,5 × 20,5 cm
Private Collection

Filippo Tommaso Marinetti
Words-in-Freedom (Respiration de la terre)
1915 c.
ink and pastel on paper, 31 × 21 cm
Private Collection

Filippo Tommaso Marinetti
Words-in-Freedom
(Manicure-Faire les Ongles à l'Italia)
ink on paper, 31 × 21 cm
Private Collection

triangles mous courbes losanges
aigu aigu concave vallonnement

ONDULATIONS ~~~~~ RÉGIME DES ARTHRITIQUES
vert vert ~~~~~ VICHY CÉLESTINS

SCIERIES DE PIERRES BLEUES

différents degrés de décomposition du bois
des affiches dans la prairie macération
des fibres qui tendent à se séparer

GLIN MONS
CHARBON 4 pyramides de scories

Entassement soigneux des scories utilisables = REVENUS

" " " haines ouvrières = G R È
Cri cris de Nom de Dieu Cris CRAAA ~~~ A A AAAA

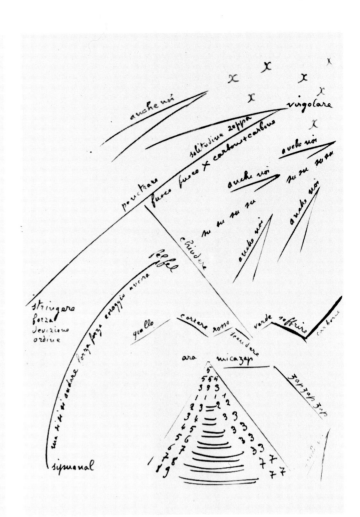

TIÉDEUR DES LACS = réservoir
de soleil absorbé durant l'été
qui se répand durant l'hi[ver]
sur les élégantes vitesses
des routes

vrrtrrrrrrrrrrrrr vrrrrr

RESPIRATION DE LA TERRE
ÉCHANGE RÉGULIER DE GAZ
ENTRE L'INTÉRIEUR DU GLOBE
ET L'ATMOSPHÈRE

de 7 heures matin à 5 heures soir pres
sion des gaz terrestres < pression atmo²
sphérique inverse durant la
nuit

TERRE ABSORBER EXHALER

Lâcher le volant et se faire faire les ongles
MANICURE FAIRE LES ONGLES à L'ITALIE

TUER SES PEAUX PASSÉISTES

TÊTE SOUS LE RASOIR

ONGLES BRILLANTS AGRESSIFS

FIANCAILLES de mu

COUPERET GUILLOTINE
DANGER IMMINENT
MAIN DU COIFFEUR

MAIN GAUCHE
ABANDON

sur un coussinet blanc
entre les doigts fluets
ongles brillants
peins vibrants de
la manicure
sa bouche attentive
bibliothèque chi-
rurgie lime légère
se renverser sur les peaux
effrangées
mes doigts lourds trop
vivants devenus étran-
gers au fond d'un océan
de crème abîme
de tiédeurs féminines
3 petits pots VASELINE
BLANCHE pour détruire
les peaux
nettoyer l'ongle sous
l'ongle vaseline oxigé-
née lime à ongles en
acier lime à ongles
en carton plus vite lé-
gèreté zèle ART pruits
sensualité poudre rose
des maisons arabes sur la
mer bleue pierre ponce
polissoir rose

DEUX THÉORIES
CONTRE LES PEAUX
les couper : elles renaissent
les repousser : ANGOISSE D'UN
MINISTRE EN TEMPS DE GRÈVE

PETITE LAMPE
abajourée
intensité féminin
ROSE

RASOIR

RASOIR

c'est fait arroser
pulvériser été de
mon visage au soli
dité sous le massage
électrique ivrrrrrrr
ivrrrrrrrrrrrrrresse
de ma peau pores
ouverts chauds froids
chauds

HENNISSEMENT de
tous les 15000 chevaux
massssssacrés
ÉCCCRAbouillés en
TAS (sanguinolence)
suivant les ordres de
Clovari Pacha avant
de capituler

MAIN DROITE
BÉATITUDE

de mes doigts oui ils
sont 5 je les reconnais
séparés l'un de l'autre
bataille de gosses dans
la Méditerranée chaude
velours huileux
des contact flic
flac d'argent
ATTENTE D'UNE
ARMÉE qui va
bientôt entrer en
action
allons courage l'opéra
tion n'est pas grave
veille d'examen
me morfondre sous la
pluie-fenêtre d'une
jolie fille en chemise
son salut rose et blanc
romantisme mouillé
d'ennui
devant la porte du pou
lailler à 15 ans pour en
tendre du Wagner (l'un
des 463 doigts ficelés par
les agents) ORDRE
PROPRETÉ caresser
rêveusement les mains
d'une femme qui compare
ses doigts aux miens
à table les doigts doivent
être apitissants.

BOL
D'EAU CHAUDE
+ SAVON
+ ÉPONGE

189

Filippo Tommaso Marinetti
Words-in-Freedom (Premier Récord)
1914
China ink on paper, 35 × 26,5 cm
Rome, Private Collection

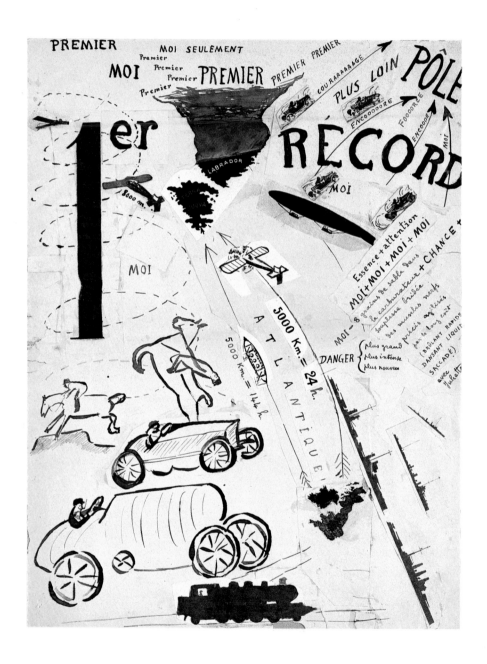

Filippo Tommaso Marinetti
Words-in-Freedom (Train anguish)
1915 c.
ink on paper, 21 × 31 cm
Private Collection

Filippo Tommaso Marinetti
Words-in-Freedom (Rideau drapé)
1915 c.
ink on paper, 21 × 31 cm
Private Collection

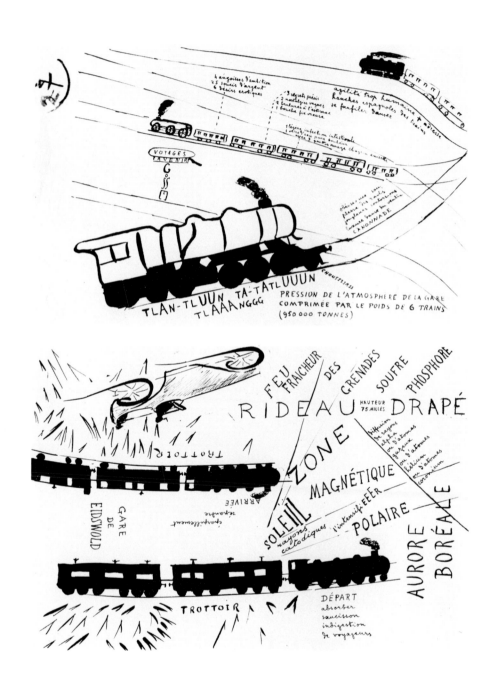

Filippo Tommaso Marinetti
Words-in-Freedom (Irredentismo)
ink and collage on paper
Private Collection

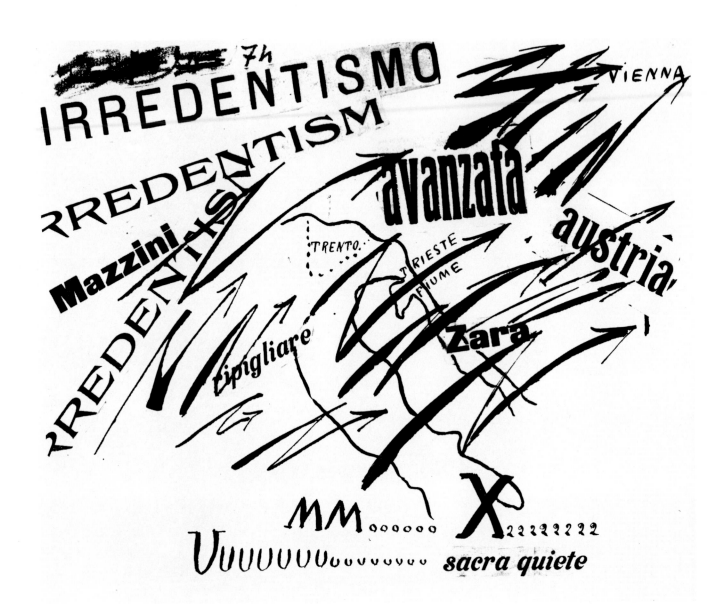

Filippo Tommaso Marinetti
Zang Tumb Tumb
1912
book cover

Filippo Tommaso Marinetti
Words-in-Freedom (Bombardamento)
1915
collage, 22 × 31 cm
New York, E.V. Thaw and Co., Inc.

Filippo Tommaso Marinetti
Words-in-Freedom
(Bombardamento sola igiene)
1915?
ink and collage on paper
Private Collection

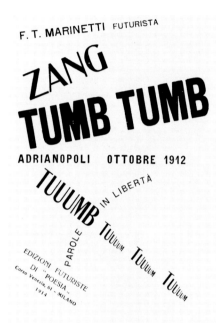

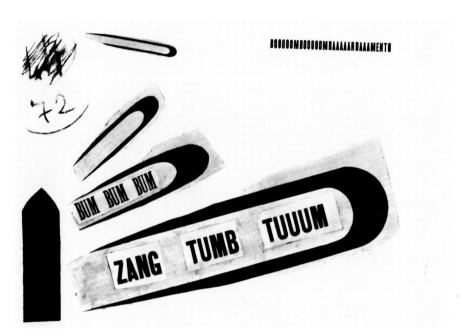

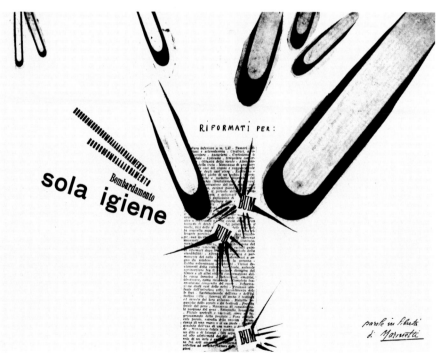

Filippo Tommaso Marinetti
Words-in-Freedom
(Casa del popolo)
ink on paper, 21,5 × 27,5 cm
Private Collection

Dosso Cassina Lago di Garda, 1915
ink on paper, 31 × 42 cm
Private Collection

Lake between Two Mountains, 1915
ink on paper, 31 × 42 cm
Private Collection

Filippo Tommaso Marinetti
Words-in-Freedom
Telegramma 69, 1914-15
ink on cable form, 17,5 × 26,5 cm
Private Collection

Mountain Defence, 1915
pencil on paper, 15 × 21 cm
Private Collection

Lake between Two Mountains, 1915
ink on paper, 31 × 42 cm
Private Collection

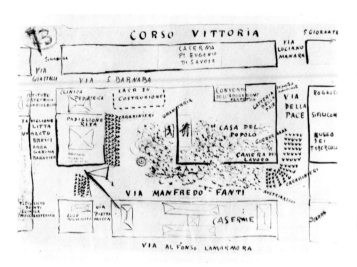

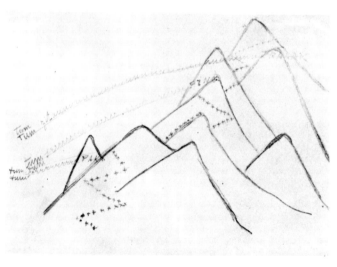

Filippo Tommaso Marinetti
Words-in-Freedom
Vive la France, 1914-15
ink and collage on paper, 31 × 32,5 cm
Private Collection

Propeller, 1915-16?
ink on letter paper, 21,5 × 27,5 cm
Private Collection

Bombing, 1915-16?
ink on paper, 21,5 × 27,5 cm
Private Collection

Filippo Tommaso Marinetti
Words-in-Freedom
Duel, 1915-16?
ink on paper, 21,5 × 27,5 cm
Private Collection

Air Raid, 1915-16?
ink on paper, 21,5 × 27,5 cm
Private Collection

Action, 1915-16?
ink on paper, 21,5 × 27,5 cm
Private Collection

195

Enrico Prampolini
Space Rhythms
1913
tempera and collage on paste-board
48 × 31 cm
Rome, Private Collection

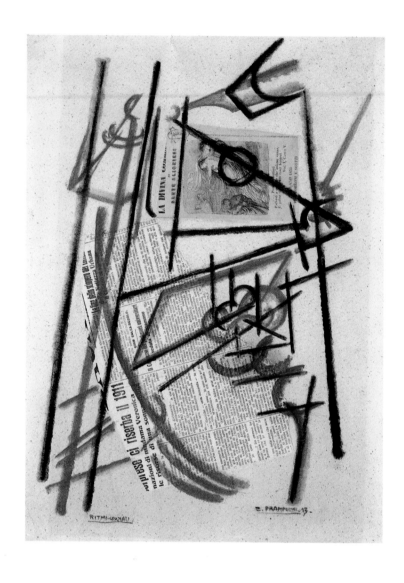

Enrico Prampolini
Woman + Ambience
1915
oil on canvas, 116 × 50 cm
Private Collection

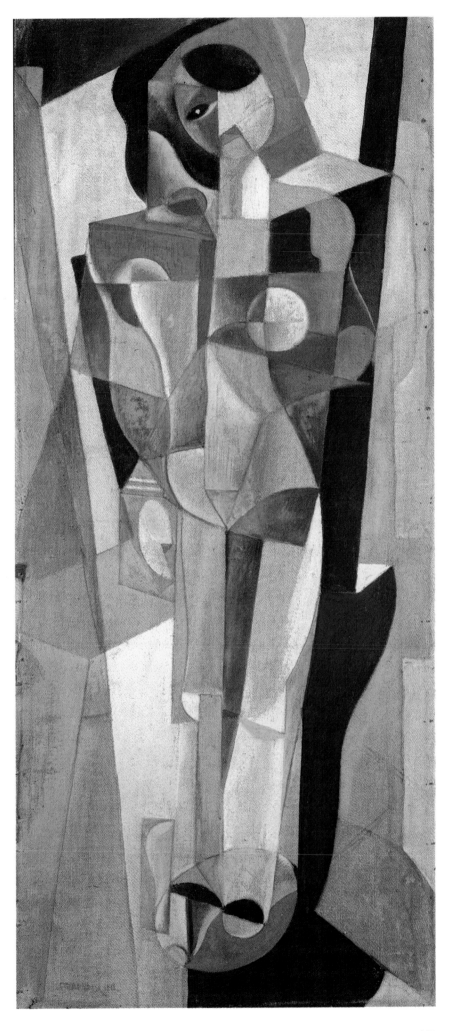

Enrico Prampolini
Béguinage
1914
collage on wood, 18 × 22 cm
Modena, Galleria Fonte d'Abisso Edizioni

Enrico Prampolini
Third Embryonal Scribbling
Materialization of Atmospheric Thickness
1914
China ink on thin paste-board
22 × 29 cm
Cologne, Rudolf Kicken Collection

Enrico Prampolini
Futurist Portrait of Poet Luciano Folgore
1915
watercolour and charcoal on paper, 48 × 33 cm
Private Collection

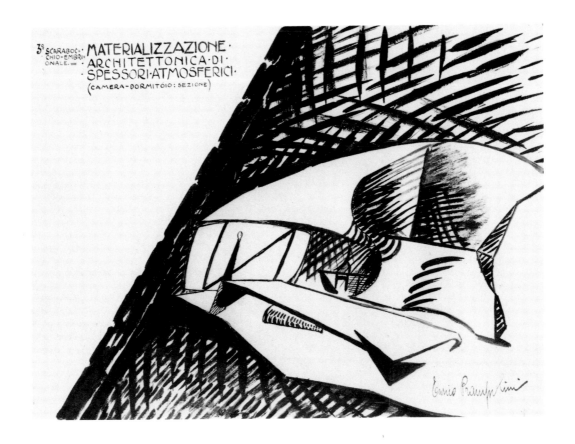

Francesco Balilla Pratella
War. Three Dances for Orchestra, op. 32
1913
Ravenna
Eda Pratella Iwaszkiewicz Collection

Francesco Balilla Pratella
Pilot Dro, op. 33, page from score
1913-14
Ravenna
Eda Pratella Iwaszkiewicz Collection

*Tempo =

= Si coprirà la Scena =

= Fine dell' Opera =

G. Balilla Pratella =

Lugo di Romagna. 5 marzo 1914 – 9 maggio 1914.

Casa Musicale Sonzogno

N.° 333 Visto per la presentazione fatta alla Prefettura di Milano dalla Casa Musicale Sonzogno Via Pasquirolo N° 12 per gli effetti del testo unico delle leggi 25 Giugno 1865, n: 2337, 10 Agosto 1875, n: 2652 e 18 maggio 1882, n: 756 (serie 3ª) e del regolamento della stessa data n: 1013 (serie 3ª) sui diritti di autore.

addì 26 Febbraio 1923 ore 11.30

113

Ottone Rosai
Dynamism Bar San Marco
1913
oil on paste-board, 51 × 55 cm
Milan, Mattioli Collection

Ottone Rosai
Zang Tumb Tumb
1913-14
oil on canvas, 42 × 34 cm
Milan, Riccardo and Magda Jucker Collection
on loan to Pinacoteca of Brera

Ottone Rosai
Decomposition of a Street
1914
oil on canvas, 63 × 53 cm
Milan, Mattioli Collection

Luigi Russolo
Music
1911
oil on canvas
225 × 140 cm
on loan from Salome
and Eric Estorick

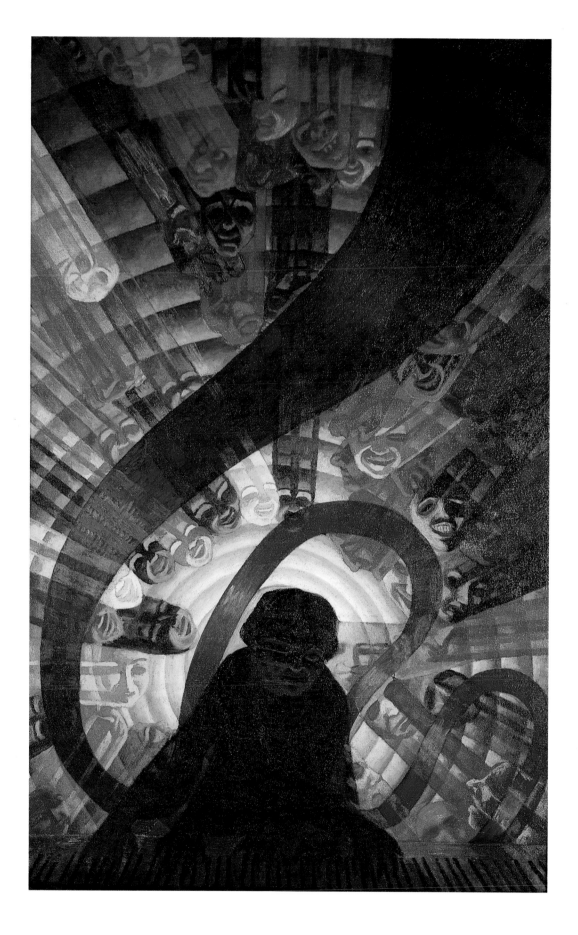

Luigi Russolo
Revolt
1911
oil on canvas, 150 × 230 cm
The Hague, Haags Gemeentemuseum

Exhibited at the Mostra d'Arte libera, Casa del Lavoro, Milan, on 30 April 1911.
One of the five large canvases
by the five major futurist painters

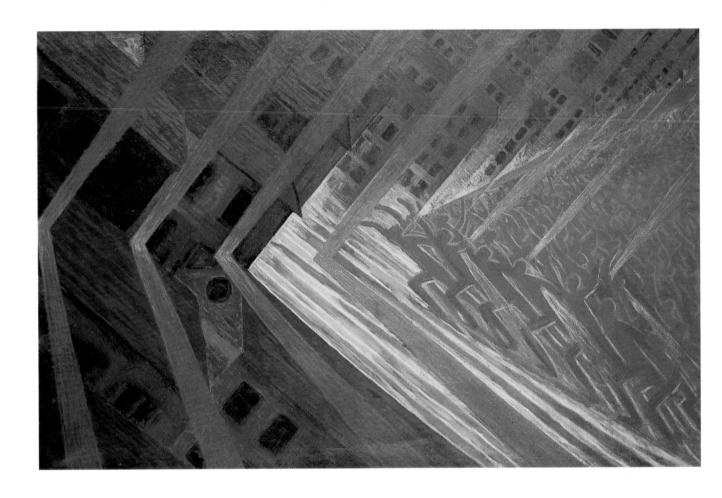

Luigi Russolo
The Solidity in Fog
1912
oil on canvas, 100 × 65 cm
Milan, Mattioli Collection

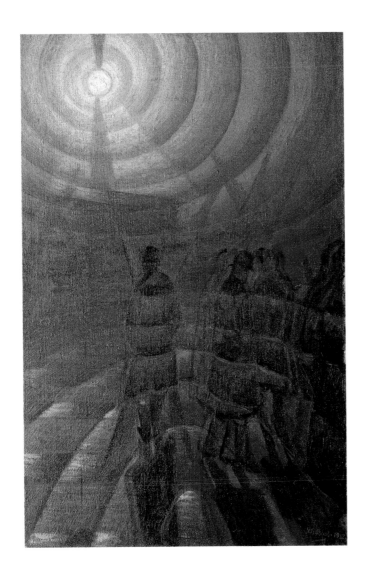

Luigi Russolo
Untitled
1912
colour pencils on paper, 18,6 × 51,2 cm
Geneva, Jean Krugier Gallery

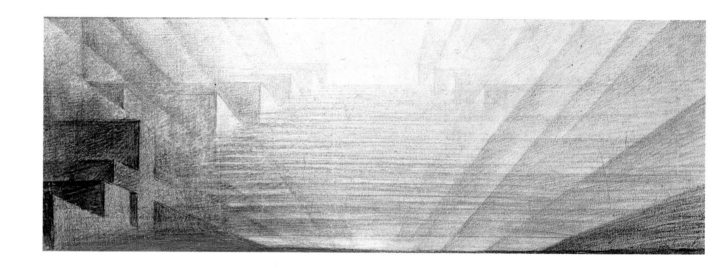

Luigi Russolo
Untitled
1912
colour pencils on paper, 18,6 × 51,2 cm
Geneva, Jean Krugier Gallery

Luigi Russolo
Plastic Synthesis of a Woman's Movements
1913
oil on canvas, 86 × 65 cm
Grenoble, Musée de Peinture et de Sculpture

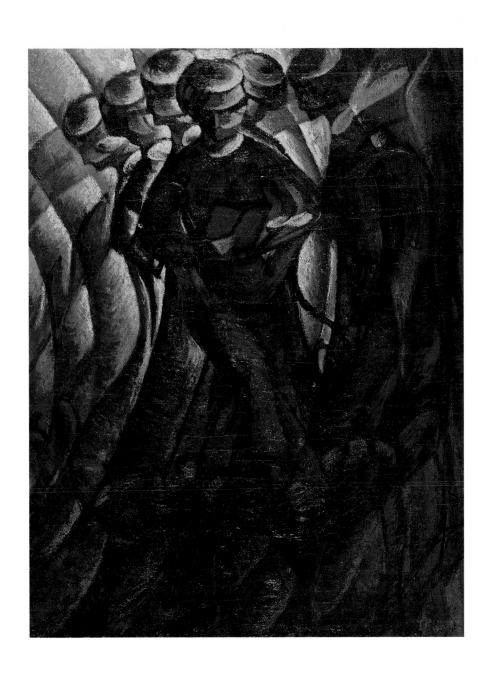

Luigi Russolo
Dynamism of a Car
1912-13
oil on canvas, 104 × 140 cm
Paris, Musée National d'Art Moderne
Centre Georges Pompidou

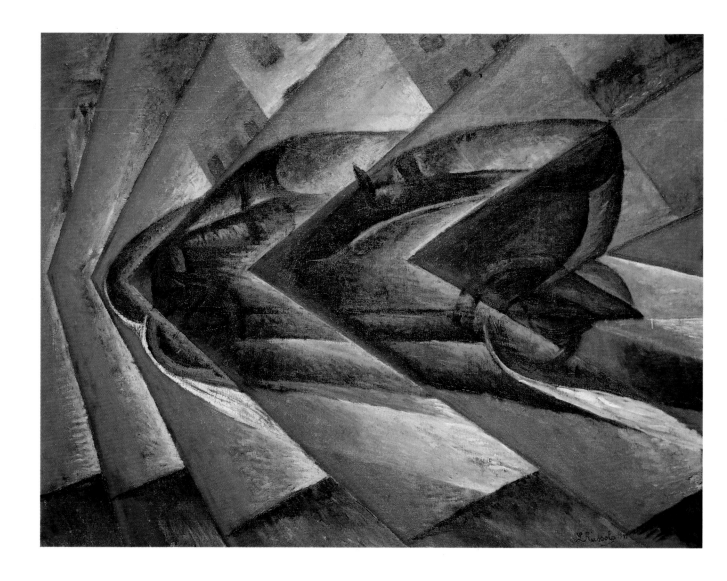

Luigi Russolo
Houses + Light + Sky
1912-13
oil on canvas, 100 × 100 cm
Basel, Oeffentliche Kunstsammlung Kunstmuseum

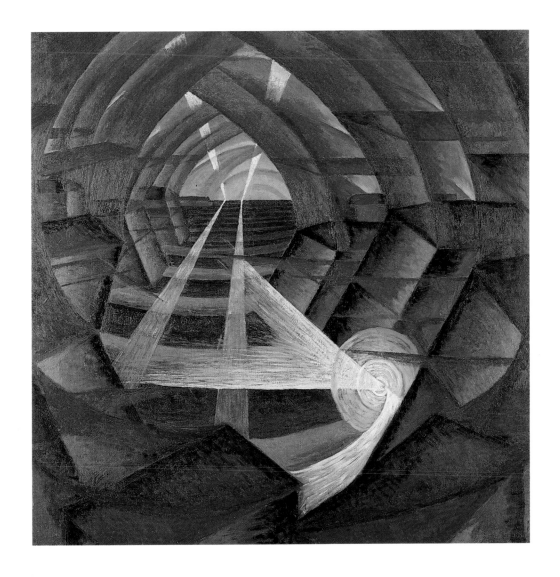

Antonio Sant'Elia
New City, Tenement Building
with Terrace on Double Level Street
1913
ink and pencil on paper, 27,5 × 11,5 cm
Milan, Paride Accetti Collection

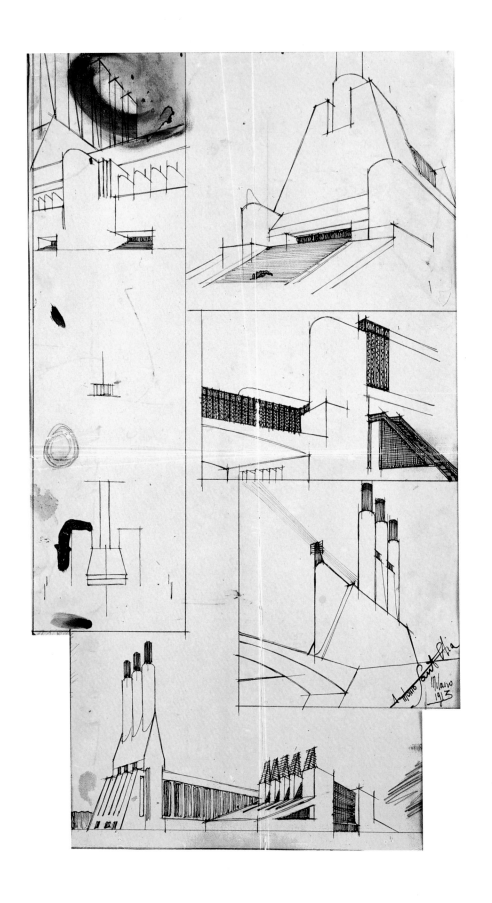

Antonio Sant'Elia
New City, study
1914
ink on paper, 30 × 17 cm
Milan, Paride Accetti Collection

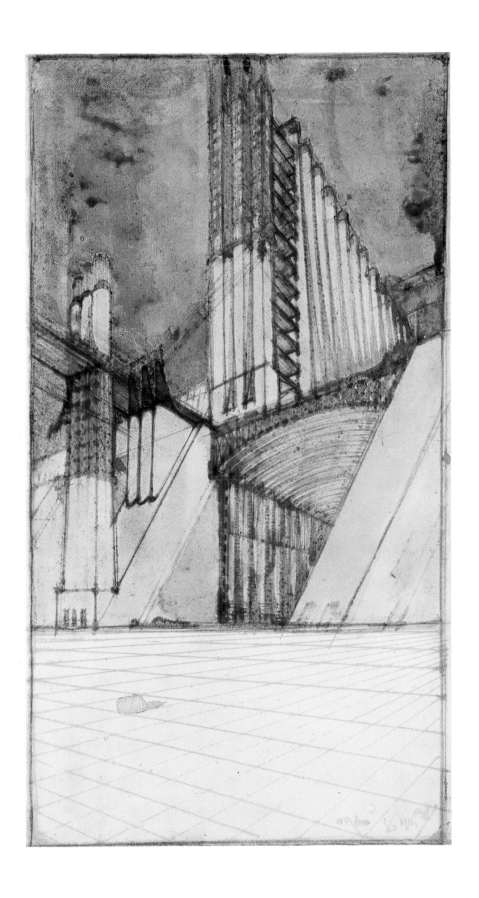

Antonio Sant'Elia
The New City, study
1914
watercolour on paper, 45,3 × 35,3 cm
Private Collection

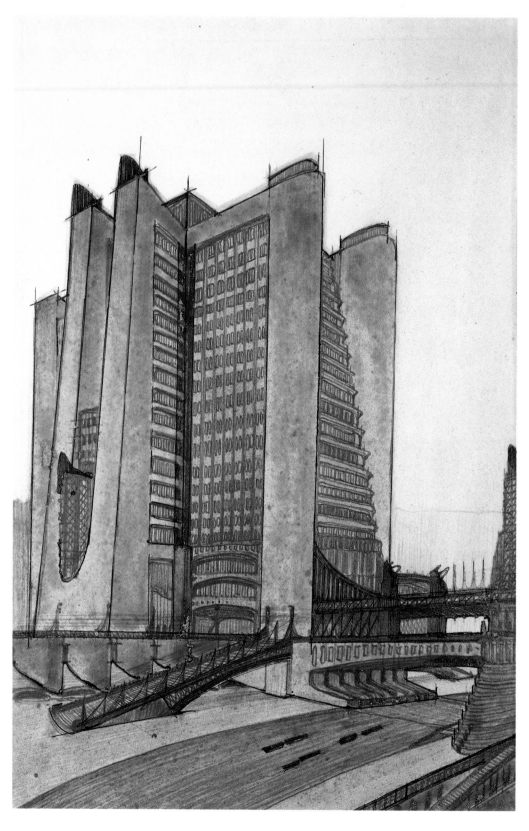

Antonio Sant'Elia
The New City, Tenement Building with
exterior elevators, gallery, sheltered
passage over three levels
(street-car line, motorway, metal footway)
1914
ink and colour pencil on paper
52,5 × 51,5 cm
Como, Musei Civici

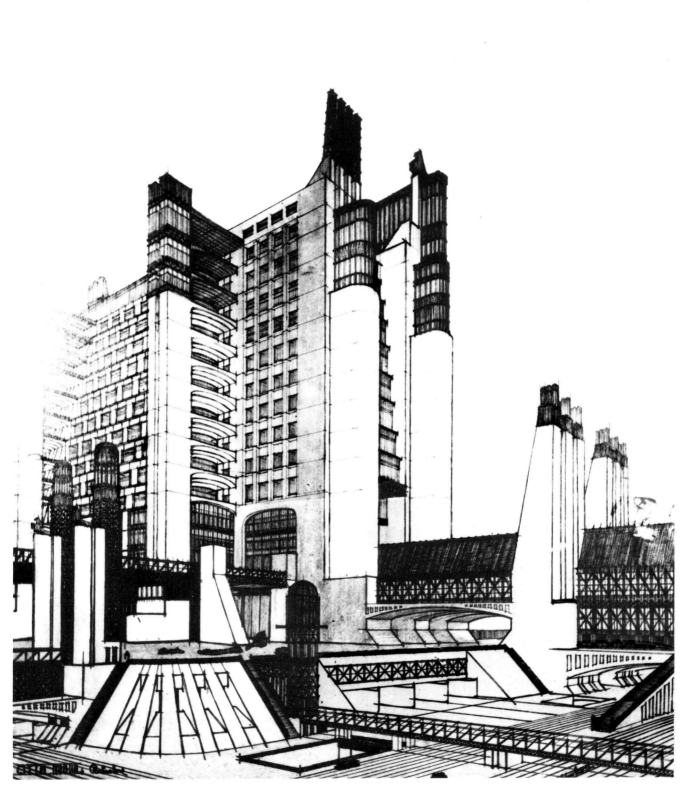

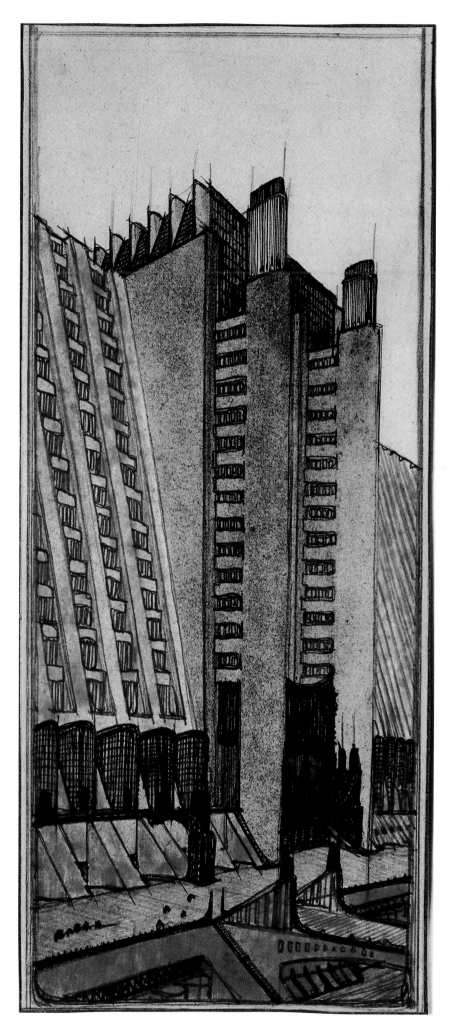

Antonio Sant'Elia
*New City, Terraced Building
over two-levelled Street*
1914
ink on paper, 27,5 × 11,5 cm
Milan, Paride Accetti Collection

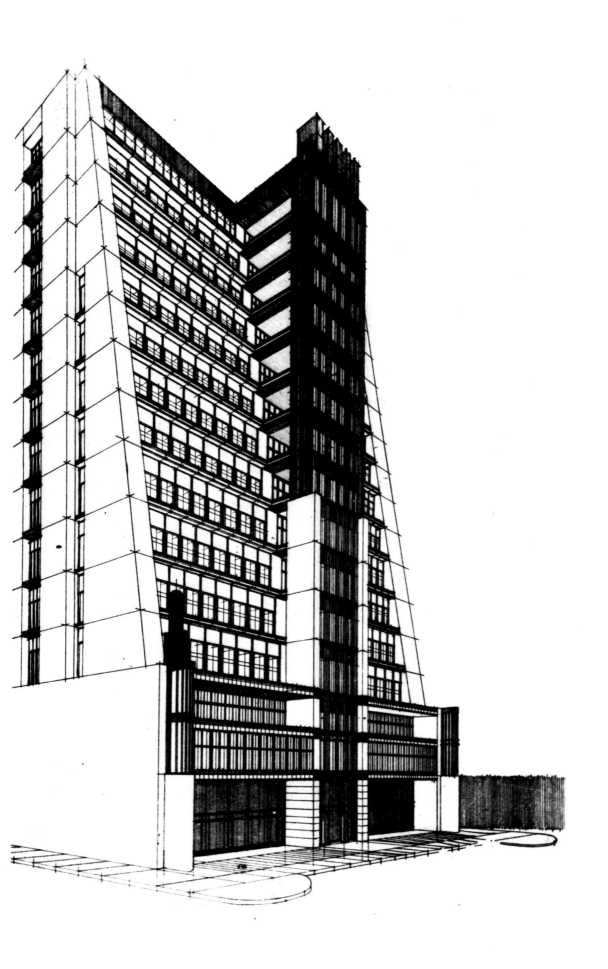

Antonio Sant'Elia
Terraced Building with exterior elevators
1914
ink and pencil on paper, 38,5 × 24 cm
Como, Musei Civici

Antonio Sant'Elia
Terraced Building with exterior elevators
1914
ink and pencil on paper, 28,8 × 17,9 cm
Como, Musei Civici

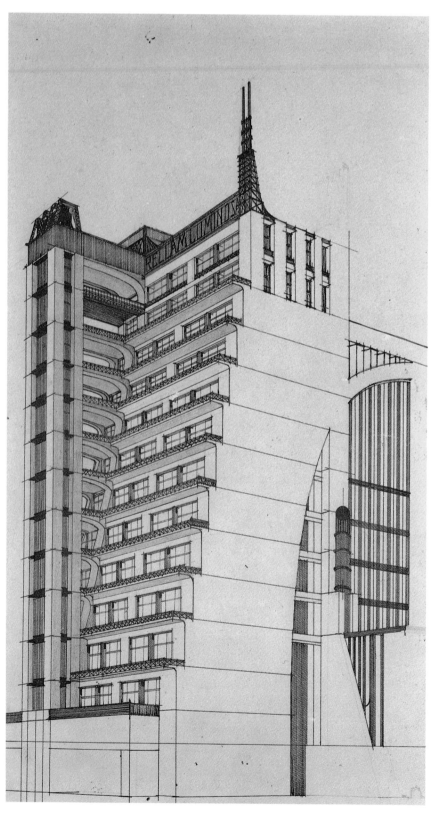

Antonio Sant'Elia
Airport and Railway Station with Elevators
and Funiculars over Three-levelled Street
1914
ink and pencil on paper, 50 × 39 cm
Como, Musei Civici

Drawing published on the leaflet
of the Manifesto of Futurist Architecture
and in Lacerba, *1914*

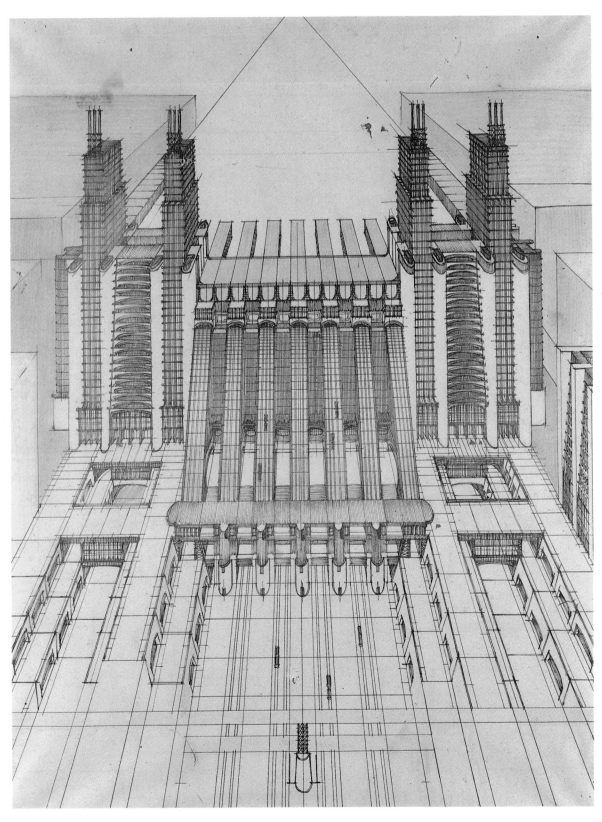

Antonio Sant'Elia
Power House
1914
inks on paper, 30 × 20 cm
Milan, Paride Accetti Collection

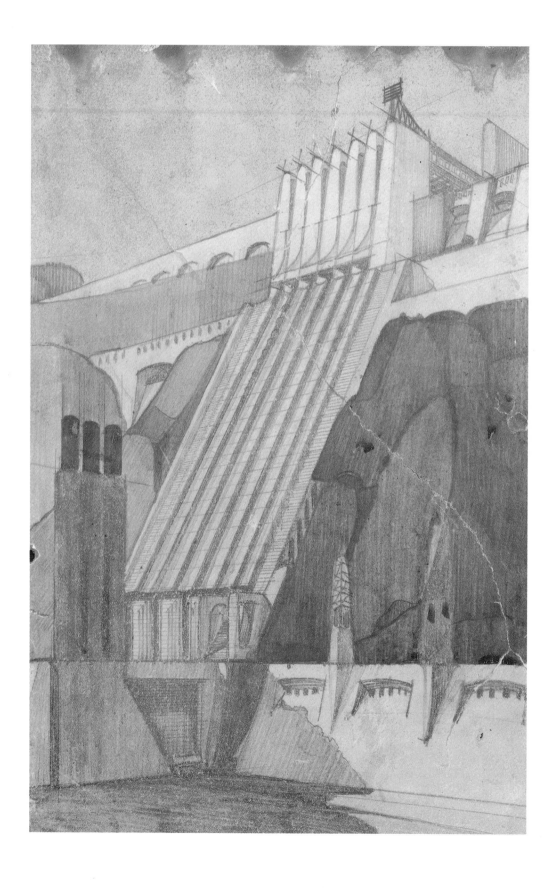

Antonio Sant'Elia
Power House
1914
pencil and inks on paper, 30,5 × 20,5 cm
Milan, Paride Accetti Collection

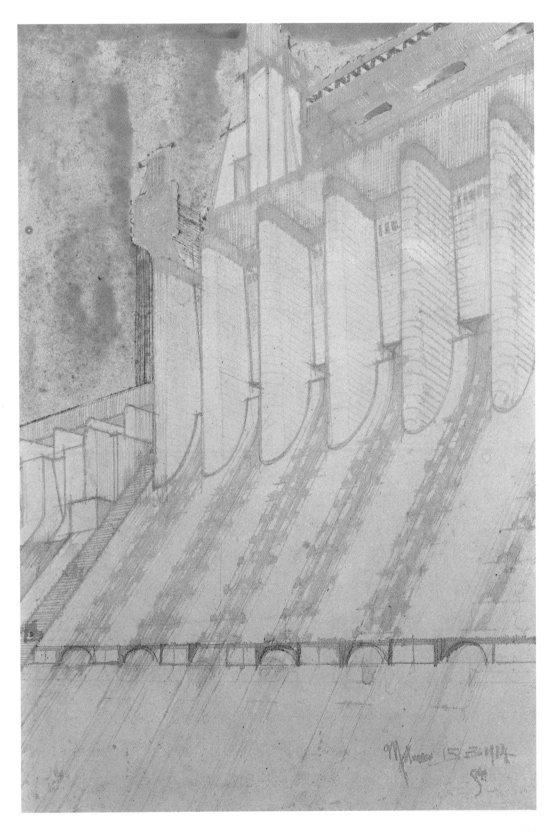

Antonio Sant'Elia
Power House
1914
pencil and inks on paper, 31 × 20,5 cm
Milan, Paride Accetti Collection

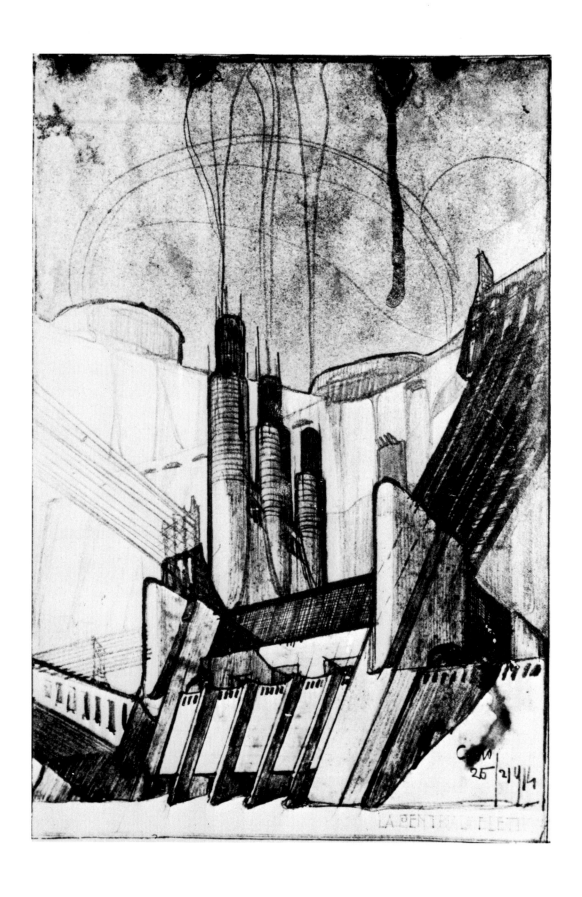

Antonio Sant'Elia
Monumental Building
1915
ink, watercolour and pencil on paste-board
32 × 23 cm
Como, Musei Civici

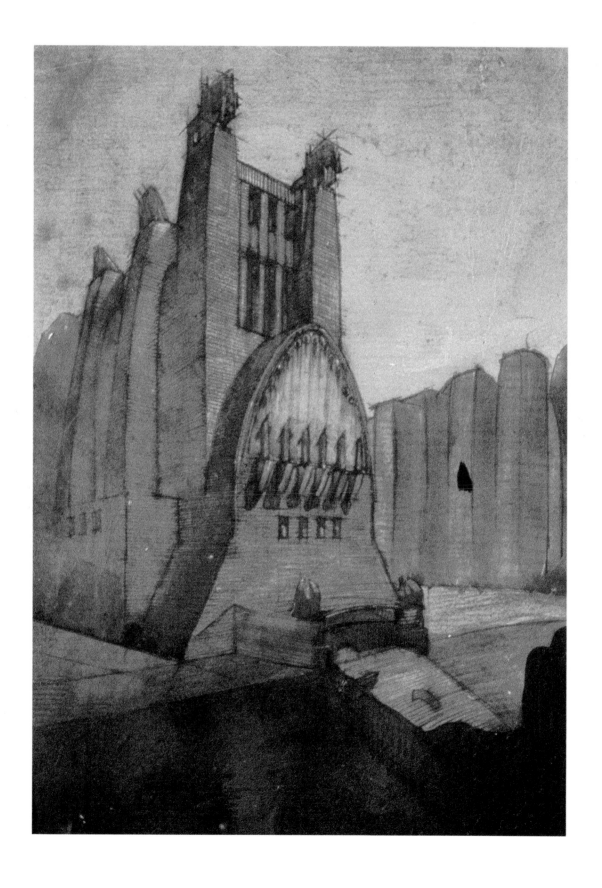

Gino Severini
The Boulevard
1911
oil on canvas, 63,5 × 91,5 cm
on loan from Salome and Eric Estorick

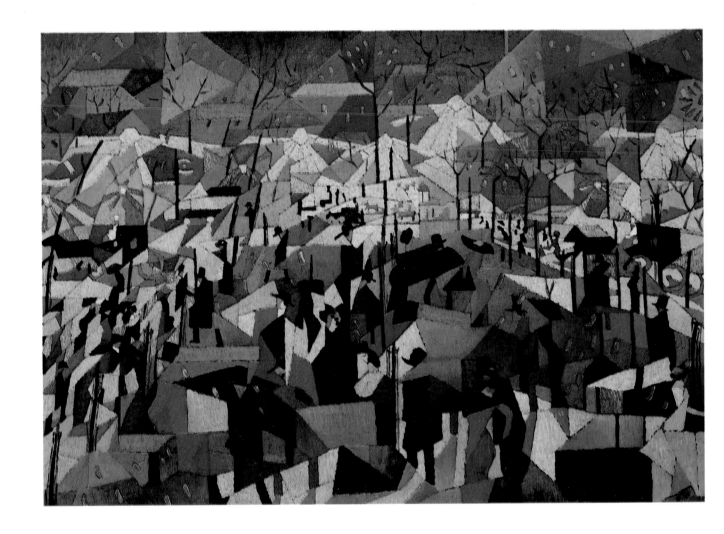

Gino Severini
La danseuse obsédante
1911
oil on canvas, 73,5 × 54 cm
Private Collection

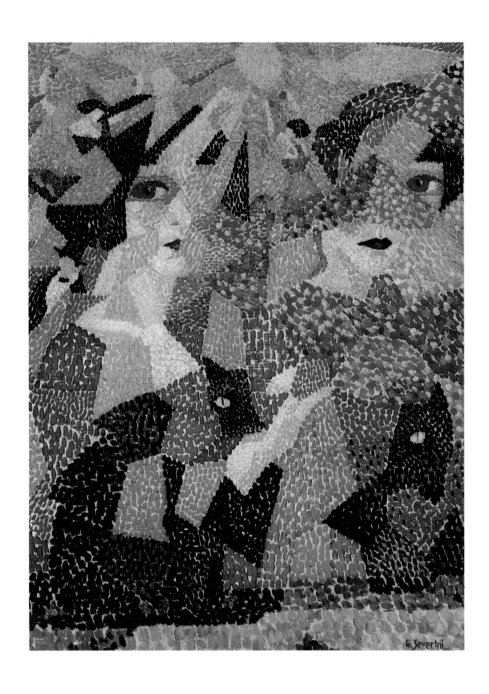

Gino Severini
Nord-Sud
1912
oil on canvas, 49 × 64 cm
Milan, Pinacoteca of Brera

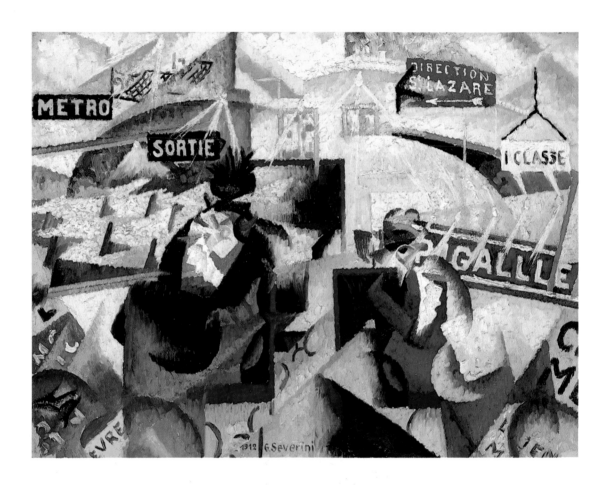

Gino Severini
Self-Portrait
1912-13
oil on canvas, 55 × 46 cm
Private Collection

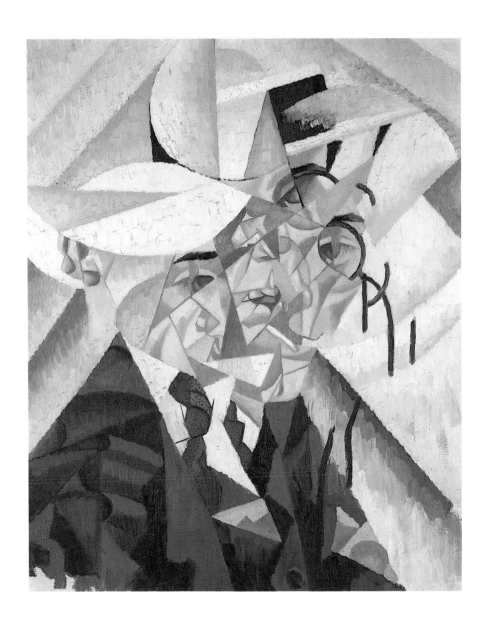

Gino Severini
The Blue Dancer
1912
oil on canvas, 61 × 46 cm
Milan, Mattioli Collection

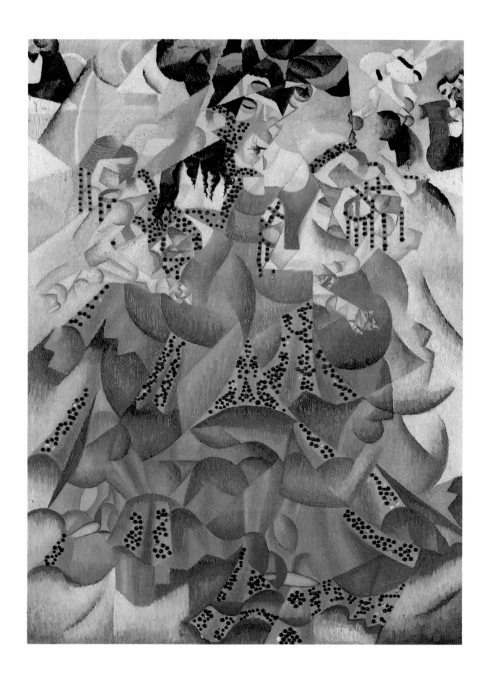

Gino Severini
Dynamism of a Dancer
1912
oil on canvas, 60 × 45 cm
Milan, Riccardo and Magda Jucker Collection
on loan to Pinacoteca of Brera

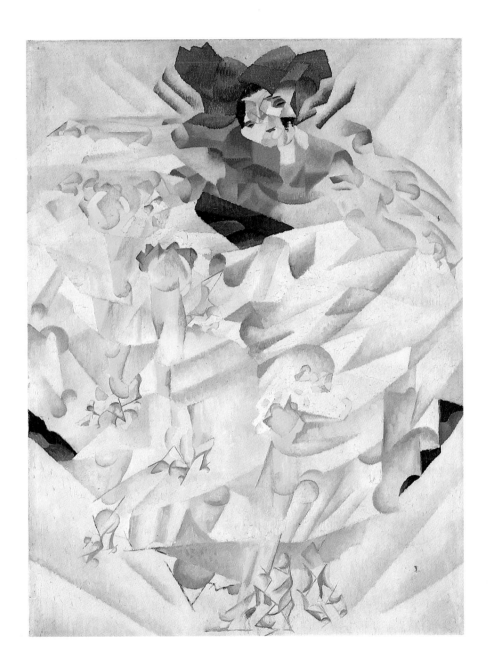

Gino Severini
Speeding Car
1912-13
oil on wood, 20 × 50 cm
Switzerland, Private Collection

Gino Severini
Portrait of Mrs Paul Fort
1913
watercolour on thin paste-board
56 × 76 cm
Prato, Farsetti Gallery

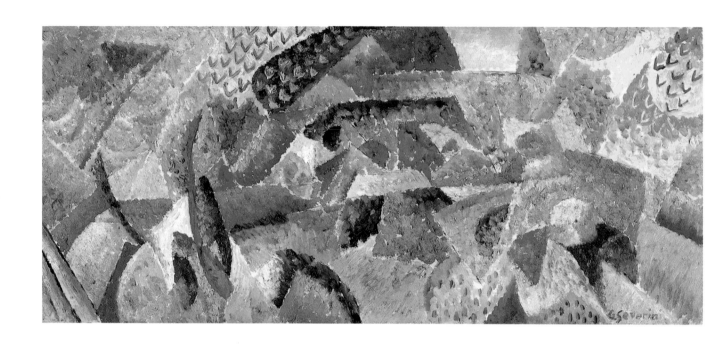

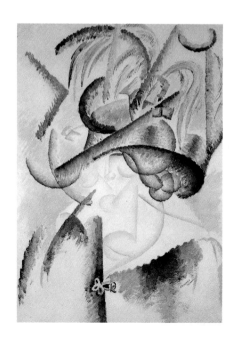

Gino Severini
Fête at Montmartre
1913
oil on canvas, 86 × 116 cm
New York, Richard S. Zeisler Collection

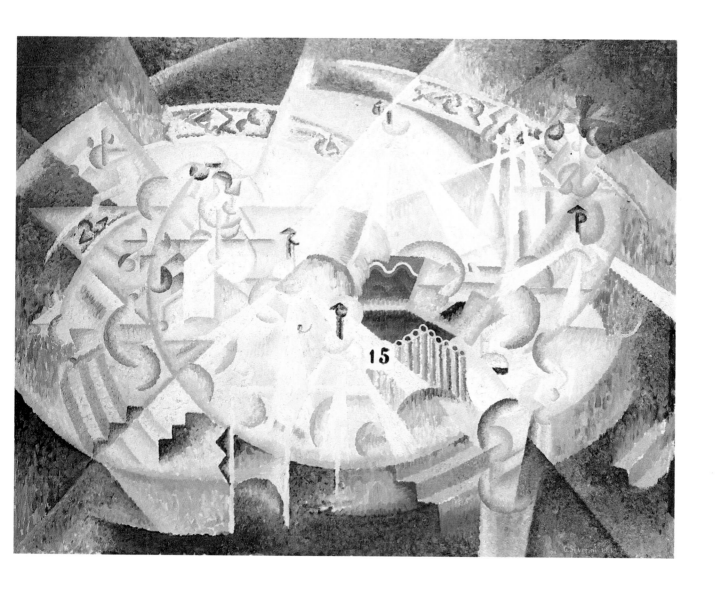

Gino Severini
Plastic Rhythm on July 14th
1913
oil on canvas, 85 × 68 cm
Rome, Nino and Gina Franchina Collection

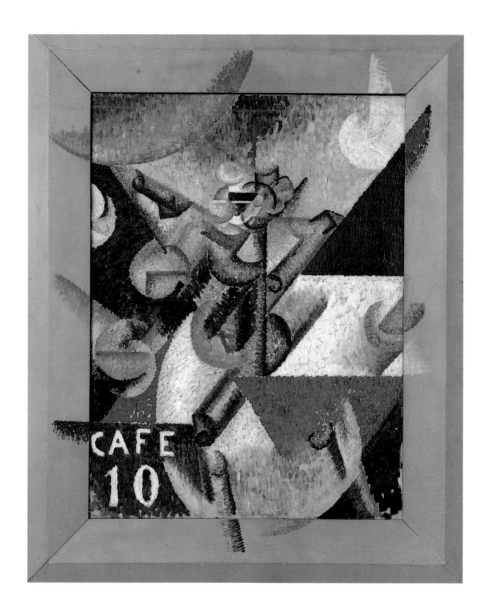

Gino Severini
The Bear Dance
1913-14
oil on canvas with sequins, 90 × 104 cm
Prato, Farsetti Gallery

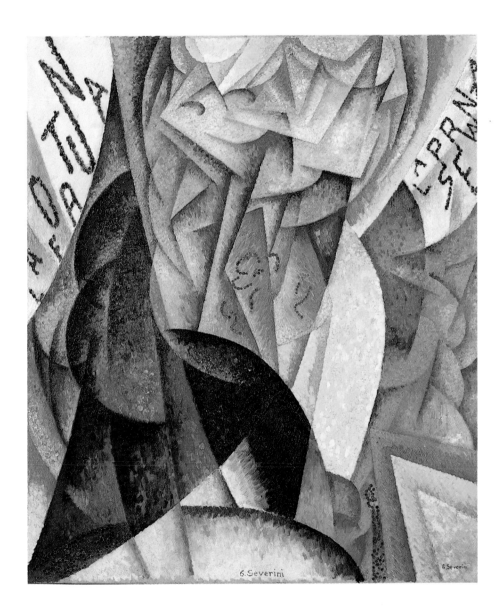

Gino Severini
Train in the City
1913
charcoal on paper, 50 × 65 cm
New York
The Metropolitan Museum of Art
The Alfred Stieglitz Collection, 1949

Gino Severini
Flying over Rheims
1915 c.
charcoal on paper, 60 × 47,5 cm
New York
The Metropolitan Museum of Art
The Alfred Stieglitz Collection, 1949

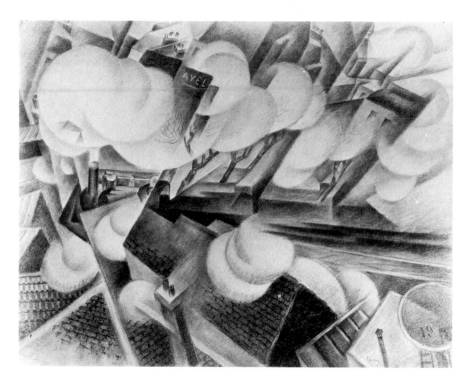

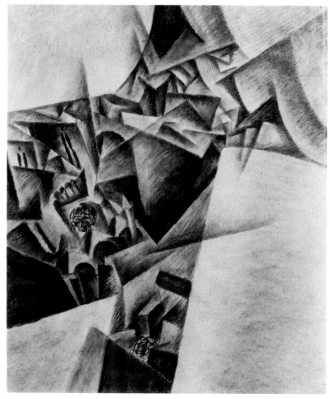

Gino Severini
Italian Lancers at a gallop
1915
oil on canvas, 50 × 65 cm
Private Collection

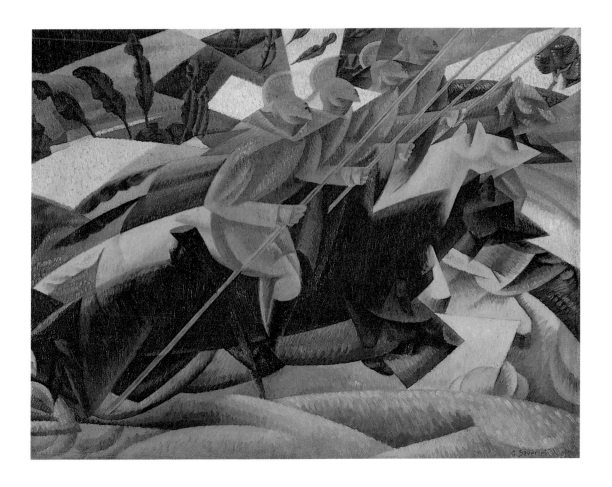

Gino Severini
Armoured Train
1915
oil on canvas, 116,5 × 87,5 cm
New York, Richard S. Zeisler Collection

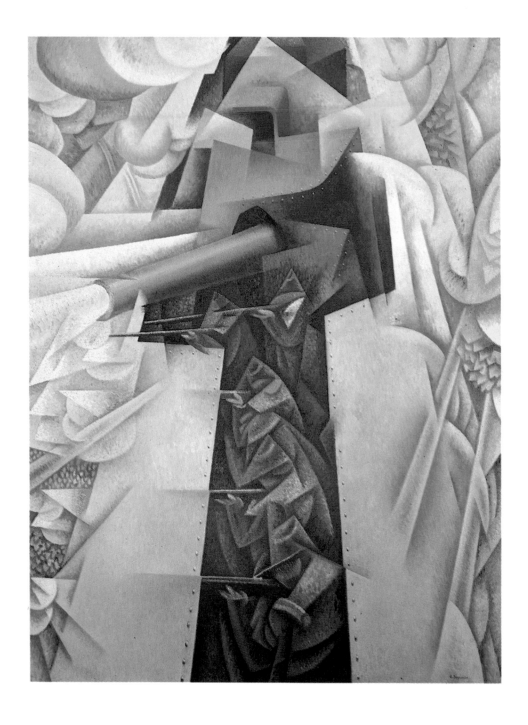

Gino Severini
The Hospital-Train
1915
oil on canvas, 117 × 90 cm
Amsterdam, Stedelijk Museum

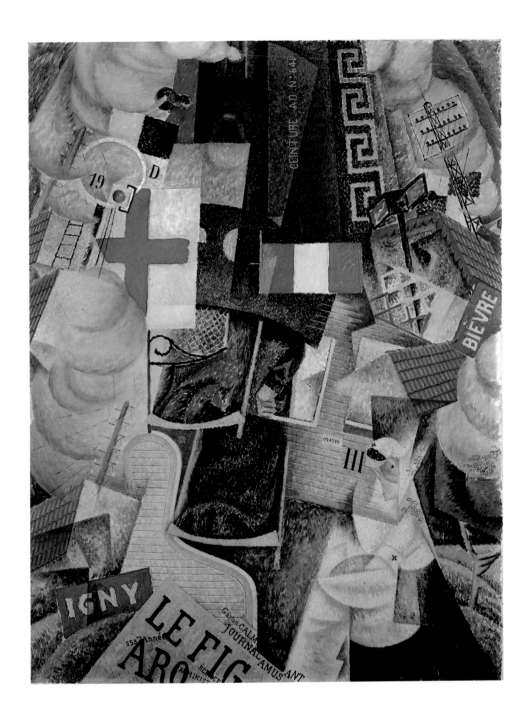

Gino Severini
Homage to Flaubert
1916-17
oil on canvas, 71 × 69 cm
Venice, Private Collection

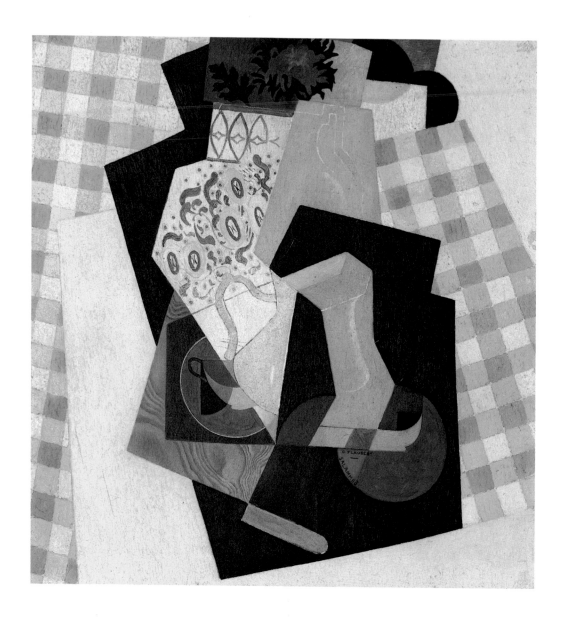

Gino Severini
Still Life
1917
oil on canvas, 61 × 50,2 cm
New York, The Metropolitan Museum of Art
bequest Glickstein Foundation, 1982

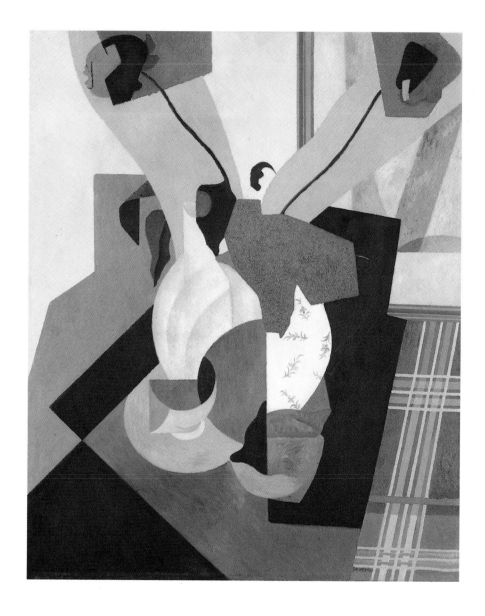

Mario Sironi
Cafè
1913
pencil on paper, 19 × 17,5 cm
Private Collection

Mario Sironi
Plasticity and Rhythm of Things
1914
tempera and pencil on paper, 14 × 11 cm
Private Collection

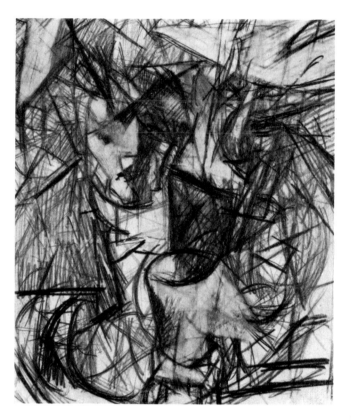

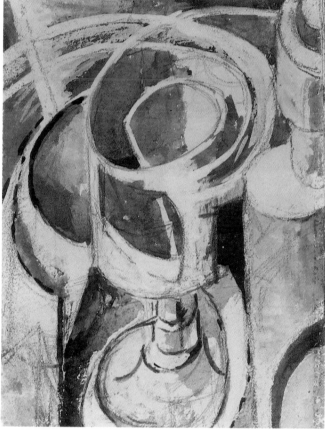

Mario Sironi
Composition with Horse
1914 c.
ink on newspaper, 18,5 × 15,5 cm
Private Collection

Mario Sironi
Synthesis of a Landscape
1915
tempera on paper, 17 × 11 cm
Private Collection

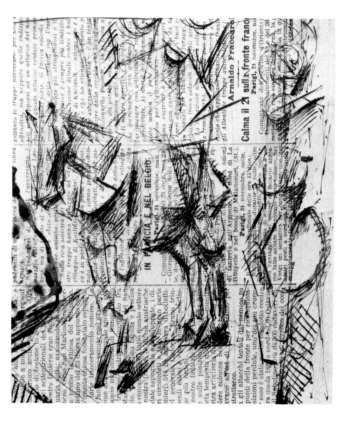

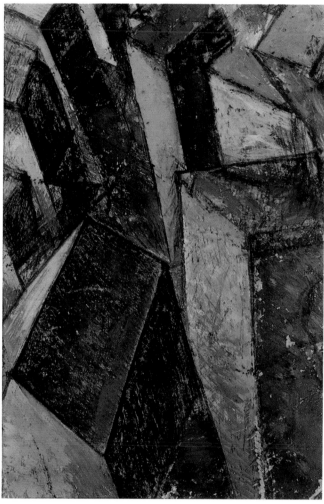

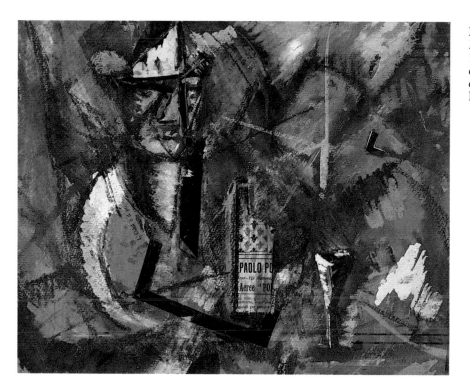

Mario Sironi
Drinker
1914
collage and tempera on paper pasted
on canvas, 28,5 × 36 cm
Private Collection

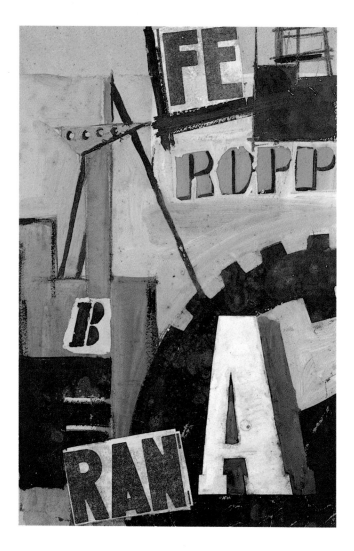

Mario Sironi
Futurist Composition
1915-16 c.
tempera and collage on paper
37 × 24,5 cm
Private Collection

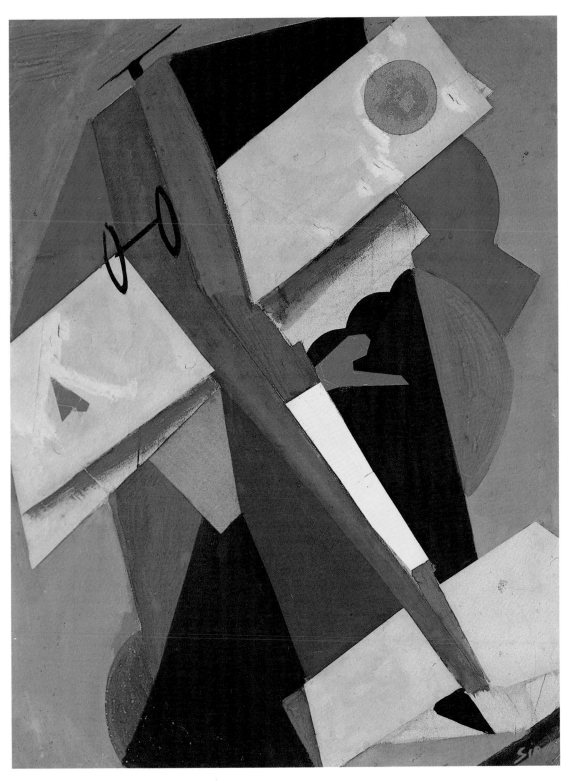

Mario Sironi
The Airplane
1916
collage and tempera
on paper
pasted on canvas
72,5 × 55 cm
Private Collection

Mario Sironi
The Truck
1915
oil on paste-board, 90 × 80 cm
Milan, Riccardo and Magda Jucker Collection
on loan to Pinacoteca of Brera

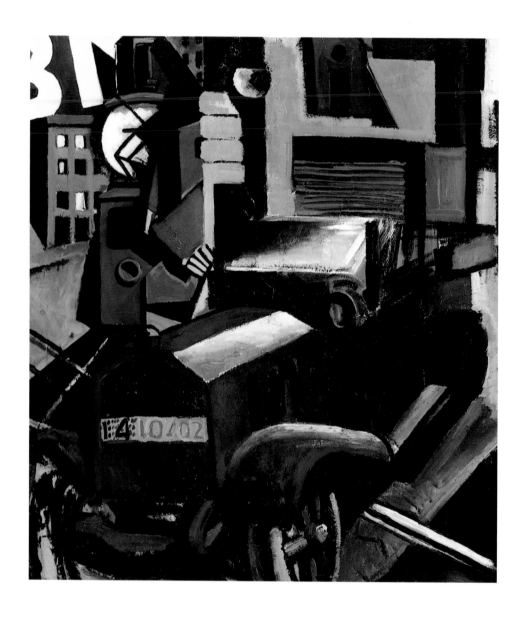

Mario Sironi
The Cyclist
1916
tempera and collage on paste-board
75,5 × 64,5 cm
Private Collection

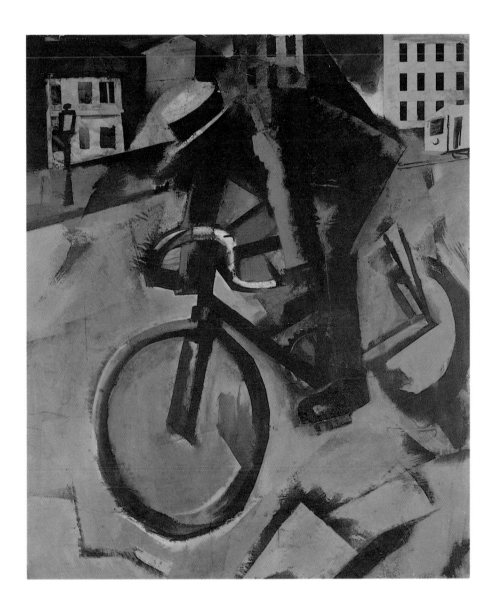

Mario Sironi
The Dancer
1917
tempera and collage on paste-board
76 × 55 cm
Milan, Riccardo and Magda Jucker Collection
on loan to Pinacoteca of Brera

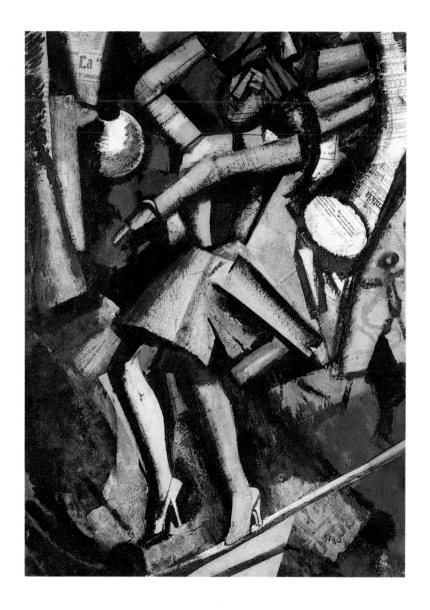

Mario Sironi
Composition with Propeller
1915
tempera and collage on paste-board
74,5 × 61,5 cm
Milan, Mattioli Collection

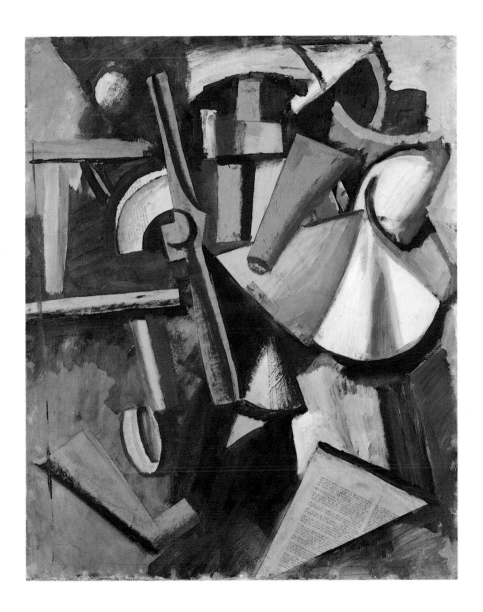

Ardengo Soffici
Decomposition of the Planes of a Lamp
1913
oil on canvas, 51,5 × 41,5 cm
on loan from Salome and Eric Estorick

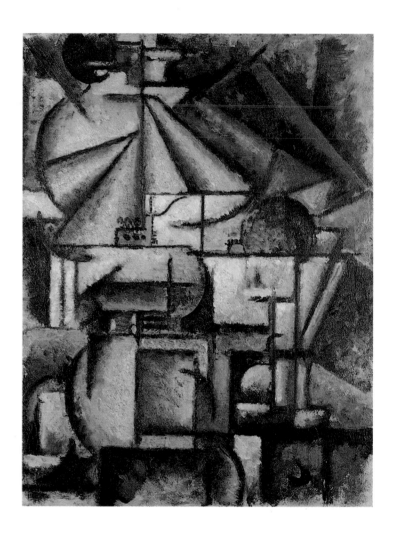

Ardengo Soffici
Synthesis of an Autumn Landscape
1913
oil on canvas, 45,5 × 43 cm
Private collection

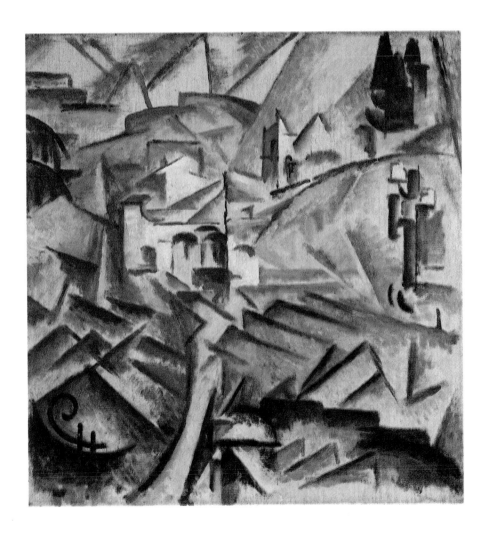

Ardengo Soffici
Pear, Book and Cup
1914
tempera on paste-board, 32,5 × 40,5 cm
Private Collection

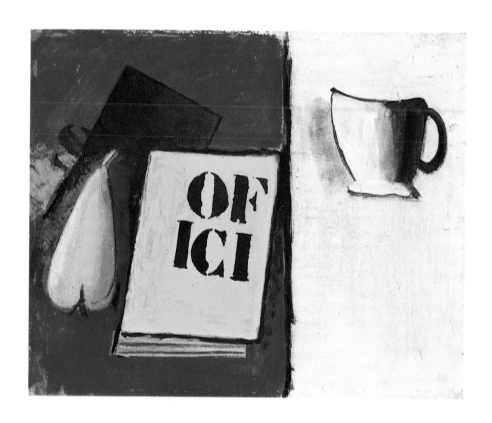

Ardengo Soffici
Fruit and Liquor
1915
oil on canvas, 65 × 54 cm
Milan, Mattioli Collection

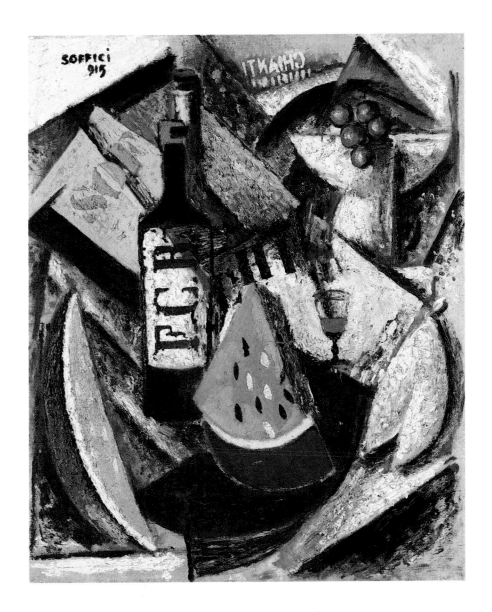

Leonardo Dudreville
Rhythms from Antonio Sant'Elia
1913
gouache and mixed media on paper
64,5 × 45,1 cm
New York, N. Richard Miller Collection

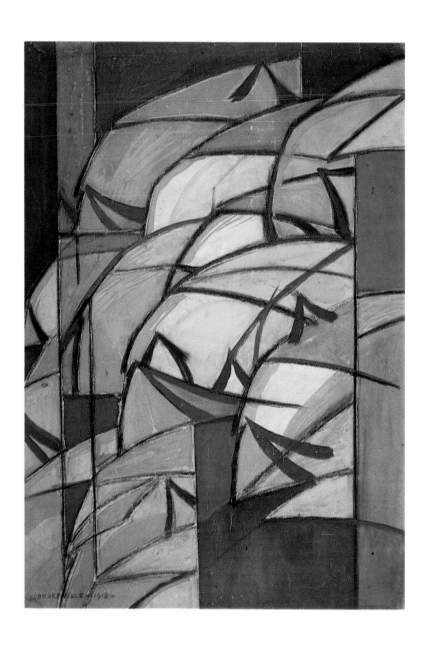

Leonardo Dudreville
Expansion of Poetry
1913
oil on canvas, 129,5 × 129,5 cm
New York, N. Richard Miller Collection

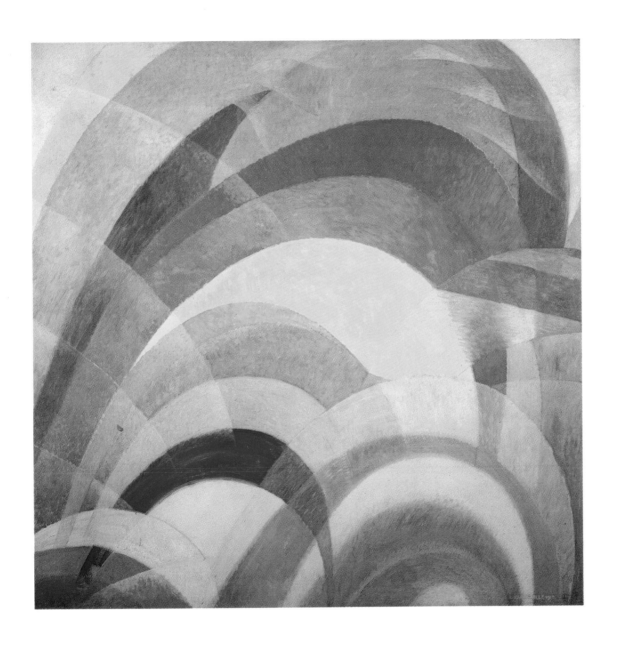

Leonardo Dudreville
By Train in the Po Valley
1914
oil on canvas, 54 × 75 cm
New York, N. Richard Miller Collection

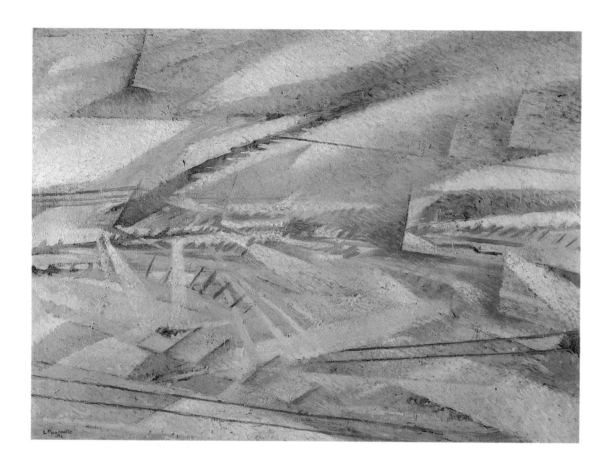

Roberto Melli
A Portrait of Vincenzo Costantini
1913
tufa, (piperino) 56 × 80 × 39 cm
Rome, Galleria Nazionale d'Arte Moderna

Roberto Melli
Lady with Black Hat
1913
bronze, 36 × 41,5 × 29 cm
Rome, Galleria Nazionale d'Arte Moderna

Futurisms 1909 — 1930

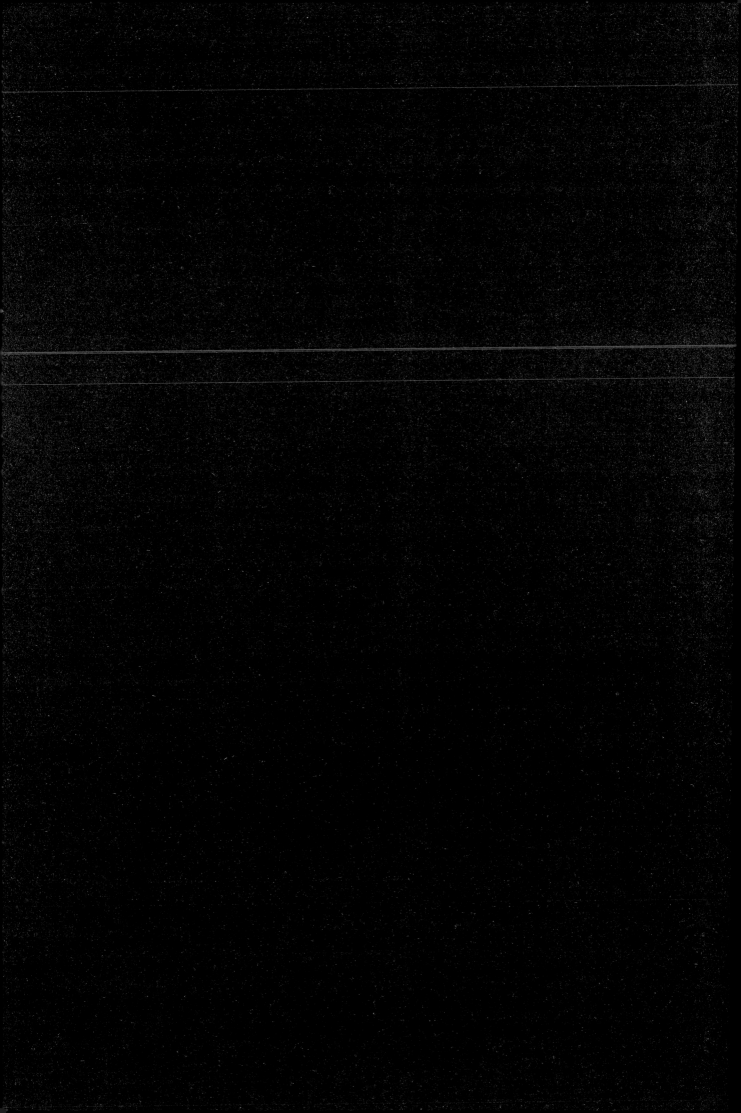

Emilio Pettoruti
Futurist Composition
1914
oil on canvas, 38 × 46 cm
Paris, René Jean Ullmann Collection

*This painting was completed during those
few years when the artist lived in Florence*

Paul Joostens
Car
1916
China ink and pen on paper, 16,7 × 20,1 cm
Antwerp, Lohaus-De Decker Collection

Paul Joostens
Train
1917
China ink on paper, 13,8 × 19 cm
Antwerp, Lohaus-De Decker Collection

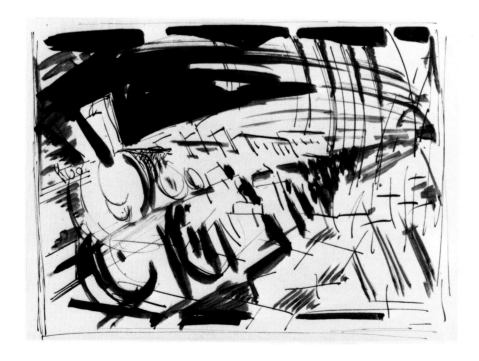

Jules Schmalzigaug
Volume + Light:
The Sun on the Chiesa della Salute
1914
oil on canvas, 95 × 105 cm
Antwerp, Van De Velde Galerie

Schmalzigaug lived in Venice and exhibited
with the Futurists

Jules Schmalzigaug
Café Florian
1914
chalk, watercolour and gouache on paper
31,7 × 39,3 cm
Private Collection

Jules Schmalzigaug
Cancan. The Dancers
1914-15
chalk, watercolour and gouache on paper
33,9 × 50,6 cm
Bruxelles, Musées Royaux des Beaux-Arts
de Belgique

Jules Schmalzigaug
Dynamic Expression of a Speeding Car
1914
crayon, watercolour and gouache on paper
30 × 40 cm
Bruxelles, Private Collection

Jules Schmalzigaug
Dynamic Expression of a Speeding Motorcycle
1915-16
oil on paste-board, 73 × 100 cm
Hove, Belgium, Maurice Verbaet Collection

Jozef Čapek
Silhouette of a Woman
1913
oil on canvas, 100 × 70,5 cm
Prague, Private Collection

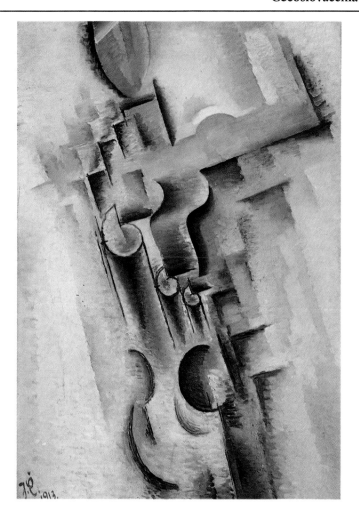

Bedřich Feuerstein
R.U.R. by Karel Čapek, project for stage
1921-22
watercolour and ink on paper, 25 × 34 cm
Prague, Národní Muzeum

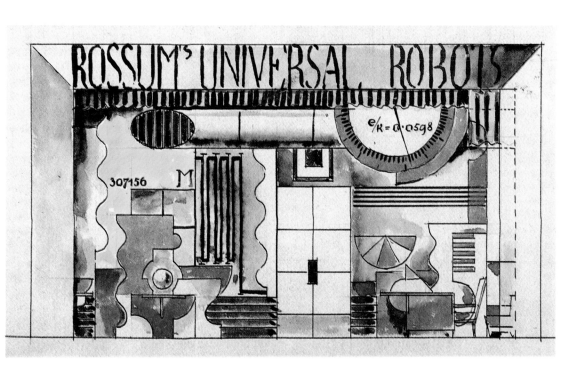

Otto Gutfreund
Viki
1911
bronze, 33 × 10 × 10 cm
Prague, Národní Galerí

Otto Gutfreund
Lying Woman with a Glass in Her Hand
1912-13
bronze, 19,5 × 28 × 14 cm
Prague, Národní Galerí

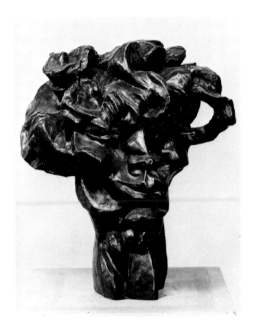

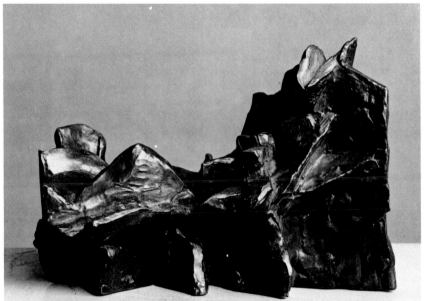

Otto Gutfreund
Embracing Figures
1912-13
bronze, 64,8 × 31,8 × 24,1 cm
New York
Mrs. and Mr. N. Richard Miller Collection

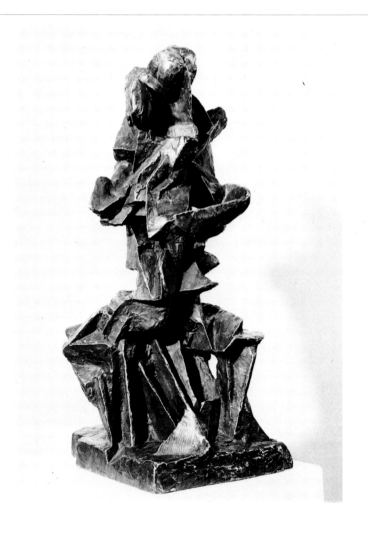

Otto Gutfreund
Violoncellist
1912-13
bronze, 47,5 × 18 × 21 cm
Prague, Národní Galerí

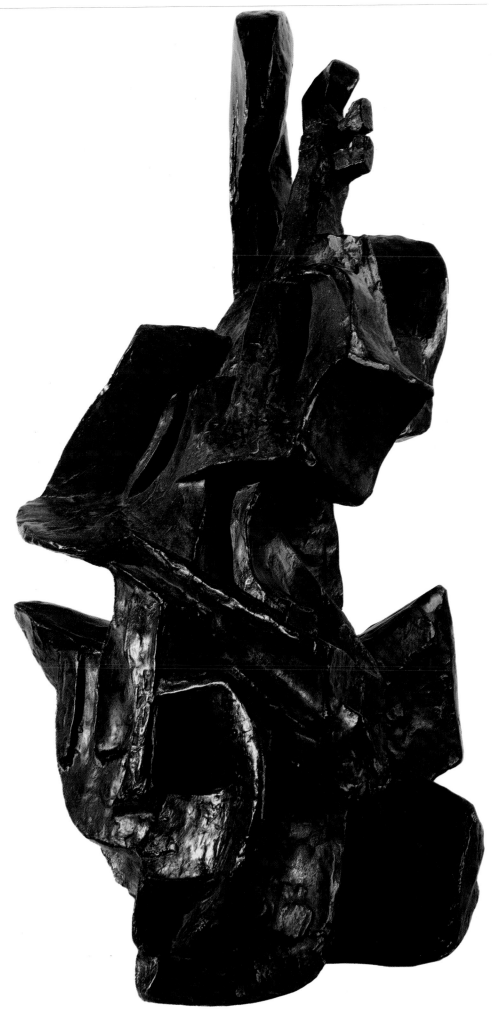

Cecoslovacchia Czechoslovakia

Jiří Kroha
Costume for "Matěj Poctivy"
by A. Dvořak and J. Klima
1922
watercolour on paper, 30 × 20 cm
Prague, Národní Muzeum

Jiří Kroha
Costume for "Matěj Poctivy"
by A. Dvořak and J. Klima
1922
watercolour on paper, 31 × 21 cm
Prague, Národní Muzeum

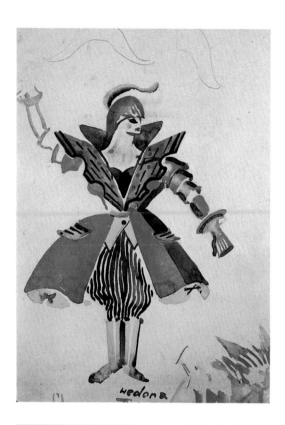

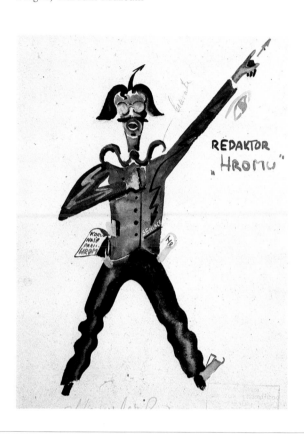

Jiří Kroha
Sketch for "Matěj Poctivy"
by A. Dvořak and J. Klima
1922
watercolour on paper, 34 × 28 cm
Prague, Národní Muzeum

Jiří Kroha
Sketch for "Matěj Poctivy"
by A. Dvořak and J. Klima
1922
watercolour on paper, 32 × 28 cm
Prague, Národní Muzeum

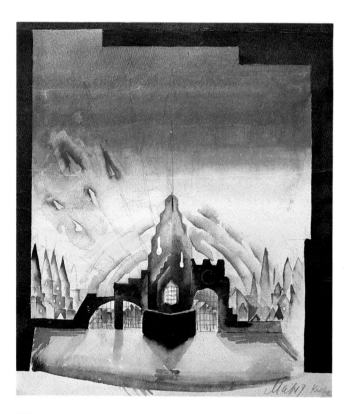

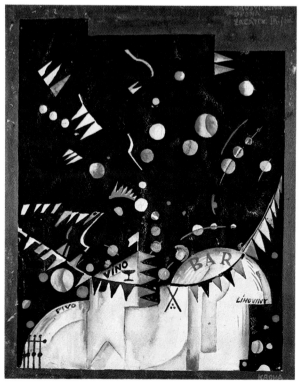

Jiří Kroha
Sketch for "Matěj Poctivy"
by A. Dvořak and J. Klima
1922
watercolour on paper, 34 × 27 cm
Prague, Národní Muzeum

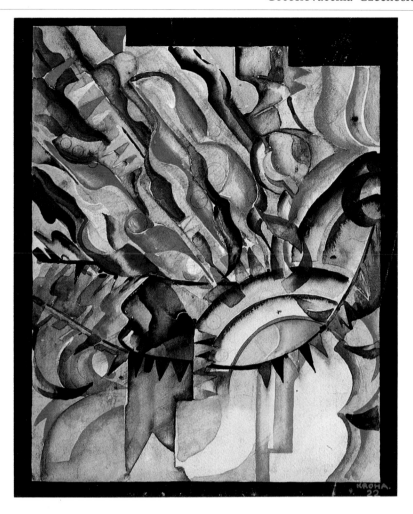

Bohumil Kubišta
Heavy Artillery in Action
1913
oil on canvas, 37 × 49,5 cm
Prague, Národní Galerí

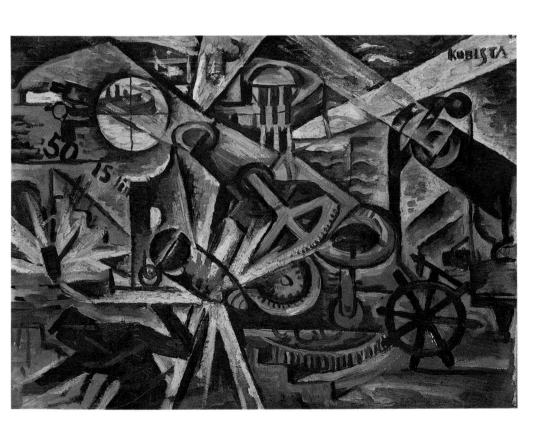

267

Cecoslovacchia Czechoslovakia

Bohumil Kubišta
The Sailor
1913
oil on canvas, 49,5 × 37,5 cm
Pilzen, Západočeská Galerie

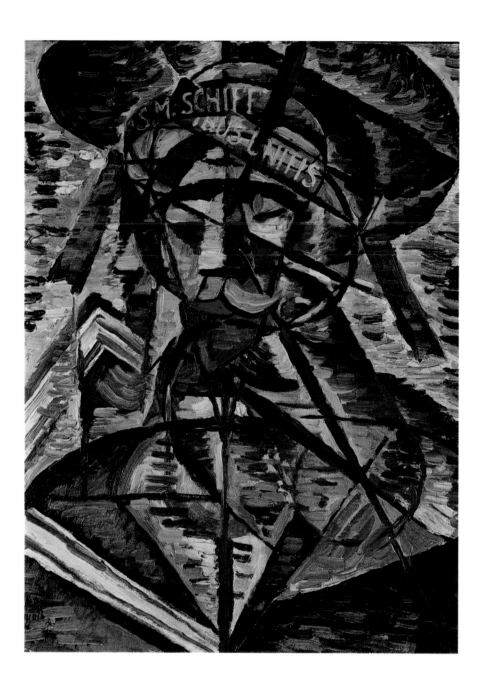

František Kupka
The Cathedral
1912-13
oil on canvas, 180 × 150 cm
Washington
Jan and Meda Mladek Collection

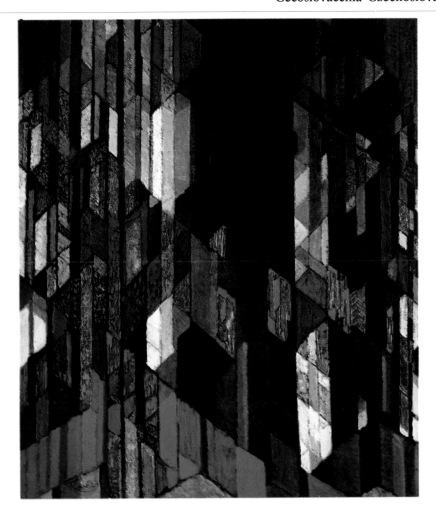

František Kupka
Creation
1911-1920
oil on canvas, 115 × 125 cm
Prague, Národní Galerí

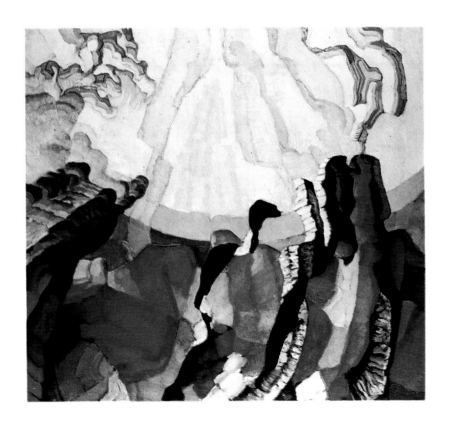

Josef Šíma
The Train
1920
oil on canvas, 34,5 × 44 cm
Brno, Galerie Moravská

Josef Šíma
The Bridge
1921
pencil and watercolour on paper
23,5 × 33,7 cm
Brno, Galerie Moravská

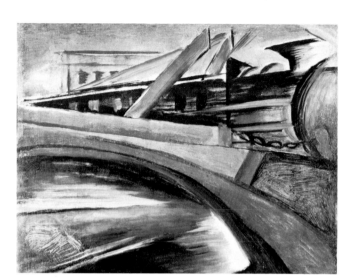

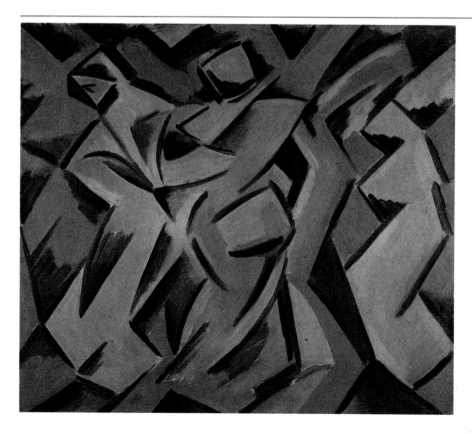

Václav Špála
The Three Spinners
1913
oil on canvas, 72 × 81,5 cm
Prague, Národní Galerí

Jais Nielsen
Departure!
1918
oil on canvas, 120 × 101 cm
Maribo, Lolland-Falsters Kunstmuseum

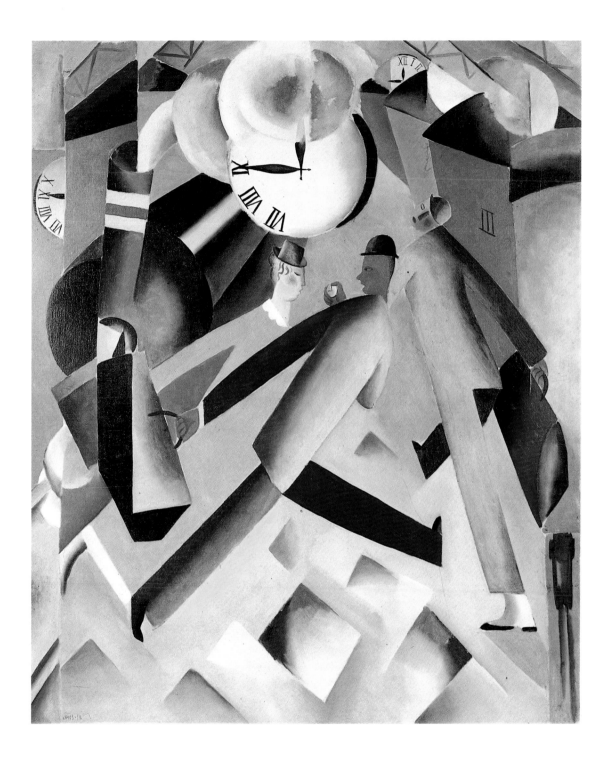

Georges Braque
Basket of Fish
1910-11
oil on canvas, 50,2 × 61 cm
Philadelphia, Philadelphia Museum of Art
The Samuel S. White III and Vera White Collection

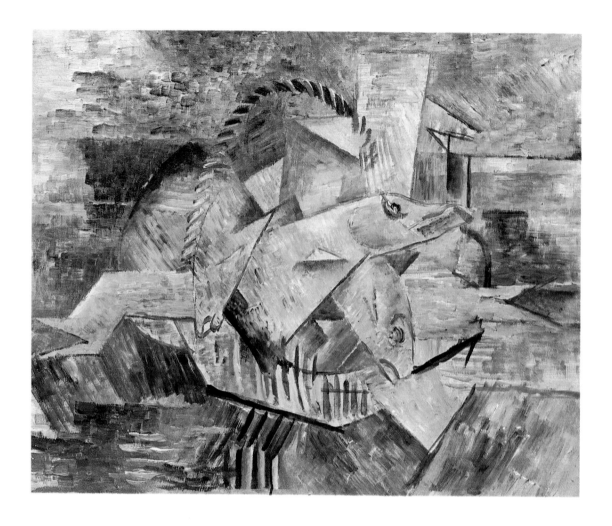

Robert Delaunay
The Cardiff Team
1912-13
oil on canvas, 193,5 × 132 cm
Eindhoven, Van Abbemuseum

This painting was shown together
with the Futurists
at the first Deutscher Herbst Salon, Berlin
1913, organized by Walden

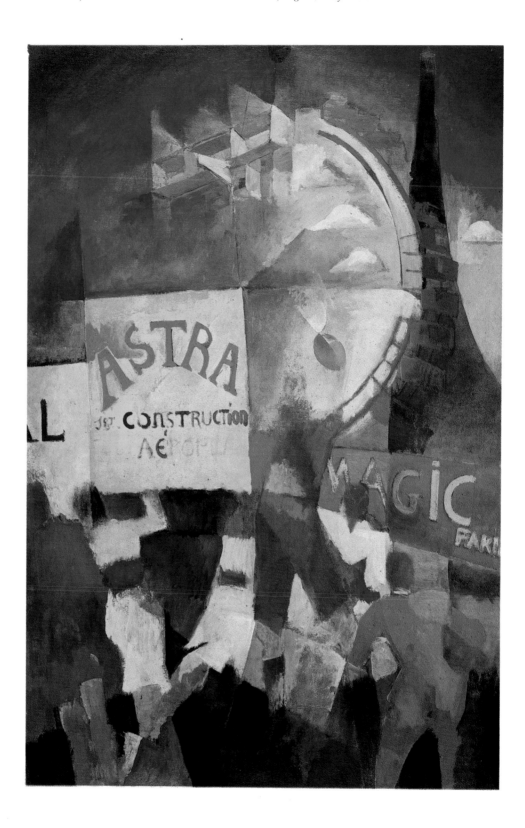

Robert Delaunay
Windows
1912
encaustic on canvas, 79,9 × 70 cm
New York, The Museum of Modern Art
The Sidney and Harriet Janis Collection

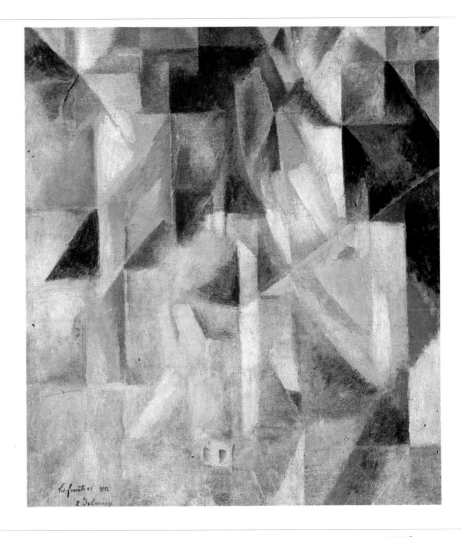

Robert Delaunay
Circular Forms, Moon no. 3
1913
wax on canvas, 25,5 × 21 cm
Paris, Charles Delaunay Collection

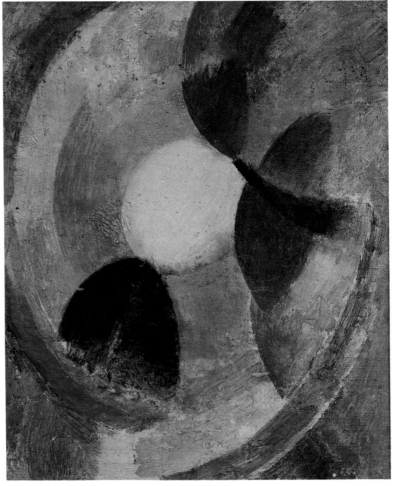

Robert Delaunay
Homage to Blériot
1913-14
watercolour pasted on cardboard
78 × 67 cm
Paris, Musée d'Art Moderne
de la Ville de Paris

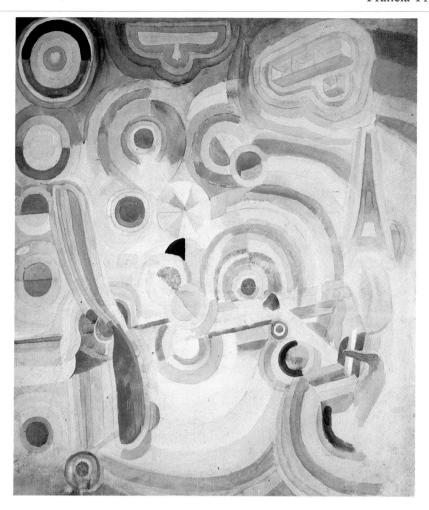

Robert Delaunay
Subscription Bulletin for Album no. 1
Itinerant Exhibitions
undated
watercolour on paper, 10 × 31 cm
Lisbon, Calouste Gulbenkian Foundation
Centro de Arte Moderna

Sonia Delaunay
*Prose of the Transsiberian and Little
Jehanne of France* by Blaise Cendrars
1913
watercolour on paper, 193,5 × 37 cm
Paris, Charles Delaunay Collection

Sonia Delaunay
*Prose of the Transsiberian and Little
Jehanne of France* by Blaise Cendrars
1913
oil on canvas, 193,5 × 18,5 cm
Paris, Musée National d'Art Moderne
Centre Georges Pompidou

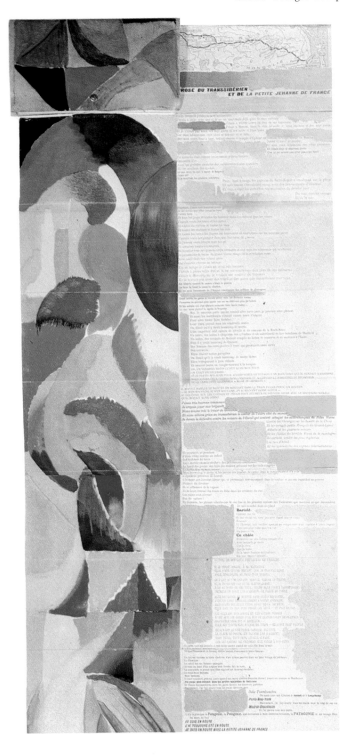

Sonia Delaunay
Simultaneous Contrasts
1913
watercolour on paper, 64 × 49,2 cm
Paris, Charles Delaunay Collection

Sonia Delaunay
Bookbinding for "Les Pâques à New York"
by Blaise Cendrars
1912
collage on brown Morocco leather
jacket, 25 × 15 cm (closed)
Paris, Musée National d'Art Moderne
Centre Georges Pompidou

Sonia Delaunay
Little Coffer
1913
oil on wood, 21 × 36 × 24,5 cm
Paris, Musée National d'Art Moderne
Centre Georges Pompidou

Felix Delmarle
Endeavour
1913
charcoal and crayon on paper
42,2 × 69,8 cm
New York, The Museum of Modern Art
The J.M. Kaplan Fund

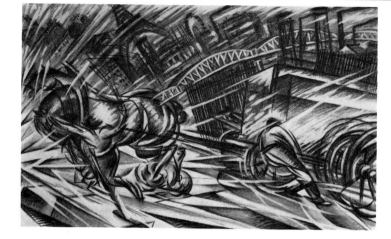

Felix Delmarle
Cats
1913
charcoal and ink on paper
49,8 × 77,2 cm
Valenciennes, Musée des Beaux-Arts

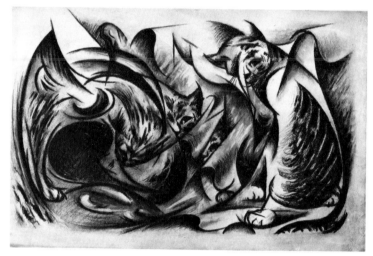

Felix Delmarle
Portrait, study
1913
charcoal and pastel on paper, 62 × 48 cm
Private Collection

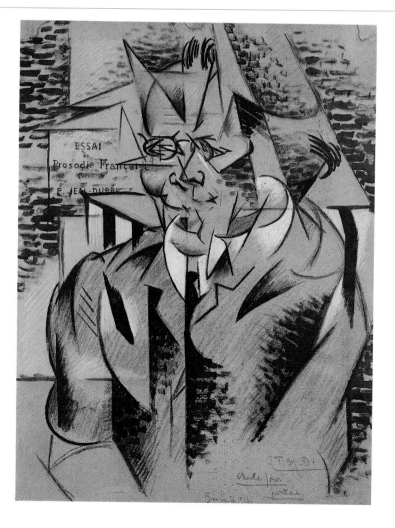

Felix Delmarle
The Port
1913-14
oil on canvas, 64,8 × 50,2 cm
New York, Carus Gallery

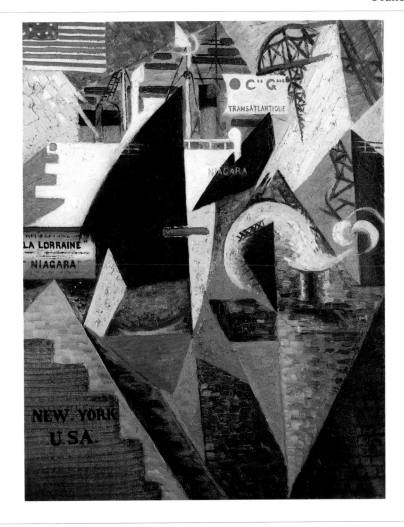

Felix Delmarle
The Port
undated
oil on canvas, 81 × 65 cm
Valenciennes, Musée des Beaux-Arts

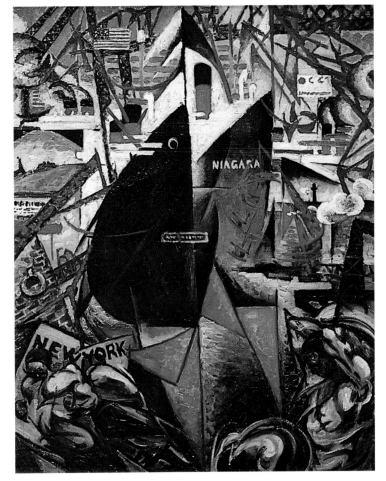

Marcel Duchamp
Portrait (Dulcinée)
1911
oil on canvas, 146,5 × 114 cm
Philadelphia, Philadelphia Museum of Art
The Louise and Walter Arensberg
Collection

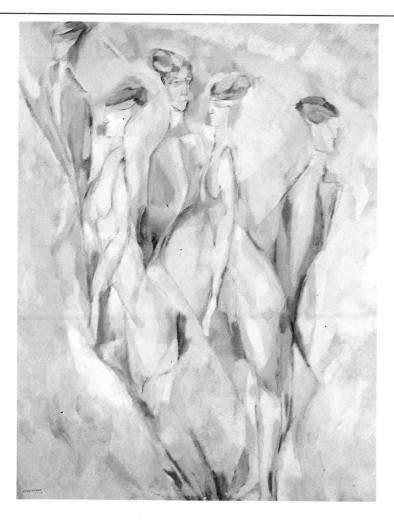

Marcel Duchamp
Nude. Sad Young Man in a Train, study
1911-12
oil on paste-board, 100 × 73 cm
Venice, Peggy Guggenheim Collection
(Solomon R. Guggenheim Foundation)

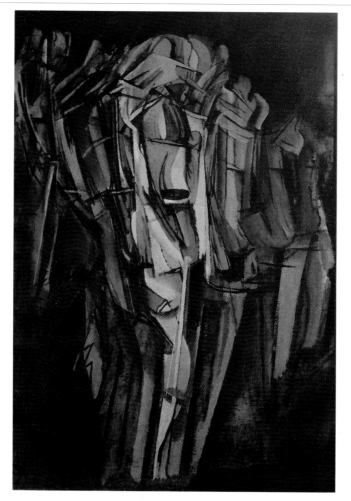

(following page)
Marcel Duchamp
Nude Descending a Staircase no. 2
1912
oil on canvas, 146 × 89 cm
Philadelphia, Philadelphia Museum of Art
The Louise and Walter Arensberg
Collection

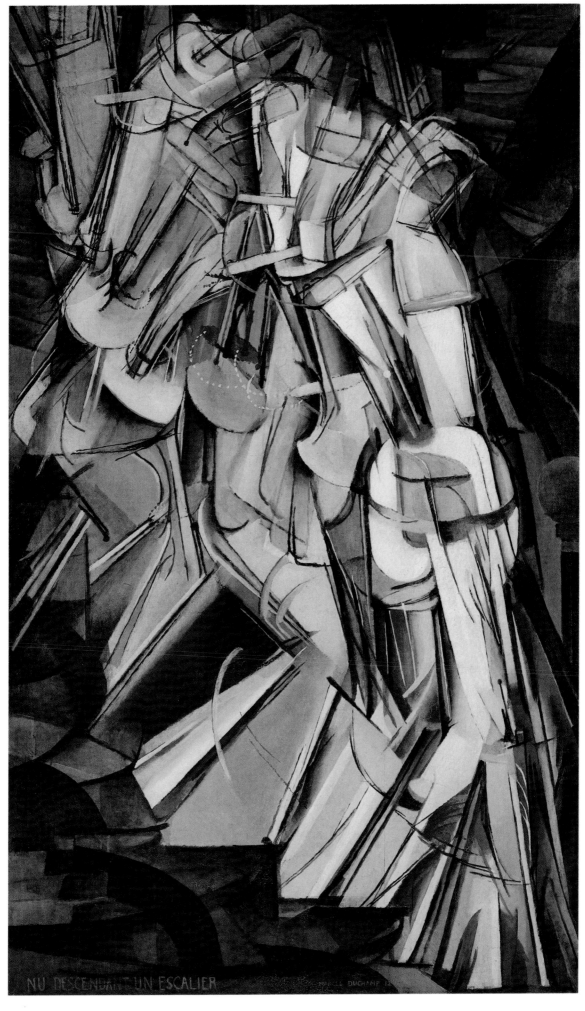

NU DESCENDANT UN ESCALIER MARCEL DUCHAMP 12

Raymond Duchamp-Villon
Horse and Rider, first version
1914
bronze, 21 cm
Rouen, Musée des Beaux-Arts

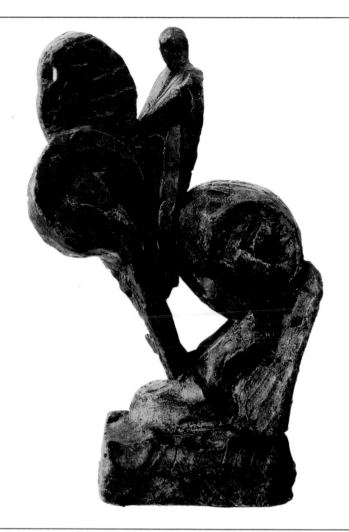

Albert Gleizes
The Port
1912
oil on canvas, 90,2 × 116,5 cm
Toronto, Art Gallery of Ontario
Junior Women's Committee Fund Gift

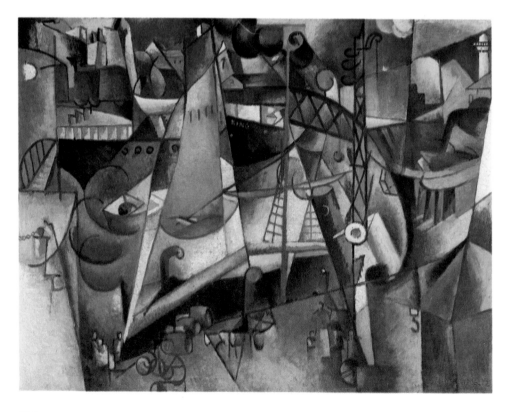

Albert Gleizes
Brooklyn Bridge
1915
oil and sand on paste-board, 150 × 120 cm
Private Collection

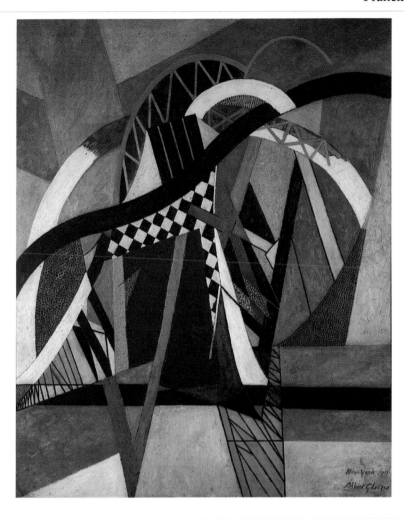

Henri Laurens
The Clown
1915
painted wood, 53 × 29,5 × 23,5 cm
Stockholm, Moderna Museet

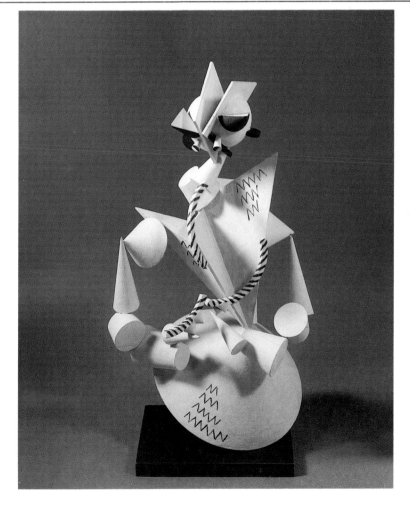

Henri Le Fauconnier
Abundance
1910
oil on canvas, 146,5 × 98 cm
Stockholm, Moderna Museet

Malevich analyzed this painting in his book
The Non-Objective World

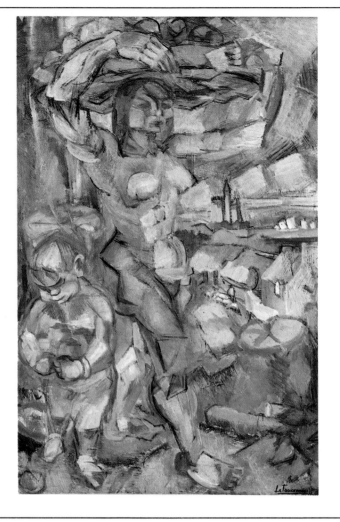

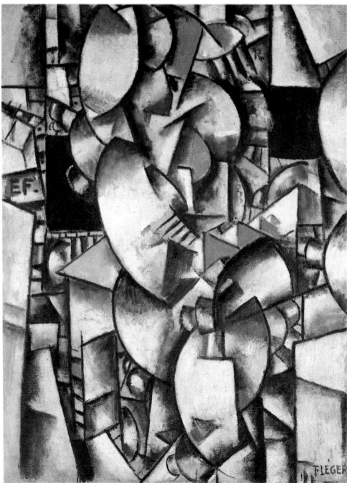

Fernand Léger
Nude Model in the Studio
1912-13
oil on burlap, 127,8 × 95,7 cm
New York, The Solomon R. Guggenheim Museum

Marinetti expressed his admiration for this
work on several occasions

Francis Picabia
Star Dancer and Her School of Dance
1913
watercolour on paper, 55,9 × 76,2 cm
New York, The Metropolitan Museum of Art
The Alfred Stieglitz Collection

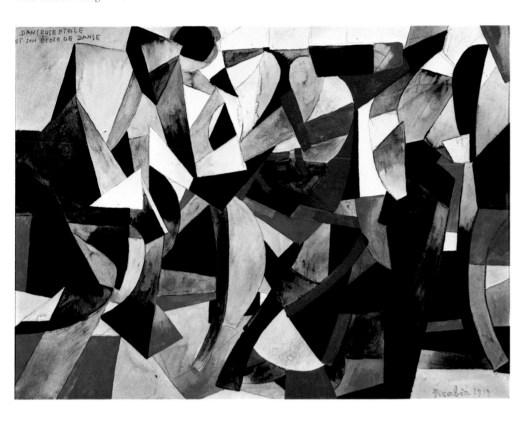

Francis Picabia
Star Dancer on a Liner
1913
watercolour, 75 × 55 cm
Private Collection

Francis Picabia
Negro Song I
1913
watercolour on paper, 66 × 56 cm
New York, The Metropolitan Museum of Art
The Alfred Stieglitz Collection

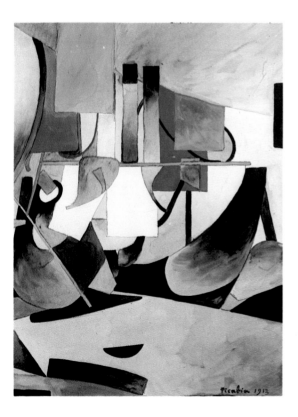

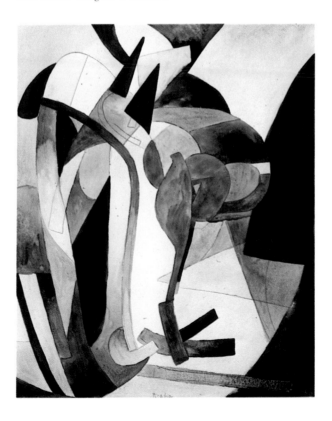

Pablo Picasso
Fernande
1910
bronze, 41 cm
Stockholm, Moderna Museet

Pablo Picasso
The Glass of Absinth
1914
polychrome bronze with silver sugar
strainer, 21,6 × 16,5 × 6,4
New York, The Museum of Modern Art
Bertram Smith Gift

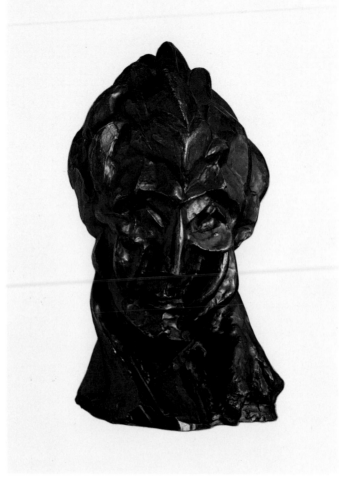

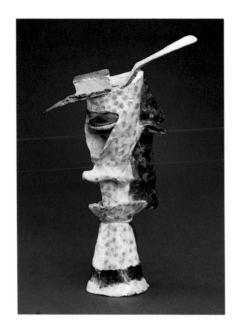

Pablo Picasso
Man with Violin
1911-12
oil on canvas, 100 × 76 cm
Philadelphia
Philadelphia Museum of Art
Louise and Walter Arensberg Collection

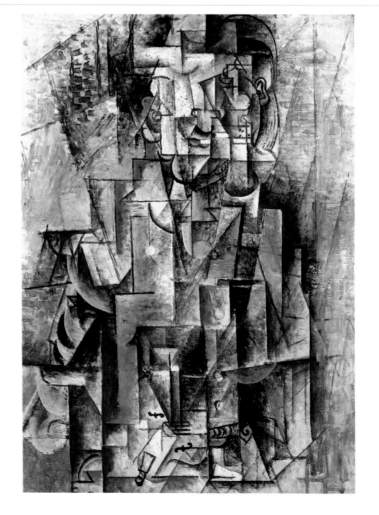

Léopold Survage
Coloured Rhythm
1913
inks on paper, 49 × 45 cm
Paris, Musée National d'Art Moderne
Centre Georges Pompidou

Léopold Survage
Coloured Rhythm
1913
inks on paper, 49 × 45 cm
Paris, Musée National d'Art Moderne
Centre Georges Pompidou

Léopold Survage
Coloured Rhythm
1913
inks on paper, 49 × 45 cm
Paris, Musée National d'Art Moderne
Centre Georges Pompidou

In spite of Apollinaire and Cendrars's
support the film never materialized

Jacques Villon
Soldiers Marching
1913
oil on canvas, 65 × 92 cm
Paris, Musée National d'Art Moderne
Centre Georges Pompidou

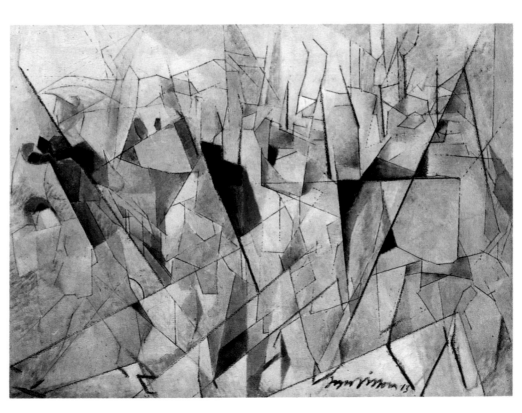

Otto Dix
War
1914
oil on paste-board, 98,5 × 69,5 cm
Düsseldorf, Kunstmuseum

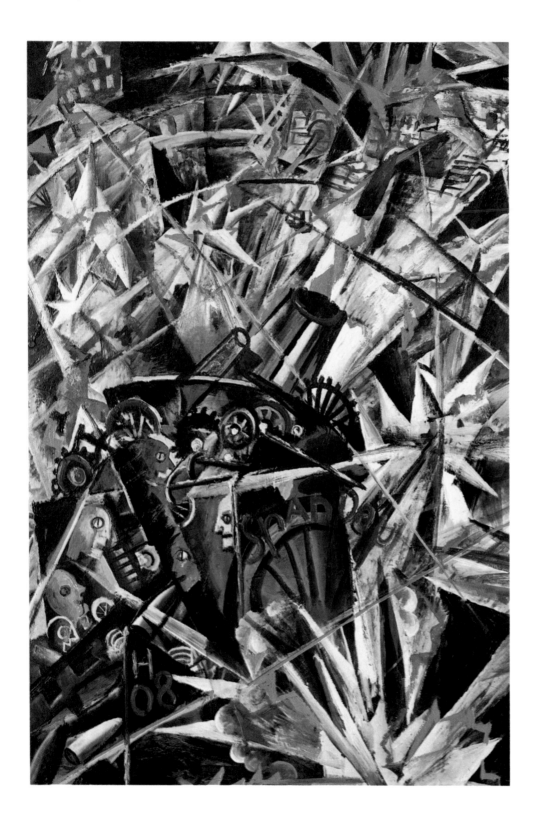

Otto Dix
Head
chalk on paper, 42 × 32,5 cm
Albstadt, Städtische Galerie
Walther Groz Foundation

Max Ernst
Portrait
1911-12
oil on paste-board, 51 × 43 cm
Ludwigshafen/Rh.
Wilhelm-Hack-Museum

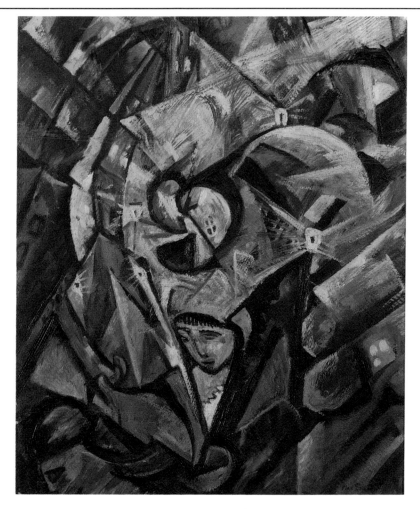

George Grosz
Metropolis
1916-17
oil on canvas, 100 × 102 cm
Lugano, Thyssen-Bornemisza Collection

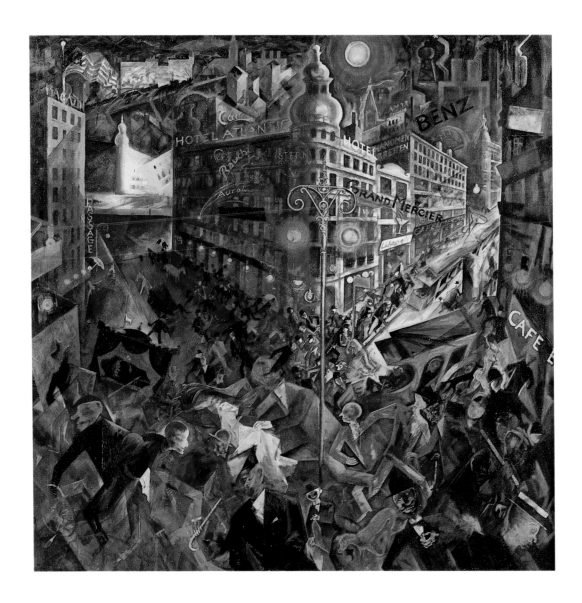

Franz Marc
Tyrol
1913-14
oil on canvas, 135,7 × 144,5 cm
Munich, Bayerische Staatsgemäldesammlungen

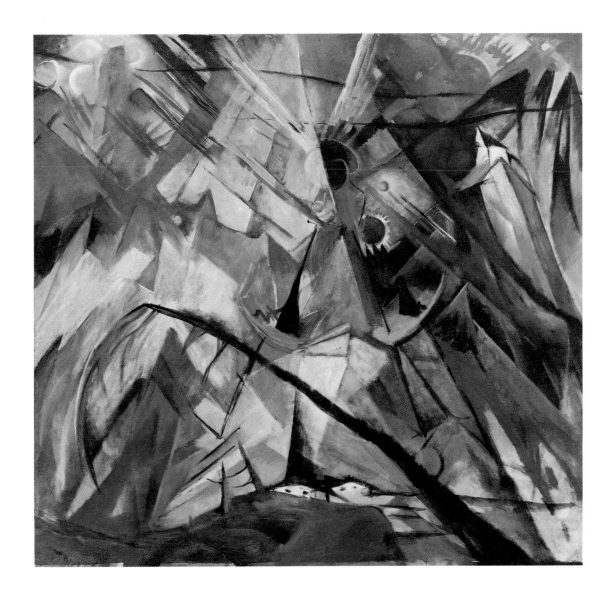

Tai Kanbara
Studies on Futurism
1925
book
Okayama, Ohara Bijutsukan

Tai Kanbara
Translation of "Les Poupées Electriques"
by F.T. Marinetti
book
Tokyo, Kokuritsu Kindai Bijutsukan

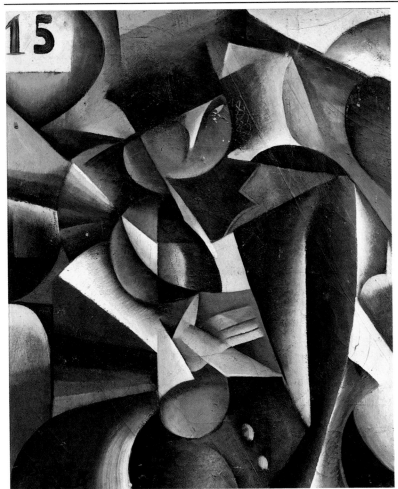

Seiji Togo
Man with a Hat
1921-22
oil on canvas, 73 × 61 cm
Private Collection

Masamu Yanase
Retaliation of the Bottom
1922
oil on wood, 24,2 × 24,2 cm
Private Collection

Masamu Yanase
Nap
1922
oil on canvas, 24,2 × 23,7 cm
Private Collection

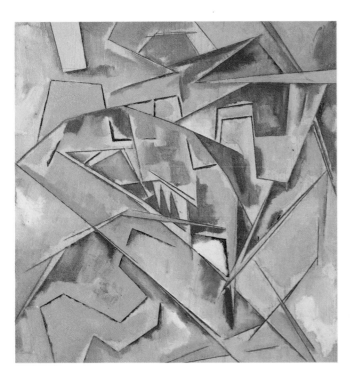

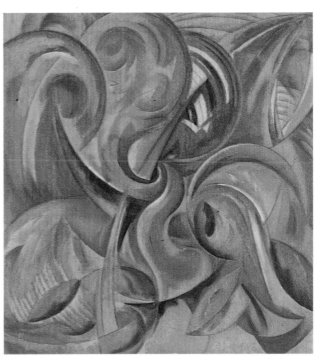

Tetsugoro Yorozu
Perpendicular View of a Town through Trees
1918
oil on canvas, 59,5 × 79 cm
Iwate, Kenritsu Hakubutsukan

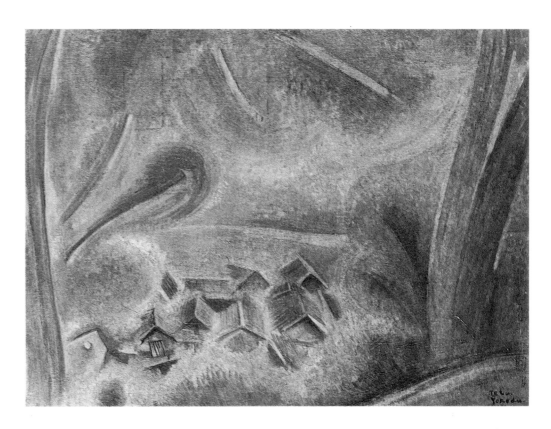

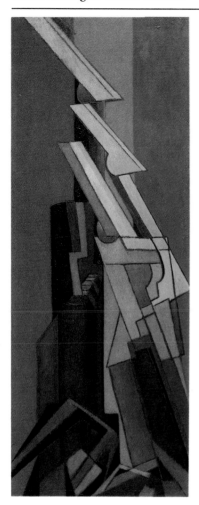

Lawrence Atkinson
Abstract
1915-20
oil on wood, 129,5 × 50,8 cm
Arts Council of Great Britain

Lawrence Atkinson
The Lake
1914-18 c.
ink and watercolour on paper
25,5 × 37 cm
London, The Trustees of the Tate Gallery

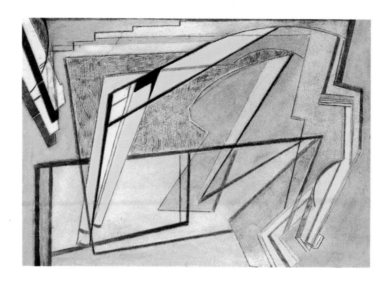

David Bomberg
Vision of Ezekiel
1912
oil on canvas, 114,3 × 137,2 cm
London, The Trustees of the Tate Gallery

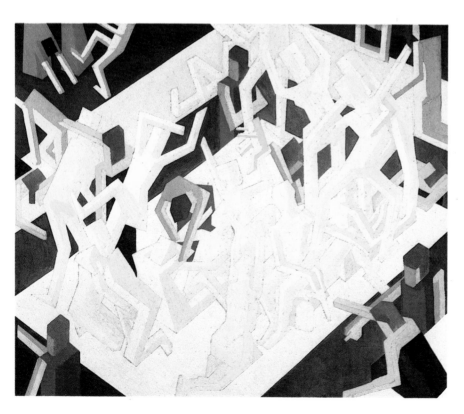

David Bomberg
The Dancer
1913
watercolour and charcoal on paper, 38,1 × 27,9 cm
Bedford, The Trustees of The Cecil Higgins
Art Gallery

David Bomberg
The Dancer
1913-14
crayon, watercolour and gouache on paper
67,5 × 55,5 cm
London, Anthony d'Offay Gallery

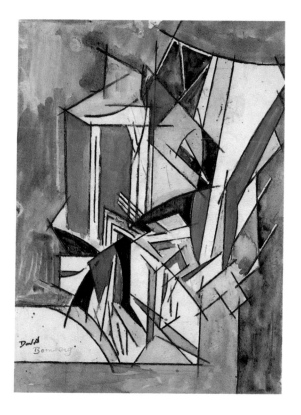

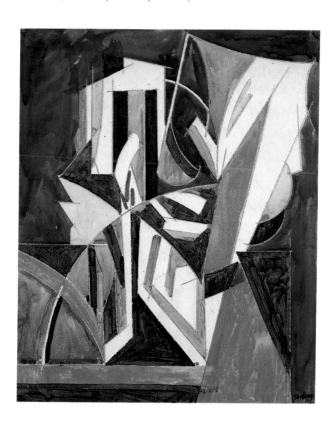

David Bomberg
In the Hold, study
1914
black chalk on paper, 55,5 × 66 cm
London, The Trustees of the Tate Gallery

David Bomberg
In the Hold
1913-14 c.
oil on canvas, 196,2 × 231,1 cm
London, The Trustees of the Tate Gallery
(not exhibited)

Alvin Langdon Coburn
Vortograph of Ezra Pound
1917 c.
gelatin silver print, 20,4 × 15,2 cm
Rochester, New York, International Museum
of Photography, George Eastman House

Alvin Langdon Coburn
Vortograph of Ezra Pound
1917 c.
gelatin silver print, 20,4 × 15,4 cm
Rochester, New York, International Museum
of Photography, George Eastman House

Alvin Langdon Coburn
Vortograph
1917 c.
gelatin silver print, 28,2 × 21,8 cm
Rochester, New York, International Museum
of Photography, George Eastman House

Alvin Langdon Coburn
Vortograph
1917
gelatin silver print, 27,5 × 20,3 cm
Rochester, New York, International Museum
of Photography, George Eastman House

Alvin Langdon Coburn
Vortograph
1917
gelatin silver print, 27,2 × 20,6 cm
Rochester, New York, International Museum
of Photography, George Eastman House

Alvin Langdon Coburn
Vortograph
1917
gelatin silver print, 28,2 × 22,5 cm
Rochester, New York, International Museum
of Photography, George Eastman House

Stanley Cursiter
The Sensation of Crossing the Street
The West End, Edinburgh
1913
oil on canvas, 51 × 61 cm
Glasgow
Mrs. and Mr. William Hardie Collection

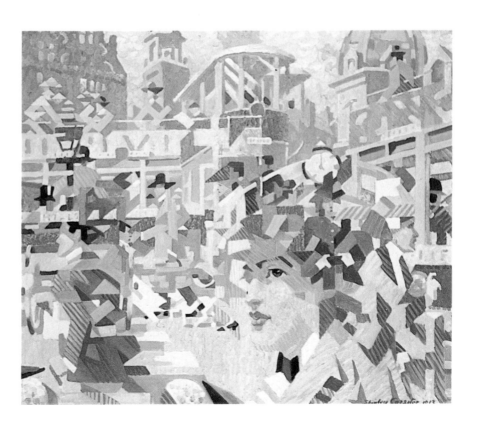

Jessica Dismorr
Landscape: Edinburgh Castle
1914-15 c.
ink and watercolour on paper, 24 × 19 cm
London, The Trustees
of the Victoria & Albert Museum

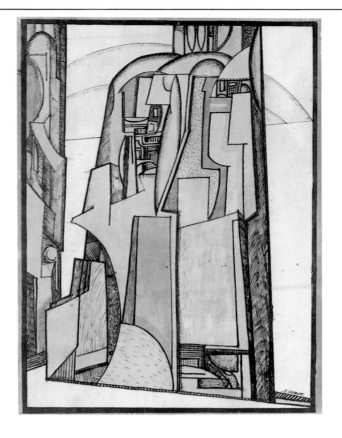

Jacob Epstein
Sunflower
1910 c.
stone, 58,5 × 26 × 24 cm
Melbourne, National Gallery of Victoria
bequest of Felton

Jacob Epstein
Rock Drill, study
1913 c.
crayon on paper, 63,5 × 47 cm
London, Anthony d'Offay Gallery

Jacob Epstein
Rock Drill, study
1913 c.
crayon on paper, 64,1 × 53,3 cm
London, The Trustees of the Tate Gallery

Jacob Epstein
Rock Drill, study
1913 c.
crayon on paper, 67,5 × 40,5 cm
London, Anthony d'Offay Gallery

Jacob Epstein
Rock Drill
1913-14
bronze, 70,5 × 44,5 × 58,4 cm
London, The Trustees of the Tate Gallery

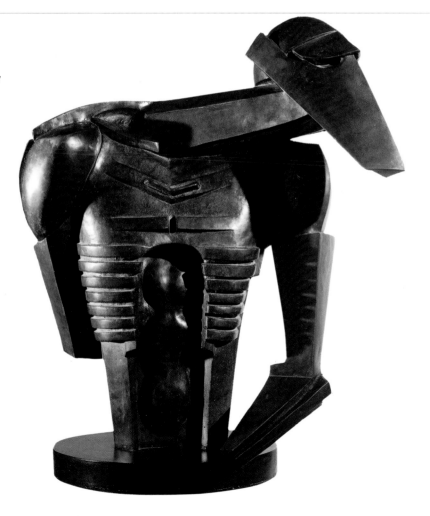

Jacob Epstein
Female Figure, study
1913 c.
crayon on paper, 68,5 × 42,5 cm
London, Anthony d'Offay Gallery

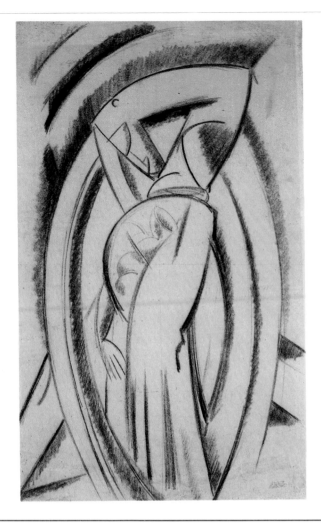

Frederick Etchells
Stilts
1914-15
gouache and pencil on paper
31,5 × 23 cm
The British Council

Frederick Etchells
The Comedian
1914-15
ink on paper, 27,5 × 18 cm
London, The Trustees
of the Victoria & Albert Museum

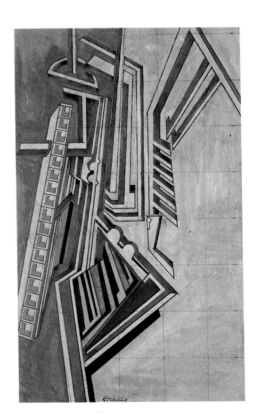

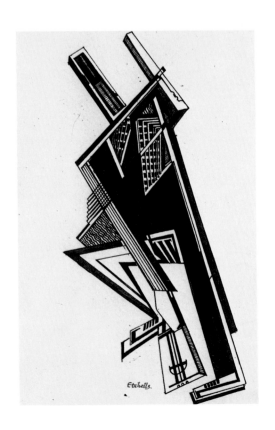

300

Frederick Etchells
Progression
1914-16
pen, brush and inks on paper, 15,3 × 23,3 cm
Bedford, The Trustees of the Cecil
Higgins Art Gallery and Museum

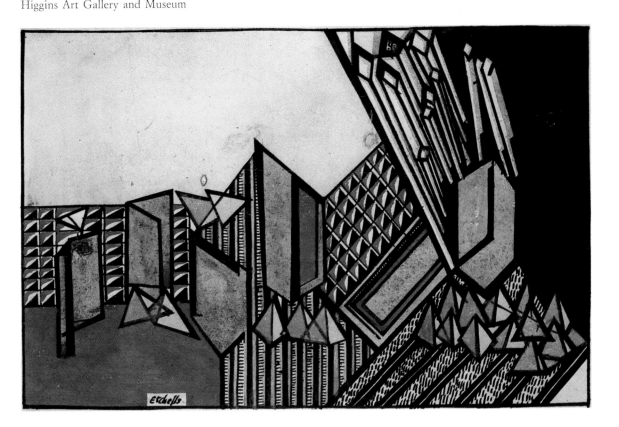

**Roger Fry and Joseph Kallenborn
(Omega Workshops)**
Giraffe Marquetry Cupboard
1916
inlaid woods, 213,4 × 115 × 40,6 cm
London, Anthony d'Offay Gallery

**Roger Fry and Joseph Kallenborn
(Omega Workshops)**
Marquetry Table: Winter
1913
inlaid woods, 70,5 × 72,4 × 72,4 cm
London, Anthony d'Offay Gallery

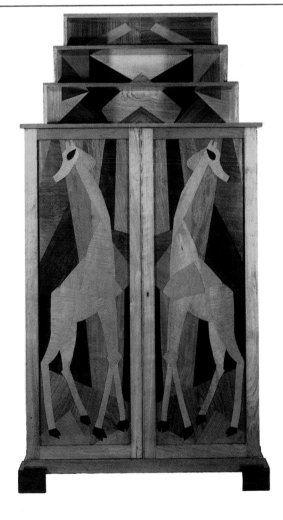

Henry Gaudier-Brzeska
Redstone Dancer
1913
bronze, 43 × 23 × 23 cm
Cambridge, Kettle's Yard
University of Cambridge

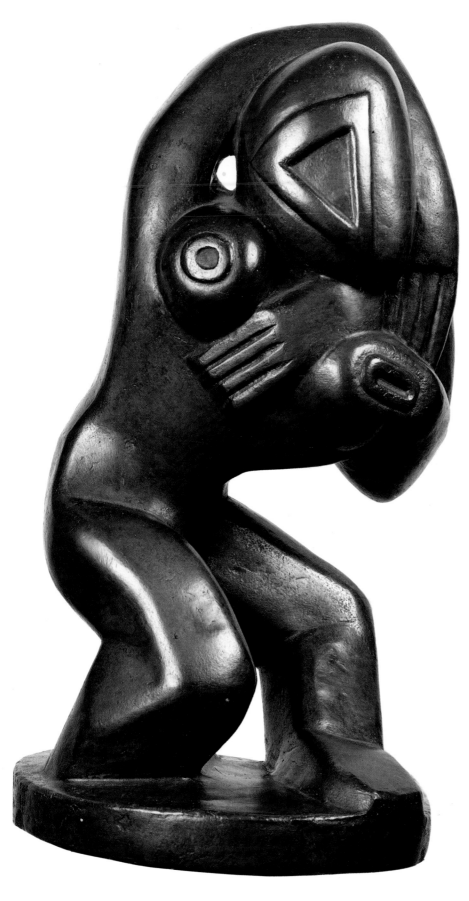

Henry Gaudier-Brzeska
Portrait of Ezra Pound, study
1913
China ink on beige paper, 26 × 38 cm
Paris, Musée National d'Art Moderne
Centre Georges Pompidou

Henry Gaudier-Brzeska
Wyndham Lewis
1914
pastel on paper, 23,8 × 15,5 cm
London, Anthony d'Offay Gallery

Henry Gaudier-Brzeska
Abstract
1914
ink on paper, 32 × 12 cm
Orléans, Musée des Beaux-Arts

Henry Gaudier-Brzeska
Ornament/Toy
1914
brass, 15,9 × 3,8 × 3,2 cm
Toronto, Art Gallery of Ontario

Henry Gaudier-Brzeska
Bird Swallowing a Fish, study
1914 c.
green ink on paper, 14 × 23,1 cm
Paris, Musée National d'Art Moderne
Centre Georges Pompidou

Henry Gaudier-Brzeska
Bird Swallowing a Fish, study
1914
pencil on paper, 30,5 × 47 cm
Cambridge, Kettle's Yard
University of Cambridge

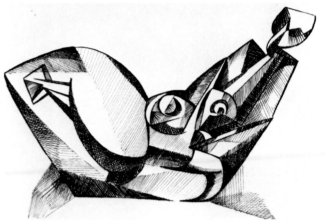

Henry Gaudier-Brzeska
Bird Swallowing a Fish
1914
bronze, 32 × 61,5 × 29 cm
Paris, Musée National d'Art Moderne
Centre Georges Pompidou

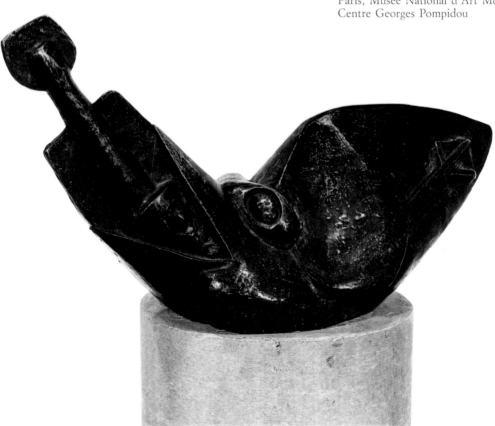

Henry Gaudier-Brzeska
Dog
1914
bronze, 15 × 33,5 × 8 cm
Cambridge, Kettle's Yard
University of Cambridge

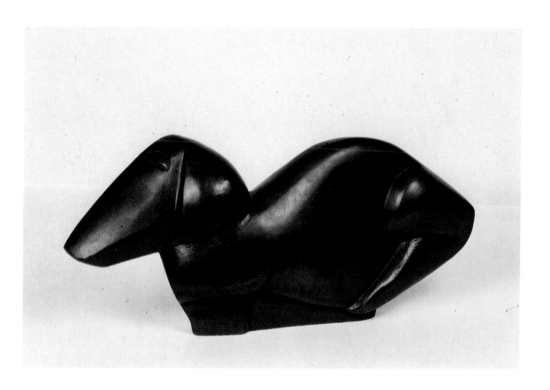

Percy Wyndham Lewis
Futurist Figure
1912
pencil, pen, ink and watercolour
on paper, 26,3 × 18,3 cm
London, Anthony d'Offay Gallery

Percy Wyndham Lewis
Timon, study
1912-13
watercolour, 56 × 38 cm
Hartford, Wadsworth Atheneum
The Ella Gallup Sumner
and Mary Catlin Sumner Collection

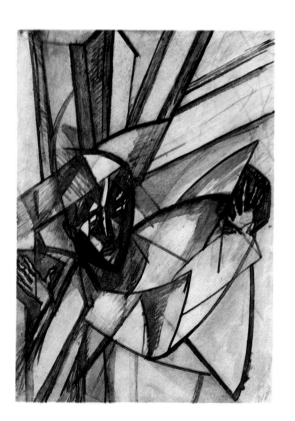

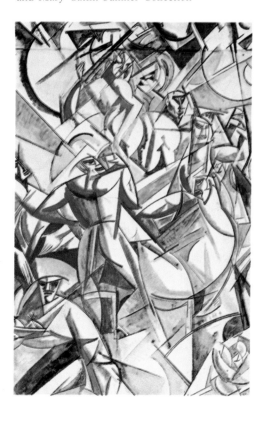

Percy Wyndham Lewis
Figure Composition
1912-13
pencil, ink and gouache on paper
23,5 × 31 cm
London, Anthony d'Offay Gallery

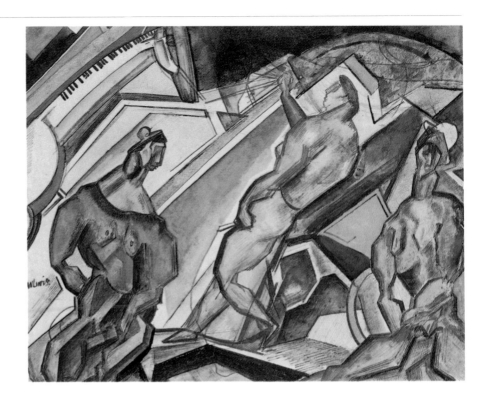

Percy Wyndham Lewis
Portrait of an Englishwoman
1913-14
watercolour on paper, 56 × 38 cm
Hartford, Wadsworth Atheneum
The Ella Gallup Sumner
and Mary Catlin Sumner Collection

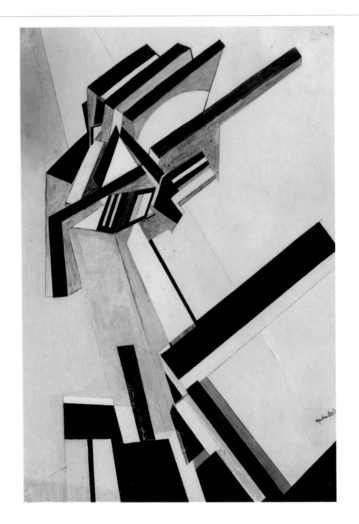

Percy Wyndham Lewis
The Crowd
1915
oil on canvas, 200,7 × 153,7 cm
London
The Trustees of the Tate Gallery
(not exhibited)

Percy Wyndham Lewis
Dancing Figure
1914
pencil, ink, pastel, gouache and oil
on paper, 21 × 50,2 cm
London, Anthony d'Offay Gallery

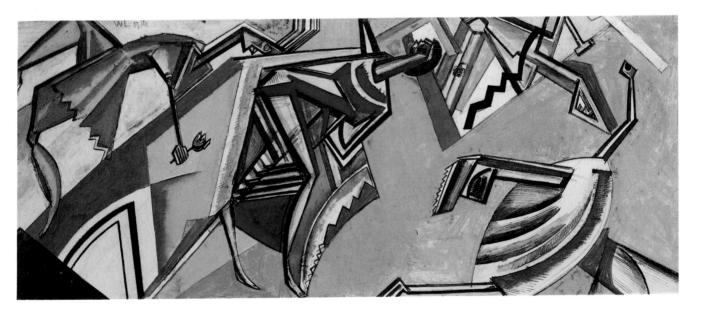

Percy Wyndham Lewis
New York
1914
ink, pastel, watercolour and gouache
on paper, 31,7 × 26 cm
London, Anthony d'Offay Gallery

Percy Wyndham Lewis
Red Duet, study
1915
pencil, ink, watercolour and gouache
on paper, 31,7 × 24,5 cm
London, Anthony d'Offay Gallery

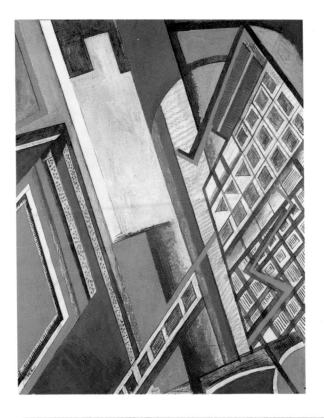

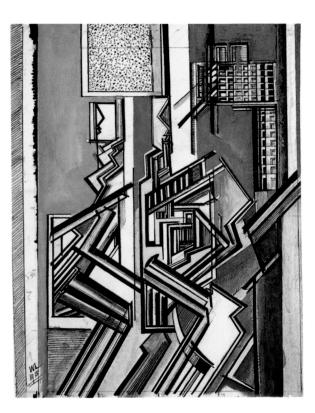

Percy Wyndham Lewis
A Battery Shelled
1914-18
oil on canvas, 182,8 × 317,5 cm
London, The Trustees
of the Imperial War Museum

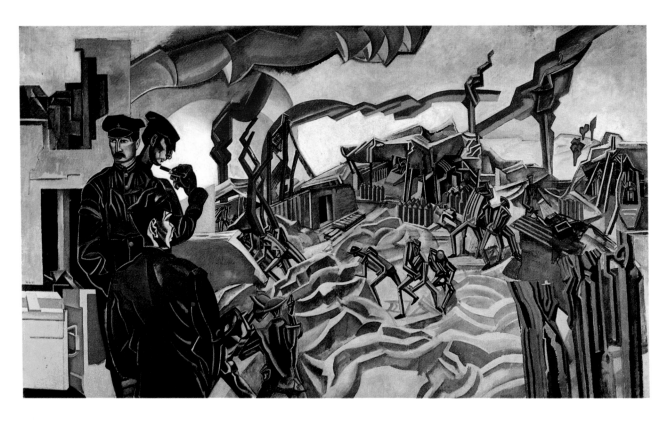

Christopher R.W. Nevinson
Departure of Train de Luxe, study
1913 c.
pastel, 37 × 29 cm
London, Anthony d'Offay Gallery

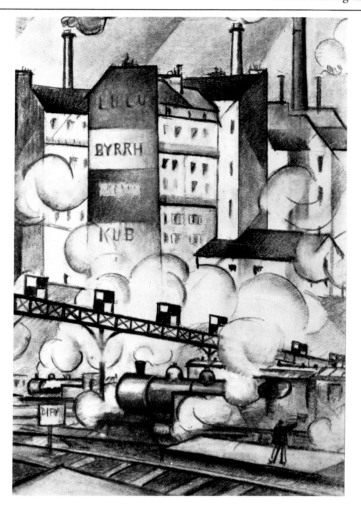

Christopher R.W. Nevinson
Dance Hall Scene
1913-14 c.
chalk, gouache and watercolour on paper
20,5 × 17 cm
London, The Trustees of the Tate Gallery

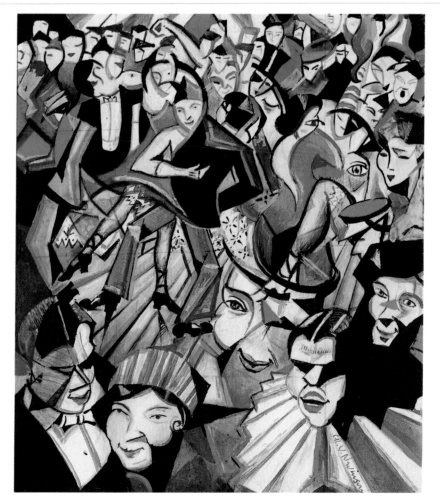

Christopher R.W. Nevinson
A Bursting Shell
1915
oil on canvas, 75,5 × 55 cm
London, The Trustees of the Tate Gallery

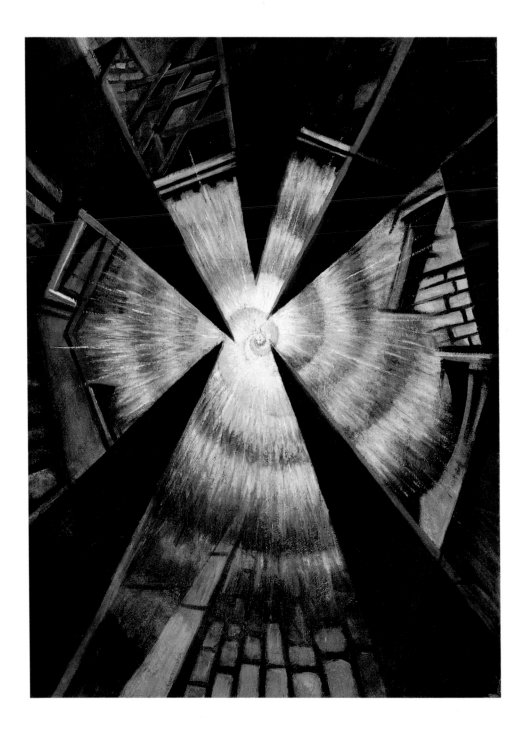

Christopher R.W. Nevinson
Returning to the Trenches
1914-15
oil on canvas, 51 × 76 cm
Ottawa, National Gallery of Canada

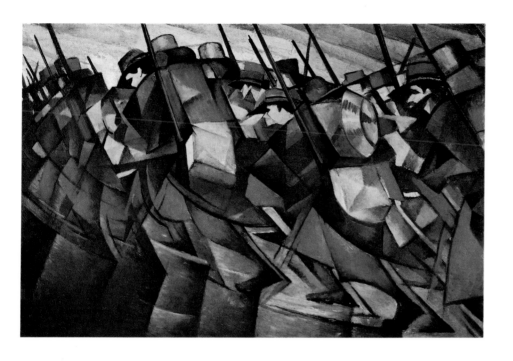

Christopher R.W. Nevinson
Troops Resting
1916
oil on canvas, 71 × 91,5 cm
London, The Trustees
of the Imperial War Museum

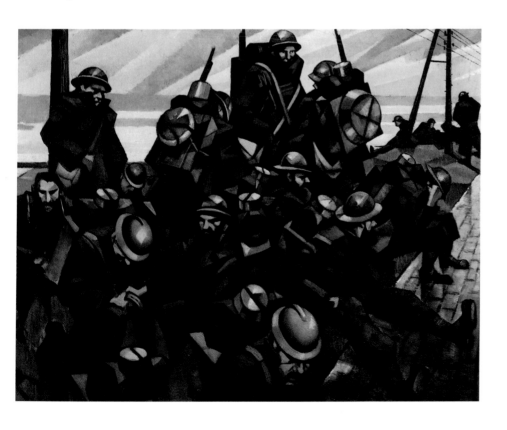

William Roberts
The Return of Ulysses
1913
watercolour on paper, 30,5 × 45,7 cm
London, The Trustees of the Tate Gallery

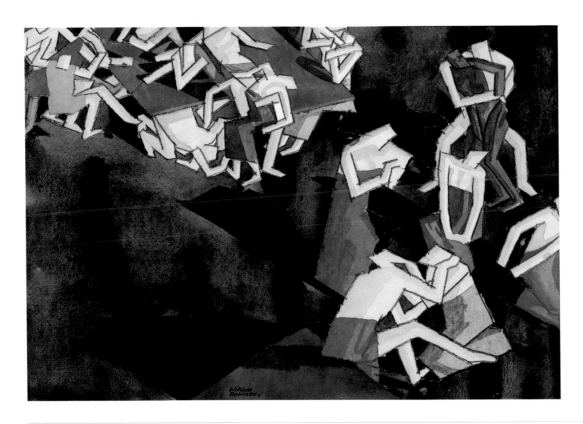

William Roberts
St George and the Dragon, study
1913 c.
pencil on paper, 25,4 × 20,3 cm
London, Anthony d'Offay Gallery

William Roberts
Theatre
1914
pencil on paper, 22,5 × 15,5 cm
London, Rodney Capstick-Dale Collection

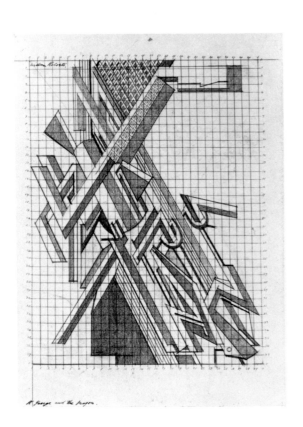

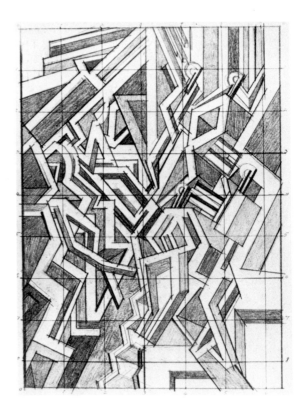

Helen Saunders
Abstract Composition in Blue and Yellow
1915 c.
watercolour and pencil on paper
27,6 × 17,1 cm
London, The Trustees of the Tate Gallery

Dorothy Shakespear
Plane Tree
1918
watercolour on paper, 35 × 25 cm
Omar Shakespear Pound Collection

Edward Wadsworth
Landscape
1913
gouache and pencil on paper
27,6 × 29,5 cm
London, The Trustees of the Tate Gallery

Edward Wadsworth
Mytholmroyd
1914
xylograph, 37,9 × 30,4 cm
Manchester, Whitworth Art Gallery
University of Manchester

Edward Wadsworth
Untitled: Vorticist Composition (The Port?)
1914-15 c.
xylograph on paper, 16 × 11 cm
London, The Trustees
of the Victoria & Albert Museum

Edward Wadsworth
Cape of Good Hope, study
1914
ink, pastel, watercolour and gouache
on paper, 33 × 25 cm
Anthony d'Offay Gallery, London

Giacomo Balla
Science against Obscurantism
1920
oil on panel, 24,3 × 35 cm
Rome, Private Collection

Giacomo Balla
The End of the Enchantment
1922
oil on canvas, 106,3 × 75,5 cm
Rome, Private Collection

Giacomo Balla
Numbers in Love
1923
oil on canvas, 77 × 55
Private Collection

Giacomo Balla
Forces of Life
1928
oil on canvas, 99 × 115,3 cm
Rome, Private Collection

Giacomo Balla
Heading for "Dinamica"
or *"Dinamo",* study
1913
China ink on paper
12,5 × 30 cm, 12 × 30 cm, 12 × 30 cm
Milan, Calmarini Collection

Giacomo Balla
Drawing Room Furniture, project
1918
inks on paper, 44,5 × 56 cm
Rome, Private Collection

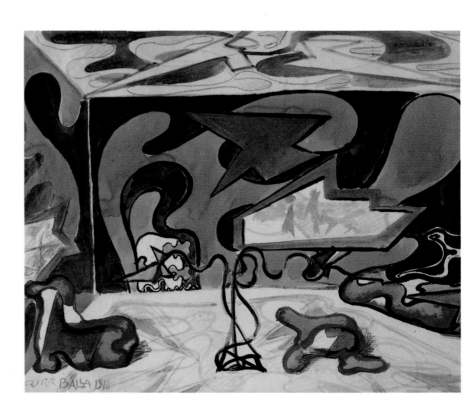

Giacomo Balla
A Car for All, study for a poster
1920
colour inks on paper, 54,5 × 37 cm

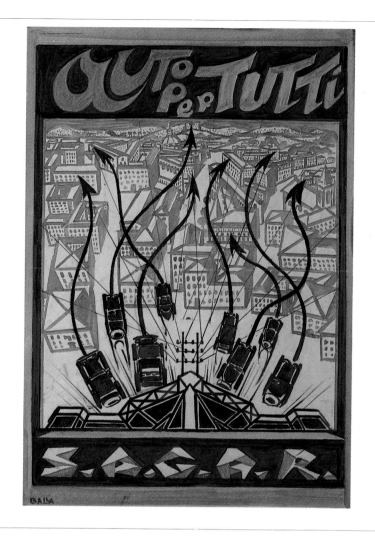

Giacomo Balla
Sea and Plane
1925
oil on tapestry, 280 × 380 cm
Private Collection

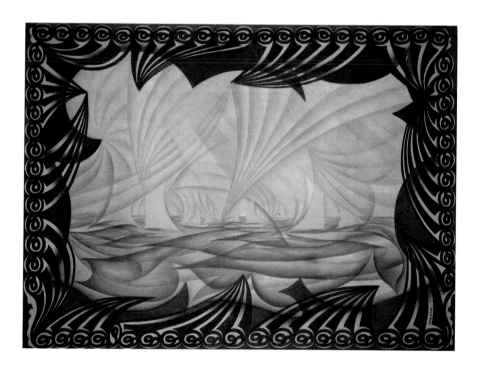

Italia Italy

Giacomo Balla
Lamp, study
1914
tempera on paper, 54 × 44 cm
Private Collection

Giacomo Balla
Butterfly
1916
lacker and watercolour on paper
30 × 42 cm
Private Collection

Giacomo Balla
Tea-set
1928
painted ceramics, 17 cm (teapot)
11 cm (sugar-bowl), 15 cm (saucers)
8 cm (cups)
Private Collection

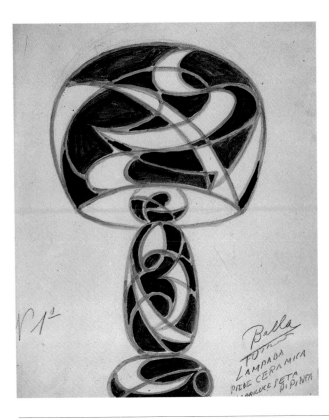

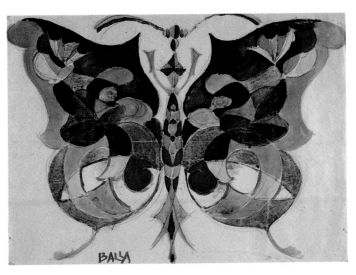

Giacomo Balla
Fan, project
1918
lacker and colour inks on paper, 39,5 × 51 cm
Private Collection

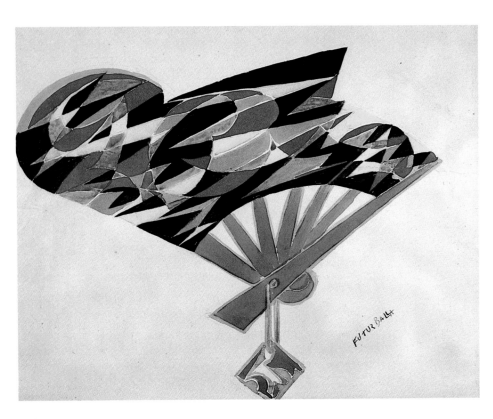

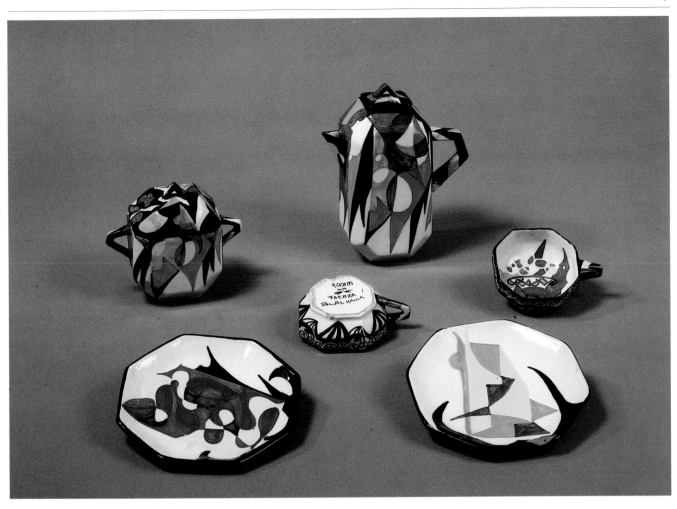

Giacomo Balla
Futurist Flower
1925
painted wood, 29 cm, 58 cm, 39 cm
Rome, Private Collection

Giacomo Balla
Futurist Flower
1925
painted wood, 32 cm, 43 cm, 21 cm
Rome, Private Collection

Giacomo Balla
Screen
1916-17
oil on wood, 124 × 115,5 cm
Rome, Private Collection

Giacomo Balla
Chair
1918
painted wood, 102 × 37 × 41 cm
Private Collection

Giacomo Balla
Small Table
1918
painted wood, 53 × 28 × 36 cm
Private Collection

Giacomo Balla
Screen (with Speed Lines)
1917
oil on canvas, 151 × 126 cm
Kansas City, Beatrice B. Davis Collection

Giacomo Balla
Cupboard for a Dining-Room
1918
painted wood, 188 × 154 × 55 cm
Private Collection

Giacomo Balla
Jacket, sketches
1930
tempera on paper, 18,5 × 13,5 cm (each)
Private Collection

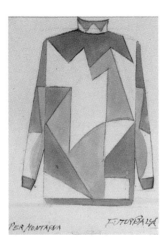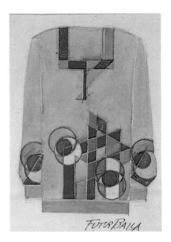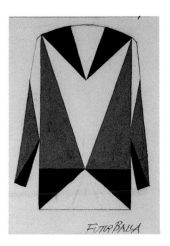

Giacomo Balla
Man's Clothing
1918
coloured fabrics
Private Collection

Giacomo Balla
Woman's Clothing
1929
coloured fabrics
Private Collection

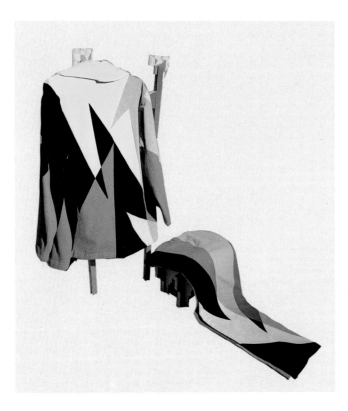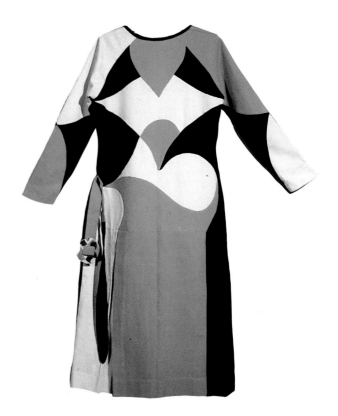

Giacomo Balla
Jacket, sketches
1930
tempera on paper, 18,5 × 13,5 cm (each)
Private Collection

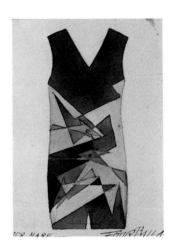

Giacomo Balla
Waistcoat
woollen embroidery on cloth, 53 × 41 cm
Private Collection

Giacomo Balla
Futurist Clothing, study
1914
tempera on paper, 29 × 21 cm
Private Collection

Giacomo Balla
Fabric Design
1913
tempera on paper, 13 × 19 cm
Private Collection

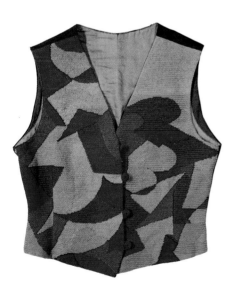

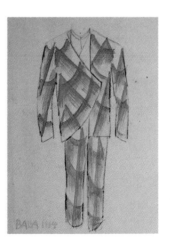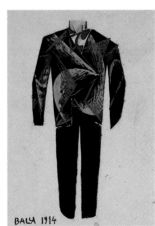

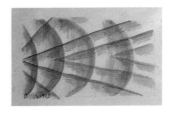

Benedetta
Speeding Train by Night
1924
oil on canvas, 49,5 × 66,5 cm
Rome, Luce Marinetti Collection

Primo Conti
Sower
1914
watercolour and pencil on paper, 21 × 15 cm
Fiesole, Fondazione Primo Conti

Primo Conti
Simultaneity of Ambiences
1917
oil and collage on paste-board, 49 × 40 cm
Fiesole, Fondazione Primo Conti

Fortunato Depero
Procession of the Big Doll
1920
tapestry, 330 × 230 cm
Rovereto, Galleria Museo Depero

The Court of the Big Doll, 1920
One of the first large tapestries in the
Casa d'Arte Depero or Casa del Mago
founded in Rovereto in 1919

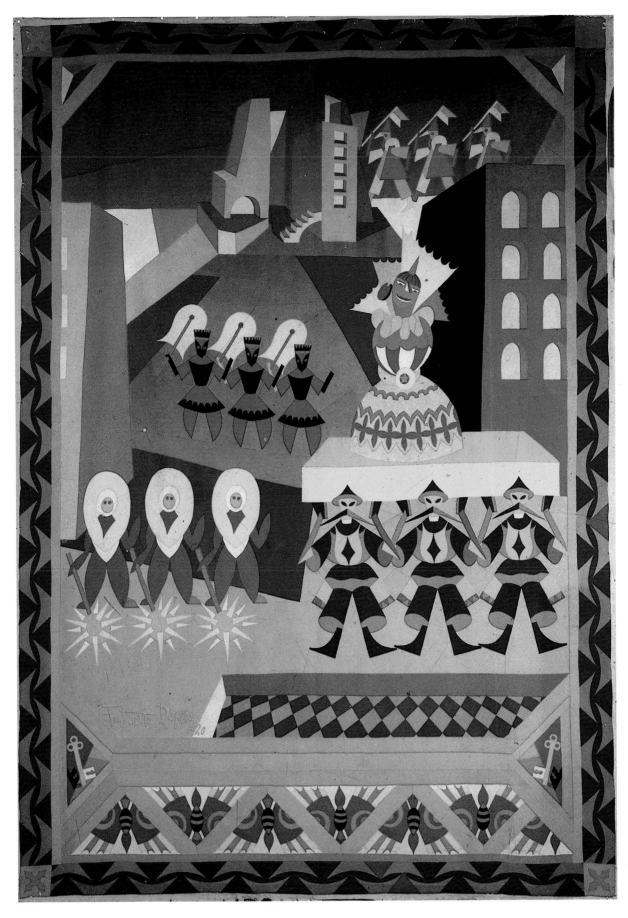

Fortunato Depero
Devil's Cabaret (Fantasy)
1921
China ink on paper, 27,8 × 44,7 cm
Rovereto, Galleria Museo Depero

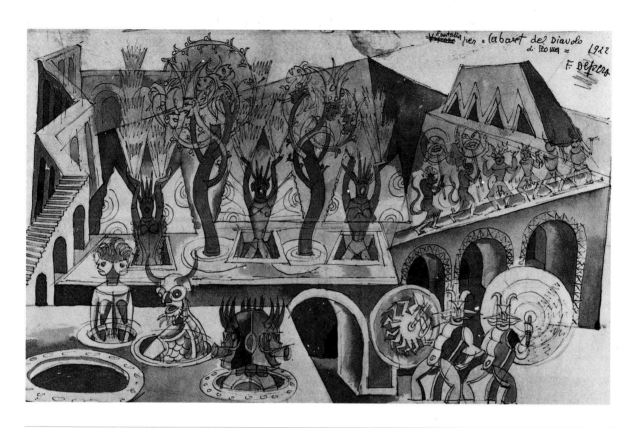

Fortunato Depero
Devil's Cabaret, (Hell)
1921
China ink on paper, 40,8 × 21,2 cm
Rovereto, Galleria Museo Depero

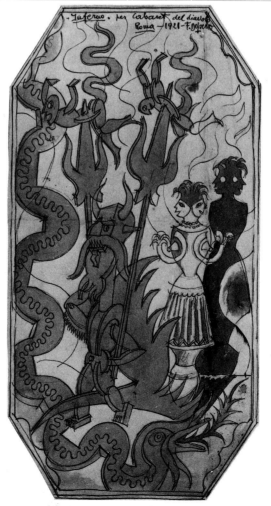

Fortunato Depero
Waistcoat
1924
appliqué, 52 × 45 cm
Private Collection

Fortunato Depero
Waistcoat
1924
appliqué, 52 × 45 cm
Modena, Galleria Fonte d'Abisso Edizioni

These were worn by Marinetti, Jannelli and Depero in Bologna and on top of the Eiffel Tower in 1925

Fortunato Depero
Rhinos (Toys)
1923
painted wood, 16,3 × 35 cm (each)
Trento, Museo Provinciale d'Arte
Sezione d'Arte Contemporanea

Fortunato Depero
Bear and Rhinos (Toys)
1923
painted wood, 26,5 × 23,8 cm (bear)
16,3 × 35 cm (rhinos)
Trento, Museo Provinciale d'Arte
Sezione d'Arte Contemporanea

Fortunato Depero
Train Born from the Sun
1924
oil on canvas, 131 × 90,5 cm
Private Collection

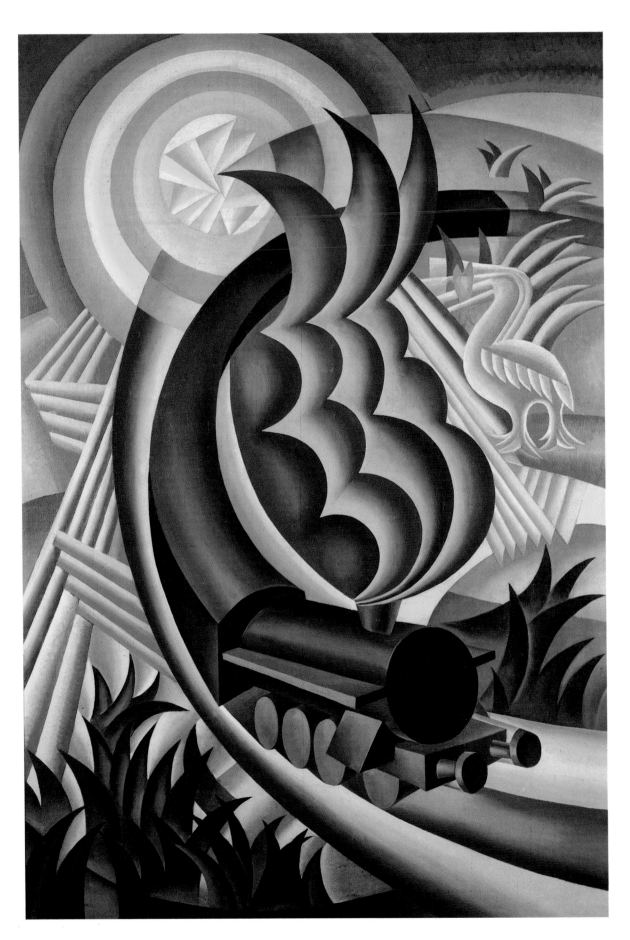

Fortunato Depero
Campari, plastic model
1925
wood, 65 × 46 × 27 cm
Rovereto, Galleria Museo Depero

Fortunato Depero
If Rain were Bitter Campari
1926
China ink and collage on paper
49 × 29,5 cm
Rovereto, Galleria Museo Depero

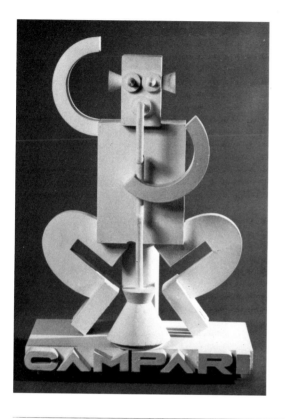

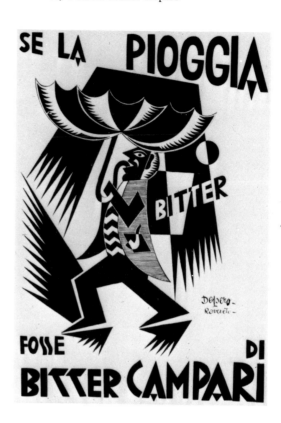

Fortunato Depero
Vanity Fair
1930
collage of colour papers, 46 × 35 cm
Rovereto, Galleria Museo Depero

Fortunato Depero
"Emporium", cover for magazine
1927
collage of colour papers, 48,5 × 34,8 cm
Rovereto, Galleria Museo Depero

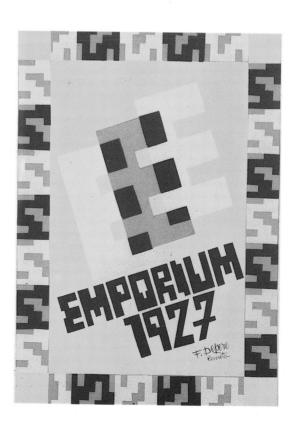

Nicola Diulgheroff
The Parisian
1926
oil on canvas, 110 × 97 cm
Private Collection

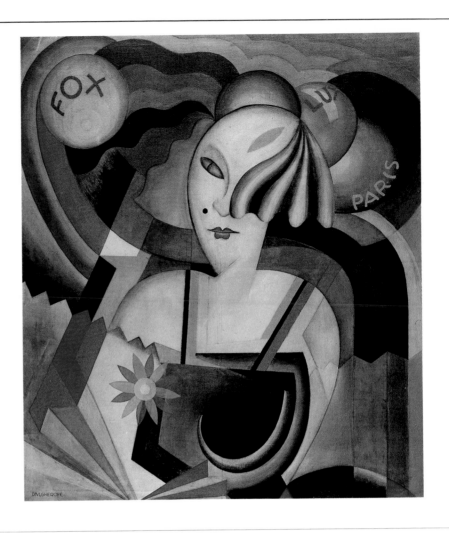

Nicola Diulgheroff
The Rational Man
1928
oil on canvas, 113,5 × 99 cm
Turin, Galleria Narciso

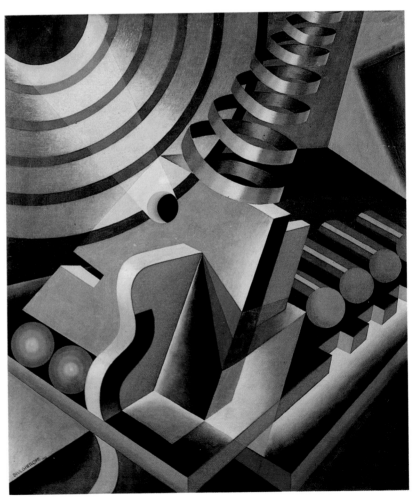

Gerardo Dottori
The Lake
1920
oil on canvas, 96 × 124 cm
Private Collection

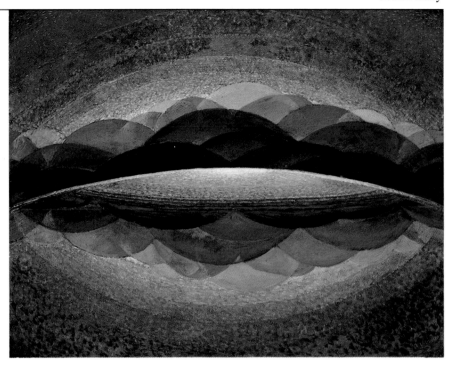

Gerardo Dottori
Ascensional Force
1920
oil on canvas, 108 × 122 cm
Brescia, Musei Civici d'Arte e Storia

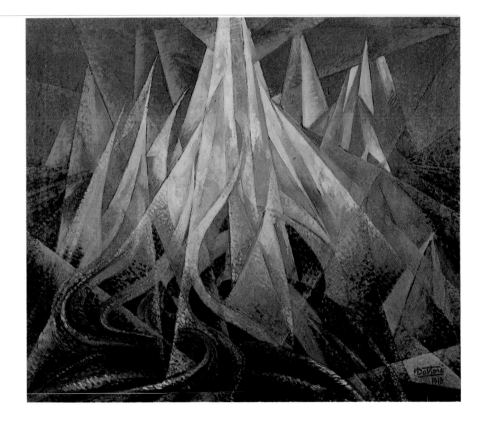

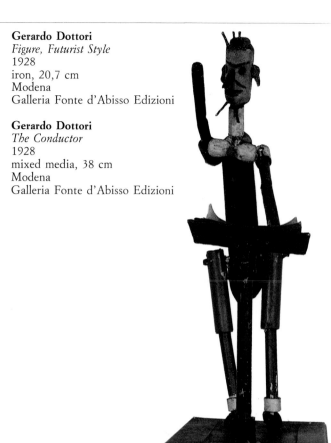

Gerardo Dottori
Figure, Futurist Style
1928
iron, 20,7 cm
Modena
Galleria Fonte d'Abisso Edizioni

Gerardo Dottori
The Conductor
1928
mixed media, 38 cm
Modena
Galleria Fonte d'Abisso Edizioni

Gerardo Dottori
Don Quixote without... Mancha
1928
mixed media, 22,5 cm
Modena, Galleria Fonte d'Abisso Edizioni

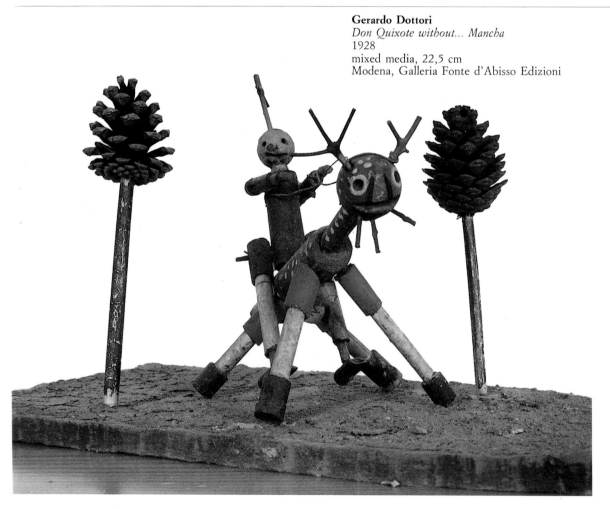

Farfa
The Umbrellas
1921
plate in terracotta, lacker, enamel, 37 cm
Turin, Galleria Narciso

Farfa
Prows Meeting
1929
wood and tin, 70 × 99 cm
Turin, Galleria Narciso

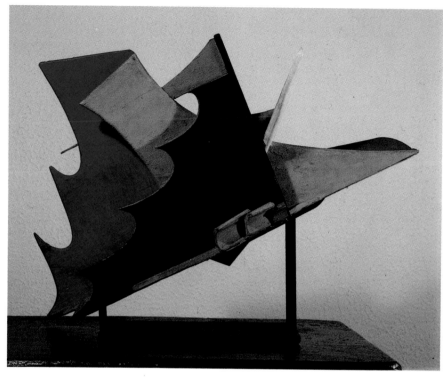

Fillia
Drummer
1927 c.
oil on canvas, 36,5 × 25,5 cm
Private Collection

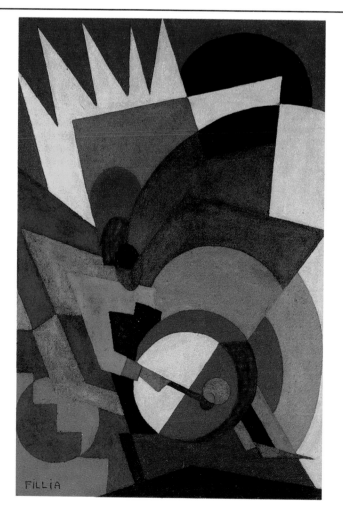

Alberto Magnelli
Lyric Explosion no. 7
1918
oil on canvas, 125 × 140 cm
Florence, Galleria d'Arte Moderna
di Palazzo Pitti

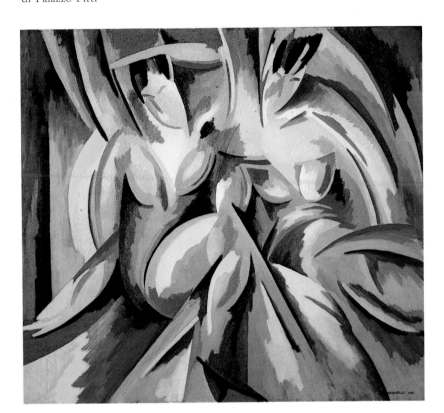

Alberto Magnelli
Lyric Explosion no. 2
1918
oil on canvas, 125 × 125 cm
Meudon, Susi Magnelli Collection

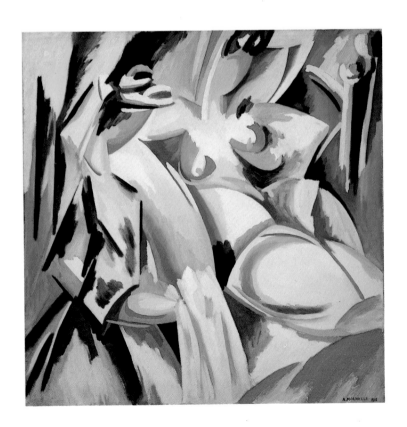

Virgilio Marchi
City
undated
ink and watercolour on thin paste-board
75,5 × 50 cm
Private Collection

Virgilio Marchi
Architectural Study: Search for Volumes
in a Building
1919 c.
pencil and watercolour on paper, 38,7 × 57,2 cm
New York, The Metropolitan Museum of Art
Gift Lita Annenberg Hazen, Charitable Trust

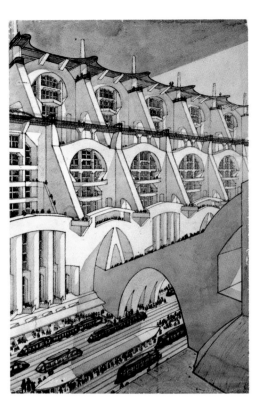

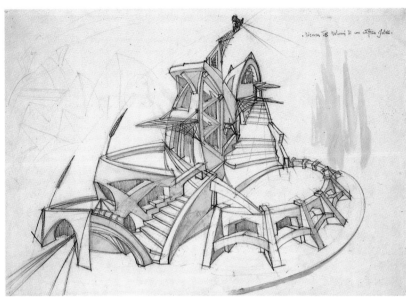

Virgilio Marchi
Fantastic City
1919-20
tempera on paper pasted on canvas
185 × 185 cm
Private Collection

Virgilio Marchi
Fantastic City
1919-20
tempera on paper pasted on canvas
180 × 145 cm
Private Collection

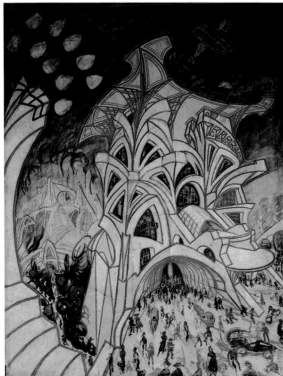

Filippo Tommaso Marinetti
Paris-Soudan
1921
assemblage on paste-board, 46 × 22 cm
Private Collection

Filippo Tommaso Marinetti
Les mots en liberté futuristes
1919
cover and inside of the book

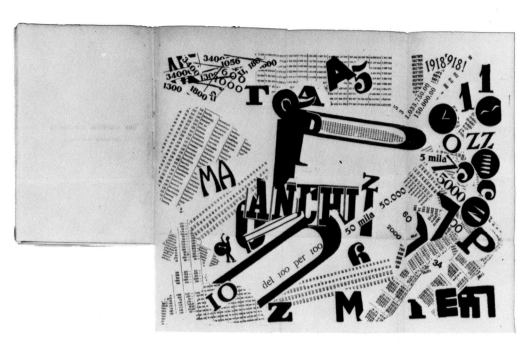

Ivo Pannaggi
Speeding Train
1922
oil on canvas, 120 × 100 cm
Macerata, Cassa di Risparmio
della Provincia di Macerata

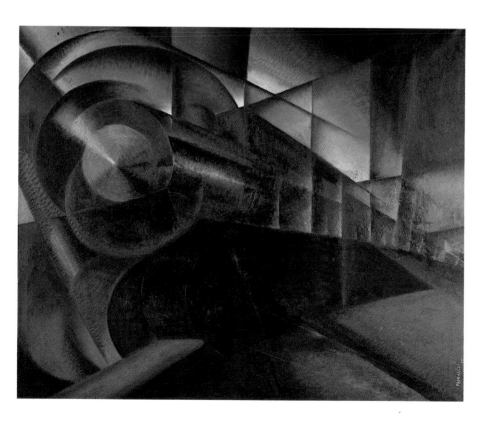

Enrico Prampolini
Parallelepipeds, sketch for stage
1921
tempera and collage on thin paste-board
22 × 30,5 cm
Private Collection

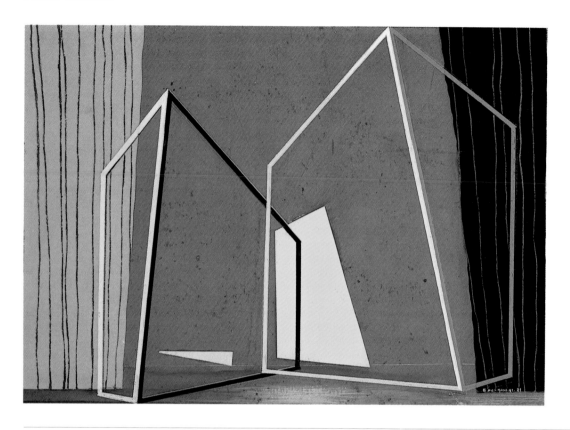

Enrico Prampolini
The Firedrum, sketch
Text by F.T. Marinetti. Music by B. Pratella
1922
watercolour on paper, 39 × 58 cm
Prague, Národní Muzeum

Enrico Prampolini
The Firedrum, sketch
Text by F.T. Marinetti. Music by B. Pratella
1922
tempera on paste-board, 26 × 35 cm
Private Collection

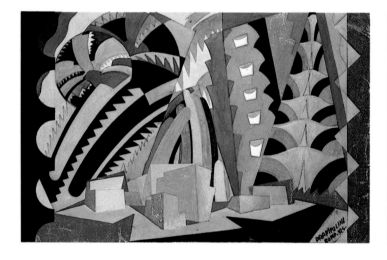

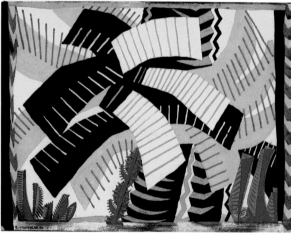

Enrico Prampolini
Composition B 3
1922
oil on canvas, 34 × 33 cm
Modena, Galleria Fonte d'Abisso Edizioni

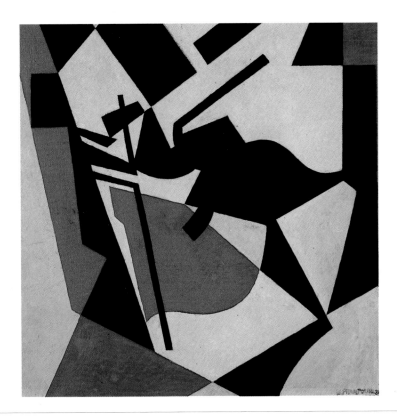

Enrico Prampolini
Landscape
1924
woollen carpet, 210 × 250 cm
Private Collection

Italia Italy

Enrico Prampolini
Benches for the Artist's House
1925-26
wood, 40 × 40 × 30,5 cm
Private Collection

Enrico Prampolini
Table for the Artist's House
1925-26
wood, 42 × 107 × 87 cm
Private Collection

Enrico Prampolini
Cocktail, costume for a barman
1927
tempera on thin paste-board, 25 × 17 cm
Modena, Galleria Fonte d'Abisso Edizioni

Enrico Prampolini
Roi Bombance
1920-26
watercolour and tempera on paper, 36 × 52 cm
Modena, Galleria Fonte d'Abisso Edizioni

Enrico Prampolini
The Salamander, sketch for stage
1928
tempera on thin paste-board, 20 × 31 cm
Modena, Galleria Fonte d'Abisso Edizioni

Enrico Prampolini
The Heart Merchant, sketch for stage
1927
mixed media on thin paste-board
42 × 63 cm
Private Collection

Enrico Prampolini
Portrait of F.T. Marinetti
1929
mixed media on panel, 50 × 50 cm
Private Collection

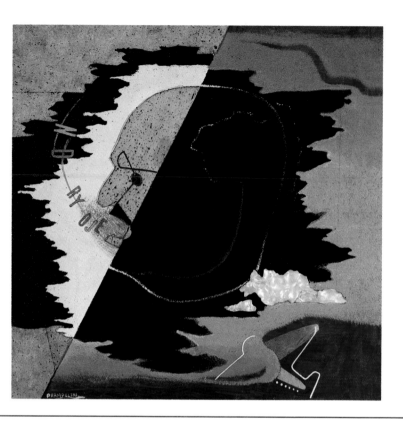

Mino Rosso
Manikin
1927
bronze, 82 × 22 × 12 cm
Turin, Galleria Narciso

Mino Rosso
The fugitive
1927
bronze, 45,2 × 64,5 × 14 cm
Turin, Galleria Narciso

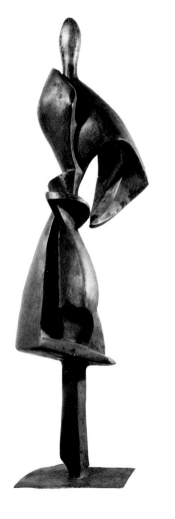

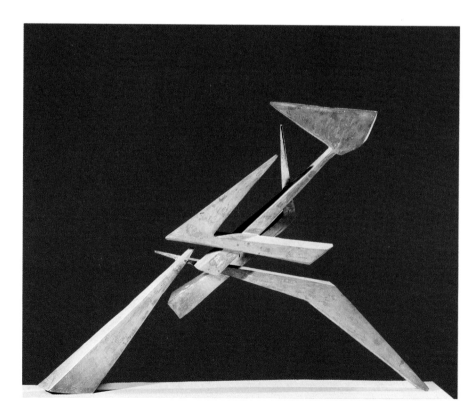

Luigi Russolo
Musical Score
1921
notes for concerts

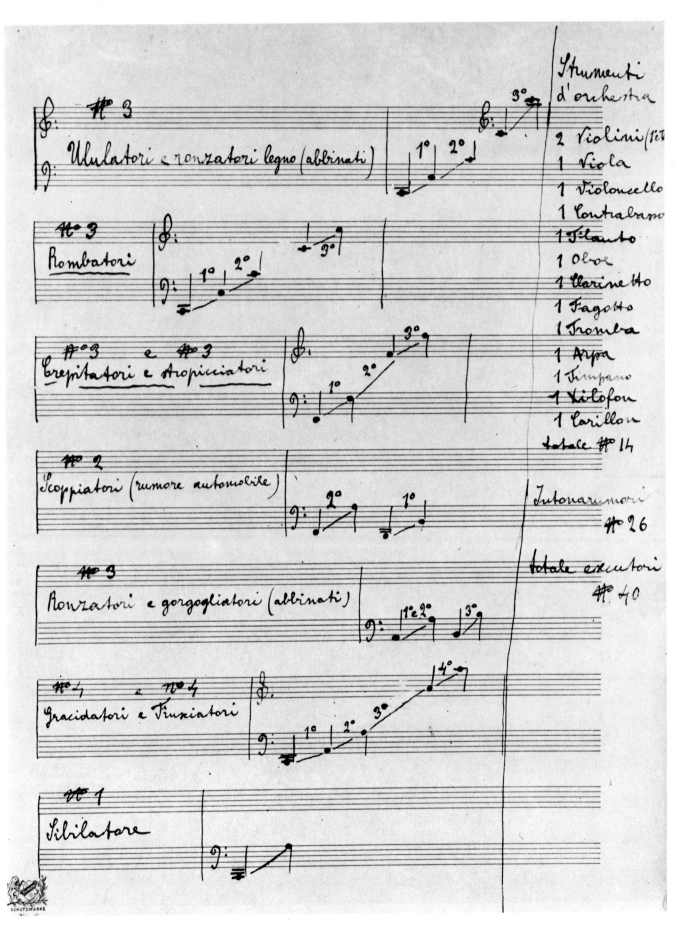

Luigi Russolo
Musical Score
1921
notes for concerts

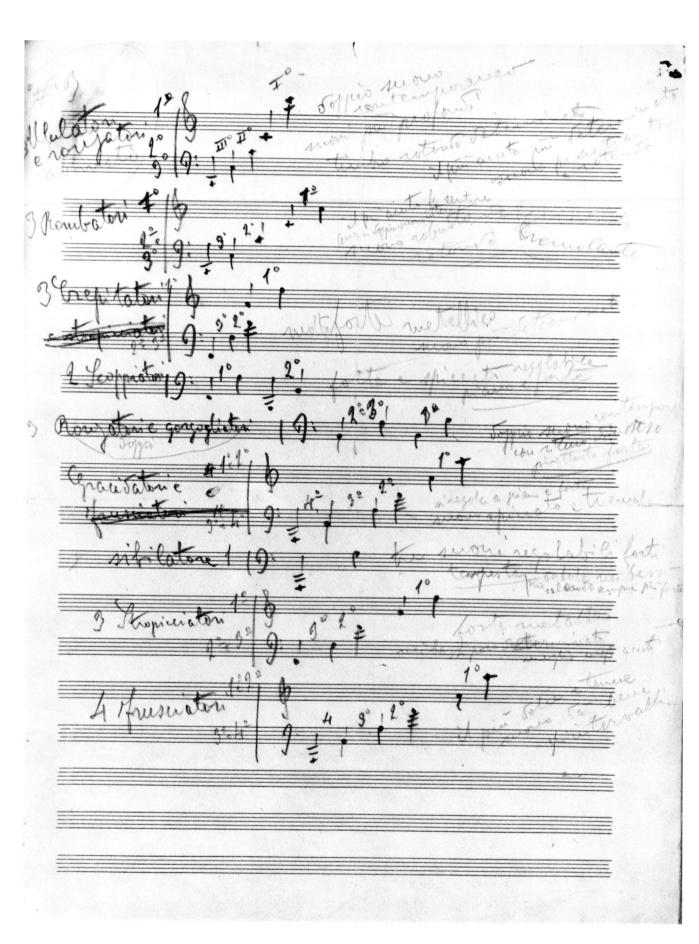

Rougena Zatkova
Marinetti Sun
1920
oil on canvas, 105 × 96 cm
Rome, Luce Marinetti Collection

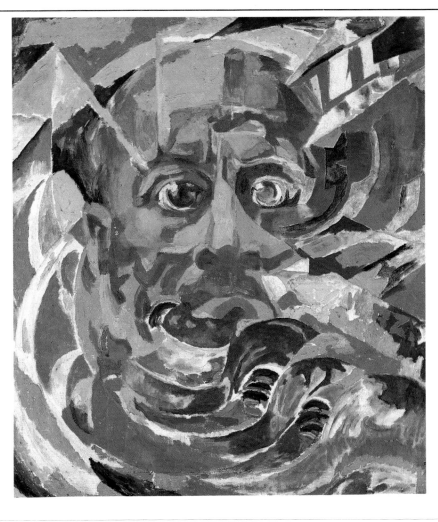

Rougena Zatkova
Snow in the High Mountains
1914 c.
mixed media on canvas, 44,5 × 40,5 cm
Rome, Luce Marinetti Collection

Rougena Zatkova
Water running under ice and snow
1914 c.
mixed media on paste-board
49 × 39 cm
Private Collection

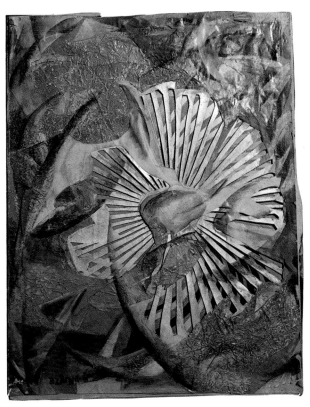

Ramón Alva de la Canal
El Cafe de Nadie (Nobody's Café)
1924 c.
oil on board, 77,5 × 64,5 cm
Mexico City
Blanca de Maples Arce Collection

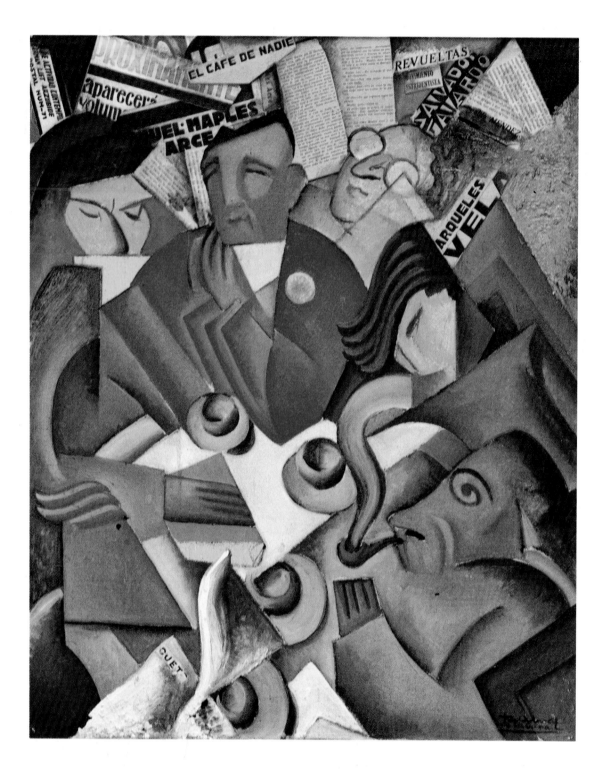

Ramón Alva de la Canal
Maples Arce in the Cafe de Nadie
1924-25
pencil on paper, 45 × 29 cm
Mexico City
Blanca de Maples Arce Collection

Ramón Alva de la Canal
Cover for El viajero en el vertice
by G. List Arzubide
1925

Ramón Alva de la Canal
Cover for El pentagrama electrico
by Salvador Gallardo
1925

Ramón Alva de la Canal
The Window
1925 c.
ink on paper, 12 × 20 cm
Mexico City
Alva de la Canal Family Collection

Ramón Alva de la Canal
"All the power..."
1925 c.
ink on paper, 11 × 17,5 cm
Mexico City
Alva de la Canal Family Collection

Dr. Atl
Cosmic Curves
1914 ?
pencil and ink on paper, 36 × 28,5 cm
Mexico City
Lic. L. Araujo Valdivia Collection

Dr. Atl
Composition
1914 ?
pencil and ink on paper, 48 × 31 cm
Mexico City
Lic. L. Araujo Valdivia Collection

Jean Charlot
Urbe by M. Maples Arce
1923-24
woodcut, 22,5 × 16 cm

Germán Cueto
Mask of List Arzubide
1925-26
terracotta and paint, 27 cm
Mexico City
Maria Galan de Cueto Collection

Fernando Leal
illustration for *Metropolis*
by M. Maples Arce
1929
hand-painted

Leopoldo Méndez
Man
1924
woodcut, 27 × 17 cm
Mexico City, Instituto Nacional
de Bellas Artes

Fermín Revueltas
Composition with Rainbow
1921
oil on canvas, 75 × 84 cm
Mexico City, Fernando Leal Collection

Fermín Revueltas
The Day of the Holy Cross
undated
watercolour, 27,5 × 34,5 cm
Mexico City
Ing. Silvestre Revueltas Collection

Leon Chwistek
Butterflies
1918-19
oil on canvas, 48 × 72 cm
Warsaw, Muzeum Narodowe

Leon Chwistek
Industrial City
1920
oil on paste-board, 81 × 65 cm
Warsaw, Muzeum Narodowe

Leon Chwistek
Project for a Hotel in Zakopane
1921
ink on paper, 33,5 × 21 cm
Private Collection

Leon Chwistek
Viaduct with Trains
1920
ink on paper, 20 × 18 cm
Cracow, Alina Dawidowicz Collection

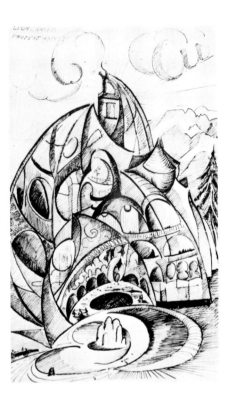

Tytus Czyzewski
Poster of the II Exhibition of the Formists
1920
lithography on paper, 80 × 65 cm
Cracow, Academy of Fine Arts

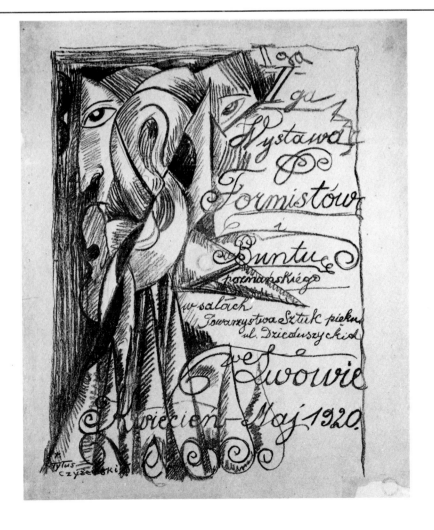

Henryk Gotlib
Joseph and Potiphar's Wife
1921
painted plaster, 56 cm
Lódź, Muzeum Sztuki

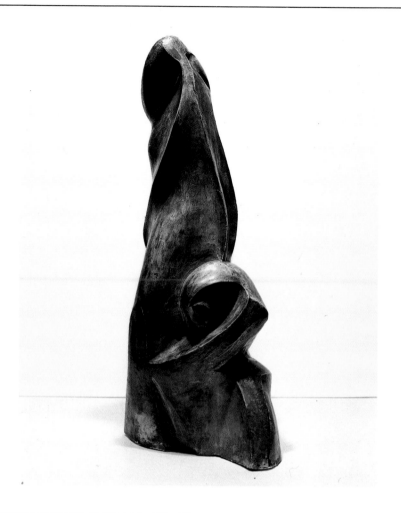

Jan Hrynkowski
The Lift and I
1917
oil on canvas, 66 × 50 cm
Warsaw, Muzeum Narodowe

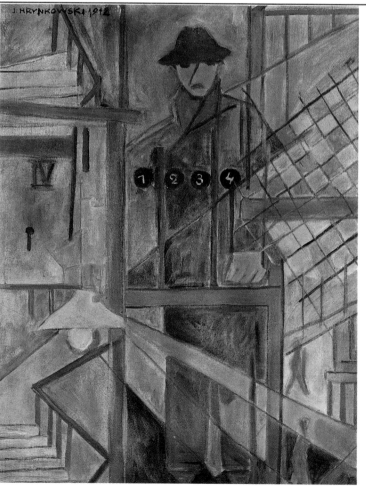

Jerzy Hulewicz
Composition
1920
watercolour on paper, 32,7 × 24 cm
Bytom, Muzeum Górnośląskie

Jerzy Hulewicz
Temptation of Christ
1919
etching on paper, 22,3 × 16,6 cm
Warsaw, Muzeum Narodowe

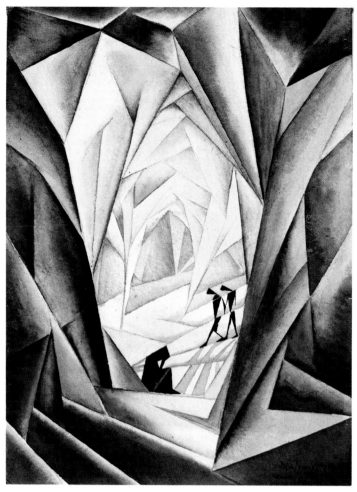

Zygmunt Radnicki
Industrial Landscape
1922
watercolour and collage on paper
50,9 × 38,6 cm
Warsaw, Muzeum Narodowe

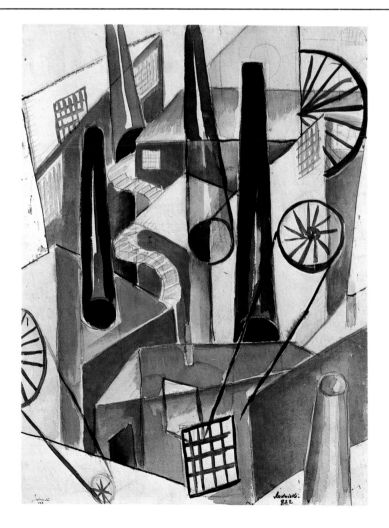

357

Wladislaw Skotarek
Improvisation I
1917-18
China ink on tracing paper, 15 × 20,5 cm
Poznán, Muzeum Narodowe

Wladislaw Skotarek
Improvisation II
1918
China ink on tracing paper
14,3 × 20,2 cm
Poznán, Muzeum Narodowe

Zwrotnica no. 3
1922-23
magazine cover, 29,4 × 22,2 cm
Warsaw, Muzeum Narodowe

Stanislaw Ignacy Witkiewicz (Witkacy)
The Fight
1921-22
oil on canvas, 98 × 108 cm
Lódź, Muzeum Sztuki

Amadeo de Souza Cardoso
Brut 300-T.S.F.
1917
oil on canvas, 86 × 66 cm
Lisbon, Centro de Arte Moderna
Calouste Gulbenkian Foundation

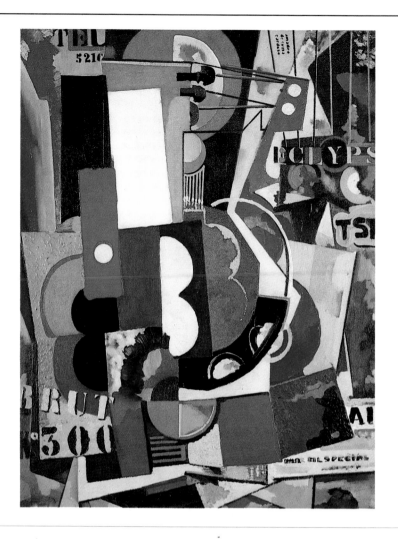

Amadeo de Souza Cardoso
Painting (Typewriter)
undated
oil and collage on canvas, 93 × 76 cm
Lisbon, Centro de Arte Moderna
Calouste Gulbenkian Foundation

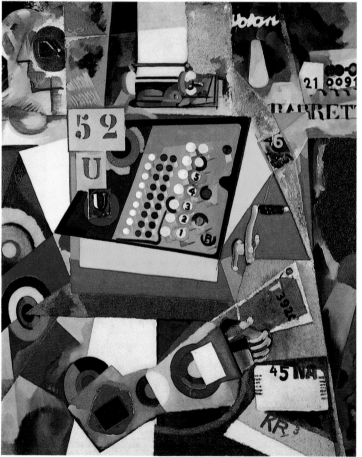

Rafael Barradas
Portrait of Carmen
1919
oil on canvas, 80 × 60 cm
Barcelona, Salvador Riera Collection

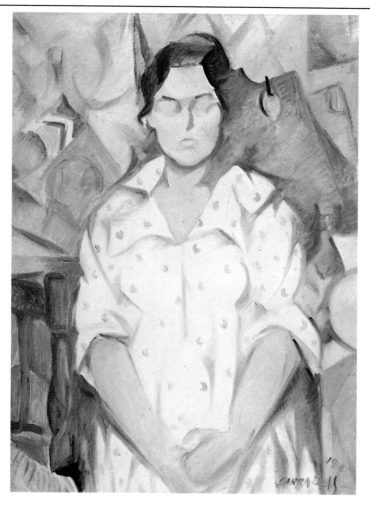

Rafael Barradas
From the Pacific to the Gates of Antioch
1920 c.
oil on canvas, 61 × 84 cm
Spain, R. and M. Santos Torroella
Collection

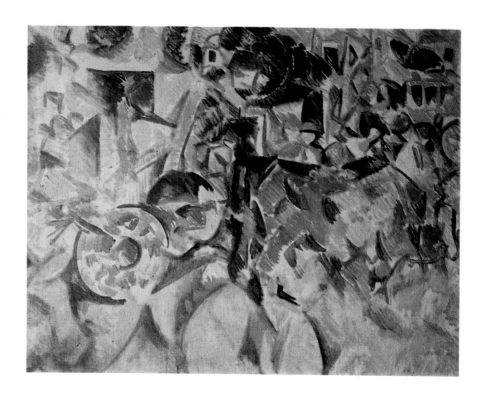

Konrad Cramer
Improvisation n. 2
1913
oil on canvas, 70 × 60 cm
Austin, James and Mary Michener
Collection, Archer M. Huntington Art Gallery
The University of Texas at Austin

James H. Daugherty
Three Base Hit
1914
gouache and ink on paper, 31 × 43,5 cm
New York, The Whitney Museum
of American Art, purchase

Charles Demuth
Bermuda no. 4
1917
watercolour on paper, 24,5 × 33,5 cm
New York, The Metropolitan Museum
of Art, The Alfred Stieglitz Collection

Charles Demuth
Sailboats (The Love Letter)
1919
tempera on paste-board, 65 × 72,5 cm
Santa Barbara, Santa Barbara Museum of Art

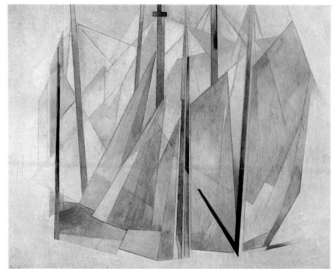

Arthur G. Dove
Dark Abstraction, study
1921
pastel on paper, 51,7 × 45,7 cm
New York, courtesy Hirschl
Adler Gallery

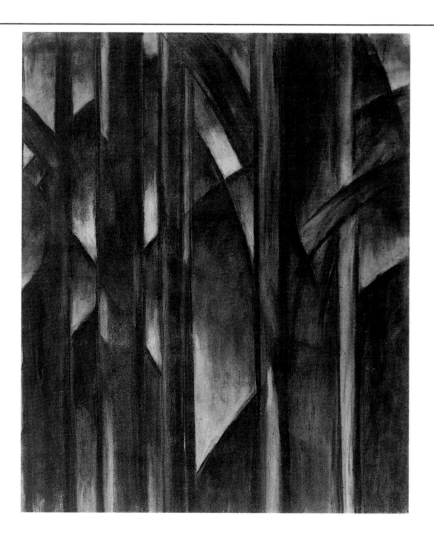

Marsden Hartley
Abstraction
1915 c.
oil on canvas, 61 × 51 cm
Minneapolis, The Regis Collection

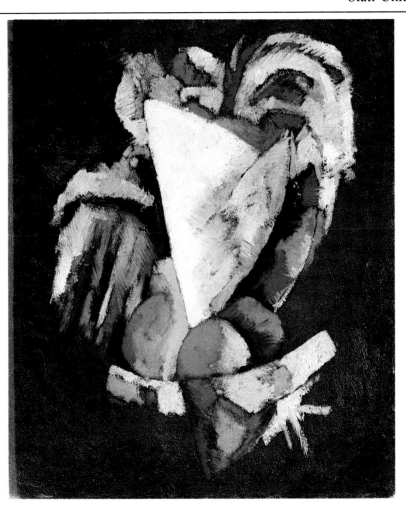

Stanton Macdonald-Wright
Aeroplane: Synchromy in Yellow-Orange
1920
oil on canvas, 61,6 × 60,8 cm
New York, The Metropolitan Museum
of Art, The Alfred Stieglitz Collection

Stanton Macdonald-Wright
Self-portrait
1929
oil on canvas, 76,3 × 61 cm
Ithaca, Private Collection

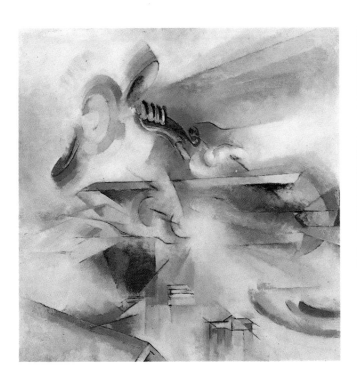

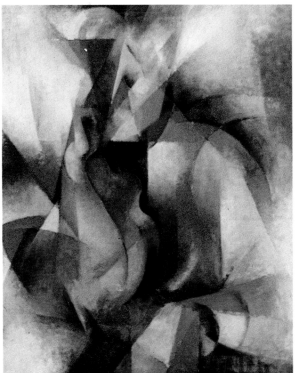

John Marin
Tree Forms, Maine
1915
watercolour and pencil on paper
49,5 × 41,5 cm
New York, The Metropolitan Museum
of Art, The Alfred Stieglitz Collection

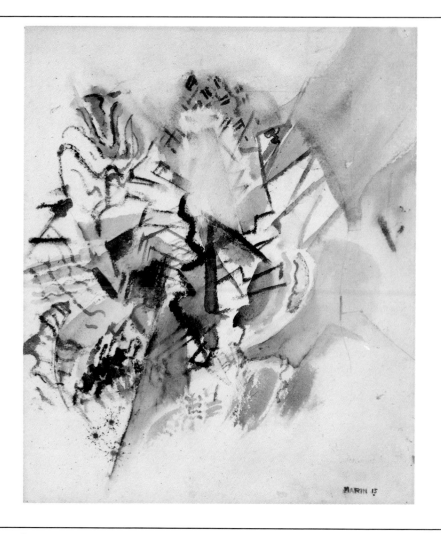

Morgan Russell
Synchromy in Violet Blue, study
1913
oil on canvas, 55,2 × 38 cm
Minneapolis, The Regis Collection

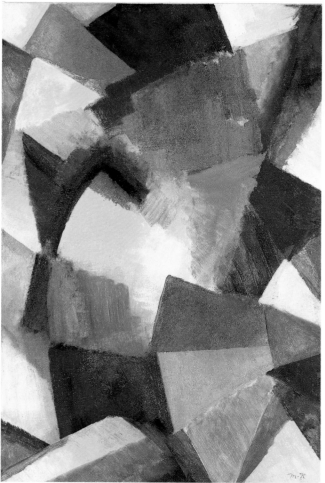

Morton L. Schamberg
Untitled
1916 c.
pencil on paper, 18,5 × 12 cm
New York, The Metropolitan Museum
of Art, Gift of Bertram F.
and Susie Brummer Foundation, Inc.

Morton L. Schamberg
Untitled
1916 c.
pencil on paper, 13,4 × 11,5 cm
New York, The Metropolitan Museum
of Art, Gift of Bertram F.
and Susie Brummer Foundation, Inc.

Morton L. Schamberg
Untitled
1916 c.
pencil on paper, 14 × 11,5 cm
New York, The Metropolitan Museum
of Art, Gift of Bertram F.
and Susie Brummer Foundation, Inc.

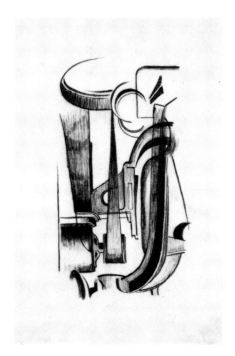

Frances Simpson Stevens
*Dynamic Velocity of Interborough
Rapid Transit Power Station*
1914 c.
oil and charcoal on canvas
123 × 91 cm
Philadelphia, Philadelphia Museum
of Art, The Louise
and Walter Arensberg Collection

Joseph Stella
Battle of Lights, Coney Island
1914-18
oil on canvas, 99 × 75 cm
Lincoln, Sheldon Memorial Art Gallery
University of Nebraska-Lincoln

Joseph Stella
Gas Tank
1918
oil on canvas, 102,2 × 76,2 cm
New York, Neuberger Museum
State University of New York
Purchase Roy R. Neuberger

Joseph Stella
Spring. The Procession
1914-16 c.
oil on canvas, 131,5 × 102,3 cm
New Haven, Yale University Art Gallery
Gift of Collection Société Anonyme

Joseph Stella
American Landscape
1924
oil on canvas, 201 × 99 cm
Minneapolis, Walker Art Center
Gift of the T.B. Walker Foundation

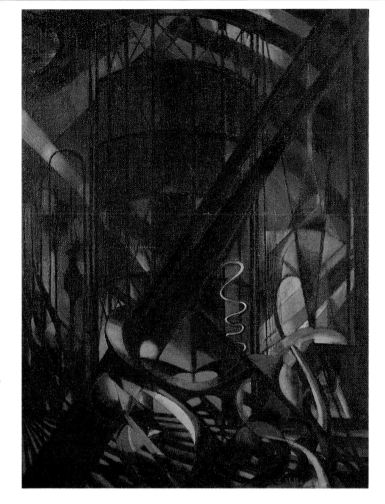

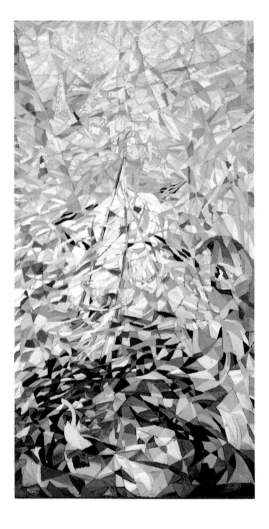

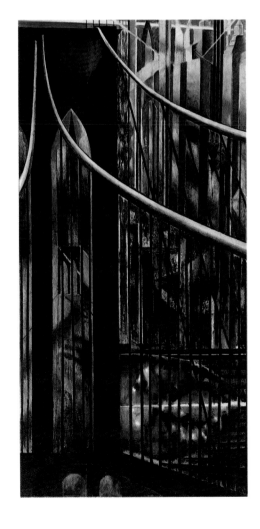

Max Weber
Athletic Contest
1915
oil on canvas, 101,5 × 152,5 cm
New York, The Metropolitan Museum
of Art, George A. Hearn Fund

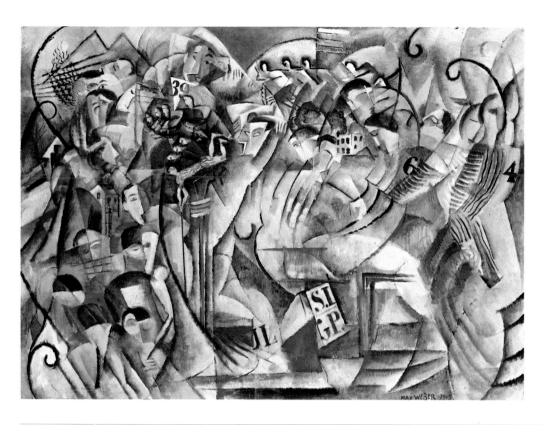

Max Weber
Rush Hour, New York
1915
oil on canvas, 92 × 76,9 cm
Washington, National Gallery of Art
Gift of the Avalon Foundation

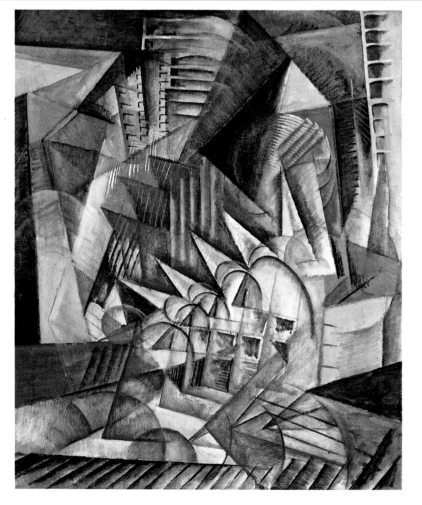

Max Weber
Spiral Rhythm
1915
bronze, 61,1 × 36,1 × 37,6 cm
Washington, Hirshhorn Museum and
Sculpture Garden, Smithsonian
Institution

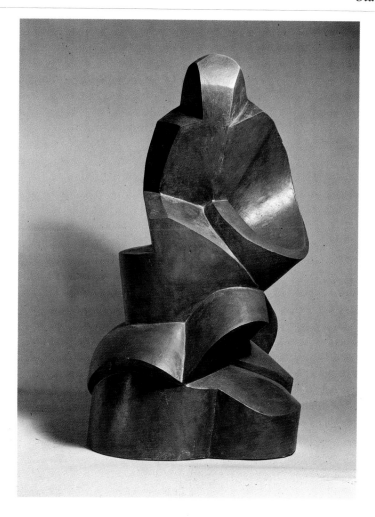

Unknown Author
Untitled
undated
oil on canvas, 56 × 76 cm
New York, Martin Diamond Collection

*This canvas was exhibited in Stieglitz
Gallery before World War I; since then its
author's name was lost.
It has been attributed to Marsden Hartley
but might be Arthur Carles or some
other painter whose name might be
discovered some day*

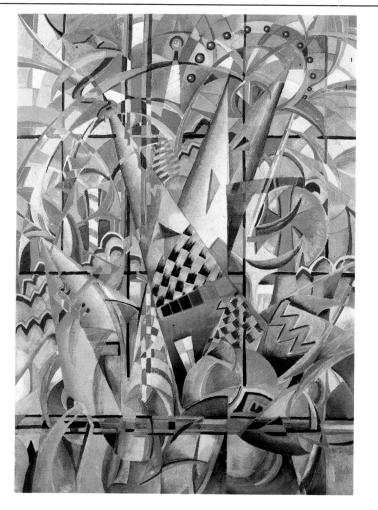

Gösta Adrian-Nilsson
Furnace, Heat, Light, Movement
1915
oil on canvas, 65 × 55 cm
Stockholm, Frederik Roos Collection

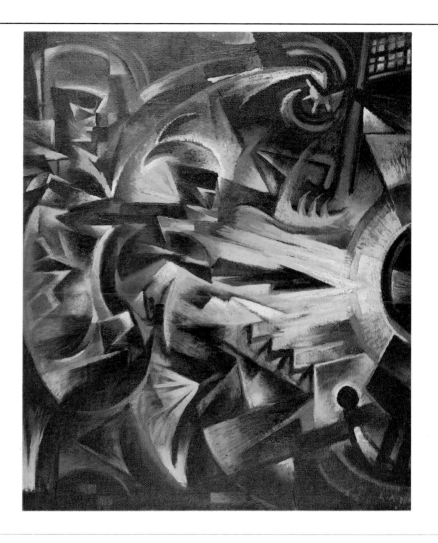

Gösta Adrian-Nilsson
Express Train
1915
oil on paste-board, 39,5 × 45 cm
Malmö, Malmö Museum

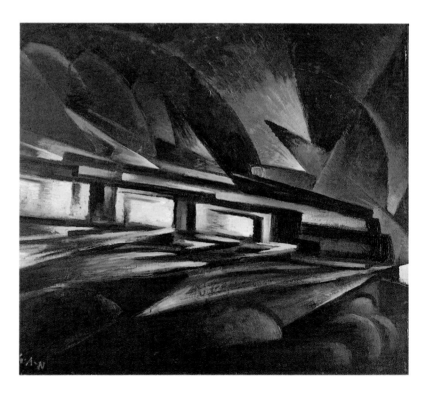

Gösta Adrian-Nilsson
Sailors' Dream of War
1917
oil on canvas, 140 × 130 cm
Malmö, Malmö Museum

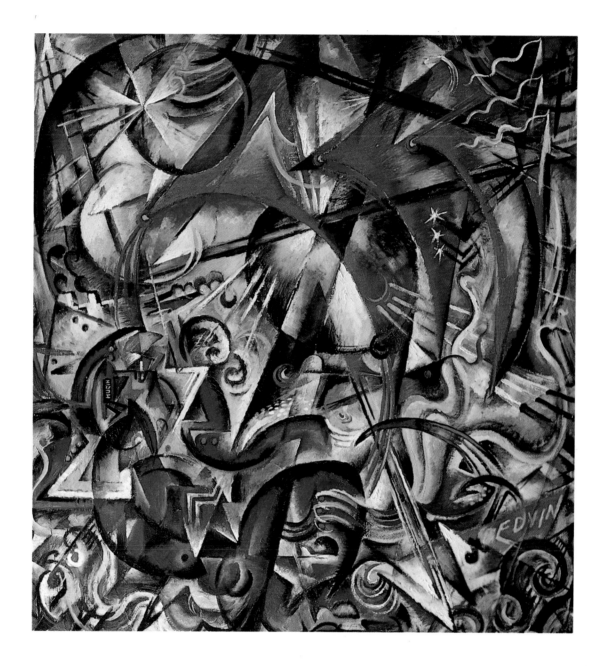

Gösta Adrian-Nilsson
Sailor
1918
oil on canvas, 60 × 43 cm
Stockholm, Moderna Museet

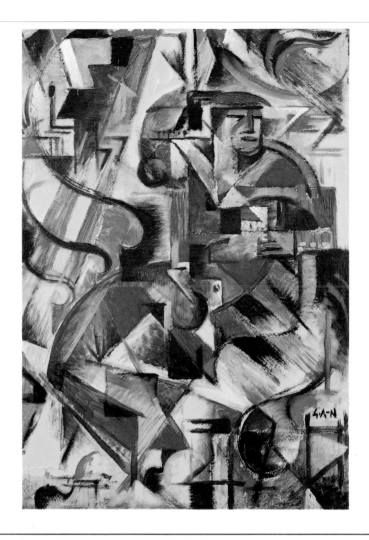

Nell Walden
Passion
1918
oil on canvas, 100 × 80,5 cm
Stockholm, Moderna Museet

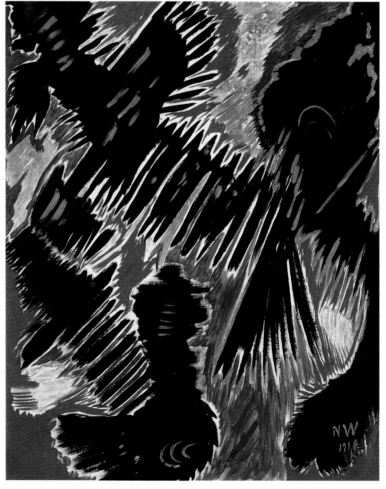

Sándor Bortnyik
*Cover for "Futurism, Constructivism
and Expressionism"* by Hevesy
1917
pencil on paper, 24 × 16,8 cm
Budapest, Magyar Nemzeti Galéria

Sándor Bortnyik
Dynamic Composition
1918
watercolour and pencil on paper
37,2 × 26,2 cm
Budapest, Magyar Nemzeti Galéria

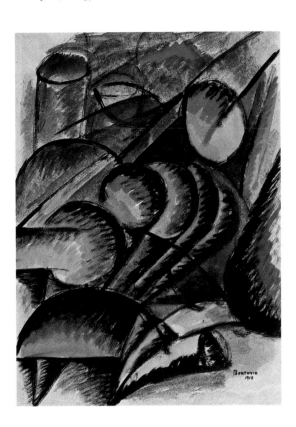

Sándor Bortnyik
Composition with Six Figures
1918 c.
oil on canvas, 75 × 95 cm
Budapest, Magyar Nemzeti Galéria

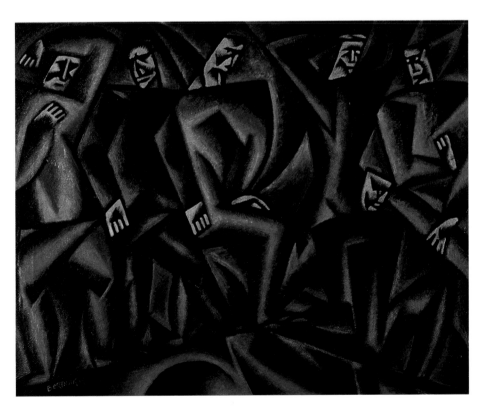

József Csáky
Head
1914
stone, 39 × 20 × 21,5 cm
Paris, Musée National d'Art Moderne
Centre Georges Pompidou

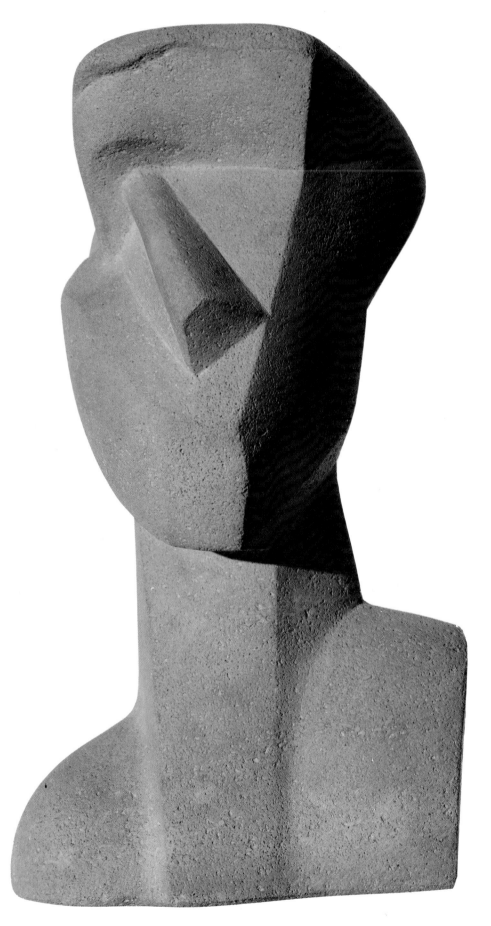

János Mattis Teutsch
Blue and Red Landscape
1918
crayon on paper, 15,4 × 16 cm
Budapest, Magyar Nemzeti Galéria

János Mattis Teutsch
Spiritual Flower
1923
oil on paper, 36 × 29 cm
New York, Paul Kovesdy Gallery

János Mattis Teutsch
Spiritual Flower
1921
oil on paper, 36 × 27 cm
New York, Paul Kovesdy Gallery

János Mattis Teutsch
Landscape
1919-22
watercolour on paper, 25 × 30 cm
New York, Paul Kovesdy Gallery

Hugo Scheiber
Dancer
1920 c.
crayon on paper, 51 × 35 cm
New York, Paul Kovesdy Gallery

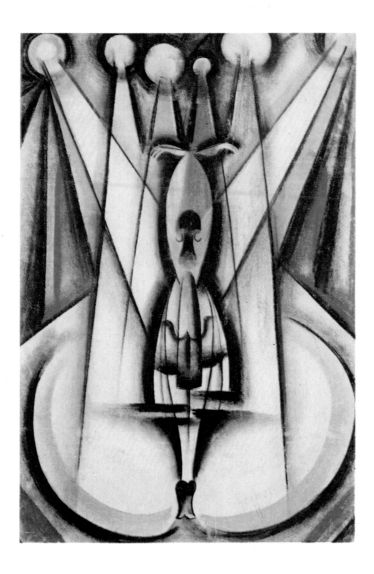

Hugo Scheiber
Night Club
1925 c.
gouache on paper, 45 × 40 cm
New York, Paul Kovesdy Gallery

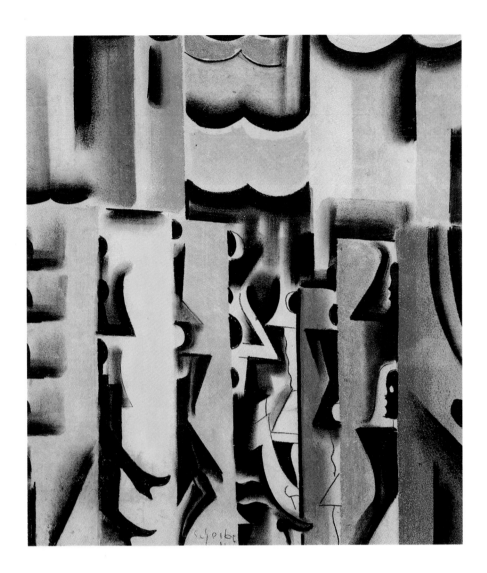

Lajos Tihanyi
Portrait of Marinetti
1925 c.
pencil on paper, 49 × 29,5 cm
Budapest, Magyar Nemzeti Galéria

Lajos Tihanyi
Portrait of Lajos Kassák
undated
pencil on paper, 50,4 × 35,5 cm
Budapest, Magyar Nemzeti Galéria

Lajos Tihanyi
Portrait of Vincent Huidobro
1924
pencil on paper, 52 × 32 cm
Budapest, Magyar Nemzeti Galéria

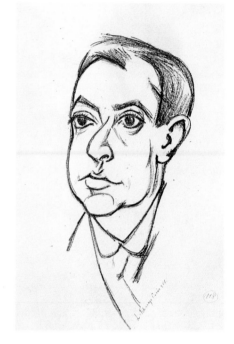

Béla Uitz
St Basil's Cathedral in Moscow
1921
tempera on paste-board, 60 × 45,5 cm
Budapest, Magyar Nemzeti Galéria

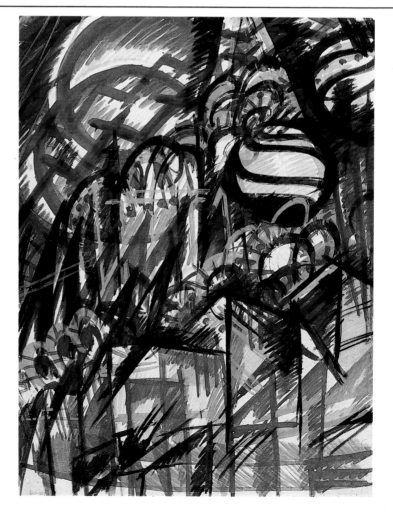

Béla Uitz
Analysis of an Icon
1921 c.
oil on canvas, 160 × 145 cm
Private Collection

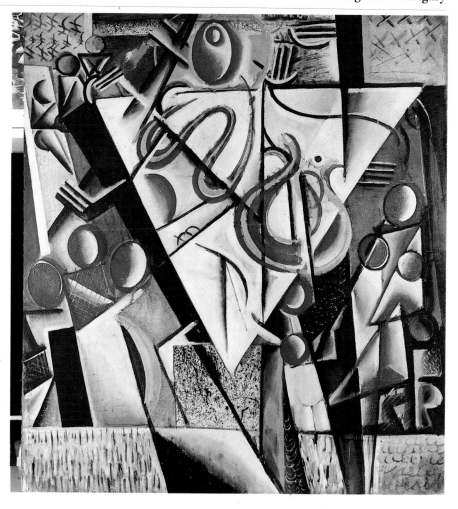

Béla Uitz
The Fight
1922
oil on canvas, 156 × 143 cm
Budapest, Magyar Nemzeti Galéria

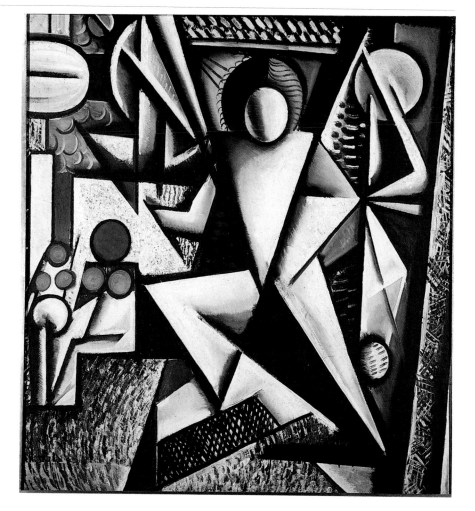

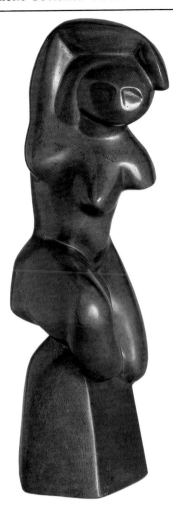

Alexander Archipenko
Young Woman
1909
bronze, 27 × 10 × 10 cm
Stockholm, Moderna Museet

Alexander Archipenko
Collage
1913
collage and gouache on paper, 47,5 × 31,5 cm
Stockholm, Moderna Museet

Alexander Archipenko
Gondolier
1914
bronze, 83,8 × 30,1 × 25,5 cm
New York, The Museum of Modern Art
Gift of Frances Archipenko
in honour of Alfred H. Barr, Jr.

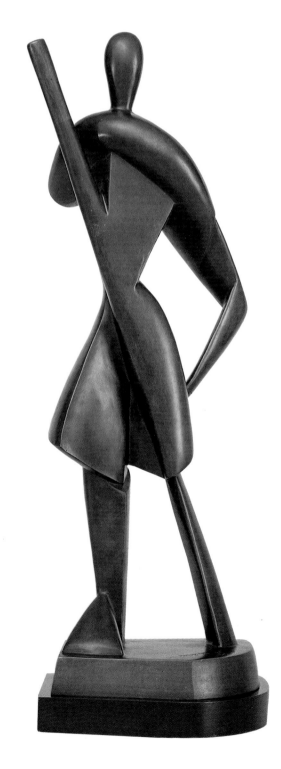

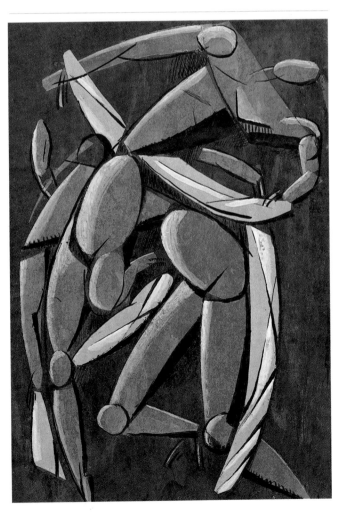

Alexander Archipenko
Standing Woman and Still Life
1919
papier mâché, 46 × 36 cm
Private Collection

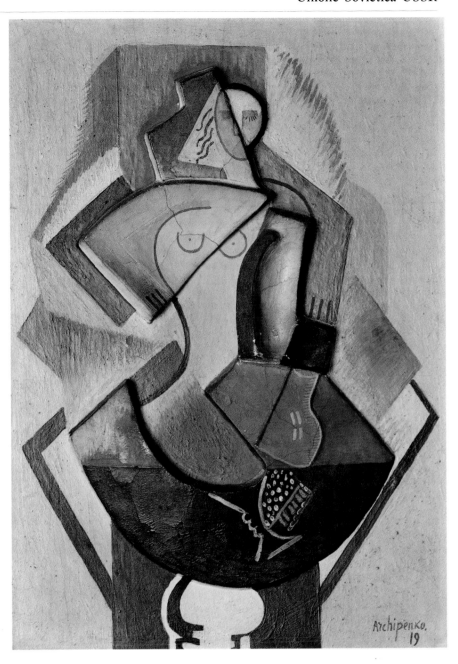

Wladimir Baranoff-Rossiné
Optophonic Piano
1915-23
Optophonic piano, electric box, box with record
piano 45 × 100 × 65 cm
Paris, Eugène Baranoff-Rossiné Collection

Wladimir Baranoff-Rossiné
Record for Optophonic Piano

David Burliuk
Siberian Flotilla
1911 c.
oil on canvas, 45 × 38 cm
on loan from Salome and Eric Estorick

David Burliuk
The Poet Kamensky
1916-18
collage and oil on paste-board
45,7 × 35,5 cm
New York, Ella Jaffe Freidus Collection

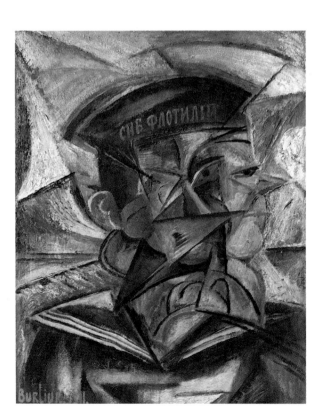

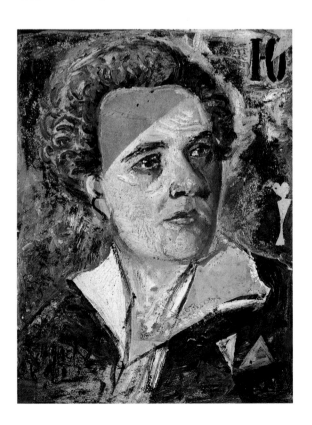

David Burliuk
Carpenter
1922 ?
collage and oil on paste-board
40,5 × 53,5 cm
New York, Ella Jaffe Freidus Collection

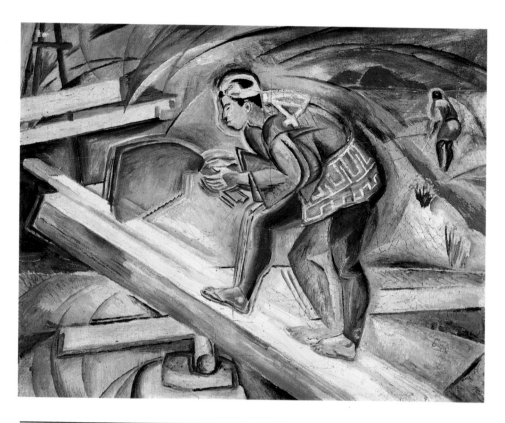

Vladimir Burliuk
Portrait of the Poet Benedikt Livshits
1911
oil on canvas, 45,7 × 35,5 cm
New York, Ella Jaffe Freidus Collection

Marc Chagall
Homage to Apollinaire
1911
oil on canvas, 200 × 189,5 cm
Eindhoven, Van Abbemuseum

This was the largest picture on view at
Chagall's one-man exhibition, held in Berlin
at Walden's Der Sturm gallery in June
1914, where it was shown in public for the
first time

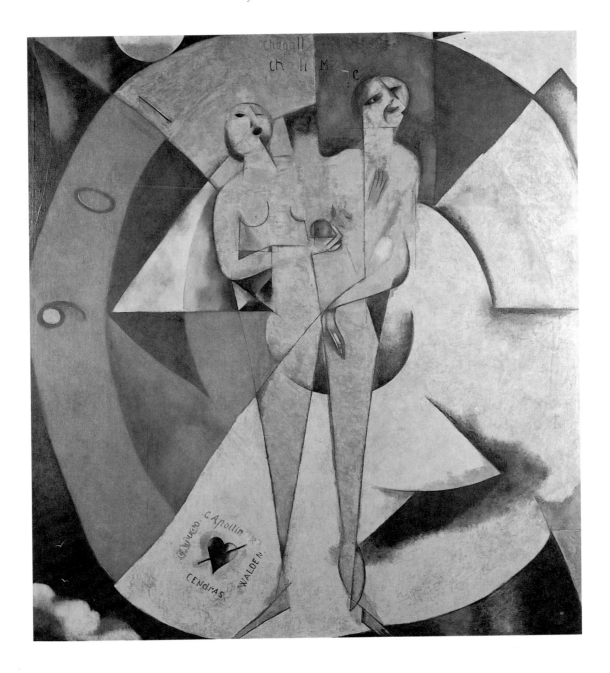

Alexandra Exter
Cubist Interior
1912
oil on canvas, 115,5 × 86,5 cm
Private Collection

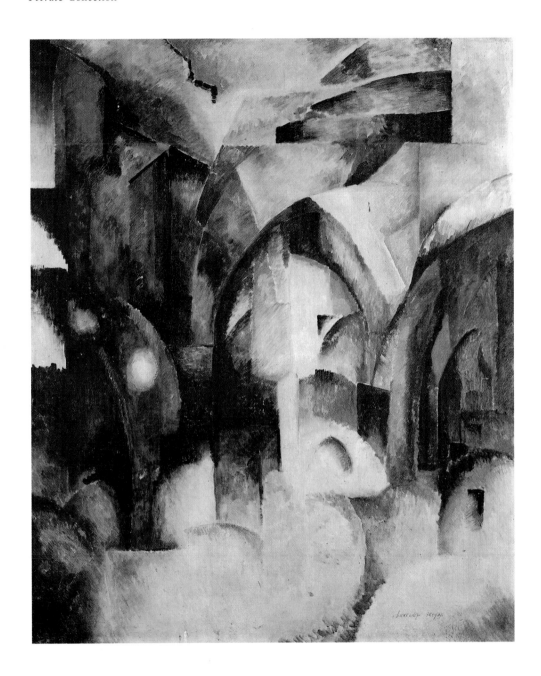

Alexandra Exter
Cubo-Futurist Composition
1913-14 c.
oil on canvas, 52 × 40 cm
Private Collection

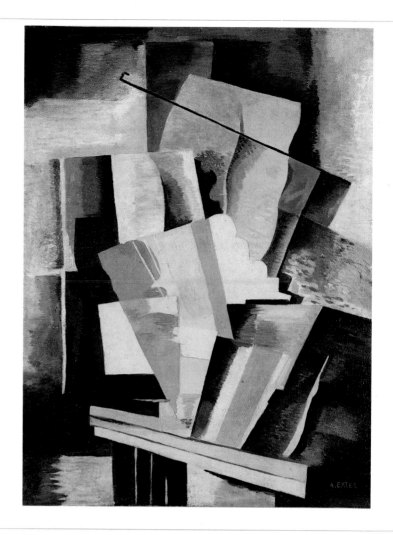

Alexandra Exter
Composition
1916
oil on canvas, 78,5 × 59,5 cm
Private Collection

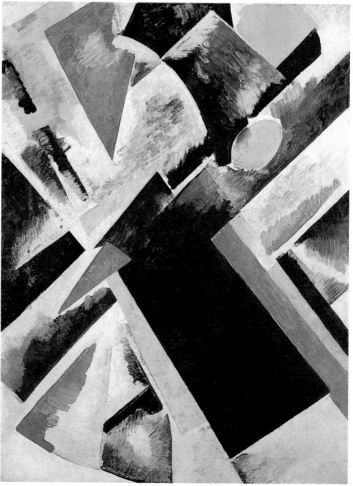

Alexandra Exter
Dynamic Composition
1916 c.
gouache on paper, 65 × 50 cm
Private Collection

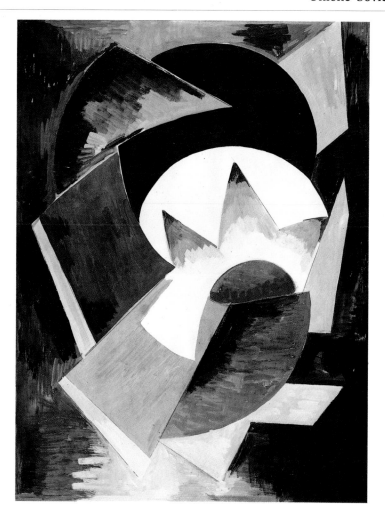

Alexandra Exter
Sketch for Stage
1924 c.
gouache on paper, 56 × 54 cm
Venice, Francesco Dal Co Collection

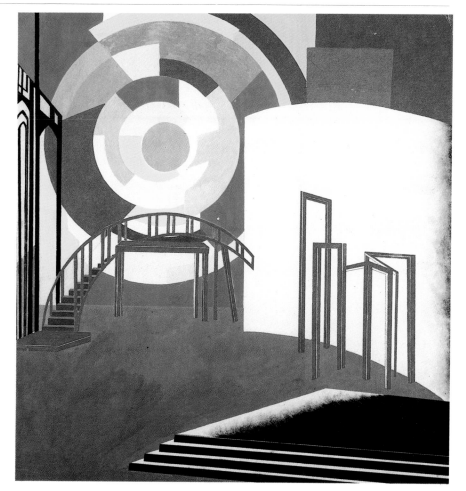

Boris Ender
Movement of Organic Form
1919
oil on canvas, 104 × 100 cm
George Costakis Collection
(property Art Co. Ltd.)

Ksenia Ender
Untitled
undated
watercolour on paper, 15,4 × 16,7 cm
George Costakis Collection
(property Art Co. Ltd.)

Pavel Filonov
Head
1925-26
oil and tempera on paper, 86,7 × 60,7 cm
George Costakis Collection
(property Art Co. Ltd.)

Natalia Goncharova
Little Station
1911 c.
oil on canvas, 66 × 74 cm
Private Collection

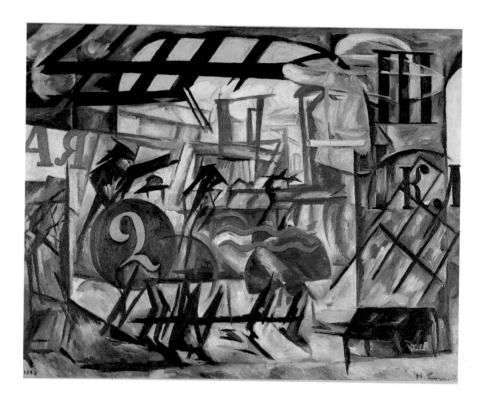

Natalia Goncharova
Flower Vase
1914
oil on canvas, 73 × 55 cm
Private Collection

Natalia Goncharova
The Cyclist
1913
oil on canvas, 78 × 105 cm
Leningrad, Russian Museum

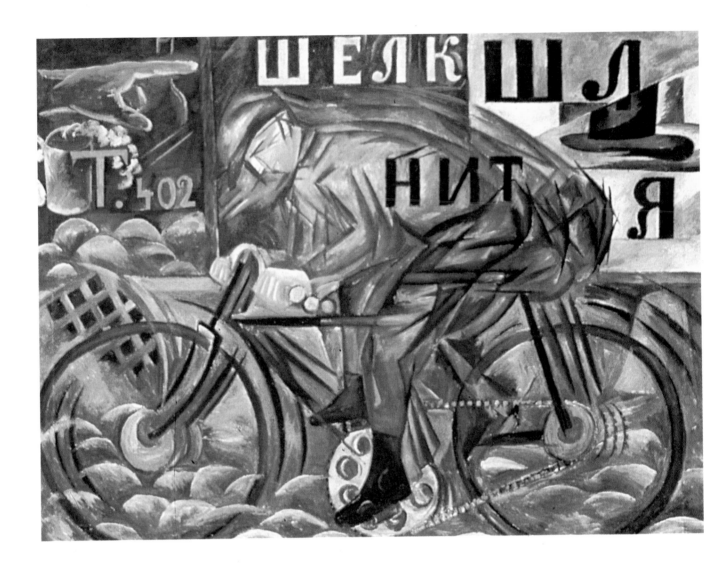

Vasilii Kandinsky
Train in Murnau
1909
oil on cardboard, 36 × 49 cm
Munich, Städtische Galerie im
Lenbachhaus

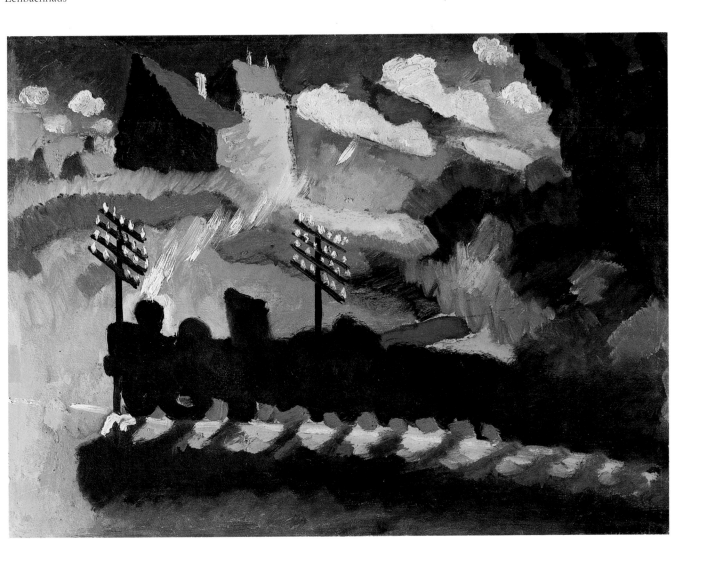

Unione Sovietica USSR

Vasilii Kandinsky
Improvisation 28 (second version)
1912
oil on canvas, 111,4 × 162,1 cm
New York, The Solomon R. Guggenheim
Museum

Mikhail Larionov
Blue Rayonism
1912
oil on canvas, 70 × 65 cm
Private Collection

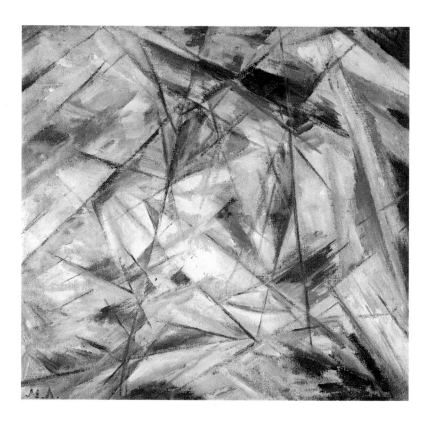

Mikhail Larionov
Portrait of Tatlin
1911
oil on canvas, 89 × 71,5 cm
Paris, Musée National d'Art Moderne
Centre Georges Pompidou

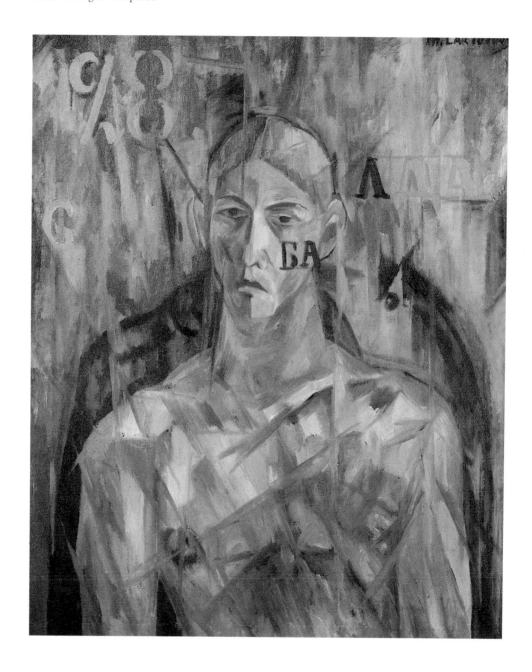

Vladimir Maiakovsky
Composition
1915
oil on canvas, 88,5 × 70,5 cm
Moscow, Maiakovsky Museum

Vladimir Maiakovsky
Yellow Blouse (Self-portrait)
1918
oil on canvas, 51 × 32 cm
Moscow, Maiakovsky Museum

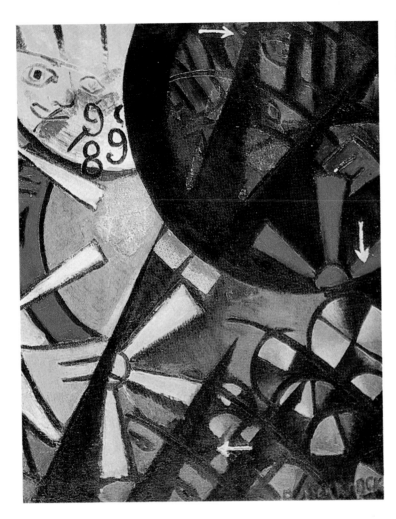

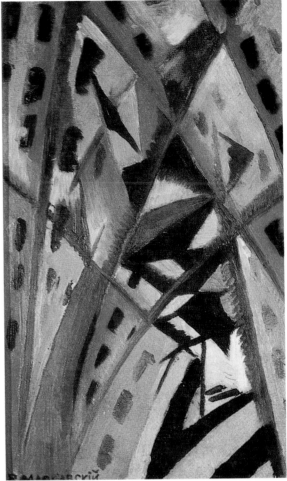

Vladimir Maiakovsky
Composition
1915
oil on canvas, 88,5 × 70,5 cm
Moscow, Maiakovsky Museum

Vladimir Maiakovsky
Yellow Blouse (Self-portrait)
1918
oil on canvas, 51 × 32 cm
Moscow, Maiakovsky Museum

Kazimir Malevich
The Knife Grinder
1912-13
oil on canvas, 79,7 × 79,7 cm
New Haven, Yale University Art Gallery
Gift of Société Anonyme Collection

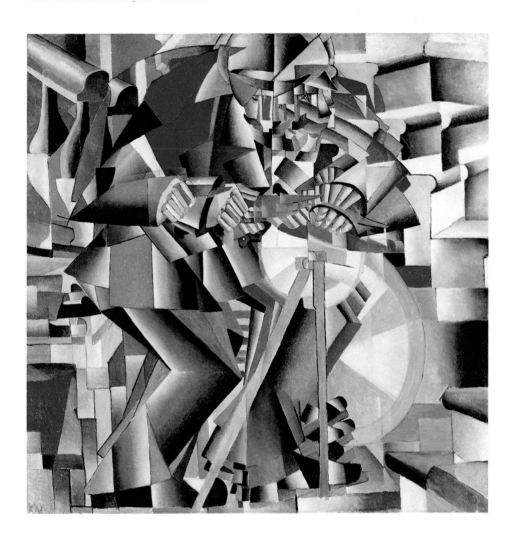

Kazimir Malevich
Violin
undated
oil on canvas, 70,3 × 53,4 cm
George Costakis Collection
(property Art Co. Ltd.)

Kazimir Malevich
The Pilot
1914
oil on canvas, 124 × 74 cm
Leningrad, Russian Museum

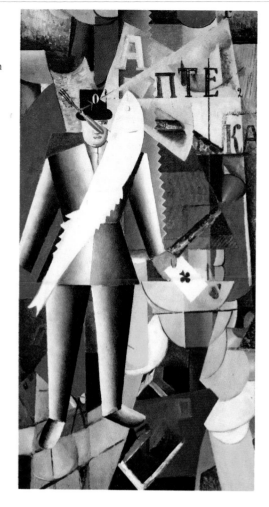

Kazimir Malevich
Victory over the Sun. The Big One
sketch for a costume 1913
pencil, gouache, China ink on paper
26,2 × 21,2 cm
Leningrad, State Theatrical Museum

Kazimir Malevich
Victory over the Sun. The New One
sketch for a costume, 1913
pencil, gouache and China ink on paper
26,2 × 21,2 cm
Leningrad, State Theatrical Museum

Kazimir Malevich
Victory over the Sun. The Enemy
sketch for a costume, 1913
pencil, gouache and China ink on paper
27 × 21,2 cm
Leningrad, State Theatrical Museum

Kazimir Malevich
An Englishman in Moscow
1913-14
oil on canvas, 88 × 57 cm
Amsterdam, Stedelijk Museum

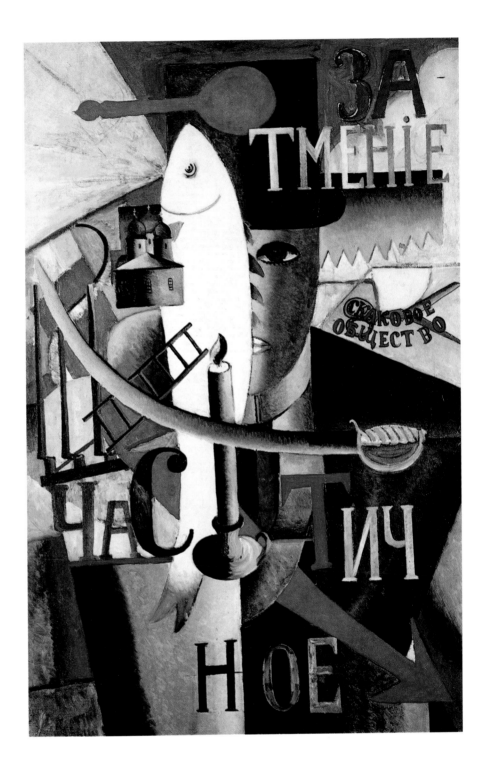

Mikhail Matiushin
Painterly-Musical Construction
1918
gouache on paste-board, 51,4 × 63,7 cm
George Costakis Collection
(property Art Co. Ltd.)

Liubov Popova
Landscape
1914-15
oil on canvas, 106 × 69,5 cm
New York, Solomon R. Guggenheim
Museum, Gift George Costakis

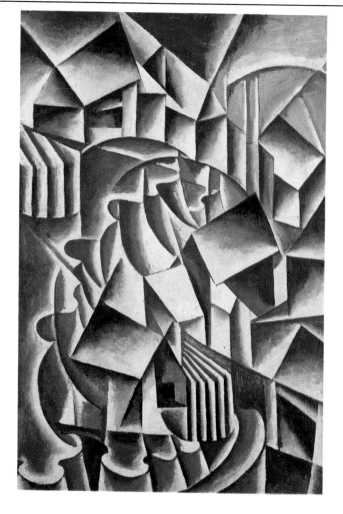

Liubov Popova
Travelling Woman
1915
oil on canvas, 158,5 × 123 cm
George Costakis Collection
(property Art Co. Ltd.)

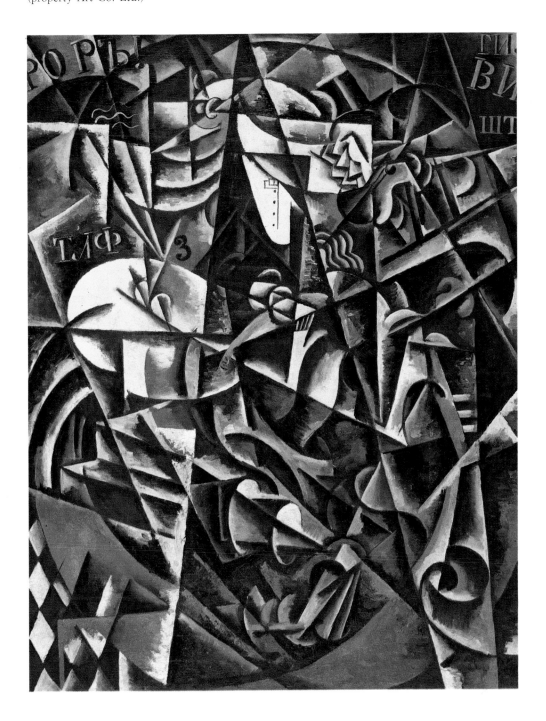

Ivan Puni
Chair, Palette and Violin
1917-18
oil on canvas, 100 × 73 cm
Paris, Musée National d'Art Moderne
Centre Georges Pompidou

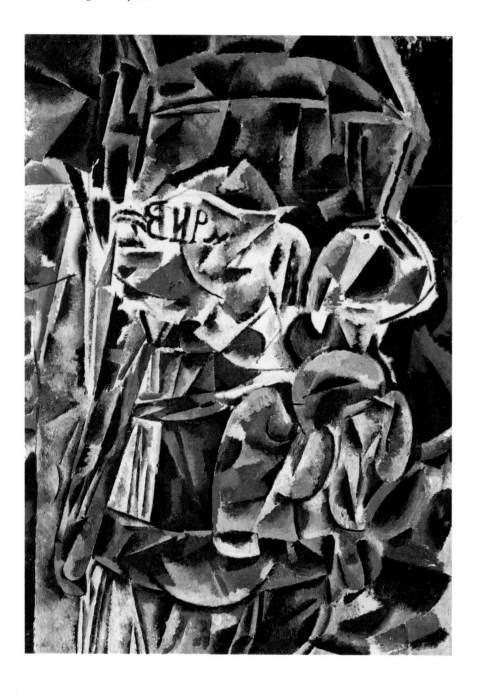

Olga Rozanova
Port
1912
oil on canvas, 100,4 × 79,2 cm
New York, Private Collection
Courtesy Leonard Hutton Galleries

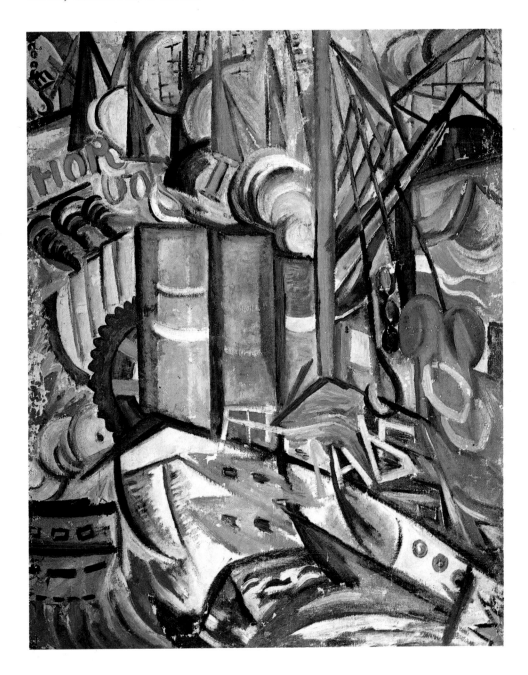

Olga Rozanova
A Duck's Nest... of Bad Words
1913
book, 22 lithographs
text by Alexei Kruchenykh 19,3 × 27,9 cm
New York, Leonard Hutton Galleries

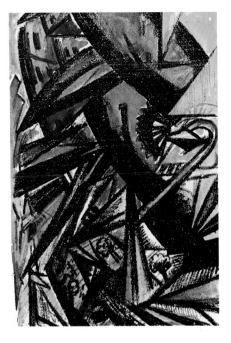
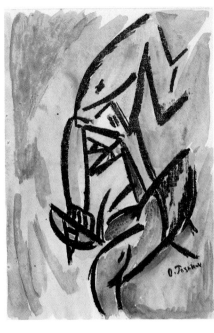

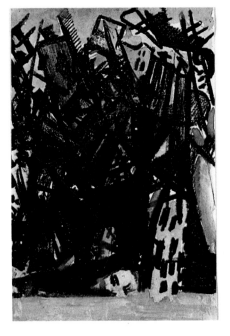
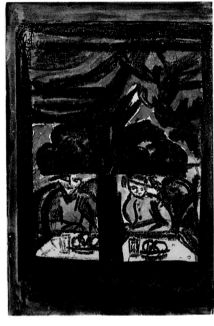

Кидая стозубость плевка
кровь собирая в сосуд
все доставала худая рука
на ладонь укладая минут

Глупости рыжей жажду
и забвенія давних путей
буду дик я дважды
коль убегу
мыслей

по полю оглохших камней
буду срывать плевков
цвѣты
и надежды больными
руками
схвачу резиновый шип
невѣсты
или сяду на наковальню
и поскачу громыхая
и подымется крик зава-
ленных
и не буду знать
может там мать
родная…

И вот не знавшаго болѣзней
краснѣла сальная нога
что бунт или начинка пирога
что для отечества полезнѣй

а-а! жадно вст начну живых
законы и пребѣлы мнѣ ли?
и костью запущу в ряды
чтобы навѣк глазѣ онѣмѣ-
ли

Лит. Т-ва „Свѣт
Невскій, 136

Взлетѣли
новыя книги:
Утиное гнѣздышко
А. Кручены книга 7-ая
рисунки О. Розановой, ц. 40 к.
Бух лѣсинный
Кручены - Хлѣбников
книга 8-ая
рис. Розановой Кульбина и
Кручены, ц. 30 к.
Взорваль Кручены
книга 9-ая
рис. Н. Кульбина, Н. Гончаровой
Малѣвич Розановой ц. 60 к.
Склад: Максимиліанов.пер.
д. 16 кв. 6

Vladimir Tatlin
Fishmonger
1911
tempera on canvas, 77 × 99 cm
Moscow, Tretiakov Gallery

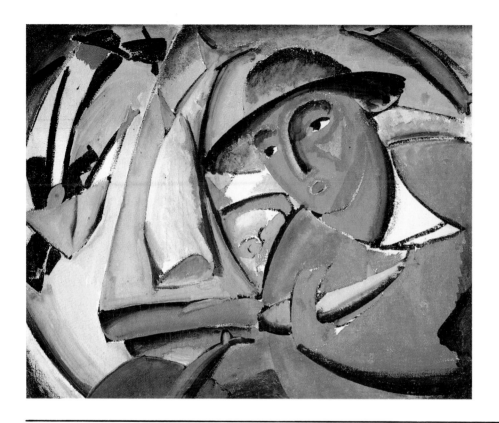

Vladimir Tatlin
Reclining Nude
1911-13 c.
ink on paper, 25,5 × 33 cm
New York, Courtesy Rosa Esman Gallery

Vladimir Tatlin
Seated Nude
1911-13 c.
ink on paper, 34 × 25,5 cm
New York, Courtesy Rosa Esman Gallery

Vladimir Tatlin
The Sailor (Self-portrait)
1911-12
oil on canvas, 71,5 × 71,5 cm
Leningrad, Russian Museum

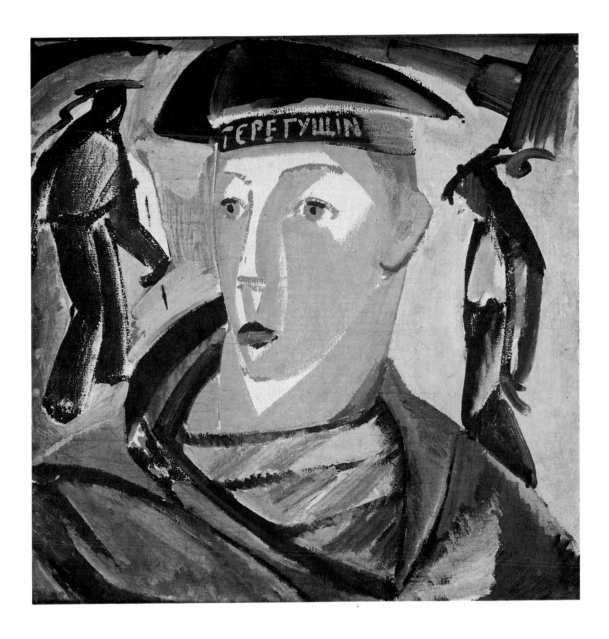

Dictionary of Futurism

The core and achievement of Futurism spans a short period of time and has been studied extensively in a great number of publications. Rather than repeating or summarizing these, it seemed more original and convenient to concentrate this large amount of already available information in a dictionary of major names, places, concepts and other subjects related to Futurism, written by reknown specialists. This dictionary is completed by an international chronology of Futurism and the Avant-Garde and a bibliographical selection. To an extended number of people it will provide an easy introduction and possibilities for a deeper study. (PH)

(JAJ)	Joan Abelló Juanpere
(TA)	Toru Asano
(MCac)	Massimo Cacciari
(MCal)	Maurizio Calvesi
(LC)	Luciano Caramel
(MC)	Massimo Carrà
(JC)	Jacques Caumont
(GC)	Germano Celant
(EC)	Ester Coen
(RC)	Richard Cork
(ECr)	Enrico Crispolti
(RDF)	Renzo De Felice
(LDM)	Luciano De Maria
(GDM)	Gabriella Di Milia
(AF)	Annateresa Fabris
(SF)	Serge Fauchereau
(VG)	Vittorio Gregotti
(JGC)	Jennifer Gough-Cooper
(PH)	Pontus Hulten
(GL)	Gail Levin
(JL)	Jeremy Lewison
(FMa)	Franco Maffina
(FM)	Filiberto Menna
(PP)	Piero Pacini
(GR)	Gianni Rondolino
(AR)	Angelica Rudenstine
(CS)	Claudia Salaris
(FS)	František Šmejkal
(GS)	Gerald Silk
(VS)	Vittorio Strada
(MV)	Mario Verdone
(SZ)	Stanislas Zadora

Activism

This was a politically-oriented literary movement inspired by various philosophies of action adopted by representatives of the plastic arts.

It developed in Germany (through the magazines *Die Aktion* and *Der Sturm*) between the first and third decades of the century, but it took on the aspect of an autonomous movement only between 1915 and 1926, in Hungarian plastic arts and literature.

"The struggle that we are carrying on", wrote Lajos Kassák, the head and organizer of Activism, "and which we hope to see spreading as widely as possible, is not aimed at generating anarchy, but at preparing the way for a more collective society than the present one. Isolated in Hungary, is it possible that abroad we already have companions in art and in politics?"

In fact, the two organs of Hungarian Activism, *A Tett* and *Ma*, largely adopted the points of view and the goals of *Die Aktion* and *Der Sturm*. *A Tett* was founded in Budapest in 1915 by Lajos Kassák and his friends Bela Uitz, Matyas Gyorgy and Imre Vajda. The programme of the magazine was summarized in the declaration in the publisher's letter of the first issue: "We do not accept things as they are! The artist and the writer are again becoming workers among the workers, warriors among warriors." Art, according to Kassák and his fellow-workers, must become creative and constructive, rather than contemplative and separate from life. Nevertheless, *A Tett* never formulated an aesthetic of its own: its intention was rather that of promoting the penetration into Hungary of foreign writers and artists according to the criteria of modernity. So, doubtless influenced by Marinetti (the first poem by Marinetti translated into Hungarian was "Peso + sangue" - Weight + Blood, published in *A Tett* no. 15), the poets of *A Tett* introduced free verse that was formally Futuristic, with an extremely dynamic structure obtained by alternating words and phrases. In addition to Futurism, the Activist poets were inspired by Apollinaire's Simultaneism and by Expressionist drama, although they maintained their revolutionary political objectives. With a profoundly international and pacifistic approach, *A Tett* readily published translations of Russian, French and Serbian works at a time when propaganda was pounding its drum in support of the bellicose patriotism of the Austro-Hungarians. For this reason the magazine was abolished in 1916, after its seventeenth issue, but it was soon born again under the name of *Ma*.

By the end of a year, *Ma* was no longer just a periodical, but had also become a publishing house, an association of artists, an exhibition hall and a theatrical school. As the revolutionary situation became more heated in Hungary, *Ma* took an increasing interest in politics. A few weeks before the creation of the Republic of Councils in February 1919, the activists published their first manifesto, which summed up their idea of revolution: "After the economic revolution, which we supported, the principal programme of our group consists in the preparation of a spiritual revolution and the guarantee of its permanent mobility."

MA, *1918, cover*

Actual, *Stridentist Manifesto, Mexico, 1921*

The Activists however believed that this revolution could not be achieved with violence: Kassák and the majority of his friends always maintained the sovereignty of art and prohibited any ruling class — including the proletariat — from imposing themes and forms on the artist.

The independence and internationalism of *Ma* provoked a great deal of argument with the officials of the Republic of the Councils and the magazine was silenced by a decree in July 1919, two weeks before the collapse of the Hungarian revolution.

In May 1920 *Ma* was born again in Vienna, where Kassák, Uitz and Bortnyik and others had taken refuge. The magazine continued to appear until 1926, and adopted positions that were increasingly close to those of Russian Constructivism and the Bauhaus. (SZ)

Actual

(Mexico City, 1921 - 1923) Mexican periodical

Although only three issues of *Actual* were published, between 1921 and 1923, its appearance generated great surprise. "Avant-garde broadsheet and Stridentist compendium by Manuel Maples Arce", *Actual* no. 1 had the format of a large newspaper, which allowed it to be distributed through normal channels but also allowed it to be easily used as a poster.

The first issue was in fact the manifesto of Stridentism, articulated in fourteen points that framed a photograph of the dandified author. It also included a remarkable "Directory of the Avant-Garde", listing some hundred different names ranging from Paolo Buzzi to Max Weber, and Albert-Birot to Diego Rivera, all taken from avant-garde publications of the period: *La Voce, Dada, Littérature, Ultra*, etc. *Actual* was followed by *Irradiador* (1924) and *Horizonte* (1926-27). (SF)

Aeropainting

Codified in 1929 by Marinetti and Mino Somenzi in the manifesto *Aeropittura futurista*, "Aeropainting" gained wide support, and throughout the Thirties and early Forties was a fundamental and characteristic aspect of the new collective fund of images in experimental painting (and also in plastic art, since there was the parallel movement of "aerosculpture") in the context of Italian Futurism and the machine-myth (which remained a constant of the Futurist imagination). Closely connected to literature, it developed naturally from the better-known analytical phase of dynamic simultaneity practiced by Futurist painters and sculptors in the early, "heroic", second decade of the century, and also from the later phase of synthesis, initially worked out by Balla, along with Depero and Prampolini, in the second half of that decade.

At the beginning of the Twenties, and indeed almost throughout them, Aeropainting was defined in terms of "mechanical art" (see the 1922 manifesto issued by Prampolini, Paladini and Pannaggi). But behind the convergence of theories of general interest in the 1929 manifesto, the diversity of imaginative interpretation of the theme of Aeropainting was very pronounced, and was openly declared in the various statements of "poetics", both

group and personal, published in the catalogue of the 1931 Futurist exhibition at the Galleria Pesaro in Milan. On the other hand there was a clear inner dynamic running from the initial determination of the subject as "mechanical" (as the ultimate characterization of "mechanical art" in formal terms, from Balla to Depero, early Crali and Thayaht) in the later Twenties, to a substantially (though not invariably) lyrical treatment of the same subject-matter in the Thirties. This diversity of position manifested itself in at least three different ways: a vision of cosmic projection, at its most typical in Prampolini's "cosmic idealism" (passing from Prampolini to Fillia and Oriani in particular); a "reverie" of aerial fantasies, sometimes verging on fairy-tale (for example in Dottori and Benedetta, Corona and Bella, Di Bosso, Rosso, Mori, Monacheẓi, Benedetto, Angelucci, Delle Dite, Peruzzi and Abbatecola); and a kind of aeronautical documentarism that comes dizzyingly close to a direct celebration of machinery (particularly in Crali, but also in Tato and Ambrosi). (ECr)

Albert-Birot, Pierre
(Angoulême, 1876 - Paris, 1967) French poet

Before he began writing poetry, Albert-Birot was a painter and sculptor. His early formation can be followed in the poster-poems and signboard-poems that he created in 1918, and in the poems in colour that were later collected in *La joie des sept couleurs* (*The Joy of the Seven Colours*) and *La lune* (*The Moon*), in which Futurist and Cubist influence can also be detected. In 1916 he founded the magazine *SIC*, which welcomed contributions from Cubists, Futurists and Surrealists. His first collection, *Trente et un poèmes de poche* (*Thirty-one Pocket Poems*, 1917) has a preface by Apollinaire. He contributed to several late Futurist magazines, such as *Noi*. His *Matoum and Tévibar* was staged by Prampolini in 1917. Although Albert-Birot was primarily a writer, he also produced important art works. (SF)

Alimandi, Enrico
(Turin, 1910 - Turin, 1984) Italian painter

Enrico Alimandi was a self-taught artist who began to paint at a very early age. After two years in Paris (1928-29), where he worked as a set-designer for Gallay Frères, he returned to Italy because of illness. At the Caffè San Carlo he met Fillia, who encouraged him to take part in the Futurist movement in Turin, which he joined at the end of 1929. He exhibited with the group in numerous shows. The paintings from this period show the influence of abstract and Surrealist art, while the handling is Expressionist. (EC)

E. Prampolini, costumes for Matoum et Tévibar *by Albert-Birot*

Almada-Negreiros, K 4, Lisbon, 1917

Almada-Negreiros, Portugal Futurista, 1917

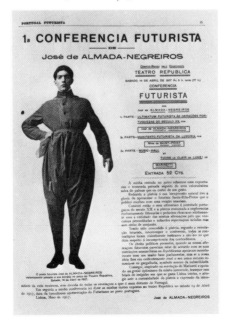

Almada-Negreiros, José de
(Cape Verde, 1893 - Lisbon, 1970) Portuguese painter and writer

A painter by vocation (his first show took place in 1913), José de Almada-Negreiros also published poems and novels. Futurism does not appear in his painting and writing until 1915 but during the few years in which he adopted a Futurist style, he did so with a vengeance. In 1915 he also published numerous Futurist manifestos, the most violent of which was *Futurist Ultimatum to the Portuguese Generations of the Twentieth Century*, which appeared in *Portugal Futurista*. The manifesto borrowed extensively from Marinetti, accusing Portugal of "decadence" and calling for war, a "great experience", as a solution to the "refined masturbations of the old civilizations". (SF)

Alomar, Gabriel
(Majorca, 1873 - Cairo, 1941) Catalan writer

Having enjoyed scant success in the diffusion of his ideas, Alomar is chiefly known for his militant Catalanism, which was sparked by the rapid industrial expansion of Barcelona. On 18 June 1904 at the Ateneo of Barcelona, Alomar delivered a lecture entitled *El Futurisme*, which was published in book form by L'Avenç in 1905, and translated into Spanish in the magazine *Renacimiento* in September and November 1907. Both publications were widely reviewed. In Catalonia the response must have been considerable, because various Futurist magazines appeared shortly afterwards: in 1907 in Barcelona, *Futurisme*; in 1908 in Villafranca del Panades, *El Futurisme*, and in Terrassa the weekly *Futurisme*. The ideas of Alomar were not confined to Catalonia — both Rubén Darío, then the best known poet writing in Spanish, and Azorín soon applauded them. In 1908 Marcel Robin, reviewer at the *Mercure de France*, published a detailed review praising Alomar's *El Futurisme*. At that time Marinetti was gravitating around the *Mercure de France*, where he published *Le Roi Bombance* in 1905; and his magazine, *Poesia*, was maintaining close contact with the entire Iberian peninsula. Interested as he was in anything new, Marinetti must have been aware of Alomar's contribution. Alomar, like many of his contemporaries (and later the Futurists), was thoroughly steeped in the ideas of Nietzsche and Bergson. He criticized Positivism and exalted intuition and change: "I believe in the continuous and mysterious change of all of nature, in epoch-long activity that transforms and destroys things, that extracts life and consciousness from the amorphous mass of chaos."

Just as Marinetti in 1912 was to urge the hatred of "libraries and museums... hate intelligence by reawakening in yourselves divine intuition", Alomar condemned "the dark and sinister libraries" and "the glacial rigidity of schools": "we leave wisdom behind us as a horrible disease"; it is necessary to go "beyond the dominion where reason reigns supreme", to intuition, without which science itself would be nothing more than "a granary... unable to generate a spark or a ray of light". Like Marinetti, Alomar glorified "the rebels, fighters and heroes", and his bellicose nationalism led him to

justify imperialism. His social ideas mirror those of Futurism: he wanted to destroy conservative society and everything that was based on the family and on religion and that inculcated morality or religion. The first Futurist, according to Alomar, was the rebel Lucifer (a statement which connects him to Papini as a Futurist). He wished to liquidate all art, since it was nothing but "thoughtful immobility, ecstasy and dreams". Alomar's tone recalls Marinetti's manifestos: "Oppose established methods of teaching and proclaim with ardour the independence of the individualistic spirit. Resound in the lethargic chorus of the lower classes! Overturn! Destroy! Scandalize! Terrorize! Be different! Be yourselves!... Tomorrow is a monster that feeds on the crippled body of today, and today has in its turn devoured the bloody corpse of yesterday. The law of the future cannot be obtained from the law of the present, but in opposition to it and at the cost of its destruction. The new world must be built upon the inevitable ruins of the old." As early as 1907 in *El Canto errante* (*Wandering Song*) Rubén Darío had hailed "that great spirit and that great heart named Gabriel Alomar", and he reminded Marinetti in an article in *Poesia* that "Futurism has already been founded by that great native of Majorca, Gabriel Alomar". In vain, for Marinetti was never to utter a word about Alomar. The Catalan theoretician was a less able impresario with a smaller circle of acquaintances in the European avant-garde; Marinetti therefore should receive credit for having taken the theory of Futurism and turned it into a fully-fledged movement capable of revolutionizing literature and art.

Among Alomar's works, are *Un poble que es mor* (*A Dying People*, 1904), *De poetitzacio* (*Poetics*, 1908), *Catalanisme socialista* (*Socialist Catalanism*, 1910), *La pena de mort* (*The Death Penalty*, 1912), *La littérature catalane moderne* (*Modern Catalan Literature*, 1915), *La guerra a través de una alma*, (*War Seen Through a Soul*, 1917). (SF)

Altomare, Libero
pseudonym of Mannoni, Remo
(Rome, 1883 - Rome, 1966) Italian poet

After publishing *Rime dell'Urbe e del suburbio* (*Rhymes of Rome and the Suburbs*) in 1908, Altomare sent his book of poems, *Procellarie* (*Stormy Petrels*), to Marinetti, and immediately joined the ranks of the Futurists, sending his poem "Apocalisse" (Apocalypse) to be published in an issue of *Poesia*. "Not by chance, when I joined the Futurists I assumed the combative pseudonym of Libero Altomare (Free Seas), arousing the ironic incomprehension of some of my self-styled friends of both sexes." He met Marinetti and took part in the *soirée* at the Mercadante Theatre in Naples (April 1910). In July he signed the manifesto *Futurist Venice* and on 11 January 1911 the *Manifesto of Futurist Playwrights*, which proclaims their contempt for all "kinds of historical reconstruction", a new use of free verse and a "delight at being booed". His name is mentioned in Apollinaire's manifesto *Futurist Anti-Tradition* (29 June 1913), but for personal reasons, after 1913 he participated less enthusiastically in the movement's propagan-

G. Alomar, El Futurisme, *Barcelona, 1905*

Alva de la Canal
cover for Andamios Interiores, *1922*

Alva de la Canal
design for a poem by Maples Arce, 1925 c.

da, though he did form a Rome Futurist group. Altomare left the Futurist movement in June 1915, announcing his decision in *Piccolo Giornale d'Italia*. (EC)

Alva de la Canal, Ramón
(1898 - 1985) Mexican painter and engraver

During the years of Stridentism, Alva de la Canal gained a reputation as an innovative painter. In particular, his woodcuts made him the leading Stridentist artist — his utopian urban landscapes were charged with a real dynamism, and he created boldly stylized portraits. Along with Jean Charlot, he was the first to paint frescoes on Mexican walls, an innovation which others made good use of in later years. (SF)

Antheil, George
(Trenton, 1900 - New York, 1959) American composer

Antheil came to Europe as a classical pianist, but by 1922 he was known in Berlin as a "Futurist pianist", because his compositions were scandalizing the public, even though their apparent innovation was the product of a fairly superficial mixture of Stravinsky and jazz: *Aeroplane Sonata*, and *The Death of the Machine*. During the composer's Parisian career, his friend Ezra Pound published *Antheil and the Treatise on Harmony* (Paris, 1924). Between 1924 and 1925 Antheil composed the music for Fernand Léger's film *Ballet mécanique*, the first performance of which required eight pianos, a player piano, a complete percussion set and the roar generated by an aeroplane propeller. In 1927 the work was performed at Carnegie Hall with the participation of sixteen pianos, several small anvils, saws, car horns and an aeroplane propeller, and generated an enormous controversy. Following a similar inspiration Antheil composed an opera, *Transatlantic* (1930), and then moved away from experimentation. (SF)

Apollinaire, Guillaume
pseudonym of Kostrowitzky, G. de
(Rome, 1880 - Paris, 1918) Writer of Polish origin, naturalized French

Since he was first and foremost an ally and supporter of the Cubists, Apollinaire's relations with Futurism were as complex as relations between Cubism itself and the Italian movement. Apollinaire must have been familiar with the name of Marinetti early on. According to André Salmon, the first contacts between the two men took place around 1906, after the foundation of the magazine *Poesia*.

We can understand why Apollinaire would make no mention of Marinetti's French verse — he was not familiar with the works of Italian poets. It is however surprising that he should say nothing about the Futurist manifesto of 1909 or the collection of theoretical writings *Futurisme*, published in French in 1911, because he evidently knew both of these publications. Only towards the end of 1911 did a note in the *Mercure de France* mention Futurist theory, but only to conclude that it was "above all sentimental and childish". On the occasion of the first Futurist exhibition, in February 1912 at the Bernheim-Jeune Gallery, annoyed by the thundering tones of the Futurist declarations, Apollinaire was still

harsher, though he did confess an interest in the work of Boccioni and Severini from the point of view of Cubism: "In reality, Futurist painters have so far had more philosophical and literary ideas than plastic ideas. They insolently — perhaps it is more accurate to say, blithely — declare: 'We can state without boasting that this first Futurist exhibition in Paris is also the most important exhibition of Italian painting that has hitherto been offered for the judgement of Europe.' This is imbecility... we dare not even judge such idiocy..." Apollinaire however concluded his article with a note of encouragement: "Futurist art makes us smile a bit in Paris, but it should not make the Italians smile, or it will be the worse for them."

The debate over Orphism took place in the spring of 1913. On this occasion Marinetti and Boccioni, in *Lacerba*, accused Apollinaire of plagiarism for having applied to other painters a concept which they claimed was their personal property. Later, peace was established between the two fac-

tions to the extent that on 29 June 1913 Apollinaire wrote a manifesto for Marinetti, *L'antitradition futuriste*, published in *Lacerba* — in which Apollinaire said *merde* to many concepts and persons, both past and present, and offered a *rose* to many of his writer and artist friends. While it may not have been the "joke" that André Salmon says it was, one must agree with André Breton that this manifesto was written in a "light tone" and remains rather superficial. It was at any rate a gesture of friendship towards Futurism. Relations were cordial from that point on, even though the caricatural description of Marinetti published in *Les Soirées de Paris* in May 1914 did not lack venom, and an article by Apollinaire in 1916 decried the *Manifesto of Futurist Science* as showing "absolute ignorance".

Apollinaire maintained a good relationship at least with *Lacerba* and with Marinetti. A few weeks before he died, he sent Marinetti a postcard in which he lauded "this great and lovely war" as though he had accepted

Futurism's patriotic bellicosity.

Was Apollinaire truly influenced by Futurism? As a poet, he was interested in all the new developments of his time, and he could not fail to see Futurism as an interesting experiment and perhaps as the source of new ideas. The hero of *Le poète assassiné* (*The Murdered Poet*, 1917) had more than a few modes of behaviour and wrote more than a few poems that linked him to Futurism. As to the invention of calligrammes, Apollinaire often claimed that he took his inspiration from ancient and medieval poetry, but despite these declarations it is probable that he was greatly encouraged in this direction by the typographical research of the Futurists. In the same way, while the direction of his poetic development after the beginning of the century led him to rupture his syntax more and more, to fragment it into simultaneous notes, the example of the Cubist painters, and of the Futurist manifestos and paintings, was nevertheless important. (SF)

G. Apollinaire, original manuscript of Lettre-Océan

Archipenko, Alexander

(Kiev, 1887 - New York, 1964) Ukrainian sculptor, naturalized American

As a student in Kiev, Archipenko first showed a bent for mathematics and then for painting; in the end he decided on sculpture. In 1905 he was expelled from the School of Fine Art for having criticized the outdated teaching of the professors, but in 1905 and 1906 he took part in several exhibitions. In 1908 he came to Paris where he became friendly with Modigliani and, for a short period, with Gaudier-Brzeska. Shortly afterwards, Apollinaire, Cendrars and the artists of the Section d'Or became his friends. From 1910 on he exhibited sculptures that consistently generated scandal, so unusual for the period was their stylization, tending towards abstraction.

His plastic research developed along lines parallel to Cubism and Futurism; he was not strongly influenced by the two movements, but he shared many of their ideas. The dynamism of *The Dance* (1912) or *Boxing Match* (1914) is related to that of Futurist art. Several multicoloured works combine different materials (glass, wood, metal, stone, etc.) which Archipenko named "sculpto-painting" (*Medrano*, 1913; *Carousel-Pierrot*, 1913; *Woman at a Mirror*, 1914). Without adhering to Futurist theories, Archipenko exhibited from time to time with the Futurists, and contributed to *Lacerba* and *Noi*. After travelling extensively through Europe after the war, in 1923 Archipenko settled in the United States. (SF)

A.G. Bragaglia, Prampolini and Archipenko, 1920 c.

Architecture

Architecture was annexed by Futurism some five years after the first *Futurist Manifesto* was published in *Le Figaro* and in *Poesia* in February 1909. It seems appropriate to use a word like "annex" because in those five years there developed within the movement a need to extend the Futurist ideology — or some specific version of it — to what we would today call physical space. Art, seen as dynamics and action opposed to any environmental nostalgia, was to be applied to the entire visible world. Unhindered by the traditional limits of artistic disciplines, it would embrace everyday objects, landscape, and architecture.

The word "annex" is also appropriate because in 1914 there already existed an important autonomous tradition which was undergoing a radical change, and which played a major role in defining the characteristics of the leading Futurist architects. On the one hand, technical solutions were being developed out of which new principles, and a new ideology were taking form. On the other hand, stylistic transformations were occurring that were linked to the new ideology. As an example of the former, we may note the growing influence of industry on architectural production (culminating in the foundation of the Werkbund in 1907), and the importance that, throughout the second half of the 19th century, was attributed to the culture of engineering and the urban vision created by industry, represented by Tony Garnier's celebrated designs of the *cité industrielle* in 1902. As an example of stylistic transformations, before 1919 a series of important avant-garde linguistic experiments began influencing architecture, ranging from early Expressionism, to Czechoslovakian Cubism, to Art Nouveau in its various international versions, especially that of the Viennese school of Otto Wagner, whose influence on the early work of Sant'Elia has been well documented.

Certainly as far as Russia is concerned, any definition of "Futurist" architecture is, if not improper, extremely vague. Any discussion of the birth of Russian Futurism is complex. When, towards 1910, the *budetljani* (men of the future) began producing literature and paintings, their principles developed independently from those of their Italian Futurist brothers. Furthermore, while the Russian Cubo-Futurist painters were producing works of considerable interest and maturity even before 1914, only after 1917 and the Revolution did the remarkable new architectural production begin. It is safe to say however that the language of this new architecture, more than any other in Europe, was marked by the principles of Cubo-Futurism, and perhaps no architecture in the world can more correctly be called Futurist than Tatlin's celebrated monument to the Third International created in 1920.

Czechoslovakian Cubo-Futurism (although it never used this term to define itself) is also an extremely complex case. It began as a movement in 1908 centred around the magazine *Styl* and the group SUV, and by 1918 had already completed the most important part of its rich production of designs, projects, architecture, objects of

applied art, and furniture. Josef Go-car, Vlatislav Hofman, Pavel Janak, and Jan Kotera were the leading members. Although the dynamism of the architectural forms was expressed mainly in decorative terms, the theoretical positions propounded by its members were consciously linked to an internationalist position which aimed at a radical future renewal of language.

It must also be remembered that by 1912 Frank Llyod Wright had already held his big exhibition in Holland, by 1914 Walter Gropius had built the Fagus workshops, and by 1911 Adolf Loos the house in Michaelerplatz. As for the idea of the metropolis as a site central to social experience even more than to development, certainly the experiments described and dreamed of by the illustrators of American skyscraper cities, and still earlier of the 19th century cities of underground and elevated railways, were decisive to Futurism. The influence of Henri Sauvage and of his projects of 1911-12 on Sant'Elia's designs of 1914 is probably less important than the formal resemblance of the "stepbacks" might lead one to suppose. Between 1909 and 1914, there was a strong interest in architecture within the Futurist movement that was naturally connected with urban ideology. The concept of the city as the principal site of transformation and as a symbol of production and energy — almost a new form of nature and a priority subject — had begun with Marinetti's first manifesto. The rejection of the historic city — antiquated and nostalgic — was emphasized in the speech to the Venetians in 1910 and in the manifesto against Montmartre of August 1913. The Futurist writings extolling a new artificial landscape, the beauty of new materials and "of iron and crystal cages" (Marinetti, 1911) are well known.

Futurist Architecture, a manifesto by Umberto Boccioni written between 1913 and the beginning of 1914 and rediscovered by Zeno Birolli in 1971 when Feltrinelli published the complete writings of Boccioni, argues against historical and folk architecture styles, and also attacks speculation and "foreign styles". The renewal of architecture, according to Boccioni, requires a return to necessity, and necessity equals velocity, that is, plastic dynamism. Against decorativism, Boccioni praised the "shining exactitude" of the work of engineers, and their new materials and products — architecture as "a rigid, light and mobile art". Furthermore, Futurist architecture was to be "the architectural setting developed in all directions". Here Boccioni came closest to the images of Sant'Elia's Futurist city.

Boccioni's manifesto is undoubtedly also important for the link it establishes between the processes of painting and architecture, both of which are seen as developing from internal structural laws according to growth process which differs from the one suggested by the sketches of Sant'Elia and Chiattone himself.

This interest in constructed environment can be seen as culminating in the manifesto by Fortunato Depero and Giacomo Balla, *The Futurist Reconstruction of the Universe*, which was published on 11 March 1915 but already existed as a rough draft in 1914.

A. Sant'Elia, Self-portrait, *1913*

A. Sant'Elia, New City, *study, 1914*

The year 1914 also witnessed the official birth of Futurist architecture. On the one hand (29-30 January) the Rome *Piccolo Giornale d'Italia* published Enrico Prampolini's text "Anche l'architettura futurista: E che è?" (A Futurist Architecture As Well: So What Is It?), with accompanying design projects including the "plan and elevation of the building for a single university department". On the other hand, in Milan the annexation process was more complex: contact with Sant'Elia was established through Carrà (as he himself describes in his autobiography), and in March 1914 Sant'Elia joined the group Nuove Tendenze (New Trends) together with other artists and the architects Giulio Ulisse Arata and Mario Chiattone (Sant'Elia shared a studio with Chiattone in corso Concordia in Milan). The Nuove Tendenze group organized its first art exhibition in May 1914, in which Sant'Elia showed sixteen drawings with titles such as *The New City*, *Power Stations*, *The New House*. Mario Chiattone participated in the same show with drawings entitled *Apartment Houses* and *Constructions for a Future Metropolis*.

Sant'Elia had also taken part in an exhibition of the association of Lombard architects two months earlier, and it was probably this show that brought him into contact with Carrà and the Futurists. The question of the exact date of the meeting between Sant'Elia and the Futurists, and the discovery of a text by Sant'Elia which accompanied the Nuove Tendenze show — differing in several important details from the *Manifesto of Futurist Architecture* of July 11 — have given rise to a long philological and ideological debate. One can therefore speak of the annexation — or convergence, if one prefers — of a series of historical forces, which found in Futurism a powerful accelerator, or rather, found in Sant'Elia an extraordinary interpreter who undoubtedly succeeded in establishing a clear stylistic leap in quality with respect to earlier experiences.

Although there has been much discussion about the absence of plans and concretely functional suggestions, his drawings must be considered design-oriented, especially as regards the possibility of integrating the different elements of the city into a new synthesis. Whereas Mario Chiattone's drawings, which were more decidedly proto-rationalist and aimed at the renewal of the single building unit, could be used directly in the Italian Rationalist experimentation of the Twenties and Thirties (for example, in the earliest designs of Adalberto Libera), Sant'Elia's innovations were not directly reutilized in modern experimentation either in Italy or abroad during the same period. Many critics have rightly noted that from 1914 onwards, two radically different types of architectural Futurism developed: the Milanese variety, more closely linked to the European proto-rationalist experimentation, and the Roman variety, more painterly and expressionistic, and interested in the applied arts.

From 1919 to 1927 (the year that the Rationalists' Group 7 was formed), the condition of avant-garde architecture in Italy remained rather ambiguous. In the context of an overpowering recall to order and to

Novecento stability, Futurism tended to be seen as the last episode in an experimental *crepuscolarismo* (a form of Decadentism) of no further cultural use. The positions of the Futurists and Neo-Futurists in the ten years following the war were influenced by this new condition. Balla, Depero, Marchi, Prampolini, and Ivo Pannaggi (who was the most closely linked to the international avant-garde) were certainly the major figures of this decade. Giacomo Balla became interested in the applied arts as early as 1912 with his design for the furnishings of the Loewenstein house (Düsseldorf); in 1919 he designed the furnishings for his own house in Rome, and created numerous other furniture designs (probably linked with the experimentation of Duilio Cambellotti) using freely coloured dovetailed surfaces, as well as utilitarian objects, fabrics and clothing. This activity was all part of that Futurist reconstruction of the universe which we have already mentioned — a concept that should not be confused with the discussions on industrial art (the future "product design") which had been going on for more than fifty years in England and Germany.

In 1920 Francesco Cangiullo produced his *Manifesto of Futurist Furnishings - Surprise Talking and Free-Word Furniture.*

Virgilio Marchi also played an important role in the postwar period of Roman Futurism. In 1920 he published a *Manifesto of Dynamic Futurist Architecture - Dramatic State of Mind,* which was strongly supported by Marinetti. In 1921 Marchi began collaborating with Anton Giulio Bragaglia and his theatre. His designs between 1919 and 1922, the year of his first solo exhibition at the Casa d'Arte Bragaglia, unite the principles of Sant'Elia's new city with an extremely personal perspective vision largely derived from his experience as a set designer. He was strongly influenced by the experimentation of the prewar Czechoslovakian Cubists.

Probably the most interesting contribution to Futurist architecture in those years came from the work of Fortunato Depero, who influenced a group of Italian Rationalists in Rovereto — including Gino Pollini and Adalberto Libera. His series of "pavilions", which culminated in the Bottega del Libro at the Venice Biennale in 1927, and continued until 1935, founded a "typographic architecture" which had vast international repercussions. Depero had already made an original contribution before the war with the publications *Padiglioni plastici futuristi* (*Futurist Plastic Pavilions*) and *Città aerea* (*Aerial City,* 1916) in Rome, where he developed the idea of a dynamic Futurist architecture based on three states — earthly, mechanical, and plastic: the aerial and mobile city of "leisure".

Prampolini, who designed interiors of aeroplanes and automobiles in 1917, in 1920 also created furniture for the Casa d'Arte Italiana in Rome.

Then in 1928 in Turin, the first show of Neo-Futurist architecture opened with a retrospective of Chiattone, Sant'Elia, Marchi and Balla and the recent works of Prampolini, Depero, Balla, Pannaggi, and the Turinese Futurist group — Fillia, Ugo Pozzo, Diulgheroff, Beppe Ferdinando, Mino

Rosso, and Alberto Sartoris, an eleventh-hour Futurist. The Turinese Futurist group had formed in 1923 around Luigi Colombo (Fillia), with the aim of proposing Futurism as the art of the new Fascist State. Angelo Mozzoni joined the Futurist movement in 1933, the year in which he also became joint editor of the magazine *Sant'Elia.* In that period many of his most important works were constructed: the Edificio della Squadra Rialzo in the Florence railway station and the Colonia Calambrone.

By this time, however, the definition "Futurist" had become entirely a matter of cultural and political tactics. Rather than list the latecomers to a Futurism that had become simply a State fad, perhaps at this point it would be more interesting to determine the degree to which Futurism influenced Italian architecture of the Thirties in terms of language and principles, becoming a component of its style. In this respect an extremely interesting list could be made, running from several projects by Aldo Andreani dating from 1933-34 (such as the plan for the Assicurazioni Toro in Milan or the plan for the executive building of the Opera Balilla) to Giuseppe Terragni's plan for a foundry in 1927, and the Notari Bookshop project by Luciano Baldessari in the same year, to the famous and extraordinary "Sala del 1922" at the exhibition for the tenth anniversary of the Fascist revolution, created in 1932 by Terragni. (VG)

Manifesto of Futurist Architecture
(Futurist manifesto, Milan, 11 July 1914)

No architecture has existed since the 18th century. What is called modern architecture is a senseless mixture of different stylistic elements used to mask the skeletons of modern houses. The new beauty of cement and iron is profaned by superimposing motley decorative incrustations justified neither by constructive necessity nor by our (modern) taste, taken from Egyptian, Indian or Byzantine antiquity and that amazing flowering of stupidity and impotence that took the name of *Neoclassicism.*

These architectural prostitutions are welcomed in Italy, and the greedy ineptitude of foreigners is passed off as great invention and brand-new architecture. The young Italian architects (those who get inspiration by secretly poring over art journals) show off their talents in the new districts of our cities, where a cheerful mixture of ogival columns, 17th century foliation, Gothic pointed arches, Egyptian pilasters, rococo scrolls, 15th century cherubs, swollen caryatids, is seriously passed off as style and conceitedly claims to be monumental. The kaleidoscopic appearance and reappearance of forms, the multiplying of machinery, the constantly growing needs imposed by the speed of communications, the concentration of population, hygiene, and a hundred other phenomena of modern life, never cause these self-styled renovators of architecture a moment's hesitation. They persevere obstinately with the rules of Vitruvius, Vignola and Sansovino plus some published scrap of information on German architecture. Using these, they continue to stamp the image of imbecility on our cities, which on the contrary should be the immediate and faithful projection of

ourselves.

And so this expressive and synthetic art has become in their hands an empty stylistic exercise, a digest of muddled formulae meant to disguise a passéist box of bricks and stone as a modern building. As if we who are accumulators and generators of movement, with all our added mechanical limbs, with all the noise and speed of our lives, could live in streets built for the needs of men four, five or six centuries ago!

This is the supreme stupidity of modern architecture, perpetuated by the venal complicity of the academies, prison camps for intelligence where the young are forced into the onanistic copying of classical models instead of throwing their minds open to the search for new frontiers and the solution of the new and pressing problem: *the Futurist house and city.* The house and the city that are ours both spiritually and materially, in which our excitement can seethe without appearing a grotesque anachronism.

The problem posed in Futurist architecture is not one of linear rearrangement. It is not a question of finding new shapes and frames for windows and doors, of replacing columns, pilasters and corbels with caryatids, flies and frogs. Nor is it a matter of choosing whether to leave a façade in bare brick, plaster it or face it with stone, nor of determining formal differences between the new building and the old one. It is a question of creating the Futurist house ex-novo, constructing it with all the resources of technology and science, generously satisfying all the demands of our habits and our spirit, trampling down all that is heavy, grotesque and antithetical to us (tradition, style, aesthetic, proportion), determining new forms, new lines, a new harmony of profiles and volumes, an architecture whose sole justification lies in the unique conditions of modern life and its aesthetic correspondence to our sensibilities. This architecture cannot be subjected to any law of historical continuity. It must be new, just as our state of mind is new.

The art of construction has been able to evolve over time and pass from one style to another while the general characteristics of architecture have remained unchanged. This is because in history changes determined by fashion and by new religious convictions and political orders are frequent, while profound changes in the state of the environment are extremely rare. Such revolutionary changes are caused by the discovery of natural laws, the perfecting of mechanical means, the rational and scientific use of materials. In modern life the process of stylistic development in architecture has been brought to a halt. *Architecture now makes a break with tradition. We are compelled to make a fresh start.*

Calculations based on the resistance of materials, the use of reinforced concrete and iron, exclude "architecture" in the classical and traditional sense. Modern building materials and scientific concepts are absolutely incompatible with the discipline of historical styles, and are the main reason for the grotesque appearance of "fashionable" buildings where the architect has tried to use the lightness and superb grace of the iron beam, the fragility of reinforced concrete, to render the heavy curve of the arch and the weight of marble.

The utter antithesis between the modern world and the old is brought about by all those things that formerly did not exist. Elements have entered our lives which the ancients never dreamed of. Material circumstances have arisen and spiritual attitudes have appeared whose repercussions are infinite. The most important is the growth of a new ideal of beauty that is still obscure and embryonic, but already fascinating even to the masses. We have lost our feeling for all that is monumental, heavy and static, and we have enriched our sensibility with a *taste for what is light, practical, ephemeral and swift.* We feel that we no longer belong to cathedrals, palaces and podiums. We are the men of the great hotels, the railway stations, the wide streets, colossal ports, covered markets, luminous arcades, straight roads and beneficial demolitions.

We must invent and rebuild the Futurist city like an immense, tumultuous construction-yard, agile, mobile and dynamic in every detail; and the Futurist house must be like a gigantic machine. The lifts must no longer be hidden away like tapeworms in the niches of stairwells; the stairs themselves, rendered useless, must be abolished, and the lifts must scale the lengths of the façades like serpents of iron and glass. Houses of concrete, glass and iron, stripped of paintings and sculpture, rich only in the innate beauty of their lines and relief, extraordinarily *ugly* in their mechanical simplicity, will be higher and wider according to need rather than the specifications of municipal laws. They must rise on the brink of a tumultuous abyss: the street will no longer lie like a doormat at ground level, but plunge down into the earth, with multiple levels carrying the metropolitan traffic and linked up for necessary interconnections by metal gangways and fast, moving pavements.

The decorative must be abolished. The problem of Futurist architecture must be resolved, not by continuing to pilfer from Chinese, Persian or Japanese photographs or growing senile over the rules of Vitruvius, but by flashes of genius, and scientific and technical expertise. Everything must be revolutionized. Roofs and underground spaces must be used; the importance of the façade must be diminished; issues of taste must be transplanted from the field of fussy mouldings, finicky capitals and flimsy doorways to the broader concerns of *bold groupings of masses* and *large-scale organization of plans.* Let us make an end of funerary commemorative architecture. Let us overturn monuments, pavements, arcades and flights of steps; let us sink the streets and squares; let us raise the level of the city.

I combat and despise:
1. All the pseudo-architecture of the avant-garde, Austrian, Hungarian, German and American;
2. All classical architecture, solemn, hieratic, scenographic, decorative, monumental, pretty and pleasing;
3. The embalming, reconstruction and reproduction of ancient monuments and palaces;
4. Perpendicular and horizontal lines, cubical and pyramidical forms, which are static, solemn, oppressive and absolutely foreign to our utterly new sensibility;
5. The use of massive, voluminous, durable, antiquated and costly materials.

I proclaim:
1. That Futurist architecture is the architecture of calculation, of bold courage and simplicity; the architecture of reinforced concrete, of steel, glass, cardboard, textile fibre, and all those substitutes for wood, stone and brick that give maximum elasticity and lightness;
2. That this does not result in an arid combination of practicality and usefulness; Futurist architecture remains art, i.e. synthesis and expression;
3. That oblique and elliptic lines are dynamic, and by their very nature possess an infinitely greater emotive power than

F. Depero, Book Pavilion, *study, 1927*

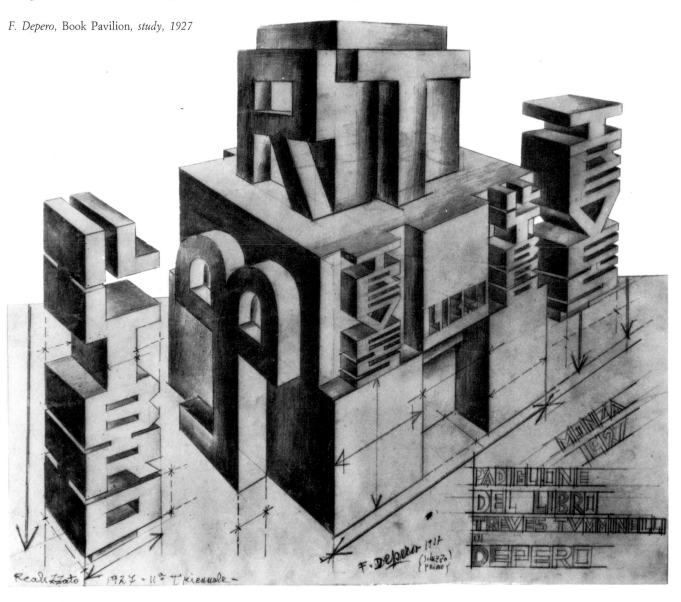

perpendiculars and horizontals, and that no integral, dynamic architecture can exist that does not include these;

4. That decoration as an element superimposed on architecture is absurd, and that *the decorative value of Futurist architecture depends solely on the use and original arrangement of raw or bare or violently coloured materials;*

5. That, just as the ancients drew inspiration for their art from the elements of nature, we — who are materially and spiritually artificial — must find inspiration in the elements of the utterly new mechanical world we have created, and of which architecture must be the most beautiful expression, the most complete synthesis, the most efficacious integration;

6. That architecture as the art of arranging forms according to pre-established criteria is finished;

7. That architecture means the endeavour to harmonize the environment with Man, with freedom and great audacity, making the world of things a direct projection of the world of the spirit;

8. From an architecture conceived in this way no formal or linear habit can grow, since the fundamental characteristic of Futurist architecture will be impermanence and transience. *Things will endure less than us. Every generation must build its own city.* This constant renewal of the architectonic environment will contribute to the victory of Futurism which has already been affirmed by *words-in-freedom, plastic dynamism, music without quadrature and the art of noises,* and for which we fight without respite against traditionalist cowardice.

A. Sant'Elia. architect

Architecture, Soviet Utopian

In the Russia of 1920, painters and poets, literature, plastic arts and avantgarde theatre, were still following guidelines established before the Revolution. The new architecture had not yet been discovered. Although already in 1913 Malevich had dreamed of workshops and towns suspended in space, this idea would not become concrete before the Twenties, with the construction of "architectons" and "planits".

Between 1920 and 1925 the students of Vkhutemas, the school of technical architecture in Vitebsk where many painters were enrolled, developed the idea of an architecture which would create expressive forms. In 1922, I.A. Golossov, speaking to the students of the Architects' Association, said: "The power of technology is growing every day. The old art is becoming increasingly irrelevant to our lives. We must look forward, not back — clinging to the leftovers of the past cannot help us." Believing in the infinite potential of science in the service of the Revolution, filled with revolutionary spirit and enthusiasm, these young people created numerous workshop projects all characterized by complete indifference to the practical aspect of architecture. The projects themselves generated new theories, such as "architecture as an organism", "as a rhythm", "as movement". It was a triumph of non-orthogonality and dissymmetry: the door and window lintels went in all directions, the facades were spiral-shaped, the planes were staggered in relation to the volumes. The influences of Futurism, Cubo-Futurism and Suprematism were paramount. The

concept of a dynamic deformation of objects was introduced into the architectural composition by Tatlin and Malevich, but the principle had been cultivated in painting and sculpture long before it appeared in architecture. These affiliations continued even after 1925, the year which marked the end of the romantic period of Soviet architecture: they showed themselves in Krutikov's cosmic projects for flying cities (1928), in the work of the Vesnin brothers (plan for the Lenin Library), in Ladovsky's designs, all of which were inspired by Malevich's ideas and work.

In this profusion of experiments, a few important designs became landmarks in what was a real renewal and evolution of Soviet architecture: first, the *Monument to the Third International* (1920) by Tatlin, the *Pravda* building and the *Palace of Labour* by the Vesnin brothers (1923), and finally K. Melnikov's pavilion at the 1925 Paris Exhibition of Decorative Arts, which revealed Constructivist architecture to the whole world, showing that the utopian dream was over, replaced by a utilitarian purpose. (SZ)

C. Melnikov, Monument to Christopher Columbus, *project, 1929*

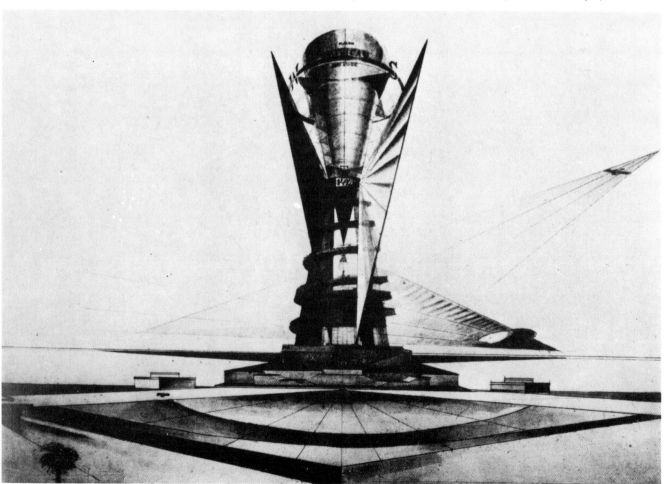

Aschieri, Bruno

(Verona, 1906) Italian poet and writer

A journalist on the editorial staff of *L'Arena* in Verona, Bruno Aschieri was sacked in 1930 "for personal exuberance". Subsequently he taught drawing. His published works include *Montebaldina - canto della mia terra, 16 liriche ardite (Montebaldina - Song of My Homeland, 16 Daring Lyrics)*, containing a "free-word" composition, *Visita a Boccioni (Visit to Boccioni)*, a late re-elaboration of early Futurist inventions, and *Tomaso Dal Molin - Stato d'animo in dodici rate (Tomaso Dal Molin - A State of Mind in Twelve Instalments)*. His writings are characterized by a lack of structural variation and by the imitation of old, outworn models; their patriotic enthusiasm is imbued with strong political overtones. (EC)

Atkinson, Lawrence

(Charlton, Manchester, 1873 - Paris, 1931) British painter

Lawrence Atkinson was brought up in the Northwest of England. He began a career as a musician, studying singing and music in Berlin and Paris. He then studied painting at La Palette and exhibited at the salon of the Allied Artists Association (1913), in the "invited to show" section of the "Vorticist Exhibition" (1915) and with the London Group (June 1916). He held a one-man show at the Eldar Gallery in May 1921. He joined the Rebel Art Centre early in 1914 and signed the *Blast* manifesto. Atkinson's earliest work was fauve. His conversion to Vorticism appears to have taken place after meeting Lewis and he developed an abstract idiom whose powers of expression he thought might surpass those of music. Generally his drawings and paintings consisted of muted tones occasionally punctuated with sharp accents of colour. By 1921, according to Leigh Henry, Atkinson was producing paintings "based entirely on an analysis of the psychological stimulus produced by architectonical arrangements of abstract mass". Atkinson also made sculpture directly related to his Vorticist work; he was awarded the Grand Prix at the 1921 Milan Exhibition. (JL)

L. Atkinson, Vital, 1913-15

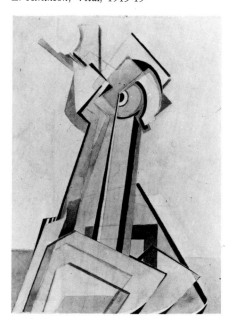

Atl, Doctor

pseudonym of Murillo, Gerardo
(Guadalajara, 1875 - Mexico City, 1964) Mexican painter and writer

Gerardo Murillo took the name of "Doctor Atl" in 1911 out of his sympathy for the Indians and his dislike for the Spanish painter Murillo. He lived in Europe from 1897 until 1903, and exhibited in Paris several times. Upon his return to Mexico, his role as a renewing force in the arts was confirmed by the younger Rivera, Siqueiros and Orozco. During his second stay in Paris, from 1911 to 1914, he became acquainted with the Cubists (Apollinaire gave a favourable description of one of his exhibitions held in 1914), and, through Paul Fort, with the Futurists. He exhibited at the Salon d'Automne and the Salon des Indépendants. According to Mexican specialists on his work, Doctor Atl composed an entire series of *Cosmic Interpretations* shortly before returning to Mexico. These drawings — unusual for an artist whose work was generally representational and characterized by a fondness for volcanoes — may have been executed later but, leaving aside the question of the exact date, their presence in a Futurist exhibition would have been quite natural. (SF)

Automobile

Almost as soon as it was invented in the late 19th century, the automobile made inroads into the world of art. Italian Futurism, however, was the first major movement to use the car as an important subject and symbol. In over one hundred works by Giacomo Balla, a speeding automobile is the primary subject. Images of motorized vehicles, including automobiles, buses, electric trams, and motorcycles, are also present in the works of the other major Futurist artists, Umberto Boccioni, Luigi Russolo, Gino Severini, and Carlo Carrà, and in the works of lesser-known Futurists like Mario Sironi, Achille Funi, and Gino Galli. Car imagery recurs throughout Futurist literature and poetry, especially in the manifestos and verse of its leader, Filippo Tommaso Marinetti, as well as in the writings of Auro d'Alba, Mario De Leone, Guglielmo Janelli, and Luciano Folgore.

The automobile became an important symbol because it embodied major principles of Futurist ideology, much of which was inspired by the contemporary technological revolution. The Futurists regarded the automobile as a paradigmatic innovation that was altering the environment and changing man's perception of the world; it thus symbolized their ideas about modernity and technological progress. Connecting the experiences of car travel with the contemporary French philosopher Henri Bergson's theory that reality was in constant flux, the Futurists intuited that the sensations of speed, dynamism, and simultaneity produced by new technology and the new urban environment also constituted the essence of reality. These concepts of rapidity and flux, moreover, were associated with the forward motion and continual change characteristic of avant-gardism, and were antithetical to the classical canons of stability and order against which Futurism rebelled. Further-more, car travel, a highly personal means of transport, provided sensations of power, exhilaration, and emancipation that contributed to the aggressiveness of the Futurist program.

Futurist art invariably depicted the automobile in motion. In a series of images of swiftly-moving motorcars done mostly between 1911 and 1915 with titles such as *Speeding Car, Speed of a Car*, and *Abstract Speed: The Car Has Passed*, Giacomo Balla concentrated on the speed and dynamism rather than on the form or design of the car. By superimposing a repeating, diminishing image of the car from right to left and overlaying a network of lines and forms, Balla was able to emphasize the appearance of directional energy and activate the space surrounding the car, nearly obliterating the shape of the vehicle and creating strong sensations of velocity and mobility. The phalanx of vectors in many of these pieces (also characteristic of Luigi Russolo's famous painting, *Dynamism of a Car*) are examples of "force-lines" — pictorial signifiers of basic units of force that the Futurists believed constituted the core of all objects.

As the incarnation of speed and forward motion, the car in such works appears symbolic of Futurism itself; indeed, the idea originated in the movement's christening broadside, Marinetti's 1909 *Founding and Manifesto of Futurism*. One of the manifesto's best known affirmations — "the world's magnificence has been enriched by a new beauty: the beauty of speed. A racing motorcar, whose hood is adorned with great pipes like serpents of exploding breath... a roaring motorcar that seems to run on shrapnel is more beautiful than the Victory of Samothrace" — belligerently announced Futurism's rejection of the past in favour of the ideas of the modern world. Similar in theme to Marinetti's 1905 pre-Futurist poem "A l'automobile" (To the Car, later called "A mon Pégase" and "A l'automobile de course"), the introduction to the manifesto describes a violent, sensuous joy-ride, in which man and machine join forces to flee the past and forge into the future. The car becomes a kind of cultural "get-away" vehicle; the artist, a cultural race-car driver.

The car affected not only the content of Futurist art but also its form. To express the tumultuous sensations of motorized travel, the Futurists, with the help of Cubism, attempted to develop a new pictorial vocabulary. "[For] the new conditions of life", Boccioni declared, "the Futurists intend to discover a new means of expression." The insight into the dynamic and simultaneous essence of reality provided by the car also encouraged the Futurists to work abstractly. As an object that has revolutionized modern life, the automobile was a prophetic selection as a Futurist symbol, and it has continued to be of iconographic significance in modern art. Nearly all the themes explored in later art — the car as symbol of technology, modernity, freedom, power, machismo, sexual initiation, etc., and creator of dynamic, simultaneous, intoxicating sensations — have their precedent in Futurism, although Futurist "autolatry" has often been replaced by a more critical attitude. (GS)

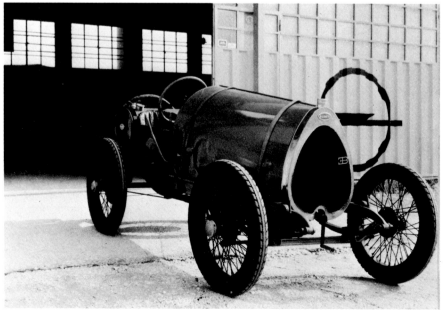

*Photograph of F. Azari dedicated
to F.T. Marinetti*

*Bugatti car Type 13, 1910-21
Two-seater racing version
Maximum speed 160 km/h
Private Collection*

Aviation

Of all the means of transport, only the aeroplane interested the Futurists as much as automobiles, but the older systems were not completely neglected — there are trains in Boccioni, GAN and Severini; ships and sailors in Nevinson, Wadsworth, Tatlin and Dix, for example. However, aeroplanes are considered "superior": "We will cut our aeroplanes from the ochre-coloured canvas of sailing ships", proclaimed the manifesto *Let's Kill Moonlight!*. Although the Futurist praise of aviation symptomatically intensified under Fascism, it is significant that "trembling aeroplanes" were present already in the first manifesto of 1909.

The Futurists saw the aeroplane as expressing machines, speed and weapons, but the *Technical Manifesto of Futurist Literature* in 1912 suggested another reason for valuing it: "Looking at objects from a new point of view, no longer from in front or behind, but from above — that is to say, foreshortened — I was able to break the old logical shackles and the plumb-lines of the old understanding." Their admiration was not always passive: the Russian Kamensky was famous as a stunt pilot before the First World War and before he joined Futurism; and the *Manifesto of Aeropainting* (1929) recalled that "in 1926 the Futurist painter and aviator Azari created the first 'aeropainting' — *Perspectives of Flight*, shown in the big Futurist hall at the Venice Biennale" (see *Choreography*).

There are frequent references to aviation in Futurist literature — Marinetti's *The Pope's Aeroplane*, Buzzi's *Aeroplanes*, the *Aeroplane Poems* by the Russian Constantin Olimpov, and *Aeroplane* by the Mexican Kyin Taniya. Certain texts by Apollinaire and Cendrars also come to mind, and the *Cape of Good Hope* which Jean Cocteau dedicated to the aviator Roland Garros. Aeroplanes appear in the paintings of the Italians, but also in others — the Synchromist MacDonald-Wright, the Stridentists Charlot and Alva de la Canal, Delaunay, Duchamp. Finally, the flying machine invented by Tatlin should not be forgotten. (SF)

J. Schmalzigaug, *letter to his parents*, 1911

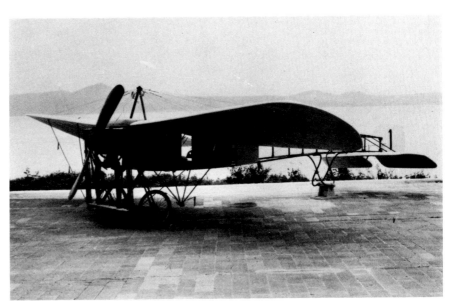

Blériot XI, monoplane, 1910

F.T. Marinetti
The Pope's Aeroplane, *1914*

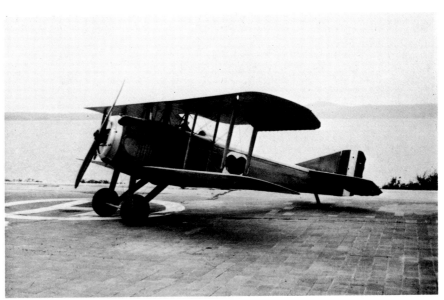

SPAD VII, 1917 Fighter plane produced in the First World War
Museo Storico Aeronautica Militare

Azari, Fedele

(Pallanza, 1896 - Milan, 1930) Italian painter and writer

From 1915 onwards, Fedele Azari made an important contribution to the Futurist poetic myth of aeromechanics, as an aviator, "aeropainter", "aviopoet", playwright, theoretician, printer and publisher. He was a respected forerunner of "aeropainting" who used a typical "mechanical art" idiom. In the second half of the Twenties he promoted the production of utilitarian objects, furnishings and editions by the Dinamo-Azari company in Milan. He wrote several manifestos: *Futurist Aerial Theatre* (1919); *Futurist Flora and Plastic Equivalents of Artificial Odours* (1924); *Futurist Simultaneous Life* (1925); *In Favour of a Society for the Protection of Machines* (1925). (ECr)

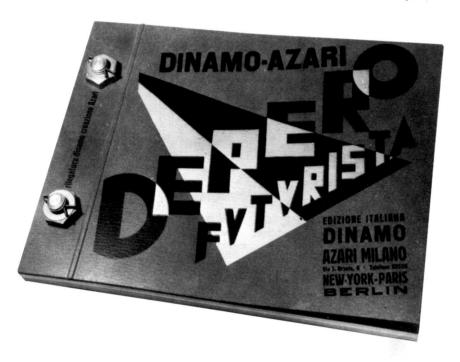

F. Depero, Bolted Book, *1927*

G. Balla, Ceramic Box, *1917-18*

Balla, Giacomo

(Turin, 1871 - Rome, 1958) Italian painter

Giacomo Balla studied the violin as a boy and began to draw and paint early. Around 1891 he enrolled at the Albertine Academy in Turin for a few months. His first known painting, a self-portrait, dates from 1894. In 1895 he moved to Rome with his mother. In 1900 he spent seven months in Paris. He taught painting to Gino Severini and Umberto Boccioni. In 1910, when he joined Futurism and signed the *Manifesto of Futurist Painters*, and the *Technical Manifesto of Futurist Painting*, he was already widely known.

In 1912 he went to Düsseldorf to decorate the Löwenstein house. In 1913 he put all his paintings up for auction announcing: "Balla is dead. Here the works of the late Balla are on sale." In the same year, and again in 1914, he returned to Düsseldorf to complete the decoration and furnishing of the Löwenstein house. With Depero, he signed the *Manifesto of the Futurist Reconstruction of the Universe* (1915). In 1921 he designed the interior of the Bal Tik-Tak a Futurist-style dance-hall. With Depero and Prampolini, in 1925 he participated in the "Exhibition of Decorative Arts" in Paris with six large painted wall-hangings.

Towards the end of the Thirties he dissociated himself from Futurism, "in the conviction that pure art is to be found in absolute realism, without which one falls into decorative ornamental forms".

In his pre-Futurist production, Balla's starting points were the Pointillism of Pellizza da Volpedo and Segantini, Eugène Carrière's Intimism, and his knowledge of the French Impressionists and Postimpressionists, as well as his interest in photography which suggested particular viewpoints — "zoom shots" of details, or a wide, decentralized perspective. His rendering is both intense and realistic in its perception. The colour is fresh and applied in commas, filaments or dots, interwoven in a dynamic texture.

His first painting was *Street Light* (*Arc Lamp*), inspired by Marinetti's *Let's Kill the Moonlight!* and dated 1909, like the manifesto; in reality it was painted in 1910-11. But it was only in 1912 that Balla — who did not participate in the Futurist exhibition in Paris at the beginning of the year — definitely turned towards the new Futurist ideas of dynamism, with paintings such as *Dynamism of a Dog on a Leash* and *The Hand of the Violinist*. In their rendering of movement these are related to Anton Giulio Bragaglia's *fotodinamismo*, which his ex-pupil Umberto Boccioni rejected.

Whereas Carrà, Severini, Boccioni and Russolo show coincidences and synchronicities in their phases of development, Balla followed an independent evolution. And whereas Boccioni aimed at a subjective synthesis, Balla kept to an objective analysis. He focusses on a detail, not on the whole, and creates linear arabesques rather than complex structures. His Positivist, scientific approach is overlaid with the Theosophical magic principle of "correspondence". This is the deep connection that the *Iridescent Compenetrations*, painted between the end of 1912 and 1914, aim to explore. These are totally abstract compositions based on the interlinking of triangular forms with a flat surface, inspired by the Secession, but Balla uses the motif with a purity and pictorial intensity that has no precedents in that culture. The idea of interpenetration refers to the concepts — fundamental in hermetic and Theosophical thought — of "mercurial" integration or conjunction. The same thought lies behind the theme itself: the rainbow symbolizes the simultaneous presence and harmony of all colours, a poetic idea of totality interpreted as the law of love and process of attraction. This totality is grasped in the detail, since the great cosmic structures are reflected in the small, the macrocosm in the microcosm.

For Balla, 1913 was the year of the speeding automobiles and swallow flight. Movement is now rendered in decidedly more abstract terms, although Balla remains faithful to dynamic representation as a sequence or trajectory. The image opens out in rapid succession like a fan, and the chiaroscuro, with its crescendo and fading, expresses a sense of swiftly passing time. Amid the darting and diving of the swallows, abstract luminous trajectories appear which Balla called "movement lines"; often they identify a mobile viewpoint corresponding to the painter's as he walks up and down in his studio with its windows opened wide; the double evaluation of motion — of the subject and of the object — is in fact necessary for a realistic image of movement.

Another obvious symbol of mercurial "conjunction", in the astronomical field, is *Mercury Passing in front of the Sun*, which Balla painted in several versions in 1914, reducing the interpretation of this event in the sky to an interpretation of the elements themselves, triangles and circles alluding to the abstract dynamism of automobiles. The triangle is the dynamic form par excellence, the penetrating form.

At this stage Balla's painting no longer aimed to represent the object, but to render its essence, the state of revelation; and the

essence condensed in the image is, in the final analysis, sensibility, in other words lyricism, the diffused ethereal element which permeates everything. This delicate constant does not however preclude the stereometric strength of the composition, or the vibrant energy of the colour which conveys a joyous, optimistic message. The optimism is intensified by the influence of Marinetti's humour and Palazzeschi's playful poetry which inspired Balla's own coloured "words-in-freedom". In the *Manifesto of the Futurist Reconstruction of the Universe*, Balla, together with Depero, adopted Marinetti's suggestion of the work of art as "Presence", "Object", and "Action". Developing Boccioni's ideas for Futurist sculpture, and remembering Marinetti's and Palazzeschi's onomatopoeias, Russolo's manifesto on *The Art of Noises*, and Carrà's on *The Painting of Sounds, Noises and Smells*, Balla and Depero in fact planned — and even made — fixed or mobile "plastic complexes". These were made of "coloured strands of wire, cotton, wool, silk, of every thickness. Coloured glass, tissue paper, celluloid, wire-netting, transparent materials of all sorts, brightly coloured. Fabrics, mirrors, metal sheets, coloured tin-foils, every sort of gandy

material. Mechanical and electrical devices, musical and noise-making elements; chemically luminous liquids of variable colours, springs, levers, tubes etc., water, fire, smoke". The object of inspiration and attention will be "every action that develops in space". They propose the "Futurist toy", the "plastic-motor-noise concert in space", "transformable clothes", the "transformable building in noise-ist style". The aim is to "reconstruct the universe making it more joyful, in other words by a complete re-creation. We shall give skeleton and flesh to the invisible, the impalpable, the imponderable, the imperceptible. We shall find abstract equivalents for all the forms and all the elements of the universe, then we shall combine them together according to the caprice of our inspiration, to form plastic ensembles that we shall set in movement".

The *Manifesto of the Futurist Reconstruction of the Universe* springs from a convergence of Futurism with the Jugendstil current which had already suggested to Balla an interest in the human environment, in furniture and interior decoration. Besides the decoration of the Löwenstein house in Düsseldorf (1912-14; destroyed), in which the motif of bichrome, iridescent "com-

penetrations" was widely applied, Balla designed many pieces of furniture. Initially he used the same triangular shapes, and then the imaginative, unrestrained forms of his more mature abstract work, which he continued for many years, after Boccioni and Sant'Elia were dead and Carrà, Severini and Russolo had left Futurism.

In the Twenties, particularly after 1925, however, Balla began to alternate figurative paintings with his Futurist work. In the former, abstract compositions are sometimes relegated to the background to suggest a dynamic environment. His Futurist production became increasingly slight, often limited to decorative work (wall-hangings, furniture etc.), and after 1934 completely ceased.

In his post-Futurist paintings, his original Pointillist technique is replaced by a pursuit of light based on brilliant colours and flaking thicknesses of material, creating a vague, melting vision. The Futurist concept of the ectoplasmic identification of dynamism-energy-matter-light remains, but is expressed with a strong realistic accent (and with a persistent mystical, almost parapsychological allusion), avoiding any contact with the parallel work of the Novecento artists. (MCal)

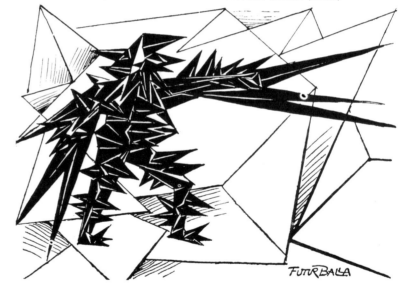

L'Italia Futurista, *25 August 1916*

(*right, above*)
G. Balla, metal costume for a ballet, 1918

G. Balla, Bal Tik-Tak
design for an electric sign

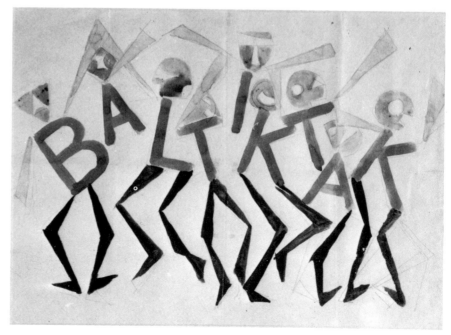

Baranoff-Rossiné, Vladimir

(Kherson, 1888 - Germany, 1944?) Russian painter

After studying at the Imperial Academy and the Higher Technical School, Baranoff-Rossiné showed in the earliest exhibitions of the Petersburg avant-garde under the name of Vladimir Baranov (Venok-Staphanos in 1909, the "Impressionists", organized by Kulbin, the Union of Youth in 1910). In 1910 he arrived in Paris where he stayed until 1914. He then used the name Daniel Rossiné and exhibited regularly at the Salon d'Automne. In 1912 he lived at "La Ruche" and participated in the activities of the Russian colony in Paris which centred around the salon held by the Baroness Oettingen. He became a friend of Robert Delaunay and Sonia Terk and started experimenting with colour and simultaneity. Around this time the critics began to discover his work and Apollinaire, in *L'Intransigeant* of 5 March 1915, called him the "French Futurist whose metallic and polychrome sculpture, the *Symphony*, has qualities".

At the outbreak of the First World War, Baranoff-Rossiné returned to Russia but left again immediately for Norway, where the Blomquist Gallery organized a large show of his work in November 1916. After the fall of the Czarist regime, he returned to Petrograd. Thanks to the friendships he had established with his compatriots during his first stay in Paris, particularly with Shterenberg and Lunacharsky, he was given an official job: in 1918 he organized a painting workshop in the old St. Petersburg Academy, before leaving for Moscow where he taught at Vkhutemas. While continuing to teach, he devoted himself to perfecting his "phono-optic piano", patented in Russia on 18 September 1923 and presented to the public the following year at the Bolshoi Theatre.

In 1925, helped by his friends the Delaunays, Baranoff-Rossiné left Russia and settled in France. He showed regularly at the Salon des Indépendants and also perfected and promoted a number of inventions, such as the "Measurer" or "photochromometre", an instrument for analyzing and classifying precious stones.

In 1943 he was arrested by the Gestapo and deported to Germany, where he died. (SZ)

Barradas, Rafael Perez

(Montevideo, 1890 - Montevideo, 1929) painter of Uruguayan origin

In 1911 Rafael Perez Barradas travelled to Europe on a scholarship and visited Italy, France and Spain. In Milan he met Marinetti and became very enthusiastic about the Futurist movement. He reached Barcelona in 1913 and decided to settle in Spain, where he was to develop his own personal version of painterly dynamism, "Vibrationism". Between 1913 and 1928 he lived in Barcelona, Madrid and Saragossa acting as an intermediary between the avant-garde groups of these cities. He produced numerous drawings for magazines, including the earliest issues of the prestigious *Revista de Occidente* (Madrid, 1923). In Barcelona he made his living by illustrating magazines for children (*Alegria*) and books. He organized weekly meetings in his house near Barcelona fre-

Poster for concert by Baranoff-Rossiné Moscow, 1924

R. Barradas, Portrait of Salvat-Papasseit *1918*

Benedetta, Human Forces, *1924*

quented by artists and literati from all areas, including Salvador Dalí, García Lorca and Marinetti. At the end of 1928 he went back to Montevideo as the director of the Museum of Modern Art, and died a few months later. Barradas's character, which impelled him to an unending search for the new, led him to experiment with different theories and techniques of painting: "planism", "clownism", mystical-religious compositions and, most important, Vibrationism. (JAJ)

Benedetta

(Rome, 1897 - Venice, 1977) Italian painter and writer

Benedetta Cappa married the "leader" of Futurism in 1923 after their meeting between 1917 and 1918 in Balla's studio in Rome. Working alongside Marinetti, she enjoyed a long and varied creative career within Futurism. She studied painting and during the Twenties and Thirties developed a personal lyric form that contained "aero-painting" themes (in 1934 she painted five *Panels of Land, Sea, Air, Telegraphic, Telephonic, and Radio Communications*, for the Post Office Building in Palermo); in the early Twenties she delved into the new experimentation with Tactilism. She also wrote *Le forze umane* (*The Human Forces*, 1924), an abstract novel with graphic elements, and a shorter work, the *Viaggio di Gararà* (*Gararà's Journey*, 1931), a cosmic novel for theatre, with proposals for poetic visualization that reached the limits of graphic abstraction in a psychological analogy. Along with the "designed states of mind" by Giuseppe Steiner and Pietro Illari, these proposals constitute the most radical examples of the graphic aspect of the Futurist "words-in-freedom" experimentation. (ECr)

Bergson, Henri

(Paris, 1859 - Paris, 1941) French philosopher

The insistence of the philosopher Bergson on criticizing rational intelligence in order to give greater importance to intuition, made him a perfect link between the Symbolist era and the various trends of Cubism, Surrealism, and Modernism. Futurism and its related movements accepted the French philosopher eagerly. Together with Nietzsche, he lies at the source of the Catalan Futurism of Gabriel Alomar. He also inspired the English Imagist T.E. Hulme. In 1909, Giovanni Papini's *Filosofia dell'intuizione* (*The Philosophy of Intuition*), assembled a selection of writings by Bergson; the philosopher's name later appeared repeatedly in the Futurists' writings in *La Voce* and in *Lacerba* — for instance, in *Il dinamismo futurista e la pittura francese* (*Futurist Dynamism and French Painting*) by Boccioni. (SF)

Berlin

Futurism reached Berlin through the magazine *Der Sturm*, which besides being the official organ of German Expressionism was alert to all new developments in Europe. Futurist manifestos were published in it in 1912, the same year in which a gallery of contemporary art linked to the magazine was opened. The second exhibition of that year was devoted to the group of Futurist works that had recently been presented in Paris. Also in 1912 in Berlin, Meyer published a selection of poetry by Marinetti, collected under the title *Futuristische Dichtungen* (*Futurist Poetry*) translated by Else Hadwinger. Marinetti himself visited Berlin often. In this way, Italian Futurism spread in Germany and influenced painters such as Lyonel Feininger, Franz Marc and August Macke, and writers such as August Stramm and Alfred Döblin. In 1913, after the *Technical Manifesto of Futurist Literature* appeared, Döblin published his *Futurist Verbal Technique*; he was not entirely satisfied with those theories, but he often utilized such Futurist techniques in his prose as long "strings" of verbs and nouns without punctuation. There is no doubt that future Dadaists such as Richard Huelsenbeck and Kurt Schwitters were to consider these procedures with careful attention. In 1922 Ruggero Vasari published in Berlin the magazine *Der Futurismus*, but by then Futurism in Germany had outlasted its time. (SF)

Blast

(London, 1914-15) British periodical

The arrival of the Vorticist movement in England was announced, very dramatically, by the first issue of *Blast* magazine (July 1914). Influenced by the freewheeling typography of Italian Futurist publications, and by Apollinaire's manifesto *Futurist Anti-Tradition* (1913), *Blast* used bold capital letters, geometric page designs and a brilliant pink cover to punch home its exuberant message. The preliminary manifestos were written by members of the group in collaboration, and a selection of their works was reproduced in the magazine. Ezra Pound, Henri Gaudier-Brzeska and Edward Wadsworth contributed written material as well, but most of *Blast No. 1* was written by its energetic editor Wyndham Lewis. He also wrote most of the essays in the second and last issue of *Blast* (July 1915). But it was a more sombre publication, a "war number" with a harsh, monochrome cover. Gaudier's tragic death in the trenches was announced, and soon afterwards most of the other Vorticists became involved in the fighting in France. Lewis's attempt to produce a third issue of *Blast* in 1919 came to nothing. (RC)

Der Futurismus, *Berlin, June-July, 1922*

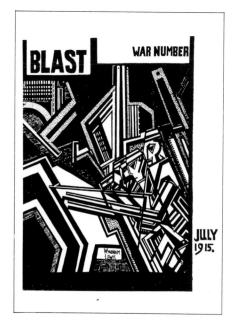

Blast, War Number, *London, July 1915*

Boccioni, Umberto

(Reggio Calabria, 1882 - Sorte, Verona, 1916) Italian painter and sculptor

As a child Umberto Boccioni moved from place to place, following his father Raffaele who was a civil servant. A few weeks after his birth the family moved to Forlì for three years; then to Genoa (1885), and then in 1888 to Padua, where Umberto started school. Ten years later (1898) he followed his father to Catania, while his mother and sister Amelia remained in Padua. In Catania he enrolled at the Technical Institute. In the autumn of 1899, having obtained his diploma, he moved to Rome where he enrolled at the Free School of Nude Painting and took drawing lessons from a commercial artist by the name of Mataloni. In the summer of 1900 the painter Basilici introduced him to Severini, who became his friend. His first known work is from 1901 — a drawing dated 30 May done for his sister Amelia's birthday, and a painting with a male figure, on the back of a canvas of 1905.

In 1906 Boccioni left Rome for Paris, where he arrived on 1 April and remained until 27 August, when he departed for Russia. He visited Tsaritsin, Egoritsin, Moscow and St. Petersburg. On his return journey he stopped at Warsaw and Vienna, reaching Padua at the beginning of December. In April 1907 he moved to Venice; in August he finally settled in Milan, where his mother was living.

In January 1910 he met Marinetti and in February signed the *Manifesto of the Futurist Painters* with Balla, Carrà, Russolo and Severini. With the same artists he also signed the *Technical Manifesto of Futurist Painting*, dated 11 April 1910. In 1912 he produced the *Technical Manifesto of Futurist Sculpture*, also dated 11 April. In March 1914 he published the book *Pittura scultura futuriste* (*Dinamismo plastico*) - *Futurist Painting and Sculpture* (*Plastic Dynamism*). He also wrote, but did not publish, a manifesto of Futurist architecture.

Up to 1914 he contributed to all the main exhibitions of the Futurist movement. In July 1915 he enrolled in the Battalion of Cyclist Volunteers and left for the front. At the beginning of December he was discharged and returned to Milan. In July 1916 he returned to military service and was assigned to an artillery regiment at Sorte, near Verona, where he was thrown from a horse and killed.

Boccioni's pre-Futurist production is marked by his Roman schooling. During those years, when he studied under Giacomo Balla and was in touch with painters like Cambellotti, Ettore Ferrari, Otto Greiner, Prini, Basilici and others, his work was based on two fundamental currents which he would continue to combine or contrast: Postimpressionism or Divisionism, and Symbolism, with influences of the Berlin, Munich and Vienna Secessions studied in reproductions.

An increasing plasticity of drawing and chiaroscuro accompanied the solidity of the perspectival setting achieved by well-balanced horizontal divisions and vigorous diagonals. He also learned an important lesson from the practice of pure drawing and the drastic simplification or emphatic viewpoints needed for the commercial

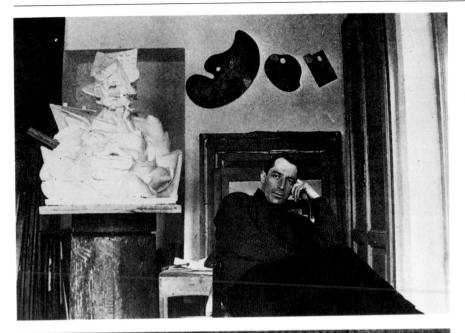

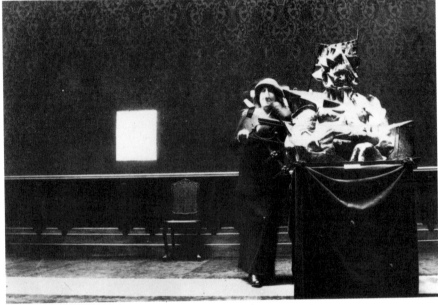

U. Boccioni in his studio, 1914

U. Boccioni, Head + House + Light
1913, La Boétie Gallery, Paris

U. Boccioni at the front, 1916

automobile illustrations he did before leaving for Paris. Alongside this graphic work, his painting moved in a parallel but separate direction, seeking the effects of a saturation of light and colour both in the atmosphere, and the forms themselves; this is evident particularly in his open-air subjects.

During his stay in Paris he discovered Cézanne, and also van Gogh and Toulouse-Lautrec. Within the limits of a plastically structured Postimpressionist style, this influence led to a more decided stress on planes, while his palette acquired greater brilliance in the flesh tones. The months in Venice suggested luminous effects, and when he finally settled in Milan he discovered Previati, the drawings of Beardsley and Käthe Kollwitz, and also rediscovered Munch. On the threshold of his Futurist period, in paintings like *Against the Light* or *Three Women* (1909-10), the animating quality of light is emphasized by the swirling brilliance of the colours broken up into the solar spectrum.

In his Futurist work, Boccioni is fundamentally concerned with rendering "dynamism" and "simultaneity". This he does by an intense, almost Expressionist use of colour and light, by using symbolic line directions and an original version of the Cubist break-up of form. But unlike Balla and the other Futurists, who tend to a mechanical and analytical solution, his translation of dynamism is synthetic, based in particular on Bergson's vitalistic principle of "duration".

Boccioni's violent aversion to the "schematic or successive reproduction of immobility and motion" practised by Balla or Russolo, is analogous, in fact, to Bergson's rejection of the "spatialized time" of positive science — time reduced to a succession of moments rather than evaluated globally as "duration" and a dimension of consciousness. For Boccioni, an immobile body moves (participating in the universal dynamism) no less than one which changes place. Hence Boccioni is interested not so much in the optical principle of the persistence of images on the retina as in the idea of the persistence of the contents of consciousness — the principle of "duration" which is realized in the dimension of memory. In "simultaneity", memory acts for a long time (real recollection) as if at very short range: the immediate recollection of the position assumed a moment before by the figure that we now perceive, dynamically and provisionally, in a new position.

In Boccioni's work before he discovered Cubism, simultaneity is created according to the mechanism, described in the *Technical Manifesto*, of the figure which "comes and goes", "rebounds", "appears and disappears, stimulated by the "universal vibration". The figure presents itself in multiple moments and multiple situations, also from the side and from behind, in an optical-mnemonic synthesis of viewpoints and times. In 1911 Cubism would give Boccioni new ideas for achieving simultaneity by breaking up the figure and distributing its parts.

Typical examples of his work before the meeting with Cubism are *Mourning* (second half of 1910) and *The City Rises* (1910-11). In *Mourning*, contrary to appearances, we

are not faced with the figures of six old women, but two, reproduced in three attitudes of desperate grief; one has white hair, the other red hair, and perhaps they are all a single figure whose white hair, in an expressionistic projection, becomes flame. This figure, or these figures, are therefore seen in different moments, presented simultaneously, of deep pain. It is curious that the same motif of plural dislocation of a single figure in various points in space is foreshadowed in a photograph of a few years before, in which Boccioni is portrayed from five different points of view combined in a montage.

In *The City Rises*, the whirl which surrounds the horse is the force of progress, of becoming, of life, but it is also a psycophysical flux in which time and space pursue one another in a circle. The vision is as though fixed in a mesh of dazzling moments, magnesium flashes, coordinated simultaneously in an optical and mnemonic dimension: the same group of the man and the horse is repeated near and far, on the right and on the left, in various points of the picture. In *The Farewells* (1911), painted after Boccioni had met Cubism, again we are faced not with several couples embracing, but with a single couple

reproduced in different space-time locations and projections. Henceforth Boccioni would increasingly break up the figures, displacing their different parts in various locations instead of repeating them whole within the picture space. Nearly always it was a search for "simultaneity", for a "synthesis between what is remembered and what is seen", in which there is scarcely any difference between memory, intuition and perception, because time is not divided into a succession of points but expressed as "duration" and convergence of all these different mental acts.

For Bergson, "duration" is memory and at the same time *élan vital* — vital energy, becoming and creation in process; and this suggestion, too, is reflected in Boccioni's Futurism. But to Bergson's absolute value of consciousness and his spiritualism, Boccioni — who talks about "universal vibration" and feels Impressionism deeply — adds the fact of sensation and the principle of light, which appears solid and dense, molecular. Boccioni does not follow Bergson when the philosopher distinguishes between matter and movement, matter and life; he rather accepts the solution of the physicists — the point which Einstein himself started from — according to which

matter is ultimately energy. This is a new intermediate value also with respect to the traditional antinomy of matter and spirit — a physical and psychic value, dynamic and expressive, touching the very life of the human psyche. *Matter*, of 1912, already proposes this synthetic solution, orchestrating the figure and the environment in a sort of chaos in tension in which they are connected by reciprocal "force-lines". In the splendid series of "Dynamisms" of 1913, the bodies melt in whirls with the space they move through. During the same year Boccioni also produced his sculptures which unite the figure with the space-energy in spirallic progressions and introduce the principle of *polimaterismo*, fusing a variety of materials in the dynamic tension.

Boccioni's last years were marked by a "return" to Cézanne. The series of portraits executed at Pallanza, before his departure for Sorte, even seem to mark a complete break with Futurism and a "return to the norm". However, since these were commissioned works, done for buyers who almost certainly did not want "Futurist" portraits, they cannot be taken as an absolute indication of Boccioni's real intentions and of what his future development might have been. (MCal)

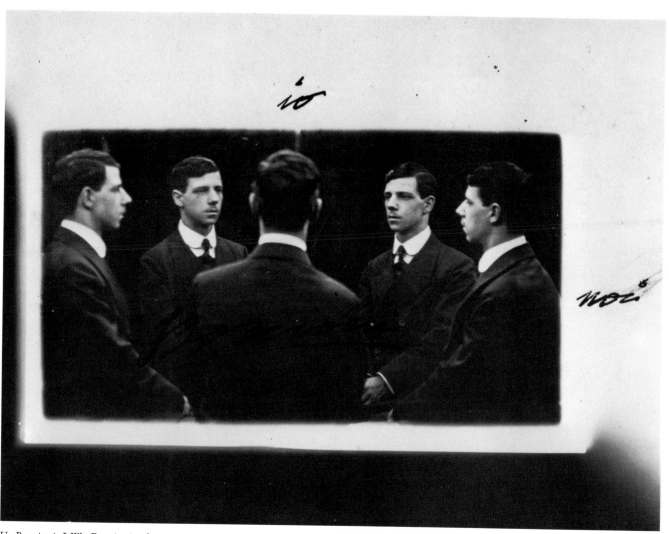

U. Boccioni, I-We-Boccioni, *photo*

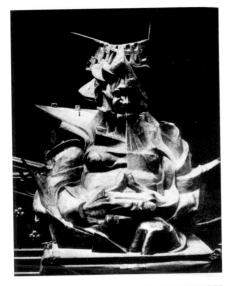
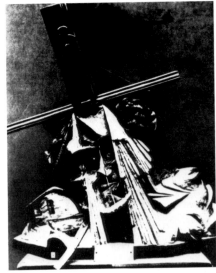
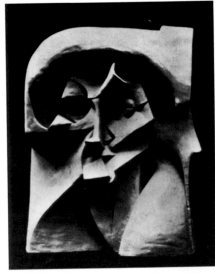

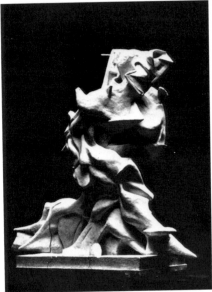
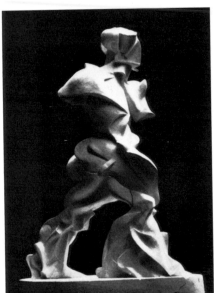
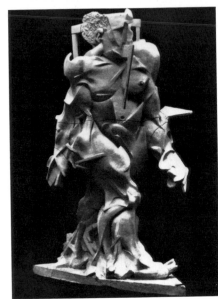

Boccioni's lost sculptures
Sculpture played an important role in Boccioni's rich production.
After having seen Cubist sculpture in Paris in 1912, Boccioni produced at least twelve important works between 1912 and 1914.
Some were in plaster, one in wood and others made out of several materials. Five of these sculptures have survived. The others seem to have been left in a more or less open space, after the retrospective of 1916-17, and were destroyed by the weather.

(from left to right, from above)
U. Boccioni, lost sculptures:

Head + House + Light, *1911-12*

Fusion of a Head and a Window
1911-12

Abstract Masses and Voids of a Head
1912

Muscles in Movement, *1913*

Spiral Expansion of Muscles in
Movement, *1913*

Synthesis of Human Dynamism, *1912*

Technical Manifesto of Futurist Sculpture
(Futurist manifesto, Milan, 11 April 1912)

The sculpture that we can see in the monuments and exhibitions of Europe affords us so lamentable a spectacle of barbarism and lumpishness that my Futurist eye withdraws from it in horror and disgust. We see almost everywhere the blind and clumsy imitation of all the formulae inherited from the past: an imitation which the cowardice of tradition and the listlessness of facility have systematically encouraged. Sculptural art in Latin countries is perishing under the ignominious yoke of Greece and of Michelangelo, a yoke carried with the ease of skill in France and Belgium, but with the most dreary stupefaction in Italy. We find in Germanic countries a ridiculous obsession with a hellenized Gothic style that is industrialized in Berlin and enervated in Munich by heavy-handed professors. Slavic countries, on the other hand, are distinguished by a chaotic mixture of Greek archaisms, demons conceived by Nordic literature, and monsters born of oriental imagination. It is a tangle of influence ranging from the sibylline and excessive detail of the Asiatic spirit to the puerile and grotesque ingenuity of Laplanders and Eskimos.

In all these manifestations of sculpture, from the most mechanical to those moved by innovating currents, there persists the same error: the artist copies live models and studies classical statues with the artless conviction that he can find a style corresponding to modern feeling, without giving up the traditional concept of sculptural form. One must add also that this concept, with its age-old ideal of beauty, never gets away from the period of Phidias and the artistic decadence which followed it.

It defies explanation how generations of sculptors can continue to construct dummies without asking themselves why all the exhibition halls of sculpture have become reservoirs of boredom and nausea, or why inaugurations of public monuments, rendezvous of uncontrollable hilarity. This is not borne out by painting which, by its slow but continuous renovations, harshly condemns the plagiaristic and sterile work of all the sculptors of our time. When on earth will sculptors understand that to strive to build and to create with Egyptian, Greek, or Michelangelesque elements is just as absurd as trying to draw water from an empty well with a bottomless bucket?

There can be no renewal of an art if at the same time its essence is not renewed, that is, the vision and the concept of the line and masses which form its arabesque. It is not simply by reproducing the exterior aspects of life that art becomes the expression of its time; this is why sculpture as it was understood by artists of the past century and of today is a monstrous anachronism. Sculpture absolutely could not make progress in the narrow path it was assigned by the academic concept of the nude. An art which has to undress completely a man or woman in order to begin its emotive function, is stillborn.

Painting fortified, intensified, and enlarged itself thanks to the landscape and the surroundings that the Impressionist painters made act simultaneously on the human figure and on objects. It is by prolonging their efforts that we have enriched painting with our *interpenetration of planes* (*Technical Manifesto of Futurist Painting*, 11 April 1910). Sculpture will find a new source of emotion and, therefore, of style, by extending its plasticity into the immense domain which the human spirit has stupidly considered until now the realm of the subdivided, the impalpable, and the inexpressible. One must start with the central nucleus of the object one wants to create, in order to discover the new forms which connect it invisibly and mathematically to the *visible plastic infinite* and to the *interior plastic infinite*. The new plasticity will thus be the translation in plaster, bronze, glass, wood, or any other material, of atmospheric planes that link and intersect things. What I have called *physical transcendentalism* (*Lecture on Futurist Painting* at the Circolo Artistico in Rome, May 1911) can render plastically the sympathies and mysterious affinities which produce the reciprocal and formal influences of the objects' planes.

Sculpture should give life to objects by rendering their extension into space palpable, systematic, and plastic, because no one can deny any longer that one object continues at the point another begins, and that everything surrounding our body (bottle, automobile, house, tree, street) intersects it and divides it into sections by forming an arabesque of curves and straight lines.

There have been two modern attempts to renew sculpture: one is decorative, for the sake of the style, the other is decidedly plastic, for the sake of the materials. The first remained anonymous and disordered, due to the lack of a technical spirit capable of coordinating it. It remained linked to the economic necessities of officialdom and only produced traditional pieces of sculpture more or less decoratively synthesized, and surrounded by architectural or decorative forms. All the houses and big buildings constructed with modern taste and intentions manifest this attempt in marble, cement, or sheets of metal.

The second attempt, more serious, disinterested, and poetic, but too isolated and fragmentary, lacked the synthesizing spirit capable of imposing a law. In any work of renovation, it is not enough to believe with fervour; one must also choose, hollow out, and then impose the route to be followed. I am referring to a great Italian sculptor: to Medardo Rosso, the only great modern sculptor who tried to enlarge the horizon of sculpture by rendering into plastic form the influences of a given environment and the invisible atmospheric links which attach it to the subject.

Constantin Meunier contributed absolutely nothing new to sculptural feeling. His statues are nearly always powerful fusions of the heroic Greek style and the athletic humility of the stevedore, the sailor, or the miner. His concept of plasticity and structure of sculpture in the round and bas-relief remained that of the Parthenon and the classical hero. He has, nevertheless, the very great merit of having been the first to try to ennoble subjects that before his time were despised, or else abandoned to realistic reproduction.

Bourdelle displays his personality by giving to the sculptural block a passionate and violent severity of masses that are abstractly architectonic. Endowed with the passionate, sombre, and sincere temperament of a seeker, he could not, unfortunately, deliver himself from a certain archaicizing influence, nor from the anonymous influence of all the stone-cutters of Gothic cathedrals.

Rodin unfolded a greater intellectual agility, which permitted him to pass with ease from the Impressionism of his *Balzac* to the irresolution of his *Burghers of Calais*, and to all his other works marked by the heavy influence of Michelangelo. He displays in his sculpture a restless inspiration, a grandiose lyrical power, which would be truly modern if Michelangelo and Donatello had not already preceded him with nearly identical forms some four hundred years ago, and if his gifts could have brought to life a completely re-created reality.

One finds then in the work of these three talents the three influences of three different periods: Greek in Meunier's work, Gothic in Bourdelle's, Italian Renaissance in Rodin's.

The work of Medardo Rosso, on the other hand, is revolutionary, very modern, more profound, and of necessity restricted. There are hardly any heroes or symbols in his sculptural work, instead the plane of the forehead of one of his women or children embodies and points to a release toward space which one day will have in the history of the human mind an importance far superior to that now acknowledged by contemporary critics. Unfortunately, the inevitably Impressionistic laws of his endeavour limited the researches of Medardo Rosso to a sort of high or low relief; it is proof that he still conceived of the figure as an isolated world, with a traditional essence and episodic intentions.

The artistic revolution of Medardo Rosso, although very important, starts from a pictorial point of view too much concerned with the exterior, and entirely neglects the problem of a new construction of planes. His sensual modelling, which tries to imitate the lightness of the Impressionists' brushstroke, creates a fine effect of intense and immediate sensation, but it makes him work too quickly after nature, and deprives his art of any mark of universality. The artistic revolution of Medardo Rosso thus has both the virtues and the faults of Impressionism in painting. Our Futurist revolution also began there but, by continuing Impressionism, it has come to the opposite pole.

In sculpture as well as in painting, one can renew art only by seeking the *style of movement*, that is, by forming systematically and definitively into a synthesis that which Impressionism offered in a fragmentary, accidental, and consequently analytical way. This systematization of the vibration of light and of the interpenetrations of planes will produce Futurist sculpture: it will be architectonic in character, not only from the point of view of the construction of the masses, but also because the sculptural block will contain the architectonic elements of the sculptural milieu in which the subject lives.

Naturally we will create a sculpture of environment. A Futurist sculptural composition will contain in itself the marvellous

Photodynamic of U. Boccioni, attributed
to Giannetto Bisi

mathematical and geometric elements of modern objects. These objects will not be placed alongside the statue, like so many explanatory attributes or separate decorative elements but, following the laws of a new conception of harmony, they will be embedded in the muscular lines of a body. We will see, for example, the wheel of a motor projecting from the armpit of a machinist, or the line of a table cutting through the head of a man who is reading, his book in turn subdividing his stomach with the spread fan of its sharp-edged pages.

In the current tradition of sculpture, the statue's form is etched sharply against the atmospheric background of the milieu in which it stands. Futurist painting has surpassed this conception of the rhythmic continuity of lines in a figure and of its absolute isolation, without contact with the background and the *enveloping invisible space*. "Futurist poetry", according to the poet Marinetti, "after having destroyed traditional prosody and created free verse, now abolishes syntax and the Latin sentence. Futurist poetry is a spontaneous, uninterrupted flow of analogies, each of which is intuitively summed up in its essential substantive. From this come *untrammelled imagination and words in freedom*". The Futurist music of Balilla Pratella destroys the chronometric tyranny of rhythm.

Why, then, should sculpture remain shackled by laws which have no justification? Let us break them courageously and proclaim the *complete abolition of the finished line and the closed statue. Let us open up the figure like a window and enclose within it the environment in which it lives.* Let us proclaim that the environment must form part of the plastic block as a special world regulated by its own laws. Let us proclaim that the sidewalk can climb up your table, that your head can cross the street, and that at the same time your household lamp can suspend between one house and another the immense spider-web of its dusty rays.

Let us proclaim that all the perceptible world must hurry toward us, amalgamating itself with us, creating a harmony that will be governed only by creative intuition. A leg, an arm, or any object whatsoever, being considered important only if an element of plastic rhythm, can easily be abolished in Futurist sculpture, not in order to imitate a Greek or Roman fragment, but to obey a harmony the sculptor wishes to create. A sculptural ensemble, like a painting, can only resemble itself, because in art the human figure and the objects should live outside of and despite all logic of appearances.

A figure can have an arm clothed and the rest of the body nude. The different lines of a vase of flowers can follow one another nimbly while blending with the lines of the hat and neck.

Transparent planes of glass or celluloid, strips of metal, wire, interior or exterior electric lights can indicate the planes, the tendencies, the tones and half-tones of a new reality. By the same token, a new intuitive modulation of white, grey and black can augment the emotive force of the planes, while a coloured plane can accentuate violently the abstract significance of a plastic value.

What we have already said about *line-forces* in painting (Preface-Manifesto of the Catalogue of the First Futurist Exhibition in Paris, October 1911) applies equally to sculpture. In effect, we will give life to the static muscular line by merging it with the dynamic line-force. It will nearly always be a straight line, which is the only one corresponding to the interior simplicity of the synthesis that we oppose to the baroque exterior of analysis. However, the straight line will not lead us to imitate the Egyptians, the primitives, and the savages, by following the absurd example of certain modern sculptors who have hoped that way to deliver themselves from Greek influence. Our straight line will be alive and palpitating; it will lend itself to the demands of the infinite expressions of materials, and its fundamental, naked severity will express the severity of steel, which characterizes the lines of modern machinery. Finally, we can affirm that the sculptor must not shrink from any means in order to obtain a *reality*. Nothing is more stupid than to fear to deviate from the art we practice. There is neither painting, nor sculpture, nor music, nor poetry. The only truth is creation. Consequently, if a sculptural composition needs a special rhythm of movement to augment or contrast the fixed rhythm of the *sculptural ensemble* (necessity of the work of art), then one could use a little motor which would provide a rhythmic movement adapted to a given plane and a given line.

One must not forget that the tick-tock and the movement of the hands of a clock, the rise and fall of a piston in its cylinder, the meshing and unmeshing of two gears with the continual disappearance and reappearance of their little steel rectangles, the frenzy of a fly-wheel, the whirl of a propeller, all these are plastic and pictorial elements of which Futurist sculptural work must make use. For example: a valve opening and closing creates a rhythm as beautiful but infinitely newer than that of a living eyelid.

Conclusions

1. The aim of sculpture is the abstract reconstruction of the planes and volumes which determine form, not their figurative value.

2. One must *abolish in sculpture*, as in all the arts, the *traditionally "sublime" subject matter*.

3. Sculpture cannot make its goal the episodic reconstruction of reality. It should use absolutely all realities in order to reconquer the essential elements of plastic feeling. Consequently, the Futurist sculptor perceives the body and its parts as *plastic zones*, and will introduce into the sculptural composition planes of wood or metal, immobile or made to move, to embody an object; spherical and hairy forms for heads of hair; half-circles of glass, if it is a question of a vase; iron wires or trellises, to indicate an atmospheric plane, etc., etc.

4. It is necessary to destroy the pretended nobility, entirely literary and traditional, of marble and bronze, and to deny squarely that one must use a single material for a sculptural ensemble. The sculptor can use twenty different materials, or even more, in a single work, provided that the plastic emotion requires it. Here is a modest sample of these materials: glass, wood, cardboard, cement, iron, horsehair, leather, cloth, mirrors, electric lights, etc.

5. It is necessary to proclaim loudly that in the intersection of the planes of a book and the angles of a table, in the straight lines of a match, in the frame of a window, there is more truth than in all the tangle of muscles, the breasts and thighs of heroes and Venuses which enrapture the incurable stupidity of contemporary sculptors.

6. It is only by a very modern choice of subject that one can succeed in discovering *new plastic ideas*.

7. The straight line is the only means that can lead us to the primitive virginity of a new architectonic construction of sculptural masses and zones.

8. There can be a reawakening only if we make a *sculpture of milieu or environment*, because only in this way can plasticity be developed, by being extended into space in order to model it. By means of the sculptor's clay, the Futurist today can at last *model the atmosphere* which surrounds things.

9. What the Futurist sculptor creates is to a certain extent an ideal bridge which joins the exterior plastic infinite to the interior plastic infinite. It is why objects never end; they intersect with innumerable combinations of attraction and innumerable shocks of aversion. The spectator's emotions will occupy the centre of the sculptural work.

10. One must destroy the systematic use of the nude and the traditional concept of the statue and the monument.

11. Finally, one must at all cost refuse commissions of subjects determined in advance, and which therefore cannot contain a pure construction of completely renewed plastic elements.

Umberto Boccioni, painter and sculptor

C. Carrà, Caricature of Boccioni, *1911*

Bomberg, David

(Birmingham, 1890 - London, 1957) British painter

David Bomberg spent most of his childhood in the Whitechapel area of London. The fifth child of a Polish immigrant leather-worker, he suffered considerable hardship. After leaving school, Bomberg was apprenticed to the lithographer Paul Fischer, but he already wanted to become a painter. Having studied under Walter Bayes and Walter Sickert at evening classes, he abandoned lithography and — with the help of John Singer Sargent — he was accepted by the Slade School of Art. Between 1911 and 1913, when Bomberg studied at the Slade, London was invaded by a succession of avant-garde exhibitions from the continent. Post-Impressionism, Cubism and Futurism all impressed Bomberg, and their influence overshadowed his earlier admiration for Sickert, Degas and Michelangelo. Professor Tonks and his other Slade teachers disapproved, but Bomberg was among the first students of his generation to develop an uncompromising Cubo-Futurist style.

In 1912 he painted *Vision of Ezekiel*, inspired by the Old Testament prophet but executed in an idiom which suggests an intelligent awareness of Wyndham Lewis, Severini and Picabia. Severely simplified figures gesticulate on a geometric platform, and many of their bodies are painted in a dazzling combination of yellow and pink. It was a precocious achievement, fusing his Jewish interests with an enthusiasm for European painting at its most experimental. Wyndham Lewis was so intrigued by this 22-year-old artist that he made a special trip to visit Bomberg in his Whitechapel studio. Their relationship was marred by rivalry, for Lewis and Bomberg were both proud and independent men. But they recognised a shared commitment to revolutionize British painting, and remained in wary contact with each other.

Bomberg's involvement with the avant-garde was strengthened by a visit to Paris in the early summer of 1913. He went there with Epstein to find artists for the special "Jewish Section" of a "Twentieth Century Art" exhibition to be held at the Whitechapel Art Gallery. Epstein introduced him to many leading French artists, who confirmed his already avid interest in Cubism. Bomberg's art, at this stage in his career, concentrated almost exclusively on the human figure. Pared down to their essential forms, his bulky bodies assert weight and strength in monumental compositions of impressive authority. Sometimes, as in *Jewish Theatre* (1913), Bomberg drew specific inspiration from his early life, employing a language of dramatic human gesture which must have been af-fected by the Jewish drama he enjoyed at the local Pavilion Theatre. He was also interested in sport, and his painting *Ju-Jitsu* (1913) probably deals with the wrestling activities he witnessed in an East End gymnasium. *Ju-Jitsu* is the first of his paintings to reveal a squared-up grid, which fragments the figures and stamps a brazen geometrical pattern over the representational scene.

Bomberg used this device again in an early masterpiece called *In the Hold* (1913-14). Working this time on a much larger scale, he split the painting up into 64 separate squares. Each square is further subdivided into four triangles, so that everything is sliced and shattered. A harsh, jarring vitality is the result, reinforcing the dynamism and clangour of the subject Bomberg selected. *In the Hold* takes as its starting-point a group of workers shifting passengers on board ship — a scene he would have observed many times at the riverside docks near his home. It is a celebration of their strength and dignity, but at the same time Bomberg's grid breaks up their bodies and implies that they are being overtaken by the forces of mechanization.

In the Hold established Bomberg's reputation when it was exhibited at the first London Group show in March 1914. Many critics were baffled by its apparent abstraction, but others (including Roger Fry and

D. Bomberg and his painting, Ju-Jitsu, *1914*

T.E. Hulme) were impressed by the confidence and sturdy individuality of the painting. Wyndham Lewis tried to enlist Bomberg's support for the Vorticist movement, and asked him to send some illustrations to *Blast No. 1*. But Bomberg always resisted any approach which threatened his independence, and he refused to be associated with Vorticism. Nor did he need Lewis's help. In July 1914 he staged a large and highly impressive one-man show at the Chenil Gallery in Chelsea. It was an extraordinarily assured exhibition for such a young man, and the most recent painting it contained was one of his finest achievements. The painting was called *The Mud Bath*, probably as a reference to Schevzik's Vapour Baths in Whitechapel where the Jewish community used to meet, bathe and enjoy a massage. Bomberg's painting is in no sense a faithful record either of the baths or their inhabitants. The area of water is a strident red rectangle, and the bathers' bodies are blue and white. Most of the painting relies on these three colours, the red, white and blue of Britain's national flag. Bomberg emphasized this by exhibiting *The Mud Bath* outside the Chenil Gallery and decorating it with Union Jacks. Harsh, angular and machine-like in their movements, the figures who hurl their metallic limbs around this taut and energetic painting implement the beliefs Bomberg defined in a terse catalogue statement. "I APPEAL to a *Sense of Form*", he declared, explaining that "I look upon *Nature*, while I live in a *steel city*". He even insisted that "my object is the *construction of Pure Form*. I reject everything in painting that is not *Pure Form*".

In June 1915 Bomberg did agree to exhibit in the "Invited to Show" section of the Vorticists' London exhibition, but soon after he enlisted in the Royal Engineers. The war was for him a harrowing ordeal, and it changed his outlook very profoundly. After 1918 he returned to a more representational style, and in later life concentrated largely on highly-charged and expressive landscape painting in Palestine, Spain, Britain and Cyprus. (RC)

Bortnyik, Sándor

(Marosvasarhely, Hungary, 1893 - Budapest, 1977) Hungarian painter

After studying with Post-Impressionists such as Rippl-Ronai, Bortnyik first painted in a Fauve style, and then in the manner of the Expressionists. After joining Lajos Kassak's group "Ma", he turned towards political activism and towards a style of painting that was midway between Cubo-Futurism and a geometrical and dynamic Expressionism. This influenced his subject-matter — athletes in action, marching figures which at times resembled robots, locomotives, factories, etc. All this reached a climax in 1919, the year of the Hungarian revolution. After the revolution, Bortnyik lived in exile in Vienna and later in Weimar (1919-25) while continuing to contribute to *Ma*, the eponymous review published by the group. From 1920 on, under the influence of Kassak and Moholy-Nagy, he chose a more static art, a mixture of Purism and Constructivism. Paradoxically, it was in the Der Sturm Gallery that a collection of his work was exhibited for the first time. (SF)

A.G. Bragaglia, self-portrait, 1909

Arturo Bragaglia, portrait of A.G. Bragaglia

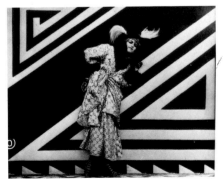

A.G. Bragaglia, still from the film Thais *1916*

Bragaglia, Alberto

also known as Visconti, Alberto
(Frosinone, 1896 - Rome, 1984) Italian painter and writer

From 1913, Alberto Bragaglia was a theorist of abstract theatre. His brother Anton Giulio Bragaglia devoted a chapter to him in *Del teatro teatrale ossia del teatro* (*On Theatrical Theatre, that is, Theatre*), and was influenced by his ideas. He produced a body of theoretical work including "Policromia spaziale astratta" (Abstract Spatial Polychromia), published in *Cronache d'Attualità* (1919, in five instalments), "Pan-plastica" (in *Cronache d'Attualità*, 1924), and "L'avvenire delle città" (The Future of Cities, 1930) on urban studies. Anton Giulio Bragaglia derived many theoretical concepts from Alberto Bragaglia. (MV)

Bragaglia, Anton Giulio

(Frosinone, 1890 - Rome, 1960) Italian set designer, and theatre and film director

Anton Giulio Bragaglia was a key personality in Italian theatre in the years of the historic avant-gardes. At the age of seventeen he worked as an assistant director at Cines, alongside Mario Caserini and Enrico Guazzoni. In 1910 he experimented with photography and in 1911 he suggested a theoretical basis for Futurist photography, "photodynamism", probably inspired by Jules Marey's chronophotography. In 1916 he directed several films: *Thais, Perfido incanto* (*Perfidious Enchantment*) and *Il mio cadavere* (*My Corpse*) with set designs by Enrico Prampolini. With the concept "photodynamism", he meant to free photography from natural realism and the limits of the snapshot. "Involved in the incessant race of our day, we see everything as a race", he declared in paragraph 9 of his *Fotodinamismo futurista* (*Futurist Photodynamism*), Nalato, 1911. Dynamic photos would not show movement as a blurring (a fault in photographic technique) nor as in chronophotography — it was not intended to reproduce the successive moments of the gesture, but to give a feeling of the movement and reconstruct it.

On 4 October 1918, at via Condotti n. 28 in Rome, he opened the Casa d'Arte Bragaglia with a solo exhibition of Giacomo Balla's work. In 1922 the Case d'Arte moved to via degli Avignonesi and then in 1932 to Scalone Mignanelli. Among the artists whose works he exhibited were Boccioni, Beckmann, De Chirico, Dottori, Evola, Farfa, De Pisis, the photographer Arturo Bragaglia, Futurist and Dadaist groups, Russians, Klimt, Paladini, Pannaggi, Prampolini, Mansurov, Sciltian, Scipione, Valente, Zadkine — a total of 275 shows.

In via degli Avignonesi, the Casa d'Arte occupied the ancient Roman baths of Septimius Severus (2nd century A.D.), and Bragaglia decided to build his own theatre there. The work of adaptation was entrusted to Virgilio Marchi; Balla, Depero, and Prampolini decorated the rooms.

Inaugurated with *Siepe a nord-ovest* (*Hedge to the North-West*) by Massimo Bontempelli (1923), the Teatro degli Indipendenti adopted the formula of "theatrical theatre", which meant non-academic directing and acting. The aim was to "reform the stage in order to renovate theatre". It favoured unpainted chromatic sets (*sceno-*

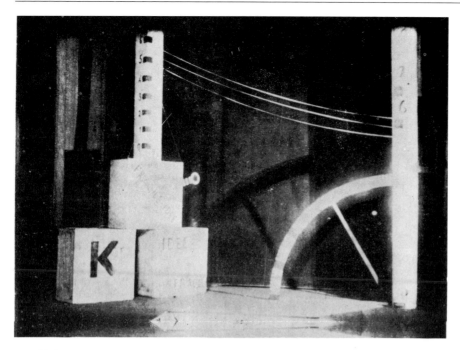

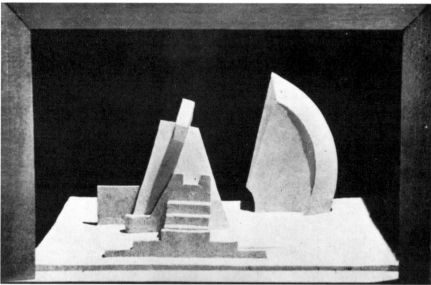

plastica), based on "psychological light", a criterion that Bragaglia had already adopted in the 1919 production of *Per fare l'alba* (*To Make Dawn*) by Rosso di San Secondo, with sets by Antonio Valente. The numerous works staged in the period from 1922-30 include *L'uomo dal fiore in bocca* (*The Man with the Flower in His Mouth*) and *All'uscita* (*At the Exit*) by Luigi Pirandello; *Bianca e Rosso, Fantocci elettrici* (*Electrical Puppets*), and *Il suggeritore nudo* (*The Nude Prompter*) by Marinetti; selections of Futurist syntheses (according to ideas set forth in the *Manifesto of Synthetic Theatre* by Marinetti, Settimelli, and Corra); texts by Soffici, Rosso di San Secondo, Campanile, Laforgue, Ribemont Dessaignes, Aniante, Jarry, O'Neill, Čapek, Sternheim, Schnitzler, and Apollinaire. An alert cultural organizer and impresario, Anton Giulio Bragaglia wanted a new theatre that would be open to the experimentation of the most important foreign schools (Russian, German, etc.). Refusing to follow the Futurist repudiation of the classics, he carefully studied the Commedia dell'Arte, Roman masks, the history of set design, and folk theatre. Among his many publications were *La maschera mobile* (*The Moveable Mask*, 1926); *Del teatro teatrale ossia del teatro* (*On Theatrical Theatre, That Is, Theatre*); and *Il teatro della rivoluzione* (*The Theatre of Revolution*, 1929). He also wrote on dance: *Scultura vivente* (*Living Sculpture*, 1928; film: *Il film sonoro* (*Talking Movies*, 1929); *Evoluzione del mimo* (*Development of Mime*, 1930); archaeology: *Nuova archeologia romana* (*New Roman Archaeology*, 1915). He was very active as a critic and journalist, editing the periodicals *Cronache d'Attualità*, *La Ruota*, *Bollettino della Casa d'Arte Bragaglia*, *Index Rerum Virorumque Prohibitorum* or *Breviario Romano*, based on "aesthetic grumbling" and "literary gossip", with anonymous contributions by Corrado Alvaro, Curzio Malaparte, Orio Vergani and many other writers of the period (the "Independents"), and drawings and caricatures by Longanesi, Bartoli, Pannaggi, Toddi, Deiva De Angelis, etc. With Sebastiano Arturo Luciani and the Futurist musician Franco Casavola, he signed the *Manifesto of Synopsy or Visual Transposition of Music* (1919). (MV)

Bragaglia, Arturo

(*Frosinone, 1893 - Rome, 1962*) *Italian photographer and actor*

Arturo Bragaglia experimented with Futurist photodynamics, as theorized by his elder brother Anton Giulio, trying to capture "immobile motion". Later, he became a well-known character actor, appearing particularly in his brother Carlo's films. (MV)

Bragaglia, Carlo Ludovico

(*Frosinone, 1894*) *Italian photographer, and theatrical and film director*

With his brother Anton Giulio, Carlo Ludovico Bragaglia, founded the Casa d'Arte Bragaglia (1918) and the Teatro degli Indipendenti (1922). At the Indipendenti he produced twenty-three works, including *Il suggeritore nudo* (*The Nude Prompter*) by Marinetti, and works by Vinicio Paladini, Umberto Barbaro and Diòtima, and Eugene O'Neill. (MV)

(from above) A.G. Bragaglia The Nude Prompter, *set design*

A.G. Bragaglia, Scenoplastic

A.G. Bragaglia, opening-day with the Futurists at the Casa d'Arte Bragaglia, 1922

Braque, Georges

(Argenteuil-sur-Seine, 1882 - Paris, 1963)
French painter

Of the two leading cubists, Braque and Picasso, Braque's work probably had the lesser influence on the Futurists, as he was the more classically oriented of the two. Nevertheless, in a few cases — as with the great *Nude* of 1909 (which seems to be Braque's answer to Picasso's *Les Demoiselles d'Avignon* of 1907), and in certain still life paintings from 1910 — Braque created some fairly dynamic compositions. The great portraits and still lifes of the analytical Cubist period also made a great impression, because of their clarity, and the strong logical consistency in the development of the space and the objects depicted. Braque was seriously wounded in the war, and in the post-war period never quite played the same role as Picasso in the evolution of painting. (PH)

Brazil

Although a Futurist movement never fully developed in Brazil, the debate between Marinetti and the *Lacerba* group was fundamental in determining some of the guidelines of literary Modernism in São Paulo, the prototype of the "modern city" in Brazil. However, although Oswald de Andrade called it a "city for all Futurism", the first discussion of Futurist ideas did not take place in São Paulo, nor were the Modernist intellectuals the first to use Marinetti's slogans. The *Foundation and Manifesto of Futurism*, translated from the March-April edition of *Poesia*, was published in *Jornal de Noticias* in Bahia by Almáquio Diniz on 30 December 1909. The first articles on Futurism were written by critics who did not support the new trend, and soon the adjective "Futurist" became a synonym for "pathological", "crazy", "bizarre", "strange". It was used indiscriminately to define all antirhetorical artistic experiences, whether anti-Parnassian or anti-academic.

The first, and only, issue of the "Futurist" *Orpheu* was published in Lisbon in 1915; it presented a variety of modern poetic theories and was co-edited by the Brazilian Ronald de Carvalho. By 1920 Futurism had become a fighting word, indicating opposition to all forms of past artistic expression. Marinetti, Govoni, Palazzeschi, Papini and Soffici were read and discussed, but for the Modernists Futurism represented more than a literary form of expression: it was an opportunity to affirm the modernity of São Paulo, and the younger generation's widespread anti-positivism and interest in Bergson. They took notice of Marinetti's extremist version of Futurism, but found more congenial ideas in Papini and Soffici, who were known chiefly through *L'esperienza futurista* (*The Futurist Experience*) and *Primi principi di una estetica futurista* (*First Principles of a Futurist Aesthetic*).

In 1921, the "Futurist question" was undoubtedly fundamental in the definition of the aims and strategy of the São Paulo Modernist group. The term "Futurismo paulista", coined by Oswald de Andrade, was used by the Modernists to indicate their own aesthetic credo — maximum liberty, spontaneous originality — and to react to any type of school, including

Invitation for the Modern Art Week São Paulo, 1922

Marinetti's "orthodox dogma", since they had been influenced by the *Lacerba* split between Futurism and Marinetti. The so-called "Futurismo paulista" did not go beyond a "simultaneous lyricism" related to the poetic theories of Apollinaire and Cendrars, or a superficial modernity. Its relationship with the latest Italian ideas and with modern art in general was not yet clear. Indeed, the performance of some Futurist pieces — *Zero meno zero* (*Zero minus Zero*) *Radioscopia* (*Radioscopy*), *Grigio + Rosso + Violetto + Arancione* (*Grey + Red + Violet + Orange*) — during Petrolini's tour in Brazil, between September and November of 1921, failed to provoke any public declaration from the Modernists, although they had access to the leading newspapers in São Paulo.

The debate over Futurism became more lively when the "Modern Art Week" (initially "Futurist Week") was organized on 11-18 February 1922. This represented the deliberate application of some of the essential strategies advocated by Marinetti: the "appropriation" of the main organs of the press in order to conduct the battle in defence of the new ideas; the union of the arts in a common front; the search for scandal and shock-effects; provocation and conflict with the public; and the presentation of works still "immature" or modern only in the subject matter, as an affirmation of the principles of the new aesthetic. On this occasion the Modernists again remained aloof from Marinetti, from the "dogmatism" and "liturgy" of his school, and from his "contradictory Futurism". Nevertheless, there was a Futurist vein in the magazine *Klaxon*, founded in May, evident particularly in its search for a modern language that was appropriate for a civilization based on technology and speed.

In this context it became clear that Futurism represented a "break in Brazilian evolution", becoming synonymous with

modernity and with Brazil's full participation in international cultural movements. The Modernist aesthetic was a necessary up-dating of Brazilian thought. It was completed by a national traditionalism which Mario de Andrade's publication *A escrava que não era Isaura* (*The Slave Who Was Not Isaura*, 1925), presented in anti-Marinetti terms. The author is close to Soffici in rejecting the "free-words", judged hermetic, false and monotonous, in favour of a "poetic polyphony" clearly simultaneist in character. Oswald de Andrade followed the same experimental lines, although in his *Memórias sentimentais de João Miramar* (*Sentimental Memories of João Miramar*, 1924) he used a "telegraphic style" not far from the "parolibere" ideas and the wild use of imagination propounded by Marinetti.

The subject of Futurism, by then rejected as threatening the specifically national quality of Modernist experiences, took on political overtones in 1926 on the occasion of Marinetti's tour of Brazil. He was received favourably in Rio de Janeiro, where Almáquio Diniz published *F.T. Marinetti: sua escola, sua vida, sua obra em literatura comparada* (*F.T. Marinetti: His School, Life and Work in Comparative Literature*) and Graça Aranha brought out a collection of manifestos in French entitled *Futurismo: manifestos de Marinetti e seus companheiros* (*Futurism: Manifestos by Marinetti and His Companions*). Nevertheless, the Italian poet did not succeed in gathering the Modernists in São Paulo around him. Accused of having hindered the development and the acceptance of the Modernist movement in Brazil, Marinetti found an unexpected ally in Brasil Gérson, who on 28 May published the *Manifesto futurista paulista*. The pamphlet was a collection of slogans from the manifestos of the second decade of the century and proposed a government which would abolish parliament and parties and act as an administration which would allow Brazil to become "Lord of all America". Considered by the São Paulo intelligentsia as a left-over, modernity turned into "modernolatry", Futurism appeared increasingly distant from the real interests of Brazilian culture. The nationalistic sentiments already voiced in the *Manifesto paubrasil* (1924) and in *Verde-amarelismo* (1926) were taken up by the magazine *Revista de Antropofagia* and in Mario de Andrade's rejection of industry in *Macunaíma* (1928). Factories and machines, Marinetti's symbols of modernity, came under fire: factories were a spurious element in Brazilian reality and machines were an obstacle in the Brazilian people's march towards a "tropical civilization", a civilization that, with Oswald de Andrade, took on a "cannibalistic attitude" of assimilation and creation.

Modernism, which had been moving towards the definition of a critical itinerary since 1923, found the means to realize its "emotional synthesis" between external reality and art in Expressionism. The "modernity at all costs" of Futurism could perhaps appeal to São Paulo, but not to the rest of the country.

However, whether it was accepted or rejected, Futurism is undoubtedly a necessary reference point for understanding Brazilian Modernism. From the meeting with Fu-

turism, from its challenging posture, its hostility towards the old (but not towards the past as such, because the "modern" idea runs parallel to the discovery of a non-academic past in Baroque art) and its love for the new, some of the fundamental strategies of the Brazilian avant-garde originated. Futurism prompted the birth of the Brazilian "dialogue with oneself", the clarification of the peculiar meaning of modernity in a "peripheral" country, a theme subsequently developed in Expressionist idioms. (AF)

Burliuk, David

(Kharkov, 1882 - New York, 1967) Russian painter

David Burliuk studied in 1898-99 in the art schools of Kazan and Odessa, then went on in 1902-03 to the Academy of Munich and, in the following year, to Paris. He exhibited in Moscow and St. Petersburg, and in 1911 contributed to the Blaue Reiter and Der Sturm shows, thus entering the history of European art, though without the momentum of other Russian artists of the period. In 1911 he was admitted to the Moscow Institute of Painting, Sculpture and Architecture, where he met Maiakovsky.

Besides being a professional painter, David Burliuk was a man of letters, and he regularly published poetry. Aside from exhibiting that synthesis of literary and artistic interests typical of the Futurists, he was possessed of remarkable organizational ability, of which he had already given proof in the publication of the first volume of the collection *Sadok sudej (A Trap for Judges)* in St. Petersburg in 1910. This volume, which marked the debut of Russian Proto-Futurism, included contributions by Vasily Kamensky, Elena Guro, Khlebnikov, and all three of the Burliuk brothers.

David Burliuk was the driving force behind the conception and organization of Russian Futurism and all its main publications, beginning with the first Russian Futurist manifesto, *A Slap in the Face of Public Taste*, issued in Moscow in 1912, and signed by David Burliuk, Alexei Kruchenykh, Maiakovsky and Khlebnikov.

In 1911 he invited Benedikt Livshits to his father's home in Chernjank, in Tauris — a region known to the ancient Greeks, and mentioned by Herodotus, as Hylaea (in Russian, Gileja). This primordial spot saw the birth of Russian Futurism, and gave the movement its first name. The artistic revolutionaries who belonged to it (later some of them would also be involved in politics) were known as "Hylaeans".

David Burliuk's biography is merged with the history of "his" Futurism (Cubo-Futurism). His poetry has meaning and worth only as a step in the overall creation of Futurism. As an artist, he was also a minor figure, overtaken by his brother Vladimir.

After the 1917 revolution, the Russian Futurist period ended and a new era began for all Russian literature and art. Burliuk's life also entered a different phase. After living in Vladivostok, in the Far East, where he contributed to the Futurist-Proletarian magazine *Tvorchestvo (Creation)*, he moved to Japan in 1920 and in 1922 settled in the United States. (VS)

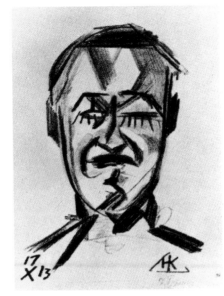

N. Kulbin, Portrait of David Burliuk 1913

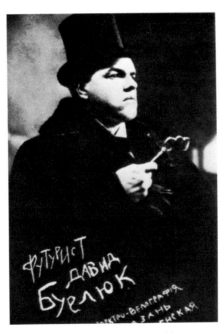

David Burliuk, the Futurist, 1914

D. and V. Burliuk
Vladimir Maiakovsky: A Tragedy, 1913

Burliuk, Nikolai

(1890 - 1920?) Russian writer

Like his brothers David and Vladimir, Nikolai Burliuk published poetry and prose in *The Impressionists' Studio* (1910). He was represented in most of the Futurist group's collective publications: *A Trap for Judges, A Slap in the Face of Public Taste, Service-Book of the Three, Croaked Moon, The Milk of Mares* etc. Unlike the other Russian Futurist poets, he was not interested in formal experimentation and is often more Impressionist than Futurist, and even close to the Acmeists (in *Roaring Parnassus* he refused to sign against the Acmeists and he remained a friend of their leader, Nikolai Gumilev). Nikolai Burliuk kept aloof from the noisy manifestations of his Futurist friends. On the occasion of Marinetti's visit to Russia, he disapproved of the hostility expressed by Khlebnikov towards the Italian poet. During the First World War he was conscripted and later demobilized, but nothing more is known of him; probably he was killed during the civil war. Although he was not the "untalented windbag" that Khlebnikov called him, he left only a minor body of work, remembered chiefly because it appears in most of the Russian Futurist magazines and almanacs. (SF)

Burliuk, Vladimir

(Kerch, 1886 - Salonika, 1917) Russian painter

Vladimir Burliuk visited Paris with his brother David in 1904. In 1907 he showed at the Blue Rose salon, but his art matured together with Futurism. He exhibited at the Jack of Diamonds in 1911-12. A friend of all the Futurists, he illustrated their books (together with his brother, Kamensky's famous *Tango with the Cows* in 1914) and painted their portraits. The most famous of these is his *Portrait of Livshits*, in which the Cubist break-up of form and a Futurist dynamism are combined in a rather schematic way — at that time the work of the Western avant-garde was known in Russia chiefly through photographs.

Vladimir Burliuk is probably best known for his illustrations for Futurist collective publications: *A Trap for Judges* (1910), *The Milk of Mares* (1914), *The Archer* (1915) and others. He also published some writing of his own (for example, in *The Roaring Parnassus*, 1914). He fought in the First World War and was killed by a shell near Salonika. (SF)

Buzzi, Paolo

(Milan, 1874 - Milan, 1956) Italian poet

Co-founder and co-director, with F.T. Marinetti and Sem Benelli, of the magazine *Poesia* in 1905; poet, narrator and critic; Buzzi joined the Futurist movement in 1909 and became a leading literary figure. He was willing to experiment, and he had an inclination toward philosophical speculation. In 1915 he published a volume entitled *L'ellisse e la spirale, film + parole in libertà (The Ellipse and the Spiral, Film + Words in Freedom)*.

In 1963 several other of his "words-in-freedom" texts were published posthumously in manuscript form in *Conflagrazione* (1915-18). He was a prolific writer whose publications spanned the range of

Futurist experimentation: *Aeroplani - Canti alati* (Aeroplanes - Winged Songs, 1909), *Versi liberi* (Free Verses, 1913), *Canto quotidiano* (Daily Song, 1933), and *Poema di radio-onde* (Poem for Radio-Waves, 1933-38). He also wrote Futurist theatrical syntheses. (ECr)

Café-Cabaret in Italy

Among the various possible locations for mass public interaction, the Futurist movement preferred the café-cabaret. As Marinetti wrote in the *Daily Mail* on 21 November 1921, café-cabaret was the only setting for variety theatre "that uses cinema, enriching it with countless visions and 'impossible' spectacles, a renovating show-window for innumerable inventive efforts", and today is "the crucible in which the elements of a new sensibility are boiling for the future". As in the tradition of all the avant-gardes, the café-cabaret is therefore the space which allows the greatest possible linguistic experimentation together with the maximum intensification of the relationship with a large number of spectators. And it is to the café-cabaret, with its cultural and spectacular possibilities, that Balla, Depero, the architect Marchi, Bragaglia and Prampolini turned in order to bring about a sensory transformation of the collective according to Futurist ideas. Since the experiments took place in Rome, the settings alternated between visual purism and applied arts — linked to Giacomo Balla's Jugendstil culture — and the mechanical and neo-plastic Constructivist influence of Prampolini and Pannaggi. All of them — together with Bragaglia and Depero — were linked by the common denominator of an interest in décor. The result was the creation of a series of messages intended to influence the life of the participating group as a whole.

In 1921 in Rome, Giacomo Balla took a Futurist approach in designing the *Bal Tic Tac*, using elements ranging from urban mechanisms to personalized furniture. The outside sign — six meters wide — had letters like people and was illuminated. Inside, he painted the walls with men and women dancing and lines in motion, and designed the chairs, tables and objects to give the space a dynamic impact, so that the movement of the setting would interpenetrate with the movements of the audience.

This phantasmagorical idea of décor was also adapted to the underground rooms of the Cabaret del Diavolo (The Devil's Cabaret) and the Casa d'Arte Bragaglia. The first, planned and executed in 1921 by Depero in the basement of the Hotel Elite et des Entrangers in Rome, consisted of a scenic "three-dimensional calligraphy", labelling the different levels Inferno, Purgatory, and Paradise. The spaces were distinguished by variations in the furniture and the wall decorations. From Paradise, all in light blue tones, the way led down to the completely green Purgatory, and lastly to the black Inferno.

The list of Futurist inventions in décor is remarkable and was linked to the propagandistic activities of the group. The public space was always fundamental and its importance was shown in the effect it had on neophytes. Bragaglia, after inaugurating his Casa d'Arte in 1918, invited architects and artists to give it a Futurist form for years afterwards. The ancient underground rooms of the Baths of via degli Avignonesi were transformed by Marchi, Pannaggi, Balla, into synthetic forms alternating between the organic shapes of the vaults and arches and the geometric abstraction of the furniture and other colourful structures.

At the same time Prampolini and Racchi founded the Casa d'Arte Italiana, also in Rome, with the idea of opening it to concerts, meetings, and lectures as well as exhibitions of "pure and applied art". The intention, unlike in previous settings designed for lovers of night life, was to create a Futurist cultural centre, where production and entertainment would be one and the same. At this point, however, Futurist décor moved from the idea of ephemeral consumption to that of industrial manufacture and distribution. (GC)

Café-Cabaret in the World

Cafés and cabarets have always played a part in the lives of writers and artists, but until the beginning of this century their importance was only as convenient meeting places. Already at the Chat Noir, where Bruant and some of the Symbolists recited poetry, posters and decorations done by artists began to appear on the walls. However it was only with the 20th century, and in particular with Futurism, that artists and writers decided to make these places their own, arranged according to their taste, where they could talk, meet the public, exhibit, recite their writings or organize *soirées*, performances and concerts. The whole of Futurism was marked by this, above all in Italy, but also in many other countries where Futurism had an impact.

In pre-revolutionary Russia there was the Cabaret no. 13, where in 1913 a Futurist film was shot featuring Goncharova and Larionov with painted faces. Marinetti spent several evenings at the Stray Dog, talking to Kulbin and his friends. After the revolution the habit remained and Yakulov designed the decorations of the Picturesque Café where the intelligentsia liked to gather. In Georgia, there was also the Fantastic Cabaret in Tiflis, where the 41 Group used to meet, and which gave its name to a famous anthology of Futurist writing. The English Vorticists met at the Golden Calf, decorated by Wyndham Lewis, or at the Eiffel Tower café-restaurant. The Mexican Stridentists had their Café de Nadie (Nobody's Café) where they held discussions or recitals for the public; it was decorated with their paintings and sculptures and they even held concerts there, as had become the custom in avant-garde cafés of Mexico, Italy, Poland and elsewhere. (SF)

Photo of P. Buzzi dedicated to F.T. Marinetti, 1914

F. Depero, handbill for the Devil's Cabaret 1921

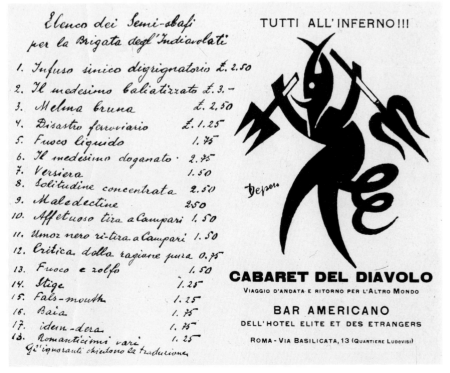

Cangiullo, Francesco

(Naples, 1884 - Leghorn, 1977) Italian painter, writer and "words-in-freedom" poet

In the visualization of Futurist "words-in-freedom", Francesco Cangiullo was an outstanding figure. In the second half of the Teens and the early Twenties, his work appeared in the pages of *Lacerba*, *Vela Latina* and *L'Italia Futurista*. His *Piedigrotta* of 1916 (which he dated September-October 1913), *Caffè-concerto - Alfabeto a sorpresa (Café Chantant - Surprise Alphabet)* of 1918 (dated 15 January 1915 in the manuscript) and *Poesia pentagrammata (Staved Poem)* of 1923 — are notable for their wealth of imaginative graphic solutions, even when the literary element remained decisive. His work was clearly influenced by Balla, his fellow-painter in the Futurist *soirées* at Giuseppe Sprovieri's galleries in Rome and Naples in 1914. Like Balla himself — with whom Cangiullo composed "words-in-freedom" in the famous *Palpavoce* of 1914 — he created fully-fledged painted "free-word plates", in an attempt to create "humanized letters". Cangiullo reinvented the typography of the printed page in the form of narrative fireworks, borrowing from advertising in a manner typical of the "collage" mentality, as for example in *Piedigrotta*. Later he began a fantastic deformation of writing, reducing it to an image of its alphabetic origin, visually theatricalized, as in the "surprise alphabet" in *Caffè-concerto*. He made his debut as a painter and sculptor in Rome in 1914 in the International Futurist Free Exhibition, exhibiting paintings created with Marinetti and Balla, and object sculptures. At the end of the Teens he exhibited "surprise alphabet" plates along with his younger brother Pasqualino. In 1920 he published the manifesto *Futurist Furniture*, with "surprise talking and free-word furniture". He was deeply interested in theatre in the early Twenties. In 1921 he was the art director of the Company of the Theatre of Surprise, directed by Rodolfo De Angelis, and he published with Marinetti the manifesto *The Theatre of Surprise*. After he left the Futurist movement in 1924, he contributed a memoir, *Le serate futuriste (The Futurist Soirées)*, published in 1930. (ECr)

Canudo, Ricciotto

(Gioia del Colle, Bari 1877 - Paris, 1923) Italian writer

In 1901 Ricciotto Canudo moved from the province of Bari to Paris, where he spent the rest of his life. Canudo — known in literary circles as le "barisien de Paris" — was a poet, novelist, critic, theoretician, musicologist, and playwright — in short, a most versatile figure. His literary works are multiform and still highly interesting today, not for their achievements, but for the creative impulses they carry. Canudo actively participated in the heated cultural debates of the Paris of his epoch as a Modernist. Though he was in favour of "modern, spontaneous, rebellious art, free from all dogmatism", he cannot be considered an avant-gardist. His sense of tradition was too strong and — unlike Marinetti — he saw no need for a clean slate, a break with the past. The most interesting side of Canudo's work is his aesthetic theory,

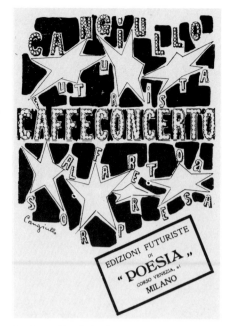

F. Cangiullo, Café-chantant Surprise Alphabet, *1916*

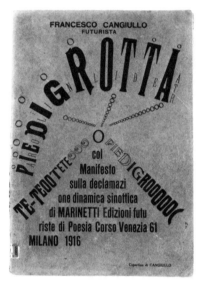

F. Cangiullo, Piedigrotta, *1916*

F. Cangiullo, Staved Poem, *1923*

which pursued the ideal of a dynamic unity in art. Important in this sense was his manifesto *L'art cérébriste (Cerebral Art)*, published in *Le Figaro* on 9 February 1914. This manifesto opposed sentimentalism in art and asserted the necessity of the "new" as an absolute aesthetical category. Canudo proposed an aesthetics founded on the "seven arts theory", in which cinema is the "seventh art... that partakes of the arts of time and of space". Freed from the demands of naturalism, for Canudo cinema becomes a "new means of expression", an "image-workshop", a "writing through light". (LDM)

Čapek, Josef

(Hronoo, 1887 - Belsen, 1945) Czech painter, writer and journalist

Josef Čapek was the elder brother of the writer Karel Čapek. In 1911 he joined the Prague Cubist group SVU and edited the first six issues of its periodical *Umělecký Mesíčník (Art Monthly)*. Unlike most of the members, he did not consider Cubism to be the one and only artistic doctrine, but remained open to other new influences. His article *The Position of the Futurists in Contemporary Art* in issue number 6 of *Umělecký Mesíčník* (March 1912), was the first relatively complete and objective information about the Futurist movement to appear in Czechoslovakia, although it was based mostly on the manifestos and articles, and on the catalogue of the exhibition at the Bernheim Gallery in Paris which Čapek had not seen. When the exhibition reappeared in Berlin at the Sturm Gallery, it was seen by the leading representative of the orthodox wing of the Cubist group, Emil Filla, who condemned it mercilessly in number 9 of *Umělecký Mesíčník* as an expression of impotence and artistic arrogance which brought only disorder and anarchy to contemporary art. Čapek engaged in indirect controversy with Filla in his review of the Futurist exhibition of Boccioni, Carrà, Russolo and Severini, held at the end of 1913 in the Havel Gallery in Prague (*Lumír* 42, no. 3, January 1914). Čapek's review praised Futurism's destructive programme, which demolished the academic tradition of Italian art, but found that its pictorial production was too naturalistic and showed insufficient mastery of form. The Futurists, wrote Čapek, "feel and understand things as meeting-points of powerful dynamic forces, they exalt them to the point of paroxysm. This excited — and up to a point poetic — concept has a fundamental defect: its naturalistic tonality and its insistence on the sensational, rich and marvellous complexities of the outer world".

There are also distant echoes of the Futurist programme in Čapek's own paintings, not so much in their formal structure — derived from Cubism — but in their subject matter, which reveals his interest in the phenomena of modern life: *The Factory* (1912), *The Sailor*, *Harmonikář* (1913), *The Buffoon* (1914-15), *Boxing Match*, (1915). His *The Prince of Darkness* (1920), resembles the later costume designs by Prampolini for Marinetti's *Tamburo di fuoco (Firedrum)*. In 1922 Čapek designed the cover for the translations of Marinetti's *Free-Words* and the *Firedrum*, which was performed at the

Stavovské Theatre in Prague. Two years earlier Čapek had illustrated Neumann's book *Ať žije život* (*Long Live Life*), which contained the Futurist "feuilleton" *Otevřená okna* (*Open Windows*, 1913). By 1924, however, in his prose piece *Umělý člověk* (*The Artificial Man*), Čapek has already begun to mock the Futurists' "modernolatry" and admiration for machines in an amusing parody. (FŠ)

Čapek, Karel
(Prague, 1890 - Prague, 1938) Czech writer and playwright

Karel Čapek was already familiar with the Futurist movement before the First World War, as shown by his review of the exhibition of Italian Futurists in Prague (*Česká Revue*, 1913-14, no. 3, p. 191), which ended with these words: "From an artistic and moral point of view, Futurism is very remote from our concerns; however, this must not lead us to a facile aversion and derision, which would show vain incomprehension." Despite this statement, his post-war production had something in common with Futurism: the vision of a technical, scientific Utopia, seen however from an opposite moral perspective.
Where the Futurists were socially optimistic, Čapek was skeptical. His novels and dramas are scientific fantasies which express his fears of the negative consequences of one-sided technical progress, which turns against man, leading to the degeneration or destruction of human life. This negative Utopia is depicted in Čapek's world-famous play, *RUR — Rossum's Universal Robots* (1920), in which he coined the term which came to be used for the leading figure in most science-fiction works: *robota* (robot). As Čapek saw it, the robots which should have helped mankind end up by destroying it. Čapek's belief in the omnipotence of love does, however, lead him in the end towards a conciliatory conclusion: human feelings are awakened in the robots and from them a new generation is born. The sets for this frequently performed play were Futurist in style: this is true of Bedřich Feuerstein's sets for the premiere of *RUR* at the Prague National Theatre (25 January 1921), and particularly of Frederick Kiesler's designs (1922), in which kinetic elements appeared in the mechanical structure. Čapek's other plays and novels also expressed a negative view of man's future: *Věc Makropulos* (*The Makropulos Affair*, 1922), *Továrna na absolutno* (*The Factory of the Absolute*, 1922), and *Krakatit* (1924), in which he foresaw many later scientific discoveries, notably the use and abuse of nuclear energy. (FŠ)

Photo of C. Carrà dedicated to G. Papini

U. Boccioni, Caricature of Carrà, *1910*

C. Carrà, Warpainting, *1915*

Carrà, Carlo
(Quargnento, Alessandria, 1881 - Milan, 1966) Italian painter

Born into a family of artisan craftsmen, Carlo Carrà left home at the age of twelve to work as a house-decorator, first at Valenza Po (Piedmont) and from 1895 onwards in Milan. He spent the years 1899 and 1900 in Paris, where he worked on the decoration of the pavilions for the Universal Exhibition. Here, in museums and private galleries, he had his first contact with modern French painting, from Delacroix and Courbet to the Impressionists and Post-Impressionists. He then spent a few months in London and finally returned to Milan in 1901. In 1906, a small allowance from an uncle at last enabled him to enrol at the Accademia di Brera in Milan and follow a regular course of painting. At the Brera he studied under Cesare Tallone and made friends with the young painters Ugo Valeri, Romolo Romani, Aroldo Bonzagni and Umberto Boccioni. In these years, starting from a Lombard realism which was still typically 18th century, Carrà discovered modern trends in the Pointillism of Segantini, Previati, Grubicy and Pellizza. As in the cases of Boccioni, Severini, Balla and Russolo and other young artists who later became part of the Futurist movement, Pointillism represented the key moment in Carrà's development and the beginning of a great stylistic change.
His Pointillism, however, is of a particular sort, characterized by a compact texture of bold strokes in contrasting, even violent, but sombre colours, and flashes of dusky lighting. Carrà's Pointillism rejected the Art Nouveau and Symbolist tendencies present in Milan following Previati, and was given solidity by the straightforward, instinctive realism of the Lombard tradition and of Tallone. But what was to prove most important and lasting in this Pointillist experience was the idea of a form of painting which aimed to interpret, in the light of subjective emotion, the new quality of the social and cultural life developing in Italy. Paintings like *Leaving the Theatre* or *Piazza del Duomo* (1909) or the immediately subsequent *Night Scene in Piazza Beccaria* — and some drawings from the same period: *Suburb*, *Milan Suburb* or the sketch for *Funeral of the Anarchist Galli* — show clearly how his experimentation with the possibilities offered by the Pointillist technique is combined with new elements suggested by the life of an expanding city. In addition to its stylistic innovations, then, Pointillism was also a means towards new existential contents. This immediately precedes Carrà's radically innovative proposals, which were published in the *Futurist Manifesto* on 11 February 1910, after his meeting with Marinetti.
Futurism can be seen as an artistic-existential phenomenon with its roots in Pointillism, as far as painting is concerned, and more widely speaking, in a European culture of Symbolism and Decadentism, Materialism and Spiritualism, with particular reference to Bergson and modern scientific thought, including Chevreul, Henry, Roentgen and Einstein's theory of relativity. For Carrà, however, Futurism was first and foremost an experience of form.

Carrà brought to Futurism the fruits of his Pointillist experience and of all he had learned from Tallone, and this allowed him to interpret in his own way the principles common to the whole group. Carrà refused any tendency towards spiritualistic or mechanistic mysticism. What we find in him is not the worship of machines, but rather a close attention to the consequences machines were to have on the quality of life and man's sensibility. Carrà also continued to reject the decorative sensuousness of the Viennese Secession, which in those early stages still tended to influence Boccioni. He preferred the direction of French painting and the example of Cézanne, because his natural inclination was towards solid volumes that could guarantee a concrete relationship with the objective world; the problem of abstraction could arise only in consequence of a need for the plastic transfiguration of that relationship. Examples of this early stage in Futurism are paintings like *The Swimmers* from late 1910, *The Moment of Moonlight*, *What the Streetcar Told Me*, *Milan Station* and *Funeral of the Anarchist Galli*, all from 1911.

However, in autumn of the same year and in February 1912, Carrà made two trips to Paris to organize the Futurist exhibition at the Bernheim-Jeune Gallery. There he had his first contacts with Cubist art, in particular with Braque and Picasso. The meeting was fruitful despite disagreement, and gave him an important key for his own definition of the Futurist concepts of dynamism, simultaneity of the image, and interpenetration of planes, paving the way for his spatial organisms based on volumes broken up and recomposed in diagonal lines of direction.

The paintings which followed between 1912 and 1913 employed systems of rotating movements which could produce the synthesis of physical and psychical facts demanded by the Futurists (that is to say, of an objective fact and its psychological reflection). But they also reaffirmed the need for well-structured architectural values with a balance between mass and volume, fullness and void, light and shade, never losing sight of the concrete reality of the objective world.

These are the pictorial solutions which have rightly led critics to speak of Carrà's Cubo-Futurism. Works like his *Portrait of Marinetti*, *Rhythms of Objects* or *The Absinth Drinker* from the end of 1911, his *Woman on a Balcony* and the *Galleria di Milano* of 1912, and *Rhythms and Spatiality* of 1913, with their long laborious execution, and their many preparatory drawings, corrections and variations, show him slowly moving towards solutions which go beyond the formulas of dynamism and the illustrative contents of the orthodox Futurist environment, thanks to the possibilities opened by a synthesis of Futurism and Cubism. This attitude is a long way from the ideas Boccioni expressed in an article published in *Lacerba* in March 1913: "What we want to convey is the object experienced in its dynamic development, that is to say, the synthesis of the transformations the object undergoes in its two motions, relative and absolute. We do not wish to observe, dissect and turn things into images; we identify ourselves with the object and this is

Lacerba, *July 1914*
painting and text by Carrà

Carrà as a soldier in Ferrara, 1916

completely different... The prior rejection of reality, this is the abyss that divides us from Cubism."

Another factor which became very important in Carrà's Futurist work was his relationship with the young Florentine artists from *La Voce*. In early 1913, after overtures made by Soffici in autumn 1912, an agreement was reached with these artists, who were about to launch *Lacerba*. In his autobiography Carrà writes: "Futurism and *La Voce* were two youthful, impetuous forms of expression, stemming from the same source: both set out to do something new, to break down the old, heavy edifice of bourgeois culture, with its rigid, out-of-date principles which were suffocating the free development of art." Although this agreement was soon to prove precarious, in those first months of 1913 it was complete and productive. The artists were united in their polemical opposition to the culture of the past, to Croce's philosophy and to the idea that art could not be revitalized by development from one form to another. On 21 February 1913, Futurists and Lacerbians held a *soirée* at the Costanzi Theatre in Rome. In the foyer, paintings by Balla, Boccioni, Carrà, Severini, Russolo and Soffici were hung side by side. Then on 15 March Carrà published his first article in *Lacerba*, "Plastic planes as spherical expansion in space". This is his most important statement of artistic theory from that period, expressing his attempt to go beyond Cubism from within its syntax, to reach the dynamic vitality of form and material without losing the weight and function of volumes in an airy vibrant space. In other words, Carrà developed Cubist structures in a dynamic direction in order to reach the primary energies that sustain the mysterious apparition of the form, expressed through mass rather than line, through its palpable solidity.

Another essential aspect of Carrà's artistic theory was presented in an article published in *Lacerba* almost a year later, on 15 February 1914: "dynamic deformation", conceived as an idea of space. "A blank canvas has no space," wrote Carrà. "Space begins with the plastic arabesque, as the values of surface and depth gradually take on the special characteristics of the emotion which guides the painter... The spatial value of a certain form makes the different plastic values of a painting concrete and subordinates them to itself in a unified expression."

In 1914, a prolonged stay in Paris made possible close contact with Apollinaire and Picasso, and even moreso in 1915, this line of thought led Carrà to a crisis with Futurism. He left Marinetti's movement. In that phase, which seems to have been a crisis of conscience, Carrà accepted some of the anti-Marinetti arguments put forward in the meantime by the Florentines, but without disowning his beliefs or making strong disclaimers. He adjusted his course progressively. In fact, for a few years he continued to present himself as a dissenting Futurist, as can be seen from the catalogue for his one-man exhibition held at the Chini Gallery in Milan from 18 December 1917 to 10 January 1918.

Carrà subsequently wrote in his autobiography: "I continue to look upon my

Futurist experience as useful and I am convinced that Futurism had its importance. Thanks to Futurism many doors are now open. Young Italian artists took advantage of it.'' And further on: "It was no personal disagreement that led me to take this step, and in fact my friendship with Marinetti and my old comrades continued without substantial changes... Those who think that you can break away without sorrow from dear old friends with whom you have fought so many battles and even risked your life, will never know what real friendship is.''

Of course there had been differences of opinion with Boccioni, which emerge in his autobiography and in Carrà's correspondence with Soffici and Severini; but Carrà maintained a close friendship with Boccioni right up to his death: in fact it was Carrà himself, along with his friend Emilio Piccolo, who in the autumn of 1916 arranged for Boccioni's body to be moved from a common grave to the Verona cemetery; on that occasion Carrà published at his own expense a short study in memory of his friend.

Carrà left the Futurist movement because he had doubts about the validity of the romantic formulas and myths, and because he saw that the movement risked becoming a new academy, a risk increased by the indiscriminate propaganda of Marinetti and Boccioni. Another reason was his own search for expression, by then directed towards "concrete forms", and leading to spatial solutions based on dynamic-static contrasts. In the new "concrete forms" pursued by Carrà, the principles of structure, the essentiality of expression and the architectural values of the composition remained fundamental, subordinating all other representational values. From objects the painter now drew out symbolic, highly simplified forms: reality as the symbol of itself, a reality in its own way magic, able to transfigure the language that expressed it. In almost all his works there is that "abstractive passion for reality" which characterizes the entire span of Carrà's painting.

In 1914 and 1915 Carrà created collages, mostly still-lifes in which a rugged synthesis of objects, grooves, shadows, and words appears to be suspended in subtle spatial and geometric rhythms. This was the means the painter chose to express his intellectual discomfort and his need for an answer to the question of what relationship was still possible between the artist and real things ("ordinary things", Carrà was to call them a few years later).

Reality and intellectual values in reciprocal symbiosis were the basis of his new artistic theory when he left the Futurist movement; his departure marked the conclusion of his previous experiences and the beginning of new research.

The re-established connection with things through "concrete forms" and the intrinsic values of matter, which inspired his new theoretical and practical standpoint, also led to a need for a new relationship with the history of art, a further development of the lively iconoclastic fury of Futurism. Giotto, Masaccio, Paolo Uccello and Piero della Francesca were to be the lasting figures in this rediscovery.

Carrà's work was to have a diversified yet consistent development along certain lines which he kept as constants, starting from the "antigrazioso" (anti-graceful) concept and the collages and passing through metaphysical painting to his new relationship with nature, which was to develop from 1921 onwards. Henceforward Carrà was committed to a form of painting which combined the stylistic and spatial achievements of the avant-garde with all that was living and vital in the history of Italian art. (MC)

The Painting of Sounds, Noises and Smells
(Futurist manifesto, Milan, 11 August 1913)

Before the 19th century, painting was the art of silence. Painters of antiquity, of the Renaissance, of the 17th and 18th centuries, never envisaged the possibility of rendering sounds, noises and smells in painting, even when they chose flowers, stormy seas or wild skies as their subjects.

In their bold revolution, the Impressionists made some confused, hesitant attempts at sounds and noises in their pictures. Before them — nothing, absolutely nothing!

However, we should point out at once that between the Impressionists' swarming brush-strokes and our Futurist paintings of sounds, noises and smells there is an enormous difference, like the contrast between a misty winter morning and a sweltering summer afternoon, or to put it better, between the first signs of pregnancy and an adult man in his fully developed strength. In the Impressionist canvases, sounds and noises are expressed in such a thin, faded way that they might have been perceived by the eardrum of a deaf man. This is not the place for a detailed account of the principles and experiments of the Impressionists. There is no need to enquire minutely into all the reasons why the Impressionists never succeeded in painting sounds, noises and smells. We shall only mention here what they would have had to drop to obtain results:

1. The extremely vulgar *trompe-l'œil*, a game worthy of an academic of the Leonardo da Vinci sort or a foolish set-designer of realistic operas.

2. The concept of colour harmonies, a characteristic concept and defect of the French which inevitably forces them into Watteau-style prettiness and an abuse of light blues, pale greens, mauves and pinks. We have said more than once how much we despise this tendency towards soft, feminine, gentle effects.

3. Contemplative idealism, which I have defined as a *sentimental mimicry of natural appearances*. This contemplative idealism contaminates the pictorial construction of the Impressionists, just as it contaminated those of their predecessors, Corot and Delacroix.

4. Anecdote and detail, which (although it it a reaction and an antidote to false academical construction) almost always leads them to photographical reproduction. As for the Post- and Neo-Impressionists, such as Matisse, Signac and Seurat, we see that far from perceiving the problem and dealing with the difficulties of sounds, noises and smells in their paintings, they preferred to withdraw into static representation in order to obtain a greater synthesis of form (Matisse) and a systematic application of light (Signac, Seurat).

We Futurists therefore claim that in bringing the elements of sound, noise and smell to painting we are opening fresh paths. We have already taught artists to love our essentially dynamic modern life with its sounds, noises and smells, thereby destroying the stupid passion for values which are solemn, academic, serene, hieratic and mummified: everything purely intellectual, in fact. *Imagination without strings, words-in-freedom, the systematic use of onomatopoeia, antigraceful music without rhythmic quadrature, and the art of noises* — these were created by the same Futurist sensibility that has given birth to the painting of sounds, noises and smells.

It is indisputably true that (1) silence is static and sounds, noises and smells are dynamic; (2) sounds, noises and smells are nothing but different forms and intensities of vibration; and (3) any succession of sounds, noises and smells impresses on the mind an arabesque of form and colour. We must measure this intensity and perceive these arabesques.

The painting of sounds, noises and smells rejects:

1. All muted colours, even those obtained directly and without using tricks like patinas and glazes.

2. The banality of those velvets, silks and flesh tints which are too human, too refined, too soft, and flowers which are too pale and drooping.

3. Greys, browns and all muddy colours.

4. The use of pure horizontal and vertical lines, and all other dead lines.

5. The right angle, which we consider *passionless*.

6. The *cube*, the pyramid and all other static shapes.

7. The unities of time and place.

The painting of sounds, noises and smells calls for:

1. Reds, rrrrreds, the rrrrrreddest rrrrrrreds that shouuuuuuut.

2. Greens, that can never be greener, greeeeeeeeeeeens that screeeeeeeam, yellows, as violent as can be: polenta yellows, saffron yellows, brass yellows.

3. All the colours of speed, of joy, of carousings and fantastic carnivals, of fireworks, café-chantants and music-halls; all colours seen in movement, colours experienced in time and not in space.

4. The dynamic arabesque, which is the sole reality created by the artist in the depths of his feeling.

5. The clash of all the acute angles, which we have already called the angles of will.

6. Oblique lines which fall on the observer like so many bolts from the blue, along with lines of depth.

7. The sphere, the ellipse that spins, the upside-down cone, the spiral and all the dynamic forms which the infinite powers of an artist's genius are able to uncover.

8. Perspective obtained not as the objectivity of distances but as a subjective interpenetration of hard and soft, sharp and dull forms.

9. As a universal subject and as the sole reason for a painting's existence: the significance of its dynamic construction (polyphonic architectural whole). Architecture is usually thought of as something

static; this is wrong. What we have in mind is an architecture similar to the dynamic musical architecture achieved by the Futurist musician Pratella. Architecture is found in the movement of colours, of smoke from a chimney, and in metallic structures, when they are experienced in a violent, chaotic state of mind.

10. The inverted cone (the natural shape of an explosion), the slanting cylinder and cone.

11. The collision of two cones at their apexes (the natural shape of a water spout) with flexible or curving lines (a clown jumping, dancers).

12. The zig-zag and the wavy line.

13. Ellipsoidal curves considered as straight lines in movement.

14. Lines and volumes seen as plastic transcendentalism, that is, according to their characteristic degree of curvature or obliqueness, determined by the painter's state of mind.

15. Echoes of lines and volumes in movement.

16. Plastic complementarism (for both forms and colours), based on the law of equivalent contrasts and on the opposite poles of the spectrum. This complementarism derives from an imbalance of forms (which are hence forced to move). The consequent elimination of the complements of volumes. We must reject these because like a pair of crutches they allow only a single movement, forward and backward, and not the total movement that we call spherical expansion in space.

17. The continuity and simultaneity of the plastic transcendency of the animal, mineral, vegetable and mechanical kingdoms.

18. Abstract plastic wholes, corresponding not to our sight but to the sensations which derive from sounds, noises, smells and all the unknown forces that surround us.

These polyphonic and polyrhythmic abstract plastic wholes correspond to a requirement of inner enharmonics that we Futurist painters believe to be indispensable to pictorial sensibility.

These plastic wholes have a mysterious fascination and are more meaningful than those created by our visual and tactile senses, being closer to our pure plastic spirit.

We Futurist painters maintain that sounds, noises and smells are incorporated in the expression of lines, volumes and colours just as lines, volumes and colours are incorporated in the architecture of a musical work. Our canvases will therefore express the plastic equivalents of the sounds, noises and smells found in theatres, music-halls, cinemas, brothels, railway stations, ports, garages, hospitals, workshops, etc., etc.

From the point of view of form: sounds, noises and smells can be concave, convex, triangular, ellipsoidal, oblong, conical, spherical, spiral, etc.

From the point of view of colour: sounds, noises and smells can be yellow, green, dark blue, light blue or purple.

In railway stations and garages, and throughout the mechanical and sporting world, sounds, noises and smells are predominantly red; in restaurants and cafés they are silver, yellow and purple. While the sounds, noises and smells of animals are yellow and blue, those of a woman are green, blue and purple.

We do not exaggerate in claiming that smell alone is enough to create in our minds arabesques of form and colour which can constitute the motive and justify the necessity of a painting. In fact, if we are shut in a dark room (so that our sense of sight no longer functions) with flowers, petrol or other strong-smelling things, our plastic spirit gradually eliminates the memory sensations and constructs particular plastic wholes whose quality of weight and movement corresponds perfectly to the smells found in the room. These smells, through an obscure process, have become an environment-force, determining that state of mind which for us Futurist painters constitutes a pure plastic whole.

This bubbling and whirling of forms and lights composed of sounds, noises and smells has been partly rendered by me in my *Anarchist's Funeral* and *Jolts of a Taxi-cab*, by Boccioni in *States of Mind* and *Forces of a Street*, by Russolo in *Revolt* and Severini in *Pan Pan*, paintings which aroused violent controversy at our first Paris Exhibition in 1912. This kind of bubbling over requires a powerful emotion, even delirium, on the part of the artist, who in order to render a vortex must be a vortex of sensation himself, a pictorial force and not a cold logical intellect.

This is the truth! In order to achieve this *total painting*, which requires the active cooperation of all the senses, *a painting which is a plastic state of mind of the universal*, you must paint, as drunkards sing and vomit, sounds, noises and smells!

C.D. Carrà

Casavola, Franco
(Modugno, Bari, 1891 - Bari, 1955) Italian composer

Franco Casavola studied under La Rotella at the music school in Bari and Respighi at the Conservatory in Rome. By 1921 he was already composing music for Futurist productions. He wrote music to Cangiullo's play *Le mani di cristallo* (*Crystal Hands*) for the Teatro della Sorpresa, and to Anton Giulio Bragaglia's *Ranocchi al chiaro di luna* (*Frogs in the Moonlight*) and *La danza delle scimmie* (*The Dance of the Monkeys*) for the Teatro degli Indipendenti. In 1922 he wrote a musical elaboration of Cangiullo's "free-word" poem "Piedigrotta", and in 1923 the music for Buzzi's *Preghiera del lumicino* (*Prayer of the Little Light*) and Cavacchioli's *Ballata dei gnomi* (*Ballad of the Gnomes*).

In 1924 he wrote five manifestos on Futuristic music: *La musica dell'avvenire* (*The Music of the Future*), *La musica illustrata* (*Illustrated Music*), *Le versioni scenoplastiche della musica* (*Scenoplastic Versions of Music*), *Le atmosfere cromatiche della musica* (*Chromatic Atmospheres of Music*), and *Le sintesi visive della musica* (*Visual Synthesis of Music*, signed also by Luciani and Bragaglia); and three manifestos on theatre: *Teatro degli istanti dilatati* (*Theatre of the Dilated Moments*), *Teatro immaginario* (*Imaginary Theatre*), and *Piccoli teatri* (*Little Theatres*). In the same year he composed *La danza dell'elica* (*The Dance of the Propeller*) for the Futurist Nuovo Teatro (with an internal combustion motor and a wind machine included in the orchestra), and *Canzone rumorista* (*Noise-ist Song*) for Depero's ballet *Anihccam del 3000*.

Between 1925 and 1926 he wrote the musical intermezzi for Marinetti's plays *Prigionieri* (*Prisoners*) and *Vulcani* (*Volcanoes*), and several pieces for Russolo's "rumorarmonio" and "enharmonic bow".

In 1927 he composed the incidental music for Luciano Folgore's *Tre momenti* (*Three Moments*) and Prampolini's *Mercanti di cuori* (*Merchants of Hearts*), and conducted their performance during the Futurist pantomime production at the Théâtre de la Madeleine in Paris.

In 1931 he composed the music for Benedetta's play *Il viaggio di Gararà* (*Gararà's Journey*).

However, in 1929 his interests turned to a type of "neo-verist" music, and after 1936 he dedicated his efforts to film music.

Casavola also wrote a Futurist novel, *Avviamento alla pazzia* (*Introduction to Madness*, 1924), and *Il gobbo del califfo* (*The Caliph's Hunchback*, 1929). (FMa)

Casella, Alfredo
(Turin, 1883 - Rome, 1947) Italian composer

Alfredo Casella's Futurist activity was so casual and sporadic that when he created the executive committee of the Società Italiana di Musica Moderna in 1917, he excluded F.B. Pratella from the list of candidates because he was the official representative of Futurist musicians and composers. His version of *Pupazzetti* (*Puppets*) op. 28 for piano, woodwinds, and string quartet (originally written in 1916 for four-hand piano) was the incidental background music for *I Pagliacci* (*The Clowns*) in the Futurist spectacle *I balli plastici* (*The Plastic Dances*) by Depero, produced on 15 April 1918 at the Teatro dei Piccoli at the Palazzo Odescalchi in Rome. He also appeared as conductor.

In 1921 he composed two piano pieces, *Pièces enfantines* (*Children's Pieces*) and *A modo di tango* (*In Tango Form*), for performance in Anton Giulio Bragaglia's Teatro degli Indipendenti. In 1927 he wrote the music for Luciano Folgore's *L'ora del fantoccio* (*The Hour of the Puppet*), which was produced as part of the programme of the Futurist Pantomime Theatre at the Théâtre de la Madeleine in Paris. (FMa)

Catalan Futurism

Italian Futurism as an artistic and cultural trend had an important but variable influence in the areas where Catalan was spoken (Majorca, Valencia, and Catalonia), over a period stretching from 1916 to 1930. It is important to distinguish the artistic and cultural Futurist movement from the pre-existing political movement with the same name founded in 1904 by the Majorcan intellectual Gabriel Alomar, with the aim of producing a "regeneration". An ample bibliography supports the hypothesis that the name chosen by Marinetti for his movement was inspired by a review which appeared in the *Mercure de France* on 1 December 1908 of Alomar's pamphlet "El futurisme" (1905).

In 1912 Josep Dalmau returned from a trip to Paris and opened the Galeries Dalmau, a centre for the diffusion of modern art, inaugurating it with an exhibition of French Cubist painters. In 1916 Josep M. Junoy published a selection of calligrammes, including several shown at Dalmau's, in *Troços*. One of these calligrammes, "Oda a Guynemer", published in *Iberia* a year previously, was praised by Apollinaire. In *La Publicidad* (23 February 1918) Junoy explained the Futurist techniques employed in his "Oda". Catalan Futurism, unusual because of its French descent, more than an articulated movement was an individual adventure for a few intellectuals: Junoy, Joaquim Folguera, J.V. Foix and Joan Salvat-Papasseit. Junoy, prior to his conversion to classicism around 1919, followed a Futurist inspiration in *Troços*. He published the calligramme "Films Sergi Charchoune", interspersing the text with music by Balilla Pratella, and an obituary of Boccioni, "Estela angular" (Angular Star). The poetry of Folguera, which appeared posthumously in *Un Enemic del Poble* in March 1919, shows that he was very familiar with free-word plates. Foix was careful to seek a balance between avant-garde theories and the need to nurture a Catalan culture (the language at that time was unifying its spelling rules). In the same period he also practiced automatic writing but published the results only later (*Gertrudis*, 1927; *Krtu*, 1932). Both Foix and Folguera collected Futurist manifestos. Salvat was interested in the revolutionary possibilities of Futurism, and emphasized its ideological and subversive aspects. He was the author of the theories and programmatic manifestos of Catalan Futurism.

The magazines published by these intellectuals were a dominant influence throughout this period: *Un Enemic del Poble* (1917-19), *Arc Voltaic* (1918), *Proa* (1921), edited by Salvat; *Troços* (1918), *La Consola* edited by Sarriá (1919-20), *Monitor* by Foix (1921-23). All these publications emphasized the nationalistic character of Catalan Futurism. In 1925 Foix drew up a critical balance-sheet of the movement and turned to Surrealism as an alternative. Some of Salvat's disciples remained faithful to Futurist aims even in the Twenties and Thirties: Carles Sindreu, Carles Salvador, and S. Sánchez-Juan. Many intellectuals and artists who participated in the Futurist adventure wound up in the ranks of Surrealism, and made decisive contributions to this movement. (JAJ)

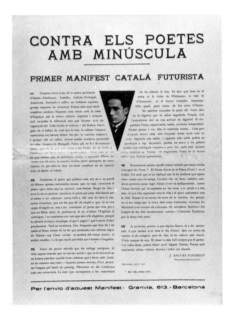

J.M. Hunoi, Guynemer, *1918*

J. Salvat-Papasseit, Against Poets with a Small "p", *Barcelona, 1920*

S. Sanchez-Juan, Second Catalan Futurist Manifesto, *1922*

Cendrars, Blaise

pseudonym of Frédéric Sausser
(La Chaux-de-Fonds, Switzerland, 1887 - Paris, 1961) Writer of Swiss origin, naturalized French

From his earliest years, before he had adopted a pseudonym, the young Frédéric Sausser travelled widely. Two long visits to Russia provided inspiration for his *Prose du Transsibérien* and he returned from a stay in New York with the material for *Les Pâques à New York* (*Easter in New York*). After composing poems in the style of French and German Symbolism, which he later rejected, Cendrars published *Les Pâques à New York*, his first book, in 1912. If a particular influence marks this poem — apart from that of Rémy de Gourmont — it comes from German Expressionism rather than Cubism or Futurism. Apollinaire was very impressed by this book, and together with Mallarmé's example, it probably influenced him to stop punctuating his poetry.

From this point on Cendrars was closely tied to all the avant-garde writers and artists; Apollinaire and Jacob considered him their equal. Evidence of the respect in which he was held are his portraits by Modigliani, Picabia, and even Fernand Léger — who rarely painted portraits. Cendrars himself wrote extensively about artists: Picasso, Braque, Survage, Chagall, Archipenko, Csáky, and particularly Léger and the Delaunays.

Cendrars was undoubtedly the writer who was closest to Fernand Léger, so much so that, in their respective theoretical writings of this period, it is difficult to distinguish what belongs to one and what to the other. In particular, they shared the same passion for cities, wilderness, machines, speed, the new media and advertising. Cendrars proposed the equation "Poetry = Advertising" and admitted having envied the Futurist Maiakovsky the possibility given to him by the Revolution to express himself on walls. It is clear that his choices were very close to those of the Futurists, but Cendrars, like Léger, was never to reach an understanding with them; neither of them had the temperament to participate in organized groups. His friendship with Léger produced two magnificent works marked by their simultaneous research into text and image: *J'ai tué* (*I Have Killed*, 1917) and *La fin du monde* (*The End of the World*, 1919).

It was however with Sonia Delaunay that Cendrars created the masterpiece of Simultaneist books, the *Prose du Transsibérien*, a sheet of folded cardboard three meters long in which the poem and the coloured forms are combined without the text losing its legibility. The absolute book desired by Mallarmé? A creation inspired by Futurist experiments? We do not know. Apollinaire, again, was very impressed: "Cendrars and Mme Delaunay Terk have made a first attempt at written simultaneity in which the colour contrasts accustom the eye to read an entire poem at a single glance, the way an orchestra conductor reads the superimposed notes of sheet music simultaneously, or the way the graphic and written elements of a poster are seen together."

In all his writings of this period, Cendrars

worked to capture "today", live, violent, colourful, where machinery recalls the primitive world: "Extravagant posters on the multicoloured city, with strips of trams climbing up the avenues, howling monkeys hanging on to each other's tails, and the incendiary orchids of the buildings which collapse upon them, killing them all. In the air, the virgin cry of the trolley-buses."

Cendrars contributed to numerous avant-garde publications, at times without knowing it — the Cubist *Les Soirées de Paris*, the Expressionist *Der Sturm*, the Futurist *Noi* and *Portugal Futurista*, and the Dadaist *Cabaret Voltaire* etc. In the course of the Twenties, reporting, cinema, and travel came to take up all his time and interest. (SF)

Chagall, Marc

(Vitebsk, Russia, 1887 - Saint Paul de Vence, 1985) French painter of Russian origin

His earliest surviving paintings are dated 1908-09 and already show signs of that poetic and fantastic universe that was to be typical of him, where animals take holidays in the sky and violin players squat on roofs. This universe was always present, but was to take different forms according to the influence of the movements and foreign painters and writers that Chagall met and who influenced him in spite of his independence.

On the occasion of his first trip to Paris in 1911, he became interested in Fauvism and above all in Cubism. At La Ruche he became a friend of Léger, the Delaunays, Cendrars, Apollinaire and the Italian-French poet Riciotto Canudo. Paintings such as *The Poet* (1911), *Adam and Eve* (1912) or *Golgotha* (1912) certainly bear signs of Futurism and Orphism. Perhaps he had seen Futurist works, but he transformed in his own way whatever he drew from them. However, Chagall is not *a priori* without affinities with the Futurists, for he was an enemy of logic.

Homage to Apollinaire (1911-12) was perhaps his most Futurist work: a two-headed androgynous figure, the original man and the man of the future, appears at the center of a whirling group of circles and coloured dials, where the hands and the numbers marking time have almost disappeared into geometric shapes, displaying only the names of four friends as the four cardinal points of the compass — Apollinaire, Walden, Cendrars, Canudo — all representing radically different cultural horizons. (SF)

Charlot, Jean

(Paris, 1898 - Honolulu, 1979) American-Mexican painter of French origin

Having developed a passion for engraving and murals during his studies in Paris, Jean Charlot moved to a country that deeply attracted him, Mexico, where in 1921 he completed one of the first modern frescoes and, in the same year, established relations with the Stridentists. Stridentism and mural painting are more closely linked than one might at first presume. During the Twenties Charlot often illustrated Stridentist publications, using both representational and abstract woodcuts, of which the best-known were those created for *Urbe* (1924) by Maples Arce. (SF)

Chiattone, Mario

(Bergamo, 1891 - Lugano, 1957) Swiss architect and painter

After joining the group Nuove Tendenze with Sant'Elia, Dudreville, Erba and Funi, Mario Chiattone had a minor position compared with Sant'Elia, but nevertheless developed a personal vision of Futurist architecture. In the group's 1914 Milanese show, his works were clearly subordinate to those by Sant'Elia, and it is entirely probable that Chiattone took from him the projection of the architectural imagination on a metropolitan scale. However, the use of such a scale does not seem to have been as essential to him as it was to Sant'Elia, due to an evident preference — even within the context of metropolitan iconography, but expecially explicit in the design of the individual buildings — for choices that tended toward stereometrics and proto-Purism and almost proto-Rationalism. And it was in his attention to individual architectural objects that Chiattone's linguistic repertory was enriched in its formal purism: a display of pure formal values, alongside the more properly plastic factor of colour elements. Chiattone's practical interests were those of a painter, and a deeply committed one. In his study of the single elements of the "modern metropolis" Chiattone dealt with different buildings according to their type: industrial, commercial, residential, public, etc. On the other hand, in his analysis of single buildings Chiattone appeared to abandon the scale of metropolitan gigantism, tending between 1914 and 1916 toward proto-rational Purism. Between 1918 and 1919 his interest turned toward neo-Medieval and neo-proto-Renaissance design. (ECr)

Chiti, Remo

(Staggia Senese, 1891 - Rome, 1971) Italian writer

Remo Chiti was one of the most active supporters of "Synthetic Theatre". He contributed to *Difesa dell'arte*, *Il Centauro*, *La Rivista*, *Saggi Critici*, *Testa di Ferro*, *L'Impero*, *Oggi e Domani*, and *L'Universale*. He organized and took part in Futurist *soirées*, and was a member of the Florentine group *L'Italia Futurista*. His only publication was the pamphlet *I creatori del teatro sintetico futurista* (*The Creators of Futurist Synthetic Theatre*, 1915). *La vita si fa da sé* (*Life Makes Itself*, 1973) is a posthumous collection of his prose and one-act plays, edited by Mario Verdone. (MV)

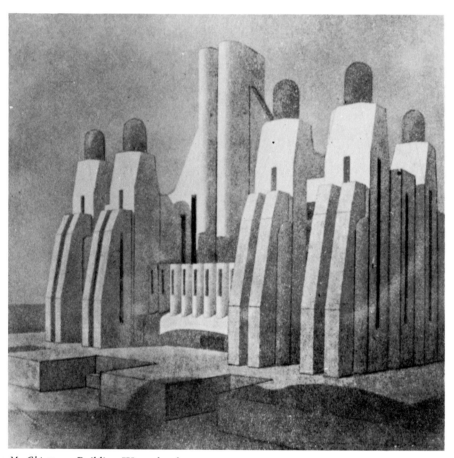

M. Chiattone, Building IV, *undated*

Choreography

The painter, writer and pilot, Felice Azari, with his aerial dances, was the most sensational Futurist choreographer. In 1918, he expressed his moods in the sky of Busto Arsizio, near Milan. Glued to his pilot's seat by centrifugal force, scornful of danger, he created spiralling vortices, sharp rolls, exhilarating loops, dazzling spins and dives, long fluttering descents. For this pilot-dancer his aeroplane was an extension of his body, as if bones, tendons, muscles, nerves were connected with the spars and metal wires.

On the invisible trapeze of the atmosphere, he invented new acrobatics, turned into art those already existing in aviation and thus originated a new genre: expressive flight. A year later, he wrote: "The loop signifies joy, the barrel-roll impatience or irritation, while repeated side-slips to the right and to the left mean gaiety, and the long, fluttering descents give a sense of weariness and nostalgia. The sudden stops followed by longer or shorter spins, zooms, dives, rolls, all the infinite variety of manoeuvres, linked and coordinated in careful succession give the spectator an *immediate* and *clear* understanding of what you are trying to represent or state with your aeroplane."

In 1914, another pilot and poet, Vasilii Kamensky, expressed in verse the sensations felt during a flight and by a triangular composition of the text gave a visual image of the plane slowly disappearing into a small dot. Using the sky as a canvas for his "Futurist aerial paintings" or as a stage on which to dance "mobile constellations", Azari expanded the field of expression immensely. His dances were accompanied by *rumoristica* music; with the clever Russolo, in fact, he had created a special top which amplified the engine sound, and an exhaust pipe which allowed the noise to be regulated. He intended to add even more astonishing elements when the sky would be "free" again. This "clown of the celestial canopy" wanted to create an ever-changing, multi-coloured milieu for his flying leaps. He intended to exalt the Futurist sense of wonder and the spectators' emotions by using airplanes decorated by artists like Balla, Depero and Ginna, by dropping perfumed powder, rockets, and confetti, by using coloured lights and smoke. Azari's *fisicofollia*, "body-madness", gave the aeroplane a "poly-expressiveness" that allowed a total identification with the machine, exceeding all Marinetti's theories on using the body as a metaphor.

In his *Manifesto of Futurist Dance* Marinetti had advocated a gymnastic approach and the imitation of mechanical movements in order to attain the ideal of a "multiplied body". The dancer, he said, needed to "woo steering-wheels, wheels, and pistons for a melting of man and machine that would create the metallic quality of Futurist dance". In the three choreographic scores that Marinetti published together with the manifesto — *Danza dello shrapnel* (Shrapnel Dance), *Danza della mitragliatrice* (Machine-gun Dance), *Danza dell'aviatrice* (Woman Pilot's Dance) — the movements represented war machines. The brand new sounds of modern war had inspired Marinetti's free-word poem on the siege of Adrianopole. This discovery of noise in art

La Vie Parisienne, 19 February 1921
"Futurist Dances"

suggested *rumorista* music to Russolo. Futurist dance also drew from war its aim of reaching the "optimum of courage, instinct, and muscular endurance".

According to Marinetti's directions, the dancer was to emulate the parabolic trajectories of bullets fired by shrapnels. "Through the vibrations of her body, the swaying of her hips, and swimming movements of her arms", she was to mime "the waves, the ebb and flow, the concentric vibrations of the echo created in the bays, in the roadsteads, along the mountain slopes".

All expressions of the Futurist theatre were founded on a synthesis, and dance found its natural complement in Russolo's music, an orchestra of *intonarumori*. But still the dancer, by stamping her feet, would emphasize the *tum-tum* of shell-fire, and by clacking her fingers adorned with long, metal thimbles would produce a sound — *paaaak* — simulating the "silvery, blissful and proud explosion of the shrapnel". Besides creating onomatopoeic effects with her gestures, the dancer would also give scenographic hints by piling up green cloth to simulate a mountain over which she would jump (*Machine-gun Dance*). In the course of her dances, she would also hoist ironical placards, adding to the gaiety and lightness of the performance. For Marinetti war did not mean death; with its magnificent explosions and "Milky Way of shrapnel stars", it became a festivity, a game suggesting all kinds of bravery. In Marinetti's third choreography (*Woman Pilot's Dance*), the dancer, by swaying and shaking her body, would imitate a plane trying to take off. The celluloid propeller attached to her breast vibrated at every jolt and symbolized the symbiotic union between man and machine.

In 1917, Diaghilev asked Depero to create the scenes and costumes for the ballet *Song of the Nightingale*. His designs were inspired by the different forms of modern life, but, unlike Marinetti, Depero tried to reduce the human figure to a mere moving force for his armoured costumes. The sharply angled, fluorescent sets were matched by rigidly stylized costumes in bright colours. The human body disappeared under cylindrical, square and triangular shells covering heads, arms and hands. These constrictive elements — which recall the Dada costumes of the Cabaret Voltaire — ended up by conditioning the dance and provoking surprising effects.

In April 1917, in Rome, when Diaghilev's company opened its season at the Teatro Costanzi, Leonid Mjasin tried dancing wrapped up in these concave and convex structures made of wire and enamelled cloth. In front of the mirror in Depero's studio, he realized that his simplified movements were surprisingly like those of a robot. Though the performance was never staged, Mjasin used his experiments with Depero in the choreography of *Parade*. In his autobiography, *My Life in Ballet*, Mjasin acknowledged the influence that Italian Futurism had upon him.

Jean Cocteau, author of *Parade* — who had been in Rome with Diaghilev, Mjasin, and Picasso — requested Eric Satie to introduce in the music the realistic effects that the Italian Futurists claimed were signs of

modern feeling: the clicking of a typewriter, wailing of a siren, the roar of an aeroplane engine. Picasso turned the two dancers playing the managers into moving scenery. Dressed in rigid, gigantic frames that synthesized vertical sections of sky-scrapers or megaphones, they could not paralyze Mjasin's fantasy. The choreographer created for these sandwich-men dance steps that reflected the methodical dynamism of modern men. Even the Chinese conjuror (whom he played) jerked his head at every step like a robot.

Futurist experimentation not only created choreographies that were like mechanical devices and dancers who moved like objects, but also abolished the human figure. This occurred in the totally abstract sets created in 1915 by Balla for *Feux d'artifice*, performed during Diaghilev's Roman season. To express the feelings aroused by Stravinsky's music, the artist used the most rarefied matter, electric light, creating firework displays with simultaneous flashes. By using this artificial method to "rebuild" the stage, Balla gave luminous colour the power to manifest an invisible reality. Thus the artist gave life and emotional force to the flickering *acteur-gaz* imagined by Prampolini in *Scénographie futuriste*. The manifesto is dated the same year as Balla's designs (1915), and Prampolini in fact wrote a postcard to Balla confirming his "telepathic" contact with the latter's research. Reacting to the excessive use of geometrical shapes which transformed the human body into a "super-puppet", in his manifesto Prampolini suggested using effects obtained by using variously coloured lights.

The technical innovations introduced by the Futurists allowed a revolution in set-design and choreography that stripped the performance and revealed its spirit. (GDM)

Chwistek, Leon

(Cracow, 1884 - Moscow, 1944) Polish painter, writer, philosopher and mathematician

Chwistek was the author of a number of scientific works, and a widely respected logician. One of the most important theorists of the Formist group, Chwistek organized Futurist events and *soirées* in Poland from 1920 to 1923. In 1921 he invented his own pictorial theory, called Strefizm, which he applied in numerous paintings, drawings, and architectural and theatrical designs.

Chwistek was the author of the theory of "plurality of realities in art", first published in 1918, in which he related different styles in art to different aspects of reality, classifying them as follows: 1) the reality of objects, expressed in primitive art; 2) physical reality, presented in realistic art; 3) the reality of feelings, conveyed by Expressionists; 4) the reality of "visionaries": children, naïve artists, baroque painters and Futurists.

His rationalism and his passion for order made it impossible for Chwistek to remain part of the Futurist adventure for very long. From 1923 onwards he became progressively more involved with the Marxist Left, and in the year of his death was made a member of the Communist government of Poland that was formed in Moscow. (SZ)

Cinema

Rather than making an attempt to define Futurist cinema theoretically and historically, it is better to try and understand the real relationship between Futurism and the cinema, their reciprocal influence, and their points of convergence. On close examination, in fact, one cannot really talk about Futurist cinema in the strict sense of a theory and practice, of a history or of a technical-linguistic experimentation which would define a clear field. In other words, Futurist cinema does not exist and has never existed. (The only film which to all effects could be defined as such, *Vita futurista*, made in 1916 by Marinetti, Balla, Corra, Ginna and Settimelli, was lost; it had little circulation, little effect and its influence was negligible.) What did exist however, and can be used as a basis for a historical reconstruction, was the interest the Futurists showed in the cinema, the relationship which undoubtedly existed between the formulation of their aesthetic, literary, artistic and linguistic programmes, conceived and published in the years from 1909 to 1916, and the cinema as a technical and formal "presence" in contemporary society, exactly symbolizing the "simultaneity", "speed" and "rhythm" which pervade modern life.

It is well known that in the *Manifesto of Futurism* (1909) the cinema is not mentioned, yet to a certain extent Marinetti felt its presence when he wrote, for example: "We intend to exalt aggressive action, a feverish insomnia, the racer's stride, somersaults", or when he added: "We affirm that the world's magnificence has been enriched by a new beauty: the beauty of speed." It is as though he wished to emphasize that literature, too, and the traditional artistic languages in general, could find new vigour by understanding and, like the cinema, representing the dynamism of modern society.

This reference to the new technical medium and to the new popular entertainment can be found in other writings of that time, such as the *Technical Manifesto of Futurist Literature* (1912), in which one can read: "The cinema offers us the dance of an object which is divided and recomposed without human intervention. It also offers us the backward leap of a swimmer whose feet come out of the sea and bounce violently on a diving-board. Finally, it offers us a man running at 200 kilometres an hour. These are all movements of matter beyond the laws of intelligence and therefore more meaningful in their essence." And in the manifesto *The Variety Theatre* (1913) Marinetti writes of the cinema and the "incalculable numbers of visions and otherwise unrealizable spectacles" which it can provide. And finally, in *The New Religion - Morality of Speed* (1916), Marinetti mentions "cinematic films" among those "places inhabited by the Divine".

It was therefore more than a superficial tie that linked the cinema and Futurism. The new world-view which Marinetti and his followers proposed as fresh material for literature and art was perhaps influenced most of all by their experience as interested spectators of the cinema. Roger Allard was probably right when, in 1911, he described Futurists as those "who had cinecameras in their stomachs".

However, this interest in the cinema and other forms of popular art and entertainment (for example, variety theatre), was never anything more than a general term of reference, an argument to be used in the battle for a "simultaneist" art, against "passéism", under the banner of Futurism. The literary talents of Marinetti and the musical, architectural and artistic abilities of some of his disciples never prompted them towards a true search for new techniques of expression. They used the traditional fields of art, naturally with the intention of subverting them (Russolo's "art of noises" was an exception). The cinema provided stimuli for the literary and the pictorial imagination, and showed a series of fantastic possibilities which the Futurists were able to use in other media. For them, rather than a technique to be learned or experimented, it was a source of "anti-aesthetical" enjoyment, of surprise and provocation (as it would be, on the whole, for the Surrealists).

From this point of view — as a repertory of unusual situations and images, a montage of heterogeneous elements, a fragmentation of time and space (and of the actors' bodies) — the cinema, especially the comic cinema of that time, can be considered intrinsically "Futurist". One only has to think of Italian films like the grotesque comedies of André Deed (Cretinetti), particularly *Cretinetti e le donne* (*Cretinetti and Women*, 1910) in which the main character is decomposed, dismembered like a puppet (Marinetti's "multiplied man"). Certain short films by Ferdinand Guillaume (Polidor) also spring to mind, with their absurd, almost surrealist comicality. Above all there was *Amor pedestre* (*Pedestrian Love*, 1914) by Marcel Fabre (who had appeared as Robinet in a series of comedy films), which is like a Futurist microdrama with its erotic-grotesque game of feet and legs. These films and film-makers certainly influenced Marinetti and the Futurists, and their influence is to be found in certain theatrical syntheses and in the manifesto *The Futurist Synthetic Theatre* (1915), signed by Marinetti, Settimelli and Corra, where it says: "With this essential and synthetic brevity, the theatre will be able to face and win the competition with the Cinema." Moreover Marinetti and Corra at that time were planning a film called *Le mani* (*Hands*), obviously "synthetic", and Marinetti, in the microdrama *Le basi* (*Bases*), was clearly inspired by *Amor pedestre*. There was therefore an interchange of experience and ideas, of inspiration and example, between Futurism and the cinema, which became a thread linking the various artistic events of the avant-garde in the second decade of the 20th century.

This leaves little space for the experiments of *cinepittura* (cine-painting) or *musica cromatica* of the Corradini brothers (Arnaldo Ginna and Bruno Corra), or the *fotodinamica futurista* of Anton Giulio Bragaglia, or the latter's films made in 1916 and 1917, *Thaïs* and *Perfido incanto* (*Wicked Enchantment*). However, these works do fit into the general picture of so-called "Futurist cinema" in the sense that together they constitute a set of tendencies, attempts, experiments, proposals which

"Dance of Geometric Splendour"
from the film Vita Futurista, 1916

clearly influenced the manifesto *Futurist Cinema* (1916), signed by Marinetti, Corra, Settimelli, Ginna, Balla and Chiti, and the contemporary film *Vita futurista*, already mentioned, which was the practical expression of the manifesto.

In 1910-12, the Corradini brothers made some short "hand-made" films using unexposed film to compose a visual symphony of forms and colours. These works, described in detail in Bruno Corra's essay *Musica cromatica*, published in the volume *Il pastore, il gregge e la zampogna (The Shepherd, the Flock and the Bagpipe*, 1912), have unfortunately been lost, but from their description they can be defined as "abstract films" which followed the same line of research later developed in France and Germany in abstract art and kinetic painting. As for Bragaglia, in his *Fotodinamismo futurista* (1911), which contains interesting photographic experiments, he explicitly opposes the idea of cinema as an "art of movement" and denies its aesthetic possibilities. Finally his film *Thaïs (Perfido incanto* is lost) remains within the limits of D'Annunzio's prevailing influence except for certain set designs of undoubted quality and modernity, thanks to Enrico Prampolini's collaboration.

Vita futurista was also lost but the description published in *L'Italia Futurista* (1 October 1916) gives us an interesting summary. The film was divided into a series of episodes, scenes and short scenes performed by the Futurists themselves with their friends, mixing various shooting techniques and tricks.

The introduction states: "Let us free cinematography from its slavery of having to simply reproduce reality, like a moving photograph, and let us raise it to the level of art, a means of expression like painting, sculpture, architecture, literature, etc."

The description lists the following episodes: "How a Futurist sleeps", "Morning gymnastics", "A Futurist lunch", "Argument between a foot, a hammer and an umbrella", "A Futurist walk", "Futurist work - Images ideally and externally deformed". It was really a sampler of cinematic possibilities, more interesting in its ideas for breaking down forms (anticipating Dadaist poetry), than in its language. And it only partly put into effect the ideas contained in the manifesto *The Futurist Cinema*, published the same year.

This manifesto is the only text we can refer to when discussing Futurist cinema. It anticipates many ideas of successive avant-garde cinema, but it is also generic and overly ambitious. Claiming the utmost liberty for this new medium, it identifies the authentic Futurist elements and possibilities, in the conviction that "the cinema, being essentially visual, must first follow the evolution of painting, detach itself from reality, from photography, from the graceful and solemn", and become "anti-graceful, deforming, impressionistic, synthetic, dynamic, free-wording". The manifesto then lists the characteristics of Futurist cinema, from "cinematic analogies" to "cinematic simultaneity and interpretation of different times and places", from "cinematic musical researches" to "filmed dramas of objects", from "filmed unreal reconstructions of the

L. Survage, Coloured Rhythm, *1913*

A. Ginna, Still from the film Vita Futurista, *1916*

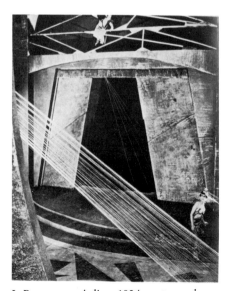

J. Protazanov, Aelita, *1924, costumes by A. Exter*

human body", to "linear, plastic, chromatic etc., equivalents of men, women, events, thoughts, music, feelings, weights, smells, noises", and so on, concluding: "We decompose and recompose the universe according to our marvellous whims."

As we have seen, these programmatic intentions mostly remained confined to paper: Futurist cinema was never really born. However, the various currents of the subsequent cinematic avant-garde all drew, directly or indirectly, from this tumultous, somewhat clouded, flow of ideas. If Futurist cinema had a precarious and transitory existence, the influence of Futurism and its manifestos on the avant-garde of the cinema was on the contrary fundamental, decisive and absolute.

We need only remember certain experiments of the avant-garde cinema in Germany in the years immediately following the First World War, and the practical and theoretical work of certain Soviet filmmakers — not to mention the direct influence of Italian Futurism on Russian Cubo-Futurism in the film *Drama v kabare futuristov no. 13 (Drama in the Futurist Cabaret no. 13)* by V. Kasianov, or the experiments of Maiakovsky, Larionov and others. In Germany, the work of two Dadaist painters, Hans Richter and Viking Eggeling, who explored the possibilities of abstract cinema with films of great interest like *Rhythmus 21* by Richter, and *Diagonal Symphony* by Eggeling, is certainly connected, however indirectly, with the *Manifesto of Futurist Cinema* and the Corradini brothers' first experiments; these films are in any case part of a Dadaist experimentation that has its roots in a ground already tilled by Futurism.

In the Soviet Union, Kuleschov's first writing and experiments with editing, and more particularly Dziga Vertov's "cinemaeye", and Eisenstein's early theoretical and practical work, are part of that breaking down of traditional idioms and discovery of speed and simultaneity that the Soviet film avant-garde inherited from Italian Futurism, via Russian Cubo-Futurism. It is also fair to mention certain currents of so-called "Impressionism" in the French cinema, and the whole Paris avant-garde movement, from Léger's *Ballet mécanique* to Clair-Picabia's *Entr'acte*, to Man Ray's *Retour à la raison (Return to Reason)*, and the Surrealist cinema and "visual symphony", which were certainly influenced — probably through other artistic and cultural channels — by the ideas formulated in the Italian Futurists' manifesto.

This is a vast field of explorations and experiments, which should obviously not be confused or all put together in a single category. Behind the work of these and other artists there are other lessons besides that of Italian Futurism, nor is it enough to merely identify provocative, subversive or purely playful intentions, or aims that somehow have a single common principle behind them.

However, there is no doubt that at least as far as the spread of ideas is concerned, pointing out new paths and also making naïve or unrealistic suggestions, the *Manifesto of the Futurist Cinema* is a fundamental text for the history of the avant-gardes in the cinema. (GR)

The Futurist Cinema

(Futurist manifesto, Milan, 11 September 1916)

The book, a wholly passéist means of preserving and communicating thought, has long been fated to disappear like cathedrals, towers, fortress walls, museums, and the pacifist ideal. The book, immobile companion of the sedentary, the nostalgic, the neutralist, cannot entertain or exalt the new Futurist generations intoxicated with revolutionary and warlike dynamism.

The conflagration is enlivening the European sensibility. Our great hygienic war, which should satisfy *all* our national aspirations, multiplies the innovative energy of the Italian race. The Futurist cinema, which we are preparing as a joyful deformation of the universe, an alogical, fleeting synthesis of life around the world, will become the best school of youth: a school teaching joy, speed, strength, courage and heroism. The Futurist cinema will sharpen and develop the sensibility, quicken the creative imagination, and give the mind a prodigious sense of simultaneity and omnipresence. The Futurist cinema will thus take part in the general renewal, supplanting the literary review (always pedantic) and the drama (always predictable), and killing the book (always tedious and oppressive). Propaganda needs will force us to publish a book once in a while. But we prefer to express ourselves through the cinema, through great tables of words-in-freedom and mobile illuminated signs.

With our manifesto "The Futurist Synthetic Theatre", with the triumphant tours of the theatre companies of Gualtiero Tumiati, Ettore Berti, Annibale Ninchi, Luigi Zoncada, with the two volumes of *Futurist Synthetic Theatre* containing eighty theatrical syntheses, we have begun the revolution in the Italian prose theatre. An earlier Futurist manifesto rehabilitated, glorified, and perfected the Variety Theatre. It is logical therefore for us to carry our vivifying energies into a new theatrical area: the *cinema*.

At first sight the cinema, born only a few years ago, may seem to be Futurist already, lacking a past and free from traditions. Actually, as a *theatre without words*, it has inherited all the most traditional rubbish of the literary theatre. Consequently everything we have said and done about the stage applies to the cinema. Our action is legitimate and necessary in that the cinema up to now *has been and tends to remain profoundly passéist*, whereas we see in it the possibility of an eminently Futurist art and *the expressive medium most adapted to the complex sensibility of a Futurist artist.*

Except for interesting films of travel, hunting, wars, and so on, the film-makers have inflicted on us only the most backward-looking dramas, great and small. Even the scenario, whose brevity and variety might appear advanced, is usually nothing but a trite and wretched *analysis*. Therefore all the immense *artistic* possibilities of the cinema still rest entirely in the future.

The cinema is an autonomous art. The cinema must therefore never copy the stage. The cinema, being essentially visual, must first follow the evolution of painting and detach itself from reality, from photography, from the graceful and solemn.

It must become antigraceful, distorting, impressionistic, synthetic, dynamic, free-wording.

The cinema must be freed as an expressive medium so that it may become the ideal instrument *of a new art*, much wider and more flexible than any existing art. We are convinced that only the cinema can achieve that *multi-expressiveness* sought by all the most modern artists. Today the Futurist cinema creates precisely the *multi-expressive symphony* that a year ago we announced in our manifesto "Weights, Measures and Prices of Artistic Genius". The Futurist film will use the most varied elements of expression: from the slice of life to the streak of colour, from conventional dialogue to words-in-freedom, from chromatic and plastic music to the music of objects. In other words it will be painting, architecture, sculpture, words-in-freedom, music of colours, lines and forms, a jumble of objects, a reality in chaos. We shall offer new inspiration for painters who are trying to break out of the limits of the frame. We shall set in motion the words-in-freedom that dissolve the boundaries of literature as they march towards painting, music, and noise-art, throwing a marvellous bridge between the word and the real object.

Our films will be:

1. *Cinematic analogies* that use reality directly as one of the two elements of the analogy. For example: to express the anguished state of one of our characters, instead of describing his various phases of suffering, we can give an equivalent impression by showing a jagged, cavernous mountain.

The mountains, seas, woods, cities, crowds, armies, squadrons, aeroplanes will often be our formidably expressive words: *the universe will be our vocabulary*. For example: to create a sensation of bizarre hilarity we can show a group of chairs flying gaily around an enormous coat-stand until they decide to hang themselves up. To give the feeling of anger we can break the angry man up into a whirlwind of yellow pellets. To represent the anguish of a hero who has lost his faith in neutrality we show him making an inspired speech to a great crowd; suddenly we bring on Giovanni Giolitti who unexpectedly stuffs a thick forkful of macaroni into the hero's mouth, drowning his winged words in tomato sauce.

We shall give colour to the dialogue by simultaneously flashing on the screen the images that pass through the characters' minds. For example: if a man says to his woman: "You're as lovely as a gazelle", we shall show the gazelle. If a character says: "I gaze on your fresh and luminous smile as a traveller after a difficult voyage gazes on the sea from a mountain top", we shall show traveller, sea, and mountain.

Thus our characters will be as easy to understand *as if they talked*.

2. *Cinematic poems, speeches and poetry.* We shall flash all of their component images on the screen.

Example: "Canto dell'amore" [Song of Love] by Giosuè Carducci: "In their German strongholds perched / Like falcons meditating the hunt..."

We show the strongholds and the falcons in ambush.

"From the churches that raise long marble / arms to heaven, in prayer to God... / From the convents between villages and towns / crouching darkly to the sound of bells / like cuckoos among far-spaced trees / singing boredoms and unexpected joys..."

We show churches that gradually change into imploring women, God beaming down from on high, convents, cuckoos and so on.

Example: "Sogno d'Estate [Summer's Dream] by Giosuè Carducci: "Among your ever-sounding strains of battle, Homer, I am conquered by / the warm hour: I bow my head in sleep on Scamander's bank, but my / heart flees to the Tyrrhenian Sea."

We show Carducci wandering amid the tumult of the Achaians, nimbly avoiding the galloping horses, paying his respects to Homer, going for a drink with Ajax to the Red Scamander inn, and at the third glass of wine his heart, whose palpitations we ought to see, pops out of his jacket like a huge red balloon and flies over the Gulf of Rapallo. This is how we make films out of the most secret impulses of genius.

In this way we can ridicule the works of the passéist poets, to the great benefit of the public, transforming the most nostalgically monotonous weepy poetry into violent, exciting and highly exhilarating spectacles.

3. *Cinematic simultaneity and interpenetration* of different times and places. We shall project two or three different visual episodes at the same time, one beside the other.

4. *Cinematic musical experiments* (dissonances, harmonies, symphonies of gestures, events, colours, lines, etc.).

5. *Dramatized states of mind on film.*

6. *Daily exercises in freeing ourselves from mere photographed logic.*

7. *Filmed dramas of objects* (objects animated, humanized, made-up, clothed, impassioned, civilized, dancing — objects removed from their normal setting and put into an abnormal state that, by contrast, reveals their amazing construction and non-human life).

8. *Show windows of filmed ideas, events, types, objects, etc.*

9. *Congresses, love-affairs, fights and marriages of grimaces, mimicry, etc.* For example: a big nose silences a thousand congressional fingers by ringing an ear, while two policemen's moustaches arrest a tooth.

10. *Filmed unreal reconstructions of the human body.*

11. *Filmed dramas of disproportion* (a thirsty man pulls out a tiny drinking straw that lengthens umbilically as far as a lake and dries it up *instantly*).

12. *Potential dramas and strategic plans of filmed feelings.*

13. *Linear, plastic, chromatic equivalents, etc.*, of men, women, events, thoughts, music, feelings, weights, smells, noises (with white lines on black we can show the inner and the physical rhythm of a husband who discovers his wife in adultery and chases the lover — rhythm of soul and rhythm of legs).

14. *Filmed words-in-freedom in movement* (synoptic tables of lyric values — dramas of humanized or animated letters — orthographic dramas — typographical dramas — geometric dramas — numeric sensibility, etc.).

Painting + sculpture + plastic dynamism + words-in-freedom + composed noises

[intonarumori] + architecture + synthetic theatre = Futurist cinema.

Thus we can break up and recompose the universe according to our marvellous whims, multiplying the force of the Italian creative genius and its absolute pre-eminence in the world.

F.T. Marinetti, B. Corra, E. Settimelli, A. Ginna, G. Balla, R. Chiti, Futurists

City

The vision of the "Futurist city", a utopian city, a city of desire, already appears on the first page of Marinetti's manifesto, published in *Le Figaro* of Paris on 20 February 1909: "We had stayed up all night... arguing up to the last confines of logic and blackening many reams of paper with our frenzied scribbling... Alone with stokers feeding the hellish fires of great ships, alone with black spectres who grope in the red-hot bellies of locomotives launched headlong down their crazy courses, alone with drunkards reeling like wounded birds along the city walls. Suddenly we jumped, hearing the mighty noise of the huge double-decker trams that rumbled by outside, ablaze with coloured lights, like villages on holiday suddenly struck and uprooted by the flooding Po and dragged over falls and through gorges to the sea. Then the silence deepened. But, as we listened to the old canal muttering its feeble prayers and the creaking bones of sickly palaces above their damp green beards, under the windows we suddenly heard the famished roar of automobiles."

A new city must be born and must grow together with the new ideology of movement and machines. A city that loses its immobility and is set in motion by the lights, the tramways and the noises that multiply the points of view. "Trains and tramways racing along the great thoroughfares built over your canals, filled in at long last, will bring you mountains of merchandise, amidst a crowd of shrewd, wealthy, bustling manufacturers and tradesmen!..." shouted Marinetti in his Futurist speech to the Venetians (July 1910), stressing the rot and putrefaction emanated by the ancient city, a city he saw as the support of romantic memories and dreams. "All this absurd, abominable and irritating stuff sickens us! And it is time for electric lamps with a thousand points of light to brutally cut and tear your mysterious, enchanting and seductive shadows!"

In the *Technical Manifesto of Futurist Painting* (11 April 1910) the spatial vision was wider, the object was no longer separated from the atmosphere, and the city witnessed its deflagration: "Space no longer exists; the street pavement, soaked by rain and glistening in the glare of electric lamps, gapes right down to the very centre of the earth. Thousands of miles divide us from the sun yet the house in front of us fits into the solar disk." And shortly afterwards Boccioni began to paint *The City Rises*, a painting "inspired by the purest intention, that of erecting a new altar to modern life, an altar vibrant with dynamic energy, as pure and exalting as those that were erected to the mystery of the divine by religious contemplation; I say that a painting with such an aim is infinitely superior to any more or less subjective repro-

duction of real life" (from a letter from Boccioni to Barbantini).

The theme of the city was therefore developed at a very early stage by the Futurists. Individual artists were depicting the urban landscape even before the theory was elaborated. Balla sought new perspectives of Rome at the beginning of the century, while Severini set out to portray the lights of the city. The vision of the city became violent in Boccioni's works of 1911; in *Simultaneous Visions* and in *The Street Enters the House*, intersecting angles, concentric forms and interrupted planes create the image of the vortex of the modern metropolis. There was a strongly-felt "need to Americanize ourselves by entering the all-consuming vortex of modernity through its crowds, its automobiles, its telegraphs, its noises, its screeching, its violence, cruelty, cynicism and unrelenting competition; in short, the exaltation of all the savage anti-artistic aspects of our age". The theme of the city fascinated the other Futurists too. Carrà seemed to portray a convergence of sensations through solid formal elements: a chaotic city dominated by bright colours appears in *What the Tram Told Me* and in *Jolts of a Cab*, composed along Cubist lines, with very few objective references to reality as in *The Galleria in Milan* of 1912. Russolo, in *Memories of a Night* (1911) was still tied to Divisionist and Symbolist idioms, but he abandoned them completely in *Dynamism of a Car*, in which the city is cancelled by speed, expressed in a succession of wedge-shaped blocks of colour. Severini studied and portrayed "arabesque, rhythmic and deliberately ordered constructions able to produce a new qualitative architecture, composed exclusively of qualitative quantities", as in *Plastic Rhythm of the 14th of July, Nord-Sud* and *The Boulevard*. In a text of 1911, *Le futurisme*, Marinetti seemed to have come down to reality and to no longer dream of an imaginary ideal metropolis: "In the mechanized and democratic city... we no longer need the vast, elaborate buildings that once expressed royal authority, theocracy and mysticism. The contradictory forces of the banks, the leaders of fashion, revolutionary trade unions, metal-workers, engineers, electricians and aviators, the right to strike, equality before the law, the authority of numbers, the usurping power of the masses, the speed of international communications and the habits of hygiene and comfort, demand large well-ventilated apartment houses, absolutely safe railways, tunnels, immense meeting-halls and bathrooms designed for the rapid daily care of the body." Interest in a new dimension of reality widened to include practical projects, like the *Manifesto of Architecture* drawn up by Boccioni in 1914 with the aim of revolutionizing the very concept of architecture: "We have said that in painting we shall put the viewer at the centre of the picture making him the centre of the emotion rather than a mere spectator. The architectural environment of the city is also being transformed to include the people. We live in a spiral of architectural forces. In the past, construction unwound in a successive panorama: one house followed another, one street followed another. Now around us we see the beginnings of an ar-

chitectural environment that develops in every direction: from the luminous basements of the large department stores, from the several levels of tunnels of the underground railways to the gigantic upward thrust of American skyscrapers." However, these images of bursting dynamism and violent movement still develop in a dimension of perception. In Sironi's works of that period the city appears sombre, a construction of plastic forms determined by a solitary, thoughtful vision. The sense of motion and speed, as opposed to monumentality and weight, returns in Sant'Elia's manifesto (signed on 11 July 1914 and published in *Lacerba*, 1 August 1914): "We must invent and rebuild the Futurist City like an immense, tumultuous construction-site, agile, mobile and dynamic in every detail; and the Futurist house must be like a gigantic machine." But the new metropolis rose only in drawings left by Sant'Elia: cities with gigantic connecting structures between the buildings, thrust upwards by a rising vertical movement.

From 1914 specific projects took the place of the visions of the early years. Balla's drawings followed Chiattone's "Proto-Rationalism", Depero (1916) had a more plastic-mechanical concept, while Prampolini (1913-14) was more interested in the breakdown of form. At the end of the second decade of the century, Marchi worked out an architectural style for his dream city that resembled Expressionist models. In the Twenties and Thirties new projections and new proposals followed one after the other (Fillia, Prampolini, Paladini, Diulgheroff, Mosso and Mazzoni), but they increasingly lost the earlier utopian urge and became immersed in reality or, as in the case of the second-generation Futurists, came to terms with the new Futurist air mythology. (EC)

Ciurlionis, Mikhalojus Konstantinas

(Varena, 1875 - Vilnius, 1911) Lithuanian painter

Like a true primitive, Ciurlionis believed in the omnipotence of his thoughts, and he transferred into painting the rules of resemblance and contiguity of unconscious associative processes. An isolated figure in the world of art, he painted fantasies in which filigreed geometricized viaducts connect chimerical perspectives, and points of rocks and pyramids rip through sky and clouds. In his subjective topography, space expands magically and everything which is related seems to be physically joined. Every image creates germinating replicas; trees may be reproduced in the sky or clouds descend below the surface of the earth. In the *Sonata of the Pyramids* of 1909, long lines of pyramids with diaphanous bubbles and pinnacles at their peaks are paired and become archetypal mirages of air and light. Thrust upwards by an irresistible verticality, they seem to stretch toward the sun — the ideal centre of the universe — along a path marked by a threadlike bridge and by stairways on which white mummies lie. Before our eyes three orders of worlds, each with its own horizon, appear, becoming brighter in an upward progression. The development of a theme in a succession of canvases (two, three or four) — which Ciurlionis referred to as a "sonata", differentiating each canvas with a musical term: "andante", "allegro", "scherzo" and "finale" — was an allusion to the genesis of a creative process and at the same time to the gradual attainment of a higher spiritual state. This division, reminiscent of a musical score, is only incidentally connected to the fact that Ciurlionis, before discovering that painting was his true calling, had studied music. In reality his images were inspired by a symbolism of ascent, that of the holy mountain, the tree of the world, the ziggurat, the ladder, the bridge — all of which, according to ancient traditions, can be traced back to the fundamental image of the central axis of the universe. He who has reached the centre, that is, the primordial state of Eden (to which the 1909 painting *Paradise* seems to refer), can rise to higher levels along this axis. Ciurlionis was interested in experimental psychology and he developed parapsychological powers such as pranotherapy and hypnosis from a distance. His interest in Lithuanian folk art, with its legends of the serpent, as protector of the hearth, and the sun symbol of the swastika drawn on the houses of peasants, led him to examine the close affinities between Indian and Lithuanian mythology. After moving to Warsaw, during the years of his formation as a painter (1901-07) he continued to study Indian philosophical and religious systems, astrology, and sun-worship in ancient Egypt. His contacts with the Krakow group Sztuka (Art) — which was connected to the Theosophical group in Munich directed by Rudolf Steiner — strengthened in him that special vein of creativity which was generated by occult revelation. In his series of twelve paintings, the *Signs of the Zodiac* of 1907, the skies, absorbing light from below, come alive with a secret life. The transparent colour, uninterrupted by the perspectival lines of Euclidean space, is presented as a vibrating condensation of sky-blue. The solitary stellar divinities and the horizon appear with barely distinguishable outlines, because they are projected into an infinite distance. In his experiments with transparency and clouding, Ciurlionis was influenced by Wilhelm Wundt's theories on visual perception, which he learned about in a series of lectures in 1901 in Leipzig. Wundt in fact maintained that if the perception of an image is in some way blocked, if for example we look at an object from a distance or with bad lighting, the object will be transformed by suggestion into a fantastic image. In Ciurlionis the shades of green, pale yellow, tenuous violet and ultramarine help to establish an equivocal atmosphere with diffuse luminosity, far from the brassy sharpness of the colours of reality.

It is remarkable that the very tonalities preferred by Ciurlionis should be said by Steiner, in his *Theosophy* (1904), to be the constituent elements of the aura of men who are spiritually awake, visible to the eyes of a seer as an interpenetration of fluid colours that seem self-generating.

Ciurlionis's unlimited visions of other worlds and of colour in its gaseous state interested Kandinsky so much that he invited the Lithuanian artist to the show of the Kunstlervereinigung in Munich in 1910. The invitation reached Ciurlionis too late and he was unable to attend. (GDM)

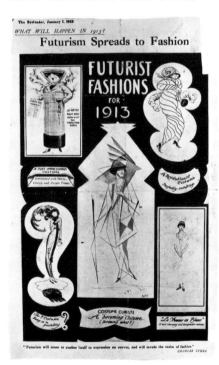

The Bystander, *London, "Futurist Fashions for 1913"*

Clothing

In Europe around 1910, after decades of flowing, gauzy dresses made of tulle and satin in pale, delicate colours, often decorated with ribbons and feathers, there was a sudden change in clothing fashion. The reason is to be found in the wave of Orientalism brought by Paul Poiret and the Ballets Russes, in particular the production of *Shéhérazade* with costumes designed by Léon Bakst. The appearance on the stage of materials in strong colours, cut so as to create surprising angles, revolutionized the design of men and women's clothing. Colours became violent and the lines crossed the body irregularly, creating geometrical openings like the revolutionary "V-neck" of 1913.

The Futurists, interested in speed and the Ballets Russes, were aware that fashion could be used to stimulate perception in the same way as their elimination of sitting figures, so they threw themselves into this field and tried to make clothing more actively expressive. Giacomo Balla and Fortunato Depero, painters who in 1915 were to work with Diaghilev's company, were the first to see clothing as a dynamic interface between the body and the atmosphere, between physical gestures and the urban context, which could be translated into encounters between forms and colours, volumes and architecture. For them, clothing began to exist as an object and an event, something to be removed from a mainly static conception and made mobile, active. Balla began in 1912 by drawing white lines on completely black fabric to create a series of optical intersections from the neck down to the trousers which abolished the symmetry of male clothing and gave it an animated, almost kinetic look. The geometrical and spatial disintegration of clothing was taken further after 1913, when Balla proposed other visual breaks in the shape of the jacket and the neck-tie, arranged on the body to create extremely original optical patterns. These were based on the line-forces of the paintings inspired by speed and the chromatic systems of his "iridescent interpenetrations", and created an irregular, active disorder and dispersal. The continually changing forms were accompanied by the aggressive colours of the materials, often phosphorescent or covered with electric bulbs so as to include the element of light and relate the costume to the environment. The interrelation of the shapes created unstable spiral effects almost as if the function of the body's second skin — clothing — was to multiply the colours and volumes of its movements rather than organize them into formal rigidity, as men's fashion had done up to 1913.

The interaction between movement and clothing was based on the relativity of perception: the appearance and disappearance of the body produced points without dimension or duration which served, as Balla wrote in the *Futurist Manifesto of Men's Clothing* (1914), to "renew incessantly the enjoyment and impetuous movement of the body". The Futurist vision of the components of clothing — jacket, waistcoat, shoes, trousers, shirt, tie — aimed to create "clothing machines" whose parts would interact to accelerate the movement — real or virtual, inner and

outer — of the human being. According to the manifesto, "Futurist clothes will therefore be *aggressive*, able to increase courage... *dynamic* because of the dynamic patterns and colours of the fabrics which inspire a love of danger... *illuminating*, in order to spread light around when it rains, and correct the twilight greyness in the streets and in our nervous systems". These machines of the psycho-physical Futurist "I" are intended to stimulate the central energy source of the personality and transmit the vibrations of bodies to the streets of the metropolis. Futurist clothing was in fact designed for the stages and streets of the great cities of Europe, where the costume of the new "citizen of speed" was another element of surprise for the audience during theatrical performances and "synoptic recitals".

The same search for a revolution in clothing proceeded in other countries as well, with intentions that were different but complementary to those of Marinetti's group. In Paris, Sonia Delaunay invented "simultaneous" clothes, based on the interaction of pure form and colour, while in Moscow, where the emergence of the body's importance followed different ideological models, Alexandra Exter and Varvara Stepanova designed linear clothes that were plastic in structure.

Futurist concern with clothing, however, was not limited to its appearance in terms of cut and colour. Important was also the way it appeared and disappeared according to fashion. It was a "fast substance", able to reflect rapid, sudden changes of social and aesthetic taste. Marinetti, like the other Futurists, paid great attention to this. Between 1914 and 1933 three further manifestos appeared, dedicated to women's fashion, hats and "the Italian neck-tie". According to Marinetti, fashion was one of the fundamental elements of the "new religion-morality of speed"; together with "trains, restaurant-cars, bridges and tunnels, radio-telegraph stations, combustion motors and automobile tyres, bicycles and motorcycles", fashion could be considered another "space of the divine", in which "we create the passion for what is new and hatred for what has already been seen". (GC)

Coburn, Alvin Langdon

(Boston, 1882 - Rhos-on-Sea, Wales, 1966)
American photographer, naturalized English

Persuaded by his cousin Holland Day to take up photography, he followed him to London in 1899 where he met Edward Steichen and took part in various exhibitions. After a stay in France, he came back to the United States in 1901, opened a studio in New York, and exhibited often at Alfred Stieglitz's 291 Gallery. He returned to England in 1904, and decided to remain there. At first he gained relative celebrity by doing portraits of Rodin, G.B. Shaw, H.G. Wells, G.K. Chesterton, W.B. Yeats and others. These portraits were later collected in photographic anthologies (*Men of Mark*, 1913, 1922). In 1913 in London he met his compatriot Ezra Pound who introduced him to the Vorticists, and he did a number of portraits of them. He himself helped to develop Vorticism, and explained why he joined the group: "I did not see why

A. Langdon Coburn
design for the cover of his catalogue
Vortographs and Paintings, *1917*

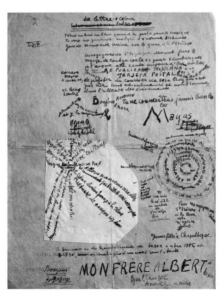

G. Apollinaire, original manuscript
of Lettre-Océan

my own medium should lag behind modern art trends, so I aspired to make abstract pictures with the camera. For this purpose I devised the Vortoscope late in 1916. This instrument is composed of three mirrors fastened together in the form of a triangle, and resembling to a certain extent the kaleidoscope — and I think many of us can remember the delight we experienced with this scientific toy. The mirror acted as a prism splitting the image formed by the lens into segments."

With this device Coburn photographed both objects and persons. The best-known photos are the portraits of Pound, who was fond of the resulting photos in which the subject exploded into facets and luminous shards: "They bear the same relation to Vorticist painting that academic photography bears to academy painting. Almost any fool can paint an academy picture, and any fool can shoot off a Kodak."

In February 1917, Coburn exhibited his photographs at the Camera Club of London, and later said the following about the exhibition: "Ezra Pound wrote an anonymous preface to the catalogue... The Vortoscope, he said, freed photography from the material limitations of depicting recognizable natural objects. By its use the photographer can create beautiful arrangements of form for their own sake, just as a musician does; but Pound warns that the Vortoscope is useless to a man with no eye for form or pattern." It is significant that in the same period Coburn displayed a passion for music and experimented with a player piano, attempting to attract the interest of musicians and composers with whom he was acquainted. Coburn did not continue this experimentation for long, but he never gave up his "Vortographs". His interest in abstract photography reappears in his later photographs of metal shards. (SF)

Collage

Following the example of Picasso and Braque, several Futurists introduced fragments of newspapers, posters, wallpaper, pages of books, labels, corrugated cardboard and so on into the pictorial composition. They intended to revolutionize the traditional expressive media and to offer a reality that was more complex than reality itself, because raw or "found" material was united to the formal invention produced by consciousness. Futurist collages appeared simultaneously with Cubist *papiers-collés*, although those aggregations of material were more isolated and less influential. Boccioni used pieces of newspaper rarely (*Dynamism of the Head of a Man*, 1914 and *Charge of the Lancers* of 1915), and more out of a need for formal synthesis than to develop the elaborate constructions of his "multimaterial" predecessors. But more than anyone else it was Severini who, working in Paris, introduced the technique of collage into graphics and painting, thus initiating the move toward mixed media. The date of *Still Life with a Box of Matches* was 1912; here an ordinary little box manages to restore a link between the real object and the conceptual reality; in the same year the artist started a sequence of *Danseuses* and used sequins and stucco. Between 1912 and 1913 the painter made use of costume jewelry, moustaches and cloth (*Portrait of*

Marinetti, *Portrait of Paul Fort*). The effect was not limited to decoration; the collage technique extended the impact of colour contrast from the visual field to the mental field. The sequins and metal slabs that Severini inserted into the joyous colouring of *Dance of the Bear = Sailboats + Flowerpot* of 1913 also served as a temporal link; the decisive insertion of sheets of newspaper into the graphic context of *Still Life (Bottle and Vase and Newspaper and Table)* of 1914 marks the emblematic intervention of reality itself in a pictorial continuum based on the analytic restitution of the real object. We have, on the other hand, no reliable data to establish the development of Severini's Futurist *papiers-collés*, several of which have been destroyed or lost, while others unquestionably matured through the critical revision of Futurist, Cubist and Abstract techniques.

Far more consequential and symptomatic of a return to form were the collages that Carrà and Soffici executed between the end of 1913 and 1915. Picasso's influence was rapidly assimilated in a progressive and personal appropriation of the materials employed but, unlike the Cubists who offered a different reality, useful for plumbing reality itself, Soffici and Carrà opposed to the intellectualization of the idea the immediacy of vision and compositional clarity that they were discovering in the solutions adopted by popular decorators and in posters. However, once they had escaped from the seductive rhythms of Picasso, Carrà and Soffici attained an emblematic restitution of reality (the image, glimpsed in its essence, contains and suggests many other images). Among works by Soffici we mention *Small Velocity*, *Composition with a Green Bottle*, *Still Life* and *Hoodlum*; by Carrà *Bottle and Glass*, *Still Life with Syphon* and *Café on the Outskirts*. Completely separate works can be noted in *Chase* and *Interventionist Manifesto* (*Patriotic Celebration*) of 1914.

Soffici's work is marked by an extremely personal synthesis and allusiveness; Carrà's by an original concentration and orchestration of verbal and material stimuli, with references to the *divertissement* of the collage and the evocative possibilities of "words-in-freedom". In *Patriotic Celebration* Carrà confidently arranges a tumult of emotions and collective impulses in an image of concentrated force and virtual expansion.

The works produced by Carrà and Soffici can be linked to the collages of Ottone Rosai and the concentrated mixed media of Primo Conti; in contrast, certain compositions by Prampolini show no relation to the technique of collage, due to evident links with the avant-gardes of Russia and Germany. (PP)

P. Conti, Imbottigliature, *1917*

N. Nannetti, Synthetic Caricature of Bruno Corra, *1916*

Conti, Primo

(Florence, 1900 - now living in Fiesole) Italian painter and writer

Conti came into contact with Futurism while still a boy through the Lacerba exhibition in Florence in late 1913. He first experimented with Expressionism and Symbolism (following Costetti's example), and later, in 1917-18, infused his work with elements of Futurist dynamic decomposition, characterized by a dense and intimate application of colour that bound the image within a sensory overload of the materials used. These experiments constituted his participation in the Florentine Futurist group that revolved around *L'Italia Letteraria*. In 1919, when he published the little magazine *Il Centone* with Corrado Pavolini in Florence, his painting began to reflect a certain grotesque synthesis, with an increasingly evident metaphysical reference; this was the gateway to the Novecento experience. He also wrote Futurist literature, such as *Imbottigliature* (*Bottlings*, 1917) and *Fanfara del costruttore* (*The Builder's Fanfare*, 1920). (ECr)

Corra, Bruno

pseudonym of Ginanni Corradini, Bruno (Ravenna, 1892 - Varese, 1976) Italian novelist and playwright

Bruno Corra wrote Futurist theoretical texts with his brother Arnaldo Ginna. His first book was *Proposte* (*Proposals*, 1910), moral proposals, followed by *Con mani di vetro* (*With Glass Hands*) and *Madrigali e grotteschi* (*Madrigals and Grotesques*), in which he tried to create "mediumistic chords" and "synthetic moments". He developed these further in the novel *Sam Dunn è morto* (*Sam Dunn Is Dead*) and in the "theatrical syntheses" published with Marinetti and Emilio Settimelli in 1915 (along with a *Manifesto of Synthetic Theatre*). *Sam Dunn* is, he wrote, "the first novel without preparatory chapters, fillers, useless details and clichés, restful and watered-down material"; therefore it is "essential". The occult, mediumistic character of Corra's works of this period can be linked to the Novecento "miracles" and "magic" of Massimo Bontempelli. In subsequent narrative works (*L'isola dei baci*, *The Island of Kisses*, a novel with erotic and social themes written with Marinetti) Corra professed anti-literature and declared his support for "stylistic crudity". When he left the Futurist movement, he proclaimed his desire to write "proper, respectable novels" which would "amuse". He produced texts like *Il passatore*, as well as commercial plays written with Giuseppe Achille.

"When my energy as a great artistic acrobat failed, I made my way into the respectable, philistine publishing world. Now I am in the position of a cabaret singer who has married and leads an irreproachable existence, but who always meets in salons someone who remembers the time when she was known as Fifì and Lulù... You are still Futurists. I no longer am one." (MV)

Crali, Tullio
(Igalo, Dalmatia, 1910 - now living in Milan)
Italian painter, architect and set designer

In the late Twenties, Crali became interested in the theme of speed within a mechanical synthesis of the pictorial vision. In the second half of the Thirties and in the early Forties, he concentrated increasingly on creating images of "aeropictorial" views. Extremely personal and containing powerful representational elements, they were among the most significant paintings created in the context of a descriptive approach to the "aerial" vision. At the beginning of the Forties he co-authored with Marinetti the manifesto *Plastic Illusionism of War and Perfecting the Earth* and the *Manifesto of Musical Words - Alphabet in Freedom*. (ECr)

Cramer, Konrad
(Wurtzberg, 1888 - Woodstock, N.Y., 1963)
German painter, naturalized American

Konrad Cramer came to New York in late 1911 from his native Germany where he had encountered the local avant-garde. He soon associated with the most radical aesthetic circle in New York — Alfred Stieglitz's coterie. Cramer quickly absorbed the new from Kandinsky's Expressionism to Cubism and experimented with his own colourful non-objective paintings. He soon returned to representation and created some modernist landscapes and cityscapes. His 1917 untitled linocut of New York City shows a dynamic urban view which might have been inspired by published reproductions of Futurist paintings, or more probably, through the watercolours of New York by John Marin, a fellow artist in the Stieglitz circle. Cramer even included repeated rhythmic lines echoing the thrusts of the buildings and evoking the Futurists' lines of force. (GL)

Creationism
The Chilean Vicente Huidobro set forth his theory of Creationism in Buenos Aires in 1916, but he offered examples of the theory only in Europe, in Paris and Spain, with *Tour Eiffel* (Madrid, 1918) and several calligrammes (the first were published in Chile beginning in 1914). In 1921 he published in Madrid the magazine *Creación*, whose contributors spread through a cosmopolitan avant-garde and included Futurists such as Settimelli. Nonetheless, he took an extremely aggressive stance toward Futurism which, in his view, was "a cold and imperialistic dream... a little noise and a lot of confusion". He had been greatly encouraged by the example set by the Futurists, however. (SF)

Csáky, József
(Szeged, Hungary, 1888 - Paris, 1971)
Sculptor of Hungarian origin, naturalized French

After his studies at the School of Applied Arts in Budapest, József Csáky opted for sculpture and painting. He took up residence in Paris in 1908 and lived at La Ruche where he met Léger, Archipenko, Chagall, Laurens, and — later — Cendrars. From 1911 he was interested in Cubism and in 1912 exhibited with the Section d'Or. The sculptor, however, remained outside all groups. Marcel Duchamp wrote: "For

A. Soffici, Cubism and Futurism, *1914*

G. Apollinaire, Cubist Painters, *1913*

Csáky, the theory of Cubism was a springboard towards unknown lands, and although he was influenced by Cubism, he introduced his own ideas on the treatment of space." (SF)

Cubism
The relationship between Cubism and Futurism is extraordinarily complicated. The two movements are closely inter-related, yet quite different in character. When Cubism first appeared in Paris around 1905, it was seen as a totally revolutionary art form. In its formal expression it was new and shocking, and yet it was the product of a long evolution, deeply rooted not only in the development of French art in the latter part of the 19th century, but also in the cultural and scientific progress of Europe. How the interrelation could occur between a painter (for example Picasso) and what was going on in physics and mathematics (represented by, for example, Einstein), is not easy to understand and explain. It could perhaps be described as a kind of unconscious osmosis in a world populated by men of extreme intelligence. At all events, Picasso and Braque produced works of art that in many ways can be seen as illustrations of the most advanced scientific discoveries of their time.

Marinetti, with his extraordinary sensibility and ambition, discovered that something of great importance was going on in Paris in those years after 1905. Marinetti was probably to a certain extent jealous of what was happening around Picasso and Apollinaire, jealous not only for his own sake, but also for his country. As he had the gift, the willpower and the financial means to come up with an Italian version, he set to work. The *Futurist Manifesto* (20 February 1909) was the result of his decision. At that time no Futurist pictorial art was yet created. If Cubism had something secretive and inward-looking in its character, Futurism was exactly the opposite — determined, aggressive, outgoing, even propagandistic. The Cubists never talked about their relationship to earlier art, but they never denied their fathers. The Futurists, of course, repudiated anything older than themselves.

The contrast between the more static Cubist compositions and the more dynamic Futurist ones expresses a deeply rooted difference. The favourite Cubist composition is the still life, the interpretation of objects existing in the artist's studio. These objects do not move. Certainly the Cubist conception also contains a new dynamic element, but this element comes from the artist and his eye, not from the things he is looking at. In the Cubist composition, the artist's eye wanders over the objects he is studying and interpreting. He sees them at the same time from one side, from the other side, and from above, as superimposed images. The Cubists introduced a new way of seeing. They broke away from the one-point perspective on the world that Brunelleschi and Alberti had invented and which had dominated the arts for five hundred years. The Cubists introduced a more psychological and introverted way of seeing.

They did not perceive space from a central perspective that unifies all that is seen by one static eye. It is not the illusory space

that is seen through the frame of the painting, but rather the space of the studio. Instead of making a hole in the wall it is hanging on, the painting develops from the wall into the space of the studio. In contrast, the Futurists' favourite motifs were the cities, objects already in motion. Their attitude was not individualistic, but social. They were not interested in redefining the object and the space; they were interested in the environment, people and the masses.

It is interesting to consider the relation between Marcel Duchamp, the youngest of the Cubists, and Futurism. That he must have been impressed by formal aspects of Futurist paintings is shown, for example, in his most famous work, *Nude Descending a Staircase* from 1911 (although his studies of the photographs by Marey might be a contributing element that can explain the formal pattern of the successive stages seen simultaneously). When this work was compared with the works of the Futurists, Marcel Duchamp was not entirely at his ease (which was something very rare). He wanted his critics to understand that he had come to this formal expression through a process that was different from that employed by the Futurists. His work resulted from an inner labour in his studio, not from an exalted enthusiasm for the new. He went so far as to accuse Futurism of being just an "urban Impressionism".

In the extraordinarily rapid development of the Futurist style immediately after the publication of the *Manifesto* in 1909, the Futurists used the formal pictorial language borrowed from the Cubists, but they very quickly transformed it into their own characteristic style, adapted to the new content that they were developing. Their intention was to be efficient, effective, and socially aggressive. (PH)

Cubo-Futurism

This term was used by Russian art critics to designate a group of painters and writers (Cubo-Futurists), together with their painting which represented, entirely or partially, objects, words, figures and surface elements in a limited space.

The invention of the term is usually attributed to David Burliuk: he used it in 1913 to distinguish himself from the other Futurists (both Russian and Italian) and also to give an adequate name to the type of experimentation being conducted by a small group of artists who considered him their leader. Originally called Hylaea, the group centred round the Burliuk brothers, Khlebnikov and Kruchenykh; later they were joined by Maiakovsky, Matiushin, Malevich, Olga Rozanova, Elena Guro and Benedikt Livshits. They kept close ties with the members of the Moscow art associations, the Jack of Diamonds, and later the Union of Youth. Like other vanguard artists of the period, the future Cubo-Futurists practised both poetry and painting and were also interested in theatre, music and cinema. They were particularly concerned with the theoretical and technical aspects of art. Nevertheless, until 1912 the associations and groups of the Russian avant-garde had no precise programme.

Their alliances were as ephemeral as their quarrels were momentary; what united them was their rejection of tradition, their desire to destroy the existing system and build another in which art would cease to be a plaything of the bourgeoisie and find its own autonomous value in the service of the masses. Therefore, between 1909 and 1912, the Russians hardly used the word "Cubism"; they remained reluctant to use the term even after it had become current in Europe because it seemed to them too limiting. In fact, although the Russian avant-garde was well informed about artistic events in Western Europe, its contacts with Cubism and Futurism, at least up to 1912, were the result of spontaneous sympathy rather than a systematic approach. Marinetti's manifesto was published in the St. Petersburg evening paper a month after it appeared in *Le Figaro* in Paris, and Cubism was known in Russia from 1909 onwards through art magazines, exhibitions like Izdebski's "Salon" (1909), "100 Years of French Painting" (1912); "French Contemporary Art" (1912), and finally the Shchukin and Morozov collections. In reality, although the influence of French Cubism on the Russian avant-garde is undeniable, the young Moscow and Petersburg painters used it to create a style

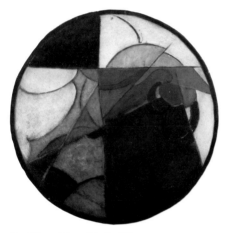

P. Albert-Birot, Nude Woman in the Bath, *1916*

of their own, introducing elements drawn from Old Russian art, from modern poetry and *zaum.* Above all, Cubism helped the Russian painters to discover pictorial values as an end to themselves. Matiushin, who translated Gleizes and Metzinger's *Du Cubisme,* remarked that "Cubism guided our awareness along the path of a new conception of space... The direct representation of nature became a thing of the past". David Burliuk, who gave two lectures on Cubism and wrote several articles, recognized that Cubism had been very useful to poets in helping them to restructure language. It must be remembered that nearly all the Russian avant-garde poets also practised painting, and the painters liked to experiment with poetry. From this meeting and interchange between Cubist painters and Futurist poets, Russian Cubo-Futurism was born.

Examples of strongly characterized Futurism are relatively few in Russian painting: amongst the best known are *The Knife-Grinder* by Malevich, *Aeroplane Over a Train* and *Cyclist* by Goncharova, *The City* and *A Walk on the Boulevard* by Larionov, and *City on Fire* by Rozanova. The influence of Italian Futurism certainly found a fertile ground in the public events prepared by the Russians, in their taste for scandal and provocation. Maiakovsky and Burliuk liked to upset the public not only by their statements, but also by wearing odd clothes (the famous yellow blouse) and painting their faces. Zdanevich used to present an old, ragged shirt at his lectures declaring it to be "more beautiful than the Venus of Milo".

In their declarations, however, the Cubo-Futurists categorically refused to recognize Italian primacy and — like the artists of many other countries at the time — claimed to be the only real Futurists in the world. The term "Futurism" itself annoyed them and they preferred to call themselves "men of the future" (*budetliani*).

Between 1913 and 1914 Cubo-Futurism reached its peak; then it began to lose its original character. Some of the artists joined groups which led them back to a more conventional aesthetic; others, like Malevich with Suprematism, developed their own new theories, and others, headed by Maiakovsky, chose an ideological commitment and tried to turn Futurism to the service of the Revolution. (SZ)

Cueto, Germán
(1893-1975) Mexican sculptor

Germán Cueto created his first original sculptures as a result of his contact with the Stridentists: grotesque masks with violent colours, portraits of friends, which mingled the pre-Columbian tradition with the extreme avant-garde. Without ever completely abandoning his work on masks, Cueto turned toward abstraction and worked with various materials. At the beginning of the Thirties he was a member of the Parisian group Cercle et Carré. (SF)

Cuisine

As far back as 1910, on the occasion of the first Futurist *soirée* held in Trieste, a dinner was organized in which the normal order of the courses was inverted. The same order was suggested later by the "free-word" Irba in the manifesto *Culinaria futurista* (*Futurist Cookery*, in *Roma Futurista*, Rome, 9 May 1920), which emphasized the importance of the "form" and "colour" of the dishes. Futurist gastronomy was officially launched with the *Manifesto of Futurist Cuisine* (*La Gazzetta del Popolo*, Turin, 28 December 1930), in which Marinetti proposed the abolition of pasta and of "the traditional combinations in favour of experimenting with completely new, absurd combinations", thus obtaining absolute originality at the table. The recipes appeared shortly afterwards in the volume *La cucina futurista* (*Futurist Cuisine*) by Marinetti and Fillia (Sonzogno, Milan, 1932).

On the evening of 8 March 1931, the Taverna del Santopalato (*Tavern of the Holy Palate*), decorated by Fillia and Diulgheroff, was inaugurated in Turin with a Futurist dinner which included dishes invented by Fillia, P.A. Saladin, Diulgheroff, Prampolini and Mino Rosso, such as *Aerovivanda* (*Airfood*), *Carne-plastico* (*Meat Sculpture*) and *Pollofiat* (*Fiat-Chicken*). In 1931 and '32, banquets and lectures were organized in Italy and abroad.

Futurist cuisine placed great importance on the aesthetics of food, "conceiving an original architectural style for every dish, possibly different for each individual, so that everyone has the feeling of eating not only good food but also a work of art". The dishes were to be "tasty plastic ensembles whose unique harmony of form and colour nourishes the eyes and excites the imagina-

tion before tempting the lips". Futurist meals were real happenings where all the senses were stimulated by scents, noises, music, lights and textures. (CS)

Cummings, Edward Estlin

(Cambridge, Mass., 1894 - North New Conway, N.H., 1962) American painter and writer

He tried his hand at painting but was a writer and poet by profession. An acute sense of tradition always counterbalanced his most extreme moments of modernism. In 1923 he wrote *Tulips and Chimneys*, sonnets set next to poems whose verses and words exploded and disappeared across the page.

The graphic aspect of these poems, though far more controlled than and profoundly different from Futurist poetry, are reminiscent of "words-in-freedom". (SF)

Cursiter, Stanley

(1887 - Stromnoss, 1976) Scottish painter and museum director

Stanley Cursiter, who for a brief period became a Scottish Futurist, studied at Edinburgh College of Art. He was deeply impressed by Roger Fry's "Second Post-Impressionist Exhibition" in London (1912-13), and borrowed a number of works from that show for a Society of Scottish Artists exhibition in Edinburgh (1913). The paintings by Gauguin, Cézanne, Van Gogh, Matisse and others created enormous controversy in Scotland, but Cursiter himself was also excited by Futurism. He had probably seen the Futurists' first London exhibition at the Sackville Gallery (1912), and the influence of Severini's *The Boulevard* (1911) was particularly decisive in his own work. In 1913 he painted *The Sensation of Crossing the Street — the West*

End, Edinburgh, which conveys the bustle of trams, pedestrians and police in an angular, fragmented composition. It is heavily reliant on Futurist ideas about simultaneity, and so is his painting of *Rain on Princes Street* (1913), where Boccioni's influence is discernible as well. Cursiter's Futurist period came to an end with the outbreak of war, when he fought in France. In later life he continued to paint, and he also became Director of the National Galleries of Scotland in 1930. (RC)

Czyzewski, Tytus

(Przybyszów, 1885 - Krakow, 1945) Polish writer and painter

From 1902 to 1907 Tytus Czyzewski studied at the Academy of Fine Arts of Krakow, but he did not neglect literature. His first book, *The Death of a Faun*, was published in 1907. Aware of the latest innovations in the plastic arts, Czyzewski created a personal synthesis of varying trends. Expressionism, Cubism, and Futurism (which was introduced in Krakow in 1912) cheerfully coexisted in the exhibitions of the Polish plastic avant-garde; one of the first of these took place in 1913 in Lvov.

However, it was only in 1917 that Czyzewski, together with the Pronaszko brothers, Chwistek and others, organized a truly significant exhibition. There was much hesitation over what to call the group: Extreme Modernists, Formists, or even Expressionists. What was being done in Germany under the name of Expressionism was not really considered: "The name does not matter — Futurism, Cubism, Orphism and many others are just haphazard names for groups that all belong to Expressionism." A few years later, Czyzewski began an extremely creative period: he composed strange paintings that had elements of Expressionism, Futurism, and the Dadaist spirit, combining signs and colours with no relationship to reality. More importantly, he created three-dimensional works with constructions of multicoloured wood fixed to the surface of the picture. His writing was permeated with the same bizarre spirit, which for a certain period he called "Formist"; he wrote poems collected in *Green Eye - Electric Visions* (1920), *Night-Day* (1922) and *The Serpent, Orpheus and Eurydice* (1922). These poems are neither calligrammes nor free words, strictly speaking, but they use interesting typographical effects and layouts that recall the work of Cangiullo and Albert-Birot rather than that of the Constructivists, with whom he was to collaborate during the Twenties and Thirties.

Czyzewski is a complex personality. He was not exclusive in practice or in theory, so that all the avant-gardes could claim him. Thus, although he belonged to the Futurist movement for only a short period, he followed its efforts with a certain sympathy; he created the layout of the *Manifesto of the Polish Futurists* for Jasienski and Stern. (SF)

Guests at table at the Devil's Cabaret, 1921 c.

Dada

In the 1909 Futurist Manifesto, Marinetti proclaimed: "When we are forty, let other younger and worthier men toss us into the rubbish bin, like useless manuscripts... Against us will come our successors; they will come from far away, from everywhere, dancing to the winged cadence of their first songs, stretching out the hooked fingers of predators, and sniffing dog-like, the good smell of our putrefying minds, already destined for the catacombs of the libraries." Ten years later, forgetful of this promise, Marinetti continued to publicize Futurism as though it had just been created. From far away, in fact, from everywhere, dancing to the winged cadence of the first songs, a movement was being created that was better adapted to the period and to the internationalist spirit: the Dada movement. In January 1921, a flyer distributed in order to inveigh against a talk delivered by Marinetti in Paris on Tactilism claimed: "Futurism is dead. What killed it? *Dada.*" The truth is a bit more complex.

The word Dada first emerged in 1916 among a group of artists and poets at the Cabaret Voltaire in Zurich. They were German-speaking, such as Hugo Ball, Hans Arp or Richard Huelsenbeck, or French-speaking such as Tristan Tzara and Marcel Janco (both of whom were Rumanian). Still earlier, however, beginning in 1915, Hugo Ball — as his diary *Die Flucht ans der Zeit* testifies — was corresponding with Marinetti while preparing to start the Cabaret Voltaire, and was interested in all new developments. Marinetti sent him several "words-in-freedom" by Buzzi, Cangiullo and Govoni, and several of his own which were later shown at the Cabaret and published in the collection *Cabaret Voltaire* (1916). Later Ball turned the job over to his young friend Tristan Tzara who oversaw contacts with the Italians — first with Marinetti, later with Prampolini, Cangiullo and others. During a trip to Italy in the summer of 1916, Tzara met Savinio and De Chirico in Ferrara, and Bragaglia and Prampolini in Rome. Between 1917 and 1918 in *Dada* there appeared several engravings by Prampolini and poems by Meriano, Nicola Moscardelli, Maria D'Arezzo, Gino Cantarelli, San Miniatelli and Camillo Sbarbaro. At the same time, in the pages of *Noi*, works by Tzara and Janco were published. There was, therefore, a constant interchange at the time.

In 1918 relations deteriorated. Tzara, aware of the autonomy of Dada, decided to be freed of the Futurist elder brother. In a 1916 manifesto Tzara declared that Dada was "decisively opposed to the future", and in his fundamental *Manifesto Dada 1918* he pulled no punches in attacking Futurism. Dada refused to pay its debts: "We recognize no theories. We've had enough of Cubist and Futurist academies: laboratories of formal ideas." In the pages of *Noi* Prampolini answered harshly. From then on, aside from a relative resumption of contact with Prampolini during the Twenties, Tzara proved severe and even unfair toward a movement that had once interested him deeply. The Parisian Dadaists never took the Futurists seriously and they noisily disrupted both the talk Marinetti delivered on Tactilism and the Rumorist concert performed by Russolo in 1921. In fact, many Futurist ideas were absorbed by Dada although they were deformed to meet the Dadaist style. Ball's phonetic poems, as well as Janco's abstract constructions, owed considerable debts to Futurism; the typographic experimentation in Dadaist magazines was preceded by analogous Futurist experimentation, as were the more "grand guignolesque" aspects of Dadaist theatre and set design.

The Dadaist spirit did not hover only over Zurich. Without using the name, it hovered over Tiflis in the group surrounding Kručhenykh, over the Fantastic Cabaret, and — still more — starting in 1915, in New York around Duchamp, Picabia, Man Ray and others. In both cases the recent developments in Futurism were unknown (only Marius de Zayas in New York was interested). In Germany the situation was entirely different. Germany had been familiar with Italian Futurism ever since Walden's magazine *Der Sturm* published several texts following an exhibition in 1912, and Marinetti himself went to Berlin twice before the war. Russian Futurism was introduced through the Blaue Reiter. All this struck not only a few Expressionists but also several young artists who entered the ranks of Dada during and after the war. Max Ernst in Cologne was one of the first to execute works in which a Futurist influence can be recognized: *Streets of Paris* (1912), *Portrait* (1913), etc. Richard Huelsenbeck, after a trip to Zurich and then Berlin, wrote of Boccioni: "We all know his great book *Pittura scultura futuriste* (*Futurist Painting and Sculpture*)." The Futurist lesson was to prove useful to contributors to the Berlin magazine *Der Dada* (1919-20) — Hausmann, Grosz and their fellow artists Otto Dix and Kurt Schwitters. The 1920 International Dada Fair (Dada Messe) in Berlin offered no room to the Futurists, with the exception of the Russian Tatlin. (SF)

D'Alba, Auro

pseudonym of Bottone, Umberto
(Rome, 1888 - Rome, 1965) Italian poet

His first poems were published in 1905. He sent Marinetti a few lyrics which were read during the Futurist *soirée* at the Teatro Dal Verme in Turin, and by 1911 he had signed the *Manifesto of Futurist Playwrights*. He formally joined the movement in 1912, and three of his poems were published in the anthology *I poeti futuristi* (*The Futurist Poets*). He met Marinetti at the Futurist *soirée* at the Teatro Costanzi in Rome (21 February 1913), and numerous other activities with the group followed. Several of his poems in free verse appeared in *Lacerba* from May 1913, and some were republished in the collection *Baionette* (*Bayonets*, It. ed. 1915, by Poesia).

Lacerba also printed two theoretical articles filled with the iconoclastic violence of the Futurists — "Il puro lirismo nella sensibilità futurista" (Pure Lyricism in Futurist Sensibility), 1 March 1914; "Il soggetto in poesia" (The Subject in Poetry), 1 June 1914.

The new Futurist sensibility was proclaimed to be "increasingly in harmony with the whirl of modern life".

By the time his short collection of tales in verse, *Canzoni della guerra* (*Songs from the War*) was published in 1916, his verbal aggressiveness and newfound poetical expression had given way to a desire-filled languor which would mark all his later activity. Two of his short plays were still inspired by Futurism, *I carri* (*The Chariots*) and *Il cambio* (*The Change*), in *Teatro futurista sintetico*, Milan, 1916. (EC)

D'Albisola, Tullio

pseudonym of Mazzotti, Tullio
(Albisola, 1899 - Albisola Marina, 1971)
Italian ceramicist, sculptor and poet

Son of Giuseppe, the "master-potter" of Albisola (whose pupil he was) Tullio Mazzotti (known as Tullio d'Albisola) was the leading Futurist ceramicist.

He was active in the later Twenties with highly original projects of his own (moving from Art Deco towards a very personal style of invention, both in terms of form and colour), as well as executing the designs of numerous other Futurist artists (Depero, Fillia, Farfa, Diulgheroff, Munari, Mino Rossi, Prampolini).

In 1932-33 he published a number of books printed in what he called "lithotin", with texts by Marinetti and himself. (ECr)

MoUvEmEnT DADA

D. Burliuk and V. Maiakovsky, 1914

Dandyism

The dandy showed his arrogance towards the society of his time by using unusual, past-oriented words, gestures, clothes and manners. His way of living was based on art, and the discovery of attitudes that would clash with the ideals of progress and success of the 19th century bourgeoisie. From the end of 18th century to the beginning of the 20th century, figures like Beau Brummell, Byron, Chateaubriand and Baudelaire transformed their love for luxury and elegant allusions, their longing for the futile and fleeting moment into a form of public behaviour which disturbed the aesthetic and functional canons of a Positivist, future-oriented culture. In refusing industrial technics and speed, dandyism was opposite to Futurism. While dandyism felt an increasingly mechanical world as an impoverishment, Futurism was fascinated by it. Yet in their arrogant love for waste, for gratuitous gestures and anachronisms, the dandies created images and appearances so original in their freedom, variety and uniqueness that Futurists like Marinetti and Maiakovsky copied their attitudes. The desire to be unpredictable and shock "others" was common to them all.

It was their fascination with the unusual that provoked the Russian and Italian Futurists, as well as the English Vorticists, to invent an innovative look for themselves in every facet of private and public life. The clothes and furniture designed by Depero and Balla, by the Omega and MAPU groups, and by Valmier and Melnikov, like Fillia and Marinetti's gastronomy, transgressed ordinary taste in the same way as dandyism did. The architectural and cultural make-up of Futurism had the same reactionary interest in exalting the individual as an "exceptional being". The Nietzschian artist-hero was so strongly present in the Futurist movement that he even imitated the gesticulations of D'Annunzio and later those of Mussolini. (GC)

D'Annunzio, Gabriele

(Pescara, 1863 - Gardone Riviera, 1938) Italian poet

For the young Marinetti, Gabriele D'Annunzio represented both a point of reference and a literary rival. Marinetti tried to exorcise this powerful figure with the weapons of critical acumen and irony in his book *Les Dieux s'en vont, D'Annunzio reste* (*The Gods Go, D'Annunzio Remains*, 1908), in which he offered several definitions that can still be applied to D'Annunzio's writing: "eclecticism" and "derived art". After founding Futurism, Marinetti rejected D'Annunzio as a "younger brother of the French Symbolists", who was obsessed, among other things, with "a professorial passion for the past and a mania for ancient relics and collections". Despite this evaluation, D'Annunzio's example continued to exert a profound influence both on the political stance of the Futurist movement and on Marinetti's writing, especially in the "traditional register", such as his novel *Gli indomabili* (*The Untamable Ones*, 1922). Nevertheless, in 1922 and 1924 Marinetti happily detected a Futuristic "paroliberist", or "free-word" influence in D'Annunzio's *Notturno* (*Nocturne*, 1921); which in a certain sense was true. A veiled

V. Maiakovsky, the Futurist, 1914

F.T. Marinetti, D'Annunzio at Home

F.T. Marinetti, The Gods Leave D'Annunzio Remains, *1908*

but easily deciphered reference to *paroliberismo* is contained in D'Annunzio's *Libro segreto* (*Secret Book*, 1935): "I understand that some artists... began by subverting the laws of grammar and especially those of construction..." D'Annunzio and Marinetti today appear as two "strenuous literati", two untiring experimentalists. However, D'Annunzio set out from "an accepted Museum and preferred illusions to criticism" (L. Anceschi), while Marinetti voluntarily opted for the *tabula rasa* and only by degrees allowed in his writing the "return of what was suppressed" (emotional content, syntax, etc.). (LDM)

Daugherty, James Henry

(Asheville, North Carolina, 1887 - 1974) American painter

James Henry Daugherty was among the first American artists to be influenced by Futurism. He may have learned of Futurism through his friend Joseph Stella, or perhaps through an Italian painter and friend, Athos Casarini, who lived in the same Brooklyn apartment building. Also a popular illustrator, Daugherty produced a Futurist-inspired illustration published in the *New York Herald* newspaper issue of 12 April 1914. Entitled *Futurist Picture of the Opening Game*, Daugherty's clever composition introduced ideas of Futurist movement through space to a popular public. That same year, he developed this theme into a painting, *Three Base Hit*. Still other examples of Daugherty's inventive modernist work of this period suggest his knowledge of the work of Giacomo Balla. Daugherty also shared his interest of evening entertainment as subject matter with Gino Severini, whose work he may have known in reproduction before it was shown at Stieglitz's Gallery 291 in March 1917. (GL)

Dawson, Manière

(Chicago, 1887 - 1969) American painter

He studied architecture in Chicago, but was attracted to painting. In 1910 he took a trip to Europe and met Gertrude Stein, who purchased one of his paintings and introduced him to Cubism.

A great admirer of Marcel Duchamp, he purchased his *Sad Young Man in a Train* after the Armory Show.

He took part in the most important shows of the period, but after 1914 lost interest in painting and devoted himself to agriculture. (SF)

De Angelis, Rodolfo

pseudonym of Tonino, Rodolfo
(Naples, 1893 - 1964) Italian theatre director

Starting as a music-hall actor, Rodolfo de Angelis formed several theatrical companies. A chance meeting with Cangiullo on a train brought him to Marinetti and Futurism. Common interests led the three to form the company Teatro della Sorpresa (Surprise Theatre), the manifesto of which was written in Naples on 9 October 1921, but was signed and dated by Marinetti and Cangiullo "Milan, 11 October 1921". The company, directed by de Angelis with the participation of Marinetti, and made up of Cangiullo, Prampolini, Depero, Franco Casavola, Silvio Mix and others, made its debut in Naples on 30 September 1921 at the Real Teatro Mercadante. In 1924, after another tour as actor-manager, de Angelis left variety theatre. A few years later he founded the record library *La parola dei grandi* (*The Words of the Great*), which was to become the nucleus of the future state record library. (EC)

Delaunay, Robert

(Paris, 1885 - Montpellier, 1941) French painter

Robert Delaunay worked in a scene-painting atelier (1902-04) before devoting himself entirely to painting. His first works were Impressionist. In 1906 he was intrigued by the painting of Le Douanier Rousseau, who became his friend. In 1907 he discovered, at the same time, Cézanne's paintings and the simultaneous contrasts of colour in Chevreul's books. He passed through a neo-Impressionist period during which he painted canvases like *Solar Disk*, which presage Futurism rather than Cubism. However, his first version of the *Tour Eiffel* and the series of *Cities* and *Saint Severin* (1909) are more suggestive of Cubism. The versions of the *Tour Eiffel* which he drew and painted in 1910 were violently disjointed, swept by a movement and joy in colour which was unusual compared with other Cubists, except for Sonia Terk (whom he married that year) and Fernand Léger, who became his friend. Delaunay's originality was soon recognized — in 1911 he was invited to exhibit at the Blaue Reiter in Munich; among the painters who admired him were Marc and Klee, and a few Americans who were later to become Synchromists. In 1912 Apollinaire saw him as the leading painter of the plastic and literary schools which he invented: Orphism and then Simultaneism. An argument with the Futurists resulted, in particular with Boccioni. The debate started in 1913, when Delaunay was in Berlin with Apollinaire and Cendrars for an exhibition at Der Sturm Gallery, and came to a head at the beginning of 1913, when Apollinaire spoke of Futurism *tournoyant*, with reference to Delaunay's *Homage to Blériot*, which upset both the Italian painters and Delaunay himself, who protested: "I am not nor have I ever been a Futurist, no critic has ever made a mistake in this matter. I am surprised at M. Apollinaire's ignorance in the matter of simultaneous contrasts, which constitute the construction and novelty of my work." An open letter from Carrà, Papini and Soffici disputed the precedence of Delaunay's research over

R. Delaunay
Loudspeakers for "The Poets' Hut"

R. Delaunay, Helix, 1923

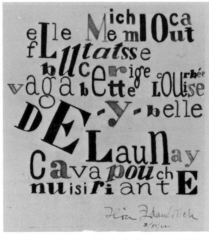

I. Zdanevich, For Sonia Delaunay, 1922

their own; Apollinaire wrote to Soffici that "Delaunay had already covered his canvases with the ruins of his towers when Boccioni was still wavering"; while Delaunay accused the Futurists of being "publicity hungry". Peace eventually settled over the two camps. However, although Apollinaire was to become a friend of the Futurists, Delaunay always remained somewhat distrustful. From that moment on, Delaunay was extremely careful to personalize his work, always identifying it as "simultaneous", especially because several friends, including Cendrars, encouraged him to do so. It should be noted however that Delaunay was on excellent terms with the Portuguese Futurists, and was also friendly with the Futurists in Spain, Gómez de la Serna, the Chilean Creationist Huidobro and the Spanish Ultraist Guillermo de Torre. (SF)

Delaunay Terk, Sonia

(Ukraine, 1885 - Paris, 1979) painter of Russian origin, naturalized French

With *Simultaneous Contrasts* (1912), now in the Musée National d'Art Moderne in Paris, Sonia Delaunay Terk created a new abstract language which she called "simultaneous painting". "For the first time, pure colours become planes placed in simultaneous contrast, producing a form based on the relationship of the colours themselves, rather than on chiaro scuro effects." In this painting sunlight is represented in the form of concentric circles and triangles in vibrant colours.

Towards the end of 1911 Franatisek Kupka had already experimented with pure colour, painting a series of rotating discs, using transparency and prismatic beams to create movement. Unlike the paintings of Sonia Delaunay, in which the density of the colour was related to surface values without any sense of perspective, Kupka placed his circular forms in an undefined space alluding to the cosmic dimension. The motif of the star-wheel, represented as an immobile combination of helicoidal and spherical sections, later became the leitmotif of the more famous *Disques* painted by Robert Delaunay in late 1912 and 1913. It is not certain that the Delaunays knew Kupka as early as 1911. We do know, however, that the Czech painter at that time went to the meetings of the Puteaux group, at the home of Duchamp-Villon and his brothers, where Robert and Sonia were occasionally guests. In 1913, however, Sonia Delaunay felt the need to release the new art from the private sphere of easel painting. She began to create clothing, furniture, wall-paper, lampshades, and even book covers. This aspiration towards total art, common to the Russian avant-garde at the time, did not derive from a Futurist idea of "reconstruction of the universe", but from a Modernist revival of folk arts and crafts which aimed to create a domestic kind of total art work. When Kandinsky, during his trip to Vologda in 1889, entered a peasant home full of painted utensils and furniture, where even the costumes of the inhabitants were part of the whole, he felt he was entering a painting. He was later to transform his paintings into an inner space which invited the viewer to enter. For Sonia, on the other hand, art came to mean

a form of painting that overflows into the environment and onto living forms.

In February 1913, fascinated by the modern quality of the poem *Les Pâques à New York* (*Easter in New York*) by Blaise Cendrars, she used pieces of coloured paper to create the cover. Her ability to find plastic analogies for the emotions this poem provoked in her enlarged the concept of simultaneity. With Blaise Cendrars, in October of the same year, she invented the first "simultaneous book": *Prose du Transsibérien et de la petite Jeanne de France* (*Prose of the Trans-Siberian and Little Jeanne of France*). For this poem, conceived as a folding pamphlet six feet long, Sonia painted the cover. Inside, she created rhythms of bright colours as a background for single words and phrases, as though a common inspiration had produced both the poem and the painting. The use of different type styles and sizes, the variable spacing of the words, and the emotional use of coloured letters, all contributed towards a result that surpassed the contemporary typographical innovations of the Italian Futurists. The book was a synthesis of art forms aiming at a single effect, like a musical score that must be read as a whole. When she created her first "simultaneous dress" in 1913, Sonia Delaunay made the human body into a walking paradox. The flat colours of the different pieces making up the dress created a fixed geometry which was contradicted in use: draped over, and in motion with, the body, the coloured lozenges and circles changed shape and lost clarity. The meeting of abstract and organic forms created an antithesis, a pulsating relationship between art and nature. (GDM)

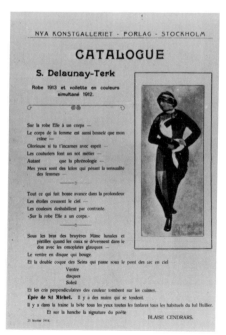

S. Delaunay, exhibition catalogue Stockholm, 1916

Delmarle, Félix

also known as Del Marle, or Mac Del Marle (Pont-sur-Sambre, 1889 - Paris, 1952) French painter

Delmarle came from the north of France and took up residence in Paris in 1912 after completing his studies at the School of Fine Arts in Valenciennes near Lille, and in Brussels. In 1913 he met Apollinaire, Max Jacob, André Salmon and the Cubists. He shared a workshop with Gino Severini and through him came into contact with the Italian Futurist environment, finally joining the movement himself — the only avowedly Futurist French painter.

Delmarle's painting, at first neo-Impressionist and then Cubist, became openly Futurist in 1913. In particular his drawings of female dancers were decidedly influenced by Severini. During Boccioni's Parisian show, Delmarle discovered the extent of the impact of the manifestos and public events of the Futurists. Shortly afterward, in July 1913, he launched his *Futurist Manifesto against Montmartre*, published in *Paris-Journal*. At the exact moment when several celebrations had just taken place in honour of Montmartre, its cabarets and its apprentice painters, Delmarle inveighed against this "old romantic infection". A scandal erupted. The press, with the exception of André Salmon, attacked the painter. Severini, interestingly enough, hurried to disassociate himself, perhaps driven by envy of the attention focused on his companion. But Marinetti, glad to have a new recruit in the movement, approved of the French painter in an open letter: "Your courageous Futurist initiative shows clearly that Futurism is neither a small cloister for experts nor is it a school, but a great movement of intellectual energies, in which the individual is as nothing, while the will to destroy and renew is all. It is as absurd to consider Futurism as a monopoly of Marinetti, Boccioni, Carrà, Russolo, Severini, Buzzi, Palazzeschi, etc. as it would be to attribute to electric lightbulbs a monopoly on atmospheric electricity or to Etna the monopoly on earthly fire and earthquakes..."

In the magazine *Poème et Drame*, which published the work of Duchamp-Villon and of a few poets, Delmarle published in 1914 "Some Notes on Simultaneity in Painting". In it he declared that "Cubism as set forth by Gleizes and Metzinger will remain a necessary point of departure for any effort aiming at a Futurist aesthetic", which seems to have signalled his departure from Futurism. Shortly afterward Apollinaire wrote that he had recognized in Delmarle the influence of Albert Gleizes. Boccioni's example would seem to be more important, especially in the nervous touch so characteristic of the French painter. The material of his canvases, for instance of *The Port* (1914), was at times heavier than was generally typical of Futurism, but his graphic works — note *Cats* of 1914, the watercolour-like *Port Aviation* of 1914 and his portraits — are extremely delicate. The First World War almost completely interrupted Delmarle's work, as he was under arms nearly all through the war. He continued, however, to correspond with Marinetti and the Italian Futurists. At the beginning of 1915 Marinetti published in

Grande Illustrazione several of his drawings and a letter from the front. Delmarle's Futurist period only lasted three or four years, but the works completed in this brief span of time were sufficient to ensure him an important place in the world movement. At the beginning of the Twenties, influenced by Kupka, he selected abstract art and thereafter, was influenced by Mondrian and Van Doesburg, Constructivism. (SF)

Futurist Manifesto against Montmartre
(Futurist manifesto, 1913)

When we erected the solid pedestal of Futurism in Paris, we thought of you, Montmartre, old romantic infection! Now, as your last degenerate and crippled sons yap helplessly around you, we finally rise and shout at the top of our voices: *Forward, demolishers!*
Make way for the picks!
Montmartre must be destroyed!!!
And we mean the Butte itself, let it be clear. The bars and the night restaurants don't matter, but we have had enough of sentimental adventures, little houses, little gardens, little birds...

Montmartre, scrofulous mound, the shadow of your hideous goitre dedicated to the Sacré Cœur shelters a rabble of antiquarians and retired shopkeepers — get rid of them! Together with your miserable endowment, those antiquated hussar trousered artists (!), those passéist moth-eaten parrots. Yes, we know you have the Rue Saint-Vincent, the Rue des Saules, the Place du Calvaire — so what? That all belongs to the past; once it was a flower, now it is a dung heap, and we are young, alive and strong, and those morbid, sickly alleys with their tottering half-dead houses fill us with disgust and loathing.

So stop luring from their distant provinces those comic-opera supernumaries, those long-haired daubers whose marrow you suck before leaving them to rot in the filthy water of your ruts. Oh yes, you have cherished them, these lovers of a night, these ambitious bohemians, like a prostitute defends "her man", and have also pushed them into the deepest shame, even as far as the Pont des Arts.

Have you forgotten, Montmartre, that once you were a rock of resistance against all that belonged to yesterday, all that glorified the obvious? But Donnay has left the "Chat Noir", Pierrot has become diseased by honours and wants to join the institution, and Louise, weak and repentant, has returned to the respectable bosom of her family.

Crumbling old houses, rotting walls, fences hiding mountains of excrement — your time is up!

Away with you, vile merchants of holy objects who beckon prostitutes, with your pseudo-artistic cabarets and awful bric à brac, cemeteries of *objets d'art*. Flee into the night of the past with all your multicoloured rags, your stillborn dreams, and take with you your hoarse Mimi Pinsons, your elderly Musettes. But you go on rotting where you are. You lack the energy to rebel, and in the demolished ruins we shall find nothing but stinking dust.

Call us savages, barbarians — we don't care! We are strong, I assure you, and we are climbing to attack your maggoty cheese

followed by the great army of victors with metal scaffolding, dynamite and explosives. Your Moulin de la Galette will be swallowed up by a Métro station. Your flea-ridden Place du Tertre will be crossed by buses and trams, and from all the dung that you are trying to defend today an apotheosis of skyscrapers will rise to pierce the heavens, great blocks of houses infinitely tall. And then you will laugh with us at your attachment to these remnants of another century. Like us, you will want to perceive all the new beauty of geometrical buildings, stations, electrical instruments, aeroplanes, our whole life whirling with steel, fever and speed.

There are corpses that must be killed.
Montmartre must be killed!
The last windmills will fall, the twisting coy old streets collapse.
Make way for the Futurist pick!
Montmartre will have ended its life. It will cease to be the rotten brain crowned with a clerical cap, weighing on a Paris which is awakening to the inspiration of the future. And in the evening, when the sun goes down, the brilliant beams of a thousand electric lamps will pierce the great highways filled with noise and movement. The majestic façades with their multicoloured electric signs will light up violently; the wild trembling of our wonderful speed machines will be heard, and at the window of your departed and forgotten Louise the electric advertisements will wheel tirelessly against the sky, conquered at last.
Montmartre must be destroyed!!!
 A.-F. Mac Del Marle, Futurist painter

Demuth, Charles
(Lancaster, 1883 - Lancaster, 1935) American painter

Charles Demuth made three trips to Paris, the last of which, from late 1912 through early 1914, thoroughly exposed him to the work of the avant-garde. Although he missed seeing the Futurists' Paris exhibition at the Bernheim-Jeune Gallery, Demuth was acquainted with artists such as Marcel Duchamp, whose work at the time reflected their influence. Eventually, Demuth's Cubist-inspired cityscapes included broken patterns of light, expressed abstractly through the use of a ray technique which suggests the possible influence of Futurist painting. His 1928 masterpiece, *I Saw the Figure 5 in Gold*, a tribute to his friend, the poet William Carlos Williams, recreates the sensation of a moving firetruck with its dramatic sounds and lights as described in the subject's poem. (GL)

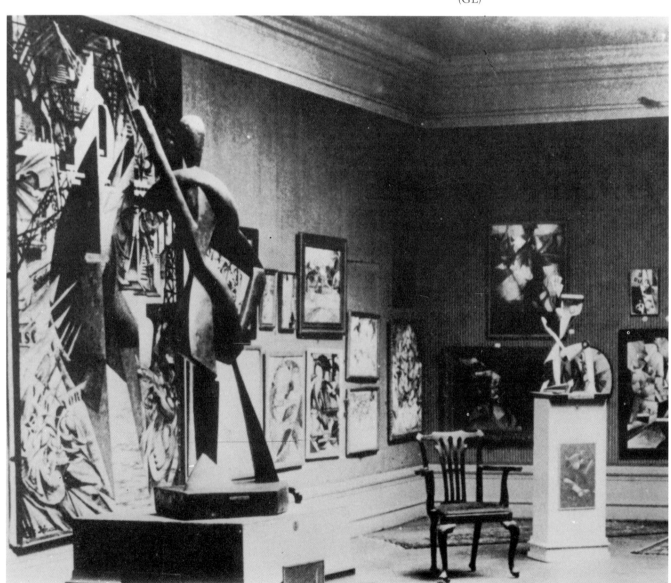

Salon des Indépendants, Bruxelles, 1914: The Port *by Delmarle behind* The Gondolier *by Archipenko*

Depero, Fortunato

(Fondo, Trento, 1892 - Rovereto, 1960)
Italian painter, sculptor, d̶ ̶i̶ ̶ ̶ ̶ ̶ writer

After studying at the S̶ ̶ ̶ ̶ ̶e Elisabettiana in Rovereto, F̶ ̶ ̶ ̶ Depero made his debut as an a̶ ̶ ̶ ̶ ̶7. His work as a painter, sculptor and w̶r̶i̶t̶e̶r̶ evolved towards Social Realism and an accentuated Symbolism; in 1913 he published the booklet *Spezzature - Impressioni - Segni e ritmi* (*Breakings - Impressions - Signs and Rhythms*) containing grotesque Symbolist poems, prose and drawings. In Rome, towards the end of 1913, he met the Futurists. In 1914 he showed at Giuseppe Sprovieri's Galleria Futurista and also took part in recitals and events organized there, working particularly with Balla, Cangiullo and Marinetti. He continued to show with the Futurists in one-man and group exhibitions until after 1935.

Around 1914-15 his painting was characterized by a strong, abstract dynamic synthesis using flat spreads of brilliant colour with curvilinear outlines. The subjects, taken from the plant and animal world, are treated with a sort of excited surprise, as though the artist were discovering a fantastic story-land. Depero wrote a first draft of the manifesto *Futurist Reconstruction of the Universe*, calling it *Complessità plastica - gioco libero futurista - L'essere vivente-artificiale* (*Plastic Complexity - Free Futurist Play - The Living-Artificial Being*); in this text he talked about "abstract plastic emotion". He subsequently re-worked the manifesto together with Balla and both of them signed it as "Futurist abstract artists" when it was published in 1915.

Depero also constructed "motor-noise plastic ensembles", different in their kinetics from Balla's contemporary experiments. Continuing along the same lines, in 1918-19 he was to propose "mobile" or "living pictures" using natural analogies. In 1915-16 he composed "noise-ist" songs and poems in "onoma-language", which tended to pure verbal analogy. In 1916 he also projected architectural visions: *Padiglioni plastici futuristi* (*Futurist Plastic Pavilions*) and *Vegetazione a deformazione artificiale* (*Artificially Deformed Vegetation*). In the catalogue of his one-man show in Rome, he spoke of "dynamic architecture (aerial city). *First* bold architectural application of the abstract style. - Stylization in 3 clear parts of the Futurist city built with an absolutely new criterion", in which the "3rd Plastic layer (aerial city)" embodies every possible playful, imaginative, marvellous idea in "Squares - Aerial parks - Station for aeroplanes - Flying houses - Cafés on immensely tall piles, 100-200-300-1000 metres above the ground".

In this painting, already in 1916 he was developing syntheses on a wider scale, inventing analogical forms with a sharp plasticity which created a "mechanical metaphysical" world. His work in the immediately following years (1917-19) typically suggested a magical fairy-tale enacted by elementary geometrical forms. The same power of fantastic imagination is evident in his theatrical designs. After creating the set for *Mimismagia* (1916), in 1916-17 he was invited to design for Diaghilev's Ballets Russes (*Nightingale* and *Zoo*) although his work never reached the stage. The best ex-

F. Depero, 1926

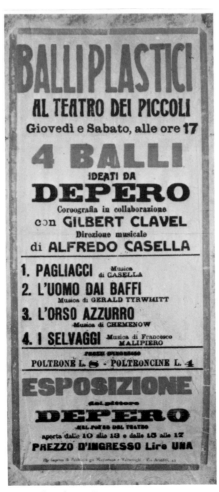

Poster for Plastic Dances, *1918*

ample of his re-invention of reality in terms of fabulous mechanisms was *Balli Plastici* (*Plastic Dances*), designed as "plastic theatre" in collaboration with Gilbert Clavel, the Swiss poet and Egyptologist. The work was started in 1917 and produced at the Teatro dei Piccoli in Rome the following year.

In 1919 Depero returned to Rovereto, where he founded his own "Casa d'Arte". There he produced designs for furnishings, particularly wall-hangings done with his wife Rosetta, and also furniture, advertising posters and other examples of applied art. In his painting, his theatrical experience showed in a volumetrical accentuation of the images, set in a "metaphysical" climate. This new style, developed in 1917 during his stay with Clavel in Capri, continued in his drawings for the latter's book, *Un istituto per suicidi* (*An Institute for Suicides*), published in Rome in 1918.

In 1919-20 the fantastic fairy-tale narrative which was to be typical of Depero's painting in the Twenties and after, was already established. It was his highly personal answer to a certain European "purism" and contained the same "metaphysical" suggestions. For Depero, the "mechanical" style was a modern means to express a fabulous inner dimension, creating the image of his own present moment — not as an anecdote, but as part of the recurrent cycle of work and nature, a dimension of domestic or collective daily life. Using this "modern", "mechanical" style, Depero conveyed the symbolic force of an archaic narrative synthesis. He represented the daily continuity of a cyclic time — an eternal world, stamped as contemporary only by the new quality of his sensibility. Nature, machines, man, manual and mechanical work are reabsorbed into a fabulous primordial dimension. He is a stupefied primitive gazing at the modern world.

In Capri in 1917 Depero also made "constructions" — brightly coloured objects in wood, and sometimes cardboard, with elementary geometrical volumes, which reflected his feeling for peasant handwork. In 1921-22 he designed the interior and furnishings for the Devil's Cabaret in the Hotel Elite et des Etrangers in Rome, fantastic and animistic settings based on a complex symbology of different psychological states. In 1923-24 he designed the Tridentine Venice Pavilion at the Milan Trade Fair, with advertising stands which represent a strong plastic and chromatic synthesis. In subsequent designs he developed the plastic-architectonic use of writing — "typographical architecture" — as another aspect of what he called "advertising architecture". One of his creations in this field has remained famous: the Book Pavilion (*Padiglione del Libro, Bestetti, Tumminelli & Treves*) at the Second International Biennale of Decorative Art in Monza in 1927. He also designed a stand for his own Casa d'Arte Futurista in 1924, and another around 1930 for the Campari company, which commissioned numerous drawings from him. For Depero, the environment was a magical story-book world: this was the style of the interiors he created in New York at the end of the Twenties and the beginning of the Thirties (Enrico and Paglieri Restaurant, 1929, and Zucca

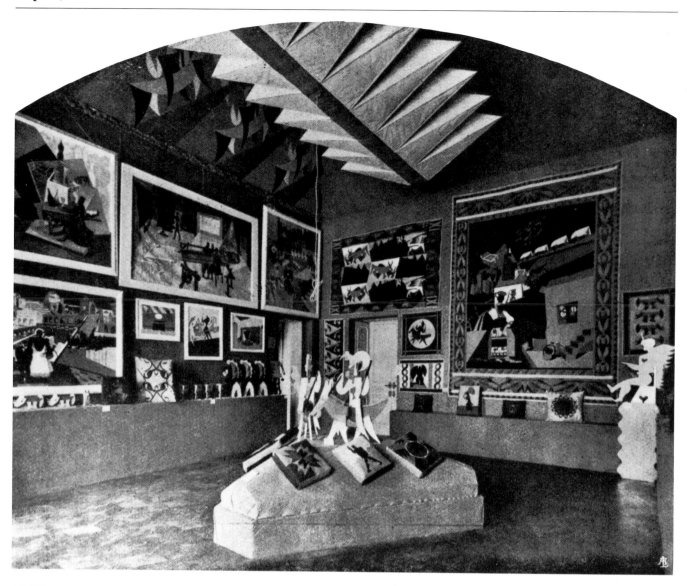

*Depero Room, First Exhibition
of Decorative Arts, Monza, 1923*

Azari and Depero, 1922

*Depero, Marinetti and Cangiullo with
waistcoats by Depero*

Restaurant, 1930-31).

After his invention of a new "Magic Theatre", in 1924 Depero's ballet *Anihccam of the Year 3000*, a comic grotesque reversal of the mechanistic theme, was staged in Milan and elsewhere. In New York he designed *The New Babel*, scenes of swirling cosmopolitan life, and costumes for the ballet *American Sketches* (1930). For Depero, the stage was another setting in which he could exalt the artificial, "new fantastic world", "making a work of art above all an invented work — autonomous, clear, exact, precise, lit with its own light, having its own style, its own flower and animal life", he wrote in *L'Impero* in 1925. Particularly in the Twenties, but afterwards as well, Depero's Casa d'Arte Futurista was extremely active.

Its work was presented at the First International of Decorative Art in Monza in 1923 (including a *Polychrome Plastic-Luminous Glorification of F.T. Marinetti*, a project for a statue-building designed to hold a Futurist theatre-cabaret), and at the International Exhibition of Modern Decorative and Industrial Arts in Paris in 1925. Depero was in Paris in 1925-26, and in New York between 1928 and 1930, where besides the interiors already mentioned he produced designs and advertising work (covers for *Vanity Fair*). In Italy he designed covers for *Emporium* (1927), *La Rivista* (1927) and *Vogue* (1929). Most of his advertising designs were done for the Campari company (published in *Numero unico futurista Campari 1931*) and the Verzocchi company. He theorized this work in *Manifesto of Advertising Art* published in 1932. He was also active as a journalist, contributing to newspapers and magazines (*La Sera*, *L'Illustrazione Italiana*, *Il Secolo Illustrato*, and others). In Rovereto in 1932 he published the almanac *Futurismo 1932 - Anno X - S.E. Marinetti nel Trentino* and the magazine *Dinamo Futurista*.

As a *paroliberista* he invented the famous "bolted book", *Depero Futurista*, published by Dinamo-Azari in 1927, a masterpiece of "free-word" typographical "deformation" applied to a mainly expositive text; and in 1931 he designed the free-word "sound" book, *New York - Film vissuto* (*New York - A Real-Life Film*), which however was never published. His *Liriche radiofoniche* (*Radio Lyrics*, 1934) contained poetry created especially for the new medium.

Although in 1929 he signed the *Manifesto of Futurist Aeropainting*, the imaginative direction of his painting did not change.

Throughout the Thirties and after, his narrative became more elaborate and even ambitious, and a different, often dramatic tension replaced the fairy-tale gaiety of his earlier work. (ECr)

De Pisis, Filippo
pseudonym of Tibertelli, Filippo
(Ferrara, 1896 - Milan, 1956) Italian painter

Like Rosso di San Secondo, Filippo De Pisis was also involved in "Synthetic Theatre". In December 1967 *Sipario* published a collection of 18 "Theatrical Syntheses" by De Pisis (1917-1921) excerpted from a Futurist manifesto. They were a reaction against his own three-act plays and a satire of the provincial world he frequented in Ferrara. (MV)

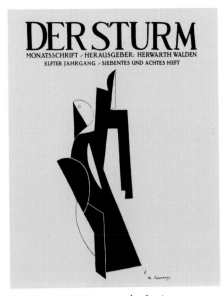

Der Sturm, *1921, cover by Larionov*

M. Larionov, Diaghilev and Mjasin, *1915*

Der Sturm

Der Sturm was a large cultural operation mounted by Herwarth Walden in Berlin at 1910. It included a gallery, a publishing house and an art review. Walden managed to attract to his gallery some of the most important artists of the period. Der Sturm became known to a wider public thanks to "Erster Deutscher Herbstsalon" in 1913, which included works by Archipenko, Chagall, Kandinsky, Kokoschka, Franz Marc and many others. Later, from 1918, Der Sturm also included a theatre, "Die Sturmbühne", where productions were directed by Lothar Schreyer. Walden became more and more attracted by politics and joined the Communist Party. Later he moved to Moscow. He died in a prison camp in the USSR probably in 1940. (PH)

Diaghilev, Sergei
(Novgorod, 1872 - Venice, 1929) Russian choreographer and impresario, naturalized French

All contemporaries agree that Diaghilev's influence in the creation of the Ballets Russes was extraordinary and was not confined to his artistic management. According to Mikhail Larionov, he was the inspirer more than the organizer. In reality, Diaghilev and his collaborators followed a method that was the result of years of common studies. The designers of the first Paris season (1909-14) were painters belonging to Mir Iskusstva, the World of Art group founded in 1898 in St. Petersburg. Their interests in music, painting, literature and theatre were similar. In Diaghilev's ballets they achieved a synthesis of arts that they had been working towards for years, designing interiors in which the furniture, decorative panels and objects were all inspired by Art Nouveau. In creating a ballet, the painters Benois, Bakst and Roerich not only designed the scenery and costumes, but also helped to draft the libretto, and choreograph the movements which the music followed (Stravinsky's score for *Petrouchka* is based on a libretto by Benois). The same is true for the painters who came to the second Paris season (1914-29).

In this organic and revolutionary creation of ballets, Diaghilev was the guiding light. As a youth, he had studied music but renounced his composer's career when his teacher, Rimsky-Korsakov, advised him against it. In the group Mir Iskusstva, he was an art critic and an organizer of exhibitions and concerts. He had the gift of discovering the hidden talents in artists and of bringing them into the open. Thanks to Diaghilev, unknown dancers and choreographers such as Nijinsky, Fokine, Mjasin and Balanchine, became immediate celebrities; artists like Picasso, Braque, Balla, Larionov and Derain, avant-garde musicians like Stravinsky and Prokofiev became world-famous. Unlike his friends of Mir Iskusstva, his taste continued to evolve and so he could go on bringing fresh life to ballet. After the folkloristic and Dionisiac vitality of the first performances, he moved to Cubism, Futurism, and Constructivism. The artists who worked with Diaghilev created solutions that have become part of modern ballet, such as the sharp, "mechanical" dance steps, the abstract scenery and the cacophony of certain musical chords. (GDM)

Dismorr, Jessica

(Gravesend, 1885 - London, 1939) British painter and writer

Jessica Dismorr studied at the Slade School of Fine Art, London (1902-03), at Etaples under Max Bohm (c. 1905-08) and at La Palette (1910-13). During this period she contributed illustrations to *Rhythm* magazine and exhibited at the salon of the Allied Artists Association. She was a frequent visitor to Paris in 1913-14 and was included in the Salon d'Automne in 1913. She met Wyndham Lewis that year and joined the Rebel Art Centre in early 1914. She signed the *Blast* manifesto and contributed drawings and writings to *Blast No. 2*. She exhibited in the "Vorticist Exhibition" (1915) and the New York "Vorticist Exhibition" (1917). In 1920 she became a member of Group X and was elected to the London Group in 1926, in which year she also became a member of the Seven & Five Society. In the mid-Thirties, when her work was at its most abstract, she contributed to *Axis* magazine. From her Fauve beginnings Dismorr developed a Vorticist style, clearly influenced by Lewis and Bomberg, consisting of broad architectural and geometric forms executed with a certain crudeness. Her written contributions to the "war number" of *Blast* express Vorticist images in poetry. Only three paintings and two drawings by Dismorr from this period survive. (JL)

Diulgheroff, Nicola

(Kustendil, Bulgaria, 1901 - Turin, 1982) Italian painter, architect and designer of Bulgarian origin

Diulgheroff joined the Futurist movement in 1926 in Turin. He showed with the group until 1938 and took an active part in working out new Futurist theories, particularly the idea of Aeropainting. After the Second World War he devoted himself entirely to architecture. (SZ)

Dix, Otto

(Untermhaus, 1891 - Singen, 1969) German painter

Between 1910 and 1914 Dix studied at the School of Decorative Arts in Dresden, an important centre for Expressionist painting, especially for the Die Brücke group. He became interested in the painting of the Blaue Reiter and of the Italian Futurists. The influence of the latter can be detected especially in the paintings between 1915 and 1919 in which the subject, be it a self-portrait or a wartime scene, explodes in angles and powerfully coloured lines of force scattered across the canvas. Marked by the war, which rapidly lost for him the exaltation it produced in the Futurists, Dix turned for some time toward Dada, and then toward New Objectivity. He was an activist alongside George Grosz and Conrad Felixmüller, and was severely persecuted for this activity. (SF)

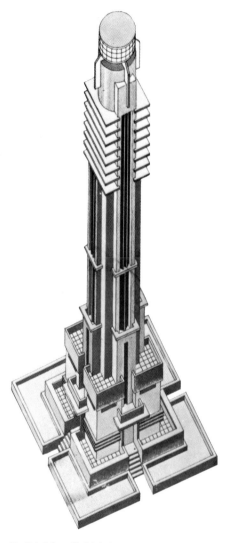

N. Diulgheroff, Lighthouse to Celebrate the Victory of the Machine, *design*

G. Dottori, "The Other World" Restaurant, Perugia

Dottori, Gerardo

(Perugia, 1884 - Perugia, 1977) Italian painter, poet and art critic

Trained in Perugia, Gerardo Dottori settled there permanently after two years spent in Milan (1906-07) and later on thirteen years in Rome (1926-39). After contributing to the Florentine publication *La Difesa dell'Arte* (1910), he entered the Futurist movement in 1912. He began as a Symbolist painter using a Divisionist technique, but later attained a quality of plastic dynamism, largely in the wake of Balla. During the First World War he wrote and published "words-in-freedom" under the pseudonym G. Voglio. He then returned to an intense activity as a painter with a dynamic vision of (chiefly Umbrian) landscape revealing a strong and highly personal lyrical synthesis. In 1920, with Presenzini Mattoli, he founded the magazine *Griffa!* in Perugia. A constant presence at Futurist exhibitions throughout the Twenties and even into the early Forties, he is one of the leading personalities of the second phase of Futurism. In 1929 he signed the *Futurist Aeropainting Manifesto*, and in 1941 wrote the *Umbrian Futurist Aeropainting Manifesto*. Primarily a painter, he also produced numerous interior designs and murals. Prominent among these are the decoration of the "Altro Mondo" in Perugia (1927-28) and the murals in the hydroport at Ostia (1928). He also worked with furniture and ceramics, and was active as a freelance writer and art critic in Futurist and related

Dove, Arthur

(Canandaigua, 1880 - Centerport, 1946) American painter

Arthur Dove was one of the first American artists to create and exhibit a body of abstract art, when he showed ten abstract pastels at Stieglitz's New York Gallery 291 in February 1912 and subsequently in Chicago. Dove's early experimental abstractions were largely based on nature and some stressed representations of moving forms. By 1913, he represented music in abstract paintings and long maintained an interest in alluding to sound.
In Paris from June 1908 through June 1909, Dove discovered Fauvism and changed his work. Immersed in the cultural ferment of Paris, he probably read the first *Futurist Manifesto* when it appeared in *Le Figaro* in February 1909, but returned home before he had a chance to become acquainted with the Futurists' art. He certainly knew of their work by 1914, when Arthur Jerome Eddy, who had purchased one of Dove's pastels in 1912, published his book, *Cubists and Post-Impressionism*. Dove must have responded to Marinetti's call for artists to find inspiration in contemporary life and to shun tradition. Already a sympathetic follower of Fauvism with its radical use of colour, Dove, then a young man in his twenties, would have liked the *Futurist Manifesto*'s appeal to youth and its insistence on the beauty of speed as a paradigm of modern life. Dove eventually depicted machinery in works of the Twenties such as *Mowing Machine, Gear,* and *Outboard Motor*. But his works never possess the violence of Futurism, emphasizing a more lyrical approach that reconciles rather than attacks. (GL)

Duchamp, Marcel

(Blainville, 1887 - Neuilly, 1968) French painter

The Italian Futurists appeared on the Paris scene in February 1912 with the masterly timing of seasoned troupers just when Marcel Duchamp was ready to spread his wings. In that vintage year of 1912, everything conspired to propel Duchamp into an unexplored trajectory: it was the year he painted the *Nude Descending a Staircase* and suffered a rebuff by the Cubists at the Salon des Indépendants; it was the year of Raymond Roussel's extraordinary theatrical version of *Impressions d'Afrique* and Igor Stravinsky's *Sacre du printemps*, both of which Duchamp attended; it was the year of Duchamp's disappearance for three months; it was also the year in which his friendship with Gabriele and Francis Picabia waxed and the influence of his brothers waned. Then the Italian Futurists arrived, whose mood tallied with Duchamp's own frame of mind and can only have confirmed his resolve.

Duchamp visited the exhibition "Les peintres futuristes italiens" at the Bernheim-Jeune Gallery in February 1912. At this time Duchamp was completing a canvas for the Indépendants which he no doubt hoped would cause a sensation and which he based graphically on Etienne Jules Marey's scientific observations of the moving figure (a formula with which he had already experimented a few months earlier in *Sad Young Man in a Train*). The idea for its title, or the subject — Duchamp couldn't remember which — came to him while he was drawing an illustration for Jules Laforgue's poem *Encore à cet astre*, giving it, in addition to its scientific basis, a literary source. "It was a breaking down of forms into linear sections, which follow one another like parallels and deform the object. The object is completely extended, as though it were elasticized. The lines follow in parallel, changing gradually to create the movement or the form in question."

The "static representation of movement" in the *Nude*, Duchamp maintained, was quite different from the Futurists' attempt to suggest movement with dynamic lines. Duchamp believed that his painting was Cubist but, as it turned out, the *Nude Descending a Staircase* was as welcome to Cubist theorists as a dog on a putting green. When Duchamp submitted the picture to the Salon des Indépendants in March 1912, the hanging committee led by Albert Gleizes, who undoubtedly scented a mockery of their Cubist ideals, issued him the ultimatum to remove the title, change it or withdraw it.

The incident of the *Nude* at the Indépendants was decisive. In June 1912, after having completed a series of works with the theme of *The King, The Queen* and *Fast Nudes* which he considered "peut-être un peu futuriste" and which also may have indicated to him that he was in a cul-de-sac, Duchamp disappeared to Munich where he spent three months exploring new ground: "I was finished with Cubism and with motion mixed up with oil paint. The whole trend of painting I didn't care to continue... I decided to stop being a painter in the professional sense."

Duchamp realised that to sever all connec-

Marcel Duchamp by Camille Lieucy
Rouen-Gazette, *1911*

tions with the past (a problem which the Futurists themselves had failed to solve stylistically) he would need to inject his art with a new ingredient, something other than colour or form. A pictorial translation of Raymond Roussel's unique method of literary creation, using a tissue of puns as a starting point, was Duchamp's solution, although "Kandinsky's book was in all the shops" that summer. Duchamp evidently preferred to pursue the *spirituel* in art rather than the spiritual.

The first drawing that he made in Munich Duchamp entitled *Vierge* as if he were asserting, in Futurist terms, that "[ses] mains sont assez vierges pour tout recommencer". Then, in quick succession, *Vierge* became *La mariée* with, in between, *Le passage de la vierge à la mariée*. Finally came Duchamp's major work *La mariée mise a nu par ses célibataires, même*, known as the *Grand verre*, which was to occupy him for the next eleven years.

In 1915 the elements of this motley composition accompanied Duchamp across the Atlantic to the city whose architecture, for him at this date, embodied Futurism: "New York itself is a work of art. Its growth is harmonious, like the growth of ripples that come on the water when a stone has been thrown into it. I believe that your idea of demolishing old buildings, old souvenirs is fine. It is in line with that so much misunderstood manifesto issued by the Italian Futurists which demanded, in symbol only however, though it was taken literally, the destruction of the museums and libraries. The dead should not be permitted to be so much stronger than the living. We must learn to forget the past, to live our own lives in our own time."

Duchamp's tribute to Umberto Boccioni, whom he met in Paris just before the Italian Futurist exhibition opened in 1912, written

in 1943 for the Société Anonyme Catalogue, sums up his views of Futurism: "Unlike other movements, Futurism had its manager, Marinetti — but the real brain of Futurism was Boccioni, who conceived the most convincing manifestos at the time when the world was thirsty for new art expressions. Boccioni's painting and sculpture followed the theory and completed point by point the explanation which words were unable to give. Of all the Futurists, Boccioni was the most gifted and his premature death is certainly a reason for the lack of cohesion in the maintenance of the movement. But if artistic movements remain, as time goes on, the vague label of a period, the artists live on in their works and Boccioni will be remembered more as an original artist than as a Futurist." (JGC-JC)

Duchamp-Villon, Raymond

*pseudonym of Duchamp, Raymond
(Damville, Eure, 1876 - Cannes, 1918) French sculptor*

The second of the three Duchamp brothers, Raymond was the most gifted of the Cubist sculptors. He died in 1918, as a consequence of the war. He started very early to be interested in movement in sculpture, and treated themes with a strong dynamic content such as athletes and boxers. He soon came to quite radical solutions in terms of abstraction and expressive evocations of movement, as for example in his *Football Players* of 1905. In his famous *Horse* of 1914 he combined animal forms and mechanical shapes. He declared that he had almost reached "the point where one views life in such a way that it appears only in the form of a higher dynamic". In contrast to the Futurist sculptors like Boccioni, in whose work the rendering of movement generally tends to be complex, pictorial, and somehow philosophical, Duchamp-Villon's *Horse* and other sculptures are more architectural. Duchamp-Villon concentrated on an essentially static form and built up tensions within it. The impression of movement derives, as in Cubist painting, from multiple intersecting perspectives. (PH)

Dudreville, Leonardo

(Venice, 1885 - Lago Maggiore, 1975) Italian painter

In 1902 Leonardo Dudreville attended the preparatory course of the Brera Academy in Milan. Besides painting, he also composed and performed music. In Milan he became friendly with Anselmo Bucci and in 1906-07 went with him to Paris, where he met Severini. His painting from this period is naturalistic in feeling and influenced by the Pointillist style then dominant in Lombardy. In 1910, according to a letter from Boccioni and Dudreville's own autobiography, he was to have been one of the signatories of the *Manifesto of Futurist Painting*. In fact Dudreville's name does not appear even in the first leaflet, which included two names — Bonzagni and Romolo Romani — absent from the final version.

Dudreville played a prominent role, however, in the preparation of the group Nuove Tendenze. The organizers, who were the critics Nebbia, Macchia and Buffoni, invited him to contact interested Milanese artists in the summer of 1913. Dudreville

signed the programmatic declaration and contributed to the group's only public show, held at the Famiglia Artistica in Milan from 20 May to 10 June 1914. He exhibited ten large works, most of them painted in 1913, including *The Four Seasons*, *The Impact of Tragedy*, *Everyday Domestic Quarrel*, *Rhythms Emanating from Antonio Sant'Elia*. These canvases show the new direction of his work, influenced by the Futurist experimentation with plastic movement. The lesson of Severini is evident in the bright colours and a certain liveliness of expression, combined with formal idioms suggested by Boccioni and Carrà — diagonals, dynamic planes, luminous energy, rays and circular radiations. However, like the other members of the group, his work still has late Secession and Symbolist overtones. The author declared that his aim was to attain "more effective expression through abstraction", meaning "an a priori determination to abolish even a partial depiction of the exterior, photographic appearance of the object that generates an emotion, in order to reach at all costs its inner, characteristic and synthetic expressive essence, translating it graphically into the multiple power of shape, colour, depth, etc.".

From this sort of experimentation, dominated by light and aimed at rivalling the power of music "to fascinate and attract", Dudreville soon switched to a more controlled approach, increasingly anchored to the objective world and tending to a clear, precise realism. A study for a portrait of his wife, dated 1914, already points in this direction, confirmed in the following years. *Bells Pealing in Celebration* and *The Fallen One* (1919) are characterized by an extreme clarity in recording facts which produces an almost "Flemish" result (as Carrà noted in 1923), reminiscent of the German Neue Sachlichkeit.

In the postwar period Dudreville drew closer to Marinetti. In 1920 he co-signed the manifesto *Against All Steps Backward in Painting* together with Funi, Sironi and Russolo, after having taken part the previous year in the large Futurist exhibition at the Caffè Cova in Milan, where he also performed a piece for "intonarumori" with Russolo. In 1921 however he showed at the Galleria Pesaro in Milan, presented by Ojetti, and exhibited with the group Valori Plastici. In 1922 he was one of the founders of the Novecento group, with Sironi, Bucci, Funi, Malerba, Oppi, and Marussig. In 1923 he exhibited with them at the Galleria Pesaro and then in 1924 at the Venice Biennale. Shortly afterwards he resigned from the group since he did not agree with Sarfatti's aim and no longer shared the formal interests of the other members. Although he contributed on an individual basis to the first exhibition of the Novecento Italiano, by then he was in total disagreement with his former companions and did not show with the group again. He continued to work in isolation on his own form of realism. Besides painting, he also produced illustrations and a great deal of writing. (LC)

Dynamism

"Dynamism" is a key concept for the Futurists. It is present in the *Technical Manifesto of Futurist Literature* of 1912 (advocating the use of the infinitive verb, the manifesto states that no other form "can give the sense of the continuity of life and the elasticity of the intuition that perceives it"), and in the painters' manifesto of the same year, *The Exhibitors to the Public* ("what must be rendered is the *dynamic sensation*, that is to say, the particular rhythm of each object, its inclination, its movement, or, more exactly, its interior force"). The concept, which probably owes much to Bergson and Nietzsche, is also central to Boccioni's 1913 manifesto on Futurist sculpture. Partly as a reaction against a certain staticity in Cubism, Futurist art wanted to express life in its movement and in objects themselves. As the *Technical Manifesto of Futurist Painting* proclaimed already in 1910: "The gesture which we would reproduce on canvas shall no longer be a fixed *moment* in universal dynamism. It shall be simply the *dynamic sensation* itself." The same concern is to be found in related movements elsewhere in the world: Russian Cubo-Futurism, English Vorticism, Mexican Stridentism, etc. (SF)

Ego-Futurism

Separately from the Russian Cubo-Futurist group, Ego-Futurism developed between 1911 and 1915 around the poet Igor Severianin (1887-1942). The movement published its own programme, nine almanacs, and collections of poetry written by members. Its aesthetics were characterized by the exaltation of "urbanism" of and by extreme individualism, with certain Theosophical components.

More than for any real Modernism, Severianin rapidly became famous for his dandyism and for some remnants of Decadentism in the pamphlets *Intuitive Colours* (1909), *Electric Poems* (1911), and *The Cup Boiling Over with Thunderclaps* (1913). Others associated with him were Konstantin Olimpov (*Airplane Poetry*, 1912) and Ivan Ignatiev (*Ego-Futurism*, 1913). Ego-Futurism was also connected with the Petersburg poetry group of the Mezzanine, whose driving force, Vadim Shershenevich (1893-1942), translated Marinetti (*Manifestos*, 1914; *The Battle of Tripoli*, 1915; *Mafarka the Futurist*, 1916). (SF)

Ender, Boris

(Petersburg, 1893 - Moscow, 1960) Russian painter

Ender was the best known of a group of brothers and sisters, all artists (his sisters were Xenia and Maria Ender). In 1911 he came into contact with the musician and painter Mikhail Matiushin and his wife, the poet Elena Guro, whose home was frequented by Russian Futurists. A welcome and frequent guest there before, during and after the Revolution, Boris Ender met there Malevich, Kruchenykh, Khlebnikov and others. But the chief influence was that of Matiushin — it was he who urged Ender to explore "organic shapes" and to carry out colour research. His watercolours and oils became assemblages of abstract shapes, often dripping with lively colours which, even in the Twenties, made him infinitely closer to Futurism than to Constructivism or Suprematism. (SF)

Dr. Atl, The Great Galaxy
Valdivia Collection, Mexico

England

The *Futurist Manifesto*, first published in *Le Figaro* in 1909, was published in English in 1910, the year that Marinetti gave his first lecture in London. The initial impact was relatively small. English painting in 1910 was still imbued with the spirit of Impressionism with Sickert in the vanguard. Two exhibitions organized by Roger Fry, "Manet and the Post-Impressionists" (1910) and the "Second Post-Impressionist Exhibition" (1912), introduced more recent developments to the British public. The second exhibition was of particular importance for not only did Fry include Cubist works by Picasso and Fauve paintings by Matisse, but he also invited Clive Bell to select an English section to stand alongside a rather weak Russian section. Fry deliberately omitted Italian Futurism, stating that "the Futurists have succeeded in developing a whole system of aesthetics out of a misapprehension of some of Picasso's recondite and difficult works".

Futurist painting first came to London in March 1912 with the exhibition of Italian Futurism at the Sackville Gallery, which had been transferred from the Bernheim-Jeune Gallery in Paris, and contained the works of Boccioni, Carrà, Russolo, Balla and Severini. It was seen by more than 40,000 people and was mentioned or written about in more than 350 articles. In general, press reaction was hostile. The *Pall Mall Gazette* classified it as a "nightmare exhibition", the *Observer* as "a thoroughly objectionable tendency" and the *Morning Post* described it as "an immorality". The exhibition's impact was further enhanced by lectures given by Marinetti. Marinetti considered London to be an ideal Futurist city with its underground railway and he returned to lecture again in 1913 and 1914. Two of his most notorious performances were at the Bechstein Hall on 9 March 1912 and at the Colosseum in June 1914, when he introduced the music of Russolo. These lectures were popular amusements but their provocative nature was largely ignored by a passive British public. As Frank Rutter wrote retrospectively, Marinetti's lecture at the "Post-Impressionist and Futurist Exhibition" (Doré Galleries, 1913) had little effect because "London is so peace-loving".

Futurism was also represented by Severini's one-man exhibition at the Marlborough Gallery in 1913 which had a great impact in particular on Christopher Nevinson, Edward Wadsworth and Wyndham Lewis. Severini and Boccioni, more than any of the other Futurists, influenced those artists who were eventually to become Vorticists, or in the case of Nevinson, to remain a committed Futurist.

Futurist publications were also of importance. *Blast* would have been unthinkable without the precedents of *Lacerba*, Marinetti's *Parole in libertà* (Free-Words) and Apollinaire's *L'antitradition futuriste* (Futurist Anti-Tradition), both in terms of content and typography. The *Futurist Manifesto* and the *Technical Manifesto* were both published in the Sackville Gallery catalogue, and on the occasion of the "Second Futurist Exhibition" at the Doré Galleries (1914), Boccioni published *Sculptures ensembles plastiques* (Sculptures

Caricature of the exhibition of Italian Futurists at the Sackville Gallery London, 1912

The Sketch, 1914, the "intonarumori" at the London Coliseum

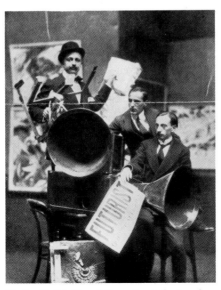

Marinetti, Piatti and Russolo at the London Coliseum

Plastic Ensembles). Severini also wrote a lengthy introduction and catalogue notes for his one-man show. The only manifesto conceived specifically for the British public was *Vital English Art*, written by Marinetti and Nevinson and purporting to be issued from the Rebel Art Centre, although this was immediately denied by Lewis and his fellow "rebels" who repudiated their implied collusion in the document. *Vital English Art* was Marinetti's last attempt to bring the "rebels" under his umbrella, but he merely provided a catalyst for the formation of a Vorticist group. *Vital English Art* was, in the words of the *Daily Express*, "more moderate than most of Signor Marinetti's utterances" and scarcely put forward any concrete ideas. Although the manifesto had little impact, the word "Futurist" by now was common parlance for anything regarded as new.

Futurist influence was at its peak in 1913-14, as evidenced both in certain examples of British painting and in the writing of Lewis, for example in his introduction to the "Cubist Room" at the exhibition of the "Camden Town Group and Others" held in Brighton in 1913, where he expressed ideas which were wholly compatible with Futurism in spite of asserting that it was a purely Italian movement. The basic failure of Futurism to have a lasting impact on English art (it had one Scottish follower, Stanley Cursiter) can be ascribed principally to three causes: the manner in which it was perceived by English artists, particularly Lewis, as an extension of Impressionism; the "rebels" refusal to accept the leadership of the pugnacious Marinetti, and the lack of respect accorded to it by Fry and Clive Bell who were highly influential in artistic circles. As Ezra Pound put it: "Impressionism, Futurism — a type of accelerated Impressionism — deny the vortex. Marinetti is a corpse." (JL)

Enharmonic Bow

In 1925 Luigi Russolo invented and constructed the "enharmonic bow" in order to obtain sounds similar to the thunder and crackle of the "intonarumori" beyond those available with a normal bow on the viola and violoncello.

The enharmonics bow made the use of the left hand superfluous: changes of pitch were achieved by placing the bow directly on that point of the string normally stopped by the fingers of the left hand. Like the "rumorarmonio", this instrument was destroyed and no recordings exist. (FMa)

Enharmonic Notation

"Enharmonic notation" was a new system of musical notation invented in 1913 by Luigi Russolo for the "Intonarumori". It maintained the normal stave and treble and bass clefs, but instead of notes, solid lines were used to designate specific pitches and the fine gradations between them.

The only example of this notation appears in the score for *Risveglio di una città* (The Awakening of a City) published in the first issue of the periodical *Lacerba* on 1 March 1914. (FMa)

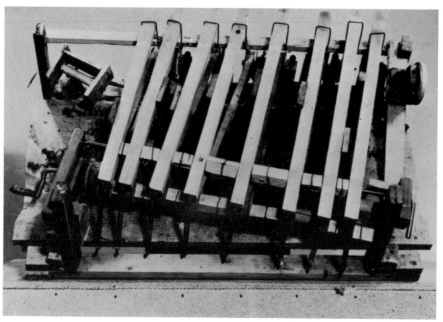

L. Russolo, octave of the enharmonic piano, 1931

Enharmonic Piano

Observing that the secondary vibrations in string instruments had never been exploited, in 1931 in Paris Luigi Russolo built a new instrument that would utilize those vibrations in bowed (violin, viola, cello), struck (piano), and plucked (guitar, harp, mandolin) string instruments.

He constructed a one-octave prototype of what he called an "enharmonic piano", whose sounds cover a wide range due to the wealth and variety of harmonics. (FMa)

Epstein, Sir Jacob

(New York, 1880 - London, 1959) British sculptor

After studying at the Arts Student League in New York and the Académie Julian in Paris, Jacob Epstein moved to London in 1905. He was virtually unknown and still tentative as a sculptor, although his draughtsmanship was already assured. Within a couple of years, however, Epstein was fortunate enough to secure a major public commission. Charles Holden, who was designing a new London headquarters for the British Medical Association, invited him to make 18 over-lifesize figures for the building's facade.

Epstein was delighted, and the stimulus he gained from the commission gave him the confidence he needed. With the help of assistants he modelled the figures, cast them in plaster, and then began work carving the stone versions on site at The Strand. The BMA directors favoured a scheme which emphasized medical history, but Epstein wanted his figures to embody "the great primal facts of man and woman". Throughout his life he had no hesitation in dealing with themes like maternity, birth and sexual desire. Inspired by the frankness and celebratory spirit of Walt Whitman's poetry, he carved proud and dignified figures on the BMA's walls. But the National Vigilance Association offices were situated opposite the building, and its members complained about the well-proportioned woman who embodied *Maternity*. A loud and ridiculous campaign against Epstein's statues ensued in the British press. The mounting hostility almost forced the BMA to censor the statues, but Epstein's work was finally saved by the support of distinguished artists, critics and museum directors. (Twenty years later, the building's new owners finally succeeded in mutilating the figures despite another fierce battle between their opponents and defenders.)

It was the first of many public scandals in Epstein's long and controversial career. He bore the brunt of the public's hostility against modern art, but the BMA carvings now look almost conventional. At that stage Epstein was influenced by Greek sculpture, Donatello and Rodin rather than his experimental contemporaries. By the time he completed the monumental *Tomb of Oscar Wilde* for Père-Lachaise Cemetery in Paris, however, he had found other sources of inspiration in the British Museum. Both he and his close friend Eric Gill admired Indian carving, and in the *Tomb of Oscar Wilde* (1912) the wings of the "flying demon-angel" pay overt homage to Assyrian sculpture. Once again the result caused a public scandal, but Epstein benefited from his stay in Paris. During the latter months of 1912 he met Modigliani, Picasso and Brancusi, whose example encouraged him to pursue an even more audacious course when he returned to England the following year.

Settling in the isolation of Pett Level, Sussex, he carved a sequence of pregnant female figures in flenite. The impact of primitive sculpture on these strange, hunched figures was by now very pronounced. So was Epstein's determination to respect the character of the stone he carved, allowing it to shape his work. Another series, concentrating this time on copulating doves, was directly influenced by the purist simplicity of Brancusi. Several of these pioneering works were included in Epstein's first one-man show at the Twenty-One Gallery, London, in December 1913.

At the same time, however, Epstein was also working on a more ambitious sculpture which would demonstrate a new involvement with the machine age. Supported by his friendship with the philosopher and critic T.E. Hulme, who predicted that the new art would be "clean, clear-cut and mechanical", he purchased a second-hand American rock drill. This powerful machine, mounted on a tripod, was itself a revolutionary invention. With astonishing audacity, Epstein decided to incorporate it in his sculpture. On top of the black drill he placed his own white plaster figure of the driller — a man he later described as "a machine-like robot, visored, menacing, and carrying within itself its progeny, protectively ensconced". He even considered attaching pneumatic power to the drill, and setting it in movement — a remarkably Futurist idea. But he eventually rejected the idea, opting instead for a motionless sculpture which set up an eerie contrast between white and black, plaster and metal, the man-made and the machine-made.

He called it *Rock Drill*, and when this extraordinary sculpture was first exhibited at the London Group show in 1915 it was widely discussed. On one level, it symbolizes the triumph and potency of mechanized man — a worker who bestrides his drill like a hero and pounds the rock with virile determination. But the form of a baby lodged inside his rib cage is a reminder of the driller's responsibilities to the next generation, and the ghostliness of the white plaster figure gives it a haunted air as well. By this time, war had been declared and Epstein was already beginning to realize that machine power possessed a devastating destructive potential. No wonder that, when he exhibited his final version of *Rock Drill*

in 1916, he discarded the heroic drill and turned the driller into a fearful bronze victim with severed arms.

Like his friend David Bomberg, Epstein was reluctant to become closely associated with Vorticism. But he admired Wyndham Lewis's work, accepted his invitation to contribute illustrations to *Blast No. 1*, and for a while shared the Vorticists' desire to forge a radical art for the machine age. The moment soon passed, however. A pair of monumental *Venus* figures, mounted on copulating doves, soon reasserted a more humanist approach. His second one-man show, at the Leicester Galleries in the spring of 1917, already contained evidence of a return to representation. In later life Epstein became celebrated for modelling expressive portrait busts, but he also pursued an intermittent and controversial career as a carver of monumental·sculpture, sometimes for public locations. (RC)

Ernst, Max

(Brühl, Germany, 1891 - Paris, 1976) German painter and sculptor, naturalized French

Before the First World War Max Ernst, the son of a painter, had already decided to follow the same career. He belonged to a circle of avant-garde artists and poets in Cologne and had met others during a visit to Paris. For a short time he was strongly influenced by the Futurists, and produced some powerful paintings in a Futurist style with elements taken from German Expressionism. Ernst served four years in the army and was wounded in 1917. (He and Paul Eluard, who became his closest friend, later discovered that in February of that year thay had fought on the same front, on opposite sides.) After the war, Ernst travelled to Munich where he saw Dada publications from Zurich and also the Italian magazine *Valori Plastici*. He was fascinated by reproductions of works by Giorgio de Chirico. Ernst became one of the leading German Dadaists. In 1921 he moved to Paris and played an active role in the Surrealist movement. (PH)

Esenin, Sergei Alexandrovic

(Kostantinovka, 1895 - Leningrad, 1925) Russian writer

Although his sense of aesthetics was very different from that of the Russian Futurists, Esenin was often linked to them, especially to Kruchenykh and Khlebnikov, and he co-authored — with Khlebnikov and with Anatol Marienhof — *L'Auberge des Aubes*, which was published in 1920. (SF)

Esotericism and Spiritism

An interest in magic and esoteric phenomena was common to all the important cultural centres of Italy around 1909. Turin concentrated on psychic condensation and materialization through Lombroso's coterie, Rome elected a mayor, Nathan, who was a Freemason and an occultist, Milan gave its attention to "panpsychism" and the occultist and spiritist ideas propounded by Marzorati.

Altogether, the atmosphere of Italian culture at the dawn of Futurism was decidedly esoteric and the individual artists participated in the trend. Balla described himself as "a temperament which gets on much better with the voices of the infinite than with our own", and in his notebooks he refers to Hoepli manuals, like *Spiritismo* by Pappalardo and *Ipnotismo e magnetismo* by Belfiore, and to compendiums of psychiatry, including an important treatise by Lombroso. Balla knew Lombroso and had attended some of his lectures at the University of Turin. Boccioni's interest in mediums and the occult is shown by a passage in *Lacerba* in 1915 in which he recalls giving a talk in 1911 about "perceptions of luminous emanations from our bodies which have already been reproduced on plates". He confirmed his interest in ectoplasmic phenomena in *Pittura scultura futuriste* (*Futurist Painting and Sculpture*, 1914): "For us the biological mystery of medium-induced materialization is a certainty, a clear fact in our intuition of psychic transcendentalism and plastic states of mind." Marinetti, in *La grande Milano futurista* (*The Great Futurist Milan*), described how he had been influenced by his father's interest in the history of Eastern religions and telekinesis. The poet and theoretician of the movement translated the phenomenon into modern terms, as can be seen in this extract from *L'uomo moltiplicato e il regno della macchina* (*Man Multiplied and the Reign of Machinery*): "We believe in the possibility of an incalculable number of human transformations, and we declare without a smile that wings slumber within the flesh of man. When man is able to externalize his will so that it extends beyond him like an enormous invisible arm, Dream and Desire, which today are vain words, will reign supreme in vanquished space and time." He adds that this human species can be imagined by "studying the phenomena of externalized will continually manifested during séances".

With the aim of demonstrating the difference between spirit photography and "photodynamism", Bragaglia studied the evidence of psychic condensation. In an essay in *Humanitas* (Bari, 21 December 1913), he spoke of the "photography of the invisible", and in a later article he further developed his ideas about mediumistic phenomena, stating that "there exist in us different principles, and different bodies that interpret them, and the visible body — in this psychic sense — is only a tool of the invisible body". The article was accompanied by photographs of ectoplasms. All this came after his photographic experiments of 1911 and 1912, illustrated in *Fotodinamismo futurista* (*Futurist Photodynamism*). There, in paragraph 9, to illustrate the change in man's sensibility at the beginning of the new century, Bragaglia stressed how "through that remarkable intuition belonging to our ultrasensitive beings of men living rapidly and feverishly, we possess a hundred voices and a hundred visions, emotional and intellectual views of things, which mix, interpenetrate, and merge with the real view of the present moment".

The brothers Ginna and Corra, who had read Indian texts and were familiar with hypnotism and occultism, were the Futurists most deeply involved in esoteric experimentation. They read about Theosophy and hypnotic therapy, and influenced Balla and certainly Bragaglia with their spiritualist and occult theories. Ginna wrote *Arte dell'avvenire* (*Art of the Future*, 1910); and in reference to his esoteric interest, declared: "My brother and I purchased spiritualist and occultist books from the publishers Diurville and Charcormac. We read works by the occultists Eliphas Levi, Papus, Theosophists such as Blavatsky and Steiner, Besant — the secretary of the Theosophical Society — Leadbeater, Edouard Schuré."

The Futurist group is thus almost complete: Severini, although extremely religious, was interested in mediumistic séances, and took part in several with his wife Jeanne.

Depero, when he came to Rome, fell under the influence of the great magician and alchemist Balla, and with him signed *The Futurist Reconstruction of the Universe*, a manifesto which opens with the declaration: "We shall give flesh and bones to the invisible, the impalpable, the imponderable, the imperceptible." For Carrà and Russolo no documents survive indicating an interest in esotericism, but ultra-sensitivity is unquestionably one of the topics of Carrà's *Music* (1911). The painting shows a sequence of auras irradiating from the figure, residue-images spread and dispersed in a sinuous, undulating vortex of blue, red, and yellow stripes. *Music* expresses with a metaphysical light — also present in *The Overcome* — the "traces" or waves produced by a pianist in a particular state of mind. Interest in the occult sciences did not of course remain an isolated element, determining a particular attitude or a specific production. The Futurists were gifted with a receptivity to known and unknown events, and were particularly interested in new scientific and parascientific theories. They integrated the two types of knowledge, merging their experience of mediumistic phenomena with scientific information on light and X-rays. The association of these different phenomena is urged in the *Technical Manifesto of Futurist Painting*.

This interweaving is part of the continuous need, felt by both scientists and Futurists, to combine science and spiritualism, science and parascience, science and parapsychology, in order to emphasize the perceptive "immensification" — as Marinetti put it — of the Futurist "I" in relation to reality. (GC)

Etchells, Frederick

(Newcastle upon Tyne, 1886 - Folkestone, 1973) British artist and architect

Frederick Etchells studied at the Royal College of Art in London (c. 1908-11), and then lived in Paris for a while. There he met Picasso, Braque and Modigliani. His enthusiasm for the French avant-garde recommended him to Roger Fry, who commissioned Etchells to paint a large mural and then included him in the "Second Post-Impressionist Exhibition" at the Grafton Galleries, London (1912-13). Etchells' paintings of this period are similar in style and spirit to the Bloomsbury painter Duncan Grant: the influence of Post-Impressionism is strong, but a semi-Cubist severity of structure is also apparent. So is a quirky sense of humour, which led him to develop strangely distorted figures and even to paint a traditional English hunting scene in a Post-Impressionist style.

In the summer of 1913 Fry invited Etchells to join the newly-formed Omega Workshops, where he designed textiles and rugs. But Etchells was now becoming very friendly with Wyndham Lewis. They visited Dieppe together, and shared a growing dissatisfaction with the way Fry ran the Omega. In October 1913 Etchells joined Lewis, Cuthbert Hamilton and Edward Wadsworth when they walked out of the Omega, accusing Fry of unfairly exploiting their abilities. At the same time Etchells contributed to Frank Rutter's "Post-Impressionist and Futurist Exhibition" at the Doré Galleries, a landmark in the acknowledgment of Futurism's influence on young English artists.

Although Etchells joined the Rebel Art Centre in spring 1914, and contributed illustrations to *Blast No. 1*, he was a somewhat reluctant Vorticist. He did not add his signature to the Vorticist manifesto in *Blast No. 1*. But he contributed illustrations to *Blast No. 2* (July 1915) and also participated in the Vorticist exhibitions in London and New York (1915 and 1917). His few surviving drawings and watercolours of the period prove that he adopted a thorough-going Vorticist style. They show a strong emphasis on architectural forms, and after the war Etchells gave up painting to become an architect. In 1930 he designed one of London's earliest modernist buildings, Crawfords in Holborn, and he translated Le Corbusier's *Towards a New Architecture* into English. (RC)

Monogram of the Rebel Art Centre, 1913

Evola, Julius

(Rome, 1898 - Rome, 1974) Italian writer

Evola is chiefly famed as a theoretician of the traditionalist right wing and for his studies in the history of hermeticism and esoteric religion. Around 1920, however, he participated briefly in Dada as a writer and painter: he was a friend of Tristan Tzara and worked on such avant-garde magazines as *Dada*, *Bleu*, and *Noi*. Evola was the author, among other things, of a poem named "La parole obscure du paysage intérieur", and of an essay "Abstract Art" (1920), which contained historical and critical observations useful for any interpretation of Futurism. For example, when Evola speaks of "orgiastic subjectivism" and a "plunge into brutality for the sake of purification", he provides precise information for an analysis of Marinetti's early *paroliberismo* exemplified in "Zang Tumb Tumb" (1914). (LDM)

J. Evola
The Dark Word of the Inner Landscape

Expressionism

It is generally agreed that the birth of German Expressionism can be established with the foundation of the group Die Brücke in Dresden in 1905; the group included such painters as E.L. Kirchner, Erich Heckel, Max Pechstein, K. Schmidt-Rottluff, Emil Nolde, Otto Mueller.

Expressionism took many paths over the years, including that of the Blaue Reiter. Of an abstract tendency, this group was established in 1911 after the Futurist Manifesto, and included such painters as Vasilii Kandinsky, Franz Marc, Paul Klee, Alexis von Jawlensky, August Macke. Since it continued for several years after the war — in the opinion of some right up until the Bauhaus — Expressionism could not ignore its neighbour, Futurism.

It is well known that the first manifestos, writings and paintings of the Futurists that appeared in Berlin were presented in 1912 by the magazine and gallery run by Herwarth Walden, *Der Sturm*. Expressionism was already a large and solidly established movement in German arts and literature, and also in countries with German cultures, but it lacked an overall organization and a clear programme. Expressionism had an amazing capacity to import and absorb every new development: from Fauvism to Constructivism by way of Cubism, all the important movements left their mark on Expressionism. The same is true of Futurism, perhaps because the two movements share a common ancestor — Nietzsche — and a fundamental propensity for the "pathetic" or *pathos*; the "states of mind" of Boccioni or the slightly insistent Symbolism of Russolo are not far from Expressionist painting.

Expressionism was as emotional as Futurism, but in a completely different fashion: in Kirchner, in Kokoschka and in Weidner the world was deformed by the emotion of the artist and generally appeared to be scornful and sinister, corresponding to the fundamental pessimism characteristic of all Expressionists. Futurist works, however, were characterized by a deformation provoked by sensation, by the artist's vision, which was altered by the speed and new conditions produced by modern technology; the artist however had no fear of the world, but was exalted by it, and was pushed toward real optimism. The consequent subjectivity in both cases constituted a bridge between Italian Futurism and German Expressionism.

Lyonel Feininger, who had an angular brush stroke ever since the *Comics* he produced in 1906, was first influenced by the Cubists and then by the Futurists. His *Cyclists* of 1912, for instance, are filled with so cheerful a movement that they have no connection with Expressionism and show links with Futurism. The apocalyptic explosions of Ludwig Meidner were undoubtedly encouraged by Cubism. Franz Marc defended the Futurists, and his art after 1912 resembles a cross between Delaunay's Orphism and Futurist dynamism. One must mention also George Grosz and Otto Dix. In German literature the interest in Futurism was equally widespread but rarely acknowledged. First among the writers interested in Futurism was the poet August Stramm, followed by Behrens, Otto Nebel and even Kurt Schwitters. The writer Alfred Döblin, with some reservations, was successful in mastering several Futurist techniques. In this field, as in painting, the Futurist influence was widespread, hidden, but unquestionable. (SF)

Exter, Alexandra

(Bielostok, Kiev, 1882 - Fontenay-aus-Roses, 1949) Russian painter and designer

Alexandra Exter used colour lavishly in all her works, which included painting, theatre and textile design. Even in her period of greatest conceptual rigour, when she was engaged in Cubist experimentation, she incurred the disapproval of her friend Léger, who found her paintings excessively chromatic. Exter's irrepressible tonal expressivity derived from her Ukrainian origin: the popular imagination of this country has traditionally found expression in the brilliantly coloured decoration of household utensils, embroidered articles, musical instruments and peasant architecture. Even Exter's most advanced works were inevitably enlivened by the vibrant warmth of folk art colours.

In a series of synthetic visions of cities which she began creating in 1912, the artist introduced a rhythmic dynamism which suited the urban theme of Futurism. Sections of objects alternate with sheets of pure colour, charged with energy by variations in density or transparency. Her particular sensitivity to texture (*faktura*) and her interest in flat chromatic surfaces paved the way for her later Suprematist experiments in 1916, and for her Constructivist production which dates from around 1920.

From 1909 to 1914 Exter travelled between Paris, Kiev and Moscow, thus creating an immediate link between the Russian and French avant-gardes. In 1911 she took with her the first photographs of Cubist works by Picasso, which were to influence David Burliuk. In 1914 she urged the poet Axionov to write his work on Picasso (1917), which reflects the critical position expressed by Ardengo Soffici in *Cubismo e futurismo* (*Cubism and Futurism*, 1914). In the spring of 1914 Exter was particularly close to Soffici and shared his studio in Rue Boissonade. Both of them worked independently of Cubism, and they developed a common style in the field of collage.

Exter, however, soon displayed a constructive and dynamic impulse that was to be typical of all her work. Lively advertising slogans, static right-angled shapes and receding diagonal elements are placed in an active interrelationship, which in her creations from 1915-16 equalled the angular aggressiveness of Tatlin's counter-reliefs. The increasing influence of Tatlin is evident in Exter's relief paintings, which foreshadow both her three-dimensional work for the Tairov Theatre and her interest in the intrinsic qualities of materials. In fact, in 1916-17 her Suprematist, Tatlinian and Futurist experiences came together in highly inventive, non-objective set-designs. Dispensing with painted back-drops and all symbolic references, Exter constructed a solid scenic universe of geometric forms. In *Salome* (1917), the stage was divided diagonally into two parts with a spiral staircase in the centre. The differences in level were related to the movements made by the actors. The projection of coloured lights and the sudden screening with pieces of cloth visualized the most subtle states of mind, using the tensions generated by the forms and by the physiological and psycho-logical force of the colour. The costumes were stiffened into geometric shapes with wire to make the actors' movements more mechanical, while the materials were used so as to bring out their intrinsic nature: silk conjured up sensations of lightness, brightness and speed, while velvet conveyed slowness and heaviness.

The "culture of materials" reached a level on which it could even determine psychological characterization. In the film *Aelita* (1924) the Martian type was represented by the transparency and mirror luminosity of glass, perspex and metal-foil, made into sharp, spiralling and squared-off costume structures.

Exter's work is interesting for its ability to combine elements not strictly tied to a single tendency, which expressed a very original form of research.

In 1924 Alexandra Exter emigrated to Paris where she continued to work in different fields of design. (GDM)

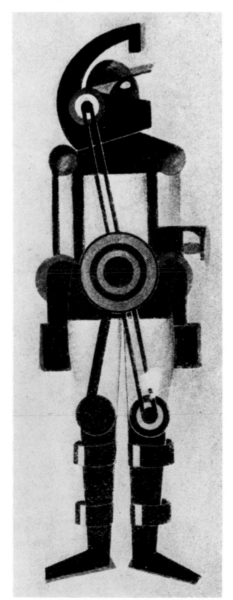

A. Exter, costume of a warrior for Aelita *1924*

Face-Painting

The *Budetljanes* looked upon the future as a start from scratch, a new beginning, but sought to return to a primitive innocence by re-evoking man's remote past. Mikhail Larionov brought a crude force to painting, aligning it with precultural or non-codified expressions of art like children's drawings, shop signs and anonymous graffiti. The most extreme example of his return to the primitive world, however, is face-painting. The artistic theory of face-painting was set forth in the manifesto *Why We Paint Ourselves*, published at the end of December 1913 in the popular magazine *Argus*. The text was illustrated with examples of cheek painting by Larionov and with photographs of a couple dancing the tango. This dance, which was scandalizing and thrilling Europe (though Marinetti was not impressed) had been introduced in Russia by Max Linder, who had performed in a sketch entitled *Love and Tango* in St. Petersburg at the end of November of the same year. For Larionov, who signed the manifesto together with Ilia Zdanevich, the tango expressed drunken, excessive sounds which, like the grating of a streetcar, were appropriate to the new modern sensibility. In his turn, Marinetti considered that the performances most apt to transform the collective sensibility were music-hall shows, because they lent themselves to experiments in "physical folly", such as painting colours on women's bodies to make them more seductive. He was convinced that the *chanteuses* should be obliged to dye their hair green, paint their arms purple, their *decolletés* sky-blue and their *chignons* orange. But Larionov beat him to the draw. In September 1913 he exhibited himself at the Kuzneckii Most with his face plastered with hieroglyphics and radial markings, leaving the Moscow passers-by astounded. His gesture had nothing to do with the prevailing fashion in Paris for painting designs on dancers' legs, nor with the latest fad in make-up: Egyptian style eye-liner. As he stated in *Why We Paint Ourselves*, Larionov had already painted a model's body in 1905, continuing on her skin the patterns of the carpet she was lying on. The face-painting of 1913 stemmed from a deeply-felt need to change the social function of art and was intended to start a new collective, popular art. The segmentation and the bright shades of Larionov's face-painting, contrasting with the softness of the skin and the muscular curves, committed an outrage against nature and suggested a process of ritual dehumanization. The exorcism consisted in adapting one's facial expressions to correspond to the delirious city of arc-lamps.

Larionov and Zdanevich even painted their house-numbers on their cheeks, along with other signs and words which symbolized the marriage of men and buildings. They succeeded in provoking that ambiguous feeling, defined by Freud as "disquieting alienation", which is created by the transformation of anything we considered intimately familiar and our own and which marks the return of what has been repressed. Larionov's body-painting set out to provoke in civilized beings the resurgence of primitive phantoms. (GDM)

Farfa

pseudonym of Tommasini, Vittorio Osvaldo (Trieste, 1881 - Sanremo, 1964) Italian poet and painter

Although he met Futurism already in 1910, Farfa's activity as painter and poet belongs mainly to the second Futurist generation. A member of the Ligurian group, he kept close contacts with Fillia and the Turin group, exhibiting with them in 1924. During the Twenties and Thirties he participated in various Futurist exhibitions and events; he also designed a number of ceramics that he executed with Tullio d'Albisola.

His paintings, poster designs and ceramics all show an intense, fantastic imagination. He was the first "national record-poet", writing verse veined by irony towards men and machines. He published several collections of poetry: *Noi miliardario della fantasia* (*We, Fantasy's Millionaire*, 1933), *Poema del candore negro* (*Poem of Black Whiteness*, 1935), *Marconia* (1937). In 1943, together with Marinetti, Giovanni Acquaviva and Aldo Giuntini, he edited *Canzoniere futurista amoroso guerriero* (*Futurist Song-Book of Love and War*). (ECr)

Feininger, Lyonel

(New York, 1871 - New York, 1956) American painter who worked in Germany

After settling in Germany in 1887, Lyonel Feininger started his career as an artist drawing comic strips for children in the *Chicago Tribune*. He made his debut as a painter in 1907 and discovered Cubism in 1911, through Robert Delaunay. The exhibition at Der Sturm probably introduced him to Futurist painting. In 1913 he exhibited with the Blaue Reiter group. By this time he had already evolved his own style, a synthesis of lessons drawn from Cubism, Futurism and Expressionism, built up in a solid architecture with elegant angles. From 1919 to 1933 he worked at the Bauhaus and finally returned to the United States in 1937. (SF)

Fillia

pseudonym of Colombo, Luigi (Cuneo, 1904 - Turin, 1936) Italian painter and writer

Fillia grew up in Turin where he continued to work, apart from a few visits to Paris. In 1923, with Tullio Alpinolo Bracci and Ugo Pozzi, he founded the Turin Futurist Movement and the Futurist Artistic Unions, which embraced the proletarian revolutionary perspective of the city's working class.

During the Twenties and Thirties, these two groups formed the core of one of the most important Futurist group in Italy, and Fillia remained their undisputed leader. From 1922, besides paintings shown at Futurist exhibitions, he created interior designs (*Ambiente novatore*, Turin, 1927), furniture and decorative objects, including ceramics (with Tullio d'Albisola).

He also wrote Futurist manifestos and essays on art and architecture which usually appeared in reviews he published and edited himself (*La Città Futurista, Vetrina Futurista, La Città Nuova, Stile Futurista*) and as monographies or anthologies: *La nuova architettura* (*New Architecture*, 1931), *Il futurismo* (1932), *Gli ambienti della nuova*

Farfa, self-portrait, 1931

architettura (*The Interiors of the New Architecture*, 1935). He also wrote free-word poetry, novels and, during the Twenties, plays: *La morte della donna* (*Death of Woman*), *Lussuria radioelettrica* (*Radio-Electric Lust*), *Sensualità* (*Sensuality*, 1925), *L'uomo senza sesso* (*The Man without Sex*, 1927), all based on a poetic myth of machines and expressing a "machinist" sensuality.

His pictorial evolution as a painter falls into three different periods: the first, around the mid-Twenties, is his abstract "mechanical" period where bright, flat colours suggest psychological analogies; in the late Twenties he practised a strong, sombre "mechanical" plasticism, and finally, towards the beginning of the Thirties, Prampolini's influences were projected into a fantastic and cosmic dimension.

With his intense creative and publicizing activity, his variety of interests and connections, Fillia is one of the most important figures of the Second Italian Futurism. (ECr)

Filonov, Pavel Nikolaevich

(Moscow, 1883 - Leningrad, 1941) Russian painter

After learning house painting and decorating in St. Petersburg, from 1903 to 1908 Filonov attended the private art studio run by Lev Dmitriev-Kavkazsky. He came from a poor family and during his studies earned his living as commercial artist and retoucher of photographs. In 1910 he joined the Union of Youth and enrolled at the Academy of Arts, which expelled him for "perverting his companions by his work".

In the Union of Youth Filonov met the avant-garde painters and poets and discovered the new currents coexisting within the organization: Cubo-Futurism, Cézanne's painting, Oriental art and the primitives, in the widest sense of the word.

The original skill and naturalism of the primitives, added to the training he had received with Dmitriev-Kavkazsky and his serious scientific studies, enabled Filonov to work out his own pictorial language.

In 1912, after a journey to Italy and France, Filonov settled in St. Petersburg and dedicated himself exclusively to painting. He exhibited regularly with the Union of Youth, illustrated Futurist anthologies (*Roaring Parnassus*, 1914) and designed theatrical décor (*Vladimir Maiakovsky: A Tragedy*, 1913). At the same time he developed a theory about painting and formulated concepts of "analytical art", "the made picture" and "universal flowering". According to his analytical method, "quality in painting is not given, but produced or conquered through patience and perseverance". Each work, at each moment of its creation, must be subjected to a constant analysis, since "the growth and development of the object represented must be produced atom by atom as organically and regularly as in natural growth". During the first stages of execution of a work, colour is completely subordinated to form. It is only when the drawing is complete that colour is introduced. That is why painting considered as an action and a process is in reality a coloured drawing. The completion of the work or "conclusion" becomes the

"made picture" which can serve as a "formula". Several canvases by Filonov bear that name and exist in several versions: "Formula of the Proletariat", "Formula of Spring", "Formula of Imperialism", etc. Called up in 1916, Filonov was sent to the Caucasian front where he participated actively in the Revolution. On returning to Petersburg he was largely represented at the First National Exhibition (1919) and the "Erste Russische Kunstausstellung" at the Van Diemen Gallery in Berlin (1922). While continuing to paint and teach, he also developed his theoretical elaboration, first at Inkuhk (National Institute of Artistic Culture) and then at the head of his own Collective of Masters of Analytical Art (MAI). After 1928, his "struggle against formalism" made him an increasingly isolated figure. A large retrospective exhibition of his work prepared in 1929 for the Russian Museum in Leningrad was cancelled just before it opened. He lost all his official functions, but kept a small group of disciples who continued to paint according to his analytical method.

Filonov died during the siege of Leningrad. Almost all his work is preserved in the Russian Museum in Leningrad. (SZ)

Fiorda, Nuccio Giuseppe
(Civitanova del Sannio, Campobasso, 1894)
Italian composer

After graduating from the Accademia Filarmonica in Bologna in 1919, Nuccio Fiorda toured with Toscanini in America until 1923 and worked for La Scala theatre in Milan; this period is the subject of his book *Arte, beghe e bizze di Toscanini* (*Art, Whims and Wrangles with Toscanini*, 1969). He had only a brief relationship with Futurism: *Procession sous la pluie* (*Procession under the Rain*) was a short symphonic poem performed at the Théâtre des Champs-Elysées in 1922, accompanied by Luigi Russolo's "intonarumori" music. *Serraglio*, written with Labroca on a theme by Luciano Folgore, was a ballet in a Futurist vein. Later, during the era of silent films, he conducted symphony orchestras and wrote the musical accompaniment for numerous Italian and other films. (EC)

La Testa di Ferro, *15 August 1920*
"Manhood remains in Fiume"

Caricature of Luciano Folgore by Fabiano

L. *Folgore,* Bridges over the Ocean, *1914*

Fiume

"On 11 September Gabriele D'Annunzio took Fiume. Heading the Legionaries were the Futurists Mario Carli, Keller, Mino Somenzi, Pinna, Cerati, Testoni, Alessandro Forti, Targioni, Tozzetti, Scambelluri and Furio Drago, who founded the newspaper *La Testa di Ferro* (the organ of *Fiumanesimo*), the importance of which was enormous. However, D'Annunzio's occupation did not, as had been hoped, lead to a great Italian revolution. The Fascist ranks were still thin", recounted Marinetti, who in the immediate post-war period headed the Futurist groups in the struggle for the defence of the victory, for Fiume (Rijeka) and for Dalmatia. Many *Arditi* (daredevils) and Futurist Legionaries took part with D'Annunzio in the Ronchi march on Fiume, which was undertaken on 12 September 1919, but which soon had to be abandoned (31 December 1919). In a letter to the *Giornale d'Italia* (19 October 1919), replying to those who claimed that he had quarrelled with D'Annunzio, Marinetti wrote: "I have spent three marvellous weeks in Fiume in an atmosphere of unstinting and heroic patriotism. My first speech to the troops and all those that followed in the squares and in the various messes of the Grenadiers, the *Arditi* and the Engineers, were received with the keenest enthusiasm... I had a dozen or so important talks with Gabriele D'Annunzio. After the last one, D'Annunzio embraced me warmly, thanking me once again. I know perfectly well who my slanderers are, but I willingly sacrifice any desire to engage in polemics for the sake of Fiume now Italian and the divine Italy which commands us." (EC)

Folgore, Luciano
pseudonym of Vecchi, Omero
(Rome, 1888 - Rome, 1966) Italian poet and writer

Folgore's first collection of Futurist poems, *Il canto dei motori* (*The Song of the Engines*, 1912), was still influenced by D'Annunzio's language even though his subject matter was new. He struck a fresh path with *Ponti sull'oceano* (*Bridges over the Ocean*, 1914), where the influence of free-work theory becomes evident and decisive. In his manifesto, *Lirismo sintetico e sensazione fisica* (*Synthetic Lyricism and Physical Sensation*), published in *Lacerba* in January 1914, Folgore contributed to the theory of *paroliberismo*, taking a step beyond Marinetti and proposing the abolition of even the infinitive verb. In *Ponti sull'oceano* he dropped Futurist dogma (no more engines, propellers, garages, hangars, etc.) and experimented with a syntax which used almost exclusively nouns, sustained by a naïve yet refined sensualism expressed in quick, naturalistic analogies. Later on, in *Città veloce* (*Speedy City*, 1919), Folgore — like Marinetti — reclaimed some of what he had rejected partially reaccepting syntax and widening his range of topics. Some of his most outstanding poems belong to this last collection. (LDM)

Furniture, Furnishings and Interior Decoration

At the beginning of the century the Italian Futurists began a movement that was to shatter the monolithic or miniature structures of canvas and stone (the traditional fine-art forms) in order to embrace the entire environmental context, ranging from furnishing to interior decoration. Their attitude toward the world was "all-enveloping", implying free power over all things and over the energy inherent in them. In a search for new sensory activity, the Futurists produced groups and agglomerations of materials, from "plastic complexes" to "tactile chambers", which formed a synthesis between art and the structural habitat, environment and furniture. The unification of polarities according to a new sensibility constituted a practical development, since its objective was the multiplication of energetic material at the expense of any separation between the object and its setting, art and reality, aesthetics and life. In order to dissolve all boundaries into the living synthesis of materials, Futurism accepted the general indications of Art Nouveau and Jugendstil and, began to search for a reciprocity between everything contained in a single environment. In this way, it aimed to resolve the oppositions between different "states" and establish interrelations that might make things permeable to all linguistic and behavioural infiltrations. Thus space could become a "field" or site of dynamic solids and voids, in which the Futurist artist could immerse himself in order to turn it into pulsating and vital material. To attain this goal, the Futurists proposed an interaction between the individual boundaries of things that — in their opinion, being immersed in the same atmosphere and the same field of energy — could influence one another. The initial call was for a plastic-visual fusion between object and setting, in which the object would be extended into the environment until it incorporated various parts of it, ranging from the spectators themselves to elements of the architecture. Thus "the spectator was set in the midst of the painting" and a "basically architectural sculpture" was created. Space became elastic and malleable, capable of absorbing the movements of all environmental factors, while sculpture "systematizes", as Boccioni wrote in 1912 (the date of Balla's first Futurist environmental project), "the vibration of the light and the interpenetration of planes ... so that the sculptural block may contain the architectural elements of the *sculptural environment* in which the subject lives", and so become "an *environmental* sculpure".

Futurism therefore passes directly, without a break, from the object to the concrete atmosphere of the setting; the wall enters into the sculpture and the ceiling enters into the piece of furniture; the respective linear boundaries dissolve until it is possible to proclaim "the absolute and complete abolition of the finite line and of the closed statue. We throw open the figure and enclose within it the environment in which it lives", because "there can be no renewal except through *a sculpture of milieu or environment;* only this way can plastic form develop, extending itself in order to model

E. Prampolini, chest of drawers, 1925

E. Prampolini, woollen carpet, 1924

G. Balla, Futurist Tools, 1922

the atmosphere that surrounds things". Boccioni's declarations — although aimed at polarizing the environmental field around the sculptural object — already in 1912 assume that the contextual elements continuously interrelate and interact and that a connective tissue exists which is not suddenly interrupted at the edges of objects but *surrounds* those edges. For the Futurist sculptor there existed areas of energy exchange, and "sculpture must give life to objects by rendering their prolongation into space perceptible, systematic and plastic, because today no one can deny that an object finishes where another begins" and "a painting is an irradiating architectural construction, whose central core is the artist and *not the object.* It is an emotional architectural environment that creates a sensation and surrounds the spectator", so that "the edges of the object flee toward a periphery (environment) of which we are the centre". Space therefore is structured, as Bergson said, in fields of personal energy, and emotional and sensory tunings are modified as the individual inhabitant-artist adapts to the environment, which is not only a container but also the field of action for an aesthetic fluid, based on a relationship of interaction between organic and inorganic "actors". Placing them in the centre, therefore, means forcing them to participate actively. Psychical and physical movements are stimulated. The Futurist environment should not be seen merely as a constructed and static image or assembly of planes and figures, but as a *space that acts and is acted upon.* It is a potential backdrop for the behaviour of its inhabitant-author and a self-propelled piece of machinery. It is no accident that all the Futurist artists, from Balla to Prampolini, from Depero to Pannagi, when taking up the challenge of interior design, should be interested also in the "personification" of the active space of the stage. Their respective innovations in spectacle and setting — both public and private — were practically simultaneous in 1914. It was therefore time to integrate the stasis of design and theorize its movement and dynamics, which implied the action of its inhabitant and its "scenographic" dynamics. It is indeed impossible to imagine the Futurist environment without the presence of action: the action of objects among themselves, the action of the inhabitant upon the objects, the action of the architectural shell upon its contents and actors, the action of the environment itself. This environment was conceived as an instrument made up of a mosaic of elements, whose constantly changing positions and functions in turn changed the visual and plastic results. The greater number of components, materials, colours and "actors", the greater the dynamic result, to the point that it was possible to imagine a "Futurist reconstruction of the universe", which would include, among other things, "a building in transformable rumorist style". To this end, "we Futurists, Balla and Depero, seek to create a total fusion in order to reconstruct the universe by making it more joyful, in other words by a complete re-creation. We shall give skeleton and flesh to the invisible, the impalpable, the imponderable, and the imperceptible. We shall find abstract equivalents for all the

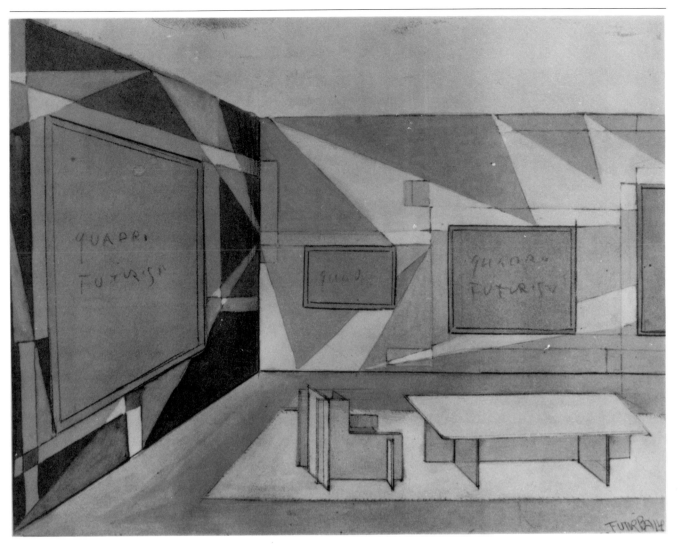

G. Balla, interior design project, 1919

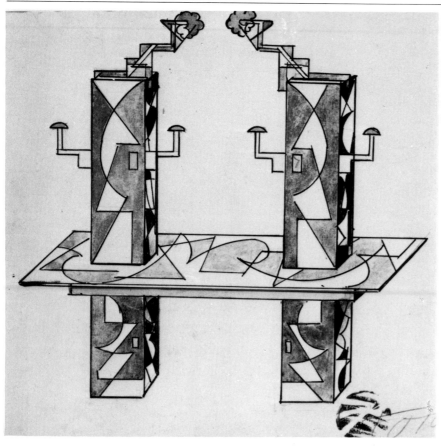

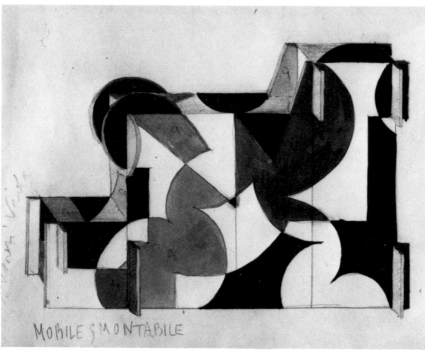

G. Balla, design for a piece of hall furniture, 1922

G. Balla, design for a piece of furniture made of elements, 1920

forms and elements of the universe, and then we shall combine them according to the caprice of our inspiration, to shape plastic complexes which we shall set in motion''.

This projection produced *pyrotechnical cavities* — in architectural and plastic terms — that were capable of satisfying or awakening active capacities, the rhythms of individual tension and relaxation. In them the circumscribed area of the artistic object expands and communicates not only metaphorically and allusively, as in paintings or sculpture, but realistically — with the world. This result is determined by the declared and assumed ductility and extensibility of materials that manage to interweave with architectural surfaces and volumes without changing their shapes, but rather accepting them as they are.

At the same time, colours adorn the walls, surfaces and curves of the individual environments, resulting in a saturation, in optical terms, of the available space, in which all elements are confused in synthesis. A visual field is established and optical effects of structuring and expansion are produced, the first designs of which can be dated 1912. In that year Balla designed the first example of a Futurist environmental synthesis — a total environment which puts into practice the theory of colour irradiation, aimed at dynamizing and potentiating the environmental space. When one analyzes the design (tentatively dated 1912) for the dining room of the Lœwenstein house in Düsseldorf, one notes that the design of the furniture and the architectural space has been simplified in order to allow the optical motif room in which to act. This motif is derived from the triangular and diagonal signs of Balla's ''iridescent compenetrations''. In the project, Balla chose the rectangle as a constant and made it dynamic with the flow of diagonals. He gave a rectangular form to all the environmental elements (doors, lintels, backs of chairs, tables, picture frames, ceilings, floors, carpets), perhaps because he wished to exploit the visual wealth of this geometric form, whose unequal sides create a dynamic symmetry of diagonals and medians. In the vertical and horizontal rectangle the diagonals close and open, so that the entire environment is subjected to an optical metamorphosis, which ''mixes'' the furniture and the wall structures. The vectors also convey a sensation of unity as though at their points of intersection, which break the flow of the objects, a rhythmic element intervened and reestablished a current.

The regions of inhabitable space are therefore connected by optical-concrete ties: either the diagonals visually join or the objects themselves dovetail (the ''confidence'' chairs). The entire space is pervaded by an internal dynamics that lies in the capacity of the furniture to both reveal and annul itself, a capacity displayed either through material motion or through visual factors. In this way the parts of the environment become acting devices, according to the axes of diagonal perception. As Portoghesi pointed out: ''It is the theory of lines of force that finds a rigorous application, giving each object involved in the linear flow an incompleteness that obliges the eye to look elsewhere for factors of

equilibrium; thus the items of furniture, the paintings, the doorframes are not available for contemplative enjoyment but continually refer to one another, while floor and ceiling, in a complex linear interweaving and a typical superimposition of 'iridescent compenetration', perform a process of synthesis and immerse objects in a cohesive atmosphere charged with indications and virtual motion.'' This chromatic and optical fluctuation of the object was studied by Balla in all his later works, from the bedroom of circa 1914 to the projects of 1918 and 1922 — in which one in particular, the design of Futurist furnishings of 1918, draws its vital intensity not from a formal or colour phenomenon but from the light that impregnates the space with a plastic quality.

In the drawing of a study with a desk and chair — a single block with an open hexagonal structure — lights on the wall and desk are indicated and underlined in writing almost as if the modification of colour and lines depended totally upon these elements. Considering the mural decoration (the references for which, as Calvesi has pointed out, can be traced back to the painting of Hans Schmithals, and interior designs by Klimt and Olbrist) is a ramification of forms from which it would be impossible to distinguish a lamp without some indication, and considering that the desk lights are revealed "under cover", one must suppose that "luminous surprise" was meant to be part of the ritual of writing. The potential inhabitant-writer who occupied that space would live within an environmental complex that — like the sculptural "plastic complex" — could be extremely variable: "1. *Abstract.* - 2. *Dynamic.* Relative motion (cinematographic) - absolute motion. - 3. *Totally transparent.* Speed and volatility of the plastic complex, which must appear and disappear, light and impalpable. - 4. *Extremely colourful* and *extremely luminous* (by means of interior lighting). - 5. *Autonomous*, that is, resembling only itself. - 6. *Transformable.* - 7. *Dramatic.* - 8. *Volatile.* - 9. *Odorous.* - 10. *Noisy.* Simultaneous plastic noise with plastic expression. - 11. *Explosive*, simultaneous appearance and disappearance of explosions.''

Although the "plastic complexes" correspond to sculptures which also move, the hypothesis con be legitimately extended to cover all animate and inanimate elements, so that any motif derived from real life would become a stimulus for a Futurist transformation. Analogously all bodies emit a second skin that expands in space; light is covered by shades, just as the body is covered with clothing, and both add active effects to the environmental dynamics. Further instruments of non-verbal activation are offered by objects such as furniture and ornaments, which influence body movements. Their basic function is to propose a dynamic reality, chiefly based upon a dialectical relationship between the actor and the object. Let us remember, for example, the double confidence-seat designed by Balla in 1912 for the dining room, an object that is almost an environment within an environment, which "awaits" a series of events. Or let us note the refined chromatic fluctuation of the furniture and ornaments

in Balla's house-study in via Paisiello 39 in Rome. The furniture, designed and produced between 1914 and 1920, is simplified to the point that in order to make it "moveable", variations of colour are chiefly used (green and yellow) which strike the faces of the tables, chairs, and flowers. What counts is the mobility of the colours and forms which, aligned or vibrant, appear progressively with varying visual and volumetric accents. The double movement of the furniture and the image of the furniture clearly serve to stimulate the imaginative, visual and muscular capacities of the inhabitant-actor. In this field, experiential expansion is in fact linked to the emotional state of the visitor; Balla extended invitations to his Futurist surprise-box/house, for publicity but perhaps also for behavioural testing.

The search for an art form capable of occupying an intermediate zone between decoration and interior design manifested itself also in the English Vorticist circle, when in 1913 the critic and art historian Roger Fry founded the Omega Workshop, which produced objects and furniture, ceramics and carpets, textiles and other artifacts designed and made by Duncan Grant, Henri Gaudier-Brzeska, Vanessa Bell and Wyndham Lewis. Contrary to the anti-traditionalist vision of the Italian Futurists, the Omega Workshop was linked to the heritage of craftsmanship established by the Arts and Crafts Movement and the ideas of William Morris. It sought a link with the "old world" of the craftsman, and a "cooperation", rather than a synthesis, between art and furnishings. Techniques and forms were also traditional — tables and cupboards were not reinvented but decorated with inlay and lacquered woods. More than inventing new functions and settings, the Omega Workshop aimed to establish an example of artistic hard work — a decorative morality.

The question of the mechanization of design arose with Neo-Plasticism. Following the indications of the Werkbund and Bauhaus, the Italian Futurists Pannaggi, Prampolini, Diulgheroff and Fillia developed a more simplified and geometric approach to design, examples of which still survive. These are pieces of furniture and ornaments, dated around 1930, in which irregular forms and decorations have been replaced by more elementary shapes such as the square and the triangle, in a gradual move towards the Rationalist vision. Examples include the interior designs by Paladini and the Futurist but almost Rietveldian furnishings of Casa Zampini at Esanatoglia, by Ivo Pannaggi in 1925-26. Based on alternating horizontal and vertical planes lacquered black, red and white, the interior of the Casa Zampini no longer seems aimed at creative participation as were the previous Futurist phantasmagorias, but interested in a colder and more conceptual relationship, announced in the painting hanging in the front room, called *Architectural Function H03*. The artist-architect Pannaggi seems more attracted by philosophy than by the sensory aspect of shapes. The planes that make up the single elements are made of cold materials such as marble and metal, and lacquered, which eliminates all "tactility" almost as if the

aim were to emphasize the calculation and theoretical abstraction rather than the finished product. The point of maximum impalpability, accompanied by the maximum amount of information, is achieved in the "Radio-Listening Room": "A radio-listening room constitutes the newest theme that can be presented to an architect and as such should be resolved with the greatest possible freedom, limited only by inevitable requirements. Location and space are eliminated: one travels thousands of kilometers and changes countries at will. It is therefore reasonable to create a fantastic setting using the freest inventions of plastic architecture. Relationships between inclined planes with hidden lights that play with one another; sofas that fit into the walls, wrapped in beams of light that pour down from above through opaline glass. Tenuous and pale shadows of crystals which intersect with the heavier shadows of opaque solids. Comfortable and useful luminous surprises of easy chairs nesting in the thickness of the walls, equipped with supplementary lamps that are lighted or extinguished automatically as persons sit or rise. A shiny black truncated cone, amidst the red, black and grey masses of the furniture and walls, surmounted by a disk of folded parchment circled with nickel, expresses the ideal axis of the construction. This is the loudspeaker, whose base projects it from the equipment bank toward the centre of the room. The equipment in view is present as a plastic assemblage of the most savoury materials: valves made of mirrors, porcelain insulators, spools swathed in celluloid, ebanite, brass, nickel finishings. Solid full-relief letters connect typographical taste with the mechanical precision of elementary geometry in dynamic interpenetration, indicating the call letters of the principal stations and the names of the inventors: Herz, Righi, Marconi, Popoff. Mirrored surfaces multiply the forms to infinity, complicating the play of perspective with fantastic riches.''

Within this nucleus, crackling with typographical, technological and architectural solutions, lie the aims and the achievements of the historic avant-gardes, intent on discovery in every field, in order to create a general expression of international culture which abolished space and boundaries. (GC)

Futurist Soirées

The Futurist *soirées* were the true precursors of the "Synthetic Theatre" performances. The first of these meetings was held at the Teatro Costanzi in Rome on 2 March 1913: Giovanni Papini delivered a speech against the city of Rome ("Some advice for the Romans") and the audience's reaction created, in Remo Chiti's words, a "model for soirées of this sort", with shouted complaints, arguments and fights, but also with open signs of approval, particularly from the younger spectators. There were similar reactions in other cities. The *soirées* were both poetic and political meetings. They sometimes opened with a Futurist symphony, like Francesco Balilla Pratella's *Inno alla vita* (*Hymn to Life*), followed by a performance by Luigi Russolo on his "intonarumori". These meetings inevitably turned into theatrical events. Some were even held in art galleries (where Balla and Cangiullo improvised *I funerali del critico*, *The Critic's Funeral*) and in literary clubs. But their natural home was in the theatre, principally because F.T. Marinetti was a playwright, as were Emilio Settimelli and Bruno Corra, the other two creators of Futurist Synthetic Theatre. Marinetti had already written *Le Roi Bombance* (1905, staged in Paris by Lugné-Poe in 1909) and

Poupées électriques (*Electric Dolls*, 1909, staged in Trieste that same year with the title *La donna è mobile*), but the new formula for theatrical performances came from the first evening at the Teatro Costanzi, which initiated a new kind of rapport with the audience.

According to Remo Chiti, Marinetti improvised marvellous speeches at each *soirée* (which were never repeated in the same city), sometimes arousing an enthusiastic response from the audience. Then followed the presentation of paintings (by Boccioni, Balla, Marasco, Dottori, etc.), the reading of lyrics (often in prose) by Marinetti, Palazzeschi, Buzzi, Cangiullo, Mazza and others, and finally a series of "theatrical syntheses".

The *Manifesto of Futurist Playwrights* (1911) affirmed that dramatic art must tend toward "a synthesis of life in its most typical and significant tendencies", and that "dramatic art cannot exist without poetry, that is to say, without rapture and without synthesis". The negative part of the manifesto concentrated on historical reconstructions and rejected the 19th century dramatists and Gabriele D'Annunzio; the affirmative aspect aimed to teach "contempt of the audience". The "Synthetic Theatre" of the Futurists grew out of its

need for synthesis and its aggressive attitude toward the spectator.

Sarah Bernhardt's theatrical evenings, and the "Popular Saturdays" of Catulle Mendès and Gustave Kahn, can be considered the primary sources of the Futurist *soirées*; there poetry was declaimed and poetic energies unleashed.

In 1898 Marinetti presented a lyric poem, "Les vieux marins" (The Old Sailors), at a competition, and won. This was the beginning of his poetry readings, first at the Grand Théâtre du Gymnase in Paris and then in numerous Italian cities. In his youth Marinetti had attended many Socialist political meetings, and his taste for the poetic-political meeting (a passion he shared with Gabriele D'Annunzio) was carried over into his activity as a Futurist. The poetic rally, marked by aggressiveness, arguments with the audience, elements of surprise and improvisation, fights and incidents, was definitely a theatrical spectacle. The successive *soirées* of the Russian Futurists, the Dadaists and the Surrealists in Central Europe and France were simply further developments of the theatrical techniques of the Futurist *soirées*, techniques which remained a part of theatrical tradition and developed into the "happenings" of our own day. (MV)

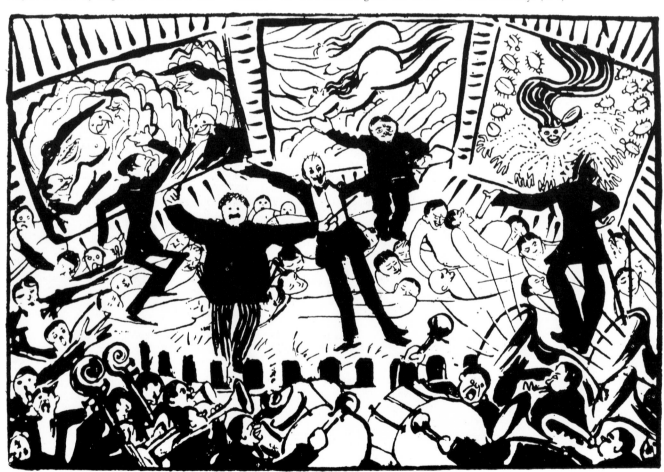

U. Boccioni, *Futurist soirée in Milan*, 1911

Poster for the Great Futurist Soirée
Rome, 1913

Galli, Gino

(Rome, 1893 - Florence, 1954) Italian painter
Gino Galli, who studied under Balla,
was active as a Futurist painter from 1912
to 1920. His work, which has not yet been
fully studied, was characterized by a strong
dynamism and rich colouring. In 1914 he
showed in the Free Futurist International
Exhibition at Giuseppe Sprovieri's Galleria
Futurista in Rome. In 1917 he published a
few illustrations in *L'Italia Futurista*, and in
1918-20 he contributed essays (including
two on Futurist painting) and drawings to
Roma Futurista. In 1920 he became the
editor of *Roma Futurista* with Balla,
Giuseppe Bottai and Enrico Rocco (with
whom he signed the *Programma a sorpresa
per il 1920 - Surprise Programme for 1920*);
the latter were then replaced by Mario
Carli, Marinetti and Emilio Settimelli. He
succeeded in making this magazine, which
for the first two years was mainly political,
the organ of the Futurist art. (ECr)

GAN

pseudonym of Adrian-Nilsson, Gosta
*(Lund, 1884 - Stockholm, 1965) Swedish
painter*
GAN painted his first Futurist work in
Berlin towards the end of 1913, inspired by
painters like Kandinsky and Marc, and
others that he saw at Der Sturm. He also
saw the show organized by H. Walden,
"Erster Deutsche Herbstsalon", in 1913.
GAN produced a series of paintings in a
dynamic style, dealing with subjects such as
factory scenes, sailors, cowboys and
townscapes. He was strongly attracted by
the Futurist imagery and style, which cor-
responded to aspects of his personality. His
art always expressed a certain aggres-
siveness. Through Herwarth Walden,
GAN got the job of director of Bruno
Taut's "Glashaus" in the "Deutscher
Werkbund Ausstellung" in Cologne in the
summer of 1914. The "Glashaus" was con-
structed around the ideas of the great Ger-
man writer Paul Scheerbart, whom Walden
called "the first Expressionist". GAN was
in charge, amongst other things, of the
gigantic kaleidoscope that was part of the
"Glashaus". In August 1914, the outbreak
of the war forced GAN to return to
Sweden. The most interesting part of his
later production is oriented towards Con-
structivism and Surrealism. (PH)

Gaudí y Cornet, Antoni

*(Reus, 1852 - Barcelona, 1926) Catalan ar-
chitect*
His opus, the beginning of which dates
back to 1878, was not limited to architec-
ture, but included furniture design and all
the applied arts. It certainly drew its origins
from Art Nouveau, but Gaudí moved for-
ward from there, so far and with such inter-
pretative freedom that he was a forerunner
of many later artistic movements, including
Futurism. It is worthy of note that Gaudí's
work evolved in a provincial setting, in a
city that was rapidly undergoing industrial
expansion; it is reminiscent of Futurism
because of its sense of excess, its increasing-
ly daring shapes — drawn from nature and
the soul, and juxtaposed without inhibition
— and because of its faith in the possibility
of creating a new environment for man, in
a modern metropolis. (SF)

GAN in the Glass House, Cologne, 1914

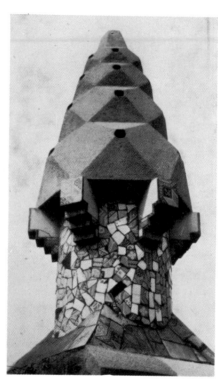

*A. Gaudí, chimney, Palacio Güell
Barcelona*

Gaudier-Brzeska sculpting the Head of
Ezra Pound, *1914*

Gaudier-Brzeska, Henri

*(St. Jean de Braye, 1891 - Neuville St. Vaast,
1915) French sculptor*
While still attending school in his village
near Orléans, Gaudier-Brzeska displayed an
uncommon gift for drawing. Even later,
when he had become a sculptor, he never
forgot this aspect of his art; as Ezra Pound
wrote: "He was a master draughtsman and
sculpture is consummate draughtsmanship.
It is an infinite number of contours in one
work and on that rests much of its durabili-
ty of interest."
Between 1906 and 1909 several scholar-
ships allowed him to stay in London and
Bristol at length. In 1909 he went to Nürn-
berg and Munich before taking up residence
in Paris. He was enthusiastic about Rodin,
he read Bergson, and he toyed with the
anarchists. He missed the countryside but
took full advantage of city life: museums
and libraries where he studied anatomy, the
zoo where he executed great numbers of
animal sketches. In 1910, around the time
when he must have met Archipenko, he
decided to devote himself to sculpture. It
would seem that, aside from Rodin's work,
he did not know much about modern art.
What he knew he learned from museums —
the museum of Orléans where he was im-
pressed by the Gallo-Roman bronzes, the
Louvre, the British Museum. He might
have known of François Pompon, who since
1908 had been exhibiting animal sculptures
that were considered ridiculous because
they were as slick as pieces of machinery.
When he landed in London in 1911 he was
a young sculptor who knew nothing of the
avant-garde, accompanied by a Polish
woman twenty years his senior, Sophie
Brzeska, whose surname he was to add to
his own. He continued to study ancient
sculpture but did not forget living creatures
— both animals and men. Following a path
similar to that of Franz Marc, he studied
the dynamics of forms. In 1912, still ig-
norant of Futurism, he wrote: "When I
think, I see that in modern sculpture mo-
tion, without being more powerful, is more
authentic.
One no longer sees a single motion as in
primitive sculpture; motion is *compound*; it
is an uninterrupted series of other
movements which in turn can be broken
down, and the various parts of the body can
move in opposed directions with varying in-
tensity. Motion is a translation of life, mo-
tion must be part of art, since we are con-
scious of life because it moves." Indeed,
even his commissioned works from this
period betray his interest in motion: the
Madonna of 1912 leans forward as though
she were about to rise from her seat; the
Bust of Wolmark turns its head at a right-
angle. In 1912 Gaudier met Jacob Epstein:
this was his first real contact with modern
sculpture. Gaudier progressed rapidly, and
the influence of Rodin lessened as the
Cubist and Futurist exhibitions in London
became more frequent.
An entire world separates the *Ballerina* of
1912 — stylized but still obedient to the
rules of the representational image — from
the *Red Stone Ballerina* of 1913-14, whose
face recalls De Chirico — in the prepar-
atory drawings she has three heads, four
legs, etc. This period was an eventful one
for Gaudier. In 1913 Roger Fry, whom

he had met through Nina Hamnet, introduced him to the members of the Omega Workshop. Later he met Ezra Pound, who encouraged him and introduced him to the future Vorticists. Vorticism's foremost goal was to distinguish itself from Futurism. Out of *esprit de corps* and in order to show that he spoke French at least as fluently as the Italian poet, Gaudier engaged in lively debates with Marinetti upon his arrival in London. Nonetheless, although he was inspired by the primitives, his lively dialectic was reminiscent of Futurism. In *Blast*, his *Vortex n. 1* declared: "We, the moderns, Epstein, Brancusi, Archipenko, Dunikowski, Modigliani and myself, through the incessant struggle in the complex city, have likewise to spend much energy."
Reviewing an exhibition of the Allied Artists, Gaudier praised Epstein, Brancusi, Zadkine, Sousa-Cardoso and his friends Lewis and Wadsworth, but harshly criticized Nevinson (as well as Kandinsky): "A Futurist painter. It is Impressionism using false arms." The 1914 sculpture *Bird Swallowing a Fish*, even more than his pastels of abstract mechanical objects, is related to Futurist dynamics. In this work Gaudier eliminated all emotion in order to highlight the animal brutality of action, an opposition between rounded and sharp forms, in which sharpness triumphs. In the animal sculptures of this period, often small in scale, Gaudier transformed the muscular appearance of the models into increasingly abstract geometric structures.
Shortly after war was declared, although he was a conscientious objector, Gaudier went voluntarily to France to don the uniform. He wrote a new *Vortex* for his friends in which he displayed conflicting feelings about the war, expressed sympathy for the suffering of animals rather than that of men, and almost displayed the spirit of "war, great hygiene for the world". "This war is a great remedy", he declared.
This declaration was published in July 1915; Gaudier had died a few weeks earlier, from a bullet in his head. (SF)

Giacometti, Augusto

(Stampa, 1877 - Zurich, 1947) Swiss painter

A cousin of Giovanni Giacometti, and the father of the well-known sculptor Alberto Giacometti, Augusto received his artistic education in Zurich and later in Paris. From 1902 until 1915 he lived in Florence where several young Futurists learned of his work. Later he went back to Switzerland for good, where his work was published in Dadaist magazines. During the Teens, his work developed slowly, from a mixture of Jugendstil and his special interest in light to total abstraction. (SF)

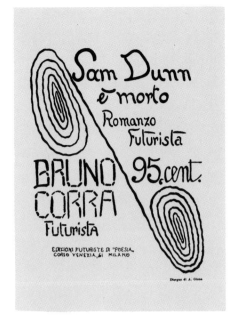

A. Ginna, cover for Sam Dunn is Dead *by B. Corra, 1917*

A. Ginna, Painting of the Future, *1917*

J. Metzinger, Portrait of Gleizes, *1911*

Ginna, Arnaldo

pseudonym of Ginanni Corradini, Arnaldo (Ravenna, 1890 - Rome, 1982) Italian painter and writer

According to his own explanation, Arnaldo Ginna was "usually forgotten, since I was *beyond the reach* of most people, being *encyclopaedic*, that is, able to handle various media, both artistic and technical. I was a man of letters, journalist, painter, filmmaker, sound engineer, photographer, radio technician, etc. The confusion arose from having too many names. Balla came up with the pseudonyms 'Ginna', from Ginanni, and 'Corra', from Corradini. Both suited the dynamism of the Futurists: Ginna as in *ginnastica* (gymnastics), Corra like *correre* (running). Immediately after the Sprovieri show I opted for the pseudonym Ginna".
There were no fully representative showings of Ginna's paintings until 1985, three years after the artist's death, when the Pinacoteca Comunale of Ravenna organized an exhibition thoroughly documenting the artist's varied activities, and published a useful catalogue. He was both a painter of reality — to the point of freezing reality photographically, and then distorting it — and a painter of the abstract. In both cases he sought the invisible, essential, and occult. Ginna's works reveal a Futurist expressive vein in the drawings *City of the Sun*, *The Widow*, *The Wind*, in the sculptures *Village Celebration* and *The Solitary Man*, and in his only film, now lost, made in 1916 with Marinetti, Corra, Balla, Chiti, and Settimelli: *Vita futurista* (*Futurist Life*).
Yet he also painted in a naturalist vein in his numerous landscapes, and in an abstract vein in such paintings as *Neurasthenia* (1908), *Chromatic Harmony* and *Waking with Open Window* (1909), *Dance Music* (1912), etc.
His works are characterized by a consistency of intention and a desire to explore and experiment in every possible direction.
As a writer, like his brother Bruno Corra, Ginna included pre-Surrealist and occultist elements in the novel *Locomotive con le calze* (*Engine with Stockings*, 1919) and in his "Synthetic Acts".
The treatises *Arte dell'avvenire* (*Art of the Future*, 1910) and *Pittura dell'avvenire* (*Painting of the Future*, 1915) are an attempt to define a "system" in avant-garde art and painting. (MV)

Gleizes, Albert

(Paris, 1881 - Avignon, 1953) French painter and theoretician

Albert Gleizes first appeared in the Unanimist group of the Abbaye de Créteil (1906); thereafter he was linked to the Duchamp family and the group of Puteaux; he participated in their discussions and in the exhibition of the Section d'Or in 1912. In the same year, he published his first theoretical work, *Du cubisme*, with Jean Metzinger.
Although he was fundamentally linked to Cubism, during the years between 1915 and 1919, which he spent almost completely in New York, his work showed a dynamism not at all characteristic of Cubism — the disjointedness of *Brooklyn Bridge* (1915) and the movement of the *Acrobats* (1916) are very close to the Futurist spirit. (SF)

Gómez de la Serna, Ramón

(Madrid, 1888 - Buenos Aires, 1963) Spanish writer

A prolix but original writer, Ramón Gómez de la Serna was interested in every novelty and defended all the avant-gardes without ever joining one of them. The portrait Diego Rivera painted of him in 1915 expresses his mobile and extravagant personality. He was therefore sympathetic towards Futurism and supported it in his magazine *Prometeo*, which published Marinetti's *Futurist Proclamation to the Spaniards*. (SF)

Goncharova, Natalia

(Negaevo, 1881 - Paris, 1962) Russian painter

Natalia Goncharova studied only in Moscow. In the period when she was studying with the sculptor Pavel Trubechkoy (1898-1900) she met a fellow student, Mikhail Larionov, who became her lifelong companion. In any history of Russian Primitivism, Rayonism, and modern theatrical set design, the names of Larionov and Goncharova appear side by side.

Originally influenced by Expressionism (1901-06), Goncharova discovered her own version of Fauvism (1906-09) which she soon joined to Cubism, ikon art and peasant art, in a blend that produced Primitivist works such as *The Reapers* or *Peasants Dancing* (1911). Religious art and popular art were always to be two subjects of major interest for Goncharova: their lack of realism and their rejection of any naturalistic perspective is echoed in her own work. By 1911 Goncharova had been exhibiting for some time, and not only in Russia — in 1906 Diaghilev had exhibited four of her pastels at the Salon d'Automne in Paris. She also contributed to the Salon of the Golden Fleece, later the Salon of the Union of Youth, 1908-12.

Her largest exhibition in this period was with the "Jack of Diamonds" group in 1910, where she showed thirty-three paintings. Moving away from the "Jack of Diamonds" in 1911 — because they considered it excessively francophile — Goncharova and Larionov organized the "Donkey's Tail" group, which was concerned exclusively with Russian painting. At the "Donkey's Tail" exhibition in 1912, Goncharova showed fifty canvases. In 1913 Larionov and Goncharova organized the show "The Target" which included painters such as Malevich and Ledentu; in the catalogue, Larionov announced the birth of Rayonism, a movement of which he and Goncharova became the principal representatives.

During her Primitivist period, Goncharova was in contact with the writers and painters of the Hylaea group, who shared her concerns and those of Larionov, especially their interest in creating a specifically Russian art. Shortly afterwards she met Maiakovsky and, more importantly, Khlebnikov and Kruchenykh. Books such as *A Game in Hell* and *Hermits* (1913) owed much to the illustrations by Goncharova.

During the following Cubo-Futurist period, Goncharova produced several of her best known works: *The Factory* (1912), *The Weaving Machines* (1913), and *The Cyclist* (1913); in the last-named canvas there is an evident effort to render the dynamism of

Prometeo, magazine edited by R. Gómez de la Serna

N. Goncharova, catalogue of her exhibition in Moscow, 1913

the subject — the confusion of the street, the movement of the man and of the wheels as street signs and advertising posters slip by.

The Rayonist paintings by Goncharova cover a relatively brief period of time (1913-14) but they are no less spectacular: *Portrait of Larionov* (1912-13), *The Cats* (1913), *The Peacocks* (1914). In these paintings the subject is no longer broken down into planes or lines of force but literally explodes in luminous jets and streaks. She also employed a Rayonist style in her illustrations for *Gardeners on the Vines* by Sergei Bobrov.

Rayonist artists wished to distinguish themselves from other movements and from Futurism in particular — when Marinetti came to Russia, Larionov and Goncharova in several articles and lectures denounced his Futurism as obsolete. Goncharova's painting gradually became known throughout Europe: in Munich at the Blaue Reiter in 1911; in London at the exhibition of the Post-Impressionists organized by Roger Fry in 1912; in Berlin at the Der Sturm Gallery in 1913; in Paris with Larionov at Paul Guillaume's, after she was introduced to him by Apollinaire in 1914. In 1913 there was also a retrospective showing of her works in Moscow. In 1914 the costumes and sets she created for Rimsky-Korsakov's *The Gold Rooster* met with a tremendous success. Invited by Diaghilev, she went to Switzerland in 1915. After visiting Italy and Spain — which made a great impression upon her, and inspired several important canvases and collages — she settled in France in 1916 with Larionov and, abandoning Cubo-Futurism and Rayonism, worked chiefly on theatrical designs (*Sadko*, 1916; *Les noces*, 1923, etc.). (SF)

Gotlib, Henryk

(Cracow, 1890 - South Godstone, Surrey, 1966) Polish painter and sculptor

After studying from 1908 to 1914 in Cracow, Vienna and Munich, Gotlib settled in Cracow where he became a member of the Formist group. He was among the organizers of the activities of this group until 1923, when he moved to France to start his own research in the field of colour, which he continued after his return to Poland in 1930.

Most of his work up to 1939 was destroyed in an air raid.

During and after the Second World War he lived in England where he became well known particularly as a teacher. (SZ)

Govoni, Corrado

(Ferrara, 1884 - Anzio, 1965) Italian poet

Though already mature as a Symbolist and *crepuscolare* poet, and though as such he continued to publish collections of poems, he also tried Futurist expression with *Poesie elettriche* (*Electrical Poems*, 1911-14), and *Rarefazioni e parole in libertà* (*Rarefactions and Free-Words*, 1915). "Rarefactions" is his most radical expression of drawn poetry; the text is completely hand-written creating a highly original verbal and visual narrative. In his "freewords" Govoni used typography, but his aim of closely uniting text and image remains clear. (ECr)

Guro, Elena

pseudonym of Notemberg, Eleonora
(St. Petersburg, 1877 - Usikerkko, Finland, 1913) Russian writer, painter and composer

Unlike the other Futurists, Elena Guro came from the upper class. She studied at the Society for the Encouragement of the Arts from 1890 to 1893, and then with the painter Yan Tsionglinsky from 1903 to 1905. It was here that she met Mikhail Matiushin, who later became her husband. From 1905 to 1906 she studied under Bakst and Dobuzhinsky. Beginning in 1908, she took part in the exhibitions organized by Nikolai Kulbin.

Guro's painting started out as Impressionistic but later developed toward Fauvism, and finally toward a personal style that used motifs borrowed from nature (leaves, trees, stones). She derived more or less abstract forms from these motifs. Her writing activity developed in a similar manner. She began to publish in 1905. Her first book, *The Hurdy-Gurdy*, appeared in 1909. Like her other books (*Autumn Dream*, 1912; *The Camels of Heaven*, 1914) it was a collection of prose, verse, and theatre generously illustrated with her drawings. Despite her love for nature, Elena Guro was equally attracted by urban themes — the city, its streets, its people.

Her style used neither violence nor flamboyant colours, but she was nevertheless the first to introduce neologisms, fractured words and words derived from baby talk, all typical of Russian Futurism.

Although the victim of an early death, Elena Guro is an important background figure in the dawn of Russian Futurism: many meetings took place at her house, and she contributed to five collective publications of the Futurists, including *A Trap for Judges*, published by Matiushin at the beginning of 1910. The Futurists, and Kruchenykh in particular, never failed to emphasize the importance of the role she played. *The Missal of the Three* (1913) was dedicated to her memory; illustrated by Malevich, the book was a posthumous collection of texts and poems by Khlebnikov, Kruchenykh and Guro herself. (SF)

Gutfreund, Otto

(Dvůr Králové, 1889 - Prague, 1927) Czech sculptor

Otto Gutfreund was a pupil of E.A. Bourdelle. In 1911 he joined the Prague Cubist group of figurative artists (SVU). Gutfreund was the first European sculptor, after Picasso, to apply the principles of analytical Cubism to three-dimensional form. His work was not directly influenced by Futurism, but there are some points of contact with Umberto Boccioni's ideas and production. They each developed independent and parallel solutions to similar problems, which sometimes appear in Gutfreund before they do in Boccioni. This similarity is evident in Gutfreund's capacity to make the surrounding space active and draw it into the statue; but also in the rhythm and dynamism given to the material as a whole, and in his alternating concave and convex volumes, the edges of which are modelled in mobile lines of force which recall Boccioni's *linee-forza*. The Expressionistic distortion in some of Gutfreund's early sculptures breaks classical

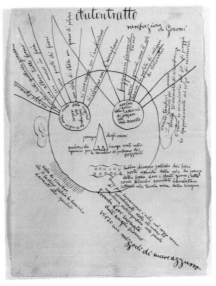

C. Govoni, Self-portrait, *Fondazione Primo Conti Collection*

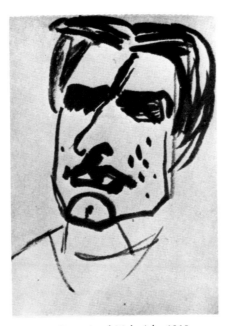

E. Guro, Portrait of Malevich, *1910 c.*

canons of beauty, symmetry and harmony and becomes an expression of inner states of mind. There is an evident affinity between Gutfreund's series *Portraits of the Artist's Father I-IV* (1911), in which the material becomes progressively lighter and the volumes are transformed into dynamic lines, and Boccioni's later *Portrait of the Artist's Mother - Anti-Graceful* (1912). *Viky* (1912) is also very close to Boccioni, but is characterized by a greater inner dynamism and by a more consistent interpenetration of material and space to the very core of the statue.

Certain points of Boccioni's *Technical Manifesto of Futurist Sculpture* also correspond to some of Gutfreund's contemporary theoretical reflections: "The figure becomes the centre that binds the surrounding space to it — uses violence on it. It has a dramatic relationship with the surrounding space." And elsewhere: "The statue is no longer time stopped, transformed space, but rather an expression of a flowing series of events, an incessant movement, with the same rhythm as the creative process before thought becomes fixed in images." Many other analogies of the same kind can be found. (FŠ)

Hamilton, Cuthbert

(India, 1884 - Cookham, Great Britain, 1959) British painter

Cuthbert Hamilton attended the Slade School of Fine Art, London (1899-1903), overlapping with Wyndham Lewis. He collaborated with Lewis on the decorations for the Cave of the Golden Calf and four of his works were included in the rehang of the "Second Post-Impressionist Exhibition" in January 1913. He joined the Omega Workshops in 1913 but left with the other rebels in October, becoming a member of the Rebel Art Centre in early 1914. He exhibited in the "Post-Impressionist and Futurist Exhibition" (Doré Galleries, 1913), the "Cubist Room", Brighton (1913), and the first London Group exhibition (1914).

He contributed one illustration to *Blast No. 1* entitled *Group* and signed the *Blast* manifesto. Shortly thereafter he appears to have withdrawn from the Vorticist group but he joined ranks with some of them in 1920 to form Group X. Very few works by Hamilton survive but generally they show the influence of Lewis and of Picasso. In *Reconstruction*, exhibited with Group X, his treatment of the cityscape is reminiscent of Lewis's *Workshop* and Wadsworth's woodcut *Cleckheaton* (1914). (JL)

Hartley, Marsden

(Lewiston Ellsworth, 1877 - New York, 1943) American painter

Marsden Hartley missed the Futurists' exhibition at the Bernheim-Jeune Gallery, as he did not arrive in Paris until April 1912. Attracted to avant-garde circles, including the coterie of Gertrude and Leo Stein, Hartley came into contact with many new ideas. The theories and work of Vasilii Kandinsky interested him more directly than the work of the Futurists, and he soon moved on to Germany. Visiting London in the spring of 1914, Hartley came into contact with Futurist ideas indirectly through his association with Ezra Pound and the Vorticists. While celebrating military pageantry, Hartley rejected the Futurists' admiration of military force in favour of pacifist American Indian themes. He nonetheless shared their interest in depicting motion, in abstract paintings like *Movements* (1913) and *The Aero* (1914). (GL)

Hrynkowski, Jan

(Zelekow, 1891 - Cracow, 1971) Polish painter

Hrynkowski studied at the Cracow School of Fine Arts and then at the André Lhote Academy in Paris. His painting, particularly the "Dance" and "Dancers" series, shows a clearer Futurist influence than does the work of other Polish artists in his circle. From 1925 onwards Hrynkowski belonged to the Colourist movement, which was dedicated to the investigation of colour according to the principles of Matisse and Bonnard. He continued along this line for the rest of his life. (SZ)

Hulewicz, Jerzy

(Koscianki, 1866 - Warsaw, 1941) Polish painter

Hulewicz was the driving force of the Bunt group in the city of Poznan and the editor of its organ *Zdroj*, in which, between 1918 and 1920, he published work by German Expressionists and French Cubists side by side with contributions from the Italian Futurists, in particular Severini, Boccioni and Soffici. (SZ)

Idelson, Vera

(Riga, 1893 - Paris, 1977) painter and set designer

Educated in Moscow, she was influenced by avant-garde set designers such as Tairov, Exter, and Meierkhold. Between 1922 and 1925, in Berlin, she became closely connected with Ruggero Vasari and thus came into contact with the Futurist movement. Amongst her multiple activities were designs for furniture, ceramics and embroidery. In 1924, obviously inspired by the movement of machines, she created the highly "mechanical" sets and costumes for Vasari's *Angoscia delle macchine* (*The Machines' Anguish*), staged in Paris in 1927 in an abstract, almost Constructivist version. In the same year she designed sets for Prampolini and Ricotti's Futurist Pantomime Theatre. (ECr)

Ideology

Futurism has been the subject of in-depth studies mainly as regards its more strictly artistic manifestations, and especially the figurative arts. Its cultural contents and its less "technical" literary aspects — decisive for any serious consideration and reconstruction in terms of ideology — have begun to be studied from a modern scientific viewpoint only over the last few years. Their importance for a critical study of the political and ideological aspect is still on the whole underrated — they are either practically ignored, or else dealt with schematically, using ideas that are quite inadequate or based on misunderstandings and polemical arguments created by Futurism itself, or on an acritical and superficial reading of its political and social context in Italy and Europe.

This has resulted, for example, in the hasty reduction of Futurism to the category of Fascism. Other avant-gardes, which compromised with Communism instead, are viewed as positive in comparison to Futurism. This explains why the ideological-political aspect of Futurism has been the most neglected. Good partial and general studies are lacking, despite essays by Luciano De Maria, Emilio Gentile and Niccolò Zapponi on Marinetti and the Futurist Political Party, and by Anna Scarantini on Carli and Settimelli's *Impero*; observations and ideas contributed by Maurizio Calvesi and Fernando Cordova, and, most particularly, Umberto Carni's important work of criticism and documentation.

This also explains why the subsidiary research instruments for this aspect are lacking: reprints and analytical indexes of periodicals (the only one available is for *L'Italia Futurista*, a publication obviously not without interest, but of marginal importance to the main problems for an historical understanding of Futurism, much less significant than *Roma Futurista* and *La Testa di Ferro*), anthologies (with the single exception of the Mondadori edition of Marinetti edited by De Maria, which is very useful, but from the point of view of political ideology, too much focussed on the period from 1914 to 1922), etc. To this can be added the almost total lack of studies on Futurism after the "march on Rome", when the movement broke up and came together again with different personal and group alignments; on Futurist periodicals and their attitude to the Fascist regime; and the attitude of the various currents of Fascism towards Futurism, etc. This dearth is well illustrated by the absence of good biographical studies dedicated to the most important Futurist figures, starting from Marinetti — and moreover at a time when the biographical genre is very popular.

The current schematizations about Futurist ideology must therefore be received with extreme caution. In fact they are almost always based on premises which need to be examined against a systematic and unprejudiced reading of the sources. Even at first contact, the sources themselves indicate that to speak of "ideology" in the case of Futurism is to go too far, and at the same time not far enough. Such a focus will not help us to reach a solid understanding of Futurism beyond its purely artistic meaning, nor of its manifestations and their

results in the more strictly political sphere. In fact, the sources suggest that to understand the phenomenon of Futurism, rather than for an ideology, we should look for an attitude to life. On the whole Futurism had no ideology, nor did it want one. If to some extent it is possible to construct an ideology after the fact, this assumes contradictory, changing forms which vary according to the groups composing the movement, so it cannot be forced into the narrow limits of an abstract lowest common denominator. George L. Mosse indicated the focus on an attitude to life as the way to understand finally the basic differences which distinguish certain mass movements — and their collective and elitist myths — from others. The same indication is already present to a certain extent in the "Balance-sheet of Futurism" drawn up by Francesco Meriano in *Il Resto del Carlino* in 1927, when he had already left the movement, where he writes that "it was intended to be a moral rather than an aesthetic system, a new way of living and of viewing life". As Mosse has shown in his studies, Fascism was essentially also an attitude to life. From this general point of view, Futurism and Fascism both had their roots in a common condition of disquietude — psychological, social, moral and cultural — and of radical rejection of the society that caused it; and the Great War of 1914-18 intensified this disquietude and rejection, giving them new political overtones. Previously these had been present only in particular circles, borrowed from the left wing, in particular from Anarchism and Revolutionary Syndicalism. Now the new forms of political opposition set in motion by the war tended to influence and assume the leadership of these movements, giving them a new and wider social base, and new ethical and cultural values — above all in an anthropological sense, in the form of myths. To a certain extent these values were connected with the old ones, but in general they profoundly revolutionized the character of the traditional left wing opposition; introducing elements traditionally belonging to the culture of the right, and also new themes which had emerged or become important during the war, as a consequence of the frustrations, expectations and transformations it had generated. In the general context of what may be called a traumatic crisis of modernization and massification of traditional civilization, Futurism and Fascism in their beginnings were the product of a common existential condition and of a common rejection of its causes, real or imagined. This explains why in 1914-15 Futurism sided with revolutionary interventionism (supporting intervention in the First World War) and in 1919, although a year earlier it had founded its own political party, it was one of the three main groups which created the *Fasci di combattimento*.

This fact, however, does not allow us to identify the two movements as one, to say that Futurism and Fascism were substantially the same.

The difficulty of making a sharp distinction between democratic and revolutionary interventionism is now evident. To label as Fascist all those who participated in revolutionary interventionism or in the *Fasci di combattimento* is a simplification which has

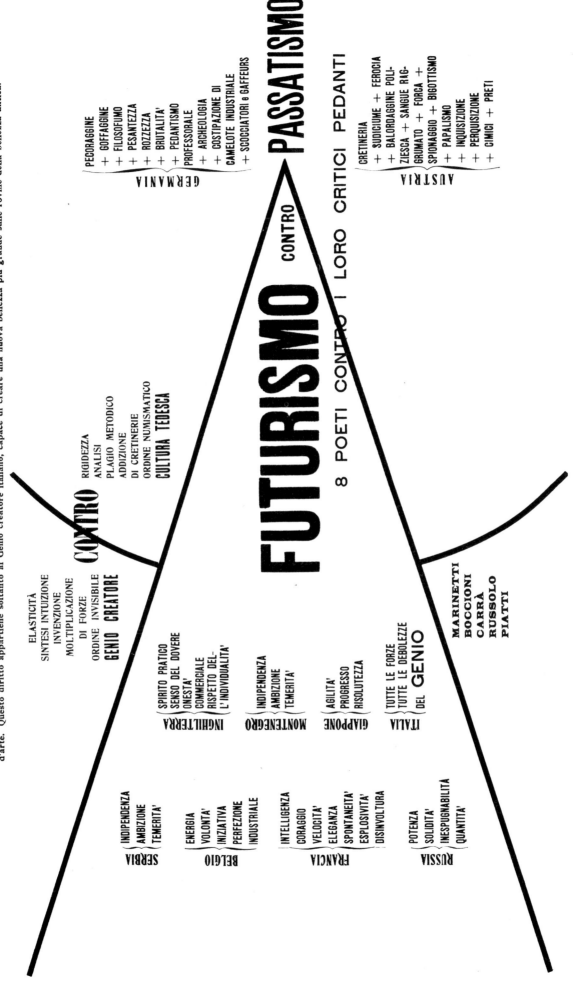

SINTESI FUTURISTA DELLA GUERRA

Glorifichiamo la Guerra, che per noi è la sola igiene del mondo (1° *Manifesto del Futurismo*) mentre per i Tedeschi rappresenta una grassa spanciata da corvi e da iene. Le vecchie cattedrali non c'interessano; ma neghiamo alla Germania medioevale, plagiaria, balorda e priva di genio creatore il diritto futurista di distruggere opere d'arte. Questo diritto appartiene soltanto al Genio creatore italiano, capace di creare una nuova bellezza più grande sulle rovine della bellezza antica.

FUTURISMO CONTRO **PASSATISMO**

8 POETI CONTRO I LORO CRITICI PEDANTI

GERMANIA
PECORAGGINE
+ GOFFAGGINE
+ FILOSOFUMO
+ PESANTEZZA
+ ROZZEZZA
+ BRUTALITA'
+ PEDANTISMO
PROFESSORALE
+ ARCHEOLOGIA
+ COSTIPAZIONE DI
CAMELOTE INDUSTRIALE
+ SCOCCIATORI e GAFFEURS

AUSTRIA
CRETINERIA
+ SUDICIUME + FEROCIA
+ BALORDAGGINE POLI-
ZIESCA + SANGUE RAG-
GRUMATO + FORCA +
SPIONAGGIO + BIGOTTISMO
+ PAPALISMO
+ INQUISIZIONE
+ PERQUISIZIONE
+ CIMICI + PRETI

CONTRO
RIGIDEZZA
ANALISI
PLAGIO METODICO
ADDIZIONE
DI CRETINERIE
ORDINE NUMISMATICO
CULTURA TEDESCA

GENIO CREATORE
ELASTICITÀ
SINTESI INTUIZIONE
INVENZIONE
MOLTIPLICAZIONE
DI FORZE
ORDINE INVISIBILE

INGHILTERRA
SPIRITO PRATICO
SENSO DEL DOVERE
ONESTA'
COMMERCIALE
RISPETTO DEL-
L'INDIVIDUALITA'

MONTENEGRO
INDIPENDENZA
AMBIZIONE
TEMERITA'

GIAPPONE
AGILITA'
PROGRESSO
RISOLUTEZZA

ITALIA
TUTTE LE FORZE
TUTTE LE DEBOLEZZE
DEL **GENIO**

MARINETTI
BOCCIONI
CARRÀ
RUSSOLO
PIATTI

SERBIA
INDIPENDENZA
AMBIZIONE
TEMERITA'

BELGIO
ENERGIA
VOLONTA'
INIZIATIVA
PERFEZIONE
INDUSTRIALE

FRANCIA
INTELLIGENZA
CORAGGIO
VELOCITA'
ELEGANZA
SPONTANEITA'
ESPLOSIVITA'
DISINVOLTURA

RUSSIA
POTENZA
SOLIDITA'
INESPUGNABILITÀ
QUANTITA'

become historically untenable. This can be seen from the history of D'Annunzio's legion during and after Fiume (which included a number of Futurists) and in a series of personal cases which can be considered typical, like those of Alceste De Ambris and Pietro Nenni.

Nor can Futurism and Fascism be equated just because Marinetti and other leaders of the Futurist Political Party — who in May 1920 left the *Fasci di combattimento* in protest against Mussolini's new conservative course, and in particular his refusal to accept their intransigent anti-monarchical and anti-clerical demands — after the "march on Rome" accepted Fascism and remained with it to the end.

In 1922-23 it was difficult to foresee what the evolution of Fascism would in fact be, and many people even considered it a transitory pheomenon which could actually have the useful function of modernizing and "cleaning-up" ("If Mussolini can get rid of these old mummies and rotten figures", remarked Gaetano Salvemini "he will have performed a useful service to the country. After he has done his job of sweeping away rubbish, new people will appear and sweep him away"). Apart from this, an examination of the Futurists' relations, as individuals and as a group, with Fascism when it was in power, shows that their acceptance of the Fascist government (or rather, of Mussolini) and their membership in the Fascist party, never constituted a renunciation of their own positions, much less a mere identification with the Fascist regime. The artistic policy and the relationship with the intellectuals developed by the regime had nothing in common with what the Futurists would have liked; and they also dissented from some of the most important strictly political decisions made by the Fascists.

With the exceptions of Mario Carli and Emilio Settimelli (whose participation in the Futurist movement had been relatively late and atypical, more in alignment with *Lacerba* than with Marinetti, and who already in 1921-22 had begun to turn to the right, showing strong ultra-monarchist, aristocratic and imperialistic leanings, no notable representative of Futurism had an important post in the Fascist party and regime, or played a politically significant role.

Marinetti himself, despite his friendship with Mussolini, his personal respect for the *duce* and his nomination to the Accademia d'Italia in 1929, remained essentially outside politics.

On 1 November 1922, just after the Fascists had taken over the government, *Il Resto del Carlino* published an article by Marinetti entitled "For each man, each day a different job! Inequalism and artocracy". Despite a certain ambiguity and a rather cryptic tone, this article leaves no doubt as to the writer's meaning, especially if it is read as the third part of a sort of trilogy expressing Marinetti's political disappointment over Mussolini's "revolutionary wisdom" (i.e. his opportunism). The series began with *Oltre il comunismo* (*Beyond Communism*), published in August 1920, and continued with what is probably Marinetti's most interesting and revealing political text, *Gli indomabili* (*The Untamables*), published in June-July 1922; among

Roma Futurista, *1920, "Against Feminine Luxury"*

Lo Sport Illustrato, *1915, "War, the Only Hygiene for the World"*

the characters, Mussolini is easily recognizable as the paper revolutionary Mah. The article in *Il Resto del Carlino* was particularly explicit on three points: the rejection of politics, the reaffirmation of freedom through individualism, and the decision to be henceforward only an artist. These three statements, made at that particular time, could only be read as a cautious movement away from the new regime, and a warning to avoid confusion: "Down with equality! In fact I am not equal to anybody. Unique type. Inimitable model. Don't copy me. Plagiary clouds!... Glory to the Difference! Long live the Distinction! Be atypical! Unique!... Long live Art, which deceives, differentiates, gives value to the world! Death to the common genre! Death to monotony! Variety, variety, variety! Long live unequalism, divine juice of the Earth, orange that I, a little cabin-boy hanging from the only hook of the highest sail, throw, throw, throw to the little girl Stars... Increase human inequality. Everywhere unleash and intensify individual originality. Differentiate, appreciate, disproportionate everything. Impose variety of work. For each man, each day a different job. Free the workers from the crushing monotony of the same grey toil and the same alcoholic Sunday. Humanity is dying of equalizing dailiness. Only Inequality, by multiplying contrasts, chiaroscuri, volumes, inspiration, warmth and colour, saves Art, Love, Poetry, Sculpture, Architecture, Music and the indispensable Pleasure of Living. Destroy, annihilate politics, which opaques everybody. It is a tremendously tenacious leprosy-cholera-syphilis!''.

To get away from active politics and at the same time act as defender of the "artistic rights claimed by the Italian Futurists", was not easy however. In the following years Marinetti allowed himself a series of concessions and recognitions of Fascism. It is hard to say whether, and how much, these weighed upon him, but certainly they played a large part in strengthening the idea that no real ideological and political difference existed between Futurism and Fascism. At the beginning, Marinetti still tried to distinguish somehow the respective positions. In 1924, before the assassination of Matteotti, in *Futurism and Fascism* he made it clear that Fascism was still a long way from creating the new mentality and the new national spirit the Futurists hoped for. "Vittorio Veneto and the coming to power of Fascism represent the realization of the minimum Futurist programme, launched — with a maximum programme that has not yet been achieved — fourteen years ago by a group of courageous youths, who with persuasive arguments set themselves against the entire nation abased to senility and mediocrity by fear of foreigners."

The following November, when the crisis following Matteotti's assassination made it possible to speak more openly, Marinetti seized the opportunity. He asked a Futurist congress to approve a declaration in which he invited Mussolini to go back to "the Great Mussolini of 1919", and to *give back* "to Fascism and Italy the wonderful spirit of 1919, pure, bold, anti-socialist, anti-clerical, anti-monarchical" — that is, to return to the programme and the original

spirit of the Fascist party and the *Fasci di combattimento*. And four months later, at the convention of Fascist cultural institutions held in Bologna, he argued against the proposal (put into effect as the "Gentile manifesto") to create a sort of definitive doctrine of Fascism.

In the new climate following the *coup d'état* of January 3, Marinetti and the Futurists made no further declarations, giving the impression that they had accepted the situation and dropped any idea of somehow distinguishing between their position from that of Fascism. Apparently they limited themselves to defending their idea of art, which the regime found increasingly objectionable — anachronistic and even politically dangerous.

In reality, Marinetti and the Futurists could not avoid seeing that as time passed, Fascism was increasingly creating and spreading, in a more acute form, many of the ills which they had fought against in the Liberal state and denounced in the Communist state; that "Mussolini's Italian" was the polar opposite to their "unique Italian"; that Mussolini's totalitarianism was the negation of the individualistic democracy and the new anti-statist, essentially anarchical state they longed for; that the tasks assigned to intellectuals by the regime were quite different from the mission of freeing the individual which Futurism had given to artists.

As for Marinetti — who not by chance after his death in 1944 was described by the Socialist *Avanti!* as "unquestionably the best of the Fascist bosses" — there is plenty of evidence that in private he often disagreed with these and other aspects of Mussolini's policy (the Conciliation with the Vatican, the alliance with Hitler, etc.) and did not refuse to use his influence to help young people and anti-Fascists who were in difficulty. For one of these interventions, in 1928, Croce thanked him personally with a letter that does honour to them both. On one occasion, at least, Marinetti came out into the open: in 1938, to argue against the adoption of the anti-semitic policy, and in fact the issue of *Artecrazia* in which his statement appeared was immediately banned.

Despite this, Marinetti and many Futurists remained faithful to Mussolini at least up to 1943. Marinetti, who despite his age had wanted to fight in the Russian campaign, just as in 1935-36 he had gone as a volunteer to Africa, even joined the Italian Social Republic.

To explain such behaviour is not easy, nor obviously can a single explanation cover all the cases. For some, practical considerations probably outweighed questions of consistency. Many must have been affected in one way by the slight blunting of consciences typically produced by all totalitarian regimes; in another, by the strong sense of comradeship and interpersonal loyalty so often found amongst people who have actively participated in a small community of struggle; and in yet another, by the power of Mussolini's myth, and the identification of the *duce* with the mother-country. In a letter to Mussolini, Marinetti mentioned "the terrible pain of seeing Italy, you and Fascism murdered", as his reason for supporting the Social Republic.

Marinetti as an Academician with Benedetta, 1930 c.

La Testa di Ferro, 1920, "Gabriele d'Annunzio's Masterpiece"

The Futurist ideology must also have been an important factor; but not in the sense meant by those writers who have seen an essential identity in this respect between Futurism and Fascism, and believe that this is confirmed by the fact that the Futurists who remained in the movement did not disassociate themselves from the regime.

As Maurizio Calvesi has rightly pointed out, Futurism — the Futurism of Marinetti, Boccioni and then of the "political" Futurists of the Futurist Political Party and *La Testa di Ferro*, not that of *Lacerba* and Soffici — "was a way of radically understanding existence as ardour, adventure; a perpetual challenge to inertia"; "it believed in a positive, concrete and immediate renewal of the structures of behaviour in art and society, and was animated by a feverish enthusiasm." Its relentless struggle against tradition, sentimentality and *passatismo* (passéism), its cult of the new, of the machine, of speed, instinct and intuition, come not only from a cultural conviction and an idea of art and its function (and the function of artists), but were also a moral fact, a radical rejection of an individual and collective way of life, "a revolt of action against contemplation, of spontaneity against reflection, of anarchy against sociality."

For an historian, it is correct and necessary to identify the sources, the influences that contributed to determining this way of seeing life (according to Meriano, "the aristocratic aesthetic theory of the superman; intuitionism, pragmatism, activism, and the America of Whitman and Roosevelt") and fit Futurism into its natural context: that of the first really traumatic crisis of modernization suffered by our society and our whole civilization — a crisis which in certain ways it understood and foresaw more than other movements. But it is equally necessary not to draw mechanical conclusions from these influences. Such conclusions are particularly misleading in the case of Futurism, where the ethical-aesthetical aspect which derived from the basic identification between Art and Life, and Art and Action, conditioned all the others, including the political one.

This conditioning was particularly evident in the years preceding the First World War. During this first period, the Futurists' relationship with politics was in fact only a secondary aspect of the general activism which was intended to state their ethical and aesthetical vision; and on the whole that relation was determined more by international events — the Libyan war and the Balkan wars — and to a lesser extent, by national ones, than by any deliberate initiative on their part. The political contents of the 1909 manifesto are in fact very general. Point 9 ("We will glorify war — the world's only hygiene — militarism, patriotism, the destructive gesture of freedom-bringers, beautiful ideas worth dying for, and contempt for women") rather than having a concrete value as a programme of intentions, was an exemplification, by extension, of the statements made in the previous points; particularly in 3 ("Up to now literature has exalted a passive immobility. We intend to exalt aggressive action, a feverish insomnia, the racer's stride, somersaults, the punch and the

slap'', and ''Except in struggle, there is no more beauty. No work without an aggressive character can be a masterpiece. Poetry must be conceived as a violent attack on the unknown forces to induce them to prostrate themselves before man''). The following, more ''political'' statements — the two manifestos published for the elections of 1909 and 1913, and the 1911 manifesto for the war in Libya — add nothing very significant.

Emilio Gentile is therefore right when he says that in this period, the Futurists had an attitude rather than a real political interest. This attitude — which was influenced by their desire to publicize their ideas — was characterized essentially by three elements (which remained the same later, one can say): ''Italianism'', anti-Socialism and a generic sympathy for the subversive movements of the left. Their Italianism, except for its Pan-Italian aspect, was very different from the nationalism of the Nationalists and had nothing really militaristic, imperialistic and racist about it (this latter characteristic was something Futurism never lost; it was particularly alive in Marinetti — as can be seen for example in his *Il tamburo di fuoco, The Firedrum* — and even led him to praise half-breeding). In fact after the war, any tendencies in these directions were moderated rather than accentuated.

Their anti-Socialism did not prevent the Futurists from agreeing with most of the Socialists' criticisms of Liberal society, and it can be correctly evaluated only by bearing in mind the motivations and limits of their sympathy for the left wing subversive movements, and of the audience that Futurism had in considerable sectors of these movements before and immediately after the war. This fact is very important for understanding political Futurism, as Ugo Carpi has pointed out. It can be explained, more than by the fundamental ''anarchism'' of Marinetti's Futurism, by the objectively revolutionary impulse that the movement seemed to have in the eyes of the irregular left, and after the war, of certain Bolshevist or Bolshevizing sectors. However, at this point it must be said that Futurism's political engagement, in the field of theory as well, was most intense after the outbreak of the First World War, and particularly between 1918 and 1921. In this period, without ever losing its fundamentally ethical and aesthetical character, the Futurists' political attitude expressed itself in more concrete, social terms. There was even an effort to create a socio-political plan — the main evidence is in Marinetti's *Democrazia futurista* — which previously the Futurists had completely neglected, since they were basically interested in the destructive moment of the struggle against passéism and its various manifestations.

This engagement and this constructive planning — besides the ethical-aesthetical background, obviously — must be emphasized in order to understand and evaluate the Futurist position in the context of post-war Italian political events: the foundation of the Futurist Political Party, their participation in constituting the *Fasci di combattimento*, and their subsequent withdrawal; their support for the Fiume adventure; and the repeated attempts of some of the contributors to *Roma Futurista* in 1919, and then of the group of *La Testa di Ferro* in 1920-21, to establish a closer relationship with the political left — with the Anarchists in particular, but also with the Bolshevik sectors of the Socialist Party. In this perspective, it is also possible to understand the way the Futurists behaved towards Fascism when it came to power, and when it became a regime.

In a situation now clearly tending towards a general demobilization and a social and political reintegration, for the Futurists *Italianismo* remained the only winning, or potentially winning element, which was at any rate worth fighting for to try and keep it from falling into passéism. This explains their acceptance of the Fascist takeover of the government, and their subsequent alignment with, and loyalty to the regime and to Mussolini in particular. For most of them, this did not entail giving up or denying their artistic ideal, and at least in some individual cases, like Marinetti, it did not even entail consciously abandoning some of the most characteristic moral attitudes of Futurism. But neither did they ever think, in my opinion, that they would one day come to represent a ''soul'' of Fascism.

On the other hand, it is quite wrong to explain the Futurists' alignment with Fascism as the logical consequence of the decisive, central position in Futurism of the ''polemological'' concept. It is an incontrovertible fact that ''struggle'' was an essential element of the Futurists' moral and aesthetic attitude to life, and to all the manifestations of passéism. However, it is a misinterpretation, a mistake which distorts our understanding of Futurism, to transpose this attitude from the sphere of struggle as a manifestation of life and art, to the sphere of the struggle between nations, thus making *war* central to the Futurists' view of life. The fact that Marinetti hated the idea of a ''pacified'' existence should not mislead us: for him, as for most of the Futurists, a pacified existence meant only an existence that at a certain point would cease to experience progress; this is what he abhorred and rejected, this is what led him to consider himself a true revolutionary and to consider Futurism the only truly and totally revolutionary movement. War was seen by him as fullness of life and even as rejoicing, essentially as an individual and artistic fact, which became collective for the Italians in 1911 and more particularly in 1915-18 (as it did for the other nationalities, please note) because it took on the value of a ''revelation'' of the ''true Italian powers'', that is, of the triumph of ''futurism'' over ''passéism''. The word ''hygiene'' used by Marinetti when speaking of war is significant in this context. And it is also significant that in 1929, in the concluding pages of his *Marinetti e il futurismo (Marinetti and Futurism)*, where he affirms the need to prepare Italian youth to face a new outbreak of war and conquer an empire for Italy, Marinetti is not theorizing war for its own sake, but claiming the need, on the one hand for Italy to ensure possession of territories which are ''indispensable'', and on the other, for ''victorious ideas to hold fast the positions they have gained''. The explanation is therefore founded partly on ''practical'' considerations and partly on the fear that without another ''hygienic treatment'' traditionalism would triumph again.

The idea that Futurism constituted the apotheosis of war for war's sake, war as a rejoicing and satisfaction of the whole human personality, is not only untrue, but implies a very serious historical misapprehension, which makes Futurism into a wandering monad in an existential, cultural and artistic condition of which, in reality, it was fully a part, and indeed in many ways an essential element. (RDF)

Intonarumori

The ''intonarumori'' were musical instruments invented in 1913 by Luigi Russolo and Ugo Piatti to create ''sound-noise'' and extend its range. They were patented by Russolo in Milan on 11 January 1914. By 1921 there were 27 varieties with different names according to the sound produced: howling, thunder, crackling, crumpling, exploding, gurgling, buzzing, hissing and so on.

The instruments were in the form of boxes of various sizes containing the necessary mechanism. A crank in the back was turned to produce the noise while a horn in the front collected and reinforced the sound. A lever on top could be moved over a scale in tones, semitones, and the intermediate gradations to determine the pitch of noise desired. The ''intonarumori'' had a range of more than an octave each, and several varieties were available in three registers: high, medium, and low. The original instruments have all been destroyed. (FMa)

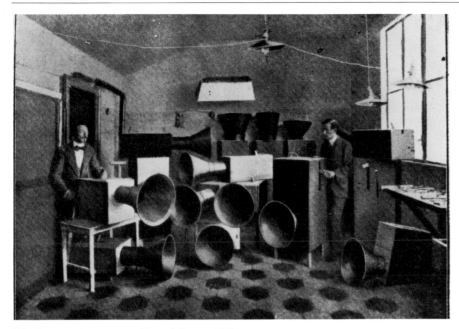

The Futurist "intonarumori" workshop in Milan

M. Janco, woodcut

Janco, Marcel
also known as Jancu
(Bucharest, 1895 - Tel Aviv, 1985) Rumanian
painter and engraver

Janco became acquainted with Tristan Tzara in 1912 and worked with him and with Ion Vinea on the magazine *Simbolul*. He studied architecture in Zurich in 1915, where he again met Tzara. He was one of the artists most involved in the Cabaret Voltaire, for which he executed woodcuts and abstract reliefs (his pictures were generally more representational), posters, costumes and masks. Beginning in 1916 he established friendly relations with Cangiullo and Prampolini, who were especially impressed by his reliefs. In 1917 he exhibited with Prampolini in Palermo and his works were published in *Noi*. After a stay in Paris he returned to Bucharest, where he was an active contributor to the magazine *Contimporanul*. (SF)

Jankowski, Jerzy
(Wilno, Lithuania, 1887 - Wilno, 1941)
Polish writer

Jerzy Jankowski is the true founder of Futurism in Poland: his poems began to appear in 1913, although they were not collected in a single volume until 1920, in *Tram across the Streat*. In his only collection, Jankowski celebrated modern technology, large cities, and his faith in the future, in verses in which — just as in the texts of the Russian Futurists — the spelling was intentionally garbled. (SF)

Japan

In the wake of Impressionism, the art of Van Gogh, Gauguin, Matisse, the renovating current of European Post-Impressionism and not least Italian Futurism, spread steadily in Japan from 1910 onwards.

Neither Cubism nor Italian Futurist painting had a decisive stylistic influence on Japanese art. A considerable number of painters were drawn into the creative flow of Western art, but this proved to be a passing phase. However, the reaction against the past and academicism, and the interest in the Futurists' search for a new era for mankind, attracted a group of young Japanese artists between 1910-20, giving life and impetus to a significant artistic current of the avant-garde. Futurism arrived before Cubism. Marinetti published the most significant part of his *Futurist Manifesto* in 1909 in *Le Figaro*. A few months later, it was translated and printed by the writer Ogai Mori and then republished by the art magazine *Subaru* (*Pleiades*).

In 1912, first in February in Paris, then in March in London, the exhibition of Italian Futurist paintings was held. Japanese newspapers and art magazines immediately spread the word. Amongst those who heard about the Futurist movement were a few painters, unknown at the time, who wrote directly to Marinetti for more information about the movement he was promoting. Marinetti replied, sending them documents on Futurism and prints in the basic colours. In this way the Futurist movement became known to many more painters. The *Self-Portrait* by Tetsugoro Yorozu, painted in 1912, is a fine example of the influence of Futurist painting in Japan.

In 1915 the critic and painter Ikuma Arishima published in an art magazine a partial translation of Boccioni's *Pittura scultura futurista - Dinamismo plastico* (*Futurist Painting and Sculpture - Plastic Dynamism*). Arishima certainly had no sympathy for Futurism, but thanks to him Seiji Togo and Tai Kanbara were profoundly attracted to the movement.

In 1916 Togo painted *Woman with Parasol*, which is unquestionably Futurist in style. Then in the early Twenties he went to France and shortly afterwards met Marinetti in Turin.

Kanbara, a poet and painter with a profound knowledge of Futurism, became well-known for his active role in spreading the word. He was also the leading spirit in Action, a group of avant-garde painters formed in 1922. In 1920, during his first one-man show, Kanbara published *Tai Kanbara's First Manifesto*, which clearly shows the influence of Futurist thought on the painter.

At that time in Japan Futurism was seen as a new, non-naturalistic trend in all the arts, rather than as a particular artistic current, and therefore the small group of Futurist artists which formed in the Twenties had no specific ties with Italian Futurism.

In October 1920 David Burliuk, who called himself "the father of Russian Futurism", arrived in Japan and joined the group of Futurist artists. In this way the influence of Russian Futurism started to spread. Burliuk stayed for only two years, but he left a deep mark on the Japanese avant-garde artistic movement. The artists came into contact with the Mavo group, which was Dadaist in its use of colour; they were also influenced by Socialist thought, and many artists played an active part in the proletarian art movement at the end of the Twenties. (TA)

Jarry, Alfred
(Laval, 1873 - Paris, 1907) French writer

Marinetti, more than the other Futurists, was fascinated by Jarry; he met him when living in Paris and was familiar with his work. Alfred Jarry was the non-conformist's non-conformist, with his love of pistols and bicycles, and he was provocative in every field. As a writer, Jarry was a hermetic and disconcerting poet in *Minutes de sable mémorial* of 1894 and in *César-Antéchrist* of 1895, and a novelist in *Surmâle* of 1902, whose hero was a deliriously virile as well as Futurist *ante litteram* who mates with a machine that — overcome — falls in love with him.

The Ubu cycle impressed the Futurists, especially *Ubu Roi*, which generated great scandal at the Théâtre de l'Œuvre in 1896, as well as *Ubu enchaîné* published in 1900. All the plays and farces that involve Ubu are terribly funny: he is a despicable character, greedy, stupid and often murderous. Marinetti makes no secret of his debt to Jarry in *Le Roi Bombance*, a satirical farce performed in 1905. Jarry in turn looked favourably upon this play by the Italian poet and complimented him. Jarry promoted theatrical *à-côtés* — he created a *Théâtre des Pantins* in 1897 and a *guignol* in 1901 — and insisted on having songs and the attractions of a café-concert. All this could not fail to win over the Futurists. Nevertheless, it was not until 1926 that An-

A. Jarry, drawing for the Ouverture of Ubu Roi, *by C. Terrasse*

A. Jarry, drawing for the Ouverture of Ubu Roi, *by C. Terrasse*

ton Giulio Bragaglia produced *Ubu Roi* in Italy with a translation by Nino Frank.

Jarry died early, and Futurism had few direct contacts with him, but the rare letters addressed to Marinetti testify to the warmth of their friendship. From 1905 on Jarry wrote more than once in *Poesia*. Immediately after his death the same magazine published the complete version of *Objet-aimé*, several fragments of which had been published by Apollinaire in *Festin d'Esope* (1903). Marinetti also announced that *Poesia* had purchased the rights to Jarry's unpublished works, which were to be published in various volumes, but this project was never carried out. (SF)

Jasienski, Bruno
(Klimontow, Poland, 1901 - Vladivostok, 1939 or 1941) Polish writer

Since he studied mainly in Moscow, Bruno Jasienski was well informed about the innovations of the Russian Futurists; he greatly admired Maiakovsky and, like him, was committed to the struggle of the Communists. In 1919 he was in Krakow with Tytus Czyzewski and Stanislaw Mlodozeniec. In 1921 he was the driving force behind the *Manifesto of the Polish Futurists*, as well as of the *Nife in the Beli*. In the same year he published *A Boot in the Buttonhole*, and in the following year, *Songs for the Hungry*, which was characterized by an aggressive anti-intellectualism: "I read neither Strindberg nor Norwid / I recognize no heredity / I read the freshly printed newspapers that smell of ink / With a pounding heart I skim through the list of / accidents."

With his friend Anatol Stern he published *The Land to the Left* (1924). After 1924 he went to live first in Paris, and then in the Soviet Union. (SF)

Joostens, Paul
(Antwerp, 1889 - Antwerp 1960) Belgian painter and writer

Both ingenious and versatile, Joostens passed through various styles, such as Cubism, Futurism, Dadaism, Constructivism and Surrealism, and is therefore practically impossible to classify as a painter. His Futurist period lasted from 1911 to 1916 and was responsible, in particular, for a number of drawings with a rather nervous line. His first book, *Salopes*, appeared in 1922, during Joostens's most intense period of Dadaism. (SF)

Kadar, Bela

(Budapest, 1887 - Budapest, 1955) Hungarian painter

After visiting Vienna, Munich and Paris, in 1902 Kadar enrolled at the Fine Arts Academy in Budapest. He was attracted by German Expressionism and from 1910 onwards was in close touch with the Der Sturm group. In 1922, 1924 and 1926, invited by Herwarth Walden, he exhibited with Der Sturm. Katherine Dreier chose his work for international avant-garde exhibitions and Kadar acquired a certain fame. In 1932 the political situation in Germany compelled him to return to Budapest, where he showed regularly at the Tamas Gallery. His style, which was a mixture of Expressionism, Futurism and naïve art, is not without interest, but remains marginal in the context of contemporary avant-garde experimentation. (SZ)

Kamensky, Vasilii

(Borovskoe, 1884 - Moscow, 1961) Russian writer, painter and aviator

Born in the Urals, Vasilii Kamensky travelled extensively through Russia and the Middle East, and was imprisoned for his participation in the 1905 revolution. Later he settled in St. Petersburg and devoted himself to literature.

Over the following years, names that were more or less directly linked to Futurism appeared in his magazine *Vesna*: Viktor Shklovsky, Nikolai Aseev and above all Velemir Khlebnikov. During the year 1910, Kamensky contributed to *A Trap for Judges* and published *The Mud Hut*, a Primitivist novel which exalted the return to nature and the savage state. The failure of this book made him turn to aviation and he began a career as a stunt pilot, travelling across Europe for the various air meetings. He gave up aviation (though not in his verse) after a potentially fatal accident. Malevich's *Aviator* may well be a portrait of Kamensky. Burliuk and the Futurists pushed him back into writing; at their side he became one of the most brilliant participants in the movement. Kamensky's best known collection was *Tango with the Cows* (1914), printed on painted, hexagonally-shaped paper. After 1913 he published "iron-concrete" poetry (a reference to reinforced cement) in which he mixed abstract drawings and typographical experimentation. He took part in the exhibition "No. 4" organized by Larionov in 1914. After the revolution he reappeared in Maiakovsky's Constructivist magazine *Lef*. (SF)

Kanbara, Tai

(Tokyo, 1898) Japanese poet, artist and critic

Tai Kanbara, a scholar and propagator of Italian Futurism, was one of the greatest vanguard artists of the mid-Twenties. He started as a poet, but soon developed a deep and lasting interest in modern European art.

He was introduced to Futurism by Ikuma Arishima, read Boccioni's *Futurist Painting and Sculpture (Plastic Dynamism)* and became so enthusiastic that he started corresponding with Marinetti who sent him his Manifesto and many other writings.

In 1917 Kanbara published a collection of poems, *Late Cubist Poetry*, clearly influenc-

V. Kamensky, Tango with the Cows, *1914*

Tai Kanbara, Futurism, Expressionism, Dadaism

ed by Futurism. He then turned to abstract painting and held his first exhibition in 1920. Later he published *Tai Kanbara's First Manifesto*, preceded by a dedication signed by Marinetti.

In 1922 he founded the group Action together with other vanguard artists, then in 1924 he joined Sanka, another vanguard art movement. When Sanka was dissolved the following year, Kanbara and the other ex-members of Action created Plastic Art, which two years later joined the Proletarian Art movement.

At this point Kanbara separated himself from the movement and remained active only as a critic. His essays include studies on Picasso. (TA)

Kandinsky, Vasilii

(Moscow, 1866 - Neuilly-sur-Seine, 1944) Russian painter

After graduating in Law and Economics at the University of Moscow, Kandinsky refused a teaching post there and from 1896 dedicated himself completely to painting. He studied painting in Munich, visited France several times, travelled to Holland, Tunisia and Italy, and finally settled down in Murnau, Bavaria.

Under the influence of the wandering Russian artists, his realistic painting, which reflected Impressionism hardly at all, turned towards abstraction. In December 1911, while painting a series of decisive pictures and water colours, Kandinsky published his theoretical thoughts under the title *The Art of Spiritual Harmony*. Immediately, in January 1912, Kulbin presented long excerpts to the Moscow artists, who welcomed it enthusiastically. Though he lived in Germany, Kandinsky was always up to date with all the new tendencies in Paris, Milan, and, of course, Russia. Initially enthusiastic about the new Russian avant-garde, as it became more radical he broke away from it. When Herwarth Walden asked him to organize the Russian section of the Erster Herbstsalon (September 1913) he presented a choice in which the Cubo-Futurists were practically absent.

When the authors of the anthology *A Slap in the Face of Public Taste*, a gem of Russian Futurism, included a poem from the series *Klänge*, Kandinsky immediately protested and officially dissociated himself. His correspondence with Walden testifies how little he thought of Futurism. When the Italians, invited by *Der Sturm*, presented an exhibition in Munich, Kandinsky wrote to his friend: "If possible, please do not push in any particular way the Futurist painters... their last manifesto (painting of sounds, noises, smells — where there is no grey, no brown!) is even wilder than the previous ones. The Futurists play with important ideas which they put forth here and there. But it is all so little pondered, so little felt!" (12 November 1913).

Kandinsky not only disliked the publicity-seeking of the Futurists, he also doubted their professional competence. On 15 November 1915 he wrote to Walden: "I have again examined the Futurist paintings from the point of view of drawing... Those things are not drawn! The works in the Futurist catalogue are all, without exception, superficial... Nowadays hurry and superficiality are characteristic of many

radical artists; like this the Futurists have ruined the good side of their ideas.''

In 1914 Kandinsky went back to Russia and after the October Revolution became director of the Museum of Artistic Culture. Then, and later when he worked at the Bauhaus, he continued to cricitize Futurism. It is sad to note how only in 1932, for political reasons, he remembered the existence of Futurism. Marinetti had announced his visit to the Bauhaus in Dessau, and Kandinsky intended to avail himself of the authority of the Futurist leader. On 23 July 1932, he wrote to Marinetti: "I would like to show you our Bauhaus, our school for advanced studies which is based on a synthesis that is unique in the *whole* world... You may have learned from the newspapers that Anhalt, a German region of which Dessau is the capital, 3-4 months ago acquired a new administration, of fascist tendency, which deeply admires the Italian political system, even though it does not follow its example." (SZ)

Kassák, Lajos

(Ersekujvar, 1887 - Budapest, 1967)
Hungarian writer and painter

According to Kassák himself, it was meeting people like Apollinaire, Picasso, and Modigliani in Paris — where he arrived (on foot) in 1909 — that convinced him to devote himself to art and literature. His first magazine was called *A Tett*; it was followed by *Ma* (1916-25), which was published first in Budapest and later in Vienna, where he moved after the failure of the Hungarian revolution in 1919. Kassák took an interest in all the avant-garde movements of his time and gave them a forum in the magazine *Ma*. Futurism was represented, of course, as it was in *The Book of New Artists* (1922). Kassák personally preferred Constructivism, and he publicly expressed his reservations about Marinetti during the Italian poet's visit to Vienna in 1925. (SF)

A. Kruchenykh and V. Khlebnikov
Game in Hell, *1912, cover by K. Malevich*

Khlebnikov, Velimir (Viktor)

(Astrakhan, 1885 - Santalovo, Novgorod, 1922) Russian writer

Born near Astrakhan, Viktor Khlebnikov (he later changed his name to the more Slavic Velimir) was to lead a wanderer's existence crisscrossing the Soviet Union; he died of exhaustion and malnutrition by the side of a road.

After studying mathematics, biology and philology at the universities of Kazan and St. Petersburg, he devoted himself wholly to literature. In his earliest surviving writings, dated 1903-05, Khlebnikov was influenced by the Symbolists; Viaceslav Ivanov was his mentor for a certain period, but Khlebnikov's pronounced Pan-Slavism and the Francophilia of the Symbolists could not co-exist. Furthermore he had already begun his experiments with an invented language based on neologisms. His works circulated. He was both admired and ridiculed, but his writing was not published. Finally in 1908 Khlebnikov met Kamensky, who published his earliest works.

In the *Studio of the Impressionists* published by Nikolai Kulbin at the beginning of 1910, Khlebnikov's contributions were considered the most important, and in particular his "Enchantment by Laughter", which is often cited as the first Futurist work in Russia; it is a poem constructed with great freedom using invented words based on the root word "laughter" (*smekh*). A few weeks later, several aggressively unrealistic works by Khlebnikov were included in *A Trap for Judges*. In *The Crane*, for example, a colossal bird, a sort of robot composed of metallic parts, terrorizes a city. And in the comedy *The Marchioness Desaix*, Khlebnikov depicts a socialite reception in St. Petersburg, in which artists and writers witness the arrival of a marchioness from another century, accompanied by her gallant companion and even the painter Raphael in person, when they were only expecting an aperitif (called St. Raphael); the marchioness takes part in the reception, and suddenly the objects come to life, her furs turn back into animals that try to run away, her feathers take flight, her clothes are transformed back into flax flowers; the marchioness and her companion turn to stone and nothing is left but the guests exchanging idle chatter in front of the statues of two lovers. This is Khlebnikov at his most characteristic: it is not only the language that is reversed, but all the principles of verisimilitude — several centuries coexist simultaneously, real and imaginary persons meet, and ordinary objects come to life and take part in the action.

Shortly before Futurism appeared, the Primitivism promoted by Larionov and Goncharova and by the Hylaea group (composed of Burliuk, Kamensky, Livshits) attracted Khlebnikov, who was enamoured of Slavic folklore, popular art and children's language. *Game in Hell* (1912) is typical of this period; it was written together with Kruchenykh, with the collaboration of Goncharova, who executed lithographs as harsh as the text itself.

Khlebnikov was a discreet man who did not enjoy the noisy public manifestations of the Futurists; he attended them, but his verses were declaimed by more fiery personalities,

like Burliuk or Maiakovsky. Yet he was not merely a passive member of the group. The *Slap in the Face of Public Taste* of 1912, like the manifestos that followed, bears the mark of his ideas. That he disliked the "waves of screaming scorn and indignation" (the "delight of being booed", Marinetti would have said), is evident in the way he disposes of the Symbolists and Realists, and in his support for the right of poets "to increase the volume of their vocabulary through the use of derived and arbitrary words (verbal innovation); to an irrepressible hatred toward the language that existed before them... If for the moment, even in the pages of our work the filthy stigmata of your good sense and your good taste still exist, there also palpitates in those pages for the first time the light of the New Future Beauty of the Self-sufficient Word". In various manifestos, generally written with Kruchenykh, Khlebnikov went much further, claiming the right to his own syntax and spelling — hence the books composed by the poet reproduce his handwriting and his spelling mistakes (for example, *The World Upside Down*, 1912). He also invented *zaum*, a "transmental language" of which he offered a convincing example in his play *Zangezi* (1922). Long before anyone spoke of Futurism, Futurists, or Cubo-Futurists, Khlebnikov had spoken of a "futurism" that he called *budetlian* (from *budu*, the future of *byt* = "to be") to define himself and his friends.

His desire to separate himself from the Italian movement and his aggressive stance toward Marinetti never softened. In *The Word as Such* (1913) he declared: "The Italians have proved to be loud talkers but twittering or silent artists." When Marinetti visited Russia at the beginning of 1914, Khlebnikov's hostility was even more evident than Larionov's; he wanted everyone to boycott "that Italian vegetable" and with Livshits he published an insulting broadsheet: "Foreigner, remember, you are not in your own country!" He was angry with Kulbin for having discussions with the Italian poet, and with Burliuk and Maiakovsky for simply having been present at one of Marinetti's readings. After a period of detachment, however, he participated again in the Futurists' collective publications, in which several of his works appeared, including *Uah!*, *Creations 1906-1908*, *Selected Poems*, and *Battles of 1915-1917*. During the war Khlebnikov wandered across the country more than ever. When the Revolution broke out, this fierce individualist joined the ranks of the Bolsheviks. He continued his research into time, which he had been working on for years (*Time Is a Measure of the World*, 1916). He had even imagined a "government of time" more general than our government of space, and tried to interest H.G. Wells in his project. The work of Khlebnikov covers a vast range, from poetry to philosophical speculation. After his death, Maiakovsky wrote: "I wish to publish in black and white, in the name of myself and of my friends and fellow-poets Burliuk, Kruchenykh, Kamensky and Pasternak, that we considered and continue to consider Khlebnikov as our master in poetry and as the most pure and magnificent knight of our poetic battle." (SF)

Kom-Fut

(Abbreviation of Komunisty-Futuristy = Communist-Futurists)

Kom-Fut was an association of painters and poets founded in Petrograd in January 1919 by Boris Kuchner, Vsevolod Meierkhold, Ossip and Lily Brik, Nathan Altman and David Shterenberg. In the programmatic declaration published in the review *Iskusstvo Komuny*, Kuchner announced that "all forms of life, morality, philosophy and art must be recreated according to Communist principles"; it was therefore necessary to invent a new art by completely rejecting all the products of bourgeois culture. This idea, already put out by Maiakovsky in 1914 although the poet never officially belonged to the organization, was met by severe criticism from Lenin and Lunacharsky, concerned with preserving the cultural heritage and shocked by the "anarchizing, destructive" nature of Futurism. The committee of the Bolshevist Party in Petrograd refused to register the Kom-Fut as a party association: "The Futurists came to see us," Lunacharsky recounted a few years later. "They were young people and wanted to call themselves Kom-Fut, but we refused and told them they must come into the Party according to the ordinary rules."

Nevertheless, in April 1921, dedicating his poem "150,000,000" to Lenin, Maiakovsky signed it "Kom-Fut Maiakovsky". After that date, whenever the word "Futurist" appeared in the official press it was with a slighting connotation, and later as an insult. (SZ)

Konoupek, Jan

(Mladá-Boleslav, 1883 - Prague, 1950) Czech designer and graphic artist

Jan Konoupek was a member of the second Symbolist generation which formed the Sursum group. After 1910, the decorative structure of his Symbolist drawings was considerably modified by Expressionism and two years later by Cubism, from which he derived his geometrizing, transparency and analytical breaking down of form. Almost simultaneously, however, Futurist elements appeared in some of his drawings: for example, in the attempt to express movement through the successive multiplication of outlines (*Cyclist*, 1913), or in the dynamic rhythmic effect of the geometrical surfaces (*Christ Appears to the Fishermen*, 1913), which were at times drawn into a centripetal whirling movement (*Daniel in the Lion's Den*, 1914).

Cubo-Futurist morphology, sometimes modified by Expressionist distortion, was often used by Konoupek to express themes which were still essentially Symbolist: biblical subjects, states of mind and psychic energy. A similar formal syncretism, which reacted to the newest trends in contemporary art, was also evident in his post-war production, which more than once brought him close to Futurism again, this time, however, in a much more abstract dimension. (FŠ)

N. Kulbin, Portrait of Kruchenykh

A. Kruchenykh, Explodity, *illustrated by Kulbin, 1913*

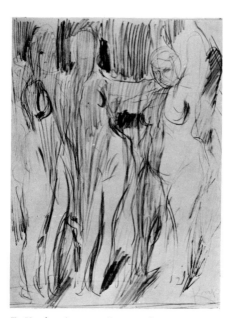

F. Kupka, Autumn Sun, *study, 1905*

Kroha, Jiří

(Prague, 1893 - Prague, 1974) Czech architect and set designer

In his projects and productions during the years 1918-22 Kroha was drawn towards the pre-war Prague Cubist tradition, developing it in the direction of a radical dynamization of matter and space. Using a complex interpenetration of diagonally composed stereometrical bodies and empty volumes, he achieved the fusion of inner and outer space and created an expressive crystallographic model of space. Through the dramatic stratification and the rhythmic repetition of rhomboidal forms, and the alternation of concave and convex volumes, he arrived at an extremely dramatic and emotional expression that approached the aesthetics of Futurism.

Kroha first applied these principles in the interior design of the Montmartre cabaret (1918), the main haunt of Prague Bohemian life, and later in many projects for sacred buildings and crematoria in the years 1919-20. During 1921-23 he also designed theatrical sets in which some of the scenic elements moved and even substituted for the actors at certain moments (A. Dvořak - L. Klíma, *Matěj Poctivy - Matthew the Honest Man*, Prague National Theatre, 1922; Ch. D. Grabbe, *Žert, ironie a hlubší význam - Jest, Irony and Deep Meaning*, Švanda Theatre, Prague, 1922).

In his theoretical articles, Kroha imagined a dynamic mechanical stage which would be the center of the dramatic action and even eliminate the need for actors; this became the principle of Prampolini's Magnetic Theatre. (FŠ)

Kruchenykh, Alexei

(Olevka, 1886 - Moscow, 1968) Russian writer

Like other Futurist friends of his, Alexei Kruchenykh began by studying art in Odessa and then became a drawing teacher. Although he published a few lithographs, after he met the Burliuk brothers he became completely absorbed in poetry. With Larionov, Goncharova, Malevich, or with his wife Olga Rozanova, he created some of the finest books in the history of Futurism. Although he did not enjoy foreign travel, Kruchenykh was perhaps the most typical representative of Russian Futurism: radical, spontaneous, disorderly, and at times disconcerting, he took part in all their battles. His friends claimed that he looked like an eccentric Englishman (he was the subject of Malevich's portrait, *An Englishman in Moscow*). In 1913 his opera *Victory over the Sun* was staged with music by Matiushin and sets by Malevich.

In his first booklets, written alone or with Khlebnikov, Kruchenykh showed his great capacity for innovation: deliberate mistakes, misprints and aberrant typography are distinctive traits. In his production, the following titles stand out: *Game in Hell* (1912 with Goncharova, 1914 with Malevich and Rozanova), *Old Love* and *Forestal Noise* (1912 with Larionov, 1913 with Rozanova), *The World Upside Down* (1912 with Larionov, Goncharova and Tatlin), *The Hermits* (1913 with Goncharova), *Half Alive* and *Pomade* (1913 with Larionov), *Te li lé* (1913 with Rozanova and N. Kulbin), *Let's Grumble* (1913 with

Malevich and Goncharova), *Duck's Nest of Ugly Words* (1914 with Rozanova). Influenced by his friend Khlebnikov on the one hand, and by popular art and baby talk on the other, with *Pomade* Kruchenykh created the first *zaum* poem: "dir bul shchil / ubesh chur / skum / vi so bu / rr ll es." The manifesto *The Word as Such* by Khlebnikov and Kruchenykh states that in "these five verses there is more Russian national character than in all the poetry of Pushkin". More seriously still, in his *Declaration of the Word as Such* (1913), Kruchenykh explained that "thought and the word cannot follow the experience of inspiration, and this is why the artist is free to express himself not only in common language (concepts) but also in his personal language (the creator is an individual)".

Extremely active in all Futurist events and publications, Kruchenykh was in Georgia beginning in 1916, among the founders of the 41 Group and the most surprising contributor to "Fantastic Cabaret" (1919). After the Revolution Kruchenykh took part in the Lef group organized by Maiakovsky, but he did not fit in with Constructivism and social commissions. In the Thirties he published chiefly memoirs and small monographs on his Futurist friends; later he lapsed into obscurity. (SF)

Kubicki, Stanislaw

(Zigenheim, 1886 - Berlin, 1943) Polish painter

A member of the Bunt group, Kubicki was associated with the German avant-garde and with the general artistic life of Berlin where he lived until the Thirties. Between 1919 and 1924 he was an important link between *Der Sturm* and *Die Aktion*, and the Polish Expressionists and Futurists. (SZ)

Kubišta, Bohumil

(Vlčovice, 1884 - Prague, 1918) Czech painter

An important representative of pre-war Czech Cubism, Kubišta became a member of the Die Brücke group in 1911, and

adopted the Cubist analysis of form (1911) after experimenting with Expressionism. His Cubism, however, had from the first a totally personal character: an emphasis on the purely constructivist analysis of the painting (inspired by the analysis of the composition of works by old masters), on the symbolic function of colour and the geometric infrastructures of the composition, and a search for a spiritual content in the new forms. His non-orthodox relationship with Cubism, which contrasted with the dogmatic respect for Picasso's example shown by other members of the Cubist SVU, soon led him to extend his interest to some principles of Italian Futurism. In April 1912 Kubišta probably saw the Futurist exhibition in Der Sturm Gallery in Berlin, the catalogue of which is preserved in his archive, and in the same year elements of Futurism began to appear in his works.

In his paintings *Murder* and *Hypnotist*, both from 1912, the accent on dramatic dynamic action and the attempt to express inner psychic states were totally extraneous to Cubism. *The Nervous Lady* (1912) shares these qualities, and renders the neurotic sensibility and feverish vitality of modern life; similarly, in the more abstract *Obstacle* (1913), a closed fist seen from several viewpoints emerges from the geometric structure. The fascination with technology, speed, modern transportation and engineering is expressed in *Train in the Mountains* and *Waterfall in the Alps*, both 1912, in which the trains, bridges, signals and tunnels are compared with the unbridled force of natural elements. In *Coastal Batteries Fighting with a Fleet* (1913), painted while the artist was on active service on the Adriatic coast, Kubišta came even closer to Futurism, from the point of view of form and content, and at the same time anticipated many later Italian works on the theme of war, for example Severini's *Armoured Train* (1915). Kubišta's painting is not however a celebration of war, but a dramatic representation of its murderous

machinery: the simultaneous depiction of successive events, the focusing on the ship that fires a shell into a tangle of mechanical parts, figures, iconic signs and intersecting beams of light, flashes of shots and explosions. The later, Expressionist *Bombing of Pulja* (1915) is a similar work. The military world also inspired Kubišta's *Sailor* (1913), a painting with fresh colours that is based on a system of elliptical lines.

Before the war Kubišta often exhibited in Germany with the Neue Secession, but in 1913 he also took part in the exhibition of Futurists and Expressionists in Budapest and the exhibition of Futurists, Cubists and Expressionists in Lvov. (FŠ)

Kulbin, Nikolai Ivanovich

(St. Petersburg, 1868 - St. Petersburg, 1917) Russian painter

By profession a doctor and teacher at the Military Academy, Kulbin was a self-taught painter who became prominent as an organizer of exhibitions and patron of the young Petersburg artists. In 1908 he founded the group of "Impressionists" and organized an exhibition for them, in which he presented among others Elena Guro, Matiushin, Khlebnikov and Kamesky. Kulbin's eclecticism and 19th century decadent spirit (Matiushin called it "Vrubelism") soon led to a split in the group; the dissidents founded "Vision of Youth".

In 1911 Kulbin and Evreinov opened a cabaret, the Stray Dog, which soon became a favourite meeting place for the Russian avant-garde. Marinetti, invited by Kulbin to Russia in the spring of 1914, gave several talks at the Stray Dog and spent almost every night there. In 1915, in an anthology entitled *The Archer*, Kulbin presented the Hylaea group (the book was described by Matiushin as the funeral rite of Cubo-Futurism). Kulbin left a great many drawings, chiefly portraits of his artist friends. He also wrote a series of theoretical articles about modern painting. (SZ)

Kupka, Frantisek

(Opocno, Czechoslovakia, 1871 - Puteaux, 1957) Czech painter, naturalized French

Frantisek Kupka attended the Academy of Fine Arts of Prague (1887) and then the Academy of Fine Arts of Vienna (1891), where he began to exhibit. In 1894 he went to Paris and settled there permanently, living by painting, designing posters and illustrating books and periodicals such as *L'Assiette au Beurre*. In 1905 he illustrated *The Truth about Pyecraft* by H.G. Wells. Kupka was interested in spiritism and occultism. In 1907 he studied Chevreul's theories on colour. A fellow traveller of the Cubists, he was a neighbour and close friend of the Duchamp brothers. His objective of depicting movement in painting was expressed in his works of 1909-10, for example *Woman Gathering Flowers*, in which the figure is depicted in various positions, recalling the chrono-photography of Marey and Muybridge. After 1911 Kupka often chose titles for his abstract oils that refer to music: *Fugue*, *Nocturne*. One would think of Russolo, who also learned from Symbolism, but in developing his alternately dynamic or static coloured structures, Kupka rejected all figures. (SF)

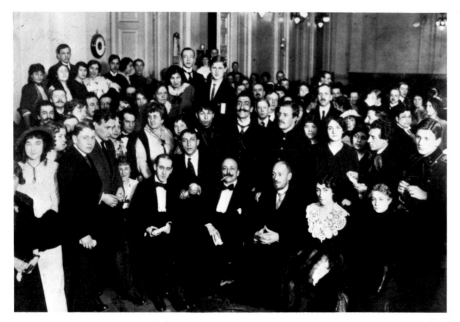

Marinetti in Moscow, surrounded by artists including Larionov, Livshits, Kulbin and N. Burliuk

Lacerba

(1913-15) Italian periodical

Lacerba, which appeared from 1 January 1913 to 22 May 1915, was founded by Giovanni Papini and Ardengo Soffici, after they broke away from *La Voce*. Published in Florence, *Lacerba*, though heavily influenced by Futurism, was not a Futurist magazine, but gave space to discussions and polemics revolving around the movement or addressed to it in and outside Florence. From the start, its graphic appearance was of an extreme purity and clarity. From mid-1913, under the Futurists' influence, it started accepting more drawings, and in 1914 the magazine reached its peak of visual density with the tall, self-advertising heading, provocative headlines, numerous drawings and a wide variety of imaginatively designed "free-word plates". Having become the essential organ of Futurist theory, journalism and creativity, it was later supplanted locally by *L'Italia Futurista* (1916-18), edited first by Bruno Corra, then by Arnaldo Ginna and Emilio Settimelli. (ECr)

Larionov, Mikhail Fedorovich

(Tiraspol, Bessarabia, 1881 - Fontenay-aux-Roses, France, 1964) Russian painter

Larionov entered the Moscow Institute of Painting, Sculpture and Architecture in 1898 and only left ten years later. He was expelled three times because of disagreements with the faculty and always preferred to work in his own studio rather than follow academic teaching. Until 1906, however, he was influenced by his teachers, V. Serov and Isaac Levitan, who were among the first to support Impressionism in Russia. In 1906 Larionov and his companion Goncharova were invited to Paris by Diaghilev and their paintings were shown at the Salon d'Automne in the rooms decorated by Léon Bakst.

On his return to Russia, Larionov became friendly with the Burliuk brothers and together they organized the Zvierjok exhibition, and with Kuznetsov, Yakulov, Sarian and other artists, founded the Blue Rose group. This marked the beginning of Larionov's Neo-Primitivist period inspired by Oriental art, icons, *lubok* (traditional Russian woodblock illustrations) and shop signs. In 1908, financed by the great art merchant and patron Nikolai Riabushinsky, he organized the first Golden Fleece exhibition, where his Russian friends appeared side by side with French painters like Pissarro, Cézanne, van Gogh, Matisse, Derain and Braque. In 1908 he was called up for military service. The nine months he spent in the army produced the "soldiers" and "hairdressers" which he presented at the third Golden Fleece exhibition, in December 1909. A year later, at the Jack of Diamonds show which he organized together with the Burliuk brothers, Larionov was already vaguely hinting at Rayonism, the theory he was beginning to apply in his paintings without abandoning his Primitivist style (the *Venus* series and *The Seasons*). At the show organized by The Target in Moscow in 1913, Larionov presented sixteen pictures and on the same occasion published the *Rayonist Manifesto*, signed by eleven artists.

On the eve of the First World War,

Lacerba, 1 November 1914

Larionov, telegram to Apollinaire

Larionov and Goncharova accompanied Diaghilev's Ballets Russes to Paris, where Paul Guillaume organized a big exhibition of their work with a catalogue introduction by Apollinaire. Having returned to Russia at the outbreak of the war, Larionov was sent to the front. Discharged in 1915 following serious injuries, he joined Diaghilev and his troupe in Switzerland and accompanied them to Spain and Italy. In January 1917, in Rome, Larionov met the Italian Futurists, including Marinetti and Prampolini. In 1919 he settled in Paris, where he remained for the rest of his life. While continuing to paint, he devoted more and more time to theatre design, particularly for the Ballets Russes (he published a history of the company in 1930).

Even more so than in the case of Malevich, Larionov's relationship with Futurism was complex and ambiguous. He was familiar with developments in Western art and was careful not to be caught up in them — he wanted to take only elements which could serve to create a truly original art. His Primitivist works are deeply rooted in traditional Russian culture (they are in line with the literary experimentation of the Hylaea group, that of Kamensky in *The Mud Hut*, and even more, with Khlebnikov's work) and are unlike anything being produced at that time in the West by Fauvism or Expressionism. The concern with light and movement that was so important to the Italian Futurists was partly anticipated by Larionov in paintings from 1904-06 like *The Rain* or *Fish at Sunset*. This explains his hostile declarations when Marinetti arrived in Russia. However, it is certain that his Rayonism, his way of breaking up the picture into force-lines, was influenced by the theories of the Italians, which he knew. Larionov and Goncharova's Rayonism would probably not have been so radical if they had not been wishing to emulate the Italian Futurists. Larionov's abandonment of easel painting in favour of a more immediately dynamic art — theatre, dance, ballet — was in line with his dual passion as a painter, for popular art and movement in life. (SZ-SF)

Latin America

At the beginning of the century, the great figure of modern Latin American literature was the Nicaraguan Rubén Darío (1867-1916). He lived in Europe and was close to Symbolists like Rémy de Gourmont, and younger writers like Juan Ramón Jiménez and Gabriel Alomar. It was therefore natural that Marinetti should invite him to contribute to *Poesia*. Darío took note of early Futurism but did not participate in the movement. Although the Futurist manifesto was translated into Spanish soon after its appearance in 1909, the first serious profession of faith in a Futurist development of Latin American art came only in 1913, when the Chilean Vicente Huidobro (1893-1948) wrote in his publication, entitled *Azul* in homage to Darío: "Today we are living in another age and the true poet is the one who can vibrate with his time or precede it without looking back." Huidobro believed that the world should be re-invented in complete opposition to Realism; he called this Creationism and supported it in America, France and

Spain. In 1917 he was close to Pierre Reverdy and the Cubists, then to the Spanish Ultraists the following year. But although Futurism was certainly useful to him in elaborating his own theories and he showed sympathy to related movements (Ultraism, Stridentism), he remained totally hostile towards the Italian movement and strongly condemned it in *Pasando y pasando* (Santiago, 1914) and again in his *Manifestes* (Paris, 1925). However, he had much in common with Marinetti: bilinguism, a taste for manifestos and an interest in typographical experimentation (his first ideographic poems appeared in *Canciones en la noche* in 1913).

From Torres-Garcia to Siqueiros, many Latin Americans met up in Spain, particularly in Barcelona. Here the Uruguayan Barradas created Vibrationism, and Ultraism gained the active support of the Argentine Jorge Luis Borges and his sister Nora. When Borges returned to Argentina at the end of 1921 he introduced Ultraism there by publishing several manifestos, while the periodical *Martín Fierro* and the painter Pettoruti introduced Cubism and Futurism. During the Twenties, there were signs of interest in Futurism in several Latin American countries, but the Futurist-related movement which really triumphed in America was Mexican Stridentism.

The history of Brazil's relationship with Futurism is more complicated. Although the first Futurist manifesto was published in Brazil in 1909, the same year as it appeared in *Le Figaro*, it had no consequences, while the Brazilian Ronald de Carvalho, a contributor to the magazine *Orfeu*, introduced Pessoa, Sá Carneiro, Santa Rita, Almada-Negreiros and Portuguese Futurism to Brazil. Mario de Andrade (1893-1945) knew Soffici's books, but he was influenced by Verhaeren and the French avant-garde, as were all the Brazilian Modernists, writers and painters alike. At the end of 1921 Oswald de Andrade (1890-1954) consigned Futurism to oblivion: "Theoretical, accomplished Futurism has not just died in Italy — it died a long time ago. Which is not to say that it was not responsible for a great artistic renewal, whose echoes have even reached Brazil." (SF)

Laurens, Henri
(Paris, 1885 - Paris, 1954) French sculptor, engraver and collagist

Henry Laurens had no more than academic preparation when he met Braque in 1911; this was the period when Braque was attempting to transpose the Cubist experience into three dimensions with cardboard constructions, an idea which Picasso and Boccioni were to take up in their turn, using more durable materials. Laurens, won over by Cubism, also saw in 1914 Archipenko's first sculptures in polychrome wood. His first really personal sculptures date from 1914-15.

During the decade in which he developed his own Cubist idiom, he showed a typically Futurist interest in expressing movement, both in the choice of subjects and in the expressive means: lively colours, pointed shapes, precariously balanced structures — from the *Clown* in polychrome wood of 1915 to the collage of the dancer *Josephine Baker* of 1925. (SF)

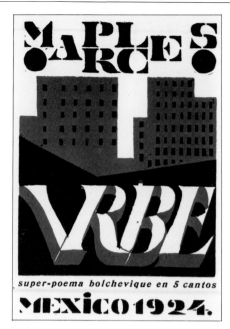

J. Charlot, cover for Urbe, *1924*

F. Léger, cliché for the Mechanical Ballet

Leal, Fernando
(1897 - 1964) Mexican painter

He completed his studies with Siqueiros, Revueltas, Alva de la Canal and many other Mexican painters who later executed mural paintings. Like his friend Jean Charlot, Leal was an important fellow-traveller of Stridentism and one of the first to make woodcuts. An impassioned reader of Mallarmé's *Un coup de dés jamais n'abolira le hasard*, he arranged to have *Metropolis* (a translation by John Dos Passos, completed in 1929, of the poem *Urbe* by Maples Arce) published in the same format, with his hand-painted woodcuts as illustrations. (SF)

Ledentu, Mikhail
(St. Petersburg, 1891 - Caucasus, 1917) Russian painter

After attending courses at the Theater Institute of his native city until 1907, Mikhail Ledentu was active in the Youth Union, an association that brought together both artists and theatre people. His chief contribution in this area was his effort to involve the spectators and to have them participate in the on-stage action. Alongside the brothers Kyril and Ilia Zdanevich, who were his close friends, he discovered the work of the Georgian primitive painter Niko Pirosmanishvili. From 1911 onwards Ledentu exhibited with Larionov, Malevich, and Tatlin at the "Donkey's Tail", "The Target", and the "No. 4" shows. Ledentu's paintings, which clearly show the influence of Futurism and Rayonism, are few in number but sufficient to gain him a place among the finest painters. After his early death in an accident, Ilia Zdanevich made him the prototype of the modern painter in his spectacular book *Ledentu, the Lighthouse* (1923). (SF)

Le Fauconnier, Henri
(Hesdin, Paris, 1881 - Paris, 1946) French painter

Henri Le Fauconnier made his debut at the Salon des Indépendants in 1905. He became known in Russia, where he showed in most of the avant-garde exhibitions between 1908 and 1914. Representing a moderate Cubism, his painting *Abundance* attracted considerable attention in the "Cubist" room at the 1911 Indépendants; Malevich and Marinetti were particularly interested in the treatment of the subject, divided into multiple facets. Between 1914 and 1920 Le Fauconnier lived in Holland, where he evolved towards a more Expressionist painting. (SF)

Léger, Fernand
(Argentan, 1881 - Gif-sur-Yvette, 1955) French painter

Fernand Léger studied architecture before turning to painting. His earliest efforts show the influence of Impressionism, but the retrospective show of Cézanne's works at the "Salon d'Automne" in 1907 revolutionized all his previous conceptions. Having taken up residence in La Ruche, he met Chagall, Archipenko, Csáky, Laurens, and Apollinaire. But his best friend was Delaunay; a short time later he also became a close friend of Cendrars. From 1910 onwards he was often among the Puteaux group at the home of the Duchamp bro-

thers, with Gleizes, Metzinger, Kupka and a few others. Léger's Cubism was extremely personal from the very beginning, far more colorful and dynamic than that of most of his fellow painters. The *Nudes in the Forest* that he exhibited at the Salon des Indépendants in 1911 slightly disconcerted Apollinaire: "Léger still has the least human accent in the room. His art is difficult. He creates, if one may say so, cylindrical painting, and has not attempted to avoid giving to his compositions the wild appearance of stacked tyres." (Did reproductions of paintings of this sort fall into Malevich's hands? It is certainly a possibility.) This mechanomorphic aspect was to become more marked in Léger's painting, and he himself never had any doubts about what Marinetti called "mechanical beauty". The nudes rushing along in *The Stairway* (1914) and swarming in *The Wedding*, (1911) look like robots. Compared to the art of Picasso, Braque, and Juan Gris in that period, Léger proposed far greater mobility — something which might have brought him towards the Futurists. "The existence of creative men", he wrote, "is far more crowded and complicated than that of men who lived in previous centuries. The image is much less stable, the object per se is much less observable than it used to be. A landscape that is crossed and divided by an automobile or an express train diminishes in descriptive value but gains in synthetic value; the windows of railway carriages and the windshields of automobiles, added to the new speed, have changed the habitual appearance of things." Léger was too profoundly independent to join an organized group, although Apollinaire listed him with the Orphists because of his love of color, or the Simultaneists because the contrast of colors and shapes seemed too essential to the life of a painting — two groups which existed only in the mind of the French poet for practical purposes of classification. Léger however did not scorn teamwork. With Cendrars he created the splendid edition of *J'ai tué* (*I Have Killed*) and *La fin du monde* (*The End of the World*. In 1921 he designed the scenery and costumes for the Swedish ballet *Skating Rink* by Canudo and Honegger, and in 1923 the sets for *La création du monde* (*The Creation of the World*) by Cendrars and Milhaud. He collaborated in the set-design for the film *L'inhumaine* (*The Inhuman*, 1923) by Marcel L'Herbier (and later for *The Shape of Things to Come* by H.G. Wells). With Man Ray and Dudley Murphy, with music by Georges Antheil, he himself created the first film without a screenplay, *Le ballet mécanique* (*The Mechanical Ballet*, 1924), a rhythmic *assemblage* of objects in motion and characters treated as inanimate objects. This lack of sentimentality, this mechanization of the world throughout his work, is the element that brings Léger closest to Futurism. (SF)

Wyndham Lewis in front of Woman Climbing a Staircase, *in* The Daily News *1914*

A.L. Coburn, Portrait of Wyndham Lewis, *1916*

Letter, Futurist

Being well aware of the importance of spreading information, the Futurists were interested in the development of postal communication in the 20th century — the speed of telegrams, the convenience of postcards. Besides this technical aspect, they also saw the expressive possibilities of letters and postcards, and even telegrams — Marinetti wrote signs and words-in-freedom on telegram forms. Mallarmé had already observed that a quatrain matched the format of a letter, but the Futurists went further and systematically redesigned the forms of correspondence in various ways: from drawn and painted letters and postcards (Balla, for example) to the printed sheets prepared by Cangiullo in 1915 which left spaces for only a few chosen words to be filled in (oddly, during the Second World War in certain occupied countries like France, this form of elliptical communication became a system imposed by the censorship). Having experimented with books made of tin, the Second Futurism even created a few examples of metal postcards. (SF)

Lewis, Percy Wyndham
(Amherst, Nova Scotia, 1882 - London, 1957)
British painter and writer

Although Wyndham Lewis's father was American, his British mother was largely responsible for his upbringing. He was educated at Rugby School and then studied at the Slade School of Fine Art in London (1898-1901). Lewis spent the next eight years in an oddly indecisive state. His interest in writing both poetry and prose was also developing, and it probably prevented him from committing himself full-time to drawing and painting. He travelled restlessly, visiting Madrid with his friend Spencer Gore, Holland, Munich and above all Paris, where he lived for several years and heard Bergson lecture at the Collège de France. Here he started to paint, and in 1907 his great friend Augustus John saw *Les Demoiselles d'Avignon* in Picasso's studio. Lewis probably heard about the painting from John, but he was not yet ready to pursue a singlemindedly experimental path. John, an older artist already enjoying considerable acclaim in Britain, inhibited Lewis. He found more satisfaction in writing short stories about the itinerant acrobats and assorted eccentrics he encountered during his travels in Brittany. Lewis's first success came in 1909, when Ford Madox Ford published several of these short stories in *The English Review*. But the drawings which survive from this period, like *The Theatre Manager* (1909), show that Lewis the artist was still caught uneasily between several disparate influences. A growing interest in primitive art and Cubism is married, rather awkwardly, to his interest in Dürer and Leonardo's grotesque heads.

By 1912, however, Lewis had decided to devote more of his energies to art. He had already appeared in two exhibitions of the Camden Town Group (June and December 1911), where his interest in harsh distortions marked him out from the other members. But Lewis really began to define his own vision when Madame Strindberg commissioned him to make murals, stage-

paintings and other designs for her new Cabaret Club in London. It became known as the Cave of the Golden Calf, and other decorations were provided by Jacob Epstein, Eric Gill, Spencer Gore and Charles Ginner. Lewis's contributions were outstanding, especially a large painting called *Kermesse* (1912). Here his alert awareness of Cubism, Futurism and Expressionism was conveyed in an individual way — bleak, incisive and charged with ferocious energy. In this arresting canvas of three dancing figures Lewis became a mature painter, and he fortified his reputation when Roger Fry included his illustrations to Shakespeare's *Timon of Athens* in the "Second Post-Impressionist Exhibition" (1912-13).

Like Timon, Lewis adopted an adversarial stance. Restless, satirical and ceaselessly productive, he had no patience with most of the art then produced in Britain. His ability as a draughtsman was already outstanding, with a distinctive emphasis on whiplash line. At this stage he admired Marinetti's forceful advocacy of an art that would match the dynamism of a new century. He also respected Picasso and Matisse, as well as admiring the black harshness of the German Expressionist woodcut.

Roger Fry enlisted Lewis's services when the Omega Workshops opened in the summer of 1913. He executed a painted screen, some lampshade designs and studies for rugs, but his dissatisfaction with the Omega soon erupted into antagonism. No longer willing to be dominated by Fry, Lewis abruptly left the Omega with Edward Wadsworth, Cuthbert Hamilton and Frederick Etchells in October 1913. By the end of the year he had begun to define an alternative to Fry's exclusive concentration on modern French art. His essay for the "Cubist Room" section of "The Camden Town Group and Others" exhibition in Brighton (1913-14) announced the emergence of a more volcanic group of artists, far more involved with the machine age than Fry would ever be. At the same time Lewis carried out a startling decorative scheme for Lady Drogheda's dining-room in Belgravia, shrouding the walls in black, mirrored panels and painting a semi-abstract frieze underneath the ceiling. Its fierce austerity challenged the more gentle mood of the Omega's interiors, and aroused a great deal of controversy. Lewis was becoming the most hotly debated young painter in Britain, and he established a rival to the Omega when the Rebel Art Centre was founded in March 1914. Many of the artists who allied themselves with the Vorticist movement attended the Rebel Art Centre, including Wadsworth, Hamilton, Gaudier-Brzeska, Atkinson, Dismorr and Saunders. Ezra Pound also supported it warmly, and he joined forces with Lewis to bring about the birth of Vorticism.

The movement finally emerged in the rumbustious magazine *Blast* (July 1914), which Lewis edited. He also wrote many of the essays it contained, and illustrated a wide selection of his work in its large, boldly designed pages. Lewis had by now defined his opposition to Marinetti and the Italian Futurists. He objected to the way Futurism rhapsodised about the machine age, and he also disapproved of the emphasis on blurred movement in their work. Lewis opted for hardness and clarity of definition in his own art. However explosive his Vorticist designs may be, they are always enclosed by decisive contours. The skyscraper forms of the modern city may sway and induce vertiginous sensations, but Lewis insists on structural lucidity. Vagueness and indistinct forms were abhorrent to him. He wanted his Vorticist work to take on some of the character of the machines which fascinated him, and he hoped Vorticism would be able to develop an art that made people more aware of the rapidly changing character of modern life.

The First World War frustrated that hope. No sooner had *Blast* been published than war was declared, and Lewis had very little time to build on the Vorticist initiative. He was able to pursue his interest in large-scale schemes, decorating the study of Ford Madox Ford's London house with blazing red murals and then devising a complete "Vorticist Room" for the Restaurant de la Tour Eiffel in Percy Street (1915-16). He also organized London's only Vorticist Exhibition in June 1915, and produced a second issue of *Blast* (a "war number") at the same time. But the entire country was being overtaken by the escalating war, and in 1916 Lewis joined the army as a gunner.

His experiences in the war served him well as an artist. He painted two enormous canvases based on his memories of life in a gun pit, and one of them (*A Battery Shelled*, 1919) is among his finest achievements. But it also revealed that Lewis was returning to a more representational style, and leaving his Vorticist concerns behind. The destructive power of a war dominated by terrible mechanical weapons altered Lewis's attitude towards the machine age. He also felt, in common with many other artists, that he needed to submit himself to the discipline of drawing from life again. His first one-man show, held at the Goupil Gallery in February 1919, contained many drawings of the war in a frankly figurative style.

Lewis's move towards a more representational idiom was prompted, too, by his fast-developing interest in writing fiction. His first novel, *Tarr*, was published in 1918, and in later life Lewis devoted an increasing amount of his formidable energy to writing. The exhibition called "Group X", held at the Mansard Gallery in spring 1920, brought together many of the artists formerly associated with Vorticism. But it was more of an end than a beginning, and they never again joined forces for group activities. From now on Lewis, the self-styled "enemy", was a man alone. (RC)

Livshits, Benedikt
(Odessa, 1886 - 1939) Russian writer

Benedikt Livshits was writing Neo-Symbolist verse when the painter Alexandra Exter introduced him to David Burliuk at the end of 1911. Along with the Burliuk brothers he joined the Primitivist and Proto-Futurist group called "Hylaea". To the collective publication *The Cracked Moon* (1913), Livshits contributed an essay entitled *The Liberation of the Word* in which, on behalf of the Futurist group, he made a declaration of anti-realist faith in favour of a form of poetry that would be close to music and painting. "Our poetry is free and for the first time we need not worry whether it is realistic, naturalistic, or fantastic — after its point of departure, it has no relationship at all with the world around; any meeting-point between this poetry and the world is *a priori* accidental." Pushed by Khlebnikov, who was violently hostile to Marinetti, Livshits added his signature to the anti-Marinetti pamphlet published on the occasion of the Italian poet's visit to Russia (January 1914). From that time on Livshits refused to be considered a Futurist, although his main collection of poems *Sun of Wolves* (1914) appeared with that denomination; it also contained translations of Corbière and Rimbaud. Along with poems and translations of French poetry, Livshits also published a valuable memoir on Russian Futurism, *The Archer with One and a Half Eyes* (1933) before he disappeared in a Stalinist camp. (SF)

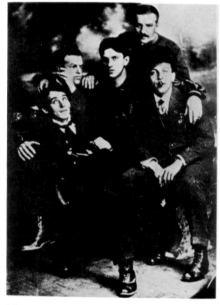

The Hylaea group: Kruchenykh, D. Burliuk, Maiakovsky, N. Burliuk, Livshits

London

London was the major artistic centre in England during this period as it has been ever since. Artists were attracted to the capital not only on account of the galleries and museums but also because it offered the broad cultural attractions of a thriving theatre (G.B. Shaw was at his height), a lively concert programme and good communications with the Continent. In addition it could boast an important assembly of literary and artistic men and women, many of them enforced or self-inflicted exiles from other countries, who would meet regularly at private salons (for example, the salon hosted by Mrs Kibblewhite, a friend of T.E. Hulme, was of particular interest to the Vorticists) or in bars and restaurants such as the Café Royal or the Restaurant de la Tour Eiffel, the latter immortalized in a well-known painting by William Roberts. English art was dominated at the beginning of this period by two London-based groups in particular, the New English Art Club (including Augustus John) and the Camden Town Group (including Walter Sickert). Both these groups promoted an Impressionist and Post-Impressionist manner of painting which was acceptable to the public. Cubism, Futurism and Vorticism had little impact on those artists who, after the burgeoning of Vorticism, remained within these groups. By 1913 Cézanne, Gauguin and Van Gogh were generally accepted as masters and frequently held up as paradigms by the press.
The more avant-garde exhibitions, such as Fry's two Post-Impressionist exhibitions and the Futurist and Vorticist shows, were exceptionally well-attended and given very wide coverage in the press. However press reporting was generally derogatory, especially in the most widely read newspapers which seized upon new developments with alacrity because of their potential for sensationalism and mockery. For example, the *Daily Sketch* deliberately reproduced Delaunay's *Cardiff Football Team* upside down "in order to show it doesn't matter". Not a trick was to be missed. Nevertheless, the news of the publication of both *Vital English Art* and *Blast* was widely reported and seriously discussed even in provincial newspapers.
London was also an important exhibiting centre for avant-garde artists. The Allied Artists Association, for example, held an annual salon to which Kandinsky, Brancusi and Zadkine among others contributed works, and other exhibitions contained works by Picasso, Matisse, the Italian Futurists and others. After the war a new generation of private galleries opened and mounted many more exhibitions displaying continental developments in art. Prior to the war, however, true awareness of what was happening abroad, particularly in Paris, could only be achieved through travel which Lewis, Epstein, Wadsworth, Nevinson and others undertook. (JL)

AN IMPRESSION OF THE FUTURIST LEADER.

M. Marinetti, the leader of the Futurist movement in London, declaiming one of his poems at the Cabaret Club on Sunday.

Caricature of Marinetti in London by Horace Taylor

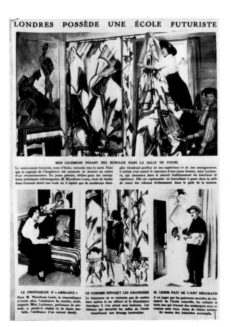

LONDRES POSSÈDE UNE ÉCOLE FUTURISTE

"London has a Futurist School"

Love and Sexuality

The phenomenon of love as a hub on which a romantic and emotional conception of the relationship between man and woman revolved was rejected by the Futurists, who preferred instead a collision between the two sexes. Indeed they exalt it; as Marinetti said in *Contro l'amore ed il parlamentarismo* (*Against Love and the Parliamentary Process*), "the war between the sexes has been unquestionably prepared by the great agglomerations of the capital cities, by nocturnal habits, and by the regular salaries given to female workers". Since the conflict pivots on the inequality between the contenders and on the destructive value of erotic energy, the Futurists — in open contradiction to their enthusiastic support of the suffragettes and the feminist movements in the early part of the century — establish in the worst sexist tradition that masculinity corresponds to positivity, superiority and creative intelligence, while femininity corresponds to negativity, inferiority, the animalistic. Veiled behind an apparent rejection of the bourgeois idealization of woman, in the social archetypes of male and female in the Futurist movement — beginning with the first manifesto — we see the existence, alongside the "contempt for women", of a terror that opening oneself emotionally may result in a loss of power. Although she was a threat because of her negative values, the female could also be "used" to propagate panic in the political system and poison the territory of the family: "Women hasten to give, with lightning speed, a great proof of the total animalization of politics... the victory of feminism, and especially the influence of women on politics will in the end succeed in destroying the principle of the family." Aside from this disruptive and poisonous function, women remained inferior subjects, to be exploited in their roles as mothers.
Marinetti's masculine hysteria — in 1916 he wrote *Come si seducono le donne* (*How to Seduce Women*) — provoked a reaction from Valentine de Saint-Point in the *Manifesto of the Futurist Woman* (1912). She attempted to awaken the conscience of the movement by declaring that it was absurd to divide humanity into groups of creatures with different attributes, and proposed a new differentiation according to the principles of "femininity" and "masculinity", which — once they were channelled into society — would return to the single principle of "virility". Saint-Point meant by "virility" an absolute energy: it constituted an outlet and a stimulus that enabled one to overcome all resistance. Futurism was therefore continuing to reserve for the male all sexual pleasure (victory and the successful passage through all obstacles), reinforcing feminine dependency: women can find fulfillment by identifying themselves with the men who possess them. Saint-Point's successive *Futurist Manifesto of Lust* (1913) defended this sexual system by establishing that "the pleasures of the flesh are the weapon of the conqueror". It justified rape and annihilation of the passive and past-oriented society. Aggression is carried out in the name of the pleasures of the flesh and of the desire to fertilize the world with creativity. The

world deserves rape since it is available and inferior before the ardent and dynamic glance of Futurism.

The insolent lust for possession displayed by Marinetti and his fellow Futurists tended to seduce and then strip bourgeois culture of all its moral and emotional defenses (though in Futurist iconography the nude was banned and rarely appeared). What counted was the penetration of Futurist ideas: "Coitus," Marinetti wrote, "aims at the Futurism of the species." Woman and society emerge from anonymity when selected by the hero. Marinetti's doctrine of inequality corresponds to the development of custom: an aristocratic view of the male caste was perpetuated, but access to it was conceded to women. Valentine de Saint-Point continued to depict the sovereignty of one sex over the other and she referred to herself as "chosen among the chosen". Chosen by the Futurists, she accepted their authority unquestioningly, so that the movement became a "family" of intellectuals, with Marinetti as the "father". Portraits by Futurist sculptors and painters were devoted to the theme of "father" and "mother". For Futurism there was only one woman — the mother — who with her immense natural energy conquered and absorbed the totality of the world; while the beloved male was the father — Marinetti — accumulator of a vital charge as a being capable of performing the possible and the impossible through his infinite fertility. (GC)

Futurist Manifesto of Lust

(Futurist manifesto, Paris, 11 January 1913)

A reply to those dishonest journalists who twist phrases to make the Idea seem ridiculous; to those women who think what I have dared to say; to those for whom Lust is still nothing but a sin; to all those who in Lust find only Vice, just as in Pride they find only Vanity.

Lust, when viewed without moral preconceptions and as an essential part of the dynamism of life, is a force.

Lust is not, any more than pride, a mortal sin for the race that is strong. Lust, like pride, is a virtue that urges one on, a powerful source of energy.

Lust is the expression of a being projected beyond itself. It is the painful joy of perfected flesh, the joyous pain of a flowering. And whatever secrets unite two beings, it is a union of flesh. It is the sensory and sensual synthesis that leads to the greatest liberation of spirit. It is the communion of a particle of humanity with all the sensuality of the earth. It is the panic shudder of a particle of the earth.

Lust is the quest of the flesh for the unknown, just as Cerebration is the spirit's quest for the unknown. Lust is the act of creating, it is Creation.

Flesh creates just as the spirit creates. In the eyes of the Universe their creation is equal. One is not superior to the other and creation of the spirit depends on that of the flesh.

We possess body and spirit. To curb one and develop the other is evidence of weakness and is wrong. A strong man must realize his full bodily and spiritual potential. The satisfaction of their lust is the conquerors' due. After a battle in which men have died, *it is natural for the victors, proven in war, to turn to rape in the conquered land, so that life may be re-created.*

When they have fought their battles, soldiers seek sensual pleasures, in which their constantly battling energies can unwind and be renewed. The modern hero, the hero in any field, experiences the same desire and the same pleasure. The artist, that great universal medium, has the same need. And the exaltation of the initiates of those religions still sufficiently new to contain a tempting element of the unknown, is no more than sensuality diverted spiritually towards a sacred female image.

Art and war are the great manifestations of sensuality; lust is their flower. A people esclusively spiritual or a people exclusively carnal would be condemned to the same decadence — sterility.

Lust excites energy and releases strength. Pitilessly it drove primitive man to victory, for the pride of bearing back to a woman the spoils of the defeated. Today it drives the great men of business who direct the banks, the press and international trade to increase their wealth by creating centres, harnessing energies and exalting the crowds, to adorn, increase and glorify with gold the object of their lust. These men, weary but strong, find time for lust, the principal motive force of their action and of the reactions caused by their actions affecting multitudes and worlds.

Even among the new peoples where sensuality has not yet been released or acknowledged, and who are neither primitive brutes nor the sophisticated representatives of the old civilizations, woman is equally the great galvanizing principle to which all is offered. The secret cult that man has for her is only the unconscious drive of a lust as yet barely awakened. Amongst these peoples as amongst the peoples of the North, but for different reasons, lust is almost exclusively concerned with procreation. But lust, under whatever aspects it shows itself, whether they are considered normal or abnormal, is always the supreme spur.

The hard life, the life of energy, the life of the spirit, sometimes demand a respite. And effort for effort's sake calls inevitably for effort for pleasure's sake. These efforts are not mutually harmful but complementary, and realize fully the total being.

For heroes, for those who create with the spirit, for dominators of all fields, lust is the magnificent exaltation of their strength. For every being it is a motive to surpass oneself with the simple aim of emerging, of being noticed, chosen, picked out.

Christian morality alone, following on from pagan morality, was fatally drawn to consider lust as a weakness. Out of the healthy joy which is the flowering of the flesh in all its power, it has made something shameful and to be hidden, a vice to be denied. It has covered it with hypocrisy, and this has made a sin of it.

We must stop despising Desire, this attraction at once delicate and brutal between two bodies, of whatever sex, two bodies that want each other, striving for unity. We must stop despising Desire, disguising it in the pitiful clothes of old and sterile sentimentality.

It is not lust that disunites, dissolves and annihilates. It is rather the mesmerizing complications of sentimentality, artifical jealousies, words that inebriate and deceive, the rhetoric of parting and eternal fidelities, literary longings — all the histrionics of love.

We must get rid of the dark debris of romanticism, counting daisy petals, moonlight duets, heavy endearments, false hypocritical modesty. When beings are drawn together by a physical attraction, let them — instead of talking only of the fragility of their hearts — dare to express their desires, the inclinations of their bodies, and to anticipate the possibilities of joy and disappointment in their future carnal union.

Physical modesty, which varies according to time and place, has only the ephemeral value of a social virtue.

We must bring awareness to lust. We must make of it what a sophisticated and intelligent being makes of himself and of his life; *we must make lust into a work of art.* To allege unawareness or confusion to explain an act of love is hypocrisy, weakness and stupidity.

We should desire a body consciously, like any other thing.

Love at first sight, passion or failure to think, must not prompt us to be constantly giving ourselves or taking others, finding inevitably disappointment when tomorrow comes. We must choose intelligently. Guided by our intuition and will, we should compare the feelings and desires of the two partners and unite and satisfy only those that complement and exalt each other. With the same awareness and the same guiding will, the joys of this coupling should lead to the climax, develop its full potential, so that all the seeds sown by the merging of two bodies may flower. Lust should be made into a work of art, formed like every work of art, at once instinctively and consciously.

We must strip lust of all the sentimental veils that disfigure it. These veils were thrown over it out of cowardice, because smug sentimentality is so satisfying. Sentimentality is restful and therefore diminishing.

In one who is young and healthy, when lust clashes with sentimentality, lust is victorious. Sentiment is a creature of fashion, lust is eternal. Lust triumphs, because it is the joyous exaltation that drives one beyond oneself, the delight in possession and domination, the perpetual victory from which the perpetual battle is born anew, the headiest and surest intoxication of conquest. And as this certain conquest is temporary, it must be constantly won anew.

Lust is a force, in that it refines the spirit by bringing to white heat the excitement of the flesh. The spirit burns bright and clear from a healthy, strong flesh, purified in the embrace. Only the weak and the sick sink into the mire or are diminished. And lust is a force in that it kills the weak and exalts the strong, aiding natural selection.

Lust is a force, finally, in that it never leads to the insipidity of the definite and the secure, doled out by soothing sentimentality. Lust is the eternal battle, never finally won. After the fleeting triumph, even during the ephemeral triumph itself, reawakening dissatisfaction spurs a human being, driven by an orgiastic will, to expand and surpass himself.

Lust is for the body what an ideal is for the spirit — the magnificent Chimaera, that one ever clutches at but never grasps, and which the young and the avid, intoxicated with the vision, pursue without rest.
Lust is a force.

Valentine de Saint-Point

Lucini, Gian Pietro
(Milan, 1867 - Como, 1914) Italian poet and writer

While Lucini can be considered a representative of Lombard Scapigliatura, he can also be seen as a leading figure in "Italian Symbolism". Lucini, who was extremely well informed on events in France, tried to transplant Symbolist poetics into Italy, both in his theoretical writings (*Pro Simbolo*, 1896-97) and in his numerous collections of poetry. As a poet he was far from remarkable (somewhere between D'Annunzio and late Scapigliato), and his greatest achievement is that of having been the forerunner of a few Futurist themes and of having inspired in Marinetti several of the fundamental tenets of his literary ideology. In this connection, Lucini's most important work is *Il verso libero* (*Free Verse*), published in 1908 by the Edizioni di Poesia, founded and directed by Marinetti. In this weighty tome one finds "totalitarian" essays typical of the early 20th century. Here Lucini, with vast erudition and at times great historical and critical perceptions, sets forth his "ragione poetica", an exhaustive aesthetic theory. The structure underlying this theory is a typical philosophical approach to "becoming", containing elements of Hegelian thought and a pervasive Nietzschean influence combined with Spencer's Evolutionism. These philosophical references were specifically adopted by Marinetti. From a more literary point of view, Lucini proposed the "shaking off of habits", and the use of "free verse, that long poetic word". These theories were adopted by Marinetti, who pushed them to the point of incandescence. The *fare nuovissimo*, or new approach, that Lucini proposed became for Marinetti a *tabula rasa* preceding poetic values; and free verse was replaced by "words-in-freedom", in an effort to create, the erasing of new poetry appropriate to the new epoch. This led to a break between the two writers. In reality Lucini was in favour of an "old-and-new" in literature, and wanted to find a form that reconciled the modern and the traditional. "An amazingly fiery fossil", is how Marinetti described him — a felicitous and still valid definition. Lucini is a great transitional figure who pointed the way to many of Futurism's themes. (LDM)

Lumière, Auguste and Louis
(Besançon, 1862 - Lyon, 1954; Besançon, 1864 - Bandol, 1948) French inventors

Because of their love for technology and the machine environment, the cinema certainly played a central role for the early Futurists. The first movie presentation had taken place in Paris on the evening of 28 December, 1895. What the Lumière Brothers then presented to the public was the practical realization and commercialization of what had been developed by Etienne-Jules Marey in Paris and Italy in the previous decades. The marriage between technology and art that was part of the Futurists' dream was eventually accomplished by the film industry, but in a way that is generally far from what the Futurists had envisioned. As so often happens, what seemed like an answer to a request developed into something entirely independent and different. There was nevertheless a strong influence from the Futurists in the exploitation of the Lumière machine, especially in Russia, with creators like Vertov, Eisenstein and others. (PH)

G.F. Lucini, The Usual Song of Melibeo *1910*

A. Magnelli, Lacerba, 1914, *Flinker Collection*

Macdonald-Wright, Stanton
(Charlottesville, 1890 - Pacific Palisades, 1973) American painter

Stanton Macdonald-Wright joined with Morgan Russell to exhibit as a Synchromist. He recruited his brother, the writer Willard Huntington Wright, to serve as a publicist for their work. Willard attacked Futurism, because he claimed that it "owed much of its fury to the flying machine craze and auto speeding" and had "succeeded only in giving us a disordered display of lines and colors". Despite his brother's criticism of Futurist subject matter glorifying movement, Macdonald-Wright painted *Aeroplane: Synchromy in Yellow-Orange* in 1920. This was a departure from his earlier synchromies which were based almost entirely on the figure, still life and landscape. Macdonald-Wright gave up painting synchromies in 1920 and only resumed nonobjective canvases during the Fifties. Several years after Morgan Russell's death in 1953, from 1959-1962, Macdonald-Wright also experimented with a kinetic color light machine, the Synchrome Kineidoscope, a varient of the invention he and Morgan Russel had envisioned as a joint project during the 1920s. (GL)

Magnelli, Alberto
(Florence, 1888 - Meudon, France, 1971) Italian painter

A self-taught artist, Magnelli came into contact with Papini, Soffici and Palazzeschi between 1911 and 1912. Much later he recalled: "In Paris there was Cubism, and then Orphism, but all that was far away and there were no contacts. In Florence I saw no one but the Futurists to whom I was deeply tied." In truth, although he tended toward abstraction from the beginning, his way of using colour recalled Matisse. He was not represented in Futurist magazines, nor at their exhibitions. Encouraged by Palazzeschi, he went to Paris in 1914; there he established friendships with Apollinaire, Picasso, Léger, Archipenko and others. During the winter of 1914-15 he painted the "completely invented canvases" to which he had been aspiring, abstract works whose cheerful energy shows how carefully he had observed the works of his Futurist friends. In 1917-18 his ellipses and angles gave way to some representational images — this was his period of "lyrical explosions". From the beginning of 1919 he returned to representation, and thereafter to abstraction, but all reference to Futurism disappeared. (SF)

Magritte, René
(Lessines, Belgium, 1898 - Brussels, 1967) Belgian painter

Magritte became acquainted with Cubist and Futurist painting in 1919 through the painter and poet Pierre-Louis Flouquet. A sporadic Futurist influence can be detected in his early works up to 1922; thenceforth he developed — like his friend Servranckx — a more static mode, finally creating his own particular form of Surrealism. (SF)

Maiakovsky, Vladimir

(Bagdali, Georgia, 1893 - Moscow, 1930)
Russian writer

Vladimir Maiakovsky very early became involved in a revolutionary commitment that several times led to his arrest and imprisonment (1908 and 1909). While a student at the Institute of Fine Arts of Moscow, he met David Burliuk who encouraged him to write poetry (1911). At the end of 1912, with Burliuk, Khlebnikov and Kruchenykh, he signed the manifesto *A Slap in the Face of Public Taste*, where they cheerfully threw overboard all classic and recognized writers, affirming: "We are the true face of our times." At the same time he published his first two poems, "Night" and "Morning", already very original although without the passion for neologisms to be found in Khlebnikov and Kruchenykh. Maiakovsky is already there in full, with his unbounded sentimentality and egocentrism, his anthropomorphic art in an urban setting. In February 1913, during a meeting for the second exhibition of the Jack of Diamonds, Maiakovsky declared himself a Futurist and thus launched the new Russian movement.

From then on, Maiakovsky appeared in every Futurist publication and event. The titles of his poems included in the anthology *The Croaked Moon* are very characteristic: "I", "Love", "Along the Echoes of the City", "On the Pavements of My Trampled Soul". With little or no punctuation, these poems were already set out with the particular serrated typography that was to become typical of Maiakovsky. It was also in 1913 that Maiakovsky started showing the first signs of an eccentric dandyism; he appeared at cabarets and recitals dressed in a disconcerting yellow blouse.

At the end of 1913, with Burliuk and Kamensky he started a tour of Cubo-Futurist recitals around the country that lasted several months, visiting Kharkov, Sebastopol, Odessa, Kishinev, Nikolaiev, Kiev, Minsk, Kazan, Samara, Rostov, Saratov, Tiflis, Baku, and other cities. Futurism spread very quickly; the artists consciously stirred up scandals by dressing outrageously in shocking colours, by painting their faces (following the example set by Larionov and Goncharova) or by wild behaviour. They poured tea over the audience, or rang church bells in their ears, going to any lengths to create publicity for themselves. Maiakovsky's tall silhouette was soon well-known.

The poet's first important work was certainly *Vladimir Maiakovsky: A Tragedy*, staged in St. Petersburg in December 1913. While his career as a film actor started only after the Revolution, on this occasion Maiakovsky played his own rôle, supported by a group of amateur actors. And a little later, in his *Flute of Vertebras* and *The Cloud in Trousers* (1915), he gave full voice to his dynamic rhetoric: "If you were as hungry as I am / you would have gnawed the farthest / of East and West / as the sky bone is gnawed / by the smoky mouths of factories..."

Though his tone at times recalled the Italian Futurists, in November 1913, in a lecture in Moscow, Maiakovsky denounced them as "men of fights and fists".

Maiakovsky was active and forceful, quick

V. Maiakovsky in the film Not Born for Money, *1918*

V. Maiakovsky and A. Rodchenko advertising poster

to intervene, and yet he was a peaceful man. At the outbreak of war, after a short burst of patriotic and belligerent excitement, he became disgusted by it. If any violence was left in him, it was only to send a call for revolution: "Take your hands out of your pockets and grab a stone, a knife, a bomb." In 1916 he wrote a long pacifist poem, *War and the Universe*. By this time Larionov and Goncharova had left, Malevich and Tatlin were looking in another direction, and so it was Maiakovsky, with his provocative clothing (and not the organizer Burliuk or the poet Khlebnikov) who became the real representative of Futurism.

Then came the Revolution. Maiakovsky was to explain: "October. Should we join or not? This was not a question for me (nor for the other Moscow Futurists). It was *my* revolution." In fact all the important Futurist artists supported it. When the leaders of the Revolution asked for the artists' help, Maiakovsky wrote a great popular play, *Mystery-Bouffe*, Meierkhold directed it and Malevich designed the sets. It is a simple, funny, science-fiction parable: after a planetary war, the human survivors start travelling towards the planet of the future. During this journey, the "pure ones", the old exploiters, reveal their mediocrity, while the "impure ones", the old exploited, show a generous pragmatism that allows for a beneficial revolution of objects and machines. It was an optimistic version of H.G. Wells's *The Time Machine*. Maiakovsky — who confessed that his childhood had been influenced by Jules Verne's novels — returned to science-fiction in his later plays, *The Bed Bug* and *The Bathhouse*.

Times changed. To the Futurist Maiakovsky it was clear that after the period of aesthetic revolution, now only a total revolution involving everyone would do. In 1918 he wrote: "We do not need art museums to worship dead works, we need living factories of the soul — in the streets, in the trams, in the factories, in studios, and in the workers' houses." From 1919 to 1922, Maiakovsky worked at the Rosta agency and invented hundreds of slogans, posters, advertising texts and images for the masses, where he praised the victories of the revolutionary army, the virtues of hygiene, of a certain brand of shoes or of rubber dummies. Blaise Cendrars, who proclaimed that "Poetry = Publicity", envied him his opportunity to address the masses. Maiakovsky claimed that this was some of the most useful work he had done. Referring to one of his slogans for the State department store he said: "I believe that *Nowhere / like at Mosselprom* is poetry of the highest order."

During 1919, the old Futurists created "Kom-Fut", an abbreviation for Communist-Futurism. Maiakovsky wrote: "Comrades, / give us a new art / that will drag from the mud / the republic!"

Yet Futurism could not face the new events (civil war, blockade, poverty and crises) without undergoing a further transformation. And this was what Constructivism did. Maiakovsky joined the group and in 1923 created LEF (Left Front of Art); in his manifesto he explained that this was a necessary historical transformation, and the

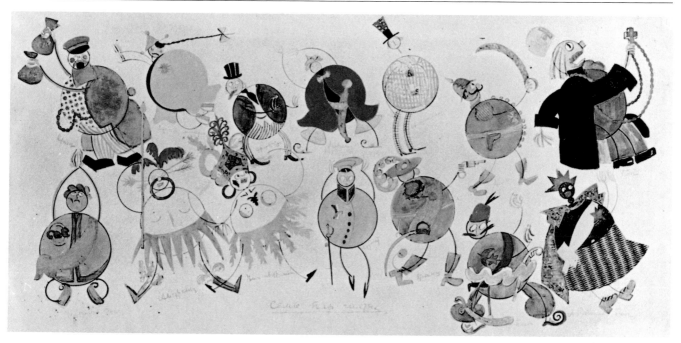

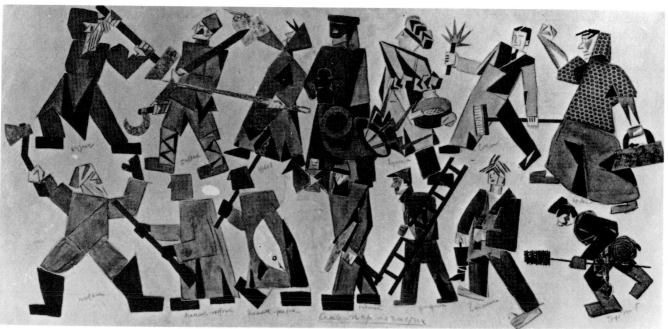

V. Maiakovsky, sketch for the "Pure" Mystery-Bouffe, 1918

V. Maiakovsky, sketch for the "Impure" Mystery-Bouffe, 1918

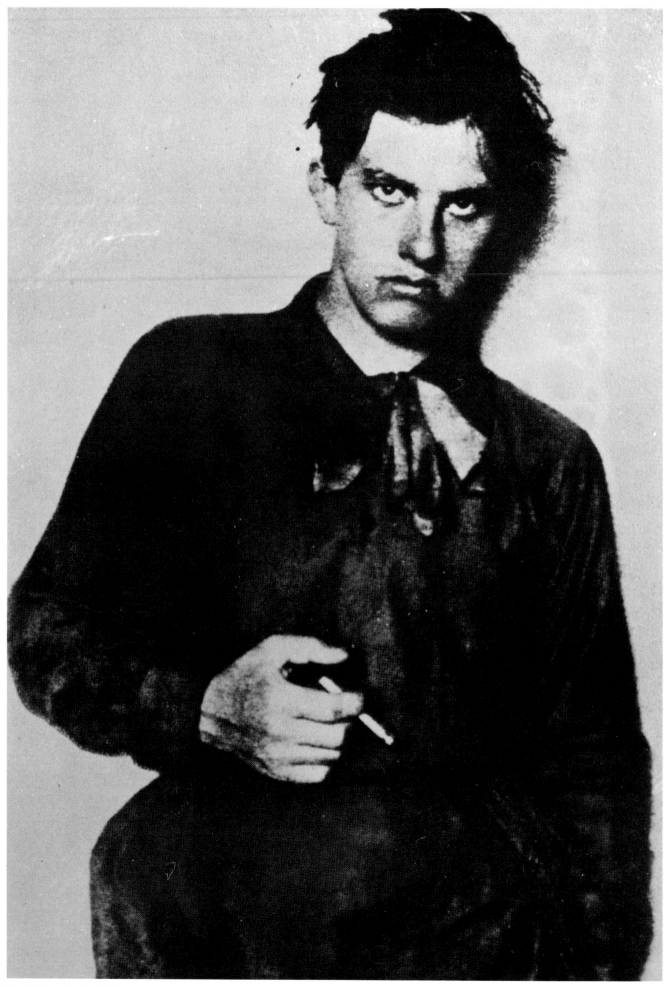

V. Maiakovsky in 1913

evolution of post-revolutionary Futurism: "October has purged, created, reorganized. Futurism has become the Left Front of Art. We have become ourselves." Several old friends like Kamensky and Kruchenykh collaborated with LEF but could not really adapt themselves to it. Only Maiakovsky succeeded in transforming his art to make it more accessible to the masses. He became one of the most famous Russian intellectuals and carried his aesthetic revolutionary message all over the world (just as he had carried Cubo-Futurism through Russia), to Europe, the United States, Mexico (1925) and Paris, Berlin, Prague and other capitals. He travelled, worked intensely, increased his publications, his lectures, his exhibitions until he broke down, became depressed and committed suicide. (SF)

Malevich, Kazimir
(Kiev, 1878 - Leningrad, 1935) Russian painter

With Larionov, Malevich is the most important of the Russian Cubo-Futurists, a term introduced by Malevich himself immediately after Cubist ideas had been taken up in Russia. His *Knife-Grinder* (c. 1912) seems to have particular affinities with Léger's early Cubist paintings, which were well known in Russia at that time through exhibitions and reproductions. The stairs also bring to mind those in Duchamp's *Nude Descending a Staircase* of 1911, although successive steps are of course an obvious device to use in a pictorial description of rhythmic movement. Malevich had previously painted several studies of figures engaged in various occupations, but this is his only preserved machine subject. Here the man has become one with the machine, as his eyes focus on the shining edge and his foot works the pedal that revolves the stone. The painting is a monument to the happy relation that may exist between a man and a simple device which he owns and operates to make his living. It is thus based on a conception of the machine which is different from that of the Italian Futurists, who were more concerned with the products: the cars and the factories and the conditions of the masses. Nevertheless, in its formal aspects the *Knife-Grinder* is the most Futurist of Malevich's paintings.

It is interesting to compare the conceptions of the Italian and the Russian Futurists. In two relatively peripheral countries of Europe, the Italians produced a much more aggressive and active art. The Russians seemed to look at the industrial age with more objectivity and humour.

Malevich's Cubo-Futurist period ended in 1915, when he drew the conclusions from his previous work and painted the first Suprematist composition; the square, the cross and the circle on a white background. Malevich's influence on the Russian avant-garde was not limited to the plastic arts. His personal contribution as a painter and theorist extended to literature and even music; for example, his set designs for the opera *Victory over the Sun* by Kruchenykh and Matiushin, or his illustrations for the books of his friends. Malevich's theoretical thinking had meeting points with the ideas of Khlebnikov, Matiushin and Kruchenykh. Finally, it must be recalled how, starting from a highly personal Cubo-

K. Malevich and M. Matiushin in 1918

Futurism (certain works like the portraits of his friends, *The Pilot* and *An Englishman in Moscow*, even suggest Dadaism in the way the signs and symbols clash) Malevich finally reached his own Suprematism and after the revolution, explored the field of applied arts. (PH)

Mallarmé Stéphane
(Paris, 1842 - Valvins, 1898) French poet

Marinetti classed Mallarmé — along with Poe, Baudelaire, and Verlaine — as one of the "great Symbolist geniuses", although he was to reject him regretfully when he became a Futurist. For the general public at the turn of the century, Mallarmé was an unknown or considered the essence of incomprehensibility. But the most innovative poets and painters were familiar with his most important works, especially *Un coup de dés* (*A Throw of the Dice*, 1897), works that, even though they were not republished, were widely read and discussed. Writers such as Paul Valéry, André Gide, and Léon-Paul Fargue praised, him, as did the art dealer Ambroise Vollard, who in 1898 started to produce an edition of *Un coup de dés*, which however remained incomplete following the poet's death. Another dealer enamoured of the avant-garde, D.H. Kahnweiler, was to say later: "It was only after 1907 that the poetry of Stéphane Mallarmé, in my opinion, exerted a powerful influence on plastic art, an influence that was combined with Paul Cézanne's painting. It was through reading Mallarmé that the Cubists found the courage to invent freely..." Pierre Reverdy was to confirm this judgment, adding Rimbaud: with these two poets a new era was opened, "of which, strangely enough, the painters were the first to take advantage".

Marcel Duchamp never abandoned his love for a few poets such as Mallarmé and Laforgue. Marinetti, by his own admission, "passionately loved" Mallarmé, but what was the opinion of the Futurist painters? We do not know whether Mallarmé was anything more for them than a name venerated by their poet friends, but

Severini, at any rate, underlined the importance of a lesson which could, in his opinion, be directly applied to painting: "The words chosen by Mallarmé, according to their complementary qualities, used in groups or separately, constitute a technique for expressing the prismatic subdivision of the idea, a simultaneous penetration of images."

Mallarmé introduced formal innovations that won over both poets and painters: after the progressive elimination of punctuation from his poems, through free typographic invention, he achieved the great poetic score of *Un coup de dés*. Both Cubists and Futurists found in him a common ancestor, although Mallarmé's intentions were different from those behind the creation of Apollinaire's "calligrammes" and the Futurists' free-words. One should add that Mallarmé, though he belonged to the Symbolist school, did not reject modernity and the most controversial manifestations of the age — he defended both the Tour Eiffel and the bicycle. (SF)

Manifestos

Between 1909, the date of the *Founding Manifesto*, and 1916, the Futurist movement published over fifty manifestos on every form of art, including literature, cinema, architecture, painting, politics, sculpture, music, theatre, dance — even the pleasures of the flesh and the music-hall. The speed and frequency of publication — there was a manifesto almost every two months — shows the value that Marinetti and the Futurists attributed to this form of communication. First of all, the manifesto embodies the idea of a proclamation; it is a way of providing operational and poetic coordinates to an entire community. Whereas the reading of books and poetry is fundamentally a private matter, the manifesto intervenes in collective and general thought. It is an unusual way, spread through the Industrial Revolution, of circulating in an imperious fashion, a synthetic overview of ideological, ethical, and political values. By adopting the manifesto as an instrument for continuous

intervention in the outside world, the Futurists intended its use as a form of social responsibility. With its radical and absolute declarations, the manifesto reveals ties to the incendiary programmes of the French Revolution and the political and scientific analysis of Marx — it is an iconoclastic document of its time.

Since the manifesto was aimed at a large mass of consumers and had to work as street-level propaganda, the language used was synthetic, persuasive, almost advertising-oriented. The manifestos were propagated in mass publications such as the daily newspaper *Le Figaro* and the magazine *Lacerba*, or else in flyers and leaflets distributed in thousands of copies. They contained peremptory declarations and all possible topics, including science and fashion. The conclusions were always irrevocable and monumental ("we proclaim", "we combat", "we want"), listed in numerical order so as to assail the reader with a series of orders that would alarm him and push him into sharing the manifesto's poetic will.

The multiplication of declarations created a swirling flood of messages and information that drowned out words and poetics. This turbulent movement was a tool used by Marinetti to communicate the idea that Futurist poetics was based on the speed and dynamism of action. Reversing the idea of other avant-gardes which believed only in the poetic and formal outcome, it put its stock in the proliferation of messages. The immobility of Cubism and Impressionism appeared obsolete and the intellectuals of the period were shown that survival in a period increasingly dominated by communications media depended not only on the quality of the cultural product, but on the growing quantity of proclamations tending to occupy all possible information spaces. The cumulative instantaneity of publication was therefore of prime importance. The manifestos had to find their way rapidly into books and magazines and be spread by telegraph and radio, photography and cinema. It was essential that they should continue to appear because the informational sequence and the speed in transmission could generate a strong light and shroud the past-oriented opposition in darkness. (GC)

Maples Arce, Manuel
(1900 - 1981) Mexican writer

Manuel Maples Arce had only published a booklet of poetry when, in late 1921, he launched the manifesto of Stridentism (name derived from a phrase of Laforgue); he was followed by other writers and several painters. Passionately interested in art, Maples Arce henceforward defended painters who were as yet unknown such as Firmín Revueltas or Rufino Tamayo. His Stridentist work is represented by the concise poems with striking images collected in *Inner Scaffolding* (1922), *Metropolis: Bolshevist Super-poem in Five Cantos* (1924), and *Forbidden Poems* (1927). (SF)

Marasco, Antonio
(Nicastro, 1896 - Florence, 1975) Italian painter

Antonio Marasco studied in Florence. In 1913 he met the Futurists and became interested in the ideas expounded in *Lacerba*. He was then painting landscapes with dynamic forms clearly influenced by Boccioni. In 1914 he travelled to Russia and Germany with Marinetti. After the First World War he actively participated in Futurist activities both in Italy and abroad. In 1921 Marasco was in touch with Ruggero Vasari in Berlin; in 1923, in Berne, he organized the group Der Schritt Weiter, and in Florence the group Italia. He exhibited with the Futurists from 1922 until the early Thirties. Initially he explored abstract solutions, developing towards "machine" ideas during the second half of the Twenties.

In 1932 he founded a movement in Florence, the Gruppi Futuristi di Iniziative, independent of Marinetti's Futurism and interested in architecture, applied art, theatre and cinema. He wrote his own manifesto (1933) and published the single number of *Supremazia Futurista* (1933). He also became interested in theatrical design and in 1924 helped to organize the "Company of Synthetic, Surprise, Antipsychological, Sensory, Amazing, A-logical etc. Theatre". In 1934 he published *Panorami allo zenit* (*Panoramas at the Zenith*). (ECr)

Marc, Franz
(Munich, 1880 - Verdun, 1916) German painter

After his studies at the Fine Arts Academy in Munich, in 1903 Franz Marc dedicated himself to the study of animal anatomy, convinced that life and the universe could be better expressed through the medium of animals than of men. During a visit to Paris in 1907 he discovered the work of van Gogh and Gauguin. Towards the end of 1912 Marc and Kandinsky founded the Blaue Reiter group.

During 1912, Marc was deeply impressed by a Futurist exhibition at the Der Sturm Gallery, and he met Delaunay in the same year. Up to this time, Marc had painted in a jagged, muscular style, reminiscent of Fauvism (*Yellow Cow, Blue Horses*, 1911), but now, influenced by both movements,

M. Maples Arce, by Alva de la Canal, 1924

without abandoning the animal theme, his paintings and woodcuts became structurally even more dynamic and complex. His use of colour, already entirely subjective, took on a new Futurist strength and, born from a vision marked by an intense vitality, his paintings between 1912 and 1915 literally exploded in jets of colour. Examples are: *In the Rain, The Enchanted Mill, The Destiny of Animals, Forms in Colour*, and the great *Tyrol*, a kind of cosmic fireworks display. "We must paint pictures which build the future", Franz Marc declared in 1915, while he was at the Front and unable to paint. During the war period his pictures tended towards abstraction. Using strong lines and splashes of colour, he painted animals or fragments of animals, combined with no concern for realism and without bothering to depict a scene. Marc's last work was a notebook filled with keen, precise drawings in pencil or in ink, perhaps his work most akin to Futurism: "I was surrounded by strange shapes, black, steelblue, green, hurling themselves clamourously at one another so that my heart cried out in grief... My seething ardour saw another image, the profound image. The shapes rose up creating a thousand barriers. The colours hurled themselves against the barriers, rolled over them and were lost in the most distant depths."

Marc was killed at the Battle of Verdun, shortly after writing a letter protesting the fate of the "poor horses" which man had forced into battle. Gaudier-Brzeska had recently died, and soon it would be Boccioni's turn. War, "the hygiene of the world", overwhelmed great artists. (SF)

Marchi, Virgilio
(Livorno, 1895 - Rome, 1960) Italian architect and stage designer

Educated in Siena in an Art Nouveau taste with structural connotations, Virgilio Marchi came into contact with Marinetti during his military service. He moved to Rome where he joined the Futurist movement. Under the influence of Balla (1913), Prampolini (1914-15), Depero (1916) and, in his metropolitan projects (the surviving drawings are dated between 1919 and the early Twenties), of Sant'Elia's "Futurist City", he developed a new architectural vision, characterized by a "lyrical", Expressionist plastic dynamism. His approach became the inventive, Expressionistic Roman alternative to the proto-Rationalist Futurist architecture designed by Sant'Elia and Chiattone in Milan.

He contributed to *La Testa di Ferro, Dinamo* and particularly *Roma Futurista* where, on 29 February 1920, he published the *Manifesto of Futurist Architecture - Dynamic, a State of Mind, Dramatic*, stating: "We claim architecture back from art. It should stand beside the lyric artists: painters, musicians, poets, and sculptors." This new architectural style aims "to give to all the elements of the construction *forms*, or better *deformations*, or even better *exaltations of form* that are in tune with the inner tension of the components and the mechanical properties of the materials", especially reinforced concrete.

In 1924 he published a small volume, written in 1919, *Architettura futurista*, where he developed his theoretical position and

documented his studies. He felt that Futurist architecture (his own) should start from a purely plastic inspiration — "pure sculptural abstraction". This recalls the visionary plastic designs of German Expressionist architects like Finsterlin, Hablik and the Luckhardts. The second step is to combine this with a vision of urban architecture, then finally comes the creation of actual plans for specific buildings of various types: an electric cabin, an elevated railway, a hotel, a railway station, a factory, an apartment house, a Post Office building. These plans show constructive similarities with German Expressionist architecture (Berg, Poelzig, Stirner, Bartning) and with the stark concrete structuralism of the French movement (Perret, Garnier). This French influence is particularly evident in the last projects, published in Marchi's *Italia nuova, architettura nuova* (1931). Although Marchi's Futurist architecture was mostly on paper, he created the interiors of Anton Giulio Bragaglia's Casa d'Arte and Teatro Sperimentale degli Indipendenti in via degli Avignonesi, Rome (1921-22) and the Teatro Odescalchi (1924), also in Rome. (ECr)

Marey, Etienne-Jules
(Beaune, 1830 - Paris, 1904) French physiologist, scientist and inventor

The French scientist Etienne-Jules Marey was the first physiologist to devote himself to the study of movement, which he investigated in all its forms: in the bloodstream, in the muscles, in the gait of horses, in the flight of insects and birds. His fascination with the subject, to which he devoted a lifetime of research, led him to invent a series of instruments for observing and recording movements that for one reason or another the eye cannot perceive. Siegfried Giedion said of Marey: "This scientist sees his objects with the sensibility of a Mallarmé."
The evolution of flying machines was directly dependent on Marey's discoveries. In 1872, while studying the flight of birds, often on his property near Naples, he built a working model of a monoplane with two propellers driven by a compressed motor. Marey constructed his photographic gun in 1882, so that he could register the successive stages of a bird's flight. The barrel houses a camera lens; the plates are carried on a revolving cylinder and changed by the action of the trigger, which permits twelve exposures a second. Marey expanded the two-dimensional images that he thus obtained into three-dimensional birds made out of plaster, which he later had cast in bronze. He made a synthetic model in plaster showing the flight of a seagull. The bronze cast after this plaster is now in the Marey Museum in Beaune, France.
Marey's methods differed considerably from those of Muybridge. Marey wanted to synthesize on a single plate successive movements as seen from a single point of view by a lens that followed the trajectory of the subject. Muybridge, however, set up his cameras side by side, so that each one in the row caught an isolated phase of movement. In 1894 Marey summarized the results of his studies in his most important book, *Movement*, with which he opened up an unknown dimension to the general

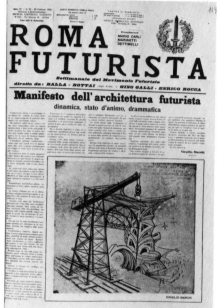

public and also to artists such as Marcel Duchamp. It is safe to say that all the essential knowledge that was needed for the construction of the cinematographic camera-projector was available in this publication. Marey is, more than any other, the father of the cinema. (PH)

Marin, John
(Rutherford, 1870 - Cape Split, 1953) American painter

John Marin was probably the first American artist to create paintings which incorporate the dynamic principles of Futurism. In Europe as early as 1905-10, he encountered modern art firsthand and subsequently was in contact with most of the important American avant-garde figures of his day. He produced watercolours as early as 1912 which feature distorted architecture in city settings, expressing graphically the chaotic changing rhythms of modern urban life. Marin, who admitted that he wanted to capture the inner forces of the forms and figures he observed, probably learned about the Futurists through a number of secondary sources. The subjects Marin chose for his intentionally expressive distortions include the Brooklyn Bridge, the towers of the lower Manhattan church called St. Paul's, and skyscrapers around the city. (GL)

V. Marchi, by Bragaglia

"Manifesto of Futurist Architecture"
Roma Futurista, *1920*

E.J. Marey, Photographic Rifle
Musée Marey, Beaune

Marinetti, Filippo Tommaso

(Alexandria, Egypt, 1876 - Bellagio, Como, 1944) Italian writer

Marinetti studied at a Jesuit school in France and received a *baccalauréat* in literature in Paris, but then, following the wishes of his father — a well-known commercial lawyer — he graduated in law at the University of Genoa. This was typical of Marinetti: he was a loving and docile son, a tender husband and father. In his daily life he always showed an exquisite gentleness; his violence, his delight in scandal, his exhibitionism seem to have been calculated and to stem from deeper motives. His first literary success was "Les vieux marins" (The Old Sailors), a short poem in free verse. It was published in *Anthologie-Revue* of 1898, praised by Catulle Mendès and Gustave Kahn and recited by the famous Sarah Bernhardt. In 1902, Marinetti published his first book, an epic poem in French, *La conquête des étoiles* (*The Conquest of the Stars*), which already shows his strong tendency towards the use of allegory, and a baroque style of imagery which is sometimes excessive and bombastic. In 1905 Marinetti revealed his social pessimism in *Roi Bombance*, a "comic tragedy", a kind of farce, in the Rabelaisian tradition. During the same year in Milan he started an international review, *Poesia*, together with Sem Benelli and Vitaliano Ponti. The issues of this publication show how Marinetti moved within a few years from a position of respect towards traditional poetical values to the fiercely destructive attitude of early Futurism. The movement was born from a strong act of volition: the desire to create a new literary formula that would reflect the new age. The political renaissance was to be followed by a literary and artistic renaissance. In the Paris *Le Figaro* of 20 February 1909 Marinetti published the first *Futurist Manifesto*. He chose the French newspaper and the French language to reach a wider audience. This manifesto, like those that followed, is written in a narrative style using extremely elaborate allegories; its texture is so dense that it is not surprising his readers were baffled. In a text which can be considered the Italian *pendant* to the Parisian manifesto — his preface to *Revolverate* (*Pistol-Shots*) by Lucini (1909) — Marinetti's aims are much more precise, his language is sharper and clearer, his theories more profound. Within a few years Marinetti had literally invented the prototype of the historical avant-garde, which Dada and Surrealism were to follow. In this sense, Futurism is the first authentic avant-garde movement: a group whose members shared an elective affinity, with an ideology which is not limited to the arts but includes politics, morals and manners. While Cubism is confined to one art, Futurism opens itself to multiple forms of expression by creating a global ideology. Marinetti and his followers have their say in every sphere, in literature, theatre, cinema, politics, dance, eroticism, photography, cuisine, etc. The movement is animated by a "totalitarian" impetus. The Futurists' aim, like the Surrealists' later, is to change not only life's exterior conditions, but also man's innermost depths; in short, *changer la vie*, as Rimbaud put it. Between 1909 and 1920 — the so-called "heroic" period of

F.T. Marinetti at home in Milan

F.T. Marinetti, caricature by E. Sacchetti

the movement — Marinetti and a handful of brave spirits laid the milestones of modern art in dizzying succession. The best people gathered around him. Even though Futurism cannot be identified with him, with his ideas and creativity Marinetti is the moving spirit of the movement. In this sense his multi-faceted personality is absolutely new: he is a patron, impresario, organizer, expert in maieutics, breeder and trainer of artistic minds and personalities, friend of Futurists, loving, though at times rough, companion of everyone. Among the main figures who belonged to the movement or revolved around it were Boccioni, Balla, Carrà, Palazzeschi, Govoni, Papini, Soffici, the fellow-traveller Lucini; the "young men" of the second Florentine Futurism, Ginna, Corra, Settimelli, Conti; and some very well-known figures touched more or less deeply by Futurism, like Ungaretti, Campana and Bontempelli.

As a theorist and polemicist, Marinetti is at his best in what he himself called the "art of writing manifestos". At the end of the 19th and the beginning of the 20th century, the "manifesto" was already a favourite form, used as a witty but peaceful medium for expressing literary ideas. With Marinetti it becomes a symbolic, paradoxical, incandescent and terroristic medium.

Marinetti's series of manifestos is rich and fascinating: from the *Founding Manifesto* to the allegorical and narrative *Uccidiamo il chiaro di luna* (*Let's Kill Moonlight*), from the "technical manifestos" theorizing the use of "words-in-freedom", to the witty and inventive *Variety Theatre*, and many more.

Marinetti needs to be remembered also as a polemicist and political writer. From the beginning, politics were inherent in the movement's ideology. In fact, Marinetti and other Futurists participated in early Fascism. It was only at the second conference, held in Milan in 1920, that Marinetti, Mario Carli and other Futurist angrily slammed the doors on Fascism because their anti-clerical, anti-monarchical proposals had not been accepted. Marinetti's most important political works, *Democrazia futurista* (*Futurist Democracy*, 1919), and *Al di là del comunismo* (*Beyond Communism*, 1920), indicate a deeper reason for the wide gap between Futurists and Fascists. It lies in the Futurist anarchic element that rebels against all state hierarchies. Although in 1923-24 Marinetti returned to the ranks of Fascism and in 1929 he was elected to the Academy of Italy, Marinetti and Futurism were never supported by the Fascist régime, but merely tolerated. Between Marinetti's work as a creative writer and his work as an ideologist and inventor of poetical theories, there are continuous interactions, reactions and encounters. His French poetry belongs to the "crisis of Symbolist values" described by Michel Décaudin. After his Futurist pronouncement and his words-in-freedom theory, Marinetti maintained his insistent images and vivid colours, but voluntarily abandoned his overabundant adjectives in favour of an intensified use of analogy, already present in his early French works. Marinetti's free-word compositions "Battaglia peso + odore" (Battle Weight + Smell, 1912), and "Zang Tumb Tumb"

F.T. Marinetti in a car, 1908 c.

(1914) are very important literary documents, but contain little poetry. With his "explosive novel" *8 anime in una bomba* (*8 Souls in a Bomb*, 1919), Marinetti used his own free-word theory as a scaffolding for a more complex literary composition. He was now able to accept what he had earlied rejected: sentimental and narrative contents, psychology, and a swift, springy syntax that allows for metaphors, analogies, colours — here Marinetti's poetic inspiration reaches its highest peak. Marinetti's free-word masterpiece is *Spagna veloce e toro futurista* (*Speedy Spain and Futurist Bull*, 1931), a divertissement echoing the Surrealists' *automatic writing*. In his two autobiographical texts, *La grande Milano tradizionale e futurista* (*The Great Traditional and Futurist Milan*), and *Una sensibilità italiana nata in Egitto* (*An Egyptian-born Italian Sensibility*), his *paroliberismo* becomes more narrative and his baroque imagery softens into Art Nouveau languors and preciousness.

As a prose-writer, Marinetti's best work is *Mafarka le futuriste* (*Mafarka the Futurist*), an allegorical novel in the same tradition as Flaubert's *Salammbô*, the novel *Gli indomabili* (*The Untamables*, 1922) and his travel book *Il fascino d'Egitto* (*The Charm of Egypt*, 1933), which bears traces of D'Annunzio, of the *Ronda* group and poetic prose.

Certainly most of Marinetti's works belonging to the second period of Futurism (1921-44) today seem frail. The triumph of Fascism reduced Futurism from an all-encompassing movement which was necessarily also political, to a stale "school", whose official poetic technique was *paroliberismo*.

Although they possess some undeniable merits, all the poems that belong to the *aeropoesia* period seem repetitive and weary, such as "L'aeropoema del golfo della Spezia" (Aerial Poem on the Gulf of La Spezia, 1935), "Il poema non umano dei tecnicismi" (The Non-Human Poem of Technicisms, 1940), or "Il poema africano della divisione XXVIII Ottobre" (The African Poem on XXVIII October Division, 1917). It is only in his last page, written before his death, "Quarto d'ora di poesia della X Mas" (A Fifteen Minutes' Poem of the X Mas) that Marinetti rediscovers his deepest poetic expression. (LDM)

The Founding and Manifesto of Futurism
(Futurist manifesto, Paris, 20 February 1909)

We had stayed up all night, my friends and I, under hanging mosque lamps with domes of filigreed brass, domes starred like our spirits, shining like them with the imprisoned radiance of electric hearts. For hours we had trampled our atavistic ennui into rich oriental rugs, arguing up to the last confines of logic and blackening many reams of paper with our frenzied scribbling. An immense pride was buoying us up, because we felt ourselves alone at that hour, alone, awake, and on our feet, like proud beacons or forward sentries against the army of hostile stars twinkling at us from their celestial encampments. Alone with the stokers feeding the hellish fires of great ships, alone with the black spectres who grope in the red-hot bellies of locomotives launched at wild speed, alone with drunkards reeling like wounded birds along the city walls.

Suddenly we jumped, hearing the mighty noise of the huge double-decker trams that rumbled by outside, ablaze with coloured lights, like villages on holiday suddenly struck and uprooted by the flooding Po and dragged over falls and through gorges to the sea.

Then the silence deepened. But, as we listened to the old canal muttering its feeble prayers and the creaking bones of palaces dying above their damp green beards, under the windows we suddenly heard the famished roar of automobiles.

"Let's go!" I said. "Friends, away! Let's be off! Mythology and the Mystic Ideal are behind us at last. We're about to witness the Centaur's birth and soon we shall see the first flight of Angels!... We must shake the gates of life, test the bolts and hinges. Let's go! Look there, on the earth, the very first dawn! There's nothing to match the splendour of the sun's red sword, slashing for the first time through our millennial gloom!"

We went up to the three snorting beasts, to lay amorous hands on their torrid breasts. I stretched out on my car like a corpse on its bier, but revived at once under the steering wheel, a guillotine blade that threatened my stomach.

The raging broom of madness swept us out of ourselves and drove us through streets as rough and deep as the beds of torrents. Here and there, sick lamplight through window glass taught us to distrust the deceitful mathematics of our perishable eyes.

I cried, "Scent, scent alone is enough for wild beasts!"

And like young lions we ran after Death, its dark pelt blotched with pale crosses as it raced away over the vast violet living and throbbing sky.

Yet we had no ideal Beloved raising her divine form to the clouds, nor any cruel Queen to whom to offer our corpses, twisted like Byzantine rings! There was nothing to make us wish for death other than the longing to be free at last from the weight of our courage!

And on we raced, crushing watchdogs against doorsteps, curling them under our burning tyres like collars under a flatiron. Death, domesticated, overtook me at every turn, gracefully holding out a paw, or sometimes hunkering down with a sound of grinding jaws, fixing velvety caressing eyes on me from every puddle.

"Let's break out of the horrible shell of wisdom and throw ourselves like pride-ripened fruit into the wide, contorted mouth of the wind! Let's give ourselves utterly to the Unknown, not in desperation but only to fill the deep wells of the Absurd!"

The words were scarcely out of my mouth when I spun around with the frenzy of a dog trying to bite its tail, and there, suddenly, were two cyclists riding up to say I was wrong, wobbling like two convincing but contradictory arguments. Their stupid dilemma was blocking my way — what a bore!... I cut it short and in disgust plunged into a ditch with my wheels in the air...

O maternal ditch, almost full of muddy water! Fair factory drain! I gulped down your nourishing sludge; and I remembered the blessed black breast of my Sudanese nurse ... When I came up — torn, filthy, and stinking — from under the capsized car, I felt the white-hot iron of joy deliciously pierce my heart!

A crowd of fishermen with handlines and gouty naturalists were already swarming around the marvel. With patient, loving care those people rigged a tall scaffold and iron nets to fish out my car, like a big beached shark. Up it came from the ditch, slowly, leaving at the bottom, like scales, its heavy body of good sense and its soft upholstery of comfort.

They thought it was dead, my beautiful shark, but a caress from me was enough to revive it; and there it was, alive again, running on its powerful fins!

And so, our faces smeared with good factory muck — a mixture of metallic waste, senseless sweat, and celestial soot — bruised, our arms in slings, but unafraid, we declared our intentions to all the *living* of the earth:

Manifesto of Futurism

1. We intend to sing the love of danger, the habit of energy and fearlessness.

2. Courage, audacity and revolt will be essential elements of our poetry.

3. Up to now literature has exalted thoughtful immobility, ecstasy, and sleep. We intend to exalt aggressive action, feverish insomnia, the racer's stride, the somersault, the punch and the slap.

4. We affirm that the world's splendour has been enriched by a new beauty: the beauty of speed. A racing car whose hood is adorned with great pipes, like serpents of explosive breath — a roaring car that seems to ride on grapeshot — is more beautiful than the *Victory of Samothrace*.

5. We will hymn the man at the wheel, with its column that passes through the Earth, as it races round the circuit of its orbit.

6. The poet must spend himself with ardour, splendour and generosity, to swell the enthusiastic fervour of the primordial elements.

7. Except in struggle, there is no more beauty. No work without an aggressive character can be a masterpiece. Poetry must be conceived as a violent attack on the unknown forces, to induce them to prostrate themselves before man.

8. We stand on the last promontory at the end of centuries!... Why should we look back, when our desire is to break down the mysterious doors of the Impossible? Time and Space died yesterday. We already live in the absolute, because we have created eternal, omnipresent speed.

9. We will glorify war — the world's only hygiene — militarism, patriotism, the destructive gesture of freedom-bringers, beautiful ideas worth dying for, and contempt for woman.

10. We will destroy the museums, libraries, academies of every kind, will fight moralism, feminism, and every opportunistic or utilitarian cowardice.

11. We will sing of great crowds excited by work, by pleasure, and by revolt; we will sing of the multicoloured, polyphonic tides of revolution in the modern capitals; we will sing of the vibrant nightly fervour of arsenals and shipyards blazing with violent electric moons; greedy railway stations that

Fot. COLETTI

devour smoke-plumed serpents; factories hung on clouds by the crooked lines of their smoke; bridges that leap the rivers like giant gymnasts, flashing in the sun with a glitter of knives; adventurous steamers that sniff the horizon; deep-chested locomotives pawing the tracks like enormous steel horses bridled by tubing; and the sleek flight of planes whose propellers chatter in the wind like banners and seem to cheer like an enthusiastic crowd.

It is from Italy that we are launching throughout the world this manifesto charged with overwhelming incendiary violence. We are founding *Futurism* here today because we want to free this land from its foul gangrene of professors, archaeologists, guides and antiquarians. For too long Italy has been a market-place for second-hand dealers. We mean to free her from the innumerable museums that cover her like so many graveyards.

Museums: cemeteries!... Identical, surely, in the sinister promiscuity of so many bodies unknown to one another. Museums: public dormitories where one lies forever beside hated or unknown beings! Museums: absurd abattoirs of painters and sculptors ferociously slaughtering one other with colours and lines along fought-over walls!

That one should make an annual pilgrimage there, just as one goes to the cemetery on All Souls' Day — that I grant. That once a year a floral tribute may be left beneath the *Gioconda*, I grant you that... But I cannot accept that our sorrows, our fragile courage, our morbid restlessness should be taken for daily walks through museums. Why poison ourselves? Why rot?

And what is there to see in an old picture except the painful contorsions of an artist who threw himself against the insuperable barriers that prevented him from expressing his dream completely? ... Admiring an old picture is like pouring our sensibility into a funerary urn instead of projecting it into the distance in violent spasms of action and creation.

Do you wish to waste all your best powers in this eternal and futile worship of the past, from which you emerge inevitably exhausted, lowered, crushed?

In truth I tell you that the daily round of museums, libraries, and academies (cemeteries of vain efforts, Calvaries of crucified dreams, registries of aborted beginnings!) is as damaging for artists as the prolonged guardianship of parents is for certain young people drunk with their talent and ambitious desire. The beauties of the past may console invalids, prisoners and dying men, since the future is barred to them — but we want no part of it, we who are young and strong *Futurists*!

So let them come, the gay incendiaries with charred fingers! Here they are! Here they are!... Come on! Set fire to the library shelves! Turn aside the canals to flood the museums!... Oh, the joy of seeing the glorious old canvases bobbing adrift on those waters, discoloured and shredded!... Take up your picks, your axes and hammers and wreck, wreck the venerable cities, pitilessly!

The oldest of us is thirty: so we have at least a decade to finish our work. When we are forty, other younger and stronger men will probably throw us in the wastebasket like useless manuscripts — we want it to happen!

They will come against us, our successors, will come from far away, from every quarter, dancing to the winged cadence of their first songs, flexing the hooked claws of predators, sniffing doglike at the academy doors the pungent smell of our decaying minds, which will already have been promised to the literary catacombs.

But we won't be there ... At last they'll find us — one winter's night — in open country, beneath a sad roof drummed by a monotonous rain. They'll see us crouched beside our trembling aeroplanes in the act of warming our hands at the poor little blaze that our books of today will give out when they take fire from the flight of our images.

They'll storm around us, panting with scorn and anguish, and all of them exasperated by our proud daring, will hurtle to kill us, driven by a hatred the more implacable the more their hearts will be drunk with love and admiration for us.

Injustice, strong and sane, will break out radiantly in their eyes.

Art, in fact, can be nothing but violence, cruelty, and injustice.

The oldest of us is thirty: yet we have already scattered treasures, a thousand treasures of strength, love, courage, astuteness, and raw willpower; have thrown them away impatiently, in haste, without counting, without hesitating, without ever stopping, at breakneck speed... Look at us! We are still not tired! Our hearts are not exhausted because they are fed with fire, hatred, and speed! ... Does that amaze you? It should, because you can never remember having lived! Erect on the summit of the world, again we hurl our challenge to the stars!

You have objections? — Enough! Enough! We know them. We've understood! Our fine, deceitful intelligence tells us that we are the sum and continuation of our ancestors. Perhaps! Let it be so! Who cares? We don't want to hear it! Let nobody say those infamous words to us again!

Lift up your heads!

Erect on the summit of the world, again we hurl our challenge to the stars!

F.T. Marinetti

Destruction of Syntax — Imagination without Strings — Words-Freedom
(Futurist manifesto, 11 May 1913)
The Futurist Sensibility

My "Technical Manifesto of Futurist Literature" (11 May 1912), with which I invented *essential and synthetic lyricism, imagination without strings*, and *words-in-freedom*, deals exclusively with poetic inspiration.

Philosophy, the exact sciences, politics, journalism, education, business, however much they may seek synthetic forms of expression, will still need to use syntax, punctuation and adjectives. I am obliged, for that matter, to use them myself in order to make myself clear to you.

Futurism is grounded in the complete renewal of human sensibility brought about by the great discoveries of science. People today make use of the telegraph, the telephone, the phonograph, the train, the bicycle, the motorcycle, the automobile, the ocean liner, the dirigible, the aeroplane, the cinema, the great newspaper (synthesis of a day in the world's life) without realizing that these various means of communication, transportation and information have a decisive influence on their psyches.

An ordinary man can go by train in a single day from a little dead town where the sun, dust, and wind play silently in empty squares, to a great capital city bristling with lights, gestures, and street cries. By reading a newspaper the inhabitant of a mountain village can tremble with anxiety every day, following insurrection in China, the London and New York suffragettes, Doctor Carrel, and the heroic dog-sleds of the polar explorers. The timid, sedentary inhabitant of any provincial town can enjoy the intoxication of danger by watching a film about big game hunting in the Congo. He can admire Japanese athletes, Negro boxers, tireless American comedians, elegant Parisian women, by paying a franc at a variety theatre. Then, lying in his bourgeois bed, he can enjoy the distant, expensive voice of a Caruso or a Burzio.

Having become commonplace, these opportunities arouse no curiosity in superficial minds which are as incapable of seeing the implications of new facts *as the Arabs who looked with indifference at the first aeroplanes in the sky of Tripoli*. For the keen observer, however, these facts have all changed our sensibility because they have caused the following significant phenomena:

1. Acceleration of life to today's swift pace. Physical, intellectual, and emotional equilibration on the cord of speed stretched between opposite poles. Multiple and simultaneous awareness in a single individual.

2. Dread of the old and the known. Love of the new, the unexpected.

3. Dread of quiet living, love of danger, and an attitude of daily heroism.

4. Destruction of a sense of the Beyond and an increased value of the individual whose desire is *vivre sa vie*, in Bonnot's phrase.

5. The multiplication and unbridling of human desires and ambitions.

6. An exact awareness of what is inaccessible and unrealizable in every person.

7. Semi-equality of man and woman and a lessening of the disproportion in their social rights.

8. Disdain for *amore* (sentimentality or lechery) produced by the greater freedom and erotic ease of women and by the universal exaggeration of female luxury. Let me explain: today's woman loves luxury more than love. A visit to a great dressmaker's establishment, escorted by a paunchy, gouty banker friend who pays the bills, is a perfect substitute for the most amorous rendezvous with an adored young man. The woman finds all the mystery of love in the selection of an amazing ensemble, the latest model, which her friends still do not have. Men do not love women who lack luxury. The lover has lost all his prestige. Love has lost its absolute worth. A complex question; all I can do is to raise it.

9. A modification of patriotism, which now means a heroic idealization of the commercial, industrial, and artistic solidarity of a people.

10. A modification in the idea of war, which has become the necessary and bloody

F. T. MARINETTI FUTURISTA

ZANG TUMB TUMB

ADRIANOPOLI OTTOBRE 1912

IN LIBERTÀ

TUUUMB TUUUM TUUUM TUUUM TUUUM

PAROLE

EDIZIONI FUTURISTE
DI "POESIA"
Corso Venezia, 61 - MILANO
1914

test of a people's strength.

11. The passion, art, and idealism of Business. New financial sensibility.

12. Man multiplied by the machine. New mechanical sense, a fusion of instinct with the efficiency of motors and tamed forces.

13. The passion, art, and idealism of Sport. Idea and love of the "record".

14. New tourist sensibility bred by ocean liners and great hotels (annual conventions, synthesis of different races). Passion for the city. Negation of distances and nostalgic solitudes. Ridicule of the "holy green silence" and the ineffable landscape.

15. The earth shrunk by speed. New sense of the world. To be precise: one after the other, man gained the sense of his home, of the district where he lived, of his region, and finally of his continent. Today he is aware of the whole world. He hardly needs to know what his ancestors did, but he has a constant need to know what his contemporaries are doing all over the world. The single man must communicate with every people on earth. He must feel himself to be the centre, judge, and motor of the explored and unexplored infinite. Vast increase of a sense of humanity and a constant, urgent need to establish a relationship with all mankind.

16. A loathing of curved lines, spirals, and the *tourniquet*. Love for the straight line and the tunnel. The habit of visual foreshortening and visual synthesis created by the speed of trains and cars that look down on cities and countrysides. Dread of slowness, pettiness, analysis, and detailed explanations. Love of speed, abbreviation, and synthesis. "Quick, give me the whole thing in two words!"

17. Love of depth and essence in every exercise of the spirit.

So these are some elements of the new Futurist sensibility that has generated our pictorial dynamism, our antigraceful music in its free, irregular rhythms, our noise-art and our words-in-freedom.

Words-in-Freedom

Casting aside every stupid formula and all the confused verbalism of the professors, I now declare that lyricism is the exquisite faculty of intoxicating oneself with life, of filling life with the inebriation of oneself. The faculty of changing into wine the muddy water of the life that swirls and engulfs us. The ability to colour the world with the unique colours of our changeable selves.

Now suppose that a friend of yours gifted with this faculty finds himself in a zone of intense life (revolution, war, shipwreck, earthquake, and so on) and comes straightaway to tell you his impressions. Do you know what this lyrical, excited friend of yours will instinctively do?

He will begin by brutally destroying the syntax of his speech. He wastes no time in building sentences. Punctuation and the right adjectives will mean nothing to him. He will despise subtleties and nuances of language. Breathlessly he will assault your nerves with visual, auditory, olfactory sensations, just as they come to him. The rush of steam-emotion will burst the sentence's steampipe, the valves of punctuation, and the adjectival clamp. Fistfuls of essential words in no conventional order. Sole concern of the narrator, to render every vibration of his being.

If the mind of this gifted lyrical narrator is also populated by general ideas, he will involuntarily bind up his sensations with the entire universe that he intuitively knows. And in order to render the true worth and dimensions of his experience, he will cast immense nets of analogy across the world. In this way he will reveal the analogical foundation of life, telegraphically, with the same economical speed that the telegraph imposes on reporters and war correspondents in their swift reportings. This urgent laconicism answers not only to the laws of speed that govern us but also to the rapport of centuries between poet and audience. Between poet and audience, in fact, the same relationship exists as between two old friends. They can make themselves understood with half a word, a gesture, a glance. So the poet's imagination must weave together distant things *with no connecting strings* by means of essential *free* words.

Death of Free Verse

Free verse once had countless reasons for existing but now is destined to be replaced by *words-in-freedom*.

The evolution of poetry and human sensibility has shown us the two incurable defects of free verse.

1. Free verse fatally pushes the poet towards facile sound effects, banal double meanings, monotonous cadences, a foolish chiming, and an inevitable echo-play, internal and external.

2. Free verse artificially channels the flow of lyric emotion between the high walls of syntax and the weirs of grammar. The free intuitive inspiration that addresses itself directly to the intuition of the ideal reader finds itself imprisoned and distributed like purified water for the nourishment of all fussy, restless intelligences.

When I speak of destroying the canals of syntax, I am neither categorical nor systematic. Traces of conventional syntax and even of true logical sentences will be found here and there in the words-in-freedom of my unchained lyricism. This unevenness in conciseness and freedom is natural and inevitable. Since poetry is in truth only a superior, more concentrated and intense life than the one we live from day to day, like the latter it is composed of hyper-alive elements and moribund elements.

We ought not, therefore, to be too much preoccupied with these elements. But we should at all costs avoid rhetoric and banalities telegraphically expressed.

Imagination Without Strings

By imagination without strings I mean the absolute freedom of images or analogies, expressed with unhampered words and with no connecting strings of syntax and with no punctuation. Up to now, writers have been restricted to immediate analogies. For instance, they have compared an animal with a man or with another animal, which is almost the same as a kind of photography. (They have compared, for example, a fox terrier to a very small thoroughbred. Others, more advanced, might compare the same trembling fox terrier to a little Morse Code machine. I, on the other hand, compare it with gurgling water. In this there is an *ever vaster gradation of analogies*, there are ever deeper and more solid affinities, however remote.)

"Analogy is nothing more than the deep love that links distant, seemingly diverse and hostile things. An orchestral style, at once polychromatic, polyphonic, and polymorphous, can embrace the life of matter only by means of the most extensive analogies.

"When, in my *Battle of Tripoli*, I compared a trench bristling with bayonets to an orchestra, a machine gun to a *femme fatale*, I intuitively introduced a large part of the universe into a short episode of African battle.

"Images are not flowers to be chosen and picked with parsimony, as Voltaire said. They are the very lifeblood of poetry. Poetry should be an uninterrupted sequence of new images, or it is mere anaemia and greensickness.

"The broader their affinities, the longer will images keep their power to amaze." (*Technical Manifesto of Futurist Literature*)

The imagination without strings and words-in-freedom will bring us to the essence of matter. As we discover new analogies between distant and apparently contrary things, we will endow them with an ever more intimate value. Instead of *humanizing* animals, vegetables, and minerals (an outmoded system) we will be able to *animalize, vegetize, mineralize, electrify, or liquefy our style*, making it live the life of matter. For example, to represent the life of a blade of grass, I say, "Tomorrow I'll be greener."

With words-in-freedom we will have: *Condensed metaphors. Telegraphic images. Maximum vibrations. Nodes of Thought. Closed or open fans of movement. Compressed analogies. Colour balances. Dimensions, weights, measures, and the speed of sensations. The plunge of the essential word into the water of sensibility, minus the concentric circles that the word produces. Restful moments of intuition. Movements in two, three, four, five different rhythms. The analytic, exploratory poles that sustain the bundle of intuitive strings.*

Death of the Literary "I"
Molecular Life and Matter

My Technical Manifesto opposed the obsessive *I* that up to now the poets have described, sung, analysed, and vomited up. To rid ourselves of this obsessive *I*, we must abandon the habit of humanizing nature by attributing human passions and preoccupations to animals, plants, water, stone, and clouds. Instead we should express the infinite smallness that surrounds us, the imperceptible, the invisible, the agitation of atoms, the Brownian movements, all the exciting hypotheses and all the domains explored by the high-powered microscope. To explain: I want to introduce the infinite molecular life into poetry not as a scientific document but as an intuitive element. It should mix, in the work of art, with the infinitely great spectacles and dramas, because this fusion constitutes the integral synthesis of life.

To give some aid to the intuition of my ideal reader I use italics for all words-in-freedom that express the infinitely small and molecular life.

Semaphoric Adjective
Lighthouse-Adjective or Atmosphere-Adjective

Everywhere we tend to suppress the qualifying adjective because it presupposes a break in intuition, too minute a definition

of the noun. None of this is categorical. I speak of a tendency. We must use the adjective as little as possible and in a completely new manner. One should treat adjectives like railway signals of style, employ them to mark the tempo, the retards and pauses along the way. So, too, with analogies. As many as twenty of these semaphoric adjectives might accumulate in this way.

What I call a semaphoric adjective, lighthouse-adjective, or atmosphere-adjective is the adjective apart from nouns, isolated in parentheses. This makes it a kind of absolute noun, broader and more powerful than the noun proper.

The semaphoric adjective or lighthouse-adjective, suspended on high in its glassed-in parenthetical cage, throws its far-reaching, probing light on everything around it.

The profile of this adjective crumbles, spreads abroad, illuminating, impregnating, and enveloping a whole zone of words-in-freedom. If, for instance, in an agglomerate of words-in-freedom describing a sea voyage I place the following semaphoric adjectives between parentheses: (calm, blue, methodical, habitual) not only the sea is *calm, blue, methodical, habitual*, but so are the ship, its machinery, the passengers. What I do and my very spirit are *calm, blue, methodical, habitual*.

The Infinitive Verb

Here, too, my pronouncements are not categorical. I maintain, however, that in a violent and dynamic lyricism the infinitive verb might well be indispensable. Round as a wheel, like a wheel adaptable to every car in the train of analogies, it constitutes the very speed of the style.

The infinitive in itself denies the existence of the sentence and prevents the style from slowing and stopping at a definite point. Whereas *the infinitive is round* and as mobile as a wheel, the other moods and tenses of the verb are either triangular, square, or oval.

Onomatopoeia and Mathematical Symbols

When I said that we must spit on the Altar of Art, I incited the Futurists to liberate lyricism from the solemn atmosphere of compunction and incense that normally goes by the name of Art with a capital A. Art with a capital A constitutes the clericalism of the creative spirit. I used this approach to incite the Futurists to destroy and mock the garlands, the palms, the aureoles, the exquisite frames, the mantles and stoles, the whole historical wardrobe and the romantic bric-a-brac that have comprised a large part of all poetry up to now. I proposed instead a swift, brutal, and immediate lyricism, a lyricism that would seem antipoetic to all our predecessors, a telegraphic lyricism with no literary feeling about it but, rather, as much as possible of the feeling of life. And the bold introduction of onomatopoetic harmonies to render all the sounds and noises of modern life, even the most cacophonic.

Onomatopoeia that vivifies lyricism with crude and brutal elements of reality has been used in poetry (from Aristophanes to Pascoli) more or less timidly. We Futurists initiate the constant, audacious use of onomatopoeia. This should not be systematic. For instance, my *Adrianople Siege-Orchestra* and my *Battle Weight +*

Smell required many onomatopoetic harmonies. With the same aim of giving the greatest number of vibrations and a deeper synthesis of life, we abolish all stylistic bonds, all the bright buckles with which the traditional poets link images together in their prosody. Instead we employ succinct or anonymous mathematical and musical symbols and include between parentheses indications such as (fast) (faster) (slower) (two-beat time) to control the speed of the style. These parentheses can even cut into a word or an onomatopoetic harmony.

Typographical Revolution

I initiate a typographical revolution aimed at the bestial, nauseating idea of the book of passéist and D'Annunzian verse, on 17th century handmade paper bordered with helmets, Minervas, Apollos, elaborate red initials, vegetables, mythological missal ribbons, epigraphs, and Roman numerals. The book must be the Futurist expression of our Futurist thought. Not only that. My revolution is aimed at the so-called typographical harmony of the page, which is contrary to the ebb and flow, the leaps and bursts of style that run through the page. On the same page, therefore, we will use *three or four colours of ink*, or even twenty different typefaces if necessary. For example: italics for a series of similar or swift sensations, boldface for the violent onomatopoeias, and so on. With this typographical revolution and this multicoloured variety in the letters I mean to redouble the expressive force of words.

I oppose the decorative, precious aesthetic of Mallarmé and his search for the rare word, the one indispensable, elegant, suggestive, exquisite adjective. I do not want to suggest an idea or a sensation with passéist airs and graces. Instead I want to grasp them brutally and hurl them in the reader's face.

Moreover, I combat Mallarmé's static ideal with this typographical revolution that allows me to impress on the words (already free, dynamic, and torpedo-like) every velocity of the stars, the clouds, aeroplanes, trains, waves, explosives, globules of seafoam, molecules, and atoms.

Thus I realize the fourth principle of my First Futurist Manifesto (20 February 1909): "We affirm that the world's beauty is enriched by a new beauty: the beauty of speed."

Multilinear Lyricism

In addition, I have conceived *multilinear lyricism*, with which I succeed in achieving that lyric simultaneity that has obsessed the Futurist painters as well.

On several parallel lines, the poet will throw out several strings of colour, sound, smell, noise, weight, thickness, analogy. One of these lines might, for instance, be olfactory, another musical, another pictorial.

Let us suppose that the chain of pictorial sensations and analogies dominates the others. In this case it will be printed in a heavier typeface than the second and third lines (one of them containing, for example, the chain of musical sensations and analogies, the other the chain of olfactory sensations and analogies).

Given a page that contains many bundles of sensations and analogies, each of which is composed of three or four lines, the chain

of pictorial sensations and analogies (printed in boldface) will form the first line of the first bundle and will continue (always in the same type) on the first line of all the other bundles.

The chain of musical sensations and analogies, less important than the chain of pictorial sensations and analogies (first line) but more important than that of the olfactory sensations and analogies (third line), will be printed in smaller type than that of the first line and larger than that of the third.

Free Expressive Orthography

The historical necessity of free expressive orthography is demonstrated by the successive revolutions that have progressively freed the lyric powers of the human race from shackles and rules.

1. In fact, the poets began by channelling their lyric intoxications into a series of equal breaths, with accents, echoes, assonances, or rhymes at pre-established intervals (*traditional metrics*). Then the poets varied these measured breaths of their predecessor's lungs with a certain freedom.

2. Later the poets realized that the different moments of their lyric intoxication had to create breaths suited to the most varied and surprising intervals, with absolute freedom of accentuation. Thus they arrived at *free verse*, but they still preserved the syntactic order of the words, so that the lyric intoxication could flow down to the listeners by the logical canal of syntax.

3. Today we no longer want the lyric intoxications to order the words syntactically before launching them forth with the breaths we have invented, and we have *words-in-freedom*. Moreover our lyric intoxication should freely deform, reflesh the words, cutting them short, stretching them out, reinforcing the centre or the extremities, augmenting or diminishing the number of vowels and consonants. Thus we will have the *new orthography* that I call *free expressive*. This instinctive deformation of words corresponds to our natural tendency towards onomatopoeia. It matters little if the deformed word becomes ambiguous. It will marry itself to the onomatopoetic harmonies, or noise-summaries, and soon permit us to reach *onomatopoetic psychic* harmony, the sonorous but abstract expression of an emotion or a pure thought. But one may object that my words-in-freedom, my imagination without strings, demand special recitation if they are to be understood. Althouth I do not care for the comprehension of the multitude, I will reply that the number of Futurist public reciters is increasing and that any admired traditional poem, for that matter, requires a special recitation if it is to be understood.

F.T. Marinetti

Masnata, Pino

(Stradella, 1901 - Stradella, 1968) Italian poet and playwright

Before he was twenty, Pino Masnata became a follower of the Futurist movement, devoting himself both to theatre and free-word poetry. In 1920 he published the manifesto *Visionic Theatre*, describing how "cinematographic transformations" would give the protagonist a "creating" role in the "beautiful dynamic chronological disorder of remembrance". During the Twenties and Thirties, his already intense activity as a playwright (*Anime sceneggiate - Dramatized Souls*, 1930) was expanded to include radio. In 1931 he wrote the libretto for the radio opera *Tum Tum Ninna Nanna (o il cuore di Wanda) - Tum Tum Lullaby (or Wanda's Heart)*, and in 1933, together with Marinetti, he published the *Futurist Manifesto of Radio*. In his *Tavole parolibere (Free-Word Plates*, 1932), dating from the second decade of the century, by transforming the text into images with a very pungent irony, he achieved a totally visual narrative. (ECr)

Matiushin, Malevich and Kruchenykh with the dummy of the book The Three, *1913*

Mass Audience

Futurist excitement and desire to act tended to skim over the social and political contradictions that tormented Italy at the beginning of the 20th century. Rather than supporting democracy and the demands of the working-class (between 1893 and 1908, from Sicily to Emilia, there were demonstrations, clashes with the police, and towards the end strikes), rather than denouncing the faults of a technology guided by a decrepit bourgeoisie, the Futurists merely sympathized. They sensed the discontent of the workers, but admired individualistic Anarchism and enthused about Sorel or the power of machinery. Instead of marching in the streets to ask for shorter working hours or rebelling against the exploitation of women and children, they fought for the destruction of museums and against traditionalist professors while still trying to conform to a mass society.

Without any philosophical background, the movement tried to root itself in an historical situation where values of quantity and consumption were taking the place of an élite search for quality. The Futurists saw the importance of the new means of mass communication, which made the overpowering speed of the telegraph, automobiles and locomotives a central feature of the new society. They wanted a total renewal of artistic sensibility and created alternative forms of poetry, painting, cinema and theatre, but also tried to combine them aesthetically with cabaret, politics, lust, gastronomy, fashion and furnishings. It was a provocation for the masses, not for the élite.

Futurist dandyism expressed itself in public actions, creating intense artistic moments where the masses became active *voyeurs*. As Marinetti and Cangiullo wrote in 1922, their aim was "to provoke in the audience totally unexpected words and actions so that every surprise can give birth to further surprises in the theatres, in parks and in the city". In other words, the masses, through their active participation, their excited exchange with the artists, would have so much influence upon the actors' behaviour that they and not art would become the ad-

vocates of freedom of expression and the real cultural protagonists.

The Futurists gave voice to the audience; they searched for their public in the streets and in the stalls, hoping, as Cangiullo said, "to break down the physical barrier between actors and spectators, and unify the hall". It was an attempt to switch artistic power to the masses, to bring out the creativity of ordinary humanity. In this sense Marinetti's proselytism is understandable: the Futurists tried to integrate themselves into the "common people", believing that all could become "exceptional people".

The Futurists also realized that art is a source of power and transformation and so they came down into the streets and held aesthetical meetings. As they were not ashamed to work in the world, they invented gestures which would amaze and instead of concentrating on a limited sphere of action, they spread themselves everywhere. The choice was in favour of quantity. The first Futurist manifesto was published in the Paris *Le Figaro* (1909), while the *Manifesto of Variety Theatre* appeared in the pages of a London newspaper, *The Daily Mail* (1913). The choice of newspapers as their media was not casual. The Futurists' philosophy of art was propaganda and as such it had to live in daily life, not in sophisticated, limited publications. And so on 8 July, 800,000 copies of the manifesto *Against Passéist Venice* were thrown from the Clock Tower over the crowd coming from the Lido, and 300,000 copies of *Futurist Synthesis of War* were printed with the request that they be "posted in public places and at home". The events were multiplied so that the message, the information would reach more people and thus be socially supported by many. "During Futurist *soirées*, it was the audience that was performing", said Cangiullo. To use different forms of dialogue with the public became a Futurist concern.

With their limited expansion, Impressionism and Cubism would not have been able to accept hundreds of people on their "stages". Such an indiscriminate spread of

artistic values would have destroyed their private spaces. But the Futurists moved in a different direction, organizing their work in public, non-artistic places because they thought contemporary reality — mass society — existed only in the world outside the studio and the gallery. (GC)

Matiushin, Mikhail Vassilievich

(Nijni Novgorod, 1861 - Leningrad, 1934) Russian composer, painter, sculptor and writer

After studying at the Moscow Conservatory of Music, in 1881 Matiushin joined the Imperial court orchestra as a violinist and stayed with it until 1913. At the same time he was studying painting in Bakst and Dobuzhinsky's studio, where he met his future wife, Elena Guro. Nikolai Kulbin introduced the couple to other young avant-garde artists and literati: the Burliuk brothers, Kruchenykh, Maiakovsky and then Malevich, who became their closest friend. From 1910 onwards Matiushin's home was a headquarters for the Moscow and Petersburg Futurists, a place where discussions and meetings were held and theoretical ideas worked out. Although Matiushin regularly presented his work at the Vision of Youth exhibitions (he had been a founding member of the society), his main activity in 1911-16 was centred on the publication of his Futurist friends' writing. He became their main publisher, producing the anthologies *The Roaring Parnassus, The Three, A Trap for Judges*, and Khlebnikov's books. He also continued his activity as a composer, setting Elena Guro's poems to music (*Hurdy Gurdy*, 1909; *Autumn Dream*, 1912; *Don Quixote*, 1915).

In June 1913, during the "First Pan-Russian Congress of Seekers of the Future", which Matiushin organized on his estate in Finland, he wrote the score for *Victory over the Sun* (libretto by Kruchenykh, costumes and sets by Malevich) which was staged in December of that year in St. Petersburg. At the same time he started to develop a theory of painting, a system of "enlarged vision" based on Cubist experiments (he was the first to translate the theoretical writings of Gleizes and Metzinger from

and Metzinger from French into Russian) and on his research on the fourth dimension. In 1919-22 Matiushin headed the Studio of Spatial Realism in the Free Art Workshops and continued his enquiry into space and colour. In 1927 he became head of Inkhuk together with Malevich. With his assistant Boris Ender he started research into the possibilities of widening visual perspective; his studies were put together and published as a book entitled *Colour Primer*.

A very small proportion of this artist's work is known to the Western public, and only a few fragments have been published from his vast archive (containing, among other things, the manuscript of a *History of Russian Futurism*) deposited with the Russian Museum in Leningrad. (SZ)

Mattis Teutsch, Janós

(Brasov, Rumania, 1884 - Brasov, 1960) Rumanian painter of Hungarian origin

Mattis Teutsch studied at the School of Fine Arts of Budapest (1901-02), then at the Academy of Munich (1902-05).

Neo-Impressionist, and the Fauvist, it was only after 1910 that he developed a personal style based on an extremely colourful lyricism, with loose shapes, which linked him to the "Orphic" painters (see Orphism), and to Franz Marc; but while the German painter conducted an intense experimentation based on animals, Mattis Teutsch preferred the shapes of trees and landscapes. He produced an almost abstract form of painting that often used whirlpool motifs. Parallel to his painting, he also created polychrome sculptures, usually in wood, with abstract, tormented shapes reminiscent of the vegetable kingdom.

He admired the painters of the Blaue Reiter but felt closer to those of Der Sturm. He probably was not personally acquainted with the Futurists, but he certainly was familiar with their theories and their works through *Der Sturm*. He held his first personal show in 1913 in the Der Sturm Gallery in Berlin; his engravings often appeared in the pages of their magazine. Although he leaned toward Germany, Mattis Teutsch was also linked to the artists of Kassak's group Ma, and he exhibited with them several times. After the failure of the Hungarian revolution in 1919 he returned to Brasov, his native town, which had just been annexed to Rumania. Settling in Brasov, he established ties to the Constructivists, and particularly the Rumanian periodical *Contimporanul*, where he met the painter Marcel Jancu. He maintained his contacts with the Ma and Der Sturm, and continued to exhibit with them. (SF)

Meidner, Ludwig

(Bernstadt, 1884 - Darmstadt, 1966) German painter and writer

Meidner studied art at Breslau and later in Paris. After returning to Berlin in 1912 he exhibited in the first Sturm show; he was also one of the poets and artists that founded the club Die Pathetiken. He executed numerous Expressionistic portraits of his friends during this period, and at the same time painted canvases depicting apocalyptic urban landscapes: an infinite and chaotic universe filled with houses and cities in flames. He was interested in the Italian Futurists but professed political ideas opposed to theirs, and published these ideas repeatedly (after the war Meidner joined the ranks of the Communists). He remained an extremely individualistic Expressionist painter. During the war he published such pessimistic books as *Im Nacken das Sternemeer* (1918). He was a friend of Grosz, and was politically involved during the Twenties; when the Nazi party came to power Meidner was forced to flee. After returning to Germany, he remained shrouded in relative obscurity as a painter and writer. (SF)

Méliès, Georges

(Paris, 1861 - Paris, 1938) French film-maker and director

Méliès began his career as a magician and director at a theatre specializing in illusionist spectacles. After seeing the first presentation of Lumière's motion pictures, he immediately offered a large sum to buy the apparatus, but was refused. Undiscouraged, he bought and experimented with other kinds of photographic equipment and eventually became a producer, author, photographer, decorator, actor and film director. By the turn of the century, he dominated an epoch in the history of film. Transferring his interest in trick effects to motion pictures, Méliès created a new art form, which presented a romantic-ironic image of the world of technology and machinery. The motion picture was for Méliès, above all, a machine for creating enchantment. Beginning with *A Trip to the Moon* in 1902, he made a long series of films (*The Impossible Voyage*, *The Conquest of the Pole*, *20,000 Leagues under the Sea*, and so forth). In these films, Jules Verne's optimistic outlook and unlimited confidence in progress and science were subjected to a light, good-natured scepticism and often exaggerated to the point of absurdity.

Méliès injected a healthy doubt into the unwavering popular faith in science by making vast technological and scientific enterprises appear too easy to be believed by even the most credulous. His space ships made a trip to the moon as easy for passengers as a tram ride. Using a technological feat of an artistic nature, he mocked those who placed too much confidence in technology. Between the Cubist and the Futurist view of the world of technology, Méliès, with his detached scepticism, is certainly more of a Cubist than a Futurist. (PH)

Melli, Roberto

(Ferrara, 1885 - Rome, 1958) Italian sculptor

Although he studied with the painter Nicola Laurenti, Melli was greatly impressed by the works of the sculptor Arrigo Minerbi, which led him to become a sculptor. In 1911 he moved to Rome. Fascinated by Soffici's book on the work of Medardo Rosso, Melli tried his first plastic experiment in 1906 with *Portrait of a Little Girl* in wax. Around 1913 he executed his first work with a more solid and volumetric basis, derived from a profound knowledge of the material and a desire to invent a new and non-traditional plastic feeling that could be imposed on space through the hardness and essentiality of its formal appearance: *Woman with a Black Hat* in bronze; *A Portrait of Vincenzo Costantin* in stone. "I remember that Boccioni came to my studio, with Sironi, to see these sculptures of mine, the result of the formal application of a theory, of a polemic and formal quality which displayed a programmatic and arbitrary dynamism which left things exactly where they were, starting from a physical enchantment, physical exasperation and not from indications of the spirit." He exhibited his works in the "Roman Secessions" of 1913 and 1914 and at the same time took up painting "the values of light and of space as light". (EC)

Mexico City

Immediately after the revolution, when calm was restored and cultural activities resumed (1920-21), Mexico City was deserted by its avant-garde intellectuals: Tablada, Zayas, Rivera, Siqueiros (the last two returned to their country in 1921 and 1922). Orozco was still considered only a caricaturist, and the poet Lopez Velarde was on his deathbed. But a younger generation was awakening, and at the end of 1921 Maples Arce published the *Manifesto of Stridentism* distributing and posting it all over the city. The Stridentist group included painters like Firmín Revueltas, Alva de la Canal, the engraver Leopoldo Méndez, the sculptor Germán Cueto, the composer Silvestre Revueltas and the poets Gallardo, List Arzubide, Quintanilla. They had the sympathy of foreign artists and of artists who had recently returned from abroad — Diego Rivera and Jean Charlot. Their meetings took place at the Café de Nadie (The Nobody Café) where they discussed and organized events: exhibitions of paintings, of Cueto's sculpture, poetry readings, concerts. Alva de la Canal also had the idea of organizing outdoor exhibitions of painting in the public parks. Soon, alongside reviews like *Actual* or *Ser*, Stridentist publishing houses were established, where poets and authors collaborated to create fine books (just as in Italy there were Futurist publishers and in France there were to be Surrealist editions). Stridentism spread outside Mexico City and struck root in several provincial cities, notably Jalapa, which was nicknamed "Stridentopolis". (SF)

Milan

The most important Italian city in the early history of Futurism was Milan. Marinetti lived there and it was there that, early in 1910, he met Boccioni, Carrà and Russolo; following this meeting, the *Manifesto of Futurist Painters* was launched on 11 February 1910. Then on 15 February one of the first organized Futurist *soirées* was held at the Teatro Lirico. Important events followed, in particular the first public exhibition of a group of Futurist works in the Ricordi Pavilion, on the occasion of the "Free Art Exhibition". Marinetti's Casa Rossa at 61, Corso Venezia, was the headquarters of the Futurist movement, where meetings were held and manifestos were drawn up. In the period May-June 1914 the Famiglia Artistica housed the first exhibition of the group Nuove Tendenze, heretical but not very far from Futurist positions; Sant'Elia, Chiattone, Dudreville, Erba and Funi were among its members.

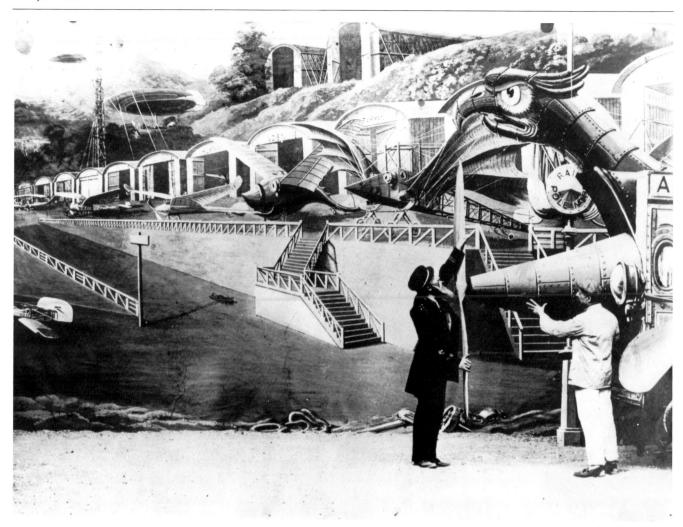

G. Méliès in The Conquest of the Pole
Cinémathèque Française

G. Balla, Portrait of Silvio Mix, *1926*

From September 1914 onwards Milan became the stage for the Futurist demonstrations urging Italy's intervention in the First World War; Boccioni, Marinetti, Mazza, Piatti and Russolo took part and some of them were arrested after the gatherings at the Teatro Dal Verme and in Piazza del Duomo. During the war their activity died down, partly because the majority of Futurists left for the front. Sant'Elia and Boccioni died in the war and Marinetti, in honour of the latter, organized a large retrospective of his works at Palazzo Cova between the end of 1916 and the beginning of 1917.

Between 1919 and 1920 Marinetti took an active role in politics, participating in the meetings of the Milanese *Fascio*. In May 1920 he left the *Fasci*, accusing them of *passéism* and reactionary tendencies. The first national Futurist exhibition was held at the Galleria Centrale d'Arte (1919), followed by exhibitions of Futurist painters at the Galleria Pesaro (November-December 1927; October 1929). (EC)

Mix, Silvio
(Trieste, 1900 - Gallarate, Varese, 1927) Italian composer

Mix moved to Florence from Trieste, where he met the Futurists who gathered at the Libreria Gonelli. There he often improvised at the piano upon themes given him by the audience.

In 1921 he and Casavola composed music for productions at Cangiullo's Teatro della Sorpresa. In 1924 he wrote the music for the ballets *Psicologia delle macchine* (*Psychology of Machines*) and *Bianco e rosso* (*White and Red*), both for the "Nuovo Teatro Futurista" ballet company directed by De Angelis. In 1927 he wrote the incidental music for Vasari's play *L'angoscia delle macchine* (*Anguish of the Machines*), produced at the "Art et Action" theatre in Paris. He also composed music for the Futurist Pantomime shows which were produced the same year at the Théâtre de la Madeleine, for Orazi's *L'estasi paradisiaca di Santa Teresa* (*St. Teresa's Paradisiacal Ecstasy*), and for Marinetti's *Cocktail*.

Other compositions included *Profili sintetici* (*Synthetic Profiles*), piano music inspired by the paintings of Marasco and Prampolini, and a *Symphony* for Marinetti's novel *Mafarka il futurista* (*Mafarka the Futurist*).

It was discovered from newspaper articles after his death that he also wrote *Inno alle Corporazioni* (*Anthem to the Corporations*), *Sinfonia umana e fantastica* (*Human and Fantastic Symphony*), *Rapsodia veneta* (*Venetian Rhapsody*), an intermezzo for the play *Astrale* (*Astral*), *Inno imperiale* (*Imperial Anthem*), a string quintet, several compositions for violin and piano or violoncello and piano, and many preludes for solo piano. (FMa)

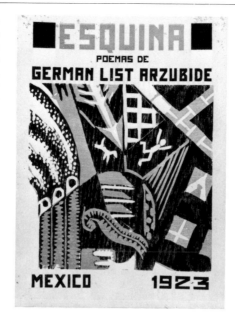

J. Charlot, book cover for Esquina *by G. List Arzubide, 1923*

List Arzubide, G. Cueto, Maples Arce L. Méndez and A. Vela in Mexico, 1925 c.

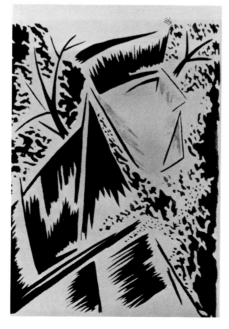

N. Goncharova, Portrait of Mjasin, 1916 c.

Mjasin (Massine), Leonid
(Moscow, 1894 - USA, 1979) Dancer and choreographer of Russian origin, naturalized American

At the age of eighteen, Mjasin made his debut as a dancer with Diaghilev's Ballets Russes in Richard Strauss' *The Legend of Joseph* (1914). Fokine's choreography made the ballet almost a mime drama, recalling Isadora Duncan's free dance. Mjasin became a choreographer during the second season of Ballets Russes in Paris and used this same dance expression. His first choreographic work, *Donne di buon umore* by Scarlatti, orchestrated by Tommasini, was presented at Teatro Costanzi in Rome on 12 April 1917. The movements have a clockwork precision so that the dancers look almost like comical robots. Mjasin's use of stiff, precise mime is inspired by *Commedia dell'arte*, by the techniques used in cinema and circus (see, for example, *Parade*, 1917), by Picasso's Cubist paintings, and by Balla's and Depero's Futurist abstraction. During the time he spent in Rome in 1917, Mjasin started collecting Italian Futurist works. (LDM)

Mlodozeniec, Stanislaw
(Sandomierz, 1895 - Warsaw, 1959) Polish writer

Educated in Russia, Stanislaw Mlodozeniec returned to Poland only after the First World War. Introduced to Futurism by Bruno Jasienski, he published *Traits and Futurotraits* (1921), *Futurogrammes*, *Futurolandscapes* (1924) and *Squares* (1925). Rather than Jankowski's simplified spelling, Mlodozeniec preferred experimenting with neologisms and puns: "I dewarsawize I comit I solarize."

His humour recalls Dada and, even more, Khlebnikov's *zaum*. (SF)

Moscow and St. Petersburg
In the geography of Russian culture and literature, Moscow and St. Petersburg are two symbolically opposed points. Moscow is the organic city, spontaneously generated in the heart of Holy Russia, while St. Petersburg is the calculated, artificial city, founded in an unhealthy marginal area of the Empire. St. Petersburg is the city without history, the starting point for Russia's new European phase, while Moscow is tied to history and tradition — the essence of archaic Russia to such a degree that it is not even a city in the proper sense of the term, but simply a "big village". "For a Russian who was born and always lived in St. Petersburg, Moscow is as surprising as it is to a foreigner", said Belinsky, showing how much the former capital was an expression of patriarchal Russia.

This mythology of the Moscow-St. Petersburg dichotomy must be kept in mind in order to understand modern Russian literature in its cultural habitat. That literature was chiefly St. Petersburg-based, not merely because that is where its most important practitioners and institutions were located, but by spirit and focus of interest. Modern Russian literature was fed by the Europeanization of Russian civilization, and therefore founded on an ongoing relationship between the Russian and the European aspects of that civilization.

The "Petersburg cycle" of Russian culture

and literature ended in the Twenties, when St. Petersburg, renamed Petrograd in 1914 and then Leningrad in 1924, started its definitive decline, and the centre of gravity of Russian literature shifted for good to Moscow, which had become the capital again.

Symbolism, between the end of the 19th century and the beginning of the 20th, was still chiefly a St. Petersburg phenomenon, though it had an important base in Moscow — for example, the magazine *Vesy* (*The Scale*) was produced in Moscow by the publisher Skorpion. Acmeism was also part of the "Petersburg cycle". Futurism, on the other hand, was a largely Muscovite phenomenon, if by Futurism we mean the central core of the movement, Cubo-Futurism. Ego-Futurism, on the other hand, is Petersburg-based as far as the Peterburgsky Glashatai (Petersburg Herald) group is concerned, and Moscow-based with reference to the Mezanin Poezii (Mezzanine of Poetry) group. The Centrifuge group, in which Boris Pasternak started, was also Moscow-based. Cubo-Futurism was Muscovite even though the first book by writers gathered around Khlebnikov (*A Trap for Judges*) was published in St. Petersburg in 1910; but Moscow saw the launching of the first programmatic manifesto of Futurism, *A Slap in the Face of Public Taste*, in 1912.

Although Moscow was the home of the Russian avant-garde, one should not ignore the many extensions and ties that Moscow had in the artistic world of St. Petersburg, where numerous "manuscript" books by Kruchenykh and Khlebnikov were published and where the publishing house Zuravl (The Crane) — run by Matiushin — operated.

During the Twenties, Moscow and Leningrad remained the two poles of the avant-garde, with Moscow definitely in the lead. Maiakovsky's magazines *Lef*, 1923-25, and *Novy Lef*, 1927-28, were published in Moscow, and the two most important artistic centres, Inchuk (Institute of Artistic Culture), and Vchutemas (Higher Technical and Artistic Studios) were based there. In Petrograd, from December 1918 to April 1919, the weekly *Iskusstvo Kommunity* was published, an important forum for the development of the revolutionary Futurist-Constructivist avant-garde. With the transfer of the capital to Moscow, that city gradually became the center of all literary life, while Leningrad, home of the old intelligentsia, gradually lost all independent cultural status, in line with the centralizing aim of the new political forces. In the former capital, however, avant-garde artists such as Malevich and Filonov continued to work in complete isolation; the last Russian avant-garde movement, Oberiu (Union of Real Art), enjoyed a brief existence there between 1927 and 1928. With the absurdist avant-garde of the Oberiutes, St. Petersburg-Petrograd-Leningrad dropped the curtain on the triumphant season of its autonomous literary life, just when Moscow, the new cultural leader, was losing its former creativity. The era of "Socialist Realism" began. (VS)

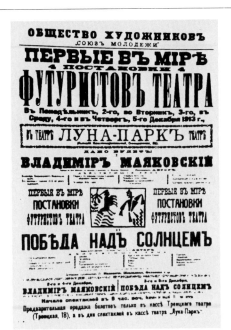

V. Maiakovsky, Vladimir Maiakovsky: A Tragedy, *1924*

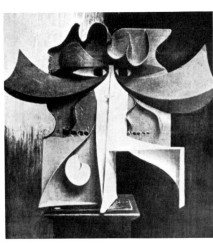

G. Balla, The Marquise Casati, *mica and wood, 1915*

Multimaterialism

Boccioni, in *Pittura scultura futuriste* (*Futurist Painting and Sculpture*, 1914), claimed to be the inventor of *polimaterismo* (multimaterialism), that is, figurative design achieved by superimposing and juxtaposing the most diverse materials. However, this technique seems to have been used by Picasso in certain works during 1911 and 1912. In his *Technical Manifesto of Futurist Sculpture* (April 1912) Boccioni stressed the use of "absolutely all realities to reconquer the essential elements of plastic feeling", and he stipulated that the necessity of understanding "plastic zones", justified the use of "planes of wood or metal, immobile or made to move, to embody an object; spherical and hairy forms for heads of hair, half-circles of glass, if it is a question of a vase; iron wires or trellises, to indicate an atmospheric plane". The influence of Medardo Rosso is superseded by creations which in plastic terms suggest the impact of the environment and the atmospheric ties which attract it to the subject, in an unexpected mutual interaction of real objects and inward mental forms.

Boccioni, in his sculpture *House + Head + Light* (1912), inserts a metal railing among the plastic planes of the head to evoke from the outset both the material fact and an environment which is at once shown and dematerialized by the transitoriness of light. In *Fusion Of Head and Window*, a metal frame and a woman's hair are shown on equal terms by the rays of light coming through the glass, since light vitalizes everything and stamps objects on the consciousness. Boccioni evolves a pictorial *continuum* which puts into visual terms the constant coming into being of matter, the "duration" of the factual event; the object embodies the state of mind which inspired the work. As opposed to Picasso and Archipenko, who aim at an illusive and ironical restoration of the object, Boccioni works out his "plastic states of mind" by using ever more elemental forms, which are nonetheless functional and communicative.

In 1915 Boccioni achieved one of his most inspired creations, *Horse + Houses*. Despite damage and thoughtless restoration, this rhythmic assemblage of wood, copper, tin and cardboard embodies the enthusiasm and the transitoriness of the act of making it. The crude object gives us the very flavour of the event itself. For many of the Futurist group this *polimaterismo* was the ultimate goal of their most frenetic insights, later developed by other artists according to their sensibilities. For example, in 1915 Severini exhibited *Sentries-Vases*, a "sculpture-painting" now lost, but which we may imagine to have evolved out of Boccioni's "plastic analogies" and multi-material experiments. Another example of this particular plastic "direction", which aspires to overcome the limitations of pure painting and involve the spectator in the work, is seen in *Articulated Dancer* — or rather, by what remains of the articulated ballerina exhibited in Paris in 1916. The Parisians could amuse themselves by pulling strings and blowing on mobile planes to make the ballerina move.

Around 1915 a more humorous, ironical

element began to creep into the notion of a pictorial *continuum*. This was expounded by Balla in his manifesto *Plastic Reconstruction of the Universe* and exemplified in the *Portrait of the Marchesa Casati (with Mica Eyes and Wooden Heart)*. This work, truly Futuristic in its irreverence and humour, surpasses the so-called "objects" of Marinetti and Cangiullo, as it does the rhythmic equilibria of Archipenko. It also provided a point of departure for the burlesques staged by the troupe of *Parade* and Depero. (PP)

Munari, Bruno

(Milan, 1907) Italian painter, sculptor and designer

Member of the Milanese Futurist group from the mid-Twenties, between 1927 and 1935 Bruno Munari showed at numerous Futurist exhibitions and events. First, as a painter, he engaged in an analytical plastic dynamism with "aeropittura" connotations, then from 1933 he created plastic constructions which he called "useless machines".

In 1930, together with Cesare Andreoni, Mario Duse, Carlo Munari, Ivanhoe Gambini and Oswaldo Bot, he signed the theoretical declaration of the Milanese group. In 1932 he published the *Cantastoria Campari* (*Campari Street-Singer*) with 27 plates, and in 1934, in Milan, he signed the *Technical Manifesto of Futurist Aeroplastics* with Manzoni, Gelindo Furlan, Riccardo Ricas and Regina. His art production includes collages, photomontages, book illustrations, theatre designs, advertising posters, and ceramics (with Tullio d'Albisola). (ECr)

Munch, Edvard

(Löten, 1863 - Oslo, 1944) Norwegian painter

Munch's great pictorial innovation was the transfiguration of nature in light of an existential vision. His vision of the world gave life to the giants, phantoms and monsters that lurk in private everyday life, and his lead was followed by other historic 20th century avant-garde movements. For the Futurists in particular, the voyage into the unknown emotional life of the individual, with its obscure symbolism, was a source of vital perceptions — for example in Boccioni's *Mourning* (1910) and *States of Mind* (1911). Such paintings reveal intense moments, in which the perception of formal and private emptiness gives physical reality to figures that come to life only to produce further "traces" of sensory energy.

However, the similarity is not limited to the subject matter. Both painters obtain images of solitude and silence through undulating lines and vortexes of brushstrokes. The expressivity of the pictorial sign is of primary importance, indicating an interpenetration between interior and exterior atmosphere, and giving form to the sensory emanations of the unknown. This is further attested by the density that bursts forth from the "relations with existence" and from the mystery of an alien identity. (GC)

Music

Marinetti had begun by gathering together poets and authors in his effort to breathe new life into Italian culture, to bring it into step with contemporary European activity or even surpass it. However, it soon became evident that Futurism would involve other cultural sectors such as the visual arts, music, architecture, theatre, and cinema in a process of interdependent integration. In this process, music gradually lost its primacy and began to play a supportive role in Futurist theatrical productions, both in Italy and abroad.

Francesco Balilla Pratella (1880-1955) was the first musician to "surrender to the persuasion of promises and liberation". By joining the vital new movement he hoped to abandon his constricting role as the *enfant gâté* of musical life in Romagna and be recognized internationally as the principal author of a new musical language, a development long desired and already largely achieved by several musicians in Europe. His vehement declarations in *Manifesto of Futurist Musicians* of 11 October 1910, *Futurist Music, a Technical Manifesto* of 11 March 1911, and *Destruction of the Scheme* of 8 July 1912, which proclaimed that "the new order of disorder should be created by destroying the ancient schemes", were all flavoured by Marinetti's arbitrary ideology. In contrast, Pratella's works of this period, such as *Musica futurista - Inno alla vita* (*Futurist Music - Hymn to Life*) op. 30, *La guerra* (*War*) op. 32, and *L'aviatore Dro* (*The Pilot Dro*), musically represent the idea of the new Futurist man opposed to the mythical Wagnerian hero of Romantic origin, and demonstrate that in fact his revolutionary aspirations resulted only in generic declarations against outdated customs.

To Marinetti's rigid, iconoclastic ideology which venerated the machine age, Pratella opposed a "genuinely intimate expressivity, which results from adjusting one's technical means of expression to an essentially human spirit far from an inhuman and arbitrary expression". Marinetti encouraged him to produce music which was "more than modern, prophetic, liberated from all cloudiness, myths and legends, pastoral idyllic obsession and sentimental erotomania", but Pratella laced his compositions with themes taken from Italian folk songs. Even in *The Pilot Dro*, according to the composer, "the melodic, lyric, dramatic element was conditioned by modern expression and by the particular gestures of the purest, most authentic elements of Romagnolo folk singing..."

Thus, while Pratella must be given credit for being the first to attack excessive attachment to the past, stirring the drowsy Italian musical world and its traditional structures, it is necessary to examine his work objectively, not so much in a Futurist as in a historical context, bearing in mind that his contemporaries were Pizzetti, Malipiero and Casella.

The life and work of Luigi Russolo (1885-1947) — who had begun as a leading exponent of Futurist painting — is of great interest in the small select circle of Futurist musicians, for his theories and instruments had a significant effect upon successive developments in the musical language of Europe. On 11 March 1913 he wrote the manifesto *The Art of Noises*. Its content was very upsetting to musical tastes of the time, for it proposed to destroy the barrier which separated the world of precise harmonic sounds from that of indeterminate noise. This was in perfect agreement with Marinetti's theory of machines. The sounds of nature and modern life were primary sources of "sound-noise" which, according to Russolo, was capable of enriching the limited sources of pure sound, providing an infinite variety of timbres for the needs of modern composers. He established that every sound-noise had a pitch and often a chord which could be heard over the collective irregular vibrations; consequently every factory could one day become an exhilarating orchestra of noises, offering new acoustical delights superior to those of the *Heroic* or *Pastoral* symphonies.

These proposals placed Marinetti in considerable embarassment because they were likely to render the efforts of Pratella — to whom Marinetti had entrusted his hopes of obtaining international success — useless and outdated. Marinetti was thus forced to institute a section in Futurism that included Russolo's *Art of Noises* as a sister art to music, creating a misunderstanding which was unprofitable for both music and Russolo's art.

Only when he created his "intonarumori" — machines of Da Vincian originality capable of creating different types of sound-noise and of modifying their pitch and rhythmic emission — was Russolo able to achieve that "enharmonic music" which Pratella had so fervently advocated as the maximum goal of Futurist music.

Russolo's discovery of new sound sources in the world of machines and modern life was perhaps Futurism's most revolutionary achievement to date. His results were matched only years later when Pierre Schaeffer developed his "musique concrète" in 1948. From the introduction of the "intonarumori" through to the end of the Thirties Russolo's fame predominated over that of Pratella. His instruments and his concert activity in Italy and abroad stimulated the interest of the international press and attracted the attention of such musicians as Ravel, Stravinsky, Prokofiev, Honegger, and Varèse who, apart from his initial opposition, can be justly considered the continuator of Russolo's theories.

But despite the clamour aroused by his memorable concerts in Milan, Genoa, London and Paris, the advent of Fascism (to which Russolo, in contrast with many other Futurists, never subscribed) completely excluded him from the lively activity which Futurism was enjoying in the years following the First World War, both in Italian and other European theatres. For its musical needs, the movement turned to Pratella and to Franco Casavola and Silvio Mix (who died young in 1927). This unjustified ostracism did not, however, prevent Russolo from continuing his experimental activity in Paris, independently of Futurism's organizational structures.

It was Russolo's personal drama to be misunderstood both by his contemporaries and by his Futurist friends. Though his message was ignored by the Italian musical world and his instruments ridiculed by a

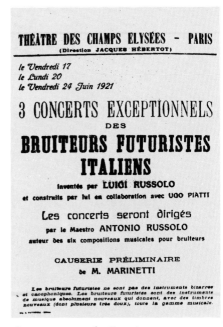

Announcement of a Futurist concert
by Russolo, 1921

Fantasio, 1913, satirical score by an
anonymous author

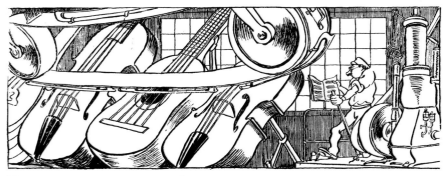

Russolo's "intonarumori" in 1919

The Rumorists, Futurist Music, caricature
by J.J. Roussau

skeptical public, with Russolo, Futurist music not only reached its height of notoriety, but his theories and experiments went beyond Italy's borders to figure in the larger context of European avant-garde.

Second generation Futurist musicians such as Casavola, Mix, Bertoccini, Mantia and Giuntini, merit only brief mention, so scarce was their production and so much less incisive their theories.

After reaching its apex with Russolo's *Art of Noises*, Futurist music entered a phase of decline. The exciting glorious revolutionary spirit of its early days had gone, leaving Italian musicians to adjust to the heavy reactionary climate imposed by the new Fascist regime. Replacing the noise of the "intonarumori" was a growing preference for the gurglings of Respighi's *Fountains of Rome*, the various "Scarlattiane", and even the simulated rumblings of Casella's *Corazzate in crociera* (*Battleships on a Cruise*).

By that time the problems of musical language had largely been solved. Pratella was slowly pulling away from the Futurist movement to dedicate himself completely to the study of folk music and the "Camerata dei Canterini Romagnoli", a group of Romagnolo musicians. The next generation of Futurist musicians had only the theatre to justify their ideological existence, even though they did not refuse to collaborate with musicians of other affiliations. This occurred in various performances at Bragaglia's Teatro degli Indipendenti and at the Futurist Teatro della Pantomima, where Pratella, Casavola and Mix worked alongside Malipiero, Casella, Respighi, Davico, Scardeoni, Sommi-Picenardi, and even Bontempelli. Russolo's theories had absorbed all prospective future innovation; the efforts of Casavola, Mix, and Giuntini could not advance beyond the accomplishments of other European countries. Casavola wrote five manifestos in 1924 on the problems and possibilities of new musical languages. From these it is evident that the symbiosis he advocated among music, colour and staging had already been proposed in the years 1910-12 by the brothers Bruno and Arnaldo Ginanni Corradini (see Corra and Ginna), by Ricciardi with his Teatro del Colore, by Pratella in 1916 with his *Nuovo poema sceneggiato per la musica* (*New Poem Dramatized for Music*), etc. Apart from these theatrical occasions, the music of Casavola and Mix did not surpass the general contemporary production in Italy. Mix in particular wrote rhetorical celebratory compositions such as *Inno alle corporazioni* (*Anthem to the Corporations*) and *Inno imperiale* (*Imperial Anthem*) which were perfectly compatible with other long-winded compositions produced for the pompous Fascist regime. Russolo's timbric and colouristic asperity was repeatedly alternated with the flutters and trills of small, pseudo-modern quintets or quartets, *Lieder* on texts by Pascoli, D'Annunzio and Tagore, music for Fascist youth choirs and nationalistic songs. Under the influence of jazz, Bertoccini and Mantia turned to musical improvisation, and Giuntini began producing *aeromusica* with inflated compositions such as *Angoscia a tremila metri* (*Anguish at Three Thousand Meters*), *Battaglia di terra, mare e cielo* (*Battle of Land, Sea and Sky*), *Gioia del mitragliere*

(Joy of the Machine-Gunner) and *Orgoglio dei chimici (Pride of the Chemists).*

After 1920, thanks to technological breakthroughs and to Russolo's theories, new techniques for the elaboration of instrumental and vocal sound were discovered by composers such as Milhaud, Varèse and Cage. Electronic instruments were invented to create sound artificially, while the Futurist musicians slowly sank into the folds of rhetorical and academic orchestration. Russolo's seeds were the only ones to take root in a hostile, dry terrain, bearing fruit in the years following the Second World War when Schaeffer invented his *musique concrète...* but by then Russolo was dead and no critic dared vindicate him, despite the obvious Futurist sources of information. (FMa)

Muybridge, Eadweard

pseudonym of Muggeridge, Edward James (Kingston-on-Thames, 1830 - London, 1904) British photographer

Muybridge's straight forward photographic studies of motion were originally motivated by an interest quite different from Marey's scientific research. His experience as a photographer for the United States government led the ex-Governor of California, Leland Stanford, to commission him in 1872 to take photographs of a racehorse of which he was especially proud. The famous story that Stanford wished to win a bet about whether a galloping horse ever has all his feet on the ground simultaneously, unfortunately seems to be apocryphal; however, Muybridge's photographs did in fact establish that, at one stage of the gallop, all the horse's feet do leave the ground and are bunched below his belly.

It was in 1878 that Muybridge attained the desired results by arranging a battery of cameras alongside a race track. Their high-speed shutters were released by woollen strings stretched across the track, which were broken as the horse rushed past. Later Muybridge expanded his research to study the movement of other kinds of animals, and of men, women and children. He also devised an apparatus that enabled him to show the consecutive frames of his photographs in motion. As Leland Stanford predicted in his foreword to Muybridge's first published album, *The Horse in Motion:* "The facts demonstrated cannot fail, it would seem, to modify the opinions generally entertained by many, and as they become generally known, to have their influence on art." In fact, his contemporary, Thomas Eakins, already made use of Muybridge's research for his painting as well as in his teaching.

We have no direct indication that the Futurists used Muybridge's pictures in their studies, but it is quite possible. We do know that they were very important as an inspiration for Francis Bacon and that they have continued to fascinate later generations. The fact that Muybridge's approach is pictorial where Marey's is more scientific, has made his work more easily accessible. (PH)

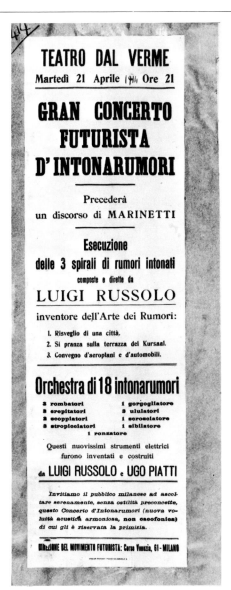

Announcement of a Futurist concert by Russolo, 1914

E. Muybridge, Rearing Horse

Neumann, Stanislav Kostka

(Prague, 1875 - Prague, 1947) Czech poet and journalist

First influenced by Anarchism and Symbolism, Kostka Neumann underwent a radical conversion at the beginning of 1913 and became a fanatical supporter of Cubism and Futurism. He expressed his personal opinions on modern art in a series of enthusiastic articles published in *Lidové Novimy* (June 1913 - June 1914) and collected after the war in the book *Ať žije život (Long Live Life,* 1920), illustrated by Josef Čapek.

Most characteristic of Neumann's new orientation was his delight in contemporary life in the big cities and his admiration for the beauties of technology. In the article entitled "Oltář umění a nový patos" (The Altar of Art and the New Pathos) he wrote: "From an artistic point of view we approach contemporary life as its poets, first spitting definitively on the altar of art ... and then adopting a new, appropriate poetic language, which will have the pathos of the flight of an aeroplane and the expressiveness of the posters of the metropolis." Pathos, expressiveness, dramatic content, dynamism and prosaic beauty were for Neumann the fundamental signs of modern art, which brought a totally new iconography, taking its themes mainly from the world of technological civilisation.

At the same time, Neumann emphasized that modern art was above all the result of a new formal will and of a radical change of figurative language, and that it must go hand in hand with permanent experimentation.

Neumann was the keenest Czech supporter of Futurist standpoints, many of which he incorporated into his own poems and poetic theory *(Nové zpěvy - New Cantos).* His article entitled *Otevřená okna (Open Windows),* dated 9 August 1913, was even described as the "Czech Manifesto of Futurism" in *Umělechý Mesičník (Art Monthly),* the organ of the Cubist SVU. Here Neumann was inspired by Apollinaire's manifesto *Futurist Anti-Tradition,* published a month earlier. Believing that "there is no reason why what happens in 1913 in Paris, London, Rome and Berlin cannot happen in 1913 in Prague", Neumann immediately applied the Futurist programme to the Czech environment. First he examined the existing local achievements, recalling Symbolist experiments with typography, punctuation and free verse, then he summarized the conflict between modern life and aestheticizing art and concluded with this forecast: "We shall have a marvellous autumn. We shall betroth the *De profundis* of passéism with the torches of Futurism." Neumann ended his statement, following Apollinaire's example, with the iconoclastic exclamations "Let it perish! Evviva!", in the Futurist tradition of provoking the bourgeoisie. After the war Neumann became the theoretical spokesman of the group Tvrdošíjní (Čapek, Špála, Zrzavý and others), whose paintings reveal distant echoes of Futurist ideas. (FŠ)

Nevinson, Christopher

(London, 1889 - London, 1946) British painter

Son of H.W. Nevinson, a war correspondent and author, Christopher Nevinson studied painting at the Slade School of Fine Art (1909-12) and at the Académie Julian and Cercle Russe (1912-13). He exhibited at the salon of the Allied Artists Association (1913-14), in the "Post-Impressionist and Futurist Exhibition" (1913), the "Cubist Room", Brighton (1913), and was a founding member of the London Group. He was included in the Whitechapel Art Gallery's exhibition of "Twentieth Century Art" (1914) and was invited to show in the "Vorticist Exhibition" in 1915 as a Futurist. He joined the Rebel Art Centre in spring 1914 but fell out with Lewis after the publication of *Vital English Art: Futurist Manifesto* in June 1914. He initiated with Lewis the publication *Blast* and claimed the credit for conceiving the title. He contributed one illustration to *Blast No. 2*. During the war he held two successful one-man exhibitions of war paintings at the Leicester Galleries (1916 and 1918). At the beginning of 1919 he renounced Futurism and reverted to a more traditional style of painting.

Nevinson's earliest works depict urban subjects in an Impressionist style. In spite of his early encounter with Post-Impressionism as a young boy on holiday in France, it made little impact on him until 1912. Nevinson's conversion to Futurism followed hard on this advance and came about directly as a result of seeing the Futurist exhibition in London in 1912.

He met Severini, who was present in London for the duration of the exhibition, and returned to Paris with him where he was introduced to Boccioni, Soffici, Apollinaire and Modigliani. He shared a studio with the latter.

Nevinson is credited by Frank Rutter with having painted the first British Futurist painting; the *Departure of the Train de Luxe* (c. 1913). It depicts a train speeding through an urban landscape in a cloud of steam and smoke. Beyond the train are advertisements for Byrrh and Kub indicating its modernist standpoint. The houses are slightly Cubistic and there is little doubt but that this work bears the influence of Severini's *Nord-Sud* (1912). In 1913 Nevinson also showed *The Rising City*, which probably made close reference to the painting of a similar title by Boccioni exhibited at the Futurist exhibition in 1912, as well as another lost painting entitled *Waiting for the Robert E. Lee* which again displayed a debt to Severini's *Spanish Dancers at the Monico*. Nevinson was regarded as one of the more intelligible avant-garde artists who could make the Futurist style presentable to the public. Nevertheless, he was also the subject for ridicule in the popular press when for example *Waiting for the Robert E. Lee* was illustrated in the *Daily Sketch* upside down under the headline "you wouldn't think these were paintings would you" in order to show that it doesn't matter.

However clumsy Nevinson's first Futurist paintings were he showed considerable commitment to his new cause. In November 1913 he arranged for Marinetti to visit London and with Wyndham Lewis organized a welcoming dinner for him. On occasions Nevinson also assisted Marinetti in giving lectures and ultimately became his only disciple in London, co-publishing with him *Vital English Art: Futurist Manifesto* (1914), a rather innocuous document which had little impact and was overshadowed by the subsequent publication of *Blast*.

Nevinson's painting in 1914 became increasingly Futurist. His *Non-Stop* (1914) was described as "a Futurist Frith with less than Frith's skill" by one uncharitable reviewer but, on the whole, his paintings were better received by a press which was increasingly mystified and horrified by the "rebel" artists. P.G. Konody wrote in the *Observer* that, compared with the work of Lewis and Bomberg, Nevinson's "disjointed world in motion becomes as intelligible as photographic realism". Nevinson's debt to Severini in these and other paintings such as *Tum-Tiddly-Um-Tum-Pom-Pom* (1914), with its Marinettian title, was remarked upon frequently. In this latter painting he even used confetti, where Severini might have used sequins, and in *Portrait of a Motorist* he embedded pieces of glass in the canvas to stand for goggles. One of Nevinson's most successful paintings, *The Arrival* (c. 1914), displays a command of Futurist vocabulary unparalleled in his previous work. Depicting the arrival of a cross-channel steamer viewed simultaneously from the deck, the shore, from above and below, it also demonstrates Nevinson's awareness of the work of Delaunay. One critic quoted Nevinson as saying that "it represented a 'state of simultaneous mind' ".

Although Nevinson joined up with the Royal Medical Army Corps fairly soon after

C. Nevinson as an ambulance-driver, photograph dedicated to Marinetti

war broke out he soon became disillusioned with it and the unexpected horror he witnessed was given expression in his war paintings which he first exhibited in 1915. These works are amongst his finest achievements and were recognized as such by Frank Rutter and P.G. Konody.

Konody, by this time, had begun to appreciate Nevinson and wrote that *Returning to the Trenches* was "the most logical, the most convincing practical demonstration of Futurist principles that I have so far seen. No purely representative method could ever render so happily the swinging rhythm of the marching soldiers' movements". Rutter noted the mechanistic quality of the painting when he wrote in retrospect: "What was returning to the trenches was not a column of nicely groomed, romantically seen soldiers: it was merely a spare part of the complicated War Machine." Nevinson's experience of war led him to renounce his Futurist beliefs in January 1919.

Although he was never to paint in a Futurist style again, his trip to New York shortly after the conclusion of peace encouraged him to readopt urban subject matter and to paint works which are clearly critical of life in New York. As Rutter wrote, Nevinson "is at his best when he is painting something he greatly hates". (JL)

Vital English Art
(Futurist manifesto, 1914)

I am an Italian Futurist poet, and a passionate admirer of England. I wish, however, to cure English Art of that most grave of all maladies — passéism. I have the right to speak plainly and without compromise, and together with my friend Nevinson, an English Futurist painter, to give the signal for battle.

Against:

1. The worship of tradition and the conservatism of Academies, the commercial acquiescence of English artists, the effeminacy of their art and their complete absorption towards a purely decorative sense.
2. The pessimistic, sceptical and narrow views of the English public, who stupidly adore the pretty-pretty, the commonplace, the soft, sweet, and mediocre, the sickly revivals of mediaevalism, the Garden Cities with their curfews and artificial battlements, the Mayopole Morris dances, Aestheticism, Oscar Wilde, the Pre-Raphaelites, Neo-Primitives and Paris.
3. The perverted snob who ignores or despises all English daring, originality and invention, but welcomes eagerly all foreign originality and daring. After all, England can boast of Pioneers in Poetry, such as Shakespeare and Swinburne; in Art, Turner and Constable (the original founders of the Impressionist and Barbizon School); in Science, Watts, Stephenson, Darwin, etc. etc.
4. The sham revolutionaries of the New English Art Club, who, having destroyed the prestige of the Royal Academy, now show themselves grossly hostile to the later movements of the advance guard.
5. The indifference of the King, the State and the politicians towards all arts.
6. The English notion that Art is a useless pastime, only fit for women and schoolgirls, that artists are poor deluded fools to be pitied and protected, and Art a ridiculous complaint, a mere topic for tabletalk.
7. The universal right of the ignorant to discuss and decide upon all questions of Art.
8. The old grotesque idea of genius — drunken, filthy, ragged, outcast; drunkenness the synonym of Art, Chelsea the Montmartre of London: the Post Rossettis with long hair under the sombrero, and other passéist filth.
9. The sentimentality with which you load your pictures — to compensate, perhaps, for your praise-worthy utter lack of sentimentality in life.
10. Pioneers suffering from arrested development, from success or from despair, pioneers sitting snug on their tight little islands, or vegetating in their oases refusing to resume the march, the pioneers who say: "We love Progress, but not yours"; the wearied pioneers who say: "Post-Impressionism is all right, but it must not go further than deliberate naïveté" (Gauguin). These pioneers show that not only has their development stopped, but that they have never really understood the evolution of Art. If it has been necessary in painting and sculpture to have naïveté, deformation and archaism, it was only because it was essential to break away violently from the academic and the graceful before going further towards the plastic dynamism of painting.
11. The mania for immortality. A masterpiece must disappear with its author. Immortality in Art is a disgrace. The ancestors of our Italian Art, by their constructive power and their ideal of immortality, have built for us a prison of timidity, of imitation and of plagiarism. They sit there on grandfather chairs and for ever dominate our creative agonies with their marble frowns: "Take care, children, mind the motors, don't go too quick, wrap yourselves up well, mind the draughts, be careful of the lightning. Forward! HURRAH for motors! HURRAH for speed! HURRAH for draughts! HURRAH for lightning!"

We want:

1. To have an English Art that is strong, virile and anti-sentimental.
2. That English artists strengthen their Art by a recuperative optimism, a fearless desire of adventure, a heroic instinct of discovery, a worship of strength and a physical and moral courage, all sturdy virtues of the English race.
3. Sport to be considered an essential element in Art.
4. To create a powerful advance guard, which alone can save English Art, now threatened by the traditional conservatism of Academies and the habitual indifference of the public. This will be an exciting stimulant, a violent incentive for creative genius, a constant inducement to keep alive the fires of invention and of art, so as to obviate the monotonous labour and expense of perpetual raking out and relighting the furnace.
5. A rich and powerful country like England ought without question to support, defend and glorify its advance guard of artists, no matter how advanced or how extreme, if it intends to deliver its Art from inevitable death.

F.T. Marinetti, C.R.W. Nevinson

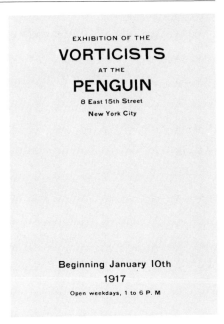

Catalogue of the Vorticist Exhibition in New York, 1917

New York

New York newspapers briefly reported on the Futurists' manifestos and activities as early as 1909, but by December 1911, the *New York Herald* reported on the "New Cult of Futurism". At the time, the critic André Tridon dubbed the "archpriest of Futurism in America", was said to have a Futurist studio on East 19th Street in New York. Interpreted in a very general way, the term Futurism is used to convey the rejection of the past in favour of searching for a new means of expression. In the August 1911 issue of *Current Literature*, the Italian Futurists were discussed and an excerpt of the first *Futurist Manifesto* was translated. While the Futurists were not represented in the 1913 Armory Show, the exhibition that introduced European modern art to a large American public, the term Futurist was used in a general manner in the popular press to describe the new art. Finally, the Futurists were introduced to the United States in 1915, not in New York, but in San Francisco at the "Panama-Pacific Exhibition", where they had a gallery to themselves. Later, Stieglitz gave Gino Severini a one-man show at his Gallery 291 in March 1917. (GL)

Nielsen, Jaïs

(Copenhagen 1885 - Gentofte, 1961) Danish painter

For a certain period Nielsen took an interest in Futurist theories, although sometimes in a rather superficial way. For some years during and immediately after the First World War, contemporary art of the very best quality, especially French Cubism, could be seen in Copenhagen in the Tetzen-Lund collection. (PH)

Nietzsche, Friedrich

(Röcken, 1844 - Weimar, 1900) German philosopher

The philosophical work of Nietzsche was quickly translated into French, and it was through the Mercure de France editions that Marinetti must have become acquainted with Nietzsche's vitalistic and dynamic theories. In 1902, the Mercure de France published a book that created a certain stir: *La morale de Nietzsche* by Pierre Lasserre. Along with Bergson, Nietzsche supported Gabriel Alomar's Futurism, and the German philosopher's influence could soon be detected in the manifestos of the Italian Futurists, to such a degree that Marinetti felt it wise to draw a distinction, and published *What Separates Us from Nietzsche*, in which he criticized Nietzsche for having conceived — despite his impulse towards the future — a superman based on the ancient model. However, Nietzsche's influence endured, integrated with other later influences, such as that of Georges Sorel and Mario Morasso. (SF)

Nizzoli, Marcello

(Reggio Emilia, 1887 - Nervi, 1969) Italian painter

Marcello Nizzoli exhibited in Milan in 1914 at the Famiglia Artistica together with the group Nuove Tendenze which claimed to be sympathetic to Futurism, but free of any given guidelines.
Nizzoli presented two paintings, *Sails* and *Sensation of Green*, and four embroidered fabrics, *Notes of Colour*. Ugo Nebbia, in the periodical *Vita d'Arte* (June 1914) emphasized the balance of "transparencies and the harmonic contrasts of line and colour", encouraging him to be bolder. Two characteristics stood out in these works: the striking colouring in a decorative-abstract style, and the desire to reaffirm the superiority of artistic objects over industrial production. An interest in materials and design was also evident in his successive work, along with a decorative sense and a feeling for tonal rhythms. (EC)

Noi

(1917-20, 1923-25) avant-garde periodical

This "international review of avant-garde art", published in Rome between 1917 and 1925, is the chief monument to Enrico Prampolini's graphic design (he was always the editor) and to his tireless activity in keeping in touch with various avant-garde circles throughout Europe. The first series came out between June 1917 and January 1920, and from a graphic point of view still had a somewhat handmade look, though the layout of the page is remarkably clear, with many woodcuts side by side with photographic reproductions. It is linked not only to Futurism, but to late Cubism,

Noi, no. 1, second series, 1923

Metaphysics and the most recent manifestations of Dada, to which it gave a voice in Italy. The second series, from April 1923 until 1925, is extremely precise graphically, and indeed a paradigm for the aesthetics of avant-garde typography, even in terms of the balance between the text and the ample illustrative material. It already expressed the "purist" point of view of "the aesthetic of the machine" (heralded by Prampolini in the perennial cover-design), with much exchange of views on an international scale, and considerable attention paid to furnishings and fittings, and in particular to stage design. (ECr)

Nuove Tendenze

The brief life of the Milanese group Nuove Tendenze (New Trends) spanned the period between the summer of 1913 and the spring of the following year. The group was organized by the critic and illustrator Ugo Nebbia, probably together with Gustavo Macchi — a painter, critic and journalist — and Decio Buffoni, a critic and journalist. This trio produced the initial idea and programm, while the painter Dudreville contacted and recruited artists who might be interested in the project (Dudreville is the author of a letter dated 20 August 1913 — the earliest documentation of this group — in which he sounds out the painter Adriana Bisi Fabbri as to her availability; she in fact joined Nuove Tendenze). Once this initial phase was over, the group's existence was announced on 15 March 1914 in the magazine *Pagine d'Arte*. The signatories of the manifesto, futuristically distributed in the form of a flyer, were Giulio Ulisse Arata, Buffoni, Mario Chiattone, Dudreville, Carlo Erba, Achille Funi, Macchi, Nebbia, Giovanni Possamai, Antonio Sant'Elia. The following 20 May, at the Famiglia Artistica centre in Milan, the "First Art Exhibition of the Nuove Tendenze Group" was inaugurated. It was to be the group's only public showing. Nuove Tendenze in fact split up as soon as the show closed (10 June 1914), torn apart by internal dissent. The architects Chiattone and Sant'Elia and the painters Dudreville, Erba, Funi, Bisi Fabbri, Alma Fidora, and Marcello Nizzoli took part in the show. The three latter artists had joined the group of "founding members", while the architect Arata — although among the founders — did not contribute to the exhibition. Neither Buffoni nor Macchi appeared in any way, but Nebbia wrote the introduction to the catalogue which also contained self-presentations written by the exhibiting artists. In Nebbia's introductory text there is an explicit declaration of respect for the individuality of the various efforts, against any contrived programmatic unity or avant-garde extremism. This is in clear opposition to Futurism, with its radical theories and refusal to accept other languages. "We have no wish to be excessively incomprehensible," Nebbia emphasized, "not do we wish to outrage the aesthetic feelings of the majority just out of a wilful desire to be different and new. We wish to be seen only as honest artists who are seeking increasingly wide and free forms of expression, the only condition in which our art can — and indeed must — discover its most vital

elements.'' The group therefore adopted a polemical position towards Marinetti's movement. Arata (in *Pagine d'Arte*, 1914) went as far as to speak of a "right wing of Futurism", seen as an "extreme revolutionary left wing in art". These opinions bear the marks of the failure of Nuove Tendenze (they were in fact prompted by Sant'Elia's decision to join Futurism), but they should not be taken literally and should certainly not be understood in political terms. In fact the intention was rather to reject an all-encompassing militant stance in favour of specific contributions to be made in given areas. Futurism itself, for the matter, was undergoing a redefinition due to growing symptoms of internal crisis over its radical attitudes — a redefinition followed with interest by Arata and the other members of Nuove Tendenze.

As far as the stylistic approach of the artists is concerned, beyond the individual positions one can note a combination of Futurist idioms — often derived directly from Boccioni and Severini — with elements of Secessionist, Symbolist and at times even Expressionist origin. The group was therefore open to the innovations of the avant-garde while still keeping in touch with an earlier European culture going back as far as the late 19th century — a substantially middle-of-the-road approach. (LC)

Omega Workshops

Roger Fry, one of the leading art critics in Britain in the first two decades of this century and organizer of two seminal exhibitions in London, "Manet and the Post-Impressionists" (1910) and the "Second Post-Impressionist Exhibition" (1912), founded the Omega Workshops in 1913 as a means of supplementing the income of artists. Artists were to be paid 5 shillings per half-day with a maximum of 30 shillings per week. They were forbidden to work more than 3 1/2 days per week to ensure that they did not neglect their own painting. As early as 1910, in an article in the *Burlington Magazine*, Fry wrote deploring the separation between the fine and applied artist, claiming that the fundamental properties of colour and form were common to both branches. Fry's idea was to form a group of artists "to work together, freely criticizing one another and using one another's ideas without stint". He considered it important to play down the individuality of artistic creation and insisted that all products of the Omega Workshops were marketed anonymously. This would encourage experimentation in design. The styles adopted by the Omega were Post-Impressionist and Abstract.

Fry found premises at 33 Fitzroy Square in the heart of Bloomsbury, London, where he belonged to a closely knit group of artists and writers including Vanessa Bell, Duncan Grant, Virginia Woolf and Clive Bell. The first two became co-directors of the Omega.

Fry's interest in the workshop was not manufacturing but decorative. Generally, the furniture was purchased, and then decorated either by the artists or by assistants following the artists' designs. The workshop also produced household goods such as candlesticks and lampshades as well as dyed fabrics. In 1915 the Omega extend-

R. Fry and J. Kallenborn, inlaid tray Omega Workshops, 1916, A. d'Offay Collection

Orpheu, 1915

ed its production to pottery, illustrated books and dressmaking. Among those who worked for the Omega were Vanessa Bell, Duncan Grant, William Roberts, Wyndham Lewis, Gaudier-Brzeska, Frederick Etchells, Cuthbert Hamilton, Edward Wadsworth and Fry himself. Through the Omega, Fry, whose theories of art adumbrated the concept of pure form, encouraged the evolution of English abstraction which culminated in 1914 in Vorticism.

Among the major achievements of the Omega was the decoration of rooms for its clients who were largely from the upper echelons of society. Commissions were received from Lady Hamilton (1914), the Cadena Café (1914), Arthur Ruck (1916) and Mrs Vandervelde (1916), none of which survive. It was over a commission for the "Ideal Home Exhibition" (1913) that he and Lewis fell out, leading to the secession of the "rebels", Lewis, Wadsworth, Etchells, Hamilton and Jessie Etchells and to the subsequent formation of the rival Rebel Art Centre. The Omega Workshops existed until July 1920 when they went into voluntary liquidation. (JL)

Orpheu

(1915; Portugal Futurista, 1917) Portuguese journals

Although Marinetti's manifesto had been translated into Portuguese in 1909, Portuguese artists did not react immediately. Fernando Pessoa and Mário de Sá-Carneiro published two issues of the journal *Orpheu* in April and July of 1915, with the collaboration of the painter Almada-Negreiros. Besides Sá-Carneiro's "Manicure" and the well-known "Maritime Ode" by Alvaro de Campos — inspired by Futurism — we find Pessoa's Intersectionist poem "Oblique Rain". Intersectionism proposed to "express a multitude of sensations crossing the field of consciousness simultaneously". The same contributors, with an even more aggressive tone, can be found in the single issue of *Portugal Futurista*, published by the painter and poet José de Almada-Negreiros in 1917 in Lisbon. The painters Santa Rita Pintor and Amedeo de Souza-Cardoso were also represented in its pages with studies and reproductions. The journal included poems in French by Apollinaire and Cendrars, sent by Sonia Delaunay, Italian manifestos in translation (Valentine de Saint-Point's *Futurist Manifesto of Lust* and Marinetti's *Variety Theatre*) or reproduced in French (*Futurist Painters*). Alongside poems by Sá-Carneiro, Pessoa, and Almada-Negreiros, there were also several violent Portuguese manifestos by Alvaro de Campos and Almada-Negreiros. (SF)

Orphism

Orphism seems to have been born when Robert Delaunay and Fernand Léger, walking through a room of paintings by their Cubist colleagues, observed that they painted "with spider-webs". The limited colour range which the masters of Cubism, Picasso and Braque, allowed themselves could not please all the other Cubists. Aware of this, their friend Apollinaire hastened to create a name for the most colourful and lyrical dissident school — Orphism — and soon declared that a similar movement had appeared among poets like Cendrars and himself, who worked alongside these painters. In reality, Apollinaire's concept — like his concept of "Simultaneism", which he applied later to more or less the same painters — is pretty vague. He tried to define it in 1912, writing about Robert Delaunay who had painted his series of *Windows*: "Orphism originates from Matisse and from Fauvism, especially from their luminous and anti-academic tendencies." In the new trends toward lyricism and colour, Apollinaire soon grouped painters who were fairly heterogeneous: "Picabia, breaking with the Conceptualist formula, simultaneously with Marcel Duchamp devoted himself to an art form that no longer held any rule. For his part, Delaunay, in silence, invented an art of pure colour. We are moving towards an entirely new art that to painting, as it had been conceived up to now, will be what music is to poetry. It will be pure painting." To these painters Apollinaire added Morgan Russel and "the vaguely Orphic" P.H. Bruce, two American artists.

Orphism was to create a dispute between Apollinaire and the Futurists. When the French poet told Severini that he was thinking of using the term to describe the Futurists, they considered this belittling, as the word had already been applied to others, and they felt it would put their work in a secondary position. They therefore claimed this term and this genre of painting as an invention of their own. In 1913, in a long letter to Giovanni Papini, Marinetti asked for space in *Lacerba* so that Boccioni could denounce "that egregious plagiarist, Apollinaire", since according to him the Orphists were imitators of the Futurists. Boccioni did indeed publish a virulent article attacking Apollinaire and Orphism in *Lacerba*; Apollinaire did not respond but he must have been especially annoyed because Boccioni was the Futurist whom he appreciated most. His relations with Futurism were rather chilly for some time after that; this may be why he chose another "ism" — Simultaneism — to refer to the same painters. (SF)

Cover for the magazine Het Overzicht *Antwerp, 1922*

A. Palazzeschi by Nunes-Vais in 1914

A. Palazzeschi, L'Incendiario, *1910*

Ostaijen, Paul van

(Antwerp, 1896 - Dinant, 1928) Belgian writer in the Flemish language

Paul van Ostaijen was the chief poet of the movement known as Flemish Expressionism. In his books of poetry, *Festival of Fear and Sorrow*, and more particularly *Occupied City* (1921), he used a simplified syntax, harsh images and a free typography which scattered words and parts of sentences over the page, more in the manner of literary Cubism than of Expressionism properly speaking. Van Ostaijen was also an outspoken defender of the avant-garde plastic arts in Belgium. (SF)

Paladini, Vinicio

(Moscow, 1902 - Rome, 1971) Italian painter and journalist

Vinicio Paladini graduated in architecture and was self-taught as a painter. On 20 June 1922, with Ivo Pannaggi he signed the *Manifesto of Futurist Mechanical Art*, which in October of that year became part of a manifesto with the same title cosigned by Prampolini.

From 1922 to the mid-Twenties he participated in Futurist exhibitions and events. His Futurist "mechanical" painting, developed in Rome in the early Twenties, was based on a revolutionary left wing ideology (he wrote for *Avanguardia*, 1922, and *Pagine Rosse*, 1923). Stylistically, around 1925 he combined influences from Post-Cubist European groups and De Chirico's Metaphysical paintings. In 1922, with Pannaggi, he designed *Ballo meccanico futurista* (*Futurist Mechanical Dance*). He also created photomontages and in 1927, in contact with the Roman Immaginista movement, experimented with a film, *Luna-park traumatico* (*Traumatic Fair*). As a journalist he also wrote political articles (up to 1925) and was one of the first in Italy to pay attention to the ideas of Russian Constructivism, in *Arte nella Russia dei Soviets* (*Art in Soviet Russia*, 1925). In 1933 he published *Arte d'avanguardia e futurismo* (*Avant-garde Art and Futurism*). (ECr)

Palazzeschi, Aldo

pseudonym of Giurlani, Aldo
(Florence, 1885 - Rome, 1974) Italian writer

When he joined the Futurist movement in May 1909, Palazzeschi had already written three books of poetry, published at his own expense: *I cavalli bianchi* (*The White Horses*, 1905), *Lanterna* (*Lantern*, 1907), and *Poemi* (*Poems*, 1909). These first poems present an unreal and archaic world of suspended images, a contracted and frozen atmosphere like that in fairy tales, a sense of indolence, at times a sort of drowsiness or dream vitality. The well-defined environment (castles, cypress trees, fountains, orchards, etc.) is populated by a strange collection of human types (old men, old women, princes, young girls and "people", a multitude of unspecified "people"). From a metric point of view, his "system" is defined by the succession of lines nearly always of six, nine and twelve syllables, while rhyme, barely used at the beginning, becomes more frequent in the second two collections of poems, creating effects of comic realism fully exploited in the first *Incendiario* (*The Incendiary*, 1910, second enlarged and revised edition, 1913).

His contact with Marinetti and the poetic theory and ideology of Futurism changed Palazzeschi completely. Although certain elements were already present in *Lantern* and, even more, in the *Poems*, the general direction of *The Incendiary* is new. Its manner can be defined as a poetic realism which is often comic, grotesque, expressionistic. The previous metric structure is shattered, rhyme appears frequently and dialogues break in; furthermore, in this collection of poems we can see the emergence of a systematic criticism of bourgeois sensibility, ideology and behaviour, which in many ways coincides with the Futurist "opposition".

As a novelist Palazzeschi had made his debut in 1908 with *Riflessi* (*Reflections*; the title was changed later to *Allegoria di novembre - November Allegory*), which the author himself called his "Art Nouveau" novel.

A completely different context is suggested by *Il codice di Perelà* (*Perelà's Code*, 1911), Palazzeschi's masterpiece, one of the great examples of modern Italian literature. The author himself considered it his "heavenly tale", the "highest point" of his imagination. It is an allegorical novel: the allegory of a society and the allegory of the hero Perelà and his impossible attempt to save the world. A few salient points of the novel intentionally resemble the life of Christ. The tone is farcical and the story is permeated with a melancholy, tragic humour that emerges from the schizoid shape of the chapters and from the scenes with "vivacious concerted voices" (L. Baldacci). Perelà is the new man, the man purified by the fire which has burned the remains of the old man. But he is not understood and therefore his bizarre Messianism fails. The novel is Futurist in its obvious, even if parodied, Messianism, in its theme of the purifying fire and its appeal for a liberating madness, but *Il codice di Perelà* contradicts the collective beliefs of the movement with its pessimistic conclusion and the final failure of the utopia. It should be noted, however, that Futurism was by no means as squarely optimistic as is usually believed.

Palazzeschi's last Futurist contribution before he broke with the movement in 1914 was the manifesto *Il controdolore* (*The Counterpain*, 1913). In this work a playful, clownish, pre-Dadaist tendency emerges, similar to that foreshadowed earlier in the same year by Marinetti's manifesto *The Variety Theatre*, and which Palazzeschi, with surprising verve, brings to a point of high brilliance. (LDM)

I. Pannaggi, photographic study for a mechanical architecture film

I. Pannaggi, characters for a mechanical theater

Panama-Pacific International Exhibition

Delayed by the outbreak of war, this exhibition opened only in the summer of 1915 and without the presence of European artists. It was held in San Francisco at the Department of Fine Arts. Balla participated with nine works on cars and speed, Boccioni with *Dynamism of a Cyclist* and *Matter*, (Mattioli Collection, Milan), *Elasticity* (Jucker Collection, Milan), *Dynamism of a Human Body* (Museum of Modern Art, New York), *Development of a Bottle in Space* and *Muscles in Speed* (destroyed). Carrà was present with fifteen works, Russolo with five and Severini with fourteen, all of which had already been exhibited.

Though the catalogue was very comprehensive, this exhibition had little impact because of the confusion created by the outbreak of war. (PH)

Panizza, Oscar

(1853-1921) German writer

Often legally prosecuted for his violent attacks on religion and on Kaiser Wilhelm II, Oscar Panizza wrote poetry, short stories and pamphlets all marked by a great scorn for grammar, spelling and punctuation — an attitude subsequently shared by many Russian Futurists.

His play *The Council of Love* (1895) was so insulting to the papacy that it earned him a year in prison, which disturbed him profoundly. He spent the last fifteen years of his life in an insane asylum. Unknown outside Germany during his time, Panizza was highly appreciated by George Grosz and his friends. (SF)

Pannaggi, Ivo

(Macerata, 1901 - Macerata, 1981) Italian architect and painter

After studying architecture in Rome and Florence, Ivo Pannaggi began to paint after the First World War, in contact with the Roman Futurists. He exhibited with the movement from 1921 to the end of the decade. His Futurist work is divided into distinct periods: the first (1919-22) and the third (1925-26) were closely connected with the theme of machines and Futurist dynamism; the second, central period (1922-26) was more Constructivist (El Lissitzky), but still used an abstract mechanical formula.

Pannaggi remained basically a representative of the Futurist "mechanical art" embodied by the Roman group: Prampolini, Paladini, De Pistoris, and — up to a point — Balla. On 2 June 1922, at Anton Giulio Bragaglia's Circolo delle Cronache d'Attualità, the *Ballo meccanico futurista* (*Futurist Mechanical Dance*) was presented. Invented by Pannaggi and Paladini, this was a dialogue between a Constructivist mechanical figure designed by Pannaggi, and a human puppet created by Paladini, with a musical accompaniment made by orchestrating the noise of two motorcycles.

On the following 20 January, again with Paladini, Pannaggi signed the *Manifesto of Futurist Mechanical Art*, published in a special issue of *Lacerba*. The text suggests interesting revolutionary implications by connecting machines to the importance of the working-class. The following October, both artists signed a broader and more for-

mal manifesto along the same lines, written by Prampolini.

As an architect, in 1925-26 Pannaggi designed the interior and furnishings of Casa Zampini at Esanatoglia (Matelica), creating four rooms each with a different psychology reflecting its specific function. He also worked as a designer for Bragaglia's Teatro degli Indipendenti, creating the stage setting for Guido Sommi Picenardi's pantomime *La torre rossa* (*The Red Tower*, 1923-24), a set for *Pierrot fumiste* by Jules Laforgue (1925), scenery that the actors could move on for one act of Marinetti's *I prigionieri di Baia* (*The Prisoners of Baia*, 1925), and the mechanical costumes for Ruggero Vasari's *L'angoscia delle macchine* (*The Machines, Anguish*, 1927). He also designed a set for Vasari's *Raun* (1926-27). He invented an original "magic lantern" which projected giant shadows.

Subsequently he lived in Germany, where he kept in touch with the innovations in architecture (the meeting between Expressionism and Rationalism) describing them for Italian periodicals and newspapers (*La Casa Bella, Domus, Quadrante, L'Architettura Italiana, Ottobre, L'Impero, L'Ambrosiano*, and others). In the early Thirties he established a connection with Katherine S. Dreier's Société Anonyme in New York. He also worked as a graphic artist, using Constructivist principles. He created photomontages (1923-26) and invented and practiced "postal collage" (1920, 1926). (ECr)

Papini, Giovanni

(Florence, 1881 - Florence, 1966) Italian writer

A tireless, self-taught man, Giovanni Papini's writing and ideas helped to create the cultural climate of Italy at the beginning of the century. He edited the review *Leonardo* (1903-07) and contributed to Prezzolini's *Voce*. In 1913, with Soffici and a few others, he founded *Lacerba*, the review that for some years published Marinetti's and other Futurists' writings, thus contributing to the movement's success.

Papini began his career as an "antiphilosopher" with *Crepuscolo dei filosofi* (*Twilight of the Philosophers*, 1906), a book which became one of the sources for Marinetti's Futurism. In 1905 he started writing a series of critical essays which were eventually collected in the notorious *Stroncature* (*Slatings*, 1916), in which he also expounded an avant-garde aesthetical "system". Today Papini's avant-garde attitudes of those years appear moderate: he joined Futurism but could never completely agree with its revolutionary proposals for an artistic, literary and political ideology. In *Lacerba* and in *L'esperienza futurista* (*The Futurist Experience*, 1919), a collection of articles originally published in the review, Papini set forth in typically theatrical style, with his usual touch of melodrama, his support for Futurism, which followed three different stages: "Expectancy, defence and acceptance."

More interesting, however, is the balance-sheet he drew up in a peaceful, objective spirit in the article "Il futurismo e Lacerba" (Futurism and Lacerba), in which he describes his collaboration with the Futurists as an attempt to create "a new

G. Papini by Nunes-Vais, 1914 c.

C. Carrà and A. Soffici, caricature of G. Papini, 1914

Le Roi Bombance

avant-garde aesthetic" and recognizes that "Futurism had beneficial effects" even on the *Lacerba* entourage. However, in the same book, in the article "Futurismo e marinettismo" (Futurism and Marinettism), Papini laid the foundation for that mistake in historical evaluation which consists in setting Marinetti apart from the Futurist movement. In reality, Marinetti was the main animator and promoter of the movement, but he was also quick and voracious in assimilating what was produced around him, in the group and elsewhere (as in the case of "simultaneity", which was discovered so to speak by Futurist painters and immediately recycled by Marinetti).

Papini's main contributions to Futurism are in two spheres: first, the movement's "ideology", in which he identified the tendencies he shared ("freedom from the past", "search for novelty and personality", "use of violence", etc.), and then introduced "the acidity of his skepticism", as he said himself, and second, the stimulus of his wide and profound culture. In considering the movement's "poetics", Papini took Palazzeschi's example as a starting-point and enlarged on the concept of art as licence and whim — an amusement, a game, a prank. This idea was to bear fruit with Cangiullo, Balla and Depero. Finally, one of his indirect accomplishments was to have conducted a famous debate with Boccioni, published in the 1914 *Lacerba* issue, in which the painter made some important and prophetic statements on the future of art. (LDM)

Paris

Following the Symbolist manifesto by Moréas, Marinetti arranged for the first Futurist Manifesto to appear in *Le Figaro* on February 1909. Before and for a long time after the publication of the manifesto, Marinetti's books appeared in French — often at the author's expense, it is true — before they were published in Italian, and his *Roi Bombance* (*Re Baldoria* or *King Frolic*) was first produced in French. Marinetti contributed to a number of French periodicals; no one had great illusions as to the quality of his French verse, but his personality, with its rich inventiveness and magnificence, won widespread sympathy. His magazine, *Poesia*, in Italian and French, was published simultaneously in Paris and Milan.

Marinetti was not the only Italian that chose France as a second home. After the Italian sculptor Medardo Rosso and the writer Ricciotto Canudo, there was Soffici, who quickly recognized the French avant-garde. Gino Severini, even more committed than Soffici to Futurism, settled in Paris and married Paul Fort's daughter.

One of the most important exhibitions in the history of Futurism took place in Paris, at the Bernheim Gallery, in February 1912. Although Apollinaire was fairly harsh about the exhibition, there is reason to believe that most of the painters and writers of the various schools came to see it. Later Apollinaire was to prove more open to the Italian movement. Two French artists immediately gave proof of their belief in the movement — the writer Valentine de Saint-Point with her *Manifesto of the Futurist Woman* (1912) and *Futurist Manifesto of*

Lust (1913), and the painter Delmarle with his *Futurist Manifesto against Montmartre*, 1913. Before the war, Marinetti's movement aroused a certain interest or at least curiosity among French writers and artists, even generating some mediocre imitations like Nicolas Beauduin's Paroxysm and H.M. Barzun's Dramatism. After the war Marinetti multiplied his manifestos and lectures in vain — other avant-garde groups had come into the limelight and won the attention of Paris. (SF)

Passatismo - Passéism

Passatismo (passéism) was defined by Marinetti as a "state of mind which is passive, traditional, professorial, pessimistic, pacifist, nostalgic, decorative and aesthetic" (*Guerra sola igiene del mondo — War, the Only Hygiene for the World*, 1915). Used publicly for the first time in the manifesto *Contro Venezia passatista* (*Against Passéist Venice*, 27 April 1910), signed by Marinetti, Boccioni, Carrà and Russolo, this was the negative term with which the Futurists labelled everything they wished to abolish. In the *Futurist Manifesto* (signed on 11 January 1909, but published on 20 January in *Le Figaro*) Marinetti inveighed against museums, libraries, "venerable cities" and academies which hindered every new creation or action born of the "beauty of speed". *Passatismo* (passato = past), the exact opposite of Futurism, represented everything that had been produced by the traditional academic culture of the past. (EC)

Peiper, Tadeusz

(Podgorza, Poland, 1891 - Warsaw, 1969) Polish writer

Tadeusz Peiper is one of those personalities, like Kassak in Hungary and Mitzitch in Yugoslavia, who took an interest in all the avant-garde movements of his time. He studied in Krakow, Berlin, and Paris where he became fascinated by Bergson. He then spent several years in Spain where he met Robert Delaunay, and also the Ultraists. Upon his return to Poland in 1921 he founded a periodical called *Zwrotnica* (*Junction*) which between 1922 and 1927 published the best Polish work in art and literature (the Futurists and later the Constructivists) and also the entire international avant-garde, from the painter Kazimir Malevich to the poet Tristan Tzara. He was therefore in contact with the Italian Futurists and particularly with Marinetti. Besides his activity as the editor of a journal, Peiper wrote a great deal on theory, applying his ideas in several collections of extremely fine poetry, like *A* and *Living Lines*, 1924. Some of his essays, such as *Métropolis-Mass-Machine* (1922), are essential links in the passage from Futurism to Constructivism in Poland: "It is not enough to choose the city as a subject for art, as many poets do today, without altering the old negative attitude toward the new theme. It is necessary to say yes to the city, to its deepest nature, to what constitutes its most specific property, to what makes it different from everything else... Mass-society will impose its structure upon art... Works of art will be organized like society. The work of art will be society." (SF)

Pellizza da Volpedo, Giuseppe

(Volpedo, Alessandria, 1868 - Volpedo, 1907) Italian painter

At fifteen Pellizza attended courses in painting at Volpedo and in Milan, where he studied under Mentessi and Stramezzi at the Brera Academy. In 1888 he frequented Fattori's school in Florence. The following year he made his first journey to Paris where he visited the Universal Exhibition. He took part in numerous exhibitions (Milan, 1884, Genoa, 1892, Florence, 1895, and Turin, 1896). By this time he was applying a near-Divisionist technique to his painting in order to obtain the maximum luminosity.

At the Paris Exhibition of 1900 he greatly admired Monet's paintings, which "correspond most to my vision of colour". Nomellini and Segantini were the figures to which Pellizza looked in the isolation and solitude of Volpedo; his correspondence with critics (Pica, Ojetti and Cena) and other artists, including Grubicy, Morbelli and Bistolfi, some of whom he had met in Florence, kept him active and in touch with new experimentation with colour. His correspondents also kept him informed about social problems, which had begun to interest him in 1897, the year before he began his huge canvas originally called *The March of the Workers*, now know as *Fourth Estate*. Luminist constructions covering all the colours of the spectrum and new geometric clarity in a Symbolist setting characterize his landscapes between 1903 and 1906 *Field with Flowers, Love in Life, Old Mill at Volpedo, Sun* and *Snow*.

His last paintings show a more free and flowing stroke, and a livelier chromatic range. On 16 June 1907 Boccioni noted in his diary: "Yesterday at the age of 39 Pelizza [sic] da Volpedo committed suicide. He hanged himself a month after the death of

his wife which had evidently crushed him! I had met him in Rome and we had talked a lot. He was not a very strong artist. He was too delicate, too docile; in real life he was no different and he has killed himself. It is terrible."

Boccioni considered him too weak, although he respected him and appreciated his work. Severini's opinion was more positive: "The only person who used the technique of the 'division' of colour for poetic ends was Pellizza da Volpedo." In this way Severini contrasted him with Segantini, Previati and Morbelli who, in his opinion, used Divisionism to obtain predominantly naturalistic effects. It is this aspect of Pellizza's painting which influenced the later development of Futurism: the use of Divisionism as a technical means and Symbolism as an expressive means to realize a harmony and an affinity between the feeling for nature and the idea, "which is' I feel", wrote Pellizza, "an essential condition in order to create organic works". (EC)

Pessoa, Fernando

(Lisbon, 1888 - Lisbon, 1935) Portuguese writer

Shortly after discovering that he possessed the ability to multiply his personalities and write not only with his own name and his own style but also under other names and with other personalities (*heteronyms*), Fernando Pessoa became interested in the European avant-garde movements: his friend Sá-Carneiro kept him informed from Paris. Together they published two issues of the magazine *Orpheu* in 1915; Pessoa himself came up with Intersectionism, the simultaneous expression of numerous experiences taking place in different places at different times; from this came images such as "the stained glass

VIVA IL FUTURISMO !

Il futurista *Il passatista*

window of a church seen from without are the sound of the rain heard from within", or "my hands are the steps of that girl, down there, walking away". At the same time, his flamboyant heteronym, Alvaro de Campos, developed Sensationism, with the simultaneous use of the sensational and the sensation, which claimed to include the lessons of Symbolism and Whitman, Cubism and Futurism. Two years later, in *Portugal Futurista*, Alvaro de Campos signed a violent *Ultimatum* in which he glorified "the era of machinery", "the epoch of electrical things"; he proclaimed the necessity for the "abolition of personality", and, "in politics: the total abolition of the concept of democracy." With a nationalism typical of Pessoa, these ideas are close to Italian Futurism, even though he took care to make a distinction — with a letter addressed to Marinetti in 1917 — against Marinetti's bellicosity and nationalism: "Do not fall into the sterility of a humanitarian universalism, but do not fall either into the brutality of an extra-cultural nationalism. We wish to impose a language, not a force; we do not attack a race"; "I pursue nationalism with a purely ultra-nationalistic aim: synthesis is a totality which lacks nothing." Even after the public manifestations of Portuguese Futurism had ended, Alvaro de Campos remained faithful to his Sensationist ideal. (SF)

Petrolini, Ettore

(Rome, 1896 - Rome, 1936) Italian actor

Theatre actor and author of plays and character-studies, parodies and iconoclastic sketches, Petrolini was beloved by his Roman public and also popular abroad. The Futurists considered him one of theatre's innovators because he was capable of destroying "the Solemn, Sacred, and Sublime in Art with a capital A", according to the *Manifesto of Variety Theatre*. In 1919 Marinetti wrote in *L'Italia Futurista*: "Pure Futurist humour triumphs in Petrolini's completely original art. His gags kill a moonlight which can never be killed enough. The most difficult of his masterpieces to analyze is the famous Fortunello, who with his mechanical, motor rhythm, endlessly hammering absurdities and grotesque couplets, digs spiral tunnels of astonishment and illogical, inexplicable happiness among the audience." His other significant creations include Hamlet, Paggio Fernando, Gastone, Giggi er Bullo, Nero and Sganarello.

In 1916 he produced several Futurist "syntheses", and in 1918 collaborated with Francesco Cangiullo in writing *Radioscopia*, a combination of music hall and "backstage drama". (MV)

E. Petrolini, photomontage

Lamanna, Negri, Pettoruti and the tenor Codegoni, Florence, 1914

Pettoruti, Emilio

(La Plata, 1892 - Buenos Aires, 1970) Argentine painter

Born in a family of Italian immigrants to Argentina, Pettoruti is most noted for his Cubist paintings, which are reminiscent of Braque and Juan Gris, but he also went through a Futurist period. At an exhibition in Florence in 1913, he became acquainted with Marinetti, Boccioni, Carrà, Russolo, Papini, Soffici, Rosai and the *Lacerba* group. The meeting took place at the Gonelli Gallery, where he himself was to exhibit in 1916.

Pettoruti remained deeply influenced by the encounter, as we see from various paintings and collages produced between 1914 and 1917 which render homage to *Lacerba* and *La Voce*. After contact with the Futurists he suddenly became one himself,

and the titles of this period show it clearly: *Sun, Centrifugal Force, Harmony-Movement-Space*, in 1914, and *Dynamic of Wind, Violent Expansion* in 1915. In December 1914, at the first Tuscan Winter Exhibition, he exhibited (most notably) *Harmony: Abstract Design*. Circular forms and sunlike effects are frequent in his Florentine work, but it lacks the impetuosity of much Italian Futurist painting. His own nature, and the periods he spent in Paris, gradually led him to adopt the Cubist aesthetic, and he exhibited Cubist work at the Berlin Der Sturm Gallery in 1923.

The following year saw him back in Argentina where, with the help of magazines such as *Martín Fierro*, he became one of the true initiators of modern painting. It was he who received Marinetti when he visited Buenos Aires in 1926. (SF)

Philosophy

Several different philosophical currents converged in the Futurist "invention". Although they have all been examined singly, there is really still no critical study aimed at evaluating the importance of each single current and their interrelations within the movement. Lacking an exact knowledge of the philosophical sources quoted, critics often produce a list juxtaposing figures and themes, and thus extremely complex connections are simply set out in dry sequences. Typical is the case of the undoubted presence in Futurism of two authors as dissimilar as Nietzsche and Bergson, indicating a duality or contradiction in the movement itself which is rarely pointed out.

The Nietzsche of Futurism is largely, if not exclusively, the "maniac" (see *Religion*) of certain parts of *Zarathustra* — the philosopher of the hammer who has declared war on traditional values and overturns the "old academic chairs" (Marinetti). One would say that the relation with Nietzsche does not go beyond a generic knowledge of the *pars destruens* of his philosophy. The Futurist Nietzsche is the "weak" superman of decadence: apart from a few references to the connection between art and deceit ("our fine deceitful intelligence", says the first manifesto) which could have led to a decisive understanding of Nietzsche's philosophy, what interests Marinetti in Nietzsche is the "tonality", or rather the aura — that is to say, precisely that dimension of aesthetic perception that Futurism claimed it wanted to cancel at all costs!

It is much easier to emphasize the points on which Futurism is in radical disagreement with Nietzsche's thought: the idea of the continual return (however this may be interpreted), to which Futurism opposes the monster (in Nietzsche's eyes!) of infinite semeiosis, the unending — although in itself discontinuous and broken — chain of interpretations; and the relation with Classicism. This second point is decisive: to Modernism, Nietzsche opposed a mighty, heroic continuation of Classicism, interpreted in a *tragic* key — and tragedy is exactly what Futurism intended to leave behind! On the fundamental problem of "tradition", Futurism and Nietzsche are irreconcilable: "In our struggle against the professorial passion for the past, we violently reject Nietzsche's doctrine and ideal"; Nietzsche is a "traditionalist who walks on the peaks of the Thessalian mountains with his feet unfortunately weighed down by long Greek texts" (Marinetti); his Superman is a corpse built with the ruins of Athens, bewitched by the demon of admiration. These considerations are already enough to show that Bergson's influence should be seen, not as an addition, but as an opposition to Nietzsche's. The Futurists could assimilate Bergson's philosophy in positive terms exactly to the extent that they fundamentally disagreed with Nietzsche. The real meeting with Nietzsche in early 20th century Italian art occurred in De Chirico's Metaphysical painting. The Futurist Nietzsche is no more than a follower of Stirner's "One".

The relation with Bergson, on the contrary, was profound, and fundamental for the development of Futurist ideas. Marinetti spoke about intelligence and intuition in perfectly Bergsonian terms — for example, in *Risposta alle obiezioni* (*Reply to Objections*), 11 August 1912. Life "goes beyond intelligence", he wrote in *Guerra sola igiene del mondo* (*War, the World's Only Hygiene*), inasmuch as intuition differs from didactic intelligence. Intuition is knowledge-contact, coincidence with the seen object. The abstract separation into subject-object is not valid for intuition, which understands real duration, real flux, the real and indivisible changing which cannot be seen in terms of space. For Bergson and for the Futurists, nothing is truly real but the *dynamic* — which cannot be determined geo-metrically — of relations and connections. No physical-material "atom" exists as the building-block of reality, there is no All given for eternity, but only duration, eternally recreating itself.

The nature of duration cannot be reduced to a single form of temporality, nor is it predictable or plannable. Duration is truly the creator; that is, it does not express the possible as though it already existed in a latent form and just needed to be pulled out of a "cupboard". Nor does duration represent a "value" equal for all, a common line of time for the *omnitudo*: each thread of the universe has its own specific time — each point of view represents a particular temporality. The Futurist problem of the simultaneous image is therefore the most pregnant analogue of Bergson's thought.

However, it must be added that Boccioni and Balla, for instance, had quite different connections with Bergson. The latter became increasingly interested in a schematic-sequential reproduction of movement through tendentially geometrical forms and tendentially pure colours, which from a Bergsonian point of view would be considered as wrongly "spatializing" duration. Boccioni was much more influenced by French culture in general and by Bergson in particular; although — as has been pointed out — his plastic dynamism does not correspond directly to Bergson's complete dissolution of every material "state" (seen as mere inertia) into the flux of duration.

Beyond these necessary specifications, however, it is quite clear how the influence of Bergson in Futurism is a reaction to that of Nietzsche. Generic concepts like "vitalism" are not enough to bridge the contrast. Bergson denies the tragic dimension of Nietzsche's thought; his philosophy ends in a metaphysics of intuition which coincides with the *reality* of duration. And there is no doubt that what Futurism aimed at was this result, and the "idea" behind it.

However, besides Bergson's influence, there was another which has been much less studied, in fact hardly at all. The Futurist's general, violent reaction against Croce's aesthetics has obscured the understanding of the fundamental influence of Idealism in Futurism. Certainly, neither Croce nor Kant are to be found in the movement, but there is an evident presence of Fichte — and therefore of Gentile and his "Actualism".

The Futurist ego, or "I", is its own act; it acts itself and is nothing without this acting. The universe of objects is the pure "not" of egoness; the ego incessantly opposes its own nonego — its action aims to produce something totally ideal, that is to say, totally free from the inertia and gravity of the world of objects. This constitutes the ideal or idea of the ego, the never-completed sense of its action. No "meaning" hinders this act or "spatializes" the creative urge. The truth of its action does not consist in corresponding or adapting itself to the object, but in denying it, in showing it as nothing.

An artistic theory like that of Futurism, which is against the very idea of representation, with the Futurist word "freed" from any meaning, cannot be fully understood without reference to this specific tradition of Idealism. Much more than to Nietzsche, we should look to this tradition to explain the more violently immanentistic aspects of the Futurists' "will to power" (Marinetti's "the earth... the fine orange so long promised to our thirst!").

Certainly, the idea of an art free from the servitude of meaning, the idea of a perfectly *intransitive* poetic word, is essentially Romantic (especially where the relation with Futurist "religiosity" and mythology is apparent). In certain ways, the Futurists seem to look not so much to the Schlegel brothers and Novalis, as to the nihilism of Fichtian Idealism — and therefore to Gentile, whose philosophy strictly speaking has nothing to do with Croce's. And the cultural and philosophical development of the movement seem to confirm this line of interpretation. In *Arte astratta* (*Abstract Art*) of 1920, one of the most philosophically pregnant texts of the European avant-garde, Julius Evola in fact explains this "actualist" inspiration of contemporary art and takes his distance from his Futurist "friends" precisely because they have not succeeded in corresponding to it: Evola calls them "the latest Romantics" whose nihilism ends up by saving the Ego as creator, Man, the Subject; they have not realized that by cancelling the object, they cancel the subject itself; that subject and object form a single polarity. "The new way towards pure art" (Evola) will lead to the coincidence of necessity and choice: underneath the Futurist freedom lies the necessity of pure chance. (MC)

A.G. Bragaglia, The Slap, *photodynamic, 1913*

Photography

Beginning in 1878, when Eadweard Muybridge made a series of photographs of the silhouette of a trotting and galloping horse, the visual vocabulary of artists was enriched by the depiction of bodies in motion. In 1879, Thomas Eakins and Edgar Degas depicted running figures in bronze and on canvas, creating images which were plastic and chromatic "snapshots" of animals and human beings in the act of moving from one point in space to another. The successive "chronophotographic" studies by Etienne-Jules Marey, Seraut and De Segonzac showed, on paper and in paint, the sequence of gestures and the movement of limbs and clothing of a person dancing or leaping.

The Futurists too (as studies from Calvesi to Lista have shown), in an effort to analyze the continual modification of a body in motion, may have referred to Muybridge and certainly looked to Marey. Both Boccioni in *Mourning* and *The City Rises* (1910), and Balla in *The Hands of the Violinist* and *Girl Running on a Balcony* (1912), show a knowledge of the chronophotographic process which divides up action and feeling into single moments of time. Their aim is to transmit in paint, using information deduced from scientific observation, the sense of the ubiquity of the body as it spreads out and moves through time and space. However, the translation of photography into painting, though it modified the Futurists' idiom of painting and sculpture, did not create what can be called Futurist photography until *Fotodinamismo* (1911) by Anton Giulio Bragaglia. From 1910, helped by his brother Arturo and financially supported by F.T. Marinetti, Anton Giulio Bragaglia experimented with a dynamic modification of photographic language, recording not movement but speed and the trajectories of the body. Compared with Muybridge and Marey, Bragaglia's photodynamics eliminate the interval; rather than indicating movement by the differences between one image and another, they register the trajectory of gesture and action in a single image. What was recorded on film and in each photograph was not intended to break down reality into fragments that the intellect would then reassemble to create the idea of movement, but to provide an instantaneous depiction of motion. The reference was not cognitive and physical, but atmospheric. It is in fact the atmosphere that gives solidity to a ubiquitous body, whose gestures live in a transparency and rhythm that tend to dematerialize them. Photodynamics therefore sought a figured luminosity that would show the movement of a body as a space of speed and "transcendental" images. Appearance is replaced by transparency; the object and the figure tend to disappear, as though the speed imparted to their mass and bulk made them immaterial and invisible. Bragaglia in fact maintained that his art depicted the "interior essence of things" and that speed applied to events and bodies made them disappear. The transparency and immateriality of the images made it possible to superimpose and merge them, creating "dissolutions and interpenetrations of figures and events".

From 1916 onwards photography, from

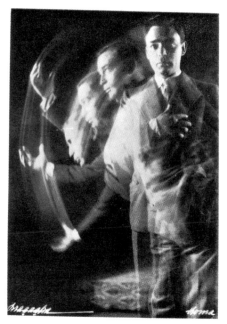

A.G. Bragaglia, Photodynamic, 1913

Coburn to Tato, following the path of cinema, attempted to record "superimpressions", whirlwinds of images whose telescoping spirals recall the effects of Futurist typography and plastic dynamism. The beauty of a body moving at speed almost annuls the limits of time and two-dimensional space. (GC)

Piatti, Ugo

(Milan, 1880 - Milan, 1953) Italian musician, painter and restorer

After graduating from the Brera Academy, Piatti frequented the group of Futurist painters. In 1911 he participated in the first "Mostra d'arte libera" (Exhibition of Free Art) at the Salone Ricordi in Milan, which is probably where he met Luigi Russolo. He collaborated with Russolo in the construction of the "intonarumori", though in the original patent only Russolo's name appears; Piatti's name is included in the programme of the first intonarumori concert, which was held at the Teatro Dal Verme in Milan in 1914. He appeared again with Russolo in 1921 for the Parisian concerts at the Théâtre des Champs-Elysées. In 1923 he was present in Prague for the production of Marinetti's play *Il tamburo di fuoco* (*The Firedrum*), featuring musical intermezzi by Pratella and background noise by the "intonarumori", of which he constructed a series on commission from the theatre.

In the early post-war years he took part in the exhibitions dedicated to Italian 20th century art. (FMa)

Picabia, Francis

(Paris, 1879 - Paris, 1953) French painter and writer

Picabia's success began in the first years of the century, when the paintings he showed were Impressionist. In 1908-09 he began experiments which led him to abstraction (*Caoutchouc*, 1909) rather than to out-and-out Cubism. In 1911, having met Apollinaire and Marcel Duchamp, he joined the group La Section d'Or, in the Duchamp brothers' house at Puteaux. In 1912 he exhibited abstract paintings with the group, such as *Procession in Seville* and *Dances at La Source*, based on colour and the expression of movement. Throughout 1913 and 1914 he continued to follow this mode of expression through colour and movement, which Apollinaire associated with Orphism. Without joining Futurism, which did not interest him, he felt the need to differentiate between himself and his Cubist friends. In the *New York Times* in February 1913, he explained all this in a way that could not fail to be appreciated by the Futurists. Like Marinetti, Picabia was mad about automobiles: "When I paint a motor race, can you distinguish the precise shapes of the cars shooting past at crazy speed on the track? No. All you see is a confused mass of colours, of shapes which might seem strange, even disquieting. But if you are vulnerable, sensitive to pictorial impressions, from my pictures you will feel the excitement, the inebriation of someone driving at 200 kilometers an hour. With colour I am able to communicate the very idea of movement, so that you feel, experience and appreciate the thrill of speed."

Picabia's first mechanical works appear at this time. Just as cars fascinated the Futurists, so they did Picabia, but in a different way. He did not see them as power, as a moving abstract essence, but as forms which he carefully reproduced, often — and not without some humour — seeing in them sexual symbols: a cog-wheel has the title *The Fiancé*, a light-bulb is *Young American Girl*, a self-driven fan is *Portrait of Marie Laurencin*. This was the time (1915-16) when the spirit of Dadaism first appeared in New York with Cravan, Duchamp, De Zayas and others.

After leaving New York, Picabia continued to work alongside the Dadaists in Switzerland and then in Paris. Independent, however, from this as from other movements, he was not in any way aggressive towards Marinetti, who was often scorned by the Dadaists. He limited himself to occasionally reminding Marinetti not to think he had invented everything. Picabia writes in 1921, à propos of Tactilism: "I like Marinetti very much because he seems a good fellow, and I am therefore truly sorry to displease him by reminding him that tactile art was invented in New York in 1916 by Miss Clifford-Williams... It is absolutely impossible that Marinetti should not have heard about this new departure, since he has many friends in America. Marinetti prides himself on having given birth to everything, but I am sure that these are nothing but hysterical pregnancies." This is the malice of one who shares the same fault. (SF)

EXTRAIT DE JÉSUS-CHRIST RASTAQUOUÈRE

LA PLUS BELLE DÉCOUVERTE DE L'HOMME EST LE
 BICARBONATE DE SOUDE.

IL N'Y A PAS D'INCONNUS EXCEPTÉ POUR MOI.

NOUS SOMMES DANS UN TUBE DIGESTIF.

EAU DE COLOGNE VERTÉBRALE.

DIEU ÉTAIT JUIF. IL FUT ROULÉ PAR LES CATHOLIQUES.

IL Y A BEAUCOUP MOINS DE CHOSES SUR TERRE QUE
 NE NOUS LE FAIT CROIRE NOTRE PHILOSOPHIE.

SPINOZA EST LE SEUL QUI N'AIT PAS LU SPINOZA.

LE SATYRE A QUEUE-DE-RAT.

NOTRE TÊTE A DEUX BESOINS COMME LE VENTRE.

LA PUDEUR SE CACHE DERRIÈRE NOTRE SEXE.

L'ŒIL FROID

Après notre mort, on devrait nous mettre dans
une boule ; cette boule serait en bois de plusieurs couleurs,
on la roulerait pour nous conduire au cimetière et les
croque-morts chargés de ce soin porteraient des gants
transparents, afin de rappeler aux amants le souvenir des
caresses. Pour ceux qui désireraient enrichir leur ameu-
blement du plaisir objectif de l'être cher, il existerait des
boules en cristal au travers desquelles on apercevrait la
nudité définitive de son grand-père ou de son frère jumeau !

Il y a des gens qui ont la tête en bas, comme
les plantes, et qui regardent avec leurs pieds.

La connaissance et la morale ne sont que papier
à mouches, je conseille aux mouches de vivre dans les
confessionnaux, les péchés étant une nourriture bien plus
agréable que le caca.

TOUT EST POISON, EXCEPTÉ NOS
 HABITUDES.

IL FAUT COMMUNIER AVEC DU
 CHEWING-GUM.

Francis PICABIA

LAMPSHADE

MAN RAY.

391 Numéro 13
JUILLET 1920
(5e Année)
Le Gérant : RIBEMONT-DESSAIGNES.

PRIX : 1 FR. 50 (PARIS)
Dépositaire : AU SANS-PAREIL
37, Avenue Kléber, PARIS

S.P.I. — 67, Rue Nicolo, PARIS (XVIe)

Ce numéro est entouré d'une
dentelle rose.

LA PEINTURE EST FAITE POUR LES DENTISTES

FAR-NIENTE BEAU PARTI

LA COULEUR DE LA LUNE

VRAIMENT CELA M'EST IMPOSSIBLE
DE FAIRE PARAÎTRE "CANNIBALE"
RÉGULIÈREMENT, C'EST TROP IDIOT.
J'ESPÈRE QUE VOUS ACCEPTEREZ
POUR CETTE FOIS "391".

FRANCIS PICABIA

FRANCIS PICABIA.

391

F. Picabia, double page from 391, July 1920

Picasso, Pablo

(Malaga, 1881 - Mougins, 1973) Spanish painter, naturalized French

Picasso's enormously important painting of 1907, *Les Demoiselles d'Avignon*, and his studies for it, had a great influence not only on the evolution of Cubism but also, in a formal sense, on Futurism. The dynamic and rather aggressive distortions of the human face and body made a great impression; few other paintings in the history of modern art are as radical.

Picasso, as a leading figure in Cubism, was eagerly studied by Boccioni and the other Futurists when they developed their message. Boccioni's *Farewells* is clearly an answer to some of Picasso's more static compositions. The authoritative position that Picasso established at an early stage in the Cubist movement obviously made him, for the Futurists, the most eagerly studied of the competitors in this race between two schools of painting — schools that in reality were racing in slightly different directions. Picasso's art developed in a logical sequence, one painting leading to another; the Futurists moved in a more passionate way towards the strongest and most dynamic expression of their more socially oriented ideas. (PH)

Poesia

(1905-09) literary periodical

Founded in Milan in February 1905 by Marinetti and edited by him (until 1906 with the collaboration of Sem Benelli and Vitaliano Ponti), *Poesia* was the organ of Italian Symbolism (the cover was designed by Alberto Martini). The international relations of *Poesia*, subtitled an "international review", were aimed chiefly at maintaining a dialogue with its twin culture in France. It lasted until October 1909, and in the first issue of that year (an issue which declared it to be the "organ of Futurism") it printed the main points of the Futurist Manifesto. Under the title *Foundation and Manifesto of Futurism*, the magazine published a pamphlet containing the full text which had appeared in *Le Figaro* in Paris on 20 February. Around the magazine there was a great deal of publishing activity which survived it and preceded the Futurist experiment. Under its auspices, in the second decade of the century and long after, many fundamental creative and theoretical Futurist literary texts were published. (ECr)

Popova, Liubov Sergeevna

(Ivanovskoe, Moscow, 1889 - Moscow, 1924) Russian painter

Liubov Popova began to study art in 1907, attending the studios of Stanislav Zhukovsky and Konstantin Yuon in Moscow, where she discovered Impressionism and Cézanne but was equally interested in Vrubel and ancient Russian art.

In 1910 she visited Italy for the first time. On her return to Moscow she frequented different studios but worked particularly at the Tower, founded by Tatlin and Rogovin. In 1912 and 1913 she lived in Paris, where she studied at La Palette with Le Fauconnier and Metzinger. Her Cubist paintings and drawings date from this period, together with her first sculptures, also of Cubist inspiration, influenced by Zadkine

Poesia, no. 7-8-9, 1909

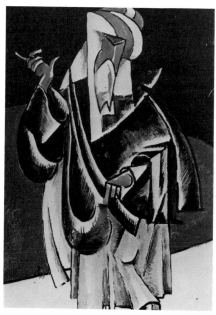

L. Popova, stage costume

and Archipenko whose studios she often visited. She spent the summer of 1914 in Italy; several paintings of this period, particularly her *Italian Still-life* dedicated to her Italian friends, show a Futurist influence. The futurist concepts of dynamism and movement were to remain a constant in her work.

1915 was a particularly important year for Popova. She wrote: "After the Jack of Diamonds exhibition, Tramway V, 0-10 and The Store, my Cubist period (the problem of form) was followed by a period of movement and colour (Futurism), which was finally replaced by a consideration of the presence — or rather the absence — of the object, leading directly and logically to non-objectivity." At the moment, then, Popova took advantage of the example of Malevich and Tatlin to develop her own original style, although from 1916 she adhered unconditionally to the Suprematist group.

In fact her work of that period shows an interest in the presentation of surface planes, containing an energy of inner tension, where the coloured masses, the lines and the volumes interrelate creating a very homogeneous formal unity. Almost in parallel with this research, perhaps under the influence of Malevich, Popova started her experiments with "painted architectons" — works which fuse painting and sculpture. This synthesis of arts continued during the post-revolutionary period when Popova, appointed a teacher at Vkhutemas and then at Inkhuk, enlarged her sphere of interest. She ultimately gave up easel painting and devoted all her energy to theatrical, industrial and textile design. In 1922 she created a décor which was to become famous, for Meierkhold's production of *The Magnanimous Cuckold*. In 1923 she was named head of the Design Studio of the First State Textile Factory. Her designs for dresses and fabrics are the best example of what the other avant-garde artists of her generation called "art in the service of the people and the Revolution". (SZ)

Porzudkowski, Yan

(Warsaw, 1886 - Warsaw, 1968) Polish painter

Yan Porzudkowski was linked to the Formist movement at the beginning of the Twenties and edited the periodical *Czartak*. Between 1922 and 1924 he exhibited with other avant-garde artists at the Garlinski Salon and the F9 Exhibition (1922). After 1924 he became well known as a caricaturist and contributor to the magazine *Mucha*. (SZ)

Pound, Ezra

(Hailey, USA, 1885 - Venice, 1972) American writer

In 1908 Pound came to Italy and had his first book published in Venice : *A lume spento*, in which the Symbolist term "vortex" already appeared. He then settled in England, where he lived until 1920. Although Pound himself said in 1915 that without Wyndham Lewis there would have been no Vorticist school and no Vorticist painting, nor even the jolly, irritating magazine *Blast*, it is certain that without Pound, Vorticism would not have had such fire and such an impact on English art. Most of the battles in the press were conducted by Pound, who wrote numerous articles and manifestos in defense of his poet and artist friends.

For the poet Pound, Vorticism began with Imagism, which was essentially a literary movement. In 1908-09 Pound frequented a pre-Imagist circle in London with Richard Aldington and F.S. Flint, but Imagism was only codified much later, after he had assimilated the lessons of Symbolism and Impressionism and after an experience that in 1914 he described as follows: "Three years ago in Paris I got out of a Metro train at La Concorde and saw suddenly a beautiful face, and then another and another... I found suddenly the expression. I do not mean that I found words, but then came an equation... Not in speech, but in little splotches of colour... I realised quite vividly that if I were a painter, or if I had, often, *that kind* of emotion, or even if I had the energy to get paints and brushes and keep at it, I might found a new school of painting, of 'non-representative' painting, a painting that would speak only by arrangements in colours." The poem that suddenly came, Pound went on, at first had thirty-two lines, but in order to keep it to the essential he reduced it to two elliptical lines: "The apparition of these faces in the crowd: / petals on a wet, black bough."

Imagism was born. "In the Spring or early summer of 1912, H.D., Richard Aldington and myself decided that we were agreed upon three principles following: 1. Direct treatment of the *thing*, whether subjective or objective. 2. To use absolutely no word that does not contribute to the presentation. 3. As regarding rhythm: to compose in sequence of the musical phrase, not in sequence of the metronome." He developed the theory shortly afterwards with recommendations like the use of free verse, and "go in fear of abstractions", and "I believe that the proper and perfect symbol is the natural object". To widen the movement Pound recruited other English language writers such as Amy Lowell, William Carlos Williams, J.G. Fletcher and even James Joyce.

Yet with the development of the more widely-based Vorticist movement, and the revelation of Italian Futurism, Imagism came to be no more than a sector of Vorticism dedicated to poetry.

Although during the Twenties Pound came close to Marinetti for political rather than for aesthetic reasons, and in 1933 described him as "thoroughly *simpatico*", during the brief period of Vorticism he had been opposed to him, and refused to see in his movement more than "a sort of accelerated

Wyndham Lewis, Portrait of Ezra Pound, *University of Texas, Austin*

RED, *"Marinetti and World Futurism" 1929*

J. Seifert, Město v Slzach, *1922, cover by K. Teige*

Impressionism". The same argument can be found in T.E. Hulme and, later on, in Tristan Tzara. According to Pound (in *Blast no. 1*), "the vortex is the point of maximum energy. It represents in mechanics the greatest efficiency", while "Futurism is the disgorging spray of a vortex with no drive behind it, *dispersal*." The Vorticists and Pound may have been the more eager to distinguish themselves from the Italian because their own verbal violence, their machine metaphors, and even a certain vocabulary ("lines of force") seemed to derive directly from Futurism. In September 1914 Pound wrote: "The Vorticist has not this curious tic for destroying past glories. I have no doubt that Italy needed Mr. Marinetti but he did not set on the egg that hatched me, and as I am wholly opposed to his aesthetic principles I see no reason why I, and various men who agree with me, would be expected to call ourselves Futurists."

In his study on Pound in 1927, T.S. Eliot wrote: "Pound has perhaps done more than anyone to keep Futurism out of England. His antagonism to this movement was the first which was not due merely to unintelligent dislike for anything new, and was due to his perception that Futurism was incomparable with any principle of form."

This overly schematic view needs to be qualified: like Wyndham Lewis and Gaudier-Brzeska, Pound rejected Futurism together with Cubism, but that was because he did not want a Cubist or Futurist art colony in England; he wanted an original, autonomous art — and he himself and his friend were nevertheless greatly indebted to these direct predecessors. (SF)

Pozzo, Ugo

(Turin, 1900 - Turin, 1981) Italian painter and designer

Pozzo was close to Fillia and Tullio Alpinolo Bracci at the moment when the Turin Futurist group began. He exhibited his work along with theirs at the Winter Club in 1922, and as a painter was constantly present in Futurist shows until 1939, working in terms of plastic dynamism revealing a strongly "mechanical" synthesis, and also in aeropainting. He was active in the field of design, and among other things illustrated works by Fillia and texts on the aesthetics of printing (e.g. the exemplary graphic layout of the fortnightly magazine *La Città Nuova*, edited in Turin by Fillia from 1932 to 1934). In the late Twenties he designed posters and interior decoration, while in the mid-Thirties he was particularly concerned with "mural plastic art". He also made ceramics in collaboration with Tullio d'Albisola. (ECr)

Prague

In the manifesto *World Futurism* (1924), among known and unknown Futurists Marinetti named a whole group of artists from Prague: Teige, Neumann, Feurstein, Filla, Hofman, Špála, Čapek, Krejcar, Seifert, Muzika. In reality only a few of them had anything in common with Futurism, but there were others, unknown to Marinetti. Prewar Prague was one of the centres of European Cubism, which largely obscured the other currents of contemporary art. However, a few Czech artists, in particular Bohumil Kubišta, Otto Gutfreund, Josef Čapek and Jan Konůpek, produced Futurist works. The first objective information about Futurism was given at the beginning of 1912 by Josef Čapek in *Umělecký Měsíčník* (*Art Monthly*); then in December 1913 an exhibition of Italian Futurists, organized by Ardengo Soffici, was held in Prague at the Havel Gallery (with Boccioni, Carrà, Russolo, Severini). On 9 August 1913 the poet Neumann published the Czech Futurist manifesto *Otevřená okna* (*Open Windows*).

Futurism, however, had much more effect on post-war art. In the years 1918-22 it influenced a number of architectural and theatrical projects by Jiří Kroha, and in 1920-21 it was reflected in the themes and forms of some paintings and water-colours by Josef Šíma. In 1921 Prague was literally submerged by Futurism. In October the Artists' Emporium held an exhibition of Italian modern art organized by Prampolini, where a number of works by young Futurists were exhibited alongside twenty-one works by Umberto Boccioni, including some sculptures made with non-traditional materials which have since been lost. In December the Švanda Theatre presented several Futurist theatrical syntheses directed by Prampolini with the participation of Marinetti (Buzzi, Settimelli, Marinetti, Folgore, Boccioni). A year later the Stavovské Theatre performed *Il tamburo di fuoco* (*The Firedrum*), designed and directed by Prampolini. In 1922 the Czech translation of *Parole in libertà* (*Words-in-Freedom*) and *The Firedrum* came out, both with covers by Josef Čapek. At this point the young Czech avant-garde that was centred around the Devětsil group began to take an interest in Futurism. Teige, Černík and Honzl wrote articles criticizing some aspects, but they included others in their own concept of the world: admiration for modern mechanical civilization, the words-in-freedom, tactilism, scenic lyricism and so on. The Osvobozenté divadlo (Freed theatre), the theatrical section of the Devětsil, performed some short plays and sketches by Marinetti directed by Honzl: in 1927 *Non si vede neanche un cane* (*Not Even a Dog in Sight*) and *Il teatrino dell'amore* (*The Theatre of Love*) and in 1929, *I prigionieri* (*The Prisoners*). The Devětsil built up very close ties with Prampolini, who became a foreign correspondent for the periodicals *Disk* and *Horizont*; his works were often reproduced in Czech magazines. Futurism in Prague also met with considerable success among the public, as in the case of the cabaret comic Fiala, who changed his name to Ferenc Futurista. Prague was the native city of the painter Rougena Zatkova, who joined Marinetti's group after the war. (FS)

E. Prampolini and Maria Ricotti, Paris, 1927

M. Ricotti, Futurist pantomime, 1927 c.

Prampolini, Enrico

(Modena, 1894 - Rome, 1956) Italian painter, sculptor and stage director

Prampolini is generally considered to be the most famous representative of the second generation Futurists, but his work can only be understood in relation to the first period of Futurism. In his first works, produced at a very young age — the earliest pieces are dated between 1912 and 1913 — his inspiration was closely linked to the two leading exponents of Futurism, Boccioni and Balla. From the former he inherited his intellectual restlessness and the need to translate discoveries in painting and sculpture into terms of general culture and even cultural politics; from Balla he took the concept of art as a totality, including architecture, manufacturing and theatre, and ultimately implicating the most varied aspects of everyday life.

His presence in the Futurist group is documented by a letter from Sironi to Boccioni dated 15 October 1913; the following year he took part in the "Free International Futurist Exhibition" held at the Sprovieri Gallery in Rome. He wrote a series of manifestos, the most interesting of which are: *Costruzioni assolute di motorumore* (*Absolute Constructions of Motion-Noise*), which was dedicated to the realization of plastic objects in movement; and *Scenografia futurista* (*The Futurist Stage*), in which he lays the foundation of the theatrical theory that made him a leading figure in international stage direction between the two wars.

Compared to the other Futurists, Prampolini is notable for his strong interest in plastic objectivity and his indifference towards any expression of psychic aspects, states of mind or literary content in art. Pure painting and the realism of objects therefore coexist in the early period of Prampolini's art, when he combined abstraction and the use of real elements to create a work of art intended as a concrete, autonomous object. The technical world and the presence of machines (in 1923 Prampolini signed the manifesto on *Mechanical Art* with Pannaggi and Paladini) meet this fundamental need: the machine acts as a model to direct the formative processes towards greater objectivity and structural rigour. Whether it retains figurative elements or moves towards abstraction, these works tend to appear as objective entities, perfectly self-contained and directed by autonomous laws, like a mechanical device.

In theatre, as well, Prampolini created a kind of scenic machine that could ultimately dispense with the actors themselves. In "Magnetic Theatre", presented in Paris in 1925, the actor is in fact replaced by a play of lights, scored in such a way as to take over the function of the human figure.

Two years later, at the Théâtre de la Madeleine in Paris, Prampolini presented the "Futurist Pantomime" shows by Luciano Folgore with music by Franco Casavola, accompanied by Russolo's "intonarumori". The artist put the principles of the Magnetic Theatre into effect by abolishing the actors in the second scene and substituting them with mechanical elements — a lift, a ventilator, a gramophone.

This need of extroversion was dominant in the moment when Prampolini was most open to fantastic suggestions, in his "cosmic idealism" phase, when he accepted some Surrealist ideas and created a new universe of images that foreshadowed the future conquest of cosmic spaces. At that time, around 1930, the artist used technical and scientific knowledge to create a science fiction painting in which the love of adventure and the unknown is combined with the urge to prefigure new worlds and new possibilities of existence, to transform technology into an instrument which can transport mankind into a totally new dimension transcending body and mind.

Immediately after 1930, Prampolini also created a series of multi-material works. His earlier experiments in collage and the realism of objects had been based on objects and fragments of objects taken directly from a real context, whereas the multi-material works considered matter in its purely physical aspect, before it takes on the form of this or that natural object or man-made article. Prampolini spoke of a "biological presence of matter", of a "matter organism", an entity with autonomous life subject to a continual process of transformation, filled with "unknown forces" which the artist could bring to light by intervening as little as possible and allowing matter itself to become the protagonist of the drama. (FM)

B. Pratella, 1920

Pratella, Francesco Balilla

(Lugo di Romagna, 1880 - Ravenna, 1955)
Italian composer

Balilla Pratella was admitted in 1899 to the Liceo Musicale "G. Rossini" of Pesaro (directed at the time by Mascagni), and received a composition diploma in 1903. During those years he wrote piano music, and the songs that he used in later years for the prologue to *Ninna nanna della bambola* (*The Doll's Lullaby*) op. 44, for *C'era una volta* (*Once upon a Time*) op. 16, for the orchestral suite *I paladini di Francia* (*The Paladins of France*) op. 47, and the opera *Lilia* which was produced in 1905 at the Teatro di Lugo. In the months following his formal study he composed the symphonic cycle *Romagna: notti, ebbrezze e sangue* (*Romagna: Nights, Raptures and Blood*) op. 17, *Canzone di primavera* (*Spring Song*) op. 18, *Vortici di danza* (*Vortices of Dance*) op. 19, *Baccanale d'autunno* (*Autumn Bacchanal*) op. 20, and *Notte di Natale* (*Christmas Night*) op. 21, each one incorporating a theme taken from the folk songs of Romagna.

Between December 1905 and May 1908 he composed the opera *La Sina d'Vergöun*; it won the Premio Baruzzi sponsored by the Teatro Comunale of Bologna and was produced there on 4 December 1909.

In 1910 he became director of the music school of Lugo. He met Marinetti on the evening of 20 August at the Teatro Comunale of Imola, where selections of his works were being performed. He thereafter joined the Futurist movement and his home became a meeting place for members and sympathizers of the movement in Romagna. He wrote three manifestos (*Manifesto of Futurist Musicians*, 11 October 1910; *Futurist Music, Technical Manifesto*, 11 March 1911; and *The Destruction of the*

Caricature of B. Pratella, Piccolo Giornale d'Italia, 1914

Scheme, 18 July 1912) which were bound together with the piano score to his *Musica futurista* op. 30 in a volume also entitled *Musica futurista* theorizing the way to liberate the composer from the rules of classical harmony.

On 21 February and 9 March 1913 at the Teatro Costanzi of Rome he directed his *Musica futurista — Inno alla vita* (*Futurist Music — Hymn to Life*) op. 30, causing violent reactions and arguments between public and critics. During this period he also composed *La guerra* (*War*), three orchestral dances based upon texts taken from an old French ballad and dedicated to the poetess Valentine de Saint-Point.

Between 10 June 1913 and 1 May 1914 he wrote his most famous Futurist opera, *L'aviatore Dro* (*The Pilot Dro*) op. 33, including several of Russolo's "intonarumori" in the orchestration.

In these years he frequently contributed articles to the magazine *Lacerba*, as well as to other Futurist publications such as *La Balza* of Messina, *Vela Latina* of Naples, and *Gli Avvenimenti* of Milan. He wrote the music column for this last periodical until it ceased publication in 1917.

In 1915 he wrote several pieces for the Futurist Synthetic Theatre. The same year he joined Malipiero and Pizzetti in the direction of the *Raccolta nazionale di musiche italiane* (*National Collection of Italian Music*) a publishing project begun by Notari which re-discovered over fifty musical works from the sixteenth to eighteenth centuries. Pratella translated and re-elaborated oratorios by Carissimi and edited harpsichord sonatas by Sandoni, Serini, and Rutini.

In April 1917 the Società Italiana di Musica Moderna was formed in Rome through the initiative of Casella, but Pratella was excluded from the board of direction because of his affiliation with Futurism. In September he met and established a lengthy collaboration with the writer Beltramelli, setting some of his poems to music, such as *Le canzoni del niente* (*Songs of Nothing*) op. 36.

In 1918 he began his contributions to *Il Resto del Carlino* of Bologna, Podrecca's *Primato Artistico Italiano*, Bragaglia's *Cronache di Attualità*, *Roma Futurista*, and *Il Popolo d'Italia*.

In 1920 he joined Beltramelli and Spallicci to begin a cultural magazine for Romagna called *La Pié* and to form the choral group "Camerata dei Canterini Romagnoli", for which he set three series of *Cantate romagnole* (*Romagnolo Songs*).

His theatre pieces were produced by Bragaglia's Teatro degli Indipendenti and the Futurist Pantomime Theatre in Paris. He also wrote the music for Folgore's *Rose di carta* (*Paper Roses*), for Ricciardi's *Teatro del colore* (*Theatre of Colour*) productions, for Marinetti's *Il tamburo di fuoco* (*The Firedrum*), and for De Maria's *The Paladins of France*.

From 1922 to 1924 he was director of the Bolognese review *Pensiero Musicale* and in 1929 he became director of the musical institute of Ravenna.

His long compositional career includes operas which met with varying success: *The Doll's Lullaby* op. 44 (1923), *Dono primaverile* (*Spring Gift*, 1924), *La leggenda di San Fabiano* (*The Legend of St. Fabian*,

1939), and *L'uomo* (*Man*, unpublished), as well as chamber music and works for voice and instruments.

In addition to his extensive collaboration with Italian and foreign newspapers and periodicals, he wrote the following books: *Teoria della musica* (*Theory of Music*, 1912), *Musica futurista* (*Futurist Music*, 1912), *Musica italiana per una cultura della sensibilità musicale italiana* (*Italian Music for a Culture of Italian Musical Sensibility*, 1915), *Cronache e critiche dal 1905 al 1917* (*Notices and Reviews from 1905 to 1917*, 1918), *Evoluzione della musica* (*Evolution of Music*, 1919), *Appunti per lo studio dell'armonia* (*Notes for the Study of Harmony*, 1930).

He also did important work in the fields of popular music and the study of folk music. Amongst his books on this subject are: *Saggio di gridi, canzoni, cori e danze del popolo italiano* (*Examples of Cries, Songs, Choruses and Dances of the Italian People*, 1919), *Poesie, narrazioni e tradizioni popolari in Romagna* (*Poems, Tales and Popular Traditions in Romagna*, 1921), *Canzoniere dei canterini romagnoli* (*Song-Book of the Romagnolo Popular Singers*, 1923). (FMa)

Previati, Gaetano

(Ferrara, 1852 - Lavagna, 1920) Italian painter

Previati studied first at the local school of fine arts and then in Florence with Amos Cassioli, before going to Milan (1877) where he followed Giuseppe Bertini's courses at the Brera Academy for three years. He combined an academic spirit with a taste for clashing chromatic effects. It was only after a slow, elaborate evolution and a long period of crisis and spiritual concentration that Previati reached — for example in *Maternity* (1890-91) — his long-studied "division" of luminous matter into thin, predominantly monochrome strokes. This painting aroused controversy at the Milanese Triennale in 1891 and gained Previati an invitation to the Salon des Rose-croix in Paris in 1892.

His passion for the study of light and his desire to transform material, conceived as spiritual dynamism, into an ethereal substance, led him to develop his theories in writing (*La tecnica della pittura* - *Technique in Painting*, 1905; *I principi scientifici del divisionismo* - *Scientific Principles of Divisionism*, 1906 and *Tecnica ed arte* - *Technique and Art*, 1913).

The figure of Previati was very important for the Futurists; Boccioni, in particular, was fascinated by Previati's Idealism: "I am reading Previati's *Tecnica della pittura* and I feel humiliated before such technical erudition. I am a thorough ignoramus", he wrote in his diary on 21 December 1907; and later: "After such a long time I made up my mind and I paid a visit to Gaetano Previati. He welcomed me with the greatest courtesy and we talked for three hours!... I found he agreed with me about almost everything. He is a soul full of faith and courage. He knows that he is looked upon with derision but remains undiscouraged" (2 March 1908).

Previati was certainly the artist who most influenced Boccioni, who considered him a master. Boccioni was particularly interested in Previati's application of Divisionism — he spoke about this in one of his lectures in Rome in 1911 — which was not rigidly subjected to the laws of complementarity.

He never ceased stressing Previati's importance: "[He] is the only great Italian artist of our times who has conceived art as a representation in which visual reality is only a starting point ... Gaetano Previati was the forerunner in Italy of the idealistic revolution that today is triumphing over Verismo (realism) and the documented study of reality."

The other Futurists also had great respect for Previati; his name appears in the *Manifesto of the Futurist Painters* (11 February 1910) as one of the artists despised by the critics but worthy of great consideration, and he is also listed among the important artists in Carrà's article *Pittura passata = illustrazionismo pittura futurista = pittura, Passéist Painting = Illustrationism Futurist Painting = Painting* (*Lacerba*, 15 October 1913). (EC)

Prezzolini Giuseppe

(Perugia, 1882 - Lugano, 1982) Italian writer

Bright, active and self-educated, Prezzolini was a genuine cultural promotor. In 1903 with Papini he founded *Il Leonardo* and contributed to Enrico Corradini's *Regno*, while from 1908 to 1913 he directed *La Voce*, one of the most prestigious and respected magazines in Italy during the early 20th century. Prezzolini was an active but objective adversary of Futurism. He never succeeded in understanding either the underlying reasoning of the movement or the nature of Marinetti, whom he considered erroneously to be a man "of scanty culture", but at an early point he outlined the ideological opposition between Futurism and Fascism (in *Il Secolo*, 3 July 1923). In 1929, in the second edition of his *La cultura italiana*, he wrote a calm overview of the Futurist movement in which he recognized that "the influence of Futurism on literature and painting", both in Italy and abroad, had been "considerable". (LDM)

Puni, Ivan (Pougny, Jean)

(Kuokkala, 1894 - Paris, 1956) Russian painter, naturalized French

After graduating from the Military Academy and the élite Cadets' School, in 1910, under the influence of the painter Ilia Repin, a friend of the family, Puni abandoned his military career and dedicated himself totally to art. He left for Paris that same year and enrolled at the Académie Julian. He returned to Russia only in 1912 after having travelled widely in Europe, especially in Italy. Back in St. Petersburg he had contacts with Kulbin, the Burliuks and with Malevich, who soon became his friend. In 1913 he married the painter Xana Boguslavskaia and their home became a favourite meeting place for the avant-garde. In 1912 and 1913, invited by Kulbin, he participated in the exhibitions of the Union of Youth, while working with Burliuk's group. In 1914 he designed the cover of *The Roaring Parnassus*, a Futurist anthology.

In February 1914 he left for Paris where he exhibited at the Salon des Indépendants. On his return to Petrograd, he organized the "First Futurist Exhibition of Paintings: Tramway V" and in 1915 the "Last Futurist Exhibition: 0-10". This was the time when his painting evolved from a classic Cubo-Futurism into a pronounced "a-logism", accompanied by a search for new materials.

On these lines, for the "0-10" exhibition he painted new pictures (stigmatized by the contemporary critics as "absurd mixtures of knick-knacks and unlikely poems") which were a juxtaposition of unrelated objects, enigmatic words and lines mainly inspired by Khlebnikov's poems. During the exhibition Puni signed the *Suprematist Manifesto* together with Malevich, Kliun and Boguslavskaia. According to Malevich, it was Puni who first saw his Suprematist work and it was actually Puni's unexpected visit to Malevich's studio that forced the inventor of Suprematism to finally exhibit his

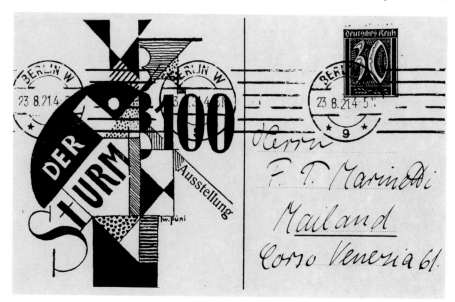

I. Puni, postcard from Berlin to Marinetti

paintings. This relationship with Malevich lasted until 1918 when Puni started to teach at Petrosvomas (Free Workshops of Petrograd). In 1918-19 he took part in agit-decoration for the buildings and streets of the city (his best known decoration was for Liteinyi Prospekt). Invited by Chagall, he spent the winter and spring of 1919 in Vitebsk and then went to Finland.

During the autumn of 1920, Puni and his wife decided to emigrate. They went first to Berlin, where he exhibited at Der Sturm Gallery and contributed to the "Erste Russische Kunstausstellung". In 1924 Puni settled in Paris where, besides painting, he created stage sets and designs for objects. (SZ)

Radia and Abstract Sound-Poetry

Various studies have established that the recovery of the acoustic determination of words has roots in the late 19th century, when artists such as Morgenstern and Scheerbart produced a series of phonetic poems emphasizing the sound of the word. In 1897 in Berlin, Scheerbart published a "phono-poem" (poetry of pure sounds) entitled "Kikakoku", while in 1905 Morgenstern presented the collection *Galgenlieder*, in which some verses are made up only of metric and phonetic signs. An attempt to discover the acoustic qualities of writing surfaced again after the turn of the century in the phono-poems of the Russian and Italian Futurists.

In 1913, after launching together with Kruchenykh, Burliuk, Kamensky and Maiakovsky the manifesto of the *Declaration of the Word as Such*, Khlebnikov announced the birth of Zaumism. Here words became mere sound.

Khlebnikov broke down words into their radical and phonic elements and played on the phonic-visual aspects of a verse, splitting words into phonetic particles until he reached a stuttering mass of vocables.

At his side were the other Cubo-Futurists. Kruchenykh invented words at random, created a welter of arbitrary networks and nexuses, and used guttural monosyllables reminiscent of the babbling of babies and the chanting of religious sects; while Zdanevich composed several phono-plays, in which each character was distinguished by a different phonetic range.

Experimentation with accidental sounds and the frequent variation of phonetics were common strategies among the Italian Futurists.

All of their poetry aimed at exasperating the harshness of sound in language.

They were fond of consonants and they fragmented vowels in order to obtain a chain of clashing sounds and verbal fractures. Like the Russian Futurists, artists such as Marinetti, Petronio, Masnata, Buzzi and Cangiullo created strident combinations of vowels and interruptions in the acoustic fabric. Their poems exasperated the ears and tested the larynx. Influenced as well by the sonic theories of Luigi Russolo (proclaimed in *The Art of Noises*, 1913), which referred to the voice as a musical instrument, the Italian Futurists emphasized the phonetic colouring of their work.

They were convinced that pronunciation was determined by emotional selection, and that the translation into sound modified the expressive power of a word, and therefore they called on poetry to suit a "dynamic declamation" (1916) which would offer more possibility of stressing the biological vibrations. In their performances poetry became a theatrical score which accompanied the physical movements.

In 1933 Marinetti and Masnata drafted the manifesto of the *Radia*, in which they proposed acoustic solutions for the world of art. "Reception amplification and transfiguration of vibrations emitted by living and dead noise-ist states of mind without words Reception amplification and transfiguration of vibrations emitted by material..." In the same year, on 24 November, Depero and Marinetti broadcast the first transmission of phonetic art over Radio Milano. Unfortunately, of all this phonic production, nothing remains but Marinetti's late recording of the *Battaglia di Adrianopoli* (*Battle of Adrianople*, 1926), a record produced by La Voce del Padrone, Milan.

In Dadaist poetry pure phonetics was chiefly pursued by Ball, Huelsenbeck, Hausmann and Schwitters. They used relationships and contrasts between syllables and consonants. In their poems, of which fortunately recordings remain, certain techniques of alliteration and repetition with acoustic aims are notable. In 1918 Raoul Hausmann published his poems "bbbb et fmsbw", "kperioum", and "offeah" in van Doesburg's magazine *Mecano* and in *Der Dada*; they were monosyllabic consonant-based poems, made of invented sounds, which he later recorded. Fundamentally the value of the voice is brought into play here, "an organ that represents", as Ball wrote, "the soul, the individual forced into a personal odyssey among demonic companions. Noise forms the background, all that is inarticulate, fatal and decisive.

Poetry desires to emphasize the disappearance of man in the mechanical process. In a typical view it shows a conflict with the human voice, which the world threatens, utilizes and destroys". Huelsenbeck also experimented with phonetic poems. In 1916 he read one of his poems at the Cabaret Voltaire in Zurich, while his accompanist, Tzara, pounded on a car muffler.

His voice whistled, murmured and sang. Later, with Tzara and Janco, again at the Cabaret Voltaire he presented a long roll of vowels, accompanied by a series of noises such as howls, sirens and whispers. The sonic absurdities and the vowel were used by Kurt Schwitters in "An Anna Blume" (1919), a declaration of love declaimed during a "merz" evening in his house in Hanover and in his "Spate, in Urlaten" (1927), performed on the local radio Sud-Deutsche Rundfunk. The lastmentioned sonic poem bears a series of analogies to the phono-poem by Hausmann, although it is based on an improvisational process that made the poetry dynamic and continuously varied.

Between the Twenties and Forties a series of cultural events allowed the diffusion — not merely in artistic and poetic terms — of phonetic experimentation. In 1928, Jakobson, Trubetzkoy and Karchevsky presented a report entitled *Proposition 22* in which the creation of a new philological and semiotic discipline was announced: "phonology", the scientific study of the sounds produced by human language. Following this scientific breakthrough came a number of poetic and artistic experiments, notably the analysis of signs undertaken in the Bauhaus area, in which artists such as Arp, van Doesburg, Seuphor, Bryen and Kandinsky himself composed numerous phono-visual poems in the wake of abstract theory. In the Futurist area, Fortunato Depero proposed his "Onomolingua, o verbalizzazione astratta", in which the sounds of speeding cars or trains were reproduced verbally. Simultaneously, Artur Petronio laid the theoretical foundations for his "verbophonie", a method of declamation which allowed outside noise to mix with syllables and consonants. (GC)

Radnicki, Zygmunt

(Lwow, 1894 - Cracow, 1969) Polish painter

Radnicki was one of the few Formists from the town of Lwow. He was influenced by Futurism only for a very short period and is best known for his Colourist paintings inspired by Cézanne and Bonnard. (SZ)

Rayonism

Rayonism was a theory elaborated by Mikhail Larionov and Natalia Goncharova, and the first attempt to create a non-objective style in Russia.

The first mention of Rayonism occurs in a letter written by Larionov on 20 September 1912 to L. Zheverzheev: "I am sending you an article on Rayonism, a new pictorial style which I am developing", while the first Rayonist works were shown at the Fourth Exhibition of the Union of Youth in December of the same year.

In 1913 Larionov published the manifesto *Rayonist Painting* in which he declared: "Painting is autonomous — it has its own forms, colour, tonality... Rayonism is concerned with spatial forms which are obtained through the crossing of reflected rays from different objects, forms which are singled out by the artist."

Like Delaunay, Larionov based his paintings on the physical laws of colour and light. According to him, Rayonism was founded on the following facts: 1) the radiation created by reflected light forms a sort of coloured dust in the space between the objects; 2) the theory of radiation; 3) radioactive rays, ultra-violet rays, reflections. The object as it exists, Larionov explained, and as it is represented in a picture, by whatever means, is not what we perceive with our eyes. We see only the sum of the rays that emanate from a source of light and reach our visual field reflected by that object. Consequently, in Rayonist painting "the ray is represented on the picture surface by a line of colour". From this point of view, the object as we see it in life is irrelevant and the very essence of painting can emerge clearly: combinations of colour and density, and the relationships between the colour masses, depth and texture. In this way, Rayonism "eliminates the boundaries that exist between the surface of the painting and nature".

According to Larionov and his little group of disciples (painters who for varying periods adopted the principles of the

theory: Kyril Zdanevich, Michel Le Dentu, Alexandr Shevchenko), Rayonism was a synthesis of Cubism, Futurism and Orphism, and part of the great experimentation with light begun by the Impressionists. The presence of the idea of movement in Rayonist works was inspired by Italian Futurism. Larionov himself declared: "The Italians have been the first to launch Futurism, a dynamic style which enlarges the painting, puts the painter at the centre of things, sees the object from every point of view, proclaims the transparency of objects and the representation of what the painter knows to exist but cannot see." Futurism, in Larionov's opinion, introduced "a breath of fresh air into an art encumbered by the weight of traditions, and represents a real benefit for modern Italy". The problem of breaking up light and the concepts of "line-forces" or "line-rays" were the central concern of many Futurist painters, for example Balla with his "iridescent compenetrations"; a similar use of line-forces is to be found in Boccioni (*The Forces of a Street*), in the work of Lyonel Feininger, Joseph Stella, Charles Demuth, and amongst Larionov's compatriots, in Liubov Popova. (SZ)

Reconstruction of the Universe, Futurist

Drawn up in Rome by the "abstract Futurists" Depero and Balla, the manifesto *Futurist Reconstruction of the Universe* was dated 11 March 1915 from Milan, the main centre of the movement.

The manifesto presented a clear programme that totally abolished any sectorial division of Futurist activity (previous manifestos had already announced the extension of their interest to many other fields besides the visual arts) showing that the Futurists were well aware of the simultaneous existence of multiple levels of communication, and intended to use them for an unlimited expansion of their inventive energy and optimistic, playful approach to life. The title of the manifesto stands as a symbol of the totality of the Futurist creative effort that between 1910 and 1930 expressed itself in every possible field: architecture, the urban environment, interior decoration, artificial nature, stage productions, painting and sculpture, "plastic complexes" or assemblages, "Tactilism", photography, photomontage, cinema, furniture, set design, ballet, dramaturgy, fashion, utilitarian objects, "words-in-freedom" literature, imaginative typography in "free-word tables", advertising, mass communications, postal art, science and its critique, politics, behaviour and morals.

A constant collective (and individual) creative aspiration aimed at revolutionizing the surrounding environment, was the moving force behind Futurist thinking and also explains the provocative quality of their work.

This global aspiration is in fact the most distinctive characteristic of the Italian Futurist movement in comparison to all other European and non-European avant-gardes of the first decades of the century, some of which inherited it, but only partially. (Although an immediate comparison with the Russian movement, for example, suggests itself.)

Pasqualino, The Duel, *in* L'Italia Futurista 1916

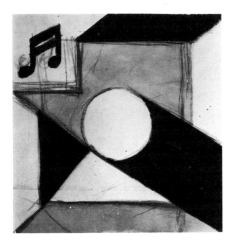

G. Balla, record cover, *1918*

F. Cangiullo, Finale of a Stravinsky Score, *1923*

A comprehensive study of all creative Futurist expression shows that this effort extends beyond the time limits fixed in the past — and also recently — by historians and critics. Futurist activity in fact continued for three decades, from the first years of the century to the early Forties. From an historical and critical point of view, the idea of "universal reconstruction" is important because it shows that the significance of the Futurist movement lies precisely in its interdisciplinary interests and contributions.

The concept of a "Futurist reconstruction of the universe" covers all the many theories and concrete realizations the Futurist movement produced in the most varied fields. It is however useful to consider the chronological order in which new fields were opened and activities occurred. Two aspects can be distinguished: a constant, progressive refusal of traditional artistic values, and the desire to create a total work of art involving the whole environment.

In 1915 Futurism reached its maturity. The movement expanded to embrace all forms of sensory perception (*synaesthesia*) and absorbed the environment in its totality, breaking down the separations between painting, sculpture, etc. This was only six years after Marinetti's manifesto which laid the literary foundations of the movement (published in *Le Figaro*, Paris, on 20 February 1909 and in *Poesia* no. 1-2, Milan, 1909), completed by (*Let's Kill Moonlight* in *Poesia* no. 7-9) and the first *Political Manifesto* (Milan, 1909).

At the beginning of 1910 Futurism incorporated the visual arts, with the painters' manifesto (11 February) and the *Technical Manifesto of Futurist Painting* (11 April, signed by Boccioni, Carrà, Russolo, Balla and Severini). Then between the end of 1910 and the beginning of 1911, the movement extended itself to music (Balilla Pratella's *Manifesto of Futurist Musicians*, 11 January and the *Manifesto of Futurist Music*, 29 March) and to theatre (Marinetti's *Manifesto of Futurist Playwrights*, 11 January). Already in 1911, in his booklet *Le Futurisme*, published in Paris, Marinetti offered a theoretical summing-up and defined the spheres of Futurist intervention: literature, painting and music.

In 1912, the Futurist painters became internationally known. The collective introduction to the catalogue of their February exhibition in Paris stated that the new painting was the result of "totally Futurist ethical, aesthetical, political and social ideas". The effort to grasp "simultaneity" meant involving all the senses. "Environmental simultaneity", according to this text, implied "the synthesis of *what we remember* with *what we see*". The simultaneous participation of the spectator was ensured by surrounding him with the "lines-forces" of the painting, which drew him inside the picture. This "painting of states of mind" created a new harmony (musical extension), born from the clash of opposite rhythms, and a new "emotional environment". The *Technical Manifesto of Futurist Sculpture* (11 April, 1912) proposed "a sculpture of environment" which creates an empirical link between sensitiveness and material. It can be compared, in literature,

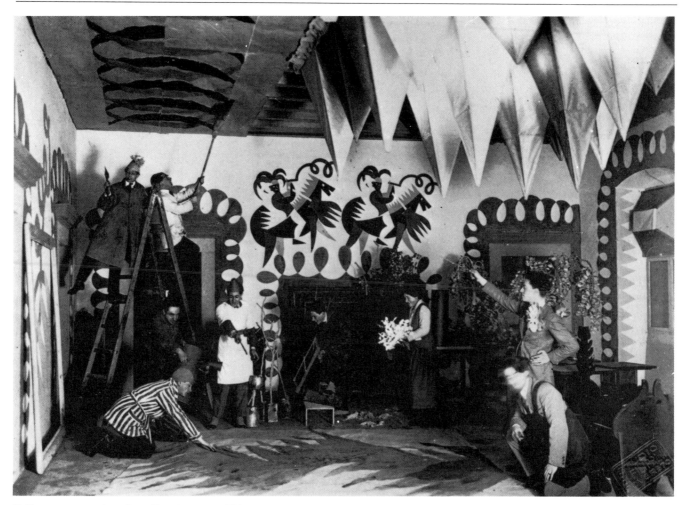

F. Depero, preparations for a Futurist party, 1923

with the "spontaneous unbroken string of analogies", and the "imagination without strings and words-in-freedom" of Marinetti; in music with the rebellion against the "chronometric tyranny of rhythm" of Pratella. Introducing his sculpture exhibition (Paris, June-July 1913), Boccioni said that "the figure has to become the center from which plastic directions depart into space". Literary writing, traditionally concerned only with the intellect, was now combined with visual communication. Marinetti's "typographical revolution" is "aimed at the so-called typographical harmony of the page, which is contrary to ebb and flow, the leaps and bursts of style that run through the page". And, he says, "words-in-freedom" use a "*new orthography* that I call *free expressive*", in an "instinctive deformation of words" corresponding to "our natural tendency towards onomatopoeia". The aim is an "onomatopoeic psychic harmony, the sonorous but abstract expression of an emotion or a pure thought".

In *After Free Verse, Words-in-Freedom*, which together with the previous manifesto was published in 1914 under the title *Destruction of Syntax - Imagination without Strings - Words-in-Freedom*, Marinetti took a decisive step towards synaesthesia by introducing a "multilinear lyricism", "through which", he said "I achieve that lyric simultaneity that obsesses the Futurist painters as well".

Russolo's manifesto *The Art of Noises* (11 March 1913) expresses the same desire to relate to a concrete world of matter: "This limited circle of pure sounds must be broken and the infinite variety of noise-sound must be conquered." He compares city noises with Marinetti's written translation of the noises of war in "Zang Tumb Tumb" (published as a book in 1914, but already partially recited and also published in *Lacerba*).

Carrà's manifesto *The Painting of Sounds, Noises and Smells* (11 August 1913) is more decisive and explicit: "Imagination without strings, words in freedom, the systematic use of onomatopoeia, antigraceful music without rhythmic quadrature, and the art of noises — these have derived from the same sensibility that generated the painting of sounds, noises and smells."

Almost simultaneously the young Prampolini, in *Chromophony and the Value of Atmospherical Movements* talked of working with "chromophony", "the colours of sounds, noises, smells, gestures and words", or "the chromatic vibrations of any atmospheric movement".

In his manifesto *Plastic Analogies of Dynamism* (unpublished at the time but dated September-October 1913), Severini emphasized the plastic analogies of images. In the meantime, the range of Futurist interests continued to grow. In 1913 Anton Giulio Bragaglia published the definitive formulation of his theory on Futurist photography, in *Futurist Photodynamism*. In his *Manifesto of the Variety Theatre*, published on 1 October 1913, Marinetti explained how he would transform popular theatre by introducing "surprise and the need to move among the spectators of the stalls, boxes, and balcony".

Valentine de Saint-Point's manifesto of 11 January 1913 invited men and women to "strip lust of all the sentimental veils that disfigure it", to recognize in it "the quest of the flesh for the unknown", and make it "a work of art". In his *Il controdolore* (*Counterpain*, 29 December 1913) Palazzeschi urged modern man not "to stop in the darkness of pain", but "to rush through it to enter the light of laughter". On 11 October 1913, Marinetti, Boccioni, Carrà and Russolo signed a *Futurist Political Programme*. On 11 March 1914, in the manifesto *Weights, Measures and Prices of Artistic Genius*, Carrà and Settimelli proposed a new critique of objective art: the "Futurist measurement" of the work of art, that is to say "the exact scientific determination expressed in formulae of the quantity of cerebral energy represented by the work itself, independently of the good, bad or non-existent impression".

In *Geometric and Mechanical Splendour and the Numerical Sensibility* (18 March 1914) Marinetti extended his vision of the new literary dimension by describing "synoptic tables of lyric values" in which words-in-freedom would be arranged in such a way as to finally unite the verbal dimension to the visual one (Balla, Cangiullo and Carrà created examples that same year). This was to "allow us as we read to follow many currents of interconnected or parallel sensations at the same time". "The words in freedom naturally transform themselves into self-illustrations by means of free expressive orthography and typography, the synoptic table of lyric values and graphic analogies." The new writing would also include body movements: "Free expressive orthography and typography also serve to express facial mimicry and the gesticulation of the narrator."

In the meantime Sant'Elia drew up what was to become the official *Manifesto of Futurist Architecture* (11 July 1914).

In 1914 Boccioni published *Pittura scultura futuriste* (*Futurist Painting and Sculpture*), a theoretical compendium of the new plastic arts. The chart that appears in the collection *I manifesti del futurismo* (*Manifestos of Futurism*, 1914) indicates the following fields of creative intervention: poetry, painting, music, sculpture, women's action, art of noises, anti-philosophy. In the same year Balla proposed Futurist clothing; in an interventionist climate, this became *Anti-Neutral Clothing* (11 September). Intervention in politics became "interventionism" in favour of Italian participation in the First World War. On 20 September 1914, Marinetti, Boccioni, Carrà, Russolo and Piatti signed the *Futurist Synthesis of War*. The plan for political intervention narrowed down to polemics. On 29 November Marinetti addressed the "students of Italy" in *This Futurist Year*. And the new decisive intervention in theatrical art was also in an interventionist key: *Futurist Synthetic Theatre* (11-18 January 1915) by Marinetti, Settimelli and Corra.

In May 1915, Prampolini proposed a renewal of the stage (and choreography): not an "illuminated stage", but "the stage that illuminates", "through chromatic emanations from a source of light created by electrical spot lights", which would create "an abstract entity corresponding to the spirit of the action represented". Balla's and Depero's manifesto of 11 March 1915, *Futurist Reconstruction of the Universe*, is the key point of Futurist maturity; it formulates a new aesthetic object, "the plastic complex", which marks the leap from a statement of synaesthesia to a concrete "reconstruction". In 1914 Depero wrote a first draft called *Plastic Complexity - Futurist Free Play - The Artificial Living Being*. The "plastic complex" is "poetry + painting + sculpture + music", "a noise-ist-pictorial-psychic, complex plasticism", which uses "onomatopoeia, graphic equivalents of noises, phonoplastic equivalents, psycho-plastic equivalents".

Balla and Depero's manifesto imagines "plastic complexes", "Futurist toys", "artificial landscapes", "metallic animals", but above all "systematic, infinite discovery-invention, using constructive, complex, noise-ist abstraction, in short the Futurist style". And the potential scope of Futurist reconstruction is illustrated by possible inventions: "plastic moto-noise concert in space", "launching of aerial concerts above the city", "transformable clothes", "roto-plastic noise fountain", "phono-moto-plastic advertisement", "pyrotechnic-plastic-abstract contests", "magical transformable moto-noisy flower", "a building in noise-ist transformable style", which all challenge and accept the ephemeral.

After that manifesto the Futurists no longer spoke in terms of a further step towards synaesthesia, but in terms of a "universe". In the catalogue of his Rome exhibition of April-May 1916, Depero listed the "simultaneities" "in the abstract picto-plastic drama" for "the re-creation of a living, abstract Futurist Universe" and imagined a "dynamic architecture" and an "aerial town".

Marinetti, Corra, Settimelli, Balla and Chiti's manifesto *The Futurist Cinema* (11 September 1916) concludes: "Painting + sculpture + plastic dynamism + words-in-freedom + *intonarumori* + architecture + synthetic theatre = Futurist cinema. This is how we decompose and recompose the Universe according to our marvellous whims." Almost contemporaneously the movement in a joint effort produced the film *Vita futurista* (*Futurist Life*), directed by Ginna. In the same year Anton Giulio Bragaglia produced the film *Thaïs*. The cinema continued to be a sphere of Futurist activity throughout the Thirties (*Speed*, by Oriani, Cordero and Martina; Prampolini's *Hands*; another manifesto by Marinetti and Ginna in 1938).

Gesture was introduced into the poetical world of "words-in-freedom" by Marinetti's *Dynamic and Synoptic Recitation*, 11 March 1916, which followed the direction indicated by the dramatized recitation of Cangiullo's *Piedigrotta* (Rome, 1914). This had been a real behavioural happening, a moment of poetical-theatrical-scenic-plastic involvement going far beyond the polemical didacticism of the early Futurist *soirées*.

The following year Marinetti wrote his *Manifesto of Futurist Dance* (8 July 1917); dance will be "disharmonious, impolite, antigraceful, asymmetrical, synthetic, dynamic, free-wordist" and "accompanied by organized noises".

1916-17 and the early Twenties saw the Futurist renewal of the stage: Balla's *Fuoco*

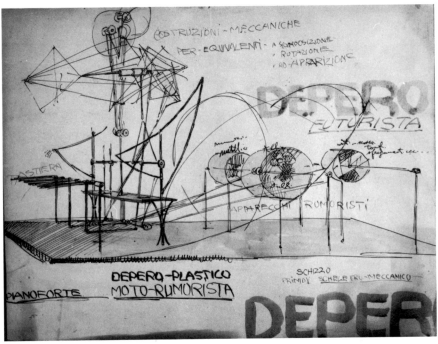

F. Depero, Rumorist Plastic Gloves,
Depero Museum

F. Depero, Motor-rumorist Piano, *1915*
Depero Museum

Guillermaz, advertisement for The Surprise
Alphabet

d'artificio (*Fireworks*) created for Stravinsky
and Diaghilev (1917); Depero's *Il canto
dell'usignolo* (*Nightingale Song*) and *Il giar-
dino zoologico* (*The Zoo*) for Diaghilev
(1916-17); *Balli plastici* (*Plastic Dances*) with
Clavel (1918); Prampolini's *Matoum and
Tévibar* (1919); Ricciardi's Theatre of Col-
our (1920); the experiences in Prague
(1921-24), the Theatre of Futurist Mime in
Paris (1927) and Turin (1928).
In 1919, Azari proposed *Aerial Futurist
Theatre* (April 11) with "dramatized flights,
aerial mime and dances, aerial Futurist pic-
tures, aerial words-in-freedom". In 1920,
Masnata presented *Visionic Theatre* and in
1921 Marinetti and Cangiullo theorized a
Theatre of Surprise which would present,
"besides all the body-madness of a Futurist
café-chantant, with gymnasts, athletes, illu-
sionists, comics, and conjurors, besides the
Synthetic Theatre, a *Newspaper-Theatre* of
the Futurist movement, and a *Gallery-
Theatre* of visual arts, not to mention
dynamic and synoptic recitation of words-
in-freedom mixed with dances, dramatized
free-word poetry, improvised musical
discussions between pianos, or between
piano and singer, free orchestral improvisa-
tions, etc."
Marinetti's booklet *Les mots en liberté
futuristes* (*Futurist Words-in-Freedom*, 1919),
summed up the results of several years of
experimentation: in *Lacerba* and in Mari-
netti's "Zang Tumb Tumb", in 1914; in
Folgore's *Ponti sull'oceano* (*Bridges on the
Ocean*, 1914); Auro d'Alba's *Baionette*
(*Bayonets*, 1915); Govoni's *BIF & ZF + 18:
simultaneità e chimismi lirici* (*BIF & ZF + 18:
Simultaneity and Lyrical Chemisms*, 1915)
and *Rarefazioni & parole in libertà* (*Rarefac-
tions & Words-in-Freedom*, 1915); Can-
giullo's *Piedigrotta* (1916), the work publish-
ed in *Italia Futurista* (1916-17); in Can-
giullo's *Caffé-concerto* (*Café-chantant*),
Alfabeto a sorpresa (*Surprise Alphabet*, 1918);
Meriano's *Equatore notturno* (*Night
Equator*, 1916); Marinetti's *8 Anime in una
bomba* (*8 Souls in a Bomb*, 1919), and his
writing for *Roma Futurista* in 1920.
Marinetti intervened on the subject of
morals with *The New Religion - Morality of
Speed* (11 May 1916) and *Against Feminine
Luxury* (11 March 1920), the former echoed
by Azari's *Simultaneous Life* (1928).
The manifesto remained the typical,
favourite form of Futurist proselytizing. In
1916, Corra, Ginna, Chiti, Settimelli,
Carli, Mara and Mannetti launched the new
dimension of *Futurist Science*, which would
be "anti-German, adventurous, whimsical,
safety-phobic, drunk with the unknown".
At the beginning of the Twenties, the in-
tense Futurist theatrical activity coincided
with the discovery of interior design, in
which the work of art is extended to the
whole room. Balla designed some interiors
in 1918 and created the rooms of his own
house in Via Porpora. In 1921 he decorated
the Bal Tic Tic, in 1921-22 Depero created
the Cabaret del Diavolo. Rome was the
most important centre for this aspect of the
Futurist "reconstruction of the universe".
Balla and Depero also worked intensively
on furniture and fabrics. The Casa d'Arte
Futurista Depero, in Rovereto, became a
busy workshop. In Rome, the Casa d'Arte
Italiana, directed by Prampolini, created in-
terior decorations. The new "Futurist

decorative art" proclaimed its existence in Paris at the International Exhibition of Decorative and Industrial Arts, in a climate of "Art Déco", and flourished in the various "Case d'Arte": in Rome, with Giannattasio, in Bologna with Tato, in Palermo with Rizzo and Corona.

Prampolini's magazine *Noi*, in its second series (1923-25) was concerned with interior and theatrical design; it expressed a climate of "machine art" that reflected European Purism and marked a new stage of the movement, the beginning of what is now commonly called Second Futurism.

In 1920, with a new manifesto, Marchi launched another version of Futurist architecture, with a vision of "lyrical deformation", and in 1924 he published the booklet *Architettura futurista* (*Futurist Architecture*). Ginna, in 1916, and Cangiullo, in 1920, wrote about the new Futurist furniture.

In 1925-26 Pannaggi decorated Casa Zampini at Esanatoglia. In 1927, Depero created "typographical architecture" at the Monza Biennale and Fillia showed his "Ambiente novatore" in Turin. The way was thus opened for all the decorative work of the late Twenties and of the Thirties, the numerous designs in the fields of furniture and fashion.

In 1924 Azari, in his *La flora futuristica ed equivalenti plastici di odori artificiali* (*Futurist Flora and Plastic Equivalents of Artificial Smells*), brought synaesthesia back again by pointing out "the correspondence that exists between form-colour and perfume, in the same way as between music and colour". Marinetti's manifesto on *Tactilism* (11 January 1921) had led the way by imagining "tactile tables"; and tactile cushions, sofas, beds, shirts and chothes, and especially tactile "rooms", expressing a complete environmental tactilism. Marinetti concluded: "The distinction between the five senses is arbitrary. One day we shall certainly discover and catalogue many other senses. Tactilism will facilitate this discovery."

In the post-war period and in the early Twenties, Futurism was also present on the political scene. 1918 saw the creation of the "Futurist Fasci" (listed by Marinetti, Settimelli and Carli in the manifesto *What Is Futurism*, 1919). The *Manifesto of the Futurist Party*, published at the beginning of 1918, marked the beginning of a "revolutionary" adventure that a year later in Milan was to involve the Futurists in the foundation of the "Fasci di combattimento", in collusion with early Fascism. In 1919 and 1920 Marinetti published his most important political texts: *Futurist Democracy: Political Dynamism* and *Beyond Communism*. The Futurists broke away from Fascism in 1920, but returned in 1923. Related to this are *Futurismo e fascismo* (*Futurism and Fascism*, 1924), and *Marinetti e il futurismo* (*Marinetti and Futurism*, 1928).

When Fascism came to power, any Futurist political claim dissolved. Now necessarily limited to cultural artistic action, the movement however kept space for new proposals and guaranteed a vigorous front in defense of the avant-garde tradition in Italy against the attacks coming from the Fascist right wing, which towards the end of the Thir-

G. Balla, design for a chest of drawers and hat-stand

F. Depero, wooden toy

ties, when anti-semitism became official policy, were particularly threatening.

During the Thirties, contributions to "reconstruction" continued, though the range of possible fields was already marked. Marinetti proposed *Futurist Cuisine* (28 December 1930) and wrote a book on the subject with Fillia (1932).

We have traced in broad outline the path of the Futurists' increasing awareness of their desire to "reconstruct", and the progressive widening of the range of different creative fields they felt could be "reconstructed". The detailed analysis of these fields coincides with the actual history of Futurist creativity in its multiple expressions, forms, times and places (for Italian Futurism, the "reconstruction" in fact involved different cities throughout the country). (ECr)

Futurist Reconstruction of the Universe
(Futurist manifesto, Milan, 11 March 1915)

With the Technical Manifesto of Futurist Painting and the preface to the catalogue of the Futurist Exhibition in Paris (signed by Boccioni, Carrà, Russolo, Balla, Severini), with the Manifesto of Futurist Sculpture (signed by Boccioni), the Manifesto of the Painting of Sounds, Noises and Smells (signed by Carrà), with the volume *Pittura scultura futuriste* [*Futurist Painting and Sculpture*] by Boccioni and Carrà's *Guerrapittura* [*Warpainting*], pictorial Futurism has succeeded in the course of six years in progressing beyond Impressionism and in solidifying it, proposing plastic dynamism and the moulding of the atmosphere, interpenetration of planes and states of mind. The lyrical appreciation of the universe, by means of Marinetti's words-in-freedom and Russolo's Art of Noises, combines with plastic dynamism to provide a dynamic, simultaneous, plastic and noise-ist expression of the universal vibration.

We Futurists, Balla and Depero, seek to realize this total fusion in order to reconstruct the universe making it more joyful, in other words by a complete re-creation.

We will give skeleton and flesh to the invisible, the impalpable, the imponderable and the imperceptible. We will find abstract equivalents for every form and element in the universe, and then we will combine them according to the caprice of our inspiration, creating plastic complexes which we will set in motion.

Balla initially studied the speed of automobiles, thus discovering the laws and essential line-forces of speed. After more than twenty exploratory paintings, he understood that the flat plane of the canvas prevented him from reproducing the dynamic volume of speed in depth. Balla felt the need to construct, with strands of wire, cardboard sheets, fabrics, tissue paper, etc., the first dynamic plastic complex.

1. *Abstract.* 2. *Dynamic.* Relative movement (cinematographic) + absolute movement. 3. *Extremely transparent.* Because of the speed and volatility of the plastic complex, which must appear and disappear, light and impalpable. 4. *Brightly coloured and extremely luminous* (using internal lights). 5. *Autonomous*, that is, resembling itself alone. 6. *Transformable.* 7. *Dramatic.* 8.

Volatile. 9. *Odorous.* 10. *Noise-creating.* Simultaneous plastic noisiness with plastic expression. 11. *Explosive*, elements appear and disappear simultaneously with a bang. The free-wordist Marinetti, when we showed him our first plastic complexes, said enthusiastically: "Before us, art consisted of memory, anguished re-evocation of a lost Object (happiness, love, landscape), and therefore nostalgia, immobility, pain, distance. With Futurism art has become action-art, that is, energy of will, optimism, aggression, possession, penetration, joy, brutal reality in art. (e.g. onomatopoeia; e.g. noise-attuner [*intonarumori*] = motors), geometric splendour of forces, forward projection. Art becomes Presence, a new Object, the new reality created with the abstract elements of the universe. The hands of the traditionalist artist ached for the lost Object; our hands longed for a new object to create. That is why the new object (plastic complex) appears miraculously in yours."

Material construction of the plastic complex
Necessary means: Coloured strands of wire, cotton, wool, silk, of every thickness. Coloured glass, tissue paper, celluloid, wire netting, every sort of transparent and bright material. Fabrics, mirrors, sheets of metal, coloured tin-foil, every sort of gaudy material. Mechanical and electrical devices; musical and noise-making elements, chemically luminous liquids of variable colours; springs, levers, tubes, etc. With these means we will construct:
Rotations: 1) *Plastic complexes rotating on a pivot* (horizontal, vertical, oblique). 2) *Plastic complexes rotating on several pivots*: (a) in the *same* direction but with varying speeds; (b) in *opposite* directions; (c) in the *same and opposite* directions.
Decompositions: 3) *Plastic complexes which break up*: (a) into volumes; (b) into layers; (c) in successive transformations (cones, pyramids, spheres, etc.). 4) *Plastic complexes which break up, talk, make noises and play music simultaneously.*
Decomposition, Transformation → Form + Expansion → Onomatopoeias, Sounds, Noises.
Miracle Magic: 5) *Plastic complexes which appear and disappear*: (a) slowly; (b) by repeated jerks (in scales); (c) with unexpected explosions. *Pyrotechnics — Water — Fire — Smoke.*
The discovery — infinite systematic invention
Using complex, constructive, noise-producing abstraction, in short, the Futurist style. Every action developed in space, every emotion felt, will represent for us a possible discovery.
Examples: Watching an aeroplane swiftly climbing while a band played in the square, we had the idea of *plastic-motor*-noise music in space and the *launching of aerial concerts* above the city. The need to keep changing our environment, together with sport, led us to the idea of *transformable clothes* (mechanical trimmings, surprises, tricks, disappearance of individuals). The simultaneity of speed and noises inspired the *rotoplastic noise fountain.* Tearing up a book and throwing it down into a courtyard resulted in *phono-moto-plastic advertisement* and *pyrotechnic-plastic-abstract contests.* A spring garden blown by the wind led to the concept of the *Magical transformable motor-*

noise flower. — Clouds flying in a storm suggested *buildings in noise-ist transformable style.*
The Futurist toy
In games and toys, as in all traditionalist manifestations, there is nothing but grotesque imitation, timidity (little trains, prams, puppets), immobile objects, stupid caricatures of domestic objects, *antigymnastic and monotonous, which can only cretinize and depress a child.*
With plastic complexes we will construct toys which will accustom the child:
1. *to completely spontaneous laughter* (through absurdly comical tricks);
2. *to maximum elasticity* (without resorting to thrown projectiles, whip cracking, pin pricks, etc.);
3. *to imaginative impulses* (by using fantastic toys to be studied under a magnifying glass, small boxes to be opened at night containing pyrotechnic marvels, transforming devices, etc.);
4. *to the continual exercise and sharpening of his sensitivity* (in the unbounded realms of acute and exciting noises, smells and colours);
5. *to physical courage, to fighting and to war* (with gigantic, dangerous and aggressive toys that will work outdoors).
The Futurist toy will be very useful to adults too, keeping them young, agile, jubilant, spontaneous, ready for anything, untiring, instinctive and intuitive.
The artificial landscape
By developing the first synthesis of the speed of an automobile, Balla created the first plastic ensemble. This revealed an abstract landscape composed of cones, pyramids, polyhedrons, and the spiral of mountains, rivers, lights and shadows. Evidently a profound analogy exists between the essential line-forces of speed and the essential line-forces of a landscape. We have reached the deepest essence of the universe and have mastered the elements. We shall thus be able to construct.
The metallic animal
Fusion of art + science. Chemistry, physics, continuous and unexpected pyrotechnics all incorporated into a new creature, a creature that will speak, shout and dance automatically. We Futurists, Balla and Depero, will construct millions of metallic animals for the greatest war (conflagration of all the creative energies of Europe, Asia, Africa and America, which will undoubtedly follow the current marvellous little human conflagration).
The inventions contained in this manifesto are absolute creations, generated entirely by Italian Futurism. No artist in France, Russia, England or Germany anticipated us by inventing anything similar or analogous. Only the Italian genius, which is the most constructive and architectural, could invent the abstract plastic ensemble. With this, Futurism has determined its style, which will inevitably dominate the sensibility of many centuries to come.

<div align="right">G. Balla, F. Depero
Futurist Abstractionists</div>

Regina

(Mede Lomellina, 1894 - Milan, 1974) Italian sculptress

After her Post-Impressionist, figurative sculptures in marble and bronze of the mid-Twenties, at the beginning of the Thirties Regina Bracchi started to create her first sculptures in tin and aluminium foil. In 1934 she became part of the Futurist movement, joining the Milanese group. From 1934 to 1940, her works were shown in many Futurist exhibitions and events. Together with Bruno Munari, Carlo Manzoni, Gelindo Furlan and Riccardo Ricas, she signed the *Technical Manifesto of Futurist Aeroplastics* (Milan, 1934). Among the sculptors of the Second Futurism, she was a remarkable and independent figure; she radically criticized the interpretation of plastic dynamism as material density and inevitable — though dynamic — corporeity, aiming instead at an almost ephemeral spatial levitation. (ECr)

Religion

Critics have changed the focus of their attention from the "exoteric" aspects of Futurist theory and invention to more hidden and fruitful sides. However, the body of material and criticism so far collected under the general heading of "Futurist religiousness" lacks unity and is more like *disiecta membra* — disconnected and meaningless parts. It is now obvious that "modernolatry" (worship of the modern) is not machine-fetishism, and that the religion of speed is not Positivist Progressivism, but this clarification has produced various consequences. All the so-called "avant-gardes" can be seen in terms of "modernolatry" and yet this has nothing to do with the 19th century secularized theories of God. Extremely disparate ideological and cultural motives, and contradictory philosophical trends have been introduced to explain the Futurist cult of the New. For example, Nietzsche and Bergson are constantly cited and wrongly bracketed together. On the other hand, by focussing on the question of religion in Futurism, it may be possible to isolate and study one of the main elements which made it a truly epoch-making cultural and artistic movement.
It is my belief that the roots of Futurist poetry and the Futurist world vision lie in a Gnostic religiousness, or as we will see, irreligiousness. Long before other modern artistic movements, and in a much more radical way, Futurism tended to reveal an esoteric dimension with a definite gnostic imprint. The whole of modern cultural life possesses this esoteric dimension. Futurism does not negate every tradition *in toto*; it is fully part of the great underground movement of the Western Gnostic tradition, and is one of its most revealing trends. We can talk of Futurist "religiousness" only in connection with this tradition. The connection is not at all accidental, nor limited to a specific "theme". Futurism represents a moment when this religiousness emerges with the most strength, the most explicit "will to power" and with a declared "missionary" spirit. In order to show this, we must examine the founding texts of the movement.
The young lions of Solitude stand full of pride, "against an army of hostile stars"

(first manifesto, 1909). They are "aliens", *alloi*, "extra-terrestrials", people whose home lies beyond the visible cosmos, the *kosmos* of the stars or their archons. These "alien" souls on earth have created a *genos*, a race which resembles the invisible, divine essence. It is the race of the *asaleutoi*, or *akinetoi*, the Indestructibles. In 1922, Marinetti published the story "Gli indomabili" (The Untameable Ones). The religious meaning of this work was intended to be precisely that of the great Gnostic mythologies — the vision of humanity thirsting for a truth that cannot be compromised. In their very first manifestos, the Futurists present themselves as metaphysical strangers, *allogenes*, beings belonging to another species or another race, who cannot be tamed by the forces of the visible cosmos. The stars and moon represent the guardians of Necessity: they govern the laws of time and space, in the name of the unrelenting principle of causality. Thus the moon must be destroyed. The theme of the dimming of all cosmic light, already present in various early 20th century works (e.g. *Victory over the Sun*, by Malevich), finds its most convincing explanation here.

Gnosticism has always seen the starry sky as an oppressive "army", as the bars of the earth-bound prison of the soul. To go beyond these limits, the soul must learn to fly, must find wings (Marinetti's "We want wings!"), must become an Angel. The theme of flight as an escape from the world, from the laws of time and space within the visible cosmos, is fundamental to the Gnostic *imaginatio* and it comes to life in the Futurist symbol of the "aeroplane" and Marinetti's *conquêtes des étoiles*. Marinetti's *aeropoesia* (air-poetry) does not exalt speed for speed's sake, but as a way for the "alien" to go beyond the limits of the firmament, of the *coelum stellatum* where the demonic archons and lower entities dwell. The theme of breaking away from the *omnitudo*, the common world and its general laws that claim to dominate everything, has infinite variations in Futurism. Its derivation from Nietzsche is only apparent (see *Philosophy*); in reality, this theme expresses the experience, the "fundamental *Stimmung*" of the Gnostic tradition. To the casual *logos* of the town, or *astro-logos* seduced by the dominion of Ananke, fate, this tradition in all its variants opposes the *mania*, the *sacred* madness ("Be wary of this solid gold word" — Marinetti) of those exiled into the world, those who *thirst* for that Light and long to be reunited with it ("Let us surrender to the unknown..." — Marinetti), in a merging which will dissolve every *principium individuationis*. The *mania* transforms the individual, cracks his normal identity and leads him through paths "as difficult and deep as streambeds" to "the mysterious doors of the Impossible" (Marinetti). Madmen are the only really alive people, because to be *alive* means to "break through the insuperable barriers" of time and space ("Time and space died yesterday"); to be *alive* is to challenge the stars ("our challenge to the stars!"...), and to demolish the walls of the cities of Paralysis and Podagra. "The army of madness" (the *enthusiastic* "aliens") attacks Podagra's walls "with cries, heads and fists" (Marinetti).

The fact that the madmen, once freed, go East and reach "the sublime world altar, the Persian plateau" (Marinetti) and pass the Ganges, shows that the Futurists were aware of the Gnostic-Manicheist origin of these inventions. The basic dualism which is behind them came precisely from that "plateau". The sacred Gnostic-Futurist madman breaks away from the cosmic gods, returns to his country, and as a stranger ventures towards an unknown, hidden ineffable God — towards the Impossible. The *naturaliter ignotus* God cannot be represented in any way. Only in iconoclastic fury does a certain sense appear. This God, who cannot be represented by means of the senses, can be "signified" only through the very gesture of separation, of de-cision from the cosmos. With his "courage, audacity, rebellion" (Marinetti), the madman is the one elected to make such a gesture.

By irreversibly *de-ciding* and separating himself from the city of Paralysis (reminiscent of the Nietzschian "spirit of gravity"), by renouncing all *religio* of the *omnitudo*, the Futurist is reborn. The madman is alive because he is continuously reborn into an infinite series of masks. By dying to the world of the senses, he is reborn to a life which cannot be taken away from him. The Futurist thus follows the path of all initiates. The obsessive Futurist insistence on the movement's "age" is typical of such a Gnostic *Stimmung*: the Futurist is the *Puer* who never grows old, because his "creation" constantly touches the depths of the *aorgico* (the "maternal ditch" of the First Manifesto), where new forms continually spring up. So on the one hand there is the dying god who belongs to the order of the cosmos, and on the other the "beauty" ("There is beauty only in fighting" — Marinetti) of the eternal *Puer*, animated by the "feverish insomnia" of a continuous creation.

The Gnostic origin of Futurist "religiousness" is obvious, and so is its relation to tradition. The Futurist *hybris* of a radical *novitas* is the most traditional element of Futurism! Every Gnosis, and in particular the Christian one, is obsessed with breaking away from the past, with rebelling against the *traditum*: the Coming of Christ is totally separate from Judaism; the biblical Father represents the accursed *kosmokrator* from whose chains Christ frees us. The Christian language *reveals* an *unheard*-of message which shocks and surprises man; to understand it, he needs to become *Puer* again, forget what has already been said and drop the old language. Only when totally *denuded* of every tradition (the "real naked ones" of certain Gnostic sects) will he be able to face and understand the lightning, aggressive, autonomous and *anarchic* revelation of the Saviour. The *new* Pact overthrows the old *ab imis fundamentis*. St. Irenaeus sums up this aspect of the Gnostic mentality by saying it leads to an absolute *contrarietas et dissolutio praeteritorum*.

Here we can only hint at some of the consequences that this *contrarietas* had in the Futurist style of writing: *broken* time, the emphasis on the *discontinuous*, and the word liberated from the "army" of syntax. Futurist religiousness wants to connect only with the oncoming, with the God who is the unknown future, and this yet-to-be can be foreshadowed here-and-now only through a language that dissolves the past and burns the old, that frees the field ("Giiive me a brooom!" cries Marinetti) from the gods of death, paralysis and gravity.

This "lyrical exaltation" (Boccioni) of Futurism as "new religiousness" is already present, in the same terms, in the first *Painters' Manifesto*. On the one hand there is the "fanatical religion of the past" and its "docile slaves", and on the other, the free creation of "those who are confident in the radiant splendour of our future" (which does not mean "the miracles of contemporary life". "Victorious science" is always exalted by Futurism as a manifestation of the creativity of the free, alive man, against the "Law of the Father" which coincides with the law of representation through the senses because it is the Father's very essence to create an illusion about the reality of the cosmos of which he is the Lord). The painters will look for a fourth dimension which goes beyond the limited horizon of appearances ("We must express the invisible which moves and lives behind the gross forms" — Boccioni). They will try to reflect the inner force of an object, together with the force of the observer and the memory left by the object. Whereas the time-space of traditional painting is an arithmetical progression of consecutive moments, the Futurists seek a simultaneous revelation according to the unpredictable rhythm of universal dynamism.

However, Boccioni's "gnosis" seems to have lost the Promethean abundance, the symbolic emphasis of the tradition, which is always present in Marinetti. In the series *Stati d'animo* (*States of mind*), Boccioni's outsiders, the strangers, the unrooted ones, are the images themselves, broken and fragmented in the game of the universal dynamic. They are frozen ghosts, caught by their own unfamiliarity, or moving without knowing where they are going, whose goodbyes echo endlessly, beyond the spiral of the lines or torn veil of the colour. Futurist Gnosticism discovers its deep, true *melancholia* here. The Lords of Light, who wanted to drink "at the living sources of the Sun" (Boccioni), reveal themselves in their *ou-topico* wavering: they are amorphous and formless, always caught in either a gesture of goodbye or of ceaseless waiting. And yet as *ou-topie*, they reveal their measure: the purest lyric and religious measure of madness. (MC)

Revueltas, Fermín

(Santiago Papaquiaro, 1903 - Mexico City, 1935) Mexican painter

Younger brother of the composer Silvestre Revueltas, who was also linked to the Mexican Stridentist group, Fermín Revueltas studied painting in Chicago and later in Mexico City. As early as 1921 he was presented by Maples Arce as one of the most promising artists of his generation, and he soon joined the Stridentist movement founded by Arce during that year. During the same period he painted extremely colourful works tending to abstraction and linked to both Cubism and Futurism. He did not reject representational images in his mural painting, which he began in 1922 alongside Rivera, Orozco, Jean Charlot, Alva de la Canal and Fernando Leal. Encouraged by the examples set by his friends, he also worked in woodcuts and produced a remarkable and important body of work on paper, including drawings and watercolours. The influence of Stridentism is evident in his graphic work of the Thirties, particularly in his many illustrations for the magazine *Crisol*. (SF)

Reynaud, Charles-Emile

(Ivry, Paris, 1845 - Montreuil-sous-Bois, 1918) French film-maker

Reynaud started to experiment with hand-painted strips of film in Paris in 1877 and he eventually succeeded in projecting them into a screen. For a time he enjoyed great public success with his "Théâtre Optique" entertainments, but around 1911 the development of the motion picture resulted in so little interest in his marvellous cartoon films that he destroyed his projector and threw his films into the Seine in despair. One of Reynaud's films, *Autour d'une cabine* (*Around a Cabin*), has recently been lovingly reconstructed from existing worn-out strips, and can give us an idea of Reynaud's art. Its lighthearted comedy is reminiscent of Boccioni's early tempera paintings from 1910, which show automobiles in all kinds of extraordinary situations. (PH)

Ricciardi, Achille

(Sulmona, 1884 - Rome, 1923) Italian writer

In 1920 Achille Ricciardi published *Il teatro del colore - Estetica del dopoguerra* (*The Theatre of Colour - Postwar Aesthetic*), in which he expounded the theories he had been developing since 1906 and which had appeared for the first time that year in *Il Secolo XIX*. The author proposed a relationship between the state of mind (or psychic state) of the leading character and the use of colour, which has no decorative or aesthetic function but "marks the movement of the orchestra within the scenic space".

Between 20 and 30 March 1920 at the Teatro Argentina in Rome Ricciardi put his theories into practice in *Kitra* by Tagore, *Rose di carta* (*Paper Roses*) by Folgore and two plays he wrote himself, *Lo schiavo* (*The Slave*) and *Osmana*. Giannattasio and Prampolini designed the settings and costumes. In his 1923 article "L'atmosfera scenica del teatro del colore rivive nel tempo e nello spazio" (The Scenic Atmosphere of the Theatre of Colour Lives again in Time and in Space) Prampolini spoke of a certain

Crisol, October 1930, cover by F. Revueltas

F. Revueltas, The City, woodcut

F. Revueltas, Abstract Motif, woodcut

aesthetic affinity between his *Futurist Stage* manifesto (1915) and Ricciardi's ideas, which were received with considerable mistrust by the critics but with great enthusiasm by the Futurists. (EC)

Robert, Enif

pseudonym of Angelini, Enif
(Prato, 1886 - Bologna, 1974) Italian actress and writer

Enif Robert was an actress who worked with her friend Eleonora Duse. Using her husband's surname, she contributed to *L'Italia Futurista*, taking part in a discussion on the role of women and engaging in controversy with her companions in the group; her articles were published in the second edition of Marinetti's book *Come si seducono le donne* (*How to Seduce Women*, 1918). Together with Marinetti she signed the novel *Un ventre di donna* (*A Woman's Belly*, 1919), excerpts from which appeared in *Roma Futurista* in 1920. Later, she published in *L'Impero* a letter arguing against Mario Carli's proposal for "compulsory procreation". (CS)

Roberts, William

(London, 1895 - London, 1980) British painter

Roberts served an apprenticeship as a commercial artist before studying at the Slade School of Fine Art (1910-13). On leaving the Slade he travelled to France and Italy and upon his return he joined the Omega Workshops, by which time Lewis and the "rebels" had already left. Although he was never a member of the Rebel Art Centre he first showed alongside the "rebels" at the "Twentieth Century Art" exhibition at the Whitechapel Art Gallery (1914) and his work was illustrated in both issues of *Blast*. In spite of the appearance of his name on the *Blast* manifesto he claimed that Lewis never consulted him. He showed with the London Group in 1915 and in the "Vorticist Exhibition" (1915). He joined the Royal Field Artillery in 1916 and exhibited in the New York "Vorticist Exhibition" in 1917. In 1918 he was commissioned to produce a large painting for the Canadian War Memorials Fund and in 1919 he executed three paintings for the lobby of the Restaurant de la Tour Eiffel, London, a regular meeting place of the Vorticists. He was a member of Group X in 1920 and held his first one-man show at the Chenil Gallery in 1923.

Roberts' early work, while at the Slade, shows all the marks of traditional art school teaching with an emphasis on figure drawing which would remain a central concern throughout his life. Early themes such as *The Resurrection* (1912) are biblical, reflecting an interest in Pre-Raphaelite painting as well as the more contemporary work of influential former Slade pupils, Bomberg and Gertler. Even Roberts' market drawings of 1913 draw more heavily on Victorian genre painting, and its continuation in the work of the Camden Town Group, than upon more avant-garde movements.

But in the same year Roberts' work underwent a profound change: "I became an Abstract painter through the influence of the French Cubists; this influence was further strengthened by a stay in France and Italy during the summer of 1913; and then

on my return home by association with Roger Fry at the Omega Workshops", Roberts wrote in 1957 when he was keen to demonstrate his independence from Lewis. His earliest surviving Cubist works such as *The Return of Ulysses* (1913) demonstrate Roberts' method, which he shared with Bomberg, of moving from naturalism to abstraction in progressive stages, a practice he was to maintain throughout his "Abstract" period.

By 1914 Roberts was beginning to attract the attention of the English avant-garde and T.E. Hulme wrote about his *Dancers in The New Age* in April of that year, stating that Abstract Art had a base in "outside concrete objects... The fact that such forms were suggested by human figures is of no importance". Hulme's theories called for the geometricization of organic forms. Roberts' work closely reflects Hulme's arguments although Roberts argued that he arrived at his style quite separately. Indeed he rejected Hulme's insistence on the unimportance of the figurative suggestiveness of abstract forms when he stated that "the artist is always careful to retain some traces of the natural forms that have inspired him", claiming that it was precisely this which gave the picture vitality and saved it from becoming "a mechanical geometric construction".

Dancers was hung by Lewis at the Rebel Art Centre but in spite of its Cubistic appearance Roberts claimed that it was not a Vorticist work. In 1956 he maintained that "Vorticism for me is the work I did for the Doré Gallery [*sic*] exhibition together with the drawings in the second *Blast* (war number)". Clearly a work such as *The Toe Dancer* (1914) still retains a heavy debt to his Slade years whereas *Two Step* (c. 1915), known only through studies, is a mature Vorticist work. As with many of Roberts' compositions in this period the subject is viewed from an acute angle, the forms rising rapidly up the sheet, in a manner reminiscent of Michelangelo's severe foreshortening. The architectonic forms and the juxtaposition of strong reds with deep blacks endow the work with a vibrancy typical of Vorticist painting. The employment of Vorticist girders and columns all but precludes a figurative reading although Roberts has retained head-like configurations at the centre. Vestiges of figuration are entirely abandoned in *St. George and the Dragon* (1915) which comes very close to Lewis's style and indicates the influence Lewis must have exerted on Roberts during his brief Vorticist period.

The drawings illustrated in *Blast No. 2*, however, remain resolutely tied to the figure and one in particular, *Machine Gunners*, although relatively complex in design, remains clearly legible.

The Vorticist elements in this work can be largely accounted for by the subject matter itself.

Roberts did not adopt industrial subject matter but his approach to figure painting was for a brief period mechanistic.

This probably reflected the origins of his art in Cubism rather than Futurism.

On his return from the war he "gave up angular abstract designs" and he subsequently painted figures in a rather tubular manner. (JL)

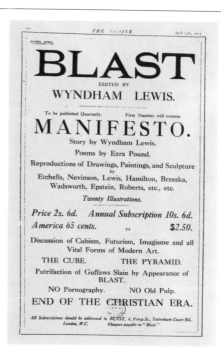

Advertisement for Blast, *magazine*

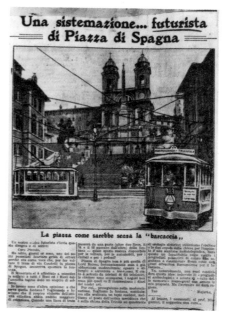

Futurist project for Piazza di Spagna

Sign of the Casa d'Arte Bragaglia

Romani, Romolo

(Milan, 1884 - Brescia, 1916) Italian painter

In 1902 Romani enrolled at the Brera Academy in Milan. In 1904, after winning a prize at the National Caricature Exhibition in Varese, he was awarded a monthly stipend and a studio in the Castello Sforzesco. During that period he became acquainted with Previati, whose work he admired deeply. Romani's paintings are marked by a Nordic symbolism and are powerfully expressive. The geometric rigour through which caricatural faces emerge — deformed by a strong stroke rich in chiaroscuro (*Observation; Fear; Jealousy or the Incubus* and *The Revolt*) — take on a plastic feeling which links them to Wildt's experiments in sculpture. From 1904-05 on he sought a link between musical interweaving and the structure of the sign (*Sound Reflections*) which led him to develop greater abstraction of line, as in *Prisms* or *Image*, though he was still tied to depiction of an exaggerated crudeness. From July 1906 until mid-1908 he contributed to the magazine *Poesia*, directed by Marinetti and Sem Benelli. He assiduously frequented young Milanese artists, and he met Carrà: "We would meet every night at the Famiglia Artistica and talk about our latest enthusiasms until late into the night. Romani, Bonzagni, Camona, Martelli and Erba were with us and from time to time the darkened face of Ugo Valeri would appear." Around 1909 he also met Sant'Elia, Chiattone, Dudreville and Boccioni. His friendship with these young and rebellious artists led him to sign the *Manifesto of the Futurist Painters*, written between the end of January and the beginning of February 1910, printed in leaflet form for *Poesia* and signed by Boccioni, Dalmazzo, Carrà, Russolo, Romani and Bonzagni. Later Marinetti recalled: "Romolo Romani entered that day into our movement bringing with him a fiery and innovative spirit... His giant lyrical anatomies and obsessive nightmare landscapes revealed an authentic Futurist." But, Carrà recalled, the reaction to the group's creation was "so harsh that it frightened our friends Romolo Romani and Aroldo Bonzagni and led them to drop out of the movement". The manifesto of 11 February in fact bears the signatures of Gino Severini and Giacomo Balla in place of those of Bonzagni and Romani. The visionary quality and flexible stroke of Romani's work — which lost its dreamlike power from 1911 on — influenced the work of his young companions Boccioni and Carrà just before they joined Futurism. (EC)

Rome

Rome was an important centre of Futurism, particularly during the period immediately preceding its birth; the Roman Giacomo Balla was fundamental to the later artistic evolution of his pupils Boccioni, Severini and Sironi.

To launch Futurism in the Italian capital, two *soirées* were organized at the Teatro Costanzi (21 February and 9 March 1913) concurrently with the first exhibition of Futurist painting in Rome; during the first *soirée*, Giovanni Papini pronounced his *Discorso di Roma* (*Rome Discourse*), in line with Marinetti's proposal to destroy

historical cities: "Rome is, to use Marinetti's term, the eternal and outstanding symbol of that historical, literary and political passéism and archaeologism which has always weakened and hindered the most original manifestations of Italian life." A few months later, Giuseppe Sprovieri's Galleria Futurista was inaugurated (it opened at the end of 1913 with an exhibition of Boccioni's sculpture and closed the following year after the outbreak of war). The gallery became the centre for Futurist activity in Rome: exhibitions, soirées, recitals and performances.

On 9 December 1914 and 11 April 1915 Marinetti staged a series of manifestations at the University calling for Italian intervention in the war, in which Balla, Cangiullo and Depero took part. During the war, those who remained in Rome (Prampolini and Balla among them) continued various activities: exhibitions, new periodicals including Noi, manifestos and contacts with the Russian Ballet. In 1925, the year in which a large group of Futurist works were included in the Third Biennale, Marinetti moved from Milan to Rome. (EC)

Rosà, Rosa
pseudonym of von Haynau, Edyth
(Vienna, 1884 - Rome, 1978) Italian writer and illustrator of Austrian origin

Born into an aristocratic family, in 1908 Edyth von Haynau married the Italian Ulrico Arnaldi and moved to Rome. In 1917, under the pseudonym "Rosa Rosà", she joined the group that centred around L'Italia Futurista, whose interest in occultism she shared. Her writings in this periodical dealt with women's emancipation, which was also the theme of her two short novels, Una donna con tre anime (A Woman with Three Souls, 1918) and Non c'è che te! (There Is Only You, 1919). She was mainly active as an illustrator, publishing abstract and fantastic drawings in several books by Bruno Corra, Mario Carli and Arnaldo Ginna. She took part in the exhibition of "Independent Art" organized by Prampolini in Rome in 1918, in the "Great National Futurist Exhibition" (Milan-Genoa-Florence) of 1919 and the "Great International Futurist Exhibition" in Berlin in 1922. Subsequently she continued to work as an illustrator and became interested in primitive art. (CS)

Rosai, Ottone
(Florence, 1895 - Ivrea, 1957) Italian painter

Ottone Rosai exhibited for the first time in 1913 in Florence, next to the rooms where, at the same time, the "Exhibition of Futurist Painting" of the Lacerba group was being held.

"A great number of people visited the exhibition, it led to a great deal of discussion and the greatest honour was to see the Futurists come in all together. They looked, talked amongst themselves and admired the work, and then Marinetti, the leader of the movement, said he wanted to meet me. I was introduced to him by Papini, and in his turn he introduced me to Soffici, Carrà and Tavolato. They invited me to join them and from that very day I became a militant Futurist and an unfailing regular of the Caffè delle Giubbe Rosse."

Rosai's work changed. From a violent brush stroke heavy with paint and the use of strident colours in a Cubist organization of space, although he did not build up a volumetric image, he changed to multimedia experimentation with aggregations of the most varied materials along with streams of colour. These are the works he exhibited in April-May 1914 in Rome at Sprovieri's Galleria Futurista: Zang-tumb-tumb + Bottle + Glass, Street Dynamism, Dynamism of Objects. He contributed two prose texts to Lacerba.

After three and a half years in the war, there followed a period of reflection. From 1919 onwards he reached a simplification of the image by means of a synthesis using archaism of Quattrocentesque origin, which over the years developed into a folk-like style with spontaneous brushwork. (EC)

Rosny, Joseph Henri
pseudonym of Boex, Joseph Henri
(Brussels, 1856 - Paris, 1940) Belgian writer, naturalized French

Rosny began to write together with his brother Séraphin (known as Rosny the Younger), and was at first greatly influenced by Zola, but he moved away from that model in 1887 with his science-fiction novel Les Xipéhuz and his social novel Le Bilatéral, which was much admired by Marinetti. Rosny's most original books are his science-fiction works, including La mort de la terre (1908), La force mystérieuse (1914), and novels about prehistory such as Vamireh (1892) and La guerre du feu (The Quest for Fire, 1911). (SF)

Rosso, Medardo
(Turin, 1858 - Milan, 1928) Italian sculptor

Medardo Rosso attended the Brera Academy in Milan (1882-83) and was educated in the climate of late Lombard Scapigliatura. Taking as his models Tranquillo Cremona, Daniele Ranzoni and the sculptor Giuseppe Grandi, he developed a pictorial style of sculpture in which the outlines are frayed and the closed surface planes loosen and vibrate in the light and atmosphere, giving the image greater unity and fusion. In works such as Singer Strolling and Lovers under the Street Light (1882 or at the latest early 1883) and above all The Flesh of Others (1883 or early 1884), The Church-Cleaner (1883), The Concierge (1883), and Impression of an Omnibus (around 1884, now lost), Rosso shatters the impermeable shell around the plastic object so that inner and outer space become interrelated. His subjects are representatives of

M. Rosso, Impression of an Omnibus, photograph

the city's poorest classes, in line with the ideal of socially committed realism that was typical of Milanese culture, but his vigorous, fresh vision untrammelled by habit places the images in an unlimited time frame. From the first, Rosso adopted the psycho-physiological approach to reality typical of the Impressionists, based on a belief in the interference of subjectivity and objectivity. However, he found that approach directly, in its scientific and Positivist origins, not through the mediation of the French painters, although he was probably familiar with their work. A further distinction between Rosso and the Impressionists at this early stage lies in his persistent ideological concern with content, and an emotional involvement that goes beyond the Impressionists' subjective vision. Rosso essentially belonged to 19th century Positivism and could not therefore be in tune with the Bergsonian concepts of "memory" and "duration" that allowed Boccioni to convey the fluid depth and complexity of the dynamic of experience. Already, however, Rosso achieved results which were to have a decisive influence on Boccioni by linking a space to time and seeking movement — life — in the dynamics of light, where being coincides with appearance and existence with becoming. This was especially true after he settled in Paris in 1889, probably following an earlier visit in 1886. It was in this period that he developed the synthesis evident in *Conversation in a Garden* (1896), or *Paris at Night* (1895-96), but also in the peremptory *Yvette Guilbert* (1895), the elusive *Woman with a Violet* (1893) and *Laughing Woman* (1890), the emotion-laden *Sick Boy* (perhaps as early as 1889) and *Jewish Boy* (1892-93), or in the realistic *Bookmaker* (1894) or *Man Reading* (1894). The image is flattened into the "slice of life"; the three-dimensional statue is forgotten; the artist is trying, as he said himself, to make the spectator "forget the material". To the nobility of marble and hardness of stone, Rosso often preferred the soft malleability of wax, as though he were competing with painting in an effort to give sculpture new expressive possibilities. His radical approach in fact precludes the link with Rodin which has often been suggested. Not even Rodin's *Balzac* (1897) is related to Rosso's work. Among Rosso's later sculptures, *Madame X* (1896, but sometimes dated as late as 1914) attains a high degree of synthesis in its exclusive focus on the head, the almost total elimination of protruding planes, and the unified modelling. *Ecce Puer* (1906) is a testimony of the artist's desire to give form to an idea, a vision of the world, a meditation on life, a moral aspiration. After this for many years Rosso produced only replicas of his previous sculptures. At their best, however, these are completely new creations, in which the original feeling is reworked and, paradoxically, becomes more immediate and direct: coloured waxes, different modelling and casting, new angles all lighten the image, making it flashing, impalpable and elusive. In his later years Rosso was also particularly fertile as a draughtsman. The many photographs of his works, however, should not be attributed to him, although he certainly took a direct interest in their production, overseeing the

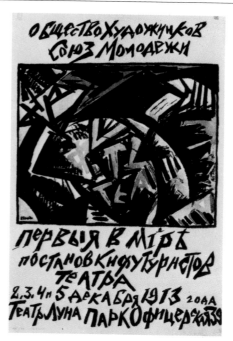

O. Rozanova, poster for the Futurists' Theatre, *1913*

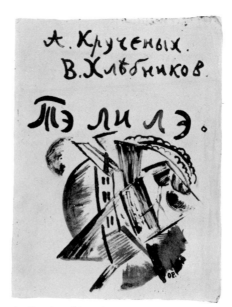

A. Kruchenykh and V. Khlebnikov
Te li lé, *decorations by O. Rozanova, 1914*

photographer's work and spending time in the darkroom to achieve particular effects in the plates and the prints, which he often cut unevenly. After the First World War he returned to Milan and spent more and more time there until his death. (LC)

Rosso, Mino
(Castagnole Monferrato, 1904 - Turin, 1963)
Italian sculptor

In 1927 Mino Rosso joined the Turin Futurist Group and up to 1938 actively participated in Futurist exhibitions and events. As a sculptor he was an outstanding figure of the Second Futurism. His early work was "mechanical", influenced by Archipenko, but subsequently he moved towards Boccioni's style, developing a full, taut dynamic plasticism. His final evolution achieved a synthesis based on the Cubist tradition (Lipchitz and Zadkine). Rosso was interested in "mural plastic art" and signed a manifesto on the subject in 1934. He also designed interior decorations and ceramics (with Tullio d'Albisola). He remained a prominent figure in the Turin Futurist group, collaborating with *Stile Futurista* (1934-35), a magazine edited by Fillia, and then with Prampolini. (ECr)

Rozanova, Olga Vladimirovna
(Vladimir, 1886 - Moscow, 1918) Russian painter

Rozanova began her art studies in Moscow, and continued them in St. Petersburg from 1913. There she met Mikhail Matiushin and his wife Elena Guro, who brought her into the Union of Youth avant-garde group. She quickly became one of its leading figures. Influenced by Larionov, she embarked on a series of Neo-Primitivist works, but this influence was soon superceded by Cubism, introduced to Russia by Shtushkin's famous collections and by exhibitions in Moscow. Unlike other Russian avant-garde painters who frequented Parisian *ateliers*, Rozanova worked only in her own country. In 1913 her husband, the poet A. Kruchenykh, introduced her to Malevich, whose friend and loyal disciple she remained until the end of her life. At this time she began a series of Cubo-Futurist paintings in which she followed Malevich's example, combining fragmented figurative elements with painted letters of the alphabet. This creative period, close to Kruchenykh's *zaum* and Malevich's "alogism", reached its peak with the appearance of "book-objects": *A Duck's Nest of Bad Words* (1913) and *Te li le* (1914), two collections of "transmental" poetry by her husband. She designed both the illustrations and the text, "transforming the verse into an original chrono-poetry analogous to chrono-music". She contributed to all the important avant-garde exhibitions, in particular those of the Union of Youth, "Tramway V" and "0-10" in St. Petersburg, and "Magasin" in Moscow, where she settled in 1915.

Following Malevich and Puni, she joined the Suprematist movement. After the Revolution, Rozanova was one of the leading organizers of the National Free Workshops, in which artists and craftsmen combined their efforts to transform the everyday environment according to revolutionary artistic principles. (SZ)

Rumorarmonio

The "rumorarmonio" (*rumore* = noise) was a musical instrument invented by Luigi Russolo, who constructed four models between 1922 and 1924 and patented the idea in Germany, France, and Italy.

It was a kind of large piano capable of producing different timbres through the simple movement of a lever, as in the harmonium. Russolo used the basic timbres of the prior "intonarumori", widening their extension and dynamic range and making the intonation more precise, thus providing new effects. This instrument provided the background effects for Prampolini's piece, *Santa velocità* (*Holy Speed*), produced in Paris in 1927, as well as the sound effects for several scientific films by Painlevé. Russolo gave concerts at the Centre International de la Musique and the Galerie 23, playing music written by his brother Antonio Russolo and by Casavola.

The example which existed in Paris was destroyed during a fire; no other models have been found and no recording exists, but there are some photographs. (FMa)

Russell, Morgan

(New York, 1886 - Broomall, 1953) American painter

Morgan Russell saw the Futurists' exhibition at the Bernheim-Jeune Gallery in Paris in February 1912 and was inspired to create his own art movement as a means of publicizing his new work and capturing the attention of a group of followers. He collected and carefully saved a large group of futurist manifestos. An expatriate American, Russell had attended Matisse's classes and become friendly with Leo Stein with whom he had shared his enthusiasm for the work of Cézanne. Russell sought to combine abstract shape and colour to achieve a spiritual exaltation equivalent to that produced by music with which he experimented. As a basis for his abstractions, he also utilized forms based on great figurative art, particularly the sculpture of Michelangelo. Together with Stanton Macdonald-Wright, Russell insisted that Synchromism stressed an artistic principle rather than a school of painting. (GL)

Russolo, Luigi

(Portogruaro, 1885 - Cerro di Laveno, 1947) Italian painter and composer

Luigi Russolo was born into a musical family: his father Domenico was the cathedral organist of Portogruaro and director of the Schola Cantorum of Latisana, and his elder brothers Giovanni and Antonio both earned diplomas from the Conservatorio "Giuseppe Verdi" of Milan, in violin and organ and in piano and organ respectively.

Luigi, after a brief interest in music, turned to painting and engraving. In 1909 he participated in the annual "Black and White" exhibition at the Famiglia Artistica di Milano with a group of etchings which showed Symbolist influence. On this occasion he began a deep friendship with Boccioni; Russolo's successive works display the strong influence of Boccioni's graphic works, characterized by maternal themes and suburban industrial landscapes.

In February 1910, together with Boccioni, Bonzagni, Camona, Carrà, Erba, Martelli

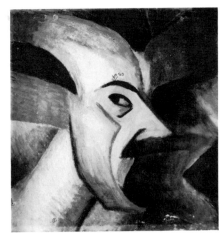

L. Russolo, Self-portrait, *1912, F. Borsani Collection*

U. Boccioni, Portrait of Russolo

Russolo in front of his second "rumorarmonio", 1928

and Romani, he met Marinetti and joined the Futurist movement. He signed the manifesto of Futurist painters (11 February) and the group's Technical manifesto (11 April), and became a militant Futurist, participating in all the Futurist *soirées* and exhibitions both in Italy and abroad. Among his paintings of this period are: *Self-portrait with Skulls* (1909), *Perfume* (1910), *Suburb-Work* (1910), *Hair* (1910), *Lightning* (1910), *The Revolt* (1911), *The Music* (1911), *Memories of a Night* (1912), *Houses + Light + Sky* (1913), *Plastic Synthesis of the Actions of a Woman* (1913), *The Solidity of Fog* (1913), *Dynamic Volumes* (1913), *Dynamism of a Car* (1913), *Futurist Self-portrait* (1913), and *Impressions of Bombardment, Shrapnels and Grenades* (1916). Those which are now lost include: *Nietzsche* (1910), *Train Speeding in the Night* (1910), *Dying Man* (1911), *One, Three Heads* (1912), *Lines, Forces of a Thunderbolt* (1913), and *Dynamic Self* (1913).

On 11 March 1913 he wrote the manifesto *The Art of Noises* (dedicated to Pratella), presenting his theories on the use of noise in a musical context. Shortly afterward he and Ugo Piatti made a series of "intonarumori", spectacular sound machines conceived to create and modify (in dynamic and pitch) specific types of noise, anticipating the experimentation which, after the Second World War, produced Schaeffer's concrete music and electronic music. From that moment on Russolo abandoned painting to dedicate himself completely to musical projects.

On 2 June 1913, during a Futurist evening at the Teatro Storchi in Modena, Russolo presented an "exploder"; on 11 August he presented 15 "intonarumori" to a group of international news correspondents at Marinetti's house in Milan. On 1 March 1914 he published an article entitled "Grafia enarmonica per gli intonarumori futuristi" (Enharmonic notation for Futurist Intonarumori) in the magazine *Lacerba*, introducing a new type of musical notation which is still in use among composers of electronic music.

On 21 April 1914 he made his debut at the Teatro Dal Verme of Milan, conducting the first "Gran concerto futurista" for 18 "intonarumori", subdivided into gurglers, cracklers, howlers, thunderers, exploders, hissers, buzzers and crumplers. Three of his compositions were played — *Risveglio di una città* (*The Awakening of a City*), *Si pranza sulla terrazza del Kursaal* (*Luncheon on the Kursaal Terrace*) and *Convegno di automobili e aeroplani* (*Convention of Automobiles and Aeroplanes*) — and were met with whistling, booing and flying vegetables. The evening deteriorated into violent scuffles between the audience and the Futurists, quelled only after police intervention.

Russolo repeated the concert at the Politeama in Genoa, and gave 12 performances in June at the Coliseum in London.

On this latter occasion he met Stravinsky. The outbreak of the First World War interrupted Russolo's international connections. He enlisted in the Lombard Volunteer Cyclist Battalion along with his Futurist friends and was promoted to lieutenant of the 5th Alpine Battalion "Brenta".

In September 1916 his book *L'arte dei rumori* (*The Art of Noises*) was published by

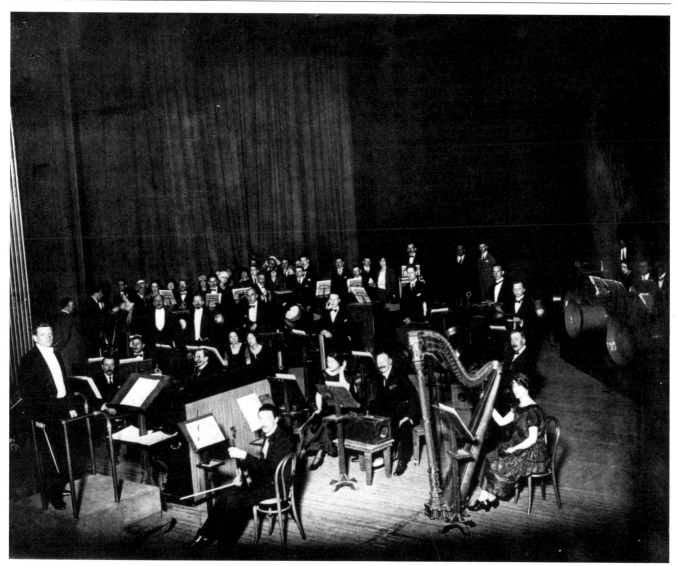

Orchestra and "intonarumori"

the Futurist editions Poesia. On 17 December 1917 he was seriously wounded at Malga Camerona and spent the next 18 months in various hospitals.

On 4 September 1920 Pratella's opera *L'aviatore Dro* (*The Pilot Dro*) was produced at the Teatro Rossini of Lugo; however, the "intonarumori" were substituted in the score by the sounds of a motorcycle and a factory siren.

In June of 1921 Russolo was in Paris for three concerts at the Théâtre des Champs-Elysées. Music composed by Fiorda and Russolo himself was played with 27 "intonarumori" inserted into the orchestra. The program was conducted by his brother Antonio who, while never adhering to Futurism, wrote many scores for the movement. At the first performance (partially disturbed by some trouble-making staged by a group of Dadaists led by Tzara) the audience included Stravinsky, an enthusiastic Ravel, Diaghilev, the Group of Six, Milhaud, Casella, Honegger, De Falla, Kahan, Claudel and Mondrian, who wrote a lengthy article on the "intonarumori" for the magazine *De Stijl*.

In 1922 Marinetti's play *Il tamburo di fuoco* (*The Firedrum*) was produced in Prague, with musical interludes by Pratella and background effects with the "intonarumori".

In 1923 Russolo began the construction of a series of "rumorarmoni", a type of harmonium which provided the player with the basic sonorities of the "intonarumori" in a single instrument. In 1925 Russolo patented the "enharmonic bow" and gave a concert using this invention in Milan, performing music by Casavola and his brother Antonio.

His refusal to join the Fascist party automatically excluded him from the lively Futurist activity of that period. For their music the Futurists turned to Pratella (who was however slowly moving away from the movement, preferring to dedicate himself to the "Canterini Romagnoli" and the study of folk music), Casavola and Mix, the new rising star.

The sudden premature death of Mix gave Prampolini the opportunity to call back Russolo and his new instruments.

The film critic Deslaw has noted the unfortunate loss of three Futurist films made in this period: *Futuristi a Parigi* (*Futurists in Paris*, for which Russolo composed the music and in which he appeared together with Marinetti), *La marche des machines* (*The March of the Machines*, again with music by Russolo), and *Montparnasse* (featuring Russolo, Marinetti and Prampolini).

The advent of sound in film rendered the use of Russolo's instruments obsolete, causing him to abandon music in disillusionment. He patented a single-octave model of his "enharmonic piano"; this model is the only surviving example of his original constructions.

On 28 December 1929 Russolo gave his last public concert, presented by E. Varèse, during the inauguration of an exhibition of Futurist painters at the Galerie 23 in Paris. In this period he encountered an Italian who cultivated the occult sciences and became interested in these and in Eastern philosophy. (FMa)

Score of A City Awakening, *1914*

L. Russolo, The Art of Noises, *1916*

The Art of Noises
(Futurist manifesto, Milan, 11 March 1913)

Dear Balilla Pratella, great Futurist composer,

In Rome, in the Costanzi Theatre, packed to capacity, while I was listening to the orchestral performance of your overwhelming *Futurist music*, with my Futurist friends, Marinetti, Boccioni, Carrà, Balla, Soffici, Papini and Cavacchioli, a new art came into my mind which only you can create: the Art of Noises, the logical consequence of your splendid innovations.

Ancient life was all silence. In the 19th century, with the invention of machines, Noise was born. Today, Noise triumphs and reigns supreme over our sensibility. For many centuries life went on in silence, or at most in muted tones. The loudest noises which broke this silence were neither intense nor prolonged nor varied. Excepting rare earthquakes, hurricanes, storms, avalanches and waterfalls, nature is silent.

Amidst this dearth of *noises*, the first *sounds* that man drew from a pierced reed or taut string were regarded with amazement as something new and marvellous. Primitive races attributed *sound* to the gods; it was considered sacred and reserved for priests, who used it to make their rites more mysterious.

And so the concept arose of sound as a thing in itself, distinct and independent from life, and the result was music, a fantastic world, inviolable and sacred, superimposed on the real one. It is easy to understand how such a concept would inevitably hinder the progress of music in comparison with the other arts. The Greeks themselves, with their musical theory, calculated mathematically by Pythagoras and allowing only a few consonant intervals, greatly limited the field of music by cutting out harmony, which was unknown to them.

The Middle Ages developed and modified the Greek tetrachordal system, and with Gregorian chant and popular songs enriched the art of music, but continued to consider sound *in its development in time*. This restricted notion lasted many centuries, and can still be found in the Flemish contrapuntalists' most complicated polyphonies. The *chord* did not exist. The development of the various parts was not subordinated to the chord that together they could produce; the conception of the parts was horizontal, not vertical. The desire, search and liking for a simultaneous union of different sounds, that is for the chord (complex sound), came gradually, in a transition from the consonant perfect chord with a few fleeting dissonances, to the complicated and persistent dissonances that characterize contemporary music.

First the art of music sought and achieved purity, limpidity and sweetness of sound. Then different sounds were amalgamated, taking care, however, to caress the ear with gentle harmonies. Today music is becoming continually more complicated and strives to amalgamate the most dissonant, strange and harsh sounds. We are coming ever closer to *noise-sound*.

This musical evolution runs parallel to the increase of machines, which collaborate with man in every sphere. Not only in the roaring atmosphere of great cities, but in the countryside too, which until yesterday was

normally silent, the machine today has created such a variety of competing noises that pure sound, so exiguous and monotonous, no longer arouses any emotion.

To excite and exalt our feelings, music developed towards complex polyphony and maximum variety, seeking the most complicated sequences of dissonant chords and somehow preparing the creation of *musical noise*. This evolution towards "noise-sound" was not possible before now. The ear of an 18th century man could never have endured the discordant intensity of certain chords produced by our orchestras (whose members have trebled in number since then). To our ears however they sound pleasant, since our hearing has already been educated by modern life, so filled with different noises. But our ears are not satisfied with this, and demand richer acoustic emotions.

On the other hand, musical sound is too limited in its qualitative variety of tones. The most complex orchestras basically have only four or five types of instrument, varying in timbre: string instruments, wind instruments in metal or wood, and percussion instruments. Modern music goes round in this small circle, struggling in vain to create new ranges of tones.

This limited circle of pure sounds must be broken, and the infinite variety of "noise-sound" conquered.

Besides, nobody will deny that all [musical] sound creates a tangle of familiar, outworn sensations which predispose the listener to boredom in spite of all the efforts of the innovatory musicians. We Futurists have deeply loved and enjoyed the harmonies of the great masters. For many years Beethoven and Wagner shook our nerves and hearts. Now we are satiated and *we find far more enjoyment in mentally combining the noises of trams, backfiring motors, carriages and bawling crowds than in re-hearing, for example, the "Eroica" or the "Pastoral".*

We cannot see that enormous display of power represented by the modern orchestra without feeling profound disappointment at the feeble acoustic results.

Is anything more ridiculous than the sight of twenty men furiously bent on redoubling the mewing of a violin? All this will naturally make music-lovers scream, and will perhaps stir the sleepy atmosphere of concert halls. Let us now, as Futurists, enter one of these hospitals for anaemic sounds. There: the first bar brings the boredom of familiarity to your ear and anticipates the boredom of the bar to follow. From bar to bar we can taste two or three varieties of genuine boredom, waiting for the extraordinary sensation that never comes.

Meanwhile a disgusting mixture is created by the monotonous sensations and the idiotic religious emotion of listeners buddhistically drunk with repeating for the *n*th time their more or less snobbish and second-hand ecstasy.

Let's go! We should leave before we are overcome by our desire to create a new musical reality by slapping some faces soundly and discarding violins, pianos, double-basses and plaintive organs. Let's go!

It is impossible to object that noise is always loud and disagreeable to the ear. It is hardly necessary to enumerate all the slight and delicate noises that give us pleasant sensations.

To understand the amazing variety of noises, we need only recall the rumble of thunder, the whistle of the wind, the roar of a waterfall, the gurgling of a brook, the rustling of leaves, the trot of a horse fading into the distance, the lurching of a cart on a paved road, and the deep, solemn, white breathing of a nocturnal city; all the noises made by wild and domestic animals, and all the noises than can be made by the mouth of man without speaking or singing.

If we go through a great modern capital with our ears more alert than our eyes, we can delight in distinguishing the murmur of water, air and gas in metal pipes, the mutter of motors, breathing and pulsing like animals, the throbbing of valves, the thudding of pistons, the screeching of mechanical saws, the jolting of a tram on its rails, the cracking of whips, the flapping of curtains and flags. We can enjoy orchestrating in our minds the crashing of metal shop blinds, the slamming of doors, the muttering and shuffling of crowds, the variety of din from railway stations, iron foundries, spinning mills, printing works, electric power stations and underground railways.

Nor must we forget the brand-new noises of modern war.

The poet Marinetti, in a letter from the Bulgarian trenches of Adrianople, recently described in admirable Futurist style the orchestra of a great battle:

"Every five seconds siege-cannons disembowel space with a chord *tam-tuum* 500 echoes mutiny to snap chop scatter it in space In the centre of those crushed tam-tuuumb 50 kilometres width leap explosions cuts punches quick firing guns Violence ferocity regularity this low bass stress the strange mad excited high notes of the battle Fury breathless ears eyes nostrils open! Alert! [...]"

We want to attune and regulate this tremendous variety of noises harmonically and rhythmically.

To attune noises does not mean to detract from all their movements and vibrations which are irregular in rhythm and intensity, but rather to give gradation and tone to the strongest of these vibrations.

Noise in fact differs from sound only in that the vibrations which produce it are confused and irregular, both in rhythm and intensity.

Every noise has a tone, and sometimes also a harmony that predominates in the sum of its irregular vibrations.

Now, this dominating characteristic tone gives the practical possibility for attuning a noise, giving it not merely one tone, but a variety of tones, without losing the characteristic timbre which distinguishes it. Certain noises obtained by a rotating movement can give an entire ascending or descending chromatic scale if the speed of the movement is increased or decreased.

Every manifestation of our life is accompanied by noise. Noise, therefore, is familiar to our ear, and has the power to pull us into life itself. Sound is extraneous to life, always musical and a thing unto itself, an occasional but unnecessary element, and has become to our ears what an overfamiliar face is to our eyes. Noise, however, reaching us in a confused and irregular way from the irregular confusion of life, is never entirely complete, and promises innumerable surprises. We are therefore certain that by selecting, coordinating and commanding every noise we shall enrich mankind with a new and unexpected delight.

Although it is characteristic of noise to recall us brutally to real life, *the art of noise must not be limited to imitative reproduction.* It will achieve its greatest emotive power in the sheer acoustic enjoyment that the artist will create from combined noises.

Here are the *6 families of noises* of the Futurist orchestra which we will soon create mechanically:

1. Rumbles, Roars, Explosions, Crashes, Thuds, Booms.
2. Whistles, Hisses, Snorts.
3. Whispers, Murmurs, Mutters, Rumbles, Gurgles.
4. Creaks, Rustles, Buzzes, Crackles, Scrapes.
5. Noises obtained by percussion on metal, wood, skin, stone, terracotta etc.
6. Voices of animals and men: Shouts, Screams, Groans, Shrieks, Howls, Laughs, Wheezes, Sobs.

In this inventory we have included the most characteristic basic noises; the others are merely associations and combinations of these. *The rhythmic movements of a noise are infinite: just as with tone there is always a predominant rhythm*, but around this numerous other secondary rhythms can be felt.

Conclusions

1. Futurist musicians must continually enlarge and enrich the field of sounds. This corresponds to a need in our sensibility. In today's best composers we can note a tendency towards the most complicated dissonances. Moving further and further away from pure sound, they almost achieve *noise-sound*. This need and this tendency can only be satisfied by *adding and substituting noises for sounds.*

2. The limited variety of tones possessed by orchestral instruments today must be replaced by the infinite variety of tones of noises, reproduced with appropriate mechanisms.

3. The musician's sensibility, liberated from facile traditional rhythm, will be extended and renewed by the use of noises, since in every noise the most diverse rhythms are combined with the predominant one.

4. Since every noise contains a *predominant general tone* in its irregular vibrations, it will be easy to construct instruments which imitate them with a sufficiently wide variety of tones, semitones, and quarter-tones. This variety of tones will not affect the characteristic timbre of each noise, but will amplify only its texture or extension.

5. There are no great practical difficulties in constructing these instruments. Once the mechanical principle which produces the noise has been found, its tone can be changed by following the same general laws of acoustics. If the instrument has a rotating movement, for instance, we will increase or decrease the speed, whereas if it has not, the noise-producing parts will vary in size and tautness.

6. The new orchestra will achieve the most complex and novel sound emotions not by

using a succession of life-imitating noises, but by imaginative juxtapositions of these varied tones and rhythms. Therefore an instrument will have to allow for tone changes and a variable extension.

7. The variety of noises is infinite. Today, when we have perhaps a thousand different machines, we can distinguish a thousand different noises; tomorrow, as new machines multiply, we will be able to distinguish ten, twenty or *thirty thousand different noises, which we shall not simply imitate, but combine imaginatively.*

8. We therefore invite courageous young musicians to continually observe all noises, in order to understand the various rhythms of which they are composed, their principal and secondary tones. By comparing the various tones of noises with those of sounds, they will perceive how greatly the former exceed the latter. This will afford not only an understanding, but also a taste and passion for noises. After having acquired Futurist eyes our widened sensibilities will at last hear with Futurist ears. One day the motors and machines of our industrial cities will be deliberately attuned, and every factory transformed into an intoxicating orchestra of noises.

Dear Pratella, I submit these statements to your Futurist intelligence, inviting your discussion. I am not a musician, I have therefore no acoustical preferences, nor any works to defend. I am a Futurist painter investing an art I love with my determination to renew everything. And so, bolder than a professional musician could be, unconcerned by my apparent incompetence and convinced that daring possesses every right and can open every door, I have been able to imagine the great renewal of music by means of the Art of Noises.

L. Russolo, painter

Two pages from Orpheu, *1915*

Sá-Carneiro, Mario de
(1890-1916) Portuguese writer

The brief literary career of Mario de Sá-Carneiro developed almost entirely in Paris. He was a friend of Fernando Pessoa with whom he exchanged a considerable correspondence from 1912 until his death. With Pessoa he founded the periodical *Orpheu*. His work was influenced by Decadent poetry, and later by Cubism and Futurism. After his suicide, his friends had four of his last poems published in *Portugal Futurista*. (SF)

Saint-Point, Valentine de
pseudonym of Desglans de Cessiat-Vercell, Anne-Jeanne-Valentine-Marianne
(Lyons, 1875 - Cairo, 1953) French writer

The great grand-daughter of Lamartine, Valentine de Saint-Point studied painting under Mucha and published many books before she joined the Futurist movement. Her volumes of poetry include *Poèmes de la mer et du soleil* (*Poems of the Sea and Sun*, 1905), *Poèmes d'orgueil* (*Poems of Pride*, 1908), *La guerre* (*The War*, 1912) and *La soif et les mirages* (*Thirst and Mirages*, 1912). She also wrote a series of novels — the "Trilogy of Love and Death": *Un amour* (*A Love*, 1906), *Un incest* (*An Incest*, 1907), *Une mort* (*A Death*, 1911). As well as *Une femme et le désir* (*A Woman and Desire*, 1910) and *L'orbe pâle* (*The Pale Orb*, 1911) de Saint-Point wrote dramas dedicated to the "Woman's Theatre", including *Le déchu* (*The Fallen*, 1919), and essays, including *La femme dans la littérature italienne* (*The Woman in Italian Literature*, 1911).

The poetess of pride and desire, de Saint-Point was influenced by Nietzsche and Barrès, and from the will to power and the cult of the ego she elaborated a theory of woman linked to the myth of a self-aware and instinctive superwoman. These convictions form the basis of the *Manifesto of the Futurist Woman* (25 March 1912) and the *Futurist Manifesto of Lust* (11 January 1913), which were translated into several languages and aroused fiery controversy.

De Saint-Point publicly abandoned Futurism in January 1914. In the meantime she had become attached to Ricciotto Canudo, the inventor of "cerebrismo", and had created the *Métachorie*, an abstract *idéist* dance which the poetess herself presented on stage at the Théâtre des Champs-Elysées in Paris in 1913 and at the Metropolitan Opera House of New York in 1917, producing a pamphlet for the latter performance entitled *Poèmes, drames idéistes du premier festival de la Métachorie* (*Poems, Idéist Dramas of the First Festival of the Métachorie*).

During the Twenties she dreamed of establishing a centre in Corsica for intellectuals from all over the world, "Le Temple de l'Esprit". Attracted by esotericism, she moved instead to Egypt and was converted to Islam, adopting the name Raouhya Nour el Dine. She supported to the cause of Arab nationalism by launching a paper called *Le Phoenix*. (CS)

Salvat-Papasseit, Joan

(Barcelona, 1894 - Barcelona, 1924) Catalan poet

Joan Salvat came of a poor family and was largely self-taught. The Futurist doctrine, which he theorized in poems and manifestos, shaped his formal and ideological rebellion. In 1916 he met Torres-García and Barradas, who introduced him to Futurism. Salvat edited several magazines with Futurist leanings, to which his artist friends contributed: *Un Enemic del Poble* (1917-19), *Arc Voltaic* (1918) and *Proa* (1921). With Torres-García, Salvat had a fruitful working partnership: in 1919 he published his friend's books on avant-garde theory, while Torres illustrated Salvat's first book of poetry *Poems in Hertzian Waves*, which has a Marinettian flavour. The first poem in the book, "Lletra d'Itàlia" (Letter from Italy), a mixture of Futurist mythology and the confessions of an Italophile, haphazardly mentions Giovanni Papini, the magazines *Noi* and *Valori Plastici*, and the painters Carrà and Soffici. In 1920 Salvat began a process of poetic purging and the Futurist elements in his work were gradually replaced by populist and Symbolist forms. The poems collected in *Óssa menor*, published posthumously in 1925, mark a break with the avant-garde. Salvat's most important theoretical writings contain both Modernist and Futurist elements, which at times coincide. In his *Contra els poetes amb minúscula - Primer manifesto futurista català* (*First Catalan Futurist Manifesto*, July 1920) he emphasizes the importance of the struggle for cultural freedom from the tradition-bound *noucentistes*, and quotes Marinetti.

Salvat played an important role in publicizing Futurist theories and the work of the Catalan avant-garde, thanks to his contacts with representatives of the European movements: Prampolini, Theo van Doesburg, Cesare Giardini, Marinetti. His influence continued even after his early death, through his disciples Carles Salvador, Carles Sindreu, and finally Sebastià Sánchez-Juan, who published the *Segon manifest català futurista* (*Second Catalan Futurist Manifesto*) in 1922. (JAJ)

Sant'Elia, Antonio

(Como, 1888 - Quota 77, Monte Hermada, 1916) Italian architect

Antonio Sant'Elia worked at the Technical Office of the City Council of Milan and studied architecture at the Brera Academy, where he met young vanguard painters such as Funi, Duvrelli, Romani, Erba, Carrà, Boccioni, Russolo. In 1912 he graduated in Bologna. In February-March 1914, some months before exhibiting with the "Para-Futurist" group Nuove Tendenze, he showed at the "First Exhibition of Architecture" in Milan some architectural drawings relating to his vision of what was obviously an industrial Milan in full development. In the review that appeared in *Vita d'Arte, Rassegna d'Arte Antica e Moderna*, Giulio U. Arata noted that the young Sant'Elia had clearly been influenced by the Viennese Secession school of Otto Wagner. He also suggested a distinction between Sant'Elia's studies for the Monza Cemetery (in collaboration with the architect Italo Paternoster, 1912) and the drawings directly related to the theme of the "city of the future", where "he suggests in a few lines how to build a viaduct, a church, an electrical power station, a building for turbines", "indicating that Sant'Elia was working at two different levels. Today these levels need to be considered together in order to understand the meaning and the programmatic clarity of his Futurist proposals. The first level was the strictly professional one, with plans and actual buildings, and started in 1911 with the project for a "small modern house" (*villino*) for the Milanino competition and continued with the Monza assignment (1912), the building of Villa Elisi in San Maurizio, Brunate (1912-13), the Caprotti tomb in Monza cemetery (1913), the competition for the Cassa di Risparmio building in Verona (with the architect Arrigo Cantoni, 1913-14), the project for the Società dei Commessi in Como (1913-14), the tomb built for his father Luigi in Como cemetery (1914), the plans for decorating the facade and for the gates of the schools in via Brambilla, for building the Quartiere Viganò San Giuseppe school, and the exterior decoration of a house in via Cesare Cantù, Como (1914-15). This was a very realistic, professionally correct, level which followed the current model of Secession culture and Lombard Art Nouveau. The other level, which made Sant'Elia an historical figure, was already evident in the drawings dated 1912 and 1913, but asserted itself fully in his images of the "new city". In this side of his work Sant'Elia moved in total imaginative freedom, using his professional and cultural experience to create a new Futurist architectural and urban vision.

At this level he left behind all the influences of the Viennese Secession and Lombard Art Nouveau (Giuseppe Sommaruga, Gaetano Moretti, etc.), as is evident from the most sensational "new city" drawings (shown at the Nuove Tendenze exhibition in Milan during the spring of 1914) which embodied absolutely new structural ideas and a decidedly prophetic vision of the modern city. When, a little later, Sant'Elia adhered to the Futurist movement, these drawings were published in *Lacerba* (10 August 1914) as a support for his *Manifesto of Futurist Architecture*, dated 11 July.

It is important to notice that these two moments are not successive, that is to say, there is no "before" of professional training and an "after" of free expression. They proceed side by side as two expressions consciously chosen to fit a particular socio-cultural context.

The futuristic urban vision of Sant'Elia's "new city" drawings, presented at the Futurist group exhibition (the catalogue contained the first draft of his manifesto; "new city" would become "Futurist city" in the final version) was a calculated imaginative break with his conservative professional "routine" embodying the Secession trend of the time. This "routine" activity would not be substituted by his futuristic vision, but would continue alongside it for years, on a different operative level. It was a conscious choice dictated not only by the need to make his utopian vision stand out as a challenge both nationally and internationally, but also by the impracticability of his proposals, which could never have been built, especially in the social and economic context of Italy. Thus it has to be understood that these futuristic drawings were created only as a utopia. Sant'Elia, given the possibility, would never have tried to build them directly, but would certainly have revised them in order to adapt his vision to real requirements of space and function. He designed not to propose definite projects, but to assert a new architectonical idea where all metropolitan structures, from the multiple horizontal traffic lines, to the vertical development through different levels, were an organic whole. It was the vision of a socialized city for the masses, befitting the ideas of a man who in 1914 had shown his political choice by presenting himself as a candidate of the Socialist Party in Como, where he was elected city councillor.

This does not mean that Sant'Elia lacked the capacity to actually work out in concrete forms his imaginative futuristic proposals, nor that the utopian character of his drawings prevented any actual execution; it simply means that, because of the contemporary social and cultural situation of Italy and Europe, his designs could only be presented as a new vision of a coming urban architecture, as mere ideas, in short as a utopia. One has to realize that Sant'Elia was not presenting visionary and fantastic images — even though his drawings could be considered a Modernist, science-fiction milestone in the tradition of "fantastic architecture" — but was controversially proposing a break with the past. Supported by his connection with Marinetti and the Futurists, he proposed new, conscious answers, new ideas — although necessarily only on paper — concerning the role of architecture and its relationship with the urban structures of a city, built on a gigantic industrial scale.

So the surviving drawings give us not the minimum of Sant'Elia's Futuristic architectural hypotheses, but all he could imagine, all that could be possible and necessary at the time, in a word the maximum he could propose to European culture concerning the new functions architecture could have in a metropolitan dimension. They are the figurative realization of a utopian programme:

ideas for interconnected urban structures, suggestions for possible projects, theories created by a very original and fascinating imagination, that enchanted first the European avant-garde and then architectural historians outside Europe as well. Through a morphological structural analysis of Sant'Elia's drawings, one can recognize his imaginative originality in comparison with his own cultural background and his influence on the European architectural avant-garde of the second two decades of the 20th century. The theses put forward in his manifesto dated 1914 remain valid: the connection with the new industrial technologies, the transience of architectural production and urban planning, "mechanical" inspiration, the stark plasticism of the architectural masses dynamically moved by oblique and elliptic lines, the spirituality expressed by architecture as an audacious harmony between man and the environment. In Sant'Elia's activity different periods can be distinguished. The first, from 1910 to 1912, is mainly shaped by the Secession climate of Wagner and his school. From 1912 to 1915 there followed a period of intense professional activity, with plans and realizations, which ended with his military service. Within this second period, from 1913 to 1914, falls the moment when he elaborated his futuristic vision of the "new city" with all its interconnected structures. Then there is a final moment, from 1915 to 1916, during which Sant'Elia's imagination again seemed to reflect some Secessionist influences.

During his first period, when Sant'Elia was influenced by Wagner's school, he was probably particularly interested in certain solutions and in the designs of Josef Hoffmann and his students. But in this search for affinities and possible sources we touch only the outer aspect of Sant'Elia's search, not his real concerns.

His true interests were closely related to Wagner's theories, and precisely to the consciousness (which in Sant'Elia was to become clear and decisive) that architecture is indissolubly bound up with the city, that the new dimension is not the building itself, but the urban structure; "the acknowledgment that the only starting point is modern life", the reality of new techniques and new materials.

The distinctive feature of Sant'Elia's "new city" in 1914 was not the power plant, nor the factory, but the skyscraper.

It was in fact an unusual subject, not only in Italian Modernism, but also in the European movement or in Wagner's school.

It was a theme which pointed straight at America. The skyscraper was mentioned by Boccioni in his *Manifesto of Futurist Architecture*, written at the beginning of 1914 but published only later, and was recurrent in the Futurist mechanical and urban "poetics".

It had also been popularized by illustrations, which Sant'Elia must have seen.

Breaking away from the European vision of town-planning, from the Vienna of Wagner, from the London recognized, during the first decade of the century, as the best example of a new, decentralized planning, Sant'Elia found his imaginative utopian instrument for a new urban vision in the vertical solution, and projected himself

Sant'Elia at the front

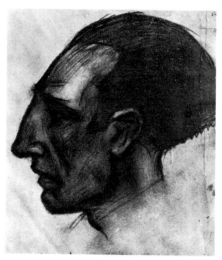

Sant'Elia by Dudreville

The Futurists at the front: Marinetti, Sant'Elia, Russolo, Boccioni, Sironi

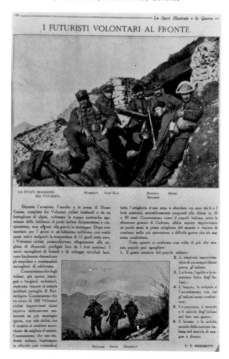

into this myth, represented in all its primitive vitality by industrial North America. But while he accepted the colossal scale of the American metropolis, he was against the skyscraper as an isolated building which did not organically harmonize with a town-planning structure. The harmony of the single parts with a whole plan was for Sant'Elia an essential modern requirement. Such insights give him a precise historical position in the architectural and urban debate that took place in Europe between 1910 and 1920, next to Le Corbusier, Hilberseimer, and others. His was the prominent position of a mediator who influenced the theories and projects of the European architectural avant-garde (see, for example, the pages of *De Stijl* and the imaginative projects of Russian Constructivism).

Sant'Elia was the best, if not the only exponent of Futurist architecture. His suggestions were the main and fundamental ones, even though they were restricted to one area — Milan, with Chiattone and in opposition to the plasticism of the Roman group of Balla, Prampolini, Depero and Marchi — and to a limited period, around 1915. For the Futurist architectural movement, which with different expressions lasted until the Thirties, Sant'Elia's drawings of metropolitan architecture were an essential ideal landmark and a spur to discussion (from Marchi to Sartoris, from Prampolini to Diulgheroff, from Fiorini to Crali, from Poggi to De Giorgio and Rancati). (ECr)

Sartoris, Alberto
(Turin, 1901) Italian architect

Trained as an architect in Geneva, Paris and Turin, Alberto Sartoris joined the Futurist movement at the beginning of the Twenties. In 1928 he participated in the First Exhibition of Futurist Architecture in Turin, and as a member of MIAR, in the First Italian Exhibition of Rational Architecture (1928) and the Second Exhibition of Rational Architecture (1931), both held in Rome.

With Fillia he co-edited the magazine *La Città Futurista* (Turin, 1929). He was active as a writer and in 1930 published a monography on Antonio Sant'Elia. His contribution to Futurism was characterized by a strong "rationalist" tendency linked to international experimentation, thanks to his contacts with the major avant-garde representatives of European Concretism. In 1941 he was a member of the abstract Futurist group founded by Marinetti and promoted by Franco Ciliberti. He also co-signed the manifesto of the Gruppo Futurista Primordiale Antonio Sant'Elia, founded by Marinetti and Ciliberti. (ECr)

Saunders, Helen

(London, 1885 - London, 1963) British artist

Helen Saunders studied art at the Slade School of Fine Art (1906-07) and at the Central School, London. Soon afterwards she became interested in Post-Impressionism, Cubism and Futurism. A meeting with Wyndham Lewis early in 1915 led her to join the Rebel Art Centre, and she signed the Vorticist manifesto in *Blast* (July 1914) as "H. Sanders". She contributed to the 1915 "Vorticist Exhibition" at the Doré Galleries, London, as a member of the movement. In July 1915 she published a poem and several monochrome illustrations in *Blast No. 2*.

Saunders was very closely associated with Lewis at this period, and she collaborated with him on the decoration of the "Vorticist Room" at the Restaurant de la Tour Eiffel in London (1915-16). Surviving watercolours are related in style to Lewis's Vorticist work, but they have a bold, unpredictable feeling for colour which belongs to Saunders alone.

During the First World War she worked for the Records Office in London, but also participated in the 1917 "Vorticist Exhibition" in New York. After the war she developed a more representational style, at times similar to the work of her friend Jessica Dismorr. (RC)

Scandal

The Futurists early discovered that scandals and insults could be used to make themselves known and help spread their ideas. They attacked revered cities like Venice and Rome (Marinetti, Papini), institutions ("Let's bombard the academies", cried Prampolini) or famous personalities like D'Annunzio and Benedetto Croce (Marinetti, Papini). They created noisy, insulting public occasions and were happy to come to blows if the "delight of being booed" was not enough. They provoked scandal without fearing the legal consequences.

All the other related movements throughout the world followed the Futurists' example: Delmarle consigned Montmartre to the demolisher's pickaxe; Apollinaire shouted *merde*, Maples Arce launched a manifesto whose motto was "Long Live Turkey Stew"; Wyndham Lewis, Pound and Gaudier-Brzeska displayed caustic tongues in public. It was probably the Russian Futurists who created the liveliest scandals by "slapping the face of public taste", as they put it: Larionov and Goncharova painted their faces, Maiakovsky paraded in a bright yellow shirt, Kruchenykh doused the public with tea. Several movements which came in the wake of Futurism, particularly Dada, would also use the power of scandal and provocation to shake the public out of its lethargy. (SF)

Comoedia, 1910, "Mafarka the Futurist before the Judge"

Schamberg, Morton L.

(Philadelphia, 1881 - Philadelphia, 1918) American painter

After studying architecture and painting, Morton Schamberg travelled to Europe where he met and was influenced by the Fauves and the Cubists. In 1913-14 his painting was close to Synchromism and Orphism. Then in W.C. Arensberg's circle he met Picabia and Duchamp, whose example stimulated him to move in a new direction: after 1916 his interest was all for machines and mechanics. The result is a spare art with sharp angles, recalling simultaneously Dada, Futurism and Abstraction. (SF)

Scheerbart, Paul

(Danzig, 1863 - 1915) German writer and architect

A brilliant eclectic, Paul Scheerbart published several fantastic novels combining utopia with humour and poetry, which recall his contemporary Alfred Jarry. Scheerbart illustrated his own novels and theoretical works punctuating them with abstract marks, for example *Rakkox der Billionär* (*Rakkox the Billionaire*, 1900) and *Revolutionäre Theater-Bibliothek* (*Revolutionary Theatre-Library*). His novel *Ich liebe dich, Ein Eisenbahn Roman* (*I Love You, a Railway Novel*) of 1897, includes the first German poem to be composed in a completely invented language. Scheerbart was equally important as a theorist of architecture: "We live in closed rooms," he wrote, "which constitute the setting of our culture... We cannot raise our culture except by introducing a glass architecture which will allow the light of the sun, the moon and the stars to penetrate into the rooms, not through a few windows but through the greatest possible number of walls made of glass, using stained glass as well. Through the creation of this new environment, a new culture will come." The architect Bruno Taut hailed him as a master and wrote the preface to his book *Glasarchitektur* (1914). The first Expressionists, and particularly the Sturm group, greatly admired him and considered him their precursor. (SF)

Scheiber, Hugo

(Budapest, 1873 - Budapest, 1950) Hungarian painter

After completing his studies at the School of Decorative Arts in Budapest, Scheiber became acquainted with the artist who later made up the Ma group; he also showed an interest in German Expressionism, a school which was to exert enormous influence over Central European painting. In 1915 he came into contact with Marinetti and joined the Futurist movement, which had a lasting influence on his work. In 1920 he emigrated to Vienna and then to Berlin where he frequented Der Sturm. During the Twenties many of his works were reproduced in the magazine *Der Sturm* and were exhibited throughout Europe. From the Thirties on, he was gradually forgotten. (SF)

Schmalzigaug, Jules

(Antwerp, 1882 - Netherlands, 1917) Belgian painter

Schmalzigaug studied in Antwerp, Karlsruhe, Brussels and Paris. In the course of his travels during 1905-06, while still a student, he discovered Italy and Venice, to which it became his dream to return. He was delighted by the play of light and "the magical effect which the brightness of the air here alone is capable of producing on the silvery walls of the marble palaces, when a ray of morning light plays on the cupolas of the church and makes them sparkle. But while the building is cloaked in a violet light, with golden mosaics that rise like amber towers, when the skies are overcast, even the Grand Canal is flecked with silver, and the houses, though less of a contrast, develop a clearer framework, their delicate architecture picked out by soft shadows...". So Schmalzigaug wrote in 1905, but it was another seven years before he realized his dream of living in Venice. In the interim two things happened that permanently influenced his work, which was then oscillating between Neo-Impressionism and Expressionism. In 1911 he saw the Cubists at the Salon des Indépendants, and he also became enthusiastic about the exhibition at the Salon de l'Aéronautique. And in 1912 he discovered the Futurists at the Bernheim-Jeune Gallery. He wrote to a friend: "A short while before (April 1911) I saw my first Cubist works, and I have already told you what an impression they made on me. These Futurist works brought my excitement to a head. The picture I was showing at the Salon de la Société Nationale — a view of the fish-market in Bruges — profoundly disgusted me... I could divine new merits in Cubist and Futurist works, but I did not yet understand them. I was reluctant to imitate their outward characteristics alone. I wanted to find my own centre of gravity even in this new direction." Even more than in Cubism he was interested in the experiments of the Futurists in the fields of motion and light, and was especially influenced by "a painter in the Futurist group, Severini, who has brought something really new to art: the dynamism of motion in painting".

Schmalzigaug's first works produced in Venice are still a legacy of the Fauves. Only in 1913, in paintings such as *Piazza San Marco - Gold + Flags + Parasols*, did he free himself from his concern with figurative art. Form and light here mingle in a whirlwind of gaiety. Here at last is the true Futurist Schmalzigaug, intent on every kind of Futurist concern: automobiles, motor-cycles, speed and electricity, dance and the cabaret. Perhaps his most unique contribution to Futurist art was the fact that he was the Futurist "bard" of Venice, its fireworks, churches, squares and canals. Whether in painting or drawing, *La Salute* or the *Caffè Florian*, all receive the same enthusiastic treatment, and break up into facets pulsing with life, or arise in flaming, luminous spirals over the buildings and the water.

For this reason the Belgian artist was taken up by his Italian colleagues. He was especially close to Balla and Prampolini, to whom he was linked by his abstract studies in iridescence and motion (*Speed*, 1914).

J. Schmalzigaug, Movement, *1914, watercolour and pencil, Van de Velde Collection*

F. Kupka, illustration for Pyecraft *by H.G. Wells, 1905*

Along with those artists, he took part that year in the International Futurist Exhibition at the Sprovieri Gallery in Rome. At the moment when his art had reached complete maturity the outbreak of war forced him to leave Venice for Belgium. Here the work of Joostens, Peeters, Servranckx and Vantongerloo was only in its first infancy. This enforced isolation prostrated Schmalzigaug, who was already prone to depression. Settling down in The Hague with his family, he found himself isolated.

However, he continued his reflections on Simultaneism and the studies in colour and panchromatics stemming from his Futurist experiments. His work, whether on canvas or paper, branched out in various directions. While not forsaking Futurism (*Passage La Haye*, 1915-17), works such as *Delbeke* (1917) tend towards Cubism, and *Still-Life with Elephant* towards Expressionism, while many of his pastels show a movement towards lyrical abstraction.

Either as a result of physical and psychological exhaustion, or from a feeling of failure, he put an end to his life. Apart from a handful of obituaries printed just after his death, and a few notices and reproductions published in Italy (mostly in *Noi*, thanks to the faithful friendship of Prampolini), his work was ignored until the Eighties. (SF)

Science

The Futurists rejected the objectivity and impartiality of science, which they felt was a traditional concept contrary to the fantastic and liberating precognition of things to come. Their evaluation of science was therefore negative — they considered it professorial and anti-inventive — so much so that in their manifesto *Futurist Science*, of 15 June 1916, the field was rejected with "disgust". The manifesto called for "an audaciously exploratory Futurist science, sensitive, vibrant, influenced by far-off intuitions, fragmentary, contradictory, happy to discover today a truth that destroys the truth of yesterday, completely afloat in the unknown", which is to say, a science that presumed paranormal manifestations, in which the absolute value of phenomena could be adapted to a primitive and magical vision. Nevertheless, the hypothesis of scientific knowledge with a specific function was not based solely on creative intuition — the Futurists were familiar with experiments in electrodynamic transmission and with Einstein's theories of relativity. They had also taken an interest in complex fields of energy in terms of variations in physical flow that could determine velocity and laws of motion. Most importantly, they had become acquainted with Roentgen's studies of the energy of light and with Marey's analyses of motion, the basis of photodynamic photography and of the optical-volumetric decomposition of space and time in painting and sculpture. (GC)

F. Kiesler, stage-set for R.U.R.
by K. Čapek

Science Fiction

Futurist art is full of subjects that seem to belong to science fiction. In Khlebnikov's poem "The Crane" the world is destroyed by a giant metal bird, while in Marinetti's novel *Mafarka the Futurist* (1910), the character called Gazourmah is a mechanical being that can fly. Although the word "robot" occurs first in Karel Čapek's play *R.U.R.* (1920), it is in fact a robot that we see in Depero's painting *The Automaton* as early as 1916. All Maiakovsky's plays are set in other and future worlds, while Protazanov and Exter's film *Aelita* is a kind of space-opera set on Mars.

This was all preceded by a "pre-history" in literature, which without going too far back we can trace to Jules Verne and his novels of "scientific wonder". Even closer to modern science fiction are Rosny (with *Les Xipéhuz*, 1887), one of the authors most often quoted by Marinetti, and Wells, whose *Time Machine* (1895) and *War of the Worlds* (1898) were admired by the Russian Futurists and the Mexican Stridentists. Unlike the Futurists, these authors have a basically pessimistic philosophy. The future war described by Marinetti in *La guerra elettrica* (*Electric War*) is an optimistic complement to Wells. The weird machines found in Paul Scheerbart, Alfred Jarry or Apollinaire certainly owe a great deal to Wells. Just before the Futurist Manifesto was published the genre enjoyed a considerable vogue. In 1908 the *Mercure de France* published a novel by Maurice Renard, *Le Docteur Lerne*, which Apollinaire judged to be "superior to the fantasies of the Englishman Wells, to whom it is dedicated". In it, a mad scientist manages to instal a human brain in an automobile. Was Marinetti perhaps thinking of this when, some time later, he wrote: "We must prepare for the impending and inevitable identification of man with machine?"

Thereafter Futurism enriched science fiction not only with new themes, but also by suggesting fresh environments. To give only one example, the fantastic architecture of science fiction films, from *Things to Come* to *2001, Space Odyssey*, might well not have achieved such bold effects without the work of people like Sant'Elia or the Russian Utopian architects. (SF)

Settimelli, Emilio

(Florence, 1891 - Lipari, 1954) Italian writer and journalist

Emilio Settimelli directed various literary journals, including *Il Centauro*, and later became part of the group around *L'Italia Futurista*, which included Ginna, Corra, Mario Carli and Remo Chiti. In 1915, with Marinetti and Bruno Corra he published *Teatro sintetico futurista* (*Futurist Synthetic Theatre*), which contained his "syntheses" *Il superuomo* (*The Superman*), *La scienza e l'ignoto* (*Science and the Unknown*), *Il pranzo di Sempronio* (*Sempronius' Dinner*), *Grigio + rosso + violetto + arancione* (*Grey + Red + Violet + Orange*), *Verso la conquista* (*Towards the Conquest*), *Passatismo* (*Passéism*), etc. (some written with Corra). One of his most significant works is the prose poem "Mascherate futuriste" (*Futurist Masquerades*), which reveals his "boundless eagerness to embrace moments of lyric joy not only in art but in reality as well". His other works include: *Duchessa Pallore* (*Duchess Pallor*), *Strangolata dai suoi capelli* (*Strangled by Her Hair*), *Donne allo spiedo* (*Women on the Spit*), *Nuovo modo di amare* (*New Way of Loving*) and *Sassate* (*Throwing Stones*), a collection of iconoclastic portraits. In 1914, with Corra, he produced a manifesto on criticism entitled *Pesi misure e prezzi del genio artistico* (*Weights, Measures and Prices of Artistic Genius*).

In 1930 Settimelli and Mario Carli directed the newspaper *L'Impero* and its sequel *Oggi e Domani*; Marinetti maintained that *L'Impero* was the only political newspaper edited by poets and considered it "Futurist". Settimelli was a restless, deliberately contrary character: he was capable of alienating everyone, and was eventually exiled by the fascist regime. (MV)

Weights, Measures and Prices of Artistic Genius

(Futurist manifesto, 11 March 1914)

Criticism has never existed, and does not exist. The passéist pseudocriticism which has been nauseating us up to now has never been more than the self-abuse of the impotent, the peevish outbursts of failed artists, fatuous prattle, arrogant dogmatism in the name of non-existent authorities. We Futurists have always said that this amphibious, uterine and imbecile activity has no right to make judgments. Today sees the birth in Italy of the first real criticism, thanks to Futurism. But since the words critic and criticism have already been besmirched by the foul use that has been made of them, we Futurists are abolishing them, once and for all, and will use in their place the terms *measurements* and *measurer*.

Observation no. 1. Every human activity is a projection of nervous energy. This energy, which is one of physical constitution and of action, undergoes various transformations and assumes various aspects according to the material chosen to manifest it. A human being assumes greater or lesser importance according to the quantity of energy at his disposal, and according to his power and ability to modify his surroundings.

Observation no. 2. There is no essential difference between a human brain and a machine. It is mechanically more complicated, that is all. For example, a typewriter is a primitive organism governed by a logic imposed on it by its construction.

It reasons thus: if one key is pressed it must write in lower case; if the shift and another key are pressed, it follows that it must write in upper case; when the space-bar is pressed, it must advance; when the back-space is pressed, it must go back. For a typewriter to have its E pressed and to write an X would be nonsensical. A broken key is an attack of violent insanity.

A human brain is a much more complicated machine. The logical relationships which govern it are numerous. They are imposed on it by the environment in which it is formed. Reasoning is the habit of linking ideas in a particular way. It is useful because it coincides with the way in which the phenomena of our reality develop. But they coincide because our reasoning is drawn from the reality which surrounds us. If our world were different, we would reason differently: if chairs falling over usually caused deafness of the left ear in all cavalry officers, this relationship would be true for us. Thus, most notions are arranged in every brain in a definite pattern. For example, snow-white-cold-winter, fire-red-hot, dance-rhythm-happiness. Everyone is capable of associating blue and sky. While on the other hand there are pieces of knowledge between which it is difficult to establish a relationship, because they have never been associated together, because there are no obvious similarities between them.

Observation no. 3. Nervous energy, in the act of applying itself to a cerebral task, is faced with a combination of elements arranged in a particular order. Some united, close, like and similar, others distant, unconnected, extraneous, dissimilar. The energy acting on these particles of knowledge can only discover affinities and establish relationships between them by mixing and separating them and by forming combinations.

From this springs *Futurist measurement*, which is based on the following incontrovertible principles:

1. Beauty has nothing to do with art. *Discussing a painting or a poem, by starting with the emotion that it gives one, is like studying astronomy by choosing as one's point of departure the shape of one's navel.* Emotion is an accessory factor in a work of art. Whether it is there or not, varies from individual to individual and from moment to moment — it cannot establish an objective value. "Beautiful" or "ugly", "I like it" or "I don't like it", this is all subjective, gratuitous, uninteresting and unverifiable.

2. *The sole universal concept: value, determined by natural rarity.* For example, it is not true for everyone that the sea is beautiful, but all must recognize that a diamond has great value. Its value is determined by its rarity, which is not a matter of opinion.

3. In the intellectual field *the essential* (not casual) *rarity of a creation is in direct proportion to the quality or energy needed to produce it.*

4. The combination of elements (drawn from experience) more or less dissimilar is the necessary and sufficient raw material for any intellectual creation. The quantity of energy necessary to discover affinities and establish relationships between a given

number of elements is greater when the elements to be combined are more distant, more unlike each other, and when the relationships discovered are more complex and more numerous. That is: *the quantity of cerebral energy necessary to produce a work is directly proportional to the resistance which separates the elements before its action is felt and to the cohesion which unites them afterwards.*

5. *The Futurist measurement of a work of art means an exact scientific determination expressed in formulas of the quality of cerebral energy represented by the work itself, independently of the good, bad or non-existent impression which people may have of the work.*

All this brings about a completely Futurist conception of art, that is to say essentially modern, without preconceived ideas and brutal. This resolute surgery will complete the destruction of the traditionalist view of Art with a capital A. Here in the meantime are a few immediate consequences:

1. *Immediate disappearance of all intellectual sentimentality* (corresponding to an amorous sentimentality in the field of sensuality) *which forms around the word "inspiration".* Having demonstrated the puerility of the idea that a work of art should move us, it is more than justified to work lucidly, coldly, even with indifference and laughingly on a particular theme — e.g., given 43 nouns, 12 atmospheric adjectives, 9 verbs in the infinitive, 3 prepositions, 13 articles and 25 mathematical or musical signs, to create a masterpiece in words-in-freedom using only these.

2. Logical abolition of all kinds of illusion about one's own value, of vainglory and modesty, for which there will no longer be any reason, given the possibility of an exact and unchallengeable evaluation. Right to proclaim and affirm one's own superiority and one's genius. The Futurist measurer will be able to issue certificates of imbecility, mediocrity or genius to be appended to personal identity papers.

3. *Because all that matters is the quantity of energy manifested, the artist will be permitted all forms of eccentricity, lunacy or illogicality.*

4. For the same reason, the concept of art will have to be enormously widened in another direction too. There is no reason why every activity must of necessity be confined to one or other of those ridiculous limitations which we call music, literature, painting, etc. And why one should not for example dedicate oneself to creating objects out of pieces of wood, canvas, paper, feathers and nails, which, dropped from a tower 37 metres 3 centimetres in height, would describe, falling to the ground, a line of more or less complexity, more or less difficult to obtain and more or less rare. Therefore *every artist will be able to invent a new form of art,* which would be the free expression of the particular idiosyncrasies of his cerebral make-up, with its modern madness and complication, and in which would be found, mixed in accordance with a new measure and scale, the most diverse means of expression — words, colours, notes, indications of shape, of scent, of facts, noises, movements and of physical sensations; *i.e. the chaotic, unaesthetic and heedless mixing of all the arts already in existence and all those which are and will be*

created by the inexhaustible will for renewal which Futurism will be able to infuse into mankind. In addition Futurist measurement will clear away from our civilization, which will be full of the new "geometric and mechanical splendour", the stinking dungheap of long hair, romantic neckties, ascetic-cultural pride and of idiotic poverty which delighted former generations. The work of the Futurist measurer will have as its immediate effect the definitive placing of the artist in society. The artist of genius has been and is still today a social outcast. Now genius has a social, economic and financial value. Intelligence is a commodity in vigorous demand in all the markets in the world. Its value is determined, as with every other product, by its essential rarity. A given quantity of a commodity known to be saleable acquires, in a certain market, a fixed value; however, it rarely happens that one manages to establish a fixed value for a certain quantity of artistic energy, determined by an objective state of affairs which can be verified by anyone. A piece of gold, or a precious stone, has in the world at a given moment a well-defined rarity value on the basis of which the buyer's price is determined. *The Futurist measurer will have therefore to analyse the work of art into the individual discoveries or relationships of which it consists, determine by means of calcultations the rarity of each discovery, that is the quantity of energy necessary to produce them, fix on the basis of this rarity a fixed price for each one of them, add up the individual values, and give the overall price of the work.* Naturally the price must always be justified by a formula of measurements which would indicate the quantity of artistic energy represented by the work and the higher or lower quotation for artistic energy on the market at that moment. Thus, having destroyed the snobbish passéism of art-as-ideal, of art-as-sublime-holy-inaccessible, of art-as-torment-purity-vow-solitude-disdain for reality — the anaemic melancholy of the spineless who cut themselves off from real life because they are unable to face it — the artist will finally find his place in life, along with the butcher and the tyre-manufacturer, the grave-digger and the speculator, the engineer and the farmer. This is the basis of a new universal financial organization through which a whole series of activities, formidable in their development, completeness and importance, which have remained up to the present time in the grip of barbarism, will be fitted into modern civilization. We Futurists affirm that a whiff of steam from a locomotive and the febrile, crowded pulsation of modern life, passed across the bloodless body of art, will have as their immediate effect the production and selection of works a thousand times better than we now have. It is in addition a violent purgative and remedial cure which art needs to eliminate the last elements of traditionalist infection circulating about its body.

While on one side Futurist measurement will give the artist unchallengeable rights, on the other it must impose on him precise duties and responsibilities. For example, a painter who has attributed to his painting formulas of value indicating, let us suppose, that it contains 10 discoveries of the first

quality (30 lire each), 20 of the second (18 lire each), 8 of the third (10 lire each) and fixes the price at 740 lire, if by chance it happens that this is checked and that some of the discoveries have a lower value than indicated or indeed have no value, he must be put on trial for fraud and fined or sent to prison. *We therefore ask the state to create a body of law for the purpose of guarding and regulating the sale of genius.* One is astonished to see that in the field of intellectual activity fraud is still perfectly legal. It is really a relic of barbarism which survives anachronistically in the midst of modern progress. In this field Futurist fists are logical and necessary — they fill the functions which in a civilized society are carried out by the law. Being absolutely certain that the laws for which we are calling will be given to us in the very near future, we demand at once that *D'Annunzio, Puccini and Leoncavallo be the first to be tried on the accusation of persistent fraud contrary to the public good.* These gentlemen in fact sell for thousands of lire works whose value varies from a minimum of thirty-five centimes to a maximum of forty francs.

Until these laws are enacted, we should regard ourselves as inhabitants of a barbarous country. And so be it. But where barbarism rules, the fist and the bullet are arguments which count. Let us therefore conduct the discussion in this way.

As can be seen, the Futurist evaluator will exercise an effect totally different from that exercised today by the traditionalist critic. He will be a true professional, doctor and psychologist, fulfilling an office made valid and practical by the law. The same for the artist. *Tomorrow we should fix on to our front doors plates reading — mensurator, fantasticator, philosopher, specialist in astronomical poetry, genius, madman.* Yes, Madman, because it is time for madness (the upsetting of logical relationships) to be made into a conscious and evolved art. An individual who is able to construct in his own mind a complicated lunacy assumes a value. *A good madman may be worth thousands of francs.* Another activity which will be purged and regulated by Futurist evaluation is prostitution. For here too there are often forced victims of deplorable frauds.

And now affirming: (1) that *intuition is no more than rapid and fragmentary reasoning,* that between reasoning and intuition there is no essential difference and that therefore any product of the latter may be controlled by the former; (2) that reasoning and intuition are cerebral functions explicable and traceable down to their smallest details, using a Futurist analysis of the contents of knowledge down to its mediumistic depths; (3) that Futurist measurement will be made in accordance with logic (together with the relationships which govern material reality, reflected in the human brain), with the physical laws of energy and with the circumstances, independent of all subjective considerations (we have valued at 12,000 lire a picture by the painter Boccioni which makes us feel indescribably sick; and we are forced to admit the enormous value of an onomatopoeia by the poet Marinetti, which is hideously ugly, anti-aesthetic and repulsive); we formulate the following absolute:

Futurist Conclusions

1. Art is a cerebral secretion capable of exact calibration. 2. Thought must be weighed and sold like any other commodity. 3. The work of art is nothing but an accumulator of cerebral energy; creating a symphony or poem means taking a certain number of sounds or words. 4. The kind of work has in itself no value; it may acquire a value through the conditions in which it is produced. 5. The producer of artistic creativity must join the commercial organization which is the muscle of modern life. Money is one of the most formidably and brutally solid points of the reality in which we live. It is enough to turn to it to eliminate all possibility of error and unpunished injustice. In addition a good injection of financial serum will introduce directly into the bloodstream of the intellectual creator an exact awareness of his rights and responsibilities. 6. In addition to the words "criticism" and "critic" the following terms must be abolished: soul, spirit, artist and any other word which like these is irremediably infected with traditionalist snobbery; these must be replaced by exact denominations like: brain, discovery, energy, cerebrator, fantasticator, etc. 7. All past art must be resolutely thrown overboard, art which does not interest us and which besides we are unable to measure given our absolute and necessary ignorance of all the details and circumstances which constitute the framework of life in which it was created.

8. The stupendous importance of our affirmations regarding the will of genius and of Futurist renewal must be exalted. We are extremely pleased to see that Futurism, born in Milan, and launched five years ago for the whole world by the poet Marinetti in the colums of Le Figaro, having triumphed in the field of art with words-in-freedom, plastic dynamism, antigraceful, polytonal music without quadrature and the art of noises, is about to burst into the laboratories and schools of passéist science, the museums and cemeteries of mummified syllogisms and torture-chambers of free creative madness.

Bruno Corradini, Emilio Settimelli

Seurat, Georges

(Paris, 1859 - Paris, 1891) French painter

Georges Seurat carefully studied earlier masters — Ingres, and particularly Delacroix — before deciding to pursue his researches alone. He plunged into the scientific study of colours, and in Chevreul's writings discovered the law according to which "the simultaneous contrast of colours contains all the modifications which differently coloured objects appear to undergo in their physical composition and the tonality of their respective colours when seen together". His *Baignade* of 1884, shown at the first Salon des Indépendants, was admired by several painters, including Signac. A small group soon formed around Seurat. Its members were to be called "pointillists" because they painted with dots of pure colour instead of mixing the colours on the palette. Verhaeren, Seurat's friend, said of him: "All his friends, painters and otherwise, felt he was the real strength of the group... He was the keenest researcher, with the firmest will, the main explorer of the unknown."

Seurat's experimentation was to be continued by the Fauves and even the Cubists; and amongst the latter, particularly by the Simultaneist and Orphist Delaunay. In the same way the Futurists obviously learned from him his lesson can be seen, for example, in Balla's *Arc Lamp* or Severini's *Expansions*. Seurat was also their forerunner in his choice of subject-matter: the circus (*Le cirque*, *La parade*), the Eiffel Tower, musicians and dancers (*Le chahut*). (SF)

Severini, Gino

(Cortona, 1883 - Paris, 1966) Italian painter

At the first Futurist exhibition in February 1912, Gino Severini stood out from the other members of the group because of the way he celebrated modern life: instead of depicting tense, exciting situations (as the manifestos of the movement urged) his paintings rejoiced in the gay spectacle of Parisian life and were subtly permeated with that sense of the poetic quality of things which is hidden in the memory or feelings of those who live their youth with abandon and optimism. At the time of this brilliant début Severini had behind him little more than a decade of disciplined, consistent work.

Severini moved to Rome at the beginning of the century, where he started a fruitful association with Umberto Boccioni and the members of a heterogeneous cultural *milieu* with only vague creative aspirations, but serious intentions and a pronounced humanitarian spirit. Led by Balla, who was familiar with the most advanced experiments of French art, Severini soon became aware of the limitations of Italian painting, the snares of Naturalism and Intimism. Some portraits done around the time of his arrival in Paris (November 1906) already show a tendency towards an elegant translation of form, and this became clearer within a few months, as he explored the French capital and discovered the congenial aspects of life there.

Through his contact with the *milieu* of the Oeuvre Theatre — the shrine of Duse and Duncan, Ibsen and Bjornson — Severini refined his concept of representation and invention and succeeded in reconciling apparently antithetical aspirations and modes. In the work of Seurat and Signac he found suggestions that enabled him to develop an idiom which was simultaneously orderly, gay and elegant; Dufy then helped him to penetrate the secrets of scientific Pointillism and apply them to form. Immersed in memories of limpid Quattrocento painting and in the atmosphere of Paris at the height of the season, to Seurat's palette Severini added black, grey and all the nuances of the primary colours.

At first this lavish chromatism is organized within serene spaces and clearly-defined perspectives, as in *Civray Landscape* and *Spring in Montmartre*; later, after further studying Cézanne and the Cubist works exhibited at the Salon d'Automne in 1910, Severini developed his style in a decidedly original direction. The artist rehabilitated the constructive function of colour (in contrast to the Cubists who looked upon it as a destructive element, *sensoriel*) and used fluid geometric rhythms to express a sense of life which was not that invoked by Marinetti and Boccioni, but rather the subtle poetry of a Paris which, to the prospect of machines and electric light, still continued to oppose the eternal seduction of beauty and the joy of life.

Travel Memories (1909) is a sort of photomontage in which Severini brought together events both recent and long past, faces imprinted in his mind and aspects of city life, presenting the contents of a photographic memory with restrained nostalgia and genuine surprise. A slightly later painting, *The Voices of My Room*, with its cautious breaking down of form and the soft colours, represents the silent life of things celebrated by Jules Romains. In *The Boulevard* (1911) the geometrical syntheses of the passers-by, the carriages, the trees and the buildings are orchestrated with a new concept of space and with colours alternately soft and bright, immediately evoking the gay atmosphere of an elegant boulevard. Memory performs an increasingly important function in Severini's breaking-down of form: the evocation of *The Obsessive*

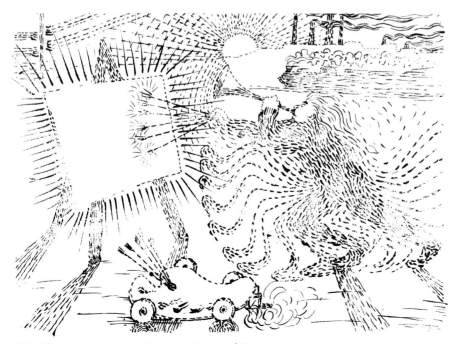

Pointillist caricature against Russolo, Carrà and Boccioni

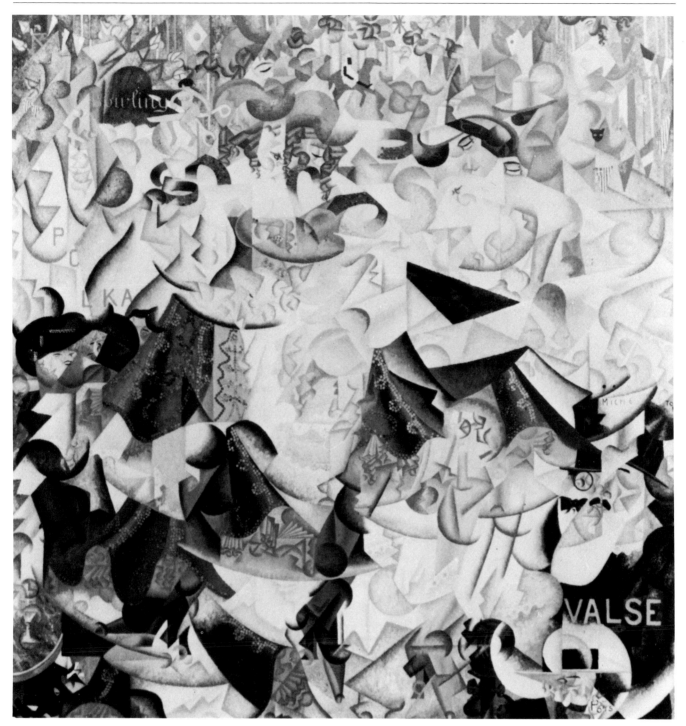

G. Severini, Dynamic Hieroglyph
of the Bal Tabarin, *oil and sequins, 1912*

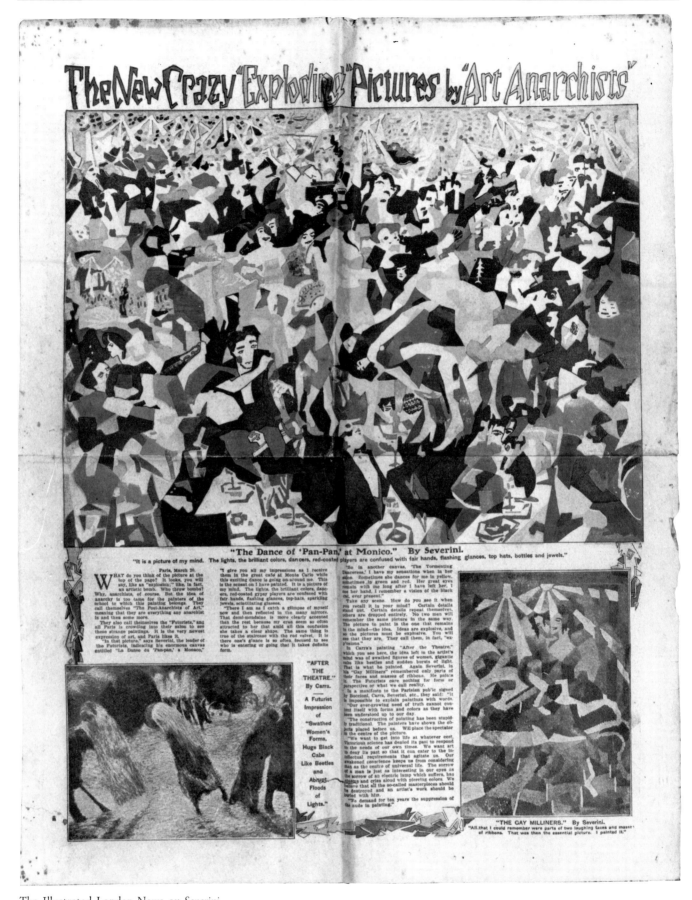

The Illustrated London News *on Severini*
and Carrà

Dancer (1910-11) both as a fleeting figure and a familiar presence implies the realization of the space-time concept by means of a suitable contrast of forms and the filter of varied lighting; in *Milliner* (1911), construed as the never-ending discovery of chromatic parallels, the figure serves as a pretext for a free expression of the transitory nature of things in a fascinating succession of events. But it was with the vast *The Pan-Pan at the Monico*, painted between 1911 and the beginning of 1912, that Severini offered his greatest homage to the luxury, elegance and liveliness of Paris nightlife. The originality of this work immediately impressed the leading figures of the literary world: Marinetti, by then a cosmopolitan personality and a sophisticated intellectual, was fascinated by the incessant and unpredictable rhythms of the large canvas. Apollinaire defined it as "the most important work painted by a Futurist brush" and, before Boccioni clashed with the touchy Cubist group, made a point of publicizing it. In the rhythms of the *Pan-Pan*, Jules Romains said he found again that rarefied atmosphere and silent life of things that he had evoked in *La vie unanime*. Maritain too — although he was still a long way from his Neo-Thomist reproposal of Beauty — was attracted by the successful breaking-down of form in *The Obsessive Dancer*.

The Pan-Pan established Severini as an original artist — not for nothing did it attract the attention of Picabia, Delaunay, Metzinger and other exponents of the synthetic Cubism *milieu*. At the same time this painting marked the beginning of a positive period in the artist's work in which he used theatrical events and musical suggestions as a pretext for developing an undisturbed effusion of flowing forms: *Blue Dancer*, *Cabaret Dancer*, *Dancer at Pigalle*; and more intense plastic expressions: *Spanish Dancers at the Monico*, *Portrait of Madame M.S.*, *Portrait of Mlle Jeanne Fort*, etc. Starting with the aim of offering the viewer the most meaningful synthesis of the kinetic sequence of the subject, the artist purges the form, creating abstract equivalents whose only function is to imply movement as an end in itself. Form is again an elegant factor and an abundance of ethereal, agile rhythms involve the viewer in an emotional reflection of the dancing and music in the environment.

In the various versions of *Argentine Tango* (1913) and in the astonishing *Plastic Rhythm of 14 July* Severini began a search for abstraction in the true sense of the word, although he continued to find his inspiration in visual reality. This did not prevent him from continuing his exploration of a joyous, timeless Paris: his panoramas with the Tour Eiffel and his rich impressions of city life (*Nord-Sud*, *Autobus*, etc.) transmit immediate and indelible sensations unconnected with any nostalgia for the past, since the painter's curiosity and *joie de vivre* constantly offer new seductions of light and colour. To the scorching tension of Boccioni, Severini preferred the anxious expectation of new events. By purifying the form even further, in the autumn of 1913 Severini achieved the *Plastic Analogies*, his most mature paintings.

These polyvalent figurative inventions were undoubtedly inspired by Marinetti's "literary analogies", but it has also been established (Martin, 1981 and 1983) that Severini enriched his scientific understanding of colour by further reflection on literary innovations and the effects of music and dance. His assimilation of the most abstract imagery of Mallarmé, and of the emotional echo of the modern dancing of Loïe Fuller, Suzanne Meryen and Sahary-Djheli acted strongly on his conception of painting, which he began to understand as the outcome of varied experiences linked by a single common denominator. With an energy controlled by his technique, Severini succeeded in bringing together in a single painting the abstract equivalents of different realities. Thus *Dancer = Sea* of 1914 conveys the image of whirling, recurrent movement with a strong feeling for colour and a skilful elaboration of the plastic rhythm. *Bear Dance = Sail/Boats + Flower Vase* from 1913-14 represents one of the finest moments of the painter's imagination; he had mastered the mobile rhythms of things and could instil in his colour contrasts deep sensations and lasting lyrical states. In his *Plastic Analogies* the most heterogeneous materials are included (sequins, plaster, cardboard and metal sheets); they do not allude to anything, but rather accentuate the "contrast" created by the complementary colours.

The paintings he produced between 1911 and 1915 achieved recognition in the most important cultural centres (Paris, Berlin, Rotterdam, London, Brussels, Florence and Rome), but Severini turned away from these plastic experiments, fearing to lose contact with reality. The dramatic European situation seemed to demand that artists remain within more tangible limits.

Once the Futurist group broke up, to satisfy his constant need for rationality and also to solve urgent financial needs, Severini entered Léonce Rosenberg's Cubist "stable". He did not disown his previous experiences; on the contrary, he made full use of them to enliven the repeated Cubist *assemblages* and to modify a certain decorative tendency. Thanks to his refined taste for the rediscovery of motifs, the ex-Futurist was able to repropose the static subject as a growth of virtual forms and conceptual forms and to refine the colour relationships. The work of Juan Gris and Braque influenced certain inventions in 1917 and 1918, but Severini continued to stand out for his personal concept of "contrast" and his limpid, intellectual use of colour.

In his passage to a modern Neo-classicism, codified in his *Du cubisme au classicisme* (*From Cubism to Classicism*) of 1921, and in his decorative painting of the Twenties and Thirties, Severini gave fresh energy to forgotten laws of composition and established a connection between tradition and the so-called "avant-gardes". (PP)

Shakespear, Dorothy
(London, 1886 - Cambridge, 1973) British artist

Dorothy Shakespear was self-taught as an artist, and concentrated from an early age on landscape watercolours. Through her mother, the novelist Olivia Shakespear, she met Ezra Pound in 1908. He later introduced her to Wyndham Lewis, Henri Gaudier-Brzeska and the Rebel Art Centre. She married Pound in April 1914, and with Lewis's encouragement developed an elegant, concise, Japanese-influenced version of the Vorticist style. Shakespear contributed a decoration and an illustration to *Blast No. 2* (July 1915). She always remained an amateur artist and never exhibited her own work. (RC)

Shershenevich, Vadim
(1893 - 1942) Russian writer

Active in the Ego-Futurist poetry group of the Mezzanine and a careful observer of Italian Futurism, Shershenevich was the author of *Futurism without Masks* (1913). In 1914 he translated the *Manifesto of Italian Futurism* as well as *Le concile féerique* by Jules Laforgue, and in 1915-16 he translated two books by Marinetti, *La battaglia di Tripoli* (*The Battle of Tripoli*) and *Mafarka il futurista* (*Mafarka the Futurist*). After the First World War he became a member of Imagism. (SF)

SIC
(1916-20) French periodical

SIC, an abbreviation of *Sons, Idées, Couleurs*, was founded by Albert-Birot in 1916. At first he was the only contributor, but gradually he drew into the magazine painters such as Severini and Braque, and many avant-garde poets. Although it was entirely devoted to what was from then on called literary Cubism, *SIC* was the French journal that most willingly published the drawings and poems of the Italian Futurists (Severini, Balla, Depero, Cantarelli, Prampolini, Settimelli). Using the magazine, Albert-Birot also made an unsuccessful attempt to launch a movement called "Nunism". During a public event put on by *SIC* in 1917, Apollinaire's *Les mamelles de Tiresias* was staged. (SF)

Šíma, Josef
(Jaroměř, 1891 - Paris, 1971) Czech painter, naturalized French

From 1921 onwards Josef Šíma lived in France, where in 1927-32 he was a member of the group "Le Grand Jeu".
In his early production, 1920-21, he was influenced by the Futurist admiration for technology, speed and industrial civilization.
His paintings of the modern urban scene — factories, warehouses, bridges, locomotives and cars — are characterized by clean geometrical forms, by dramatic contrasts of solid, raw colours, and by an interest in the movement and dynamism of modern life: *The Train, Car* (1920). His fascination with technology continues in the early drawings and paintings of his French period, although these have a far more abstract character. He achieved the dynamization of the painting by the multiplication or division into phases of highly simplified forms, which create the impression of movement: *The Bridge, View from a Train* and others,

1921. The rhythmic scansion of the geometrically structured surface area led him in some later studies towards the almost total elimination of representation, substituted by the direct emotional effect of pure forms: series of *Compositions* (1921). (FŠ)

Simpson Stevens, Frances
(1881 - 1961) American painter

Frances Simpson Stevens was the American most directly involved with the Futurists. Living in Italy before the First World War, she came to know Marinetti. She participated in the "Free Exhibition of International Futurists" in Rome in 1914. Then in March 1916, she exhibited her work in New York in a solo exhibition at the Braun Galleries. For the occasion, she wrote a catalogue essay inspired by the tenor of the Futurists' manifestos. Of the twenty-one works she exhibited in 1916, only one is known to have survived.
Dynamic Velocity of Interborough Rapid Transit Power Station of circa 1915 was purchased by the avant-garde collectors, Louise and Walter Arensberg. Stevens depicted movement through a skillful repetition of line and three-dimensional spatial illusion, choosing industrial and mechanical themes rather than pure abstraction. (GL)

Simultaneism

Apollinaire outlined the history of "simultaneity" in a succinct passage: "The idea of simultaneity had concerned artists for some time; in 1907, already, it interested Picasso and Braque, who strove to depict figures and objects from different aspects at the same time. Then all the Cubists were interested in it, and you may ask Léger what delight he feels when he renders a face seen simultaneously from the front and in profile. However, the Futurists extended the sphere of simultaneity and spoke about it clearly, using the term itself in the preface of their catalogue. Duchamp and Picabia explored for a while the borders of simultaneity; Delaunay then declared himself its champion, and based his aesthetics upon it. He opposed the simultaneous to the successive and saw in it the new element in all modern arts — painting, sculpture, literature, music, etc."
According to Boccioni (*Lacerba*, 1 January 1914) the Futurists had used the notion of simultaneity before anyone else, and this word certainly appeared in their manifestos. They were chiefly thinking of the simultaneity of experiences perceived by the consciousness of modern man, but a manifesto by the painter Delaunay, which appeared in *Der Sturm* translated by Paul Klee, was perhaps the first to apply the term to light and colour: "Reality is endowed with depth (we see all the way to the stars) and so becomes Rhythmic Simultaneity.
Simultaneity in light is harmony, the rhythm of colours that create the Vision of Men."
According to Apollinaire, the best example of simultaneity is Robert Delaunay's, *The Cardiff Team* (1913). In music, in *Le sacre du printemps* (1913), there is the juxtaposition of a waltz by Lanner and a popular ditty. In literature we can find examples in Léon-Paul Fargue, Max Jacob, in Apollinaire's *Poèmes conversations* and certainly in "the first simultaneous book", the spectacular *Prose du Transsibérien* created by Blaise Cendrars and Sonia Delaunay. (SF)

Sironi, Mario

(Sassari, 1885 - Milan, 1961) Italian painter

Mario Sironi came to Futurism through his close tie with Umberto Boccioni, with whom he had attended the Free School of Nude Drawing in Rome before 1905, and in particular through Giacomo Balla's studio, where he learned the Pointillist technique. In a letter to Severini written during a brief visit to Rome in the summer of 1910, Boccioni mentioned having seen Sironi, who "naturally disapproves of us"; he was referring to the new Futurist ideology just proclaimed in the painters' manifesto. He received catalogues and manifestos and participated from a distance in the new movement.
In October 1913 Sironi wrote to Boccioni: "After your paintings left [he was referring to the first Roman exhibition of Futurist painting in the foyer of the Teatro Costanzi], having matured my ideas on your art, and indeed those of all of you, I have fallen in love with it, with yours in particular." He was immediately drawn into the movement; on 29 March 1914 together with other Futurists he took part in the performance at Sprovieri's Galleria Futurista as a "fischiatore" (booer) in the troupe of dwarfs that accompanied Marinetti. In April-May, he exhibited sixteen paintings in the "International Futurist Free Exhibition" in the same gallery.
On 26 March 1915 Marinetti announced to Severini that the Futurist group committee (Carrà, Balla, Boccioni and himself) had decided to admit Mario Sironi among the painters; he considered him "a real Futurist, in the true sense of the word, who has embarked in a profound and highly original way on research into plastic dynamism".
He contributed illustrations to various periodicals published in Rome and Milan, including *Gli Avvenimenti*.
Together with his new Futurist companions, he enrolled in the Volunteer Lombard Battalion of Cyclists and Motorists (June-December 1915) and signed the manifesto *The Italian Pride*, calling on Italy to enter the war.
In 1919 he again exhibited with the Futurists, and on 11 January 1920 a new, contradictory Futurist manifesto appeared, *Against All Revisitations in Painting*, signed by Dudreville, Funi, Russolo and Sironi.
As a Futurist painter, Sironi owed much to Boccioni in the dynamic-plastic forms he developed between 1913 and 1916, and he acknowledged this with great humility. Sironi differed in his more monumental constructive solidity and in his breaking-down of the image, which aimed at analyzing its structure rather than synthesizing it in movement. This tendency towards volume and firmness — best shown in *Cyclist* (1916, Rome) — fixed the subject (which was rendered in dark tones except in the collages) in a deliberate timelessness. (EC)

Skotarek, Wladislaw
(Wojnowice, 1894 - Poznan, 1938) Polish artist

A member of the Bunt group, Skotarek was influenced by Futurism and Symbolism in the early Twenties. After 1925 he devoted himself to Symbolist inspired religious painting. (SZ)

B. Cendrars and F. Léger, The End of the World, *1919*

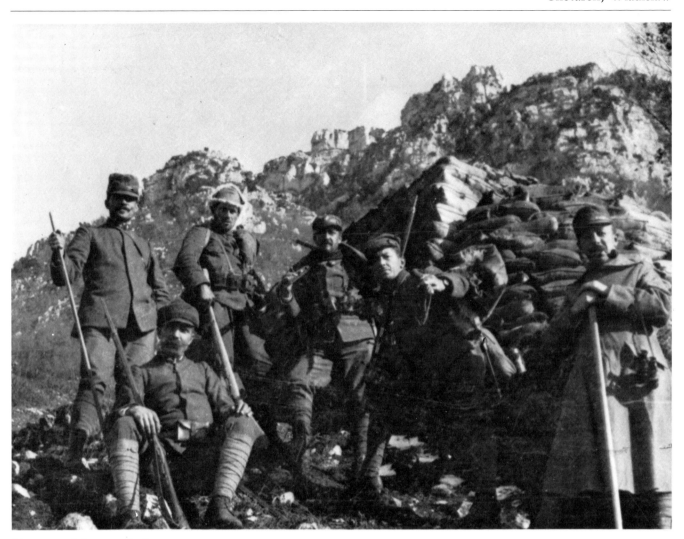

Marinetti and Sironi at the front

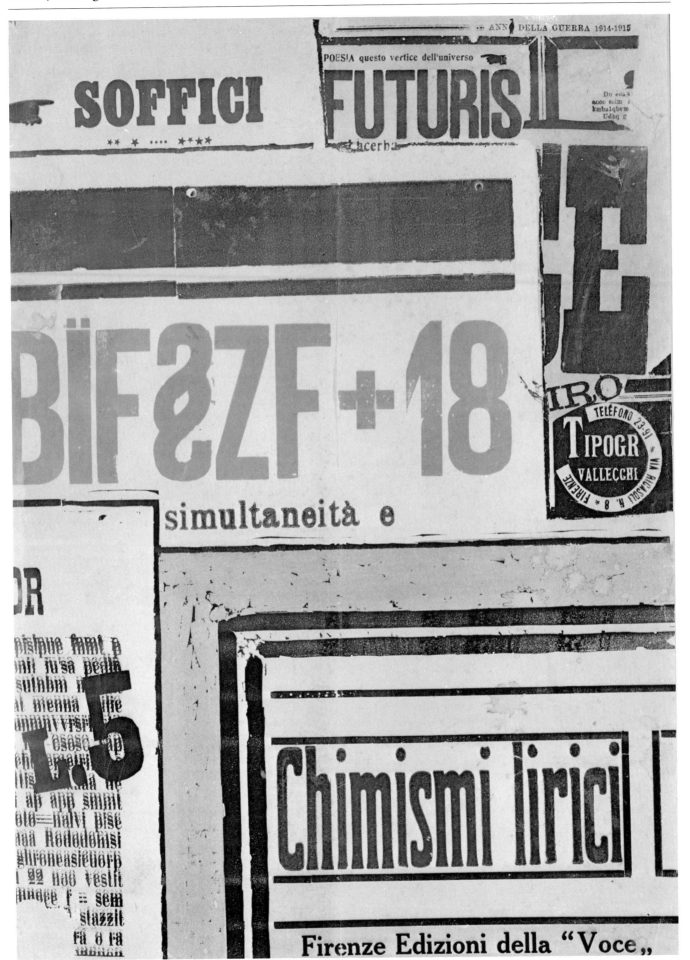

A. Soffici, extract from BIF & ZF + 18
1915

Soffici, Ardengo

(Rignano sull'Arno, 1879 - Poggio a Cajano, 1964) Italian painter

When Soffici had finished school, his father died, and at the age of nineteen he had to begin work in a lawyer's offices. He attended the Academy of Fine Arts and the Nude Drawing School until 1900, then with a group of friends, including Brunelleschi, he went to Paris to visit the Universal Exposition. He remained in Paris for several years, working as an illustrator for various magazines, including *Le Rire* and *L'Assiette au Beurre*, and as an illustrator and writer for *La Plume* and the *Revue Blanche.* After 1903 he returned to Italy each year for three or four months, working mostly at Poggio a Cajano. In Paris he associated with Picasso, Apollinaire, Moréas, Bloy, and young, unknown artists. In 1907 he came back to Italy to settle, although he continued to spend several months each year in Paris; in Florence he contributed to the magazine *Il Leonardo* and wrote an article on Cézanne for *Vita d'Arte.* At the end of 1908 the first issue of the new magazine *La Voce* came out; the heading was designed by Soffici and the editor was Prezzolini. In 1909 *La Voce* published his articles "Medardo Rosso, L'impressionismo e la pittura italiana", ("Impressionism and Italian Painting"), "La ricetta di Ribi Buffone" (Ribi Buffone's Recipe), which had the merit of spreading knowledge of French art and literature in Italy; he also brought an exhibition of Impressionist painting to Florence, which was to be of great importance for Italian culture. In Paris he met Medardo Rosso, whom he included in the show, giving him a room of his own. In 1909 *Ignoto toscano* (*The Unknown Tuscan*), his first literary work, came out; he wrote the book *Arthur Rimbaud* (published the following year in *Quaderni della Voce*), and began *Lemmonio Boreo* (published in 1912 in *Quaderni della Voce*). In *La Voce* he published an article on Henri Rousseau (15 September 1910), from whom he had bought sixteen drawings and a still life in Paris; and two articles (27 October and 3 November 1910) on the International Exhibition in Venice; in a footnote he attacked the exhibition of Umberto Boccioni's work held at Ca' Pesaro during the summer. In Milan he visited the "Free Exhibition of Painting", set up in the ex-Ricordi pavilion, where the Futurists were exhibiting for the first time. "My great expectations changed into indignant disappointment; a disappointment that I later expressed publicly in the Florentine magazine, in a slating review entitled 'Arte libera e pittura futurista' (Free Art and Futurist Painting), 15 June 1911). Following that slating, the Futurists organized a punitive attack on the Giubbe Rosse in Florence which ended, after violent fisticuffs, "in a most heated discussion of art and painting". On 24 August 1911 the article "Braque e Picasso" came out; he spent half of 1912 in Paris where he often saw Severini. At the beginning of 1913 the first issue of *Lacerba* appeared, to which his Parisian friends and the Futurists contributed.
His close friendship with the Futurists began. He took part in the *soirée* at the Teatro Costanzi in Rome, where nine of his

G. Papini and A. Soffici

A. Soffici, cover of BIF & ZF + 18, 1915

works were exhibited: studies and analyses of planes, lines and volumes. Nine of his works were sent to Rotterdam for the exhibition "Les peintres et les sculpteurs futuristes italiens" and three went to Berlin to the "Erster Deutscher Herbstsalon" organized by *Der Sturm. Lacerba* promoted the first Futurist exhibition in Florence, and on 12 December 1913 a violent Futurist evening was organized at the Teatro Verdi. The *Almanacco purgativo* (*Purgative Almanac*) came out with contributions from the Futurists, in particular Papini. In February 1914 Soffici took part in the Futurist exhibition at the Sprovieri gallery in Rome, in April in the group show at the Doré Galleries in London, and in May at the Galleria Futurista in Naples.
In Soffici's painting during his Futurist years the myth of form was always present. Although the images were composed in Cubist-style constructions, they never lost their realistic aspect. Soffici's cultural point of reference was outside Italy, but his works were strongly linked with his Italian origin, to which he returned a few years later.
He published *Cubismo e futurismo*, an enlarged edition of *Cubismo e oltre* (*Cubism and Beyond*, 1913) and *Arlecchino* (*Harlequin*).
His alliance with the Futurists began to break up. The spark came from an article by Papini, "Il cerchio si chiude" (The Circle Is Closing, 15 February 1914), to which Boccioni replied. With the article "Futurismo e marinettismo" (in *Lacerba*, 14 February 1915) the break with Marinetti's group became final.
From March to June 1914 Soffici was in Paris where he associated with Apollinaire and published the unpunctuated poem "Masque" in the latter's magazine *Les Soirées de Paris.* The campaign for Italian intervention in the war began in the pages of *Lacerba* while *La Voce* changed face. *BIF & ZF + 18* was printed; after May 1915 and Italy's entry into the war, Soffici volunteered for active service. (EC)

Souza-Cardoso, Amedeo de

(Manhufe, Portugal, 1887 - Espinko, Portugal, 1918) Portuguese painter

In 1908 the young painter Souza-Cardoso took up residence in Paris; his neighbour was first Modigliani, then Gertrude Stein. In 1911 he connected with the Cubists (Gris, the Delaunays, Archipenko, Rivera), and with Brancusi and Boccioni. From 1911 he exhibited at the Salon des Indépendants, and later at Der Sturm Gallery in Berlin and the Armory Show in the United States. The First World War took him back to Portugal, where he became friendly with Fernando Pessoa and the Futurist Almada-Negreiros, who wrote the preface to his 1916 show in Lisbon and reproduced several of his works in *Portugal Futurista* (1917). Souza-Cardoso became acquainted with Futurism early, but rather than marking a particular period in his work, it became a widespread general influence (*Procession to Amaranto*, 1913; *Horsemen*, 1913; *Dinghy*, 1915; *Brut 300-TSF*, 1917). (SF)

A. de Souza-Cardoso

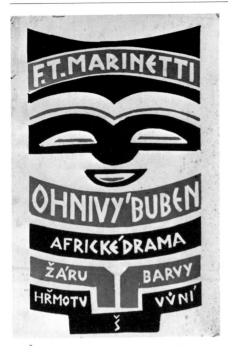

V. *Špála, cover for* The Firedrum *by Marinetti, Prague, 1922*

Špála, Václav

(Zlunik, 1885 - Prague, 1946) Czech painter

After studying at the Academy of Fine Arts of Prague, Špála spent three years in Dubrovnik (1907-10) for health reasons. In 1911 he spent a few months in Paris, then returned to Prague where he joined the Painters' Association, but soon followed the example of his Academy friends, the Čapek brothers, and left the organization. In 1913 he went on a scholarship to Italy where he stayed for a year. From 1918 onwards he contributed to all the exhibitions organized by Tverdošijgny, an avant-garde association of painters and writers. Towards the end of the Twenties he travelled widely in Czechoslovakia and painted a series of landscapes in Cézanne's style.

His painting was influenced by several sources: Impressionism, Cézanne, and Fauvism, discovered during his stay in Paris in 1911. In Italy he came into contact with Futurism and this Futurist influence was to be evident in all Špála's works until the Twenties, although not so obviously as in his compatriots, B. Kubišta and Gutfreund. (SZ)

Speed

When Marinetti stated in 1909, in the *Founding Manifesto of Futurism*, that "a new beauty has been added to the splendour of the world — the beauty of speed", he creatively and intuitively pointed out the true value of the industrial revolution. Together with the mass-produced object came the fast-moving object. When the original, unique product was replaced by copies and replicas, the ubiquity of objects became a reality. Now the same product would go rapidly round the globe, settling in every territory at the same moment. Alongside the industrial revolution, the revolution in transport created a new world in which "all things move, all things run, all things are rapidly changing. An outline is never motionless before our eyes, but it constantly appears and disappears", as the *Technical Manifesto of Painting* put it. "The gesture will no longer be a frozen movement of the universal dynamism — it will be the dynamic sensation rendered as such."

The universe becomes at once material and immaterial, the intervals and distances between things fall away, as though speed made all vectors converge towards a single pole, towards a single surface or volume. This led to the discovery of the artistic concept of linguistic and spatial simultaneity, in which elements move without relation to material geography and environmental conditions. In this whirlwind, the forms of time and space melt together and become confused in a single present time, which the Futurists try to depict by seeing how different, contrasting events mingle in one atmosphere or environment: "Our bodies penetrate the sofas upon which we sit, and the sofas penetrate our bodies. The passing tram rushes into the houses and in their turn the houses throw themselves upon the tram and are blended with it."

Speed is in fact located in the great cities, where the phenomenon of the simultaneity of bodies and routes, trajectories and movements, explodes with most intensity. Here, beside the static, unified, measurable and functional time of architecture — which with Sant'Elia will become active, however — the present moment runs on with feverish excitement, no longer bound by the simple activity of economic exchange but linked to the excess of movement and speed created by an industrial technology of communication. The city is the site of mingling, of wars and tumults, which accelerate the logistics and technique of existence itself.

In the *Founding Manifesto* Marinetti also wrote: "We will sing of great crowds excited by war, by pleasure and by riot; we will sing of the multicoloured, polyphonic tides of revolution in the modern capitals; we will sing of the vibrant nightly fervour of arsenals and shipyards blazing with violent electric moons; hungry railway stations that devour smoke-plumed serpents; factories hung on clouds by the crooked lines of their smoke; bridges that bestride the rivers like giant gymnasts, flashing in the sunlight with a glitter of knives; adventurous steamers that reject the horizon, deep-chested locomotives whose wheels paw the tracks like enormous steel horses harnessed by tubing, and the sleek flight of aeroplanes whose propellers chatter in the wind like banners and seem to cheer like an enthusiastic crowd."

The list of instruments which create speed shows the accelerating effect of technology on the development of history. In fact, the face and shape of the city, and indeed of world civilization, will be modelled on the technological violence of the First World War. With its instruments of assault and aggression, war made it clear that the logic of speed would triumph against any opposition. When the war had begun, in 1916, Marinetti published the manifesto *La nuova religione-morale della velocità* (*The New Religion-Morality of Speed*), a true hymn exalting the ritual, divine character of the sophisticated new technologies of movement related to war. He made speed into a religion or moral system, capable of transforming humanity and the world completely. The metamorphosis produced by the speed of war — or the war of speed — is in fact enormous, but above all it marks a change in forms. These dissolve, revealing all that is irrational and unthinkable — "speed-scattering-condensation of the 'I' ". Speed also destroy images, so there is a sort of contiguity between the discovery of dynamism and the dissolution of figures in art: Futurist sculpture and painting both move inexorably towards a melting of forms and volumes, used now only to manifest the energy-transit of bodies and objects. In the art of the instantaneous perception of the material world, the subject is denied, along with "any aim of realistic anecdotal reconstruction" (Boccioni), and the essential elements of "plastic sensibility" are affirmed. The use of sensibility makes painting and sculpture nomadic; they move at crossroads of languages, live in moments of real and virtual movement where they can "model the atmosphere that surrounds things". In order to communicate the physical reality of a body in movement, the Futurists overturn the rules of appearances: they deny static points in time and space and concentrate on trajectories. With speed, forms disappear, not through the inner Cubist conflagration, but for natural-technical reasons. Balla, Boccioni and Russolo do not *think* about "abstraction", they discover it experientially: speed denies the dimension of reality, dissolves the visible world and subjects all appearances to the fleeting transparency of light. Sensory acceleration therefore creates something which is "the bridge which joins the exterior plastic infinite to the interior plastic infinite, so that objects never end; they intersect with innumerable combinations of attraction and repulsion" (Boccioni). The erosion of the "figure" in movement breaks up the straightforward perspective of the images. These dissolve, creating "fades", as in Bragaglia's photographs and Vertov's films, and irradiate in every direction. Literature, poetry, music, theatre and cinema all become means for the transmission of coloured substances and images, race-courses where speeding figures are swiftly noted as they pass. But irradiation, for the Futurists, is not only visual and plastic. The exaltation of speed coincides with man's need to multiply himself, both physically and in terms of information. Marinetti and the Futurists multiply their presence with innumerable events and manifestos in order to conquer every area of society and knowledge at top speed. Using the power of promotion made possible by fast transport and communications, they "move" throughout Europe and reach even Mexico and Japan with information. Their strategy is to transfer ideas immediately; like a mobile military unit prepared to intervene on several different fronts, they attack the moving target of the traditionalist bourgeoisie. In the last analysis, Marinetti believes in the cultural hero and warrior who, by using the most sophisticated weapons of fast data transmission (telegraph, radio, aeroplane, cinema, photography, trains, automobiles etc.) succeeds in defeating a passéist intellectual class. With Marinetti and the Futurists, speed becomes a war of information. (GC)

Sprovieri, Giuseppe

(Pianette, Cosenza, 1890) Italian journalist and gallery owner

In 1911 Giuseppe Sprovieri met Marinetti and visited the "Free Exhibition" at the ex-Ricordi pavilion in Milan. His contacts with France and then with Marinetti stimulated him to react against the provincialism of Italian art. In 1913 he promoted an exhibition in Rome and opened a gallery of Futurist painting there with an exhibition of sculpture by Boccioni; the exhibition of Futurist paintings with works by Boccioni, Carrà, Russolo, Balla, Severini and Soffici followed, and in April-May the "International Futurist Free Exhibition" with Russian, English, Belgian and American painters and sculptors. Sprovieri himself showed two paintings: *Pictorial Summary of Three Streets* (study in colour) and *Simultaneity + Speed + Movement: Houses Dancing around the Char-à-bancs.* The gallery also gave space to recitations, shows, and musical performances, and became a meeting place. When war broke out in July 1914, Sprovieri decided that the gallery was out-dated and he gave up the activity. (EC)

Stella, Joseph

(Muro Lucano, Potenza, 1877 - New York, 1946) American painter

Joseph Stella visited the Futurists' exhibition at the Bernheim-Jeune Gallery in Paris in February 1912 and met Carlo Carrà. Although there is no earlier documentation of Stella's contacts with the Futurists, it is conceivable that he became acquainted with some of the Futurist artists or their work during 1910 in Italy or in Paris in 1911. Yet despite Stella's suggestions to the contrary, there is no evidence that he made close friendships with the Futurists. In later years, he apparently did come to know Gino Severini. Born and raised in Italy, Stella did not emigrate to America until 1896, at the age of eighteen. Upon his return to his native land, he became a close friend of the painter Antonio Mancini in Rome during 1910-11. Mancini's modernism was limited to an Impressionist-influenced style with bright colours and broad brushstrokes.

In Paris, Stella came into contact with avant-garde circles, including the salon of the American expatriate collectors Gertrude and Leo Stein where he came to know the work of Cézanne, Matisse and Picasso. But when he returned to America in late 1912, it was Futurism with which he chose to identify, choosing themes and stylistic means reminiscent of the experimental concerns of these Italian Modernists. Stella loved to depict movement, lights, and modern urban and industrial architecture. From 1914-18, Stella made some abstract compositions that are derived from his personal interpretation of Futurism. He concerned himself with the play of coloured lights at New York's amusement park at Coney Island, referring to the "battle of lights", suggesting his appreciation of the Futurists' fascination with force. Although personal, Stella's work most closely resembles the work of Severini in its vivacious, even explosive, dynamic atmosphere.

« New-York ».

LA PITTURA DI GIUSEPPE STELLA

Henry Mc Bride, il critico più autorevole degli Stati Uniti, nel *Sun* del 17 aprile ultimo, in un articolo magistrale, accentua l'eccezionale possanza artistica affermata dall'ultima esposizione dello Stella, ammonendo:

« Io avrei fede maggiore per la nostra comunità se essa tributasse allo Stella il massimo rispetto. Un popolo che non fosse a conoscenza intera di tale uomo è senza speranza ».

Per renderci conto appieno dell'importanza di tale asserzione, bisogna tener presenti le difficoltà grandi che ostacolano qui, in America, l'artista nell'affermazione della sua personalità.

È lotta aspra e lunga, vera prova del fuoco, da cui solo spiriti singolari, fortemente agguerriti, possono sperare di emergere.

Esposizioni seguono ad esposizioni e nuove gallerie s'aprono di continuo. La contesa, fra queste, per il primato, è accanita e si esaspera nella ricerca affannosa di tutto quello che di più significativo s'è prodotto e si produce in tutti i paesi del mondo. Dippiù, preclari raccolte di quadri antichi sono poste in mostra o in vendita, e il paragone che ne risulta, inevitabile, diviene sempre più difficile da superare, insormontabile quasi.

Questa la ragione precipua di molti fallimenti e di molte delusioni amare, si profondano pure acque lustrali di battesimi e di cresime ufficiali: l'ultima nostra esposizione nazionale in questo paese insegna.

Perchè quello che può sembrare forte, audace, in centro limitato, appare nullo nella giostra di rivalità mondiali.

Per emergere « dalla cintola in su » bisogna imporre con tono deciso il nuovo verbo proprio, e per rendersi accessibile alle moltitudini bisogna saper usare il linguaggio universale più chiaro.

* * *

L'inizio pittorico dello Stella è rudemente realista, terreno. Libero di pastoie accademiche, esprime appieno, rifuggendo da vaniloqui, il carattere ed il *pathos* di uomini e cose. Il colore è denso, aspro — alle volte cupo — appropriato però, non manierato, emanazione dello studio diretto del vero.

Il dolore ne è il tema costante: il dolore, inquadrato da ombre fitte, della vecchiaia abbandonata — il dolore, spettrale, di notte, di vinti nella solitudine dei parchi — il dolore, come incombente minaccia, di interni, nei cui fondi luce malcerta s'aggira quale vana promessa.

È periodo, questo, che si riscontra, spesso, nel principio artistico di parecchi grandi pittori, perchè è soltanto quando le ali sono divenute robuste che si possono tessere gli alti voli per le sconfinate regioni della gioiosa Fantasia.

Periodo essenziale, però, base solida, su cui solidamente deve poggiare l'opera del futuro.

* * *

Quest'opera dà le prime luci in Italia. Ritrovandosi l'artista nel paese natio, egli s'abbevera al sacrario delle emozioni che schiusero la sua sensibilità di giovinetto: malgrado le vicissitu-

54

Rivista d'Italia e d'America, 1916 on J. Stella

Other themes attempted by Stella include urban or industrial subjects like *The Gas Tank* of 1918, where beams of light energize a seemingly static image. When he turned his attention to the Brooklyn Bridge, Joseph Stella emphasized these beams of light, dissolving the massive, yet delicate structure into remarkable jewel-like facets.

Later Stella interpreted other aspects of New York, including skyscrapers, the many lights of Broadway, and the port. In his interest in dynamic movement, urban themes, and colourful jewel-like shapes, Stella demonstrated his assimilation of the Futurists' ideas. His art, however, reveals an original vision, which combines the Futurists' aesthetic innovations with a personal response to his stimulating American environment. (GL)

Stern, Anatol

(Warsaw, 1899 - Warsaw, 1968) Polish writer

Anatol Stern studied at the University of Vilno and soon attracted notice for his rebellious temperament. His first collection of poetry, *Futurisations*, appeared in 1919. He supported the *Manifesto of the Polish Futurists*, and with Bruno Jasienski worked on *Nife in the Beli* (1921): "The fat beast of Polish art, struck in the belly by sharp knives, has vomited a lake of Futurism. Citizens, help us to rip off our old skin." Stern, with Jasienski, was the first theoretician of Futurism in Poland. With Alexandre Wat he published the almanac *GGA* and with Bruno Jasienski *Land to the Left* (1924). Later, Stern was to work regularly with the Constructivists (*Europe*, 1929). He took a great interest in the cinema, and wrote some thirty screenplays. (SF)

Stramm, August

(Münster, 1874 - Horodec, Russia, 1915) German writer

In 1913, a crisis provoked by his reading of the Futurist Manifesto and his attendance at a lecture by Marinetti in Berlin led Stramm to destroy almost all his work and make a fresh start. A few plays written before this date, such as *Die Bauern* (1904-05) and *Der Gatte* (1909), survive. He devoted himself to a new poetry, helped by Herwarth Walden, and developed his own exclamatory style following such forerunners as Arno Holz — a form of poetry made up of isolated words, often repeated with a rudimentary syntax, rich in neologisms, onomatopoeia and verbs in the infinitive (as the Futurist Manifesto advised), compressed into an insistent and often obsessive or panting rhythm. Employing the same style, he also wrote several dramas, including *Sancta Susanna* (1913). After Stramm's death on the Russian front, Walden continued to publish his work posthumously and to sing his praises. Abstract poets such as Rudolf Blümmer, Otto Nebel and Kurt Schwitters had a deep admiration for him. (SF)

Stravinsky, Igor

(Oranienbaum, 1882 - New York, 1971) Russian composer

Stravinsky's contacts with Futurism were infrequent and unfruitful. In 1914 he was present at one of Russolo's "intonarumori" concerts at the London Coliseum. A letter to Stravinsky from Diaghilev indicates that at Marinetti's invitation, with Prokofiev, Massine and Diaghilev, he met the Futurist musicians Pratella and Russolo between 15 and 20 March 1915 in Milan. However, any possibility of future collaboration disappeared shortly afterwards when Italy entered the war.

In 1916 Diaghilev commissioned Depero to design the scenery and costumes for Stravinsky's *Le chant du rossignol*, but he broke the contract just before Depero's work was completed. On 17 April 1917 Balla realized some coloured lighting effects for a performance of *Fireworks* conducted by Stravinsky; the program also included *The Firebird*, *Les femmes de bonne humeur*, and *Soleil de nuit*. Finally, Stravinsky attended the first of a series of concerts with orchestra and "intonarumori" given by Russolo at the Théâtre des Champs-Elysées in Paris in June 1921. (FMa)

Stridentism

Mexican Stridentism was the first organized movement in Latin America which aspired to connect literature, the plastic arts and music. We cannot however ignore the existence of earlier isolated phenomena. In Mexico there were the painters Diego Rivera and Marius de Zayas, and the writers José Juan Tablada and Ramón Lopez Velarde, but it is significant that at the time when Stridentism was about to emerge the first three of these artists were living in Paris and New York.

In Mexico City at the end of 1921 the poet Manuel Maples Arce launched the first "Stridentist pill" in the magazine *Actual no. 1*. It was in fact a manifesto, discarding the national saints and heroes as belonging to an old culture that was considered stifling: "the particularly obtuse body of the academy...", "Chopin to the electric chair..." The main statement is definitely in the Futurist line of descent: "We must exalt with all the strident tones of our diapason of propaganda the present beauty of machines, of the gymnastic bridges with muscles of steel launched from bank to bank, the smoke of factory chimneys, the Cubist emotions of the great transatlantic liners with their smoking funnels berthed horoscopically — Huidobro — along the effervescent, congested quays, the industrial regiments of the palpitating metropolises, the blue overalls of the workers..." And he quotes a famous phrase: "An automobile in motion is more beautiful than the *Victory of Samothrace*. To this brilliant statement of the Italian avant-garde writer Marinetti, praised by Lucini, Buzzi, Cavacchioli etc., I add my undying passion for the typewriter and my exorbitant love of the literature of economic reports..." No one had, of course, seen any Futurist works, but they knew the theories propounded by Marinetti. The Stridentist manifesto differs from these in certain details, such as the rejection of handwriting in favour of the more legible typescript, or the absence of bellicosity — a sentiment that would have been out of place in a country devastated by ten years of revolution.

Basically Stridentism is closer to Russian Futurism. Its artists and writers are avowedly left wing, and were later on to break their alliance with the Futurists and the Fascists. Stridentism wished to make an impact upon the present, and for this reason took a part in the cultural activism of the revolutionary movement, as the Russian Futurists had. A Surrealist such as Robert Desnos admired the Stridentists for having been able to put themselves "at the service of the revolution".

Besides Maples Arce, the chief Stridentist writers were Salvator Gallardo, Germán List Arzubide, Luis Quintanilla (who signed himself Kyn Taniya) and the Guatemalan novelist Arqueles Vela. The principal artists of the movement were the painters and engravers Alva de la Canal, Jean Charlot and Leopoldo Mendez, the sculptor Germán Cueto, and finally Fermín Revueltas and his brother, the composer Silvestre Revueltas.

We should also mention celebrated fellow-travellers such as Diego Rivera and the photographers Edward Weston and Tina Modotti. (SF)

Sunlight

The Impressionists loved the effects of light in all its variations. The Neoimpressionists like Signac and Seurat wanted clearer and sharper colours and preferred the sun itself. Under their influence Robert Delaunay painted his first solar disks in 1907-08 and observed how intense light deformed the Eiffel Tower, a subject he particularly liked. The Futurists emphatically loved sunlight — "Let's kill moonlight!" proclaimed one manifesto — because the moon was not only the antithesis of the sun but represented the feminine principle: "The romantic sentimentality which flows from the moonlight, which rises towards woman...". The Futurists valued new "electric moons" and electric light, which breaks objects, people and landscapes into sharp angles. This is evident in Balla's *Arc Lamp* and *Mercury Passing in Front of the Sun*, and in numerous paintings by Boccioni and Severini where light is the implicit subject (with its opposite, shadow, playing with the sources of electric light): *Expansions of Light*, *Iridescences*, etc. The same interest is common to painters such as Pettoruti, Schmalzigaug, Marc, Dix, the Russian Rayonists, the Orphists, the American Synchromists, the Vibrationist Barradas, and even a sculptor, Epstein, with *Sun*. The writers were not left behind: from Marinetti, who dreamed of a *Conquest of the Stars*, to Maiakovsky who said he would use the sun as a monocle, to Wyndham Lewis, the *Enemy of the Stars* — the titles speak for themselves. Finally one should not forget the opera, *Victory over the Sun*, by Kruchenykh, Malevich and Matiushin. (SF)

Suprematism in Fashion

The organic vitality of Art Nouveau forms had invaded all the fields of applied art, whether produced by craftsmen or by industry. Into this triumph of decorativism Suprematism introduced an innovation which must have seemed harmless, but was the beginning of a great discovery: expressive geometry. This new idea came to occupy a cultural position of great prestige. The meaning of the Suprematist world and its abstract forms would become a polemical, explosive question. Initially, however, the avant-garde artists moved into the realm of everyday life with only a few very simple objects created in collaboration with peasant artisans. Their utopian ideas found support in the geometrical decorations of folk art. Since Suprematism tended to identify formal concepts with a universal philosophy, it always retained a rarefied atmosphere and held an aristocratic position in its contribution to the applied arts. In reality, the geometric universe of the Suprematists did not appeal to popular taste and because of this the Suprematist artists did no more than produce stimuli of great aesthetic-psychological value.

Only very few examples have been found of textile designs by the inventor of Suprematism, Kazimir Malevich. However, Larissa Zadova reports having heard one of Malevich's pupils say that in the Twenties his friends and relations faced the winter frosts wearing pullovers and scarves woven from the master's designs, mainly with black and white motifs.

In the catalogue of the State Exhibition of the Workshop of Applied Arts, held at the Museum of Fine Arts in Moscow in 1919, there is a mention of peasant embroidery in the village of Verbovka near Kiev, executed from designs by Olga Rozanova, Nadezhda Udaltsova and Malevich. The artist who put her Suprematist colleagues in touch with the workshop at Verbovka must have been Alexandra Exter. She was born in Kiev but also lived in Moscow and joined the Suprematist movement in 1916. As early as 1915 she had already had designs embroidered on cushions, scarves, clothes and umbrellas by women artisans in Verbovka. Exter was also in touch with Sonia Delaunay Terk. In 1914, in Paris, she saw the first "simultaneous" dress, as well as the cushions and lampshades created the previous year by Sonia Delaunay, who was also born in the Ukraine.

Amongst the most outstanding designs we know of are the models created by Rozanova between 1916-17, which in shape resemble traditional costumes, but in their triangular and rectangular embroideries reflect Suprematist experiments in painting. Typical colours of Suprematist paintings, such as pink-red and pink-violet, are used with blue or yellow or green in evocative contrasts which stand out against the plain black or white background of the material. The designs for bags from the same period, on the other hand, are also innovative in shape. The juxtaposition of asymmetrical pieces creates open outlines, straight or oblique.

In his fabric designs Malevich kept his motifs small and repeated them all over the surface area so that there would be no conflict with the body of the wearer, unlike Sonia Delaunay, who preferred aggressively large diamond-shapes. Moreover, Malevich and some of his followers always refused to mass-produce their designs, which remained unique models, because of their disgust for the conveyor-belt repetition of the machine age. (GDM)

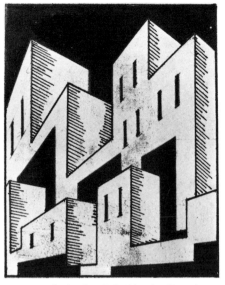

R. *Alva de la Canal*, Stridentist Drawing

R. *Alva de la Canal*, Portrait of List Arzubide

A. *Exter*, Suprematist Fan, *1923*

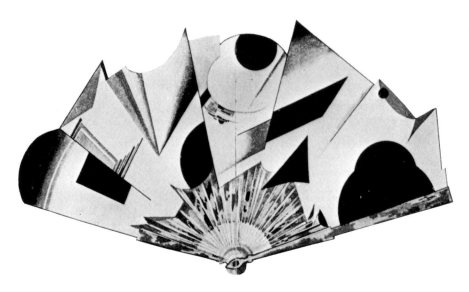

Surrealism

The Surrealists flaunted open disdain for their predecessors, the Futurists, though their judgement was based chiefly on the works and deeds of Marinetti. In 1919, when Aragon, Breton and Soupault made their protest in the magazine *Lit térature*, they did so more out of opposition to the police than for any feeling of aesthetic solidarity. At this time Aragon and Soupault were entirely indifferent to Futurism, although Breton, more aware of its methods and theories, paid it a certain heed. At the time of Dadaism the future Surrealists saw the rebirth of Futurism as merely a warmed over pre-war movement. They thought of the old Symbolists favourable to Futurism — men like Gustave Kahn and Rachilde, to whom Marinetti remained faithful — as absolutely outdated. In 1921 the Surrealists attacked Russolo's sound-effects concert, but in 1922, in *Caractères de l'évolution moderne et ce qui en participe* (*Characteristics of Modern Evolution and Its Derivations*) Breton does give a place to Futurism: "I think that Cubism, Futurism and Dada, taken all in all, are not three distinct movements, and that all three are part of a more general movement of which we do not yet know the direction or extent. To tell the truth, the second movement does not have as much interest as the other two, and if one takes it into consideration it is to recognize its good intentions." This last judgement is all the more severe if we bear in mind that, considered merely in its intentions, Futurism anticipated Surrealism in more than one respect. In his *Surrealist Manifesto* of 1924 Breton exalts the image, quoting a definition by Pierre Reverdy: "The image is a pure creation of the mind. It cannot be born of a comparison, but of the bringing together of two things more or less distant between themselves. The more distant and correct the relationship between the two things, the more powerful will be the image..." How could he have forgotten that twelve years earlier, in his *Technical Manifesto for Futurist Literature*, Marinetti had predicted "ever vaster analogies..., ever deeper and more solid relationships, however distant they may be. Analogy is nothing other than the profound love that links remote things, apparently different and hostile... Poetry must be a continuous series of new images... The more images contain vast relationships, the longer they retain their power to surprise..."

In the same way it is hard not to think of descriptions of Surrealist automatism when (in the supplement to the *Technical Manifesto*) we read: "After a number of hours of persistent, painful work, the creative spirit is suddenly freed from the weight of all obstacles, and in some way falls prey to a strange spontaneity of thought and execution. The hand that is writing seems to detach itself from the body and to float a long way free of the brain, while the latter, also somehow detached from the body and become aerial, looks down from above with terrible lucidity at the unexpected sentences emerging from the pen."

The political choices made by the Futurists further exasperated the hostility of the Surrealists. In 1927, at the Théâtre de la

Madeleine, the group organized an attack against Prampolini and his Futurist Pantomime Theatre (in spite of Prampolini's request, Tristan Tzara chose to be absent). In December 1931 *Le surréalisme au service de la Révolution* published a report by Marinetti disfigured by printing errors and cancellations put in deliberately, probably by Breton himself, such as "anti-tradition traditionalist swastika", accompanied solely by the following comment: "This is a report by Marinetti to which we do not think we have to reply." (SF)

Survage, Léopold

pseudonym of Liepold Sturzwage
(Moscow, 1879 - Paris, 1968) Lithuanian painter, naturalized French

Léopold Survage studied music and art in Moscow, where he was fascinated by the Shchukin collection. He moved to Paris in 1908, and through his friend Archipenko met Léger, Apollinaire, Marcoussis and Cendrars. He exhibited with the Cubists from 1911. In 1912-13, music gave him the idea of "coloured rhythms": he intended to animate abstract coloured forms by using cinema. His interest in combining colour and motion links Survage to the Futurists; his only contact with them, however, was through the periodical *SIC*, to which both he and the Futurists contributed. His drawings for animated cartoons with coloured rhythms still exist, but the outbreak of war in 1914 prevented the production of the film, although both Apollinaire and Cendrars supported it enthusiastically. (SF)

Symbolism, Literary

If it is true, as Apollinaire said, that one cannot always carry the corpse of one's father around, it is also sometimes difficult to get rid of it. The Italian Futurists, and especially Marinetti, violently attacked Gabriele D'Annunzio; they discarded Pascoli because of his "debasing and deleterious" influence. They found it harder to go beyond and then dispose of the French Symbolists.

The influence of French Symbolism is evident chiefly in Marinetti, whose first works were written in French. His first book, *La conquête des étoiles* (*The Conquest of the Stars*, 1902), despite the epigraphs by Dante and Edgar Allan Poe, imitated with slightly caricatural results René Ghil's verbal instrumentation, using sonorous adjectives and insistent alliteration without worrying too much about the meaning: "Le fracas effrayant du silence horrifié..." The following book, *Destruction* (1904), is more in the line of Verhaeren, an exclamatory lyricism exalting the world of machines and speed. The play *Le Roi Bombance* (*Re Baldoria* or *King Frolic*), reminiscent of *Ubu Roi*, appeared in 1905, the year in which *Poesia* produced an "international survey of free verse". The subject was obviously no longer new, but Marinetti must have been encouraged to produce the survey by Gustave Kahn — a minor figure of Symbolism who is forgotten today, but was still active at the time and claimed to have invented free verse — and by Gian Pietro Lucini, an Italian Symbolist who took an interest in nascent Futurism.

At the time when Futurism was born, the early forerunners (Whitman, Poe,

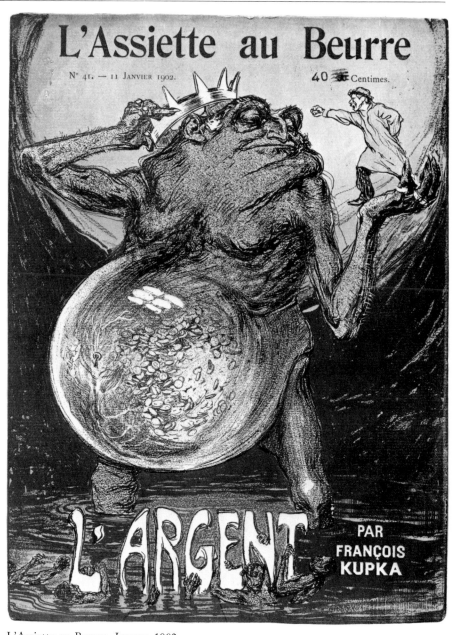

L'Assiette au Beurre, *January 1902*
Money *by F. Kupka*

Baudelaire) and the founders of Symbolism (Mallarmé, Rimbaud, Verlaine, Laforgue, etc.) were dead. In the second generation of Symbolists, Marinetti was attracted only by two or three major figures, such as Verhaeren and Jarry, who appear in *Poesia*; but in general, in his work we find the names of minor writers such as Kahn, Rachilde, Paul Fort, Paul Adam. These are the writers he continued to appreciate when he proclaimed in a manifesto that he was rejecting, "after having greatly loved them, our glorious intellectual fathers — the great Symbolist geniuses Edgar Poe, Baudelaire, Mallarmé and Verlaine". One must not however forget another great connoisseur of French Symbolism: Ardengo Soffici who, with confident taste, chose to translate Mallarmé, Lautréamont, Laforgue, and especially Rimbaud for *Lacerba*. Russia also produced a Symbolism open to the outside world — there were paintings by Ciurlionis in London at the Post-Impressionist exhibition of 1913, and poems of Valery Briusov, a Francophile poet and head of the Russian Symbolist school, in the pages of *Poesia*. Writers such as Ivanov and Balmont lived in Paris while the French poet René Ghil was an active correspondent for the bilingual magazine *The Golden Fleece*. Ghil was well known in Russia: his theories of verbal instrumentation surely influenced certain Futurist theories and also *zaum*. Another well known contemporary was Verhaeren who even visited Russia in 1913, at Briusov's invitation. Lastly, the Russian Symbolists introduced the younger Futurists to the works of Mallarmé, Rimbaud, Laforgue, Corbière, Gourmont, etc. These were names which the Futurists then claimed: David Burliuk celebrated the *Sonnet des voyelles* or imitated *Les fêtes de la faim* in *The Croaked Moon*; Livshits translated Rimbaud and Corbière and borrowed the title *Soleil des loups* from the latter. Bobrov quoted Mallarmé and a poet who was then little known, Charles Cros; Shershenevich translated two volumes by Laforgue, and so on. In England, under the influence of Ezra Pound, the Vorticists took little interest in French Symbolism, with the exception of Jules Laforgue, greatly admired by Pound, Eliot and many others. The Vorticists' points of reference were French, Italian, or Provençal, but belonged to a far more distant past (François Villon, Théophile Gautier, Dante, Cavalcanti, etc), while the essayist T.E. Hulme, more attracted to philosophy, was influenced by Bergson. The word "vortex", made fashionable by French Symbolism, was used repeatedly by Laforgue. We should add that Mexican Stridentism also owed its name to Laforgue, according to its chief creator, Maples Arce, who also recognized forerunners in Baudelaire, Mallarmé, Whitman, and Verhaeren, poets of the industrial world and the efforts of man. The French Symbolists, Mallarmé, Rimbaud, or Laforgue, left a weighty heritage not only for their more or less direct descendants like Apollinaire, Cendrars and Marcel Duchamp, but also for Futurism and its related schools. Italian Futurism was original in having felt at certain moments that it was necessary to get rid of this bond. (SF)

F.T. Marinetti, International Survey of Free Verse, *1909*

S. Mallarmé, Un coup de dés, *1914*

Symbolism, Plastic

In the Symbolist Manifesto (1886), Moréas acknowledged poets like Baudelaire, Mallarmé and Verlaine as interpreters of the invisible, and expounded upon the new aims of poetry which must not describe but rather "clothe the Idea in a form that the senses can perceive". The Idea is approached by means of symbols, which create analogies and allusions evoking images of the mysterious. Whereas for the Symbolists the Idea was the prime mover of representation, for the Futurist painters — Boccioni in particular — it was sensation that generated the rhythms and lines of the painting. Boccioni wrote, for example: "Natural sensations must suggest states of colour and states of form to the painter, so that forms and colours become self-expressive, without resorting to the formal presentation of objects or parts of objects.... Through the emotions aroused, the objects must dictate the rhythm of signs, volumes, planes, of abstract and concrete ranges which will be for the eye what sound, and not music, is to the ear." Feeling is transposed into a language which is formal rather than affective, and which Boccioni found chiefly in Previati's Symbolist painting. The French tendency towards artifice and bizarre, obscure feelings was not followed in Italy. Grubicy, Previati, Segantini, Bistolfi and Pellizza developed religious or spiritual themes using curved, wavy lines to express universal ideas corresponding to sentiments aroused by nature. English Symbolist culture, in particular Beardsley's illustrations, with their sinuous line, fascinated Boccioni already in 1907, when he was looking for a new form of painting: "I feel I want to paint what is new, born of our industrial age... How should I do this? with colour? or with drawing? with painting?... with realist tendencies that no longer satisfy me or with Symbolist tendencies which I rarely like and have never tried?" Severini was more influenced by French culture and in an article published in the *Mercure de France* (1 February 1916), "Symbolisme plastique et symbolisme littéraire", he found similarities between Mallarmé's poetic thought and Futurist aesthetics — an idea-sensation generated by external reality is represented by means of forms and colours. An "Idea-ist realism" Severini called it, in which objects become the symbol and synthesis of the idea. (EC)

Synchromism

Synchromism, from its debut in Munich in June 1913, and its subsequent exhibition at the Bernheim-Jeune Gallery in Paris the following October, was the first American avant-garde painting to attract attention in Europe. Conceived in Paris by the expatriate American Morgan Russell, along with his colleague Stanton Macdonald-Wright, Synchromism meant "with colour", stressing an emphasis on colour rhythms. Synchromist paintings were among the first to be composed of abstract shapes, often concealing the submerged forms of figures. Russell's ambition to invent a new and influential style of modern painting accompanied by manifestos was prompted by his seeing the Futurist exhibition at the Bernheim-Jeune Gallery in February 1912.

First Synchromist Exhibition, Munich, 1913

In the catalogue of their Munich exhibition, Russell and Macdonald-Wright competitively attacked the Futurists, noting: "The Futurists naively believed they had taken a big step forward by subordinating the static element in favour of movement. But static and dynamic qualities in art are two forces that supplement each other, and their concurrence permits us to feel one or the other strongly." In the foreword to the Synchromists' Paris show, Macdonald-Wright's brother, the critic Willard Huntington Wright, alleged that the Futurists "merely reverted to juvenile literary illustration". (GL)

Tactilism

Although the idea of *Tattilismo* was already present in certain proposals of previous manifestos concerning the sense of touch, smell, etc., this movement was launched by Marinetti with a Manifesto dated 11 January 1921. Picabia, in an article published in *Comoedia*, denied Marinetti the paternity of Tactilism, saying that such an attempt had already been made some years before in New York. Marinetti certainly deserves credit as the only artist to have produced interesting results in this field, with the "tactil plates" he created using varied materials. (PH)

Tatlin, Vladimir

(Moscow, 1885 - Moscow, 1953) Russian painter, architect and designer

Vladimir Tatlin received his greatest artistic shock when he visited Picasso's studio on a short trip in 1913, and saw the reliefs made out of cardboard and tin representing guitars and mandolins. When he came back to Moscow, he started to work on what he came to call counter-reliefs. Very soon however, Tatlin's reliefs departed from Cubist themes and spatial conceptions and became "real materials in real space". Abandoning the use of limiting frames or backgrounds, he built "corner-relief" constructions suspended across the corner of walls. (At about the same time Malevich, Tatlin's rival as leader of the new Russian art, was placing his famous painting *Square on Square* in a similar position, influenced perhaps by the traditional positions of icons.) Tatlin's reliefs were roughly made and the materials were crudely stuck together. He sought to move from the abstract to the real and leave aesthetics behind. The materials themselves — wood, iron, glass and concrete — were chosen because of their symbolic associations with construction. There are obvious similarities between some of the theories behind the counter-reliefs and certain works by Boccioni, for example *Fusion of a Head and a Window* (1912-13), but it has not been possible to establish whether Tatlin had ever seen photographs of Boccioni's sculptures. The great difference of course is that Tatlin's art developed a non-figurative and even architectural dimension. The *Monument for the Third International*, the famous tower from 1920, would become Tatlin's best-known work.

The similarities between the *Collation of Materials: Zinc, Palisander Wood, Deal* from 1917, now in the Tretyakov Gallery in Moscow, and what is left of the Boccioni *Horses + Houses* of 1916, in the Peggy Guggenheim Collection, is quite striking. There is however a very great difference between Tatlin's general conception and the ideas of the Futurists. Tatlin was at this time obsessed by the idea of the destruction of art, which already had a long tradition in Russia, going back more than half a century. Tatlin's ideas exerted a great influence, because they expressed something that everyone felt to be necessary in a time of such far-reaching revolutionary changes — the denial of formal values in favour of concentration on content. (PH)

Tato

pseudonym of Sansoni, Guglielmo (Bologna, 1896 - Rome, 1974) Italian painter and photographer

Tato emerged after the First World War as a leader of the Emilian Futurist group. From 1922 until the early Forties he was present in Futurist exhibitions and active as a creator and organizer. His Casa d'Arte in Bologna also produced designs for interior decoration. In 1924 he moved to Rome. He signed the *Manifesto of Futurist Aeropainting* (1929) and with Marinetti launched the *Manifesto of Futurist Photography* (1930). In 1934 he cosigned the manifestos on *Mural Plastic Art* and *African Poetry, Music and Architecture*, with Marinetti, Fillia and Carlo Cocchia.

Tato's Futurist painting was based initially on a dynamic synthesis between a strong chromatism and lively narration. During the Thirties he developed a documentary style which he used to illustrate the adventures of flying machines. He described his Futurist activity in his autobiography *Tato raccontato da Tato, vent'anni di futurismo* (*Tato Narrated by Tato: Twenty Years of Futurism*, 1941). (ECr)

Teige, Karel

(Prague, 1900 - Prague, 1951) Czech critic, graphic artist and avant-garde theorist

Karel Teige met Marinetti in 1921, when the Futurist "syntheses" were performed at the Švanda Theatre. Teige followed Futurism methodically during the Twenties and found in it certain stimuli for his artistic theory: the principle of modernity and the admiration for contemporary civilization; the negation of traditional artistic forms; the visualization of poetry, applied to poem-painting; Tactilism, applied in his concept of poetry for the five senses. Teige dedicated several long critical articles to Futurism, in which he noted the contribution of pre-war Futurism to art in Italy and worldwide, but did not conceal his reservations about several aspects of the movement. He criticized particularly the alliance with Italian Fascism, which he saw as a complete mistake. He wrote his first article, "Filippo Tommaso Marinetti a italský futurismus" (F.T.M. and Italian Futurism, Aktuality a Kuriosity, 15.1.1922) following the Prague exhibition of modern art (1921), Marinetti's lectures and the futurist *soirées* at the Švanda Theatre (December 1921). On that occasion Marinetti recited for the members of the Devětsil in Teige's apartment. Teige also met Prampolini, who had often been published in Czech avant-garde magazines and had become a foreign correspondent for the Devětsil review, *Disk*, in 1923, and for Krohe's *Horizont* in 1927.

Teige published a second lengthy article "Futurismus a italska moderna" (Futurism and Italian Modernism) in the Devětsil magazine *Pasmo* (I, 1924-25, no. 10) in which he criticized Futurism from the point of view of Constructivism: "The enthusiasm [of the Futurists] for modern civilization is too blindly poetic. They fail to see its negative aspects... Modern work, as the Constructivists see it, must be totally free from romantic delirium. It must be rational, systematic, non-intuitive and individualistic." In February 1929 Teige dedicated a special issue of the magazine *Red* to Futurism (II, no. 6), in which his essay "F.T. Marinetti + Italian Modernism + Worldwide Futurism" appeared together with numerous translations and reproductions. (FŠ)

Theatre

Futurist interest in theatre is shown in a series of manifestos on theatrical creativity. The *Manifesto of Futurist Playwrights* (1911) extolled synthesis and contempt for the audience. *Chromatic Music* developed the theory of "chromatic drama", a form of abstract theatre which Arnaldo Ginna and Bruno Corra used experimentally in the cinema. *The Variety Theatre* emphasized the important contribution which music-hall entertainment could make to avant-garde theatre. After the manifestos dedicated to *Synthetic Theatre* (1915) and *The Futurist Cinema* (1916) came *Futurist Dance* (1917), *Aero Theatre* (1919), *Visionic Theatre* (1920), *Tactile Theatre* (1921), *Surprise Theatre* (1921), *Magnetic Theatre* (1925).

According to Marinetti in the manifesto of *The Variety Theatre*, contemporary theatre (whether verse, prose or musical) vacillated stupidly between historical reconstruction and the photographic reproduction of daily life. He called it "finicking, slow, analytical and diluted". Only the Variety Theatre, born from technology with no tradition, no masters, no dogma, thriving on immediate reality, possessed the qualities that could give birth to a new genre of theatre. Marinetti focused upon its practical character (it was meant to entertain), its inventiveness (it could never stop or repeat itself), and its "marvellous" quality (made possible by modern technical equipment and use of the cinema).

The "Futurist marvellous" was produced by caricature, ridicule, irony, satire, analogy, cynicism and absurdity, by new uses of light, sound, noise and speech, and by an accumulation of events unfolded at great speed. Pain was caricatured, serious situations were rendered ridiculous, and the bizarre was dressed up to constitute the Futurist idea of the grotesque. The public was seen as collaborating in the action, which took place on stage, backstage, and in the hall itself. The actors considered exemplary were the brilliant, inexhaustible quick-change artist Fregoli, and the mocking, sacrilegious Petrolini.

The Futurist Variety Theatre was "anti-academic, primitive, and naïve". It destroyed "the Solemn, the Sacred, the Serious and the Sublime". To psychology it opposed "body-madness" (*fisicofollia*), to logic the improbable. The masterpiece was reduced to an eccentric number, a gimmick, an attraction. Surprise triumphed. Classical

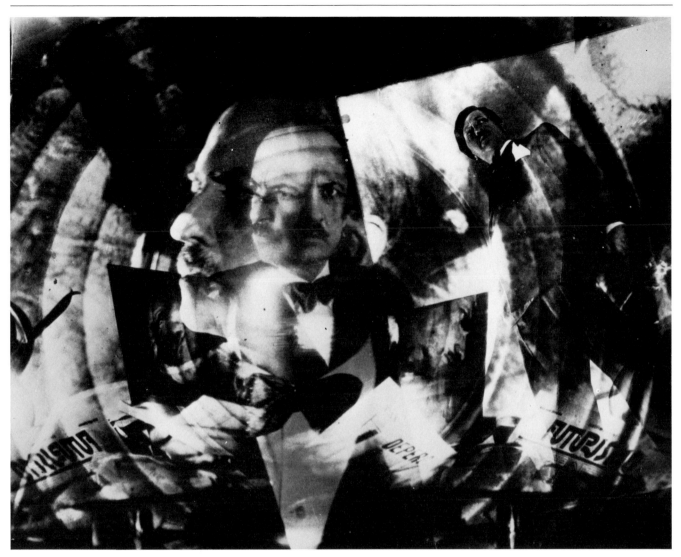

Tato, Futurist Portrait of Marinetti, *1930 c.*

art was prostituted, condensed, comically mixed up. The great musical dramas were animated by popular songs. "Perform a Beethoven symphony backwards." "Reduce all Shakespeare to a single act." "Produce *Hernani* with actors tied in sacks up to their necks."

It was the reign of the absurd and grotesque. The French writers of the absurd knew the Futurists' work and surpassed it, while the Italian authors of the grotesque did not understand it and did not go beyond it, but attempted to renew bourgeois theatre with bourgeois methods.

When they launched "Synthetic Theatre" in 1915, the Futurists started a more concrete phase of activity in their process of affirmation and negation. The Synthetic Theatre was opposed to farce, vaudeville, *pochade*, comedy, drama and tragedy. It created new forms and repudiated old definitions by inventing new ones: "lines written in free words, simultaneity, interpenetration, the short, acted-out poem, the dramatized sensation, comic dialogue, the negative act, the re-echoing line, 'extralogical' discussion, synthetic deformation, the scientific outburst."

This mini-production of drama — the works collected in the two volumes of *Il teatro futurista sintetico* (*The Futurist Synthetic Theatre*, 1915-16) and those published later in periodicals and books, and collected in *Teatro italiano d'avanguardia - Drammi e sintesi futuriste* (*Italian Avant-garde Theatre - Futurist Plays and Syntheses*, 1970) — attests to the existence of numerous trends, which can be summarized as follows: grotesque and eccentric theatre; theatre of the absurd; occult and magical theatre; abstract theatre; film and "visionic" theatre; ideological and polemical theatre; and Futurist Expressionist theatre.

Grotesque and eccentric theatre revealed two tendencies: the rejection of literary models (bourgeois theatre, so-called "poetic" theatre, historical theatre — against which a campaign had already been conducted by the Florentine paper *La Difesa dell'Arte* directed by Virginio Scattolini with the collaboration of Carli, Settimelli, and Corra), and opposition to models taken from reality (family, marriage, passéist life styles). Volt's *Flirt* and Mario Dessy's *L'ostinazione della morte* (*The Obstinacy of Death*) belong to the theatre of the absurd. A sense of magic and the occult characterizes Arnaldo Ginna's *Davanti alla finestra* (*Before the Window*) and *Uno sguardo dentro di noi* (*A Look Inside Ourselves*). The pure abstraction of colour and sound is represented by Depero's *Colori* (*Colours*), Balla's *Per comprendere il pianto* (*To Understand Grief*), and Marinetti's *Lotta di fondali* (*Struggle of Back-Drops*). Examples of film and "visionic" theatre are Remo Chiti's *Costruzione* (*Construction*) and *Parole* (*Words*); Marinetti's *La camera dell'ufficiale* (*The Officer's Room*); Dessy's *La pazzia* (*Madness*) and *La tradotta* (*Troop-Train*); and the syntheses by Angelo Rognoni, *Domenica* (*Sunday*), *Piazza di paese* (*Village Square*).

Marinetti's *Antineutralità* (*Antineutrality*) and Chiti's *Giallo e nero* (*Yellow and Black*, which is anti-Hapsburg with occultist features, so that the author called it the "drama of a telepathic nightmare") are ex-amples of ideological and polemical theatre. *Ecce Homo* and *Anarchie* (*Anarchy*) by Ruggero Vasari are examples of Futurist-Expressionist theatre (that is, of the meeting between Futurism and the German world). Vasari was not part of the first group of Synthetic Theatre authors; later he created the "machine cycle" and supported Achille Ricciardi's "Theatre of Colour", for which he wrote *Tung Ci* in 1921.

Pino Masnata also belonged to the Synthetic Theatre movement, although his manifesto *Visionic Theatre* (1920), broadened its programme and transferred a sector of the synthetic pieces from the film to the "visionic" category. ("Visionic" theatre was characterized by the presence of one "creating" character and several "created" characters, who were evoked and formed by the creating character's thought and memory.) Masnata, the first theoretician and historian of "visual poetry" (i.e. poetry to be looked at), published his "visionic" works in 1926 in the volume *Anime sceneggiate* (*Dramatized Souls*). Subsequently he also worked on dramatic texts specifically written for radio performance, which he and Marinetti called "radia", aiming at a radiophonic art.

In the Twenties Marinetti extended his theatrical activity. The inspirations and inventions of the "Theatre of Surprise", proposed by Francesco Cangiullo and Marinetti and based mainly on gags (what the Commedia dell'Arte called "inventiones et actiones"), drew considerable public attention. In the name of the Theatre of Surprise, the travelling De Angelis company carried avant-garde theatre throughout Italy, even to those provinces with little modern theatrical experience. The Teatro degli Indipendenti, a permanent avant-garde theatre established in Via degli Avignonesi in Rome, was not predominantly Futurist: its founder, Anton Giulio Bragaglia, preferred to follow and present all artistic trends, from Dadaism to Expressionism, from Surrealism to Imagism to Bontempelli's Novecentismo. Nevertheless, he gave considerable scope to Futurist authors and especially to Futurist designers — the "stage-architects" Virgilio Marchi, Enrico Prampolini, Ivo Pannaggi, Vinicio Paladini, Antonio Fornari, Antonio Valente.

Enrico Prampolini began his theatrical activity in 1915 with a theoretical article published in the Messina periodical *La Balza*; it was the first Futurist contribution to the field of stage design. Prampolini supported "dynamic" as opposed to traditional "static" settings. He wrote numerous theoretical and critical articles, and participated directly in the "Theatre of Colour" and the "Magnetic Theatre", and in numerous "Synthetic Theatre" productions with Pirandello, Marinetti and Bragaglia in the most important European theatres, including those of Prague. In 1927 he created the "Futurist Pantomime Theatre" with Maria Ricetti at the Théâtre de la Madeleine in Paris. There he was able to translate theory into practice, developing his theatrical ideas in the most committed and challenging form. Among those who collaborated with Prampolini in the "Pantomime Theatre" were Luigi Russolo with his "rumorarmonio" and "enharmonic bows", Silvio Mix (who composed the music for *Angoscia delle macchine*, *Anguish of the Machines*), Francesco Balilla Pratella, and Franco Casavola. The writers included Luciano Folgore, Marinetti (*Cocktail*), Luigi Pirandello and Vittorio Orazi. The music for Pirandello's *Salamandra* was composed by Massimo Bontempelli.

After the experience of Synthetic Theatre was concluded, Marinetti continued to write plays of a more regular type. He adopted a synthetic form composed of several acts and, at his best, showed vivid stylistic energy, but he often ignored the "cultured" stage direction then popular (that is, non-improvised, whereas improvisation was typical of many Futurist productions). Thus his work was largely unsuccessful because carelessness hid his talent. *Prigionieri* (*Prisoners*), based on the erotic nightmares of a group of convicts on an island, is perhaps his most important work of the Twenties, using dream-like forms reminiscent of Symbolism and Surrealism. *Vulcani* (*Volcanoes*) is an allegory in which the unbridled forces of nature represent the vital energies of the world. With *Tamburo di fuoco* (*Firedrum*) he returned to earlier African, social, and cosmic themes. *Ricostruire l'Italia con architettura futurista Sant'Elia* (*Rebuilding Italy with Sant'Elia Futurist Architecture*), which was never produced, was a return to his origins, a large-scale metaphor for the fundamental conflict between old and new; the rivalry between the new forces of "Spatialists" and "Speedists" allows the victory of the old "Softeners" who symbolize regressive disintegration.

Historians and critics of Marinetti's day did not acknowledge the existence of Futurist theatre. However, the impact of the first Futurist theatrical initiatives was notable: nearly the entire avant-garde was influenced directly or indirectly. Pirandello's most famous plays show that he followed the Futurists' work closely. The theatrical revolution of Marinetti and his followers opposed traditional action, the supremacy of the actor, bourgeois theatre, literary theatre, painted scenery, logical, progressive action, historical reconstruction, rationality, ready-made theatre cut off from the audience, psychological theatre, theatrical technique, anthropomorphism, sentimentality, comedy, "theatre for the ears", the traditional dimension, and the traditional stage. They were in favour of the fleeting moment, the supremacy of the author, anti-bourgeois theatre, theatrical theatre, constructed scenery or abstract scenery produced by light effects, "visionic" action by analogy (cutting and flashbacks), dynamic contemporary life, the irrational, the absurd, the abstract, theatre conceived and produced with the public, anti-psychological theatre, magnetic theatre, theatrical non-technique and multi-technique, theatre of things and objects, theatre of anti-sentimentality and cruelty, gag theatre, theatre for the eyes, multidimensionality, and the world as a stage. (MV)

The Futurist Synthetic Theatre
(Futurist manifesto, Milan, 18 January 1915)

As we await the great war we have longed for, we Futurists alternate our violent antineutralist action in the city squares and universities with our artistic action to prepare the Italian sensibility for the great hour of maximum danger. Italy must be fearless, eager, as swift and elastic as a fencer, as indifferent to blows as a boxer, as impassive at the news of a victory that may have cost fifty thousand dead as at the news of a defeat.

For Italy to learn to make up its mind with lightning speed, to hurl itself into battle, to sustain every undertaking and every possible calamity, books and reviews are unnecessary. They interest and concern only a minority, are more or less tedious, obstructive, and slackening. They chill enthusiasm, check impulses, and poison a people at war with doubts. War — Futurism intensified — obliges us to march and not to rot [*marciare, non marcire*] in libraries and reading rooms. *We therefore believe that the only way to inspire Italy with the warlike spirit today is through the theatre.* In fact ninety percent of Italians go to the theatre, whereas only ten percent read books and reviews. But what is needed is a *Futurist theatre*, the exact opposite of the passéist theatre that drags its monotonous, depressing processions around the sleepy Italian stages.

Not to dwell on historical theatre, a sickening genre already abandoned by passéist audiences, we condemn all contemporary theatre because it is prolix, analytical, pedantically psychological, explanatory, diluted, finicking, static, as full of prohibitions as a police station, cut up into cells like a monastery, musty like an old abandoned house. In a word, it is a pacifist, neutralist theatre, the antithesis of the fierce, overwhelming, synthesizing velocity of war.

Our Futurist Theatre will be:

Synthetic. That is, very brief. To compress into a few minutes, into a few words and gestures, innumerable situations, feelings, ideas, sensations, facts, and symbols.

The writers who intended to renew the theatre (Ibsen, Maeterlinck, Andreiev, Claudel, Shaw) never thought of reaching a true synthesis, freeing themselves from a technique that involves prolixity, meticulous analysis, drawn-out preparation.

Before the works of these authors, the audience has the same revolting position as a group of bystanders slowly tasting their anguish and pity as they watch the slow agony of a horse who has collapsed on the pavement. The belch of applause that finally breaks out frees the audience's stomach from all the indigestible time it has swallowed. Each act is like waiting patiently in an antechamber for the minister (*coup de théâtre:* kiss, pistol shot, surprise, explanation, etc.) to receive you. All this passéist or semi-Futurist theatre, instead of synthesizing facts and ideas into as few words and gestures as possible, savagely destroys the variety of place (a source of dynamism and amazement) by stuffing many town squares, landscapes and streets into the sausage of a single room. This theatre is therefore entirely static.

We are convinced that mechanically, by force of brevity, we can achieve an entirely

Futurist Syntheses, *Prague, 1922*

G. Valmier, costumes for Nine Comedies *by Marinetti, 1921, Seroussi Gallery Collection*

new theatre perfectly in tune with our swift and laconic Futurist sensibility. Our acts can also be moments [*atti - attimi*] lasting only a few seconds. With this essential and synthetic brevity the theatre can face and even win its competition with the *cinema. Atechnical.* The passéist theatre is the literary form that most distorts and diminishes an author's inspiration. This form, much more than lyric poetry or the novel, is subject to *the demands of technique:* (1) to omit every notion that doesn't conform to public taste; (2) once a theatrical idea has been found (expressible in a few pages), to stretch it out over two, three or four acts; (3) to surround an interesting character with many pointless types: coat-holders, door-openers, all sorts of bizarre comic turns; (4) to make the length of each act vary between half and three-quarters of an hour; (5) to construct each act taking care to (*a*) begin with seven or eight absolutely useless pages, (*b*) introduce a tenth of your idea in the first act, five-tenths in the second, four-tenths in the third, (*c*) shape your acts for rising excitement, each act being no more than a preparation for the finale, (*d*) always make the first act *a little boring* so that the second can be *amusing* and the third *devouring*; (6) to set off every *essential* line with a hundred or more insignificant *preparatory* lines; (7) never to devote less than a page to explaining an entrance or an exit minutely; (8) to apply systematically to the whole play *the rule of a superficial variety*, to the acts, scenes, and lines. For instance, make one act a day, another an evening, another deep night; make one act pathetic, another anguished, another sublime; when you have to prolong a dialogue between two actors, make something happen to interrupt it, a falling vase, a passing mandolin player. ... Or else have the actors constantly move around from sitting to standing, from right to left, and meanwhile vary the dialogue to make it seem as if a bomb might explode outside at any moment (e.g., the betrayed husband might catch his wife red-handed) when actually nothing is going to explode until the end of the act; (9) to be enormously careful about *the verisimilitude of the plot*; (10) to write your play in such a manner that *the audience understands in the finest detail the how and why of everything that takes place on the stage, above all that it knows by the last act how the protagonists will end up.*

With our synthetist movement in the theatre, we want to destroy Technique, which from the Greeks until now, instead of being simplified, has become more and more dogmatic, stupid, logical, meticulous, pedantic, strangling. *Therefore:*

1. *It's stupid to write one hundred pages where one would do*, just because the audience out of habit and infantile instinct wants to see a character in a play result from a series of events, needs to believe that the character really exists in order to find the play artistic, refusing to acknowledge any art if the author simply sketches in a few of the character's traits.

2. *It's stupid* not to rebel against the prejudice of "good theatre" when life itself (which consists *of actions infinitely more limited, regulated and predictable* than those that unfold in the world of art) is for the most part *antitheatrical* and even in this of-

fers *innumerable possibilities for the stage. Everything of any value is theatrical.*

3. *It's stupid* to pander to the primitivism of the crowd, which, in the last analysis, wants to see the bad guy lose and the good guy win.

4. *It's stupid* to worry about verisimilitude (absurd because talent and worth have no connection with it).

5. *It's stupid* to want to explain with logical minuteness everything taking place on the stage, when even in life one never grasps an event entirely, in all its causes and consequences, because reality vibrates around us, bombarding us *with volleys of fragments of inter-connected events, mortised, confused, meshed, chaotic.* For example, it's stupid to act out a contest between two persons *always* in an orderly, clear, and logical way, since in our daily modern life we nearly always encounter mere *flashes of argument* in *moments*, in a tram, a café, a railway station, which remain filmed in our minds like fragmentary dynamic symphonies of gestures, words, lights, and noises.

6. *It's stupid* to accept obligatory *crescendi, prepared effects,* and *postponed climaxes.*

7. *It's stupid* to allow one's inspiration to be burdened with the weight of a technique that *anyone* (even fools) *can acquire by study, practice, and patience.*

8. *It's stupid to renounce the dynamic leap into the void of total creation, beyond the range of territory previously explored.*

Dynamic. That is, born of improvisation, the flash of intuition, the suggestive and revealing moment. We believe that a thing is valuable to the extent that it is improvised (hours, minutes, seconds), not extensively prepared (months, years, centuries). We feel an unconquerable dislike for work written *a priori*, without considering the conditions and environment of a particular stage. *Most of our works have been written in the theatre.* The theatrical environment is our inexhaustible source of inspiration: the magnetic circular sensation invading our tired brains during morning rehearsal in an empty gilded theatre; an actor's intonation that suddenly suggests a paradoxical development; a movement of scenery that gives the idea for a symphony of lights; an actress's fleshiness that inspires rich intuitive glimpses.

We raided Italy at the head of a heroic battalion of players who imposed *Elettricità* and other Futurist syntheses (alive yesterday, today surpassed and condemned by us) on audiences that were revolutions imprisoned in auditoriums. From the Politeama Garibaldi of Palermo to the Dal Verme of Milan. The Italian theatres, used to gloomy passéist audiences, lost their wrinkles under the wild massage of the crowd and shook with earthquakes of laughter. We fraternized with the actors. Then on sleepless nights in trains we argued, goading our imaginations to the rhythm of tunnels and stations. Our Futurist theatre cares nothing for Shakespeare but listens to the gossip of actors, falls asleep over Ibsen but is inspired by red or green reflections from the stalls, suffocates over a comma in Sophocles but takes into account the individual presentation of an actress.

Autonomous, alogical, unreal. The Futurist theatrical synthesis will not be subject to logic and will reject photographic representation; it will be *autonomous*, resembling nothing but itself. It will take elements from reality and combine them as its whim dictates. Scattered through the outside world, for painters and composers there exists a narrower but more intense life made up of colours, forms, sounds, and noises. *In the same way, the man gifted with theatrical sensibility knows a specialized reality that violently assaults his nerves:* it consists of what is called *the theatrical world.*

The Futurist theatre is born of the vital currents in Futurist sensibility defined in the two manifestos "The Variety Theatre" and "Weights, Measures, and Prices of Artistic Genius". These are: (1) our frenzied passion for today's swift, fragmentary, elegant, complicated, cynical, muscular, fleeting, Futurist life; (2) our modern cerebral definition of art according to which no logic, no tradition, no aesthetic, no technique, no opportunity can be imposed on the artist's inspiration. His only concern should be to create synthetic expressions of cerebral energy that have *the absolute value of novelty.*

The *Futurist theatre* will be able to excite its audience and make it forget the monotony of daily life by thrusting it through *a labyrinth of utterly original sensations combined in unpredictable ways.*

Every evening the *Futurist theatre* will be a gymnasium where the spirit of our race will be trained in the swift, dangerous feats this Futurist year requires.

Conclusions

1. Totally abolish the technique, that is, kill the passéist theatre.

2. Fill the theatre with all the mental adventures suggested by our inspiration, however improbable, strange and anti-theatrical they may be.

3. Symphonize the audience's sensibility by exploring its darkest corners and stirring up its laziest layers using every possible means.

4. Eliminate the preconceived idea of the footlights by throwing nets of sensation between stage and audience; the stage action will invade the stalls and the audience.

5. Fraternize warmly with the players, who are among the few thinkers who avoid deforming cultural exercises.

6. Abolish farce, vaudeville, pochade, comedy, serious drama and tragedy, and gradually create instead all the many forms of Futurist theatre: free dialogue, simultaneity, interpenetration, dramatized sensation, scripted laughter, the negative act, the reechoing line, "extra-logical" discussion, synthetic deformation, the possibility of scientific exploration.

7. Through continuous contact, create between ourselves and the crowd a current of confidence without any respect, in order to instil in our audiences the dynamic vivacity of a new Futurist theatricality.

These are the *first* words on the theatre. In Milan Futurist architecture will be giving us the great metal building with the electromechanical inventions we must have in order to stage our freest conceptions.

F.T. Marinetti, E. Settimelli, B. Corradini

The Variety Theatre

(Futurist manifesto, Milan, 29 September 1913)

We are deeply disgusted with the contemporary theatre (verse, prose, and musical) because it vacillates stupidly between historical reconstruction (pastiche or plagiarism) and photographic reproduction of our daily life; a finicking, slow, analytic and diluted theatre worthy, at the most, of the age of the oil lamp.

Futurism exalts the Variety Theatre because:

1. The Variety Theatre, born as we are from electricity, fortunately has no tradition, no masters, no dogma, and lives on the swift present moment.

2. The Variety Theatre is absolutely practical, because it aims to distract and amuse the public with comic effects, erotic stimulation, or imaginative astonishment.

3. The authors, actors, and technicians of the Variety Theatre can exist and triumph only by constantly inventing new ways of astonishing. Hence the absolute impossibility of stopping or repeating oneself, hence a determined competition of brains and muscles to break all the various records of agility, speed, strength, intricacy and elegance.

4. The Variety Theatre is unique today in using the cinema, which enriches it with an incalculable number of visions and otherwise unrealizable spectacles (battles, riots, horse races, automobile and aeroplane meets, trips, voyages, depths of the city, the countryside, oceans, and skies).

5. The Variety Theatre, being a profitable show window for countless inventive efforts, naturally generates what I call "the Futurist marvellous", produced by modern mechanics. Here are some of the elements of this "marvellous": (*a*) powerful caricatures; (*b*) abysses of the ridiculous; (*c*) delicious, subtle ironies; (*d*) all-embracing, definitive symbols; (*e*) cascades of uncontrollable hilarity; (*f*) profound analogies between humanity, the animal, vegetable, and mechanical worlds; (*g*) flashes of revealing cynicism; (*h*) combinations of wit, repartee, and conundrums that refresh the intelligence; (*i*) the whole gamut of laughter and smiles to relax the nerves; (*j*) the whole gamut of stupidity, imbecility, doltishness, and absurdity, which insensibly push the intelligence to the border of madness; (*k*) all the new significations of light, sound, noise, and language, with their mysterious and inexplicable extension into the least-explored part of our sensibility; (*l*) an accumulation of events unfolded at great speed, of stage characters pushed from right to left in two minutes ("and now let's take a look at the Balkans": King Nicholas, Enver Pasha, Daneff, Venizelos, bellyblows and fistfights between Serbs and Bulgars, a couplet and everything vanishes); (*m*) instructive satirical pantomimes; (*n*) caricatures of suffering and nostalgia, strongly impressed on our feelings by gestures exasperating in their spasmodic hesitant, weary slowness; grave words made ridiculous by funny gestures, bizarre disguises, mutilated words, grimaces, pratfalls.

6. Today the Variety Theatre is the crucible in which the elements of an emergent new sensibility are seething. Here you find an ironic decomposition of all the worn-out

prototypes of the Beautiful, the Great, the Solemn, the Religious, the Ferocious, the Seductive, and the Terrifying, and also the abstract elaboration of the new prototypes that will succeed these.

The Variety Theatre is thus the synthesis of everything that humanity has up to now refined in its nerves to divert itself by laughing at material and moral pain; it is also the bubbling fusion of all the laughter, all the smiles, all the mocking grins, all the contortions and grimaces of future humanity. Here you can taste the joy that will shake men a century from now, their poetry, painting, philosophy, and the leaps of their architecture.

7. The Variety Theatre offers the healthiest of all spectacles in its dynamism of form and colour (simultaneous movement of colourful jugglers, ballerinas, gymnasts and riding masters, spiral cyclones of dancers spinning on the tips of their toes). In its swift, overwhelming dance rhythm the Variety Theatre forcibly shakes the slowest souls out of their torpor and forces them to run and jump.

8. The Variety Theatre alone seeks the audience's collaboration. The public is not immobilized like a stupid voyeur, but joins noisily in the action — singing, accompanying the orchestra, communicating with the actors in surprising witticisms and bizarre dialogues. And the actors argue clownishly with the musicians.

The Variety Theatre uses the smoke of cigars and cigarettes to join the atmosphere of the audience to that of the stage. And because the audience cooperates with the actors' imagination, the action develops simultaneously on the stage, in the boxes and in the pit. At the end of the performance it goes on among the hordes of fans, the monocled dandies who crowd the stage door to compete for the star; double final victory: chic dinner and bed.

9. The Variety Theatre is a school of sincerity for man because it exalts his aggressive instinct and strips woman of all the veils, all the phrases, sighs and romantic sobs that mask and deform her. On the other hand it brings out all woman's marvellous animal qualities, her hold, her powers of seduction, treachery and resistance.

10. The Variety Theatre is a school of heroism, constantly setting new records of difficulty and effort which create the strong, healthy atmosphere of danger on the stage. (E.g., death-diving, "looping the loop" on bicycles, in cars, and on horseback.)

11. The Variety Theatre is a school of subtlety, complication, and mental synthesis, with its clowns who are magicians, mind readers, mental prodigies, character actors, mimics and parodists, its musical jugglers and American comedians, whose fantastic pregnancies give birth to astonishing objects and actions.

12. The Variety Theatre is the only school that one can recommend to intelligent adolescents and young people, because it gives quick incisive explanations for the most emotional and abstruse problems and most complicated political events. Example: A year ago at the Folies-Bergère, two dancers acted out the meandering discussions between Cambon and Kinderlen-

Futurist Synthetic Theatre, *1916, cover by Boccioni*

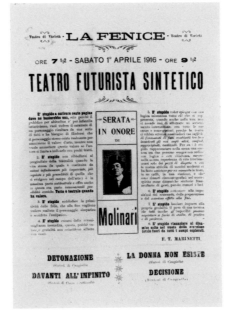

Futurist Synthetic Theater, *at La Fenice 1916*

Watcher [*sic*] on the question of Morocco and the Congo in a revealing symbolic dance that was worth at least three years' study of foreign affairs. Facing the audience, their arms linked, they made mutual territorial concessions by jumping back and forth, left and right, never separating, each keeping his eye on the goal of cheating the other. Flawlessly diplomatic, they gave an impression of extreme courtesy, skilful vacillation, ferocity, mistrust, stubbornness, precision.

Furthermore the Variety Theatre brilliantly explains the laws governing modern life: (*a*) need for complication and different rhythms; (*b*) fatal use of lies and contradiction (e.g., two-faced English *danseuses*: shepherdess and terrible soldier); (*c*) omnipotence of a methodical will that modifies and multiplies human powers; (*d*) simultaneity of speed + transformations.

13. The Variety Theatre systematically disparages ideal love and its romantic obsession by repeating the nostalgic languors of passion to the point of weariness as a monotonous routine. It mechanizes sentiment, healthily disparages and crushes the compulsion towards carnal possession, lowers lust to the natural function of coitus, deprives it of every mystery, every crippling anxiety, every unhealthy idealism.

Instead, the Variety Theatre gives a feeling and a taste for easy, light, ironic loves. Open air café-concert performances on the terraces of casinos present a most amusing struggle between spasmodic moonlight, tormented by infinite sufferings, and the electric light bouncing off the fake jewellery, painted flesh, multicoloured petticoats, velvets, sequins and false colour of lips. Naturally the energetic electric light triumphs at the expense of the soft decadent moonlight.

14. The Variety Theatre is naturally antiacademic, primitive, and naïve, hence significant for its surprising explorations and the simplicity of its means. (E.g., the systematic round of the stage made by the *chanteuses*, like caged animals, at the end of every couplet.)

15. The Variety Theatre destroys the Solemn, the Sacred, the Serious, and the Sublime in Art with a capital A. It cooperates in the Futurist destruction of immortal masterpieces by plagiarizing and parodying them, and presenting them simply, as ordinary music-hall acts, without the usual fuss and apology. So we unconditionally endorse the forty minute performance of *Parsifal* now in rehearsal in a great London music-hall.

16. The Variety Theatre destroys all our ideas of perspective, proportion, time, and space. (E.g., a little doorway with a gate thirty centimetres high, alone in the middle of the stage, which certain American comedians open and close very seriously, coming and going through it as if there were no alternative.)

17. The Variety Theatre offers us all the maximum levels of achievement: the greatest speed and the finest gymnastics and acrobatics of the Japanese, the greatest muscular frenzy of the Negroes, the greatest development of animal intelligence (horses, elephants, seals, dogs, trained birds), the finest melodic inspiration of the Gulf of Naples and the Russian steppes, the

best Parisian wit, the greatest compared strength of different races (boxing and wrestling), the greatest anatomical monstrosity, the greatest female beauty.

18. The conventional theatre exalts the inner life, professorial meditation, libraries, museums, in other words (dirty thing and dirty word), *psychology*, whereas, on the other hand, the Variety Theatre exalts action, heroism, life in the open air, dexterity, the authority of instinct and intuition. To psychology it opposes what I call "body-madness" (*fisicofollia*).

19. Finally, to countries like Italy that lack a single great capital city, the Variety Theatre offers a brilliant résumé of Paris as the supreme home of luxury and ultra-refined pleasure.

Futurism wants to transform the Variety Theatre into a theatre of amazement, record-setting, and body-madness.

1. One must completely destroy all logic in Variety Theatre performances, exaggerate their luxuriousness in strange ways, multiply contrasts and make the absurd and the improbable complete masters of the stage. (Example: Oblige the *chanteuses* to dye their décolletage, their arms and especially their hair, in all the colours hitherto neglected as means of seduction. Green hair, violet arms, blue décolletage, orange chignon, etc. Interrupt a song and continue with a revolutionary speech. Sprinkle a romantic song with insults and profanity, etc.).

2. Prevent a sort of tradition from establishing itself in the Variety Theatre. Therefore oppose and abolish the Parisian 'Revues', as stupid and tedious as Greek tragedy with their *Compère* and *Commère* playing the part of the ancient chorus, their parade of political personalities and events underscored by wisecracks in tiresome logical sequence. The Variety Theatre, in fact, must not be what it unfortunately nearly always is today, a more or less amusing newspaper.

3. Introduce surprise and the need to act among the audience in the stalls, boxes, and balcony. Some random suggestions: spread a powerful glue on some of the seats, so that the male or female spectator who gets stuck makes everyone laugh (the damaged frock coat or toilette will naturally be paid for at the door). - Sell the same ticket to ten people: traffic jam, bickering and wrangling. - Offer free tickets to gentlemen or ladies who are notoriously unbalanced, irritable, or eccentric and likely to provoke uproars with obscene gestures, pinching women, or other freakishness. Sprinkle the seats with itching or sneezing powder, etc.

4. Systematically prostitute all of classic art on the stage, for example by performing all the Greek, French and Italian tragedies, condensed and comically mixed up, in a single evening. - Enliven the works of Beethoven, Wagner, Bach, Bellini, Chopin by introducing Neapolitan songs. - Put Duse, Zacconi and Mayol, Sarah Bernhardt and Fregoli side by side on the stage. - Play a Beethoven symphony backwards, beginning with the last note. - Boil all of Shakespeare down to a single act. - Do the same with all the most venerated authors. - Have actors recite *Hernani* tied in sacks up to their necks. Soap the floorboards to cause amusing tumbles at the most tragic

moments.

5. In every way encourage the genre of the clowns and American comedians with their inspiring use of the grotesque and of terrifying energy, their crude jokes, monstrous brutalities, trick waistcoats and trousers as deep as a ship's hold out of which, with other things, will come the great Futurist laughter that should make the world's face young again.

Because remember, we Futurists are *young gunners out for fun*, as we proclaimed in our manifesto, 'Let's kill the Moonshine', fire + fire + light against moonshine and against old firmaments war every night great cities brandish electric signs immense negro face (30 metres high + 150 metres height of the building = 180 metres) open close open close golden eye 3 metres high *smoke smoke Manoli smoke Manoli cigarettes* woman in a blouse (50 metres + 120 metres of building = 170 metres) tighten loosen violet rosy lilac blue corset froth of electric light bulbs in a champagne glass (30 metres) sparkle evaporate in a mouthful of darkness electric signs dim die under a dark hand tenacious rebirth continue in the night the effort of the human day courage × folly never die nor stop nor sleep electric signs = formation and disintegration of minerals and vegetables centre of the earth blood circulation in the iron faces of Futurist houses increases, empurples (joy anger more more quick harder) as soon as the negative pessimist sentimental nostalgic shadows besiege the city brilliant awakening of streets that channel the smoky swarm of work by day two horses (30 metres tall) roll golden balls with their hoofs *Gioconda purgative waters* crisscross of *trrrr trrrrr* Elevated *trrrr trrrrr* overhead hoo-hoo-hooting whissstle ambulance sirens and fire-trucks transformation of the streets into rich corridors guide push logical necessity the crowd towards trepidation + laughter + music-hall uproar *Folies-Bergère empire crème-éclipse* tubes of mercury red red red blue violet huge letter-eels of gold purple diamond fire Futurist challenge to the weepy

night the stars' defeat warmth enthusiasm faith conviction will-power penetration of an electric sign into the house across the street *yellow slaps* for that gouty man in slippers nodding off 3 mirrors watch him the sign plunges into 3 redgold abysses open close open close 3 billion kilometres deep horror quick go out out hat stick steps taximeter push shove *zuu zuoeu* here we are dazzle of the promenade solemnity of the panther-cocottes in their musical tropics fat warm smell of music-hall gaiety = tireless ventilation of the world's Futurist brain.

F.T. Marinetti

Tiflis

Georgia (today Tbilisi, capital of the Georgian Soviet Socialist Republic)

With the outbreak of war, several Russian Futurists considered it prudent to move away. In 1916, Kamensky and Kruchenykh were in Tiflis, which was left out of the war and did not become a Soviet holding until 1920. There they discovered a well-organized, cosmopolitan avant-garde familiar with the most recent French poetry. Prominent were the Georgian poets Tizian Tabidze and Paolo Jashvili (who edited the periodical *The Blue Horns* from 1916) and the Armenian Futurist Kara-Darvish (as early as 1910, Hrand Nazariantz published a little book in Armenian, *Marinetti and Futurism*). Kruchenykh organized poetry readings and Futurist *zaum* events in various languages, particularly at the Fantastic Cabaret towards the end of 1917. A group dubbed "41" formed around Kruchenykh, the Zdanevich brothers, and Igor Terentev, and published a short-lived magazine entitled *41*. The group's activities were summed up in a collective work entitled *To Sophia Melnikova, the Little Fantastic Cabaret* (1919) in Russian (Kruchenykh, Terentev, Ilia Zdanevich), in Georgian (Jashvili, Tabidze, Grigol Rokabidzé), and in Armenian (Kara-Darvish), with splendid typographic experimentation and illustrations by Goncharova, Zdanevich and Gudiashvili. More

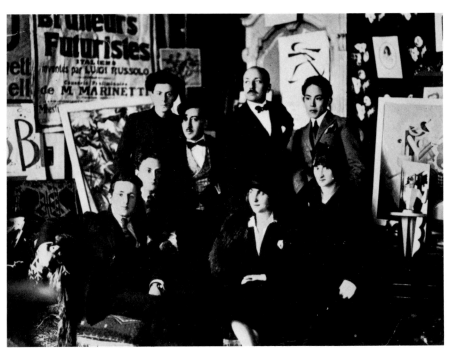

Marinetti and Togo in Turin, 1920

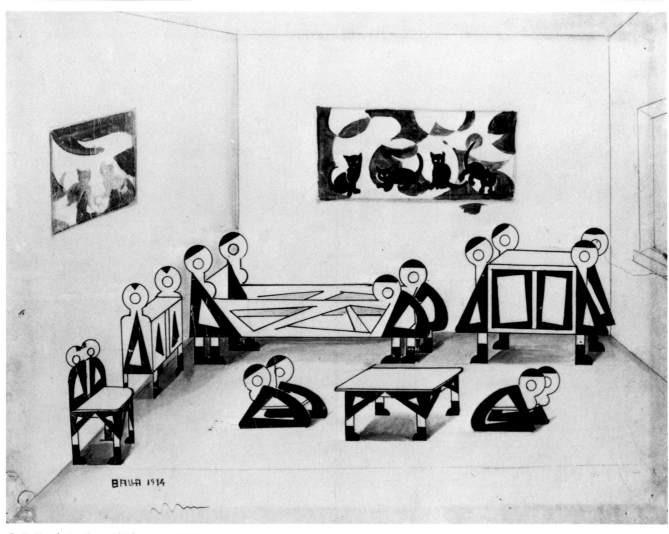

G. Balla, design for a child's room, 1914

than its external appearance, a certain nihilism and a desire to astonish the reader, evident in Kruchenykh and Terentev, make this collection an expression of the Dadaist spirit, although Dada was to make its official entry into Georgia, without Futurism, only much later, in publications like *The Dreaming Gazelles* and *H2 SO4*. (SF)

Tihanyi, Lajos
(Budapest, 1885 - Paris, 1938) Hungarian painter

A member of the Ma group, with which he exhibited in 1918, Tihanyi was acquainted with the leading figures of the contemporary European avant-garde, as his portraits of Marinetti, Huidobro and Tzara demonstrate. His painting was the product of a personal mixture of Expressionism, Cubism and Futurism. (SF)

Togo, Seiji
(Kagoshima, 1897-1978) Japanese painter

Seiji Togo was still a child when his family moved to Tokyo. Beginning in 1914 his paintings showed the influence of German Expressionism and Italian Futurist painting, artistic movements which were then barely known in Japan.

In 1916 at the Nikkaten exhibition he presented the Futurist work *Woman with Parasol*, winning the first prize.

In 1921 he was in Paris and almost certainly in the same year he went to Turin to meet Marinetti and remained for a brief period

to work together with the Italian artist. Returning to Paris, Togo was influenced by Cubism. His painting focused particularly on figures and was characterized by a lyrical and decorative style.

After returning to his own country, he became a member of the Nikkakai Fine Arts Institute. (TA)

Torres-García, Joaquim
(Montevideo, 1874 - Montevideo, 1949) Uruguayan painter

Of Catalan origin on his father's side, Torres-García moved to Barcelona in 1892. From 1907 he tended toward Mediterraneanism and the Graeco-Latin tradition. In 1917 a combination of factors converted him to the avant-garde: the Futurism of Barradas, a clash with the *noucentista* leader Eugeni d'Ors, the death of Enric Prat de la Riba (President of the Mancomunitat) which deprived him of numerous official commissions, and the scant popularity of his work. The lecture that Torres delivered at the Galeries Dalmau on 22 February 1917 confirmed his role as one of the most important theoreticians in the Catalan avant-garde. Torres developed concepts of evolutionism and plasticism, attributing value to originality as opposed to tradition. He published manifestos and articles in magazines sympathetic to Futurism — *Un Enemic del Poble, Arc Voltaic, Troços*. He also contributed to exhibitions at the Galeries Dalmau, where he showed paint-

ings that expressed the dynamism of the city of Barcelona and his famous wooden toys. Torres had a formative influence on several important figures in Catalan Futurism such as Salvat-Papasseit, with whom he collaborated. (JAJ)

Toys and Play
The desire to fuse artistic expression with daily life led the Futurists to appreciate all forms of vitality, including play. Play was seen as an antithesis to passéist seriousness, a link to the irrational and unexpected, and a fulfillment of a certain childish character of the new mechanical being. Besides, by temporarily putting a stop to social life and suspending all aesthetic laws, art appeared similar to play, so Depero and Balla found a relationship between sculpture and toys.

In their *Futurist Reconstruction of the Universe*, toys became an instrument of the artist's responsibility: "With plastic complexes (assemblages) we shall construct toys which will accustom the child: 1) to spontaneous laughter (through absurdly comical tricks); 2) to maximum elasticity (without resorting to thrown projectiles, whip-cracking, pin-pricks etc.; 3) to imaginative impulses (by using fantastic toys to be studied under a magnifying glass, small boxes to be opened at night containing pyrotechnic marvels, transforming devices etc.; 4) to the continual exercise and sharpening of his sensibility (in the un-

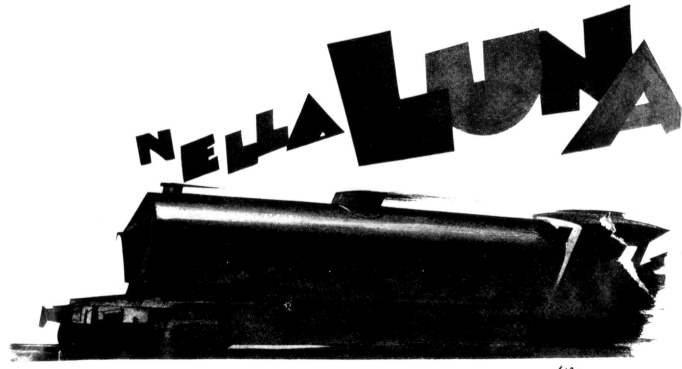

bounded realms of acute and exciting noises, smells and colours)...'' (11 March 1915). In creating toys and mechanical animals for an artificial landscape, the Futurists were consciously using techniques of visual and sensorial persuasion on future consumers. Once the banal everyday world was cancelled, a total transformation of the individual could begin. (GC)

Train

The poetry of trains and railway stations was discovered by Symbolists like Laforgue and Impressionists like Monet. The Futurists were not insensitive to the poetry of departures (Boccioni painted *Those Who Go* and *Those Who Stay*) but for them, the train was above all a powerful machine capable of developing increasing strength and speed, a form of transport which was not new but promised to have a great future. Hence the trains in Marinetti, Boccioni, Dudreville and Severini; in Goncharova, Nevinson and Delmarle; and also in Apollinaire, Cendrars, Maples Arce, Albert-Birot, Duchamp, Léger, Feininger, Bortnyik, GAN, Charlot and even Kandinsky. (SF)

Turin

Turin was the setting for one of the first Futurist *soirées* — the *Manifesto of the Futurist Painters* was read at the Politeama Chiarella on 8 March 1910 — and the city became one of the most important centres of second generation Futurism.

The Turinese group was founded in 1923 by Fillia and Bracci, who published the one and only issue of *Futurismo* the following year. The leading figures, besides Fillia, were Diulgheroff and Rosso; they participated in Cubist developments in France and in the European Constructivist and Purist trends. Later on, in the Thirties, they tended toward inner lyricism or formal plasticity. Setting themselves against the Novecento on one hand and the position of the critic Lionello Venturi on the other, the group attempted to recreate a unity of purpose, which would recall original Futurism, in defence of Rationalism and Neo-Plasticism. These positions were supported by Farfa, Sturani, Ferinando, Strumia, Zucco, Ranzi and Costantini. Fillia, the leading spirit of the group, organized the Futurist Pavilion at the Valentino International Exhibition (project by Prampolini) and founded various magazines, including *Vetrina Futurista* (1929). (EC)

Typography and Layout

On 11 May 1912 Marinetti published the *Technical Manifesto of Futurist Literature*, and on 11 August 1912 its supplement with a free-word text "Battaglia, peso + odore" (Battle, Weight + Odour) where he outlined the visual principles of Futurist poetry and layout. He proposed the abolition of punctuation, the use of mathematical signs, and the creation of pauses and rhythms to give musical and visual value to the printed page. These suggestions became more specific in "Immaginazione senza fili" (Imagination without Strings, 1913) where Marinetti proclaimed the beginning of a "typographical revolution" aimed at destroying the harmony of the page, "which is contrary to the ebb and flow, the leaps and bursts of style that run through the page. On the same page, therefore, we will use *three or four different colours of ink* and even 20 different typefaces if necessary. For example: italics for a series of similar, swift sensations, boldface for violent onomatopoeias, etc."

It was a statement in favour of a graphic poetry conditioned and inspired by the printing press, the assortment of typefaces and the industrial design of written information — a telegraphic, fast, simultaneous poetry related to advertising communication. This search for a new visualization of words turned the page into a wild concert of uncontrollable language, taken to the limits of logic and layout. In free-word poems, in fact, the words, liberated from the chains of propositions and sentences, start to move around the page. They form constellations of calligraphic arabesques, show their freedom and independence from a system of coordinates, live their own life with no hierarchies or limitations. Having discovered the relativity of their being anywhere, they travel within the territory of the page. Called on to represent actions or objects, they take on analogous forms, imitating a spiral, a running train, a diver, the sun, an explosion, a mountain, a stunt, or a cloud of smoke. Following an almost plastic idea, which rejects the conventional methods of printing, the different typefaces — Bold, Roman, Italic, Capitals — of the various characters give form to images that use unorthodox processes to communicate a poetical sensation. The result is a simultaneous vision where the reader understands the general meaning of the poem at first sight. He identifies it with the main image just as he does with an advertising poster. Borrowing the new industrial techniques of communication, the poetical message becomes "self-illustrative" — a strongly figurative spelling and printing immediately convey the lyrical sensation visually. In "Zang Tumb Tumb" (1914) by Marinetti, in *Lacerba* and in the later compositions of free-words developed in 1914 (Cangiullo's "Palpavoce", where there are only consonants and vowels) and in 1915, with Paolo Buzzi's "L'eclisse e la spirale" (The Ellipse and the Spiral), Soffici's "BIF & ZF + 18: simultaneità e chimismi lirici" (BIF & ZF + 18: Simultaneity and Lyrical Chemisms), Govoni's "Rarefazioni" (Rarefactions), the disintegrated language of Futurist poetry visualizes images and thoughts, allegories and metaphors, sounds and smells, bombardments and events by using typographical and typewritten characters which follow unusual but identifiable lines. An empty space does not mean absence, but is evidence of the fast movement of the writing, as it skims over the white territory of the page. Later on paper was replaced by metal because for the Futurist the written or printed page was a "table" or "plate" where poetical food and visual images could be quickly consumed. The ephemeral, weightless volumes suggest the chaotic mass of a bubbling world being moulded mechanically.

The rejection of the traditional ways of aligning words is also connected with the new fluidity of the language, which matches the intensity of the emotions. Ignoring every usual standard of composition, words and phonemes, syllables and vowels melt and stamp themselves into the porosity of coloured paper, slide like film negatives over metal surfaces, explore space and then let themselves be bolted into unexpected places. At times the written fragments or particles are penetrated, mutilated, overturned to form astral constellations of poetical forms that the reader will be able to grasp only with a new aerial vision. The gigantic dimensions of Balla's free-word plate *Rumoristica plastica Baltrr*, 1914, made of coloured paper and tin-foil, in fact recall a poster readable from a fast-moving car. The reading takes places through written signs, but first the explosion of colours and shapes seizes attention by its visual dynamism. One could even say that the Futurist graphic contribution already takes into consideration the coming of the "multiple man" and gives him material for his mechanical senses. That typography is a language able to transform our perception of the world was confirmed by its invasion of the stage. In Balla's *Macchina tipografica* (*Printing Machine*, 1914) all that appears on the stage is the word *Typography*, in huge letters inside which the actors create noises and onomatopoeias. In Depero's design for the *Padiglione del libro* (*Book Pavilion*, 1927) the Futurist page, with its typographical characters, has an architectural and environmental function.

By using typography for its graphic possibilities, the Futurists created a revolution in the field of artistic information. Communication no longer depended only on the meaning of the word, but also on its fast, interchangeable apparition on all the surfaces and volumes to be scanned for information. From the Twenties onwards, the Futurists, and in particular Depero, Pannaggi, Paladini, became very interested in advertising. They created posters for Campari and Zampini, covers for *Emporium* and *Vogue*, and also promotional items — posters, membership cards, writing paper, books — for the movement itself.

This great swirl of unsettled typography created a cosmos whose energy fell back into the world in a multitude of typographical forms, filling the visual field of international culture with the "bizarre rhythms of free imagination". (GC)

I. Zdanevich, As If Zga, *Tiflis, 1920*

Udaltsova, Nadezhda Andreevna

(Orel, 1886 - Moscow, 1961) Russian painter
After studying at Konstantin Yuon's private art school, she continued her studies in Paris where in 1911-12 she worked under Metzinger, Le Fauconnier and de Segonzac. In this period she met up with the other Russian artists in Paris and joined the avant-garde groups. After returning to Moscow she contributed to all the major exhibitions, including the "Jack of Diamonds" (1914 and 1916), "Tramway V" (1915) and "0-10" (1916). In 1916-17 she created an important series of Suprematist compositions. After the Revolution she temporarily left studio painting to devote herself to teaching (first at the Free Art, Workshops, then at Vkhutemas and Vkhutein) and to industrial and book design. (SZ)

Ultraism

Ultraism was an artistic and literary movement very close to Italian Futurism, prominent in Spain between 1918 and 1925. Ramón Gómez de la Serna introduced Futurism to Spain by publishing Marinetti's manifesto in his review *Prometeo* (Madrid, June 1910). The same issue presented the *Proclamas Futuristas a los Españoles* (*Futurist Proclamations to the People of Spain*) by Gómez de la Serna and Marinetti (June 1910).

The Ultraists considered Gómez de la Serna, Juan Ramón Jiménez, Rafael Cansinos-Asséns and José Ortega y Gasset their main sources of inspiration. The founding manifesto of Ultraism (*Ultra*) appeared in several Madrid papers in the autumn of 1918, signed by Guillermo de Torre, the movement's chief theorist, Cesar A. Cornet, Xavier Bóveda and others. The text was written, but not signed, by Rafael Cansinos-Assens, the organizer of the group. Of the various Ultraist manifestos published successively, the most programmatic and incisive was the *Manifiesto Ultraista Vertical* by Guillermo de Torre, which appeared in *Grecia* on 1 November 1920. In this text several Futurist ideas reappear, such as "words-in-freedom" ("descomposición tipografica: las linotipias sufren un ataque de histeria"), "dynamism" and "machinism", illustrated by explicitly sexual metaphors.

The Ultraists organized three important *soirées* using the same provocative style as the Futurists and Dadaists. In the first of these, held at the Ateneo Sevillano on 2 May 1919, poems by Apollinaire and Marinetti's "Song of the Automobile" were read. The other two, which took place at La Parisina (1 January 1921) and the Ateneo de Madrid (30 April 1921) did not enjoy a favourable press. The Ultraist movement became known throughout Spain chiefly through already existing periodicals like *Grecia* (Seville, 1918 - Madrid, 1920; in 1921 it changed its name to *Tableros*, edited by Isaac del Vando Villar and illustrated by Rafael Barradas), *Los Quijotes* (Madrid, 1915-18), *Alfar* (La Coruña, 1921-22). The Ultraists also started new magazines: *Ultra* (Madrid, 1921-22) and *Reflector* (Madrid, 1920).

The Ultraist movement can be defined as a point of convergence of the influences of various European avant-garde movements

A. Soffici, extract from BIF & ZF + 18 *1915*

and aesthetic trends. Many important elements came from Italian Futurism: the cult of speed and machinery, the adoption of iconoclastic attitudes, dynamism, the desire to destroy tradition and exalt the new. The movement brought together Spanish and international painters: Vazquez Díaz, Francisco Bores, Barradas, the Delaunays, Nora Borges, Paszkiewicz and Wladislaw Jahl. But it was in poetry that Ultraism exercised its greatest influence. Contact with modern French lyric poetry (Apollinaire, Max Jacob) also promoted familiarity with the experimental poetry of Italian Futurism. Traces of such works as Apollinaire's *Calligrammes*, Marinetti's *Futurist Words-in-Freedom*, Cangiullo's *Poesia pentagrammata* can be found in the work of Ultraist poets: Guillermo de Torre (*Hélices*, 1922), Isaac del Vando Villar (*La sombrilla japonesa*, 1924), Jorge Luis Borges and Gerardo Diego (*Imagen*, 1922 and *Manuel de Espumas*, 1924).

The end of Ultraism has been dated by Leo Geist to 1925, the year in which Guillermo de Torre published his essay *Literaturas europeas de vanguardia*, containing the first critical evaluation of the movement. (JAJ)

Unanimism

In 1906 a group of writers and painters gathered in Créteil under the name "L'Abbaye": Georges Duhamel, Charles Vildrac, Luc Durtain, H.M. Barzun, Albert Gleizes and others. With this original core, Jules Romains, author of books of verse like *L'âme des hommes* (*The Soul of Men,* 1904) and *La vie unanime* (*The Unanimous Life,* 1908), launched Unanimism. The movement, characterized by social and humanitarian concerns, celebrated the urban scene, crowds, and the new conditions of modern life, taking as its forerunners poets like Walt Whitman and Emile Verhaeren, and novelists like Zola, whom the Futurists would exalt in their turn. Marinetti was certainly aware that Unanimism preceded Futurism, and from time to time he made his bow to Jules Romains. (SF)

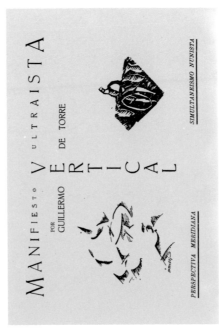

G. de Torre, Vertical Ultraist Manifesto *1920*

Valmier, Georges

(Angoulême, 1885 - Paris, 1937) French painter

Valmier attended the Paris School of Fine Arts. He was interested in Cubism and in 1913 began to exhibit his work at the Salon des Indépendants. He was greatly influenced by Cubist aesthetics, and his style became totally abstract after 1929 when he joined the group *Abstraction-Création.* However, when he designed the costumes for *Nine Comedies by Marinetti*, performed in 1922, he drew nearer to Futurist forms and dynamism. (SF)

Vasari, Ruggero

(Messina, 1898 - Messina, 1968) Italian writer

In 1921 Ruggero Vasari published *Tre razzi rossi* (*Three Red Rockets*), and in 1923 *La mascherata degli impotenti* (*The Masquerade of the Impotents*). He moved to Berlin where he was leader of the Futurist movement and director of a gallery, The International Center of Artists, and of *Der Futurismus*, a monthly magazine. In 1925 he published *L'angoscia della macchina* (*Anguish of the Machine*), a tragic synthesis in three acts performed for the first time in Paris at the Art et Action theatre on 27 April 1927. (EC)

Venice

As one of the "passéist" cities, Venice was violently attacked by the Futurists — beginning with the *Manifesto of Futurist Painters* of 11 February 1910 — as a symbol of romanticism and sentimentalism evoking memories of ancient grandeur. "We repudiate ancient Venice, exhausted and ravaged by centuries of voluptuousness, a city that we too have loved and possessed in a great nostalgic dream... We want to heal this rotting city, magnificent sore of the past... We want to prepare the birth of an industrial and military Venice able to dominate the Adriatic, that great Italian lake", was written on leaflets scattered from the Clock Tower on 27 April 1910. The battle continued on 1st August at the Teatro La Fenice during a *soirée* punctuated by the "resounding slaps" administered by Boccioni, Russolo and Carrà, and by Armando Mazzi's punches. In his Futurist speech to the Venetians, amidst verbal violence and literary flourishes, Marinetti expressed his hopes for a new city. In mid-July, the first big exhibition of Boccioni's paintings and drawings, presented by Marinetti, had opened at Ca' Pesaro, but stylistically his work was still close to Divisionism. On 7 May 1911 Marinetti gave a lecture on Futurism at the Teatro La Fenice. In *Lacerba* (15 July 1913) Govoni published a poem on Venice recalling Marinetti's vision. In 1926, Futurist works appeared for the first time at the Venice Biennale. (EC)

Against Passéist Venice

(Futurist manifesto, 27 April 1910)

We repudiate ancient Venice, exhausted and ravaged by centuries of pleasure, the Venice that we too have loved and possessed in a great nostalgic dream.
We repudiate the Venice of the foreigners, market of antiquarian fakers, magnet of universal snobbishness and stupidity, bed worn out by processions of lovers, jewelled hip-bath for cosmopolitan courtesans, great

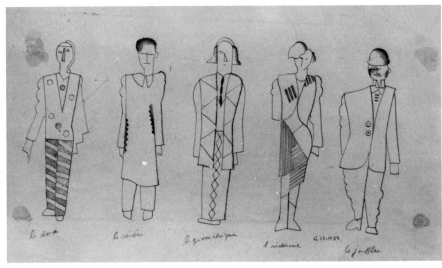

G. Valmier, costume for Nine Comedies by Marinetti, *1921, Seroussi Gallery Collection*

Comoedia, 6 January 1911, "Futurist Speech to the Venetians"

sewer of traditionalism.
We want to heal this rotting city, magnificent sore of the past. We want to give new life and nobility to the Venetian people, fallen from their ancient grandeur, drugged by a nauseating cowardice and abased by the habit of dirty little business deals.
We want to prepare the birth of an industrial and military Venice able to dominate the Adriatic, that great Italian lake. Let us fill the stinking little canals with the rubble of the tottering, infected old palaces. Let us burn the gondolas, rocking chairs for idiots, and raise to the sky the majestic geometry of metal bridges and smoke-crowned factories, abolishing the drooping curves of ancient buildings.
Let the reign of the divine Electric Light come at last, to free Venice from her venal hotel-room moonlight.

F.T. Marinetti, U. Boccioni
C. Carrà, L. Russolo

Verhaeren, Emile

(Ghent, 1855 - Rouen, 1916) Belgian writer

Of all the Symbolists, Emile Verhaeren was the one most universally acclaimed by the various branches of Futurism. He was the first to write with burning vitality about such modern themes as "the tentacular cities", the world of machines, factories, and crowds at work. Marinetti hailed in him "the rhapsodist and hallucinatory visionary" of modern times.
Verhaeren enjoyed the homage of the Futurists (after that of the Unanimists), but he himself felt closer to a movement that was soon forgotten, Paroxysm. The Italian Futurists continued to admire him. The Mexican Stridentists, chief among them Maples Arce, hailed him as a forerunner. But it was in Russia that Verhaeren was greeted with the greatest enthusiasm (1913). The Russian Futurists did not gladly accept lessons from abroad, but Verhaeren's richly coloured urban poetry seduced both Elena Guro and Sergei Bobrov. (SF)

Vesnin Brothers

Alexander (Jurevec, 1883 - Moscow, 1959);
Viktor (Jurevec, 1882 - Moscow, 1950);
Leonid (Niznij Novgorod, 1881 - Moscow,
1933) Russian architects

All architects, the Vesnins are known in
Russia mainly as the designers of the Palace
of Culture (today called ZIL), in the Pro-
letarskii district of Moscow, built between
1930 and 1934. Of the three, Alexander
was the one most closely connected with
the avant-garde. Also a painter, he ex-
hibited paintings and watercolours from
1911. After the Revolution he was one of
the founders of Vkhutemas, where he in-
troduced his brothers, and later of Vkhu-
tein. He was a leading figure in Construc-
tivism, as the organizer of OSA (Contem-
porary Architects' Association) and editor
of the magazine *Architektura*, where he
published many of the utopian architectural
projects. He also worked as a set designer at
the Maly and Kamerny Theatres in
Moscow. (SZ)

Vibrationism

Vibrationism was a style of painting in-
vented by Rafael Barradas during his long
stay in Spain (1913-28), based on his per-
sonal interpretation of Futurist pictorial
dynamism combined with Cubist in-
fluences. Vibrationism became known
through exhibitions of paintings by Bar-
radas, the most important of which were
held in March 1918 at the Galeries Dalmau
in Barcelona and in 1919 at the Sala Mateu
in Madrid. Illustrations in avant-garde
magazines of the period also contributed to
spreading his invention. One of these
magazines, *Arc Voltaic* (Barcelona, 1918)
carried a subtitle, "Vibrationism of Ideas",
clearly referring to Rafael Barradas. (JAJ)

Villon, Jacques

pseudonym of Duchamp, Gaston
(Damville, 1871 - Puteaux, 1963) French
painter and engraver

Eldest of the Duchamp brothers,
Jacques Villon studied engraving in Rouen
before settling in Paris (1895), where he
lived by selling drawings to satirical publ-
ications such as *Le Rire* and *L'Assiette au*
Beurre. Although he began painting in oils
in 1904, he concentrated mainly on engrav-
ing up till 1910. In 1912 the Duchamp
brothers became acquainted with all the
Cubists and their champions, Apollinaire,
Salmon, and Roger Allard; at their home in
Puteaux there were meetings in which
technique and theory were discussed. It was
Villon who invented the name "Section
d'or" for their exhibition in 1912. Like his
brothers, and like their neighbour Kupka,
Villon was interested in ways of expressing
motion but with a different spirit from the
chronophotography and Futurism that cer-
tain of his works might suggest, such as the
painting *Soldiers Marching* or the engraving
The Funambulist of 1913. He himself was
careful to make the distinction: "It is a
mistake to compare me with the Futurists.
First of all I do not know them, and then —
this is what counts — they conceive motion
broken down into successive steps, which is
absolutely a cinematographic procedure,
whereas I want to express the synthesis of
motion through continuity." While Villon
was not interested in Futurist theory — the

copy of the book *Pittura scultura futuriste*
(*Futurist Painting and Sculpture*) that Boc-
cioni gave him with a dedication remained
uncut — he was undoubtedly interested in
their work. (SF)

Vorticism

Vorticism was conceived as British art's
independent alternative to Cubism,
Futurism and Expressionism. The word
Vorticism was coined by Ezra Pound early
in 1914, and he explained in the Vorticists'
magazine *Blast* that "the vortex is the point
of maximum energy. It represents, in
mechanics, the greatest efficiency. We use
the words 'greatest efficiency' in the precise
sense — as they would be used in
a text book of Mechanics". Most of the
artists associated with Vorticism had
previously been impressed by Marinetti and
the Italian Futurists, who first exhibited in
London at the Sackville Gallery in March
1912. The Vorticists sympathized with
Marinetti's call for an art directly ex-
pressive of the new machine age, and they
also admired the Italian leader's dynamic
ebullience. But by 1914 they had begun to
resent Marinetti's attempts to enlist them
as members of the Futurist movement.
Pound, who had become dissatisfied with
his earlier commitment to the poetic move-
ment, Imagism, was eager to involve
himself with a new group. So was Wynd-
ham Lewis, who explained his conception
of the vortex by telling a friend to think "at
once of a whirlpool... At the heart of the
whirlpool is a great silent place where all the
energy is concentrated. And there, at the
point of concentration, is the Vorticist".
The stillness of this "great silent place" was
far removed from Italian Futurism, which
preferred to rhapsodize about the machine
age and convey its excitement through blur-
red, multiple images which stressed the ex-
hilaration of movement. Vorticism valued
energy, too, and Pound defined the vortex
as "a radiant node or cluster... from which,
and through which, and into which, ideas
are constantly rushing". But the Vorticists
preferred to define single forms rather than
embrace flux, vagueness and rapid motion.
A Vorticist picture is often explosive in its
implications, using diagonal forms redolent
of pistons and girders which reach out
towards the edges of the composition.
Alongside this restless energy, though,
there is a strong emphasis on firm, clear-cut
forms, often enclosed by strongly defined
contours. The Vorticists were fascinated by
the modern world, and wanted to incor-
porate its mechanistic structures in their
work. But they tempered this enthusiasm
with a cool, hard awareness of the machine
age's impersonal harshness. They knew how
dehumanized the modern urban world
could be, and they saw no reason to echo
the ecstatic romanticism of Marinetti's at-
titude towards 20th century dynamism.
The arrival of Vorticism was announced
with great gusto, wit and belligerence in the
first issue of *Blast* (July 1914), edited by
Lewis. Aggressive, cheeky and wildly
uninhibited, its opening manifestos set out
to attack a wide range of targets. England
was blasted first, "from politeness", and its
climate cursed "for its sins and infections,
dismal symbol, set round our bodies, of ef-
feminate lout within". Vorticism was virile

in character, and wanted to wage war on
the legacy of the Victorian era. Lewis and
his friends aimed at freeing England from
the stifling influence of the past, and their
magazine shouted: "Blast years 1837 to
1900." *Blast* used laughter like a bomb, in
order to discredit the forces which
prevented England, and English art in par-
ticular, from realizing its full potential. The
Vorticist manifestos maintained that "we
are Primitive Mercenaries in the Modern
World... a movement towards art and imag-
ination could burst up here, from this lump
of compressed life, with more force than
anywhere else".
Blast also believed that England had more
of a right than any other nation to define
the new 20th century world in its art.
The Vorticists wanted to place this "Modern
World" at the very centre of their art. They
filled their pictures with what *Blast* de-
scribed as "the forms of machinery, Fac-
tories, new and vaster buildings, bridges
and works". But they had no desire to
depict this world in too representational a
style. Lewis criticized the Futurists for
their "careful choice of motor omnibuses,
cars, aeroplanes, etc.", and declared that
"the Automobilist pictures were too 'pic-
turesque', melodramatic and spectacular,
besides being undigested and naturalistic to
a fault". Cubism, which had also influenced
many of the Vorticists at an early stage in
their careers, was likewise criticized. Lewis
announced that Picasso's Cubist sculpture
"no longer so much interprets, as definitely
makes, nature (and 'dead' nature at that)".
The Vorticists believed that their inten-
tions could best be conveyed by a more
abstract language. Not because they be-
lieved in *total* abstraction as a desirable end
in itself. The Vorticists thought that the
machine age demanded a severely
simplified, hard, bare approach. *Blast* pro-
claimed that machinery "sweeps away the
doctrines of a narrow and pedantic Realism
at one stroke", enabling the Vorticists to
develop a language which contained many
layers of references. A Vorticist picture
could therefore be read in several different
but equally legitimate ways. It could be
seen as a map, a vision, an aerial view of the
earth, a diagram, a blueprint for a machine,
or a distillation of an urban scene with
buildings and robot-like figures. All these
possibilities were contained in a single im-
age, and Lewis had no desire to restrict
them in any way. He wanted Vorticism to
be richly allusive even as it refined and
simplified its formal vocabulary. In 1915 he
explained that the Vorticist work of art
should be "a hallucination or dream (which
all the highest art has always been) with a
mathematic of its own".
Who were the members of the Vorticist
movement? The list of signatures at the end
of the manifesto in *Blast* included eleven
names, but not all of them were closely in-
volved with the group. Richard Aldington,
who had collaborated with Pound in the
Imagist movement, was a writer with only
a marginal commitment to Vorticism.
Malcolm Arbuthnot, a photographer who
had met Lewis at the Rebel Art Centre,
never made Vorticist photographs. (Alvin
Langdon Coburn performed that role in
1916-17 when he invented Vortography,
but his signature did not appear in the *Blast*

manifesto). The other nine names were all directly caught up in the Vorticist cause: Lawrence Atkinson, Jessica Dismorr, Henri Gaudier-Brzeska, Cuthbert Hamilton, Ezra Pound, William Roberts, Helen Saunders, Edward Wadsworth and, of course, the tireless Wyndham Lewis himself. But both Atkinson and Hamilton seem to have played minor roles in the movement, while Dismorr and Saunders were heavily under Lewis's influence. The most substantial and active Vorticist artists were Lewis, Wadsworth, Gaudier and Roberts. Gaudier and Wadsworth both contributed written material to *Blast* as well as illustrations of their current work, and between 1914 and 1915 the sturdy Roberts executed some of the most impressive Vorticist drawings and water-colours. Pound also contributed essays to *Blast*, and he played a crucial part in supporting and defining the Vorticist movement as a critic. But Lewis was the dominant Vorticist, performing a multi-faceted role as editor, artist, critic and writer of fiction.

The list of signatures in *Blast* excluded several artists whose work had much in common with the Vorticists. Frederick Etchells certainly executed work which can be described as Vorticist with complete confidence. So did Epstein, whose *Rock Drill* put many Vorticist ideas into compelling sculptural form. But he was almost as determined to distance himself from Vorticism itself as David Bomberg, who adamantly rejected Lewis's invitation to contribute to *Blast*. Bomberg also refused advances from Marinetti, who only succeeded in attracting the loyalty of one English artist: Christopher Nevinson.

Despite the rivalries within the group, Vorticism stood a good chance of establishing itself as a major force. So indeed it did, but only for a short time. A few weeks after *Blast* was published, the First World War erupted. The militancy of Vorticism was rapidly overtaken by the outright militarism of a call-to-arms. So the Vorticists had little more than a year to develop their ideas. In June 1915 they held the first "Vorticist Exhibition" at the Doré Galleries, London, and a month later the second issue of *Blast*, a "war number", was published. Lewis claimed in the magazine that "we have subscribers in the Khyber Pass, and subscribers in Santa Fé", but by 1916 most of the Vorticists were fighting in France. Left at home, Pound persuaded the American collector John Quinn to purchase Vorticist work on a grand scale and stage an "Exhibition of the Vorticists" at the Penguin Club in New York (January 1917). But when the Vorticists returned from war, they soon discovered that the world had changed irrevocably. They could not recapture the prewar context of heady experimentation, and by 1920 the movement had ceased to exist. (RC)

Vrubel, Mikhail Alexandrovich
(Omsk, Siberia, 1856 - St. Petersburg, 1910)
Russian painter

A mysterious, disturbing expressive quality in Vrubel's painting influenced and awed a whole generation of Russian Symbolist poets and painters. Subsequently the Cubo-Futurists were attracted to him, but because of his technical innovations connected with textural values.
Gifted with a visionary, instinctive temperament, Vrubel represented mythical and fabulous figures which seem to personify eternal realities of the psyche. His *Seated Demon* (1890), *Princess Swan* (1900), *Pan* (1901) and *Demon* (1902) dominate landscapes to which they do not belong; they merely watch the spectator as elements of subjective attention. Around them abstract geometrical motifs gather, painted in strongly evocative, luminescent colour. Organic matter seems to be crystallized and inorganic matter comes feverishly alive, making the canvas a germinating field, a dense surface in which each part is connected bidimensionally with the others.
These formal aspects, which seem to foreshadow idioms developed by Klimt, in Vrubel come from a natural inclination towards animism, and also from a direct knowledge of Byzantine mosaics which he studied during a visit to Venice and Ravenna in 1885.
The rebirth of the gods of the pagan world in his painting shows a revaluation of the unconscious imagination and a freeing of the instinct, together with a rebellion against every limit. The *Demon* of 1902, which can be considered a variant of Pan seen through a Christian imagination, is very close to the personality of the magician in Nietzsche's *Thus Spake Zarathustra*. Spirit of melancholy, peacock of peacocks, demon of the dusk, it is the emblem of the "penitent of the spirit". But it is also the expression of that which is highest in man, and can exorcise the dark. Solitary amid mauve-blue mountains, Vrubel's demon lies amid the thousand peacock's eyes of his broken wings. The shadow slowly advances, a shapeless bituminous mass, pausing to submerge the gold and mother-of-pearl iridescence of his wings. (GDM)

Wadsworth, Edward
(Cleckheaton, Yorkshire, 1889 - 1949) British
painter

Son of a wealthy industrialist, Edward Wadsworth studied engineering in Munich in 1906-07 and developed an interest in painting, which he pursued more intently on his return to London, where he studied at the Slade School of Fine Art (1908-12). He was included in the rehang of the "Second Post-Impressionist Exhibition" in January 1913 and joined the Omega Workshops in the summer of that year, leaving with the other "rebels" in October. He also exhibited in the "Cubist Room" at Brighton (1913), the "Post-Impressionist and Futurist Exhibition" (Doré Galleries, 1914), and was a founder member of the London Group in March 1914. He joined the Rebel Art Centre in spring 1914 and was included in the "20th Century Art" exhibition at the Whitechapel Art Gallery (1914), the "Vorticist Exhibition" (Doré Galleries, 1915) and the New York "Vorticist Exhibition" (1917). He also exhibited at the salon of the Allied Artists Association. His work was reproduced in both issues of *Blast* and he translated passages of Kandinsky's *Uber das Geistige in der Kunst* for *Blast* no. 1. After the war he held a one-man show of woodcuts at the Adelphi Gallery (1919) and exhibited in 1920 with Group X. He was a member of Unit 1 in 1932 and of Abstraction-Création.
Wadsworth's earliest known work shows an awareness of Impressionism and Post-Impressionism as well as of an academic classicizing art.
In 1913, he began to develop an interest in Cubism. This was a year of great experiments for Wadsworth who must also have been deeply impressed by the Futurist exhibition of 1912 and by Severini's one-man show at the Marlborough Gallery in 1913, for he began to produce his own Futurist works, notably *The Sandpit* and *The Omnibus*, both now lost. While the former retained an analytical cubist base, *The Omnibus* represented a more radical departure and an acceptance of the fundamental tenets of Futurist painting. Its subject, almost an exact transcription of a passage in the *Technical Manifesto*, echoes

The "Mauritania" in Liverpool camouflaged by Wadsworth, 1918

Severini's *Nord-Sud* as well as *The Autobus*, both of which he exhibited in his Marlborough Gallery show. In its depiction of fragmented mass, speed and movement Wadsworth's *Omnibus* testifies to his adoption of a Futurist manner. Wadsworth's development in 1913 was rapid. His friendship with Lewis, encouraged by their mutual break with Fry, stimulated him to develop a more personal style. In retrospect Lewis described Wadsworth as "a genius of industrial England" and stated that he had "machinery in his blood". One of Wadsworth's first truly industrial subjects was *Radiation* which, according to Ezra Pound, was a "pictorial equivalent of a foundry as perceived... by the retina of intelligence". *Radiation* still displayed evidence of the influence of Severini, particularly his *Spherical Expansion of Light* paintings, and also of Delaunay who had exhibited in London in 1912. Wadsworth's briefly held desire to pursue an art more abstract than Futurism, however, was reflected in his interest in Kandinsky and is further evidenced by the musical title of another painting of the same year, *Scherzo*. Both paintings were received with a certain amount of incomprehension. Industrial machinery and landscape, as Lewis noted, were the principal themes which Wadsworth depicted in 1914 in a series of woodcuts which appeared more abstract as he became familiar with the medium. His treatment of the urban landscape was more classicizing and monumental than the Futurists' and his sense of movement was less frenetic and more measured than theirs. The forms that he employed were more consistent with Parisian art than with Futurism. For example, *Slack Bottom* appears to relate to Picabia's *Procession in Seville* (1912) and *The Open Window* woodcuts of c. 1914 show an awareness of Delaunay's *Window on the City* paintings. "Cleanliness, efficiency, precision are the first notes of the show" Pound proclaimed when they were exhibited in 1919, thereby equating them with machines, and he went on to liken them to the woodcuts of Japanese artists. The other subject which Wadsworth treated most consistently was that of the port. This subject was "blessed" in *Blast No. 1* and indeed Wadsworth may have been responsible for the lengthy passage devoted to this subject on page 23 of the magazine. One woodcut, *Rotterdam*, and one painting, *Cape of Good Hope*, seem to reflect directly this passage in *Blast*. Both paintings also appear to represent aerial views and if Wadsworth did not experience a flight in an aeroplane he certainly had access to aerial photographs illustrated in *Flight* magazine. Even as abstract a picture as *Enclosure* may represent an aerial view of fields. *Enclosure* and *Abstract Composition* represent the zenith of Wadsworth's Vorticist phase with their energetic ziggurats, juxtaposed with stabilizing horizontal bands, and their sharply accented colours. Nevertheless, Wadsworth's paintings were never as aggressive as Lewis's for even in *Enclosure* the bright red is moderated by the warm beige and brown tones. Pound contrasted Lewis and Wadsworth as follows: "Turbulent energy: repose. Anger: placidity and so on." Wadsworth's Vorticist phase came to an end around 1917

when he was employed to supervise dazzle camouflage of ships in Liverpool and Bristol. The works inspired by this occupation display the mechanical precision in draughtsmanship and organizational competence associated with Vorticism but the subject matter itself accounts for any Vorticist elements within the picture. *The Dazzle-Ships in the Drydock at Liverpool* (1919) was executed for the Canadian War Memorial Fund. The dazzleships were to be Wadsworth's last contact with Vorticism. In the Twenties and Thirties he produced Surrealist marine paintings interrupted by a brief period of biomorphic abstraction in the early Thirties. (JL)

Walden, Herwarth
pseudonym of Levin, George
(Berlin, 1878 - Saratov, 1941) German writer, composer and publisher

Herwarth Walden was a pianist and composer before turning to literature, probably under the influence of the poetess Else Lasker-Schüler, who was his wife between 1901 and 1911. Walden never ceased to compose and a number of his musical works were published in *Der Sturm*. He founded the magazine *Der Sturm* after several years of experience in journalism and publishing; the first issue appeared on 3 March 1910 and the last twenty-three years later. Almost everything of importance produced by the European avant-garde appeared sooner or later in *Der Sturm*, although at the beginning, together with *Die Aktion*, it was the first German Expressionist periodical. Between 1912 and 1913 *Der Sturm* published Italian Futurist manifestos four times. The magazine also invited foreign poets and painters to lecture: Apollinaire, Cendrars, Delaunay, Marinetti, Archipenko. *Der Sturm* was already the organ of all the artistic manifestations when in 1912 Walden opened a gallery with the same name, where besides the German Expressionists he presented the major painters of the European avant-garde. In 1912 the Italian Futurists exhibited there. After the First World War, Walden tried to add a theatre to his gallery, but this project lasted only a few years. In 1924 the magazine supported the Bolshevist positions, but its importance declined towards the end of the Twenties. In 1932 Walden left as a voluntary exile for the Soviet Union. (SF)

Walden, Nell
(Karlskrona, Sweden, 1887 - Berne, 1975)
Swedish painter, born Roslund, Nelly

In 1912 Nelly Roslund married Herwarth Walden and became an active collaborator in the Der Sturm enterprise. She painted large scale, non-figurative paintings using a reduced colour range — often only three colours and gold and silver.
Her paintings have a rather aggressive, angular, dynamic style.
This is probably the reason for her nickname in the circle around Der Sturm, *Die wilde Bestie* (The Wild Animal).
Walden participated in almost all of the group exhibitions arranged by Der Sturm. In the early Twenties, when her husband became more and more interested in politics — he became a fervent Communist — their interests diverged and in 1924 they divorced. (PH)

Photograph of H. Walden dedicated to Marinetti, 1912

O. Kokoschka, Portrait of Nell Walden *National Museum, Sweden*

Herwarth and Nell Walden

War (see **Ideology**)

In Favour of War, the Only Hygiene of the World

(Futurist manifesto, 1915)

We Futurists, who for over two years, scorned by the Lame and Paralyzed, have glorified the love of danger and violence, praised patriotism and war, the hygiene of the world, are happy to finally experience this great Futurist hour of Italy, while the foul tribe of pacifists huddles dying in the deep cellars of the ridiculous palace at The Hague.

We have recently had the pleasure of fighting in the streets with the most fervent adversaries of the war, and shouting in their faces our firm beliefs:

1. All liberties should be given to the individual and the collectivity, save that of being cowardly.

2. Let it be proclaimed that the word *Italy* should prevail over the word *Freedom*.

3. Let the tiresome memory of Roman greatness be cancelled by an Italian greatness a hundred times greater.

For us today, Italy has the shape and power of a fine Dreadnought battleship with its squadron of torpedo-boat islands. Proud to feel that the martial fervour throughout the Nation is equal to ours, we urge the Italian government, Futurist at last, to magnify all the national ambitions, disdaining the stupid accusations of piracy, and proclaim the birth of *Panitalianism.*

Futurist poets, painters, sculptors and musicians of Italy! As long as the war lasts let us set aside our verse, our brushes, scalpels and orchestras! The red holidays of genius have begun! There is nothing for us to admire today but the dreadful symphonies of the shrapnels and the mad sculptures that our inspired artillery moulds among the masses of the enemy.

F.T. Marinetti

The Futurist literary, painterly and musical movement is currently suspended due to the absence of the poet Marinetti who has left for the theatre of war.

Wat, Alexander

(Warsaw, 1900 - Paris, 1967) Polish writer

After completing his studies at the University of Warsaw, Wat was converted to Futurism, and he and his friend Anatol Stern became leading figures in the Warsaw avant-garde. His poems, published in the collection *Me on One Side and Myself on the Other Side of My Little Carlin Dog Stove* (1920) are marked by a tempestuous lyricism derived from automatic writing; the careless appearance of the text is accentuated by the presence of numerous typographical errors intentionally left in it. In 1920 he published the almanac *G.G.A.* with Stern: "Civilization and culture in their depravity — obscenities. We prefer simplicity vulgarity joviality triviality and laughter... We erase history and posterity." Wat abandoned this Futurist programme and joined the Constructivists; later he gave up poetry and devoted himself to translation. (SF)

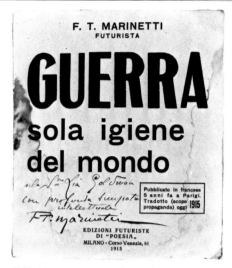

F.T. Marinetti, War, the Only Hygiene for the World, *1915*

A.L. Coburn, Portrait of H.G. Wells, *1905*

Weber, Max

(Bialystok, 1881 - New York, 1961) American painter and sculptor of Russian origin.

Max Weber encountered the European avant-garde in Paris from 1905 through 1908. He studied with Matisse, met Picasso, and formed a close friendship with Henri Rousseau. On his return to New York, Weber associated with his dealer Stieglitz and others who championed modern art. He would have learned of the Futurists from newspaper accounts and from Arthur Jerome Eddy's 1914 book, *Cubists and Post-Impressionism.* In 1915, he showed in the "Panama-Pacific Exhibition" in San Francisco that included forty-nine examples of Italian Futurist art. About this time, Weber painted canvases which suggest his sympathy with Futurist ideas. Many of Weber's 1915 paintings are concerned with depicting the city and its dynamism. Although he had represented New York in his earlier work, Weber had never before been so fascinated by movement. The works he produced that year most closely related to Futurism are *Grand Central Terminal, Rush Hour, New York,* and the sculpture *Spiral Rhythm.* Even his *Athletic Contest,* also of 1915, evokes the same kind of frenetic image as Carrà's earlier and more political painting, *Funeral of the Anarchist Galli.*

Like several other Futurists, Weber had literary aspirations. For the July 1910 issue of *Camera Work,* he had written "The Fourth Dimension from a Plastic Point of View", the first published essay on the fourth dimension in art. This concern was one Weber shared with the Futurists, particularly Boccioni. With the help of his friend, the photographer Alvin Langdon Coburn, Weber published his first book, *Cubist Poems,* in London in 1914. (GL)

Wells, Herbert George

(Bromley, Kent, 1866 - London, 1946) English writer

Before his first novel *The Time Machine* appeared in 1895, H.G. Wells had published a biology manual. His interest in science and the future evolution of human life was to remain. Futher novels followed which explored the future or various utopias and immediately became famous throughout the world: *The Island of Doctor Moreau* (1896), *The Invisible Man* (1897), *The War of the Worlds* (1898), *The First Men in the Moon* (1901), etc. Obviously the sort of speculations to be found in *The War of the Worlds* would attract the Futurists, and others; already in 1899, in the *Mercure de France* Doctor Faustroll (Alfred Jarry) published a "Commentary for Use in the Practical Construction of the Machine to Explore Time"; in 1905 Kupka illustrated Wells' short story *Pyecraft*; Apollinaire reviewed his books; Azorin, writing in 1908 about Alomar's *Futurisme,* quoted Wells: "We are at the start of the beginning." Marinetti, on the contrary, never quoted him at all — the English novelist was publicly opposed to bourgeois and Christian morality, but his political position was opposite to that of Italian Futurism. The English Vorticists, who were mostly right wing, showed no sympathy for him either; nor did Ferdinando Pessoa in *Portugal*

Futurista. On the other hand, Wells was admired by the Russian Futurists: Khlebnikov elected him a member of the world government which he believed should decide the destiny of humanity. Later Maiakovsky used the possibilities suggested by the time machine in his comedies *The Bedbug* and *The Bathhouse*. Mention should also be made of Karel Čapek, particularly his play *R.U.R.*, and the Mexican Stridentists (see Stridentism) who published works by Wells in their magazine *Horizonte*. (SF)

Witkiewicz (Witkacy), Stanislaw Ignacy

(Warsaw, 1885 - Jeziory, 1939) Polish painter, philosopher, dramatist and writer

Often dubbed a Futurist by his contemporaries, Witkiewicz always denied the description. Like all other "isms", for him Futurism was a superficial and ephemeral movement lacking any firm philosophical foundation — a perfect example of the decadence of art as a result of over-specialization. Witkiewicz invented his own artistic theory based on a conception of "the mystery of existence and of metaphysical feeling", and accused the Futurists of philosophical ignorance. As a profound individualist, he loathed the Futurists' plans for social upheaval, their desire "to drown the individual in the mass just to flirt with the ignorant crowd". In his essay *Pure Form in Art* he dismissed his formal Futurist studies as "superficial and sensation-seeking, lacking any solid scientific foundation".

Witkiewicz felt that the Futurists' methods, their scandals and provocative behaviour, presented a threat to what he called "real" art. His clashes with the Futurists, particularly his attacks on Chwistek published in several Polish reviews of the Twenties are some of the best pieces of art journalism of the period. (SZ)

Women, Futurist

In his first manifesto of 1909, Marinetti declared his "contempt for women" with the aim of rejecting the "eternal feminine" in literature. In reaction, the Frenchwoman Valentine de Saint-Point launched the *Manifesto of Futurist Women* (1912), in which the birth of a strong and instinctive superwoman was announced. This was followed by her *Futurist Manifesto of Lust* (1913), in which the rights of desire were reaffirmed, counterbalancing the rejection of sexuality inherent in the mechanistic Futurist utopia.

There were no other women active in the early years of the movement, apart from a certain Flora Bonheur, who made a parodical contribution with her *Diario d'una giovane donna futurista* (*Diary of a Young Futurist Woman*, 1914). It was only during the early years of the First World War that more Futurist women appeared. Marinetti's maid, Marietta Angelini, had "parolibere" works published in *Vela Latina*, while other women contributed to the periodical *L'Italia Futurista*: Maria Ginanni, the intellectual poetess of *Montagne trasparenti* (*Transparent Mountains*, 1917) and *Il poema dello spazio* (*The Poem of Space*, 1919); Irma Valeria, authoress of the lyric poems *Morbidezze in agguato* (*Soft-*

S.I. Witkiewicz, Self-portrait, *1910-13*

Angelini, "Words-in-Freedom", in Vela Latina, *12 February 1916*

Rosa Rosà, drawing in L'Italia Futurista *7 October 1917*

ness in Ambush, 1917) and *Fidanzamento con l'azzurro* (*Engagement with Blue*, 1918); the illustrator Rosa Rosà, who published the novels *Una donna con tre anime* (*A Woman with Three Souls*, 1918) and *Non c'è che te* (*There Is Only You*, 1919); Enif Robert, co-author with Marinetti of *Un ventre di donna* (*A Woman's Belly*, 1919); and also the actress Fulvia Giuliani, the "parolibere" Magmal (Eva Kuhn Amendola), Emma Marpillero and Enrica Piubellini, the poetesses Fanny Dini and Marj Carbonaro; and Mina Della Pergola, who wrote theatrical "syntheses".

Immediately after the war new names appeared in *Roma Futurista*, particularly during a discussion on women's emancipation: "Futurluce" (Elda Norchi), Anna Questa Bonfadini and other anonymous contributors. In this journal the movement published its proposals for the so-called "Futurist Democracy", which included the right to vote and to work for women, divorce, free love and the "child of the State".

Where "Fiumanesimo" and Futurism met, Briciola and Fiammetta were present; the latter launched a libertarian appeal to women. Between the end of the first decade and the beginning of the second, the Bohemian painter Rougena Zatkova was active in Italy. In the second period of Futurism, Benedetta Cappa Marinetti emerged as a painter and writer of experimental novels: *Le forze umane* (*Human Forces*, 1924), *Viaggio di Gararà* (*Gararà's Journey*, 1931), *Astra e il sottomarino* (*Astra and the Submarine*, 1935).

Other women active during the Twenties were the painter Alma Fidora, who belonged to the group Nuove Tendenze, the "parolibere" Alzira Braga and Aurelia Del Re, the writers Nenè Centonze and Laura Pittaluga. Outstanding in the Thirties were the "aero-painters" Marisa Mori, Brunas (Bruna Somenzi), Leandra Angelucci Cominazzini, Magda Falchetto, Barbara (Olga Biglieri Scurto), who was also an aviator, Adele Gloria, the sculptress Regina (Regina Cassolo), the dancer Giannina Censi, the photographer Wanda Wulz, the "simultaneist" interior designer Stella Mix Lonzar, the musician Maria Napoletano, and the writer and poetry-reader Artemisia Zimei. (CS)

Manifesto of the Futurist Woman

(Futurist manifesto, Paris, 25 March 1912)
A reply to F.T. Marinetti

"We intend to glorify war, the hygiene of the world, militarism, patriotism, the anarchists' destructive actions, great ideas worth dying for, and contempt for women" (*First Manifesto of Futurism*).

Humanity is mediocre. The majority of women are neither superior nor inferior to the majority of men. They are equal. Both deserve the same contempt. Humanity as a whole has never been other than the fertile ground from which geniuses and heroes of both sexes arose. But in humanity as in nature there are particularly favourable moments for flowering. In the summer of humanity, when the ground is baked by the sun, geniuses and heroes abound. We are at the beginning of a spring; we still need a great measure of sun, that is to say a great deal of blood must be shed.

Women, like men, are not responsible for the fact that those who are truly young, filled with lymph and blood, are stuck fast. *It is absurd to divide humanity into women and men:* it is composed entirely of *femininity* and *masculinity.* Every superman, every hero, however epic he may be, every genius however powerful, is the amazing expression of his time only because he is composed simultaneously of feminine and masculine elements of femininity and masculinity — he is a complete being.

An exclusively male individual is nothing but a brute; an exclusively female individual is nothing but weakness.

The history of collectivities and historical moments is the same as the history of individuals. The fertile periods, in which a great number of geniuses and heroes spring from the ground of a fermenting culture, are periods which are rich in masculinity and femininity.

The periods which saw wars with only a few representative heroes, because the epic wind flattened them, were exclusively male periods; those which denied the heroic instinct, turned toward the past and lost themselves in dreams of peace, were periods in which femininity predominated. We are living at the end of such a period. *What is most lacking in women and men alike is masculinity.*

This is why Futurism, with all its exaggerations, is right.

To give back a certain masculinity to our peoples benumbed by femininity, they must be dragged to masculinity, even to brutality.

But to all, men and women alike in their weakness, a new doctrine of energy must be taught, so that we may reach an epoch of superior humanity.

Every woman must possess, besides the female virtues, male qualities: otherwise she is weak, womanish. And the man who has only male strength without intuition is nothing but a brute.

But in the period of femininity we are living in, only exaggeration in the opposite direction can help. *It is the brute who must become the model.*

No more women who cause soldiers to fear "the lovely arms entwined around their knees on the morning of departure"; nurse-women who encourage weakness and old age, taming men to suit their personal pleasure or for their material needs! No more women who have children only for their own sakes, sheltering them from every danger, from every adventure, which means from every joy; who keep their daughters away from love and their sons away from war! No more women who are octopuses of the hearth, whose tentacles bleed men dry and make their children anaemic; *women who love like animals, and destroy the force of renewal that lives in Desire!*

Women are Erinyes, Amazons, Semiramis, Joan of Arc, Jeanne Hachette, Judith and Charlotte Corday, Cleopatra and Messalina, warriors who fight more ferociously than men, lovers who incite, destroyers who contribute towards natural selection by breaking those who are fragile, arousing pride and despair, "the despair that gives the heart all its richness".

May the next wars create heroines like the wonderful Caterina Sforza who when her city was besieged, seeing from the top of the walls the enemy threatening her son to force him to surrender, heroically displaying her sex shouted: "Kill him then! I still have the mould to make others!"

Yes, the world is "soaked in reasonableness", but by instinct woman is not reasonable, nor pacifist, nor good. Since she is totally lacking in a sense of measure, in a sleepy period of humanity she becomes too reasonable, too pacifist, too good. Her intuition, her imagination are both her strength and her weakness. She is the individuality of the crowd: she applauds the heroes, or if these are lacking, she supports the fools. According to her apostolate, woman incites to spirituality or to carnality, immolates or heals, makes blood flow or wipes it away, is a warrior or a nurse. The same woman, in the same historical period, according to the ideas produced around her by the latest event, will lie down on the tracks to stop the soldiers leaving for war or will throw her arms around the neck of the winning sports champion. This is why every revolution must include her; this is why rather than professing contempt for woman, you must address her. It is the most fruitful conquest you can make; and the most exciting, which in its turn will make more recruits.

But Feminism should be left aside, Feminism is a political mistake. Feminism is a mistake made by woman's intellect, a mistake which her instinct will recognize. *Woman should not be given any of the rights claimed by Feminism. To give women these rights would not produce any of the disorder the Futurists hope for, but on the contrary would create an excess of order.*

To give duties to woman would mean depriving her of all her fruitful power. The logic and deductions of Feminism will not destroy her primordial destiny; they can only falsify it and force it to express itself through deviations that will lead to the worst possible errors.

For centuries now humanity has clashed with woman's instinct. All that is valued in her is grace and tenderness. Anaemic man, miserly with his own blood, wants her to be only a nurse. She has allowed herself to be tamed. But call out a new word to her, give a war cry and with joy she will ride again on her instinct and lead you towards undreamed-of conquests. When your weapons are needed, woman will sharpen them. She will once more contribute towards selection. In fact, although she cannot easily distinguish genius, because she judges according to passing fame, woman has always rewarded the strongest, the victor, the one who triumphs through his muscles and his courage. She makes no mistakes about this superiority which imposes itself brutally.

Let woman rediscover her own cruelty and violence that make her turn on the beaten, just because they are vanquished, and mutilate them. Stop preaching to her the spiritual justice that she has tried to acquire in vain. *Women, become once more as sublimely unjust as every force of nature!*

Freed from control, once more in possession of your instinct, you will take your place among the Elements which oppose fate to the deliberate will of man. Be the egoistical and ferocious mother who jealously guards her young, having every right and duty over them *as long as they physically need her protection.* Let man, freed from the family, live his own life of courage and conquest as soon as he has the physical strength to do so, although he is a son, and although he is a father. The man who is sowing does not stop at the first furrow he makes fruitful.

In my *Poems of Pride* and in *Thirst and Mirages,* I rejected sentimentalism as a comtemptible weakness because it ties down energies and immobilizes them.

Lust is a force because it destroys the weak, stimulates the strong to spend their strength and hence renew it. Every heroic people is sensual: woman for them is the most glorious trophy.

Woman must be either a mother or a lover. True mothers will always be mediocre lovers and lovers will be inadequate mothers through excess. These two types of women are equal before life, and complementary. The mother who receives the child makes future out of the past. The lover dispenses the desire that is a bridge to the future.

We conclude:

The woman who keeps a man at her feet with tears and sentimentality is inferior to the prostitute who out of vainglory pushes her man to maintain his dominion, revolver in hand, over the city slums. Such a creature at least is cultivating an energy which could serve a better cause.

Women, for too long you have been lost amid morals and prejudices; come back to your sublime instinct: to violence and cruelty.

Because of the fatal tithe of blood, while men are warring and fighting create sons and act the role of Destiny among them in the name of Heroism. Bring them up not for yourselves, which diminishes them; let them find a wide freedom, a complete development. Instead of reducing man to the servitude of detestable sentimental needs, encourage your sons and your men to excel themselves.

It is you who make them. You have complete power over them. *You owe heroes to humanity. Give them to us!*

Valentine de Saint-Point

Words-in-Freedom

Marinetti defined and perfected his theory of "words-in-freedom" (*parole in libertà*) in three "technical manifestos" published within two years. They are: *Technical Manifesto of Futurist Literature*, 11 May 1912, with its appendix, *Answer to Objections*, 11 August, 1912; *Destruction of Syntax - Imagination without Strings - Words-in-Freedom*, 11 May 1913; and *Geometrical and Mechanical Splendour and Numerical Sensitivity*. It is useful to study the three manifestos together, since they were drafted more or less concurrently with "Zang Tumb Tumb", a free word poem-reportage on the siege of Adrianopole, published in 1914. As for every great inventor, for Marinetti theory and practice go together, or almost. If studied simultaneously, the three manifestos show an evolution of the "words-in-freedom" theory. The initial ideas are corrected and elaborated, their expression becomes more precise and there is greater depth. These qualities were the result not only of Marinetti's personal meditation, but also of his acceptance of outside objections, and of ideas suggested by the painters' theory of simultaneity.

Briefly, the main points of *paroliberismo* are: to destroy syntax; to use infinitive verbs; to abolish punctuation; to create "an ever vaster gradation of analogies"; to eliminate all categories of images; to create a maximum disorder in the arrangement of images; to get rid of the "I" in literature; to have a "lyrical obsession" towards matter; to introduce in literature the weight, sound and smell of objects; to bravely use the "ugly" in literature.

Many of these points are not new and can easily be found foreshadowed in the French poetical tradition, for example in Hugo, Baudelaire, Rimbaud, and Mallarmé. But this does not diminish Marinetti's originality in having gathered all these scattered elements together and given them a vital new impetus.

According to Ruggero Jacobbi, "the words-in-freedom can be considered as Marinetti's search for his own language... as a sort of release from his personal problems with form, a forced solution to an equation which would not balance... as soon as he invented this new form, Marinetti must have felt himself free of an immense burden — the weight of a vocabulary and a syntax that had been opposing him". These statements are true and yet one must not forget that words-in-freedom followed the period of free verse — introduced from France by Lucini — and that Marinetti's objective theoretical impetus was as strong as his subjective impulse to write poetry. Marinetti's aesthetic hinged upon the new; his effort was to create, through words-in-freedom, a completely original way of writing both on a literary and a cognitive level.

The first *Technical Manifesto* is concerned with destroying the "I" and cultivating a "lyrical obsession" towards matter. It is a violent attack on psychology in literature, on a "man totally decayed by museums and libraries". Marinetti denies the solipsism of Romanticism and Symbolism in favour of a total lyrical "extroversion" that projects itself on external objects so strongly as to obliterate the "I".

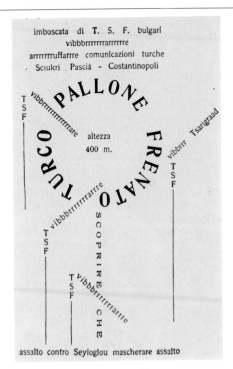

F.T. Marinetti, Captive Balloon

In the second manifesto, *Destruction of Syntax*, Marinetti uses for the first time one of the magical Futurist words: "simultaneity". He borrowed it from the painters who "discovered" and introduced it in 1912, in their preface to the *Catalogue of the Exhibitions of Paris, London, Berlin, etc.* By accepting the concept of simultaneity and talking of "multiple and simultaneous awareness in a single individual" Marinetti definitely changes direction. While the first technical manifestos promoted absolute objectivity, this one accepts a comparative subjectivity. It is enough to briefly compare the first free-word text "Battaglia peso + odore" (Battle Weight + Odour, 1912) with "Zang Tumb Tumb" (1914) to observe how strongly Marinetti's artistic creation has been influenced by the theory of simultaneity and by the poetics of moods. The third manifesto, *Geometrical Splendour*, confirms this new relationship with the subject. Marinetti objects to the realism of the "scientific and photographic viewpoint that denies any emotion", and suggests through free words a "multiform emotional viewpoint". In his later theories he confirms this switch from absolute objectivity to a relative subjectivity.

From its beginnings *paroliberismo* provoked criticisms. Papini and Soffici spoke of a "descriptive naturalism". Ezra Pound, in his manifesto *Vortex*, 1914, accused Futurism of being "a sort of accelerated Impressionism". The visual quality of free-word poems, with their "freely expressive spelling and printing" and their "pictorial analogies", is partially neutralized by the fact that the texts were intended to be "scores for recitation". As Fausto Curi says: "By completing the text, the recitation uncovers the syntagmatic connexions which the structure had concealed, but not destroyed." In this sense "Zang Tumb Tumb" is a hybrid, being on one hand an early example of concrete and visual poetry and on the other hand a late and abnormal offspring of Romantic recitative poetry.

Roman Jakobson, in his essay dated 1919, criticized words-in-freedom as being "a reform in the field of reportage, not in the field of poetic language... In this case we are faced with a linguistic system which is not poetical, but emotional". However, his objection is only partially true. Some of Marinetti's theory and his first two texts, "Battaglia peso + odore" and "Zang Tumb Tumb" definitely remind one of high-level reporting, of accelerated Impressionism, and yet they are the forerunners of what will later on be called concrete and visual poetry. Marinetti successively produced some surprising "typographical collages" — for example, in *Les mots en liberté futuristes* (1919), a summing-up of the whole free-word theoretical experience. The founder of Futurism called the free-word plates, "synoptic plates of poetry or landscapes of evocative words", but often the predominance of the graphic element is so strong that the plates tend to become paintings. The same happens in Carrà's series of *Disegni guerreschi* (*War Drawings*) and in *Guerrapittura* (*Warpainting*) which are milestones in this figurative *paroliberismo*. Other Futurists important in this context are Soffici, with his "lyrical chemisms", and Govoni with his *Rarefazioni e parole in*

G. Apollinaire, Cubist Associate calligramme

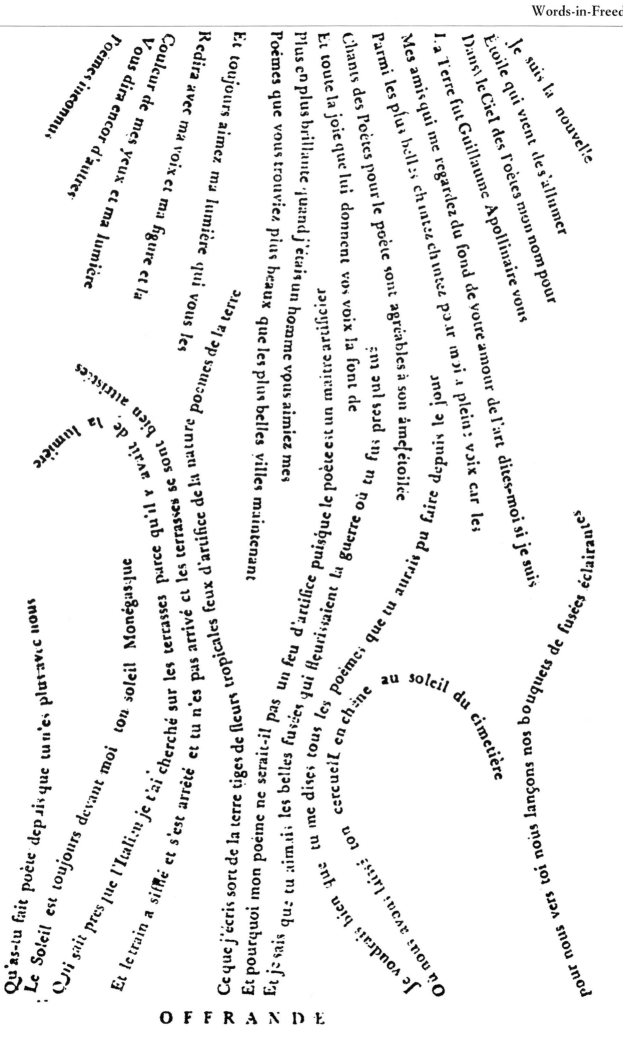

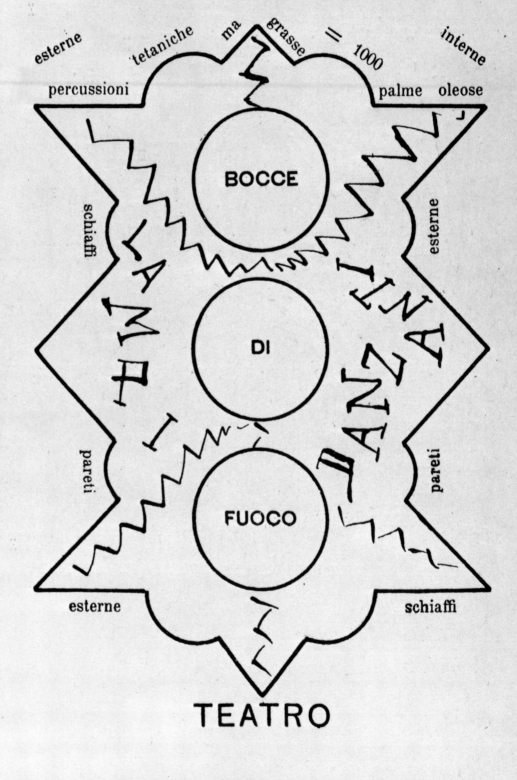

= 329 =

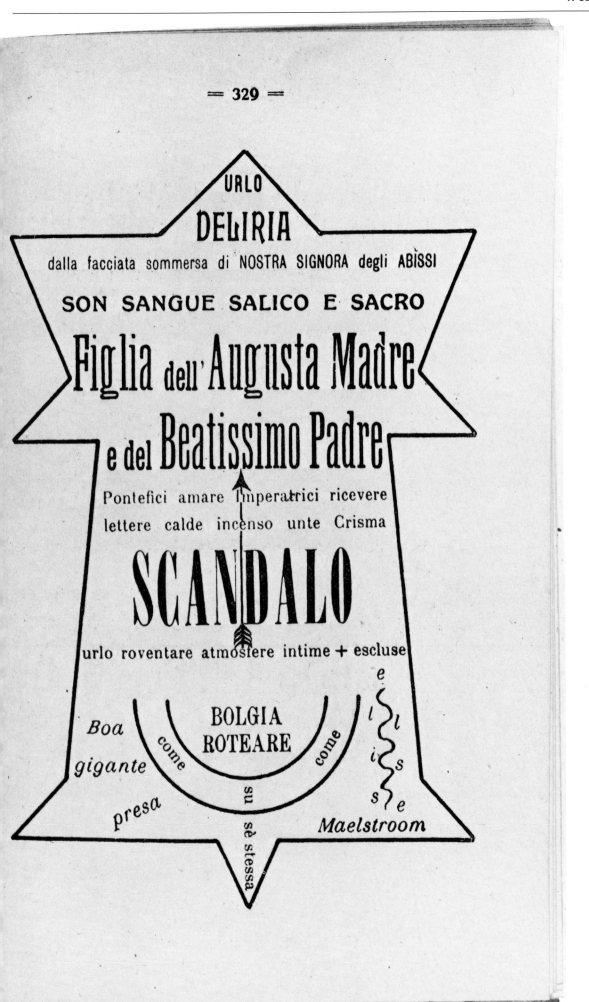

libertà (Rarefactions and Words-in-Freedom, 1915). Finally, mention must be made of Fortunato Depero's poems in *onomalingua,* which are early experiments, dated 1915, of what the author called abstract or *rumorista* (noise-creating) poetry, which today we would call "concrete poetry".

The words-in-freedom theory also developed certain ideas about the techniques of image and analogy (not taken into consideration by Jakobson) which were to prove extremely important for the future of world poetry. These ideas were taken up in the theoretical writings of the Dadaists and Surrealists, particularly by Tzara and Breton, who in some of their poetry written before 1920 adopted certain methods of *paroliberismo.* Just as Marinetti did not rigidly conform to his own codified *paroliberismo,* so other Futurist went beyond the limits of poetical reportage. In some texts of the Second Florentine Futurism (Bruno Corra, Mario Carli, Primo Conti, etc.) one can find the imprint of *ante litteram* Surrealism, a tendency towards what Jakobson, in his essay on Pasternak (1935), defines as the "emancipation of the sign in relation to the object" and "the creative determination to get rid of the object and transform artistic grammar".

The theory and practice of words-in-freedom, while giving a hard blow to existing poetical linguistics, also laid the foundations for more complex literary creations. We have already mentioned the Dadaists, the Surrealists and the Second Florentine Futurism. We can also find signs of Futurist influence in Ungaretti's first works, in some texts by Campana and Bontempelli, and later in the Neo-avant-garde, where the Futurists' inventions have been transmitted through other avant-gardes. (LDM)

Yanase, Masamu
(Matsuyama, Japan, 1900 - 1945) Japanese painter

Masamu Yanase was a self-taught artist. The first phase of his work is Impressionist in style, while the last period is decidedly Post-Impressionist.

He moved to Tokyo in 1918 and three years later took part in an exhibition of avant-garde Futurist painting held by young artists. In 1923, together with Tomoyoshi Murayama, he was the key figure behind the avant-garde group Mavo. At the first exhibition of the group he presented the works *May Morning* and *Self-Portrait before Lunch,* which attempt to portray in an unmistakably dynamic Futurist style the hubbub of large cities.

After 1925 Yanase participated in the proletarian art movement. Influenced by George Grosz, he drew caricatures of contemporary political figures, posters and illustrations for magazine covers.

In 1932, during the harsh repression of the Socialist movement, Yanase was arrested. Although he was released the following year, he was denied all possibility of continuing his political activity. (TA)

Yorozu, Tetsugoro
(Twate, 1885-1927) Japanese painter

From 1907 to 1912 Yorozu studied at the Fine Arts Institute in Tokyo. The paintings of van Gogh and the Futurists had a profound influence on the young artist, who in 1912 created a style of his own which was highly simplified in form. His first works, characterized by the stark contrast of the basic colours, date from that year. In the same period, Yorozu came across reproductions of Italian Futurist painting which were to have a great in-

fluence on his later art.

After 1915 he became interested in Cubism, and was perhaps the first Japanese painter to create important works according to Cubist guidelines. His study of Cubist art played a decisive role in his way of seeing reality and reproducing its structure, but he did not practice Cubist analysis in the strict sense of the word: interpreting and breaking down forms into their smallest units.

From 1921 onwards Yorozu was increasingly attracted to the Nanga style of the Edo era (a school of figurative art in South China). He left works of exceptional inventiveness and individuality, expressing a highly original inner world. (TA)

Zatkova, Rougena
(Ceske Budejovice, Bohemia, 1885 - Leysin, Switzerland, 1923) Czech painter and sculptress, naturalized French

Rougena Zatkova studied art in Prague and Munich, then moved to Italy where she married. In early 1915 she participated in the "*intonarumori* evening" at Marinetti's house, where she met Russolo, Prokofiev, Diaghilev, Stravinsky and Massine. She became friendly with Goncharova and Larionov and was sentimentally involved with Arturo Cappa, Benedetta's brother. Although Zatkova was influenced by Boccioni's plastic dynamism, she also created "sensation pictures", composed of kinetic elements and various materials, with nature as the evocative theme, and as a sculptress, plastic assemblages made of a variety of different materials. After having exhibited in "Futurist Rome'" as "Signora X", she showed under her own name in Rome in 1921. In the same year she wrote in *Cronache d'Attualità* about Marinetti's discussion on Tactilism, arguing for the importance of the aggressive sentiment in art. Presented by Prampolini, she exhibited at the Casa d'Arte Bragaglia in Rome in 1922, the year in which she participated in the International Futurist Exhibition at the Winter Club in Turin. She died in Switzerland of tuberculosis. (CS)

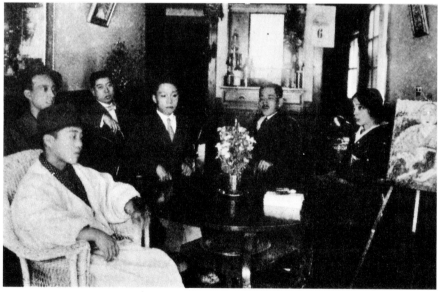

Yanase at his one-man show, 1917

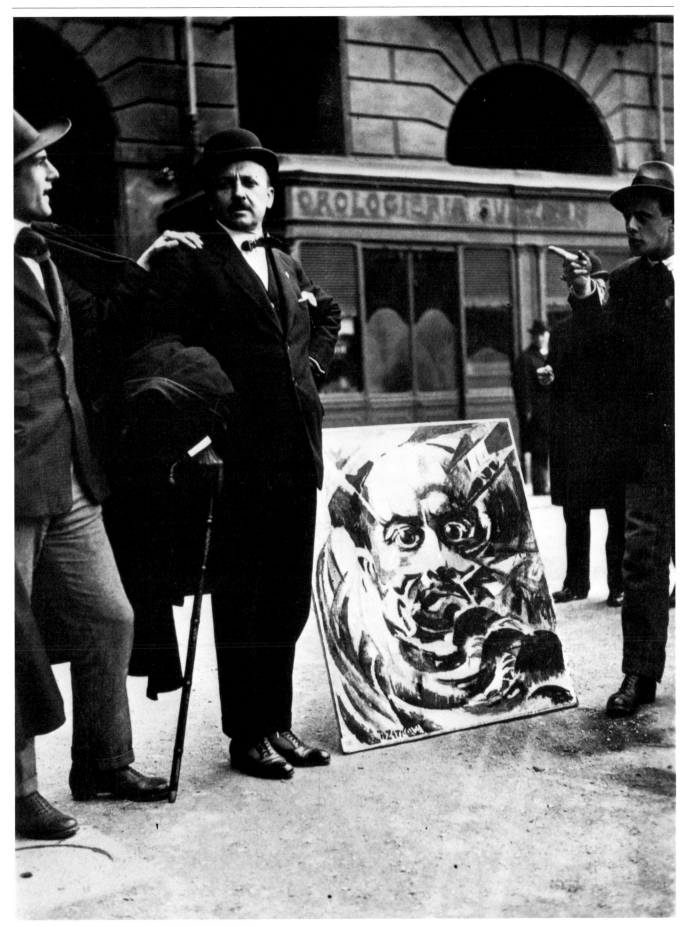

Marinetti and Marchesi in Turin
with Marinetti's portrait by Zatkova

Zaum, Zaumnyi Iasyk

Zaum (transrational language) was a neologism created in Russian Futurism (Cubo-Futurism) in 1913, probably by Alexei Kruchenykh. The word *zaum*, of feminine gender, is composed of the prefix *za*, "beyond", and the root *um*, meaning the rational faculty — mind, intelligence, reason. The palatizing affix, rendered in a transliteration as', gives the expression an abstract character. *Zaum'* therefore means "transrational", "translogical", or "transmental". In its original meaning *zaum* was the most original and extreme form of the Russian Futurist experimentation in poetry and linguistics. Nevertheless, one has to remember that: 1) this transrational language was first theorized in poetry, but reflects a wider attitude which was also expressed in other creative languages such as painting (Malevich) and theatre (Zdanevich); 2) there are differences among the Futurists who practiced and theorized *zaum* (Kruchenykh's *zaum* is unlike Khlebnikov's, for example); 3) the Cubo-Futurist linguistic revolution was not limited to transrational experiments (for Maiakovsky, these experiments were only a workshop activity he used for a different and highly personal linguistic and poetic innovation).

At the beginning of 1913, a small book containing only a few pages, that could be better called an anti-book, was published in Moscow. On the front cover there was the title, *Pomada*, and a Neo-Primitivist drawing of a barber suspended in mid-air pomading a client's hair; on the back cover the announcement that the author of the book was Kruchenykh and the designer Larionov; inside, some drawings pasted on yellow tin-foil were interleaved with pages where the designer had transcribed Kruchenykh's poems (three of them written together with E. Luniov, as announced at the end). This anti-book, so different from the refined Symbolist editions, is a perfect example of early Futurist publications, printed on wrapping paper or wall-paper, and bound in sackcloth (like *A Slap in the Face of Public Taste*). *Pomada* stands out for the hand-crafted quality of its lettering: the graphic individuality of the text is linked to the calligraphy of the drawings and underlines the newness and originality of the contents. This anti-book, in fact, contained the first presentation of the anti-language *zaum*. Some of the poems are in "normal" language, but the first three were preceded by this warning: "Three poems written in a personal language (*sobstvennom*) which differs from all others in that its words have no defined meaning."

The first poem starts: Dyr bul shchyl / ubeshchur / skum / vy so bu / r l es." Those lines were to be repeatedly quoted as an example of Futurist folly or fraudulence. The brief introduction already outlines *zaum*, as this new kind of poetry came to be called. It is a "personal" language, "different" from the normal one, and does have a meaning, although this is undefined.

Kruchenykh and Khlebnikov immediately theorized the new language, and the famous linguist, Baudouin de Courtenay, then subjected it to his authoritative criticism. At the beginning of 1914 he wrote: "Is this a human, a live language? No, these words are simply excretions or eruptions of sound from human mouths; they have less value than wax statues which at least refer to living people." He went on to say that in order to be a language, sounds made by the human body need to create "meaningful associations in the psyche" and fit into certain "morphological types" belonging to a particular language. This criticism, made in professorial accents by a scholar standing at the opposite pole to Futurism, is unexceptionable, but it does not touch on the problem that gave birth to *zaum*, nor does it see the possibilities for poetry and analysis that *zaum*, as the climax of Futurism, opened for linguistics itself.

Still in 1913, in the miscellany *The Three*, Kruchenykh had published "New Way of Words", the first theorization of *zaum*. Kruchenykh recalled how the "traditional" poets had complained about the inadequacy of language — "Oh, if only soul could find expression without words!" (Fet) and "A thought, when expressed, becomes a lie" (Tiutchev). In "thrice-fold agreement" with Fet and Tiutchev, Kruchenykh asked, "Why then don't we drop thought and write not with concept-words, but with others freely created?" And he went on to say that if an artist is "impotent", as the two poets had declared, it is because he is not "master of his material". For Kruchenykh, examples of mastery of verbal material can be found among the members of certain Russian sects. These "utterly honest people", in moments of religious ecstasy, speak in what they call "the language of the Holy Spirit", that is to say, they invent a language (well known to ethnographers, who have transcribed examples) which Kruchenykh baptizes *zaumnyi iasyk*.

So *zaum* does differ from normal language; but it is born out of a real necessity and has precedents in certain paranormal and marginal languages, such as the "speaking in tongues" of the religious sects and — as was seen later — in children's rhymes and the language of mentally disturbed people. This new linguistic reality, *zaum*, is founded on the belief that "the word is wider than its meaning", that is to say, "the word (and its component sounds) is not merely an incomplete thought, not merely logic, but above all something transmental (*zaumnoe*), it has irrational, mystic and aesthetic aspects." What the poet and theorist Kruchenykh wrote in 1913 was to remain the core of *zaum*. And it would be easy for him, a few years later, to give it a certain Freudian underpinning, interpreting it as the voice of the unconscious, with reference to the theory of anal eroticism.

Kruchenykh's interpretation and use of Freud's ideas is certainly simplified, and so is his idea of *zaum* as the expression of the inexpressible, the utterance of the unutterable. But Baudouin de Courtenay is also too hasty with his "excretions", and so were others who talked of "intestinal gurgles". For Kruchenykh, zaum is the language of a totally free body, the language of the "pleasure principle" as opposed to the language of the repressed, rational man limited by the "reality principle". But more important than its poetical achievements and theoretical value is the fact that *zaum* promotes a new attitude towards language.

It creates a kind of fantastic philology which gives the poetical language total autonomy with respect to the practical language (which was used to write the theory of *zaum*!). It allows the poet to feel language as pure sound with a new, specific relation to meaning, and to "dismantle" it and experiment with new combinations of its units. This dismantling operation, which can be seen as the tactical moment of the transrational strategy, is called *sdvig*, a word which would become central to Futurist poetry and painting. For the "verbal art" — as the Futurists called poetry — *sdvig* is a phonetical phenomenon which causes the end of one word and the beginning of the next, or two short adjoining words, to melt into one, creating a new word which changes the meaning of the discourse. Having given this new meaning to the word *sdvig*, Kruchenykh went on to create *sdvigologiya*, "the science of *sdvig*", giving numerous examples (mainly from Pushkin) of the acoustical and phonetical game which broke up and reassembled linguistic material, discovering previously unknown meanings in it.

It is evident that *zaum* is the core of the Futurist "autonomous" or "self-sufficient" word. In theory and practice, it demands that the poetic word be freed from the bondage imposed on the practical word — rational, utilitarian, calculating. However, the freedom (or autonomy) of words in Russian Futurism is totally different from Marinetti's "words-in-freedom". To Marinetti, "free-word" means a telegraphic style, a swift, condensed expression of a thought which is new in its contents (*modernolatria*, the idolatry of the modern), not in its form and structure. Apart from the "expressionistic" value it had for Kruchenykh, transrational language was meant to create a new attitude towards language and a new meaning, beyond logic. This wider and more deeply felt value was best expressed by Zdanevich, who applied pure *zaum* as a structural criterion, and by Terentev, who gave *zaum* absurdist connotations which became a stepping-stone for the Leningrad group Oberiu, the last manifestation of the Russian avant-garde. But it was in Khlebnikov that the innovative energy of *zaum* in its widest sense was most completely expressed.

Khlebnikov has been defined as "archaic", but in fact a return to the dawn of language seemed to him a necessary condition for a new dawn of both language and humanity, finally reunited after millennia of separation. He believed the Futurist revolution could mark the beginning of the end of the era introduced by the tower of Babel.

Seen in this macro-utopian perspective, Kruchenykh's *zaum* becomes a marginal and partial thing (although Khlebnikov collaborated closely with Kruchenykh and together they signed the important manifesto-declaration, *The Word as Such*, 1913).

One could speak of a limited *zaum* (Kruchenykh) and generalized *zaum* (Khlebnikov). However, it is perhaps better to separate these two distinct tendencies in Russian Futurism and describe Khlebnikov's contribution as a "verbal universe", a "fantastic philology", or a "linguistic utopia". (VS)

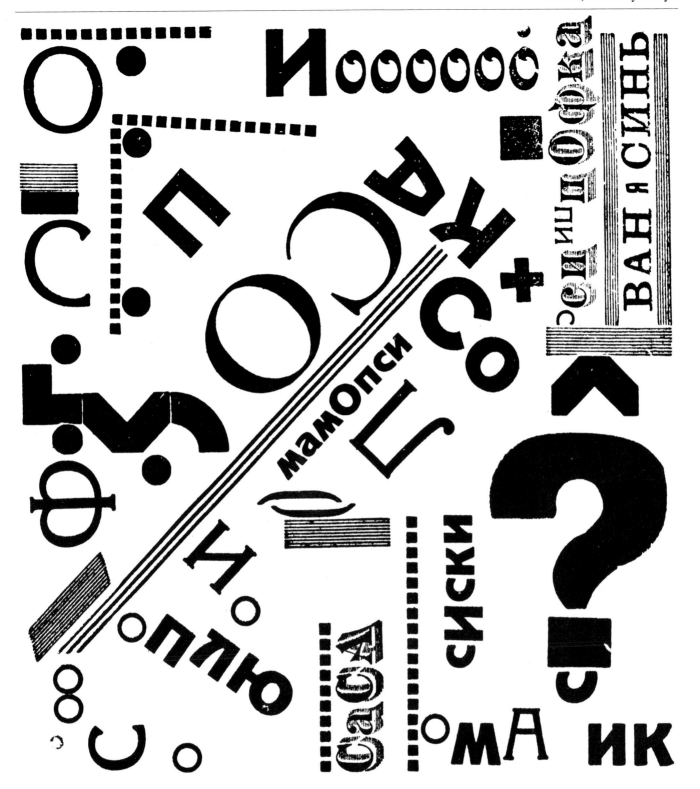

ILYA ZDANEVITCH
TYPOGRAFIESE KOMPOSITIE

I. Zdanevich, Typographic Composition

Zayas, Marius de

(Veracruz, Mexico, 1880 - Hartford, Conn., USA, 1961) Mexican caricaturist

In 1907 his opposition to the dictator Porfirio Diaz forced Marius de Zayas to flee to the United States. Subsequently he worked in America and France, where he lived near Grenoble between 1928 and 1947. Alfred Stieglitz soon noticed his extraordinary talent as a caricaturist and organized a showing of his work at the 291 Gallery. Zayas became linked to the New York avant-garde, but he never forgot the art of his native country and also kept close ties with Europe. His role as a bridge between the two continents was important for the development of modern art.

Apollinaire, Braque, Picasso and all the Cubists, were his friends, but he was also familiar with Futurism. The Futurists may well have inspired the particular style of his geometrical, almost abstract caricatures, which were much admired by his New York and Parisian friends, who frequently published his work in their magazines, and by his fellow countrymen, including Siqueiros and the Stridentists. (SF)

Zdanevich, Ilia

(Tiflis, Georgia, 1894 - France, 1975) Russian writer, known as "Iliazhd"

Ilia Zdanevich was one of the most important figures in Russian Futurism. As a writer, his most memorable work was produced for the theatre. He made an original contribution to typography and publishing, yet the sense and value of his whole creative effort is best summed up in the term *zaum* (see). With Alexei Kruchenykh and Igor Terentev, he was the most consistent and extreme representative of this linguistic-poetic experimentation specific to Russian Futurism.

Zdanevich was born in the family of a high school French teacher, two years after his brother Kiril, who became a painter. His writing is closely connected to painting. In 1911, when a friend read Marinetti's manifestos to him, he immediately became a Futurist, and thus began his career in avant-garde art. Two years later in Moscow, under the pseudonym Eli Eganbiuri, he published an essay on the painters Natalia Goncharova and Mikhail Larionov, who were his friends. His interest in Neo-Primitivism represented in the work of these artists, had already led to his enthusiastic discovery of the Georgian naïf painter Niko Pirosmanishvili (1862-1918), whose works he found in an inn in Tiflis which he visited in 1912 with his brother Kiril and another young artist, Michel Ledentu. This discovery can be compared with an episode of 1913, when Zdanevich took off his shoe and brandished it during a Futurist *soirée*, declaring that he preferred "an American shoe to the Venus of Milo". Taken together, these two moments illustrate the apparently opposed tendencies which met in this writer. Like the most authentic Russian Futurism, he was open to both the archaic and the modern, to the remote past and the remote future. In 1913 Zdanevich theorized a synthesis of these opposites with the formula *Vsiechestvo* (All-ism), stating that an artist can operate simultaneously with expressive instruments developed in different periods and by dif-

M. de Zayas, Portrait of Apollinaire, *1914*

I. Zdanevich, announcement of a lecture Paris

Zenit, *cover by Lissitsky*

ferent movements.

Zdanevich's most fruitful period was connected with his 41 Group, formed at the end of 1916 in Petrograd (where he had studied law) as a reaction to "moderate" Futurism, and reached its peak in Tiflis, where the general situation in Russia induced him to take refuge in 1917. At the end of 1919 he left for Constantinople, and two years later arrived in Paris.

The 41 Group organized a series of lectures which took the shape of a Futurist "university" and published the writing of its members, including Zdanevich's most important work, a "dramatic penatology in zaum". The separate parts, called *dra* (drama), are grouped under the title *Aslaablichiya*, which represents a concentrate of zaum (*asla* is the phonetic transcription of the Russian word *osla*, "ass's", while *ablichiya* is the phonetic transcription of *oblichiya*, "aspects", giving *Asisaspects*). The five parts of the work, written between 1916 and 1921, are entitled *Janko King of Albania*, *Hired Ass*, *Easter Island*, *As If Zga* and *Ledentu a Beacon*, the first four published in Tiflis and the last in Paris, in 1923. The series uses a complex symbology in a burlesque of the *vertep* tradition, a marionette theatre popular in Poland and the Ukraine which represented Biblical scenes and episodes of peasant life.

In Paris Zdanevich fitted completely into the cosmopolitan environment of the avant-garde. He had particular sympathy for the Dadaists and Tzara, and was very active as a lecturer on the new tendencies in Russian art and poetry, particularly the activities of the 41 Group, whose affinities with Dada were evident. The term *surdadaïsme* was coined for him, as representing Dada taken to its extreme. In 1922 Zdanevich founded a group called Cheres (Through) which was related to Dadaism and ended with the latter the following year. Zdanevich's activities during his Paris decades were so varied that it is impossible to summarize them. In 1930 he published an interesting novel, *Ecstasy*, which continued the *zaum* experimentation in a new, more accessible form compared with the *dra*. He was particularly successful in creating art books which expressed his understanding of *zaum*. (VS)

Zenitism

In Yugoslavia, poets and artists early became interested in the avant-garde movements abroad. The poet Srecko Kosovel (1904-26) made a significant contribution, but died very young, and the most influential figure was Ljubomir Micić or Mitzitch (1895-1971), who with his magazine *Zenit* created a forum comparable to that of the Hungarian Kassak's *Ma*. The magazine circulated in the Twenties in Belgrade and Zagabria and was published in several languages: French, German, Serbo-Croat. It was open to the Expressionists (Däubler, Yvan Goll), Cubists (Cendrars, Robert Delaunay, Archipenko) and of course the Futurists, particularly Marinetti. In 1926, persecuted by the police, Mitzitch turned to Marinetti for help.

Zenitism was a vague movement promoted in his magazine by Mitzitch, who was practically its only member. It found expression in literature — the poem *Anti-Europe* of 1926 is Futurist in its movement and typography — and in the plastic arts, although Mitzitch's *Optic-Plastic* (1923) is closer to Naum Gabo's Constructivism. (SF)

Zonism

Zonism (Strefizm) was a pictorial method evolved by Leon Chwistek in the early Twenties, in which the painting was divided into different geometric and colour zones. Triangular planes had to be placed in one zone, elliptical in another, and so forth; greens in one area, blues, reds and yellows in another. "By the word 'zone'", wrote Chwistek in 1924, "I mean a part of the canvas defined in such a way that one may connect two of its points without leaving it. Each different shape and principal colour (black, white and the six colours of the spectrum) can occupy only a single zone. There are particular zones for very small and very large shapes, light (pale colours) and shade (dark colours); there are also special concave and convex zones."

Zonism was described by Chwistek's contemporaries as "an attempt to classify the discoveries of Delaunay and the Italian Futurists" (A. Stern). Its aim was to organize a disciplined system for Futurism which Chwistek, a logician and mathematician, found too chaotic. However, the Zonist paintings executed by Chwistek between 1922 and 1927 do not reflect the strict geometric approach laid down in his theories. In fact, Chwistek never managed to eliminate the realistic element in his painting.

On the other hand, his Zonist architectural and theatrical designs (which on his own admission were influenced by Marinetti and the Italian Futurists) remain experiments of considerable interest. (SZ)

Chronology

Catalogue of the Works Exhibited
not Reproduced in the Colour Section

Bibliography

Index

Italy	Western Europe	Eastern Europe	America
1900			
F.T. Marinetti commutes between Milan and Paris. Balla settles in Paris.	Universal Exhibition in Paris. Death of Nietzsche. A. Jarry, *Ubu in Chains*, theatre. Freud, *The Interpretation of Dreams*. Construction begins of Gaudì's *Sagrada Familia* in Barcelona. P. Scheerbart, *Rakkox der Billionär*, novel. Strindberg, *The Dance of Death*, theatre. Husserl, *Studies in Logics*. Picasso goes to Paris for the first time. H. van de Velde at the Weimar Art School.	M. Vrubel, *Cavern-swan*.	Muybridge returns to England.
1901			
First issue of *Novissima*.	H.G. Wells, *The First Men in the Moon*. A. Loos starts work on the Turnowsky house in Vienna.		
1902			
D'Annunzio, *Francesca da Rimini*. Marinetti, *La conquête des étoiles* (The Conquest of the Stars), poem in French. Balla, *Bankruptcy*. International Exhibition of Modern Decorative Art in Turin. Croce, *Estetica come scienza dell'espressione e linguistica generale* (Aesthetic as Science of Expression and General Linguistics).	Lévy-Bruhl, *Ethics and Moral Science*. Giacometti settles in Florence. J.H. Poincaré, *Science and Hypothesis*. A. Gide, *The Immoralist*, novel. A. Jarry, *The Super-Male: a Modern Novel*. Wedekind, *Pandora's Box*. Verhaeren, *Tumultuous Forces*, poem. Méliès, *Journey to the Moon*, film. Kupka, *Money*, satirical drawings. Strindberg, *A Dream Play*, theatre. W.B. Yeats, *Cathleen n' Houlihan*, theatre. Tony Garnier presents his *Industral City*. Debussy, *Pelléas and Mélisande*.	Meierkhold founds the Society for New Drama in Moscow. Stanislavsky stages Gorky's *Lower Depths* in Moscow. L. Andreev, *The Abyss*, story. Vrubel, *The Devil*.	
1903			
Mario Morasso, *L'imperialismo artistico* (Imperialism in Art). E. Corradini founds the nationalist review *Il Regno* and B. Croce *Critica*. Papini and Prezzolini found the review *Il Leonardo*. Pellizza da Volpedo, *The Sun*. D'Annunzio, *Alcyone* and *Laudi*.	Retrospective of Gaugin at the Salon d'Automme in Paris in the year of his death. H. Bergson, *Introduction to Metaphysics*, essay. Klimt exhibition at the Secession show in Vienna. G.B. Shaw, *Man and Superman*.		Stieglitz founds the magazine *Camera Work* in New York.
1904			
Pascoli, *Poemi conviviali* (Convivial Poems). Marinetti, "*Destruction*", poem in French. Pirandello. *Il fu Mattia Pascal* (The Late Mattias Pascal).	Matisse, *Luxe, calme et volupté*. Lecture by Gabriel Alomar: *Futurism in Barcelona*. Méliès, *The Impossible Voyage*, film. Soffici meets Medardo Rosso in Paris. P. Scheerbart, *Revolutionäre Theater-Bibliothek* (Revolutionary Theatre-Library). Death of Marey and Muybrigde. Berg and Webern study with Schönberg in Vienna. G. Mahler, *Kindertotenlieder*. R. Steiner, *Theosophy*.	M. Vrubel, *Portrait of Briussov*. The magazine *The World of Art* closes. M. Larionov, *Rain*. Biely, *Gold in Azure*, poems. (B. Cendrars settles in Russia for three years). Briussov founds the magazine *The Scale*.	Coburn leaves the United States for London.
1905			
Marinetti founds the magazine *Poesia* in Milan. It will appear in French and Italian and publish an international review of "free verse". Marinetti, *Le Roi Bombance*, published in French in Paris. A. Palazzeschi, *Cavalli bianchi* (White Horses). Previati publishes *La tecnica della pittura* (The Technique of Painting). Balla, *The Madwoman*. Casella, *First Symphony*. M. Morasso, *The New Weapon: The Machine*.	Retrospective of Seurat and Van Gogh at the Salon des Indépendants in Paris. The "Fauves" in Paris: Matisse, Derain, Vlaminck, Marquet, etc. Leo and Gertrude Stein in Paris. First exhibition of Die Brücke in Dresden. Duchamp-Villon, *The Football Players*. Kupka illustrates H.G. Wells. Debussy, *La Mer*, a symphonic poem. Freud, *Three Essays of the Theory of Sexuality*. Méliès, *The Paris-Montecarlo Rally in Two Hours*, film. F. Jourdain, first metallic façade. Ch. Morgenstern, *Galgenlieder* (Gallows Songs). R. Strauss, *Salome*, Dresden. Einstein publishes the *Special Theory of Relativity*. G. Craig, *The Art of the Theatre*. M. Reinhardt founds the Deutscher Theater in Berlin.	A. Remizov, *The Pond*, novel.	In New York, at 291 Fifth Avenue, Stieglitz opens his gallery "Photo Secession". Weber, Marin And Carles go to Paris.

Italy	Western Europe	Eastern Europe	America

1906

Italy	Western Europe	Eastern Europe	America
Papini writes *Il crepuscolo dei filofosi* (The Twilight of the Philosophers), essay. P. Buzzi, *L'esilio* (The Exile), a novel-poem. Previati publishes "Scientific Principles of Divisionism". Boccioni visits Paris and Russia. Modigliani and Severini in Paris. G. Moretti, *Power Station in Trezzo d'Adda*.	Matisse, at the Salon d'Automne in Paris. Verhaeren, *Manifold Splendour*. A. Macedonsky, *The Calvary of Fire*, in French. Death of Cézanne. Kandinsky's exhibition at the Wertheim Gallery in Berlin. Larionov, Jawlensky and Kandinsky come to Paris for Diaghilev's exhibition of Russian Art at the Grand Palais. Derain paints in London.	M. Ciurlionis works in St. Petersburg. Fauve landscapes by M. Sarian. Larionov, *Fish at Sunset*. The first issue of *The Golden Fleece*.	Feininger publishes his comic strips in the *Chicago Tribune*. F.L. Wright, *Unity Church in Chicago*.

1907

Italy	Western Europe	Eastern Europe	America
Mario Morasso, *Il nuovo aspetto meccanico del mondo* (The New Mechanical Aspect of the World), essay. Boccioni works in Venice (*Canal Grande*). Death of Pellizza da Volpedo.	Cézanne exhibition at the Salon d'Automne in Paris. Picasso, *Les Demoiselles d'Avignon*. Braque, *Grand nu*, 1907-08. *Futurism*, magazine published in Barcelona. R.M. Rilke, *New Poems*. O. Mirbeau, *The 628 E 8*, novel. H. Bergson, *Creative Evolution*. Death of A. Jarry. The Werkbund is founded by German architets.	At the end of 1907, the Burliuk brothers and Larionov organize the anti-Realist, anti-Symbolist exhibition The Crown and then the exhibition The Blue Rose.	Arriving from Mexico, M. De Zayas meets Stieglitz. Diego Rivera leaves Mexico for Europe. W. James, *Pragmatism*. G. Bellows paints *42 Kids* in the realist style of the Ash Can School.

1908

Italy	Western Europe	Eastern Europe	America
G.P. Lucini, *Ragion poetica e programma del verso libero* (Poetical Reason and the Free Verse Programme). Marinetti's accident with his 4-cylinder Fiat. The magazine *La Voce* founded in Florence. Soffici, article on Cézanne in *La Voce*. Marinetti, *Les Dieux s'en vont, D'Annunzio reste* (The Gods Go, D'Annunzio Remains), in French. E. Pound publishes *A lume spento* in Venice.	*El Futurisme* and *Futurisme*, Catalan reviews. G. Sorel, *Reflections on violence*. First animated cartoons by Emile Cohl. Picasso organizes a banquet in honour of the Douanier Rousseau. Braque exhibition presented by Apollinaire at Kahnweiler's. Munch exhibition in Munich. M. Renard, *Doctor Lerne*, novel dedicated to Wells and praised by Apollinaire. Apollinaire and Derain, *L'enchanteur pourrissant*. J. Romains, *Unanimous Life*. V. Larbaud, *Poems by a Rich Amateur*. Worringer publishes *Abstraktion und Einfühlung*. Kandinski works in Murnau. A. Loos, *Ornament and Crime*.	V. Khlebnikov publishes *The Temptation of the Sinner*. Neo-Primitivist exhibition The Link by the Burliuk brothers, Goncharova and Larionov. Shchukin meets Picasso through Matisse. Larionov, *The Soldiers*, Primitivism. Ciurlionis, series of plastic *Sonatas*. A. Archipenko leaves for Paris. Stravinsky, *Fireworks*.	Stieglitz starts to exhibit in his gallery "291"

1909

Italy	Western Europe	Eastern Europe	America
February 20, *Le Figaro* publishes the *Manifesto of Futurism* by F.T. Marinetti. Marinetti publishes *Poupées électriques* (Electric Dolls) (theatre) and *Mafarka le Futuriste* (Mafarka the Futurist), a novel which will be translated into Italian by Decio Cinti; the *First Political Manifesto* and *Let's Kill Moonlight*. G.P. Lucini, *Pistol shots*. Marinetti's *Le Roi Bombance* staged at the Théâtre de l'Oeuvre in Paris. Balla, *Arc Lamp*. P. Buzzi, *Aeroplanes*, poems.	Picasso, *Portraits of Vollard* and *Kahnweiler*; *Head of a Woman*, bronze. Delaunay, *Saint-Severin* series. The Ballets Russes present *Prince Igor* at the Châtelet in Paris. Léger starts *Nudes in the Forest*. Kupka starts the series *Woman Picking Flowers*. The Futurist Manifesto is translated in several countries. Schönberg, *Erwartung*; Webern, *Five Movements*; Berg, *Quartet*. Lipchitz settles in Paris.	Shchukin commissions Matisse to paint *Dance* and *Music*. M. Denis leaves for Moscow in January. End of 1909: Third Salon of the Golden Fleece; Balla and Braque exhibited beside Kandinsky and Larionov. Ouspensky, *The Fourth Dimension*. Acmeist magazine *Apollo* founded. E. Guro, *Barrel-organ*.	Max Weber returns from Paris and introduces Cubism to the United States. Maurer and Marin exhibit at the Photo Secession Gallery.

1910

Italy	Western Europe	Eastern Europe	America
Croce, *Problemi di Estetica* (Problems of Aesthetics). Boccioni, *The City Rises* and *Riot in the Galleria*. First controversial Futurist *soirées*: Trieste Milan, Turin, Venice. Flyer, *Against Passéist Venice* and *Futurist Speech to the Venetians*. Boccioni's first one-man exhibition at Ca'Pesaro. Boccioni, Carrà, Russolo, exhibition in Milan. A. Palazzeschi, *L'incendiario* (The Incendiary). 11 February, *Manifesto of Futurist Painters*; 11 April, *Technical Manifesto of Futurist Painting*. Carrà, *Swimmers*. Russolo, *The Perfume*. Pratella, *Manifesto of Futurist Musicians*.	De Chirico in Paris paints *The Mystery of the Oracle*. Claudel, *Five Long Odes*. Léger meets Braque and Picasso. H. Walden founds *Der Sturm* in Berlin. R. Roussel, *Impressions of Africa*. E. Pound, *The Spirit of Romance*. The Neopathetisches Cabaret in Berlin becomes a meeting place for Expressionist poets. I. Stravinsky, *The Firebird*, ballet. 1909-11, Max Linder's best films. *Prometeo* in Madrid publishes a "Futurist Proclamation to the Spaniards". Delaunay starts his *City of Paris*. Matisse exhibition at the Bernheim Gallery. Manet, second Post-Impressionist exhibition in London.	*The Impressionist' Studio*, anthology, St. Petersburg. *A Trap for Judges*, anthology, St. Petersburg. The Union Youth founded in St. Petersburg by Matiushin, Guro, Rozanova, Kruchenykh. December: Jack of Diamonds exhibition in Moscow, with Larionov, Malevich, Kandinsky and the French Cubists. Larionov and Goncharova, Primitivist period. N. Kulbin, *La musique libre*, in French, St. Petersburg. Chagall leaves for Paris. Kamensky publishes *The Hut*, a Neo-Primitivist novel. Death of Vrubel.	Dove returns from his first journey to Europe: first abstract studies.

Italy	Western Europe	Eastern Europe	America

1911

Italy

Marinetti on the Libyan Front: *Manifesto to Italian Tripoli.*
Marinetti, *Manifesto of Futurist Playwrights.*
Pratella, *Futurist Music, Technical Manifesto.*
Marinetti, *Le futurisme*, a collection of articles in French.
Marinetti speaks at the Maison des Etudiants in Paris and at the Fenice Theatre in Venice.
A.G. Bragaglia, first photodynamics and *Futurist Photodynamism.*
Boccioni, Carrà, Russolo exhibition in Milan.
In October Boccioni and Carrà meet Picasso and Apollinaire in Paris.
C. Govoni, *Poesie elettriche.*
Marinetti, *Le Monoplan du Pape* and *La bataille de Tripoli.*
G. Papini writes *Un uomo finito* (A Broken Man).
I poeti futuristi, anthology published in Milan.
Boccioni, *Antigraceful; Matter, Development of a Bottle in Space; Synthesis of Human Dynamism; Fusion of Head + Window.*
A. Palazzeschi, *Il codice di Perelà.*
A. Soffici, *Arthur Rimbaud*, an essay.
Carrà, *Portrait of Marinetti; Funeral of the Anarchist Galli.*
Boccioni, *The Laughter; Forces of a Street; States of Mind.*
Russolo, *Revolt; Music.*

Western Europe

Cubism causes a great stir in Paris at the Salon des Indépendants and the Salon d'Automne.
La Section d'Or group founded in Puteaux with the Duchamp brothers, Léger, Gleizes, Le Fauconnier, Archipenko.
Saint-John Perse, *Eloges*, First Fantômas novel.
Duchamp paints *Nude Descending a Staircase* and *Sad Young Man in a Train.*
G. Middleton Murry and K. Mansfield publish the magazine *Rhythm.*
Chagall starts *Homage to Apollinaire.*
F. Pfemfert founds *Die Aktion* in Berlin.
Braque, *The Portuguese.*
Kokoschka, *The Burning Thornbush.*
Debussy and D'Annunzio, *Le Martyre de Saint Sébastien.*
Der Blaue Reiter, first exhibition in Munich.

Eastern Europe

Skriabin, *Prometheus, Poem of Fire*, symphonic poem with lighting effects.
I. Severianin founds Ego-Futurism in St. Petersburg.
Matisse travels to Moscow.
Maiakovsky meets D. Burliuk at the School of Fine Arts in Moscow.
V. Tatlin paints *The Sailor.*
Bartòk, *Allegro Barbaro.*
Plasticist Group founded by Spala, Beneš, Filla, Gutfreund, and the Capek brothers.

America

Weber exhibition at the "291" gallery.
C. Ives, *Orchestra Suite for Music Hall.*
Atl leaves Mexico for his second visit to Paris.
Barradas leaves Uruguay for Europe and settles in Barcelona.
K. Kramer leaves Germany and settles in the United Stated.

1912

Italy

V. de Saint-Point, *Manifesto of the Futurist Woman.*
Boccioni, *Technical Manifesto of Futurist Sculpture.*
Marinetti, *Technical Manifesto of Futurist Literature* and *Supplement.*
In October Marinetti is a war correspondant in the Balkans.
B. Pratella, *Futurist Music.*
Exhibition of Italian Futurist painters at Bernheim's in Paris: Boccioni, Carrà, Russolo, Severini; Marinetti gives a lecture; the exhibition goes successively to London, Berlin, Bruxelles, The Hague, Amsterdam etc. and Marinetti gives more lectures.
Balla, *Dynamism of a Dog on a Leash, Iridescent Compenetrations, Girl Running on a Balcony, The Hands of the Violinist.*
Severini, *Nord-Sud, Pan-Pan Monico, Blue Dancer.*

Western Europe

B. Cendrars, *Les Pâques a New York.*
Apollinaire writes *Les fenêtres* (The Windows) for the series of paintings by Delaunay and starts the magazine *Les Soirées de Paris.*
Marinetti's texts translated into German, Spanish, etc.
Gleizes and Metzinger, *Du cubisme.*
Second Post-Impressionist exhibition in London.
Schönberg, *Pierrot lunaire.*
Epstein, *Tomb of Oscar Wilde* in Paris; scandal.
Imagism in London: Pound, H.D., Aldington, J.G. Fletcher etc.
Pound, *Riposte*, poems.
Picabia, *The Source; Procession in Seville.*
Exhibition of Futurist painters in Paris, then throughout Europe.
Kandinsky, *Über das Geistige in der Kunst* (The Art of Spiritual Harmony), and with F. Marc, *Almanach Der Blaue Reiter.*
A. Marc and R. Duchamp-Villon, *Cubist House.*
Archipenko starts his sculpture-paintings: *Medrano.*
Soffici and Severini mediate between Cubists and Futurists in Paris.
A. Döblin, article in favour of Futurism in *Der Sturm* from which he then retracts.
Picasso and Braque, first collages, papiers collés and Cubist assemblages.
G. Benne, *Morgue*, poetry.

Eastern Europe

A Slap in the Face of Public Taste, with the first Russian Manifesto, signed by D. Burliuk, Kruchenykh, Maiakowsky, and Khlebnikov.
Marinetti, first translation into Russian.
D. Burliuk, Larionov, Goncharova and Malevich are invited to the second exhibition of the Blaue Reiter in Munich.
Malevich, *The Knife-Grinder.*
Goncharova, *Cyclist; Woman on the Boulevard.*
The Donkey's Tail exhibition (Larionov, Goncharova, Tatlin, Malevich).
December: at the sixth exhibition of the Union Youth Larionov exhibits his first Rayonist works.
Kruchenykh and Khlebnikov publish *Game in Hell* and *World Backwards.*

America

Marsden Hartley leaves for Europe and stays in Germany until 1915; he will exhibit at the Blaue Reiter.
Dove exhibits at "291" in New York.
Varius American painters are attracted by abstraction (Dove, Dawson, Kramer, Marin).
The magazine *Poetry* appears in Chicago.

1913

Italy

The Belgian Schmalzigaug adopts Futurism and settles in Venice.
January: Papini and Soffici publish the first issue of *Lacerba* in Florence.
V. de Saint-Point, *Futurist Manifesto of Lust.*
Tavolato, *Contro la morale sessuale* (Against Sexual Ethics).
Boccioni, *Unique Forms of Continuity in Space; Dynamism of a Cyclist.*
Balla, *Swallows in Flight; Speed of Cars.*
Sant'Elia, Chiattone, architectural projects.
At the Costanzi Theatre in Rome, exhibition of paintings by Balla, Carrà, Russolo, Severini and Soffici; Papini reads *Against Rome and Benedetto Croce* and Boccioni gives a talk.
Russolo, *The Art of Noises,* and first

Western Europe

Apollinaire, *Alcools* and *The Cubist Painters.*
I. Stravinsky, *The Rite of Spring*, scandal.
Morgan Russel and Macdonald-Wright: Synchromist Exhibition in Munich and Paris.
Trakl, *Poems*, Leipizg.
Canudo publishes *Montjoie* in Paris.
The Omega Workshops founded in London.
Baranoff-Rossiné, *Symphony n. 2* at the Salon des Indépendants.
Survage paints *Rythmes colorés*, (Coloured Rhythms) for a film.
Cendrars and Sonia Delaunay, *Prose du Transsibérien.*
J. Villon, *Marching Soldiers.*
Einstein, *On the Theory of General and*

Eastern Europe

Max Linder Verhaaeren visit Russia.
Futurist and Expressionist exhibition at the National Salon in Budapest.
Acmeist Manifesto in the magazine.
Apollo: Gumilev, Mandelstam, Achmatova.
Larionov, *Manifesto of Rayonism* and exhibition "The Target".
Khlebnikov and Kruchenykh publish *The World as Such* and *A Forestly Rapid.*
New Futurist group in Moscow: the Mezzanine of Poetry (Shershenevich) and Centrifuge (Bobrov).
Malevich portraits: *An Englishman in Moscow* (Kruchenykh) and *The Pilot* (Kamensky).
In Prague the exhibition of Italian Futurists is welcomed by Neumann

America

Armory Show exhibition in New York, without the Futurists.
Imagists published in the magazine *Poetry* in Chigaco.
J. Stella starts *Battle of Light, Coney Island.*
Ives, *Holidays Symphony.*
Mack Sennett, *Fatty* series.
W.C. Williams publishes *The Tempers*, poems.

Italy	Western Europe	Eastern Europe	America

1913

Italy

intonarumori (noise-attuner) concerts.
Polemics on Orphism between Boccioni, Marinetti, Apollinaire, Delaunay etc. (*Lacerba* and *L'Intransigeant*).
Soffici, *Cubismo e oltre* (Cubism and Beyond).
Marinetti, *The Variety Theatre*, manifesto.
Futurist Political Programme by Marinetti, Boccioni, Carrà, Russolo.
Bragaglia exhibits his photo-dynamics in Rome.
Lacerba organizes an exhibition of Futurist paintings in Florence during which Futurists meet the Argentinian Pettoruti and the young Primo Conti.
Carrà publishes *The Painting of Sounds, Noises and Smells* in *Lacerba* and paints *The Red Horseman*.
Pratella, *The Destruction of the Scheme*.

Western Europe

Limited Relativity.
Duchamp, *Bicycle Wheel*.
Freud, *Totem and Taboo*.
L. Feuillade starts the series of *Fantômas* films.
E. Roussel, *Locus Solus*.
Exhibition of Boccioni's Futurist sculptures at the Boétie Gallery in Paris and lecture by Marinetti, *Imagination without Strings*.
Delmarle, *Futurist Painting* and *Futurist Manifesto against Montmartre*. Scandal, but Marinetti approves.
Polemics on Orphism between Boccioni and Apollinaire.
Apollinaire, *L'antitradition futuriste*.
Epstein, *The Rock-Drill*, sculpture and machine.
Lewis, *Timon of Athens*, series of drawings.
Archipenko, "sculto-paintings".
Tatlin travels to Berlin and Paris.
Nevinson befriends Severini in London.

Eastern Europe

and the Čapek brothers.
The Plasticist group exhibits in Prague beside Braque, Picasso, Gris, Derain and Soffici.
Larionov, Goncharova and Zdanevich paint each other's faces.
Malevich, *Black Square*.
The Three (Guro, Khlebnikov, Kruchenykh and Malevich) and *A Trap for Judges II*, anthology, St. Petersburg.
Missal of the Three and *The Croaked Moon*, almanacs, Moscow.
Vladimir Maiakovsky: A Tragedy staged in St. Petersburg.
Victory over the Sun, opera by Matiushin, Kruchenykh and Malevich.
Kasianov, *Drama at the Futurist Cabaret no. 13*, film.

1914

Italy

D. Campana, *Canti orfici*.
Futurist *soirées* at the Sprovieri Gallery in Rome.
Manifestos: *Geometric and Mechanical Splendour* by Marinetti; *Counterpain* by Palazzeschi; *The Past Does not Exist Anymore* by Papini; *Down with Tangos and Parsifal* by Marinetti.
In January Marinetti leaves for Russia.
Tension between the Milanese and Florentine Futurists; diatribe between Papini and Boccioni in *Lacerba*.
Boccioni, *Pittura scultura futuriste* (Futurist Painting and Sculpture).
Cangiullo presents *Piedigrotta* at the Sprovieri Gallery.
International Futurist Exhibition at the Sprovieri Gallery; besides the Italians, Archipenko, Exter, Kulbin, Rozanova, Stevens, Schmalzigaug etc.
Russolo's concert of "intonarumori" in Milan.
Naples, Futurist Exhibition.
Sant'Elia, *Manifesto of Futurist Architecture*.
Futurist multiply interventionist demonstrations.
Balla, *Futurist Antineutral Clothing*, manifesto.
Futurist Synthesis of War, collective manifesto.
Marinetti, "Zang Tumb Tumb", words-in-freedom.
Folgore, *Bridges over the Ocean*.
Boccioni, *Horse + Rider + Houses*.
Carrà, *Interventionist Demonstration*, collage.
Severini, *Expansion of Light*.
Balla, *Mercury Passing in front of the Sun*.
Marinetti and Cangiullo, first free-word plates.
Lacerba: friction with the Futurists.

Western Europe

Duchamp, first "ready-mades".
London, Anthology of the *Imagistes*.
Vorticism: Pund, Lewis, Gaudier-Brzeska and Wadsworth publish the first issue of *Blast*.
London, Doré Galleries, exhibition of Futurist painters and sculptors.
The Vorticists are hostile.
Russolo, "*Intonarumori*", concert in London.
Gaudier-Brzeska, *Hieratical Head of Pound*, marble, London.
Nevinson, *Return from the Trenches*.
W. Lewis, *The Crowd*.
Bomberg, *In the Hold* and *The Mud Bath*.
London, Rebel Art Center founded by Lewis, Wadsworth, etc.
Marinetti and Nevinson, *Vital English Art* and *Contre l'art anglais*.
Bruno Taut, Glass House in Cologne with the Swedish artist GAN.
Satie, *Sports et divertissements*.
Apollinaire, Cendrars, Barzun, Delaunay, dispute over Simultaneism.
Duchamp-Villon, *The Great Horse*.
Larionov and Goncharova exhibit in Paris, presented by Apollinaire.

Eastern Europe

In January Marinetti arrives in Russia to give a series of lectures in Moscow and St. Petersburg; occasionally hostile reception (Khlebnikov) in spite of a few supporters: Kulbin and his translator Shershenevich. He leaves disappointed.
Tairov founds the Kamerny Theatre in Moscow.
First issue of the *First Revue of the Russian Futurists* in Moscow.
Roaring Parnassus, almanac, St. Petersburg.
The Russian Futurist start lecture tours.
4th exhibition in Moscow organized by Larionov and Goncharova.
Shershenevich translates the Italian Futurist manifestos.
Kamensky, *Tango with Cows*.
N. Asveev, *The Nocturn Flute*.
Khlebnikov, *Selected Poems*.
Guro, *The Baby Camels of the Sky*.
Khlebnikov and Kruchewnykh, *Té li lé*.
Kandinsky returns to Russia.

1915

Italy

Sironi, collages.
Synthetic Theatre tours after the publication of the manifesto *Futurist Synthetic Theatre* by Marinetti, Corra and Settimelli.
Palazzeschi, Papini and Soffici break away from Marinetti and his friends and publish *Futurism and Marinettism*.
Balla and Depero, "multimaterial plastic complexes".
Balla and Depero, *The Futurist Reconstruction of the Universe*, manifesto.
Prampolini, *Scénographie futuriste* (Futuriste Scenography) and *Pitture pure* (Pure Paintings).
Almanacco della Voce published in Florence.
Marinetti, *War the Only Hygiene for the World* (theory).
Buzzi, *The Elipse and the Spiral*.
Carrà, *War-painting*.
Govoni, *Rarefazioni e parole in libertà* (Rarefactions and Words in Freedom).
Soffici, *Simultaneità e chimismi lirici*.
Anthology, *Futurist Synthetic Theatre*.
Papini, *Cento pagine di poesia*.
Balla, *Boccioni's Fist* (cardboard).
Severini, *Armoured Train in Action*.

Western Europe

H. Laurens, first constructions and papiers collés.
Picasso returns to figurative drawing.
E. Pound publishes *Lustra*, poems.
Duchamp, *The Bride Stripped Bare*.
London, Vorticist exhibition at the Doré Galleries.
Döblin, *Wang-Lun*, a novel.
Stramm, *Kräfte*, poems published in *Der Sturm*.
Almada-Negreiros, Pessoa and Sá-Carneiro publish the magazine *Orpheu* in Lisbon.
Deaths of Gaudier-Brzeska and Stramm.

Eastern Europe

Kassak publishes the magazine *A Tett* in Budapest.
Malevich, *Suprematism*, manifesto.
A Futurist Drum, anthology.
A. Exter, *Venice*, oil.
Maiakovsky, *The Cloud in Trousers*, and *The Backbone Flute*.
The Archer, anthology, Petrograd.
Larionov and Goncharova leave Russia and work with Diaghilev.
Khlebnikov, *Battles 1915-1917*.
Tatlin shows *Counter reliefs* at the Tramway V exhibition.
The Spring, Counter-Agency of the Muses, anthology.
Kruchenykh and Jakobson, *Transmental Book*.

America

In New York, Duchamp, Picabia, Gleizes, Man Ray gather around Stieglitz's magazine *291*.
Max Weber, *Spiral Rhythm*, bronze and oil canvases on the theme of New York.
Mechanistic drawing by Picabia.
Griffith, *Birth of a Nation*, film.
Paintings by Boccioni, Carrà, Balla, Russolo and Severini shown at the Pacific International exhibition, San Francisco.
New York, first exhibition at M. Zayas's Modern Gallery: Picasso, Braque, Picabia.
New York, the Mexican Tablada writes his first "ideographical poems".

Italy	Western Europe	Eastern Europe	America

1916

Italy	Western Europe	Eastern Europe	America
Marinetti, *La nuova religione - morale della velocità* (The New Religion-Morality of Speed). *Manifesto of Futurist Cinema.* Rome, Depero one man show. Milan, Retrospective of Boccioni. Russolo, *L'arte dei rumori* (The Art of Noises). Florence, the magazine *L'Italia Futurista* is founded. Mallarmé, *Verses et proses,* translated by Marinetti. F. Cangiullo, *Piedigrotta.* Volt. *Archi voltaici* (Voltaic Arcs). Boccioni, Portrait of Busoni. Bragaglia, *Thais* and *Il perfido incanto* films. Deaths of Boccioni and Sant'Elia.	Severini, *Symbolisme plastique et symbolisme littéraire,* in French in the *Mercure de France.* Albert-Birot founds the magazine *SIC.* Apollinaire ridicules Futurist science. Kafka, *The Metamorphosis.* Paris, suicide of Sá-Carneiro. Max Jacob, *Le cornet à dés,* poems. Zurich, Dada is founded by Ball, Tzara, Arp, Janco etc. Tzara starts a correspondence with the Futurists: Marinetti, Cantarelli, Moscardelli, etc. *Gaudier-Brzeska, a Memoir* by Ezra Pound, London. Death of F. Marc.	Moscow, first Constructivist works exhibited by Tatlin and Rodchenko. Khlebnikov is proclaimed "King of the terrestrial globe" *Moscow Masters,* almanac. Maiakovsky writes *The War and the Universe,* and publishes *As Simple as a Bellow,* poems. *Secret Vices of the Academicians* by Kruchenykh, Malevich, Kliun. Khlebnikov, *The Mistake of Death,* theatre. Budapest, L. Kassak founds the magazine *Ma.* *The Blue Horns,* Georgian magazine, Tiflis.	Schamberg, Drawings and mechanical assemblages.

1917

Italy	Western Europe	Eastern Europe	America
Depero, sets for Stravinsky's *Nightingale,* never staged. Florence, the film *Vita futurista* (Futurist Life) is shown to the public. Marinetti, *Futurist Dance,* manifesto. Balla, sets and costumes for Stravinsky's *Feux d'artifices,* (Fireworks). Bruno, *Fuochi di Bengala* (Bengal Lights). Cantarelli, *Ascendenze cromatiche* (Chromatic Ascendances). Corra, *Sam Dunn è morto* (Sam Dunn Is Dead). Settimelli, *Mascherate futuriste* (Futurist Masquerades). Rome, exhibition of Russian Rayonist painting.	P. Reverdy founds the magazine *Nord-Sud.* Apollinaire, *Les mammelles de Tirésias,* theatre. First issue of *Dada* with the contribution of Futurists. Satie-Cocteau-Massine, *Parade* (sets by Picasso). Picabia founds the magazine *391.* Tzara and Janco correspond with Prampolini from Switzerland. Severini, "La peinture d'avantgarde" in French in the *Mercure de France.* De Stiil group is founded at The Hague. T.S. Eliot, *Prufrock,* poems. Pessoa, Almada-Negreiros and Santa Rita publish *Portugal Futurista.* Barcelona, the magazine *Troços* appears. Paris, Huidobro among the Cubists.	I. Axenov, *Picasso.* Yakulov decorates "Café Pittoresque" In Constructivist style. Maiakovsky, *Bolshevism and Art,* lecture. Futurists accept the invitation of the People's Commissar Lunacharsky. Tiflis, Group 41°, with Zdanevich, Terentev and Kruchenykh. Exhibition organized by *Ma*: Mattis-Teutsch, Bortniyk.	Severini exhibits at Stieglitzs gallery "291". Chaplin, *The Immigrant.* New York, Exhibition of English Vorticists. E. Pound publishes the first three *Cantos* in *Poetry.* New York, Proto-Dada magazines *The Blind Man* and *Rongwrong.*

1918

Italy	Western Europe	Eastern Europe	America
Depero, *Balletti plastici* (Plastic Ballets) in Rome. The magazine *Roma Futurista* is founded. Rome, Bragaglia opens his Casa d'Arte. Cangiullo, *Alfabeto a Sorpresa* (Surprise Alphabet). "Fasci Politici Futuristi" (Futurist Political Fasci) founded in several Italian cities.	Paris, Ozenfant and Le Corbusier found Purism. Paris, presentation of a "Futurist Synthesis". Apollinaire, *Calligrammes.* Albert-Birot, *Poèmes pancartes et poèmes affiches.* Paris, Larionov and Goncharova introduce Modern Theatre Decorative Art at the Sauvage Gallery. Madrid, Ultraism is founded. Barcelona, Vibrationist exhibition by Barradas. Barcelona, first exhibition of Miró. Madrid, Huidrobo publishes *Poemas Arcticos* and *Tour Eiffel.* Stravinsky and Ramuz, *L'histoire du soldat.* Cendrars, *Le Panama,* 1918. Tzara publishes *25 Poems* and *Dada Manifesto* in Zurich. Deaths of Apollinaire and Duchamp-Villon.	Malevich, *White on White* exhibited in Moscow. A. Blok, *The Twelve,* poem. Maiakovsky acts in many films *(The Lady and the Hooligan).* Petrograd, Meierkhold directs *Mystery-Bouffe* by Maiakovsky. *The Art of the Commune,* new magazine which gathers all the Futurists. Vladivostok, Burliuk, Aseev and Tretiakov found the Futurist group Creation. In Cracow, Witkiewicz publishes *New Ways of Painting.* Deaths of Olga Rozanova and B. Kubišta.	Duchamp, last painting, *Tu m'.* E. Pound, *Pavanes & Divisions,* an essay.

1919

Italy	Western Europe	Eastern Europe	America
De Chirico, *Sull'arte metafisica* (Metaphysical Art). First issue of the magazine *Valori Plastici.* Marinetti, *Futurism, Before, After and During the War,* a flyer; joins Mussolini's Fasci; publishes *Eight Souls in a Bomb,* and *Les mots en liberté futuristes* (Futurist Free Words) in French. After being defeated at the elections, Mussolini, Marinetti and a few others are arrested and then released. Folgore, *Città veloce* (Speed City). Azari, *The Futurist Aerial Theatre,* manifesto. Cangiullo, *Caffè concerto.* Prampolini stages *Matoum e Tevibar* by Albert-Birot. Ricciardi, *Teatro del colore* (The Theatre of Colour).	Albert-Birot publishes *La Joie des Sept Couleurs* and *Matoum et Tévibar.* Aragon, Breton and Soupault found *Littérature.* Breton and Soupault, *Les champs magnétiques.* Le Corbusier and Ozenfant found *L'Esprit Nouveau.* Weimar, Gropius founds the Bauhaus. Kafka, *The Penal Colony.* Goll, *Dithyramben; Der Torso; Der Neue Orpheus.* A. Salmon, *Prikas.* K. Schwitters, *Anna Blume.* R. Wiene; *The Cabinet of Dr. Caligari,* film. C. Brancusi, *Bird in Space,* bronze. Cendrars and Léger, *The End of the World.* B. Taut, *Alpine Architektur.* Ruttmann, *Opus 1,* film. Rivera and Siqueiros meet in Paris.	The short-lived group Kom-Fut is formed. Maiakovsky works on propaganda at *Rosta* (Windows). Posthumous exhibition of O. Rozanova. Shershenich, *Imagist Manifesto.* Chagall resigns as director of the Vitebsk Practical Institute, Malevich takes over. Moscow, Malevich retrospective. Tiflis, the Group 41° publishes *To Sophia Melnikova: Fantastic Cabaret.* Zdanevich publishes *Easter Island* and *Janko, the King of Albania.* Kassak and other Hungarian writers and artists leave the country at the end of the Revolution. In Warsaw, Stern publishes *Futurisations.* Cracow, Czyzewsky publishes the Formist magazine.	Demuth paints *After Sir Christopher Wren.*

Italy	Western Europe	Eastern Europe	America

1920

Italy	Western Europe	Eastern Europe	America
Cardarelli, *Viaggi nel tempo* (Journeys in Time) poems. T. Cecchi, *Pesci rossi* (Red Fishes) prose. Cangiullo's *Roma futurista* publishes "Futurist Furnitures" and Marchi's "Manifesto of Dynamic Futurist Architecture". Marinetti, *Against Feminine Luxury*. B. Pratella, *The Pilot Dro*, at the Rossini Theatre in Lugo. Milan, Marinetti marches in support of D'Annunzio in Fiume. J. Evola, *Arte astratta* (Abstract Art). Soffici, *Primi principi di un'estetica futurista* (First Principles of Futurist Aesthetics).	Geneva, Italian Futurists at the Modern Art Exhibition. K. Pinthus, *Menschheitsdämmerung*, an anthology of German Expressionists. E. Pound, *Hugh Selwyn Mauberley*, poems. London, Group X is founded. Tzara joins Picabia and the équipe of *Littérature* in Paris. D. Milhaud, *Le boeuf sur le toit*, ballet with the Fratellini Bros (clowns). Berlin, Dada Fair. Y. Goll, *Die Unsterblichen*, theatre. H. Arp, *Die Wolkenpumpe*. J. Salvat-Papasseit, *Poèmes en ondes hertzianes*, ill. Barradas and Torres Garcia, Barcelona.	H.G. Wells visits Russia. Malevich publishes *From Cézanne to Suprematism*. Concert of factory hooters. Pevsner and Gabo, *Realist Manifesto* G GA, manifesto of the Polish Futurists. Kassak restarts *Ma* in Vienna with the help of Hungarian refugees. J. Capek, *The Black King*. Maiakovsky, *150,000,000*, poem. Warsaw, Jankowski, *The Tram Across the Street*.	Duchamp, Man Ray and K. Dreier found the Société Anonyme. D. Burliuk in Japan. Tai Kanbara publishes his manifesto in Japan. W.C. Williams, *Kora in Hell: Improvisations*, poems. Tablada publishes *Li-Po*, ideographical poems.

1921

Italy	Western Europe	Eastern Europe	America
Pirandello, *Six Characters in Search of an Author*. Cangiullo and Marinetti, *The Theatre of Surprise*. Trieste, G.R. Carmelish founds the review *Cronache*. Togo meets Marinetti. Sironi, *Urban Landscapes*. Carrà, *The Engineer's Lover*.	Picasso, *The Three Musicians*. Marinetti, *Le Tactilisme*, at the Théâtre de l'Oeuvre, January 14. Russolo, Concert of "intonarumori" at the Champs-Elysées Theatre. Paris, exhibition of Italian Futurist painters at the Reinhardt Gallery. Severini, *Du Cubisme au Classicisme*. Madrid, first issue of the magazine *Ultra*. Claudel and Milhaud, *L'homme et son désir*, by the Swedish Ballets. Honegger, Léger and Canudo, *Skating Rink*, by the Swedish Ballets. Paris, first Max Ernst exhibition. Eggeling, *Diagonal Symphony*, abstract film. P. van Ostaijen, *Bezette Stad*, poems. Brecht, *In the jungle of Cities*. Siqueiros, *Vida americana*, magazine and manifesto, Barcelona. Wittgenstein, *Tractatus logico-philosophicus*. Wölfflin, *Das, Erklären von Kunstwerken*. Schlemmer and Klee teach at the Bauhaus.	Rodchenko, Stepanova, Sternberg found the Constructivist Group. Popova and Rodchenko soon become Productivists. Prague, K. Capek, *R.U.R.*, theatre. Prague, *Futurist Theatrical Syntheses*, with sets by Prampolini. Zagreb, Mitzitch publishes the magazine *Zenit*. Prague, in December Marinetti visits to prepare *The Firedrum* and the exhibition of Futurist painting organized by Prampolini and V. Dadone. Jasiensky, *A Shoe in the Button-hole*, Futurist poems; and *Nife in the Belli*.	W.C. Williams, *Sour Grapes*, poems. Man Ray leaves New York for Paris. Maples Arce publishes his Stridentist manifesto in *Actual*, Mexico City. C. Chavez, *The New Fire*, ballet. Borges returns to Buenos Aires and introduces Ultraism there. Togo leaves Japan for Europe. Mexico City, first modern frescoes: Charlot, Alva, Rivera, Revueltas.

1922

Italy	Western Europe	Eastern Europe	America
The magazine *Enturismo* is founded. Marinetti, *Gli Indomabili* (The Untamable Ones), a novel. Pannaggi, *Futurist Mechanical Ballet*, in Rome.	Berlin, Vasari founds the review *Der Futurismus*. G. Diego, *Images*, poems. Kandinsky teaches at the Bauhaus. Maiakovsky comes to Paris and meets Léger and Delaunay. Milhaud, Cendrars and Léger, *The Creation of the World* by the Swedish Ballets. O. Schlemmer presents *The Triadic Ballet* in Stuttgart. F. Murnau, *Nosferatu*, film. A. Gance, *La roue*, film. F. Lang, *Dr. Mabuse*, film. J. Joyce, *Ulysses*. T.S. Eliot, *The Waste Land*, poems. Man Ray, first rayographs. Y. Goll, *Methusalem*, theatre, in German. Moholy-Nagy, *Space and Light Modulator*. Iliazhd, *Ledentu le phare*, Paris.	L. Popova designs sets and costumes for Meierkhold's production of *The Magnanimous Cuckold* by F. Crommelynck. The Futurist-Productivist group Leftist Front of Art is founded. The magazine *Lef*, directed by Maiakovsky, will become its mouthpiece. Marinetti, *Words-in-Freedom* published in Prague. Marinetti, *The Firedrum* presented in Prague; with sets by Prampolini, music by Pratella, produced by Karl Dostal. L. Kassak and L. Moholy-Nagy, *Buch Neuer Künstler*, Constructivist theory, Vienna. Dziga Vertov, *The Camera Eye*. Devetsil groups the Czechoslovak revolutionary avant-garde artists. In Cracow T. Peiper founds the magazine *Zwrotnica*. Czyzewsky publishes *Day-Night, Electric-Mechanic Instinct* in Cracow. Death of Khlebnikov.	São Paulo, 11-18 February, Week of Modern Art. The Brazilian magazine *Klaxon* is hostile to Futurism. D. Burliuk settles in the United States. Varèse, *Offrandes* on texts by Tablada and Huidobro. E.E. Cummings, *The Enormous Room*, a novel. M. Maples Arce, *Andamios interiores*, poems. The Mexican Stridentist Group is founded. Tai Kanbara translates the Futurist manifestos into Japanese.

1923

Italy	Western Europe	Eastern Europe	America
Italo Svevo, *La coscienza di Zeno* (Zeno's Conscience), novel. Paladini, Pannaggi and Prampolini, *Manifesto of Mechanical Art*. Marinetti, *Tamburo di fuoco* (Firedrum), African drama. Cangiullo, *Poesia pentagrammata* (Staved Poem). Prampolini publishes the magazine *Noid*, 2nd series. Rome. Bragaglia becomes director of the Teatro degli Indipendenti.	Léger, *The Aesthetics of the Machine*. The Ballets Russes presents Stravinsky's *Les noces* with sets by Goncharova. E. Mendelsohn, *Dynamics and Function*. Le Corbusier, *Towards an Architecture*. George Grosz, *Ecce Homo*, drawings. L'Herbier, *L'Inhumaine*, film with Léger, Milhaud, Mallet-Stevens. Honegger, *Pacific 231*, a symphonic movement. Iliazhd organizes a "Transmental Ball" in Paris. R. Clair, *Paris qui dort*, film. H. Chomette, *Jeux des reflets et de la vitesse*, film.	*Lef* is published: the Futurist come out. Popova and Stepanova work at the Textile Factory in Moscow. Cracow, Witkiewicz publishes his *Theatre*. Khlebnikov's *Zangezi* is staged with sets by Tatlin.	Archipenko settles in the United States. W. Stevens, *Harmonium*, poems. W.C. Williams, *Spring and All*, poems. E.E. Cummings, *Tulips and Chimneys*, poems. Varèse, *Hyperprism*, for wind and percussion instruments. Tokyo, Larionov and Goncharova present "Modern Decorative Theatrical Art" at the Shiseido Gallery. Duchamp stops working at *La mariée mise à nu*, started in 1915.

Italy	Western Europe	Eastern Europe	America
1924			
Prampolini, *The Futurist Scenic Atmosphere.* Milan, Futurist National Congress. Marchi publishes *Futurist Architecture.* Marinetti publishes *Futurist and Fascism.* Balla, Futurist Drawing-room (furniture).	Marinetti, *Futurism in the World,* lecture at the Sorbonne. Murnau, *Der Letzte Mann,* film. J. Miró, *Tilled Earth.* H. Richter, *Vormittagsspuk.* T. Tzara, *A Cloud Handkerchief,* theatre. F. Léger, *Ballet mécanique,* film, music by Antheil. The magazine *La Révolution surréaliste* is founded. R. Clair, *Entr'acte,* film with Picabia and Satie. A. Breton, *Manifesto of Surrealism.* P. Eluard, *Mourir de ne pas mourir,* poems.	Maiakovsky, *Vladimir Ilich Lenin,* poem. A. Exter and Protazanov, *Aelita,* film. K. Capek, *The Cracatite.* J. Capek, *The Artificial Man.* Bucarest, the magazine *Contimporanul* is founded. Warsaw, the Constructivist magazine *Blok* is founded. Stern and Jasiensky, *The Earth to the Left,* Warsaw. H. Berlewi, Mecanofaktura, Polish Constructivism.	Pettoruti returns to Buenos Aires. Buenos Aires, the magazine *Martin Fierro* is founded. Gershwin, *Rhapsody in Blue.* Grant Still, *Dark America.* Mexico, Maples Arce publishes *Urbe,* illustrated by Jean Charlot.
1925			
Montale, *Ossi di seppia* (Cuttle-fish Bone), poems. Depero, Balla and Prampolini prepare the Italian Pavilion at the Exhibition of Decorative Arts in Paris. *The New Futurist Poets,* anthology. R. Vasari, *L'angoscia delle macchine* (The Anguish of the Machines) theatre.	Paris, International Exhibition of Decorative Arts. Maiakovsky visits Paris on his way to the United States. Aragon, *Le paysan de Paris.* Gropius and Moholy-Nagy start publishing the *Bauhausbücher,* which will present Mondrian, Klee, Malevich, Oud, Van Doesburg, etc. Supervielle, *Gravitations,* poems. Antheil, *Jazz Symphony,* presented in Paris. Kafka, *The Trial.* A. Berg, *Wozzeck,* opera. Schwitters, Steinitz and Van Doesburg publish Die Scheuche. *Lissitsky-Arp, The Isms of Art.*	Paris, Constructivists and Productivists contribute to Melnikov's Soviet Pavilion at the Exhibition of Decorative Arts. Seifert, *On the Waves of Radio,* poems. Prokofiev, *The Steel Step.* Eisenstein, *Potemkin* and *The Strike,* films. Witkiewcz creates his "Factory of Portraits" in Cracow.	Maiakovsky visits the United States and Mexico. Varèse, *Intégrales,* for orchestra and percussion. G. Cueto, *Stridentist Polychrome Masks.* J. Dos Passos, *Manhattan Transfer,* a novel.
1926			
Prampolini, *Futurist Architecture,* manifesto. Marinetti visits Latin America.	F. Lang, *Metropolis,* film. Mies van der Rohe becomes director of the Werkbund in Berlin. Le Corbusier, *Almanac of Modern Architecture.* P. Soupault, *Georgia,* poems. P. Eluard, *Capitale de la douleur,* poems. A. Gance, *Napoleon,* film.	Esenin commits suicide. Maiakovsky tours the Soviet Union. Pudovkin, *The Mother.* S. Syrkus and H. Stazwesky found *Praesens* in Warsaw.	Brazilian Modernists show hostility to Marinetti. The Mexican Stridentist magazine *Horizonte* is founded with List Arzubide, Maples Arce, Alva, Revueltas, Charlot, Rivera and the American Weston and Modotti.
1927			
Depero the Futurist, bolted machine-book.	J. Ivens, *A Study in Movements,* film. Stravinsky, *Oedipus Rex,* Paris. E. Krenek, *Jonny spielt auf,* opera, Leipzig. Prampolini's Theatre of Futurist Pantomine is boycotted by the Surrealist. Heidegger, *Sein und Zeit.* G. Dulac-Artaud, *La coquille et le clergyman,* film.	Maiakovsky, *Good,* poem. Eisenstein, *October.* The review *New Left* appears. K. Teife founds the review *Red* in Prague.	G. Cueto leaves for Paris where he will exhibit with the group Cercle et Carré. The Stridentists disband.
1928			
Turin, first exhibition of Futurist architecture.	Honegger, *Rugby,* a symphonic movement. Breton, *Surrealism and Painting, Nadja.* Aragon, *Treatise on Style.* Soupault, *Les dernières nuits de Paris,* a novel. B. Brecht, *The Threepenny Opera.* Garcia Lorca, *Romancero gitano,* poem.	Maiakovsky travels to Paris. Le Corbusier travels to Moscow.	C. Demuth, *I Saw the Figure 5 in Gold.*
1929			
Manifesto of Aerial Painting, collective statement. Bragaglia, *On Theatrical Theatre, or on Theatre.* Marinetti is nominated Academician of Italy.	Paris, Futurist Concert with Russolo at the Gallery 23. Picasso with J. Gonzales, iron sculptures. H. Michaux, *Mes propriétés,* poems. Max Ernst, *La femme 100 têtes.* A. Breton publishes *The Second Manifesto of Surrealism.* Döblin, *Berlin Alexanderplatz,* a novel. F. Lang, *The Woman on the Moon,* film.	Meierkhold stages *The Bedbug,* by Maiakovsky. Dziga Vertov, *Man with a Camera,* documentary film. Prague, special issue of *Red* dedicated to Futurism and Marinetti. K. Kobro, *The Block and the Sculpture,* Polish Constructivism.	W. Faulkner, *The Sound and the Fury,* novel. Stuart Davis returns to the United States.
1930			
S. Quasimodo, *Acque e terre* (Waters and Lands) poems. Marinetti, *Manifesto of Futurist Cuisine.*	First issue of *Le Surréalisme au service de la Révolution.* Buñuel, *L'âge d'or,* film. R. Desnos, *Corps et biens,* poems.	Meierkhold stages Maiakovsky's *The Bath House.* Tatlin begins work on his flying machine, the *Letatlin.* J. Przyboys, *From the Top,* with Strzeminsky. Polish Constructivism. Suicide of Maiakovsky.	T.H. Benton, frescoes for the New School of Social Research. H. Crane, *The Bridge.*

Paintings and Sculptures

G. Adrian-Nilson
The Blue Locomotive, 1915, oil on canvas, 31,7 × 33,8 cm, Belenius Collection, Stockholm

P. Albert-Birot
Nude Woman in the Bathroom, 1916, woodcut, 14,7 × 15,2 cm, Private Collection

P. Albert-Birot
Nude Woman in the Bathroom (two versions), 1916 oil on board, diameter 29 and 31,5 cm. Musée National d'Art Moderne, Centre Georges Pompidou, Paris

R. Alva de la Canal
Maples Arce, 1924, woodcut, 24 × 22 cm, F. Leal Collection, Mexico City

R. Alva de la Canal
Maples Arce, pencil, 18 × 18 cm, B. de Maples Arce Collection, Mexico City

R. Alva de la Canal
Portrait of Maples Arce, 1924, 19,5 × 17 cm, engraving on linen, Fam. Alva de la Canal Colletion, Mexico City

R. Alva de la Canal
Maples Arce nel Cafe de Nadie, 1924, pencil, 41 × 29 cm. B. de Maples Arce Collection, Mexico City

R. Alva de la Canal
El Cafe de Nadie, 1924-25, oil, 79,5 × 64,5 cm, B. de Maples Arce Collection. Mexico City

R. Alva de la Canal
List Arzubide, 1925, woodcut, 17 x 16 cm. F. Leal Collection, Mexico City.

R. Alva de la Canal
Engraving for the cover of *El pentagramma electrico,* 1925, 20, 5 × 18 cm. Fam. Alva de la Canal Collection, Mexico City

R. Alva de la Canal
Portrait of S. Gallardo, 1925, woodcut, 17 × 20 cm. Fam. Alva de la Canal Collection, Mexico City

R. Alva de la Canal
Cover for «El viajero en el vertice», 1926, woodcut, 14 × 12 cm, F. Leal Collection, Mexico City

R. Alva de la Canal
Abstract Composition, 1926-28, woodcut, 26 × 23 cm, F. Leal Collection, Mexico City

R. Alva de la Canal
Exhibition 30 × 30 in Puebla, 1928, woodcut, 19 × 19 cm, F. Leal Collection, Mexico City

R. Alva de la Canal
Abstract Composition, woodcut, 17,5 × 17 cm, F. Leal Collection, Mexico City

R. Alva de la Canal
Abstract Composition, woodcut, 46 × 29 cm, F. Leal Collection, Mexico City

R. Alva de la Canal
Todo el poder..., ink 11 × 17,5 cm, Fam. Alva de la Canal Collection, Mexico City

R. Alva de la Canal
Spiral Composition, ink, 9,5 × 22 cm, Fam. Alva de la Canal Collection, Mexico City

R. Alva de la Canal
The Window, ink, 12 × 20 cm, Fam. Alva de la Canal Collection, Mexico City

R. Alva de la Canal
Imaginary Landscape, ink, 11,5 × 23,5 cm, Fam. Alva de la Canal Collection, Mexico City

R. Alva de la Canal
City, ink, 15 × 12 cm, Fam. Alva de la Canal Collection, Mexico City

R. Alva de la Canal
City in V, ink, 9 × 17 cm, Fam. Alva de la Canal Collection, Mexico City

L. Atkinson
Composition, 1913, ink, pastel and watercolor on paper, 33,5 × 21,5 cm. A. d'Offay Gallery, London

L. Atkinson
Vital, 1913-15, ink and watercolour on paper, 61,6 × 45.7 cm, H, Mudd Collection, New Mexico

Dr. Atl
Man Is Molecule, (1914?), ink and gouache, 47,5 × 55 cm, Lic. L. Araujo Valdivia Collection, Mexico City

Dr. Atl
The Great Galaxy, (1914?), china ink, 48,5 × 57 cm, Lic. L. Araujo Valdivia Collection, Mexico City

Dr. Atl
Cosmic Curves, (1914?), pencil and ink, 28,5 × 36 cm, Lic. L. Araujo Valdivia Collection, Mexico City

Dr. Atl.
Composition, (1914?), pencil and ink, 31 × 48 cm, Lic. L. Araujo Valdivia Collection, Mexico City

Dr. Atl
The Brain, (1914?), pencil, 26,5 × 28 cm, Lic. L. Araujo Valdivia Collection, Mexico City

G. Balla
Iridescent Compenetration no. 2, 1912, oil on panel, 77 × 77 cm, Private Collection

G. Balla
Squared Iridescent Compenetration, 1912, watercolour on paper, 26 × 18,5 cm, Galleria Civica d'Arte Moderna, Turin

G. Balla
Iridescent Compenetration (from the Düsseldorf note books), 1912, study, watercolour on paper, 22 × 18 cm, 22 × 18 cm, 22 × 18 cm, 22 × 18 cm, 18 × 14 cm, 13 × 9 cm. Galleria Civica d'Arte Moderna, Turin

G. Balla
Iridescent Compenetration (from the Düsseldorf note books), 1912, study, watercolour on paper, 22 × 17,7 cm, 22 × 17,7 cm, 18,8 × 17,7 cm, 19,8 × 19,5 cm, 13,3 × 18,2 cm, Galleria Civica d'Arte Moderna, Turin

G. Balla
Iridescent Compenetration with Circles in a Round, 1912, study, watercolour on paper, 22 × 17,7 cm, Galleria Civica d'Arte Moderna, Turin

G. Balla
Iridescent Compenetration with Circles in a Round, 1912, study, watercolour and pencil on paper, 22 × 18 cm, Galleria Civica d'Arte Moderna, Turin

G. Balla
Futurist Triangle Neck-tie, 1913-14, study, pencil on paper, 11,5 × 16,5 cm, Private Collection

G. Balla
Hell or At Hell's Doors, 1914, pastel and pencil on paper, 21 × 31 cm, Museo Teatrale alla Scala, Milan

G. Balla
Hell or At Hell's Doors, 1914, sketch for a stage set, pencil on paper, 21 × 31 cm, Museo Teatrale alla Scala, Milan

G. Balla
Hell or At Hell's Doors, 1914, project for a stage set, pencil or paper, 31 × 41 cm, Museo Teatrale alla Scala, Milan

G. Balla
Screen (with Speed Lines), 1914, project, watercolour and pencil on paper, 33 × 23,5 cm, Private Collection

G. Balla
Caproni Aeroplane Forces, 1915, pastel on paper, 46 × 57 cm, Forchino Collection, Turin

G. Balla
Scarf and Handbag, 1916, felt and cotton, 125 × 22,5 cm, 22 × 18 cm, Private Collection

G. Balla
Walking-stick Stand, 1916 c., painted wood, 33,5 × 18,5 × 18,5 cm, Private Collection

G. Balla
Design for a Tray, 1916, tempera and pencil on paper, 23 × 31 cm. Private Collection

G. Balla
Design for Flower-vases, 1916, tempera on paper, 30 × 22 cm, Private Collection

G. Balla
Futurist Neck-tie, 1916, model, watercolour on paper, 36 x 13 cm, Private Collection, Rome

G. Balla
Handbag, 1916, sketch, watercolour and pencil on paper, 28 × 22 cm, Private Collection, Rome

G. Balla
Container with Lid, 1917-18, ceramic, diameter 13 cm, N. Seroussi Galérie, Paris

G. Balla
Record-cover, 1918, colour inks on paper, 31 × 31 cm, Private Collection

G. Balla
Interior Decoration Design, 1918, watercolour on paper, 27 × 22 cm, Private Collection, Rome

G. Balla
Drawing-room Decoration Design, 1918, inks on paper, 44,5 × 56 cm, Private Collection, Rome

G. Balla
Interior Decoration Design, 1919, tempera on paper, 35 × 46 cm, Private Collection, Rome

G. Balla
Shoes, 1920, Private Collection, Rome

G. Balla
Paper-holder, 1920, painted wood, 27 × 16 × 18,5 cm, Private Collection

G. Balla
Interior Decoration Design, 1920, watercolour and paint on paper, 30 × 42 cm, Private Collection, Rome

G. Balla
Women's Hats, sketches, 1920, paint and ink on paper, 24 x 16 cm, Private Collection, Rome

G. Balla
Handbags, sketches, 1920, paint and ink on paper 15,5 × 9,5 cm, Private Collection, Rome

G. Balla
Design for Unit Furniture, 1920, tempera on paper, 21 × 31 cm, Private Collection

G. Balla
Bal Tik-Tak, design for electric sign, panels for the orchestra-stage, design for the box-office, outside lamp, bar-counter and show-case, 1921, watercolour on paper, Private Collection

G. Balla
Sketch for Hall Furniture with Mirror, 1922, tempera and ink on paper, 40 × 26 cm, Private Collection

G. Balla
Sketch for Hall Furniture, 1922, tempera on paper 28,5 × 43 cm, Private Collection

G. Balla
Tarascibalbu, sketch for chest and hat-stand, 1922, tempera on paper, 24 × 23 cm. Private Collection

G. Balla
Golden Expansion of Pessimism and Optimism, 1924, oil on canvas, 46 x 61 cm., Private Collection

G. Balla
Aero Rumor, 1925, oil on canvas, 77 × 77 cm, Franchetti Collection, Rome

G. Balla
Futurist Ballet, sketch for a set, 1925, watercolour on paper, 33 × 22 cm, Museo Teatrale alla Scala, Milan

G. Balla
Ashtray, 1928, painted ceramics, 12,5 × 3,5 × 4,5 cm, Private Collection

G. Balla
Dish, 1928, painted ceramics, diameter 31 cm, Private Collection

U. Boccioni
Portrait (Luigi Russolo), 1909, tempera and pastel on paper, 40 × 30 cm, Private Collection

U. Boccioni
Giants and Pygmies, 1910, pencil on paper, 31 × 64 cm, B. Fiore Donation, Galleria Civica d'Arte Moderna, Turin

U. Boccioni
Figures for Scenes of Urban Life, 1910, pencil on paper, 12 × 16 cm, Calmarini Collection, Milan

U. Boccioni
The Farewells, 1911, ink on paper, 35 × 46 cm, left by S. and E. Estorick

U. Boccioni
The Mother, 1912, pencil on paper, 20 × 16 cm, Private Collection

D. Bomberg
The Ballerina, 1913-14, pastel, gouache and watercolour on paper, 55,5 × 50 cm, The Trustes of the Victoria & Albert Museum, London

C. Carrà
Rythms of Objects, 1911, oil on canvas, 53 × 67 cm, E. and M. Jesi Collection, Milan

C. Carrà
Still-life, ink on paper, 15,8 × 12,8 cm, Private Collection

C. Carrà
Galleria di Milano, 1912, pencil on paper, 37 × 12, Mattioli Collection, Milan

C. Carrà
Small De-composition, 1912, pencil on pasteboard, 11 × 6,6 cm, Private Collection

C. Carrà
Lover's House, pencil on pasteboard, 11,6 × 8 cm, Private Collection

C. Carrà
Running Figure, 1913, ink and watercolour on paper, 17 × 13,7 cm, Private Collection.

C. Carrà
De-composition of a Head, 1914, pencil on visiting-card, 11 × 6,6 cm, Private Collection

C. Carrà
Marine Vision, 1914, pencil on paper, 15,5 × 10,5 cm, Private Collection

J. Charlot
Man Carrying Bananas, 1923, woodcut, B. de Maples Arce Collection, Mexico City

J. Charlot
Engraving for Irradiator, 11 × 9 cm, B. de Maples Arce Collection, Mexico City

M. Chiattone
Imaginary Architecture, 1914, pencil and pastel on paper, 17 × 19,5 cm, Dip. di Storia delle Arti dell'Univ., Gab. Disegni e Stampe, Pisa

M. Chiattone
Railway Station, 1914, china ink, pastel, tempera on ochre paper, 28 × 18 cm, Dip. di Storia delle Arti dell'Univ., Gab. Disegni e Stampe, Pisa

M. Chiattone
Exhibition Building III, 1914, pencil on paper, 35,5 × 31 cm. Dip. di Storia delle Arti dell'Univ., Gab. Disegni e Stampe, Pisa

M. Chiattone
Exhibition Building I, 1915, pencil, ink, pastel and watercolour on paper, 25 × 27 cm, Dip. di Storia delle Arti dell'Univ., Gab. Disegni e Stampe, Pisa

L. Chwistek
Fencing, 1919, pencil, gouache and watercolour on paper, 24 × 26,3 cm, Private Collection

A.L. Coburn
H.G. Wells from «More Men of Mark», 1905, photograph, 20,3 × 16 cm, International Museum of Photography, G. Eastman House, Rochester, New York

A.L. Coburn
The Singer Building, 1910, silver gelatin print, 19,5 × 10,3 cm, International Museum of Photography, G. Eastman House, Rochester, New York

A.L. Coburn
House with a Hundred Windows, New York, 1912, silver gelatin print, 20,7 × 15,7 cm, International Museum of Photography, G. Eastman, House, Rochester, New York

A.L. Coburn
Jacob Epstein from «More Men of Mark», 1914, silver gelatin print, 20,6 × 15,8 cm, International Museum of Photography, G. Eastman House, Rochster, New York

A.L. Coburn
Wyndham Lewis from «More Men of Mark», 1916, silver gelatin print, 24,8 × 19,9 cm, International Museum of Photography, G. Eastman House, Rochester, New York

A.L. Coburn
Vortograph, 1917, silver gelatin print, 27,6 × 20,7 cm, International Museum of Photography, G. Eastman House, Rochester, New York

A.L. Coburn
Vortograph, 1917 c., silver gelatin print, 28,3 × 21,4 cm, International Museum of Photography, G. Eastman House, Rochester, New York

A.L. Coburn
Vortograph, 1917 c., silver gelatin, 29,5 × 24,5 cm, International Museum of Photography, G. Eastman House, Rochester, New York

A.L. Coburn
Vortograph, silver gelatin print, 46,2 × 34,6 cm, International Museum of Photography, G. Eastman House, Rochester, New York

A.L. Coburn
Vortograph, 1917 c., silver gelatin print, 47,5 × 36,4 cm, International Museum of Photography, G. Eastman House, Rochester, New York

A.L. Coburn
Vortograph of Ezra Pound, 1917 c., silver gelatin print, 18,3 × 15,5 cm, International Museum of Photography, G. Eastman House, Rochester, New York

A.L. Coburn
Vortograph of Ezra Pound, 1917, silver gelatin print, 20,7 × 15,4 cm, International Museum of Photography, G. Eastman House, Rochester, New York

A.L. Coburn
Vortograph of Ezra Pound, 1917 c, silver gelatin print, 20,8 × 15,7 cm, International Museum of Photography, G. Eastman House, Rochester, New York

A.L. Coburn
Cover for the catalogue of the exhibition «Vortograph and Painting», 1917, ink on paper, 24,3 × 19 cm, International Museum of Photography, G. Eastman House, Rochester, New York

A.L. Coburn
Liverpool Cathedral in Construction, 1919, silver gelatin print, 28,3 × 21,1 cm, International Museum of Photography, G. Eastman House, Rochester, New York

A.L. Coburn
Liverpool Cathedral, 1919 c., silver gelatin print, 28,4 × 21,4 cm, International Museum of Photography, G. Eastman House, Rochester, New York

A.L. Coburn
Liverpool Cathedral Being Built, 1920, silver gelatin print 28,4 × 21,4 cm, International Museum of Photography, G. Eastman House, Rochester, New York

A.L. Coburn
Cobweb, Liverpool, 1920 c., silver gelatin print, 24,5 × 17 cm, International Museum of Photography, G. Eastman House, Rochester, New York

P. Conti
Dynamics of an ink Pot, 1915, pen and pastel on squared copy-look paper glued on pasteboard, 20,8 × 15 cm, P. Conti Museum, P. Conti Foundation, Fiesole

P. Conti
Envelope with Apollinaire's Address, 1917 c., pencil on note-book paper glued on pasteboard, 8,5 × 11,2 cm, P. Conti Museum, P. Conti Foundation, Fiesole

P. Conti
Marinetti in a Bathrobe, 1920 c., wax crayon on paper glued on pasteboard, 31 x 21 cm, P. Conti Museum, P. Conti Foundation, Fiesole

P. Conti
Ardengo Soffici, 1920, wax crayon on ivory paper glued on pasteboard, 22,7 × 14,8 cm, P. Conti Museum, P. Conti Foundation, Fiesole

G. Cueto
Mask of List Arzubide, 1926, polychrome terracotta, h. 25 cm, M. Galand de Cueto Collection, Mexico City

G. Cueto
Bronze Mask of List Arzubide, 1926, bronze, h. 20 cm, G. List Arzubide Collection, Mexico City

G. Cueto
Design for the Monument to the Revolution, 1928-34, wood, h. 45 cm, M. Galan de Cueto Collection, Mexico City

F. Delmarle
Juvisy-Port Aviation, charcoal and gouache on paper, 48,1 × 52,7 cm, Musée des Beaux Arts, Valenciennes

F. Delmarle
War Drawing, 1914, Private Collection, Paris

F. Depero
Motor-Noise Piano, 1915, pen and ink-wash on paper, 32 × 42 cm, Gall. Museo Depero, Rovereto

F. Depero
Ballerina, 1915, diluted China ink on paper 32,7 × 37,2 cm, Gall. Museo, Depero, Rovereto

F. Depero
Costumes for «Le chant du rossignol», 1916, sketch, ink and pencil on paper, 22,3 × 34,3 cm, Gall. Museo Depero, Rovereto

F. Depero
Chinese Dancer, 1917, tempera on panel, 81,4 × 66 cm, Gall. Museo Depero, Rovereto

F. Depero
Costumes for «Le chant du rossignol», 1917, sketches, China ink and pencil on paper, 9 × 12 and 10 × 12,2 cm, Gall. Museo Depero, Rovereto

F. Depero
Ballerina, design for a costume, 1917, tempera on canvas, 75 × 52 cm, Gall. Museo Depero, Rovereto

F. Depero
Bells, red ink on paper, 46 × 32 cm, Gall. Museo Depero, Rovereto

F. Depero
Costume for «Le chant du rossignol», 1917, study, ink and pencil on paper, 16,1 × 11,1 cm, Gall. Museo Depero, Rovereto

F. Depero
Illustration for Istituto per suicidi by Clavel, 1917, sketch, pencil and white lead on paper, 28,7 × 21 cm, Private Collection, Trento

F. Depero
Ballerina and Parrot, 1917-18, pen and watercolour on paper, 21 × 16 cm, Private Collection

F. Depero
Figure from Capri and Man with Moustaches, 1918, China ink on paper, 14,9 × 6,8 and 14,9 × 9,2 cm, Gall. Museo Depero, Rovereto

F. Depero
The Great, Wild Woman with a Theatre in Her Belly, 1918, China ink on paper, 19,5 × 11,7 cm, Gall. Museo Depero, Rovereto

F. Depero
Dancer, 1919, China ink and ink on paper, 15,5 × 14,8 cm, Gall. Museo Depero, Rovereto

F. Depero
Sky Blue Scene, 1919, China ink on paper, 18,9 × 19,3 cm, Gall. Museo Depero, Rovereto

F. Depero
Oriental Head, 1920, polished wood, 45 × 20 × 20 cm, Gall. Museo Depero, Rovereto

F. Depero
Futurist Waistcoat, 1923, felt with silk lining, Mattioli Collection, Milan

F. Depero
The Locomotives Costumes, 1924, ink on paper, 26,5 × 25,5 cm. Gall. Museo Depero, Rovereto

F. Depero
Project for a Fair Stand, 1926, pencil on paper, 54,8 × 38,8 cm, Gall. Museo Depero, Rovereto

F. Depero
Project for the Futurist Casa d'Arte Depero, 1927, pencil on paper, 23 × 24 cm. Gall. Museo Depero, Rovereto

F. Depero
Book Pavilion, 1927, pencil and China ink on paper, 42,5 × 51,1 cm, Gall. Museo Depero, Rovereto

F. Depero
Project for an Advertising Stand (Campari), 1927, pencil on paper, 37 × 33,5 cm, Gall. Museo Depero, Rovereto

F. Depero
Bitter Campari Aperitif, 1928 c., silk-screen on panel with wood frame and braid trimming, 70 × 40 cm. Davide Campari-Milano S.p.A., Milan

F. Depero
Cordial Campari, 1929, China ink and tempera on pasteboard, 44 × 32 cm, Davide Campari-Milano S.p.A., Milan

F. Depero
The New Traffic-Light, Bitter Cordial Campari, 1929, china ink and tempera on pasteboard, 44 × 32 cm, Davide Campari-Milano SpA, Milan

F. Depero
Coded Costume, 1929, tempera on paper, 45,5 × 37,5 cm, Gall. Museo Depero, Rovereto

F. Depero
Vanity Fair, cover 1929-30, letterpress, 33 × 25 cm. Gall. Museo Depero, Rovereto

F. Depero
Project for Casa d'Arte Depero Stand, 1930, pencil on paper, 15 × 16,7 cm. Gall. Museo Depero, Rovereto

F. Depero
Vogue, 1930, collage with colour paper, 45,6 × 34,5 cm, Gall. Museo Depero, Rovereto

F. Depero
World Massacre, pen on paper, 28 × 21 cm, Private Collection, Rome

F. Depero
Advertising Kiosk, wood, 81 × 48 × 48 cm, Gall. Museo Depero, Rovereto

R. Duchamp-Villon
Tub, 1911, terracotta, h. 57 × 14 × 21 cm, Private Collection

R. Duchamp-Villon
Tub, 1911, bronze, h. 57 × 14 × 21 cm, Private Collection

R. Duchamp-Villon
Horse and Rider, plaster, h. 30 × 21 × 20 cm, Private Collection

M. Ender
Untitled, watercolour on paper, 33,5 × 28,4 cm, G. Costakis Collection, property of Art. Co. Ltd.

M. Ender
Untitled, watercolour on paper, 33,5 × 28,4 cm, G. Costaiks Collection, property of Art Co. Ltd.

M. Ender
Untitled, n.d. watercolour on paper 22,8 × 27,2 cm, G. Costaiks Collection, property fo Art Co. Ltd.

J. Epstein
Reconstruction of Drill, wood, drill, 205 × 141,5 cm, City Museum & Art Gallery, Birmingham

A. Exter
Le compotier aux raisins, 1913, collage and oil on panel, 51 × 61 cm, Coll. L. Hutton Galleries, New York

Farfa
Futurist Antenna, 1926, «cartopittura» on stretched paper 63,5 × 21,5 cm, Narciso Gallery, Turin

B. Feuerstein
Set Design for R.U.R. by Karel Čapek, 1922, watercolour and ink on paper, 25 × 34 cm, Národiné Muzeum, Prague

R. Fry and J. Kallenborn (Omega Workshops)
Cupboard with Marquetry Giraffe, 1916, inlaid, woods, 213,4 × 115 × 40,6 cm, A. d'Offay Gallery, London

A. Gaudí
Model of the Chimney of Casa Milá, 1906-10, plaster, 40 × 15 × 11 cm, Cattedra Gaudí, E.T.S. Architettura, Barcelona

A. Gaudí
Model of the Double Chimney of Casa Milá, 1906-10, plaster, 42 × 17 × 11 cm, Cattedra Gaudí, E.T.S. Architettura, Barcelona

H. Gaudier-Brzeska
Stylized Head of a Horse, 1914, ink on paper, 25 × 38 cm, Musée des Beaux Arts, Orléans

H. Gaudier-Brzeska
Two Heads of Cows, 1914, plaster on paper, 30,5 × 45,7 cm. Kettle's Yard, Cambridge University

H. Gaudier-Brzeska
Bird swallowing a Fish, 1914, study, pen on beige paper, 16,7 × 50 cm, Musée National d'Art Moderne, Centre Georges Pompidou, Paris

H. Gaudier-Brzeska
Bird Swallowing a Fish, 1914, study, ink on paper, 30,5 × 47 cm, Kettle's Yard, Cambridge University

C. Govoni
Self-portrait (Rarefaction), ink on paper, 30 × 22 cm, P. Conti Foundation, Fiesole

O. Gutfreund
Concert, 1912-13, bronze, 44 × 68 cm, Naradowe Galerie, Prague

P. Joostens
Untitled, 1915, China ink on paper, 12 × 21,5 cm, Musées Royaux des Beaux-Arts de Belgique, Brussels

P. Joostens
Compositions. The Dance, China ink and pen on paper, 24,7 × 39 cm, Musées Royaux des Beaux Arts de Belgique, Brussels

J. Konoupek
Untitled (Embrace), 1913 c, ink and watercolour on paper, Private Collection

B. Kubista
Air Attack on Pulja, 1914, oil on canvas, 54,5 × 33,5 cm, Zapadoceska Galerie, Plznen

N. Kulbin
Portrait of Kruchenykb, 1913, lithography, Istituto di Scriptura, Rome

F. Kupka
Woman and Horse, 1904, tempera on wood panel, 55 × 53 cm, Private Collection

F. Kupka
Autumn Sun, 1905, study pencil on paper, 20 × 17,6 cm, Private Collection

F. Kupka
Plan for Colour, 1910-11, study pencil on paper, 21 × 12,5 cm, Private Collection

M. Larionov
Homage to Roger Fry, 1919, watercolour and collage on paper 25,4 × 15 cm, The Trustees of Victoria & Albert Museum, London

F. Leal
Engraving for *Metropolis,* 1928-29, artist's proof, 32 × 23 cm. F. Leal Collection, Mexico City

F. Leal on F. Revueltas (?)
Actual, 1924, woodcut, 7 × 16 cm, B. de Maples Arce Collection, Mexico City

P.W. Lewis
Timon of Athens, portfolio, engraving on paper, R. and V. Cork Collection, London

P.W. Lewis
Futurist Figure, 1912, pen, pencil, ink and watercolour on paper, 26,3 × 18,3 cm, A. d'Offay Gallery, London

P.W. Lewis
Self-portrait, 1912-13, pencil, pastel, watercolour on paper, 23,8 × 15,5 cm, A. d'Offay Gallery, London

P.W. Lewis
Vorticist Composition, 1915, gouache, 31,4 × 17,8 cm, The Trustes of Tate Gallery, London

R. Magritte
The Retreat, 1920, oil on wood, 72 × 89,5 cm, J.D. Collection, Brusseles

V. Marchi
Study of Volumes, 1919, ink and pencil on paper, 63 × 42 cm each, four studies, Fam. Marchi Collection, Anzio

V. Marchi
Divorced Pamela, stage design, 1928, China ink wash on paper, 53 × 46 cm, Fam. Marchi Collection, Anzio

E.J. Marey
Gun for Photography with Loader, wood and metal, 19 × 84 × 13,5 cm, Musée E.J. Marey, Collège de France Collection, Beaune

E.J. Marey
Zootrope, metal, resin, wood, 140 × 75 × 120 cm, Musée E.J. Marey, Collège de France Collection, Beaune

J. Mattis-Teutsch
Composition, oil, on board, 35 × 29 cm, Magyar Nemzeti Galéria, Budapest

G. Méliès
A Trip to the Moon, 1902, China ink, 24,5 × 34,5 cm, Cinémathèque Français, Paris

G. Méliès
The Conquest of the Pole, 1912, China ink and pencil on paper, 50 × 65 cm, Cinémathèque Française, Paris

G. Méliès
The Polar Conquest, 1912, China ink, 50 × 65 cm, Cinémathèque Française, Paris

R. Melli
Portrait of Vincenzo Costantini, 1913, bronze, 79 × 82 × 40 cm, Galleria Civica d'Arte Moderna, Turin

L. Mendez
Man, 1924, woodcut, 27 × 17 cm, Inst. Nacional de Bellas Artes, Mexico City

E. Munch
Tingel-Tangel, 1895, lithograph, 76,5 × 103,5 cm, Munch-Museet, Oslo

E. Munch
Stéphane Mallarmé, 1896, lithograph, 103,5 × 76,5 cm, Munch-Museet, Oslo

E. Munch
Children on the Boulevard, 1906, oil on canvas, 75 × 90 cm, Munch-Museet, Oslo

E. Munch
Despair, 1893, oil on canvas, 92 × 63 cm, Munch-Museetz, Oslo

E. Muybridge
Animal Locomotion 4, 1887, photograph b/w 15,5 × 45,5 cm, T. Baum Collection, New York

E. Muybridge
Animal Locomotion 6, 1887, photograph b/w, 21 × 35 cm, T. Baum Collection, New York

E. Muybridge
Animal Locomotion 275, 1887, photograph b/w, 20 × 35 cm, T. Baum Collection, New York

Ch. R.W. Nevinson
The Machine-gun, 1915, oil on canvas, 61 × 50,8 cm, The Trustees of Tate Gallery, London

Ch. R.W. Nevinson
Autumn, 1919 c., oil on canvas, 51 × 61 cm, R. Capstick-Dale, London

Ch. R.W. Nevinson
Winter, 1919 c., oil on canvas, 51 × 61 cm, R. Capstick-Dale, London

Ch. R.W. Nevinson
Spring, 1919 c., oil on canvas, 51 × 61 cm, R. Capstick-Dale, London

Ch. R.W. Nevinson
Summer, 1919 c., oil on canvas, 51 × 61 cm, R. Capstick-Dale, London

F. Picabia
Relâche, 1924, design for curtain, watercolour on paper, 31,3 × 49 cm, Dansumuseet, Stockholm

F. Picabia
Relâche, 1924, model, Dansmuseet, Stockholm

F. Picabia
Relâche, 1924, choreographical designs, P. Conti Foundation, Fiesole

E. Prampolini
Aprés-midi d'un faune, 1920, design of a scene, watercolour on paper, 16,5 × 21 cm, Galleria Fonte d'Abisso Edizione Modena

E. Prampolini
Night Divers, 1920-21, tempera on paper, 33 × 50 cm, Galleria Fonte d'Abisso Edizioni, Modena

E. Prampolini
Night Divers, 1920-21, costumes designs, pencil on paper, 24 × 35 cm, Galleria Fonte d'Abisso Edizioni, Modena

E. Prampolini
Untitled (carpet), 1924, woollen fabric, 100 × 100 cm, Private Collection

E. Prampolini
Bedside Table, 1925, wood, 71 × 62,5 × 35 cm, Private Collection

E. Prampolini
The Heart Merchant, design of a scene, picture I, 1927, tempera on pasteboard, 25 × 35 cm, Private Collection

E. Prampolini
For the Eiffel Tower Bride and Groom, 1927, design, tempera on pasteboard, 24 × 34 cm, Private Collection

E. Prampolini
Cocktail, Costume for Barman, 1927, tempera on pasteboard, 27 × 15 cm, Private Collection

E. Prampolini
Cocktail, Costume for the Bottle Actor, 1927, tempera on pasteboard, 24 × 16 cm, Galleria Fonte d'Abisso Edizioni, Modena

E. Prampolini
Plate, copper, diameter 42 cm, Private Collection

E. Prampolini
Untitled, pencil and watercolour on paper, 24 × 33,5 cm, Private Collection

G. Previati
A Descent into the Maëlstrom, 1890, charcoal and watercolour on pasteboard, 31,5 × 28 cm, Alvini Collection, Milan

G. Previati
Day, study, pencil on paper, 4,9 × 13,6 cm, Calmarini Collection, Milan

F. Revueltas
Composition with Rainbow, 1921, oil 75 × 84 cm, F. Leal Collection, Mexico City

F. Revueltas
Holy Cross Day, watercolour, 27,5 × 34,5 cm, Ing. S. Revueltas Collection, Mexico City

F. Revueltas
Abstract Theme, woodcut, 25 × 19,5 cm, F. Leal Collection, Mexico City

F. Revueltas
Abstract Theme, woodcut, 25 × 21 cm, F. Leal Collection, Mexico City

F. Revueltas
The City, woodcut, 24 × 21 cm, F. Leal Collection, Mexico City

F. Revueltas
Abstract Composition, woodcut, 28 × 24 cm, F. Leal Collection, Mexico City

W. Roberts
The Toe Dancer, 1914, ink and gouache on paper, 72 × 54 cm, The Trustees of Victoria & Albert Museum, London

R. Romani
The Silence, pencil on paper, 61,5 × 46 cm, Musei Civici d'Arte e Storia, Brescia

M. Rosso
Lovers under the Street Light, 1883, bronze, 28,5 × 25,5 × 26,5 cm, D. Rosso Parravicini Collection, Milan

L. Russolo
Self-portrait, 1912, oil on canvas, 35 × 35 cm, F. Borsari Collection, Varedo

A. Sant'Elia
Design for Building, 1913, ink and pencil on yellow paper, 21 × 21,5 cm, Civici Musei, Como

A. Sant'Elia
Stepped-back House with Outside Lifts, 1914, pencil on paper, 38,4 × 22,2 cm, Civici Musei, Como

M. Schamberg
Untitled, 1916 c., pencil on paper, 18,5 × 12 cm, The Metropolitan Museum of Art, New York

G. Severini
Ballerinas, 1912-13, pastel on cardboard mounted on canvas, 45 × 60 cm, Private Collection, Turin

G. Severini
Ballerina II, 1913, watercolour on paper, 76,5 × 55,5 cm, lent by S. and E. Estorick

D. Shakespear
Catholic Anthology, 1915, ink on paper, 26,5 × 16 cm, O. Shakespear Pound Collection, Princeton

P. Signac
Portrait of Verhaeren, China ink on paper, 21,8 × 13,2 cm, Bibliothèque Royale Albert 1er, Brussels

J. Síma
Composition, 1912 c., watercolour and China ink on paper, 31,7 × 39,7 cm, Galerie Morave, **Brno**

B. Ulitz
Analysis on a Lilac Background, 1922, oil on canvas, 158 × 141 cm, Magyar Nemzeti Galéria, Budapest

E. Wadsworth
Ten woodcuts, 1914-17 c., A. d'Offay Gallery, London

Literary Documents
Books

A Trap for Judges, 2 Ed., St. Petersburg, 1910, 1913, M. Martin-Malburet Collection, Paris

I poeti futuristi, Milan, Poesia, 1912, P. Conti Foundation, Fiesole; Russolo-Pratella Foundation, Varese

Almanacco Purgativo, Vallecchi, 1914, P. Conti Foundation, Fiesole

The Archer, St. Petersburg, 1915, L. Marinetti Collection, Rome

The Futurists' Drum, St. Petersburg, 1915, M. Martin-Malburet Collection, Paris

The Moscow Masters, Moscow, 1916, M. Martin-Malburet Collection, Paris

Noi futuristi, Milan, Quintieri, 1917, P. Conti Foundation, Fiesole

I nuovi poeti futuristi, Poesia, 1925, L. Marinetti Collection, Rome

Teatro futurista sintetico, II vol., Istituto Editoriale Italiano, P. Conti Foundation, Fiesole

Il teatro sintetico futurista, printed texts with handwritten comments by Marinetti, F. Cangiullo Found, P. Conti Foundation, Fiesole

P. Albert-Birot
La joie des sept coulers, Paris, 1919, Private Collection

P. Albert Birot
La lune, Paris, 1924, Private Collection

J. Almada Negreiros
K4 o quadrado azul Lisboa, 1917, Beinecke Library, Yale Univ., New Haven

G. Alomar
El Futurisme, Barcelona, 1905, Catalonian Library, Barcelona

G. Apollinaire
Calligrammes, 1918, M. Martin-Malburet Collection, Paris

Benedetta
Le forze umane, romanzo astratto con sintesi grafiche, Foligno, Campitelli, 1924, dedicated to P. Conti, P. Conti Foundation, Fiesole

S. Bobrov
Gardeners on the Vines, Moscow, 1913, illustrated by Goncharova, L. Marinetti Collection, Rome

U. Boccioni
Pittura scultura futuriste, Ed. Futuristi, Poesia, 1914, P. Conti Foundation, Fiesole; L. Bertini Collection, Calenzano, Florence; S. Magnelli Collection, Meudon; Private Collection, Villiers-sous-Grez

A.G. Bragaglia
Fotodinamica futurista, 1st Edition, 1913, A. Vigliani Bragaglia Collection, Centro Studi Bragaglia, Rome

A.G. Bragaglia
Fotodinamica futurista, 2nd Edition, 1913, A. Vigliani Bragaglia Collection, Centro Studi Bragaglia, Rome

A.G. Bragaglia
Cronache d'Attualità, 1922, Musei Civici, Rovereto

A. Bruno
Fuochi di Bengala, Florence, L'Italia Futurista, 1917, N. Vieri and N. Neri Found, P. Conti Foundation, Fiesole; L. Bertini Collection, Calenzano, Florence

A. Bruno
Un poeta di provincia, Milan, Poesia, 1920, P. Conti Foundation, Fiesole

D. and B. Burliuk, C. Khlebnikov, V. Mayakowsky
The Service-Book of the Three, Moscow, 1913, M. Martin-Malburet Collection, Paris

P. Buzzi
L'esilio, no. 2 Milan, Poesia, 1906, Russolo-Pratella Foundation, Varese; P. Conti Foundation, Fiesole

P. Buzzi
Aeroplani, Poesia, 1909, L. Marinetti Collection, Rome

P. Buzzi
L'ellisse e la spirale, Poesia, 1915, L. Marinetti Collection, Rome; P. Conti Foundation, Fiesole

P. Buzzi
Poema di quarantanni, Milano, Poesia, 1922, P. Conti Foundation, Fiesole

F. Cangiullo
A proposito di Tripoli, Naples, Di Paolo, 1911, L. Marinetti Collection, Rome

F. Cangiullo
Caffè-concerto, Milan, Poesia, 1916, P. Conti Foundation, Fiesole; L. Bertini Collection, Calenzano, Florence; Russolo-Pratella Foundation, Varese.

F. Cangiullo
Piedigrotta, Milan, Poesia, 1916, Musei Civici Rovereto; P. Conti Foundation, Fiesole; Russolo-Pratella Foundation, Varese: L. Marinetti Collection, Rome.

F. Cangiullo
Poesia pentagrammata, Naples, 1923, L. Marinetti Collection, Rome

C. Carrà
Carrà futurista, Guerra pittura, Milan, Poesia, 1915, N. Vieri and N. Neri Found, P. Conti Foundation, Fiesole; Musei Civici, Rovereto; Istituto di Scriptura, Rome

S. Cavacchioli
Le ranocchie turchine, Milan, Poesia, 1909, L. Marinetti Collection, Rome

B. Cendras
La fin du monde, Paris, 1919, M. Blondeau Collection, Paris

P. Conti
imbottigliature, Ed. Italia Futurista, 1917, P. Conti Foundation, Fiesole

R. Corghi
Scultura futurista, Boccioni, Florence, La Voce, 1914, P. Conti Foundation, Fiesole

B. Corra
Sam Dunn è morto, romanzo sintetico futurista, Studio Editoriale Lombardo, 1917, P. Conti Foundation, Fiesole

E.E. Cummings
Tulips & Chimneys, New York, Seltzer, 1924, Houghton Library, Harvard University, Cambridge

T. Czyzewski
Was, Orfeusz i Euridiká, Cracow, 1922, L. Marinetti Collection, Rome

T. D'Albisola, F.T. Marinetti
Librolatta, parole in libertà, 1932

F. Depero
Depero futurista Libromacchina imbullonato, Ed. Dinamo-Azari 1927, Galleria Fonte d'Abisso Edizioni, Modena

F. Depero
Campari, single number, Milan, 1931 (graphics in b/w and colour), Istituto di Scriptura, Rome

G. Diego
Imagen, Madrid, 1922, Beinecke Library, Yale Univ., New Haven

I. Domino
Marinetti svelato, ed. L'attualità, P. Conti Foundation, Fiesole

J. Evola
La parole obscure du paysage intérieur, poème à 4 voix, Dada Collection; P. Conti Foundation, Fiesole

L. Folgore
Il canto dei motori, Poesia, 1912, L. Marinetti Collection, Rome

L. Folgore
Ponti sull'oceano, Versi liberi e parole in libertà, 1914, Musei Civici, Rovereto; N. Vieri and N. Neri Fund, P. Conti Foundation, Fiesole; L. Marinetti Collection, Rome

S. Gallaro
El pentagrama electrico, G.L. Arzubide, 1925, illustrated by Alva de la Canal, B. de Maples Arce Collection, Mexico City

R. Ghil
La pantoun des pantouns, Paris, 1902, dedicated to Marinetti in French and in Javanese, L. Marinetti Collection, Rome

M. Ginanni
Montagne trasparenti, Florence; L'Italia Futurista, 1917; N. Vieri and N. Neri Fund, P. Conti Foundation, Fiesole

A. Ginna
Pittura dell'avvenire, 1917, Musei Civici Rovereto; N. Vieri and N. Neri Fund, P. Conti Foundation, Fiesole

N. Goncharova
War, 1914, L. Bertini Collection, Calenzano, Florence

C. Govoni
Poesie elettriche, Milan, Poesia, 1911, P. Conti Foundation, Fiesole; L. Marinetti Collection, Rome

C. Govoni
Rarefazioni e parole in libertà, Milan, Poesia, 1915, P. Conti Foundation, Fiesole; L. Bertini Collection, Calenzano, Florence; L. Marinetti Collection, Rome

E. Guro
Camels of the Sky, St. Petersburg, 1914, M. Martin-Malburet Collection, Paris

Huidobro
Horizon Carré, Paris 1917, P. Conti Foundation, Fiesole

Huidobro
El Espejo de Agua, Madrid, 1918, P. Conti Foundation, Fiesole

A. Jarry
Ubu-Roi, 1896, M. Martin-Malburet Collection, Paris

A. Jarry
Le surmâle, 1902, M. Martin-Malburet Collection, Paris

A. Jarry
Gestes et opinions du docteur Faustroll, M. Martin-Malburet Collection, Paris

J.M. Junoy
Guynemer, Barcelona, 1918, Beinecke Library, Yale Univ., New Haven

V. Kamensky
Tango with the Cows, Moscow, 1914, M. Martin-Malburet Collection, Paris

T. Kanbara
Futurist Manifestos, 1922, dedicated to Marinetti, L. Marinetti Collection, Rome

T. Kanbara
Futurism, Espressionism, Dadaism, Istituto di Scriptura, Rome

T. Kanbara
Studies on Futurism, Okayama, Ohara Bijutsukan, 1925

T. Kanbara
Translation of *Les poupées électriques* by F.T. Marinetti, Tokyo, Kokuriton Kindai Bijutsukan, Istituto di Scriptura, Rome

I. Kassak
MA Buch, Vienna, 1923, dedicated to Marinetti, L. Marinetti Collection, Rome

V. Khlebnikov, A. Kruchenykh
Game in Hell, 1914, illustrated by Malevich and Rozanova, Private Collection, Prato; M. Martin-Malburet Collection, Paris

A. Kruchenykh
Pomade, 1913, illustrated by Larionov, L. Bertini Collection, Calenzano, Florence

A. Kruchenykh
Explodity, 1913, illustrated by Mation, Prato; M. Martin-Malburet Collection, Paris

A. Kruchenykh
Let's grrrumble!, illustrated by Malevich and Rozanova; Private Collection, Prato; M. Martin-Malburet Collection, Paris

N. Kulbin
Free Music, St. Petersburg, 1910, L. Marinetti Collection, Rome

G. List Arzubide
Esquina, Mexico City, 1923, cover by J. Charlot, L. Marinetti Collection, Rome; List Arzubide Collection, Mexixo City

G. List Arzubide
El Movimiento estridentista, Mexico City, 1926, cover by Alva de la Canal, F. Leal Collection, Mexico City; List Arzubide Collection, Mexico City

B. Livšic
Sole dei lupi, Moscow, 1914, illustrated by A. Exter, M. Martin-Malburet Collection, Paris

G.P. Lucini
Carme di angoscia e di speranza, Poesia, 1908, L. Marinetti Collection, Rome

G.P. Lucini
Revolverate, Poesia, 1909, L. Marinetti Collection, Rome

G.P. Lucini
La solita canzone del Melibeo, Poesia, 1910, Istituto di Scriptura, Rome

V. Maiakovsky
Tragedia, 1913-14, L. Bettini Collection, Calenzano, Florence

V. Maiakovsky
Il flauto vertebrato, Petersburg, 1915, M. Martin-Malburet Collection, Paris

V. Maiakovsky
Semplice come un muggito, Petersburg, 1916, M. Martin-Malburet, Paris

V. Maiakovsky
L'uomo-oggetto, 1917, M. Martin-Malburet Collection, Paris

K. Malevich
Nuovi sistemi nell'arte, L. Bertini Collection, Calenzano, Florence

S. Mallarmé
Un coup de dés, Paris, Gallimard, 1914, F. Leal Collection, Mexico City; M. Martin-Malburet Collection, Paris

S. Mallarmé
Vers et prose, 1st Edition, Private Collection, Paris

M. Maples Arce
Andamios interiores, Mexico City, Cultura, 1922, cover by Vargas, B. de Maples Arce Collection, Mexico City

M. Maples Arce
Urbe, Mexico City, Botas, 1924, illustrated by J. Charlot, B. de Maples Arce Collection, Mexico City; Beinocke Library, Yale Univ. New Haven

M. Maples Arce
Metropolis, Mexico City, 1929, translated by J. Dos Passos, illustrated by J. Charlot, F. Leal Collection, Mexico City

E.J. Marey
Le mouvement, 1894, Cinémathèque Française, Paris

E.J. Marey
Du mouvement dans les fonctions de la vie, 1896, Cinémathèque Française, Paris

F.T. Marinetti
La conquète des étoiles, La Plume, 1902, L. Marinetti Collection, Rome

F.T. Marinetti
Ma momie sanglante, Verde e Azzurro, 1904, L. Marinetti Collection, Rome

F.T. Marinetti
Destruction, Vanier, 1904, L. Marinetti Collection Rome

F.T. Marinetti
Le Roi Bombance, Mercure de France, 1905, L. Marinetti Collection, Rome

F.T. Marinetti
Les Dieux s'en vont, D'Annunzio reste, 1908, L. Marinetti Collection, Rome

F.T. Marinetti
La ville charnelle, Sansot, 1908, F.B. Pratella Fund, P. Conti Foundation, Fiesole

F.T. Marinetti
Poupées électriques, Sansot, 1908, L. Marinetti Collection, Rome

F.T. Marinetti
Enquête internationale sur le vers libre, Poesia, 1909, L. Marinetti Collection, Rome

F.T. Marinetti
Re Baldoria, Milan, Fratelli Treves, 1910, F.B. Pratella Fund, P. Conti Foundation, Fiesole

F.T. Marinetti
Mafarka il Futurista, 1910, Musei Civici, Rovereto; L. Marinetti Collection, Rome; Istituto di Scriptura, Rome

F.T. Marinetti
Le Futurisme, Sansot, 1911, and translation of *Guerra sola igiene del mondo*, Poesia 1915. L. Marinetti Collection, Rome

F.T. Marinetti
Uccidiamo il chiaro di luna, 1911, Musei Civici Rovereto; L. Bertini Collection, Calenzano, Florence, Istituto di Scriptura, Rome

F.T. Marinetti
La battaglia di Tripoli (26 October 1911), Padua, Zelveriana Typography, 1912, P. Conti Foundation, Fiesole; Russolo-Pratella Foundation, Varese; S. Magnelli Collection, Meudon

F.T. Marinetti
Zang Tumb Tumb, Adrianopolis, October 1912, Musei Civici Rovereto; S. Magnelli Collection, Meudon

F.T. Marinetti
Le monoplan du Pape, Sansot, 1912, and Poesia, 1914, L. Marinetti Collection, Rome

F.T. Marinetti
Futuristische Dichtungen, Berlin, 1912, L. Marinetti Collection, Rome

F.T. Marinetti
I poeti futuristi, Poesia 1912, L. Marinetti Collection, Rome

F.T. Marinetti
Manifesti futuristi, Moscow, 1914, translated by V. Shershenevic, L. Marinetti Collection, Rome

F.T. Marinetti
Zang Tumb Tumb, Milan, 1914, N. Vieri and N. Neri Fund, P. Conti Foundation, Fiesole (dedicated to Nannetti); L. Bertini Collection, Calenzano, Florence; L. Marinetti Collection, Rome

F.T. Marinetti
Guerra sola igiene del mondo, Milan, Poesia, 1915, P. Conti Foundation, Fiesole; Istituto di Scriptura, Rome

F.T. Marinetti
Teatro sintetico futurista, Istituto Editoriale Italiano, 1915, L. Marinetti Collection, Rome

F.T. Marinetti
Noi futuristi, Quintieri, 1917, L. Marinetti Collection, Rome

Marinetti and B. Corra
L'isola dei baci, erotic social novel, Studio Editoriale Lombardo, 1918, P. Conti Foundation, Fiesole

F.T. Marinetti
Democrazia futurista, Madrid 1918, P. Conti Foundation, Fiesole (dedicated to P. Conti)

F.T. Marinetti
Les mots en liberté futuristes, Milan, Poesia 1919, N. Vieri and N. Neri Fund, P. Conti Foundation, Fiesole, L. Bertini Collection, Calenzano, Florence; L. Marinetti Collection Rome; Istituto di Scriptura, Rome

F.T. Marinetti
8 anime in una bomba, romanzo esplosivo, Milan, Poesia, 1919, N. Vieri and N. Neri Fund, P. Conti Foundation, Fiesole, L. Marinetti Collection, Rome

F.T. Marinetti
Come si seducono le donne, Florence, Sonzogno, 1920, N. Vieri and N. Neri Fund, P. Conti Foundation, Fiesole

F.T. Marinetti
Gi indomabili, Poesia, 1922, L. Marinetti Collection, Rome

F.T. Marinetti
Il tamburo di fuoco, Milan, Sonzogno, 1922, Russolo-Pratella Foundation, Varese; L. Marinetti Collection, Rome

F.T. Marinetti
Osvobozená slova (Les mots en liberté futuristes), Prague, 1922, L. Marinetti Collection, Rome

F.T. Marinetti
Ohniví Buben (Tambour de feu), translated by U. Dadone and J. Kodiček, Prague, Obelisk, 1923, L. Marinetti Collection, Rome

F.T. Marinetti
Umberto Boccioni, Poesia, 1924, L. Marinetti Collection, Rome

F.T. Marinetti
Futurismo e Fascismo, 1924, Musei Civici, Rovereto; L. Marinetti Collection, Rome

F.T. Marinetti
I nuovi poeti futuristi, Poesia, 1925, L. Marinetti Collection, Rome

F. Meriano
Equatore notturno, Milan, Poesia, 1916, N. Vieri and N. Neri Fund, P. Conti Foundation, Fiesole; L. Marinetti Collection, Rome

L. Mitzitch
Antieurope, Zenit, 1926, Beinecke Library, Yale Univ., New Haven

N. Morpurgo
Il fuoco delle piramidi, Milan, Poesia, 1923, P. Conti Foundation, Fiesole

E. Muybridge
Anima in Motion, 1899, Cinémathèque Française, Paris

E. Muybridge
The Human Figure in Motion, 1901, Cinématheque Française, Paris

P. van Ostaijen
Bezette Stadt, 1921, Bibliothèque Royal Albert 1er, Brusseles

A. Palazzeschi
Poemi, Florence, 1909, P. Conti Foundation, Fiesole

A. Palazzeschi
L'incendiario, Poesia, 1910, Istituto di Scriptura, Rome

A. Palazzeschi
L'incendiario, 1913, Musei Civici, Rovereto; P. Conti Foundation, Fiesole; L. Marinetti Collection, Rome

T. Panteo
Il poeta Marinetti, Milan, Società Editoriale Milanese, 1908 Papini Archives, P. Conti Foundation, Fiesole

G. Papini
Il mio futurismo (Contro Firenze passatista), 1941, P. Conti Foundation, Fiesole; Destribats Collection, Paris

G. Papini
100 pagine di poesia, 1915, Private Collection, Paris

T. Peiper
A, Zurotnica, 1924, Beinecke Library, Yale Univ., New Haven

Branko ve Poliansky
Panique sous le soleil, Belgrade, Zenit, 1924, L. Marinetti Collection, Rome

E. Pound
Antheil and the Tretise on Harmony, Paris, Three Mountains, Press, 1924, L. Marinetti Collection, Rome

F.B. Pratella
Musica futurista, 1912, Russolo-Pratella Foundation, Varese; L. Bertini Collection, Calenzano, Florence; L. Marinetti Collection, Rome

F.B. Pratella
Teoria della musica, 1912, Russolo-Pratella Foundation, Varese

F.B. Pratella
Musica italiana, per una sensibilità musicale italiana, 1915, Russolo-Pratella Foundation, Varese

F.B. Pratella
Teatro sintetico futurista, Vol. I and II, Russolo-Pratella Foundation, Varese

F.B. Pratella
Cronache e critiche dal 1905 al 1917, Bologne, Pizzi, 1918, Russolo-Pratella Foundation, Varese

F.B. Pratella
Evoluzione della musica dal 1910 al 1917, Vol. I and II, Milan, Istituto Editoriale Italiano, 1918-19, Russolo-Pratella Foundation, Varese

J.H. Rosny
Le bilatéral, 1889, is Edition with dedication, Private Collection, Paris

J.H. Rosny
La mort de la terre, 1912, L. Marinetti Collection, Rome

L. Russolo
L'arte dei rumori, Milan, Poesia, 1916, N. Vieri and N. Neri Fund, P. Conti Foundation, Fiesole; L. Marinetti Collection, Rome; L. Bertini Collection, Calenzano, Florence

J. Salvat-Papasseit
Poèmes en ondes hertzianes, 1918, Catalonian Library, Barcelona

J. Salvat-Papasseit
L'irradiator del Port, 1921, Catalonian Library, Barcelona

J. Salvat-Papasseit
El poema de la Rosa als Llavia, 1923, Catalonian Library, Barcelona

P. Scheerbart
Ich liebe dich, Ein einsenbahn Roman, Berlin & Loeffler, 1897, Badische Landesbibliotek, Karlsruhe

P. Scheerbart
Rakkox der Billionär, Berlin, Schuster & Loeffler, 1900, Badische Landesbiblioteck, Karlsruhe

P. Scheerbart
Revolutionäre Theater-Bibliothek, vol. 1, Berlin, Verlag von Eisselt, 1904, Badische Landesbibliothek, Karlsruhe

J. Seifert
Město v Slzách, Prague, Komunistické Knihkupectvi, 1922, illustrated by K. Teige, dedicated to Marinetti, L. Marinetti Collection, Rome

J. Seifert
Sama Laska, Prague, 1923, Beinecke Library, Yale Univ., New Haven

E. Settimelli
Mascherate turistiche, travestimenti lirici, Florence, L'Italia Futurista, 1917, P. Conti Foundation, Fiesole

A. Shemshurin
Futurism in V. Briussov's Poetry, Moscow, 1913, dedicated to Marinetti, L. Marinetti Collection, Rome

A. Soffici
Il caso Medardo Rosso, Florence, B. Seeber, 1909, P. Conti Foundation, Fiesole

A. Soffici
Arthur Rimbaud, Florence, La Voce, 1911, B. Binazzi Fund, P. Conti Foundation, Fiesole

A. Soffici
Cubismo e oltre, Florence, La Voce, 1913, P. Conti Foundation, Fiesole

A. Soffici
Cubismo e futurismo, 2nd Edition, Florence, La Voce, 1914, P. Conti Foundation, Fiesole; L. Bertini Collection, Calenzano, Florence

A. Soffici
Dodici opere di Picasso, Florence, La Voce, 1914, P. Conti Foundation, Fiesole

A. Soffici
Arlecchino, Lacerba, 1914, S. Magnelli Collection, Meudon

A. Soffici
BIF&ZF + 18, Vallecchi, 1915, P. Conti Foundation, Fiesole

A. Soffici
BIF&ZF + 18, Florence, Vallecchi, 1920, P. Conti Foundation, Fiesole; L. Bertini Collection, Calenzano, Florence; L. Marinetti Collection, Rome

A. Stramm
Tropfblut, Berlin, Verlag der Sturm, 1916, Staatsbiblioteck Preissicher Kulturbesitz, Berlin

M. Tasteven
Futurismo, Moscow, Ed. Iris, 1914, Modena Musset, Stockholm

I. Tavolato
Contro la morale sessuale, Paris, 1913, P. Destribats Collection, Paris

G. de Torre
Helices, Madrid, 1923, Beinecke Library, Yale Univ., New Haven

G. Vasari
La mascherata degli impotenti, Noi, 1923, illustrated by Prampolini, L. Marinetti Collection, Rome

J. Verne
Mistress Branican, Paris, 1891, M. Roethel Collection, Paris

J. Verne
L'invasion de la mer, Paris, 1905, M, Roethel Collection, Paris

Volt
Archi Voltaici, words in freedom and theatrical synthesis, Milan, Poesia 1916, N. Vieri and N. Neri Fund, P. Conti Foundation, Fiesole; L. Marinetti Collection, Rome

H.G. Wells
La vérité concernant Pyecraft, L'Illustration, 1905, illustrated by F. Kupka, Private Collection, Paris

I. Zdanevich
Come se sgA, 41st, Tiflis, 1920, L. Marinetti Collection, Rome

Periodicals

Actual, no. 1, Mexico City, 1921, B. De Maples Arce Collection, Mexico City

Anthologie Revue, monthly anthology of literature and art, 1898, 1899, Istituto di Scriptura, Rome

Arc Voltaic, no. 1, Barcelona, Feb. 1918, Catalonian Library, Barcelona

L'Assiette au Beurre, 1902, special issue *L'Argent* by F. Kupka; special issue *Les empoissonneurs* by J. Villon

A Tett, no. 2, 1915, Széchény National Library, Budapest

Contimporanul, nos. 46, 53, 54, 55, 56, Paris, P. Destribats Collection, Paris

Crisol, Mexico City, Oct. 22, 1930, Ing. S. Revueltas Collection, Mexico City

Dinamo, no. 1, Paris, P. Destribats Collection, Paris; L. Marinetti Collection, Rome

291, no. 1, Paris, P. Destribats Collection, Paris

291, no. 9, Paris, P. Destribats Collection, Paris

Un Enemic del Poble, Barcelona, March 1919, Catalonian Library, Barcelona

Fantasio, no. 163, Paris, 1913, P. Destribats Collection, Paris

La Folgore Futurista, 1917, N. Vieri and N. Neri Fund, P. Conti Foundation, Fiesole

Freccia Futurista, no. 2, May 1919, Istituto di Scriptura, Rome

Der Futurismus, no. 1, Paris, P. Destribats Collection, Paris

El Futurisme, no. 3, Barcelona, July 1907, Catalonian Library, Barcelona

Het Overzicht, 1921-25, Bibliothèque Royale Albert 1er, Brussels

Intégral, no. 12, Paris, P. Destribats Collection, Paris

L'Italia Futurista, no. 1, June 1916, P. Conti Foundation, Fiesole

Lacerba, Year 1, 2, 3, Russolo-Pratella Fondation, Varese

Lacerba, Year I, nos. 6, 12, 13, 16; Year II, nos. 1, 4, 12, 14, P. Conti Foundation, Fiesole; Istituto di Scriptura, Rome

Ma, vol. III/5, Széchéyil National Library, Budapest

Noi, June 1917-January 1919 (1st complete series), B. Sanminiatelli Fund, P. Conti Foundation, Fiesole

Noi, no. 1, April 1923 (2nd series), B. Sanminiatelli Fund, P. Conti Foundation, Fiesole

L'Oeuvre, revue programme, no. 9, Paris, April 1909, illustrated by P. Iribe and P. Ranson, L. Marinetti Collection, Rome

Poesia, Year V, nos. 7-9, August-October 1909, Russolo-Pratella Foundation, Varese; P. Conti Foundation, Fiesole

Poesia, special issue on Futurism, Istituto di Scriptura, Rome

Poesia, Year XIV, nos. 11-12, December 1908-January 1909, Russolo-Pratella Foundation, Varese

Proa, nos. 0, bis, Barcelona, 1921, S. Eleuterio-Lligonta Collection, Barcelona

Red, no. 6, Prague, 1929, L. Marinetti Collection, Rome

Roma Futurista, no. 1, September 20, 1918, N. Vieri and N. Neri Fund, P. Conti Foundation, Fiesole

Sic, nos. 4, 5, 8, 9, 10, Paris, 1916, Private Collection, Paris

Sic, no. 17, Paris, 1917, Private Collection, Paris

Sic, no. 34, Paris, 1918, Private Collection, Paris

Sic, nos. 47, 48, Paris, 1919, Private Collection, Paris

Der Sturm, Year III, no. 109, May 1912, no. 125-126, September 1912, no. 150-151, March 1913; Year XVI, February 1925, Staatsbibliothek Preussischer Kulturbesitz, Berlin

Tableros, nos. 2, 4, Madrid, 1921-22, Catalonian Library, Barcelona

Teatro futurista sintetico, nos. 11, 15, 1915, 1916, L. Marinetti Collection, Rome

Testa di Ferro, 1920, sheets, Istituto di Scriptura, Rome

Trocos, nos. 0, 1, Barcelona, 1916-18, Catalonian Library, Barcelona

Ultra, Madrid, 1921, Istituto di Scriptura, Rome

Zenit, no. 23, Paris, 1923, P. Destribats Collection, Paris

Zwrotnica, no. 1922-23, Muzeum Narodowe, Warsaw

Unidentified Russian newspaper, Moscow, January, 23, 1914 (Marinetti in Moscow), L. Marinetti Collection, Rome

Manifestos

Fondazione e manifesto del Futurismo, Milan, 1909; P. Conti Foundation, Fiesole

Fondation et manifeste du Futurisme, Paris, 1909, L. Marinetti Collection, Rome

Manifesto dei Pittori Futuristi, Milan, 1910, P. Conti Foundation, Fiesole; L. Marinetti Collection, Rome

La Musica futurista - Manifesto tecnico, Milan, 1910, P. Conti Foundation, Fiesole

Proclama Futurista a los Españoles, Promoteo, Madrid, 1910

Discorso futurista ai Veneziani, 1910, L. Marinetti Collection, Rome

Contro Venezia passatista, Milan, 1910, L. Marinetti Collection, Rome

La pittura futurista: manifesto tecnico, Milan, 1911, L. Marinetti Collection, Rome

Uccidiamo il chiaro di luna, Milan, 1911, L. Marinetti Collection, Rome

Manifesto dei drammaturghi futuristi, Milan, 1911, L. Marinetti Collection, Rome

Per la guerra sola igiene del mondo, 1911, L. Marinetti Collection, Rome

Manifesto dei musicisti futuristi, 1911, P. Conti Foundation, Fiesole; L. Marinetti Collection, Rome

Manifesto della Donna Futurista, Milan, 1912, P. Conti Foundation, Fiesole; L. Marinetti Collection, Rome

Manifesto tecnico della Letteratura Futurista, Milan, 1912, P. Conti Foundation, Fiesole; L. Marinetti Collection, Rome

Supplemento al Manifesto tecnico della Letteratura Futurista, Milan, 1912, P. Conti Foundation, Fiesole

La Pittura Futurista nel Belgio, Belgio, 1912, P. Conti Foundation, Fiesole

Manifesto futurista della lussuria, Paris, 1913, P. Conti Foundation, Fiesole

Contro Roma e contro Benedetto Croce, Milan, 1913, P. Conti Foundation, Fiesole; L. Marinetti Collection, Rome

L'arte dei rumori, Manifesto futurista, Milan, 1913, P. Conti Foundation, Fiesole; L. Marinetti Collection, Rome; Russolo-Pratella Foundation, Varese

L'immaginazione senza fili e le parole in libertà, Milan, 1913, P. Conti Foundation, Fiesole; L. Marinetti Collection, Rome

L'antitradizione futurista - Manifesto - Sintesi, Paris, 1913, P. Conti Foundation, Fiesole; L. Marinetti Collection, Rome; M. Martin-Malburet Collection, Paris

L'antitradition futuriste - Manifeste - Synthèse, 1913, L. Marinetti Collection, Rome; M. Martin-Malburet Collection, Paris

La pittura dei suoni, rumori, odori - Manifesto futurista, Milan, 1913, P. Conti Foundation, Fiesole

Il teatro di varietà, Milan, 1913, L. Marinetti Collection, Rome

Programma politico futurista, Milan, 1913, L. Marinetti Collection, Rome

Il controdolore - Manifesto futurista, Milan, 1913, L. Marinetti Collection, Rome

Contro l'arte inglese, 1914, L. Marinetti Collection, Rome

Abbasso il tango e Parsifal!, Milan, 1914, L. Marinetti Collection, Rome

L'architettura futurista, Milan, 1914, L. Marinetti Collection, Rome

Lo splendore geometrico e meccanico e la sensibilità numerica, Milan, 1914, P. Conti Foundation, Fiesole; L. Marinetti Collection, Rome

Il vestito antineutrale, Milan, 1914, P. Conti Foundation, Fiesole; L. Marinetti Collection, Rome

In quest'anno futurista, Milan, 1914, P. Conti Foundation, Fiesole

Il teatro futurista sintetico (Atecnico-Dinamico-Autonomo-Alogico-Irreale), Milan, 1915, P. Conti Foundation, Fiesole

Parole-consonanti vocali numeri in libertà, Milan, 1915, P. Conti Foundation, Fiesole

Ricostruzione futurista dell'univero, Milan, 1915, P. Conti Foundation, Fiesole, L. Marinetti Collection, Rome

L'unica soluzione del problema finanziario, Milan, 1915, P. Conti Foundation, Fiesole

L'orgoglio italiano, Milan, 1915, P. Conti Foundation, Fiesole

La nuova religione morale della velocità, Milan, 1916, L. Marinetti Collection, Milan

La cinematografia futurista, Florence, 1916, L. Marinetti Collection, Rome

La danza futurista, Florence, 1917, L. Marinetti Collection, Rome

Manifesto del partito politico futurista, Florence, 1918, L. Marinetti Collection, Rome

G. de Torre, *Manifesto Ultraista Vertical,* 1920, Catalonian Library, Barcelona

J. Salvat-Papasseit, *Contra els poetes amb minuscula. Primer manifest catolé futurista,* July 1920, Catalonian Library, Barcelona; M. Martin-Malburet Collection, Paris

Il Tattilismo, Milan, 1921, L. Marinetti Collection, Rome

M. Maples Arce, *Actual: Manifesto estridentista,* Mexico City, 1921, B. de Maples Arce Collection, Mexico City

S. Sanchez-Joan, *Segon manifest catolé futurista.* Contra l'estensio del Tifisme en Literature, 1922, Catalonian Library, Barcelona

Manifesto 30 × 30, Puebla, Mexico, 1928, illustated by Alva de la Canal

Manifesto della cucina futurista, Milan, 1923, L. Marinetti Collection, Rome

L'improvvisazione musicale, Manifesto futurista, P. Conti Foundation, Fiesole

Manuscripts

P. Albert-Birot
Poème-affiche, proofs, Private Collection

P. Albert-Birot
Exposition de Toilettes d'été, manuscript, Private Collection

P. Albert-Birot
Offrande/dentelle, corrected proofs, Private Collection

P. Albert-Birot
L'offrande au poète, manuscript, Private Collection

P. Albert-Birot
L'offrande au poète, sur papier doré, manuscript, Private Collection

P. Albert-Birot, G. Severini
1ª Esposizione Futurista, manuscript, H.R.C. Univ., Austin, Texas

G. Apollinaire
Lettre-Océan, manuscript, Eredi Savinio, Rome

G. Apollinaire
L'Antitradition Futuriste, corrected proofs, Beinecke Library, Yale Univ., New Haven

F. Cangiullo
Verde nuovo, taccuino di versi e disegni autografi, 1902-8, F. Cangiullo Fund, P. Conti Foundation, Fiesole

F. Cangiullo
Elenco artistico d'una compagnia d'operette, hardwritten, poems, F. Cangiullo Fund, P. Conti Foundation, Fiesole

F. Cangiullo
6 proof-shets of Piedigrotta, M. Martin-Malburet Collection, Paris

F. Cangiullo
Article «Roma Futurista» with author's corrections, F. Cangiullo Fund, P. Conti Foundation, Fiesole

F. Cangiullo
Serata in onore di Yvonne, Naples, 1914, autograph, F. Cangiullo Fund, P. Conti Foundation, Fiesole

L. Folgore
Le printemps en carousel, manuscript, with proofs of Sic, no. 5 May 1916. H.R.C. Univ. Austin, Texas

L. Folgore
Douler occidentale, manuscript, 1916, H.R.C. Univ., Austin, Texas

A. Jarry
Le Fouzi-Yama, author's manuscript, Beinecke Library, Yale Univ., New Haven

G. Kahl
Anniversaire, manuscript poems in the author's hand, 1899 and 1901, Beinecke Library, Yale Univ., New Haven

F.T. Marinetti
Poema, 1898, Beinecke Library, Yale Univ., New Haven

F.T. Marinetti
Lettera futurista a Cangiullo, Beinecke Library, Yale Univ., New Haven

F.T. Marinetti
Navigation tactile, Beinecke Library, Yale Univ., New Haven

F.T. Marinetti
Nietzsche, Beinecke Library, Yale Univ., New Haven

F.T. Marinetti
La poesia de Mallarmé, Beinecke Library, Yale Univ., New Haven

F.T. Marinetti
Portrait olfactif d'une femme, Beinecke Library, Yale Univ., New Haven

F.T. Marinetti
Dinamismo automobile, manuscript, M. Martin-Malburet Collection, Paris

F.T. Marinetti
Il teatro futurista sintetico, manuscript, Beinecke Library, Yale Univ., New Haven

F.T. Marinetti
Le couchant en délire, manuscript, H.R.C. Univ. Austin, Texas

F.T. Marinetti
Dinamismo automobile, manuscript, H.R.C. Univ., Austin, Texas

F.B. Pratella
Notte-Passioni, manuscript, H.R.C. Univ., Austin, Texas

F.B. Pratella
Deformazione lirica, manuscript, H.R.C. Univ., Austin, Texas

J. Romains
Effets, manuscript, poem in the author's hand, Beinecke Library, Yale Univ., New Haven

G. Severini
manuscript on Boccioni, H.R.C. Univ., Austin, Texas

G. Zarian, H. Nazariantz manuscript page in Armenian

Letters and Postcards

P. Albert-Birot
Postcard to Marinetti, February 25, 1919, Beinecke Library, Yale Univ., New Haven

G. Apollinaire
Letter to Marinetti, 1909, Beinecke Library, Yale Univ., New Haven

G. Apollinaire
Postcard to Marinetti, August 24, 1910, Beinecke Library, Yale Univ., New Haven

G. Apollinaire
Postcard to Marinetti, July 25, 1913, Beinecke Library, Yale Univ., New Haven

G. Apollinaire
Letter to Papini, January 23, 1914, G. Papini Archives, P. Conti Foundation, Fiesole

G. Apollinaire
Letter to Papini dated October 20, 1916, G. Papini Archives, P. Conti Foundation, Fiesole

A. Archipenko
Letter to Marinetti, October 26, 1913, Beinecke Library, Yale Univ., New Haven

G. Balla
Postcard to Cangiullo, F. Cangiullo Fund, P. Conti Foundation, Fiesole

G. Balla
Postcard to Marchi, Fam. Marchi Collection, Anzio

G. Balla
Postcard to Soffici, Papini and Carrà. Dec 2, 1913, G. Papini Archives, P. Conti Foundation, Fiesole

G. Balla
Postcard to Papini, Dec 3, 1913, G. Papini Archives, P. Conti Foundation, Fiesole

G. Balla
Letter to Soffici and Papini, Dec. 20, 1913, G. Papini Archives, P. Conti Foundation, Fiesole

G. Balla
Letter on Stravinsky, July 6, 1915, M. Martin-Malburet Collection, Paris

G. Balla
Collage post-card to P. Conti, 1917, P. Conti Foundation, Fiesole

G. Balla
Collage postcard to P. Conti, 1917, P. Conti Foundation, Fiesole

G. Balla
Collage postcard to P. Conti, 1917, P. Conti Foundation, Fiesole

G. Balla
Postcard to P. Conti, Rome, Dec. 19, 1917, P. Conti Archives, P. Conti Foundation, Fiesole

G. Balla
Postcard to P. Conti, Rome, Sept. 28, 1918, P. Conti Archives, P. Conti Foundation, Fiesole

G. Balla
Postcard to P. Conti, Antignano, Sept. 13, 1919, P. Conti Archives, P. Conti Foundation, Fiesole

G. Balla
Letter to V. Marchi, April 8, 1920, Fam. Marchi Collection, Anzio

G. Balla
Letter to Settimelli, E. Settimelli Fund, P. Conti Foundation, Fiesole

U. Boccioni and G. Balla
Letter to Papini, G. Papini Archives, P. Conti Foundation, Fiesole

U. Boccioni
Letter to Papini, March 1913 c., G. Papini Archives, P. Conti Foundation, Fiesole

U. Boccioni
Letter to Papini, G. Papini Archives, P. Conti Foundation, Fiesole

U. Boccioni
Letter to Carrà, Russolo, Marinetti, G. Papini Archives, P. Conti Foundation, Fiesole

Buzzi
Letter to Cangiullo, Sept. 25, 1915, F. Cangiullo Fund, P. Conti Foundation, Fiesole

F. Cangiullo
Letter to Marinetti, Naples, June 1910, Beinecke Library, Yale Univ., New Haven

F. Cangiullo
Letter to Marinetti, Nov. 10, 1910, Beinecke Library, Yale Univ., New Haven

F. Cangiullo
Letter to Papini, 1913, G. Papini Archives, P. Conti Foundation, Fiesole

F. Cangiullo
Postcard, 1915, M. Martin-Malburet Collection, Paris

F. Cangiullo
Letter to Balla with drawings, 1915, M. Martin-Malburet Collection, Paris

F. Cangiullo
Letter to Settimelli, E. Settimelli Fund, P. Conti Foundation, Fiesole

G. Cantarelli
Letter to P. Albert-Birot, March 17, 1917, H.R.C. Univ., Austin, Texas

G. Cantarelli
Letter to P. Albert-Birot, Aug. 28, 1917, H.R.C. Univ., Austin, Texas

R. Canudo
Postcard to Papini, G. Papini Archives, P. Conti Foundation, Fiesole

K. Čapek
Letter to Marinetti, 1913?, Beinecke Library, Yale Univ, New Haven

C. Carrà
Letter to Papini, April 14, 1913, G. Papini Archives, P. Conti Foundation, Fiesole

C. Carrà, L. Russolo. F.T. Marinetti, U. Boccioni
Postcard to Papini, G. Papini Archives, P. Conti Foundation, Fiesole

F. Chiesa
Letter to Marinetti, August 16, 1905, Beinecke Library, Yale Univ., New Haven

P. Conti
Letter to Russolo, Funi, Marinetti, Dec. 19, 1919, P. Conti Archives, P. Conti Foundation, Fiesole

B. Croce
Postcard to Marinetti, Cesena 1911, Beinecke Library, Yale Univ., New Haven

G. D'Annunzio
Letter to Marinetti, April 20, 1906, Beinecke Library, Yale Univ., New Haven

F.M. Delmarle
Letter to Marinetti, Jan. 25, 1918, Beinecke Library, Yale Univ., New Haven

L. Folgore
Letter to Papini, Dec. 17, 1914, G. Papini Archives, P. Conti Foundation, Fiesole

L. Fort
Letter to Marinetti, March 23, 1905, Beinecke Library, Yale Univ., New Haven

R. Ghil
Letter to Marinetti, Feb. 2, 1905, Beinecke Library, Yale Univ., New Haven

A. Gide
Letter to Marinetti, August 20, 1905, Beinecke Library, Yale Univ., New Haven

C. Govoni
Postcard to Cangiullo, F. Cangiullo Fund, P. Conti Foundation, Fiesole

C. Govoni
Letter to Papini, June 24, 1903, G. Papini Archives, P. Conti Foundation, Fiesole

A. Jarry
Letter to Marinetti, March 5, 1906, Beinecke Library, Yale Univ., New Haven

G. Kahn
Letter to Marinetti, March 18, 1901, Beinecke Library, Yale Univ., New Haven

J. Kurek
Telegram to Marinetti, Cracow Dec. 30, 1924, Beinecke Library, Yale Univ., New Haven

G.P. Lucini
Postcard to Marinetti, March 6, 1911, Beinecke Library, Yale Univ., New Haven

F.T. Marinetti
Letter to Rachilde, Feb. 6, 1899, H.R.C. Univ., Austin, Texas

F.T. Marinetti
Letter to Rachilde, Oct. 19, 1899, H.R.C. Univ., Austin, Texas

F.T. Marinetti
Letter to Papini, G. Papini Archives, P. Conti Foundation, Fiesole

F.T. Marinetti
Letter to Papini, Sept. 22,?, G. Papini Archives, P. Conti Foundation, Fiesole

F.T. Marinetti
Letter to Papini, Nov. 24, 1913?, G. Papini Archives, P. Conti Foundation, Fiesole

F.T. Marinetti (Russolo, Carrà)
Letter to Papini, June 30, ?, G. Papini Archives, P. Conti Foundation, Fiesole

F.T. Marinetti
Letter to Papini, signed Boccioni Ugo Piatti and Tullio Barbari, Sept. 22, ?, G. Papini Archives, P. Conti Foundation, Fiesole

F.T. Marinetti
Letter, F. Cangiullo Fund, P. Conti Foundation, Fiesole

F.T. Marinetti
Letter given by Carrà and Russolo to Papini, G. Papini Archives, P. Conti Foundation, Fiesole

F.T. Marinetti (with Carrà and Boccioni)
Letter to Papini, G. Papini Archives, P. Conti Foundation, Fiesole

F.T. Marinetti
Letter to Cangiullo, F. Cangiullo Fund, P. Conti Foundation, Fiesole

F.T. Marinetti
Letter to P. Albert-Birot, Feb. 2, 1919, H.R.C. Univ., Austin, Texas

A. Mazza
Letter to Cangiullo. F. Cangiullo Fund, P. Conti Foundation, Fiesole

A. Mazza(?)
Letter to Cangiullo, M. Martin-Malburet Collection, Paris

L. Mitzitch
Telegram to Marinetti, Fiume Dec. 25, 1926, Beinecke Library, Yale Univ., New Haven

A. Palazzeschi
Letter to Marinetti, Rome May 4,1912, Beinecke Library, Yale Univ., New Haven

A. Palazzeschi
Letter to Cangiullo, M. Martin-Malburet Collection, Paris

A. Palazzeschi
Letter to Papini, G. Papini Archives, P. Conti Foundation, Fiesole

G. Papini
Letter to Marinetti, May 18, 1913, Beinecke Library, Yale Univ., New Haven

G. Pascoli
Letter to Marinetti, Barga April 10, 1906, Beinecke Library, Yale Univ., New Haven

E. Prampolini
Letter to P. Albert-Birot, Dec. 2, 1918, H.R.C. Univ., Austin, Texas

E. Prampolini
Letter to P. Albert-Birot, Dec. 17, 1921, H.R.C. Univ., Austin, Texas

E. Prampolini
Letter to J. Peeters, H.R.C. Univ., Austin, Texas

H. de Régnier
Postcard to Marinetti, Sept. 4, 1905, Beinecke Library, Yale Univ., New Haven

L. Russolo
Letter to Papini, Palazzeschi, Soffici, Feb. 24, 1915, G. Papini Archives, P. Conti Foundation, Fiesole

Russolo, Funi, Marinetti
Letter to P. Conti, P. Conti Archives, P. Conti Foundation, Fiesole

V. de Saint-Point
Letter to Marinetti, Christmas 1909, Beinecke Library, Yale Univ., New Haven

C. Saint-Saëns
Answer to Marinetti, on the back of Futurism Manifest, Beinecke Library, Yale Univ., New Haven

J. Schmalzigaug
Letter his parents, Paris Dec. 20, 1911, R. van de Velde Gallery, Anvers

G. Severini
Letter to Marinetti, London April 19, 1912, Beinecke Library, Yale Univ., New Haven

G. Severini
Letter to Marinetti, Dec. 9, 1912, Beinecke Library, Yale Univ., New Haven

G. Severini
Letter to Marinetti, March 31, 1913, Beinecke Library, Yale univ., New Haven

G. Severini
Letter to Marinetti, Nov. 3, 1913, Beinecke Library, Yale Univ., New Haven

G. Severini
Spanish Dancers, posatcard to Marinetti, Dec. 24, 1913, Beinecke Library, Yale Univ., New Haven

G. Severini
Spanish Dancers, postcard to Marinetti, Jan. 24, 1914, Beinecke Library, Yale Univ., New Haven

G. Severini
Letter to P. Albert-Birot, H.R.C. Univ., Austin, Texas

G. Severini
Letter to Marinetti, March 28, 1914, Beinecke Library, Yale Univ., New Haven

V. Shershenevich
Letter to Marinetti, March 19, 1914, Beinecke Library, Yale Univ., New Haven

A. Soffici
Letter to Papini, G. Papini Archives, P. Conti Foundation, Fiesole

A. Soffici
Letter to Papini, G. Papini Archives, P. Conti Foundation, Fiesole

A. Soffici
Letter to Papini, Paris Maj 14,?, G. Papini Archives, P. Conti Foundation, Fiesole

A. Soffici
Letter to Marinetti, March 14, 1913, Beinecke Library, Yale Univ., New Haven

Vallette-Rachilde
Letter to Marinetti, March 6, 1908, Beinecke Library, Yale Univ., New Haven

E. Verhaeren
Letter to Marinetti, Lièges, Sept. 5, 1905, Beinecke Library, Yale Univ., New Haven

Music

M. Butting
Lichtspiel op. 1, 1921, cassette, Svenska Filminstitutet, Stockholm

M. Butting
Lichtspiel op. 1, 1921, by Walther Ruttman, two albums, Svenska Filminstitutet, Stockholm

F. Cangiullo
Centomestieri, operetta, handwritten score, Naples, 1906, F. Cangiullo Fund, P. Conti Foundation, Fiesole

F. Cangiullo
Bré-Bré-Bré, handwritten score from "Oriente". F. Cangiullo Fund, P. Conti Foundation, Fiesole

S. Mix
Profilo sintetico, music by Marinetti, 1924, L. Marinetti Collection, Rome; Istituto di Scriptura, Rome

F.B. Pratella
Two albums of articles on music, 1910-11 and 1913-34, F.B. Pratella Fund, P. Conti Foundation, Fiesole

F.B. Pratella
Trittico dramatico op. 35, arrangement for recitation and piano, E. Pratella Iwaszkiewicz Collection, Ravenna

F.B. Pratella
Trittico dramatico op. 35, 1922, score for recitation and orchestra, E. Pratella Iwaszkiewich Collection, Ravenna

F.B. Pratella
La guerra op. 32, 1913, score, Russolo-Pratella Foundation, Varese

F.B. Pratella
Rondò della vittoria, 1913, score, E. Pratella Iwaszkiewicz Collection, Ravenna

F.B. Pratella
L'aviatore Dro, 1920, score, E. Pratella Iwaszkiewicz Collection, Ravenna; Russolo-Pratella Foundation, Varese

F.B. Pratella
Per un dramma orientale op. 40, score, Russolo-Pratella Foundation, Varese

L. Russolo
Music sheet and letter from Marinetti to Pratella, April 15, 1914, Russolo-Pratella Foundation, Varese

L. Russolo
Score sheet and letter from Marinetti to Pratella, August 18, 1921, Russolo-Pratella Foundation, Varese

L. Russolo
Handwritten music, with notes, for concerts in Paris, Russolo-Pratella Foundation, Varese

L. Russolo
German, French and Italian patents for "rumorararmonio", Russolo-Pratella Foundation, Varese

L. Russolo
L'arco enarmonico - I precedenti e le origini, manuscript, Russolo-Pratella Foundation, Varese

L. Russolo
Programme for an "enharmonic bow" concert in Milan, 1925, Russolo-Pratella Foundation, Varese

L. Russolo
Model of a fifth for "enharmonic piano", 1931, Russolo-Pratella Foundation, Varese

L. Russolo
Bibliography on Russolo's Futurist activity, Russolo-Pratella Foundation, Varese

Record with Serenade and Chorale, Russolo-Pratella Foundation, Varese

Leaflet for "intonarumori" concert, April 21, 1914, Russolo-Pratella Foundation, Varese

Drawings - Caricatures

R. Barradas
*Portrait of Salvat-Papasseit,*1918, S. Eleuterio-Lligonta Collection, Barcelona

P. Conti
Caricature of Soffici, 1920, P. Conti Archives, P. Conti Foundation, Fiesole

A. Jarry
Comédies en vers, pencil on paper, H.R.C. Univ., Austin, Texas

A. Jarry
Gde Procession di Choeur d'Estime, drawings for text, H.R.C. Univ., Austin, Texas

A. Jarry
Ouverture d'Ubu Roi d'Alfred Jarry pour piano à quatre mains par C. Terrasse, lithograph, Le Mercure de France Ed., 1898, H.R.C. Univ., Austin, Texas

A. Jarry
Marche des Polonais (extraite d'Ubu Roi d'Alfred Jarry) pour piano, par C. Terrasse, lithograph, Le Mercure de France Ed., 1898, H.R.C. Univ., Austin, Texas

Oda a Guynemer, 1918, J. Wallcorba Plana Collection, Barcelona

Photographs

Badodi
Portrait of Boccioni, 1914, Calmarini Collection, Milan

G. Bisi (?)
Photodynamic of Boccioni, Calmarini Collection, Milan

U. Boccioni
Seven signed photographs, Calmarini Collection, Milan

U. Boccioni
I-We-Boccioni, Calmarini Collection, Milan

U. Boccioni
Colleoni, Calmarini Collection, Milan

A.G. Bragaglia
Portrait of Virgilio Marchi, Fam. Marchi Collection, Anzio

T. Modotti
Portrait of List Arzubide, 1925-26, G. List Arzubide Collection, Mexico City

N. Vais
Collage of a newspaper Photo with writing by Papini, G. Papini Archives, P. Conti Foundation, Fiesole

N. Vais
Two photographs of Papini, 1913, G. Papini Archives, P. Conti Foundation, Fiesole

N. Vais
Photograph of Palazzeschi, 1914, G. Papini Archives, P. Conti Foundation, Fiesole

Portrait of Carrà dedicated to Papini, P. Conti Foundation, Fiesole

First Futurist Congress, Milan, 1921, Istituto di Scriptura, Rome

Marinetti, 1908 c., Istituto di Scriptura, Rome

Marinetti with Futurist in Florence, Istituto di Scriptura, Rome

Marinetti in Capri, 1925, Istituto di Scriptura, Rome

Marinetti in South America, 1927, Istituto di Scriptura, Rome

Photograph of Marinetti's Car Accident, 1908 c., L. Marinetti Collection, Rome

Marinetti at the Front, L. Marinetti Collection, Rome

Marinetti in his Studio, Paris, 1900-5 c., L. Marinetti Collection, Rome

Marinetti in his Youth, Milan, L. Marinetti Collection, Rome

Marinetti in Egypt, 1884 c., L. Marinetti Collection, Rome

Marinetti, Sant'Elia, Boccioni at the Front, L. Marinetti Collection, Rome

Marinetti with an Armoured-car and machine-gun, L. Marinetti Collection, Rome

The Stridentist Group, Mexico City, 1926, B. de Maples Arce Collection, Mexico City

Portrait of F. Revueltas, Ing. S. Revueltas Collection, Mexico City

Portrait of Soffici and Papini, P. Conti Foundation, Fiesole

Catalogues

Ciurlionis Exhibition, London, Grafton Gallery, 1910, Elena Gaputyte Collection, London

Les Peintres futuristes italiens, Paris, Bernheim-Jeune Gallery, February 1912, L. Marinetti Collection, Rome

Exhibition of Works by the Italian Futurist Painters, London, The Sackville Gallery, March 1912, L. Marinetti Collection, Rome

Der Sturm: Futuristen, Berlin, April-May 1912, L. Marinetti Collection, Rome

Les Peintres futuristes italiens, Brusselles, Giroux Gallery, May-June 1912, L. Marinetti Collection, Rome

Scultura Futurista (Boccioni), Rome, Futurist Gallery, December 1913, L. Marinetti Collection, Rome

Natalia Goncharova, Moscow 1913, L. Marinetti Collection, Rome; Istituto di Scriptura, Rome

Les Peintres et sculpteurs futuristes italiens, Rotterdamsche Kunstring, May-June 1913, L. Marinetti Collection, Rome

Première exposition de sculpture futuriste (Boccioni), Paris, La Boétie Gallery, June-July 1913, and invitation, L. Marinetti Collection, Rome

Post-Impressionist and Futurist Exhibition, London, Doré Galleries, 1913, P. Destribats Collection, Paris

Futurismo, Cubismo, Espressionismo al Nemezti Szalon, 1913, Széchényi National Library, Budapest

Futurist Utställning Arturo Ciacelli, Stockholm, Gamla Högskolan, April-May 1913, L. Marinetti Collection, Rome

Fante di quadri, Moscow, 1913, L. Marinetti Collection, Rome

Pittura Futurista di Lacerba, Florence, November 1913-January 1914, L. Marinetti Collection, Rome

Esposizione di Pittura Futurista, Rome, Futurist Gallery, February-March 1914, L. Marinetti Collection, Rome

Esposizione Libera Futurista Internazionale, Rome, Futurist Gallery, April-May 1914, L. Marinetti Collection, Rome

Italian Futurist Painters and Sculptors, London, Doré Galleries, April 1914, L. Marinetti Collection, Rome

The Futurist Painters, London, Malborough Gallery, 1914, P. Destribats Collection, Paris

Futuristi e Espressionisti, Budapest, Széchényi National Library, Budapest

Grande Esposizione Boccioni, Pittore e Scultore Futurista, 1916, P. Conti Foundation, Fiesole

U. Boccioni, Grande esposizione Boccioni, exhibition catalogue, 1917, Musei Civici Rovereto; L. Marinetti Collection, Rome

Der Sturm, 1920, Staatsbibliothek Preussischer Kulturbesitz, Berlin

Exposition des pentres futuristes italiens ed conférence de Marinetti, Paris, Reinhardt Gallery, 1921, P. Conti Foundation, Fiesole

A great many anthologies, studies and catalogues have been devoted to different aspects of futurism. The aim of this book is not to repertoriate them all, especially because serious bibliographies running to 1974 have been published in Italian, in English and in French, such as *Contributo a una bibliografia del futurismo letterario italiano* (Archivio Italiano, Cooperativa Scrittori, 1977) and *Futurism and The Arts* by J.P. Andreoli de Villers (University of Toronto Press, 1975). Reprints of the most important magazines and exhibition catalogues as well as numerous books by Futurist writers and artists are corrently in print. We have therefore reduced the following list to a small number of interesting publications issued between 1974 and today.

General Works

Arte e fascismo in Italia e in Germania, Feltrinelli, Milan, 1974

E. Crispolti, B. Hinz, Z. Birolli, *Arte e Fascismo in Italia e in Germania*, Feltrinelli, Milan, 1974

Le Futurisme, "Europe", Paris, 1975

U. Piscopo, *Questioni e aspetti del futurismo*, Ferraro, Naples, 1976

Il Futurismo, Fabbri, Milan, 1977

G. Pampaloni, M. Verdone, *I Futuristi italiani*, Le Lettere, Florence, 1977

Repertorio futurista (edited by S. Lotti), Arte-viva, Rome, 1977

G. Armellini, *Le immagini del fascismo nelle arti figurative*, Fabbri, Milan, 1980

Futurism and the International Avant-Garde (forward by A. d'Harnoncourt e G. Celant), exhibition catalogue, Philadelphia Museum of Art, 1980

G. Lista, *Arte e politica*. Il futurismo di sinistra in Italia, Multhipla, Milan, 1980

Manifesti, proclami, interventi e documenti teorici del Futurismo 1909-1944 (edited by L. Caruso), S.P.E.S., Florence, 1980

Nuove Tendenze. Milano e l'altro Futurismo, exhibition catalogue, Electa, Milan, 1980

Oeuvres futuristes du Museum of Modern Art, New York, Centre G. Pompidou, Paris, 1980

Ricostruzione futurista dell'universo (edited by E. Crispolti), exhibition catalogue, Turin, 1980

A. Scriboni, *Tra nazionalismo e futurismo*, Marsilio, Venice, 1980

Futurismo e fascismo (edited by A. Schiavo), Volpe, Rome, 1981

Le Futuriste. Donna e letteratura d'avanguardia in Italia 1909-1944 (edited by C. Salaris), Edizioni delle Donne, Milan, 1982

V. Fletcher, *Dreams and Nightmares*, Smithsonian Institution Press, Washington, D.C., 1983

A.C. Hanson, *The Futurist Imagination*, Yale University Art Gallery, New Haven, 1983

F. Roche-Pézard, *L'aventure futuriste 1909-1916*, Ecole française de Rome, 1983

Futurismo a Firenze 1910-1920, exhibition catalogue, Sansoni, Florence, 1984

C. Salaris, *Storia del futurismo*, Editori Riuniti, Rome, 1985

Plastic Arts

Esposizioni futuriste, 26 esposizioni 1912-1918 (reprint), S.P.E.S., Florence, 1978

Giacomo Balla

G. Lista, *Balla*, Galleria Fonte d'Abisso Edizioni, Modena, 1982

Giacomo Balla, exhibition catalogue, Padova, Ed. ES Image, Rome, 1983

Giacomo Balla, Opere dal 1912 al 1928, exhibition catalogue, Tunske and Tunske, Zurich, 1985

Umberto Boccioni

Boccioni a Milano, exhibition catalogue, Mazzotta, Milan, 1982

Boccioni prefuturista, exhibition catalogue, Reggio Calabria, Electa, Milan, 1983

M. Calvesi, E. Coen, *Boccioni - L'opera completa*, Electa, Milan, 1983

Boccioni a Venezia, exhibition catalogue, Mazzotta, Milan, 1985

Carlo Carrà

Carrà - disegni (edited by M. Carrà and F. Russoli), Grafis, Bologna, 1977

Carlo Carrà - Ardengo Soffici. Lettere 1913/1929 (edited by M. Carrà and V. Fagone), Feltrinelli, Milan, 1983

Primo Conti

Primo Conti, Disegni 1912-1921, Giunti Martello, Florence, 1978

Primo Conti 1911-1980, exhibition catalogue, Vallecchi, Florence, 1980

Fortunato Depero

B. Passamani, *Fortunato Depero*, Martano, Turin, 1974

B. Passamani, *Depero*, Rovereto, 1981

Gerardo Dottori

E. Crispolti, *Dottori*, exhibition catalogue, Palazzo Costanzi, Trieste, 1974

Luigi Colombo Fillia

M. Pinottini, *Fillia*, Scheiwiller, Milan, 1976

Giuseppe Pellizza da Volpedo

Pellizza da Volpedo, exhibition catalogue, Electa, Milan, 1980

Enrico Prampolini

Enrico Prampolini (edited by F. Menna and S. Sinisi), exhibition catalogue, Istituto Latino-Americano, Rome, 1974

A.B. Oliva, *Prampolini*, Galleria Fonte d'Abisso Edizioni, Modena, 1985

Romolo Romani

Romolo Romani (texts by R. Barilli, S. Evangelisti, B. Passamani), exhibition catalogue, Mazzotta, Milan, 1982

Medardo Rosso

Medardo Rosso, catalogue, Frankfurter Kunstverein, Frankfort on the Main, 1984

Luigi Russolo

G.F. Maffina, *L'opera grafica di Luigi Russolo*, Ceal, Varese, 1977

G.F. Maffina, *Luigi Russolo e l'arte dei rumori* (with all musical writings), Martano, Turin, 1978

Gino Severini

M. Fagiolo, D. Fonti, *Gino Severini*, Daverio, Milan, 1982

Gino Severini (edited by R. Barilli), exhibition catalogue, Palazzo Pitti, Florence, Electa, Milan, 1983

Gino Severini prima e dopo l'opera (edited by M. Fagiolo), Electa, Florence, 1985

Mario Sironi

F. Meloni, *Mario Sironi*, Daverio, Milan, 1984

F. Bellonzi, *Sironi*, Electa, Milan, 1985

Ardengo Soffici

Ardengo Soffici, exhibition catalogue, Centro Di, Florence, 1975

Ardengo Soffici. L'artista e lo scrittore nella cultura del 900 (atti del convegno di studi), Villa Medicea, Poggio a Caiano, June 1975

Ardengo Soffici (1879-1964) (edited by L. Cavallo), exhibition catalogue, Galleria Farsetti, Prato, 1979

Literature

L. Caruso. S. Martini, *Tavole parolibere futuriste,* Liguori, Naples, 1974-77

G.P. Lucini, *Marinetti, futurismo, futuristi.* Saggi e interventi (edited by M. Artioli), M. Boni, Bologna, 1975

L. De Maria, *Palazzeschi e l'avanguardia,* All'insegna del Pesce d'oro, Milan, 1976

G. Lista, *Marinetti,* Seghers, Paris, 1976

*Filippo Tommaso Marinetti futurista.*Scritti di F.T. Marinetti e altri (inediti, pagine disperse, documenti e antologia critica edited by E.S.), Guida, Naples, 1977

G. Lista, *Marinetti et le Futurisme,* L'Age d'Homme, Lausanne, 1977

Scrittura visuale e poesia sonora futurista, exhibition catalogue, Florence, 1977

Palazzeschi oggi, Il Saggiatore, Milan, 1978

S. Lambiase, G.B. Nazzaro, *Marinetti e i futuristi,* Garzanti, Milan, 1978

I poeti del Futurismo 1909-1914 (edited by G. Viazzi), Longanesi, Milan, 1978

L. Caruso, *Francesco Cangiullo e il futurismo a Napoli,* S.P.E.S., Florence, 1979

Z. Folojewski, *Futurism and its place in the development of modern poetry.* A comparative study and anthology, University of Ottawa Press, Ottawa, 1980

Nuove tendenze, Milano e l'altro futurismo, exhibition catalogue, Electa, Milan, 1980

G. Belloli, *Iconografia di F.T. Marinetti,* Zarathustra-Silvia, Milan, 1982

N. Blumenkranz-Onimus, *La Poésie Futuriste Italienne,* Klincksieck, Paris, 1984

G. Lista, *Le livre futuriste,* Panini, Modena, 1984

A. Saccone, *Marinetti e il futurismo,* Liguori, Naples, 1984

Architecture, Theatre, Photography, Popular Arts, etc.

G. Antonucci, *Cronache del teatro futurista,* Abete, Rome, 1975

U. Artioli, *La scena e la dynamis,* Patron, Bologna, 1975

G. Hendricks, *Eadweard Muybridge,* Secker & Walburg, London, 1975

G. Antonucci, *Cronache del teatro futurista,* Abete, Rome, 1976

G. Lista, *Le Théâtre futuriste italien,* L'Age d'Homme, Lausanne, 1976

P. Fossati, *La realtà attrezzata.* Scena e spettacolo dei futuristi, Einaudi, Turin, 1977

L. Lapini, *Il teatro futurista,* Mursia, Milan, 1977

V. Marchi, exhibition catalogue, Genoa, Electa, Milan, 1977

E.J. Marey 1830-1904, Centre G. Pompidou, Paris, 1977

A.C. Alberti, *Poetica Teatrale e Bibliografia di Anton Giulio Bragaglia,* Bulzoni, Rome, 1978

G. Lista, *Futurismo e Fotografia,* Multhipla, Milan, 1979

A. Gilardi, *Muybridge,* Mazzotta, Milan, 1980

Fotografia futurista (edited by G. Lista), Musée d'Art Moderne de la Ville de Paris, Paris, 1981

Fotografia futurista italiana 1911-1939, exhibition catalogue, Musée de la Ville de Paris, Paris, 1981

E. Crispolti, *La ceramica futurista da Balla a Tullio d'Albissola,* exhibition catalogue, Faenza, Centro Di, Florence, 1982

C. Salaris, *La cucina futurista,* "La gola", 1, n. 3, December 1982-January 1983, Milan

E. Godoli, *Il Futurismo,* Laterza, Rome, 1983

E. Godoli, *Il Futurismo,* Guida all'architettura moderna, Laterza, Rome-Bari, 1983

La chronophotografie (edited by M. Frizot), exhibition catalogue, Beaune, 1984

Etienne-Jules Marey, Photo Poche, Paris, 1984

A. Longatti, *Disegni di Sant'Elia,* Banca Popolare di Lecco, Lecco, 1984

Antonio Sant'Elia (edited by D. Ashton and G. Ballo), exhibition catalogue, Mondadori, Milan, 1985

B. Chardère, G. and M. Borgé, *Les Lumière,* Payot, Lausanne, 1985

I futuristi e la fotografia (edited by G. Lista), exhibition catlogue, Panini, Modena, 1985

P.G. Gerosa, *Mario Chiattone,* Electa, Milan, 1985

A.M. Ruta, *Arredi futuristi,* Novecento, Palermo, 1985

L. Sauvage, *L'affaire Lumière,* Lherminier, Paris, 1985

G.F. Maffina,*Caro Pratella,* Girasole, Ravenna, 1980

Belgium

P. Mertens, *Jules Schmalzigaug,* Van de Velde, Brussels, 1984

Czechoslovakia

Kupka, exibition catalogue, Galerie Gmunzynska, Colonia, 1981

France

G. Apollinaire, *Lettere a F.T. Marinetti* (con il manifesto dell'Antitradizione futurista) (edited by P.A. Jannini), Quaderni della Fondazione Conti, Scheiwiller, Milan, 1978

La fortuna del Futurismo in Francia, Bulzoni, Rome. 1979

Felix Del Merle, exhibition catalogue, Carus Gallery, New York, 1982

Felix Del Merle, catalogue, Mantini- Ronchetti, Genoa, 1985

Hungaria

Julia Szabo, *Mattis Teutsch Janos,* Corvine, Budapest, 1983

Japan

Masamu Yanase, catalogue, Asahi Shimbun, 1985

Great Britain

Wadsworth, catalogue, Colnaghi, London, 1974

R. Cork, *Vorticism and Abstract Art in the First Machine Age,* Gordon Fraser, London, 1976

O. Pound, P. Grover, *Wyndham Lewis: A Description Bibliography,* Arckon Books, Folkestone, 1978

Futurismo/Vorticismo, Università di Palermo, 1979

Jeffrey Meyers, *The Enemy: A Biography of Wyndham Lewis,* Routledge and Kegan Paul, London, 1980

Wyndham Lewis (J. Farrington), exhibition catalogue, Lund Humphries, London and Manchester, 1980

Wyndham Lewis, catalogue, Anthony d'Offay Gallery, London, 1980-1983

H. Gaudier-Brzeska, sculptor, exhibition catalogue, Kettle's Yard, Cambridge, 1983

Vorticism and its Allies, catalogue (edited by R. Cork), Hayward Gallery, London, 1984

Henri Gaudier-Brzeska, L.E.P. Bâtiment, Saint Jean de Braye, 1986

Henri Gaudier-Brzeska - Dessins, Les Amis du Musée, Orléans, 1986

Mexico

El Estridentismo, "La Palatra y el Hombre", Veracruz, 1981

S. Fauchereau, *Les peintres révolutionnaires Mexicains,* 1985

L.M. Schneider, *Estridentismo 1921-1927,* Mexico Autonomous University, 1985

Belgium

P. Mertens, *Jules Schmalzigaug,* Van de Velde, Brussels, 1984

Portugal

J.A.Naves, *O Movimento futurista em Portugal,* Divulgaçao, Porto, 1981

Amedeo de Souza-Cardoso, Gulbenkian, Lisbon, 1983

Almada Negreiros, Gulbenkian, Lisbon, 1984

Russia

I. Ambrogio, *Formalismo e avanguardia in Russia,* Editori Riuniti, Rome, 1974

Le Futurisme, "Europe", Paris, 1975

Majakowskij, exhibition catalogue, Electa, Milan, 1975

Vrubel', Aurora, Leningrad, 1975

Larionov-Gontcharova Ratrospective, Musée d'Ixelles, Brussells, 1976

Russian art of the Avant-Garde. Theory and Criticism 1902-1934 (edited by J. Bowlt), The Viking Press, New York, 1976

Les ballets russes de Diaghilev, Centre Culturel du Marais, Paris, 1977

M.K. Ciurlionis, Vage, Vilnius, 1977

S.P. Compton, *The World Backwards, Russian Futurist Socks 1912-1916,* The British Library, London, 1978

Art et poésie russe 1900-1930. Testi scelti, exhibition catalogue, Centre G. Pompidou, Paris, 1979

M. Böhmig, *Le avanguardie artistiche in Russia.* Teorie e poetiche dal cubo-futurismo al costruttivismo, De Donato, Bari, 1979

M. Chamont, *Gontcharova, Stage Design and Painting,* Oresko Books Ltd., London, 1979

S. Fauchereau, *L'avant-garde russe,* Belfond, Paris, 1979

C. Ferrari, *Il Futurismo e la rivoluzione d'ottobre,* Pan, Milan, 1980

An introduction to Russian Art and Architecture (edited by R. Auty and D. Obolensky), Cambridge University Press, Cambridge, 1980

Russian avant-garde Art: the George Costakis Collection, Thames and Hudson, London, 1981

L'avanguardia a Tiflis, Venice University, 1982

Sieg über die Somne, Akademie der Künste, Berlin, 1983

M.K. Ciurlionis, Lithuanian Visionary Painter for Aleksis Rannit, Lithuanian Library Press, Chicago. 1984

Archipenko for Donald Karshan, Centre College, Dauville, Kentucky, 1985

Sweden

GAN, exhibition catalogue, Liljevalchs Konsthall, Stockholm, 1984

Van Torsten, Ahlstrand, *GAN,* Bignum, Lund, 1985

USA

G. Levin, *Synchronism and American Color Abstraction 1910-1925,* Braziller, New York, 1978

Index

Pino Abbrescia, Rome
Hinz Allschwil, Basel
Archivio Fotografico Comune di Milano
James Austin, Cambridge
Pilar Bayona Escat, Barcelona
John Bigelow Taylor, New York
Giorgio Boschetti, Milan
Luca Carrà, Milan
Mimmo Capone, Rome
Cauvin, Paris
Cinémathèque Française, Film Library,
Paris
Geoffrey Clements, New York
Diamar, Mogliano Veneto, Venice
Jacques Faujour, Paris
Foto Studio 3, Milan
Vlådimir Fyman, Prague
Mario Gerardi, Rome
Carmelo Guadagno, New York
Jiří Hampl, Prague
David Held, New York
Udo Hesse, Berlin
Jürgen Hinrichs, Munich
Ludex Holub, Malmö
Jacqueline Hyde, Paris
Bruce C. Jones, New York
Nado Katalin, Pécs
Keller, New York
František Krejcí, Prague
Labbet, Stockholm
Marcel Lannoy, Paris
Mirko Lion
Mariusz Lukawski, Lódź
Tord Lund, Stockholm
Herbert Michel, Zurich
Eric Mitchell, Philadelphia
Otto Nelson, New York
Sydney W. Newbery, Oxted
Padovan, Turin
Parlantini Pugnaghi, Modena
Parvum Photo, Milan
Foto Rapuzzi, Brescia
Reproduction Department Stedelijk
Museum, Amsterdam
Routhier, Neuchâtel
Adam Rzepka, Paris
Oscar Savio, Rome
Scala, Florence
Mark Smith, Venice
José Ricardo Suarez Hernandez, Mexico
City
Sunami, New York
Joseph Szaszfai, New Haven
Rodney Todd-White & Son, London
Malcolm Varon, New York
Vicari, Lugano
Ole Woldbye, Copenhagen
Dorothy Zeidman, New York
Teresa Zótowska-Huszcza, Warsaw
Van der Zwan, The Hague
Zygfryd Photojczak, Poznán

The photos of Sant'Elia's works from the
Paride Accetti Collection, courtesy of
Arnoldo Mondadori Editore, Libri d'Arte
e Cataloghi

© 1986 SIAE - Rome
Carlo Carrà
Luigi Russolo
Gino Severini

© 1986 SPADEM - Paris
Max Ernst
Fernand Léger
Georges Méliès
Francis Picabia
Pablo Picasso

© 1986 COSMOPRESS - Geneva
Augusto Giacometti

© 1986 BILD-KUNST - Frankfurt/Main
George Grosz
Jiří Kroha

© 1986 ADAGP - Paris
Georges Braque
Jósef Csáky
Robert Delaunay
Sonia Delaunay
Marcel Duchamp
Raymond Duchamp-Villon
Albert Gleizes
Natalia Goncharova
Vasilij Kandinsky
Frantisek Kupka
Mikhail Larionov
Henri Laurens
Alberto Magnelli
Léopold Survage
Jacques Villon

Committee of Friends of
Palazzo Grassi

President
Susanna Agnelli

Marella Agnelli
Umberto Agnelli
Mirella Barracco
Vittore Branca
Cristiana Brandolini D'Adda
Francesco Cingano
Attilio Codognato
Giancarlo Ferro
Gianluigi Gabetti
Knud W. Jensen
Michel Laclotte
Giancarlo Ligabue
Pietro Marzotto
Thomas Messer
Philippe de Montebello
Giovanni Nuvoletti Perdomini
Richard E. Oldenburg
Rodolfo Pallucchini
Giuseppe Panza di Biumo
Alfonso Emilio Peres Sanchez
Claude Pompidou
Cesare Romiti
Norman Rosenthal
Guido Rossi
Giuseppe Santomaso
Francesco Valcanover
Mario Valeri Manera
Bruno Visentini
Bruno Zevi

Secretary
Furio Colombo

Fotocomposizione Ruta - Milan (Italy)

Printed and bound in April 1986
Stabilimento grafico
Gruppo Editoriale Fabbri S.p.A.
Milan (Italy)